modernism

1914–1939

designing a new world

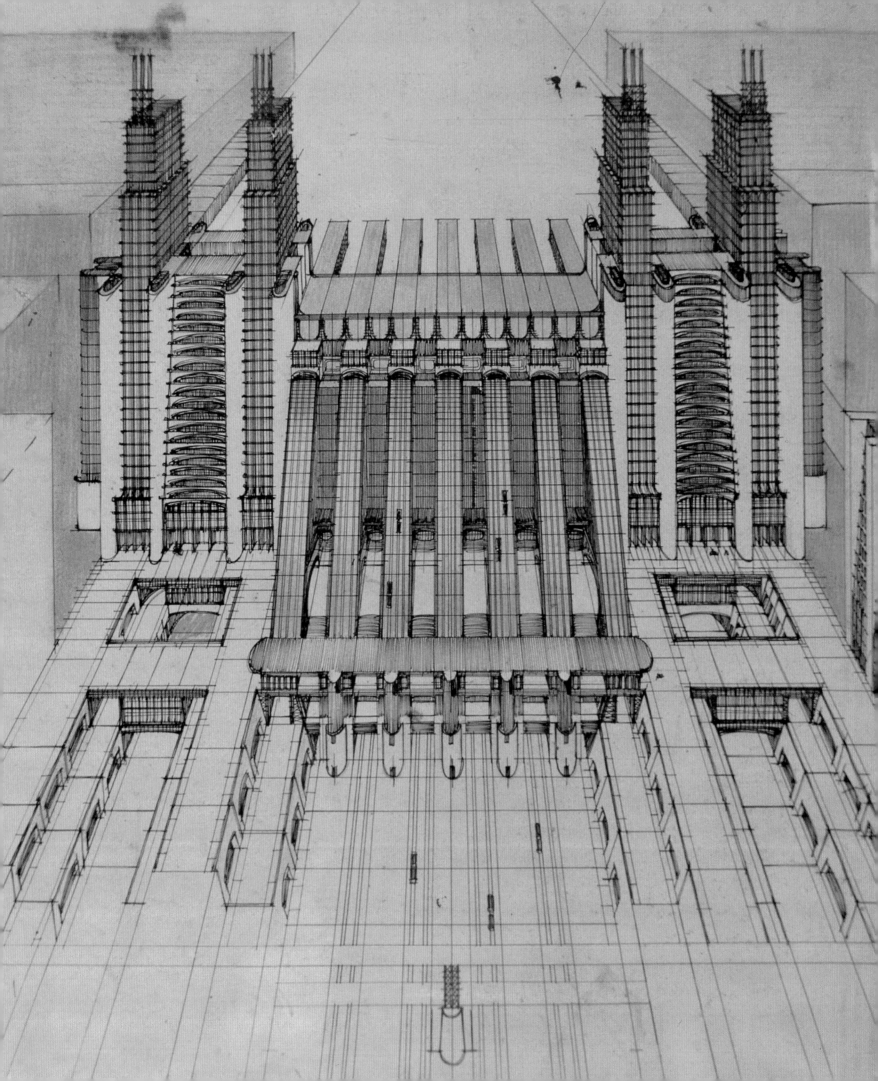

modernism

1914–1939

designing a new world

Edited by Christopher Wilk

V&A PUBLISHING

This book was published to coincide with the exhibition

Modernism: Designing a New World 1914–1939

at the following venues:

Victoria and Albert Museum, London
6 April – 23 July 2006

Museum MARTa Herford, Germany
16 September 2006 – 7 January 2007

Corcoran Gallery of Art, Washington, DC
17 March – 29 July 2007

First published by V&A Publications, 2006
Reprinted 2008
V&A Publishing
Victoria and Albert Museum
South Kensington
London SW7 2RL

Distributed in North America by
Harry N. Abrams, Inc., New York

Paperback edition
ISBN 978 1 85177 477 7
Library of Congress Control Number 2008924020

10 9 8 7 6 5 4 3
2010 2009 2008

A catalogue record for this book is available
from the British Library.

Designed by Philip Lewis
New V&A photography by Christine Smith,
V&A Photographic Studio

Cover design by Pentagram
Front jacket/cover illustrations (clockwise from top):
Alexander Rodchenko, *Dive* (cat.200); Marcel Breuer,
Club chair (cat.58); Hans Ledwinka, *Tatra T87* (cat.267)
Back cover illustration: Cornelis van Eesteren,
*Competition design for a shopping street with housing
above in Den Haag* (cat.87)
Frontispiece: Antonio Sant'Elia, *The Città Nuova* (cat.32a)
Page 6: W.H. Gispen, Giso Lampen poster (cat.137b)

Printed in Italy by Printer Trento

V&A Publishing
Victoria and Albert Museum
South Kensington
London SW7 2RL

www.vam.ac.uk

Contents

Sponsor's Foreword

Habitat is delighted to sponsor *Modernism: Designing a New World 1914–1939* at the V&A.

When Habitat was founded in 1964, our mission was clear from the outset – to make art and design an integral part of everyday life and accessible to everyone.

Modernism, the key point of reference for art, design and architecture in the twentieth century, has influenced Habitat's collections for the past four decades. Objects that embody the spirit of Modernism, from both past and current ranges, still look fresh in our stores and homes today.

Modernist ideals and aesthetics have timeless appeal. The Modernist belief that our daily lives can be improved through good-quality design – the belief that inspired the creation of Habitat – remains as important as ever.

Modernism has changed the way we live and work. We hope the exhibition and this book will inspire and excite you, just as Modernism has inspired innovative designs at Habitat over the years.

JENS NORDAHL, Habitat CEO

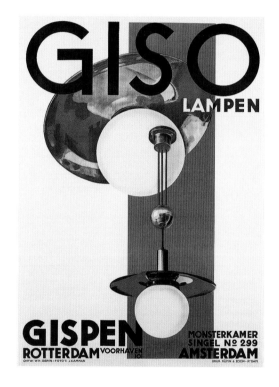

Acknowledgements

Exhibitions and publications such as this are inherently complex undertakings, which can only be realized through the hard work and expertise of large numbers of people. Though space precludes listing each and every one of them, I owe huge thanks to the staff of institutions who have lent to this exhibition or assisted with research, to many V&A colleagues, as well as to those from outside the Museum who have helped realize this project. We could not have found a more appropriate or sympathetic sponsor than Habitat. Thanks to their support, this exhibition has been realized on the scale originally envisaged.

The essay authors have been far more than contributors to the book. Originally they formed the Modernism Advisory Group, arising from a seminar held with a larger number of colleagues in the academic community. The regular meetings of the Advisory Group, taking place over the course of a year, were genuinely fruitful and enjoyable. They led both to the refinement and enlargement of the original exhibition concept and to all the members agreeing to write for the catalogue. Those who had the time also contributed substantially to the selection of objects and the writing of catalogue entries. I am grateful to all of them for their expertise and commitment.

My most immediate and long-term collaborators on this project, as Assistant Curators, have been Jana Scholze, and, more recently, Corinna Gardner. Both have worked with unstinting dedication and energy, and their efforts have been crucial in seeing both exhibition and publication to completion. The task of coordinating the loans and all aspects of the installation was meticulously managed by Tessa Hore, Exhibition Coordinator, working with Linda Lloyd Jones, Head of Exhibitions.

Our lenders are gratefully acknowledged on page 9, but among those individuals who have been especially helpful I would like to thank: Christof Groessl, Abeceda Antiquariat, Munich; Dr Christian Wolsdorff, Bauhaus Archiv, Berlin; Merrill C. Berman;

Barry Harwood and Kevin Stayton, The Brooklyn Museum, New York; Dr Bettina Gundler, Deutsches Museum, Munich; Eva Kjerström Sjölin, Museum of Cultural History, Kulturen, Lund; Dr Loránd Bereczky, Magyar Nemzeti Galéria, Budapest; Dr Helena Koenigsmarková and Dr Iva Janakova Knobloch, Museum of Decorative Arts, Prague; John Elderfield, Peter Galassi, Susan Kismaric and Cora Rosevear, The Museum of Modern Art, New York; Dr Jacek A. Ojrzynski, Muzeum Sztuki Łodz; Alfred Marks, Nederlands Architectuurinstituut, Rotterdam; Prof. Dr Florian Hufnagl, Dr Petra Hölscher, Dr Josef Straßer, Die Neue Sammlung, Munich; Pernette Perriand and Jacques Barsac; Tim Boon and Andrew Nahum, Science Museum, London; Irēna Bužinska, State Museum of Art, Riga; Dr Tatiana V. Goriatcheva, State Tretyakov Gallery, Moscow; Waltraud Fricke, Technisches Museum, Berlin; Dr Gerald Köhler, Theaterwissenschaftliche Sammlung, Cologne University; Violet Hamilton and Michael Wilson, Wilson Centre for Photography, London; and Silvia Barisione, Wolfsoniana, Genoa. We gratefully acknowledge the support of the Julie and Robert Breckman Print Fund for generously allowing us to acquire posters for this exhibition. Its long-term commitment to the V&A deserves particular thanks.

Research for this publication has benefited from the generosity of the following, in addition to those mentioned in the Notes: Jeremy Aynsley, Antoine Baudin, Paul Betts, Astrid Debus-Steinberg, Alexander Lavrentiev, Mai Petrovich Miturich, Oliver Morr, Dr Irena Murray, Maria Perers, Catherine Phillips, Jonathan Pritchard and Petr Roubal. Thanks are also owed to Prof. Aoi Morishita, University of Shiga Prefecture.

Among current and former V&A colleagues who have contributed to this project, I am particularly grateful to the members of my own department for their help and patience, especially Sarah Medlam, Linda Parry, Sonnet Stanfill and Gareth Williams. Thanks also to Lucy Trench for her sterling work on labels; Isabel Evans, Debra Isaac, Jane Rosier, Damien

Whitmore and especially Michael Murray-Fennell in Public Affairs; Betsy Fagin, Victoria Stott and Deborah Sutherland in the National Art Library; Kate Best, Rikki Kuittinen, Michael Snodin, Margaret Timmers and Zoe Whitely in Word and Image; Reino Liefkes and Eric Turner in the Sculpture, Metalwork, Ceramics and Glass Department; Ken Jackson and Christine Smith in the Photographic Studio; all sections of the Conservation Department and, especially for their work on the Frankfurt Kitchen, Shayne Rivers and Karen Melching; Robert Lambeth and Matthew Clarke of Technical Services; Rocío del Cesar and Catherine David in Exhibitions; and, finally, to colleagues in the Research Department, where the work for this exhibition was undertaken, including Glenn Adamson, Ulrich Lehmann and Carolyn Sargentson. Thanks are also due to volunteers, including Lyanne Holcombe, Susanna Huber, Alessandra Montioni, Kristine von Oehsen, Mario Pellin and Elliott Weiss, and to Eleni Bide for compiling the bibliography.

Eva Jiricna brought not only her architectural skills to the project, but a passion for Modernism that she communicated in her exhibition design. Warmest thanks are owed to her and to project architect Georgina Papathanasiou. Collaborating closely with them on graphic design was David Hillman and his colleague Amelia Gainford of Pentagram.

The publication of this book as a catalogue created many demands on those responsible for its production. I am immensely grateful to Mary Butler and her colleagues in V&A Publications, Frances Ambler, Geoff Barlow, Mora Bendesky, Clare Davis and, above all, Monica Woods, for their considerable efforts; to Mandy Greenfield, copy editor; and to Philip Lewis for his very thoughtful and sympathetic design.

Finally, I owe an immense debt of gratitude to my family, to Carolyn, Hannah, Sophie and Noah, for their understanding and support during the period of work on this project.

CHRISTOPHER WILK

List of Contributors

Tim Benton (TB) is Professor of Art History at the Open University. He has curated a number of exhibitions, including *Thirties in Britain* (1980), *Le Corbusier, Architect of the Century* (1987) and *Art and Power* (1996). He was co-editor of the V&A exhibition book *Art Deco 1910–1939* (with Ghislaine Wood and Charlotte Benton, 2003). Recent publications include 'Humanism and Fascism' in *Comparative Criticism* (2001) and 'La maison de week-end dans le paysage parisien' in *Le Corbusier et Paris* (2001).

Ian Christie (IC) is Anniversary Professor of Film and Media History at Birkbeck College, University of London, and Slade Professor at Cambridge in 2005–6. He has written widely on early cinema, British cinema and Russian cinema, and on the avant-garde. He co-curated the exhibitions *Eisenstein: Art and Life* (MoMA, Oxford, 1988) and *Spellbound: Art and Film* (Hayward Gallery, 1996). Books include *Eisenstein Rediscovered* (co-edited with Richard Taylor, 1993), *The Last Machine: Early Cinema and the Birth of the Modern World* (1994) and *A Matter of Life and Death* (2000).

David Crowley (DC) is a historian working at the Royal College of Art, London. His specialist interest is in the cultural history of Central Europe in the nineteenth and twentieth centuries. Recent publications include *Warsaw* (2003), 'Art Deco in Central Europe' in *Art Deco 1910–1939* (V&A, 2003) and an essay in *Communicate!: Independent British Graphic Design Since the Sixties* (edited by Rick Poyner, 2004).

Christopher Green (CG) is Professor of the History of Art at the Courtauld Institute of Art, University of London. He is the author of *Juan Gris* (1993), *Cubism and its Enemies* (1987), *Léger and the Avant-Garde* (1976) and of *The European Avant-Gardes – Art in France and Western Europe 1904–c.1945* (1995). He co-curated the exhibition *Henri Rousseau: Jungles in Paris* (Tate Modern, London, 2005).

Tag Gronberg (TG) is Reader in the History of Art and Design at Birkbeck College, University of London. Her publications on the art and design of the inter-war years include *Designs on Modernity: Exhibiting the City in 1920s Paris* (1998) and essays in the following exhibition catalogues: *L'Esprit Nouveau: Purism in Paris 1918–1925* (2001), *Art Deco 1910–1939* (V&A, 2003) and *Tamara de Lempicka* (2004). She is currently completing a book on Viennese art and culture around 1900.

Christina Lodder (CL) is Professor at the School of Art History, University of St Andrews. She is a leading specialist on the history and theory of twentieth-century Russian art and design. She is the author of *Russian Constructivism* (1983) and *Constructive Strands in Russian Art* (2005) and co-author of *Constructing Modernity: The Art and Career of Naum Gabo* (2000) and *Gabo on Gabo: Texts and Interviews* (2000).

Christopher Wilk (CW) is the curator of *Modernism: Designing a New World 1914–1939* and Keeper of the Furniture, Textiles and Fashion Department at the Victoria and Albert Museum. He is the author of books on Thonet, Marcel Breuer and Frank Lloyd Wright (V&A, 1993) and the editor of *Western Furniture 1350 to the Present Day* (V&A, 1996). He was the Chief Curator of the V&A's British Galleries 1500–1900 and co-editor of *Creating the British Galleries at the V&A, A Study in Museology* (V&A, 2004).

The following people have also contributed catalogue entries. All contributors are identified by their initials.

Glenn Adamson	GA	Paul Overy	PO
Kate Best	KB	Jana Scholze	JS
Corinna Gardner	CJG	Sonnet Stanfill	SS
Rikki Kuittinen	RK	Eric Turner	ET
Ulrich Lehmann	UL	Zoe Whitley	ZW

List of Lenders

Modernism: Designing a New World 1914–1939
Victoria and Albert Museum, London
6 April – 23 July 2006

Canada
Jane Corkin Gallery, Toronto

Czech Republic
Association of Czech Photographers, Prague
Brno City Museum
Museum of Decorative Arts, Prague
National Technical Museum, Prague

Finland
Alvar Aalto Museum, Jyväskylä

France
Fondation Le Corbusier, Paris
Musée Galliera, Musée de la Mode de la Ville
 de Paris
Musée National d'Art Moderne, Centre Georges
 Pompidou, Paris
Private Collection

Germany
Antiquariat Abeceda, Munich
Bauhaus Archiv, Berlin
Baumeister Archiv, Staatsgalerie Stuttgart
Deutsches Architekturmuseum, Frankfurt-
 am-Main
Deutsches Museum, Munich
Deutsches Spielzeugmuseum, Sonneberg
Galerie Schlichtenmaier, Gafenau
Kunstbibliothek, Staatliche Museen zu Berlin
Kunstsammlungen Chemnitz
Die Neue Sammlung – State Museum of Applied
 Arts and Design, Munich
Private Collection
Private Collection, courtesy of Galerie Alex
 Lachmann, Cologne
Staatliche Kunstsammlungen Dresden, Kupferstich-
 Kabinett
Stiftung Deutsches Technikmuseum Berlin
Stiftung Weimarer Klassik und Kunstsammlungen
Stuttgarter Gesellschaft für Kunst und
 Denkmalpflege

Theaterwissenschaftliche Sammlung, Cologne University
Ullstein Bild, Berlin
Wenzel-Hablik-Museum, Itzehoe
Werkbundarchiv – Museum der Dinge, Berlin
Westfälisches Schulmuseum, Dortmund

Hungary
Hungarian National Gallery, Budapest

Italy
Bühnen Archiv Oskar Schlemmer, The Oskar
 Schlemmer Theatre Estate
Centro Studi Giuseppe Terragni, Como
Galleria del Costume di Palazzo Pitti, Florence
Ottavio and Rosita Missoni Collection
Pinacoteca in Palazzo Volpi, Como
Wolfsoniana, Genoa

Latvia
Latvian National Museum of Art, Riga

The Netherlands
Centraal Museum, Utrecht
Gemeentemuseum Den Haag, The Hague
Nederlands Architectuurinstituut, Rotterdam
Stedelijk Museum, Amsterdam

Poland
Muzeum Sztuki Łodz

Russia
The Bakhrushin State Theatrical Museum, Moscow
Central State Archive of Literature and Art, Moscow
Moscow House of Photography
The Porcelain Museum, State Hermitage Museum,
 St Petersburg
Private Collection
Private Collection
Schusev State Museum of Architecture, Moscow
State Pushkin Museum of Fine Arts, Museum of
 Private Collections, Moscow
The State Tretyakov Gallery, Moscow

Sweden
KF Cooperative Union, Stockholm
Moderna Museet, Stockholm
Museum of Cultural History, Kulturen, Lund
The Royal Library, National Library of Sweden
SKF, Göteborg

Switzerland
Kunstmuseum Basel

United Kingdom
The British Museum, London
Collection of the Penthouse, Highpoint
Imperial War Museum, London
National Museum of Photography, Film and
 Television, Bradford
Private Collection
RIBA Drawings Collection, London
Sainsbury Centre for the Visual Arts, Collection of
 Abstract and Constructivist Art, Architecture
 and Design, University of East Anglia, Norwich
Samuelson Brothers
Science Museum, London
Tate, London
Wilson Centre for Photography, London

United States
Brooklyn Museum
Busch-Reisinger Museum, Harvard University Art
 Museums, Cambridge, MA
Merrill C. Berman Collection
The Metropolitan Museum of Art, New York
The Museum of Modern Art, New York
Private Collection, courtesy of Leslie Rankow
 Fine Arts, New York

*Note: the List of Lenders is correct at the time of
going to press.*

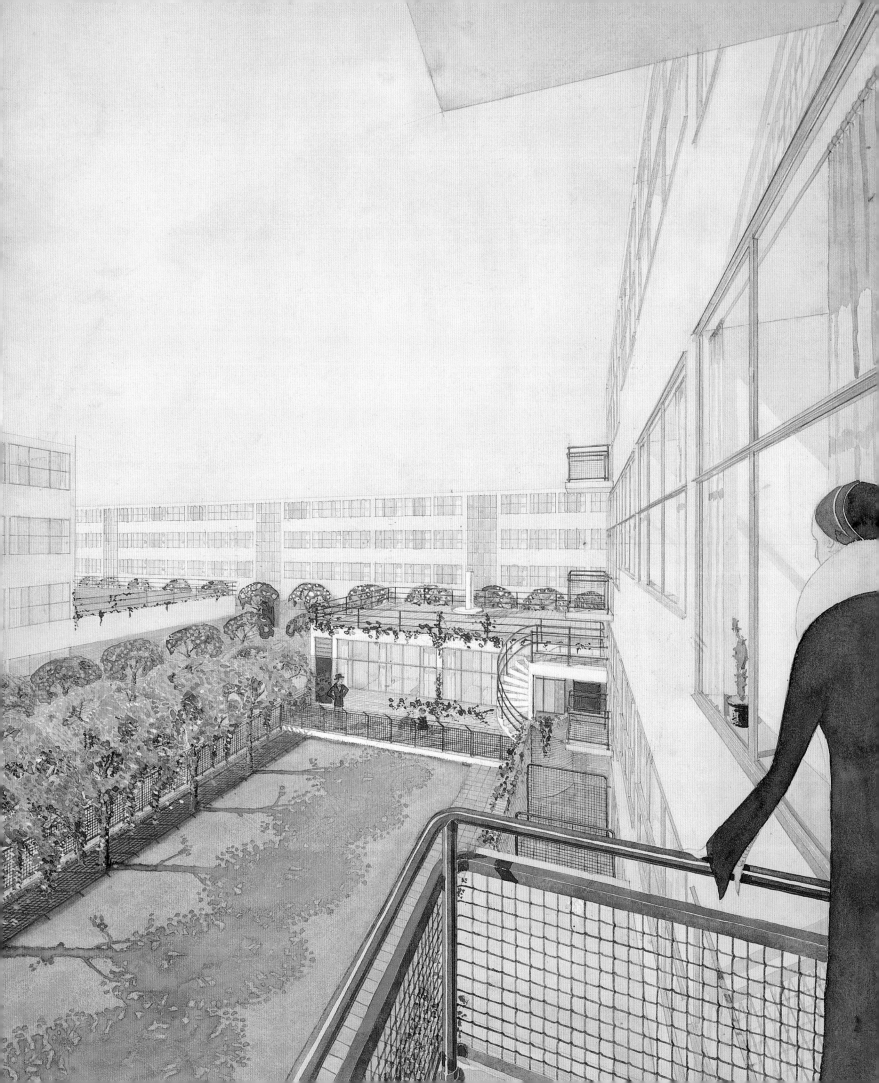

1

Christopher Wilk

Introduction: What was Modernism?

Today's artist lives in an era of dissolution without guidance. He stands alone. The old forms are in ruins, the benumbed world is shaken up, the old human spirit is invalidated and in flux towards a new form. We float in space and cannot perceive the new order.

Walter Gropius
Ja! Stimmen des Arbeitsrates für Kunst in Berlin
(Yes! Votes for the World Council for Art in Berlin)
(Berlin, 1919)

1.1 **J.J.P. Oud**, *Perspective of Courtyard*, Blijdorp Municipal Housing, 1931–2 (cat.103b)

At the beginning of the twenty-first century our relationship to Modernism is complex. Like many 'isms', it seems both to stand for something clearly definable – a major twentieth-century movement in art, architecture, design and literature, even culture – and yet to demand continuous and ever more probing investigation into its history and significance. We live with its legacy in material and intellectual terms; indeed, the built environment that we live in today was largely shaped by Modernism. The buildings we inhabit, the chairs we sit on, the graphic design that surrounds us have all been created by the aesthetics and the ideology of Modernist design. We live in an era that still identifies itself in terms of Modernism, as post-Modernist or even post-post-Modernist. It simply is not possible to work in ignorance of the most powerful force in the creation of twentieth-century visual culture.

Modernism is a term widely used, but rarely defined. Though restricted largely to the Anglo-American world, it is ubiquitous within that sphere, used not only in academic writing, but in the arts pages of newspapers and magazines, and on television and radio; yet its ubiquity hides a surprising vagueness and ambiguity of meaning. Vast numbers of articles and books – including very good ones – use the term Modernism without the authors ever explaining what they mean or how their use might differ from that of others, even when the word forms part of the title of their publications.[1] This results in a curious state of affairs in which anyone attempting to engage with the multiple meanings of Modernism (after all, many Modernisms have over the decades been retrospectively constructed) is forced into a position, by the lack of definition or explanation offered by others, of having first to explain what others mean when they use it. Some would say that ambiguity well suits work of such complexity and depth of meaning. However, when a term becomes embedded in contemporary culture, even used as a form of shorthand, it does not seem unreasonable to seek some form of clarity.

The subject of this book and the exhibition it accompanies is Modernism in the designed world. This implies the practice of 'design' in the widest possible sense of the word, including not only architecture, the hand- and machine-made object, furniture and furnishings, dress, industrial, graphic and theatre design, but also photography, painting, sculpture and drawing. However, it is also necessary to acknowledge the wider uses of the term Modernism during the period 1914 to 1939, as well as later.

While achieving agreement on a single definition of the term would be difficult, if not impossible, there would probably be a general consensus that we can readily identify examples of Modernist architecture (Le Corbusier, pl.1.2), design (products of the Bauhaus, pl.1.3), fine art (Piet Mondrian, pl.2.11), music (Arnold Schoenberg) and literature (James Joyce). Conversely, there might be agreement on what is not Modernist: historicism, academicism, that which eschews the new and embraces tradition. However, while Modernism in the categories listed above may share certain characteristics – notably formal innovation, a self-conscious desire to create something new, and a tendency towards abstraction – these different manifestations of Modernism do

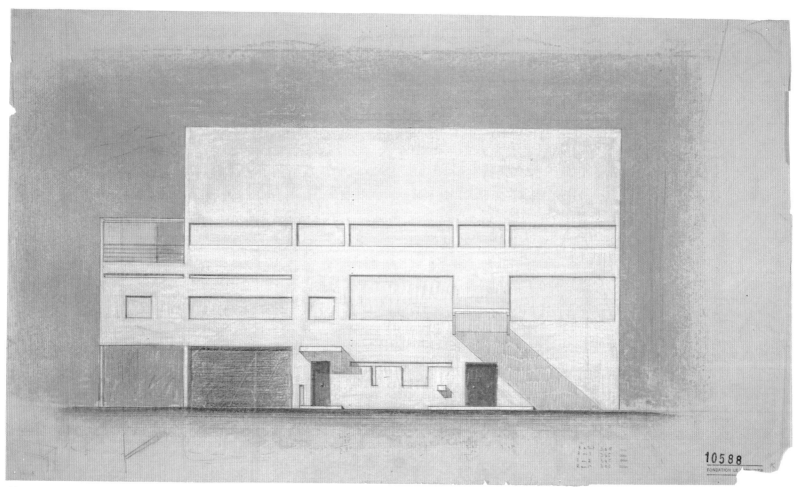

1.2

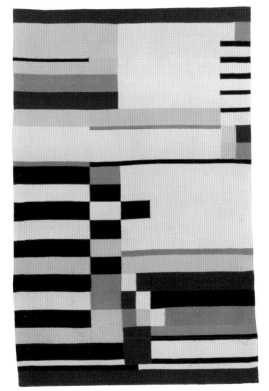

1.3

not necessarily share a chronological framework, or an engagement with the political consequences of their activity, which sometimes led to social radicalism and sometimes to a position of detached aesthetic autonomy.

How, then, was the term Modernism used historically and how is it used today, including in this publication? The *Oxford English Dictionary* cites – as did Samuel Johnson's *Dictionary* (London, 1755) – Jonathan Swift's use of the word in 1737, as a term of derogation for those he thought abused contemporary language. Nineteenth-century usage varied, but the term often meant something characteristically modern, of its time. Within the context of literature – its most common usage today – it has a lesser-known history of usage dating to 1888, most notably in Latin America.[2] *El Modernismo* referred to the French-influenced 'modern' poetry of Rubén Diarío and his contemporaries. Slightly later, the term was used in Spain to describe turn-of-the-century architecture and art.

It was in the inter-war years that the term was used more widely in literary studies, for example, in the titles of books and magazines, and (albeit less so) in a variety of other fields, for example, fashion, art and architecture.[3] In this broader usage, Modernism was rarely accompanied by a formulated ideological or aesthetic definition; rather it was used to describe the new or, in a slightly different form, a person who was an advocate of the new (a Modernist). It was thus derived from the noun 'the modern' or from the adjectival 'modern' (for instance, modern sculpture), and suggested modernness or a sense of forward-

looking contemporaneity.[4] As an abstract noun, 'modernism' was close to the German use of '*Die Moderne*' (the modern), which was widely used in the form of a noun, but also as a descriptive adjective.

Modernism was occasionally used during the 1920s to indicate the new architecture. Historian Henry-Russell Hitchcock used the word, but only in quotation marks, as a synonym for modernity in the context of criticizing architecture in New York City.[5] He used 'New Tradition' to refer to an older generation of architects of whom he approved (including Otto Wagner, Peter Behrens and Frank Lloyd Wright) and 'New Pioneers' (a phrase with particular resonance in America) for Gropius, Le Corbusier and others of the younger generation. Nikolaus Pevsner titled his 1936 book *Pioneers of the Modern Movement*.[6] Mention might also be made of the word 'modernistic', used as a term of derision during the 1930s by advocates of Modernism.[7]

One usage of Modernism widespread beyond the arts, which was used extensively during the early twentieth century, merits brief mention. Within the Catholic Church, Modernism described the attempt to reconcile historical Christianity with modern science and philosophy. In 1907 Pope Pius X issued the Vatican Encyclical 'On the Doctrine of the Modernists', which described Modernism as heretical, leading 'to atheism and to the annihilation of all religion'.[8] Although the etymology of this usage lies beyond this essay, it may well be that the negative and religious associations of the term in places where the battle over Modernism within the Catholic Church was fiercest (France, Germany and Italy) played a role in its lack of use in any other context .

Within the visual arts Modernism has different, sometimes contradictory, meanings beyond its early and most basic definition of indicating a new, distinctly modern outlook or the contemporary. Modernism in painting was given its canonical definition by the art critic Clement Greenberg, who, starting in 1939, wrote of what he called 'avant-garde art' and later described as 'Modernist painting'. Greenberg argued that such work referred only to itself and that its concerns were entirely aesthetic: 'the arrangement and invention of spaces, surfaces, shapes, colors, etc. to the exclusion of' anything outside of itself.[9] Most fundamental was 'the ineluctable flatness of the surface' in which 'one sees a Modernist picture as a picture first' rather than in terms of any subject.[10] For Greenberg and his followers, Modernism in painting began in the 1860s with the work of Manet and progressed through that of Cézanne to the defining moment of Picasso's Cubism, and then to Kandinsky and, eventually, post-war abstract art. This widely accepted definition, with its emphasis on aesthetic formalism and its rejection of any relationship between art and society, especially with popular culture, was subject to challenge by post-modern critics beginning in the 1960s, and yet it survived remarkably intact and is still used, with some modification, today.[11] It continues to serve as

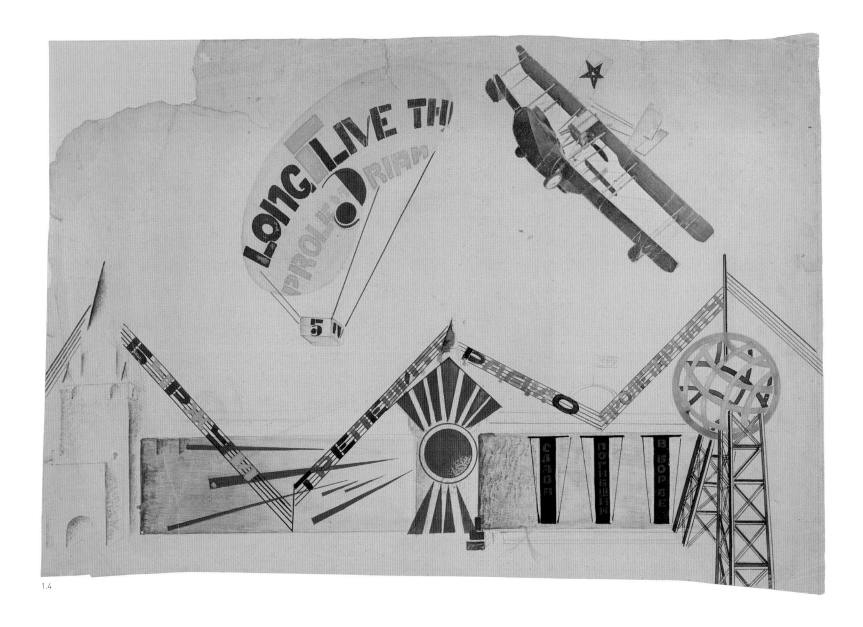

1.4

the crucial contrast to the definition of Modernism in the designed world offered below, a fundamental element of which was the engagement with social – and hence political – issues.

The use of Modernism as an historical term, divorced from meaning the contemporary, is much more recent. It was not used by Modernism's own polemicists, such as Walter Gropius, Sigfried Giedion or Nikolaus Pevsner either during the period or in later years, even when they wrote in (or were translated into) English; they adhered to earlier terminology (New Architecture, Modern Movement) and had no interest in distancing themselves from what they clearly regarded as the ongoing struggle for the values of the inter-war period.[12] However, by the late 1950s writers on architecture, at least in Britain, were using the term freely. In the pages of the *Architectural Review* 'modernism' was used both

to describe architecture of the inter-war era and recent building in the tradition of that earlier era.[13]

This book is concerned with Modernism in the designed world, and within that context it may be defined as follows: Modernism was not conceived as a style, but was a loose collection of ideas. It was a term that covered a range of movements and styles in many countries, especially those flourishing in key cities in Germany and Holland, as well as in Moscow, Paris, Prague and, later, New York. All of these sites were stages for an espousal of the new and, often, an equally vociferous rejection of history and tradition; a utopian desire to create a better world, to reinvent the world from scratch; an almost messianic belief in the power and potential of the machine and industrial technology (pl.1.4); a rejection of applied ornament and decoration; an embrace of abstraction (pl.1.5); and a belief in the unity of all the arts – that is, an

acceptance that traditional hierarchies that separated the practices of art and design, as well as those that detached the arts from life, were unsuitable for a new era. All of these principles were frequently combined with social and political beliefs (largely left-leaning) which held that design and art could, and should, transform society. While there was a wide diversity of adherence to these principles – which were subject to all manner of dissent and revision, especially in the 1930s – and considerably more complexity in practice than such a generalization can suggest, this characterization can be said to apply to a very broad range of work. In the 1930s Modernism became a style, used to identify new and innovative design based on abstract, rectilinear geometry and the use of industrial forms and materials; it was gradually stripped of its previous social and political beliefs, especially as it became part of the American marketplace. The

Museum of Modern Art 'Modern Architecture' exhibition of 1932, the accompanying publication of which was entitled *The International Style*, played a role in this, but by this time magazines (including those aimed at a popular audience) had begun to offer Modernism as one of a number of possible style choices for the home and its interior.[14]

Modernism was not only international and cosmopolitan in its outlook and practice, but, in George Steiner's term, 'extra-territorial'.[15] The leading Modernist designers and artists moved frequently between European capitals and sometimes New York and Los Angeles. Some were driven by political persecution (for example, Hungarians after the start of 'White Terror' in 1919) or by lack of opportunity, while others were attracted by the dynamism of artistic activity in Berlin or Paris. With the rise of fascism, they ranged further afield within the United States and emigrated to Palestine (under the British mandate), South America and South Africa. Modernists such as Ludwig Mies van der Rohe were correct in saying that their work was 'not just a phenomenon of our time and country, but rather part of a movement which is emerging across the whole world'.[16]

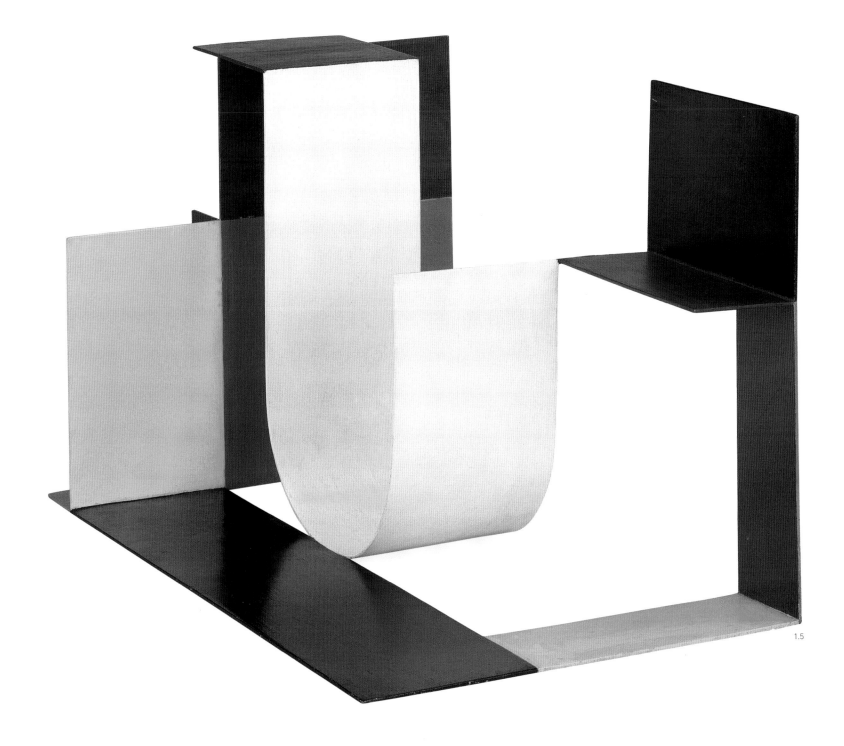

1.5

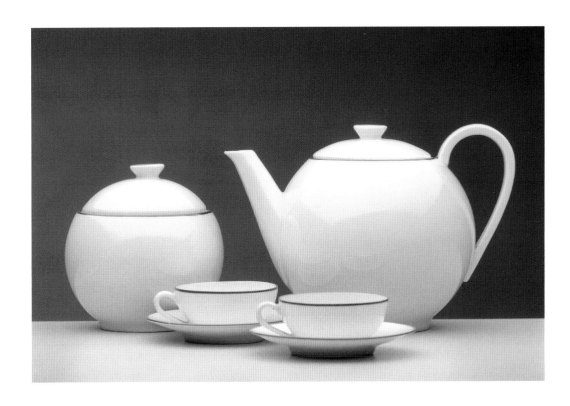

The choice of 1914 as the starting date of this publication is not meant to suggest that Modernism did not exist before the start of the First World War – Synthetic Cubism must surely be deemed Modernist painting (following Clement Greenberg's definition of Modernism), and there is architecture by Antonio Sant'Elia (frontispiece) and Walter Gropius from just before the war that can justifiably be described as Modernist. However, despite Pevsner's assertion that what he called 'Modern Movement' architecture 'was achieved by 1914', Modernism in the designed world did not exist in a fully developed form – at least as defined here – until well after the First World War. Indeed, the traumas of the war were crucial for inciting Modernism's subsequent utopianism and therefore for the forms that Modernism eventually took in the 1920s.[17]

Are there other terms that might usefully characterize some of the material and intellectual output of the inter-war period? In Germany, *Neues Bauen* (New Building or New Architecture) was used during the 1920s and is, retrospectively, used today; but although its association with architecture is not quite exclusive – it can also refer to the furnishings of those buildings – it is not all-encompassing enough to describe the full range of allied design phenomena. The English-language phrase 'the Modern movement' does not necessarily take in the full range of work represented by Modernism as used here, especially Expressionism and Nature-based Modernism. The term Functionalism, used at the time in (among other places) Scandinavia and Czechoslovakia (pls 1.6 –7), is evocative of the superior emphasis on function claimed by Modernist designers, and is inclusive not only of architecture, but a much wider range of design types. It too, however, excludes more expressive and less mainstream examples of practice. The application of the adjective 'modern' to architecture or art in many languages (for example, *moderne* in French, *moderno/a* in Italian) often indicates Modernist practice, but, as in English, can also signal solely the contemporary.

In recent years there has been much writing about the nature of modernity and its relationship to Modernism. 'Modernity' is traditionally used as a very broad term. It has been described by Jürgen Habermas as the ongoing 'project … formulated in the eighteenth century by the philosophers of the Enlightenment … to develop objective science, universal morality and law, and autonomous art according to their inner logic … for the rational organization of everyday social life'; or, more generally, by Marshall Berman as the 'mode of vital experience – experience of space and time, of the self and others, of life's possibilities and perils – that is shared by men and women all over the world today'.[18] In Berman's view, Modernity, which he described as 'the maelstrom of modern life', has been brought about by modernization, the process of scientific, technological and societal change. Modernism represents the 'visions and values' that have enabled men and women to become the subjects and objects of modernization, 'to make their way through the maelstrom and make it their own'. Such all-encompassing definitions provide a useful context and underpin the more chronologically focused

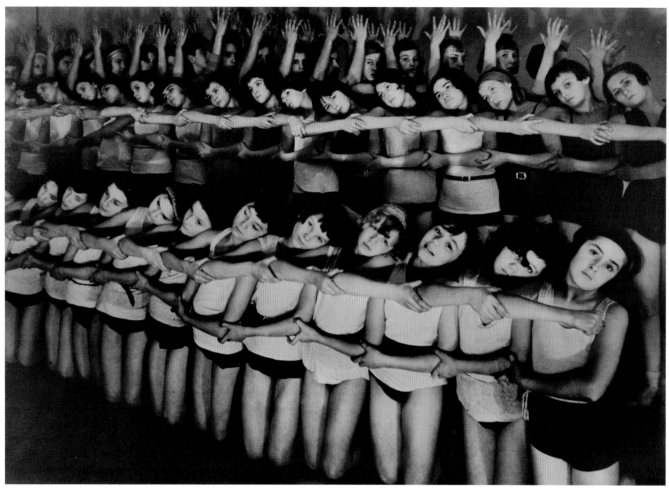

1.8

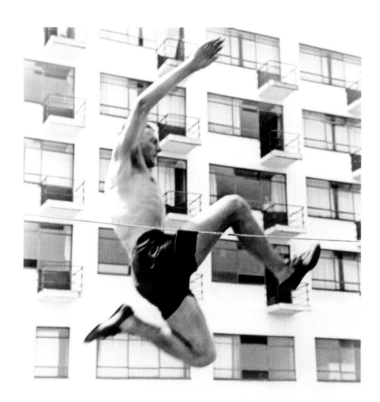

1.8 **Margaret Bourke-White**,
*Machine Dance, Moscow Ballet
School*, 1931 (cat.85)

1.9 **Hajo Rose**, *High jumper
in front of Prellerhouse*, 1930
(cat.198)

1.9

notion of Modernism described in these pages.

Exhibitions and exhibition publications tend to differ, by their nature, from monographs on large subjects like Modernism. The framing of the arguments for an exhibition are not only conceived in relation to existing literatures on the subject, but also build on the kinds of narratives that are made possible only through an engagement with surviving material. The objects and images in this exhibition, illustrated and catalogued in this book, tell a particular story. The subject of that story is Modernism in the designed world from the outbreak of the First World War until the start of the Second World War, in Europe and, to a lesser extent, the United States. It does not claim to offer a comprehensive review of that subject, country by country, discipline by discipline, nor does it attempt to include all that could possibly be described as Modernist in terms of a chronology (this might entail starting the story somewhat earlier and ending not before 1968). Instead, this book is focused on the key ideas and themes that underpin Modernism in its most crucial years, when it developed and achieved its canonical synthesis of forms and ideas. Undoubtedly others embarking on a similar project might identify different themes that merit exploration; but it is likely that any

such project would proceed from similar conceptual bases. It is difficult to see, for example, how Modernism could be understood without investigating the idea of utopia (both as a dream that existed on paper and as an experiment in actual building); the idea and image of the Machine; the special place of performance (pl.1.8) and of the healthy body culture within Modernism (pl.1.9); and, in the 1930s, Modernism's relationship with Nature (pl.1.10), national (largely politically based) reconsiderations of Modernism, and the ways in which Modernism entered the mass market. To these have been added a consideration of film as the ultimate Modernist medium, one that (while frequently acknowledged) is too often considered only on its own, segregated from other forms of Modernist art and design. While some of these topics may be seen as having long formed part of a canonical explanation of Modernism, their exposition here will hopefully suggest new approaches. As concerns looking at Modernism in terms of the contemporary view of the healthy body, of Nature and of film, these must surely be seen as a corrective to previous interpretations and hopefully as part of recovering topics that were central to Modernist practice and ideology.

In an effort to adequately address these themes,

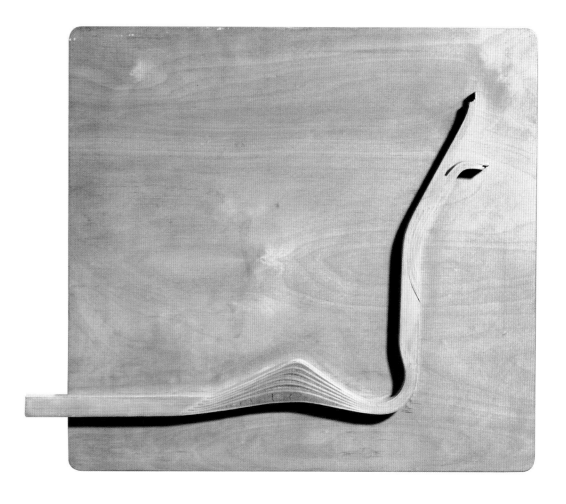

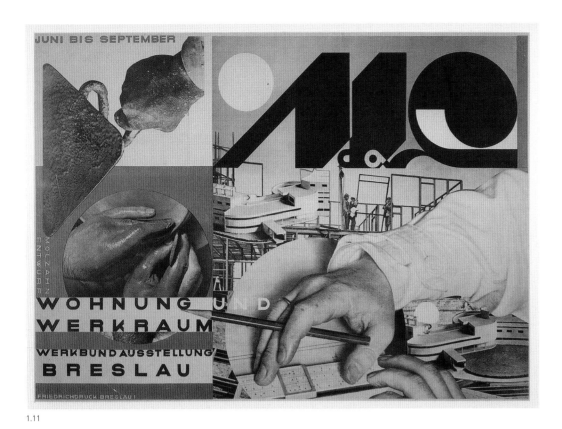

1.11

1.11 **Johannes Molzahn**, Poster for *Wohnung und Werkraum* (Dwelling and Workspace) exhibition, 1927 (cat.127)

1.12 **Charlotte Perriand**, *Fauteuil pivotant* (swivel armchair), 1928 (cat.156)

the scope of the exhibition had to be limited and compelling topics and important individuals unfortunately omitted. A global overview of the subject, however desirable, would have stretched the project's resources and prevented an in-depth consideration of Modernism's thematic core. For the same reason, and as the V&A is planning an exhibition on design during the Cold War era, an end date of 1939 has been chosen. Discussion of the Modernist view of ornament would have proved interesting, as would a consideration of the personal politics of individual practitioners; and it would have been useful to have been able to represent, for example, the work of Rudolf Schindler or the late 1930s American house; but given the organization and nature of this project, these and other topics fell outside what seemed most essential for the exhibition. The desire to emphasize architecture led to a concentration on housing at the expense of other forms – not because the skyscraper or the factory were insignificant forms, but because there were limits on what could be covered. Finally, it has not been assumed that the key figures and designs of Modernism have somehow been subjected to sufficient analysis – an attitude that has led some scholars to decide that more interesting subjects of research lie in the byways of practice, for example in amateur rather than professional output. While much fruitful work has been and remains to be done in terms of reconfiguring interpretations of Modernism or investigating its

'margins', in the context of an enterprise such as the current one such an approach would be at least wilful and at most inappropriate: despite the perception that exhibitions devoted to Modernism have been legion, the subject has in fact received little in the way of an overview.

The legacy of Modernism in the designed world for recent history is complex, controversial and naturally colours our view today. Attacks on Modernist design and its theoretical underpinnings in the 1960s ensured that, at least for some, it could no longer be regarded as ongoing. Instead it was increasingly treated by critics and friends alike as an historical phenomenon.[19] The criticism took the form of key texts such as Jane Jacobs's *The Death and Life of Great American Cities* (New York, 1961) and Robert Venturi's *Complexity and Contradiction in Modern Architecture* (New York, 1966), as well as the work of post-modern designers and architects.[20] The arguments gained momentum in the ensuing decade, finding fierce advocates in the 1970s, especially in Britain.[21] Among the most trenchant criticisms of Modernism was that in basing its argument on the idea that individuals wanted to divorce themselves from history, they lost all connection with valuable social and architectural traditions that gave pleasure, physical and intellectual comfort and a sense of place. Critics argued that by concentrating on a diffuse idea of social revolution, not to mention abstraction, Modernism was always doomed to alienate vast

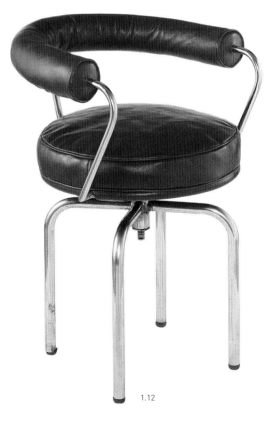

1.12

segments of the population whose views, in any case, were never sought. Within the context of a competitive intellectual climate and supportive media that value controversy, this backlash against Modernism in Britain has taken the form of attacks against Modernism's 'inhumanity' and, at its most extreme, against anything that can be tarred with the epithet of 'modern'.[22] The absurd conclusion becomes that no beauty can be found in Modernist production and nothing of worth ascribed to its ideas. Le Corbusier is thus found guilty of the crime of inspiring poorly designed and built concrete towers that actually had little to do with this work, but which were urgently needed to rehouse the population after the Second World War. This has contributed to a climate where, for some, everything to do with the Modernist project is viewed with suspicion. The key problem in blaming Modernist design of the inter-war years for the work of distant relations of the 1950s, 1960s and 1970s is precisely that it obscures crucial distinctions between the early and late work and inhibits understanding of the original enterprise. Because so many attitudes of the 1920s seem so remote to us today, there is all the more reason to pursue an understanding.[23]

Even allowing for differences in attitude and historical context during the years covered by this book between (and within), for example, Russia and Germany, Czechoslovakia and the United States, there was (especially until the worldwide economic collapse of 1929) a widespread utopianism, a belief in the possibility of a better future, and an embrace of technology (or the idea of technology) as the key means of attaining a better world, which could not be more at odds with today's thinking. However naive we find the utopianism of the years after the First World War, it is crucial to remember that Modernists sincerely and passionately believed that design based on the ideas and technologies of modern industrialization could solve the pressing problems of the day. Most Modernist designers and many artists were consciously engaged in a crusade to change the world for the better, to create a more just society,

to house (or rehouse) large sectors of the population (pl.1.11) and to create living environments that were visible and material expressions of those beliefs. Certainly there were debates regarding the extent to which technology and the machine should guide the appearance of design and art, but there was remarkable unanimity – from the communist, agrarian Soviet Union to industrialized Germany – that technology and the organization of work on the American model of Henry Ford and F.W. Taylor (at least as perceived in Europe) offered a way forward.

A world that has cumulatively witnessed not only Hiroshima but also Chernobyl, and that views human cloning and the genetic modification of crops with suspicion or outright hostility, has little faith in grand, technologically based schemes to right the world. Despite – and indeed because of – the mechanized horrors of the First World War, a wide segment of the population in 1918 saw an urgent need for reform, if not revolution, for the creation of new ways of living (pl.1.12), and for the application of scientific and technological ways of thinking to all aspects of life. This is an attitude that most seem to find foreign today.

Much as we live in a world in which most people find it impossible to believe in the idea of technology as a source for ameliorating the world's ills or as a possible means of encouraging social justice, so too we are sceptical of any type of large-scale (let alone visionary) schemes for our neighbourhoods, towns and cities. While attitudes differ between the developing and developed worlds, and between individual countries, there has been for many years – and remains – an overall disenchantment with the social engineering and the centralizing tendencies of governments that were such an integral part of the Modernist enterprise.

Modernism in the designed world may be a thing of the historical past. Some may admire it for its social goals and aesthetic achievements while others regard it as a malevolent force. As the most influential movement of the last century, however, there is a need to understand its intentions and meanings. Without that, we cannot fully evaluate its legacy.

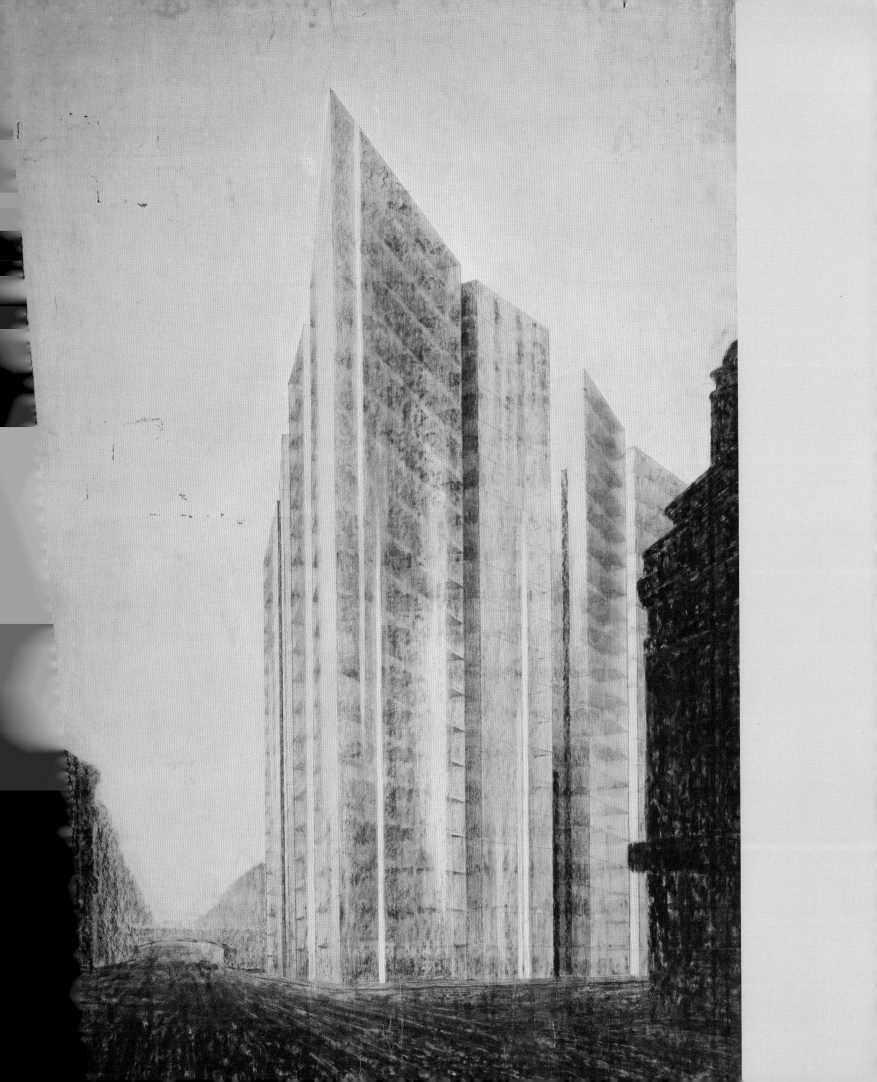

2

Christina Lodder

Searching for Utopia

There is a new spirit abroad: it is a spirit of construction and synthesis, moved by a clear conception of things. Whatever one may think of it, this spirit animates the greater part of human activity today. A great era ... has begun. [1]

Le Corbusier
L'Esprit Nouveau
(Paris, 1920)

2.1 **Ludwig Mies van der Rohe**, *Friedrichstrasse Skyscraper Project, perspective from north*, 1921 (cat.20)

Le Corbusier's consciousness of a 'new spirit' and a 'great era' of renewal was shared by many creative figures in the early 1920s. They too wanted to become significant participants in the reorganization of social life and the human environment.[2] Such aspirations had gained impetus during the First World War, when the widespread destruction and meaningless carnage galvanized artists and architects, and stimulated their visions for building a new world, which was materially, spiritually, politically, socially and visually a better place. Just as cultural certainties had disintegrated, Cubism had earlier overthrown pictorial traditions, creating two-dimensional geometric structures in which lines and planes provided new experiences of space, volume and transparency. Cubism provided a vision of a re-ordered, re-invented world, which not only artists but architects and designers cited widely in their publications as an exemplar of the great artistic changes taking place in the world around them. Cubism underpinned the solutions they devised for creating a new and better environment in the 1920s. In exploring the disparate visions of utopia within Modernism, I shall cut across familiar geographical or stylistic demarcations and suggest broader patterns and connections. I shall argue that utopianism also straddles the divides between affirmations and rejections of modernity within spiritual visions, Dionysian and rationalistic attitudes towards the Machine Age, and communist and socialist versions of a radical political ideology.

The word utopia is taken from the Greek and literally means both nowhere and a good place.[3] It was first coined by the statesman Thomas More in the sixteenth century to describe his ideal republic, where society would be rationally organized, there would be few laws, no private property, no military conflict and no war.[4] Of course, from Plato's *Republic* onwards, philosophers had conceived and written about a perfect society, in which the ills and problems that beset life in the present would be eradicated.[5] But if the drawbacks of the here and now were the constant problem, the solutions proposed were highly diverse. At one extreme was the application of science, to which I shall return. At the opposite end of the utopian spectrum was the call for a return to nature; the notion that a better world would emerge not from improving the external accessories of life or through the application of new technologies, but rather from restoring the inner world of emotional and spiritual values.

This tradition was the strongest inheritance from the late nineteenth century. Thus William Morris depicted an agrarian idyll in *News from Nowhere* (1890), reacting against the horrors of mechanized production and the problems of social dislocation associated with industrialization in Britain during the nineteenth century.[6] His vision fed the hopes and dreams of those associated with the Arts and Crafts movement both in Britain and elsewhere, inspiring the craftsmen and designers of the *Wiener Werkstätte* (Viennese Workshops) and the *Deutscher Werkbund* (German Work Association) in the early years of the twentieth century.

Spiritual utopia

Before the First World War a rejection of materialism and nineteenth-century positivist outlooks impelled painters associated with Expressionism to infuse the work of art with a spiritual dimension, and to promote the idea that art and architecture were thereby the means of saving mankind from modernity. The artists of *Die Brücke* (The Bridge) sought to alleviate their alienation from contemporary urban society by projecting images of a spiritual utopia in which man was in harmony both with his fellow man and with nature.[7] Meanwhile, the artists of *Der Blaue Reiter* (The Blue Rider), such as Franz Marc and the Russian-born Wassily Kandinsky, pursued a more explicitly spiritual aim. Kandinsky emphasized the

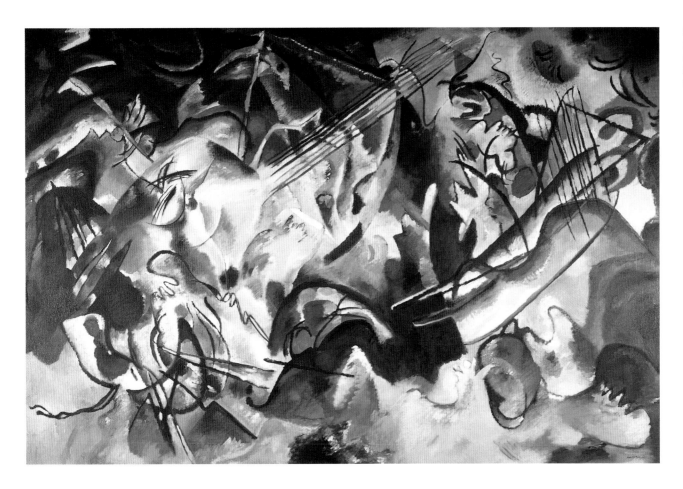

2.2 **Wassily Kandinsky**, *Composition VII*. Oil on canvas, 1913. State Hermitage Museum, St Petersburg

2.3

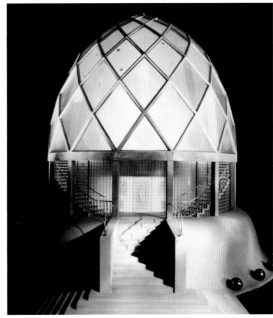

2.4

2.3 **Henry van der Velde**,
Theatre, 1914 *Werkbund*
Exhibition, Cologne.
Bildarchiv Foto Marburg

2.4 **Bruno Taut**, Model of
The Glass Pavilion, 1914/
1992–3 (cat.24)

need for art to embrace the *Geist*, a concept that included man's spirit, his soul, his intellect and his imagination – in other words, precisely those qualities that stood in direct opposition to the materialism of the modern world.[8] He explored the musical and emotional resonance of colour and produced paintings such as *Composition VII* (1913, pl.2.2), in which both forms and narrative (in this instance apocalyptic imagery) were veiled through line and colour, so that the inner spiritual truth would become manifest to his audience and create 'a direct impression on the soul'.[9]

In a similar quest for renewal, architects associated with Expressionism sought to develop a new architectural idiom, inspired by organic forms and crystalline structures. This was evident in 1914 at the *Werkbund* exhibition in Cologne, where Henry van der Velde exhibited a ground-hugging theatre, with organic curves that resembled the sleek forms of a crouching animal (pl.2.3). Bruno Taut's Glass Pavilion (pl.2.4), which was built almost entirely of glass, used a range of new products, including coloured glass bricks. The structure was no mere demonstration of glass's potential as a building material, but also explored the emotional and spiritual resonances that could be evoked. Taut even incorporated quotations from Paul Scheerbart, whose *Glasarchitektur* (*Glass Architecture*) of 1914 had presented the argument for an environment made entirely from glass:

If we wish to raise our culture to a higher level, we are forced for better or for worse, to transform our architecture. We shall only succeed in doing this when we remove the element of enclosure from the rooms in which we live. We can only do this, however, with glass architecture, which allows the light of the sun, moon and stars to enter not merely through a few windows set in the wall, but through as many walls as possible – walls of coloured glass. The new milieu created in this way must bring us a new culture ... Then we should have a paradise on earth ...[10]

Such aspirations were given added force during and after the war, when the mechanization of military conflict intensified distrust of the machine and of urban civilization among German architects generally. Taut and Walter Gropius formed the *Novembergruppe* (November Group) and the *Arbeitsrat für Kunst* (Work Council for Art) to develop further the notion that architecture was 'the direct carrier of spiritual forces, the moulder of the sensibilities of the general public'.[11] In December 1919 Taut formed *Die Gläserne Kette* (The Glass Chain), whose members (Taut, Wenzel Hablik, Hermann Finsterlin, Hans Scharoun, Wassily Luckhardt, Gropius and others) were dedicated to creating architectural visions of a new society, which included immense glass cathedrals, situated high in the unsullied purity of the mountains (pls 2.5–6). Such structures seem to possess an escapist character, especially in view of the harsh realities of contemporary Germany, but Iain Boyd Whyte argues that such visions represented a pursuit of the sublime.[12] *Die Gläserne Kette* adopted the image of the crystal, with its religious associations, while the transparency and dematerializing effects of glass took on a particular spiritual quality, encouraging contemplation and unity with nature. Taut saw the arts coming together to create an aesthetically integrated environment, which would both reflect and promote the development of an harmonious social structure. Ludwig Mies van der Rohe's Friedrichstrasse project (pl.2.1) brought such ideas

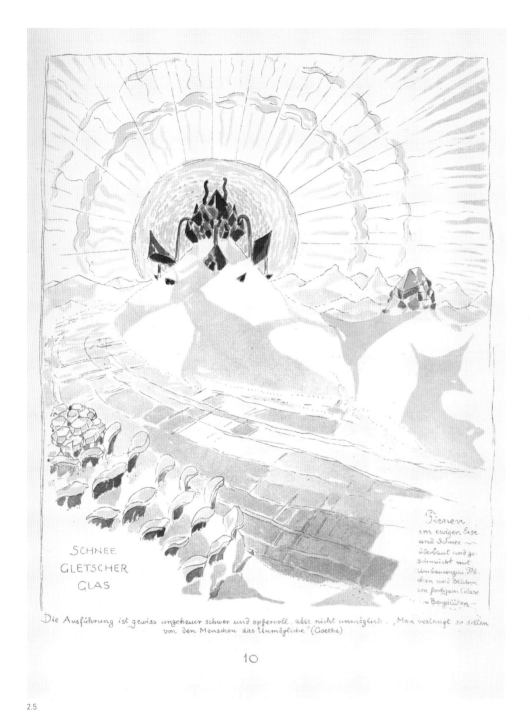

2.5

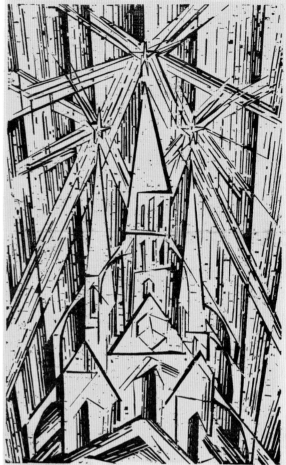

2.6

2.5 **Bruno Taut**, *Schnee Gletscher Glas*, page from *Alpine Architektur*, 1919 (cat.25a)

2.6 **Lyonel Feininger**, *Cathedral*, title page of *Programme of the State Bauhaus in Weimar*, 1919 (cat.26)

2.7 **Theodor Bogler**,
Combination teapot and
sugar bowl, 1923 (cat.18)

into the functioning urban environment, with its extensive use of glass, dematerialized form and crystalline ground plan.

Such ideals were also reflected in the early phase of the State Bauhaus school (*Staatliches Bauhaus*), as can be seen in its programme of April 1919 (pl.2.6):

Architects, painters, sculptors, we must all return to crafts! … a foundation in handicraft is essential for every artist … Let us therefore create a new guild of craftsmen without the class distinctions that raise an arrogant barrier between craftsman and artist! Let us together desire, conceive and create the new building of the future, which will combine everything – architecture and sculpture *and* painting – in a *single form* which will one day rise towards the heavens from the hands of a million workers as the crystalline symbol of a new and coming faith.[13]

Rejecting the industrialization and mechanization that were so closely associated with the war, the Bauhaus seemed to adopt the ideals of Morris and returned to hand-craft production, seeking to create 'organic forms developed from manual skills'.[14] Craft training, 'the basis of all teaching at the Bauhaus',[15] accompanied instruction in painting and drawing, colour theory, the science of materials, basic business studies and the history of artistic techniques.[16] The reference to the medieval system of workshops was made explicit in the organization and nomenclature of master and journeyman. After the six-month Preliminary Course, students enrolled for three years as apprentices in the workshops, where they received instruction from a form master (responsible for the artistic aspects) and a craft master (responsible for the technical aspects).

This educational structure inspired Bauhaus products, including hand-crafted teapots (pl.2.7) and medievalist chairs. It was particularly evident in the Sommerfeld House, Berlin, of 1923, designed by Gropius and the Bauhaus students (cat.28). Based on the traditional structure of a log cabin, with an organic feel to the deep overhanging eaves, the house was nonetheless sharper in the articulation of the windows and its hand-crafted interior decoration. The same medieval spirit underlay the design of the Haus am Horn of 1923, which had a double-height central area resembling a medieval quadrangle, around which were massed the separate living spaces, sequestered from the world and encouraging a life of contemplation and harmony.

Elements of spiritual utopia can also be found in Russia. Kazimir Malevich's abstract Suprematist paintings, which he developed during the First World War, possessed a strong mystical dimension. When he first exhibited his *Black Square* in 1915, he placed it in the corner of a room, in the position that icons occupied in a traditional Russian Orthodox home. In this way he imbued his image with the transcendental qualities of the icon and indicated that it embodied a metaphysical truth. At the same time, Malevich gave his works titles that referred to the fourth dimension, such as *Painterly Realism of a Football Player: Colour Masses in Four Dimensions*, indicating that his canvases expressed a different spatial awareness and a higher state of consciousness.[17]

After the Russian Revolution of October 1917, these spiritual and cosmic ambitions became more dominant in Malevich's paintings. He produced works such as *Dynamic Suprematism* (1917, pl.2.8), where he used a wider range of colours, including pastels, so that the forms read as concretized light. The following

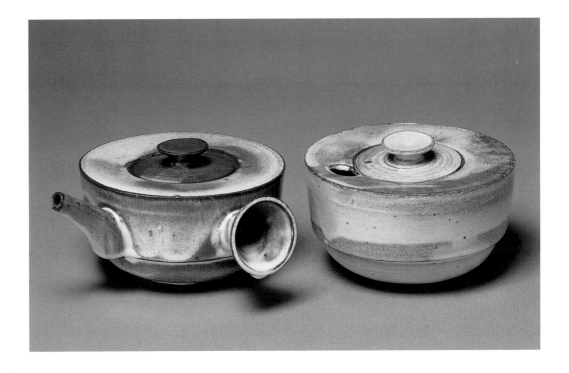

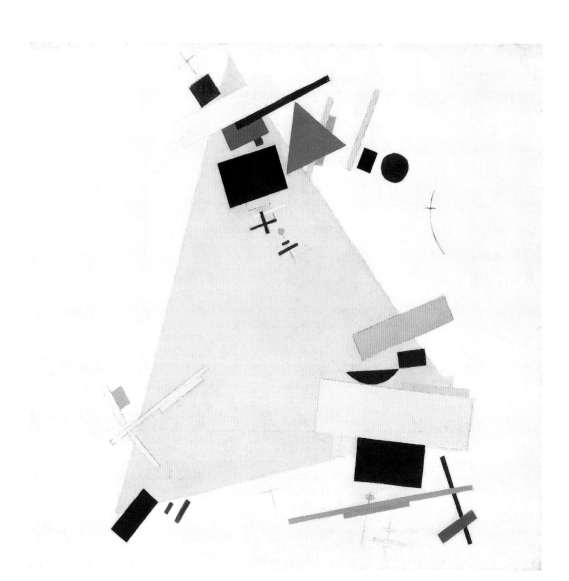

year he embarked on his series of *White on White* works. In these, the very intangibility of the form made space itself the essence of the work. Malevich subsequently sought to create a totally Suprematist environment, which would embrace all aspects of everyday life. In Vitebsk, where he was living from autumn 1919 onwards, he founded the *Unovis* group (*Utverditeli novogo v iskusstve*, Champions of the New in Art). For *Unovis*, the abstract artistic language of pre-revolutionary Suprematism, stripped down to coloured planes floating and interacting spatially against pure-white grounds, became the aesthetic corollary of the new social order. The group considered that such an art was universal in its likely impact on viewers, and in its potential application beyond the narrow confines of traditional artistic practices. It could be the basis for decorating buildings for the revolutionary festivals (1 May and 7 November) and for designing agitational posters (such as El Lissitzky's *Beat the Whites with the Red Wedge* of 1920), typographical layouts, textile prints and ceramics (cat.6).[18]

From 1920 onwards *Unovis* began to explore the architectural potential of Suprematism and produced designs such as *The Lenin Tribune* (later reworked and published by Lissitzky in the West).[19] In the early 1920s, Malevich himself started work on a series of abstract constructions, made from plaster, which he called *arkhitekton* (pl.2.9). These were abstract explorations of different combinations of cuboid elements, and were not conceived in response to the practical requirements of specific building types, such as hospitals or schools. In tandem with these, Malevich developed the notion of 'planits', or what he called 'the houses of the future', in a series of drawings (pl.2.10). These were essentially small satellites, which resembled the architectons in structure, and were arranged on the sheet horizontally to impart a feeling of flight. Occasionally Malevich specified particular locations and functions, such as *Future Planits for Leningrad: The Pilot's Planit (houses) of the Earthlings (people) of the future Leningrad.*[20] Sometimes he stipulated materials such as 'matt white glass, concrete, [and] tarred roofing

2.9 **Kazimir Malevich**,
Architecton Alpha. Plaster,
c.1920.

2.10 **Kazimir Malevich**,
*Future Planits for Earth
Dwellers*. Graphite pencil
on paper, 1923–4. Stedelijk
Museum, Amsterdam

felt' or mentioned 'electric heating without chimneys'. He even allocated colours; planits were 'predominantly black and white', but could also be 'red, black and white'. He explained: 'A planit is simple, like a tiny object, and all of it is within reach of the Earthling who lives in it. In good weather he could sit or even live on its surface . . . it is self-supporting . . . and, owing to its low shape, it is not dangerous.'[21] Malevich had an equally impractical notion of the science and engineering underlying his vision. He wrote, 'One only has to find the inter-relationship between the earth and the moon, two bodies racing along in space. Perhaps a new Suprematist satellite equipped with all the elements can be built between them; it will travel in its orbit, creating its own new path.'[22]

Malevich's planits belong to the large number of utopian visions based on the potentials of aviation in revolutionary Russia, where flight became a compelling metaphor for personal and political liberation. They possess strong affinities with the utopian ideas of the Russian philosopher Nikolai Fedorov, whose writings were published posthumously in 1906 and 1913.[23] He envisaged a communal social order based on spiritual harmony, and argued that humanity's scientific mastery would develop to the point where it would conquer death, man would attain immortality and turn the Earth into an enormous spaceship, travelling through the galaxies in search of suitable planets to colonize.[24] Malevich embraced a similar vision, although he emphasized the spiritual and physical liberation of the individual, travelling in space and immersed in the vastness of the universe.

In a less extreme form, the Dutch De Stijl (The Style) movement also manifested an impulse towards spiritual utopia during its initial phase. The group that coalesced around the magazine *De Stijl*, edited by Theo van Doesburg (cat.13), embraced a non-objective stylistic idiom, which was imbued with a spiritual meaning. De Stijl artists were profoundly influenced by the theories of Piet Mondrian, who was an ardent Theosophist and sought to create an aesthetic parallel to his spiritual beliefs. He produced paintings such as *Tableau I with Red, Black, Blue and Yellow* of 1921 (pl.2.11), in which pictorial language is reduced to the straight line, the right angle, and the three primary colours, plus white, grey and black, expressing

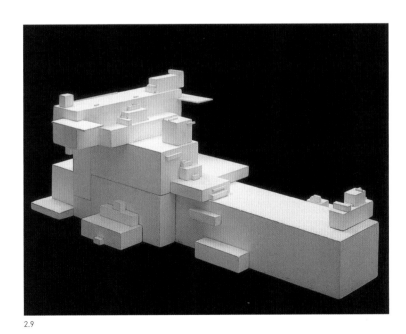

2.9

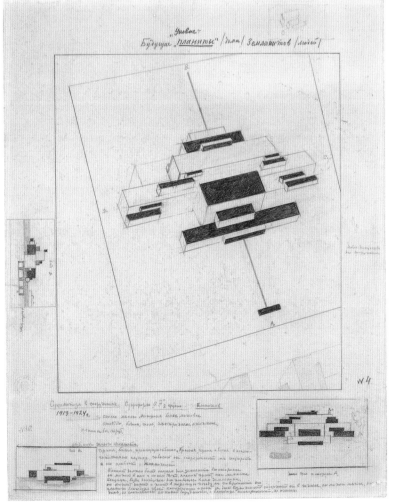

2.10

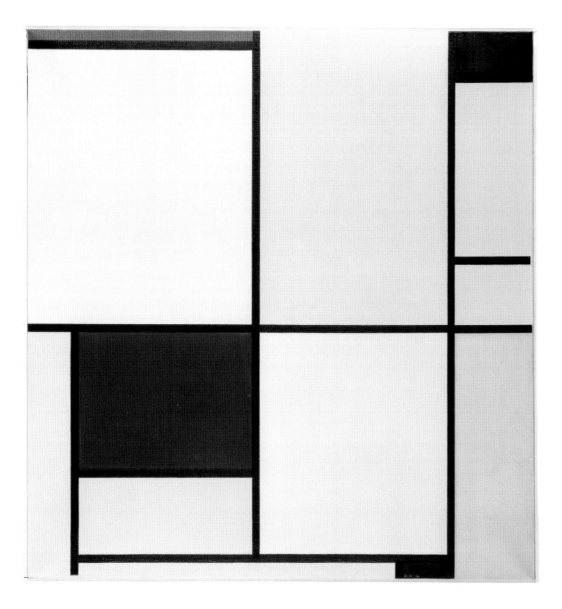

2.11 **Piet Mondrian**, *Tableau I with Red, Black, Blue and Yellow*, 1921 (cat.14)

2.12 **Gerrit Rietveld**, Armchair, 1918 (cat.12)

2.13 **Marcel Breuer**, Armchair, 1924 (cat.16)

through their interactions the dynamic equilibrium of the universe. He wrote, 'If art transcends the human sphere, it cultivates the transcendent element in mankind, and art, like religion, is a means for the evolution of mankind.'[25] From about 1916 onwards, the artists and designers associated with De Stijl sought to devise various kinds of environment that would bring all the arts into 'a constructive harmony that would herald a radically new post-war society'.[26] Gerrit Rietveld's chair (pl.2.12), although designed before his association with the movement, was seen to epitomize these ideals, with its structural supports and planar components acting as three-dimensional equivalents for the pictorial elements of Mondrian's painting.

The First World War demonstrated the total bankruptcy of a culture and a society that used reason and rational argument to send millions to their death.[27] This generated the construction of positive antidotes, but it also gave rise to more subversive and playful artistic gestures. Michel Foucault defines

heterotopia as 'a kind of effectively enacted utopia in which the real sites ... that can be found within the culture, are simultaneously represented, contested and inverted'.[28] It has been pointed out that in *Dandanah, The Fairy Palace* (cat.25b), Bruno Taut transformed children's traditional wooden building blocks into coloured glass shapes that could be used in a spirit of play, while representing a return to a naive and elemental kind of structuring.[29] These simple glass shapes also epitomized the link between glass and the spiritual state of humanity that was central to the visions of Taut and other German Expressionist architects.

More radically, the sense of disintegrating political and social structures was articulated in the aesthetic iconoclasm represented by Dada, with its goal of undermining all traditional values in literature and art. As Tristan Tzara explained in 1922, 'The beginnings of Dada were not the beginnings of art, but of disgust.'[30] Although Dada seems to have originated in Zurich in 1916, its ideas and activities were present in cities as

far apart as Bucharest, Barcelona, Cologne, Paris, New York, Hanover, Zagreb and Berlin. Dada virulently attacked the war, nationalism and materialism, pillorying the values that society held dear, overturning all artistic conventions, exploring totally unorthodox ways of creativity – everything from performance to photomontage. Its attack on reason and its celebration of the irrational was expressed by its name. In Zurich, Hugo Ball read sound poems composed of invented words, while dressed in cardboard cylinders designed by the Romanian artist Marcel Janco. In 1917 and 1918 the artist Christian Schad explored the role of chance in his *Schadographien* (Schadographs), which (like photograms) were produced by laying objects on photographic paper and exposing them to light – the same technique used by Man Ray in 1922 to produce what he called 'rayographs' (cat.51). In New York in 1917 Marcel Duchamp questioned the whole concept of art when he exhibited a urinal under the title *Fountain*. In Berlin, readymade photographic images and artefacts were assembled into satirical photomontages such as Hannah Höch's series *Schnitt mit dem Küchenmesser Dada durch die letzte weimarer Bierbauchkultrepoche Deutschlands* (*Cut with the Kitchen Knife Dada through the Last Weimar Beer-Belly Cultural Epoch of Germany*). At the first Dada Fair of May 1920 John Heartfield and George Grosz put a dressmaker's dummy in a uniform and topped it with a pig's head, while at the exhibition *Dada Vorfrühling* (the Dada Fair) in Cologne visitors entered through the lavatories and were invited to take swipes with an axe at Max Ernst's sculpture. In a sense, spiritual utopianism had reached its *reductio ad absurdum*.

Dionysian utopia

The other side of the coin was projecting science and technology as the means to creating utopia. Uniting and underlying many of the Modernist visions is the fact that they are rooted in the apparently endless possibilities that early twentieth-century science and technology had opened up. These inventions and discoveries provided the tools for forging a brave new world. In 1889 Gustave Eiffel had built his famous tower to demonstrate the potential of engineering and the way that prefabricated standardized components could be used to build tall structures (pl.5.15). By the end of the nineteenth century architects working in Chicago had solved the structural and stylistic problems of the skyscraper (pl.5.14). In 1903 the Wright brothers had defied gravity and taken an aeroplane into the air for the first sustained flight, and electric lighting was revolutionizing the urban landscape. At the same time science was discovering new qualities about reality and was revealing the complexities beneath the surface of visual appearances. By 1903 Pierre and Marie Curie had identified radium, and Wilhelm Röntgen had discovered the X-ray. Scientists had demonstrated the existence of subatomic particles such as the electron and nucleus. Radio waves were harnessed to send messages around the globe. The material world could no longer be considered solid and immutable, but rather as infused with invisible energies and forces, producing a constant state of flux.

The sense of heady excitement produced by all this is reflected in the Italian Futurists, who based their vision on the potential power of technology and celebrated the energy, violence and inherent dynamism of contemporary urban life. Their essentially emotional and sensual response to such developments might be categorized as Dionysian. Filippo Tommaso Marinetti's Futurist manifesto of 1909 includes a lurid account of a violent ride in a motor car, which careers through the city, inevitably ending in a crash.[31] Not surprisingly, his fellow Futurists declared, 'Living art draws its life from the surrounding environment … the tangible miracles of contemporary life – the iron network of speedy

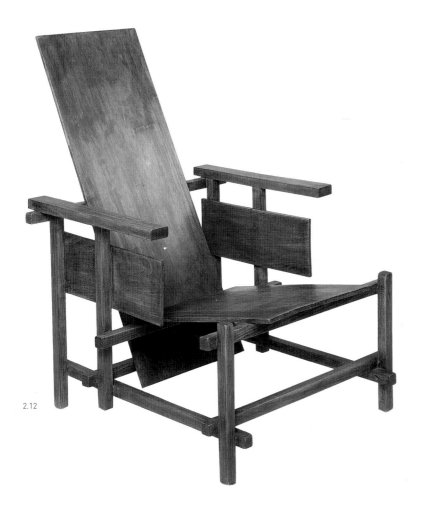

2.12

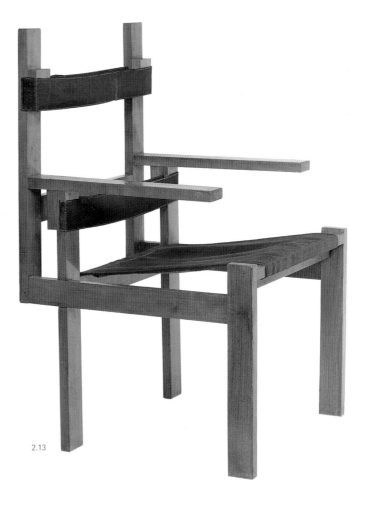

2.13

communications which envelops the earth, the transatlantic liners, the dreadnoughts, those marvellous flights which furrow our skies … '[32] Indeed, creative activity embodied the same energetic spirit. Marinetti declared, 'Art, in fact, can be nothing but violence.'[33] Painters sought to depict speed and the 'dynamic sensation' by initially employing a Divisionist technique, but after 1911 they harnessed the devices of Cubism (its networks of lines and planes) to convey the central flux of reality in their work through inter-penetrating planes. In paintings such as *States of Mind: The Farewells* of 1912, Umberto Boccioni effectively fused Cubist means with Futurist intentions, while his *Unique Forms of Continuity in Space* of 1913 expressed the fusion of man and his environment, the dynamism inherent within the figure, along with the intense motion of the figure cleaving through space.

Yet the Futurists wanted to use the machine not only to renovate Italian art and culture, but to transform every aspect of the Italian environment. They envisaged a world entirely re-created in terms of the machine: everything from music to toys, from architecture to the products of nature such as animals, vegetation and even the landscape itself.[34] Alongside designs for interiors, Giacomo Balla produced prototypes for Futurist flowers and Futurist clothing (pl.2.14). Man and buildings, too, were to be transformed. In 1914 the architect Antonio Sant'Elia became annexed to the movement, and the Manifesto of Futurist Architecture declared:

> We must invent and rebuild the Futurist city like an immense and tumultuous shipyard, agile, mobile and dynamic in every detail; and the Futurist house must be like a gigantic machine. The lifts must no longer be hidden away like tapeworms in the niches of stairwells; the stairwells themselves … must be abolished, and the lifts must scale the lengths of the façades like serpents of steel and glass. The house of concrete, glass and steel … must soar up on the brink of a tumultuous abyss; the street will no longer lie like a doormat at ground level, but will plunge many storeys down into the earth, embracing the metropolitan traffic, and will be linked up for necessary interconnections by metal gangways and swiftly moving pavements.[35]

Whatever the precise nature of Sant'Elia's links with the Futurists, his designs demonstrate an affinity with their vision (frontispiece, cat.32). The vast scale of his buildings, with their monumental massing, soaring towers, broad spans and high-slung bridges, overwhelm the viewer. These mammoth structures, possessing the latest mechanical devices, glorify the power of the machine, celebrate its dynamism and produce an environment that envelops the inhabitant with that power and energy.

Rational utopia

In stark contrast with Italian Futurism's orgiastic response to the machine, a more rationalist approach to scientific and technical progress came to prominence after the end of the war. This outlook again has deep historical roots. The first thinker to suggest that a perfect society could be attained simply by using science and technology to satisfy all of humanity's material needs was Sir Francis Bacon in *New Atlantis* (1627), in which he described a rational society ruled by scientists.[36] From this standpoint and given technological progress, attaining utopia seemed to be merely a question of time.[37] By the early twentieth century, improved methods of manufacture made the possibility of material plenty for all not merely a pipe dream, but a potential reality. Mechanization was revolutionizing all aspects of life. Goods could be manufactured more cheaply and in larger quantities than ever before. America led the way, possessing the technological expertise to which Europe and Soviet Russia aspired. Henry Ford's invention of conveyer-belt production and Frederick Winslow

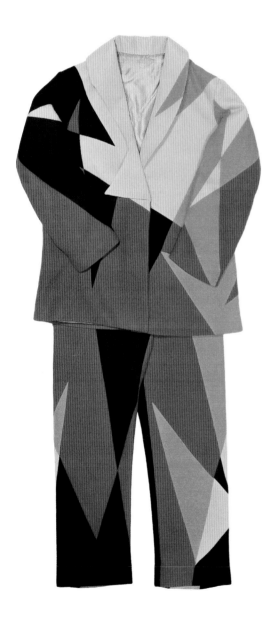

2.14 **Giacomo Balla**, Futurist suit, *c.*1920 (cat.33)

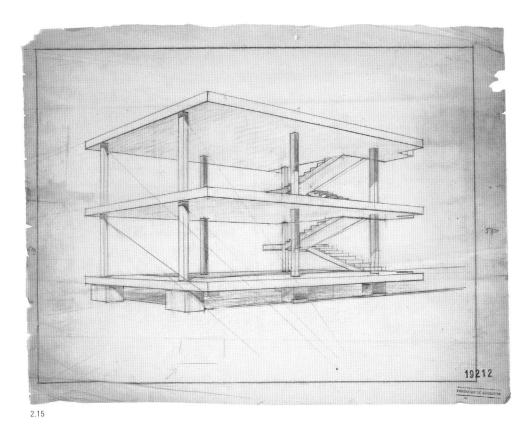

2.15

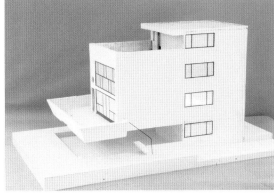

2.16

Taylor's theories of time and motion dramatically increased industrial efficiency and productivity (see Chapter 3). Prefabrication and industrial manufacture of building materials, in principle, allowed for cheap and efficient construction. It could be argued that Modernism's utopias were thus founded on the real potentials of the modern world.

Visions of the future were also formulated in opposition to the perceived evils of the present: materialism, repressive political structures and glaring social inequalities. Modernists rejected ornate bourgeois interiors along with the ugly urban sprawl and unhealthy slums of the working classes. Across the western world, industrialization and urbanization had left a legacy of overcrowded cities, 'old and rotting buildings' and poor sanitary conditions, which were responsible for all manner of diseases, general social degradation and high infant mortality rates.[38] In their place, Modernists envisaged a new type of environment – clean, healthy, light and full of fresh air (see Chapter 7).

This outlook is implicit in the notion of rational utopia that can be identified with Le Corbusier's architecture, *L'Esprit Nouveau* (The New Spirit, cat.122), French Purism and the painting of Fernand Léger (pl.3.2), Amédée Ozenfant and Charles-Edouard Jeanneret (alias Le Corbusier). For these creative figures, industry, the rationality of the machine and advanced technology were key elements in the construction of utopia. The 'object type' or the everyday object, whose form had been perfected through utility and practicality and mass production, became the chosen subject of their paintings, such as *Still-life with a Pile of Plates* (pl.3.7).

The architecture of Le Corbusier emphasized the purity of mathematics and the rationality of the machine. For him, architecture was a 'pure creation of the mind'.[39] Later his work has been associated with mechanisms of social control rather than liberation, and his designs have even been characterized as dystopian, from the Greek *dys* and *topos*, meaning a bad place.[40] Yet we should not lose sight of the progressive ideas that informed his work. Le Corbusier may not have wanted to produce radical changes in the social structure, but he did want to improve it by making it more stable. He ended *Vers une Architecture* (*Towards a New Architecture*) of 1923 with the warning 'Architecture or Revolution. Revolution can be avoided.'[41] He explained, 'The problem of the house is the problem of the epoch. The equilibrium of society depends upon it. Architecture has for its first duty, in this period of renewal, that of bringing about a revision of values, a revision of the constituent elements of the house.'[42] He conceived his Dom-ino project (pl.2.15) in response to the destruction of buildings in France, harnessing the achievements of contemporary engineering technology in order to project cheap, rapid and rational solutions to the problem of industrially produced mass housing. It has been argued that in so doing he was adapting Taylorist principles to architecture.[43]

Dom-ino and the Citrohan House (which developed from it, pl.2.16) were part of a wider vision. In 1922 Le Corbusier unveiled his blueprint for A Contemporary City with three million inhabitants (cat.36). At the centre was a transport network, which had railway stations, surmounted by motorways, which in turn were surmounted by an airport. Huge office and housing blocks were surrounded by trees and parkland. Three years later he produced the *Plan Voisin* (the Voisin Plan), which he exhibited in his Pavillon de l'Esprit Nouveau, at the *Exposition Internationale des Arts Décoratifs et Industriels Modernes* (International Exhibition of Modern Decorative and Industrial Arts). This imposed a rational order on the chaotic structure of contemporary Paris.[44] It involved demolishing 'a particularly antiquated and unhealthy part of Paris' – in fact, most of Paris between the Seine and Montmartre – in order 'to build a new city'.[45] The title reflected the support of Voisin, aircraft manufacturers who in peacetime had turned to producing motor cars, but it also emphasized the rationality of industrial production that underpinned its essential premises.[46] The grid that Le Corbusier created for the city imposed a rational structure on the existing chaos. This, as Andrew McNamara has pointed out, possessed not only technological but also emotional

ramifications, since, for Le Corbusier, the 'regulating line is a satisfaction of a spiritual order'.[47]

Peter Serenyi has related Le Corbusier's vision of a new type of city to Charles Fourier's vision of a perfect cooperative society.[48] Fourier envisaged people living in '*phalanstères*' (phalansteries), which consisted of 1,620 individuals and were small-scale rural communes, with a basic egalitarian structure (although social differences were observed), and which were dedicated to human pleasure and self-fulfilment.[49] Another interpretation is provided by Robert Fishman, who has connected Le Corbusier's ideas to the thinking of Jean-Jacques Rousseau, who also emphasized the individual's duality as part of the community and as a spiritually self-sufficient entity.[50] Such affinities underline the utopian nature of Le Corbusier's dream of creating a perfect open-air city with work and relaxation, buildings and parkland in an ideal and rational balance.

Political utopias

As we have seen, utopian aspirations took on a particular potency with the First World War. The devastating loss of life generated a widespread feeling that things had to change. Moreover, the war caused far-reaching political transformations, which seemed to make renewal possible. In the wake of the conflict, the autocratic Russian, German, Austro-Hungarian and Turkish empires crumbled, along with the values for which they stood. As old empires fragmented, new nation states, such as Poland, Czechoslovakia, Yugoslavia and Hungary, emerged, revelling in their new-found independence. Republics replaced monarchies, and the old order was turned on its head. In Russia, in February 1917, the autocracy of the Tsar fell, and in October the communists seized power, establishing the first workers' state in history. The Russian Revolution became a beacon of hope for progressive movements everywhere. In 1919 the Hungarian communists took control of the newly independent national government, but their rule was brief, lasting only from March to August. In Germany, too, the abdication of Kaiser Wilhelm II and the institution of the democratic Weimar Republic in November 1918 saw right-wing and left-wing groups vying for power; the communist Spartacus uprising of 1918–19 was brutally suppressed and its leaders, Karl Liebknecht and Rosa Luxemburg, were murdered (pl.2.17).

One might make a distinction between socialist and communist utopias, which is based on the differences between the two contexts within which Modernists were operating. I am defining socialist or social utopias as those visions formulated within the context of capitalist societies, which therefore embody an element of aspiration and struggle, are related to the perceived evils of the present and include strategies for attaining utopia within the limitations of the existing social structures. This might naturally include a wide range of ideological positions. In contrast, communist utopias are based on the assumption that the political and social conditions for socialism have been established, so that previous constraints no longer exist, and a more cohesive ideology unites creative figures. Communist utopia, therefore, primarily relates to countries in which the socialist revolution has been accomplished: this includes the brief time during which communist Hungary existed, but it refers pre-eminently to Soviet Russia, where Lenin and the Bolsheviks promoted a vision of the future that emphasized the new egalitarian and collective society, in which man would be liberated from oppression, and freedom would be enjoyed by all. Certain progressive artists embraced the communist vision of the new government. For them, it seemed that the brave new world had actually dawned. Their task, as they saw it, was not so much to develop their own utopia, as to realize the Bolshevik dream, which (in theory at least) was shared by everyone living in Russia. The fact that their interpretations of the communist future differed from the future that the political leadership itself envisaged ultimately set up tensions between artists and officialdom. Nevertheless, the context of an achieved and enduring revolution meant that the

2.17 **Ludwig Mies van der Rohe**, Monument to the November Revolution, Berlin, 1926 (cat.31)

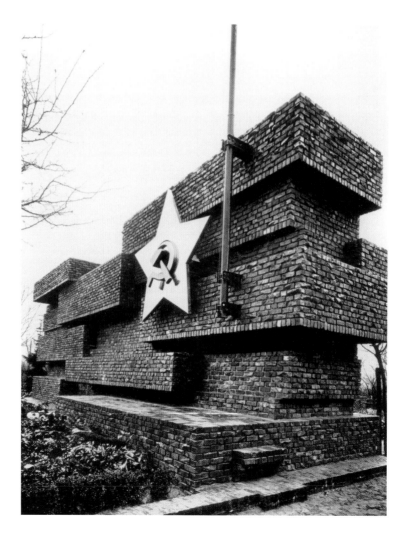

Russian experience was unique and qualitatively different from that of the West. Artists and designers were not developing a vision of the future society in a capitalist framework, but were actually attempting to realize it within an ostensibly communist society. In theory they were not working outside society, but within it and for it.

Communist utopia

Russian avant-garde artists and architects expressed their identification with the new regime by running artistic affairs during the civil war, evolving new theories of art and artistic institutions for the new state, producing revolutionary propaganda and designing new types of buildings. They provided temporary transformations of the environment, such as Gustavs Klucis's decorative schemes for the Fifth Congress of the Comintern or Third International (the communist organization dedicated to fomenting world revolution) in 1922 (pl.1.4). They also designed permanent structures that would develop new models of collective living, which included Nikolai Ladovsky's *Communal House* of 1920 (pl.2.18), Georgii Krutikov's *Flying City*, of c.1924 (pls 2.19–20), and Anton Lavinskii's *City on Springs* of c.1923.[51]

These visions of a communist utopia, in which art was to become part of everyday life and technology's potential was to be extended to its limits and beyond, are demonstrated most vividly in Vladimir Tatlin's *Model for a Monument to the Third International* of 1920 (cat.3). Its dynamic, spiralling form symbolized social progress, while the openwork steel-beam construction proclaimed its solidarity with the industrial proletariat. The structure exhibited in 1920 was merely the model for a vast functioning edifice that was to be one-third higher than the Eiffel Tower. Enormous geometric volumes, made of glass and rotating at different speeds, were to house the various bodies of the Comintern. In his accompanying statement, Tatlin called his project a synthesis of painting, sculpture and architecture, identified iron and glass as the materials of modern classicism, and invited artists to use their creative talents to transform the environment and 'exercise power over the forms encountered in everyday life'.[52] Tatlin's utopian synthesis of practical, ideological and artistic objectives offered a vivid blueprint of how artists could intervene in reality and transform it.

The Constructivist group, formed in March 1921 (including Alexei Gan, Varvara Stepanova and Alexander Rodchenko), declared 'Death to Art' and announced their intention of using their artistic explorations to achieve the 'communist expression of material structures'. They displayed their Tatlin-inspired 'laboratory works' at the exhibition of the

2.19

2.20

2.19 **Georgii Krutikov**,
City Perspective, *Flying City*,
1928 (cat.11a)

2.20 **Georgii Krutikov**,
*Apartment Complex
Perspective*, *Flying City*,
1928 (cat.11b)

OBMOKhU (*Obshchestvo molodykh khudozhnikov*, Society of Young Artists) in May 1921. The show included abstract sculptures constructed from wooden rods, plywood, glass, wire and various kinds of metal, loosely evoking contemporary engineering structures such as cranes and bridges, as well as Rodchenko's series of hanging constructions based on mathematical forms (cat.4). Such transitional experiments were, the Constructivists stressed, not artistic ends in themselves, but abstract explorations that would ultimately produce practical design solutions.

The Constructivists' emphasis on technology was in tune with official thinking. The working class was the product of machine technology, which was also valued for its potential to protect and consolidate the revolution. In December 1920 Lenin launched his plan for the electrification of Russia, with the slogan 'Communism equals Soviet power plus the electrification of the whole country'. Richard Stites argues that this was itself a utopian enterprise, and points out that the state of Russia's electricity production at the time was so bad that Lenin had to switch off the electricity supply to the rest of Moscow in order to demonstrate his model map with all its light bulbs.[53] Having denounced utopianism like a good Marxist, Lenin was clearly not completely immune to its appeal. His *Plan of Monumental Propaganda*, launched earlier, in April 1918, was partly inspired, as he acknowledged, by Tommaso Campanella's description of education in his ideal *City of the Sun* (1602).[54] Such aspects of Bolshevik policy highlight the utopian element in Marxism itself, which not only sought to harness the forces of change to create a communist society, but also argued that communism was a historical inevitability. In this respect, Marxism, like many utopian systems, justified and promoted its ideas by linking them to changes that were already happening, while trying to shape the further realization of those changes.

Tatlin's and the Constructivists' stress on glass and iron as the appropriate materials for communist structures was also sanctioned by Russian utopian literature. In 1863 Nikolai Chernyshevsky's novel *What Is to Be Done?* had described a socialist city consisting of glass and iron buildings, protected from the vagaries of the Russian winter by an enormous dome. Chernyshevsky based his own vision on London's Crystal Palace, built for the Great Exhibition of 1851, which he had seen and considered 'a masterpiece and

the true beginning of national dignity'.[55] It consequently became 'a symbol of the secular paradise on earth that man would achieve through socialism', conveying equality, the new transparency of social structure and the perfectibility of the human spirit.[56] In 1905 Alexander Bogdanov had reinforced this ideal when he described a very similar socialist environment in his science-fiction novel *The Red Star*.

On a more practical level the Constructivists evolved a design methodology at the Moscow VKhUTEMAS (*Vysshie Gosudarstvennye khudozh-estvenno-tekhnicheskie masterski*, Higher State Artistic and Technical Workshops), started producing posters, devising book layouts and typography, and making prototypes for new everyday objects. They designed furniture, fabrics and *prozodezhda* (work clothing), all of which embraced an abstract language of form and adhered to strict principles of economy. Some of these, such as *prozodezhda*, were developed in the context of the theatre, which became a kind of laboratory for utopia, where, untrammelled by the various material and industrial restrictions operating in the young Soviet state, artists could develop designs in the abstract. The most complete environment produced was Rodchenko's Workers' Club, built for the Paris Exhibition of 1925 (pl.2.21). Each item was rethought in terms of the Constructivists' principles of construction (the way it was put together), tectonics (the way it answered ideological, industrial and practical imperatives) and its *faktura* or texture (the way the material was worked).[57] Although made of wood, because it was cheap, the furniture was composed of a minimal number of strictly geometric elements and painted grey, red or black, in order to emphasize the technological rather than organic associations of the designs, as well as their revolutionary message, appropriate to the workers' clubs that were intended to be the crucibles for a new communist culture.

Although Constructivism sought to fuse art and machine technology, as the 1920s progressed certain artists, most notably Tatlin and Petr Miturich, explored what we would now call alternative technology. They returned to an intensive investigation of nature and to the fundamental principles of growth and movement in organic form. Their studies led both of them to evolve new forms of transport. Miturich based his *Volnoviks* (cat.214) and the *Letun* or flying machine on wave-like motion, while the mechanics and form of Tatlin's flying machine, the *Letatlin* or air bicycle, derived from the artist's study of small birds and the way their physique was adapted to the problem of flight. Tatlin stated, 'My apparatus is built on the principle of utilizing living, organic forms.'[58] Tatlin and Miturich both used nature to give man wings and liberate him from gravity. Tatlin said, 'The idea is as old as Icarus … I want to give back to man the feeling of flight.'[59] He also expressed his ultimate utopian aspiration for it to be used by the communist

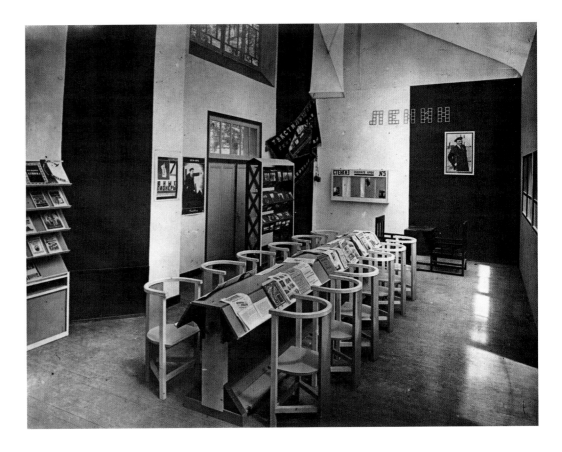

masses as an air bicycle: 'I chose the flying machine … because it is the most complicated dynamic form that can enter into the daily lives of the Soviet masses as an object of widespread use.'[60]

Social utopia

The Soviet Union remained a beacon of hope for radical artists everywhere, especially from 1922 onwards. As the chaos of the immediate post-war period in Germany retreated and economic stability was re-established in some measure, a more practical technological vision emerged, based on a more positive attitude towards the machine and industrial production. The Bauhaus and De Stijl began to move away from their earlier spiritual emphasis, and heterotopia too gave way to social utopia. Dada's 'creative anarchy' had swept away the aesthetic complacency of the past, undermined tradition and destroyed established values.[61] Perhaps not surprisingly, Dadaists now embraced the socialist utopian vision of emerging International Constructivism. At the Dada Fair of 1920, George Grosz and John Heartfield's poster announced 'Art is dead. Long live the new machine art of Tatlin', and in September 1922 the two movements came together at the Constructivists' and Dadaists' Congress in Weimar.[62] The German artist

and film-maker Hans Richter, who had himself recently moved from Dada to abstraction, later described the new consensus:

> As if by magic, a new unity in art had developed in Europe during the isolation of the war years. Now that the war was over, a kind of aesthetic brotherhood suddenly emerged … fundamental tasks on which we could all agree. These tasks were given different names in different countries and were pursued by different groups: *De Stijl*, *L'Esprit Nouveau*, *G*, *Veshch'*, *Ma* and others. There was one common purpose … to start from the beginning again by returning to the most elementary and basic concepts and to build something new upon the fundamentals, be it Gabo's 'Constructivism', Mies van der Rohe's 'New Building', Werner Gräff's 'New Technology', Eggeling and [Richter's] 'Universal Language', Kiesler's 'New Spatial Theatre', Lissitzky's Suprematist 'Proun' … or Mondrian and Van Doesburg's 'Neo-Plastic Creative Principles'.[63]

Perhaps not surprisingly, the Russians were instrumental in promoting utopian ideas and encouraging a process of creative cooperation in Germany. Lissitzky's Proun paintings (Projects for the Affirmation of the New in Art), such as *Proun 1C* of 1919 and in his

2.23

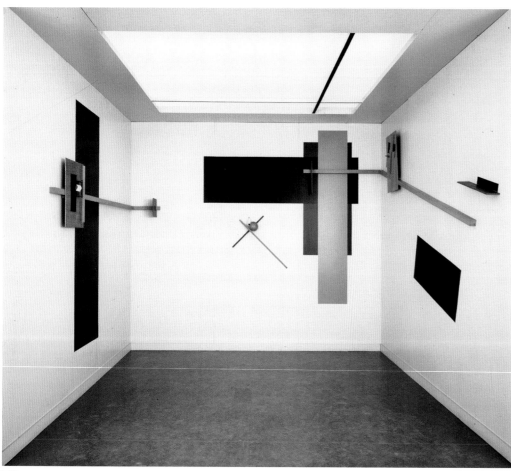

2.22

2.22 **El Lissitzky**, *Proun Room*. Painted wood, 1923 [1965]. Van Abbemuseum, Eindhoven

2.23 **El Lissitzky**, *Veshch'*, 1922 [cat.5]

2.24 **Theo van Doesburg** and
Cornelis van Eesteren,
Architecture view from above,
axonometric projection.
Ink, gouache and collage
on paper, 1922–3.
Netherlands Architectuur
Instituut, Rotterdam

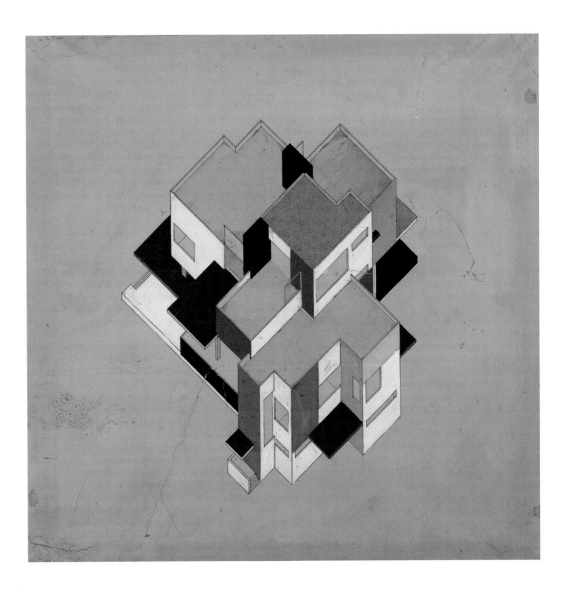

remarkable Proun Room for the *Grosse Berliner Kunst-ausstellung* (Great Berlin Art Exhibition), epitomized the new aesthetic values; they possessed geometric precision, structural emphasis and transparency, which evoked the impersonal realms of science and engineering, the intellectual and moral values of clarity and order, and the possibility of collective human progress. The three-dimensionality and spatial complexity represented in the flat Proun paintings was vividly explored in the Proun Room (pl.2.22), composed of painted surfaces and elements in relief, some moving across perpendicular walls. Lissitzky attempted to promote such approaches through the short-lived magazine *Veshch'/Gegenstand/Objet* (*Object*) (pl.2.23), which, he declared, 'will take the part of constructive art, whose task is not to adorn life but to organize it'.[64] *Die Internationale Fraktion der Konstruktivisten* (The International Faction of Constructivists) was subsequently formed in late May 1922 at *Der Internationale Kongress fortschrittlicher Künstler* (The Congress of International Progressive Artists) in Düsseldorf by Lissitzky, Van Doesburg and Richter.[65] Its founding declaration,

published that September in *De Stijl*, stated, 'Art is a universal and real expression of creative energy, which can be used to organize the progress of mankind; it is the tool of universal progress.'[66] The artists and designers associated with International Constructivism were united by this aspiration, a pragmatic attitude towards technology, a broadly radical political ethos (which encompassed a range of socialist viewpoints) and the fact that they were developing, promoting and trying to realize their visions of a socialist utopia within a capitalist framework.

In 1922 Van Doesburg was one of the moving forces behind International Constructivism and its vision of a socialist utopia. By this time he and most members of De Stijl had moved towards a more explicitly social orientation. This may reflect, as Michael White argues, De Stijl's continuity with the long-standing commitment of Dutch artists and architects to the notion of community art.[67] Certainly by 1921 this commitment was increasingly apparent within De Stijl theory and practice. The architect J.J.P. Oud applied the group's ideas as city planner to

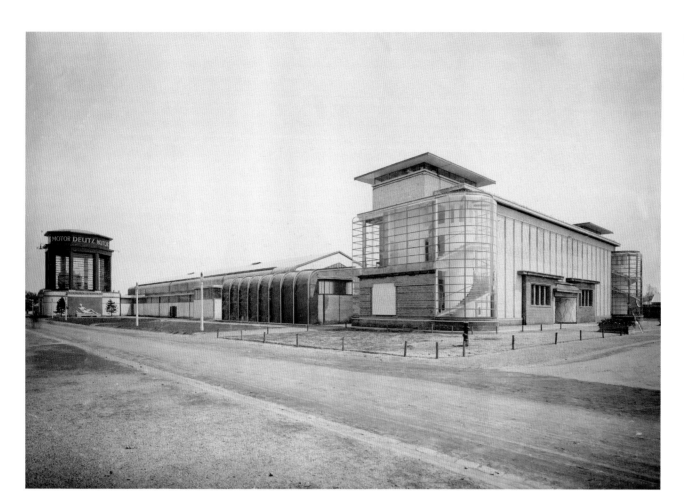

2.25 **Walter Gropius**,
New Model Factory, 1914
Werkbund Exhibition,
Cologne. Bauhaus Archiv,
Berlin

the design of mass housing schemes in Rotterdam (pl.1.1, cats 88, 103), which transformed workers' lives. Meanwhile, Russian ideas of visual energy were also having an impact, and Van Doesburg introduced the diagonal into his paintings, leading to a rift with Mondrian. In 1923, along with Cornelis van Eesteren, he devised a series of architectural models and drawings whose volumes radiated out from a central core (pl.2.24), conveying a vivid sense of spatial continuity and dynamism, and evoking notions of space and time, which he too called the fourth dimension.[68] This sense of the dynamic interaction of planes and spatial continuity is also apparent in Rietveld's furniture designs of the early 1920s, such as the Berlin Chair, and found its supreme expression in his design for the Schröder House of 1924 (cat.22). This small house presented a completely different architectural aesthetic and way of living in a building, where the spatial arrangement of the top floor could be altered at will by partitions and the use of colour created the sense of actually being within a Neo-plastic painting.

The new slogan 'Art and Technology: a New Unity', which Gropius adopted at the Bauhaus in 1923, epitomized the school's transition from Expressionism, with its craft bias and spiritual utopian ideals (cats 15, 18), to a more socialist vision with an industrial emphasis, characterized by a geometric and machine aesthetic (pls 3.1, 3.21). Such a change is usually explained in terms of the influence of De Stijl through the presence of Van Doesburg in Weimar, the exposure to the latest Russian developments, and the appointment of László Moholy-Nagy to replace Johannes Itten in the teaching of the Preliminary Course.[69] Moholy-Nagy was certainly crucial in contributing a concern with mathematical precision, technology, science and notions of spatial dynamism, along with his socialist convictions, rooted in his experiences of the Hungarian revolution, that 'constructive art … is breaking the ground for the collective architecture of the future' and 'we artists must fight alongside the proletariat'.[70] The Bauhaus's transition is marked by designs such as Marcel Breuer's wooden armchair of 1922 (pl.2.13), which indicates the influence of Rietveld (pl.2.12), and the typography associated with the 1923 exhibition. Gropius returned to the more industrial and rational idiom that he had used for buildings such as the New Model Factory of 1914 (pl.2.25), where transparent glass walls had been used to emphasize the spatial flow between interior and exterior and to celebrate the fact that the wall was no longer load-bearing. This industrial aesthetic clearly provided the model for the later Bauhaus buildings at Dessau after 1925 (cat.114). Appropriately, too, interior design took on the rigour of mathematics and machine technology and the sense of the hand-made was replaced by the ethos of mass production. This can be seen in the new tubular-steel furniture, such as Marcel Breuer's Club Chair (pl.3.21), Marianne Brandt's light fittings (cats 134, 136) and even the textiles of the Weaving Workshops (cat.142).

Post-Modernist thinkers may detect a waning of utopia, but idealistic attitudes were fundamental to Modernism in the 1920s.[71] As Timothy Benson has observed, 'Utopia functioned within Modernism as a continuous, constructive means of self-critical renewal, an enactment of the central tenet of the avant-garde: creative artistic endeavours can embody hope and prepare the way for better conditions for humanity.'[72] The visions that inspired the creative figures of the 1920s and early '30s were dreams based on the technological potential and the social experiences of that time. With Oscar Wilde they might have concluded:

> A map of the world that does not include Utopia is not worth even glancing at, for it leaves out the one country at which Humanity is always landing. And when Humanity lands there, it looks out, and in seeing a better country sets sail. Progress is the realization of Utopias.[73]

1 Plate 2.8

Painting: *Dynamic Suprematism*[1]
1916
Kazimir Malevich
(1879 Kiev –1935 Leningrad)

Oil on canvas
80.3 × 80cm
Tate, London, purchased with assistance from
the Friends of the Tate Gallery, 1978 (T 02319)

Malevich launched Suprematism at the *0.10*
exhibition in Petrograd in December 1915 when
he showed *The Quadrilateral*, now known as the
Black Square, in a corner, in the position of an
icon in a Russian Orthodox home, thus imbuing
his image with a profoundly spiritual dimension.
In the exhibition catalogue he gave some
Suprematist paintings titles that referred to the
fourth dimension, explicitly evoking associations
with ideas concerning different levels of spatial
reality as well as a higher state of consciousness.
In these ways Malevich highlighted the notion
of 'intuitive feeling' and spiritual utopia that
underpinned his new style. At the same time he
stressed that Suprematism had freed painting
from the need to imitate reality, declaring that
'colour and texture in painting are ends in them-
selves' and 'art is the ability to construct ... on
the basis of weight, speed and the direction of
movement'.[2]

In 1915 Malevich used primary colours and
black against white grounds, and primarily irregular
quadrilateral shapes to suggest a certain twisting
in the plane or motion in space. By 1916 he had
expanded his vocabulary to include pastel shades
as well as more curvilinear forms. These features
are evident in *Supremus 57* and are used to convey a
strong sense of spatial dynamism. As in the earlier
works, colour intensity and placement are vital
to indicating motion, while the layering of forms
indicates different spatial planes. The triangle is set
at an angle and its apex approaches the top, but
doesn't touch it. It fills the canvas, but leaves the
centre of the composition strangely empty.[3] For
Malevich, white was the colour of infinite space,
and the barely coloured, elusive pale forms
seem to be emerging from deep space, endowing
the painting with a strong spiritual and spatial
resonance, a cosmic dimension that he developed
further in the *White on White* canvases of 1918.[4] CL

1 The title *Supremus No. 57* is inscribed on the verso of the painting
 in Cyrillic. See A. Nakov, *Kazimir Malewicz: Catalogue Raisonné*
 (Paris, 2002), p.272, no.S-434.
2 Kazimir Malevich, *From Cubism and Futurism to Suprematism:
 The New Pictorial Realism* (Petrograd, 1916); trans. in Troels
 Anderson (ed.), *K. S. Malevich: Essays on Art* (Copenhagen, 1969),
 extracts reprinted in Charles Harrison and Paul Wood (eds.), *Art
 in Theory: 1900–1990: An Anthology of Changing Ideas* (Oxford, 1992),
 pp.166–76 (quote from p.168).
3 Charlotte Douglas, *Malevich* (London, 1994), pp.94–5.
4 See also Larissa A. Zhadova, *Malevich: Suprematism and
 Revolution in Russian Art 1910–1930* (London, 1982) and John Milner,
 Kazimir Malevich and the Art of Geometry (New Haven, 1996).

2 Plate 2.18

Drawing: *The Architectural Phenomenon
of the Communal House*
1920
Nikolai Ladovsky
(1881 Moscow –1941 Moscow)

Pencil, coloured pencil and coloured ink on
tracing paper, mounted on paper
40 × 30cm
Shchusev State Museum of Architecture, Moscow

Nikolai Ladovsky produced his design for a
communal house in 1920 as a member of the
Zhivskulptarkh group, set up in 1919 in Moscow,
to produce projects that, as the name suggested,
synthesized painting (*zhivopis*), sculpture
(*skulptura*) and architecture (*arkhitektura*). The
group aspired to use this aesthetic synthesis to
participate in the construction of a communist
utopia in Russia, by developing new building
types, such as the communal house, which was
intended to foster a new collective way of life.[1]
The emphasis in Ladovsky's design is more
upon the expressive and emotional qualities of
form and colour than upon purely functional,
technical or constructional considerations, with
the diagonal composition conveying a general
sense of progress and dynamism. This approach
reflects the general optimism of the period, but
also the fact that at that time there was little
opportunity for building, owing to the chaos of the
civil war (1918–20), which followed the economic
devastation caused by the First World War and
the Revolution.

The Communal House also indicates Ladovsky's
sustained concern for the way in which architec-
tural form was perceived. He had been an active
member of INKhUK (Institute of Artistic Culture),
and in 1920 became a teacher at the Moscow
VKhUTEMAS (Higher Artistic and Technical
Workshops), where he taught the fundamentals
of formal composition.[2] By 1923 Ladovsky had
formed ASNOVA (Association of New Architects)
along with Nikolai Dokuchaev and Vladimir Krinsky.
This group called their approach 'Rationalist' and
stressed the importance of the psychological
perception of architectural form in the design
process as a way of ensuring that the appropriate
message would be conveyed by the building.[3] CL

1 Catherine Cooke, *Architectural Drawings of the Russian Avant-
 Garde* (exh. cat., Museum of Modern Art, New York, 1990).
2 See Selim Khan-Magomedov, *Pioneers of Soviet Architecture*
 (London, 1983) and Christina Lodder, *Russian Constructivism*
 (New Haven, 1983).
3 Catherine Cooke, *Russian Avant-Garde Theories of Art,
 Architecture and the City* (London, 1995), p.30.

3

Photograph: *Monument to the Third International*
1920
Designed by Vladimir Tatlin
(1885 Moscow –1953 Moscow)

In 1919 Vladimir Tatlin was commissioned by the Department of Fine Arts within the Commissariat of Enlightenment to produce a monument to the Russian Revolution for Lenin's Plan of Monumental Propaganda (instituted in April 1918).[1] Tatlin subsequently dedicated his structure to the Third Communist International (the Comintern), which had been resuscitated in order to promote world revolution. Displayed in Petrograd in November 1920, Tatlin's model was shown in Moscow in December, in the building where the Eighth Congress of the Soviets was discussing the Electrification of Russia. In this photograph, taken in November 1920, Tatlin (facing the camera, with pipe) is shown in front of his model in the Studio of the Materials, Volume and Construction of the former Academy of Arts in Petrograd.

The model was made of wood, and stood about nine metres high. The building was to be made of iron and glass and was to extend to a height of 400 metres, one-third higher than the Eiffel Tower. Dominating the skyline of Petrograd, it would have served as a beacon for revolution. The framework consisted of two spirals supported by a strong diagonal set at the angle of the Earth's axis. This enclosed four enormous glass structures: a cylinder at the bottom, a pyramid, another cylinder and a hemisphere. These were intended to house the various departments of the Comintern and to rotate at various speeds: the lowest cylinder at one revolution per year, the pyramid at one revolution per month, and the top cylinder at one revolution per day. The monument was thus a dynamic structure with a dynamic role – a vast machine producing revolution – imbued with cosmic symbolism.[2]

The monument celebrated contemporary technology; the form (spirals and diagonal) expressed the notion of progress, and the glass symbolized the new transparency of government. In a statement, Tatlin explained that he had synthesized the arts of painting, sculpture and architecture, and he called on his fellow-artists to follow his example and design new structures for everyday life.[3] As a paradigm of new utopian possibilities, the monument stimulated the emergence of Constructivism in March 1921. CL

1 Christina Lodder, *Russian Constructivism* (New Haven, 1983), pp.55–67.
2 John Milner, *Vladimir Tatlin and the Russian Avant-Garde* (New Haven, 1983), pp.151–80.
3 Larissa A. Zhadova (ed.), *Tatlin* (London, 1988), pp.239–40.

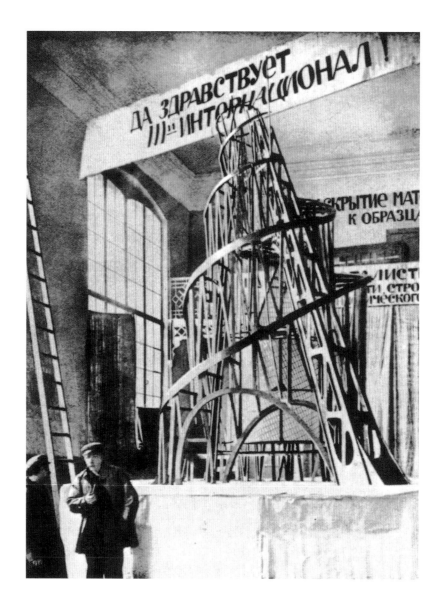

4

Ellipse or Oval Hanging Construction no.12

Originally made 1921, reconstruction 1980s
Alexander Rodchenko
(1891 St Petersburg–1956 Moscow)

Plywood, open construction, partially painted with
aluminium paint and wire
61 × 83.7 × 47cm
Museum of Private Collections, Moscow

Rodchenko made this ellipse as one of a series of hanging constructions based on mathematical forms, including the hexagon, the circle, the square and the triangle.[1] All were produced from the identical process of cutting concentric shapes from a single piece of plywood and then rotating the resulting forms in space. In this way the object literally developed from two dimensions into three. The wood was painted silver to give the works a metallic finish and an industrial resonance. It also had the effect of reflecting the light. When the constructions were displayed at the OBMOKhU (Society of Young Artists) exhibition,

which opened in Moscow in May 1921, they were suspended on wires strung across the ceiling to emphasize their spatial qualities and allow them to rotate gently in the air.

By the time of the exhibition, Rodchenko – along with the other members of the Working Group of Constructivists, set up in March 1921 – had embraced the idea of devoting his artistic expertise to the service of the state by designing everyday objects and environments for the new Soviet utopia. The aim, as stated in the group's programme, was 'the communistic expression of material structures'.[2] The works that Rodchenko and the other Constructivists put on display at the OBMOKhU exhibition were presented as 'laboratory works', in other words artistic explorations that were undertaken not with the aim of creating works of art, but with the intention of developing artistic expertise that would eventually help in the design of useful objects. The hanging constructions were in line with this aspiration. Rodchenko subsequently developed the scientific and industrial emphasis of these works in a series of modular constructions made from identical wooden rods, which explored the various permutations that could be achieved combining these basic elements.[3] CL

1 Christina Lodder, *Russian Constructivism* (New Haven, 1983), pp.22–9.
2 See Selim Khan-Magomedov, *Rodchenko: The Complete Work* (London, 1986), pp.290–91.
3 Magdalena Dabrowski, Leah Dickerman and Peter Galassi, *Aleksandr Rodchenko* (exh. cat., Museum of Modern Art, New York, 1998), pp.37–41.

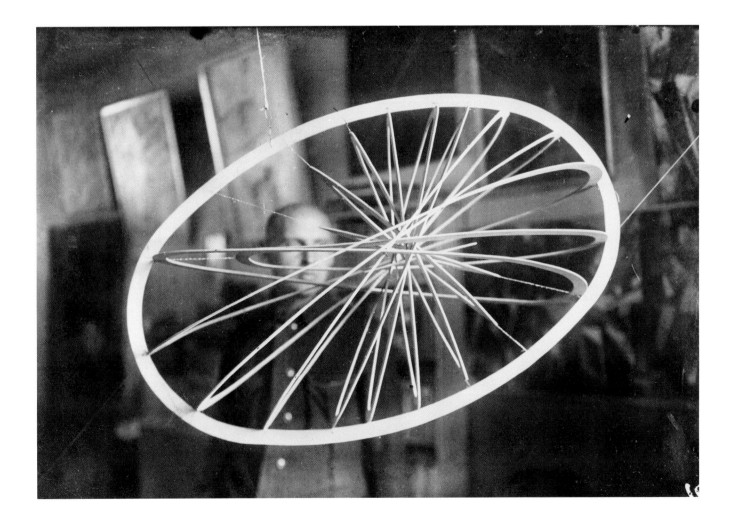

5 Plate 2.23

Magazine: *Veshch'/Gegenstand/Objet* (*Object*), no.3, 1922
El Lissitzky (Lazar Lisitskii)
(1890 Pochinok, Russia–1941 Moscow) and
Ilya Ehrenburg (1891 Kiev–1967 Moscow)

31.2 × 23.5cm
Private Collection

The journal *Veshch'/ Gegenstand/ Objet* was edited by the artist El Lissitzky and the writer Ilya Ehrenburg, and was published in three languages (Russian, German and French) in Berlin, appearing in two issues (no.1–2 March/April and no.3 May 1922). One of the main aims of the journal was to foster international cooperation among artists and create a phalanx of western artists sympathetic to the Soviet Union and socialist ideals.[1] It disseminated information about Russian developments, while also informing Russian artists about the latest European trends. This was made explicit by the inclusion in the first issue of articles about Russia in German, and Russian translations of Theo van Doesburg's text 'Monumental Art', and Le Corbusier's articles 'Contemporary Architecture' and 'Serial Houses', reprinted from *L'Esprit Nouveau*.

The first editorial announced this new internationalism and explained that the new artistic approach underpinning such cooperation was 'constructive art, whose task is not to adorn life but to organize it'. Such art encompassed painting as well as design. Although the editors asserted their independence from political parties, they embraced a radical stance and stressed that, 'We are unable to imagine any creation of new forms in art that is not linked to the transformation of social forms.'

The journal's aesthetic radicalism was reflected in the innovative typography, layout and design by Lissitzky. He explicitly linked the language of abstract art, notably Suprematism, with industrial and social progress. Malevich's *Black Square* (1915) and *Black Circle* (c.1920) were placed alongside the image of a train with a snowplough, a product of contemporary engineering, which epitomized the link between aesthetic, technical and social progress. Underneath Lissitzky explained that 'the machine is the lesson of clarity and economy'. The journal played a major role in the emergence of International Constructivism.[2] CL

1 Roland Nachtigäller and Hubertus Gassner, '3 × 1 = 1 Veshch' Objet Gegenstand', in Nachtigaller and Gassner (eds), *Veshch' Objet Gegenstand; Commentary and Translations* (Baden, 1994), pp.29–46.
2 Christina Lodder, 'El Lissitzky and the Export of Constructivism', in Nancy Perloff and Brian Read (eds), *Situating El Lissitzky: Vitebsk, Berlin, Mocow* (Los Angeles, 2003), pp.27–46.

6

Teacup and saucer
1923
Nikolai Suetin (1897 Metlevsk Station, Kaluga region, Russia–1954 Leningrad)

Porcelain, polychrome overglaze painting
6.4 × 7.3 6cm, 2.5 × 14.3cm
Porcelain Museum, State Hermitage Museum, St Petersburg

Suetin produced this decorative design along with numerous others for cups, saucers and complete tea services while working at the State (formerly Imperial) Porcelain Factory during 1923–4.[1] He was responsible for painting some of the designs onto the items himself, although the majority were reproduced by professional copyists and were applied to existing forms and old stock of the factory, as in this instance. Nevertheless, they all used the abstract language of Suprematism, geometric planes of colour set against white grounds, to produce weightless configurations of enormous vitality.[2] In this cup and saucer, Suetin has restricted his colours to red and black and his forms to the essential shapes of the circle, square and cross. In contrast to the more complex combinations of shapes that he often applied to ceramic forms, here the large elements stand almost alone. This reflected the importance that Suetin's teacher Kazimir Malevich (pl.2.8), the founder of Suprematism, ascribed to these forms as the basic elements of the Suprematist visual vocabulary. They may even refer to Malevich's series of three large paintings, *The Square*, *The Circle* and *The Cross*, produced at around this time.[3]

Suetin signed all his designs on the underside with the symbol of the black square. This had become the insignia of the *Unovis* group, which Malevich had set up soon after he moved to Vitebsk in 1919. *Unovis* was dedicated to the utopian enterprise of creating a totally Suprematist environment and extending the language of Suprematism into the everyday world. Consequently, its members decorated buildings for the revolutionary festivals, devised new typographical formats, produced revolutionary posters, created fabric designs and experimented with a new form of Suprematist architecture.[4] Porcelain was one area where this activity extended into the real manufacturing sector. It was very successful, and Suetin's designs continued to be made well into the 1930s. Although Malevich and his followers had hoped that, in this way, Suprematism would become a part of the everyday life of the masses, this dream was not realized. The bulk of Suprematist porcelain was sold abroad to generate much-needed foreign currency.

In 1932 Suetin returned to work at the Porcelain Factory, but remained true to his Suprematist ideals, producing numerous designs in a highly simplified geometric style, often with a recognizable figurative content, reminiscent of Malevich's late paintings. CL

1 *Circling the Square: Russian Avant-garde Ceramics 1917–1930* (exh. cat., Somerset House, London 2004), pp.33–8.
2 Larissa Zhadova, *Malevich: Suprematism and Revolution in Russian Art 1910–1930* (London, 1982), p.73ff.
3 Yevgenia Petrova, *Kazimir Malevich in the Russian Museum* (St Petersburg, 2000), pl.19–21.
4 Nina Lobanov-Rostovsky, *Revolutionary Ceramics: Soviet Porcelain 1917–1927* (London, 1990), pp.25–6.

7

Drawing: *Design for a Signpost for the entrance to the Exhibition of Students' work from the Basic Course of the VKhUTEMAS*
1924–6
Gustavs Klucis (1895 Rujiena, Latvia–1938 Moscow?)

Photo collage, ink, gouache and watercolour on paper
36.2 × 25.3cm
The State Museum of Art, Riga (Z-7846)

Klucis designed this signpost for the entrance to the Exhibition of Students' work from the Basic Course of the VKhUTEMAS (Higher State Artistic and Technical Workshops).[1] The workshops had been set up in Moscow in 1920 to train artists for industry. The Basic Course, like the Bauhaus's *Vorkurs* (Preliminary Course), provided the essential aesthetic foundation for further specialization in one of the faculties at VKhUTEMAS. It was crucial to the Constructivist enterprise of creating a communist utopia, because it provided the vital creative experience with form and material that was central to Constructivism's design ideology. The course content fluctuated, but in 1925 it consisted of four essential areas of study: plane and colour (painting), graphics, volume and space (sculpture) and space and volume (architecture).[2] A former graduate (1921) and a Constructivist, Klucis taught colour in the wood and metalwork faculty from 1924 to 1930.

The structure of the signpost recalls Klucis's agitational stands, which he had designed in 1922, based on the openwork skeletal structures exhibited by the Constructivists in 1921 at the OBMOKhU exhibition. The sign represents colour, painting, space, graphics and theory. It is surmounted by a colour wheel. The word *osnovnoe* (or 'basic') denotes the basic elements of art as well as the Basic Course itself. Two arms incorporate a palette for painting and the word *teoriya* (or 'theory'), representing the extensive information (about colour, science, culture and politics) that students had to acquire. Another arm contains a cube inscribed with the letters o and b from the word *obem* (meaning 'volume'), which refers to the studies in volume and space. The final square appears blank, but in the built stand it is inscribed *grafika* (or 'graphics').[3] Klucis incorporated his own photograph into the design to give a sense of scale. CL

1 See *Gustav Klucis: Retrospektive* (exh. cat., Museum Fridericianum, Kassel, 1991), p.135.
2 Christina Lodder, *Russian Constructivism* (New Haven, 1983), pp.109–40.
3 Selim O. Khan-Magomedov, *VKhUTEMAS: Moscou 1920–1930* (Paris, 1990), vol.2, p.483. This illustrates the stand as constructed.

8 Plate 8.7

Film: *The Battleship Potemkin*
(*Borontsets Potemkin*)
Directed and edited by Sergei Eisenstein
(1898 Riga, Latvia–1948 Moscow)
Written by Nina Agadzhanova-Shutko,
with Sergei Eisenstein and Nikolai Aseev
Photographed by Eduard Tisse
Designed by Vasili Rakhals

*c.*75 mins, silent (accompanying music by Edmund Meisel,
1926), black and white (with some tinting of original copies)
Produced by Goskino, USSR, 1925

Commissioned by an official state committee that
included Kazimir Malevich (pl.2.8) and Vesvolod
Meyerhold, Sergei Eisenstein's second film was
intended to commemorate the 'first' Russian
Revolution of 1905, with episodes that would range
from the Russo-Japanese War to uprisings in
Moscow and St Petersburg. In the event, the whole
film dealt with only one obscure event: a mutiny
on the battleship *Potemkin* at Odessa.[1] On location
in Odessa, Eisenstein spent two weeks improvising
a sequence in which troops march implacably
down the city's vast flight of steps, crushing the
civilians who have gathered in support of the

mutineers. Back in Moscow, with just three
weeks to edit the film before its planned premiere
at the Bolshoi Theatre, he focused on triggering
responses from the viewer through carefully
calculated juxtapositions of the troops' advance
with such vivid images as the children's nurse
who is shot and releases a pram to career down
the steps, and the older lady whose pince-nez
is bloodily shattered.[2]

While the Odessa steps sequence became
the film's most famous example of 'montage'
as a technique to stir audiences through what
Eisenstein would call 'kino-fist' in contrast to
Dziga Vertov's 'kino-eye', others became estab-
lished as classics for their use of visual metaphor
– the sailors are roused to mutiny by maggots
in their food, seen in magnified close-up; and
editing makes monumental lions seem to respond
to the ship's firing. Above all, the film's intrinsic
Modernism seemed to lie in its replacement of
normal lead characters by the dynamic masses
of sailors and townspeople, and by the ship itself
becoming the true hero, with the climax consisting
of the *Potemkin* being allowed to escape by other
warships of the Black Sea fleet.

Although well received by Russian critics and
audiences in January 1926, the film's spectacular
international career began with its release in
Germany in April. Attacked and defended with
equal passion, and equipped with a powerful

musical accompaniment by Edmund Meisel, it
broke all records and went on to open in half a
dozen other countries – while being banned in an
equal number (including Britain, where it was not
shown until late 1929). Respected everywhere for
its redefinition of filmic language in the service
of its revolutionary message, *Potemkin* put Soviet
cinema in the vanguard of film as a radical,
popular new art that had the potential to make
all other arts redundant.[3] IC

1 Amid the vast literature on *The Battleship Potemkin* and
 Eisenstein, the latter's own memoirs provide a vivid insight into
 how the film changed his life: Richard Taylor (ed.), *Beyond the
 Stars; The Memoirs of Sergei Eisenstein* (Calcutta, 1995), esp.
 pp.143–82. For details of the production and reception based
 on new research, see Oksana Bulgakowa, *Sergei Eisenstein:
 A Biography* (Berlin, 2001), pp.56–66.
2 One of the earliest definitions of Eisenstein's dialectical under-
 standing of montage in *Potemkin* after the film's release appears
 in a riposte to the Hungarian-born critic Béla Balázs: 'We look
 for the essence of cinema not in the shots but in the relationship
 between the shots, just as in history we look not at individuals
 but at the relationship between individuals, classes, etc'. 'Béla
 Forgets the Scissors' (July 1926), in Richard Taylor and Ian Christie
 (eds), *The Film Factory* (Cambridge, MA, 1988), p.147.
3 For a selection of responses to *Potemkin* and other early Soviet
 montage films, by Alfred Barr, Walter Benjamin, David Selznick,
 the editors of *Close Up* and others, see Ian Christie, 'Soviet
 Cinema: A heritage and its history', in Taylor and Christie (1988),
 pp.3–8. On other aspects of the film, see Richard Taylor, *The
 Battleship Potemkin* (London, 2000).

9

Book: *Die Kunstismen: Les Ismes de l'art:
The Isms of Art*
1925
El Lissitzky (Lazar Lisitskii) (1890 Pochinok,
Russia–1941 Moscow) and Hans Arp (Jean)
(1886 Strasburg–1966 Basle)

Published by Eugen Rentsch Verlag, Zurich
26.3 × 20.5cm
V&A, National Art Library (RC.R.24)

Although *The Isms of Art* was jointly edited by
El Lissitzky and Arp, the book (p.iv) states that
Lissitzky alone was responsible for its dramatic
typography and layout.

The result is evidence of Lissitzky's continuing
experimentation with graphic design. In contrast
to *Veshch* (pl.2.23), the diagonal line and the variety
of typefaces that are typical of Suprematist
typography are less in evidence here. Instead,
Lissitzky has made far greater use of the broad
black line and a more uniform, rather heavy
sans-serif typeface, which had been developed
and used in Russia by Constructivists such as
Alexander Rodchenko, Lyubov Popova and
Alexei Gan in their work from 1922 onwards.

In terms of its content, *The Isms of Art* was
fervently international. It provided succinct
definitions of modern and current artistic trends
from 1914 to 1925, including Cubism, Dada,
Suprematism, Purism, Neo-plasticism and
Constructivism, as well as a selection of work
by a wide range of contemporary creative figures,
from Otto Dix to Piet Mondrian (pl.2.11). The text is
fairly minimal and presented in German, French
and English, while the dominance of the visual
material underlines the fact that the book was
intended for a broad international audience. The
images start with the most up-to-date develop-
ments, notably abstract film, and work backwards
to Expressionism, ending with a painting by
Franz Marc of 1914.

Lissitzky believed that 'ideas reach you through
the eye' and typography should therefore convey
ideas optically.[1] He was also alert to technological
developments, realizing that they would have
long-term repercussions on design and format,
even envisaging a future 'electro-library'.[2] *The
Isms of Art* embodies Lissitzky's highly idealistic
concept of the book, which he considered to be
'the most monumental work of art', capable of
reaching 'hundreds and thousands of poor people'
and of transforming their consciousness.[3] CL

1 El Lissitzky, 'Typography of Typography' (1923), in Sophie
 Lissitzky-Küppers, *El Lissitzky: Life, Letters, Texts* (London, 1968),
 p.355.
2 El Lissitzky, 'Typographical Facts' (1925), in ibid, p.359.
3 El Lissitzky, 'Our Book' (1926–7), in ibid, p.359.

10 Plate 2.21

Photograph: The Workers' Club
1925
Designed by Alexander Rodchenko
(1891 St Petersburg–1956 Moscow)

Rodchenko designed the Workers' Club for the Soviet exhibit at the *Exposition Internationale des Arts Décoratifs et Industriels Modernes,* in Paris in 1925. As a prototype, worked out in every detail according to ideological, utilitarian, industrial and aesthetic imperatives, it stands as one of the great achievements of Constructivism.[1] It combined an authentic functionalism with a powerful programmatic statement about the kind of art and environment that Constructivism might create in the new communist world.

Workers' clubs were vital in inculcating the culture and values necessary for creating the communist utopia. Their ideological role is emphasized by Rodchenko in this design by the images of Lenin. His name is spelt out in skeletal letters, built up from standard squares and triangles, which act as a programmatic state-ment, linking communism with Constructivism's design methodology.[2]

For the Constructivists, geometry, economy and standardization embodied the values of the collective, so Rodchenko reduced each item of furniture to its essential geometric components. The chairs, for instance, comprised three uprights (two thinner rods at the front and a wider plank behind), which were attached together at three levels, at the top by the open semi-circle, at seat level by the flat semi-circle, and at the bottom by three rods. To economize on space, some items (such as the tribune, screen, display board and bench) were collapsible, enabling them to be stored when not required. Dynamism was also intrinsic to the design, from the revolving hexagonal display, lit from below, to the chess table with its rotating chess board.[3] Economic factors determined the choice of wood (cheap and plentiful in Russia), but Rodchenko painted it white, red, grey or black, either alone or in combination, to minimize its rural resonance, give it an industrial gloss, and reinforce the ideological significance of the design – red and black symbolizing the revolution. CL

1 Christina Lodder, *Russian Constructivism* (New Haven, 1983), pp.155–6.
2 *Art into Life: Russian Constructivism 1914–1932* (exh. cat., Henry Art Gallery, University of Washington, Seattle, 1990), pp.109–14.
3 Selim O. Khan-Magomedov, *Rodchenko: The Complete Work* (London, 1986), pp.178–85; and Magdalena Dabrowski, Leah Dickerman and Peter Galassi, *Aleksandr Rodchenko* (exh. cat., Museum of Modern Art, New York, 1998), pp.72–8.

11a Plate 2.19

Drawing: *City Perspective, Flying City*
1928
Georgii Krutikov (1899 Voronezh, Russia –1958 Moscow)

Charcoal and pencil on paper
120 × 94cm
Shchusev State Museum of Architecture, Moscow

11b Plate 2.20

Drawing: *Apartment Complex Perspective, Flying City*
1928
Georgii Krutikov (1899 Voronezh – 1958 Moscow)

Pencil and ink on paper
114.5 × 88cm
Shchusev State Museum of Architecture, Moscow

Krutikov produced his plan for a City of the Future (*Gorod budyushego*), known as the *Flying City* (*Letayushii gorod*), as his diploma project, before graduating from the Moscow VKhUTEMAS in 1928.[1] Krutikov's city was formulated in the studio of Nikolai Ladovsky (pl.2.18) and embodied the

rationalist approach of his teacher, who emphasized the importance of psychological perception in the design process and had set up a psycho-technical laboratory to explore his ideas. As a student, Krutikov was involved in the laboratory, giving lectures and compiling its first report.[2]

The *Flying City* was a utopian project that radically restructured the urban environment, relegating all industry to the Earth's surface, along with leisure activities, while suspending all human habitation in space above the manufacturing centres. Transport between the two was provided by a kind of cabin in the shape of a teardrop, which could travel through space, in water and on land.[3] The dwellings were of various types. The labour commune, also known as the highly elaborate housing commune, consisted of eight five-storey blocks connected by lifts to a lower communal building in the shape of a ring. Every storey contained six units, each of which consisted of a porch, berths for transport cabins and living space above. The compact housing block comprised an isolated eight-storey cylindrical structure with communal facilities located in a lower sphere, while the third type (not dissimilar in style) contained hotel-like accommodation, with communal spaces housed in a sphere at the top. All these structures were to be fuelled by atomic power.

Krutikov's vision of his *Flying City* can be related to other utopian projects of the time, such as Kazimir Malevich's planits (pl.2.10) or space stations (1920s) and Anton Lavinsky's *City on Springs* (1923), which were also inspired by the potential of aviation and the future possibilities of space travel. A more immediate and perhaps more pragmatic context was provided by contem-porary discussions concerning city planning for the new Soviet state. As a member of ASNOVA (Association of New Architects), Krutikov may have been involved to some extent in the group's collective work for the design of the new Shabolovka residential district in Moscow, which was commissioned in 1927. CL

1 Selim O. Khan-Magomedov, *Pioneers of Soviet Architecture* (London, 1983), pp.282–3.
2 Selim O. Khan-Magomedov, *VKhUTEMAS: Moscou 1920–1930* (Paris, 1990), vol.2, pp.558–9.
3 *Architectural Drawings of the Russian Avant-Garde* (exh. cat., Museum of Modern Art, New York, 1990), pp.98–100.

12 Plate 2.12

Armchair
Designed 1918
Gerrit Rietveld (1888 Utrecht–1964 Utrecht)
Made by Rietveld with the assistance of
G. van der Groenekan, c.1919

Purpleheart wood, stained
88.9 × 66 × 66cm
V&A: W.9–1989

Gerrit Rietveld's chair, here in its original stained version, encapsulates the utopian desire to reinvent the designed world – in this case to reinvent the idea of the chair. Although a startlingly original design that seemed to look only to the future, Rietveld's chair drew not only on the earlier work of Dutch architects (including H.P. Berlage and P.C. Klarhaamer), but also on the furniture of Frank Lloyd Wright, versions of which Rietveld had made for the architect Robert van't Hoff.[1]

Rietveld produced this chair in his cabinet workshop, just before he became a member of the De Stijl group the following year. He was pictured in 1918 sitting in a nearly identical chair outside his workshop, but with side panels slightly tapered at the bottom. A version without side panels was illustrated by Theo van Doesburg in *De Stijl* in 1919 and only around 1923 was the better-known red and blue version made.[2] This example was made for his friend and fellow Utrecht-born architect, Piet Elling.[3]

The design emphasized the structural qualities of the chair and the visual independence of each part. Each element is clearly – indeed, emphatically – articulated, and the design achieves a remarkable sense of balance and equilibrium. Rietveld wanted 'to insure that no part dominates or is subordinate to the others ... the whole stands freely and clearly in space ...'.[4] Above all, Rietveld created a design that was spatially dynamic and complex, yet was also aiming at visual transparency (perhaps the reason he eventually removed the side panels). Early versions of this chair (including the present example) were made from solid wood rather than plywood. CW

1 Marijke Küper, 'Gerrit Rietveld', in Carol Blotkamp et al., *De Stijl: The Formative Years* (Cambridge, MA, 1982), p.263, and Theodore Brown, *The Work of G. Rietveld Architect* (Utrecht, 1958), pp.17, 23.
2 Theo van Doesburg, 'Aantekening bij een leunstoel van Rietveld', *De Stijl*, vol.II, no.11 (September 1919), p.132. Küper in Blotkamp (1982) first proposed the dating.
3 A second, smaller chair was made for Mrs Elling; see Marijke Küper, 'Gerrit Rietveld', in Blotkamp (1982), pp.263–7, 273; Marijke Küper and Ida van Zijl, *Gerrit Th. Rietveld, the Complete Works 1888–1964* (exh. cat., Centraal Museum, Utrecht, 1992), pp.74–6; and Christopher Wilk, *Western Furniture* (London, 1996), pp.106–107.
4 Theodore Brown, *The Work of G. Rietveld Architect* (Utrecht, 1958), p.21.

13

Magazine: *De Stijl: maandblad gewijd aan de moderne beeldende vokken en kultuur* (*The Style: monthly magazine on modern plastic arts*), issue containing vol.3, no.1 (November 1919) and vol.3, no.6 (April 1920)
Cover image by Vilmos Huszár (1884 Budapest–1960 Hierden, The Netherlands)

25.8 × 19.3cm
V&A: RC.M.30 and V&A: L.3323–1981

The periodical *De Stijl*, edited by Theo van Doesburg, was first published in Leiden in 1917 and continued to appear regularly until 1932. The monthly journal acted as a platform for the editor and the painters Piet Mondrian, Vilmos Huszár and Bart van der Leck; the architects J.J.P. Oud, Robert van t'Hoff, Jan Wils, Cornelis van Eesteren and Gerrit Rietveld; and the sculptor Georges Vantongerloo. Despite its small print run (several hundred at most), *De Stijl* played an important role in uniting these disparate figures and in articulating (and promoting) the theory and practice of abstract geometric form (*nieuwe beelding*, now usually known as Neo-plasticism).

De Stijl means The Style, and may come from the German architect Gottfried Semper, but it also means the upright element of a crossing joint in cabinet making, indicating perhaps that *De Stijl* was not merely promoting a new visual language, but a basic structural system that would encompass the wider material environment.[1]

The De Stijl group were inspired by a utopian vision. They believed that collaboration between different branches of the arts, undertaken in a common spirit of renewal, would transform the chaotic and individualistic reality of the present day into a harmonious environment, expressing the unity of the collective in a pure and universal style and achieving the ultimate harmony of 'international unity in art, life and culture'.[2]

The cover image, perhaps comprising two abstracted heads facing each other, maybe even including the suggestion of an embrace through the inclusion of hands in the horizontal stripes, is symbolic (in one speculation) of the reconciliation of art and architecture.[3] In formal terms, it has been suggested that the design was an attempt to dispense with the differentiation between figure and ground in the composition, by giving equal value to white and black, a problem that De Stijl painters tackled in 1917–18.[4] CL

1 Paul Overy, *De Stijl* (London, 1991), pp.8–9.
2 Manifesto in *De Stijl*, vol.2, no.1 (1918), written in Dutch, French, German and English.
3 Sirjl Ex, 'Vilmos Huszár', in Carol Blotkamp et al., *De Stijl: The Formative Years 1917–1922* (Cambridge, MA, 1986), p.78, first suggested the figurative origins and the hands. Michael White, *De Stijl and Dutch Modernism* (Manchester, 2003), p.38, proposed the symbolic reading.
4 Blotkamp et al. (1986), p.92.

14 Plate 2.11

Painting: *Tableau I with Red, Black, Blue and Yellow*
1921
Piet Mondrian (1872 Amersfoort, The Netherlands –1944 New York)

Oil on canvas
103 × 100cm
Collection Gemeentemuseum Den Haag, The Hague
The Netherlands (Inv. No. SCH-1971-0169)
© 2006 Mondrian/Holtzman Trust c/o HCR International, Warrenton VA

This composition was among the first paintings produced by Piet Mondrian after he had fully articulated the style of Neo-plasticism in late 1920, and it exemplifies the characteristics of the new idiom with its asymmetrical grid of black lines enclosing rectangular planes of colour (the three primaries and the three non-colours, black, white and grey).[1] The underlying theory of the new style had, however, been enunciated earlier in his article 'The New Plastic in Painting', published in *De Stijl*.[2]

For Mondrian, Neo-plasticism was 'pure aesthetic creation', 'the exact plastic expression of the universal' and 'a pure creation of the human spirit'. Spiritual and aesthetic aims were inseparable. The diversity of natural form had to be reduced to rectangular planes and straight lines. While the horizontal line implied the outward, matter, nature and the female, the vertical line denoted the inward, the spiritual and the male. In his compositions Mondrian strove to create a living harmony between these dualities of the natural and spiritual, the inward and outward life of man, the individual and the collective. While true to the essence and laws of painting, Neo-plasticism also sought to express the essential truths of spiritual unity, harmony and universality. In so doing, Mondrian was consciously promoting a new collective consciousness and a vision of universal harmony that would transform mankind.

In *Tableau I*, a vertical and a horizontal line divide the picture plane into quarters, which have then been subdivided in different ways. The placement of the blue rectangle to the left makes the composition seem to radiate from the centre, although the red and yellow rectangles emphasize the periphery of the canvas.[3] The ground is not pure white, but rather shaded blue, a technique Mondrian used more consistently from 1922. CL

1 Yves-Alain Bois et al., *Piet Mondrian 1872–1944* (exh. cat., Haags Gemeentemuseum, 1994), p.204.
2 *De Stijl*, vol.1, no.55 (1917–18), reprinted in Harry Holtzman and Maertin James (eds and trans), *The New Art – The New Life: The Collected Writings of Piet Mondrian* (Boston, 1986), pp.28–74.
3 Els Hoek, 'Piet Mondrian', in Carel Blotkamp et al., *De Stijl: The Formative Years 1917–1922* (Cambridge, MA, 1986), pp.64–9.

13

15a

Spherical box

1920

Naum Slutzky (1894 Kiev –1965 Stevenage)

Chased copper, galvanized inside
h. 16cm
Bauhaus Archiv, Berlin (BHA 3109)

15b

Jug

*c.*1921

Anonymous

Sheet brass, hammered and galvanized inside
h. 15.2cm
Bauhaus Archiv, Berlin (BHA 3113)

The design of the various metal items produced at the Bauhaus in its early years was strongly influenced by the teaching of the Viennese painter Johannes Itten, who was the artistic director or *Form Meister* (form master) of the Metal Workshop, in addition to being responsible for running the Preliminary Course. He encouraged the students to think in terms of basic shapes and textures, and to approach the design task in a way that was less about utility and more about aesthetics and spiritual values. While the workshop's output consisted mainly of very ordinary domestic articles such as jugs, pots, teapots, dishes and boxes, the creative approach to the overall shape was highly innovative: all items were reduced to combinations of basic geometric forms, including the cylinder, cone or cube. In line with Itten's ideas and the decidedly Expressionist and craft orientation of the school at this time, the way in which each item was made (by hammering, engraving or chasing) was not disguised, but was retained as an integral feature of the design, providing evidence of its hand-made quality, as well as giving individuality and vitality to the metal surfaces.[1]

Itten's approach to form is evident in this anonymous brass pot, in which the traditional form of a jug has been translated into a combination of distinctive mathematical elements: an almost completely spherical body, a large inverted cone base and an even bigger conical top, with the spout emphatically present as a separate feature. In this way, each component of the jug is given almost equal weight and importance in the overall design. Yet the forms seem to grow in size towards the top, inverting conventional expectations and apparently defying gravity. This and the emphasis on pure geometry lift such prosaic items beyond the everyday into a more mystical realm, imbuing this jug with a chalice-like presence.

Similar qualities can be discerned in Slutzky's spherical metal box of 1920, which he made while he was acting as *Hilfsmeister* (auxiliary master) for metalwork in gold, silver and copper in the workshop, a position he occupied from 1919 onwards. Slutzky had come to the Bauhaus with Itten from Vienna and, not surprisingly, this work displays the impact of his teacher's precepts. Itten himself praised the work's shape, its proportions, and the texture of the chasing, which reiterates the curvilinear nature of the overall form.[2] The linear and dotted qualities of the chasing contrast with the box's spherical plasticity to create a perfect unity. The simplicity of the form and its treatment bear affinities with the artefacts of primitive peoples and possess a nobility, akin to that of a sacred object, suggesting the possibility of a more spiritual way of life. CL

1 Michael Siebenbrodt (ed.), *Bauhaus Weimar: Designs for the Future* (Ostfildern-Ruit, 2000), pp.123–7. See also *Die Metallwerkstatt am Bauhaus* (exh. cat., Bauhaus Archiv, Berlin, 1992).

2 *Naum Slutzky 1894–1965: Ein Bauhaus-künstler in Hamburg* (exh. cat., Museum für Kunst und Gewerbe, Hamburg, 1995), especially p.34, and *Staatliches Bauhaus Weimar 1919–1923* (Weimar, 1923), p.108.

16 Plate 2.13

Armchair
1922, this version 1924
Marcel Breuer (1902 Pécs, Hungary –
1981 New York)

Stained cherry wood, horsehair and cotton upholstery
96 × 56 × 57cm
V&A: W.6–1988

Breuer made this chair while still a student in the Cabinet-making Workshop of the Bauhaus. He produced several versions, using different woods such as oak and employing various upholstery fabrics, all of which were woven in the Bauhaus Weaving Workshop.

The overall conception undeniably reveals the influence of De Stijl's geometry and spatial principles, possessing particular affinities with the chairs of Gerrit Rietveld. Breuer employed the same type of skeletal framework of planar elements as Rietveld's Armchair of 1918 (pl.2.12). Both chairs have a dual structure to support the back and the arms, and in both the seat slopes backwards. Illustrated in *De Stijl*, Rietveld's design was well known, as were his other furniture designs.[1]

Yet Breuer's chair is distinctive. The dramatic cantilevering of the arms and the back makes the structure seem precarious, with the front legs apparently bearing the whole weight. The soft fabric for the back and seat allow for a degree of comfort, while highlighting the distinction between the supporting framework and the main seating elements. This differentiation, just like the cantilevering, became characteristic of Breuer's later designs, like the Club Chair (pl.3.21).[2]

Breuer's wooden chair was designed in 1922 when the Bauhaus was moving from Expressionism towards a more industrial ethos; from spiritual to social utopia.[3] The spatial openness of the chair contrasts markedly with the solid armchair that Breuer produced for the Sommerfeld House (cat.28). The change in approach was also dramatically manifest in the experimental Haus am Horn of 1923, which was one of the focal points of the school's 1923 exhibition. The house, which included a range of Breuer furniture, demonstrated the Bauhaus vision of an ideal environment and a new way of living. CL

1 Christopher Wilk, *Marcel Breuer: Furniture and Interiors* (exh. cat., Museum of Modern Art, New York, 1981), pp.23–6, which also notes the influence of Theo van Doesburg at the Bauhaus at this time.
2 Ibid., pp.24–9.
3 By 1924 the profile of the wood frame, especially the legs, was made flatter and the supports under the arms were redesigned, as in this example. This version was the one advertised by the Bauhaus in 1925 as their model T1/1a Living Room Chair. See Magdalena Droste and Manfred Ludewig, *Marcel Breuer: Design* (exh. cat., Bauhaus Archiv, Berlin 1992), p.12 n.8, and pp.46–7.

17

Wall hanging
1922/4
Benita Koch-Otte (Benita Otte) (1892 Stuttgart–1976 Bethel, Germany)

Part tapestry, woven cotton and wool
175.5 × 110cm
Städtische Kunstsammlung, Chemnitz (X11/7516)

Koch-Otte produced this hanging while a student in the Weaving Workshop at the Bauhaus. It epitomizes the innovations in textiles introduced by women at the school. Although the Bauhaus in theory espoused the notion of gender equality (a quarter of the students who enrolled in 1919 were women), the school found it difficult to incorporate them fully into the workshop structure.[1] Initially they were relegated to a women's class (set up in May 1920) devoted to appliqué work, and attached to the Textile Workshop under the direction of Johannes Itten. The women's class was merged with Weaving in March 1922, and Georg Muche became the form master, while Paul Klee and Wassily Kandinsky gave students tuition in colour.[2]

Otte's wall hanging exploits the stimulus derived from the various teachers she encountered. Itten provided numerous exercises using primary colours, basic geometric shapes and different materials in order to experiment with notions of contrast.[3] These explorations are reflected in Otte's abstract pattern of squares and in the vibrant colour, as well as the use of various materials (wool and cotton) to produce an interesting surface texture. The hanging is very finely woven and shows Otte's considerable skill in working in a difficult technique that combined tapestry weaving and handwork. The adoption of abstraction and bold colour may also have been encouraged by Klee and Kandinsky's teaching. The squares of colour overlap, creating an effect of transparency, which is intensified by the subtlety of the tones. The range of colours employed may also owe something to the knowledge that Otte and Gunta Stölzl (cats 141–2) had acquired when they studied dyeing with chemicals and natural materials at the Krefeld special dyeing school in March 1922, an experience that led them to set up a Dyeing Workshop at the Bauhaus.[4] As a member of the Weaving Workshop, Otte helped supply fabrics for the Sommerfeld House (cat.20) and the Haus am Horn and subsequently developed textiles for industrial manufacture. CL

1 Hans M. Wingler, *The Bauhaus: Weimar, Dessau, Berlin, Chicago* (Cambridge, MA, 1978) p.486.
2 Sigrid Weltge-Wortmann, *Bauhaus Textiles: Women Artists and the Weaving Workshop* (London, 1993).
3 *Das Bauhaus Webt: Die Textilwerkstatt am Bauhaus* (exh. cat., Bauhaus Archiv, Berlin, 1998), pp.28, 108.
4 Michael Siebenbrodt (ed.), *Bauhaus Weimar: Designs for the Future* (Ostfildern-Ruit, 2000), p.106.

17

18 Plate 2.7

Combination teapot and sugar bowl
1923
Theodor Bogler (1897 Hofgeismar,
Germany–1968 Maria Laach, Germany)

Glazed stoneware
h. 7.3cm
V&A: C.90:1, 2–1994, C.1:1, 2–1995

Bogler produced this combination teapot and sugar bowl while working as a student in the Pottery Workshop of the Bauhaus, which was located about 30 kilometres to the east of Weimar, at Dornberg an der Saale, where there was a long pottery tradition. Bogler joined the Workshop in 1921 and trained with Karl Krehan (craft master), and the sculptor Gerhard Marks (form master).

Bogler's first items were thrown on the potter's wheel, but he abandoned this in 1922, when, in accordance with Gropius's new slogan 'art and technology – a new unity', he began devising ceramics for mass production. He developed a design method that combined standardization with a sense of individuality. He used casting rather than throwing and adopted the strategy of creating basic, rather simple shapes for each item,

to which a limited number of variable features could be added. This cast combination teapot typifies his approach. It consists of a standard shape (designated as shape 'L'), which could be produced with various spouts, handles, openings, and so on, and could be given a variety of different glaze finishes. This example (L2) has a flared handle at the side, while others had loop handles in cane or metal (e.g. L6).[1] In this way, one basic form could be used to produce a large range of easily manufactured items, while additional variety and interest were obtained through the use of glazes. Here, the subtle colouring of the glaze with its chance effects adds a unique feel to the standardized industrial shape.

In 1923 Bogler and fellow-student Otto Lindig set up a separate production workshop specifically to develop prototypes for industry. Bogler's white cast-stoneware kitchen canisters (1923) were the first goods developed in the Workshop to be mass produced by the ceramics factory, Steingutfabrik Velten-Vordamm, and were shown in the Haus am Horn in 1923.[2] CL

1 Michael Siebenbrodt (ed.), *Bauhaus Weimar: Designs for the Future* (Ostfildern-Ruit, 2000), pp.139, 149–53; Klaus Weber, *Keramik und Bauhaus* (exh. cat., Bauhaus Archiv, Berlin, 1989), pp.59–70, 90.
2 Hans M. Wingler, *The Bauhaus: Weimar, Dessau, Berlin, Chicago* (Cambridge, MA, 1978), pp.323, 328–9, and *Bauhaus: Fifty Years* (exh. cat., Royal Academy of Arts, London, 1968), p.342.

19

Drawing: *Design for an Apartment Building*
1921
Vit Obrtel (1901 Prague–1988 Prague)

Pencil and ink on paper
42.7 × 26.9cm
National Technical Museum, Prague

Obrtel produced this design for a five-storey block of flats while still a student at the Czechoslovak Technical University in Prague. Although he did not join the avant-garde Devětsil group until 1923, this early project of 1921 shows affinities with the thinking of the architects within this group, known as ARDEV. It reflected their innovative ideas, their attachment to industrial forms, their espousal of reinforced concrete, and above all their revolutionary desire to transform the environment of the working man through technology.[1]

Obrtel's façade radically simplifies architectural language, eliminating ornamentation and using simple apertures for the regular rows of windows and the entrance (which is placed to one side). This strict rationalism is mediated by the introduction of what appear to be interlocking recessive and protruding masses of an essentially L shape, which combine an asymmetrical

arrangement with a repeating format. This introduces equilibrium into the façade, while allowing a limited but dynamic interplay of light and shadow. The ambiguous relations between receding and protruding elements, which run into one another, produce the visual impression that the surface of the wall is shifting slightly. The design seems to epitomize the principles that Obrtel later articulated about modern architecture as 'the expression of mathematical equations by static geometrical forms in space'.[2]

In its move towards abstraction, the design is very typical of the work of ARDEV. Although Obrtel adopted Constructivism along with Karel Teige (cat.101a) and other members of ARDEV in 1929, he rejected Teige's more scientific and utilitarian approach. Instead, Obrtel accentuated the importance of spiritual ideas in design and stressed the need in buildings for 'the comfort of fact and feeling'.[3] CL

1 Rostislav Švachá (ed.), *Devětsil: Czech Avant-Garde Art, Architecture and Design of the 1920s and 30s* (exh. cat., Design Museum, London, 1990), pp.23, 28–37.
2 Vit Obrtel in *ReD* (1927–8), p.182, cited in ibid., p.36.
3 Ibid., pp.23, 100.

20 Plate 2.1

Drawing: *Friedrichstrasse Skyscraper Project, perspective from north*
1921
Ludwig Mies van der Rohe (1886 Aachen–1969 Chicago)

Charcoal and graphite on tracing paper, mounted on board
173.5 × 122cm
The Museum of Modern Art, New York, Mies van der Rohe Archive, gift of the architect (1005.1965)

Mies van der Rohe developed his famous glass skyscraper as an entry for a competition to build an office building to fit a triangular site on Friedrichstrasse in central Berlin. This dramatic charcoal drawing was probably created for presentation purposes. In his submission, he explained that he had adopted a star-shaped, crystalline ground plan in order to maximize exposure to natural light and ensure that the inner core of the building was well lit.[1] He also employed courtyards, high ceilings and transparent walls of glass, which were motivated by the same concerns for natural light. Space was at a premium and by manipulating the ground plan so that it fully utilized the corners of the triangular site and by using the maximum height suggested (80 metres), Mies managed to design a total of 70,000 square metres of floor space over 20 floors. The brief also stipulated that commercial spaces should be provided. To fulfil this requirement, Mies included nine large shops and three main entrances, as well as six smaller ones. He did not specify a construction method, but in 1922 he cited the technological achievements of the American skyscraper (cat.53) as an inspiration, while stressing the need to find a new style.[2]

Mies's most remarkable innovation was undoubtedly to clothe the entire building in glass. This had the effect of dematerializing its mass through light and reflection. The crystalline ground plan, the use of glass and the emphasis on transparency and reflection suggested a strong link with Expressionist architecture and the concerns of the *Gläserne Kette* group. But while the Glass Chain group were projecting monumental transparent structures in the mountains (pls 2.5, 2.17), far from the contaminating influence of the contemporary urban metropolis, Mies placed their values in the heart of the city. He brought utopia into everyday life, engaging with practical requirements and technological considerations, and providing a paradigm for future buildings.[3] CL

1 Dietrich Neumann, 'Friederichstrasse Skyscraper Project', in Terence Riley and Barry Bergdoll, *Mies in Berlin* (exh. cat., Museum of Modern Art, New York, 2001), pp.180–83.
2 Detlef Mertins, 'Architecture of Becoming: Mies van der Rohe and the Avant-Garde', in ibid., pp.117–18.
3 See also John Zukowsky (ed.) *Mies Reconsidered: His Career, Legacy and Disciples* (Chicago, 1986); Franz Schulze, *Mies van der Rohe: A Critical Biography* (Chicago, 1985), pp.96–100; and Fritz Neumeyer, *The Artless World: Mies van der Rohe on the Building Art* (Cambridge, MA, 1991).

21 Plate 8.3

Films: *Lichtspiel* (*Lightplay*), *Opus I–IV*
Produced by Walther Ruttmann (1887 Frankfurt-am-Main–1941 Berlin)

10 mins; 5 mins; 3 mins; 2 mins; silent (accompanying music for *Opus I* by Max Butting), black and white, with some tinting
Germany, 1920–24

The idea of painting set in motion by means of film had been in the air since at least 1910, but was first practically achieved by Ruttmann in his abstract *Lightplay* series.[1] Here wave, cone and lozenge forms, all vividly coloured in their first presentation and accompanied by specially composed music, move freely against a black background, pulsating and creating patterns in time and space.[2] As the series progressed, Ruttmann introduced more intricate geometrical forms, with horizontal bars, columns, and shapes evoking musical instruments, building towards a complex interplay of abstraction and stylized representation. This interplay reflected the influence of Cubist painting, but was somewhat different in aim from the self-contained painterly and graphic purism of his film-making contemporaries Hans Richter and Viking Eggeling.

After training as an architect in Zurich, Ruttmann gravitated towards Munich around 1909 and became friendly with a number of artists, including Wassily Kandinsky (pl.2.2), who was then formulating his ideas about the underlying unity of painting and music.[3] As a musician himself, Ruttmann was clearly attracted to the idea of 'optical music', which had been popular among Symbolists at the *fin de siècle*. By 1920 Ruttmann succeeded in devising animation procedures that produced the desired abstract imagery. His early films proved so popular that he was soon contributing to works by very different film-makers, including Fritz Lang's *The Nibelungen* (1924) and Lotte Reininger's silhouette animation *The Adventures of Prince Achmed* (1926), before being invited to take charge of realizing Carl Mayer's ambitious plan for a comprehensive portrait of Berlin. The resulting *Berlin: Symphony of a Great City* (1927) showed Ruttmann's fundamentally musical approach applied to documentary material, creating visual counterpoint, yet also bringing him close to the aesthetic of the New Objectivity. IC

1 Reported early Futurist experiments have not survived and other such projects of the 1910s remained unfilmed (see Chapter 8).
2 An evocative account of the impact of Ruttmann's *Opus I* in Berlin in April 1921 appeared in Herman George Scheffauer, *New Vision in the German Arts* (New York, 1924), pp.145–7; quoted in Standish Lawder, *The Cubist Cinema* (New York, 1975), pp.60–61. Other sources on Ruttmann include David Curtis, *Experimental Cinema* (London; 1971), pp.28–30; and Birgit Hein and Wulf Herzogenrath, *Film als Film: 1910 bis Heute* (Cologne, 1977), pp.61–7.
3 Most significantly in Wassily Kandinsky, *Concerning the Spiritual in Art* (Munich, 1914).

22a

Model: Schröder House

1924

Designed by Gerrit Rietveld

(1888 Utrecht–1964 Utrecht)

Model made by G.A. van de Groenekan,

c.1950

Wood, plywood, cardboard, glass
10.5 × 21.5 × 9.7cm
Stedelijk Museum, Amsterdam, donated by Rietveld *c*.1951
(KNA2846)

22b

Axonmetric drawing: First floor of Schröder House

1924

Gerrit Rietveld (1888 Utrecht–1964 Utrecht)

Pencil, ink, watercolour on collotype
83.5 × 86.8cm
Rietveld Schröder Archives, Centraal Museum, Utrecht

22c

Photograph: Schröder House

c.1924

Designed by Gerrit Rietveld

(1888 Utrecht–1964 Utrecht)

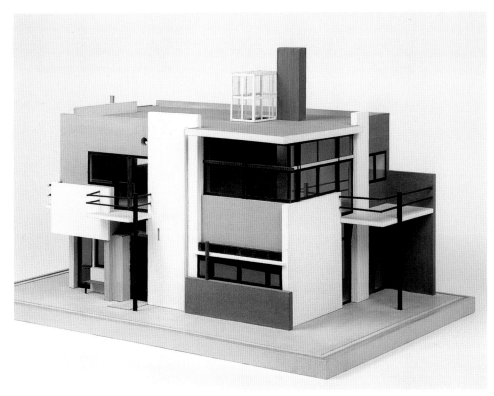

22a

In 1924 Rietveld was commissioned by Mrs Truus Schröder to design a house for herself and her three children. The house had to join the end of a terrace in what was then 'a rural spot' on the outskirts of Utrecht.[1] It was a small site, and the resulting structure is very modest in scale. Mrs Schröder's input into the design was significant, particularly concerning the arrangement of the interior, resulting in a fruitful collaboration between client and architect.[2] Indeed, the two continued working together as designers for several years after the completion of the project.

Utrecht's rather rigorous building regulations meant that the ground floor had to be fairly conventional. Hence it contained the kitchen, library, study and workroom. The top floor, which housed the sitting and dining areas, along with sleeping and washing facilities, could be classified as an attic. This meant that it could be completely open-plan, with sliding partitions providing flexibility so that private spaces could be enclosed or opened up for more sociable activities, as required. These moving screens seem to have a practical origin, but they can also be seen as a pictorial intervention in the design, complementing the blocks of colour that Rietveld applied to the floor.[3] Although the building method was of traditional brick, De Stijl principles of composition and colour were used throughout so that exterior,

interior and furnishings were all integrated into what has been seen as an architectural manifesto and a blueprint for a new way of living.[4]

The exterior demonstrates strong parallels with Theo van Doesburg's and Cornelis van Eesteren's elementarist principles and the architectural models they exhibited at the galeries de l'effort moderne in 1923 in Paris (one of which, the Maison Rosenberg, was made by Rietveld). Each façade of the Schröder House also comprises an asymmetrical composition of rods and planes, which resembles a Neo-plastic painting by Piet Mondrian (pl.2.11).[5] Rietveld himself stressed that the design embodied the spatial principles that he had first developed in his Armchair of 1918 (pl.2.12).[6] The walls seem to defy their structural role: planes are recessed and protrude to create a fluctuating surface, emphasized by the use of colour (the three primaries as well as black and white, and four shades of grey). The white slab on the balcony, facing what used to be meadowland, seems to float in space, the black balcony rails appearing to thread through it and the grey plane behind highlighting the effect of weightlessness. Cantilevering extends the roof line horizontally, while the yellow stanchion on the street façade extends beyond it vertically, and the black balcony rails seem to wind in and out among the planes through all three façades. The large windows open outwards, extending the living space and fusing interior and exterior. Of particular note is the north-eastern corner of the first floor where two windows meet without vertical support, so that,

when they are open, the corner of the room is completely open.

Initially, the upstairs interior provided for a bathroom and three spaces with beds (which became couches by day), as well as cooking and washing facilities. In 1936, after the children left home, the interior was remodelled, but the essential architectural features of the design were retained along with the furniture. The fact that the house was inhabited continually made it an effective and living demonstration of De Stijl's utopian ideals. CL

1 Rietveld cited by Michael White, *De Stijl and Dutch Modernism* (Manchester, 2003), p.127; see also pp.126–32.
2 Paul Overy et al., *The Rietveld Schröder House* (Houten, 1988), pp.16–17.
3 Yves-Alain Bois, *Painting as Model* (Cambridge, MA, 1990), p.119.
4 Gerrit Rietveld, *Architect* (exh. cat., Stedelijk Museum, Amsterdam 1971), n.p.
5 Nancy Troy, *The De Stijl Environment* (Cambridge, MA, 1983), pp.117–19.
6 Rietveld (1971).

22b

22c

23 Plate 1.5

Sculpture: *Spatial Composition (4)*

1928

Katarzyna Kobro (1898 Moscow–
1951 Łodz, Poland)

Painted steel
40 × 64 × 40cm
Muzeum Sztuki Łodz, gift of the artist
(MS/SN/R/18)

This construction is one of a series of works that Kobro produced during the 1920s, while she was a member of the Polish Constructivist movement.[1] The constructions also embody utopian aspirations generated by her own experience of the Russian Revolution and her profound knowledge of avant-garde ideas. These were inspired by her studies with both Kazimir Malevich (pl.2.8) and Vladimir Tatlin (cat.3), before she moved to Poland in 1923 with her husband, the painter Władisław Strzemiński.

Spatial Composition (4), like others in the series, reveals her belief that the fundamental problem of sculpture was the expression of spatial relationships. She also gave her works a strong

mathematical and industrial resonance, evoking the efficiency of the New Man and the tempo of Taylor's principles of time and motion by using his calculations and diagrams as the basis for her compositions.[2] Her sculptures were based on a modular system, using a ratio of 5:8, derived from the progression of numbers developed by Leonardo of Pisa, known as the Fibonacci series.[3] Some of the constructions were completely white, perhaps in accordance with Malevich's identification of white with infinity.[4] Others, such as this piece, were coloured (using the De Stijl palette of the three primaries, plus grey and black) to destroy their optical unity, dematerialize the planes and intensify the sense of spatial flow. Sometimes each side of the same plane was given a different colour. These strategies encouraged the spectator to move around the sculpture and experience its spatial and temporal rhythms.

Kobro consistently regarded her work as having the potential to lead to improved design in the wider world. In 1937 she wrote: 'The task of a spatial composition is the shaping of forms, which can be translated into life. The spatial composition is a laboratory experiment that will define the architecture of future cities.'[5] Accordingly, in 1932–4 she had based her *Design for a Functional Nursery School* on *Spatial Composition 8* of 1932. CL

1 See Hilary Gresty and Jeremy Lewinson, *Constructivism in Poland 1923–1936* (Cambridge, 1984) and Timothy Benson (ed.), *Central European Avant-Gardes: Exchange and Transformation, 1910–1930* (exh. cat., Los Angeles County Museum of Art, 2002).
2 Andrzej Turowski, 'Rytmologia stosowana' ['Applied Rhythmology'], in *Awangardowe marginesy* [*Fringes of the Avant-Garde*] (Warsaw, 1998).
3 Andrzej Turowski, 'Theoretical Rhythmology, or the Fantastic World of Katarzyna Kobro', in *Katarzyna Kobro 1898–1951* (Leeds, 1999), pp.83, 85.
4 Janina Ładnowska, 'Katarzyna Kobro – An Outline of Her Life and Work', ibid., p.64.
5 Katarzyna Kobro, untitled statement, 1937, ibid., p.169; see also catalogue entry on p.131.

24 Plate 2.4

Model: The Glass Pavilion

Originally made 1914, reconstruction 1992–3
Designed by Bruno Taut (1880 Königsberg, Germany–1938 Ankara)

MDF, brass, acrylic and other materials
h. 70cm, diam. 74cm
Werkbundarchiv, Museum der Dinge, Berlin

The Glass Pavilion was commissioned by the glass industry for the 1914 *Werkbund* exhibition in Cologne. Taut's structure demonstrated the various ways glass could be used in a building, but also indicated how the material might be used to orchestrate human emotions and assist in the construction of a spiritual utopia. Taut's interest in this aspect of glass (explored more intensively during the First World War and later in his book *Alpine Architecture* (pl.2.5) and in the Glass Chain letters) had been stimulated by the writer Paul Scheerbart. whom he had met in 1912 and who argued for an earthly paradise based on a new architecture of glass and colour.[1] Subsequently, Scheerbart wrote *Glasarchitektur* in 1914, which he dedicated to Taut, while Taut produced his Glass Pavilion and inscribed aphorisms from Scheerbart on the lintels of the 14 side walls.[2]

The Pavilion structure was raised up on a concrete plinth, the entrance reached by two flights of steps (one on either side of the building), which gave the pavilion a temple-like quality. The glazed walls were topped by a dome of reinforced concrete ribs and a double skin of glass: reflecting glass on the outside and coloured prisms inside. In the interior, the colour effects produced by sunlight were enhanced by the reflections of the pool and water cascade on the lower level, visible through a circular opening in the floor. Two flights of glass steps enclosed with glass walls produced the sensation of descending to the lower level 'as if through sparkling water'.[3] The cascade was made of yellow glass, while the pool was of its complementary colour, violet. A mechanical kaleidoscope overhead projected images, an early version of a light show, intensifying the overall impression on the visitor. CL

1 See Iain Boyd Whyte (ed. and trans.), *The Crystal Chain Letters: Architectural Fantasies by Bruno Taut and His Circle* (Cambridge, MA, 1985).
2 See Iain Boyd Whyte, *Bruno Taut and the Architecture of Activism* (Cambridge, MA, 1982), pp.32–8.
3 Cited in Wolfgang Pehnt, *Expressionist Architecture* (New York, 1973), p.76.

25a Plate 2.5

Schnee Gletscher Glas (Snow Glacier Glass), page from *Alpine Architektur (Alpine Architecture)*
1919
Bruno Taut (1880 Königsberg, Germany–1938 Ankara)

Coloured lithograph on paper
39.4 × 33.3cm
Centraal Museum, Utrecht, formerly owned by Gerrit Rietveld

25b

Dandanah, the Fairy Palace, set of 51 glass blocks
Designed 1919–20
Designed by Bruno Taut (1880 Königsberg–1938 Ankara)
Manufactured by Luxfer-Prismen Gesellschaft, Berlin, 1927

Cast glass
Box 4.1 × 27.7 × 27.7cm;
Deutsches Spielzeugmuseum, Sonneberg (Inv. No.59/449)

Taut epitomized the values of Expressionist architecture during the period of the First World War. He combined political and architectural radicalism, and firmly believed that architecture was a means of creating a perfect society and producing international harmony.[1] He promoted these ideas through the *Arbeitsrat für Kunst*, which he founded in 1918. The transparency of glass and the mystical qualities of the crystal underpinned his projects, and in 1919 he initiated *Die Gläserne Kette*, a correspondence between architects to which he contributed under the pseudonym of *Glas* (Glass).[2]

Alpine Architecture was conceived in 1917 and epitomizes Taut's utopian vision and belief that man's home is the Sublime.[3] The handwritten text is integrated into the drawings, emphasizing the unity of idea and image, while creating an aesthetic whole. The images are arranged in five sections: 'The Crystal House', 'Architecture in the Mountains', 'Terrestrial Building' and 'Astral Building'. The book is orchestrated like a spiritual journey, beginning with the approach to the new kind of temple, the Crystal House. It is set high in the Wildbachtal mountains, in the regions of snowfields and glaciers, reached through a gorge spanned by coloured glass arches, the path bordered with crystal masts sparkling in the sun. The house itself is built entirely of coloured crystal glass and represents the 'Most Sublime, the Void'. It is remote from the city because, Taut explained, 'Architecture and the vapour of cities remain irreconcilable antitheses'. Religious services are replaced by contemplating the silence, the architecture, occasional music and a few 'cosmic paintings'. 'Architecture in the Mountains' presents a series of structures, like arches of emerald glass, which are intended to act as 'a framework of space open to the universe'. This section includes *Schnee Gletscher Glas*, which shows a construction of coloured planes and glass built in the 'regions of eternal ice and snow' comprising 'Mountain flowers'. Such ideas are extended to specific locations such as the Matterhorn. Taut firmly presents his vision as the antithesis to the contemporary city and the present war, by including an impassioned plea to the People of Europe to abandon the utilitarian and embrace his vision to ensure peace and harmony throughout the world. The journey ends in the immensity of space with 'Astral Building' and 'The Cathedral Star'.

It is in this context that Taut's Dandanah, or Fairy Palace, of 1919 should be viewed. Ostensibly made as an educational toy for children, the set of 51 glass blocks are of different colours (red, blue, yellow, green and colourless) and basic shapes (triangular blocks, cubes, half-octagons, rectangular blocks and spheres). On one level, they simply represent the element of play – the basis for fantasy and imagination. This playful aspect can be linked tangentially with Dada and its cultural iconoclasm.[4] Yet the blocks comprise the essential vocabulary of architectural form and thus embody a serious architectural purpose. They epitomize the value that Taut placed on glass, and they embody the ingredients of those sublime structures that Taut created in *Alpine Architecture*. In a very real way they link utopia with the basic process of form-making. Indeed, the set came with five diagrams showing how to display them and store them in the box. In a literal way the blocks correspond to Taut's plea to man to participate in building utopia. CL

1 See Iain Boyd Whyte, *Bruno Taut and the Architecture of Activism* (Cambridge, 1982).
2 See Iain Boyd White (ed. and trans.), *The Crystal Chain Letters: Architectural Fantasies by Bruno Taut and His Circle* (Cambridge, MA, 1985).
3 Bruno Taut, 'Alpine Architecture', in Dennis Sharp (ed.), *Paul Scheerbart, Glass Architecture and Bruno Taut, Alpine Architecture* (London, 1972) from which all references in this paragraph come.
4 Timothy O. Benson, 'Fantasy and Functionality', in Benson (ed.), *Expressionist Utopias: Paradise, Metropolis, Fantasy* (Berkeley, 1993), pp.43–4.

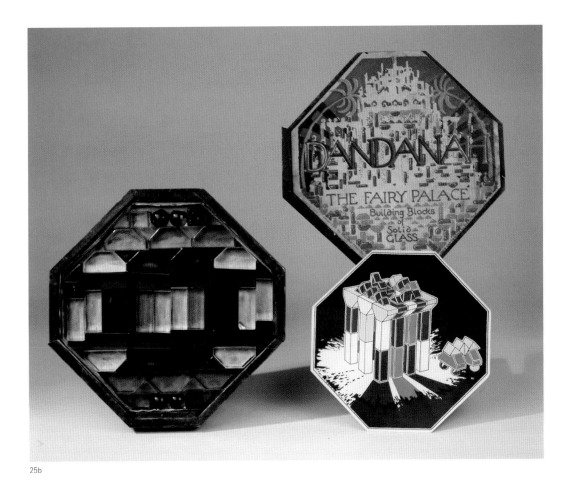

25b

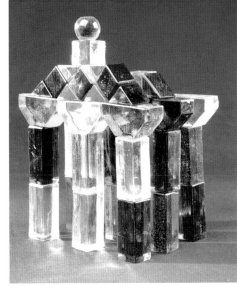

25b

26 Plate 2.6

Cathedral, title page of *Programme of the State Bauhaus in Weimar*
1919
Lyonel Feininger
(1871 New York –1956 New York)

Woodcut
51.5 × 66.5cm
Bauhaus Archiv, Berlin (BHA 1853)

This woodcut was commissioned by Walter Gropius for the title page of the *Programm des Staatlichen Bauhauses in Weimar* (*Programme of the State Bauhaus in Weimar*), issued in 1919 when the school was set up. Feininger, who was already an established cartoonist and painter, was associated with Gropius through his membership of the radical *Novembergruppe* and the *Arbeitsrat für Kunst*. In 1919 he became the first head of graphics at the Bauhaus.

Cathedral vividly evokes Gropius's programme for the Bauhaus and its utopian vision of a future architecture, synthesizing all the arts into a great *Gesamtkunstwerk* (total work of art) 'one unity ... which will one day rise toward heaven from the hands of a million workers like the crystal symbol of a new faith'.[1] The image depicts the general form of medieval cathedrals, while a certain crudity and roughness in the woodcut seem to bear the imprint of the hand of the maker, recalling the craftsmen who constructed them. The lines radiating out from the stars at the tips of the three spires express an optimism that the example of the building will itself radiate outwards into the larger world. The linear style of the drawing possesses a crystalline quality, which seems particularly appropriate to the Expressionist ethos that inspired the founding of the school. At the same time the articulation of the forms is emphatically modern, deriving a great deal from the faceting and geometricization of Cubism. Here, the style is put to Expressionist ends, penetrating beyond the externals of reality to capture an inner essence or, in Feininger's words, 'to portray our inner vision, find our ultimate form uninfluenced by nature in order to express our longing'.[2] CL

1 Walter Gropius, *Programm des Staalichen Bauhauses in Weimar*, April 1919. Trans. in Hans M. Wingler, *The Bauhaus: Weimar, Dessau, Berlin, Chicago* (Cambridge, MA, 1976), p.31.
2 Lyonel Feininger, 'Credo of Expressionism: Letter to Paul Westheim', in Hans Hess, *Lyonel Feininger* (New York, 1961), p.27.

27a

Three perspective sketches:
Einstein Tower
1920
Erich Mendelsohn (1887 Olsztyn,
Poland–1953 San Francisco)

Pen, india ink on paper, mounted on cardboard
7.7 × 13.6cm, 7.6 × 13.5cm and 7.8 × 13.3cm
Kunstbibliothek, Staatliche Museen zu Berlin
(Hdz E.M. 5149. 1-3)

27b

Model: Einstein Tower
Designed 1920, cast from original 1997
Designed by Erich Mendelsohn
(1887 Olsztyn –1953 San Francisco)

Plaster on wooden base
36 × 60 × 25cm including base
Deutsches Architekturmuseum, Frankfurt-am-Main
(025-001-002)

Mendelsohn's idea for the Einstein Tower in Potsdam emerged from a large quantity of drawings that he made in 1917, while serving in the German army on the Russian front during the First World War.[1] Being constantly in fear of losing his life seems to have given added impetus to his creativity. He later stated, 'As few before us, we felt the meaning of living and dying, of end and beginning – its creative meaning in the midst of the silent terror of no-man's land and the terrifying din of rapid fire.'[2] In 1917 he wrote, 'I live among incessant visions. Their transcendence is such, that it often carries me away.'[3] He sketched ideas for all sorts of buildings, including railway stations, airports, film studios, skyscrapers, observatories, warehouses and factories.

Although the drawings were tiny, they often depict monumental structures in a variety of forms and at different scales. Within a fluid curvilinear contour line, each combines a strong sense of organic form, a sensation of growth and a feeling of dynamic rhythm with repetitions and alternate sequences of masses. Mendelsohn wrote from the trenches, 'Problems of symmetry and of the elasticity of the building components and of the closed contour and of methods of construction concern me at every line.'[4] He deliberately gave a horizontal quality to his volumes because he associated horizontality with the new order, with 'mysticism, esoteric doctrine and miracle'.[5] In 1919 he made larger versions of his sketches in order to show them in Berlin at the exhibition *In Eisen und Beton* (In Iron and Concrete).

The Einstein Tower at Potsdam, started in 1920 and completed in 1924, was Mendelsohn's first large architectural commission. Key to its genesis was the astro-physicist Erwin Freundlich, who had worked with Albert Einstein and had discussed the theory of relativity with Mendelsohn. Freundlich was excited by the sketches from the trenches and helped to raise money for the Tower's construction.

The Tower was devised to prove an aspect of Einstein's Theory of Relativity, namely that the sun's spectral lines deviate from those of a terrestrial source of light. Consequently it had to house a telescope and astro-physics laboratories. The dome, with its two-metre slit, can be turned to follow any heavenly body. It houses the coelostat, which transmits the light through a system of mirrors to an underground laboratory, where the temperature is constant and the light can be spectrographically analysed. Sleeping quarters and a study are provided on the southern side between the shaft and the base, while there are

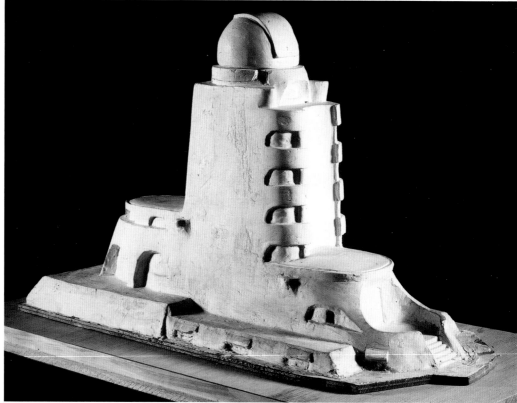

27b

external steps to the north. It was designed to be made of reinforced concrete, which Mendelsohn praised for its elasticity and dynamic tension, but since cement was rationed at the time, it was built of bricks covered with a layer of concrete. The squat tower, with its curved surfaces, rounded corners, concave entrance and deep recesses for the windows, produces a dramatic play of light and shade. It has no technical or scientific resonance, but rather looks like a powerful crouching animal. It is one of the few Expressionist designs of this time to be built, and the overall effect is of a monument rather than simply a building. Indeed, it is an emblem of Promethean power.[6] CL

1 The earliest drawing appears in a letter dated 28 May 1917, in Oskar Beyer, *Eric Mendelsohn: Letters of an Architect* (London, 1967), p.37.
2 Lecture (1948) cited in Wolf von Eckardt, *Eric Mendelsohn* (New York, 1960), p.11.
3 Letter of 17 June 1917, in Beyer (1967), p.40.
4 Letter of 27 May 1917, in Beyer (1967), p.37.
5 Lecture (1923) cited in Wolfgang Pehnt, *Expressionist Architecture*, (London, 1973), p.119.
6 Pehnt (1973), p.121.

27a

27a

27a

28

Sommerfeld House, Dahlem, Berlin
1920–21, destroyed during the
Second World War
Designed by Walter Gropius
(1883 Berlin–1969 Boston, USA) and
Adolf Meyer (1881 Mechernich, Germany –
1929 Baltrum, East Friesian Islands,
Germany)

The house was commissioned by the building contractor Adolf Sommerfeld, who had acquired teak, salvaged from an old battleship, for the project. Gropius's attitude to the commission was both pragmatic and idealistic. In an article he argued, 'Timber is the building material of the present day', precisely because it is 'so suited to the primitive early stages of our renewal of life'.[1] Despite echoes of traditional German housing and Frank Lloyd Wright (in features like the overhanging hip roof), the house had a strong Expressionist feel, with exposed log joints, a rough limestone base, splayed diagonals in the entrance and the crystalline articulation of the first-floor windows. The printed invitation to celebrate the roof's completion shows the house radiating light, like a crystal.[2]

In the double-height hall, triangular motifs symbolizing trees were used to create zigzag-patterned wall panels and carved reliefs on the doors; there the overlapping forms were treated in a variety of textures, reminiscent of teaching exercises on the Bauhaus *Vorkurs* (Preliminary Course). These carvings were produced by members of the Sculpture Workshop, predominantly Joost Schmidt, who made the vignettes on the staircase depicting Herr Sommerfeld's sawmills, in which the stylized figures and rectangular forms possess affinities with De Stijl.[3]

Other Bauhaus workshops also contributed. Josef Albers designed glass for the windows and Marcel Breuer supplied furniture, including upholstered armchairs of cherry wood and leather. The chairs' geometric qualities complemented the rectangular reliefs on the staircase, and the extension of the vertical supports beyond the back and seat give them an abstract sculptural quality.[4] The Sommerfeld house was the Bauhaus's first collective achievement, the first opportunity for all the workshops to collaborate on a single building and create a complete utopian environment, a *Gesamtkunstwerk*. CL

1 Wolfgang Pehnt, *Expressionist Architecture* (London, 1973), p.111.
2 Winifred Nerdinger, *Walter Gropius* (Berlin, 1985), pp.44–5.
3 Hans. M. Winger, *The Bauhaus: Weimar, Dessau, Berlin, Chicago* (Cambridge, MA [1969] 1978), pp.304–5, and Tim Benton, *The New Objectivity* (Milton Keynes, 1973), p.58. Invitation illustrated in Pehnt (1973), p.111.
4 Christopher Wilk, *Marcel Breuer: Furniture and Interiors* (New York, 1981), pp.21–3.

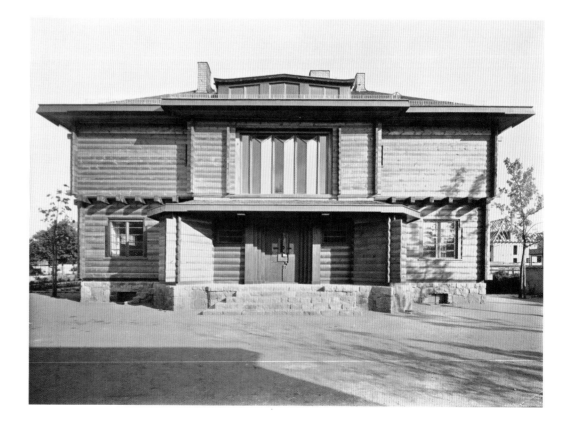

29a

Model: Monument to the March Dead, Main Cemetery, Weimar

Designed 1920–22, later cast from original
Walter Gropius (1883 Berlin–1969 Boston, USA)

Tinted plaster
45.5 × 78 × 52.5cm, ratio 1:10
Bauhaus Universität, Weimar

29b

Print: *Monument to the March Dead, Weimar*
1922
Farkas Molnár (1898 Pécs, Hungary–
1944 Budapest)

Lithograph
36.5 × 51.5cm
Bauhaus Archiv, Berlin (BHA 3168)

29a

The Monument was commissioned by the Weimar branch of the *Gewerkschafts Katel* (Trades Unions Alliance) () in order to commemorate the nine workers who were killed in March 1920 fighting against the attempted right-wing coup of Wolfgang Kapp (the event known as the Kapp Putsch). Gropius had not attended the funeral and had discouraged Bauhaus students from doing so, because he felt that the Bauhaus had to remain aloof from politics.[1] Nevertheless, he participated in the competition for a Monument to the Victorious Proletariat, organized by the Alliance. The entries went on display in December 1920 and his design was subsequently chosen by a full meeting of the Alliance membership. Appropriately the monument was unveiled with a march and a ceremony of dedication on May Day 1922.

The structure was intended to be made of stone, but was finally built in concrete, for financial reasons. Yet as a non-precious and essentially modern building material, it seemed to emphasize the link between the proletariat's struggle and the actual work of building a new world.

The Alliance's newspaper interpreted the staggered diagonals as the sharp-edged proletariat, responding with lightning speed to defend the Republic from the equally lightning attack against them by the forces of reaction. The critic Adolf Behne was more sceptical, arguing that the monument could not be a powerful socialist image precisely because it presented a more general symbol of uprising, and could therefore equally have represented Kapp's forces.[2]

What the form does seem to reflect, however, was Gropius's current immersion in the language and values of the Expressionist movement, his membership of the *Arbeitsrat für Kunst*, his involvement in the *Novembergruppe* and his participation in the *Gläserne Kette* group correspondence, signing himself as 'Mass', meaning measure, proportion, even restraint.[3] The composition of prisms has a strong crystalline feel, and the form surges upwards, cleaving through space, towards something beyond its own materiality. Indeed, the overall composition is very similar to the tip of Karl Schmidt-Rottluff's *Pillar of Prayer* of 1919, which had been designed for Bruno Taut's House of Heaven, which was to be made of glass.[4] The affinity suggests that the Monument, too, was intended to embody a general human aspiration towards the divine. It thus seems to connect political liberation and spiritual enlightenment within a design denoting a general striving towards utopia.

The dynamic thrust of the form is much more evident in the lithograph of the monument by Molnár, which he initially produced for the brochure for the dedication of the Monument in 1922 and then reworked the following year. In this later interpretation, especially, it takes on an almost phallic quality. The dark background

throws the sculpture into relief and emphasizes the drama of the composition. Molnár, who had fled Hungary when the communist regime was overthrown, seems to have imbued the highly charged image with his own emotional and radical political sympathies. He helped to design the brochure and even wrote an article about the Monument for inclusion in the publication.[5] Molnár was studying architecture at the Bauhaus and was in sympathy with Gropius's re-emerging rationalism; he attended Theo van Doesburg's courses in Weimar in 1922 and wrote the manifesto of the Kuri group of Bauhaus students, whose name was derived from its slogan 'constructive, utilitarian, rational and international'.[6]

The Monument was destroyed by the Nazis in 1935–6, but in 1946 it was reconstructed with slight alterations by the recently established communist regime of the German Democratic Republic. CL

29b

1 On the history of this monument, see Klaus-Jürgen Winkler and Herman van Bergeijk, *Das Märzgefallenen-Denkmal* (Weimar, 2004).
2 Winfried Nerdinger, *Walter Gropius* (Berlin, 1985), pp.46–7
3 Iain Boyd Whyte, *The Crystal Chain Letters: The Architectural Fantasies of Bruno Taut and His Circle* (Cambridge, MA, 1985), p.3.
4 Wolfgang Pehnt, *Expressionist Architecture* (London, 1973), pp.112–13.
5 Michael Siebenbrodt, *Bauhaus Weimar: Designs for the Future* (Ostfildern-Ruit, 2000), pp.188, 281.
6 Bernd Finkeldey et al. (eds), *Konstruktivistische Internationale schöpferische Arbeitsgemeinsaft 1922–1927: Utopien für eine Europäische Kultur* (exh. cat., Kunstsammlung Nordrhein-Westfalen, Düsseldorf, 1992), pp.178–82.

30

Painting: *Cantilever Cupola with five hilltops as basis*
1924
Wenzel Hablik (1881 Brüx, Bohemia–1934 Itzehoe, Germany)

Oil on canvas
166 × 192cm
Wenzel Hablik Museum, Itzehoe (WH Öl 201 (511))

This painting epitomizes the utopian visions and architectural fantasies that Expressionist artists created during the First World War and its immediate aftermath. Yet it was produced by Hablik in 1924, at a time when many of his Expressionist colleagues had adopted a less explicitly spiritual and visionary approach to the construction of utopia.

In this respect, the painting reflects Hablik's consistent interest in the crystal as an image of the divine, from his early portfolio of etchings *Schaffende Kräfte* (*Creative Forces*) of 1909 to his late portfolio of 1925, *Cyclus Architektur – Utopie* (*Architectural Cycle – Utopia*). Each contains imaginary crystalline structures, arches and domed buildings, perched high in the mountains,

on the sea or floating in air, even surrounded by rings of colour, like a planet.[1] Not surprisingly Hablik became involved with the *Arbeitsrat für Kunst* in 1919 and participated as 'W.H.' in the group known as the *Gläserne Kette* in 1919–20. He proposed that the *Gläserne Kette* should produce 'The Book', to which all the correspondents should contribute, and which would 'eliminate the thought of war for all time', 'inspire positive action', replace all previous religious texts and 'speak of the religion of creation'.[2] He also emphasized his own desire to 'create joy in every form' and his belief 'in beautiful towns and a communal existence'.[3]

Though trained as a master cabinet maker, and having studied in Vienna, Prague and elsewhere, Hablik had acquired a great deal of architectural knowledge. This was eventually used to a limited extent in the interior designs he created for the town hall, Hotel Central and private houses in Itzehoe in Holstein. His extensive knowledge of the crafts was reflected in his setting up of a studio for hand weaving in 1927. CL

1 See Heinz Spielmann und Susanne Timm, *Wenzel Hablik* (Schleswig, 1990) and *Wenzel Hablik: Attraverso l'espressionismo/Expressionismus und Utopie* (exh. cat., Museo Mediceo, Florence, 1989).
2 Hablik, letters January 1920, in Iain Boyd Whyte (ed. and trans.), *The Crystal Chain Letter: Architectural Fantasies by Bruno Taut and His Circle* (Cambridge, MA, 1985), p.39.
3 Hablik, letters January and July 1920, in ibid., pp.37, 136.

31 Plate 2.17

Monument to the November Revolution, Friedrichsfelde Cemetery, Berlin

1926, destroyed 1933
Ludwig Mies van der Rohe
(1886 Aachen–1969 Chicago)

This is Mies van der Rohe's only sculpture. It was commissioned by the German Communist Party to commemorate Karl Liebknecht and Rosa Luxemburg, as well as other revolutionaries, who were murdered when the Spartacus uprising of 1918–19 was brutally suppressed.[1]

The elongated format (six metres high, 12 metres long and four metres wide) and the choice of brick were inspired by the notion of the wall against which many of the victims were shot.[2] Old bricks were used to give a sense of the harshness of the executioner's wall and to convey the idea of suffering, further emphasized by the purplish colour of the burned clinker bricks. The irregularity of the bricks also gives them a sense of individuality, perhaps reflecting the role of individuals within the revolutionary collective. The cantilevered and interlocking irregular-sized rectangular masses convey a sense of solidity, while introducing an element of dynamism, which is intensified by the dramatic play of light and shadow across the surface. This approach to volumes recalls Mies's Brick Country House Project (Potsdam, 1924, pl.5.24), as well as the Wolf House (Guben, 1925–7), on which he was working at the time of building the monument.[3]

Attached to the wall was a five-pointed star (the symbol of the Red Army) enclosing the hammer and sickle (the insignia of the Soviet Union). The monument was also inscribed: 'I am, I was, I will be' ('Ich bin, Ich war, Ich werde sein'), which is similar to the slogans attached to Soviet images of Lenin, intended to emphasize the enduring nature of the revolutionary movement.

Such explicitly communist components, as well as the commission itself and the emotional intensity of the monument, are in line with Mies's participation in the *Novembergruppe*, but contrast with his later, less ideological, more pragmatic work during the Nazi regime (pl.10.15).[4] CL

1 Katherine Howe, 'Monument to the November Revolution', in Terence Riley and Barry Bergdoll, *Mies in Berlin* (exh. cat., Museum of Modern Art, New York, 2001), pp.218–19.
2 Franz Schulze, *Mies van der Rohe: A Critical Biography* (Chicago, 1985) pp.125–8.
3 Riley and Bergdoll (2001), pp.194–5, 202–5.
4 See Elaine S. Hochman, *Architects of Fortune: Mies van der Rohe and the Third Reich* (New York, 1989); *Mies Reconsidered: His Career, Legacy and Disciples* (exh. cat., Art Institute of Chicago, 1986); and Fritz Neumeyer, *The Artless Word: Mies van der Rohe on the Building Art* (Cambridge, MA, 1991).

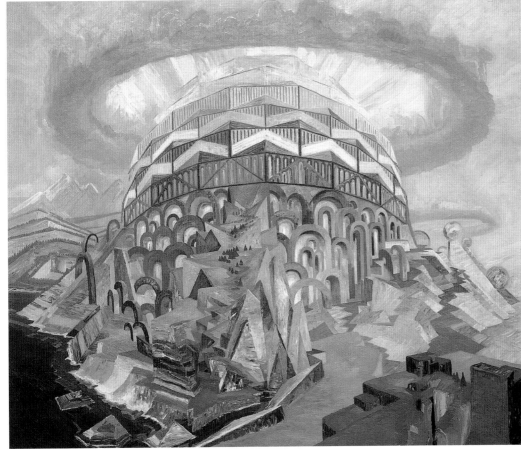

30

32a Frontispiece

Drawing: *The Città Nuova: Airplane and railroad station, with cable cars and elevators on the three street levels*
1914
Antonio Sant'Elia (1888 Como –1916 Monte Hermada, Gorizia)

Black ink, blue-black pencil on tracing paper
50 × 39cm
Museo Civico, Palazzo Volpi, Como

32b

Drawing: *The Città Nuova apartment building with external elevators, galleries, covered walkways, on three street levels (tramlines, automobile lanes, and pedestrian walkway), lamps and wireless telegraph*
1914
Antonio Sant'Elia (1888 Como – 1916 Monte Hermada)

Black ink, blue-black pencil on yellow paper
52.5 × 51.5cm
Museo Civico, Palazzo Volpi, Como

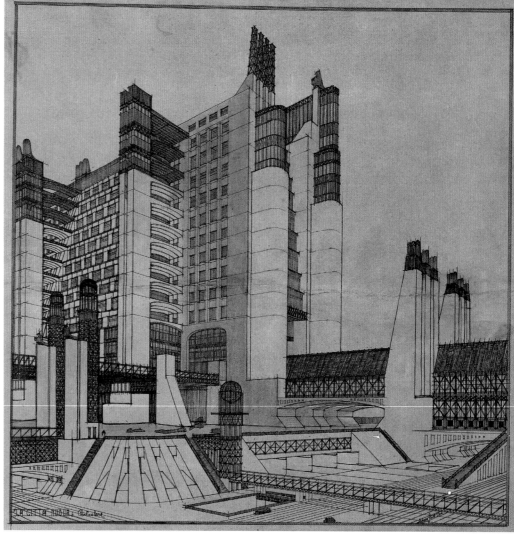

32b

In spring 1914 Sant'Elia, a professional architect working in a Secessionist idiom, exhibited a series of drawings relating to his utopian vision of a completely industrialized and technologically advanced *Città Nuova* (New City). These were shown at an exhibition of Lombard architects and, two months later, at the exhibition *Nuove Tendenze: Milano l'ano due mille* (New Tendencies: Milan the Year Two Thousand). His *Messagio*, a polemical statement, printed in the catalogue, did not mention the words Futurist or Futurism, but emphasized the need to respond to the new industrial age and to celebrate the conditions and focal points of contemporary urban life – grand hotels, railway stations and ports. Sant'Elia stressed that it was necessary to reinvent the city as a dynamic entity and to construct buildings like gigantic machines.[1] His *Messagio*, edited and slightly altered by leading Futurist Filippo Tommaso Marinetti, was printed as a pamphlet entitled 'L'Architettura futurista. Manifesto' ('Futurist Architecture. A Manifesto', dated 11 July 1914) and then reproduced in the Futurist publication *Lacerba* (10 August 1914), both also illustrating his *Città Nuova* drawings.[2] The revised text suggested a strong affiliation with the Futurist movement, although the nature and extent of Sant'Elia's attachment have recently been questioned.[3]

The drawings can be linked with the Futurists' celebration of speed and the dynamism of modern life. They convey a total vision of a future metropolis in which streets are no longer confined to ground

level and in which buildings, as tall as American skyscrapers, do not stand alone (as in New York), but are part of an integrated urban complex.

Sant'Elia's drawing style owed much to the conventions of Viennese architecture of about 1900, especially the widely published designs of Otto Wagner and his students. Sant'Elia's precise and elaborately detailed ink drawings were the result of a process of preparatory sketches and studies related to their function as exhibition drawings.

The apartment building has external elevator shafts linked to the building by a series of bridges and covered walkways. This arrangement accentuates the mechanistic components of the housing block, making them a dominant aspect of the building's façade. It is articulated with both flat and stepped-back walls and is pierced by transportation lines and bridges, which link it directly to other elements in the city. In this way Sant'Elia abolished the notion of the monolithic, free-standing building and integrated it fully into the complete urban machine. Similarly, he fused

different modes of transport (rail and air) into a single multi-levelled structure with cable cars and elevators, again emphasizing the mechanistic purpose of the building and its dynamic role within the life of the city. With its symmetrical towers and colossal scale, however, it resembles a cathedral of the future, a monument to the vision of a future way of life. CL

1 Dore Ashton and Guido Ballo (eds), *Antonio Sant'Elia* (Milan, 1985).
2 For the text of the manifesto, see Umbro Apollonio (ed.), *Futurist Manifestos* (London, 1973), pp.160–72.
3 Richard Etlin, *Modernism in Italian Architecture 1890–1940* (Cambridge, MA, 1991), pp.68–71.

33 Plate 2.14

Futurist suit

*c.*1920

Designed by Giacomo Balla
(1871 Turin–1958 Rome)

Wool and cloth
141 × 63cm
Ottavio and Rosita Missoni Collection

In 1914 Giacomo Balla published a Futurist Manifesto of Men's Clothing.[1] The text, in accordance with the Futurists' enthusiasm for modernity and the machine, rejected conventional male clothing as 'tight-fitting, colourless, funereal, decadent, boring and unhygienic'.[2] It called for the abolition of features such as turn-ups and vents as well as the traditional patterns of checks, spots and lines. In their place, Balla called for 'daring clothes with brilliant colours and dynamic lines' incorporating asymmetry and energetic shapes, such as 'triangles, cones, spirals, ellipses, circles, etc.' Such garments had to be simple in shape, but not durable, so that they would 'provide constant novel enjoyment for our bodies' and could be changed frequently to suit the wearer's

mood (cat.41). The pursuit of unremitting innovation in clothing corresponds to the Futurists' commitment to constant renewal in art, and enthusiasm for the philosopher Henri Bergson's concepts of the state of flux and '*élan vital*'.

Such ideas underpinned the design of this particular suit and other items of apparel, including ties and women's dresses by Balla, as well as waistcoats by Fortunato Depero.[3] The date of manufacture of this particular suit is uncertain. A photograph of Balla wearing it is dated 1929–30, but it relates strongly to design drawings of 1913–14.[4] The cut is simple and overlaid with striking prisms of yellow, black, orange and red, which Balla called 'forceful muscular colours'. This type of clothing was an aspect of the Futurists' utopian venture of transforming Italy into a totally Futurist environment and imbuing it with Futurist values. The suit was intended to be worn in the buildings of Antonio Sant'Elia, which pulsated with energy (frontispiece, cat.32); or in the Futurist landscape filled with robotic animals and geometric, brightly coloured artificial flowers; or in the bold and bright interiors of the Casa Balla, with its new types of furniture.[5] Balla declared, 'The happiness of our *Futurist clothes* will help to spread the kind of good humour aimed at by my great friend Palazzeschi in his manifesto *against sadness*.'[6] CL

1 Giacomo Balla, *Le Vêtement Masculin Futuriste* (Paris, 1914) and *Il Vestito Antineutrale: Manifesto Futurista* (Milan, 1914), reproduced respectively in Giovanni Lista, *Futurism* (Paris, 2001), p.151, and in *Balla: The Futurist* (exh. cat., Scottish National Gallery of Modern Art, Edinburgh, 1987), p.32.
2 Umbro Apollonio (ed.), *Futurist Manifestos* (London, 1973), pp.132–3.
3 Lista (2001), pp.150–51; *Balla: The Futurist* (1987), pp.33, 47, 112, 146.
4 Gisela Framke (ed.), *Künstler ziehen an: Avantgarde-Mode in Europa 1910 bis 1939* (exh. cat., Museum für Kunst und Kulturgeschichte, Dortmund, 1998), pp.29, 33–5.
5 See Valerie J. Fletcher, *Dreams and Nightmares: Utopian Visions in Modern Art* (Washington, DC, 1983) pp.39, 41–2; and *Balla: The Futurist* (1988) pp.138, 142, 145.
6 Apollonio (1973), p.133.

34 Plate 2.15

Perspective drawing: *Dom-ino Skeleton*
1914–15

Le Corbusier (Charles-Edouard Jeanneret)
(1887 La Chaux-de-Fonds, Switzerland–
1965 Cap-Martin, France)

Pencil on tracing paper
44 × 58cm
Fondation Le Corbusier, Paris (FLC 19212)

The Dom-ino system was developed by Le Corbusier in 1914–15, in response to the widespread destruction of Flanders during the war.[1] The system consisted of three slabs, the upper two being supported by six square-sectioned concrete posts, while the lowest slab was lifted off the ground and rested on concrete blocks. The slabs were to be made of pot tile covered with concrete and reinforced with interior steel beams. Unlike most systems of reinforced concrete at the time, Le Corbusier's floor slabs were perfectly flat, without any beams or brackets spreading the load from the posts.

The name Dom-ino derives from the Latin *domus* (house) and the game of dominoes – the placement of the posts resembling the location of the dots on a domino chip. It expressed cogently the fact that standardization and industrialization underpinned the design. Le Corbusier claimed that houses made using this system could have been constructed in 20 days.

The system also allowed for flexibility. By placing the posts away from the edges, Le Corbusier separated the frame from the fill and the structural function of the wall from its role as a screen and source of illumination. The wall ceased to be load-bearing and became merely a membrane, in which windows and doors could be placed at will, around corners, if desired. Likewise, the interior – now also free of large internal supporting walls – could also be partitioned off as required.

Le Corbusier exploited the freedom of the system in his later work, but it took him several years to realize the aesthetic potential of the 'free plan' and 'free façade'. This perspective view of the skeleton became one of the iconic images of Modernism, inspiring a generation of architects to separate form from structure.[2] CL

1 See Le Corbusier and Pierre Jeanneret, *L'oeuvre Complète de 1910–1929* (Zurich, 1937), pp.23–6, and Eleanor Gregh, 'The Dom-ino Idea', *Oppositions*, no.15/16 (Winter/Spring 1979), pp.61–87.
2 William J. R. Curtis, *Le Corbusier: Ideas and Forms* (London, 1982).

35 Plate 2.16

Model: Maison Citrohan II

Designed and made 1922
Le Corbusier (Charles-Edouard Jeanneret)
(1887 La Chaux-de-Fonds, Switzerland –
1965 Cap-Martin, France)

135 × 81 × 82cm
Fondation Le Corbusier, Paris

In 1922 Le Corbusier exhibited the Citrohan House and a plan for a Contemporary City (cat.36). The two ideas were developed in tandem and provided a blueprint for a new way of urban living. Whereas the Contemporary City would have required massive state intervention, the Citrohan House was intended to evolve directly from industrial production and market forces. The Citrohan House (the name evoking Citroën cars) embodied the ideas enunciated in *Vers une architecture* (1923). In that book Corbusier had argued for a house to

be mass-produced, to work as efficiently as a motor car, and to function effectively as a machine for living in. The Citrohan concept was intended to provide a standardized model to meet the demand for affordable housing.[1]

Le Corbusier designed two versions of the Citrohan House, both of which were intended to be prefabricated in order to provide cheap, rapidly constructed but permanent, high-quality accommodation. Both versions had flat roofs and roof terraces with a double-height main living area, in which a double-height window, made from industrial glass, occupied one wall, flooding the interior with light. The second version was raised above the ground on cylindrical posts, or *piloti*, providing parking, garage and boiler-room space at ground level.[2] There was also a large balcony, which wrapped around the front and sides of the building on the first-floor level, with an external staircase. Kitchen, bathroom, bedrooms and a maid's room were located to the rear, with some sleeping accommodation provided on the gallery of the living room, accessed via an internal spiral staircase. The Citrohan Houses were intended,

like automobiles, to revolutionize the housing market, not to provide minimum dwellings for those on the lowest incomes. CL

1 *Le Corbusier: Architect of the Century* (exh. cat., Hayward Gallery, London, 1987), pp.208–10. See also Le Corbusier and Pierre Jeanneret, *L'oeuvre Complète de 1910–1929* (Zurich 1937), pp.45–7.
2 William J.R. Curtis, *Le Corbusier: Ideas and Forms* (London, 1982).

36

Drawing: *A Contemporary City for Three Million Inhabitants*

1922
Le Corbusier (Charles-Edouard Jeanneret)
(1887 La Chaux-de-Fonds, Switzerland–
1965 Cap-Martin, France)

Gouache on print on canson paper
45 × 65cm
Fondation Le Corbusier, Paris (FLC 29711)

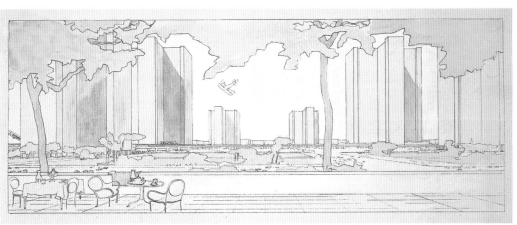

36

Le Corbusier's Contemporary City (*Ville Contemporaine*), exhibited at the *Salon d'Automne* of 1922, presented his vision of an ideal urban environment with every modern facility. His plan sought to remedy all the problems of contemporary cities (lack of light, space and greenery) and to incorporate new modes of transportation, abolish congestion, improve circulation and increase population density.[1] In this, he was building on a tradition established by French urbanists such as Eugène Hénard, whose *Etudes sur les transformations de Paris* (*Studies on the Transformations of Paris*, 1903–9) had advocated the separation of pedestrian and vehicular traffic and the use of long, set-back apartment blocks (*à redents*) flanking wide avenues.[2]

At the centre of his city, Le Corbusier placed the hub of his transport network, on seven levels, with a railway station below and an aircraft runway on the top. The Italian Futurist Antonio

Sant'Elia had already imagined something similar in his *Città Nuova* (frontispiece, cat.32). The centre of Le Corbusier's city was encircled by 24 large and widely spaced office blocks, each 60 storeys high and capable of accommodating between 10,000 and 50,000 workers. Public buildings were located to the west of this central area and all industry to the city's eastern outskirts.

A total of 60,000 inhabitants (the elite, including businessmen and professionals) were housed in 12-storey apartment blocks with set-backs, which surrounded the city centre. Further out were the 12-storey 'Immeubles Villas' (Apartment Villas), which were organized around central courtyards, full of trees and plants.[3] These villas provided inhabitants with communal facilities

(laundries, restaurants, childcare), while ensuring individual privacy in duplex apartments with a double-height studio overlooking a terrace garden. At the 1925 Paris exhibition, Le Corbusier built a life-size model of an Immeuble Villa apartment in which he displayed his 1922 scheme along with his *Plan Voisin*, which applied similar ideas to Paris, exhibited next door. CL

1 Robert Fishman, *Urban Utopias in the Twentieth Century* (Cambridge, MA, 1982).
2 Eugène Hénard, *Etudes sur les transformations de Paris* (1903–9), reprinted with an introduction by Jean-Louis Cohen (Paris, 1982).
3 *Le Corbusier: Architect of the Century* (exh. cat., Hayward Gallery, London, 1987), pp.210–11.

37

Photograph: Villa La Roche, entry hall from the bridge
Designed 1923–5
Le Corbusier (Charles-Edouard Jeanneret)
(1887 La Chaux-de-Fonds, Switzerland –
1965 Cap-Martin, France)

The Villa La Roche was built for the Swiss banker and art collector Raoul La Roche in 1923–5 in the Parisian suburb of Auteil, alongside another house for Albert Jeanneret, Le Corbusier's brother.[1] Although joined in a single form externally, the two houses are quite different internally. Albert's house had to accommodate his Swedish wife and her three daughters, as well as a servant, while the La Roche house was built to house the banker's important collection of Cubist and Purist paintings. Most of La Roche's house was given over to the collection and reception space, with only a small bedroom suite and a library for La Roche's private use.

Both structures epitomize the ideas that the architect had been developing in projects like the Citrohan House (pl.2.16). For instance, the houses exploit reinforced concrete construction by incorporating a roof terrace. The La Roche house features a large hall, rising through three storeys producing an exciting spatial organization, a subtle orchestration of volumes and an intricate interplay of light and shade. Moving through the house one experiences what Le Corbusier called the architectural promenade. This promenade is made dramatic with a balcony overlooking the hall, a curving ramp in the gallery giving access to the library and a bridge crossing the hall. Unexpected vistas are produced at every turn. Le Corbusier visited the De Stijl exhibition at the Léonce Rosenberg gallery in Paris in October 1923, and it has been argued that the treatment of surfaces in the Villa La Roche hall owes something to the models by Theo van Doesburg and Cornelis van Eesteren exhibited there.[2] Le Corbusier also experimented with polychromy, creating effects comparable to his Purist paintings (pl.3.7).[3] CL

1 Tim Benton, *The Villas of Le Corbusier 1920–1930* (New Haven, 1987), pp.43–75, and Tim Benton, '"Villa La Rocca" Die Planungs- und Baugeschichte der Villa La Roche', in Hartwig Fischer and Katherina Schmidt (eds), *Fin Haus für den Kubismus: die Sammlung Raoul La Roche: Picasso, Braque, Léger, Gris – Le Corbusier und Ozenfant* (Basle, 1998), pp.227–64.
2 Bruno Reichlin, 'Le Corbusier vs. de Stijl', in Yves-Alain Bois and Bruno Reichlin (eds), *De Stijl et l'architecture en France* (Brussels, 1985), pp.91–108.
3 William J.R. Curtis, *Le Corbusier: Ideas and Forms* (London, 1982).

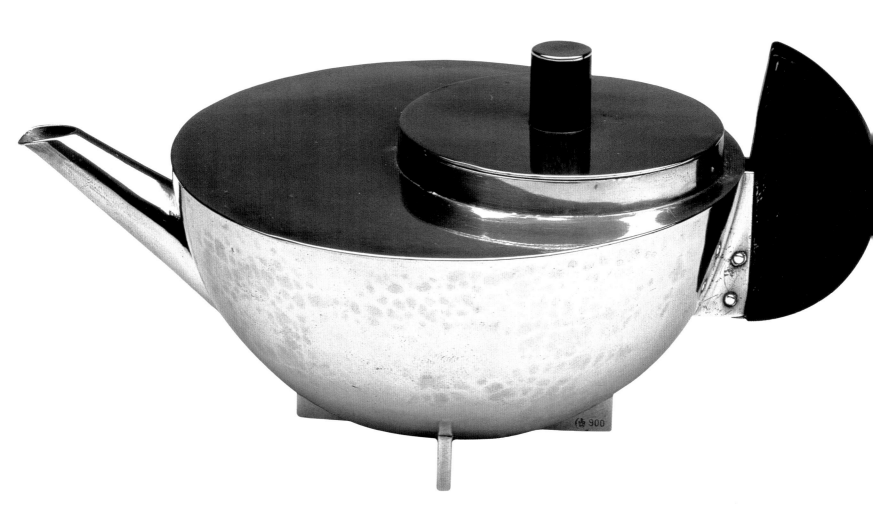

Christopher Green

The Machine

Is not the machine today the most exuberant symbol of the mystery of human creation? Is it not the new mythical deity which weaves the legends and histories of the contemporary drama? The machine in its practical and material function comes to have today in human concepts and thoughts the significance of an ideal and inspiration.[1]

Enrico Prampolini
'The Aesthetic of the Machine and Mechanical Introspection in Art'
(October 1922)

3.1 **Marianne Brandt**,
Tea infuser, 1924 (cat.54b)

A machine Modernism?

A simple way of beginning to say what a machine Modernism could be among the multiple Modernisms of the 1920s is to juxtapose two particularly striking attempts to mechanize art in that decade and a more recent meeting between art and the machine.[2]

When Fernand Léger applied all his care and attention to give final pictorial definition to his *Ball Bearings* composition in 1926 (pl.3.2), he was at the end of an assiduous planning procedure, perfected over the previous half-decade. It was a procedure consciously aligned with the designing of prototypes for manufacture, which took him from sketch to plan before squaring up the plan to execute the 'definitive' painting. The precision of execution might be flawed, given the manufacturing shortcomings of individual hand-crafted oil paintings (and Léger might be happy not to conceal the evidence of his hand), but the look of the work as well as its mechanistic subject assert unmistakably the analogy between painting and machine, artist and industrial designer.[3] When, according to his own account, László Moholy-Nagy decided four years earlier to order from a Berlin factory three paintings to be produced in porcelain enamel on sheet metal, following exactly a design he had made on graph paper, he went a step further. Later he would amplify the significance of that step by insisting that he made the order by telephone, so they are now known as *EM1*, *EM2* and *EM3*, the 'telephone paintings' (pls 3.5–6). The artist designer, again the careful planner, now claims complete detachment from the process of manufacture, and the outcome is factory-made immaculacy: three exactly repeated compositions of different sizes.[4]

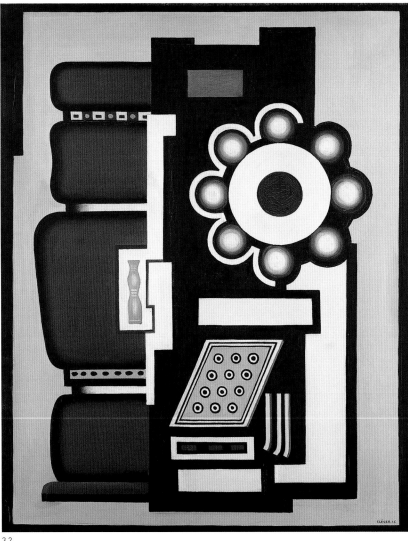

3.2 **Fernand Léger,** *Still-life with Ball Bearing*, 1926 (cat.61)

3.2

3.3

3.4

3.3 Ball bearings, 1930s (cat.62)

3.4 **Charlotte Perriand,** Ball-bearing necklace, 1927. Archives Charlotte Perriand, Paris

3.5

3.6

Moholy-Nagy made certain that the story of his telephone order was noticed and recorded by the historians of Modernism. Donald Judd and Carl Andre were simply not interested in making a public issue of it, when, as recent research has shown, they extended Moholy-Nagy's procedure in the late 1960s and early '70s, to send specifications and instructions across the Atlantic so that works could be even more immaculately fabricated by the Nebato factory in the Netherlands.[5] For Léger and Moholy-Nagy in the 1920s, the machine/art analogy was central to their entire project, and their work said so. For Judd and the other American artists who worked with Nebato, all that mattered was their concept and how that would be experienced by individual subjects when materialized: concept and consumption, not plan and production. Crucial to the machine Modernism I believe existed in the 1920s was the priority it gave to production over consumption, and, as I shall argue here, the more or less concerted attempt it represented to suppress the individual consumer.

As perceived then, and indeed still, machine Modernism revolves around a patently oxymoronic conjunction: art and the machine. 'The house is a machine for living in.' If the dwelling is taken to be architecture and so art, Le Corbusier's slogan of 1921 is the most notorious formulation of it.[6] Later in 1921, his painter ally Amédée Ozenfant could go so far as to call even paintings machines: 'human emotion machines'; he could have had in mind Le Corbusier's *Still-life with a Pile of Plates* of the year before (pl.3.7).[7] By the mid-1920s these were formulations that had crossed the Atlantic and Europe, and had reached Moscow; and certainly in Russia they were by then hardly new. Already in 1918 Vladimir Tatlin in Moscow had written of 'the artist's psychic machine'.[8]

In Western Europe it was the house as machine that drew most attention and aroused most anxiety. The manifesto showpiece at the Bauhaus exhibition of 1923 in Weimar was the Haus am Horn; it was nick-named by the hostile 'the dwelling machine'.[9] And the crux of the mechanized house was the kitchen as 'miniature factory', something that is brought out with particular clarity by the Czech champion of machine Modernism, Karel Teige, when he sums up

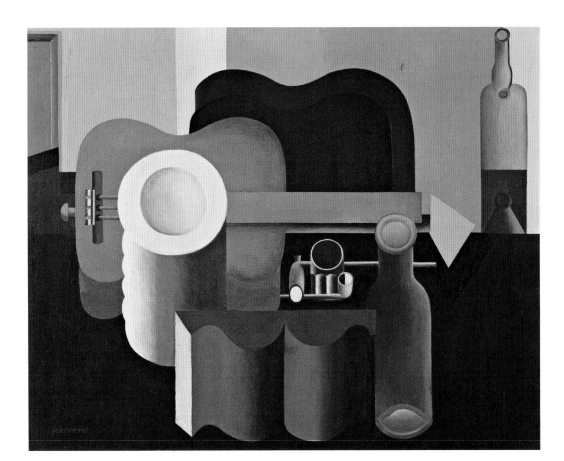

3.7 **Le Corbusier**, *Still-life with a Pile of Plates*, 1920 (cat.46)

the full range of 1920s Modernist attempts spanning Russia and the West to build 'minimum dwellings' (pl.5.10). There is no better way of highlighting the kind of anxieties aroused by the oxymoronic meeting of home and machine than Teige's identification of the railcar kitchen as the paradigm for the kitchen as factory at the heart of the dwelling machine.[10] When the new architecture in Germany was attacked in the mid-1920s, one accusation was that it was 'nomadic architecture', uprooted from place: the dwelling machine, like the railcar, was no-place.[11] By the same token, the Haus am Horn was attacked by conservative critics at Weimar, as constructed for everyone and no one.[12] The conjunction of art, architecture and the machine aroused its strongest anxieties as a denial of art's relationship to the individual and to place, each with their histories. It was the perceived distance between art's creative particularity and the machine's reproductive (not merely productive) generality that made their conjunction so disturbing an oxymoron.

At the dead centre of every machine Modernist's idea of their project was a persistent awareness of the discomfiting force of the machine/art conjunction, and a determination to show it not to be oxymoronic at all. The conviction was that by bringing art and the machine together, not only would the division of culture from industry enacted by specialization within industrial societies be overcome, but the dualist opposition between the spiritual and the material

that was fundamental to Hegelian thinking would be annulled, too. For those imbued with Marx's view of these questions (Tatlin and Teige, among many), Marx's stated aim of liberation from the division of labour and of bringing together the artist and the worker in every man was fundamental.[13] And there is no doubt that the machine Modernist commitment to the destruction of the old dualist opposition of culture and society, art and the machine, is at its most unequivocal in the Marxist drive to deny the dualism of matter and spirit altogether. In Russia, this was the position of the leading architect Moise Ginzburg, who, in 1928, argued for a 'Constructivist . . . method' that would aim 'for absolute monism', where 'emotional perception' connected so closely with the functional organization of design that the distinction between them simply disappeared. The aesthetic thrill lay, it followed, in experiencing the functioning excellence of a system designed for use, which had been materialized – constructed – in space.[14] Such a view led, of course, to the idealization not of art, but of industry, the absorption of the mechanical into the aesthetic.

Machine Modernism, even when underpinned with what can seem a supremely practical appreciation of material needs and limitations (the Van Nelle factory near Rotterdam, for instance) (pls 3.8–9), involved, thus, an idealization of industry and its potential. And, most significantly of all, it involved an ideal vision of a world concentrated on production

3.8 **Johannes A. Brinkman, Leendert Cornelis van der Vlugt** and **Mart Stam**, *Van Nelle Factory*, 1926–9 (cat.59a)

3.9 **Johannes A. Brinkman** and **Leendert Cornelis van der Vlugt**, Office building and Van Nelle Factory, 1926–9 (cat.59b)

rather than consumption, where what mattered was the artist as producer, the process of creation as production, and the artwork (painting, object, building) as product. Machine Modernists in the 1920s were, it will become clear, in denial before the actual emerging dominance, at least in the industrialized capitalist West, of the individual consumer and the product as reproducible commodity. Machine Modernism in its different forms is distinct from, say, Futurism or Vorticism in 1914, because of the visionary vehemence with which it accepts mechanical production and reproduction, but refuses Guy Debord's society of the spectacle.[15]

Different machine Modernisms

'Everywhere there rise the constructions of a new spirit, embryos of an architecture of the future … In certain utilitarian works a Roman grandeur imposes itself.'[16] *Après le cubisme* (*After Cubism*), published in November 1918, the foundational text of Amédée Ozenfant's and Charles-Edouard Jeanneret's Paris-based Purism movement, is probably the first comprehensive statement of a machine Modernism. One stimulus for a pan-European machine Modernism undoubtedly came from Purism, especially because Jeanneret, under his architectural pseudonym Le Corbusier, actually gave material expression to his machine/art analogies in vivid, always memorable built form. Most powerfully,

however, machine Modernism was given its impetus in the 1920s from two other directions: capitalist America (a major inspiration for the Purists) and the new socialist state brought into being by the Russian Revolution of October 1917, with its new capital Moscow. It is ironic that such an impetus should have been given by a country, the United States, that produced only a very few isolated works that could be called machine Modernist in the 1920s, and by a country, Russia, that had almost no industrial base on which to build an alliance between art and the machine before the later 1920s. It is worth looking at how such unlikely candidates could have provided such compelling models for machine Modernism everywhere else that variants developed.

'Model T' America

Marcel Duchamp's first readymade was chosen in a Paris department store in 1914. It was a bottle drying rack manufactured in galvanized iron for homes and cafés. His second was chosen in a New York hardware store in 1915. It was a galvanized steel snow-shovel (pl.3.10). Its simplicity of form and immaculate iron finish contrasted with the fussy complications of the equally utilitarian French object. To call it *In Advance of the Broken Arm*, as Duchamp did, was to ridicule its marvellously apparent efficiency. One cannot imagine him calling it *Certified Antique*, as he did the first replica of the bottle drier; it was too brand-new

3.10 **Marcel Duchamp**, *In Advance of the Broken Arm*, 1915/1963 (cat.38a)

American for that.[17] For him, so ubiquitous and imposing was the presence of engineering and industrial products in America that they were as readily the object of parodic ridicule as the Antique in Europe.

By the 1920s the American photographers Paul Strand, Paul Outerbridge and Margaret Bourke-White, along with the painter Charles Sheeler, would be taking simple, if skilfully controlled pleasure in what they present, without a hint of parody, as the marvellous material realities of American machines, manufactured objects and industrial complexes (pls 3.11–14)). The dominance of the United States among industrialized countries was unquestioned between the 1914–18 war and the Crash of 1929 into which it sucked the European economies. By 1913 America produced 33 per cent of global industrial output; by 1928 the figure was up to 42 per cent.[18] In 1925 America manufactured 3.5 million cars, against just over a million in Britain and 510,000 in France, the two biggest European producers.[19] A report published in 1926 by the General Confederation of German Trade Unions, after a fact-finding visit to the States, marvelled at the finding that there were fridges, electric cookers, washing machines and vacuum cleaners even in the homes of workers (though not the unskilled). The German trade unionists were there, in the wake of equally admiring German industrialists, not simply because of the mechanization of American production, but more importantly because of the exponential growth in productivity released by the 'scientific management' of factory work, and by Henry Ford's assembly lines at his Highland Park and River Rouge plants.[20] It was the River Rouge plant near Detroit that Sheeler eulogized in photographs and paintings from the late 1920s (pl.3.14).

As Sigfried Giedion saw it in his Modernist monument to industrialization, *Mechanization Takes Command*, America was not only the leader in global mechanization up to the 1940s, but was also the leader in the rationalization of work: scientific management. He identified as the key figures in American scientific management Frederick Winslow Taylor and Frank B. Gilbreth, and as the key figure who brought mechanization and scientific management together Henry Ford.[21] By the timed analysis of work operations, beginning with studies of coal shovelling, through the 1890s and 1900s, Taylor had aimed to eliminate wasted time and effort in 'the human work process'; Gilbreth had introduced photography to provide a visually precise record of motion, publishing for instance a minute deconstruction of bricklaying.[22] At Highland Park (from 1913) and River Rouge (by 1922) Henry Ford broke down the manufacturing process for workers into innumerable one- or two-movement operations, requiring almost no skill, introduced a comprehensive assembly-line system to eliminate the need for workers to move from their positions, and placed moving belts and machinery as exactly as possible to eliminate all wasted movement in work operations.[23] Most of his workforce wanted

3.12 **Paul Outerbridge**,
Marmon Crankshaft, 1923
(cat.50b)

3.13 **Margaret Bourke-White**,
Niagara Falls Power Co., 1928
(cat.50c)

3.12

3.13

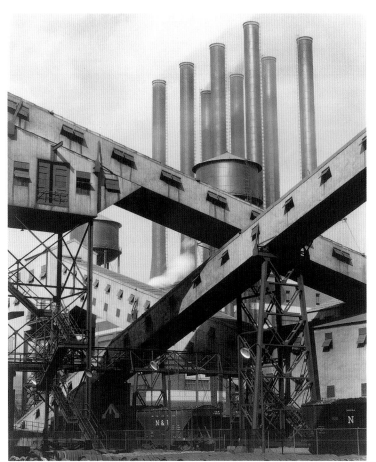

3.14

3.14 **Charles Sheeler**,
Ford Plant, River Rouge, Criss-Crossed Conveyors.
Gelatin silver print, 1927.
The Metropolitan Museum of Art

Opposite:
3.11 **Paul Strand**, *Akeley Motion Picture Camera*, 1922
(cat.50a)

3.11

the initiative taken from them by mechanization – to *be* mechanized – Ford argued in his hugely influential autobiography published in 1922, while enthusiastically contradicting himself by developing a sustained polemic on the importance of the individual and self-reliance.[24]

The German trade unionists who visited Ford's plants in the mid-1920s worried about the dehumanization of work and such questions as work intensity and fatigue, but they, like the employers, were overwhelmed by the gains in productivity that came with mechanization and scientific management.[25] With this, Ford stressed, came higher wages; but Ford's promotion of high wages went with an accent on the market and consumption, which did not so easily gel with European attitudes on the trade-union left.[26] His was a logic that put the self first at every point: products would sell if they met individual needs; if the individual needs satisfied were multiplied by millions, they would sell in millions; high productivity and high-volume production allowed low prices *and* high profits; rising wages linked to profits meant that workers could buy too, and thus an ever-expanding market. Industry's driver, for Ford, was consumption, not production.[27] Sheeler's first photographs of the River Rouge plant were commissioned as part of an advertising campaign to launch the new Ford Model A in 1927: machine idolatory in the interests of increasing consumption.[28]

The complement to industrial expansion in America from the 1890s into the 1920s was the equally exponential expansion of advertising: the professionalizing of copy-writing, the arrival of advertising account executives, the emergence of advertising art departments, the development of psychological theories of advertising, the building of huge advertising agencies: N.W. Ayer in Philadelphia (which commissioned Sheeler for Ford), Lord and Thomas in Chicago, J. Walter Thompson in New York. Ford's stress on producing to satisfy needs led him to favour advertising that demonstrated efficiency and utility: what was called 'reason why' advertising (Sheeler's photographs monumentalized the company's innovative efficiency). From the publication in 1908 of the academic psychologist Walter Dill Scott's *The Psychology of Advertising*, the American agencies were, however, drawn as much to selling by suggestion, 'atmosphere advertising'. Information to underline utility was submerged by images that associated brands with desirable people (especially women) and ways of life. The accent lay not on Ford's idealized self-reliant customer sensibly buying his Model T as an all-year-round 'necessity', but on influencing the choices made by 'free' individuals more interested in pleasure and status than utility.[29] As Dill Scott remarked on Ivory Soap's marketing by image campaigns, 'When I think of Ivory soap a halo of spotless elegance envelops it.'[30] Marx's notion of the commodity fetish was openly borne out by fetishizing campaigns that lifted products into a desirable haloed world far removed from use-value.

When Karel Teige looked across the Atlantic from Prague to consider the lack of minimum housing on the machine dwelling model in America, it was the free-market economy that he emphasized: the lack of state-financed social housing.[31] With the 'liberal principle', and the accent on the individual consumer, it was obvious that no foundation existed in that hyper-productive industrial economy for a machine art that put production for society above individual consumption.[32] Richard Guy Wilson has shown persuasively how fragmentary the American design response to mechanization in the 1920s was, and has made the connection with liberal democracy and capitalist consumerism.[33] When it was not being 'objectively' photographed, the 'Machine Age' in the United States meant style, or rather styles, and the phrase itself actually became a marketing slogan.[34] It is telling that when J. Walter Thompson inaugurated its new Manhattan headquarters building in 1927, the Machine Age-style conference room designed by Norman Bel Geddes was not far from an executive dining room reconstructed from an eighteenth-century Massachusetts farmhouse.[35] When European artists and designers looked to America, it was not American Machine Age art and design that made the impact – it was the overwhelming fact of American industrial production, grounded as it was in the equation so compellingly set out by Henry Ford between rationalized mechanization and productivity.

Swimmers in the Soviet system

Before 1929 and the Crash, projecting into America's future from the mid-1920s would have produced, for Henry Ford's ideal consumer, a magical vision filled to bursting with products to be consumed by an increasingly dynamic, yet sated population. Construction for industry and housing on any significant scale began in the new Soviet Union only late in 1925. When, in January 1921, Tatlin informed the delegates to the Eighth Congress of the Soviets in Moscow that his *Monument to the Third International* (cat.3) created the opportunity 'of uniting purely artistic forms with utilitarian intentions', his vision of the merger of art and utility was projected onto a blank screen.[36] More than three years after the October Revolution, Trotsky's ramshackle but formidable invention, the Red Army, was fighting the last battles of a civil war that had pitched it against the Whites in the Don Cossack region to the south and in the Volga basin, and against peasant uprisings and borderland opposition as far away as Siberia, Finland and the Caucasus. In February 1921 workers' insurrections in Moscow and Petrograd would further threaten the new Soviet state.[37] The First World War followed by revolution and civil war made production, as understood in America, an impossible dream in Russia, at least before development in the late 1920s of Stalin's policy of 'Socialism in one country' and the Five-Year Plans as a strategy aimed at overtaking American industrialization. Tatlin and the

3.15 **Boris Ignatovich**, *The First Tractor*, 1927 (cat.64)

3.16 **Vladimir Tatlin**, *'Novi Byt'* (*'New Way of Life'*), 1924 (cat.44)

Constructivists' machine Modernist theory and practice were developed at a moment when the destruction of the pre-1914 Russian industrial base must have seemed like the making of a *tabula rasa*. Machine Modernism in this situation could only be utopian. In 1921 the output of the major manufacturing industries was 25 per cent down on 1913; steel production was only 5 per cent of the 1913 level.[38] Still in 1922–3 almost every brick works in the country was out of production, and cement works were in almost as bad a state.[39] It was, of course, the utopianism of Russian machine Modernism that ensured its impact in Central and Western Europe; not the fact, but the strongly defined, yet unreal vision of a high-production industrialized society without capitalism, in which artists and designers committed to consumption as a *collective* ideal would have a role.

With its proletarian focus in a vast peasant country, the Communist Party in Russia and the Soviet Union was overwhelmingly urban, and its vision over-whelmingly industrial (agriculture was to be mechanized as it was collectivized, cat.64).[40] Russian machine Modernism was overwhelmingly urban, too: Moscow and the pre-revolution capital Petrograd (Leningrad from 1924) were its centres. After teaching in Kiev in the Ukraine for a couple of years, Tatlin wrote in 1927 of his feeling that he was out of things when he pleaded for a teaching post in Moscow.[41] In Petrograd between 1919 and 1924 he had been at the centre of Constructivist initiatives there, working from a position of authority within the institutions of the Soviet system. In Moscow the centre of Constructivist activity from 1920 to the end of the decade oscillated between the INKhUK (Institute of Artistic Culture) and the VKhUTEMAS (Higher State Artistic and Technical Workshops, cat.7), both state-run institutions, where the leading figures – the polemicists Osip Brik, Alexei Gan and Boris Arvatov, the artists Alexander Rodchenko, Varvara Stepanova and Lyubov Popova, and the architect Alexander

Vesnin, along with his close ally Moise Ginzburg – were all practised swimmers in the increasingly centralized Soviet system. The rhetoric that supported their Constructivist stance was proletarian, communist and almost exclusively focused on production within the realities of the Russian situation as they knew it.

By November 1921 Brik was leading those within INKhUK who had given up easel painting as a bourgeois error, including Rodchenko and Stepanova, to commit themselves to 'real practical work in production'.[42] Discussion was focused on material analysis and modes of assemblage (construction), which at least theoretically could be translated into actual industrial design and production. Teaching in the VKhUTEMAS departments (by no means all) controlled by these professed Constructivists, especially the preliminary course, was being energetically shaped by their priorities. By 1923 Stepanova and Popova would be designing for mass production in

the First State Textile Print Factory.[43] But perhaps the most compelling demonstration of Constructivist commitment to material analysis and design for production within the constraints of a semi-derelict industrial economy was Tatlin's work between 1922 and 1924 in Petrograd with his own Section for Material Culture.

Tatlin's so-called Section consisted of himself and at most nine colleagues. Attempts were made to become productively involved with manufacturing trusts set up within the Soviet system in Petrograd/ Leningrad, but the Section was essentially a small research group developing standard paint colours and prototype designs for wood stoves, clothing and crockery, which had no actual manufacturing outlet.[44] It is striking that when Tatlin reported on the Section's activities to its sponsor, the GINKhUK (State Institute for Artistic Culture), his breakdown of its research planning and procedure completely ignored consump-

tion questions. The stress was entirely on analysis of materials, establishment of 'pattern norms' (standards) and research into production methods.[45] His decision to concentrate on designing a wood-burning stove (for which five prototypes were produced) says a great deal about his appreciation of the countrywide situation for which he saw himself working. As Nikolai Punin stressed, Tatlin designed a stove that could be used across Russia in its present primitive condition, by peasant as well as proletarian, not an electric or even a gas one, 'in a word, none of those Americanized stoves'.[46] Tatlin is pictured wearing examples of the clothing 'norms' developed by his Section, alongside one of their prototype stoves, in the photomontage published in 1924 to promote his attempts to design for 'The New Way of Life' (pl.3.16). There is no hint here of advertising for consumers, though Tatlin may have dreamed of River Rouge-scale production.

Constructivist designs hardly ever got as far as

factory production. Other than agitational advertising, Stepanova's and Popova's designs for textile prints were just about the Constructivists' only mass-production successes on any scale. When the New Economic Policy of 1921 began to deliver the conditions for industrial expansion after 1923, and Gosplan (the State Planning Bureau) began to direct mechanization and construction, it was the Constructivist architects who most visibly found a role. They did so against a background in which, as Soviet industry was rebuilt, Fordism (divested of its market orientation) and Taylorism were given powerful state backing: the rationalization of factory production was led by laboratory studies of work tasks carried out in Moscow's TsIT (Central Institute for Work) under the leadership of a high-productivity fanatic, the Futurist poet Alexei Gastev. Gosplan's watchwords were 'economy' and 'rationalization'.[47] If it was nothing more than a few images, a few works of art, and a lot of tough

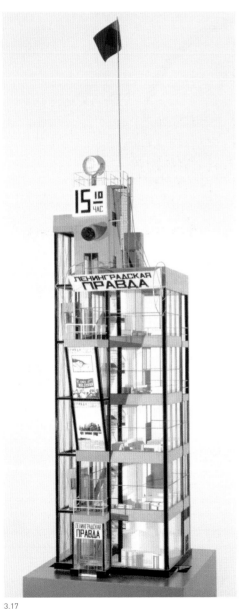

3.17

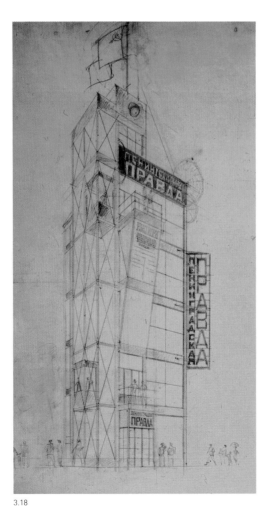

3.18

3.17 **Alexander Vesnin** and **Victor Vesnin**, model of Leningrad Pravda Office Building, Moscow, 1924 [1970] (cat.53a)

3.18 **Alexander Vesnin** and **Victor Vesnin**, *Perspective of the Leningrad Pravda Office Building, Moscow, 1924* (cat.53b)

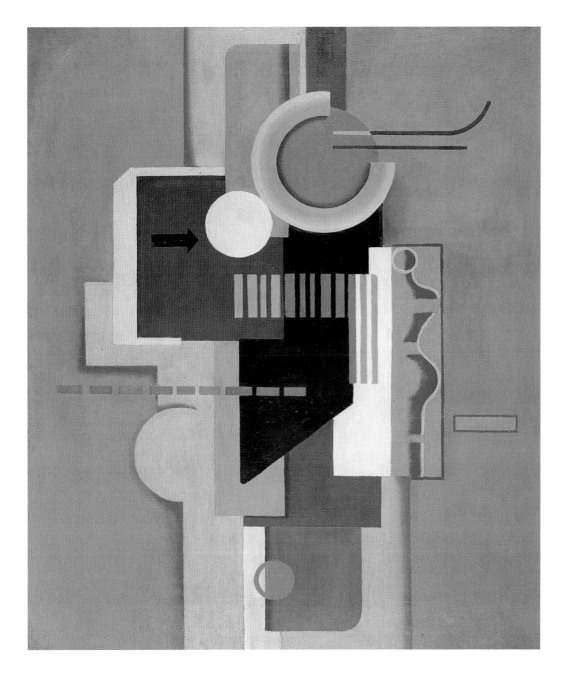

within its glazed envelope. It was simple, yet bursting with controlled energy: a communications machine with its workings exposed. El Lissitzky's concise 1930 survey of Soviet architecture, widely influential in the West, stressed that the structure was to be of wood, but the published drawings gave the impression of steel; the project represented an impossible dream at a moment when production of steel and glass had hardly restarted.[48] By contrast, Ginzburg's housing complex for employees of Narkomfin (the People's Commissariat for Finances) was one of several housing complexes actually built by architects from the association of Constructivist architects, OSA, in the late 1920s (pl.5.17). The architect himself described it as transitional because it was not adapted to the new communal life without families that he held up as a socialist ideal. Instead it stood out as a practical model for building in a new collective society: an especially attractive one, because of the ingenuity with which it jigsawed dwelling units together to minimize wasted space and material, conspicuously faithful to Taylorist principles.[49] Unlike Tatlin, Ginzburg considered consumption as well as production, but this was housing, he wrote, that answered collective needs: those of the 'social consumer'.[50] Beneficiary or user might have been better terms, less easily confused with the Western consumer making choices driven not by needs, but by wishes.

The internationalist imperative

European machine Modernists responsive to the image disseminated both by American Machine Age consumerism and by Soviet utopianism represented themselves as activists in an international movement, certainly from around 1921. As such, they marvelled at American engineering and high-production manufacturing at its most optimally Taylorized and Fordist, but aligned themselves much more decisively with the collectivist vision of a mechanized world exported by the Constructivists as the western blockade of Russia lifted. Machine Modernists operating as internationalists – some calling themselves 'International Constructivists' at one time or another – were active in Holland and Belgium and in the new 'quarantine belt' of small states created in 1918–19 'against the red virus', especially in Czechoslovakia, the most industrially developed of them.[51] Karel Teige's Prague-based role as an international polemicist for machine Modernism was significant, and Jaroslav Rössler's photomontages (cat.63a), also produced in Prague, are a striking marker of the impact of Russian Constructivism.[52] But Central European machine Modernists converged most of all on Germany.

Unquestionably, the two Western European centres of machine Modernism were Germany and France, in the latter case above all Paris, Ozenfant's and Le Corbusier's base. Bitter French anti-German policy after the allied victory of 1918 minimized contacts between the two countries before the

talking that reached the West from the artists who had given up easel painting for industry in Russia, it was both projects and the example of actual new kinds of building designed in new ways that reached the West from the architects. In the simple directness with which they externalized single or multiple functions, in their conspicuous use of modern materials (steel, reinforced concrete), these projects and buildings were designed to speak an easily understood machine Modernist language.

Never realized, the office building that Alexander Vesnin designed with his brother for the 1924 Leningrad *Pravda* Moscow branch-building competition was well known in the West through publication (pls 3.17–18). Light of structure, the building was to be animated by the revolving headlines and slogans that capped it, by its lifts going up and down on the exterior, and by the dynamism of work activity revealed

mid-1920s, but the Purists showed interest especially in Walter Gropius's Bauhaus in the early 1920s, and they and Fernand Léger developed a positive interactive relationship with the Stuttgart-based painter of *Maschinenbilder* (machine pictures), Willi Baumeister (pl.3.19).[53] Yet, as Karel Teige underlined in his international survey of dwelling machines, the conditions for the building of Modernism in Germany and France were fundamentally different. The idea of a unitary international machine Modernism across Europe, somehow achieving total consensus in their reconciliation of the opposed visions of an industrial future offered by America and Russia, was illusory. The differences between the French and German cases make this very clear.

The France of 'L'Esprit Nouveau'

Teige's analysis of the situation in France seems at least partly to have been synthesized from reports reflective of Le Corbusier's view of things, especially where the need to build healthier cities was concerned; but his tough socialist stance led him to a telling critique of Le Corbusier's response to conditions in France. There was, he stressed, a marked lack of 'state intervention dedicated to solving the housing problem'. 'Private enterprise' was 'officially considered' the norm in arriving at a solution.[54] He

acknowledged Le Corbusier's designs for light steel-frame buildings in response to the liberal politician Louis Loucheur's legislation of 1928, which offered limited subsidies for small, affordable apartments, and he took account of Pessac, the one collective housing scheme by Le Corbusier actually to have been built in the 1920s (cat.105). He grudgingly called the latter, however, 'the only [French] garden city worth closer scrutiny', before representing it as an embarrassing private-enterprise failure, dogged by opposition from the Bordeaux municipality and the local construction industry, deprived of essential services and still unoccupied.[55]

But Teige's ire was aroused most of all later in the text, when he considered more fully the urbanist theories outlined in Le Corbusier's polemic, *Précisions* (*Exactitude*, 1930). For him, these were, however technically radical, 'the clear expression of an architectural ideology closely allied with the interests of financial capital'.[56] To work willingly in free-market France as a machine Modernist designer was, as Teige saw, to produce actual built results that denied the collectivist imperative – the belief in the 'social consumer' – which in the Soviet Union seemed so integral to the new architecture. This was not, to use Lissitzky's rallying cry, an 'Architecture of World Revolution'.

Setting aside its ideological polemic, there was a

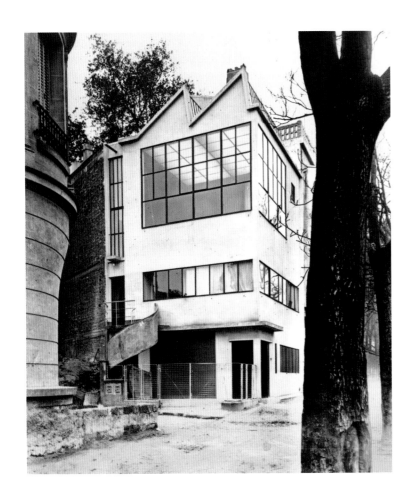

3.20 **Le Corbusier**, The Ozenfant Studio, Paris, 1923–4 (cat.52)

lot of truth in Teige's analysis of the conditions within which French machine Modernism developed in the decade after 1918, and the cases of Le Corbusier, Ozenfant and Léger, close allies all three, are demonstration enough. Léger responded positively both to the energy of American businessmen and to the utopian vision of revolutionary Russia; and his commitment to a tidied-up Cubism that associated painting and mechanization was, inevitably, dependent on the support of the art market, specifically that of his dealers Léonce Rosenberg and, from 1928, Paul Rosenberg.[57] Ozenfant was well enough off to become Le Corbusier's private client himself, commissioning his own machine Modernist studio house from him, complete with dog-tooth factory-style skylights, in 1923–4 (pl.3.20).[58] Le Corbusier, the Purist painter, only gave up dealer exhibitions of his work because of demoralizing attacks on his Purist painting at the *Salon des Indépendants* of 1923 and its commercial failure. As architect and designer, along with his associates, his cousin Pierre Jeanneret and the designer Charlotte Perriand, he worked during the 1920s exclusively for private clients, not because he necessarily preferred them to public clients – he pursued major public commissions both from the League of Nations and from the Soviet Union – but because they were the clients he could actually win and build for in France.

On the level of theory and rhetoric, there are certainly strong parallels to be made between Purist polemic in France and Constructivist polemic in Russia. The Purist repetition of 'precision' and 'economy' as the essential qualities of what they called '*L'Esprit Nouveau*' (The New Spirit) parallels the Constructivist insistence on economy in the use of materials, which was repeatedly urged by the Constructivist faithful in the VKhUTEMAS, and, as Mary McCleod has shown, very comparably went with an absorption into Purist theory of Taylorist scientific management.[59] Already in 1918 Ozenfant and Le Corbusier could write: 'Instinct, groping, and empiricism are replaced by scientific principles of analysis, organization and classification.'[60] The wartime corporatist push for production and post-war reconstruction had encouraged the car manufacturers Renault and Citroën and the aeroplane manufacturer Voisin (later to become a Le Corbusier sponsor) to rationalize working practices and introduce assembly-line production in their factories, though not yet on a scale comparable with Ford.

Again, the Purist combination of formal idealism, machine idolatry and scientism led them to a typological approach to art and architecture easy to parallel with the Constructivist approach to research in the area of art, design and architecture. Both the French and the Russians thought in terms of processes of analysis and refinement in production that would lead to the progressive perfection of design – to basic types in all areas of design (an approach close to Henry Ford's in the development of his Model T). The Purists chose to paint only what they called 'type objects' – objects such as the Bordeaux wine bottle whose form, they contended, had been perfected over time (cat.46).[61] Le Corbusier's paradigm dwelling machine, the Citrohan House (named in homage to Citroën's embrace of Fordist mass-production, cat.2.16), was conceived as a 'type', and was then adapted for unlimited reproduction in one of the housing-block types developed for his *City of Three Million*.[62] In the same way, Tatlin, as I have shown, directed research in his Section for Material Culture towards the formulation of 'pattern norms' for production, which could, of course, be further perfected as material and production technology advanced. Besides this, when Ginzburg designed his Narkomfin complex (pl.5.17) he incorporated into it 'Type Blocks', which, Lissitzky informed his western readership, had been researched in the architecture department of the VKhUTEMAS.[63] Le Corbusier, no less determinedly than Ginzburg, worked to eliminate all wasted space and material as he designed his dwelling machine prototype, the equivalent of the Citroën 10HP (itself the French equivalent of the Ford Model T).

And yet, what stands out in the actual production of machine Modernist painting and design in France is its sheer élan in the proliferation of individual artistic statements and individual design solutions to very individual design problems. Where, from 1918, Rodchenko, Stepanova and Popova used painting as 'laboratory work' to encourage generalized conclusions about line, colour and surface, before giving up easel painting altogether for design, the Purists treated painting as an inexhaustible arena for private exploration and invention, whether or not they thought of their subject matter as type objects. Like the Purists, Léger believed in general laws, 'constants' applicable to all painting, but he too did not see his actual painted work being judged simply as a demonstration of those principles. At his most rigorous, in *Ball Bearings* (pl.3.2) for instance, he was still making just one powerful statement among many, each one distinctively different. When, at about the same time, Charlotte Perriand strung together polished metal spheres to make a ball-bearing necklace, she made just as personal a statement, except that it was herself she made distinctively different by wearing it (pl.3.4). In the same way, alongside Le Corbusier's typological researches as architect and urbanist, and his Pessac housing, what he actually produced was an astonishing variety of very different, relatively small villas. Each one could be approached as the rational solution to a set of problems presented by the needs of the client and the constraints of the site, but, as Tim Benton has demonstrated comprehensively, each one was at least as much the climax of an always unpredictable and individual design process.[64]

A rationalized Germany

When Karel Teige turned his attention to the dwelling machine in Germany, he was much more in his element

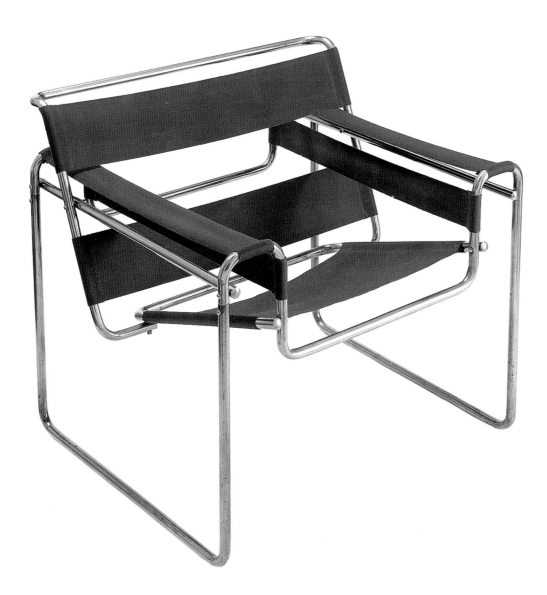

than in 'private enterprise' France, and it is not difficult to see why.[65] By the end of the 1920s, even more than in the Soviet Union, Germany offered the example of actual dwelling machines built in literally thousands as part of planned, collectively oriented housing campaigns in several cities: Magdeburg, Berlin, but most impressively of all Frankfurt-am-Main (cat.91).[66]

From 1924 to 1925 Germany, like the Soviet Union, experienced a period of industrial expansion. It allowed a start to be made on honouring the Weimar government's social democratic pledge to house its population after the turmoil of defeat and failed revolution in 1918–19, but it was no more than a short-lived mini-boom after the great inflation of 1922–3. Industry's dependency on American credit made the German economy particularly vulnerable to the American Crash in 1929. Within that brief time-frame, it was the Social Democrats (SPD), channelling funds through cooperative building societies in the cities they governed, who built most of the machine Modernist complexes described approvingly in Teige's survey. They favoured centralized, planned control of housing as a public responsibility.

As Barbara Miller-Lane first demonstrated comprehensively, machine Modernist architecture in Germany (or Bauhaus architecture, as it was often called) was predominantly SPD architecture.[67]

It is important to stress that it was, thus, the product of a combination of planned public and private business initiatives, since the policy of the SPD, as a liberal democratic party, was to work with business. When the Haus am Horn at the Weimar Bauhaus exhibition of 1923 was attacked as a 'dwelling machine', the Bauhaus project altogether was attacked as a tool of the communists, who just at that moment were threatening takeover in Thuringia.[68] The work of the Dessau Bauhaus too was described as architectural Bolshevism.[69] Yet from 1925 the Bauhaus worked with the Dessau municipality and designed product lines that could in principle be manufactured by private business, including Marcel Breuer's Club Chair, designed to be assembled from standardized parts (pl.3.21). Moreover, Gropius's architectural firm was both involved in building public housing in Dessau and was one of the firms that participated in building Siemensstadt in Berlin, for the building society set

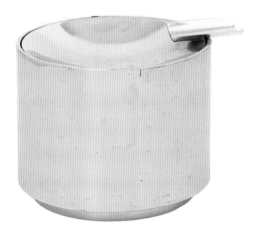

3.22 **Marianne Brandt**,
Ashtray, 1923–4 (cat.54a)

up by Siemens to house its workforce (cat.102).[70]

Furthermore, machine Modernism in Germany, far more than in France, was at the heart of a rationalizing industrial movement, committed to the development and application of Taylor's and Ford's innovations, which had the energetic endorsement of both the SPD and business. Government and business organizations dedicated to rationalization multiplied, and, as we have seen, industrialists and trade unionists followed each other to America to observe its mechanized and scientifically managed factories at first hand.[71] Besides the trade unionists' report on their visit, there was, for instance, the Siemens general director Karl Kötgen's *Economic America*, with its photographs of working American factory interiors.[72] True, for obvious reasons, the SPD and the unions favoured Ford's equation between high productivity and high wages, where private industry favoured Taylor's accent on high-tempo work; but both sides argued for reorganization according to scientific management principles and the elimination of wasted effort in work, and both sides focused on the question of production, almost to the exclusion of Ford's accent on consumption.

It cannot be denied, however, that in Germany Taylorism and Fordism in machine Modernist building, especially housing, was the complement to SPD priorities: it went with the belief that a rationalized, mechanized world would become a socialist one.[73] At Frankfurt am Main, where the SDP mayor Ludwig Landmann gave the city's chief architect and planner Ernst May absolute power over a huge construction programme, patient research by May's team went into determining the most economical use possible of space, so as to minimize the space norms allowed for dwellings.[74] The most renowned outcome of this research was Grete Schütte-Lihotsky's Frankfurt Kitchen (cat.92), fêted for instance by Teige (see Chapter 5). It says something about the compatibility of Soviet and German machine Modernist approaches to housing in the context of rationalization that, in 1930, May would accept an invitation to take his team's planning and design talents to Moscow.[75]

Where American factories were a major inspiration for political activists and industrialists, as well as for designers and architects in Germany, deepening knowledge of Constructivism in Russia was also, as I have already suggested, a major inspiration for artists, designers and architects. In Berlin, often collaborating with artists and writers connected to the Hungarian group *Ma* based in Vienna, Moholy-Nagy became in 1921–2 a vigorous promoter of Constructivist ideas on the material grounding of all art practices, and on the need for art and machine technology to come together.[76] It was as an International Constructivist that he was invited by Gropius to take over the Metal Workshop at the Bauhaus in Weimar, and it was above all Moholy-Nagy, especially after the move to Dessau, who made a reality of Gropius's unofficial motto for the

school, first uttered in 1923 not long after the Hungarian's arrival: 'art and technology: a new unity'. Moholy-Nagy himself did not, like Tatlin, Rodchenko and Stepanova, discard easel painting for industrial design and production; and his telephone paintings remained an exception to an otherwise hand-crafted practice, but at the same time as moving into the mechanized procedures of photography, he encouraged students in the Metal Workshop, Marianne Brandt among them, to design for production (pls 8.1, 3.22). Moreover, by the time he formulated Bauhaus policy for Gropius at the new Dessau school in 1925, his less than wholehearted socialist collectivism of the early 1920s had given way to a business-friendly pragmatism, appreciative of the benefits to the school of royalties from the sale of prototypes to industry. He was still on one level committed to the idea of a collective consumer answering collective needs not incompatible with Ginzburg's 'social consumer' (to which I shall return later), but simultaneously he encouraged among his students awareness of the receptiveness of 'the market' to their designs.[77]

At the Bauhaus, Moholy-Nagy's particular combination of commitment to collective needs and of entrepreneurial energy sums up the complexities of German machine Modernism, most notably the very particular way in which the German situation allowed collectivist and business forces to work together. And the case of Germany, in the way it contrasts with that of France, and connects and yet contrasts with that of Russia, can sum up finally the range of differences within what I have called machine Modernism.

The machine against the fetish

Despite the differences, on one question machine Modernists from Paris to Dessau to Prague to Moscow agreed: the convergence between art, design and the machine meant a focus, as I have argued from the start, on the producer (creator), production (process) and product (work), and with it the restoration of use-value, along with an accent on collective consumption at the expense of the individual consumer. It is worth looking more closely at the issues this raises.

Most uncompromisingly of all, it was, of course, the Constructivists in the Soviet Union who urged a return to use-value and an end to commodity fetishization. The polemicists of INKhUK, Gan, Arvatov and Brik, routinely used the term 'fetish' as Marx had, to dramatize what they believed was the suppression of use-value in bourgeois commodity culture. Art and fetish became interchangeable terms, since art in bourgeois society was simply another commodity. To restore use-value to things, it therefore became necessary for the new society governed by the proletariat to destroy the fetish that was art. To give up easel painting in favour of industry and construction was, by destroying art, to contribute to the destruction of bourgeois society.[78] Gan's 'death

to art' slogan in his 1922 polemic, *Constructivism,* was a belated echo of the literally death-dealing rhetoric produced at the end of 1918 by the Red Terror, with its proclaimed object to exterminate 'the bourgeoisie as a class'.[79] In Tatlin's 'New Way of Life' photomontage (pl.3.16) the artist, sturdy and upright in his research group's functional clothing, stands over a bourgeois modelling bourgeois dress laid out beneath: use-value knocks out overstated, uncomfortable fetishistic fashion and with it the useless bourgeois male. Fashion was also Stepanova's target when she wrote on textile design.[80] Even advertising for the Soviet Constructivists was ultimately to be judged by its use-value, an easy enough argument to make when its object was political agitation, but much less obvious when its object was, say, to sell cinema seats for the picture houses that flourished as the New Economic Policy gave smaller businesses their head in the mid-1920s. Yet, as Rodchenko argued the case, looking back years later to his collaboration in masterminding poster campaigns with the poet Vladimir Mayakovsky, to promote economic expansion by advertising was to promote the rebuilding of the country, and so, for them, to be useful to the revolution.[81]

Berlin Dada was quick to find in Tatlin's *Monument* and in his plea for useful art a clear anti-art message, as their slogan at the Dada exhibition of summer 1920 demonstrates: 'Art is dead. Long live Tatlin's Machine Art.' But the murder of the fetish by machine art was never actually a done deed in Russia, even where Tatlin was concerned. Having promoted the usefulness of Tatlin's stove designs to the absolute exclusion of aesthetics, Punin's logic gets into a lot of trouble when it comes to an artist's involvement in them; he is reduced to such words as 'passion, frenzy, brilliance' and 'spontaneity' to characterize Tatlin's special contribution. And when, in 1932, Tatlin gave an interview to promote *Letatlin,* his aerial bicycle, he insisted, 'I don't want this object to be approached in a purely utilitarian way. I created it as an artist.'[82]

In the West, Constructivism made its impact almost in every case both as a campaign to restore use-value and as a campaign for a new technologically streetwise approach to art and design. One reason for this was Lissitzky's crucial role in its promotion on his arrival in Germany from Russia late in 1921. The trilingual magazine *Veshch'/Gegenstand/ Objet* (*Object*) (pl.2.23) launched in Berlin by him and Ehrenburg in 1922 opened with a statement that reverberated with the Taylorist vocabulary of Constructivist utilitarianism (the key word is 'organization'), yet also insisted on the potential of art ('poetry, plastic form, theatre') as an organizing force. Art could be 'practical' and remain 'art'.[83] The following year Gropius's plea for a 'new unity' at the Bauhaus after 1923 kept the stress as much on art as on technology.

It would be Moholy-Nagy at the Bauhaus who would develop with particular imaginative energy the Lissitzkyan idea of art as an organizing force within society, which can be both individually inventive and collectively useful. He did so by replacing the socialist rhetoric of Constructivist collectivism with what has been called a 'technological humanism'.[84] He was concerned not so much with the idea of community, as with what he was convinced were the 'timeless biological fundamentals' that determined all human needs and that made art as the visual exploration of a fast-changing world and as the dynamic 'organization' of spaces a necessity too.[85] Writing in 1929 about the home – at Dessau he had lived in a house designed by Gropius – it is the 'shaping of space' that most concerns him (as it did Gropius), though he acknowledges the importance of solving functional problems. The house is to be conceived as if a 'practically-constructed biological organism' (linking organisms as working mechanisms to machines was by then a commonplace at the Bauhaus), but that is not all: the house 'must also contribute to the enhancement of the occupier's energies and the harmony of his activities'. As machine-like 'organism' and as art 'organizing' experience, the 'dwelling space' had, for Moholy-Nagy, 'biologically necessary attributes': it had use-value of the deepest and most essentially human kind.[86] Indeed, he actually believed that design, and in his own practice photography, could train perception and so responsiveness at this deep level, could act continually to perfect man's cognitive capacities, a belief that led him to a statement that could be the motto of most Modernist avant-gardes: 'Creative activities are useful only if they produce new, so far unknown relations.'[87]

This kind of humanist argument, using a different terminology, is replicated by the Purists too, without any dependence on either Lissitzky or Moholy-Nagy. Le Corbusier's house as machine was, of course, the ultimate symbol of the functionalist commitment to utility, but they too allowed equal or even greater value to art (or, in Le Corbusier's case, Architecture with a capital 'A'), and the art in painting or architecture was, for them, the product of 'passion', not problem-solving reason.[88] Moreover, art, for them, was a matter of 'constants', just as it was for Moholy-Nagy, because it was biologically determined in response to the human optical apparatus and biological needs. For them too, art and architecture's users were beneficiaries able to satisfy the needs they shared with everyone; they were not wilful individual consumers responding to paintings or to buildings as if to advertisements.

At the same time as words like 'passion', 'frenzy', 'brilliance' and 'spontaneity' were let into their discourse, the machine Modernists' actual reluctance in the West to murder art went with just as deep a reluctance to allow mechanical reproduction to make originality and the original obsolete. Machine Modernism in painting – the distinctively individual practices of Léger and Baumeister, Ozenfant and Jeanneret (Le Corbusier) – is evidence enough of that, and it is clear too not only in Moholy-Nagy's practice as a painter, but in his theory and practice as

3.23 **Fernand Léger**, *The Mechanic*. Oil on canvas, 1920. National Gallery of Art, Ottawa

a photographer.[89] In 1922 he set up the camera-less photogram as a means of returning photography from its 'reproductive purpose' to 'production-creation', since it generated *new* images by the placing of objects on photographic paper and then the exposure of them to light: it made visible rather than recorded the visible.[90] Later, his camera photography would always be concerned with making visible new ways of seeing (sharpening perception and cognition), and so with his own individual capacity for seeing from new angles, for framing in new ways (pls 4.10–11), for finding new juxtapositions by montaging.[91] Mechanical reproduction, for him, did not replace originality; it became above all a means to make the original available to a mass market: as he put it in 1925, to give everyone access to the 'coequal satisfaction of his needs'.[92]

Yet, if in the West the reluctance to relinquish the artist, originality and the original licensed a plethora of brilliantly inventive paintings, photographic images and designs backed by a 'machine aesthetic', the fact remains that machine Modernists from Moscow to Dessau to Paris considered the machine above all a lesson in method that taught the importance of *consciously* directing the artistic or the design process. It was especially in this that machine Modernism was distinct from the Machine Age styles of America: method came before form, and it could never be enough simply to borrow machine forms. Painters, thus, made a point of *not* simply imitating the look of machines, for instance Léger and Baumeister (pl.3.19), and, to return to Léger's *Ball Bearings* composition (pl.3.2), consciously mechanized their method to the point of using interchangeable quasi-standardized parts ('elements').

Catherine Cooke has argued in the sphere of architecture that Moise Ginzburg, as a leading Moscow Constructivist, took that lesson to altogether more clearly formulated lengths than Le Corbusier in Paris, despite the Russian's admiration for him. It is certainly so that Le Corbusier did not possess the trained understanding of design method in engineering to arrive at a convincing integration of such an understanding with his insistence on the Art in Architecture. It is also clear that he therefore needed to build a bridge between the two by erroneously convincing himself, as Reyner Banham was the first to point out, that functional designing inevitably led to the simple, geometric forms that were the basis of his Purist aesthetic.[93] By contrast, it is certainly so that Ginzburg set out his design method with the kind of clarity that came of a tight professional's grasp of engineering as well as architectural methodologies. In his case, it was a method that started with the production of a 'basic space diagram of the building', shaped by an analysis of 'flows' and 'needs'. Then, taking account of the materials and construction methods to be used, it was directed towards a result that was 'logical' and capable of communicating clearly to the building's users the essentials of its functional organization, and so was

capable of organizing them collectively in the patterns of their everyday life. But, as Cooke stresses, in Ginzburg's view clarity of method meant no wasted energy (the Taylorist echo is strong), so that freed surplus energy could be transferred 'into inventiveness and the force of the creative impulse'. Even the rigorous designer of the Narkomfin housing complex (pl.5.17) (a kind of architect-equivalent of the Party organizer under Stalin shaping every existence) is able to use the term 'artist', and to bring together inventive imagination and conscious control as an artist.[94]

It was the retention of a space in machine Modernist method for creative invention that prevented the absorption of the artist into the engineer, the scientist or the mechanic. Tatlin worked like a researcher and called the convent belfry in which he built *Letatlin* a 'Scientific Experimental Laboratory'; Ginzburg and Le Corbusier found their models in engineers; at Weimar, the Haus am Horn was built as, in Moholy-Nagy's words, an 'experimental dwelling'; while in Weimar and Dessau, Gropius with his associates 'researched' the development of a standardized 'construction kit' for architects; Fernand Léger dedicated a major painting of 1920 (pl.3.23) to ennobling the mechanic as a modernized Egyptian or Assyrian dignitary or god, and in 1923 wrote a eulogy of the mechanics who assembled the aero engines (pl.3.24) and aircraft for the annual Paris *Salon de l'Aviation* (Aviation Salon).[95] But not all of them represented themselves *as* research scientists or engineers, or as mechanics. And, although the Soviet *Proletkult* movement championed the proletariat as the only legitimate source of a new culture, not even the Constructivists aligned themselves as designers with assembly-line workers Léger aligned the artist with the modern artisan, the skilled mechanic, ignoring the unskilled mass-production workers at Renault or Citroën, and indeed he made a point of stressing the superiority of the artist as 'inventor' over even the artisan.[96]

A similar pattern of distinctions alongside analogies as is found thus in machine Modernist ideas of the technologically aware artist and the mechanized creative process is seen also in their idea of the artwork or design as product, unique or reproducible. For Léger and Baumeister, paintings cannot look like machines because they must use the material 'elements' particular to flat art: because they are paintings. 'Elementarism' was a term in use everywhere across Western and Central Europe, to indicate a commitment to working with the material 'elements' particular to the object to be constructed: building, chair, sculpture, painting, photograph. Moholy-Nagy, in relation to photography, made the point as Rodchenko might have: the key to its development, he said, was 'full recognition of its *own* laws'.[97] Such an approach had strong Constructivist endorsement. In Nikolai Tarabukin's words: 'The form of the work and its elements are the material for analysis.'[98] But, of course, just as an artist or

architect could (indeed should) be *like* a mechanic or an engineer, so an artist- or designer-produced object should be *like* a machine, an analogy that in no way challenged its still-elevated status (often as a unique original where it was artist-produced). In 1923 Léger told an interviewer that painting had found a new rival in the machine and the manufactured object.[99] The year before, caught up in the debates about industry replacing art at INKhUK, Alexander Vesnin made the analogy with particular clarity:

In just the same way as every part of a machine is a force materialized in appropriate form and material, which operates in and is necessary to the system of which it is a part … so also in objects created by an artist, each element is a materialized force and cannot be arbitrarily thrown out or changed without destroying the effective operation of the whole system…[100]

As painters, Léger and Baumeister thought of machines in the way Strand or Outerbridge photographed them in the United States (pls 3.11–12), immobilized as exact, ordered assemblages of parts. Criticism imbued with Le Corbusier's monumental vision of an architecture of primary geometric forms represents their painting as 'architectural'.[101] Vesnin, an architect and a designer in 1922 for the stage, implies the potential for movement when he writes of 'materialized force'. The analogy between the work and the machine was one pursued into the dimension of movement. When Léger turned to film in 1923–4 and made *Ballet mécanique* (*Mechanical Ballet*) with Dudley Murphy (pl.8.6), the way he used tempo in the rhythmic cutting between moving images created another kind of analogy with the mobilized, *working* machine. Tempo is a word that appears again and again in Moholy-Nagy's 1921–2 film scenario, *Dynamic of the Metropolis*.[102] It is a key word tellingly

in Taylorist 'scientific management', the gearing of machine tempo to the tempo of work. Every work operation is made reducible to a flow diagram that visualizes the economy of movement necessary to ensure optimum tempo and therefore productivity.[103] The space-shaping logic of Ginzburg's flow diagrams, designed to control the productive tempo of daily life, is closely in tune with the logic that condensed the space of the Frankfurt Kitchen to a minimum (cat.92). Every worktop and appliance in that miniature factory at the heart of the home was placed where flow diagrams determined. In the way it draws movement (tempo) and space together, it is in Modernist terms architecture and yet at the same time is demonstrably like a working mechanism.

There is a final question to pose before I can close this essay. If the machine aesthetic oxymoron fastened art and design into a circuit of analogies that kept the focus on production and product as

3.24 *Bentley BR1*, rotary engine (cat.39)

3.25 **Le Corbusier**, Pavillon de l'Esprit Nouveau, 1924. Fondation Le Corbusier, Paris

creation, could it mount anything like an effective resistance against the commodity as fetish and the consumer? The rigidly centralized Soviet system might have done the job at least partially in Russia, though the New Economic Policy allowed consumers to surface and brought even American films from the West for their delectation. Across Central and Western Europe, however, the removal of the consumer in favour of some kind of ideal collective beneficiary who is 'organized' by design was an illusion. Just how powerful an illusion it was is illuminated by the fact that one or two, including Fernand Léger, seriously believed that the message of Modernist plastic 'organization' was so irresistible that it could override any advertiser's transient message. It was on this basis that in the mid-1920s Léger offered his endorsement of the work of poster designers like Cassandre and Loupot, who had been influenced by his own machine Modernism, convinced that this new advertising art would educate thousands to see how Modernism could satisfy their collective need for the new 'beauty'.[104]

In fact, far from overriding any advertising message, machine Modernists outside Russia more often profited (intentionally or not) from the effectiveness with which their promotion strategies conveyed messages in terms that advertising professionals would have understood well. Bauhaus design was marketable, in part at least, because of the associative power of that name, 'Bauhaus', a power that was intensified by the immediately recognizable boldness, yet simplicity of Bauhaus typography: around the Bauhaus name its publications, exhibitions and advertising, formed a halo of virtue (to use the advertising guru Dill Scott's metaphor), bringing together hygiene, efficiency, the modern and the innovatory.[105] In the same way, too, the Purist magazine *L'Esprit Nouveau*, Le Corbusier's publications and his Pavillon de l'Esprit Nouveau at the 1925 Paris Exposition can be thought of as publicity campaigns, deepening the subliminal impact of the names 'Le Corbusier' and 'L'Esprit Nouveau', both of them to be associated with the daringly modern and the culturally elevated, just as Bauhaus design was. At the 1925 Exposition the Pavillon made a spectacle of use-value – Le Corbusier notoriously called its furnishings 'equipment' – but it did so with such refinement and panache that it suggested much more than use-value, especially because its interior was elevated by Art, the paintings of Ozenfant, Le Corbusier and Léger, and the sculpture of Jacques Lipchitz (pl.3.25). In the end, Bauhaus and 'L'Esprit Nouveau' promotion did not operate fundamentally very differently in relation to their clients from the advertising campaigns in Fordist America that exploited the idea of the 'Machine Age' in order to create new wishes in new, individual consumers.[106]

If machine Modernism succeeded, it was not because it actually restored collective use-value above the seduction of the image at all, but because it spoke clearly and passionately for a sharply defined cluster of values associated with reason and progress. By doing so in traumatized societies rebuilding after war and revolution, it made the machine something that could satisfy at deep levels, something that offered hope, at least for those who wanted not just the excitement of the unprecedented, but also the seeming safety of control.

38 Plate 3.10

In Advance of the Broken Arm
1915, original lost, replica 1963
Marcel Duchamp (1887 Blainville,
France–1968 Neuilly-sur-Seine, France)

Wood and iron
109 × 40 × 14.6cm
Moderna Museet, Stockholm, gift 1965 from
The Friends of the Moderna Museet (NMSK 1888)

Although Marcel Duchamp bought the bottle drying rack now considered his first unassisted 'readymade' in Paris in 1914, he first used the term 'readymade' in New York in 1915, when he purchased this snow shovel, bought from a Manhattan hardware store.[1] Arturo Schwarz has identified five categories of readymade in Duchamp's production, of which the simplest is an item 'chosen' by the 'author' and so 'consecrated' as a work of art (the category 'assisted ready-mades' – for example, the bicycle wheel attached to a stool produced by Duchamp in 1913 – involves active intervention). *In Advance of the Broken Arm* is a straight readymade, and so is *Traveller's Folding Item* (pl.3.26), a typewriter cover chosen by Duchamp also in New York in 1916. There is no evidence that the artist exhibited his snow shovel; he merely hung it from the ceiling of his flat at 1947 Broadway, apparently without annoying his flatmate, his brother-in-law Jean Crotti.[2] It is possible, however, that his typewriter cover was shown publicly in an Exhibition of Modern Art at the Bourgeois Galleries, New York, in April 1916, where two 'readymades' were listed.[3]

Duchamp himself maintained that the key to choosing his readymades was total lack of 'aesthetic emotion' – what he called 'visual indifference'.[4] Yet in 1917 he was happy to feed the controversy that followed the submission of his urinal entitled *Fountain* to the New York Independents by suggesting some kind of prefer-ence was involved, at least of American machine products above American painting or sculpture. 'The only works of art America has given the world,' he announced, 'are her plumbing and her bridges.'[5] His choice in Paris of a bicycle wheel and a bottle drying rack could be connected with the pre-eminence in the city of the great wheel and the Eiffel Tower (both relics from the Universal Exhibitions) as symbols of industrial modernity. America can only have intensified his awareness of the growing ubiquity of modern engineering and mass-produced commodities, including typewriters and snow shovels.

On one level, Duchamp's utterly undramatic, deadpan choice of a snow shovel and a typewriter cover may be open to positive interpretations: the shovel is an obviously efficient functional object, and the typewriter must have been a machine whose efficiency he routinely encountered in his temporary jobs as librarian and 'personal secre-tary' in New York. But to claim the latter as an artwork by signing and probably exhibiting it, and to extract the other from any practical use by entitling it *In Advance of the Broken Arm*, was, of course, to divert attention from all that made these items efficient. The functional here encoun-ters 'art' and, by doing so, endangers both the

3.26 **Marcel Duchamp**, *Traveller's Folding Item*, 1916.
Moderna Museet, Stockholm

transcendent claims of 'art' and the rational claims of mechanized production. Both are reduced to the level of the enigmatically personal and the manifestly inconsequential, a move that has proved immensely consequential.

The example exhibited here is a replica. Duchamp's attachment of his name to such repli-cas, authenticating them and thus granting them a share in his own 'aura', introduces a still further layer of disorienting uncertainty by underlining the way in which the impersonal can be personalized in the readymade, and at the same time the degree to which mechanical reproduction under-mines the uniqueness of the authentic. CG

1 The consensus is that *Bicycle Wheel*, a bicycle wheel attached to a stool by Duchamp in 1913 for his private amusement, was the first readymade, but this is manifestly an assemblage made up of chosen objects and thus an 'assisted readymade'. Arturo Schwarz, *The Complete Works of Marcel Duchamp* (revised edn, London, 1997), vol.1, pp.44–5.
2 Ibid., vol.2, p.636.
3 Ibid., pp.645–6.
4 Cited in Pierre Cabanne, *Dialogues with Marcel Duchamp* (London, 1971) p.48.
5 Marcel Duchamp, 'The Richard Mutt Case', *The Blind Man*, no.2 (New York, May 1917) p.5.

39 Plate 3.24

Bentley Rotary BR1, air-cooled
7-cylinder rotary engine
c.1917
Designed by W.O. Bentley
(1888 London–1971)
Manufactured by Humber and Crossley,
Coventry

Steel, aluminium, cast iron
107 × 120 × 100cm (mounted)
Science Museum, London

The aircraft rotary engine was first successfully developed in France in 1908 and used extensively in military aircraft in the First World War.[1] It repre-sented a revolution in aircraft design owing to its short length, light weight and efficiency. It is highly likely that Fernand Léger, Marcel Duchamp and Constantin Brancusi would have seen one of the very new and distinctive rotary engines – so

different in appearance from other contemporary engine types – when they visited one of the first *Salons de l'aviation* in Paris in 1912. Léger recounted Duchamp's reaction to the show: 'Painting is finished! Who can do better than this propeller?' Léger wrote, 'Personally, I was more drawn towards the engines, towards metal rather than to the wooden propellers . . . They were marvellous.'[2]

Fascination with machines and machine parts, including aeroplanes and motor cars, permeated the entire Modernist enterprise. In articles in *L'Esprit Nouveau* Le Corbusier illustrated aero-planes as supreme examples of a logically enunciated design problem ('a means of suspen-sion in the air and a means of propulsion') successfully resolved.[3] He later published an entire book (*Aircraft*, 1935) devoted to the aeroplane, illustrating various engine parts. Le Corbusier's interest in the products of industry and engineering was not unique. There were earlier examples of books discussing or illustrating machines and the products of engineering.[4] However, his publications were very widely circulated and certainly influenced

the spate of avant-garde books and journals from Prague to Moscow (pl.2.23), from Warsaw to Milan, which published illustrations of aeroplanes and other machines.

The famous First World War Sopwith Camel was fitted with a rotary engine, first a Clerget and later a Bentley, though the engine type disap-peared from use after 1918. W.O. Bentley became far better known as the founder of the motor-car company bearing his name, which produced its first car in 1919.[5] CW

1 See Andrew Nahum, *The Rotary Aero Engine* (London, 1987), *passim* and pp.27–8 on Bentley's version.
2 Dora Vallier, *Carnet inédit de Fernand Léger* (Paris, n.d.), p.140. See Christopher Green, *Léger and the Avant-garde* (New Haven, 1976), pp.84–5. The first such exhibition in Paris was held in 1908 as an annexe to the annual automobile show at the Grand Palais. In 1909 annual aviation shows began.
3 Le Corbusier-Saugnier, 'Des yeux qui ne voient pas . . . III: Les autos', *L'Esprit Nouveau*, no.9 (June 1921), p.976, reprinted in Le Corbusier, *Towards a New Architecture* (London [1923], 1946), p.105.
4 For example, Josef August Lux's *Ingenieur-Asthetik* (Munich, 1910), which celebrated the aesthetic qualities of bridges, factories and grain silos.
5 W.O. Bentley, *The Autobiography of W.O. Bentley* (London, 1958).

a b c

d e f

40

Magazine covers: *391*
Designed by Francis Picabia (1879 Paris–1953 Paris)

a) *Novia au Premier Occupant* (*Fiancée of the First Occupant*, Barcelona, no.1, 25 January 1917)
 37.1 × 27.2cm
b) *Flamenca* (Barcelona, no.3, March 1917)
 37.5 × 27cm
c) *Roulette* (Barcelona, no.4, 25 March 1917)
 37.2 × 27cm
d) *Âne* (*Ass*, New York, no.5, June 1917)
 37.2 × 27cm
e) *Américaine* (*American Woman*, New York, no.6, July 1917)
 37.2 × 27cm
f) *Ballet Mécanique* (*Mechanical Ballet*, New York, no.7, August 1917)
 36.6 × 26.6cm
 V&A, National Art Library (36.F Box IV)

391 was Francis Picabia's own periodical: his private resources financed it; he edited it and provided much of its visual material and copy. He founded the periodical in January 1917, six months into a year-long stay in Barcelona. Intent on avoiding war service of any kind, he had arrived there from New York, where he had been part of the circle of Marcel Duchamp and Walter and Louise Arensberg, to find a mixed avant-garde commu-

nity avid for the stimulus that his mischievous energy could provide. The title followed from that of the New York periodical *291*, and Picabia's new magazine, never more than a broadsheet of four or six pages, continued at least in part as a vehicle for the intensified engagement with everything modern and mechanical that Manhattan had given him. Machine imagery dominates the covers he designed for it, not only in Barcelona, but when he returned to New York in the spring of 1917.[1]

It is, however, a machine imagery designed to resist the mechanical on every level; it provided a new outlet, transatlantic in its reach, for the critique of the machine and rationalism that had been initiated in Paris before 1914 by Picabia alongside Duchamp. Picabia's *391* covers of 1917 are developments from Duchamp's readymades. They use redrawn engineering diagrams and slightly altered photographic reproductions of machine-made items, combined with textual accompaniments to make the dumbly mechanical and the impersonal suggestive and personal, and to ridicule art (as individual creation) and industry of all kinds.[2] The machine becomes both a weapon against art and a weapon against itself.

Of these covers, no.1 is an invented nonsense mechanism of Picabia's own devising, while *Flamenca* and *Roulette* are produced from redrawn engineering diagrams of car components, an exhaust and an early braking mechanism. Two

others, *Ass* and *Mechanical Ballet*, are produced from carefully drawn renderings by Picabia after illustrations of a boat's screw propeller and a metal cushion designed for the axles of early automobiles. *American Woman* is produced from a retouched halftone reproduction of a photograph of a light bulb.[3] Three covers merely subvert the mechanical with the inappropriate: the Flamenco guitar, classical ballet and games of chance, all of them using visual punning to do so. Three use words as well as images to sexualize the mechanical: *American Woman*, a light bulb that switches between 'flirt' and 'divorce'; *Ass* with its obvious screw/arse connotations; and *Fiancée*, with its 'first occupant' allusion and the punning of 'saints des saints' with 'seins des seins' (translatable as 'breasts of breasts').

Perhaps the most treacherous aspect of these visual jokes at the machine's expense is the fact that superficially they can seem as mechanically 'aesthetic' as Léger's most immaculate machine paintings (pl.3.2). CG

1 For *391*, see especially Michel Sanouillet, *Francis Picabia et 391*, 2 vols (Paris, 1966).
2 Picabia developed what Camfield has called 'composite machine portraits' using engineering diagrams and other kinds of machine image in New York in 1915. See William A. Camfield, *Francis Picabia. His Art, Life and Times* (Princeton, 1979), ch.6.
3 These sources were first spotted by Sanouillet. It is noticeable that the car components that Picabia used tended to be outdated.

41a

Drawing: *Design for the Tuta*

c.1919

Thayaht (Ernesto Michahelles)

(1895 Florence–1959 Peitrasanta, Italy)

Tempera and ink on card
23 × 22cm
Galeria del Costume di Palazzo Pitti, Florence

41b

Photograph: Thayaht wearing the Tuta

n.d.

Photographer unknown

In 1919 Ernesto Michahelles, under his pseudonym Thayaht, designed the 'tuta', a simple suit or over-all for men suitable for all occasions.[1] In the design drawing, Thayaht defines the term tuta as 'one piece, straight line garment for men and boys'.[2] The drawing shows all parts of the cut. Brief instructions to the right and left specify how the parts should be assembled. At the top left, Thayaht describes how the tuta should be accessorized: 'This one piece garment is worn with a strip of bright coloured stuff at the waist, white socks and sandals. It looks smartest when worn without hat and open white collar. A simple leather belt also looks well.' The use of English in the drawing was probably owing to Thayaht's desire to patent his design in the United States. His intention was that the tuta would be distributed in Europe, the United States, Canada and eventually South Africa.

The simplicity of the design was meant to enable people to make their own tuta. The whole garment was made from one piece of textile measuring 4.5 × 0.7 meters. In order to promote the tuta, the design was published on 17 June 1919 in the national newspaper *La Nazione*. More than a thousand patterns for the design were sold within several days. The tuta's immediate popularity caused the price of fabric to rise in Florence and, as a consequence, *La Nazione* threatened to publish the names of those suppliers seen to be taking advantage of the heightened demand.[3] A tuta for women was introduced shortly afterwards, less radical in design and replacing the trousers with a skirt.[4]

In contrast to later designs for boiler suits or overalls by Alexander Rodchenko and others, the tuta was neither defined as workers' clothing nor intended for a specific class of consumer.[5] Thayaht's aim was to change the image of the city rather than to refashion the individual. The individual wearing the tuta was meant to become a piece of art in a joint celebration of colours and forms aiming at the destruction of the monotonous world.[6] JS

1 The most detailed analysis of the tuta is Caterina Chiarelli and Giovanna Uzzani, *Per il sole e contro il sole. Thayaht and Ram la tuta/modelli per tessuti* (Florence, 2003).

2 There are several theories concerning a definition of the term 'tuta', ranging from a connection between the letter t of 'tuta' with the t-shape of the design to descriptions like 'tuta d'un pezzo' referring to the garment made from one piece or 'tuta la persona' describing the dressing of the whole person. See Viviana Benhamou, 'Ernesto Thayaht: Neue Perspektiven', in Gisela Framke (ed.), *Künstler ziehen an: Avantgarde-Mode in Europa 1910–1939* (Dortmund, 1998), p.90.

3 Giovanna Uzzani, 'Per il sole e contro il sole', in Chiarelli and Uzzani (2003), p.12.

4 Thayat published this design in the flyer 'Avvertimenti alle tutiste' ('Warnings to women wearing the tuta') and was inspired by Filippo Tommaso Marinetti's Futurist manifesto *Contro il lusso feminile* (*Against Feminine Luxuries*, 1920). Thayat pointed out the benefits of wearing the tuta, both in terms of a woman's health and beauty. Benhamou in Framke (1988), p.13.

5 Benhamou claims that the tuta was even worn by the Florentine nobility. Ibid, p.90.

6 Emily Braun, 'Futurist Fashion: Three manifestoes', *Art Journal* (22 March 1995), p.34.

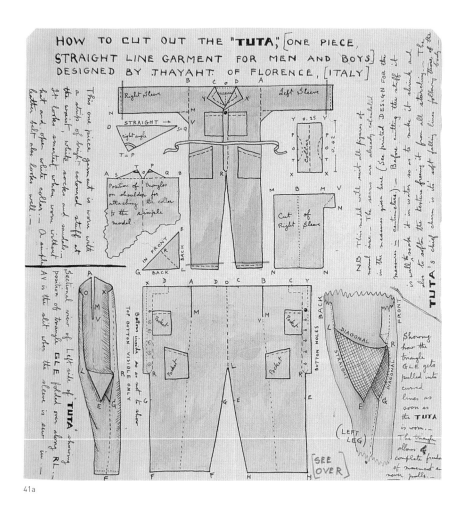

41a

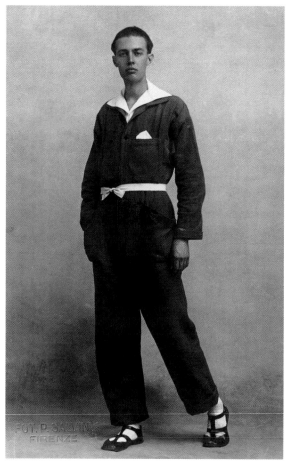

41b

42a

Drawing: *Production Clothing*
*c.*1922
Alexander Rodchenko
(1891 St Petersburg –1956 Moscow)

Ink and colour pencil on paper
35.5 × 33cm
Private Collection

42b

Production Clothing
*c.*1922, this version made by
Aoi Morishita 2005[1]
Designed by Alexander Rodchenko
(1891 St Petersburg –1956 Moscow)

Woven wool, leather trim
Shirt: chest 134cm, collar to hem 79cm
Trousers: inside waist 85cm, length 105cm
V&A: T.40:1, 2–2005

42c

Photograph: *Rodchenko wearing his
production clothing in front of
de-installed Spatial Constructions*
1922
Mikhail Kaufman (1897 –1979)

Certain European designers, artists and architects of the 1920s were deeply concerned with finding an appropriate mode of clothing for the new era in which they were living. Some male architects thought that the traditional tailored suit, particularly the English suit, was a suitable expression of the principles of simplicity, standardization and lack of ornament that contemporary architecture should follow.[2] Others, like the spiritually oriented Bauhaus teacher Johannes Itten, adopted a version of monastic attire, worn also by other colleagues.[3] There was, however, a category of dress that sought identification with the idea of the factory, and the presentation of the designer or artist as a worker or technocrat. The basis of these was either the technician's jacket or, more commonly, the boiler suit or overall.

Rodchenko's two-piece outfit was made by his wife Varvara Stepanova. It enabled the designer to portray himself as a worker, dressed in attire that would be (at least in its essence) familiar to the many, and which would be associated with the forward-looking technological agenda of Modernism.[4] Such everyday clothing or workers' uniforms also suggested the collective nature of Soviet society. Shortly after it was made Stepanova published an article in which she referred to this type of clothing as *prozodezhda* or production clothing.[5]

The garment was made of stiff wool, appropriate not only to the climate of the Soviet Union but also to the design, in which the pattern pieces were geometric in form rather than close-fitting. All the edges that would get wear were trimmed in leather. This design was an experimental one and, like so many Soviet designs, was never put into production, owing to the lack of resources in the difficult economic circumstances of the post-revolutionary period. CW

1 Based on Rodchenko Room Project (2003), Museum of Modern Ceramic Art, Gifu.
2 Adolf Loos famously compared English tailoring to contemporary architecture and found the latter lacking. See Loos, 'Die Herrenmode', *Neue Freie Press* (22 May 1889), trans. in Loos, *Spoken Into the Void* (Cambridge, MA, 1982), pp.11–14. Walter Gropius, a former Prussian army officer, consciously dressed conventionally, and Le Corbusier dressed in suits and wore a derby hat. Although the topic of Modernism and the man's suit has not received comprehensive treatment, it is discussed in Mark Wigley, *White Walls, Designer Dresses* (Cambridge, MA, 1995).
3 One image of Itten, who was a believer in Mazdaznanism, is widely reproduced; see Jeannine Fiedler and Peter Feierabend, *Bauhaus* (Cologne, 1999), p.232. His colleague Georg Muche is shown in related attire in a drawing by Paul Citroen reproduced in Michael Siebenbrodt (ed.), *Bauhaus Weimar – Designs for the Future* (Ostfildern-Ruit, 2000), p.59, fig.62.
4 The information that it was made by Stepanova appears in Selim O. Khan-Magomedov, *Rodchenko, the Complete Work* (London, 1986), p.14, in a caption to a related photograph by Kaufman – a book made with the cooperation of Rodchenko's and Stepanova's descendants.
5 See Varst [Vavara Stepanova], 'Kostium segodniashnego dnia – prozodezhda', *Lef*, no.2 (1923), pp.65–8, trans. somewhat idiosyncratically as 'Today's Fashion is the Worker's Overall', in Lidya Zaletova et al., *Costume Revolution* (London, 1987), pp.173–4. The use of the word 'fashion' seems particularly misleading. Christina Lodder has suggested 'Present Day Dress – Production Clothing' as closer to the original meaning. See Lodder, *Russian Constructivism* (New Haven, 1983), p.147.

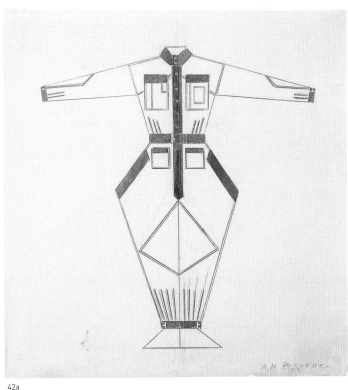

42a

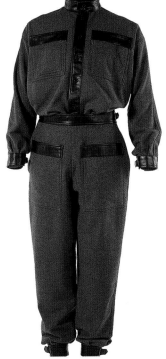

42b

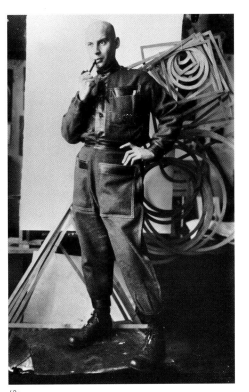

42c

43

Drawing: *Standard Clothing*
1923
Vladimir Tatlin (1885 Moscow–1953 Moscow)

Pencil, charcoal and watercolour
106.7 × 76.2cm
The Bakhrushin State Theatrical Museum, Moscow
(264421/548)

This drawing is inscribed: 'Section for Material
Culture'. It was produced by Vladimir Tatlin as part
of the programme of the Section that he estab-
lished in 1922 within the GINKhUK (State Institute
for Artistic Culture, Petrograd). The Section
implemented ideas expressed in his declaration
accompanying his *Model for a Monument to the
Third International* of 1920, in which he challenged
artists to take control of the form of objects in
everyday life.[1] Like the Constructivists at the
INKhUK (Institute of Artistic Culture), he was
forsaking the studio for the factory. Tatlin took the
practical step of forming a small research group
to develop prototypes for factory production. He
summed up the Section's aim as 'to discover the
properties of materials by analysing them and to
provide a number of patterns: a new norm which
would be the pattern for production in the USSR'.[2]
This drawing is for 'standard' or 'everyday'
clothing in this sense. It presents a design for a
working man's top-coat with trousers, completed
by neat flat hat and sturdy boots, as a pattern for
wear by an entire proletariat. True to his materialist
design principles, Tatlin excludes all that is extra-
neous, shaping the coat to a broad-shouldered
worker's body, deriving its form exclusively from
the unadorned material and cut.

In 1924 Tatlin reported that the development of
clothing 'norms' had been the first project taken
up by the Section, and that contact had been made
with the Leningrad Clothing Manufacturers' Trust,
indeed even that 'clothing-norms' were 'jointly
set up' with the Trust.[3] Yet, clever though Tatlin's
clothing designs were (the coat having removable
'flannelette' and fur linings to make it adaptable
to different seasons, and wide sleeves to prevent
the accumulation of sweat), there is no evidence
of actual mass production. CG

1 Larissa Zhadova, *Tatlin* (London, 1988), p.239.
2 Vladimir Tatlin, 'Report of the Section for Material Culture under
 the Museum of Artistic Culture to the Leningrad Division of the
 Main Directorate of Scientific Institutions', 27 May 1924; in
 Zhadova (1988), p.250.
3 Vladimir Tatlin, 'Report to the Leningrad Division of the Main
 Directorate of Scientific Institutions', 1 November 1924; in ibid,
 p.255.

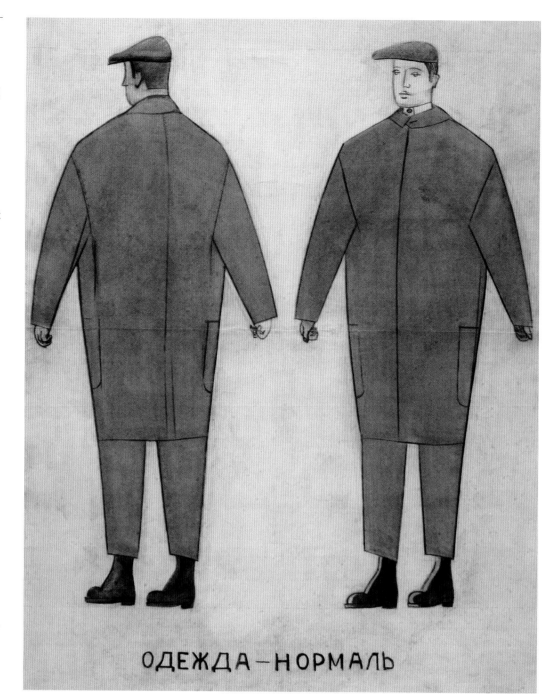

ОДЕЖДА–НОРМАЛЬ

44 Plate 3.16

Photomontage: *'Novi Byt'*
(*'The New Way of Life'*)
1924
Vladimir Tatlin
(1885 Moscow –1953 Moscow)

Collage of photographs, newspaper and paper
with ink and pencil
39.7 × 33.8cm
Central State Archive for Art and Literature, Moscow

In this montage, probably put together as a display
piece for the Exhibition Room of the Section of
Material Culture, Tatlin is shown modelling
examples of the 'standard clothing' designed by
himself and the Section.[1] These photographs were
published in the periodical *Krashnaia Panorama*
(*Red Panorama*) in 1924, which Tatlin clipped and
used in the montage.[2] At the top right he wears
his design for a simple workman's suit and, to
its left, standing in front of one of the Section's

prototypes for an economic wood-burning stove,
he wears his 'all seasons' coat'.[3] At the bottom in
the middle is a photograph of 'New everyday stan-
dard clothing', representing a further (and final)
development of his clothing designs. The clothing
is superimposed over two bourgeois in old-
fashioned dress, who are depicted horizontally as
though having been toppled. The contrast of new
against old is emphasized.[4] The text adjoining the
new working suit placed vertically across the two
bourgeois figures reads: 'This attire is warm, does
not restrict movement, satisfies hygienic require-
ments, and lasts long.' The caption for the
superseded clothing warns: 'This attire restricts
movement, it is also unhygienic, and they wear it
only because they think it is beautiful.'[5] CG

1 Vladimir Tatlin, 'Report to the Leningrad Division of the Main
 Directorate of Scientific Institutions', 1 November 1924; in
 Alelseevna Zhadova, *Tatlin* (London, 1988), p.255.
2 *Krasnaia Panorama*, no.23 (4 December 1924) in ibid., pp.142–3.
3 Christina Lodder, *Russian Constructivism* (New Haven, 1983), p.147.
4 Zhadova (1988), p.143.
5 Ibid.

45

Photograph: Portrait of László
Moholy-Nagy
1926
Lucia Moholy (1894 Prague–1989 Zurich)

Gelatin silver print
22.4 × 15.4cm
Bauhaus Archiv, Berlin (BHA 7896)

László Moholy-Nagy met his future wife Lucia
Schulz in 1920 when he arrived in Berlin after the
fall of the revolutionary Republic of Councils in
Hungary. Born and educated in Prague, Lucia was
a photographer and it was she who introduced
him to photography, opening the way for his first
camera-less rayograms in 1922.[1] This camera
shot of Moholy-Nagy was taken when he was
developing his own range of camera photography
using the 33mm Leica, a new user-friendly model
that had been launched onto the market in 1925
(cat.257).

 Lucia's portrait represents Moholy as Bauhaus
progressive rationalism personified. He is placed
before broad dark and light planes, as if a pictorial

motif in post-Suprematist space. He himself is an
image of hygiene and good order: his hair slicked
down, his spectacles framed with the minimum
display, his tie firmly gripped between crisp white
collars. Most of all, however, he is the image of
the precision worker in control, eyes fastened on
some task imminently to be completed, shoulders
back, standing firm, yet at ease. In place of a busi-
ness suit, he wears a boiler suit; he is more to be
associated with engineers or skilled machine
operators than with artists or even draughtsmen
in design studios. He had been brought in by
Walter Gropius in 1923 to head the Metal Work-
shop at the Bauhaus, first at Weimar and, from
1925, at Dessau. Just visible to the left is a clean-
edged detail of the newly completed Bauhaus
building at Dessau. Lucia proudly displays her
husband here as a key figure driving forward and
consolidating Gropius's programme for bringing
together art and technology, which indeed Moholy
was. CG

1 See Kristina Passuth, *Moholy-Nagy* (London, 1985), p.18ff.
 On Lucia Moholy, see Rolf Sachsse, *Lucia Moholy, Bauhaus
 Fotografin* (exh. cat., Bauhaus Archiv, Berlin, 1995). For the
 first rayograms, see Eleanor M. Hight, *Picturing Modernism:
 Moholy-Nagy and Photography in Weimar Germany* (Cambridge,
 MA, 1995), pp.47–8, 51.

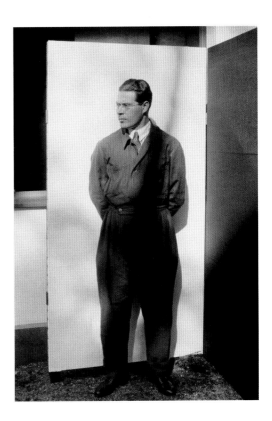

46 Plate 3.7

Painting: *Still-life with a Pile of Plates*
1920
Charles-Edouard Jeanneret (Le Corbusier)
(1887 La Chaux-de-Fonds, Switzerland–
1965 Cap-Martin, France)

Oil on canvas
80.9 × 99.7cm
The Museum of Modern Art, New York, Van Gogh Purchase
Fund, 1937 (261.1937)

This work was one of 20 paintings contributed alongside another 20 by Amédée Ozenfant to the exhibition of 'Purist' painting put on at the galerie Druet in Paris in January 1921. Le Corbusier exhibited there as Charles-Edouard Jeanneret, his real name, which until 1923 he retained for his painter persona. He and Ozenfant founded their two-man movement Purism in 1918 with a first joint exhibition and a polemical book *Après le cubisme*.[1] They wanted artists and designers to set aside what they saw as the disordered aesthetic self-indulgence of Cubism for a new ordered aesthetic attuned to the constructive principles of modern engineering and mechanical production; this was for them the key to the building of a post-war world.[2] The theoretical underpinning of the work shown in 1921 was, however, only supplied in the early numbers of the magazine they founded in 1920, *L'Esprit Nouveau*.[3]

For Jeanneret and Ozenfant, post-Cubist painting could be both of its time (a time defined by the machine) and transcendent. They proposed a fixed foundation for all art in what they termed 'primary sensations' – the effect above all of the simple forms of Euclidean geometry – which they believed were constant for all spectators of all cultures. They allowed in their painting subject matter that they acknowledged could generate 'secondary sensations' – culturally variable in effect because of the different associations they could suggest – but strictly limited that subject matter to objects which they saw as representative of fundamental evolutionary processes underlying all human development. The objects they chose were deliberately banal – cheap crockery, bottles, musical instruments – as in *Still-life with a Pile of Plates*. Yet for the two artists, even these objects, whose simple forms they found 'perfect', could symbolize evolutionary processes of refinement that characterized the development of all designed objects, from wine bottles to motor cars, transatlantic liners and aeroplanes. Such a painting stood for an ideal of perfected beauty that, for them, was as much embodied in the best industrial design as in the human figure or monumental architecture. In the Purist scheme of things, *Still-life with a Pile of Plates* was a representation of machine perfection: a perfection finally ensured by means of a proportional system refined since Antiquity by artists and architects, utilizing the Golden Section. Indeed, the painting was itself a machine – a 'human emotion machine' – and one that would reach across cultures and periods, a belief that will continue to be tested.[4] CG

1 The 'first exhibition of Purist art' was held in the premises of the couturier sister of Paul Poiret, Madame Bongard, renamed the galerie Thomas for the occasion. Le Corbusier and Ozenfant put together *Après le cubisme* in the autumn of 1918 while staying together in the Bordeaux region.
2 'The War ends, all is organized, clarified and purified.' Charles-Edouard Jeanneret and Amédée Ozenfant, *Après le cubisme* (Paris, 1918), n.p.
3 Most important of all for Purist pictorial theory is their article 'Le Purisme', *L'Esprit Nouveau*, no.4 (Paris, January 1921), which came out alongside the Galerie Druet exhibition.
4 Both the theory of 'primary' and 'secondary' forms, and that of 'type objects' are first developed in 'Le Purisme', ibid. The idea of painting as a 'machine à émouvoir' is discussed by Ozenfant in 'Revue de l'année, peinture ancienne et peinture moderne', *L'Esprit Nouveau*, no.11–12 (Paris, November 1921).

47a Plate 3.5

Painting: Telephone picture *EM2*
1922
László Moholy-Nagy
(1895 Bácsborsod, Hungary–1946 Chicago)

Porcelain enamel on steel
47.5 × 30.1cm
The Museum of Modern Art, New York, gift of Philip Johnson
in Memory of Sybil Moholy-Nagy (91.1971)

47b Plate 3.6

Painting: Telephone picture *EM3*
1922
László Moholy-Nagy
(1895 Bácsborsod –1946 Chicago)

Porcelain enamel on steel
24 × 15cm
The Museum of Modern Art, New York, gift of Philip Johnson
in Memory of Sybil Moholy-Nagy (92.1971)

EM2 and *EM3* are two of three works conceived by Moholy-Nagy and executed by order from a sign-producing factory in Berlin. All three have the same tall, rectangular format, but are of different sizes. According to Moholy-Nagy's then wife, Lucia, their purpose was partly experimental: the examination of the different effects produced when exactly the same colour weights and proportions are deployed on different scales.[1] Factory production in porcelain enamel allowed clear, bright colours to be repeated exactly. Moholy-Nagy himself describes working from colour samples and ordering the pictures from the departmental manager by telephone, each party using squared graph paper to ensure exactitude in the transfer of the concept.[2] The idea of ordering art by phone had already been suggested (though not followed up) by the Berlin Dadaists in 1920.[3] According to Lucia Moholy, however, the idea that these pictures *could* have been ordered by phone occurred to the artist only after he had actually ordered them in person at the factory.[4]

The telephone pictures were first shown in 1924 at the Galerie Der Sturm in Berlin. When Moholy's Hungarian supporter Ernö Kállai wrote about them that year, it was not the manner of their ordering that concerned him, but rather their use of industrial materials, their reproducibility and their utopian idealism.[5] Moholy's use of simple crossed bands floating in a white expanse demonstrates his early awareness of Russian developments, especially Suprematism. The way he uses contrasting white and black grounds against which to place colour underlines his quasi-scientific approach to colour perception.

Moholy seems only to have thought of these pictures as a major development in his oeuvre with hindsight; significantly, he did not include them in his important Der Sturm exhibition of 1925. CG

1 See Kristina Passuth, *Moholy-Nagy* (London, 1985), p.32.
2 László Moholy-Nagy, *The New Vision of the Abstract Artist* (New York, 1949); cited in Norbert Schmitz, 'László Moholy-Nagy', Jeannine Fiedler and Peter Feierabend (eds), *Bauhaus* (Cologne, 1999), p.292.
3 Richard Huelsenbeck (ed.), *Dada Almanach* (Berlin, 1920).
4 The evidence is presented in Passuth (1985), p.33.
5 Ernö Kállai, 'Ladislaus Moholy-Nagy', in *Jahrbuch der jungen Kunst*, vol.5 (Leipzig, 1924); discussed in Eleanor M. Hight, *Picturing Modernism: Moholy-Nagy and Photography in Weimar Germany* (Cambridge, MA, 1995), p.7.

48 Plate 8.5

Film: *La Roue* (*The Wheel*)
Written, directed and co-edited by
Abel Gance (1889 Paris–1991 Paris)

*c.*520 mins (10,500 metres) originally; later cut to *c.*200 mins,
silent (original music for performance by Arthur Honneger),
black and white
Produced by Les Films Abel Gance, France, 1922

For Jean Cocteau, *La Roue* marked a watershed
in cinema; and for Fernand Léger, its creator was
the first film-maker to have fully understood the
basis of the new art of cinema as 'making us see
everything not previously perceived'.[1] In part, the
extravagant praise heaped on Abel Gance's film
after its Paris premiere was a response to its
sheer scale. Running at nearly nine hours, it
was shown over three consecutive mornings in
December 1922 and the final sequences were
repeated as an encore by popular demand.[2]

Even the surviving version, reduced by over half
for subsequent release, reveals *La Roue* to be, for
the most part, a sentimental and far-fetched
melodrama about the frustrated love of an engine
driver for his beautiful young ward. However, what
fascinated Léger and many others were several
sequences in which Gance (probably assisted by

the poet Blaise Cendrars) experimented with
close-ups of locomotive parts intercut in a rising
tempo with images of the main characters as they
are affected by an imminent crash. The framing,
and the alternation of still and moving objects
within shots, seemed to create new inspiration for
Cubist and Purist artists, redeeming cinema from
its usual conventionality. Thus cinema (and even
much of this film) was redeemed from its visual
conventionality.

The revelation of Gance's rapid editing and
use of extreme close-ups alternating with wide
landscapes would become a key foundation for
the French film avant-garde of Louis Delluc, Jean
Epstein, Marcel L'Herbier and Germaine Dulac,
encouraging their belief in the 'specificity' of the
cinematic image as the basis for film art.[3] Léger
drew his own conclusions about the need to
isolate 'mechanical elements' and objects from
surrounding narrative when he began work on
what would become *Ballet mécanique* (1924,
cat.75). Meanwhile Gance would retreat further
from modernity, while continuing to expand
cinema's rhetorical powers with his equally vast
and uneven *Napoléon* (1927). IC

1 Cocteau comparing *La Roue* to Picasso is reported by Kevin
 Brownlow, *The Parade's Gone By* (London, 1968), p.625; Léger's
 praise appeared in a 1922 essay, '*La Roue*: sa valeur plastique'
 ['*La Roue*: its plastic value'], thought to have been commissioned
 by Gance and published in Léger, *Fonctions de la peinture* (Paris,
 [1965] 1996), p.58.

2 Richard Abel records a first-hand account of the Paris premiere
 by the future director Jean Dréville before an audience of more
 than 6,000: *French Cinema: The First Wave 1915–29* (Princeton,
 1984), p.326. See also Standish Lawder, '*La Roue*, Cendrars and
 Gance', in *The Cubist Cinema* (New York, 1975), pp.79–98.
3 Ian Christie, 'French Avant-garde Film in the Twenties: from
 "Specificity" to Surrealism', *Film as Film: Formal Experiment in
 film 1910–75* (exh. cat., Hayward Gallery, London, 1979), pp.37–45.

49 Plate 1.4

Design for the Kremlin Wall for the IV Comintern-Congress and the 5. Anniversary of the October revolution 'Quake Bourgeois! Radio to the Proletariat! Long Live the Proletarian!'
1922
Gustavs Klucis (1895 Rujiena, Latvia –
1938 Moscow?)

Gouache, ink, photo-collage and pencil on paper
31.7 × 45cm
The State Museum of Arts, Riga (VMM Z-7863)

Gustavs Klucis designed this decoration for the
wall of the Kremlin to mark the Fourth Congress
of the Comintern, which was held in Moscow in
the summer of 1922, and to celebrate the fifth
anniversary of the Revolution the following
November. He also designed about 30 agitational
stands for the same events.[1] One design, *The
Third International*, equipped with aerials and
floodlights, was actually built, on the roof of the
hotel on Tverskoi Boulevard where Congress
delegates were staying.[2] The other designs,
including this one, remained unexecuted.

The Comintern was the international commu-
nist organization dedicated to fomenting world
revolution. As a Communist Party member and
former soldier in the Latvian Rifle Regiment,
which had fought for the Revolution in 1917, Klucis
was fully committed to the revolutionary cause.
By 1922 he had also become attached to the
Constructivists, with their commitment to com-
munism, industry and technology. Like them, he
wanted to use his artistic expertise to transform
the environment and design useful objects for
the new society.

Klucis's design has transformed the medieval
walls of the Moscow Kremlin into a structure that
expresses the crucial link between the machine
and communism. Wires, evoking radio waves, are
strung from the towers, transmitting the message
'Quake Bourgeois. Radio to the Proletariat'. One
tower has been completely covered by the image
of the red sun of socialism, pulsing with energy,
radiating red rays and pointing the way to a glorious
future. The three vertical banners (forming a
V-shape, or the Latin numeral five) read: 'Glory
to those killed in the [revolutionary] struggle.' An
aeroplane, a skeletal sphere and pylon structures
complete the transformation of the bastion of
autocracy into an evocation of the new proletarian
state, marrying technology and political radicalism,
and announcing the dawn of a new technological
age. CL

1 *Art into Life: Russian Constructivism 1914–1932* (Seattle, 1990),
 pp.102–104, and Christina Lodder, *Russian Constructivism*
 (New Haven, 1983), pp.162–5.
2 Gustav Klucis, *Retrospektive* (exh. cat., Museum Fridericianum,
 Kassel, 1991), p.113.

50a Plate 3.11

Photograph: *Akeley Motion Picture Camera*
1922
Paul Strand (1890 New York–1976 Orgeval, France)

Gelatin silver print
24.5 × 19.5cm
The Metropolitan Museum of Art, New York (1987.1100.3)

50b Plate 3.12

Photograph: *Marmon Crankshaft*
1923
Paul Outerbridge (1896 New York–1958 Laguna Beach, USA)

Gelatin silver print
11.4 × 8.8cm
Wilson Centre for Photography (01:6949)

50c Plate 3.13

Photograph: *Niagara Falls Power Co.*
1928
Margaret Bourke-White (1904 New York –1971 Darien, USA)

Gelatin silver print
34.5 × 24cm
Wilson Centre for Photography (01: 6930)

Could the Modernist cult of the machine have existed without the photographic frame? The purist aesthetics that Le Corbusier found in the grain elevators, ocean liners and engines that he published, for example, depended on the total elimination of those objects' real context, through their illustration in severely cropped or airbrushed photography that completely eliminated their real context.[1] American industrial designers, too, framed their streamlined creations in glamorous promotional photos, in which clothes irons and refrigerators inhabited an autonomous realm of spotlit glamour. Classic Modernist machine photographs were, in this sense, the antithesis of a 'realist' tradition. Yet they also depended upon the medium's truth effect – as Man Ray put it, the impression that a photograph, 'itself less substantial than the paper it is printed on, can evince a force, an authority, which, like certain words, goes well beyond the force and authority of any material work'.[2] Not until the 1960s, in the work of the German artists Bernd and Hilla Becher, would the machine photograph's powerful blend of fiction and fact be seriously challenged.

In Outerbridge and Strand's pioneering photographs of the early 1920s, the tight close-up is the means of transforming machines into Modernist icons. A non-specialist would find it difficult, faced with these images, to explain the exact function of the mechanical parts depicted – an automobile engine crankshaft and the internal magazine of an early film camera.[3] But the esoteric nature of the subjects only compounds the mysterious aura of monumentality and dynamism. For Outerbridge, the machine aesthetic was a somewhat accidental discovery and one he never fully embraced. The crankshaft was simply one still-life subject among many, and he brought the same reverential formalism to a mortar and pestle, a biscuit box or two eggs sitting in a pie tin.[4] Strand's machine photographs were a more self-consciously Modernist enterprise altogether. Harold Clurman, the critical champion of Alfred Stieglitz's 291 Gallery, declared them to be portraits for the industrial age. It was as if Strand had channelled the machine's role as an agent, and not merely a

tool, in the development of Modernism: 'the machine looks out at us calmly exultant in the knowledge of its own consummate organism'.[5]

Bourke-White's image of dynamos ('more beautiful to me than pearls,' she later wrote) also renders the machine into a highly theatrical subject – indeed, this and her other photos of the Niagara Falls generators were used in the stage sets for Eugene O'Neill's play *Dynamo* in 1928.[6] Unlike Outerbridge and Strand, however, Bourke-White presents us with a deep-focus procession of repetitive forms, a tactic that she employed frequently in what she called her 'industrial pictures'. As Vicki Goldberg has written, 'the succession of objects in these photographs appears to be endless, the frame merely a rectangle arbitrarily cut out of some wider array'.[7] Bourke-White's work in this vein culminated in a photomural of machine images installed at the R.C.A. Building in Rockefeller Center in 1933 (now lost), but she would continue to pursue an austere machine aesthetic in commissions for corporate clients alongside her Depression-era documentary work.[8] GA

1 Daniel Naegele, 'Object, Image, Aura: Le Corbusier and the Architecture of Photography', *Harvard Design Journal*, no.6 (Fall 1998), pp.1–6.
2 Man Ray, 'Sur le Réalisme Photographique', *Cahiers d'Art*, no.5–6 (1935); trans. and reprinted in Christopher Phillips (ed.), *Photography in the Modern Era: European Documents and Critical Writings, 1913–1940* (New York, 1989), p.57.
3 The Akeley camera that Strand photographed was designed by the explorer Carl Ethan Akeley for use on wilderness expeditions; two were used in the filming of *Nanook of the North* (1922).
4 Elaine Dines (ed.), *Paul Outerbridge: A Singular Aesthetic* (exh. cat., Laguna Beach Museum of Art, 1981); and Jeannine Fiedler, *Paul Outerbridge, Jr.* (Munich, 1996).
5 Harold Clurman, 'Photographs by Paul Strand', *Creative Art*, no.5 (October 1929), pp.735–8; quoted in *Paul Strand: A Retrospective Monograph, The Years 1915–1968* (New York, 1971), p.42.
6 Margaret Bourke-White, *Portrait of Myself* (London, 1964), p.40; Stephen Bennett Phillips, *Margaret Bourke-White: The Photography of Design, 1927–1936* (New York, 2003), p.175.
7 Vicki Goldberg, *Bourke-White* (New York, 1988), p.12.
8 For a 1937 project on the International Paper and Power Company in Canada, Bourke-White drew on both strands of her work, taking characteristic portraits of the company's workers alongside nearly abstract images of their factory dynamos, including a nearly exact reprise of the 1928 Niagara Falls photo. John R. Stomberg, *Power and Paper: Margaret Bourke-White, Modernity, and the Documentary Mode* (exh. cat., Boston University Art Gallery, 1998), pl.26.

51

Rayograph
1922
Man Ray (Emmanuel Radnitzky)
(1890 Philadelphia–1976 Paris)

Gelatin silver print
23.8 × 17.9cm
The Museum of Modern Art, New York,
gift of James Thrall Soby (112.1941)

'When everything known as art has become
thoroughly rheumatic the photographer switched
on the thousand-candle-power of his lamp and
the light-sensitive paper absorbed by degree the
black silhouettes of ordinary things,' wrote Tristan
Tzara about Man Ray in August 1922.[1] The images
Tzara evokes here are photograms – that is, direct
exposure of objects onto light-sensitive paper, a
technique employed by various avant-garde artists
at the time in order to escape the material con-
fines of the photographic apparatus and process.
Christian Schad in Germany, László Moholy-Nagy

in Hungary and El Lissitzky in Russia all experi-
mented intensively between 1919 and 1922 with
camera-less techniques in the darkroom.[2]

This photogram (later 'rayograph') was part of
Ray's first portfolio *Champs délicieux* ('Charming
Fields'), produced in 1921–2 in direct reference to
André Breton's and Philippe Soupault's book *Les
Champs magnétiques* (*The Magnetic Fields*, 1920),
which had introduced the concept of automatic
writing as a fundamental tenet of Surrealism. The
reference was more than a textual association:
both the objects of the photogram themselves and
their arrangement use poetic devices of chance
and narrative. The gyroscope, and the pin centred
onto the magnifying glass to suggest the needle of
a gauge, allude to devices to measure 'magnetic
fields'. The direct exposure of the objects onto
paper without the aid of a camera project an air
of immediacy, spontaneity and chance. In the
same way in which Breton and Soupault created
Surrealist writing through random association,
hallucinatory states and a creative process
seemingly unfettered by reason, Ray liberates
photography from the objectifying need for a
mechanical apparatus and eschews the materiality

of the object in favour of a phantom projection of
mundane things, which in turn become fantastic
and self-conscious.

The significance of the rayograph for the devel-
opment of modern photography and, implicitly,
its incorporation into the canon of Modernism
was confirmed by the early acquisition (starting in
1935) of a large number of Man Ray photographs
by James Thrall Soby for the Museum of Modern
Art in New York.[3] UL

1 Tristan Tzara, 'Photographie à l'envers', in Man Ray, *Champs
 délicieux: album de photographies avec une préface de Tristan Tzara*
 (Paris, 1922), n.p.; on Ray's photograms and 'rayographs', see
 Perpetual Motif: The Art of Man Ray (exh. cat., National Museum
 of American Art, Washington, 1988), pp.28–33, 178–85.
2 Around 1918/19 Schad started in Geneva his experiments with
 light-sensitive paper, which were exhibited in Dada circles;
 Tzara would later call them 'Schadographien'; see Jill Lloyd and
 Michael Peppiatt (eds), *Christian Schad: Das Frühwerk 1915–1935*
 (Munich, 2002), pp.64–71. Moholy-Nagy created photograms
 between 1922 and 1927, and then again between 1937 and 1943;
 see his *Painting, Photography, Film* (London, [1925] 1969), p.32,
 and Andreas Haus, *Moholy-Nagy: Photographs and Photograms*
 (London, 1980). El Lissitzky produced his photograms from 1920
 onwards, combining and overlapping them through montage
 techniques in 1925/6; see Steven A. Mansbach, *Visions of Totality:
 Laszlo Moholy-Nagy, Theo van Doesburg and El Lissitzky* (Ann
 Arbor, 1980), pp.39–40.
3 Soby also published the first monograph on the artist, *Man Ray:
 Photographs, 1920–1934* (Hartford, CN, 1934).

52 Plate 3.20

The Ozenfant Studio, Paris

1923–4

Designed by Le Corbusier (Charles-Edouard Jeanneret) (1887 La Chaux-de-Fonds, Switzerland–1965 Cap-Martin, France)

Amédée Ozenfant was the well-off son of a building contractor of note who had been one of the first to introduce reinforced concrete construction into France.[1] By February 1923, when Le Corbusier made his first designs for Ozenfant's studio at the avenue Reille and the place Montsouris, their post-Cubist initiative, Purism, and its periodical, *L'Esprit Nouveau* (financed by Ozenfant), were widely debated within the Parisian avant-garde. The studio, which was fitted out by autumn 1924, was one of Le Corbusier's first Purist villas.

It stands as a built manifestation of the alliance between art and architecture that *L'Esprit Nouveau* represented and, as such, the Purist alliance between art and the machine.[2]

Le Corbusier ingeniously arranged the internal spaces around a spiral staircase so that, despite the awkward corner site, it offered the simplest of 'primary' volumes to the street. The little building was surmounted by a double-height studio, 'a cube of light' glazed on most of two sides, generously sky-lit from above, in which there was a monastic cell-like study reached by a metal stair and a 'laboratory' in place of the balcony sleeping area usual for Parisian artists' studios. Spaces for contemplation and scientific experiment intruded upon the space for painting, all within an envelope replete both with Pythagorean and mechanistic allusions (the Euclidian forms, the metal stair, the unconcealed flue beside the stair). On the street, the 'primary' volume of the building was crowned by dog-tooth sky-lights that echoed those typical of the factory buildings of Paris's industrial suburbs and declared the building as a factory for painting. In particular, the years immediately following the First World War were those of the very public expansion of Renault's factory complex at Boulogne-Bilancourt. Le Corbusier had written a eulogy of industrial architecture, including factories, in the second number of *L'Esprit Nouveau*, which would be disseminated worldwide with the publication of his book *Vers une architecture* (*Towards a New Architecture*) in 1923, the year he started work on Ozenfant's studio.[3] CG

1 For Ozenfant's origins and social position, see Amédée Ozenfant, *Mémoires, 1886–1962* (Paris, 1968).
2 For the history of the building, see Tim Benton, *The Villas of Le Corbusier, 1920–1930* (New Haven, 1987), pp.30–41; and Christopher Green, 'Ozenfant, Purist painting and the Ozenfant studio', in *Le Corbusier: Architect of the Century* (exh. cat., Hayward Gallery, London, 1987), pp.119–20.
3 Le Corbusier-Sanguier [Ozenfant], 'Trois rappels à MM. les architectes', *L'Esprit Nouveau*, no.2 (November 1920).

53a Plate 3.17

Model: Leningrad Pravda Office Building, Moscow

Designed 1924, reconstruction 1970
Designed by Alexander Vesnin (1883 Yur'evets, Russia–1959 Moscow) and Viktor Vesnin (1882 Yur'evets –1950 Moscow)

Wood, perspex, acrylic and metal
24.4 × 61 × 45.7cm, scale 1:15
Sainsbury Centre for the Visual Arts, University of East Anglia, Norwich (UEA 03/1247)

53b Plate 3.18

Drawing: *Perspective of the Leningrad Pravda Office Building, Moscow*

1924

Alexander Vesnin (1883 Yur'evets– 1959 Moscow) and Viktor Vesnin (1882 Yur'evets –1950 Moscow)

Pencil on paper
70.8 × 36.2cm
Shchusev State Museum of Architecture, Moscow

The design that the Vesnin brothers conceived for the Leningrad *Pravda* (*Leningradskaya Pravda*) competition stands as one of the seminal works of early Constructivist architecture.[1] The building was intended to provide a reporters' base and advertising presence for the Leningrad newspaper in Moscow, and was destined to occupy a very small plot of land, only six by six metres, on Strastnaya Square (now Pushkin Square) in the centre of the city.[2] The Vesnins' solution to this problem represented a highly efficient and economic organization of the functional spaces required. The design proclaimed the way that the building was to be constructed in the articulation of the exterior, and used the main façade to celebrate the activities conducted on the premises and the agitational nature of the newspaper. Their design was awarded joint first prize, along with the submission of Konstantin Melnikov.[3]

The Vesnin brothers proposed a five-storey building, 26 metres high, to be built using a reinforced concrete frame with a plate-glass and steel skin. The functional spaces were defined and then organized in a rational way: a reception area and newspaper sales stand on the ground floor, a public reading room on the first floor, administrative offices on the second and editorial accommodation on the remaining two floors. The double lift shaft was placed on the exterior of the building, while circular structures, evoking the big wheels of the printing presses, supported the newspaper's logo on the main façade, facing the square. This façade also contained two plate-glass windows, one above the other, where the latest news was to be displayed. These were set at an angle in order to increase visibility from the square below. There was also a device for presenting illuminated advertisements, a clock, a projector, and a loudspeaker for relaying radio broadcasts to passers-by.

These features are all apparent in the drawing, although it differs from the final variant in that the wheels at the top, supporting the logo, are less resolved, and the clock has not yet been installed. The sign attached to the right, which was discarded from the final design, underlines the way in which the brothers have sought to add yet more interest and irregularity to the building's massing. The vivacious style of the drawing increases the immediacy and vitality of what is an impressively dynamic structure.

The emphasis on the building's skeleton and its overall design derived inspiration from contemporary engineering and a whole range of Constructivist structures, including Vladimir Tatlin's model for a *Monument to the Third International* (cat.3), Gustavs Klucis's agitational stands, Lyubov Popova's set for *The Magnanimous Cuckold* (cat.71) and Alexander's Vesnin's own staging for *The Man Who Was Thursday* (cat.78). The use of explicitly agitational elements also brought out the affinity between this design and the relatively small propaganda kiosks that were built.

The design to a certain extent reflects the ideas expressed by Alexander Vesnin in his Credo of 1922 and the approach later adopted by the Constructivist Architectural group OSA (*Obedinenie sovremennykh arkhitektorov*: the Association of Contemporary Architects), set up in 1925, to which the Vesnin brothers belonged.[4] The Constructivists approached the design process as an integrated whole, taking into account the details of the brief, defining the precise nature of the functional spaces required, organizing them in an efficient way, and adopting an appropriately economic structural method that would then be honestly shown (just as the structure of a machine is undisguised) on the exterior of the building. The emphasis on economy and efficiency reflected the Constructivists' interpretation of the ideological requirements of communism and the nature of society in which industrial workers were the ruling class.[5] CL

1 Selim O. Khan-Magomedov, *Aleksandr Vesnin and Russian Constructivism* (London, 1986) p.128.
2 Anatole Kopp, *Constructivist Architecture in the USSR* (London, 1985), pp.44–5.
3 Catherine Cooke and Igor Kazus, *Soviet Architectural Competitions 1920s–1930s* (London, 1992), pp.19–21.
4 See Catherine Cooke, *Russian Avant-Garde Theories of Art, Architecture and the City* (London, 1995), p.98.
5 Ibid., ch.5.

54a Plate 3.22

Ashtray, model MT 35

1923–4

Marianne Brandt (1893 Chemnitz,
Germany –1983 Kirchberg, Germany)

Brass and silver-nickel alloy
6.7 × 9.9cm
V&A: M.73–1988

54b Plate 3.1

Tea infuser, model MT 49

1924

Marianne Brandt (1893 Chemnitz –
1983 Kirchberg)

Silver and ebony
7.3 × 10.6 × 16.1cm
British Museum, London (1979, 11-2,1)

Marianne Brandt arrived as a student at the
Bauhaus in 1924, just after Walter Gropius had
redirected the school's orientation away from
the expressive and the hand-made towards the
rational and the industrial.[1] Her arrival also
coincided with the recent appointment of László
Moholy-Nagy as Form Master (effectively, artistic

director) of the Metal Workshop. It was he who
encouraged her to enter that workshop in which
she became the first female student. While it is
undoubtedly true that the Bauhaus aspired to
Gropius's idea of 'Art and Technology – the New
Unity', the chances of the school being able to
design for genuine industrial production that
would stimulate or fulfil a market demand
were slim.[2]

Though earlier metalwork products (cat.15)
had emphasized the qualities of their hand-making,
they were also based on a clear articulation of
basic, geometric forms. Brandt continued that
tradition in her ashtray and tea infuser; by diminishing (not removing) evidence of the maker's
hand, emphasizing the smooth surface and combining geometric forms based on the influence of
International Constructivism, including the work
of Moholy-Nagy (cat.47), she moved these products
into another sphere of formal abstraction. The
ashtray presents itself as a simple cylinder, into
which the semi-spherical bowl that sits within it
pivots ashes with the merest push of the straight
cigarette holder. The diminutive tea infuser is a
remarkable construction of geometric elements,
placed in careful relationship to one another.
Both objects are raised on a base (essential in
the case of the teapot), which served to increase
their sculptural appearance. While tea infuser
and ashtray may, in their material and form,

suggest the idea of mechanized manufacture, they
represent not the reality of machine production,
but the aestheticization of the machine. CW

1 Walter Gropius, *Idee und Aufbau des Staatlichen Bauhauses*
 (Munich. 1923).
2 Judy Rudoe, *Decorative Arts 1850–1950, A Catalogue of the British
 Museum Collection* (London, 1991), p.22, in a close comparison of
 surviving examples of the tea infuser and related teapots, points
 out the lack of experience of Bauhaus designers in designing
 for industry. There is little of interest on these objects in the
 celebratory Hans Brockhage and Reinhold Lindner, *Marianne
 Brandt* (Chemnitz, 2001); or, surprisingly, in *Die Metallwerkstatt
 am Bauhaus* (exh. cat., Bauhaus Archiv, Berlin, 1992).

55

Photograph: *Self-Portrait: Constructor*

1924

El Lissitzky (Elezar Lisitskii)
(1890 Pochinok, Russia–1941 Moscow)

Gelatin silver print
19.3 × 21.2cm
V&A: PH.142–1985

The *Constructor* exists in several variants, including
both positive and negative gelatin silver prints.[1] It
is a photograph of a collage, which was produced
by adding lithographic and drawn elements to a
photographic image, which was itself produced
by superimposing two separate photographs: *The
Architect's Equipment* (showing El Lissitzky's hand
holding a compass against graph paper with an
arching line) and his *Self-Portrait*, both taken in
1924 while Lissitzky was recovering from tuberculosis in a Swiss sanatorium.[2] The resulting image
fuses the artist's head, hand and tools. While an
early print is titled *Selbstportrait (Lightbild 1924)*
(*Self-Portrait (Light Image, 1924)*), the *Constructor*
also makes explicit allusions to Lissitzky's
colleagues in the Constructivist movement.[3]

'XYZ' may refer to the magazine *ABC: Beiträge
zum Bauen* (*ABC: Contributions to Building*), which
Lissitzky worked on with Mart Stam and others
in 1924 (pl.5.29), and which expounded and
publicized the new values in architecture.

The image overall presents a new and
'constructive' view of the creative process: the
compass and the paper allude to reason and
technology, while the head indicates the importance of the imagination and the intellect, and
the hand suggests manual dexterity. This, as well
as the combination of photographic techniques,
conforms to the general ethos of International
Constructivism: its espousal of the machine,
science and engineering, and its belief that geometric form and the manipulation of mechanically
generated images of film and photography could
embody progressive social, political and cultural
values. While *The Constructor* represents the
mechanization of the artist and creative activity,
the replacement of the brush with the camera,
and the painting with the photograph, it equally
evokes the precision and transparency of the
Modernist aesthetic.[4] It is precisely this combination of reason and individual creativity (seen
here in the emphasis on the face, particularly
on the eyes) that distinguished International
Constructivism from the more utilitarian
approach of its Soviet counterpart. CL

1 See Margarita Tupitsyn, *El Lissitzky: Beyond the Abstract Cabinet*
 (New Haven, 1999), pp.27, 80–81.
2 Ibid, pp.78–9.
3 Ibid, p.76.
4 See John E. Bowlt, 'Manipulating Metaphors: El Lissitzky and
 the Crafted Hand', and Leah Dickerman, 'El Lissitzky's Camera
 Corpus', in N. Perloff and B. Reed, (eds), *Situating El Lissitzky:
 Vitebsk, Berlin, Moscow* (Los Angeles, 2003), pp.129–52, 153–76.

56

57

56

Painting: *The New Adam*

1924

Sándor Bortnyik (1893 Marosvásárhely,
Romania–1976 Budapest)

Oil on canvas
48 × 38cm
Hungarian National Gallery, Budapest (64.85 T)

This picture was painted in Weimar, where Sándor
Bortnyik was one of a community of Hungarian
exiles, some of whom (including László Moholy-
Nagy) were among the students and staff of
the Bauhaus. As a supporter of the short-lived
Bolshevik government of 1919, Bortnyik, like
Moholy-Nagy, had been forced out of Hungary
by the counter-revolutionary White Terror.[1] Both
had come to Weimar after an active interlude in
Berlin, where Bortnyik had taken up a hardline
communist position, working for an overtly politi-
cized Modernism, the object of which was to
collaborate with architects to build a new world
for the proletariat. He rejected the utopian idealism
of his fellow-countryman Lajos Kassák, whose
periodical *Ma*, published in Vienna, was the
most influential mouthpiece of the Hungarian
avant-garde in exile.[2]

Stephen Mansbach has analysed this work as
a satire of the metaphysically oriented Modernists
aligned with Kassák, suggestively contrasting
it with Bortnyik's contemporary portrait of the
Hungarian architect Fréd Forbát and his wife, also
painted in 1924. Forbát worked in Walter Gropius's
office, making an important contribution to the
development of Gropius's 'construction kit'
approach to designing with standardized units.
Bortnyik paints Forbát dressed austerely in a lab
coat, comparable in his seriousness of purpose
and scientific/industrial outlook to the photo-
graphic portrait of Moholy-Nagy in overalls
(cat.45), the polar opposite of Bortnyik's dandy.
The 'new man' portrayed here is merely fashion-
able, capable of building nothing, and deprived
even of volition as the wind-up mechanism of
the pedestal on which he stands indicates.[3]

The hovering planar arrangement behind him
quotes a particular painting by El Lissitzky, *Proun
1C* of 1919.[4] As 'junctions between painting and
architecture', Lissitzky's 'prouns' are paralleled by
Bortnyik's own *Bildarchitektur* (pictorial-architec-
ture) paintings of the early 1920s. Mansbach reads
Bortnyik's inclusion of the Lissitzky negatively,
as 'pictorial architecture' condemned by idealism
to float aimlessly, without material constructive
application.[5] But it can (and surely could) be read
positively too, as a challenge that this absurd
'New Adam' is unable to see. CG

1 Led by Admiral Miklós Horthy and supported by the Romanian
 army, this led to the murder, imprisonment and exile of
 communists, socialists, intellectuals and, without regard to
 political affiliation, Jews.
2 For Bortnyik, Kassák and the Hungarian avant-garde in exile,
 see Stephen A. Mansbach, *Standing in the Tempest. Painters of
 the Hungarian Avant-Garde 1908–1930* (Cambridge, MA, 1990),
 pp.57–74, and Stephen A. Mansbach, *Modern Art in Eastern
 Europe. From the Baltic to the Balkans* (Cambridge, 1999),
 pp.284–312. Also see the contributions of Lee Congdon and Éva
 Forgács in Timothy O. Benson, *Central European Avant-Gardes.
 Exchange and Transformation, 1910–1930* (exh. cat., Los Angeles
 County Museum of Art, 2002).
3 See especially Mansbach (1999), pp.305–7. For Forbát and
 Gropius, see Martin Kieren, 'A Review of Personal Life and
 Work – Walter Gropius, the Architect and Founder of the
 Bauhaus', in Jeannine Fiedler and Peter Feierabend (eds),
 Bauhaus (Cologne, 1999), pp.190–99.
4 John Bowlt, *Twentieth-century Russian and East European
 painting: The Thyssen-Bornemisza Collection* (London, 1993),
 pp.198–9.
5 Mansbach (1999), p.306.

57

Set design: *Kukirol* (*Time is Money*)
1925
Georgii Stenberg (1900 Moscow –1933
Moscow) and Vladimir Stenberg
(1899 Moscow –1982 Moscow)

Gouache and ink on cloth and pasteboard
59.5 × 79.3cm
The Bakhrushin State Theatrical Museum,
Moscow (297765)

The play *Kukirol* was directed by Alexander Tairov,
with sets and costumes designed by the Stenberg
brothers, and was performed at the Moscow
Kamerny Theatre during the 1925–6 season. The
production represented an attempt by Tairov to
modernize his repertoire, make it more relevant
to Soviet reality and gain official acceptance. The
play itself was innovative and represented an
experiment in combining the European dramatic
idiom of the political revue with the popular Soviet
dramatic form of living newspapers, which were
performed by various amateur and professional
drama groups. Contemporary critics considered
the actual play to be a failure, judging the text to
be lifeless and lacking tension and structure.[1]

The Stenbergs' set embodies certain
Constructivist principles; the brothers had been
members of the Working Group of Constructivists
in 1921, but had split off in 1922 and since then had
worked extensively for Tairov's Kamerny Theatre.
The openwork skeletal frameworks are economic
and possess affinities with the spatial construc-
tions that the brothers had produced in 1921 for
the exhibition of the OBMOKhU (Society of Young
Artists). The set also alludes to ideas of Taylorism
and industrial efficiency that were dear to the
Constructivists. Yet here the reference is clearly
satirical. The slogan reads 'Time is money', a
point that is underscored further by the clock and
the replacement of the metal hands with human
ones. Overall, too, there is a great deal of realism
present in both the imagery and the speakers'
tribunes, indicating a pragmatic attitude towards
everyday objects. This may be because the envi-
ronment is intended to be western. Even so, by
1925 the Stenbergs had effectively abandoned the
early Constructivist practice of using the theatre
as a micro-environment for experimenting with
structures for the real world. CL

1 Yakov Apushkin, *Kamernyi teatre* (Moscow, 1927), p.53.

58 Plate 3.21

Club Chair
Designed 1925
Marcel Breuer (1902 Pécs, Hungary –
1981 New York)
Manufactured by Standard Möbel,
Berlin, 1927

Nickel-plated tubular steel, canvas
72.5 × 76.5 × 69.5cm
V&A: W.2–2005, purchased with the support of
the Friends of the V&A

This was the first Modernist tubular-steel chair.
The year of its creation was momentous for its
young designer. Breuer, formerly a Bauhaus
student, had been appointed master of the
Cabinet-Making Workshop that year, just as the
school was moving to its new quarters in Dessau
designed by Walter Gropius.[1] There must surely
have been some link between the radicalism
of the chair design (Breuer called it his 'most
extreme') and the atmosphere around the con-
struction of one of the largest and most innovative
Modernist buildings yet conceived (cat.114).[2]

Although the use of metal and the chair's
appearance were innovative, to say the least,

Breuer's Club Chair represented a further
development of similar design elements in his
armchair of 1922 (pl.2.13). It also harked back to
Rietveld's De Stijl furniture (pl.2.12) in its spatial
complexity and emphasis on its aesthetic quali-
ties. Breuer's metal chair was a construction of
intersecting planes in space, which – in their
lightness and visual transparency – subverted
the traditionally bulky, space-encumbering form
of the upholstered club armchair. It fulfilled,
however, precisely the same function as the
traditional chair, and a pair furnished the living
room of the Gropius master's house near the
Bauhaus.

While there can be little doubt that factory pro-
duction would have been the ultimate dream for
the making of steel chairs, as it would have been
for all the geometric products of the Bauhaus
(pl.3.1, 3.22), the early versions were painstakingly
hand-made. Inspired by the remarkable strength
of his own bicycle, but rebuffed in his attempts
to interest the Adler bicycle company and the
Mannesmann steel company in the design, Breuer
built his prototype with the help of a plumber.
Between 1925 and 1927 the design and its method
of manufacture were developed and refined, first
in Breuer's studio and then in the small work-
shop of the firm he co-founded, Standard-Möbel
(cat.150). The first model had four legs, though
by the following year he had made a new version

with runners, a decisive innovation that would
become one of the most distinctive features of
all subsequent tubular-steel furniture.[3] CW

1 On the chair, see Christopher Wilk, *Marcel Breuer: Furniture
 and Interiors* (exh. cat., Museum of Modern Art, New York, 1981);
 Magdalena Droste, Manfred Ludewig, *Marcel Beuer* (exh. cat.,
 Bauhaus Archiv, Berlin, 1992); and Christian Wolfsdorff, *Bauhaus-
 Möbel/Bauhaus Furniture* (exh. cat., Bauhaus Archiv, 2003),
 pp.41–5.
2 'Metallmöbel' in Werner Gräff, *Innenräme* (Stuttgart, 1928), p.133.
3 It has been speculatively suggested that the idea for the runners
 came only once Breuer had designed his stools or tables (cat.152)
 in late 1926. See Robin Krause, 'Marcel Breuer's early tubular
 steel furniture', in Margret Kentgens-Craig (ed.), *The Dessau
 Bauhaus Building 1926–1999* (Basle, 1998), pp.34–7. See
 Wilk (1981), p.43, on its likely origins in bentwood rocking chairs.

59a Plate 3.8

Perspective drawing: *Van Nelle Factory, Rotterdam*
1926–9
Johannes A. Brinkman (1902 Rotterdam–1949 Rotterdam) and Leendert Cornelis van der Vlugt (1894 Rotterdam–1936 Rotterdam) with Mart Stam (1899 Purmerend, The Netherlands–1986 Goldach, Switzerland)

Ink on paper
41 × 42.2cm
Nederlands Architectuur Instituut, Rotterdam (BROX 5t4221)

59b Plate 3.9

Photograph: Van Nelle Factory, Rotterdam
1926–9

Mart Stam had the knack of being in the right place at the right time. He contributed houses to the Weissenhof Siedlung and a housing estate to the new Frankfurt, while contributing to *ABC* magazine in Switzerland and teaching at the Bauhaus, before leaving for the USSR to work on a new city in Siberia. In between this globe-trotting, he worked as occasional draughtsman in the Dutch firm of Brinkman and Van der Vlugt and may have played a role in the design of their best-known building, the Van Nelle tobacco, coffee and tea factory outside Rotterdam. Although Stam's role in the design of the building has been challenged, he made a number of influential perspective drawings and may have influenced the thinking in the office, due to his connection with El Lissitzky and other Constructivist architects.[1] He certainly brought into the office a breadth of experience of avant-garde ideas, which lifted this building from being a practical factory building to a dramatic example of Modernism.

Consisting of three linked buildings to package tobacco, coffee and tea, each one higher than the last, the factory made a spectacular impact with its glazed façade and clearly revealed structure. The interiors were open, clean and well illuminated. Few other buildings express so dramatically the separation of structure and surface, or suggest such a potent image of an idealized workplace. The Van Nelle company provided sanitary fittings on all the floors and sports facilities nearby (the football pitch is seen clearly in the drawing), exemplifying the lessons of Henry Ford in linking productivity to a contented workforce. Van der Vlugt was the lead architect on the project and certainly determined the form of the curving block at the entrance and the circular-roofed pavilion, which was added after managing director C.H. van der Leeuw saw the fine view from the eighth floor of the tobacco building.[2] The Van Nelle factory was illustrated again and again in international journals and exhibitions as an icon of International Modernism.
TB

1 Niels Luning Prak, 'De Van Nelle fabriek te Rotterdam', *Bulletin K.N.O.B.* (1970), pp.130–33.
2 Rob Dettingmeijer, 'De strijd om een goed gebouwde stad', in *Het Nieuwe Bouwen in Rotterdam* (exh. cat., Museum Boymans-Van Beuningen, Rotterdam, 1982), pp.43–4.

60 Plate 3.19

Painting: *Machine with Red Square*
1926
Willi Baumeister (1889 Stuttgart–1955 Stuttgart)

Oil on canvas
100.5 × 81.5cm
Galerie Schlichtenmaier, Grafenau

The artist and graphic designer Willi Baumeister had close connections to the architectural world (see cat.96) and also to the Paris art world. The machine – as celebrated by his friends Le Corbusier, Amédée Ozenfant, Fernand Léger and others – fascinated Baumeister. In the period between 1924 and 1931 he experimented with abstraction in a series of *Maschinenbilder* (Machine paintings). In these the machine served as metaphor for the New Man. One finds human figures with mechanistic features, as well as machines with human characteristics. Acknowledging the machine as a phenomenon of the period, he wrote, 'Our existence has a new foundation, the machine.'[1] It was Baumeister's belief that man and machine formed an ideal unity. He saw the human body as a functional mechanism analogous to the machine. A geometric representation of man was the product of this understanding.

In *Machine with Red Square*, geometrical shapes are fitted together into a vertical composition around a central axis. The shapes are abstracted representations of machine parts, but are assembled in a way that clearly suggests a human figure. In addition, one shape on the far right shows the abstracted contour of the human form from the side.[2] The 'Machine paintings' are not intended as representations or illustrations of social reality, but as experiments that transfer and translate technological principles into pictorial ones. The paintings do not picture the noise and chaos of the modern world, but express tranquillity and balance through their composition, order and finished surfaces. Baumeister wrote that his aim was to clarify the changes in perception caused by the technological progress by using the form and expression of the machine.[3] JS

1 Willi Baumeister in *Die Bauzeitung*, no.45, vol.23 (Stuttgart 1926), p.373.
2 The ideal form of the human figure, especially the figure in motion, seems to dominate Baumeister's artistic ideas in the 1920s. For a detailed discussion, see Ursula Zeller, 'Bewegung gegen die Ruhe. Willi Baumeisters zeichnerisches Werk der 20er Jahre', in Ulrike Gauss, *Willi Baumeister: Zeichnungen, Gouachen und Collagen* (Stuttgart, 1989), pp.33–43.
3 Willi Baumeister, *Das Unbekannte in der Kunst* (Cologne, 2nd rev.edn 1960), p.111.

61 Plate 3.2

Painting: *Still-life with Ball Bearing*

1926

Fernand Léger (1881 Argentan, France –
1955 Gif-sur-Yvette, France)

Oil on board
146 × 114cm
Kunstmuseum Basel, gift of Dr H.C. Raoul La Roche 1963
(91963-13)

In 1925 Léger was the only other artist besides
the sculptor Jacques Lipchitz to be invited by
Le Corbusier to join him and Ozenfant in supplying
fine art to enhance the Pavillon de L'Esprit
Nouveau, the Purist minimum dwelling built for
the *Exposition Internationale des Arts Décoratifs et
Industriels Modernes* (International Exhibition of
Modern Decorative and Industrial Arts) in Paris
(pl.3.25).[1] Léger was not only an easel painter
in the mid-1920s, but also a film-maker, stage
designer and mural painter, working between
painting, performance and architecture.[2] The
mural paintings he produced between 1924 and
1926 are dominated by flat planar elements in
De Stijl-like orthogonal relationships, held in
suspended stasis, an effect approached also in
the machine element compositions, like *Still-life*

with Ball Bearing. In this case, the rigid ball-bearing
roundel hovers in front of and within a complex of
planar elements and objects that includes a hefty
vase and a typewriter (reduced to the simplest of
flat signs for keyboard and paper).

From much earlier, indeed from at least 1912
and his visit that year to the *Salon de l'aviation* in
the Grand Palais in Paris, Léger had been a con-
noisseur of the polished metal surfaces and the
rigorously controlled formal arrangements found,
for instance, in aero-engines (pl.3.24), which
were made much of in such public displays of
technological ingenuity (displays that continued
throughout the 1920s).[3] In front of the flat colour
planes, everything in this painting is presented
as mechanical; even the vase is given the look of
a mechanism by its repetitive ornamentation. Yet
the association with architecture remains crucial,
underlined by the tiny baluster inset into the body
of the vase. The film Léger made with Dudley
Murphy in 1924, *Ballet mécanique* (cat.75), may
be dedicated to the machine as maker of a world
constantly in movement, never at rest, but easel
paintings like this deny movement in favour of
architectural monumentality: they relate more
to his paintings for architecture than to his filmic
celebration of machines in motion. Significantly,
Léger's contribution to the Pavillon de L'Esprit
Nouveau in 1925 was a composition centred on
a baluster treated as if it were a gigantic spark
plug.[4] CG

1 The Pavillon was conceived as single dwelling unit within one of
the housing blocks designed for Le Corbusier's utopian *City for
Three Million*, an extrapolation from which, the Voisin plan for
central Paris, was shown in a special display space alongside
the Pavillon. See Charlotte Benton, 'Esprit Nouveau Pavilion,
Paris', in *Le Corbusier: Architect of the Century* (exh. cat.,
Hayward Gallery, London, 1987), pp.212–14.
2 For Léger's relationship with the Purists, see Christopher Green,
Léger and the Avant-garde (New Haven, 1976), ch.7, 9.
3 In his lecture 'L'esthétique de la machine', delivered in June 1923,
Léger recalls his excitement at seeing the *Salon de l'aviation* being
set up alongside the *Salon d'automne*, and his disappointment at
what he takes to be the blindness of a young mechanic to the
beauty of the machines he was displaying. I have established that
the *Salon de l'aviation* concerned was almost certainly that of 1912.
See Léger (1923) and Green (1976), p.324, n.52.
4 The painting in question is *The Baluster*, 1925 (Museum of Modern
Art, New York). See Georges Bauquier, assisted by Nelly Maillard,
Fernand Léger, Catalogue raisonné, 1925–1928 (Paris, 1993), p.58,
no.424.

62 Plate 3.3

Ball bearings

1930s

Manufactured by SKF, Göteborg, Sweden

Bearing steel
Double row self-aligning ball bearing, diam. 14cm
Single row deep-groove ball bearing, diam. 8cm
SKF, Göteborg, Sweden

The ball bearing was one of a number of machines
or machine parts admired by Modernist artists
and designers as exemplars of functional and
unselfconscious design, of the perfection of form
and of the beauty of dispensing with ornamentation.
Perhaps owing to the simplicity of its geometry
and the repeating pattern of the balls, it was a form
often exhibited, illustrated and copied during the
inter-war years. Although the functionality of the
form was admired – like many of the machines or
examples of engineering illustrated in Modernist
books and magazines (see cat.39) – it seems
unlikely that there was widespread understanding
that the self-aligning type (pl.3.3, right) was for
bearing especially heavy or radial loads (machine
tools, centrifugal machines) and the deep-groove
design (pl.3.3, left) was for everyday applications
(bicycles, cars, washing machines).

The popularity of the ball bearing as a perfect
industrial type within Modernist circles may well
have owed something to an advertising photo-
graph taken by Paul Strand in 1920 for the
American firm of Hess-Bright. Published in the
international literary magazine *Broom* in 1922,
it ended up being widely reproduced at the time,
often uncredited, in avant-garde books and
journals around the world.[1] A ball bearing was
displayed at the exhibition in Prague organized by
the Devětsil group called the 'Bazaar of Modern Art'
(1923), and the Strand photograph (representing the
object exhibited) was published as an example of
'Modern Sculpture' in the Devětsil journal *Disk*.[2]
Léger painted his monumental ball-bearing
composition in 1926 (pl.3.2) and by 1927 Charlotte
Perriand designed a necklace (pl.3.4) made to
look like a string of ball bearings.

In 1934 an SKF ball bearing was included in the
exhibition 'Machine Art' at the Museum of Modern
Art, New York.[3] There it was shown amid more than
400 examples of springs, insulators, cables, tubing,
laboratory wares, scientific instruments, household
accessories and a gasoline pump. That same ball
bearing was displayed in many MoMA exhibitions
and, since the opening of their permanent Archi-
tecture and Design Galleries in 1964, has been on
near-continuous exhibition, thereby confirming its
status as an icon of modern design and reasserting
the early Modernist idea of art in industry.[4] CW

1 See 'Photography and the New God,' *Broom*, vol.3, no.4
(November 1922), pl.1. The image is also reproduced and the
commission very briefly described in *Paul Strand, Sixty Years
of Photographs* (London, 1976), p.146. This was the same year
Strand photographed his own Akeley motion picture camera
(pl.3.11, cat.50a).
2 The illustration from *Disk*, vol.1, no.1 (1923), is reproduced in
Timothy O. Benson (ed.), *Central European Avant-Gardes:
Exchange and Transformation* (exh. cat., Los Angeles Country
Museum of Art, 2002), p.116; the exhibition and the ball bearing
are discussed on pp.114–18.
3 *Machine Art* (exh. cat., Museum of Modern Art, New York, 1934),
cat. and fig.50.
4 See 'Chronology of the Department of Architecture and Design',
Department of Public Information, MoMA, May 1964 (Department
of Architecture and Design files).

63a

Collage: *Radio Marconi*
1926
Jaroslav Rössler (1902 Smilov, Bohemia – 1990 Prague)

Printed paper and photographs on paper
36 × 26.5cm
The Museum of Decorative Arts, Prague (GF 4.468)

63b

Book: *Petroleum* by Upton Sinclair
1927
Cover design by John Heartfield
(1891 Berlin – 1968 Berlin)

Letterpress
18.9 × 46.7cm
Merrill C. Berman Collection

63c

Print: *Factory, The Assembly-Line Human Being*, no.2 from the Portfolio 'Twelve Houses of Time'
1927
Gerd Arntz (1900 Remscheid, Germany – 1988 The Hague)

Woodcut
25.1 × 16.2cm
Gemeentemuseum, Den Haag (P 82-1976)

63d

Photograph: Flatiron Building, New York
1928
Walter Gropius (1883 Berlin – 1969 Boston)

Gelatin silver print
23.4 × 17.5cm
The Metropolitan Museum of Art, New York (1987.1100.466)

During the 1920s it seemed as if all of technology-obsessed Europe was in thrall to American models of scientific management and factory organization. From Moscow to Paris, London to Prague, Fordism and Taylorism were elevated to the status of panacea and Holy Grail, the basis on which a new world could be built.[1] This faith in Americanism, often based as much on hope as any sort of detailed knowledge of the work of F.W. Taylor or the operations of the Ford factory, was expressed in the work of many artists and designers of the period.

In its stylized rendering and its depiction of anonymous workers, Arntz's print might appear to be an aestheticized view of the clear organization of labour in the factory. Instead, it was a critique rather than an endorsement of Americanist

attitudes and German business practices, especially within the context of a portfolio that depicted the oppression of industrial capitalism. A member of the *Kölner Progressiven* (Cologne Progressives), Arntz was a committed communist who produced politically infused work.[2] Despite – indeed, because of – his politics, his print was a reflection of modern industrial processes not only in its subject, but also in its style and technique. Arntz's simplicity and clarity of means were a reflection of his desire to communicate directly and effectively with the largest possible audience, a pictorial equivalent of the New Typography (see cats 125–6). His use of the populist woodcut, economic to use, cheap to reproduce and of humble status within the hierarchy of print techniques, brought his work closer to the processes of modern industry.

The photographer Rössler was associated with the Devětsil group, who were enthralled by technology and engineering. Radio was a passion of his and from a young age he built radios and later took photographs of them, including some in which he appeared.[3] His photocollage, one of a series created in 1926–7, was an example of a 'picture poem', a new form theorized by Karel Teige, who described them as 'poetry by means of optical forms', with 'an ambiance of life', direct and instantly comprehensible, infused with a spirit of fun and entertainment.[4] Those qualities are clearly seen in Rössler's collage, which, as in most picture poems, combined photographs and type in a composition intended for mass reproduction.[5] The appearance of 'U.S.' and 'All-American' in the collage (which, of course, had nothing factual to do with mention of the British Marconi company) was a poetic association with technology and may have reflected that by 1927 Rössler had decided to emigrate to America, a wish he never fulfilled.[6]

In 1928 the architect Gropius set off on his first visit to America, arranging an itinerary that proclaimed his Americanist interests. He visited the Ford factory at River Rouge near Detroit (pl.3.14), met members of the Taylor Society (devoted to the work of F.W. Taylor) and investigated (with little success) the mechanized production of American buildings.[7] It was not only American management and manufacturing principles that excited Gropius and fellow European designers and artists, but the dynamism of the American city and the incredible height of the American skyscraper (see also pl.5.14). László Moholy-Nagy captured this in a letter written during his first visit to New York:

> This then is New York, and I've come all the way from a farm in Hungary to see it . . . It seemed to me then that the skyscrapers of New York were the destination of my life . . . I step on a terrace so high I floated in the air. This was unbelievable . . . This is what made it so fantastic – these buildings, the skyscrapers of New York. Obelisks, menhirs, megaliths –

every shape, historic and prehistoric – straightly perpendicular, or terraced like a pyramid.[8]

The subject of Gropius's photograph was the famous Manhattan Flatiron Building, which had been given iconic photographic treatment in Alfred Stieglitz's image of 1903. The architect's photograph relied on two key formal elements of New Photography composition to offer a very different approach to the subject: the diagonal view from below and the abstraction of the subject by removing as much context as possible.

Americanism was also reflected in Europe by the popularity of American music (jazz, above all), film and literature. The socially conscious novelist and political activist Upton Sinclair (who was a Germanophile) found a large audience in Europe. The subject of his novel *Petroleum* (titled *Oil* in America), as well as his activist socialist politics, would have found sympathy with designer and active communist John Heartfield. Published by the left-wing Berlin firm Malik, *Petroleum* was the story of politically tinged scandal and family conflict in the California oil industry. The supremacy of money in American culture, even its imprisonment of people, was suggested by Heartfield's overlay of gold ink. The use of photomontage reflected his view that photography was the key tool of propaganda and persuasion.[9] CW

1 German 'Americanism' is particularly well covered in Mary Nolan, *Visions of Modernity: American Business and the Modernization of Germany* (Oxford, 1994). See also the selection of documents in Anton Kaes, Martin Jay and Edward Dimendberg, *The Weimar Sourcebook* (Berkeley, 1994), pp.395–410. French Americanism is treated in Mary McLeod, '"Architecture or Revolution": Taylorism, Technocracy, and Social Change', *Art Journal*, vol.43, no.2 (Summer 1993), pp.132–47.
2 *Gerd Arntz: Kritische Grafik* (exh. cat., Gemeentemuseum, The Hague, 1976). My thanks to Ulrich Lehmann for generously sharing his knowledge of Arntz.
3 See Vladimír Birgus and Jan Mlčoch, *Jaroslav Rössler, Czech Avant-Garde Photographer* (Cambridge, MA, 2004), pp.29–30, fig.54, 41–3.
4 Karel Teige, 'Poetismus', in *Host*, vol.3, no.9–10 (July 1924), pp.197–204, trans. in Eric Dluhosch and Rostislav Švácha, *Karel Teige 1900–1951* (Cambridge, MA, 1999), pp.66–71.
5 See Karel Srp, 'Poetry in the Midst of the World', in Timothy O. Benson (ed.), *Central European Avant-Gardes* (exh. cat., Los Angeles County Museum of Art, 2002), p.121.
6 Vladimír Birgus, *Jaroslav Rössler* (Prague, 2001), p.22.
7 Gropius visited in April–May 1928, following his resignation as Bauhaus director, just as he was establishing an architectural office in Berlin. He also met the architects Frank Lloyd Wright, Richard Neutra and Rudolf Schindler on a trip to Arizona and California. See Winfried Nerdinger, *Walter Gropius* (exh. cat., Busch-Reisinger Museum, Cambridge, MA, 1985), p.20, and Reginald Isaacs, *Walter Gropius, Der Mensch und sein Werk* (Berlin, 1983/4), vol.2, pp.499–512 (the Flatiron visit in April is mentioned on p.506).
8 Letter to Sibyl Moholy-Nagy, published in her *Moholy-Nagy. Experiment in Totality* (Cambridge, MA, [1950] 1969), pp.141–3.
9 Heartfield in Heinz and Bodo Rasch, *Gefesselter Blick* (Stuttgart, 1930), p.53, the cover illustrated on p.54.

63a

63c

63b

63d

64 Plate 3.15

Photograph: *The First Tractor*
1927
Boris Ignatovich (1899 Lutsk, Russia –
1976 Moscow)

Gelatin silver print
24 × 17.6cm
Courtesy Alex Lachman Gallery, Cologne

This photograph captures the drama and excitement that greeted the arrival of the first gasoline-powered tractors in the Soviet Union. A boy, in his worn padded jacket, waving his fur hat in triumph, sits astride the bonnet of an American Fordson (Ford) tractor, the first mass-produced agricultural tractor. The pose emulates that of a rider on a horse, indicating that the boy is in harmony with, and in control of, the machine. This is emphasized by the low viewpoint, which stresses the tractor's radiator and engine, and produces an image of power. The boy's placement at the front of the engine, rather than in the driving seat, gives the image more immediacy and suggests his empowerment as an ordinary peasant. By looking up at the boy and thereby

eliminating the specific context, Ignatovich makes his image more general, more relevant to the entire Soviet Union and hence more effective as a piece of propaganda. It was also an image of the powerful sway of Fordism and Americanism as models for Soviet industrialization.

In the 1920s the government was encouraging the organization of collective farms and the mechanization of agriculture, but progress was slow and the peasants were highly suspicious of the tractors, which often broke down due to mechanical ignorance and general maltreatment. Ignatovich's photograph presents a positive view of developments, and it acquired additional importance as propaganda after the Forcible Collectivization of Agriculture and the First Five-Year Plan were implemented in 1928.

As this photograph indicates, Ignatovich was influenced by Alexander Rodchenko's innovative use of unusual viewpoints, dynamic framing, diagonal compositions and close-ups.[1] Ignatovich started taking photographs professionally in 1926, becoming press photographer for the newspaper *Bednota* (*Poverty*) in 1927. He also produced material for *Daesh* (*Let's Give*), *USSR in Construction* and other magazines, while belonging to October, the late Constructivist group dedicated to producing photographic propaganda.[2] CL

1 Margarita Tupitsyn, *The Soviet Photograph* (New Haven, 1996), pp.73–80.
2 *Soviet Photography of the 1920s and 1930s* (exh. cat., Moscow House of Photography, 2004), p.120. See also *Boris Igantowitsch: Pioner sowjetischer Photographie* (Cologne, n.d.); Valerie Lloyd (ed.), *Soviet Photography: An Age of Realism* (New York, 1984), pp.104–23; and Grigory Shudakov et al., *Pioneers of Soviet Photography* (London, 1983).

65 Plate 8.9

Film: *Metropolis*
Directed by Fritz Lang (1890 Vienna–
1976 Los Angeles)
Written by Thea von Harbou
Photographed by Karl Freund,
Gunther Ritau, Walter Ruttmann
Designed by Otto Hunte, Erich Kettelhut,
Karl Vollbrecht

*c.*210 mins (later cut to 93 mins; restored to 147 mins in 2001), silent (accompanying music by Gottfried Huppertz), black and white
Produced by Erich Pommer, Universum AG, Germany, 1926–7

In the year 2000 the son of the master of Metropolis revolts against a rigid social order that condemns the workers to live underground in conditions of near-slavery, while their rulers enjoy a life of frivolous pleasure amid the parks and skyscrapers of the futuristic city. The son meets Maria, who leads a religious movement among the workers, and experiences a revelation of how the Machine is consuming its servants. His father encourages a mad scientist to unleash a robot Maria in order to confuse the workers, but the son averts disaster

by overcoming the scientist and persuading his father to meet the workers' representative.

By a strange irony, the super-film that was intended to prove German cinema's ability to challenge Hollywood proved a commercial and critical disaster on its release, but has since become probably the most popular of all 1920s films, albeit in a truncated version.[1] Its key images – the densely stacked ziggurat of skyscrapers, a giant turbine-machine that becomes Moloch the robot before it impersonates Maria, dehumanized columns of workers – have lodged in the common vocabulary of both science fiction and contemporary art.[2] The design sources ranged from Pieter Brueghel's *Tower of Babel* to Modernist architecture by Bruno Taut, Erich Mendelsohn and Ludwig Mies van der Rohe and pastiche Gothic buildings by the designers Erich Kettelhut and Otto Hunte, all under the supervision of Fritz Lang, who had originally trained as an architect.[3]

However visually derivative, and however narratively muddled in surviving versions, the film provides a continuing focus for the tension between 'head and heart' (as the final reconciliation is described in the intertitles), between rationalism and humanism, or – as Tom Gunning argues – between the Gothic and the modern industrialized world.[4] Science in *Metropolis* partakes of alchemy, and the birth of the robot awakens disturbing associations between magic

and femininity, which are temporarily exorcised by the 'false Maria' being burned as a modern witch. Despite its dramatic shortcomings, *Metropolis* remains a potent Modernist icon and a myth that continues to haunt modernity.[5] IC

1 The continuing presence of *Metropolis* in contemporary culture and the ironies surrounding its career are discussed in Tom Gunning, *The Films of Fritz Lang: Allegories of Vision and Modernity* (London, 2000), ch.3. The re-editing of the film, which caused up to 20 per cent of its original material to be lost, is described in Paul M. Jensen, *The Cinema of Fritz Lang* (New York, 1969), pp.62–5. The most authoritative monograph on the film is Thomas Elsaesser, *Metropolis* (London, 2000).
2 Eduardo Paolozzi returned to motifs from *Metropolis* throughout his career as a sculptor and printmaker, while many contemporary artists, film-makers and popular musicians have invoked these motifs.
3 On the design process for *Metropolis*, see Dietrich Lohmann (ed.), *Film Architecture: Set designs from Metropolis to Blade Runner* (Munich, 1999), pp.94–103.
4 H.G. Wells saw traces of his *When the Sleeper Awakens* and *The Time Machine* in *Metropolis*; while Jakov Protazanov's *Aelita* (USSR, 1924) may well have influenced its futuristic design and the robot theme is clearly influenced by Karel Capec's 1921 play *R.U.R.*
5 On *Metropolis*, modernity and gender, see Andreas Huyssen, 'The Vamp and the Machine: Fritz Lang's *Metropolis*', in Huyssen, *After the Great Divide: Modernism, Mass Culture, Post-Modernism* (Bloomington, 1986); R. L. Rutsky, 'The Mediation of Technology and Gender: *Metropolis*, Nazism, Modernism', *New German Critique*, no.59 (Spring/Summer 1993).

66

Le Parvo film camera, model JK
*c.*1924
Manufactured by André Debrie, Paris
Samuelson Brothers

Dziga Vertov's polemical *The Man with a Movie Camera* (1929, cat.67) takes a cameraman as its hero, showing him undertaking such stunts as filming from a speeding car and from beneath a train, as well as bestriding the city in superimposed images, all to demonstrate that 'reality' can be as compelling as fiction. This is not mere reportage, but a celebration of the camera as a mechanized observer, even performing an animated solo dance on its tripod and having its own close-up, as befits the star of an extraordinary Modernist experiment. The cameraman is in fact Vertov's brother, Mikhail Kaufman (cat.42c), and his instrument is a Debrie camera, then one of the most popular film cameras in the world.[1] Debries would be used on expeditions, in the studio and for the pyrotechnics of Abel Gance's *Napoleon* (1927).

The name *Parvo* (Latin for 'small') advertised the camera's extreme compactness, which was

achieved by its two film spools being mounted side by side, with the film passing from one to the other in a skewed loop. It was patented by Joseph Debrie in 1908 and launched by his son André, first with a wooden casing, then from 1920 in the sleek aluminium box with black side panels made famous by Vertov's film. It would remain in production with minor modifications for some 40 years.

The peculiarly modern mystique of the film cameraman as a detached observer had first been broached by Luigi Pirandello in his novel *Si gira!* (*Shoot!*, 1917), narrated by an impassive camera-man who studies people around him to discover 'what I myself feel I lack'.[2] Later this image would be played for humour in Buster Keaton's *The Cameraman* (1928), in which Buster clumsily tries to impress his beloved by becoming a daring newsreel cameraman (his camera is not a Debrie, although these were used by Fox Movietone, who made his films). It is perhaps in the writings of the French avant-garde film-maker Jean Epstein that the paradoxical nature of the 'robot-brain that is the cinematic instrument' is most fully explored, as a machine that makes us think as well as see differently.[3] IC

1 Brian Coe, *The History of Movie Photography* (London, 1981), p.82.
2 Luigi Pirandello, *Shoot! The Notebooks of Serafino Gubbio, Cinematograph Operator* (New York, 1926), p.3.
3 Jean Epstein, 'L'Intelligence d'une machine' (1946) and earlier writings from the 1920s, in Epstein, *Écrits sur le cinema*, vol.1 (Paris, 1974), pp.255, 105–52.

67 Plate 8.4

Film: *The Man with a Movie Camera*
(*Chelovek s kinoapparatom*)
Conceived and directed by Dziga Vertov
(1985 Belostok, Russia–1954 Moscow)
Photographed by Mikhail Kaufman

65 mins, silent, black and white
Produced by VUFKU, Kiev, USSR, 1929

The Man with a Movie Camera was little known until the 1970s, and was often disparaged in early accounts of Soviet cinema for its alleged 'formal-ism' or avant-garde frivolity. It has since become probably the best-known of all silent-era Soviet films and certainly better known than Ruttmann's *Berlin, Symphonie of a City* (1927), which was origi-nally assumed to have been its model.[1] In fact Vertov's film is not a 'city symphony', since it syn-thesizes material from other locations as well as from Moscow. Vertov's polemical intention was also very different. A Futurist poet who had fallen into film work in the aftermath of the October Revolution and spent five formative years develop-ing a new kind of newsreel, Vertov bitterly opposed all fictional cinema, arguing that 'life caught unawares' could be much more fascinating.[2] The

four feature-length films he made before 1929 developed an elaborate style of commentary on the documentary images being shown, using repetition and elaborate Constructivist intertitles.[3] But *The Man with a Movie Camera* declares itself 'an experiment in the cinematic communication of visible events without titles', and is subtitled 'an excerpt for the diary of a cameraman'.[4] It intertwines two narratives: that of the city and its inhabitants waking up and going about their business; and that of a film being shot, edited and shown in a cinema – although we begin at the end of this process.

Never before or after did Vertov focus so com-pletely on the cinematic process itself, although his writing constantly insisted that film offers a new way of seeing, ideally suited to the creation of a new society.[5] In *Man with a Movie Camera*, the lurid promise of imported films, indicated by a poster for *A Woman's Awakening*, is mocked as the Soviet cameraman is seen turning everyday Soviet reality into a compelling film. This also serves, as the introductory intertitles state, as a manifesto for 'a truly international absolute language of cinema'. In place of fiction or Soviet propaganda as a theme, Vertov and his collaborators relied on the widespread contemporary fascination with filmic effects and tricks – here demystified. The supreme example of this fascination in *Man with a Movie Camera* was the sequence showing the

scene that the viewer is watching being edited in front of their eyes. These effects can be seen as a late and virtuoso example of the Soviet avant-garde's theory of 'productionism', or art as a vehicle for production skills, and ultimately about its own process of coming into being.[6] IC

1 See, for example, dismissive remarks in Thorold Dickinson and Catherine de la Roche, *Soviet Cinema* (London, 1948), p.23, and Jay Leyda's more appreciative account, which still focuses on the film's 'stunts', in *Kino: A History of the Russian and Soviet Film* (London, 1960), pp.250–51.
2 Dziga Vertov, 'The Birth of the Kino Eye' (1923), reprinted in Annette Michelson (ed.), *Kino-Eye: The Writings of Dziga Vertov* (Berkeley, 1984), p.41.
3 Vertov often repeated shots from film to film and within the same film. The block-lettering titles for his *Kino-Pravda* series in 1923–4 were designed by Alexander Rodchenko, who also designed posters for many of his films.
4 The original titles are included and translated in the edition of the film published on DVD by BFI Video, with a commentary by Yuri Tsivian. For discussion of Vertov's intentions, see Tsivian, '*Man with a Movie Camera*: Reel One: a Selective Glossary', *Film Studies* no.2 (Spring 2000), pp.51–4.
5 See the selection of Vertov's manifestos and other writings in Michelson (1984).
6 Christina Lodder discusses the confusion of definitions of 'production art' in *Russian Constructivism* (New Haven, 1983), pp.102–103. See also Tsivian (2000), p.55.

68

Film: *Modern Times*
Produced, written and directed by
Charles Chaplin (1889 London –
1977 Corsier-sur-Vevey, Switzerland)
Designed by Charles D. Hall

89 mins, sound, black and white
Produced by Charles Chaplin Productions and
United Artists, USA, 1936

Chaplin's tramp had become one of the most universally admired creations of the twentieth century, widely imitated and already appropriated by Modernist artists in France and Russia (cat.73), when he turned to the theme of the modern worker's alienation in his farewell to the silent cinema.[1] His inspiration was a journalist's account of how the 'factory-belt system' used in the automobile industry turned 'healthy young men into . . . nervous wrecks'.[2] The vast factory in which Chaplin works seems to produce nothing, while turning its workers into extensions of the machinery. One of the film's most famous images shows him stretched around a massive gear-wheel,

while in another sequence he is force-fed by a machine intended to speed up production.

Apart from the film's summation of industrial oppression in the three key settings (the factory, the worker's strike and the mental hospital), Chaplin's first use of Hollywood's sound technology, nearly eight years after its appearance, made a telling point about industrialization. Speech in the film is always mechanized and authoritarian, whether it is the boss appearing on a video screen, a gramophone-powered mechanical salesman, or a radio heard in prison. Otherwise the little people mime, sing or, like the tramp himself, use a form of universal nonsense language. At this fundamental, formal level the film makes its own protest against alienation.

Chaplin was predictably accused by some of making a 'communistic' film, although he was at pains to avoid propaganda and merely show the 'natural sequence of events' that could befall the tramp and his gamine companion as they 'try to get along in modern times'.[3] For Roland Barthes, 'Chaplin repeatedly approaches the proletarian theme, but never endorses it politically', presenting instead workers 'who are still blind and mystified'.[4] However interpreted, the film undeniably forged a modern myth of social injustice and mechanization, and created in its title a new phrase to describe it.[5] IC

1 Many writers and artists associated with the main Modernist movements used Chaplin's figure or myth in their work, including Ivan Goll, George Grosz, Louis Aragon, Fernand Léger, Philippe Soupault, Varvara Stepanova, Viktor Shklovsky and Sergei Eisenstein.
2 Charles Chaplin, *My Autobiography* (London, 1964), p.377.
3 Ibid., p.388. On Chaplin's political stance in *Modern Times*, see also David Robinson, *Chaplin: His Life and Art* (London, 1985), p.458, and Robinson, *Charlie Chaplin: The Art of Comedy* (London, 1996), p.97.
4 Roland Barthes, 'The Poor and the Proletariat', *Mythologies* (London, 1972), p.39.
5 Chaplin's working title was 'The Masses', but *Modern Times* has since been used repeatedly as a title – from Jean-Paul Sartre's prestigious journal *Les temps modernes* (launched in 1945) to Peter Conrad's summation on twentieth-century culture, *Modern Times, Modern Places* (London, 1998), which devoted a chapter to Chaplin as Modernist icon.

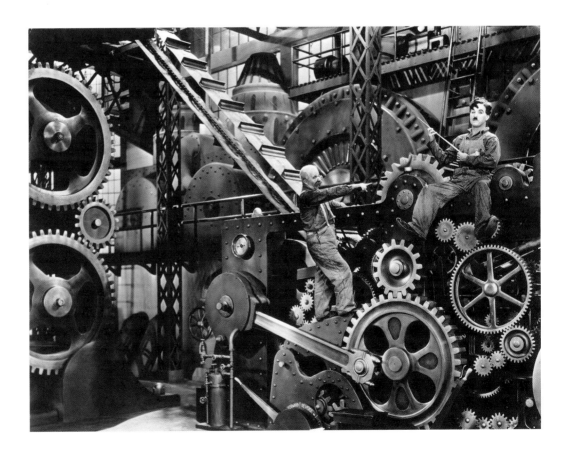

4

Tag Gronberg

Performing Modernism

The theatre is not an independent, self-sufficient, pure form of art, but merely a treaty drawn up by a bunch of different arts, a treaty according to which they promise to reproduce, supplement, explain, and reveal – by visual and acoustic media – the fortuitous, miraculous elements of the theatre...[1]

Yurii Annenkov
Teatr chistogo metoda
(The Theatre of Pure Method)
(1921)

4.1 **Erich Consemüller** or
T. Lux Feininger, *Bauhaus dances. The Bauhaus as stage*, 1929 (cat.72d)

The 1920s marked a period of intense artistic engagement with the performing arts, particularly theatre, dance and cinema. For Modernist artists and designers, the performing arts offered exciting opportunities to depict, challenge and, more fundamentally, influence the ways in which modern society was developing. In a wide variety of national and political contexts, artists were inspired by the idea of theatre as a 'total' art – a conjoining of all the arts – as a kind of laboratory for the imagination, in which a new and improved world could be enacted.[2] There had of course been a number of significant collaborations between artists and the theatre earlier in the century (such as Picasso's 1917 designs for *Parade*), and the preoccupation with performance by Italian Futurists and by Dada groups in France, Germany and Switzerland reveals the significance not only of the stage, but also of theatricality more generally for avant-garde practices.[3] An important demonstration of the range of avant-garde artistic involvement with performance took place in 1924 with the *Internationale Ausstellung Neuer Theatertechnik* (International Exhibition of New Theatre Techniques)

in Vienna. By the time of this exhibition, held in the wake of the First World War and of revolutions in Russia and Germany, theatre had assumed a renewed importance for artists. During the 1920s the theatre was a key site for debating the significance (political, social and artistic) of life in a modern, industrialized society. For many artists, performance offered the means of encouraging audiences to see – and understand – the world in different ways.[4] Theatre acquired a new urgency, not only as the means of depicting a changed world, but also (in some cases) as an intrinsic component of bringing about change.

The *Internationale Ausstellung Neuer Theatertechnik*, opened by the mayor of Vienna in September 1924, marked an important set of encounters, not only between theatre and the other arts, but also between East and West. Given its location in the 'heart' of Europe, Vienna seemed an appropriate venue for an international exhibition, but more specifically Austria's newly established diplomatic relations with the Soviet Union in 1924 meant that the show included displays by some of the most innovative Soviet artists and designers, including

4.2 **International Exhibition of New Theatre Techniques**, Schubertsaal, Konzerthaus Vienna, 1924. Netherlands Institute for Arts History (RKD)

4.3 **Frederich Kiesler**, *Raumbühne* (Theatre in Space), Mozartsaal Konzerthaus Vienna, 1924. Kiesler Foundation Vienna

4.2

4.3

El Lissitzky, Alexandra Exter, Alexander Vesnin, Vsevolod Meyerhold and Nikolai Foregger. The presence of Soviet exhibits enhanced the sense of modern theatre's potential to be 'revolutionary'. It was no coincidence, for example, that the Dutch artist Theo van Doesburg should have compared one of the major exhibits, the large-scale model for the *Raumbühne* (Theatre in Space) by the Austrian architect and stage designer Friedrich Kiesler (pl.4.3), to Tatlin's *Monument to the Third International* (cat.3).[5] The inference was not merely that the two structures were stylistically similar, but that Kiesler's theatre was somehow also to do with a fundamental change, not only in staging, but also in life.

Kiesler was involved as the organizer of, as well as an exhibitor at, the 1924 Exhibition. In addition to the Soviet participation, he was responsible for the impressive roster of foreign exhibitors, which included artists such as Fernand Léger, Georges Braque and Man Ray from France, George Grosz and Kurt Schwitters from Germany, an Italian contingent headed by Enrico Prampolini and a number of well-known participants from the Bauhaus, including László Moholy-Nagy, Oskar Schlemmer and Kurt Schmidt. The sense of theatre as a catalyst for artistic change was enhanced by Kiesler's dynamic use of graphic and exhibition design. He designed bold posters and a catalogue for the 1924 show using a new De Stijl typeface, thus further underscoring the international remit of the 'new' theatre.[6] Kiesler's professional involvement as a theatre designer ensured that the entirety of the exhibition became a kind of theatrical event. His newly evolved *Träger-System* (literally, *Beam System*) of display structures (in effect, a system of stage sets for exhibitions) involved a rejection of wall display in favour of activating the void of the exhibition room's space (pl.4.2). Kiesler's *T-* and *L-Träger*, which resembled abstract sculptures (or, indeed, inanimate actors), attracted

the attention of arts journals, appearing for example in Van Doesburg's magazine *De Stijl* (*The Style*).[7]

The Theatre Exhibition in the Vienna Konzerthaus was one of several cultural events timed to coincide in 1924 as part of the city's Theatre Festival. These included exhibitions in the Town Hall, the Albertina, the Secession Building and the Künstlerhaus, as well as a number of performances in the Konzerthaus. Here, a choir was positioned on Kiesler's *Theatre in Space* to sing Schoenberg's *Friede auf Erden* (*Peace on Earth*) Léger showed his film *Ballet mécanique* (*Mechanical Ballet*) (1924, pl.8.6) and Ludwig Hirschfeld-Mack demonstrated his *Reflecktorishe Lichtspiele* (literally, *Reflecting Light Performances*, a series of abstract light shows developed at the Bauhaus). Kiesler's innovative *Raumbühne*, constructed of wood and steel, became a kind of leitmotif of the exhibition and provided an appropriate setting for these avant-garde works. Like Tatlin's Tower, to which Van Doesburg had compared it, the *Theatre in Space* defied easy categorization; it was simultaneously stage set, monumental sculpture and architecture. Although presented in the context of the high art of theatre, Kiesler claimed to have drawn his inspiration for the curving, ramped structure from sports stadia and roller-coaster rides at funfairs, hence the designation 'railway stage'. These implied an address to mass audiences as opposed to a theatre elite. (Unsurprisingly perhaps, the structure was subjected to caricature, appearing in the Viennese press in cartoon form as a helter-skelter.)[8] During the run of the exhibition, the *Raumbühne* was used as a stage set, for plays and for modern dance, performed by dancers such as Tilly Losch and E. Jack Burton and his troupe. Unlike many of the other displays in 1924, the spiralling stage was lifesize (built on a 1:1 scale) and hence one of the most imposing exhibits. But however interesting as a spatial experiment, structurally and conceptually this represented only part of Kiesler's project. Kiesler's ambition involved not merely the redesign of the theatrical stage, but also the transformation of society through theatre.[9] He envisioned the *Raumbühne* as part of a complex that included hotels, gardens and cafés, as well as projections into the sky. This totality of theatre could continue uninterrupted for days and weeks as a centre of entertainment – everyday life transformed by (but also into) theatre. The 1924 Exhibition enabled Kiesler's stage (in its partial, modified form) to emerge from this grandiose, largely unrealizable scheme for the realization of a utopia through theatre and spectacle.

The July 1925 issue of the French arts magazine *Bulletin de l'effort moderne* (*Bulletin of the Modern Effort*) included a photograph labelled *Maquette pour un 'Railway' Théâtre* (*Maquette for a Railway Theatre*), showing Léger and Kiesler posed on the architect's model for his *Theatre in Space*.[10] The appearance of Léger in *Le Bulletin*, the house magazine of the commercial galerie de l'effort moderne run by Léonce Rosenberg, was hardly surprising, as

Léger was one of the artists promoted by the dealer. Indeed, at this period the magazine featured not only Léger's painting, but his writings, which dealt with art and theatre as well as the various manifestations of modern urban spectacle that fascinated Léger, from shop windows to dance halls. Léger, who shared Kiesler's interest in the idea of modern life as spectacle, participated extensively at the 1924 Exhibition, where he appeared as a designer for both cinema and theatre – Vienna saw the first showing of his film *Ballet mécanique*. Léger's participation was strategic. His stage exhibits demonstrated his contributions to the theatrical innovations taking place at an international level, while at the same time *Ballet mécanique* showed how to liberate film from the constraints of theatre. But where Kiesler's dream of the *Raumbühne* looked forward to a utopian future, Léger saw existing life in the modern city not merely as the object of transformation, but as a source of inspiration. An appreciation of the dynamism and energy of the modern city was crucial, he claimed, to the artist's

mission, which was to choreograph the vitality of urban life into a harmonious whole. In his essay 'The Spectacle: Light, Color, Moving Image, Object-Spectacle' (published in the *Bulletin de l'effort moderne* in 1924), for example, Léger waxed lyrical on the visual excitement to be experienced on any city street:

Life rolls by at such speed that everything becomes mobile.

The rhythm is so dynamic that a 'slice of life' seen from a café terrace is a spectacle. The most diverse elements collide and jostle one another there. The interplay of contrasts is so violent that there is always exaggeration in the effect you glimpse.

On the boulevards two men are carrying some immense gilded letters in a handcart; the effect is so unexpected that everyone stops and looks. *There is the origin of the modern spectacle.* The

4.4 **Fernand Léger**, Stage model for *La Création du monde*, 1923. Dansmuseet Stockholm

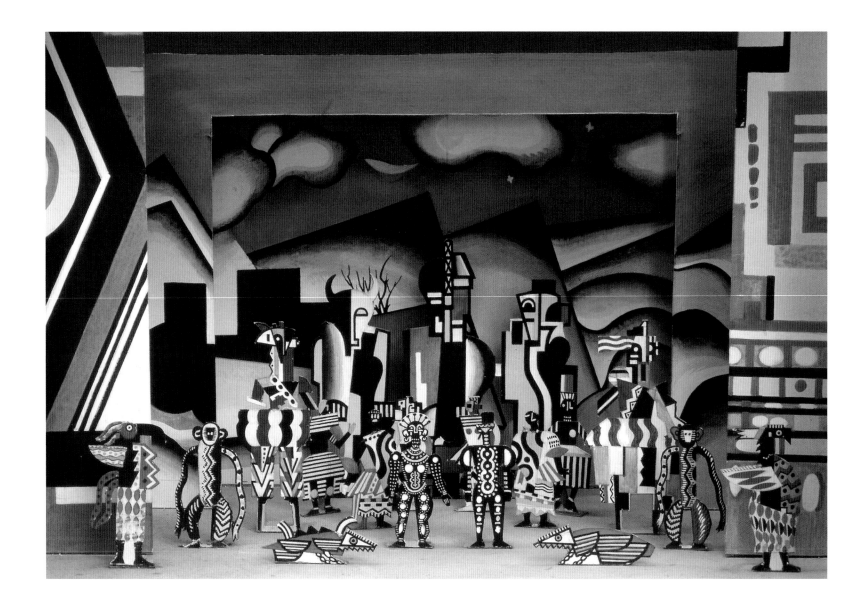

shock of the surprise effect. To organize a spectacle based on these daily phenomena, the artists who want to distract the crowd must undergo a continual renewal. It is a hard profession, the hardest profession.

Léger found theatrical effects in the street, in unexpected juxtapositions such as these, but also in the more considered displays presented by urban shop windows. He spoke of the highly organized spectacles provided by the 'astonishing art of window display'. Indeed, he went so far as to claim that the modern artist should aspire to the artisanal skills of the window dresser.[11]

Léger's theatrical displays at the 1924 Exhibition demonstrated the ways in which he felt that this drama and mobility should be harnessed as a means of reforming stage design. His exhibits included costume and set designs that he had produced for two ballets performed by the Ballets Suédois at the Théâtre des Champs-Élysées in Paris: the charming, modern-day *Skating Rink* (1922) and the primitivizing *Création du monde* (*Creation of the World*, pl.4.4) (1923).[12] The curtain and backdrop for *Skating Rink* included bold, brightly coloured geometrical shapes, which produced the kind of visual contrast and jostle that Léger so admired in the city street. The dancers performed in similarly geometrically patterned costumes, their visual connection with the backdrop emphasized by the narrow space of the stage. Léger's ideas on the modern theatre (to which he alluded in numerous of his essays) were in tune with a number of contemporary developments, ranging from those advocated by the theatrical impresario Edward Gordon Craig to the latest developments in Constructivist theatre in the Soviet Union. Léger argued that the day of the 'star artist' had passed, and that the star system was an obstacle to theatrical unity. Instead he spoke of 'human material' that could be used 'in groups moving in a parallel or contrasting rhythm'. It was necessary for the individual actor to disappear, and he praised the 'classical theatre' in which, so he claimed, 'the human material had the same spectacle value as the object and the décor'.[13] The classical use of masks was also lauded as the means of eradicating individual identity and expression. Léger conceived the African-inspired costumes of *Création du monde* as masks for the body, a dehumanizing device that would link the actors to the stage decor. He was particularly excited by the idea of mobile stage sets and conceived *Création du monde* as a set of richly coloured kaleidoscopic sequences.

Ideas concerning moving scenery and kinetic stage effects were at the heart of a number of experiments with the 'new' theatre at this period. These formed part of a more general concern with the idea of movement as a key characteristic of modernity. (Hence too the concern of so many avant-garde artists and designers with dance as an art form that was particularly expressive of the conditions of modern life; see Chapter 7.) The aspiration to transform both actors and stage sets into a unified spectacle took a variety of forms. Gordon Craig, whose ideas proved highly influential, advocated prioritizing the role of the director (as opposed to that of the actor) in order to achieve aesthetic unity. From around 1900 his distinctive stage productions involved a series of unifying devices such as the use of masks and the patterning of movement through groups of actors. His 'moving scenes' took the form of simple, undecorated screens, which could be composed in different permutations across the stage in order to become active dramatic agents.[14] Gordon Craig's ideas and productions exerted a considerable influence on the Italian Futurists, in particular on Enrico Prampolini. In 1915 Prampolini published his *Futurist Scenography* manifesto, in which he advocated the use of moving scenery as an integral part of the theatrical performance. He devised designs for a *Magnetic Theatre* in which the movement of its various elements, along with careful stage lighting, was intended to replace the presence of actors. In the case of Prampolini (as with Gordon Craig) the aspiration for a mobile, actorless stage remained more an ideal than a reality. A model for the *Magnetic Theatre* won the Grand Prize for theatrical design at the 1925 Paris Exhibition, but was never realized on stage.[15]

At the level of executed stage designs, perhaps the most radical and exciting designs for interrelating actors and sets and for producing a kinetic stage took place in pre- and post-revolutionary Russia.[16] The opera *Victory over the Sun* produced at the Luna Park Theatre, St Petersburg in 1913 included designs for costumes and sets by the painter Kazimir Malevich. These involved abstract sets and geometricized costumes that transformed actors into robotic figures, who moved slowly around the stage, suggesting a depersonalized and mechanized humanity. In connection with his designs for a later play, Malevich commented that 'the actors' movements were meant to accord rhythmically with the elements of the setting'.[17] After the 1917 Revolution, and in particular in the case of Constructivist designers whose aim was to build (as opposed to 'decorate') the stage, a whole new range of theatrical devices emerged. Ideas concerning the mobile theatre operated at two levels. On the one hand, there was the aim to bring theatre to the masses by designing productions that could easily be moved and set up in different locations around the country. On the other, there were experiments in producing new kinds of costume and stage machinery, or rather machines that became part of the theatrical scenography. These included productions such as Lyubov Popova's designs for kinetic stage sets in *The Magnanimous Cuckold* (1922, cat.71), where turning wheels not only provided a dynamic visual element, but also expanded the emotional resonance of the performance. Here the actors were dressed in Popova's identical 'work uniforms' as a means of undermining the idea of the

individual star performer (pl.4.5). In the same year (1922) Varvara Stepanova designed movable machine-objects for the *Death of Tarelkin*, a kind of mobile stage furniture through which the actors extended their range of physical movement (pl.4.6). Such devices represented a considerably more sophisticated notion of the dynamic stage than Léger's designs for *Création du monde*, where the dancers apparently complained that they did not see their role as including the moving about of stage sets.

Juxtaposed at the 1924 Vienna Exhibition, the subject matter of *Création du monde* might seem a curious contrast with Léger's cinematic work, particularly perhaps with his set designs for a futuristic science laboratory as part of Marcel L'Herbier's film *L'Inhumaine* (*The Inhuman Woman*, 1924, see pl.8.2 and Chapter 8). Unlike other Cubist artists such as Picasso and Braque, who had long evinced an interest in African artefacts, *Création* was Léger's only project to be so explicitly based on African

motifs – unsurprising perhaps, given his passion for urban modernity.[18] In fact, through Léger's adaptation of African visual culture (in particular the idea of masks), *Création* afforded the artist a new means to further his preoccupation with modern spectacle as a way of dehumanizing the actor while simultaneously animating the surrounding decor. In the case of *L'Inhumaine*, although cinema involved a more modern medium than the ballet, Léger's laboratory designs for the film appeared in what was otherwise a rather conventional melodrama (a young scientist, initially thwarted, but then successful in his love for a famous singer) – just the sort of film narrative he so often criticized in his writings. However, he must have been pleased with the subject matter of the laboratory, one example of the many futuristic themes that were so popular in cinema and theatre of the 1920s. Alexandra Exter, for example, had designed sets and costumes for the Martian sequences of the film *Aelita* (1924), and at the 1924 Theatre Exhibition

4.5 **Lyubov Popova**,
Costume design for Actor
No.7, 1921 (cat.71c)

4.6 **Varvara Stepanova**
showing how to operate
a collapsible table, designed
for *The Death of Tarelkin*, 1922.
Rodchenko and Stepanova
Archive, Moscow

4.5

4.6

Kiesler showed his stage sets (which included a factory setting) for Josef and Karel Capek's successful play *R.U.R. (Rossum's Universal Robots)*, written in 1920 and premiered in Prague early in 1921.[19]

The scenarios of *L'Inhumaine* and *R.U.R.* were very different. In *L'Inhumaine* the young scientist and his laboratory are represented as the means of restoring life to his inamorata, after she is killed by a poisonous snakebite. Indeed, with their futuristic designs and dynamic editing, the laboratory sequences form the culmination and climax of the film; they constitute the technically most innovative aspects of *L'Inhumaine*. *R.U.R.*, by contrast, presents a rather bleak and threatening picture of a society reliant upon, and ultimately dominated by, robots. Kiesler's sets for the performances of *R.U.R.* in 1923 at the Theater am Kurfürstendamm, Berlin, included not only dramatic technological motifs, but also the use of cinematic images projected onto the stage. The preoccupation of Léger and Kiesler with these futuristic designs can be seen as part of their campaign to update and redefine the role of the modern-day artist. Kiesler's catalogue for the Vienna Theatre Exhibition included a photograph of Léger (ever canny in the choice of *mise-en-scène* for his photographic portraits) posed in his laboratory film set.[20]

The most complete realization of Léger's ideas on modern spectacle, and one of the highlights of the Vienna Theatre Exhibition, was the film *Ballet mécanique* (pl.8.6), premiered in September/October 1924. This was the product of a collaboration between Léger and two Americans, the experimental film-maker Dudley Murphy and the composer George Antheil.[21] The short non-narrative film was much more successful than either *Skating Rink* or *Création du monde*, or indeed his set designs for *L'Inhumaine*, in achieving what Léger referred to as a 'new realism'. This realism involved a recognition of the potential of the manufactured object as opposed to the dominance of the film star (in cinema) or figurative subject matter (in painting). *Ballet mécanique* included banal, mass-produced objects such as flan tins, pots and pans and a typewriter. In his notes to the film, Léger again commented on the importance of shop windows in drawing attention to the manufactured product: 'We are living through *the advent* of the object that is thrust on us in *all those shops that decorate the streets*.' Léger claimed that (somewhat analogous to that of the shop vitrine) cinema's *raison d'être* was:

> a matter of *making images seen*, and the cinema must not look elsewhere for its reason for being. Project your beautiful image, choose it well, define it, put it under the microscope, do everything to make it yield up its maximum, and you will have no need for text, description, perspective, sentimentality or actors.[22]

With *Ballet mécanique*, Léger aimed not so much to eliminate the human presence as to ensure that it

was rendered the equivalent of the manufactured objects that featured in the film. A large part of the excitement in watching *Ballet* derives from this sense of objectification, which was achieved through a series of cinematic devices such as close-ups, fragmentation, editing and montage. Léger emphasized the film's rhythmic qualities:

> I thought that through film this neglected *object* would be able to assume its value as well. Beginning there, I worked on this film, I took very ordinary objects that I transferred to the screen by giving them very deliberate, very calculated mobility and rhythm.[23]

The cinematic medium ensured that, far more than was possible with the dances of the Ballets Suédois, this mechanical dance produced objects as actors and actors as objects. And yet the concept of 'ballet' was still crucial to Léger's film project. Here, with *Ballet mécanique*, that most traditional of art forms was updated, not merely by making objects themselves 'dance' (which could after all be achieved through other means, such as puppets and marionettes), but by producing a sense of rhythmic movement and beauty through carefully calculated cinematic editing and montage. This was a ballet in which the performers (both animate and inanimate) danced in a sequence of machine-like rhythms; more funda-mentally, however, it was also a dance produced by mechanical means.

At the 1924 Theatre Exhibition, Léger's film *Ballet mécanique* was not the only kind of mechanical ballet on show. There were, for example, German exhibits as well as a figurine by Fortunato Depero for stage projects, in both cases entitled *Mechanisches Ballett* (*Mechanical Ballet*). By this date, concepts regarding 'mechanized' dances and mechanical ballets for the stage had been evolved in a number of different national and artistic contexts (see cat.40); it is possible to construe the title of Léger's film as the assertion that he had more fully realized the aspira-tions of such stage performances through the medium of cinema (see Chapter 8). Italian Futurists, with their love of the energy and dynamism of the machine, were involved as designers for a number of mechanical performances. There was Giacomo Balla's *Macchina Tipografica* (*Typographical Machine*) of 1914, involving 12 performers who played the different mechanical components of a printing press, as well as numerous projects for dances identified as mechanical ballets: Pannaggi's costumes for a 1919 *Balletti Meccanici* (*Mechanical Ballets*); Depero's costumes for the *Machine of 3000* (a 'mechanical ballet' with music by Casalova in 1924) and Prampolini's designs for Silvio Mix's *Psychology of Machines* in the same year. These performances accorded with Futurist ideas of the desirable transformation of the human body into a kind of machine, and offered the means of animating the mechanized superman represented by Umberto Boccioni's heroic sculpture *Unique Forms in Space* of 1913. The modernity of these new bodies

as they danced in mechanized ballets was enhanced by the accompaniment of music or 'noise'.

In Soviet Russia there was a similar preoccupation on the part of numerous theatres and dance troupes with performing versions of living machinery and with 'noise' orchestras. Some of these, such as the Blue Blouse Theatre's *Us and Henry Ford* (1923–8) related to the Soviet fascination both with Fordist ideas about mass production and with the United States ('America') as the most technologically developed nation in the world.[24] Like the Soviet theatre more generally, dance played an important role in exploring and debating the ways in which increased technology and industrialization could serve the cause of a post-revolutionary society. During the period between the early 1920s and early 1930s, Nikolai Foregger was instrumental in staging a number of successful 'machine dances':

> In these dances the performers might imitate a train – by swaying, stamping their feet against the floor, and banging sheets of metal together, even by swinging burning cigarettes in the air so that sparks flew all over as if from a locomotive's smokestack.[25]

A photograph by Margaret Bourke-White of 1931 shows the Moscow Ballet School posed in a dance that imitated the motion of a transmission through a chain of linked young girls (pl.18). At a more fundamental level, Meyerhold's biomechanical exercises (based on theories such as Taylorism and mass psychology) were aimed at retraining the human body, to become not only more efficient in its movements, but also more expressive – a valuable component therefore in the training of the Soviet stage performer. Like Léger's view of the modern theatre, both the mechanical ballets and the system of biomechanics rejected the notion of individual, star performers. The emphasis was on movement and dance as the means of re-educating the bodies and minds of mass audiences across the Soviet Union.

At the Bauhaus in Germany, debates on what form the modern theatre should take became an important aspect of that institution's attempts to formulate designs for a new world. Here too different ideas emerged concerning the appropriate kind of stage sets and the relevance of the individual performer for audiences whose lives were increasingly shaped by the experiences of an urban, technological society. A theatre workshop was formed at the school in the early 1920s and the fourth Bauhaus book, *Die Bühne am Bauhaus* (*The Theatre of the Bauhaus*), jointly authored by Oskar Schlemmer, László Moholy-Nagy and Farkas Molnár, was published in 1925. Certain members of the Bauhaus were concerned with developing 'mechanized' forms of the stage. Moholy-Nagy's *Score Sketch for a Mechanical Eccentric* was exhibited in Vienna in 1924 and was also published as an elaborate fold-out diagram in *Die Bühne am Bauhaus*.[26] This involved a concept of the stage in which beams of coloured light were filtered and

4.7

4.8

4.9

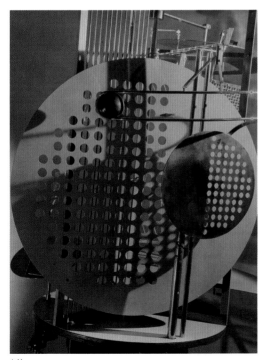

4.11

tempo' underlined the 'monotony of the mechanical'.[28] At the level of appearances human actors had disappeared, although they were of course still necessary in order to enact the performance. Schmidt subsequently worked on schemes for producing fully automated 'performers', but due to lack of resources these were never realized. At a less abstract level, Schmidt's design for *Man at the Control Panel* (1924, pl.4.8) shows three robotic, puppet-like figures, posed to suggest jerky, machine-like movements. Unlike the rather more aggressive machine-figures of Italian Futurism, Schmidt's puppet-like forms seem to have more in common with the naivety of children's book illustration. (The same is true for certain other Bauhaus stage designs of around 1924, such as Xanti Schawinsky's *Circus*, and the marionette play *The Adventures of the Little Hunchback,* designed by Schmidt and executed by T. Hengt.)[29]

In the German context, it was arguably Moholy-Nagy who produced the ultimate version of a mechanical ballet. At the 1930 *Salon des Arts Décoratifs* in Paris, Moholy-Nagy showed a version of his *Lichtrequisit einer Elektronischen Bühne* (*Light Prop for an Electric Stage*), its construction for the German section of the exhibition funded by the theatre division of AEG (pls 4.9–11). This involved a two-minute programme in which the complex mechanism moved, illuminated by 116 coloured lights (red, blue, green, yellow and white).[30] At the 1900 Paris Exhibition, the dancer Loie Fuller had performed her famous dances to a sequence of coloured electric light sequences choreographed by herself. With Moholy-Nagy's *Light Prop* in 1930, the machine had truly replaced the human performer to present a kind of brilliantly coloured mechanized dance. Here, moving scenery was produced not by stage sets, but by the mesmeric effect of shadows cast by the pirouetting machine.

The 1920s had seen a number of other forms of what might be called 'abstracting' performance. For some years the Hungarian painter Vilmos Huszár worked on a project for a *Mechanical Dancing Figure* (pl.4.12). In 1921 he published a 'Brief Technical Explanation of the Plastic Drama', a work in four acts to be performed 'with electro-mechanical or coloristic-cinematographic' means.[31] As with so many other schemes for mechanizing the stage, the actual means of achieving this goal was unclear (indeed, it was never realized in this form) and the artist suggested that the performance could be carried out by marionettes. These mechanized figures were to move to specially composed music and at certain intervals would strike poses determined by the stage set, whose colour scheme was designed in conjunction with that of the performing figures. The 'Plastic Drama' as published in *De Stijl* in 1921 shows jointed figures composed of square and rectangular elements that echo those of the stage set. Eventually the performance took place in 1923, not as a film, but with the 'Mechanical Dancing Figure' (a kind of geometricized, coloured lay-figure that Huszár had

modified by linen cloth screens, and movement was conceived of vertically, upwards and downwards. Moholy-Nagy specified techniques of fragmentation and rapid alteration, devices that made this unexecuted project for the stage resemble a film (indeed, he had produced another unrealized project, a 'sketch for a film/at the same time a typophotograph' entitled *The Dynamics of the Big City* in 1924).[27] In this formulation, the stage was mechanized (at least in part) through its implied resemblance to film.

Rather different, and somewhat more literal, conceptions of the mechanized stage were produced at the Bauhaus by Kurt Schmidt with F.W. Bogler and Georg Adams-Teltscher in 1923 with their *Mechanisches Ballett* (*Mechanical Ballet*), which was first performed as a student work to music by Hans Heinz Stuckenschmidt during the Bauhaus week at the Jena Municipal Theatre (pl.4.7). Abstract figures with movable joints (identified in the programme by the letters A, B, C, D, E) were carried by invisible dancers attached to the costumes by leather straps; these created the effect of dancing automatons. A 'uniform, constant rhythm . . . with no changes of

4.10

designed around 1920) projecting shadows onto a screen in a technique derived from Oriental shadow theatre. Although Huszár's dance project was perhaps more sophisticated in its conception than in its eventual realization, it does reveal the fascination of certain sectors of the avant-garde with both stage performance and cinema as the means of producing abstractions of and through the human form. Such preoccupations had important implications for painting, too. In 1918, for example, the De Stijl painter Theo van Doesburg produced his vertical, almost life-size painting *Rhythm of a Russian Dance* (pl.4.13). As implied by its title, what is shown here are the rhythms of the dance, rather than the figure of the performer. The movements of the dancer have been not so much represented, as translated into the syncopated rhythm established by the relationship of coloured, geometric forms to ground.

As opposed to Van Doesburg's *Rhythm of a Russian Dance*, where movement was transcribed into the static art of painting, in 1923 the artist Andor Weininger conceived his first version of 'a Mechanical Stage-Revue', in effect a kind of 'moving De Stijl

painting' (pl.4.14).[32] Weininger was a student at the Bauhaus and had been profoundly influenced by Van Doesburg's lectures given in Weimar during the early 1920s. Similarly (and perhaps influenced by Weininger's abstracting *Mechanical Revue*), in April 1928 a performance at the Friedrich Theatre, Dessau, presented animated versions of Wassily Kandinsky's paintings. This multi-media project involved Kandinsky's designs for 16 'pictures' of abstract movement set to Modest Mussorgsky's *Pictures at an Exhibition* (pls 4.15–16), which had been adapted for the occasion by Felix Klee (the son of Paul Klee). Kandinsky designed the sets and directed a series of movable coloured forms as well as the light projections. He outlined his intentions in an essay for *Kunstblatt* (*Art Paper*, August 1930); for example, in the fourth picture, *The Old Castle*:

During the first *espressivo* ... only three long vertical strips were to be seen. They disappear. With the next *espressivo* the large red backdrop moves in from the right (in two colours). Following from the left is the green backdrop.

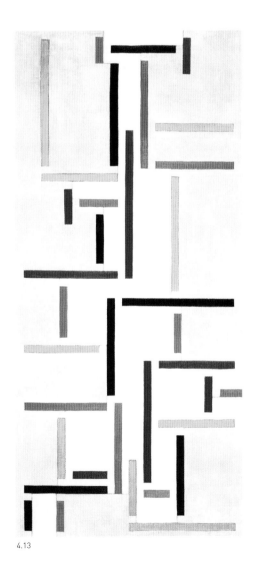

4.13

4.12

4.14

Out of the trap-door appears the center figure. Intense coloured lights are focused on that figure…[33]

This project enabled Kandinsky to further develop his long-standing interest in the correspondence of colour, form and musical sounds, aspects of which he had been involved in teaching at the Bauhaus (see Chapter 8). It was particularly satisfying to Kandinsky in that he was able to translate Mussorgsky's music (based on the sequential experience of walking around an exhibition of pictures in the mid-1870s) into a new visual form – a sequence of kinetic, abstracted pictorial shapes (pls 4.15–16).

A few years earlier the avant-garde Czech book *Abeceda* (*Alphabet*) (pl.4.17) had presented a rather different conception of animating and performing the abstract, although here too notions of poetic sequence were relevant.[34] Vitězslav Nezval's cycle of poems was based on the shape of the letters of the alphabet, and he had recited these on stage in 1926, accompanied by the avant-garde dancer Milca Mayerova. For the book (published in 1926) the avant-garde designer Karel Teige produced double-page typographical and graphic arrangements for each of the letters, which included photographs of Mayerova performing each letter. Teige claimed that he 'tried to create a "typophoto" of a purely abstract and poetic nature, setting into graphic poetry what Nezval set into verbal poetry in his verse'. Both letters and images were 'poems evoking the magic signs of the alphabet'.[35] The book thus represents a three-way collaboration – between poet, dancer and graphic designer – all three prompted and inspired by the abstract shape of the alphabetic letters.[36]

Despite the innovative qualities of such 'mechanical' and abstract stage performances, the best-known and most widely performed type of

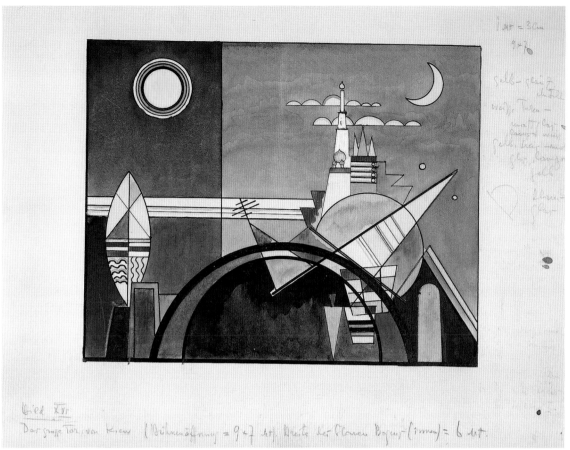

4.16

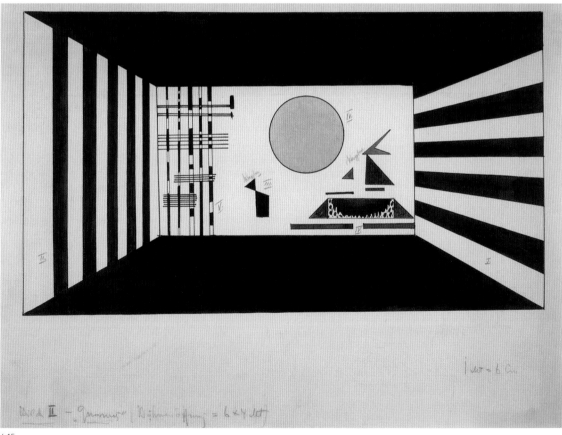

4.15

avant-garde artistic dance during the 1920s was Oskar Schlemmer's *Triadic Ballet* (cat.72), along with the other dances he designed and toured while teaching at the Bauhaus during the years 1921 to 1929.[37] Schlemmer's chief preoccupation – in dance, but also in his painting and sculpture, as well as in his teaching – was with man as the 'measure of all things' (cat.169). He saw the human body as a potentially 'new artistic medium', particularly in the context of ballet and pantomime, both of which he felt were 'freer of historical ballast than the theatre and the opera'.[38] Schlemmer was already working on ideas for ballet during the First World War, and at this time (as indeed later) was involved not only in design and directing dance, but also in performing his own dances. Like Léger, Schlemmer was inspired by some of his experiences during the war. He described the 'beautiful sight' inside one of the field tents, the 'splendor of the colors' similar to those he used in his paintings.[39] His diary of October 1915 included a poetic disquisition on the body's abstract geometry and its relationship to the surrounding world:

> The square of the ribcage.
> the circle of the belly
> the cylinder of the neck,
> the cylinders of the arms and lower thighs
> the circles of the elbow joints, elbows, knees,
> shoulders, knuckles,
> the circles of the head, the eyes,
> the triangle of the nose,
> the line connecting the heart and the brain,
> the line connecting the sight with the object seen,
> the ornament that forms between the body and
> the outer world, symbolizing the former's
> relationship to the latter.[40]

This may sound similar to the robotic figures designed by Malevich for *Victory over the Sun* in 1913 or to those of Kurt Schmidt a decade later at the Bauhaus, but Schlemmer consistently denied any interest in the mechanical stage, promoting instead his notion of a figural stage or 'metaphysical' theatre. This does not mean that he was against the mechanized world; indeed he proclaimed: 'Do not complain about mechanization; instead enjoy precision!'[41]

Schlemmer saw the modern world as polarized between two currents: on the one hand, mechanization, which had resulted in an intense awareness of 'man as machine and the body as mechanism'; on the other, the desire for 'primordial impulses' and insight into 'the deepest wells of creativity'. He claimed that theatre, with its promise of 'total art', offered the potential for synthesis between these two aspects of modern life. In particular, he felt that theatrical dance could provide the starting point for a necessary renewal.[42] He cited his *Triadic Ballet* (premiered in 1922 at the Small Theatre of the Stuttgart Landestheater) as an example of what he meant:

> dance of the trinity, changing faces of the One, Two, and Three, in form, color and movement; it should also follow the plane geometry of the dance surfaces and the solid geometry of the moving bodies, producing that sense of spatial dimension which necessarily results from tracing such basic forms as the straight line, the diagonal, the circle, the ellipse, and their combinations.[43]

In Schlemmer's view, this choreographed geometry ensured that dance, 'which is Dionysian and wholly emotional in origin, becomes strict and Apollonian in its final form, a symbol of balancing opposites'.[44]

4.17 **Karel Teige**, Letter H from *Abeceda* (*Alphabet*) by Vítězslav Nezval, 1923/6 (cat.77)

4.18 **Oskar Schlemmer**, Diver costume from the *Triadic Ballet*, [1922] 1985 (cat.72b)

4.19 **Oskar Schlemmer**, Disc costume from the *Triadic Ballet*, [1922] 1967/85 (cat.72c)

člověk vydechne a nedýchá pak již
Clown skočil s hrazdy Hudba mlčí Drum!
Jen v koutě šaška tleskat uslyšíš
Výborně já jsem také publikum!

20

4.17

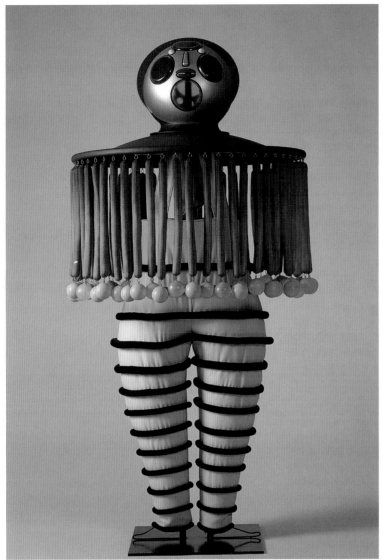

4.18

4.19

Characteristically, Schlemmer claimed to have begun work on the *Triadic Ballet* through reference to the human form, with the dance costumes, or what he referred to as the 'figurines' (pls 4.19–20). He then sought the music best suited to these. Finally, on the basis of the conjunction of figurines and music, the dance movements were composed. After its success in Stuttgart, the ballet was performed in other venues, such as Weimar and Berlin (1923). In 1926 it was included at the music festival in Donaueschingen with music by Hindemith played on the player piano. Schlemmer commented further on the symbolic significance of the triad:

> a dance of the threesome, ringing the changes on one, two, and three. One female and two male dancers: twelve dances and eighteen costumes. Other such threesomes are: form, color, space; the three dimensions of space: height, depth, breadth; the basic forms: ball, cube, pyramid; the primary colors: red, blue, yellow. The threesome of dance, costume, music.[45]

The artist saw the resemblance of the dancers to puppets (or marionettes) as a positive virtue, referring approvingly on more than one occasion to Heinrich von Kleist's essay '*Über das Marionettentheater*' ('On a Theatre of Marionettes') of 1810, which argued that aesthetically the movements of puppets were far superior to those of humans. Schlemmer felt that the theatre should aim not for verisimilitude, but rather for artifice, because 'the medium of every art is artificial'.[46] In the *Triadic Ballet*, artifice was expressed through the figurines' geometricizing abstraction of the human body, but also through the dancers' stylized movements as well as their masks – both features that reinforced the performers' similarity to marionettes.

As well as staged performances, Schlemmer's *Triadic Ballet* figurines were also shown in exhibitions, in the German section of the 1930 Paris *Société des Arts Décoratifs* (Society of Decorative Arts) exhibition (where Moholy-Nagy showed his *Light Prop*) and in 1938 at the Museum of Modern Art's 'Bauhaus' exhibition in New York. Although the exhibition of

Schlemmer's figurines undoubtedly produced an enhanced sense of their sculptural qualities, as static forms, the full impact of these figures would have been undermined. Schlemmer was keenly aware of the highly charged qualities of stage movement. In speaking of the new dances he had designed at the Bauhaus, he wrote:

> taking a step is a grave event, and no less so raising a hand, moving a finger. One should have deep respect and deference for any action performed by the human body, especially on the stage, that special realm of life and illusion, that second reality in which everything is surrounded with the nimbus of magic… [47]

Schlemmer believed that in devising 'new' dances, it was necessary to go back to basics, to reconsider the significance of the primary colours, textures and materials, as well as of movement. Such beliefs, which accorded with Bauhaus teaching (particularly on its famous *Vorkurs* or Preliminary Course), resulted in pieces such as the *Metal* and *Glass* dances, as well

as a performance in which poles were attached to dancers' bodies in order to extend their range of physical movement. In 1929 a number of Bauhaus dances were taken on tour through Germany and Switzerland, a dramatic means of conveying the Bauhaus ethos to wider audiences. These met with a varied critical response, with one reviewer in Basle commenting that 'it is a freed and freeing game … Pure absolute form', while a Frankfurt critic complained that 'We are sick and tired of having people clarify for us the "ABC of walking striding and running".'[48] Schlemmer himself viewed the wider public awareness of his dances as a crucial element in publicizing the Bauhaus.[49]

Schlemmer's contribution to performance at the Bauhaus was not limited to dance. He was also extensively involved in organizing the increasingly elaborate Bauhaus parties, which took place regularly at the school. (Weininger later referred to these 'festivities, fun and dances' as the "Fun Department of the Bauhaus".'[50]) The parties were usually given a theme that determined the decorations and costumes; in some cases these were either colours or materials, so again (as with Schlemmer's Bauhaus dances) were a kind of performative demonstration of the didactic principles that informed the school's teaching. For example, in 1926 Schlemmer helped organize the 'White Festival', which was 'four-fifths white and one-fifth color' (red, blue and yellow). Schlemmer conceived it in terms of white 'dappled, splotched, and striped'.[51] Three years later in 1929, the most elaborate party took place with the 'Metallic Festival' (pl.4.20). Originally construed as a festival of bells, the theme was enlarged to 'Metal' more generally, and included a fantastic display of spotlit gleaming metallic balls. Schlemmer described:

Steel chairs, nickel bowls, aluminium lamps, lovely cakes with a bit of glitter, and natural and unnatural art. But then on to the realms of true metallic pleasure. Bent sheets of foil glittered and reflected the dancers in distortion, walls of silvered masks and their grotesque shadows, ceilings studded with gleaming brass fruit bowls, everywhere colored metallic paper […].

The event offered numerous opportunities to confound the animate with the inanimate, especially at the joke level, as with 'a woman in flat metal disks who coquettishly wore a screwdriver on a bracelet and asked each new escort to tighten her loose screws'. But such parties also constituted a more telling form of transformation. In his diary Schlemmer wrote a poignant description of the Dessau building:

The Bauhaus looked lovely from the outside, radiating into the winter night. The windows were pasted on the inside with metallic paper; the white and colored light bulbs were concentrated according to room. The great block of glass permitted long vistas; and thus for one night this house of work was transformed into the 'high academy for creative form'.[52]

These parties attracted a certain amount of criticism both from within and without the school. Schlemmer's quasi-mystical image of the Bauhaus building decked out in its party finery, however, implies that the antics of the 'Metallic Festival' revealed the institution's higher purpose.

'Festivals' not only provided a way of promoting the Bauhaus; like dance, they offered a means of exploring contemporary issues, in particular the significance of the increasing industrialization of modern society. Schlemmer's Figural Cabinet, performed at the Jena Municipal Theatre in 1923 as part of the festival programme (Bauhaus week) that accompanied the Bauhaus's first major exhibition, is a key example. The artist described the performance as a 'mechanical cabaret':

The figural cabinet, part shooting gallery, part 'metaphysicum abstractum,' is a section of the stage, arranged with full, half, and quarter figures in relief, in multi, plain, or metallic colors. The figures are set in motion by invisible hands, and – with or without sound – walk, stand, float, slide, roll, or rollick for a quarter of an hour. Babylonian confusion, full of method, a potpourri for the eye, in form, style, and color.[53]

It involved figures in flat, colourful costumes on a travelator carrying out a series of 'grotesque' move-ments, which could be seen as a kind of parody of the assembly line, and of technology more generally.[54] The 'direction', specified by Schlemmer as Caligari – America and Oskar Schlemmer – Weimar, signalled the mass-production (America) and reproduction (film – Caligari) techniques that determined both the form and content of the performance. Like cabaret, this dance with its bizarre movements deployed humour as provocation.[55] It presented a rather different, more ambivalent concept of the assembly line than that implied by Meyerhold, who claimed that 'the labour process used by experienced workers always resembles the dance'.[56] During the 1920s the dancing body emerged as an important metaphor in debates on the relationships between art, visual culture and mass production. In his essay 'The Mass Ornament' published in 1927, the cultural critic Siegfried Kracauer focused on the Tiller Girls (whom he mistakenly identified as an American rather than an English dance troupe) to produce a powerful critique of the capitalist production process.[57] He claimed that the kaleidoscopic patterns formed by the Tiller Girls' legs were a re-enactment of the rhythmic and fragmented movements of assembly-line workers. Like the contemporary cult of physical training, Kracauer argued, such revues were a form of distraction for their audiences, 'the production and mindless consumption of the ornamental patterns divert them from the imperatives to change the reigning order'.[58] Léger, on the other hand (whose political views were broadly similar to those of Kracauer), saw a positive, even revolutionary potential in the 'girls': 'the thighs of fifty girls, rotating in

disciplined formation, shown as a close-up – that is beautiful and *that is objectivity*'.[59] In Léger's view, the fragmentation of the female body, further enhanced by the cinematic close-up, could jolt audiences into new levels of awareness.

For Modernist artists, however, even more than the 'girl' revues, it was the figure of Charlie Chaplin who most effectively embodied the period's complex and varied responses to the modern society that Kracauer scrutinized in his critique (see Chapter 8). Chaplin's appearance, with his battered bowler hat, baggy trousers and enormous shoes, was a hilarious travesty of the 'hats and spats' aesthetic of modern male dress advocated by Modernists such as Charles Baudelaire, Adolf Loos and Le Corbusier. The element of humour was crucial in engaging with serious political and social issues and enabled the actor's trademark performances to function as a kind of critique of the system from within the system. Chaplin's carefully executed movements both mimicked and distorted the rhythmic movements of the machine and of machine mass production. At the same time as being an internationally recognized movie star, he was clearly one of the most successful products of America's 'distraction factories' (to use Kracauer's term). Chaplin excited tremendous admiration and enthusiasm among artists. Léger saw Chaplin as a 'comic genius' and a master of beautiful, surprise effects, which relied on movement as opposed to speech.[60] Schlemmer felt that Chaplin was a kind of modern marionette who 'performs wonders when he equates complete inhumanity with artistic perfection' in his 'tragi-comic' performances.[61] In the Soviet Union, where film was regarded as an especially important post-revolutionary medium, he had an almost cult following among actors, artists and film-makers. The 1921 *Factory of the Eccentric Actor* manifesto, for example, proclaimed, 'we revere Charlie Chaplin's ass'.[62] The Constructivist artist Varvara Stepanova produced a number of drawings and prints of Chaplin (cat.73a), and his figure inspired many avant-garde film posters and magazine images, such as Stepanova's cover for a 1922 issue of *Kino-fot* (*Cinema-Photography*) (cat.73b).[63] Like Schlemmer, Léger appreciated the marionette-like aspect of Chaplin and appropriated the balletic potential of the actor's performance by according him a role in *Ballet mécanique*. Here, Chaplin appeared in the form of a jointed wooden doll, moving jerkily on the screen. Chaplin's surrogate appearance in *Ballet mécanique* is a perfect expression of the equivalence between the animate and inanimate, to which not only Léger but so many other artists and theatre designers aspired at this period.

By their nature, performances, parties and stage designs are intrinsically ephemeral.[64] Stage sets and costumes, as well as designs on paper, have in many cases been lost (and sometimes of course designs may not have been recorded on paper). When theatrical artefacts or photographs do survive, it is difficult to re-create the exact conditions of original performances, let alone the audience responses to them.[65] Even the most carefully researched reconstruction of dances and plays from this period can offer only a partial insight into the impact that such events created in their own time. In some cases, visionary concepts of a new stage – such as Kiesler's *Raumbühne*, Prampolini's *Magnetic Theatre* and Moholy-Nagy's *Light Prop* with its programme of coloured lighting – were presented at exhibitions, but never actually realized on stage. Such schemes were inspirational, even if they remained unrealized in the theatre. At the same time, it is clear that performance – whether as theatre, cabaret, dance or film – was vitally important to Modernist artists and designers. An engagement with the performing arts offered the means of challenging audiences' preconceptions and of raising aesthetic and political consciousness. In many cases, the experiments of avant-garde artists involved concepts of theatre as a widely shared, as opposed to an elite, experience, hence the recurring interest in the performative aspects of popular culture – circuses, funfairs, music halls and puppet shows – where viewers as well as performers play a crucial part in putting on a show. Whether as an invitation to audiences to eschew the role of passive spectator, or (as in the case of Schlemmer) through the spectacle of an inspirational harmony of man moving through space, performance was a vivid way of depicting utopian futures – visions of a reformed and improved world.[66]

In this respect, it is perhaps revealing that several of the more choreographed Bauhaus parties took place during Carnival, a holiday during which festivities traditionally enact an altered world, albeit in a temporary and humorous form. At the 'Metallic Festival' in February 1929 the foyer of the Bauhaus was decked out with a cascade of sparkling metallic balls hanging from the ceiling. Here Walter Funkat staged his dramatic photographic self-portrait (pl.4.28), which shows a distorted image of Funkat and the foyer reflected in one of the metallic balls, his left hand raised in a gesture of greeting. In this photograph the metal sphere becomes a kind of crystal ball, enabling the viewer to peer into a reconfigured world. The Bauhaus parties reveal something of the ludic qualities of Modernism and draw attention to the performativity of Modernist design and architecture more generally. The Funkat self-portrait is symptomatic of a wider tendency at the Bauhaus to use the building and its designs (particularly metallic artefacts) as the means of producing self-portraits. There are also many photographs of *Bauhäusler* (students and teachers at the Bauhaus) wearing Schlemmer dance costumes and masks posing on and around the Dessau building. A 1927 photograph by Erich Consemüller or T. Lux Feininger, for example, shows figures and a mask posed on the balconies and roof of the Bauhaus (pl.4.1).[67] Like the Funkat photograph, this is more than simply a piece of photographic documentation;

similarly, the Bauhaus building does not function merely as a stage set or backdrop.

The photographs play a dual role, on the one hand forging an identity for their protagonists through association with the Bauhaus, and on the other, presenting Bauhaus design as a means of changing the world (the photographic visual distortions suggesting the dynamism of change). Another photograph by Erich Consemüller shows a woman seated in Marcel Breuer's nickel-plated tubular-steel Club Chair. The figure wears a metal mask (as worn in Schlemmer dances), giving her an almost robotic aspect. Here again metal is associated with processes of transformation and modernization. By wearing the metal mask, the young woman in her stylish, modern short skirt is brought into close affinity with the spare elegance of Breuer's reformed version of the Club Chair. But even when not directly related to the theatre (as in the case of these Bauhaus examples featuring Schlemmer masks), in its own period there was a strong sense of Modernist design and architecture as a kind of performance, the means of play-acting the future and setting the scene for a new and improved world. (A sense enhanced perhaps by the fact that, whatever the aspirations, many Modernist designs were not immediately, or indeed ever, put into wider mass production.) Whether on stage, in the cinema or at home in the living room, Modernism in its many and various permutations was conceived as the stimulus for, as well as the product of, change. As Kiesler appreciated with his project for the *Raumbühne*, Modernism was necessarily an ongoing performance.

4.20 **Walter Funkat**,
Photographic self-portrait.
Gelatin silver print, 1929.
Bauhaus Archiv, Berlin

69 Plate 4.13

Painting: *Rhythm of a Russian Dance*

1918

Theo van Doesburg

(1883 Utrecht–1931 Davos, Switzerland)

Oil on canvas
135.9 × 61.6cm
The Museum of Modern Art, New York, acquired
through the Lillie P. Bliss Bequest (135.46)

The theme of dance had long been important for
Van Doesburg and for other artists associated
with De Stijl.[1] Writing in 1927 of the increasing
pace of cultural innovation, Van Doesburg charac-
terized the metropolitan individual attuned to the
new pace of modernity as 'modern, dancing man'
and (quoting Adolf Loos) as 'the human being
endowed "with modern nerves"'.[2] Around 1918
Van Doesburg painted a number of works with
dancers as the subject, including the lost
Tarantella.[3] Unlike *Tarantella*, where the
abstracted elements crossed and intersected
one another, those in *Rhythm of a Russian Dance*
remain discrete, neither intersecting nor touching.
The painting provided a model for Ludwig Mies
van der Rohe's plan for the arrangement of walls
in the interior of his unexecuted but seminal 1924

design for a Brick Country House (pl.5.24), and
for the interior of the German Pavilion at the 1929
Barcelona International Exposition, a building
that is like a stage set waiting for a performance.
The development of the painting can be seen in
a series of pen-and-ink drawings in which a
relatively realistic drawing of a dancing Russian
peasant with baggy trousers tucked into leather
boots is progressively abstracted into stick-like
elements.[4] This was the same process of abstrac-
tion that Van Doesburg applied in working towards
his well-known painting *Composition VIII* (*The Cow,
c.*1918) where a black-and-white Friesian cow is
abstracted through a series of Cubist-derived
stylizations into an asymmetrical composition of
brightly coloured rectangles.[5] PO

1 While living in Paris in the 1920s Mondrian became an adept (if
 idiosyncratic) performer of the Charleston and the Black Bottom.
2 Theo van Doesburg, 'Los van Duisland: Omkeer in constructivist-
 ische richting', *Het Bouwbedrijf*, vol.3, no.15 (November 1926),
 pp.477–9, trans. as '"Free from Germany": The Czech Struggle'
 in Theo van Doesburg, *On European Architecture: Complete
 Essays from* Het Bouwbedrijf *1924–1931* (Basle, 1990), p.129.
3 See Els Hoek (ed.), *Theo Van Doesburg: oeuvre catalogue*
 (Utrecht, 2000), pp.226–7.
4 The drawings are at MoMA. See 'Seven preparatory studies
 for *Rhythm of a Russian* Dance', Hoek (2000), pp.233–4.
5 Ibid., pp.215–18.

70 Plate 4.12

Mechanical Dancing Figure

1917, reconstruction 1984

Designed by Vilmos Huszár

(1884 Budapest–1960 Hierden,
The Netherlands)

Originally aluminium, paper and rope
h. *c.*100cm
Gemeentemuseum, The Hague

The *Mechanical Dancing Figure* was like a geometric
version of the traditional shadow puppets of
Indonesia – then a Dutch colony – which were
popular in the Netherlands (and elsewhere in
Europe) in the early years of the twentieth century.
It had hinged hands, arms and legs, so that it
could be placed in various positions. A sliding
plate in the head enabled it to be changed from
full-face to profile. Rectangular planes of red-
and-green translucent paper or mica were let into
the body. The puppet was controlled by a keyboard
attached to cords from the head and limbs. As
in Javanese shadow plays, a white sheet was
stretched between the puppet and the audience,
who sat in darkness. A strong light source was

placed behind the figure so that shadow and
colour were projected onto the sheet, delivering
an experience not unlike early silent cinema.
The performances that Huszár gave with the
mechanical figure were not intended to have a
narrative content, but he displayed it in different
positions creating a series of static compositions
produced by the shadow of the figure, the projected
colour planes and the white background. According
to Michael White, the *Mechanical Dancing Figure*
was a 'literal representation of the modernized
vision put in practice by Piet Mondrian and Theo
van Doesburg'.[1]

Huszár seems to have begun work on the
figure as early as 1917, when Van Doesburg wrote
in a letter to the poet Antony Kok that Huszár
had 'invented something totally new, a kind of
kinetic painting'.[2] The first performances were
given privately, but subsequently became well
known as part of the 'Dada tour' that Van Doesburg
presented to packed audiences in various Dutch
cities in early 1923. These performances were
given with his future third wife Petro (Nelly) van
Doesburg, who played Modernist pieces on the
piano, and Kurt Schwitters, who performed
his sound poems and barked like a dog.[3] Huszár
continued to give performances with the puppet
as late as the 1930s. PO

1 Michael White, *De Stijl and Dutch Modernism* (Manchester, 2003),
 p.39.
2 Van Doesburg, letter to Kok, 14 July 1917, quoted in Sjarel Ex,
 'Vilmos Huszár', in Carel Blotkamp et al., *De Stijl: The Formative
 Years, 1917–1922* (Cambridge, MA, 1986), p.95. Van Doesburg wrote
 in the newspaper *Het vaderland* on 23 February 1923 that Huszár
 had 'already advocated the possibility of a mechanical theatre
 piece in 1917, and had executed it fragmentarily'. Quoted by
 Ex in Blotkamp et al. (1986), p.119, n.21.
3 The pieces Nelly van Doesburg played included Eric Satie's
 Rag-Time, and Vittorio Rieti's *Funeral March of a Crocodile* and
 Military March of a Termite.

71a

Drawing: Set design for
The Magnanimous Cuckold
1922
Lyubov Popova (1889 Ivanovskoye,
Russia–1924 Moscow)
Ink, pen, watercolour and collage on paper

50 × 69cm
State Tretyakov Gallery, Moscow (PC12138 [no. 47112])

71b

Model: Stage set for
The Magnanimous Cuckold
Designed 1922, reconstruction date
unknown
Lyubov Popova (1889 Ivanovskoye–
1924 Moscow)

Wood, metal and gouache
58 × 113 × 70cm
Theaterwissenschaftliche Sammlung, Cologne University

71c Plate 4.5

Costume design: Actor No.7 for
The Magnanimous Cuckold
1921
Lyubov Popova (1889 Ivanovskoye–
1924 Moscow)

Pencil, gouache and cut paper
32.6 × 23.2cm
Merrill C. Berman Collection

The director Vsevolod Meyerhold intended the production of *The Magnanimous Cuckold* to be revolutionary in its style of acting and in the setting, which – for the first time in Russia – abolished the proscenium arch and the conventional framing of the acting area.[1] Conceived as the first Constructivist theatrical production, the play was developed by the GVYTM (State Higher Theatrical Workshops) in difficult financial circumstances and, following the closure of Theatre RSFSR No.1, the need to confront the problem of a production without a stage. It was finally performed at the Nezlobin Theatre in Moscow and opened on 15 April 1922.

Fernand Crommelynck's play had no revolutionary content, but was a farce about a miller who is so jealous that he forces his wife to commit adultery, which leads her eventually to run away to enjoy happy monogamy with another man. The system of acting, devised by Meyerhold and called 'biomechanics', was inspired by Taylorism (see Chapter 3) and the utopian concept that in a socialist society acting would simply be another means of production and an integral aspect of social life in which all labour would be joyful. Arguing that emotional states have a physiological basis, Meyerhold rejected psychological insight in favour of stylized gestures derived from the *commedia dell'arte*, dance and gymnastics. These turned the actor from being an emotionally complex personality into a more mechanized entity, who would convey emotion and awaken responses in the spectator through his physical actions.[2]

While the actor became a robot, the set became a machine for acting. The play was set in a water mill, which the Constructivist Popova transformed into a multi-levelled skeletal apparatus, with platforms, revolving doors, ladders, scaffolding, wheels and a chute. This free-standing structure was set on the stage with no backcloth, emphasizing its self-sufficiency and the fact that it could easily be disassembled and re-erected anywhere (even in the open air). The set was also perfectly suited to the performance of biomechanics, and even facilitated this new style of acting, by providing a plethora of gymnastic devices within an overall framework. Indeed, the apparatus became an active participant in the drama (almost like another actor), with the wheels rotating at particularly emotional moments during the action.

Popova had been teaching at the GVYTM since spring 1921 and had collaborated with Meyerhold and the architect/painter Alexander Vesnin on a projected – but unrealized – mass festival (involving some 2,500 performers) to be produced in the open air in celebration of the Congress of the Third International in May 1921.[3] Popova had been reluctant to produce the set for *The Magnanimous Cuckold* because she feared discrediting Constructivism with a design that was not fully resolved. In the interim, members of the Working Group of Constructivists, Konstantin Medunetskii, Georgii Stenberg and his brother Vladimir, had been consulted and provided some ideas (for example, the chute for the wife's lovers), which Popova subsequently adopted.[4] She had also benefited from ideas put forward by Sergei Eisenstein and a model made by Vladimir Liutse.[5]

In her costume designs for the play, exemplified here by her clothing for Actor No.7, Popova rejected the tradition of elaborate and individualistic costumes. In line with Meyerhold's concept of the actor as worker, she dressed all the characters in almost identical overalls or *prozodezhda*, a term that literally means production clothing or work clothes (see cats 41–5, 71, 83, 84). These were made of blue cloth and consisted of shirts, skirts for the women and jodhpurs for the men. They were intended to facilitate the actors' energetic and rather acrobatic movements on stage, but they also served to give the actors a collective identity. Prominent individual characters were given accessories in accordance with their role. Hence Actor No.7, the chauffeur, was given a cap and cape, while Actor No.5, the nurse, was provided with an apron. As Popova explained, she had been concerned to translate the problem from the aesthetic to the production plane, and to use the occasion to experiment with structures that could be developed further within the real world. This was particularly true of the costumes. Her designs initiated a great deal of experimentation with clothing for the Soviet citizen while working, playing sports and even relaxing.[6] To this extent, the theatre was treated as a laboratory for utopia, an ideal micro-environment and an arena for experimentation with design. CL

1 Vsevolod Meyerhold, 'The Magnanimous Cuckold', in Edward Braun (ed. and trans.), *Meyerhold on Theatre* (London, 1969), p.204.
2 Vsevolod Meyerhold, 'Biomechanics', in Braun (1969), pp.197–200.
3 René Fülop-Miller, *The Mind and Face of Bolshevism: An Examination of Cultural Life in Soviet Russia* (London, 1927), pp.145, 148–9.
4 Dimitri V. Sarabianov and Natalia L. Adaskina, *Popova* (London, 1990), pp.250–51.
5 Nancy Van Norman Baer, *Theatre in Revolution: Russian Avant-Garde Stage Design 1913–1935* (exh. cat., Fine Arts Museum of San Francisco, 1991), p.76.
6 Christina Lodder, *Russian Constructivism* (New Haven, 1983), p.5.

71a

71b

72a

**Drawing: Costume designs for
the *Triadic Ballet***
1926
Oskar Schlemmer (1888 Stuttgart–
1943 Baden-Baden)

Black ink, gouache, metallic powder, graphite and
typewritten collage elements
38.6 × 53.7cm
Busch-Reisinger-Museum, Harvard University Art
Museums, Museum Purchase (BR50.428)

72b Plate 4.18

Costume: Diver for the *Triadic Ballet*
1922, this version 1985
Oskar Schlemmer (1888 Stuttgart–
1943 Baden-Baden)

Metal, fabric, celluloid and glass
190 × 90 × 90cm
Bühnen Archiv Oskar Schlemmer,
collection C. Raman Schlemmer (FTB 1 R)

72c Plate 4.19

Costume: Disc for the *Triadic Ballet*
1922, this version 1967/85
Oskar Schlemmer (1888 Stuttgart–
1943 Baden-Baden)

Wood, papier mâché, paper and fabric on stainless steel
206 × 80 × 108cm
Bühnen Archiv Oskar Schlemmer,
collection C. Raman Schlemmer (FTB 14 R)

72d Plate 4.1

**Photograph: *Bauhaus dances.
The Bauhaus as stage***
1927
Erich Consemüller (1907 Vienna–
1928 Tel Aviv) or T. Lux Feininger
(born 1910 Berlin)

Gelatin silver print
62.6 × 33.5cm
Bühnen Archiv Oskar Schlemmer,
collection U. Jaïna Schlemmer

72e

**Poster: *Das Triadische Ballett
(The Triadic Ballet)***
1924

Lithograph, coloured with tempera, mounted on board
81 × 56cm
Bühnen Archiv Oskar Schlemmer,
collection U. Jaïna Schlemmer

'I have reason to believe that this ballet job brought out an aspect of me which usually remains invisible; I felt transformed and struck people as being very different. The new artistic medium was a much more direct one: the human body.'[1] Schlemmer described his impressions after the first public dance performance of parts of what would eventually become the *Triadic Ballet*.[2] Little is known about this performance. One reviewer in a local newspaper remarked, 'There was dance – but this time not a cliché. A cubist joke, based on an idea by the futurist Oskar Schlemmer, joyfully performed by Elsa Hötzel and Albert Burger. Two marionette figures in grotesque style, with three pleasant piano pieces by Marco Enrico Bossi. This is something which could elevate the whole evening.'[3]

Schlemmer met the two dancers, Albert Burger and Elsa Hötzel, while studying at the Akademie der Künste (Academy of Visual Arts) in Stuttgart. Inspired by a performance of Arnold Schoenberg's songs for *Pierre Lunaire*, they started working on a ballet as early as 1912. Despite Schlemmer's military service during the First World War, he continued working on the ballet. His ideas centred on the phenomenon of space and the representation of the human figure moving in space.[4] Thus he focused on abstracting the human body into geometric shapes that suggested the simplified form of a puppet or marionette. By the end of 1919 Schlemmer was concentrating on making the costumes for the piece and began rehearsals with Burger and Hötzel. In contrast to their pre-war idea of a jointly conceived narrative, Schlemmer now introduced the idea of an abstract costume ballet without a story.

When Walter Gropius invited Schlemmer to join the Bauhaus in July 1920 as director of theatre activities, he was at first reluctant to accept the appointment and did not move permanently to Weimar until June 1921 owing to his desire to complete the ballet. The *Triadic Ballet* premiered in Stuttgart on 30 September 1922.

Based on the principle of trinity, the *Triadic Ballet* consisted of three acts performed by three participants in 12 dances with 18 costumes in total. Each of these three acts was governed by a different colour, corresponding to the mood of each of the sections: '…first a burlesque, picturesque mood; second an earnest, festive one; and finally heroic monumentality'.[5] The drawing of the costume designs offers a visual explanation of the triadic division: the page is divided into three vertical columns representing the three acts and their colours: yellow, pink and black. These columns are split horizontally into 12 rows representing the 12 dances. Each row illustrates the dancers participating in each dance. The rows therefore detail the number of dancers in a dance as well as the types of costume.

For Schlemmer, the costumes were the most important component of the *Triadic Ballet*: 'For me

the costumes are everything: mummery.'[6] In the process of developing the ballet, 'First came the costume, the figurine. Then came the search for the music which would best suit them. Music and the figurine together led to the dance.'[7] The costumes were constructed from a diversity of materials, including papier mâché, wood, glass and metal, as well as stuffed and padded fabrics. These materials were formed into geometrical shapes, such as spheres, semi-spheres, cylinders, discs, spirals and ellipses.

The 'Diver' appears in the second dance of the 'Yellow series' (first act) in a duet with the figurine 'Round Skirt'. In the original version of 1922 this dance was performed to the music 'Pantomima', op.102, no.7 by Bossi. Only the feet of the diver moved freely. Indeed, it was a general characteristic of the costumes that dancers were physically only able to make a limited number of movements, which Schlemmer later described as 'the first consequential demonstration of spatially-plastic costumery'.[8] As the movement of Diver is limited to 'an uncertain tracing of floor patterns, lines, circles, and triangles, and a series of bows, turns, and wide leglifts', the figure interacts with 'Round Skirt' and yet remains isolated.[9]

Two male 'Disc' dancers appear in the 'Black series' (last act) of the ballet in similarly shaped but different-coloured costumes, of which only one colour scheme can be reconstructed from the sole surviving disc costume and other evidence. This costume divided the dancer's body by means of a papier-mâché disc, which reached from the top of the dancer's head to below the waist. Head and torso were cut out of the disc, which was divided into orange and violet on one side and silver and gold on the other. The dancer was dressed in a black leotard and tights and wore a head mask also of papier mâché. The hands were covered with silvery hard-rubber balls into which rods could be fixed on either side, to form a pole. The dance with the Disc costume could be described as energetic walking and running, accompanied by a swinging of the pole. Sudden turns and alterations of direction created colour changes that, combined with the black backdrop and stage lighting, achieved fantastic and super-natural effects.

The striking use of mechanical features resulted in the dancers appearing to act like puppets or marionettes. Schlemmer's intention was to constrain the body with the costume rather than to reduce the dancers to the status of robots or automatons, in contrast to artists like Alexandra Exter, Alexander Vesnin and Ivo Pannaggi.[10] Despite the technological associations evoked by the shapes and materials of the costumes and his acknowledgement of the possibility of a completely mechanized performance, Schlemmer argued that in order to have meaning, man's presence was required on stage. He wrote, 'Not machine, not abstract – always man!'[11]

The *Triadic Ballet* was performed for a second

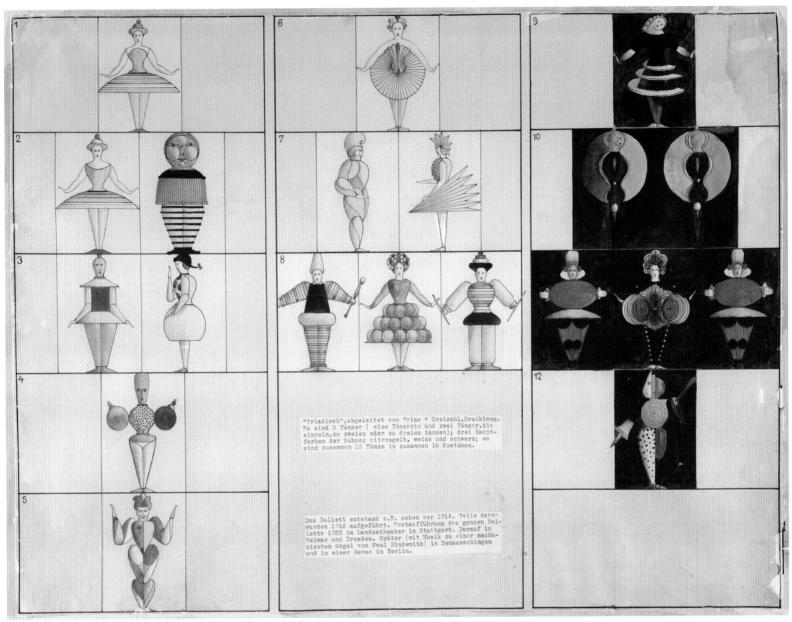

"Triadisch", abgeleitet von Trias = Dreizahl, Dreiklang.
Es sind 3 Tänzer (eine Tänzerin und zwei Tänzer, die
einzeln, zu zweien oder zu dreien tanzen); drei Haupt-
farben der Bühne: citrongelb, weiss und schwarz; es
sind zusammen 12 Tänze in zusammen 18 Kostümen.

Das Ballett entstand z.T. schon vor 1914. Teile davon
wurden 1916 aufgeführt. Uraufführung des ganzen Bal-
letts 1922 im Landestheater in Stuttgart. Darauf in
Weimar und Dresden. Später (mit Musik zu einer mecha-
nischen Orgel von Paul Hindemith) in Donaueschingen
und in einer Revue in Berlin.

72a

time in connection with the 1923 Bauhaus exhibition in Weimar.[12] In the autumn of 1923 Schlemmer drew up a programme of study for the Bauhaus theatre workshop which showed his determination to strike a balance between man and the machine, as well as figuration and abstraction. Technology in and of itself was not his goal, but only a means towards a higher end. His intention was to find a universally appropriate, standardized figural form.[13] Given the lack of a stage at the Bauhaus in Weimar, Schlemmer concentrated on 'formal matters' such as mobility, portable backdrops, mechanical effects and lighting. Later he experimented with various interior and exterior spaces as stages. The photograph by T. Lux Feininger or Erich Consemüller from 1929 shows the Bauhaus in Dessau as backdrop and stage for Schlemmer's dancers (pl.4.1). Feininger remarked, 'The most outstanding of these [special occasions at the Dessau Bauhaus] was the grand enactment of

Oskar Schlemmer's cherished dreams of using the total Bauhaus architecture – roofs, balconies, terrace – for the outdoor staging of his *Mensch im Raum* [Men in space] idea, his humanistic symbol of the mission of art. Everybody able to point a camera and press a shutter showed up for this demonstration.'[14] JS

1 Schlemmer in a letter to Otto Meyer-Amden, 11 February 1918; Tut Schlemmer (ed.), *The Letters and Diaries of Oskar Schlemmer* (Middletown, CN, 1972).
2 The performance was held at a charity event organized by Schlemmer's regiment in December 1916 in the Stadtgarten in Stuttgart.
3 'Schwäbischer Merkur', 8 December 1916, trans. in Dirk Scheper, *Oskar Schlemmer – The Triadic Ballet* (Berlin, 1985), p.7. The music mentioned was by the contemporary Italian composer Mario Enrico Bossi.
4 These ideas were his first attempts towards a fundamental reform of theatre. For a detailed discussion, see Nancy J. Troy, 'The Art of Reconciliation: Oskar Schlemmer's Work for the Theater', in Arnold L. Lehman and Brenda Richardson (eds), *Oskar Schlemmer* (exh. cat., Baltimore Museum of Art, 1986), p.139.

5 Oskar Schlemmer in a letter from Weimar to Hans Hildebrandt on 4 October 1922; trans. in Scheper (1985), p.11.
6 Oskar Schlemmer in a letter to Otto Meyer-Amden on 7 August 1920; trans. in ibid., p.9.
7 In the original version of *Triadic Ballet* a mixture of compositions from three centuries was used, 'a makeshift affair' according to Scheper. Ibid.
8 Oskar Schlemmer, 'Stage Elements' lecture (1931), quoted in Karin von Maur, *Oskar Schlemmer: Sculpture* (New York, 1972), p.43.
9 Scheper (1985).
10 See Juliet Koss, 'Bauhaus Theater of Human Dolls', *Art Bulletin* (December 2003).
11 Schlemmer (1972), p.116.
12 Following this, the *Triadic Ballet* was performed in 1923 in Dresden; in 1926 in Donaueschingen, Frankfurt am Main, Berlin; in 1927 in Dessau; and in 1932 in Paris. No information has been found regarding the 1924 performance advertised in the Leibnitz-Akademie poster. One reason for the difficulties in performing the ballet was a major dispute between Schlemmer and Burger/Hötzel as early as 1923. For details, see Scheper (1985), pp.23–34.
13 The ideas of this concept are to be found in Schlemmer's essay 'Man and Art Figure', in Walter Gropius (ed.), *Theatre of the Bauhaus* (Middletown, CN [1924] 1966), pp.17–46.
14 T. Lux Feininger, notes for an exhibition catalogue, Prakapas Gallery, New York, November 1980, as quoted in Lehman and Richardson (1986), p.180.

72e

73a

Drawing: *Charlie Chaplin Turning Somersaults*

1922

Varvara Stepanova (1894 Kovno, Russia–1958 Moscow)

Pen, pencil and ink on paper
15 × 13cm
Private Collection

73b

Cover illustration: *Kino-fot (Cinema-Photo) No.3*, 19–25 September 1922

Varvara Stepanova
(1894 Kovno, Russia–1958 Moscow)

Letterpress offprint
29.5 × 22.5cm
Private Collection

In 1922 Stepanova executed a large series of drawings of Charlie Chaplin, 10 of which were reproduced in the journal *Kino-fot*, including one that was reproduced on the cover. Although woodcuts for publication were normally cut by professionals, Stepanova personally executed blocks for the *Chaplin* series of prints.[1] The magazine was published and edited by her fellow-Constructivist, the writer Alexei Gan, and, while pursuing a broadly Constructivist line, it promoted film and photography as the new means of responding to proletarian emotions and acting as an instrument of 'social technology', channelling those emotions towards the creation of the new world.[2]

This particular issue of *Kino-fot* was devoted to Chaplin, and included appreciative articles by the film-maker Lev Kuleshov, the theatre director Nikolai Foregger, and the artist Alexander Rodchenko, who was Stepanova's partner and a founding member of the Working Group of Constructivists. Each praised Chaplin from their own perspective, for his acting, clowning and constructive movements, recognizing his value for the Russian theatre, cinema and the fine arts. Rodchenko's text suggests that Stepanova and the Constructivists admired Chaplin's artistry precisely because it embodied accuracy and economy of gesture and did not require extensive props. They also appreciated his integrity and his ordinariness, which, for them, epitomized the common humanity of the masses. Rodchenko stated that Chaplin's 'colossal achievement in precision and clarity is the result of a strong relationship to the present day – to the war, revolution and communism'. For Rodchenko, technology and communism were the two important factors determining the nature of the future ruling masses and, in the efficiency of his movements and his mastery of detail, Chaplin embodied the qualities of the future man.

Stepanova's black-and-white drawings convey these qualities effectively by focusing on the body and the tools of Chaplin's trade: his cane and his bowler hat. She has simplified his physique, transforming it into a series of bold geometric forms and distilling the poses and movements into vital combinations of rectangular planes. The sparse quality of the visual language parallels Chaplin's economy of gesture. The geometricization, which had been a consistent feature of Stepanova's paintings since 1920, evokes what the writer Victor Shklovsky had called the mechanical qualities of Chaplin's movements.[3] In this way Stepanova's images emphasize the actor's links with the industrial proletariat and the Soviet masses, who adored him. The drawings also indicate the affinities that the Constructivists identified between Chaplin's art and their own. CL

1 Alexander Lavrentiev, *Varvara Stepanova: A Constructivist Life* (London, 1988), pp.104–9.
2 Alexei Gan, 'The Cinematograph and the Cinema' (1922), in Richard Taylor and Ian Christie (eds), *The Film Factory: Russian and Soviet Cinema in Documents 1896–1939* (Cambridge, MA, 1988), pp.67–8.
3 Victor Shklovsky, 'Literature and Cinema' (1923), in Taylor and Christie (1988), pp.98–9.

73a

73b

74a Plate 4.9

Design for *Light Prop for an Electric Stage*
1922–30
László Moholy-Nagy (1895 Bácsborsod, Hungary–1946 Chicago)

Collage on top of a blue print, glazed paper, ink and tempera
60.5 × 59.5cm
Theaterwissenschaftliche Sammlung, Cologne University

74b Plate 4.10

Photograph: *Lightplay: Black/White/Grey*
1930
László Moholy-Nagy (1895 Bácsborsod–1946 Chicago)

Gelatin silver print
37.4 × 27.4cm
The Museum of Modern Art, New York, gift of the photographer (295.1937)

74c Plate 4.11

Photograph: *Lightplay: Black/White/Grey*
1930
László Moholy-Nagy (1895 Bácsborsod–1946 Chicago)

Gelatin silver print
37.4 × 27.4cm
The Museum of Modern Art, New York, gift of the photographer (297.1937)

Film: *Lightplay: Black/White/Grey*
1930
László Moholy-Nagy (1895 Bácsborsod–1946 Chicago)

6 mins, silent, black and white, Germany/Soviet Union

Moholy-Nagy was renowned for introducing technology into the varied forms of art he practised. His activities included photography, film, theatre, typography, industrial and advertising design. Around 1922 Moholy-Nagy formulated his first ideas about the making of a three-dimensional mobile object that he called *Lichtrequisit einer elektronischen Bühne* (*Light Prop for an Electric Stage*).[1] The *Light Prop* was a kinetic device that was neither meant to exist as an object-sculpture nor as a construction *per se*. As an electrically driven, rotating kaleidoscope, projecting ever-changing patterns of light, shadow and colour in a darkened space, the machine was intended to create light displays for theatre, dance or other performance spaces.[2] Contained within an illumi-

nated box with an opening to permit the projection of light displays on a screen or upon a stage, it 'served as an experimental apparatus for "painting with light"'.[3] To obtain visually rich results, the moving shapes or elements needed to be transparent. This was achieved through the use of plastics, glass, wire-mesh and perforated metal sheets. In *Vision in Motion* Moholy-Nagy described the *Light Prop*:

> The model consists of a box in cubic form, dimensions 120 × 120 centimetres, with a circular opening towards the stage, in front. Surrounding this opening on the back of the sheet a number of electronic bulbs were mounted, yellow, green, blue, red and white … In the interior of the box, parallel to the front side, there is a second sheet, also provided with electronic bulbs of various colours ranged round the opening. Solitary bulbs flash up in various places. According to a pre-arranged plan they illuminate a mechanical device which is in constant movement … in order to attain the projection of shadow-forms as linear as possible on the rear wall of the closed box.[4]

Moholy-Nagy worked on the *Light Prop* throughout his years as a teacher at the Bauhaus in the 1920s. The machine was finally constructed after his resignation from the Bauhaus in 1929, and was displayed for the first time at the '*Section allemande*' (German section), organized by the *Deutsche Werkbund*, at the twentieth annual *Salon de la Société des Artistes décorateurs* in Paris in 1930 (cat.184).[5] Despite having worked on the *Light Prop* for more than 10 years and having envisaged the effects, the first activation of the machine was a revelation for Moholy-Nagy:

> The mobile was designed mainly to see transparencies in action, but I was surprised to discover that shadows thrown on transparent and perforated screens produced new visual effects, a kind of interpenetration in fluid change. Also unexpected were the mirrorings of the moving plastic shapes on the highly polished nickel and chromium-plated surfaces. These surfaces, although opaque in reality, looked like transparent sheets when moving. In addition, some transparent wire-mesh flags, having been placed between differently shaped ground and ceiling planes, demonstrated powerful, irregular motion illusions.[6]

Having finally built his machine, Moholy-Nagy wished to explore its aesthetics in a medium ideally suited to recording the properties of pure light. He was fully aware that the light-sensitive layer of the photographic paper would capture the complex texture of moving elements. With its gleaming and reflective glass, and metal surfaces of mobile perforated discs, a rotating glass spiral and a sliding ball, the *Light Prop* created the effect of photograms in motion.[7] Thus Moholy-Nagy

took a series of photographs of the *Light Prop*, cutting off its top and bottom, and focused on the abstractions of light and the geometric forms of the machine. By emphasizing these intricate interactions of materials and moving parts, he created a complex and lively composition of light and shadow, forms and materials. In the photographs, the complexity of the design and the shapes created by light and shadow convey the dynamic possibilities of both machine and camera.

In 1928 Moholy-Nagy started to work on a film, entitled *Lichtspiel Schwarz-Weiß-Grau* (*Light Play: Black/White/Grey*).[8] The use of film offered further visualization of the *Light Prop*. He described the film as showing light in its most varied ways. However, the real subject of the film was the setting up of the *Light Prop* in the workshop and the recording of its infinitely varied mutations of light and shadow during its operation.[9] *Light Play* was originally planned as a film consisting of different parts, but only the last was filmed. The other parts were supposed to show different forms of light in set combinations: the self-lighting match, car headlights, reflections, moonlight, coloured projections with prisms and mirrors and the production of the *Light Prop*. The last part of the 'scenario' reads:

> Shadows of the rotating light prop; super-imposition of shadows on metal details.
> The light prop rotates; from above, normal, accelerated, retarded rotation.
> Positive, negative; over-setting diaphragm.
> View through a narrow aperture.
> Automatically moving masks.
> Tricks; alterations.
> The whole is revolving so quickly that everything is dissolved in light.[10]

The realized film displays the *Light Prop* in motion showing the light and movement in a cinematic abstraction.[11] According to Passuth, 'The film is the apotheosis of the machine produced by itself.'[12] The film demonstrates the importance of the connection of light and shadow as the formal basis of film, much in the same way as it was the foundation of photography. Hence, in accordance with Moholy-Nagy's overall design theory, the film reveals the connections between one art form and another.

The *Light Prop* expresses Moholy-Nagy's profound interest in the relationship between man and technology, and the articulation of light and space; or, as Joseph Harris Caton writes, the *Light Prop* 'represents in many ways the quintessential expression of his [Moholy-Nagy's] search for dynamism in art.'[13] Like the earlier experimental kinetic sculptures of Russian Constructivists Vladimir Tatlin, Naum Gabo and Antoine Pevsner, or his Bauhaus associate Ludwig Hirschfeld-Mack, Moholy-Nagy's concern was that his machine should not be confined to the static and three-dimensional, but that it should incorporate a 'fourth dimension' of time and motion.[14] JS

1 See László Moholy-Nagy, 'Lichtrequisit einer elektronischen Bühne', in *Die Form*, vol.5, no.11–12 (1930), p.297.
2 Although the *Light Prop* was designed as a moving light structure or kinetic stage 'scenery' that could act as backdrop for drama productions or film, it was never used as such. See Joseph Harris Caton, *The Utopian Vision of Moholy-Nagy* (Michigan, 1984), p.83.
3 László Moholy-Nagy, *Vision in Motion* (Chicago, 1947), p.288.
4 Moholy-Nagy (1930), p.297.
5 During 1928 and 1931 Moholy-Nagy was mostly involved in stage design, predominantly for the innovative Krolloper and the progressive theatre of Erwin Piscator in Berlin. He built the *Light Prop* in collaboration with the artist-engineer Ivstvan (Stefan) Seboek. It was made by Otto Ball in the theatrical department of the AEG company, which served as sponsor. See Veit Loers, 'Moholy-Nagy's "Raum der Gegenwart" und die Utopie vom dynamisch-konstruktiven Lichtraum', in *Laszlo Moholy-Nagy* (exh. cat., Kassel, 1991), pp.37–51.
6 László Moholy-Nagy, *The New Vision* (1928, 3rd revised edn 1946) and *Abstract of an Artist* (New York, 1946), pp.74–5. The *Light Prop* as it exists today represents only the mechanical centrepiece of a much larger kinetic device. Part of it, much restored, is in the collection of the Busch-Reisinger Museum, Boston; reproductions from 1970 are owned by the Bauhaus Archiv, Berlin, and the Van Abbemuseum, Eindhoven.
7 Moholy-Nagy acknowledged the photogram as a method for recording manipulated light sources. The 'abstract seeing' of the photogram 'by means of direct records of form produced by light' would result in the development of what he called 'optical formalism'. From Moholy-Nagy, 'A New Instrument of Vision', *Telehor* 1 (1936), p.35.
8 The script dates from 1928–30 and had two versions. It was first published in 1931 in Hungarian under the title *Fényjáték-Film* [*Light Display Film*].
9 Moholy-Nagy had intended to make a colour film, but it was never realized. See Krisztina Passuth, *Moholy-Nagy* (London, 1985), p.56.
10 Moholy-Nagy, 'Fényjáték-Film', *Korunk*, no.12 (1931), p.867; trans. in Passuth (1985), p.317.
11 See Hans Scheugl, Ernst Schmidt Jr, 'Eine Subgeschichte des Films', *Frankfurt/M.* (1974), p.611f., trans. in Angelika Leitner and Uwe Nitschke (eds), *The German Avant-Garde Film of the 1920s*, (exh. cat., Munich, 1989), p.54.
12 Passuth (1985), p.56.
13 Caton (1984), p.66.
14 For a discussion of the Russian influences, see Eleanor Hight, *Picturing Modernism: Moholy-Nagy and Photography in Weimar Germany* (Cambridge), p.93. An interpretation of the *Light Prop* as 'cosmic machine' and device for the representation of the 'fourth dimension' is provided by Veit Loers, 'Moholy-Nagy und die vierte Dimension', in Gottfried Jäger and Gudrun Wessing, *Über Moholy-Nagy* (Bielefeld, 1997), p.162.

75

Film: *Le Ballet mécanique* (*Mechanical Ballet*)
Directed, photographed and edited by Dudley Murphy (1897–1968) and Fernand Léger (1881 Argentan, France – 1955 Gif-sur-Yvette, France)

c.12 mins, silent (accompanying music by George Antheil, 1925), black and white (some copies tinted)
France, 1924

Introduced by an animated puppet of Charlie Chaplin, this film represented the most concentrated and radical attempt to demonstrate what Fernand Léger termed a 'new realism' in film, built out of fragments of machinery and everyday objects, as a 'direct reaction against films with stories and stars'.[1] Amid images of hats, bottles, gear wheels, a piston, geometric shapes, kitchen implements and a pair of window-dresser's dummy legs, all edited in rapidly alternating 'mechanical' patterns, several human figures appear, performing equally repetitive movements: a woman on a garden swing, a washerwoman carrying her load up steep steps, and a woman's face performing different expressions in close-up.

Objects of all kinds are made to dance in a new filmic choreography inspired by passages in Abel Gance's *La Roue* (1922, cat.48); while in the most extended episode a newsreel-style title, 'A 5-million franc pearl necklace has been stolen', is parsed into its constituent visual elements with playful punning on the necklace shape of the zeros and their similarity to a horse collar.

First shown by Friedrich Kiesler as part of his International Exhibition of New Theatre Techniques (*Internationale Ausstellung Neuer Theatertechnik*) in Vienna in 1924 (see Chapter 4), the film was modified before its Berlin debut the following year, soon followed by screenings in London, New York and possibly Moscow, before it was finally shown in Paris in 1926. A number of significantly different versions are known to exist; and a percussive musical score was prepared as accompaniment in 1925 by the American composer George Antheil, then being promoted by Ezra Pound. Pound has sometimes been credited with instigating the project with his fellow-Americans in Paris, Man Ray and Dudley Murphy.[2]

Creative responsibility for the film has usually been attributed to Léger, based on the importance of 'mechanical elements' in his painting and writings of the 1920s, as well as his involvement with film projects by Abel Gance and Marcel L'Herbier. Revisionist scholarship has more recently claimed that Murphy, a skilled cameraman with half a dozen experimental films to his credit before Man Ray introduced him to Léger in 1924, carried out most (if not all) of the actual film-making.[3] What is not in doubt is the film's profound influence on most subsequent attempts to explore the 'specificity' – or, in Léger's term, 'plasticity' – of the filmed image independently of narrative. IC

1 Fernand Léger, 'Autour du "Ballet mécanique"', an undated manuscript thought to have been written in 1924–5, which appeared for the first time in the 1965 collection of Léger's writing *Fonctions de la peinture*. Quotations from the edition by Sylvie Forestier (Paris, 1996), pp.133–4.
2 John Alexander, 'Parenthetical Paris, 1920–1925: Pound, Picabia, Brancusi and Léger', in Richard Humphreys (ed.), *Pound's Artists* (London, 1985), pp.106–113.
3 The most extreme claims for Murphy as sole author have been made by William Moritz, for instance in his essay 'American in Paris: Man Ray and Dudley Murphy', in Jan-Christopher Horak, *Lovers of Cinema: The First American Film Avant-Garde, 1919–1945* (Madison, 1995), pp.120–30. For more nuanced discussion of this issue, see Standish Lawder's seminal *The Cubist Cinema* (New York, 1975), ch.4–7; and Judi Freeman, 'Léger's *Ballet mécanique*', in Rudolf E. Kuenzli, *Dada and Surrealist Film* (New York, 1987), pp.28–45.

76 Plate 4.8

Scene design: *Man at the Control Panel*
1924
Kurt Schmidt (1901 Limbach, Germany–
1991 Gera, Germany)

Tempera, ink and metallic paint
34 × 50.5cm
Bauhaus Archiv, Berlin (BHA 3893)

While a student in the Theatre Workshop at the Bauhaus and under the tutelage of Oskar Schlemmer, Schmidt became part of a group that included, among others, Georg Adams-Teltscher and Xanti Schawinsky, and with whom he designed a series of scenic compositions between 1923 and 1924. Inspired by the juxtaposition of the machine and the human figure, the best known of this series is *Mechanical Ballet* (1923), a play in which actors moved geometric panels around the stage.

A slightly later and more complex design is *Man at the Control Panel*, a theatre piece from the 1923–4 series.[1] About 30 minutes in length, it was first performed on the fifth anniversary of the Bauhaus, on 19 November 1924. The design shows an engineer in front of a central control panel, which Schmidt, in a later description of the piece, referred to as the 'centre of the senses'.[2] One of five male actors, the engineer is portrayed as a powerful creator without individuality, whose increasing powers change him into a demonic robot.[3] His head, face and particularly his hands appear already transformed and adapted to the technical processes that he triggers. Activation of the control panel causes various figures to appear against a black backdrop; some abstract and geometric, such as the two-dimensional figure at the centre of the design, and others more figurative and costumed. The accompanying music was provided by Friedrich Scherber and his assistants, largely on home-made instruments.[4] The style of dance and, according to Schmidt, the music expressed the character of the diverse figures.[5] Schmidt's figures bear resemblance to geometric paintings, such as those by Willi Baumeister (pl.3.19), and to costumes designed by Oskar Schlemmer (pls 4.1, 4.18, 4.19). The piece ends with the figures turning against the now-demonic engineer, who eventually disappears in an exploding cloud of smoke. JS

1 It is called a 'pantomime' in Marina Bistolfi, 'Il Laboratorio teatrale del Bauhaus e I suoi animatori', in *Ricerche di Storia dell'Arte*, no.25 (1985), which includes Schmidt's own brief description of the piece, based on a 1979 interview.

2 Kurt Schmidt in a letter from 1 October 1973 to Dirk Scheper. Frank Whitford (ed.), *The Bauhaus: Masters and Students by themselves* (Woodstock, NY, 1993), p.177.
3 Éva Forgás, *The Bauhaus Idea and Bauhaus Politics* (Budapest, 1991), pp.124–5.
4 Peter Hahn (ed.), *Experiment Bauhaus* (exh. cat., Bauhaus Dessau, 1988), p.266, cat.210.
5 Bistolfi (1985), p.73.

77 Plate 4.17

Book: *Abeceda* (*Alphabet*) by Vitězslav Nezval
Prague 1923, this version 1926
Designed by Karel Teige (1900 Prague–
1951 Prague)
Photographs by Karel Paspa
(1862 Libcany, Bohemia–1936 Prague)

Letterpress on paper
30.5 × 47cm (open)
Abeceda Antiquariat, Munich

The book *Abeceda* is a composite of experimental poetry, modern dance, graphic design and photo-montaged typography, based on a poem by Vitězslav Nezval in the order of the letters of the Latin alphabet. Each double page features a set of quatrains facing a sometimes abstracted letter composed of a photograph of the dancer Milca Mayerova and typographic elements.

Nezval wrote the poem in late 1922, inspired by 'the intellectual gymnastics afforded by poetry's most immediate object: letters'.[1] He concentrated on letters primarily for their visual suggestiveness. Thus the opening line to many quatrains focuses on an image from which he then develops his themes and associations; for example, 'A' is introduced as a 'simple hut', 'C' as the moon.

Mayerova (a student of the Laban method, see cat.172) based her choreography, consisting of about three to four poses per quatrain, on Nezval's verses rather than conceiving an independent interpretation.[2] For 'H', she figured the simple act of respiration described in the text. Her pose has also been read as a 'triumphant step of an emancipated "modern woman" in the parlance of the time'.[3] Mayerova's outfit – a dark, sleeveless top and shorts with a stripe on both sides, topped by a tightly fitted cap of the same design – furthers heightens this emphasis. The photographs by Paspa record one pose each, matching with the line of the poem that provides the visual association for each letter.

Teige remarks in his seminal credo 'Moderní typo' ('Modern typography'): 'In Nezval's *Abeceda*, a cycle of rhymes based on the shapes of letters, I tried to create a "typofoto" of a purely abstract and poetic nature, setting into graphic poetry what Nezval set into verbal poetry in his verse, both being poems evoking the magic signs of the alphabet.'[4] In his layout Teige respects the integrity of the text, but also plays with it, as well as with photographs of the dancer and the letters themselves. He was not trying to illustrate the words through images or typography, but in this book of poetry sought to foster a similarly poetic dialogue between text and images. The entire project thereby explored the relationships between verbal and visual art, industrial technology and mass media in a new way.[5] JS

1 Vitězslav Nezval in the short preface to the 1926 edition, Nezval, *Abeceda* (Prague, 1926), pp.3–4; trans. in the facsimile edition: Vitězslav Nezval, *Alphabet* (Michigan, 2001).
2 Mayerova performed a number of stage versions of *Alphabet* accompanying recitations of the poem during the 1920s in Prague. The first performance was held at a theatrical evening in honour of Nezval in April 1926.
3 Matthew S. Witkovsky, 'Staging language: Milca Mayerova and the Czech book Alphabet', *Art Bulletin* (March 2004), p.129.
4 Originally published in *Typografia* 34 (1927), pp.189–98, and trans. in Karel Teige, 'Modern Typography' in Erich Dluhosch and Rotislav Švácha (eds), *Karel Teige 1900–1951: L'Enfant Terrible of the Czech Modernist Avant-Garde* (Cambridge, MA, 1999), p.105.
5 By doing so, *Alphabet* closely associated itself with the spontaneous and playful 'art of living' embraced by the Czech avant-garde group Devětsil in the 1920s. The poem was published in the first issue of Devětsil's journal *Disk* in December 1923, alongside the first official mention of Poetism. See Karel Srp, 'Karel Teige in the Twenties: The Moment of Sweet Ejaculation', in Dluhosch and Švácha (1999), p.23.

78

Costume design: Small robot Elektron, for *The Man Who Was Thursday* (*Chelovek kotoryi byl Chetvergom*)
1923
Alexander Vesnin (1883 Yur'evets, Russia–1959 Moscow)

Gouache on paper
50 × 69cm
The Bakhrushin State Theatrical Museum, Moscow

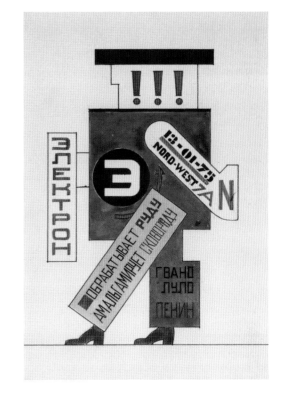

The Man Who Was Thursday was adapted from G.K. Chesterton's witty story of an anarchist conspiracy in late nineteenth-century London, in which the leading terrorist, called Thursday, is a detective and a poet. The script was written by Gleb Krzhizhanovsky, and the play was directed by Alexander Tairov and first performed at Moscow's Kamerny Theatre on 6 December 1923.[1] The set was conceived as a free-standing skeletal structure, like Lyubov Popova's stage design for *The Magnanimous Cuckold* (cat.71), but it was far more complex, incorporating two elevator shafts, moving platforms, mobile lighting, advertisements and posters. It represented a dynamic and mechanized modern city with all its resonances of industry and engineering. For the performance, Tairov kept the proscenium arch so that the audience saw only a fragment of the whole set,

amounting to what looked like the façade of a Constructivist building.[2] The drawings and the model display the set's full architectural presence and the extent to which it comprises a paradigm of architectural possibilities for the new urban environment, as well as anticipating the articulation of Constructivist designs for actual buildings. Indeed, Vesnin's set informed his later designs, such as those for the Leningrad Pravda Building (1924, pls 3.17–18) and Moscow Telegraph Office (1925).

The costumes were of enormous variety, usually brightly coloured with strong sculptural qualities. Some were based on contemporary Western clothing, but others reflected potentially new types of clothing and new ways of living. Elektron was one of five robots, which performed a live advertisement during the course of the play.[3] Each robot was a dramatic conglomeration of different geometric entities and colours, and was covered in writing. Their bodies proclaimed the merits of electricity, declaring that radios run on it, it cures rheumatism, extracts teeth and stitches shoes. While the arms of each robot held telephone numbers, the legs were given the names of different cities, such as Petrograd, Moscow, Yokohama, Chicago, Berlin, London, New York, Paris and Peking. CL

1 Nancy Van Norman Baer, *Theatre in Revolution: Russian Avant-Garde Stage design 1913–1935* (exh. cat., The Fine Arts Museums of San Francisco, 1991).
2 Selim O. Khan-Magomedov, *Alexandr Vesnin and Russian Constructivism* (London, 1986) pp.100–101, 103–110.
3 All five are reproduced in ibid., pp.106–107, 110.

79 Plate 4.14

Drawing: *Mechanical Stage-Revue, Phase I–III*
1926
Andor Weininger (1899 Karancs, Hungary–1986 New York)

Pencil, gouache, watercolour, ink and gold bronze on cardboard
40.4 × 56.6cm (mounted)
Theaterwissenschaftliche Sammlung, Cologne University

The Hungarian-born Weininger is still relatively unknown compared to other Bauhaus designers. He studied at the Bauhaus from 1921 to 1925, predominantly in the workshop of Wassily Kandinsky. After the move of the Bauhaus to Dessau in 1925, his main activities were within the Theatre Workshop collaborating with Oskar Schlemmer in designing stage sets and producing the famous 'Bauhaus Dances'.[1]

The *Mechanical Stage-Revue* was one of Weininger's most significant experimental

projects.[2] Based on the idea of moving abstract colour forms, rather than actors, across a stage, Weininger intended to develop dynamic, kinetic-mechanical sequences of movement. In the drawing, change and motion are represented by three different stages in time, during which the coloured bands of rectangles move. The annotations on each of the three drawings describe the movements as follows:

> Phase I: Movement of coloured bands: horizontal from right to left and opposite, vertical from top to bottom and opposite; Phase II: Movement of coloured bands as above. Movement of coloured side backdrops from front to back and from back to front (changes in colour); Phase III: Movement of bands, backdrops and soffits (scrolling movement). Changes in colour. Movement of carpets (blue-grey) in opposite direction. Alternations in floodlights. Progression.

The attempt to animate the stage with mechanical, abstract forms was in tune with the Bauhaus's interest in synthesizing the various arts into a *Gesamtkunstwerk* and in bringing together

technology with new aesthetics. Weininger developed his ideas for the *Mechanical Stage-Revue* in subsequent designs, extending early, relatively static versions by adding figurines into the renderings and finally elucidated the entire concept in elaborate exhibition panels.[3] JS

1 Weininger's interest in theatre and stage concepts was stimulated by a job as copy editor, stage designer and musician at the cabaret *Die Jungfrau* in Hamburg in 1923.
2 His stage design can be traced back to 1922, when he was deeply influenced by Theo van Doesburg and the aesthetic ideas of De Stijl. Indeed, the *Mechanical Stage-Revue* has been called a 'moving de Stijl painting'. See Emilie Norris, 'Andor Weininger: A Summary Chronology', in Peter Nisbet, *Andor Weininger: Works in the Busch-Reisinger-Museum* (Cambridge, MA, 2000), p.12.
3 Examples of these include the *Abstract Revue of Moving Surfaces* (Mechanical Theatre), 1926–8, at the Busch-Reisinger-Museum (1996.317) and one version with figurines at the Metropolitan Museum of Art, New York (1992.217.7). Other designs are in the Theatre Collection of the University of Cologne. See *Weininger in Wahn* (Cologne-Wahn, 1999).

80a and 80b

Drawing: *Colour scheme of floor and long walls of Cinema-Dance Hall*
probably 1928
Designed by Theo van Doesburg
(1883 Utrecht–1931 Davos, Switzerland)

Ink, gouache and metallic gouache on paper
53.3 × 37.5cm
The Museum of Modern Art, New York, Gift of Lily Auchincloss, Celeste Bartos and Marshall Cogann 1982 (391.1982)

Van Doesburg's Cinema-Dance Hall (*Ciné-dancing*) for the Aubette – a complex of cafés, restaurants and entertainment rooms in the centre of Strasburg – was designed as a dynamic arena for dancing, drinking and watching films. It was one of the main public rooms on the first floor and was decorated with diagonal rectangles of colour.[1] This drawing, almost certainly done after the completion of the decoration, does not exactly correspond to the design and colours as executed. The top of the drawing shows the colour scheme for the wall opposite the windows, the middle shows the colour scheme for the floor, and the lower part that for the window wall (which was not realized).

The diagonal decoration of the ceiling and three of the walls is offset by a number of orthogonal elements: the long windows on the external wall, the rectangular grilles that hid the radiators, the mirrors placed above them, the doors at either end of the room, the horizontal balcony with metal railings along the wall opposite the windows, the six concrete alcoves on either side of the dance floor in which tables and chairs were placed, and the rectangular cinema screen on the end wall. Van Doesburg wrote in an article in a Dutch architectural magazine in 1929: 'Since both windows and doors and all other elements which interrupted the walls had a strong orthogonal emphasis, this room was eminently suitable for an oblique independent arrangement of the colour capable of resisting the tension of the architecture.'[2]

The orthogonal forms could be seen as elements of equilibrium in this otherwise restless composition, which abstractly and diagrammatically evoked the dancing human figures on the dance floor and the moving human images on the cinema screen. However, the windows looking out onto the busy place Kléber, the mirrors reflecting both the movements of the dancers and the dynamic diagonal colour composition on the opposite wall, and the screen onto which the moving images of films were projected, were all potentially as dynamic as the slanting rectangles of clashing, dissonant colours, and greys and whites of Van Doesburg's diagonal decorations.

The Cinema-Dance Hall was an arena for various kinds of performance: the represented performance on the screen, the live performance of the dance band and of the Aubette's clients dancing on the dance floor. Even eating or drinking at the tables in the alcoves on either side of the dance floor would have felt like taking part in a performance.

The Aubette commission had initially been offered to Hans (Jean) Arp and his wife Sophie Taeuber-Arp in 1926.[3] The Arps sought assistance from Van Doesburg, whom they knew through the Dadaist activities and publications he had been involved with since 1920 and which he regarded as complementing (rather than in competition with) his De Stijl activities. Van Doesburg effectively took charge of the project, assigning to himself the design of the most important rooms and every detail of the building's interior equipment, down to the ashtrays and the electrical fuse boards. Nevertheless, the Aubette was such a major undertaking that both Arp and Taeuber-Arp also had substantial spaces to decorate. Although well received in the local Strasburg press, the designs of Van Doesburg and the Arps were unpopular with the Aubette's clientele from the start, and the proprietors began to change them almost immediately.[4] PO

1 The decoration was similar to one of Van Doesburg's best-known easel paintings *Countercomposition XVI* (1925, Gemeentemuseum, The Hague), also known as *Countercomposition of Dissonance*.
2 'De ombeedling van de Aubette te Straatsburg' ('The Reconstruction of the Aubette in Strasburg'), *Het Bouwbedrijf*, no.6 (1929), p.121, quoted in English translation in Cees Boekraad, 'Style and Anti-Style', in *Het nieuwe Bouwen: De Stijl. Neo-Plasticism in Architecture* (Delft, 1983), p.79. See also Theo van Doesburg, 'Notes on L'Aubette at Strasbourg', translated in Hans. L C. Jaffé, *De Stijl* (London, 1970), pp.233–4, originally published in *De Stijl*, vol.VIII, no.87–9 (1928), Aubette Issue.
3 Arp was a native of Strasburg, and Taeuber-Arp had painted a mural in the house of Paul Horn, one of the Aubette's proprietors.
4 Apparently the Swiss artist and designer Max Bill visited the Aubette in 1930 and found it already much changed. (Cited in Angela Thomas Jankowski, *Taeuber-Arp, 1889–1943* (Ascona, 1983), p.17.) Within a few years the interiors had been completely altered or covered over. The Cinema-Dance Hall and the Large Ballroom compositions were rediscovered, largely intact, in the late 1980s and restored in the early 1990s.

81

Isometric drawing: *Total Theatre for Erwin Piscator*, Berlin
1927
Designed by Walter Gropius
(1883 Berlin–1969 Boston)
Isometric drawing by Stefan Sebök

Ink, colour wash, spatter paint
82.8 × 108.4cm
Busch Reisinger Museum, Harvard University Art Museums, Gift of Walter Gropius (BRGA.24.90)

Erwin Piscator developed an approach to staging political theatre that emphasized a 'total' exposure of the audience to action all around them, as well as the use of back-projected film and images. Following Piscator's resignation in 1927 from the *Volksbuhne* theatre in Berlin, as a result of political pressure, he looked around for means to found his own theatre. He had already approached Gropius in spring 1927 with the idea of designing a 'total theatre'. 'What I had in mind was a theatre machine, technically as perfectly functional as a typewriter, an apparatus that would incorporate the latest lighting, the latest sliding and revolving scenery, both vertical and horizontal, numerous projection boxes, loudspeakers everywhere, etc.'[1]

Gropius responded with a design informed by the experience of experimental theatre at the Bauhaus. László Moholy-Nagy had written an article in the Bauhaus book *The Theatre of the Bauhaus* entitled 'Theater, Circus, Varieté', in which he wrote about a future 'theatre of totality' and a 'total stage action'.[2] The plan that Gropius and his assistant Sebök worked out was designed to offer the option of surround theatre and a more conventional proscenium stage. Raked seats were provided in one half of an oval plan, while the other end was taken up by a very large revolving platform incorporating a circular stage and further seating. By revolving the turntable, the latter could either continue the line of seating or surround the stage with seating. Behind this platform were three stages arranged in an arc to embrace the first rows of seats. Projection screens could be slung between the columns. Walkways, for the staging of processions or choirs, were provided both outside and inside the audience. The project fell through and Piscator set up his company in the Nollendorf theatre, where he produced a series of spectacular settings. Gropius tried to patent the principle of the Total Theatre and was said to be upset when Piscator later claimed a share in the design. TB

1 Erwin Piscator, *The Political Theatre* (London, [1963] 1980), p.179.
2 Cited by Winfried Nerdinger, *Walter Gropius* (Cambridge, MA, 1985), p.94. See also Walter Gropius (ed.), *The Theater of the Bauhaus* (Baltimore, [1924] 1996).

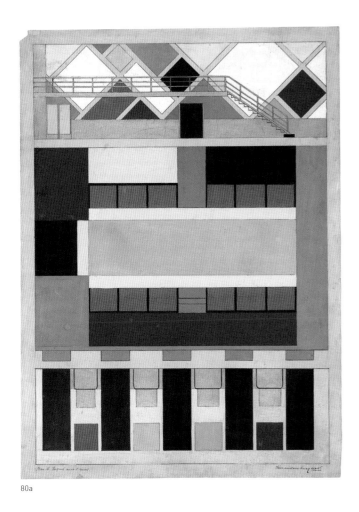

80a

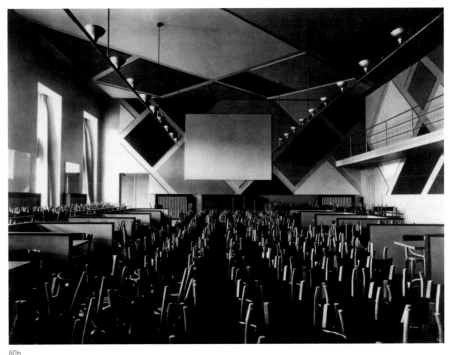

80b

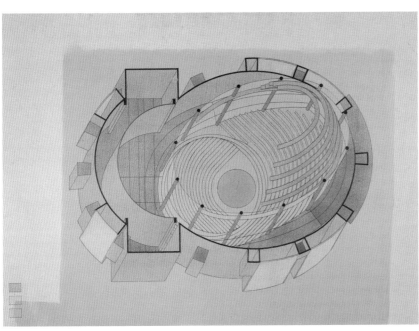

81

82a Plate 4.15

Drawing: Stage design for *Pictures at an Exhibition*, Picture II, *Gnomus* (Gnome)
*c.*1928
Wassily Kandinsky (1866 Moscow–
1944 Neuilly-sur-Seine, France)

Indian ink, watercolour and gouache on paper
20.6 × 36.1cm
Musée nationale d'art moderne, Paris, bequest of Nina
Kandinsky 1981 (AM 8 1-65-124)

82b Plate 4.16

Drawing: Stage design for *Pictures at an Exhibition*, Picture XVI, *The Great Gate of Kiev*
*c.*1928
Wassily Kandinsky (1866 Moscow–
1944 Neuilly-sur-Seine)

Indian ink and gouache on paper
21.3 × 27.1cm
Musée nationale d'art moderne, Paris, bequest of Nina
Kandinsky 1981 (AM8 1-65-133)

Kandinsky's abstract theatre piece based on
Modest Mussorgsky's *Pictures at an Exhibition*
premiered at the Friedrich Theatre in Dessau on
4 April 1928. This commission resulted in designs
for 16 scenes created from lighting effects and
moving geometric shapes, lines and colours,
following the music of Mussorgsky.[1] With the
exception of two scenes in which two dancers
were involved, the whole stage set and performance
were abstract, both in the absence of artists as
well as in the avoidance of naturalistic represen-
tation and illustration. Kandinsky never intended
to create new images for Mussorgsky's music, nor
was he aiming to evoke the naturalistic drawings,
watercolours and paintings of Victor Hartmann
that had inspired Mussorgsky's music. Instead,
Kandinsky's designs represent his only realized
stage experiment for a new form of theatre. His
theory of synthesis, the idea of a 'totally synthetic
work of art' as formulated in his book *On the
Spiritual in Art*, shaped these stage designs.[2]
In this text Kandinsky defined synthesis as a
phenomenon of transposition that transformed
experiences from one sensation into another – in
this case, sound impressions triggering visual
colours and shapes. Mussorgsky's *Pictures at an
Exhibition*, which itself represented a transposition

from visual to aural art, was an ideal vehicle for
the Bauhaus painter. Kandinsky's design used
the following principal resources: '1. form itself,
2. colour and form, to which, 3. the colour of the
lighting was added as a kind of more profound
painting, 4. the independent play of the coloured
lights, and 5. the structure of each scene, which
was bound up with the music, and of course the
necessity of dismantling it.'[3] In each scene, trans-
lating musical into pictorial events, Kandinsky
constructed and deconstructed an image,
depicted in his design drawings.[4]

In *Gnomus*, the second picture after the intro-
duction *Promenade*, the scene was created by
the following process: horizontal lines flash up in
front of a black background. Then vertical lines,
a white background and a small black figure
appear, followed by a coloured figure together
with a latticed figure. In the next sequence a circle
illuminated from the inside is lowered onto the set.
After this the whole set disappears for a moment,
the horizontal and vertical lines re-emerge and
finally all parts of the scene become visible. After
a short period of very strong light the stage goes
dark.[5] The design drawings do not represent a
backdrop for a scene (as is traditional in stage
sets), but rather the entire scene, with all of its
elements on stage at the same time. Movement,
the most essential aspect of the performances,
is missing.

In the closing scene, *The Great Gate of Kiev*,
seven different forms create the scene, including
a castle on a hill. This scene can be considered
less abstract than the others, as it uses forms
resembling Russian churches with onion domes.
However, the dramatic change of light (the scene
ends with bright, red light) is the most influential
element in this scene. After watching the perform-
ance in Dessau, Ludwig Grote, conservator at the
town's picture gallery, described his impressions:
'The effect of individual acts was large and magical
. . . You could feel the drama, the effectiveness of
shapes and colours. The floating, gliding and
standing of the shapes, the changing of the colours
depending on the type and intensity appeared as a
dramatic sequence full of excitement.'[6] JS

1 Kandinsky himself described his work in the periodical *Das
 Kunstblatt*, vol.XIV, no.8 (1930), p.246, trans. in Wassily Kandinsky,
 Kandinsky: Complete Writings on Art (London, 1982), p.750.
2 Wassily Kandinsky, *On the Spiritual in Art* (New York, [1912] 1946).
3 Kandinsky (1982) p.751.
4 See Ludwig Grote, 'Bühnenkompositionen von Kandinsky',
 in *i10, Internationale Revue*, vol.2, no.13 (1928), pp.4–5.
5 See Jessica Boissel (ed.), *Wassily Kandinsky: über das Theater =
 du théâtre = o teatpe* (Cologne, 1998), p.294.
6 Ibid. p.5.

83

Drawing: Costume design for *I Want
a Child! Milda* (*Khochu rebenka!*)
1929
El Lissitzky (Elezar Lisitskii)
(1890 Pochinok, Russia –1941 Moscow)

Watercolour, pencil and collage on pasteboard
35.5 × 52.9cm
The Bakhrushin State Theatrical Museum, Moscow
(180169/1442)

In 1926 the director Vsevolod Meyerhold decided
to stage Sergei Tretyakov's play, *I Want a Child!*
(1926), which confronts the problem of creating the
new Soviet society. The heroine, Milda, a fervent
communist and a rationalist, decides to remain
single, but to have a child, who is to be fathered
by a politically pure proletarian and is then to
be relinquished and brought up in a collective
nursery.[1] This controversial subject caused
difficulties with the state censor and it was 1929
before El Lissitzky was commissioned to design
the sets and costumes.

Lissitzky's vision involved reconstructing the
theatre's interior, so that the auditorium would
merge with the stage in order to allow full inter-
action between the actors and the audience, and
facilitate the discussion element of the envisaged
production.[2] Meyerhold was delighted by the
design with its spiral staircase, ramps, bridges,
moving lights and transparent stage floor, but
decided to postpone its execution until his new
theatre was built. In the event, this never happened,
and so Lissitzky's set was never realized and the
play was never performed.[3]

In all his costume designs, Lissitzky used
photographs in order to emphasize the agitational
nature of the play and stress the relationship
between contemporary reality and the future
Soviet society. The working men's overalls, or
prozodezhda, possess a strong collective quality
(see cats. 41–5, 71, 84). They are emblazoned with
'TM' (presumably denoting Meyerhold's Theatre –
Teatr Meierkholda) and numbers indicating each
actor's identity. Milda's simple belted jacket and
skirt match her rationalism, while her briefcase
indicates her business-like attitude, and her cap,
socks and shoes emphasize her lack of glamour
and frivolity. She stands above a photograph of
skinny present-day Soviet children, who contrast
with the single plump baby, who stands for the
future. Yakov, the selected proletarian, wears
overall trousers and a loose blouson jacket. CL

1 See Sergei M. Tretyakov, *I Want a Baby* (Birmingham, 1995).
2 Edward Braun, *The Theatre of Meyerhold: Revolution on the
 Modern Stage* (London, 1979), pp.224–5.
3 Peter Nisbet, *El Lissitzky 1890–1941* (Cambridge, MA, 1987),
 pp.40–41.

84a

Costume design for *The Bedbug*, Filter Attendant

1929

Designed by Alexander Rodchenko
(1891 St Petersburg–1956 Moscow)

Ink, colour pencil, applications, white colour on black paper
41.7 × 29.6cm
The Bakhrushin State Theatrical Museum, Moscow

84b

Costume design for *The Bedbug*, Zoo Attendant

1929

Alexander Rodchenko
(1891 St Petersburg–1956 Moscow)

Ink, colour pencil, applications, white colour on black paper
41.7 × 29.6cm
The Bakhrushin State Theatrical Museum, Moscow

The Bedbug, written by the poet Vladimir Mayakovsky and directed by Vsevolod Meyerhold with music by Dmitrii Shostakovich, opened on 13 February 1929 after only six weeks' rehearsal. The comedy stressed the danger that the Soviet petit bourgeoisie posed to the realization of a communist utopia. The first part mercilessly satirizes this new class, which had emerged during the New Economic Policy, instituted in 1921 to resuscitate the economy by allowing small-scale private enterprises to flourish, alongside state-owned heavy industry. In the second part of the play, set 50 years later in 1979, a frozen Ivan Prisypkin, a former party member and proletarian, who has married into the Soviet bourgeoisie, is defrosted along with a bedbug. Prisypkin has to come to grips with a hygienic, technologically advanced and utopian Soviet Union. It is for this section about the future that the Constructivist designer Rodchenko was commissioned (at the suggestion of Mayakovsky) to design the set and costumes.[1]

Rodchenko used minimal structures on the stage to evoke the essential qualities of a future environment: lightness, transparency and simplicity. The sparse sets complemented the streamlined and pale-coloured bedbug costumes. Together, the sets and costumes were intended to show how the petit bourgeoisie might imagine the future and, for this reason, the designs echo the text in possessing a strong element of parody.[2]

The costumes were more developed than the sets, indicating strong continuities with the earlier concept of *prozodezhda* or production clothing (cats 41–5, 71, 83). This is particularly evident in the scientists' costumes or overalls, which combine utility with comfort, simplicity and minimal

84a

decorative detail. The lines are, however, much more fluid than the starkly rectilinear cut that Rodchenko used for his own worker's suit of 1922 and Lyubov Popova employed for her actors' clothing in *The Magnanimous Cuckold*.[3]

The yellow costume with a mask attached is clearly intended for one of the attendants responsible for cleaning the filters of the cage in which Prisypkin and the bedbug are eventually put on display at the zoo, as *Bourgeoisus vulgaris* and *Bedbugus normalis* respectively. The filters on the cage catch all the obscene language and other forms of contamination that exude from the two creatures. A bedbug is emblazoned on the chest of the other costume, suggesting that it was for one of the zoo attendants responsible for the bedbug's welfare. CL

1 Edward Braun, *The Theatre of Meyerhold: Revolution on the Modern Stage* (London, 1979), pp.230–33; and Konstantin Rudnitsky, *Russian and Soviet Theatre: Tradition and the Avant-Garde* (London, 1988), pp.206–7.
2 Selim O. Khan-Magomedov, *Rodchenko: The Complete Work* (London, 1987), pp.197–203.
3 Christina Lodder, *Russian Constructivism* (New Haven, 1983), pp.146–51, 170–73.

85 Plate 1.8

Photograph: *Machine Dance, Moscow Ballet School*
1931
Margaret Bourke-White
(1904 New York – 1971 Darien, USA)

Gelatin silver print
35.2 × 49.5cm
Jane Corkin Gallery, Toronto

In 1930 photojournalist Bourke-White was sent by the American business magazine *Fortune* to document the Soviet Five-Year Plan. Said to have been the first foreign photographer allowed to work in the USSR, she was invited back the following year by the Soviet government, which clearly approved of her glorification of the machine (pl.3.13, cat.263) and of her heroic images of labour. Her photograph of students at the Moscow Ballet School was not a diversion from her self-described task of documenting 'a nation trying to industrialize almost overnight', but an example of what she called Soviet ' Machine worship'.[1]

This worship took many forms, including representations of machines and mechanization on the stage (see, for example, pl.1.4, pl.3.15 and cat.71). In terms of dance, the most influential was the 'Dance of the Machines' choreographed by Nikolai Foregger (1892–1939), which premiered in Moscow in 1923.[2] Foregger had no dance training and believed deeply in agitational and popular theatre. Intended for the variety stage (Foregger's chosen milieu), the dancers evoked the form and actions of machines through their geometric, syncopated movements, accompanied by an orchestra that made machine noises. During his 1923–4 season, Foregger produced a series of other machine dances, including the 'Constructive Hop' and 'Viewing American from Leigova'.[3]

Although the Moscow Ballet School was forced to embrace Soviet ideology and practices after the revolution, it seems unlikely that it ever embraced Foregger's music-hall approach to dance and his emphasis on unballetic, exaggerated and (literally) acrobatic movement. While the photograph may well have depicted the 'Dance of the Machines', and clearly shows Foregger's profound influence on Soviet dance, its precise subject remains undocumented.[4] CW

1 Margaret Bourke-White, *Portrait of Myself* (London, 1964), pp.90, 95.
2 See Mel Gordon, 'Foregger and The Dance of the Machines', *Drama Review*, vol.19 (1975), pp.72–3, and Natalya Sheremetyevskaya, 'The Search for New Dance Forms on the Variety Stage in the USSR 1920–1930', in G. Oberzaucher-Schüller, *Ausdruckstanz: Eine mittleeuropäische Bewegung der ersten Hälfte des 20. Jahrhunderts* (Wilhelmshaven, 2004), pp.423–4. The latter writes that the concept of Machine Dances was brought from Paris by the poet Valentin Parnakh, though perfected by Foregger. Elizabeth Souritz, 'Constructivism and Dance', in *Theatre Revolution: Russian Avant-garde State Design 1913–1935* (exh. cat., Fine Arts Museums of San Francisco, 1991), p.137, describes the two as working in parallel.
3 Gordon (1975), p.73.
4 Souritz (1991), p.137, illustrating the Bourke-White photo on the previous page, implies it is the 'Dance of the Machines'.

MOTTO: SIMULTANÉITÉ

Tim Benton

5

Building Utopia

The new artist does not imitate, he creates. He does not describe, he designs. What does he design? New values for life. And life is not only materialistic, as romanticists of utility try to present it, but is spiritual as well.[1]

Theo van Doesburg
Hrvatska Revija (*Croatian Review*)
(1931)

5.1 **Cornelis van Eesteren**,
Competition design for a
shopping street with housing
above in Den Haag, 1924
(cat.87)

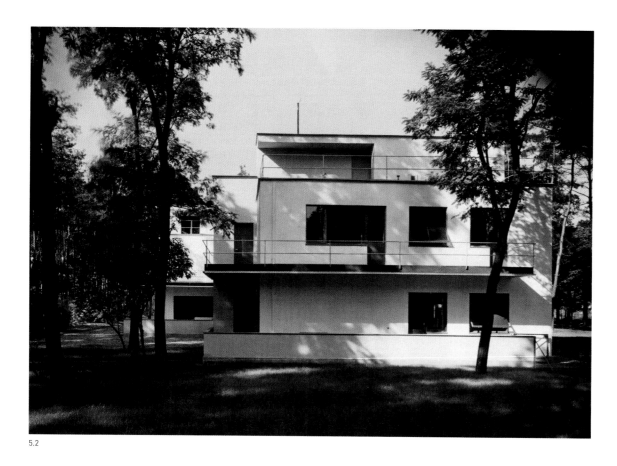

5.2

5.3

5.2 **Lucia Moholy**, Masters' houses, Dessau, east view of one of the Twinhouses, 1926. Bauhaus Archiv, Berlin

5.3 **André Lurçat**, House Guggenbuhl near Montsouri Park, Paris, 1926–7. Collection Alberto Sartoris

5.4 **Eileen Gray** and
Jean Badovici, E1027,
Roquebrune-Cap-Martin,
1926–9. Collection Alberto
Sartoris

5.5 **Le Corbusier** and **Pierre
Jeanneret**, Single and
double houses, Weissenhof
Housing Estate, Stuttgart,
1927. Collection Alberto
Sartoris

5.4

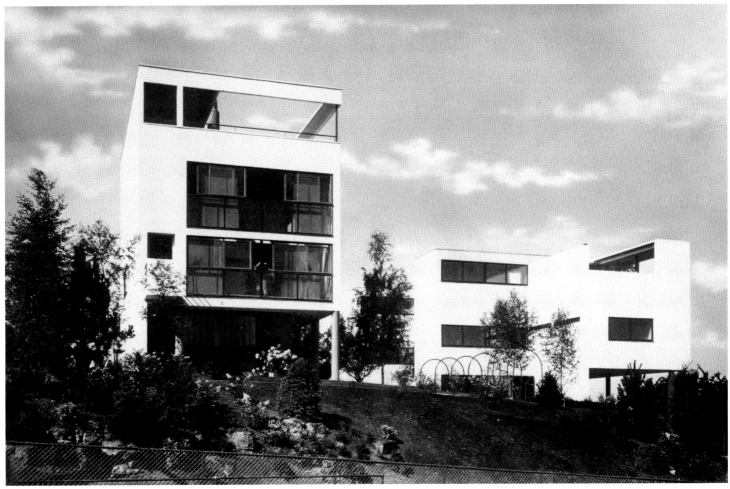

5.5

5.6

5.6 **Hannes Meyer**,
The Co-op room, Basle, 1926.
Bauhaus Archiv, Berlin

5.7 **Marcel Breuer**,
Dining room of the Piscator
apartment, Berlin, 1927.
Photograph by Sasha Stone.
Ullstein Bild

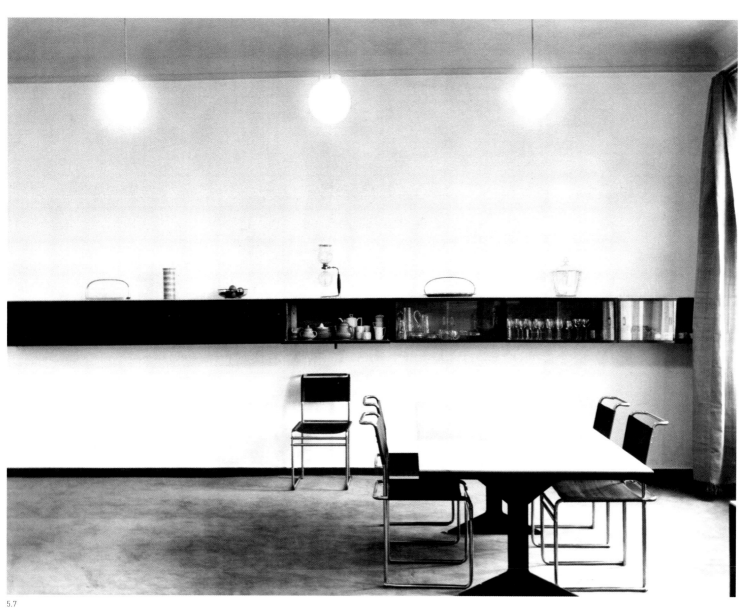

5.7

5.8 **Adolf Rading**, Living room of Rading house, Weissenhof Housing Estate, Stuttgart, 1927. Stadtarchiv, Stuttgart

5.9 **Luigi Figini** and **Enrico Pollini**, Atelier-Villa of an artist, Milan Triennale, 1933. Collection Alberto Sartoris

5.8

5.9

153

Between 1923 and 1928 a group of buildings began to appear across the world that looked broadly similar and appeared to follow the same principles of design (pls 5.1–4).[2] As reproduced in books and magazines, these buildings were typically white, with undecorated, geometric forms characterized by flat roofs, block-like compositions, striking projections and overhangs interspersed with large expanses of glass. To contemporaries, these buildings could be defined most vividly by what they were not. They belonged to none of the traditional styles. They were typically neither symmetrical nor hierarchic, apparently built neither of traditional building materials (stone, brick, wood) nor with the accustomed forms, such as pitched roofs, that went with these materials. They lacked ornamentation and, in their interiors, lacked the subdivision into traditional rooms. All this 'absence' created a kind of abstraction of the familiar, usually referred to by such adjectives as 'naked', 'headless', 'boxy', 'cubistic'. To many, the absence of ornament and familiar formal arrangements constituted an anti-aesthetic utilitarianism. Even the defenders of Modernism acknowledged this:

> …not only the lay world but also professionals look upon the unadorned and therefore unfamiliar works of the new architecture as cold and dry, raw and unfinished, purely and simply as inartistic. They miss in these buildings the familiar charm of decorations. They are put off by linear, hard and angular forms. And we must concede that such a limited judgment is to some extent justified, that the buildings of the new style do lack the effect of the pleasing, the artistic, the emotional that was evoked by the sensuous charm of detail in historical works.[3]

To others, Modernist buildings represented an expression of artistic formalism. Furthermore, the new building was understood to be 'Bolshevik' because it was seen to propose the rejection of bourgeois values and the furthering of proletarian needs and aspirations.[4] Paradoxically, it was also considered in many quarters to be 'Jewish' because of the patronage of Jewish middle-class professionals.[5] The labels 'international' or 'cosmopolitan' frequently carried both connotations. Simultaneously, the design of the interior and its artefacts underwent a similar revolution. Redesigned and reconceived objects, from the dinner trolley to the tubular-steel chair, began to appear, within a radically changed concept of how one should live. Instead of bourgeois notions of comfort and 'hearth and home' surrounded by familiar objects, there emerged a concept of the dwelling as a springboard for a more dynamic kind of life, dedicated to outdoor activity, the healthy body and intellectual pursuits. Ornamentation was purged, knick-knacks and mementoes banished, the open hearth replaced by electric heaters. Familiar pieces of furniture disappeared, replaced by built-in cupboards and fitments. All this (architecture and design) was promoted in journals redesigned in the 'New Typography' and incorporating the 'New Photography' (pls 5.26–7).

Modernist beliefs

Modernist architects shared a number of assumptions, each of them understood in different ways by different protagonists.[6] Architecture and design should be socially emancipatory, not just responding to the existing needs of society, but contributing to revolution or change. It should be international rather than national or regional, reflecting the aspirations of international socialism. Buildings and artefacts should be constructed of the new materials and methods supplied by the Industrial Revolution, and these materials should inform the design of the buildings. These ideas were drawn together in the notions of *Sachlichkeit* (from *die Sache* [thing] denoting realism, practicality and objectivity) and the *Zeitgeist* (the spirit of the age). Many of the key texts are in German, not only because so many of the important architects were German or Austrian, but because the underlying theory was published largely in German. *Sachlichkeit* stood in opposition both to ornamentation and to formal excess of any sort. By the *Zeitgeist*, Modernist architects understood that, for every historical period, there should be conformity between the imaginative world and the underlying realities of production (machines, transportation, new methods and materials). A link was frequently made by architects between this idea and structural rationalism. In the words of the Austrian architect Otto Wagner: 'New methods of construction must also give birth to new forms.'[7]

These ideas are further linked by the notion that only an industrialization of building methods using the new materials could transform conditions for working people (typically in mass-housing programmes). In using reinforced concrete to build small villas for private clients, architects were associating themselves with the momentous task of transforming society.

In the end, however, Modernism came to be interpreted as a style (a set of forms, motifs and habits of mind) and as a dogma (a set of rules and principles) and it was as such that it was handed down to the next generation in the 1930s, when it met with considerable resistance. This legacy was made more compact by the fact that by 1932 books detailing the history and theory of Modernism in architecture and design existed in a score of languages. In every European country, including those in which patronage of Modernism was luke-warm or hostile, specialist magazines published articles and illustrated work by Modernists. In unpacking this history and these ideas, I will try to draw out some of the contradictions that were never resolved within Modernism.

The social agenda

Most Modernists claimed that their work was dedicated towards social reform or revolution. Affordable

5.10 **Karel Teige**, *Nejmenší byt* (*The Minimum Dwelling*), 1932 (cat.101a)

housing was one of the fundamental needs of the inter-war period and massive changes in investment, land tenure, planning controls and architectural attitudes would be necessary to resolve the problem. Major economic efforts in rehousing were made in Austria, Britain, Holland, Scandinavia and parts of Germany in the 1920s, but these took very different forms. For example, Modernism played almost no part in the very significant housing renewal in Britain in the 1920s. By contrast, in certain cities in Holland and Germany, social democrat majorities had placed Modernist architects such as J.J.P. Oud (Rotterdam), Cornelis van Eesteren (Amsterdam), Ernst May (Frankfurt) and Martin Wagner (Berlin) in positions of authority, with the result that by 1930 a substantial body of Modernist mass housing had been built.

A book that clearly prioritized housing needs above all formal considerations was Alexander Schwab's *Das Buch vom Bauen* (*The Building Book*, 1930).[8] He argued that Modernism had a great task to fulfil in resolving both the technical and practical problems of housing. Architects would have to sacrifice their bourgeois partiality for art as an autonomous activity and notions of comfort and individualism. Necessity would have to defeat beauty as the first priority. The path forward lay in collective and anonymous design. Leftist architects and designers prioritized housing above all other forms of practice. For example, the Czechoslovak architect Karel Teige (although also a poet and artist) wrote consistently on housing throughout the 1920s and compiled an important history of Modernist housing in 1932 (pl.5.10). He began this book with the ringing declaration:

> The minimum dwelling [original emphasis] has become the *central problem of modern archi-tecture and the battle cry of today's architectural avant-garde . . . By the way, isn't modern archi-tecture*, an architecture that lays claim to the revolutionary concept of constructivism and the functionalism of a general plan, *nothing other than a utopia transformed into science, and science becoming reality in return*?[9]

Teige, like many communist and some socialist architects, advocated a high level of collectivization in housing, replacing the family apartment with bed-sitting rooms for individuals (whether married or single) supported by communal recreation, dining, childcare and study areas. Most architects and critics at the centre of Modernism did not go so far, but they considered popular housing to be a test of commitment. For example, Sigfried Giedion wrote an article in which he criticized Le Corbusier for taking on commissions from wealthy patrons such as Michael and Sarah Stein (pl.1.2).[10]

Functionalism

The catch-all concept that came to be applied to Modernists was functionalism.[11] The underlying idea was that the form of buildings should be determined by use or purpose, but there was considerable disagreement about how far to extend this premise. Some (few) Modernists believed that what serves its purpose well is necessarily beautiful, or that beauty is of secondary importance, compared to use values. Within the German term *Sachlichkeit* were concealed a range of meanings. Fitness for purpose (the Arts and Crafts expression) was only a small part of these. There was also a utilitarian connotation – that a building or thing should have wide social application. Underpinning these notions were two assumptions: that the built environment could (and should) mould human behaviour and that the efficiency and utility of buildings was more important than any aesthetic value they might have. The Swiss architect Hannes Meyer's famous statement gives the functionalist position in its extreme form:

> All things in this world are a product of the formula: (function times economy). All these things are, therefore, not works of art: all art is composition and, hence, is unsuited to achieve goals. All life is function and is therefore un-artistic . . . Building is a biological process, building is not an aesthetic process. In its design the new dwelling becomes not only a 'machine for living', but a biological apparatus serving the needs of body and mind.[12]

Whether Meyer really believed this or not (he also showed a great deal of interest in art and formal matters), few Modernist architects agreed with the hardline functionalist position. Architects like Le Corbusier or Ludwig Mies van der Rohe repeatedly asserted that architecture does not end with function, and that the architect must make purely formal decisions while still respecting structure and function. The opposite of functionalism was formalism, and architects such as Mies and Le Corbusier were occasionally accused of this, the most heinous crime in the functionalist lexicon. When functionalism was used as a criticism in the 1920s and '30s, it was above all to refer to left-wing and materialist viewpoints. Most Modernists would have agreed with more moderate statements, that what is inefficient is unlikely to be beautiful, or that the precision necessary in efficient objects (such as aeroplanes or motor cars) often contributes to their aesthetic value. Interestingly, Bruno Taut ends his chapter 'What is Modern Architecture?' in the English version of his book *Modern Architecture* in 1929 with the functionalist statement: 'The aim of Architecture is the creation of perfect, and therefore also beautiful, efficiency.' In the German original, the word 'therefore' was lacking and Taut certainly did not believe that what was functional must necessarily be beautiful.[13]

From at least 1928, two strands within Modernism, sometimes described as the functionalists and formalists, differed principally in their political orientation and on the prominence they were prepared to give to architecture as an art form. An argument frequently deployed against functionalism was that, if the form of an object is to be determined by the brief (the

function, materials and economic conditions), there would arise an anarchy of particular forms, lacking coherence and continuity. Functionalism was thus labelled 'romantic' by those who saw the role of the architect and designer as making sense of the world. Another, contradictory, argument was that functionalism would lead to standardization of forms, erasing national and individual difference.

The opponents of Modernism included many on the left as well as the right. For example, Ernst Bloch reacted against the loss of human warmth and complexity in modern design as early as 1918, in his first book *Geist der Utopie* (*The Spirit of Utopia*, 1918, revised in 1923). In this and later essays, he argued that ornament still had an important role to play as a residue of symbolic meaning and that Modernism, with all its purity of white walls, was itself only a style, lacking the potential to change society in a revolutionary way.[14] For Bloch, both Expressionism and the technique of montage offered greater potential for resisting capitalism and pointing up its contradictions than Modernism. Looking back on the first two decades of Modernism, in 1940, he wrote:

For a generation this phenomenon of steel furniture, concrete cubes and flat roofs has stood there ahistorically, ultra-modern and boring, ostensibly bold and really trivial, full of hatred towards any so-called flourish of ornamentation and yet more schematically entrenched than any stylistic copy from the nasty nineteenth century ever was.[15]

Few leftist architects in Europe willingly accepted the political subjugation of Modernism in the USSR with Stalin's imposition of Socialist Realism and the competition for the Palace of Soviets in 1932 (cat.230, see Chapter 10), which finally marked the end of official Soviet toleration of Modernism. Communists like Teige or the French architect André Lurçat could not accept the Stalinist line on Socialist Realism and Modernism. Both architects, however, attacked Le Corbusier for his 'formalism' and 'monumentalism' (see below).

Zeitgeist

Le Corbusier and Amédée Ozenfant named the review they launched in 1920 *L'Esprit Nouveau* (The New Spirit) as a clear tribute to the *Zeitgeist*. On the first page of the first issue they declared their aim: 'To make comprehensible the spirit which animates the contemporary era; to render the beauty of this era, the originality of its spirit ... '[16] And in a joint article they declared: 'There is a new spirit, it is a spirit of construction and synthesis guided by a clear concept.'[17] Mies van der Rohe gave the most evocative definition of the *Zeitgeist* principle in July 1923: 'Building art is the spatially apprehended will of the epoch. Alive. Changing. New.'[18] The *Zeitgeist* principle was expressed most succinctly at the top of the Declaration produced after the first congress of CIAM (*Congrès Internationaux d'Architecture Moderne*, International Congresses of Modern Architecture) in 1928: 'Architecture's destiny is to express the orientation of the times.'[19] This was Le Corbusier's formulation. The German version is more prolix: 'The task of architects is to assimilate

the overall conditions of the time and the great aims of society of which they are part and to create buildings accordingly.'[20] These arguments were illustrated in a series of panels designed for exhibition by a group of Swiss architects in 1934–6 (pl.5.11). From Stone Age to modern times, social systems are compared with means of transportation, weaponry, commercial exchange and manufacture. The chart aims to show the interdependence of these various systems.

Meanwhile, of course, modernity moved on, with or without Modernism.[21] The use of new building materials and a concern for light, airy interiors – hygienic and easy to keep clean – spread widely in the inter-war period, affecting traditionalist and Modernist work alike. Articles advocating make-overs of houses and flats to reduce ornament and clutter were published all over Europe, as much in response to post-war austerity and the demand for labour-saving homes as direct Modernist pressure. For example, in Britain, where Modernist ideas made little headway before 1928, the *Daily Mail* promoted an 'Efficiency Exhibition' (1921), going so far as to build a model village in Welwyn Garden City (1920–21),

to promote 'light and airy' homes equipped with the new devices.[22] And it was common to see in popular exhibitions of this kind, throughout Europe, traditional-looking homes built of revolutionary new materials.

Anonymous design

The high regard paid to anonymous and mass-produced design in the 1920s needs to be explained. There are two sources for this: an interpretation of *Zeitgeist* theory and a belief that mechanization must lead inevitably to standardization. In a series of influential articles before the First World War, the Austrian critic and architect Adolf Loos had contrasted the artist-designer unfavourably with the honest and anonymous craftsman, who was always in tune with the age because he was concerned only with making efficient tools and respecting his materials. Rather than use furniture designed by himself, therefore, Loos turned to craftsmen working within their tradition, or to machine-made furniture such as the bentwood chairs made by Thonet. Le Corbusier picked up on

this in the 1920s and used only standard chairs, either cheap Thonet bentwood chairs or well-made leather armchairs by the French branch of Maples. Only in 1927 did he join the fashion for designing tubular-steel chairs (by hiring Charlotte Perriand, whose metal furniture he saw in that year).

In 1914 Hermann Muthesius tried to persuade his colleagues in the *Deutscher Werkbund* (the German Work Association) to dedicate their creativity to designing standardized design 'types'. Virtually all the architects in the *Werkbund* took sides with Henry van de Velde, who argued passionately against Muthesius on the side of individual creativity. During the 1920s, however, the benefits of designing for industrial production became increasingly apparent with the production of artefacts of every kind. These objects were not only admired as formally satisfying and appropriate for the means of manufacture, but as a kind of litmus test of the *Zeitgeist*. As late as 1947, in his fundamental work *Mechanization takes Command*, Giedion made the case for the study of anonymous objects:

5.11 **Rudolf Steiger, Wilhelm Hess, Georg Schmidt**, *Attempt of a chart illustrating the historical development of housing and cities*, 1935. GTA-Archiv/ETH-Zürich

The sun is mirrored even in a coffee spoon. In their aggregate, the humble objects of which we shall speak have shaken our mode of living to its very roots. Modest things of daily life, they accumulate into forces acting upon whoever moves within the orbit of our civilization … The performer is led by outward impulses – money, fame, power – but behind him, unbeknown, is the orientation of the period, is its bent toward this particular problem, that particular form.[23]

Giedion's belief that 'anonymous history is directly connected with the general, guiding ideas of an epoch' helps to explain the prestige awarded to industrial design in the 1920s.[24] An exhibition designed both to celebrate good anonymous design and to inspire artists to design for industry was mounted by the *Werkbund* in Stuttgart in 1924 and then circulated for several years in Germany. '*Form ohne Ornament*' (Form without Ornament) brought together various strands of thought and made a big impact on the public. Simple, well-made objects were displayed and commended to the viewer. The message to the designers was more subtle: unify the artistic and industrial spheres to capture even more perfectly the 'authentic expressive form' of the age.[25]

Fashion

A common tactic in support of the *Zeitgeist* argument was to refer to fashion. In the words of Otto Wagner:

A man in a modern travelling suit, for example, fits in very well with the waiting room of a train station, with sleeping cars, with all our vehicles; yet would we not stare if we were to see someone dressed in clothing from the Louis XV period using such things? … It is simply an artistic absurdity that men in evening attire, in lawn tennis or bicycling outfits, in uniform or chequered breeches should spend their life in interiors executed in the styles of past centuries.[26]

Thus, through a chain of associations passing through men's fashions, modern architecture should be reformed in the image of the buildings and things that most perfectly epitomized the modern world: bridges, factories and forms of transportation.[27] The *Zeitgeist* idea necessarily implied a notion of changing fashion, and this worried architects seeking to represent themselves as rational and *sachlich*. Wagner even retitled his book from *Moderne Architektur* (*Modern Architecture*, 1898–1902) to *Die Baukunst unserer Zeit* (*Contemporary Building Art*, 1914), to avoid the association between the words *Mode* (fashion) and *moderne*. This was in response to remarks made by Muthesius in his important book *Stilarchitektur und Baukunst* (*Style Architecture and Building Art*, 1902) in which he interpreted the spirit of the age strictly in terms of the use of new materials and structural methods. As Marcel Breuer said later: 'The new in the Modern Movement must be considered simply a means to an end, not an end in itself, as in women's fashion … Novelty is not our aim. We seek what is definite and real, whether old or new.'[28]

A variant of the *Zeitgeist* idea took the form of what was later dubbed 'the machine aesthetic'. At its most fashionable and, in Modernist terms, most disreputable form, the machine aesthetic was

5.12 Sketch of a villa based on a photograph of an ocean liner, taken from *Modern Architecture* by Bruno Taut (London, 1929). V&A: National Art Library

expressed in the recognizable use of motifs copied from machines, industrial buildings or forms of transportation. To mock this kind of imitation, Taut knocked up a sketch of a Modernist villa copied from a cropped photograph of the SS *Australia* (pl.5.12).

In the more complex form found among most Modernists, the machine aesthetic was more about understanding how machines and industrialization worked and trying to learn from their underlying principles, rather than copying the external forms.

A Modernist contradiction: progress and the universal

There was another inherent difficulty with the *Zeitgeist* theory. If architecture and design should evolve continually in response to the conditions of the time, how could architects hope to aspire to the eternal values that they recognized in the great works of the past? According to Le Corbusier, there was a 'law of mechanical selection', which caused each new kind of building or object to be gradually perfected, both in function and form in response to its production and use and to the skill of the designer.[29] In a famous comparison, he claimed that the same process that had led to the 'improvement' of the Doric temple between Paestum and the Parthenon was guiding the development of motor-car design from the clumsy Humbert (1907) to the sporty Delage (1921).[30] This theoretical model is one of cyclical development, leading to perfection followed by decline and the introduction of new types. For him, the Parthenon represented perfection and could not be bettered, but neither could it be imitated because it had been a response to the conditions of its time. It was the task of every architect to try to perfect the means available to him in his time.

Stripping architecture

For Loos, in an article entitled 'Ornament and Crime' (1908, reproduced by Le Corbusier in his journal *L'Esprit Nouveau* in 1920), ornament in modern times was a sign of degeneracy, exemplified by the criminal's tattoo or the deviant's lavatory graffiti.[31] The modern intellectual existed on a higher plane. Aesthetic effects might be obtained by using light, surface, mass and texture, and even by incorporating works of art, but not by disguising architectural components with ornament. Absence of ornament became one of the defining features of Modernism.[32] In Mark Wigley's concise formulation: 'The first act of modernization strips architecture [of its fashionable clothing] and the second disciplines the structure that has been exposed. Both are explicitly understood as acts against the suspect forces of fashion.'[33]

The need to strip architecture of ornament was in part a long overdue response to the eclecticism of the nineteenth century, and in part a politically inspired attempt to rid architecture of symbolic imagery bearing associations of class and difference. André Lurçat made the connection explicit in 1926:

> At all cost, we had to dump the burden of a century of habits lacking either tradition or aesthetic laws. This is how the acute need was born to strip away, to use only primary elements, to do away with ornament. This is what gave the early work its very simple lines, its purity which was so cold sometimes that no precedent could be found in earlier times ... A great era has begun, an era of construction and above all of collective construction. For the problem stands exposed as a profoundly social one.[34]

Once again, the formal and the political are inextricably linked. Most left-wing Modernists, even on the functionalist wing of the movement, reserved a place for the poetics of form, either by appealing to the effects of pure form (*Gestalt*) on the human psyche (Karel Teige) or by invoking the ludic needs of men and women (Adolf Behne) or the '*joies essentielles*' (Le Corbusier) of sun, space and greenery.[35] Lurking behind many an appeal to hygiene and function lie the purely artistic desires of the Modernist.

The X-ray and the subconscious

The stripping of architecture can be thought of in two parts. First was the analysis of nineteenth-century and contemporary buildings to see beyond the surface and expose the 'reality' (or 'truth') of the structure inside. Next came an imaginative comprehension of this structure as aesthetically satisfying. Architects had always admired the structural daring of engineers, but the problem was how to see the apparently insubstantial filigree of structural members as aesthetically satisfying. Wagner's biographer Joseph August Lux published an influential book in 1910 entitled *Ingenieur-Aesthetik* (*The Aesthetic of Engineering*).[36] The change of attitude is revealed in his declaration, 'Artistic form must be discovered anew from the new elements [of construction].' The photographs dramatized the sublime cantilever of a crane, the transparency of a lattice of steel, the endless expanses of glass and the graceful curve of a concrete vault.[37] The implication was that a new discipline must be forged that respected the new and surprising properties of these materials. New and expressive ways must be found to reveal the tensile strength of steel or the resistance of reinforced concrete. Furthermore, Lux saw the potential of steel construction in forming a new style as being in its linearity, which created 'new spatial images'. This language benefited from a strand in architectural history that had already identified 'space' as the essential architectural element.[38] The Austrian designer and architect Rudolf Schindler had already appropriated these ideas in the context of modern architecture in 1913: 'The modern architect conceives the room [*Raum* (space)] and forms it with wall – and ceiling – slabs. The only idea is space [*Raum*] and its

5.13

5.14

organization. Lacking material-mass, the negative interior space [*Raum*] appears positively on the exterior of the house.'[39]

When the German Expressionist architect Erich Mendelsohn visited America in 1924 he was fascinated by the contrast between the steel skeletons of the soaring skyscrapers in construction and the disappointing effect once the cladding had been added. In his book *Amerika* (1926) he captioned such a photograph 'The "X-Ray" of the finished building' (pl.5.14). Mendelsohn understood the structure as the hidden 'truth' inside the building. In his architectural practice he set about expressing this 'truth' in his buildings. Two years later, in an influential book entitled *Bauen in Frankreich, Bauen in Stahl, Bauen in Eisenbeton* (*Building in France; Building in Steel; Building in Ferro- concrete*, 1928) the Swiss critic Giedion went further:

> Construction based entirely on provisional purposes, service and change is the only part of building that shows an unerringly consistent development. Construction in the nineteenth century plays the role of the subconscious. Outwardly, construction still shows the signs of the old pathos; underneath, concealed behind façades, the basis of our present existence is taking shape.[40]

The moral duty of the Modernist architect was to heal the pathology of the modern world by making the repressed visible. This is the intellectual context for statements such as that of Mies van der Rohe when he summed up his creed in 1923 as 'absolute truthfulness and rejection of all formal cheating'.[41]

For Giedion, the modern spirit was best understood by the term *Durchdringung* (interpenetration).[42] The essential experience of great engineering works

was not their rationality, but the giddy sense of vertigo looking down through the maze of girders whose fragmentation of the world around created a sensation of space akin to that of Cubism:[43]

> By their design, all buildings today are as open as possible. They blur their arbitrary boundaries. Seek connection and interpenetration. In the air-flooded stairs of the Eiffel Tower, better yet, in the steel limbs of a *pont transbordeur* (transporter bridge), we confront the basic aesthetic experience of today's building: through the delicate iron net suspended in midair stream things, ships, sea, houses, masts, landscape, harbour. They lose their delimited form: as one descends, they circle into each other and intermingle simultaneously.[44]

Giedion concluded that the category of architecture itself was placed in doubt by sensations of this kind. All boundaries, especially social ones, would be rendered redundant by a proper understanding of the new realities. And the purpose of his book was to demonstrate that the correct understanding of nineteenth-century engineering led directly to Modernism (pls 5.15–16).

We will see, however, that before this 'truthfulness' could be fully understood, a new aesthetic had to be forged from the fusing of avant-garde artistic movements. Without a taste for transparency and abstraction, the lessons of the engineers would have remained a dead letter.

Engineering as volume

The lessons of the engineers were not only in the direction of transparency. An influential collection of images of industrial buildings in concrete and steel was published by Walter Gropius in the *Yearbook* of

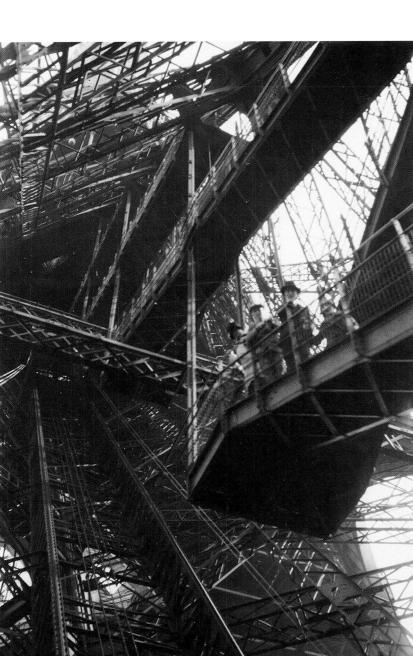

5.15

5.16

the newly founded *Deutscher Werkbund* in 1913.[45] Many of these images, with any traces of decoration airbrushed out, turned up again in an article by Le Corbusier in *L'Esprit Nouveau* entitled 'Three Reminders to Architects: Volume'.[47] For Le Corbusier, for whom architecture was 'the knowledgeable, correct and magnificent play of volumes deployed in light', the pure geometric volumes of the great concrete engineering works were as stimulating as the steel bridges, aeroplanes, cars and ocean liners that were also cited as 'eye-openers' for modern architects.[47] The articles published between 1920 and 1921, while Le Corbusier was still struggling to set up an architectural practice in Paris, were collected in *Vers une Architecture* (*Towards an Architecture*, mistranslated in the first English edition as *Towards a New Architecture*) in 1923.[48] In this and many subsequent publications, Le Corbusier drew on a wider range of reference than his contemporaries, always defending architecture as an art form. For him, the lessons of the engineers was that their precise calculation and lack of stylistic mannerisms led them to discover anew the eternal verities of pure form. Similarly, he saw in the humble products of industrial manufacture – pipes, wine glasses, chemical retorts, sanitary fittings – not only the proper productions of the age, but aesthetically satisfying works of art (see pl.3.7). In another set of articles published in *L'Esprit Nouveau* (1924) and then as *L'Art Décoratif d'Aujourd'hui* (*The Decorative Art Today*, 1925), he castigated the efforts of the decorative artists preparing for the *Exposition Internationale des Arts Décoratifs et Industriels Modernes* (International Exhibition of Modern Decorative and Industrial Arts), in 1925.[49]

Modernism as a style

The origins of the history of art and architecture are saturated with the idea that artists' imagination is necessarily channelled into a *Kunstwollen* – an artistic will to form – that was rooted in the spiritual and material conditions of the age.[50] For example, Gropius, introducing his picture book *Internationale Architektur* (*International Architecture*, 1925), appealed to the *Kunstwollen*:

> A fundamentally new attitude to architecture is emerging in all cultures simultaneously. The realization is growing that a living will to form, rooted in the life of society as a whole, embraces every aspect of human creativity in a single goal, which begins and ends with building. It is this changed and more profound mentality, coupled with the new technological methods, which has brought about change in the form of buildings.[51]

Gropius placed emphasis on the need for architects to 'return to the heart of things', to analyse the functions of buildings, but asserted that the architect still retained, in the choice between equally functional solutions, aesthetic control. Individualism must,

however, be replaced by 'the will to develop a unified world view', which will alone lead to culture. And he finished on a suitably exultant tone, which still carries traces of Expressionist fantasy:

> The architects in this book affirm the world of today, with its machines, with its motorized transport and its tempo. They are striving for ever bolder creative means to overcome gravity itself, to achieve by new techniques, both in appearance and reality, a state of hovering above the ground.[52]

But Modernists often claimed to reject style – which smacked of ready-made formal solutions, fashion and the styles of the past – and liked to claim that their productions resulted directly from an analysis of the brief. For example, Muthesius in *Stilarchitektur und Baukunst* considered both 'style' and 'architecture' as suspect (replacing the latter with the relatively novel term *Baukunst* [building art]) and declared, 'the true values in the building art are totally independent of the question of style, indeed that a proper approach to a work of architecture has nothing to do with style'.[53] In fact, the concept of the *Zeitgeist* is incomprehensible without the underlying concept of style.

Some writers continued to deploy the notion of style. For example, the influential Russian architect Moise Ginzburg wrote a book called *Stil' I epokha* (*Style and Epoch*) in 1924.[54] Ginzburg formed a group of Russian architects known as OSA and edited the journal *Sovremennaia Arkhitektura* (*Contemporary Architecture*, abbreviated to *SA*), which gave currency to avant-garde movements in Europe. He was also, with Ignatti F. Milinis, an important architect whose Narkomfin housing block (1930, pl.5.17) in Moscow

represented years of work in the government research department there (and was very influential in Europe). As an architectural historian, Ginzburg had read Heinrich Wölfflin, Paul Frankl and the German idealists, and these prepared him to locate Russian Constructivism in a historical context in stylistic terms. His first editorial for *SA* was revealingly entitled 'The Aesthetics of Modernity', distancing himself from the productivist wing of Constructivism.[55] He was not a functionalist and sought to adapt idealist theories of style to the dialectical arguments of Marxism. From the thesis and antithesis of the Classic and Gothic styles (finally exhausted in the nineteenth century) a new style must arise that would synthesize the best of both stylistic traditions and adapt them to the new conditions. He therefore shared Le Corbusier's cyclical approach to the perfection of standards, but chose to describe these openly in terms of style:

… we discern a certain self-sufficiency of style, the uniqueness of laws governing it, and the relative isolation of its formal manifestations from the products of other styles. We discard the purely individualistic evaluation of a work of art and consider the ideal of the beautiful, that eternally changeable and transitory ideal, as *something that perfectly fulfils the requirements and concepts of a given place and epoch* [original emphasis].[56]

Three years later, in 1927, Walter Curt Behrendt, an influential journalist who edited the *Deutsche Werkbund*'s journal *Die Form* (*Form*) from 1925 to 1926, wrote an important book *Der Sieg des neuen Baustils* (*The Victory of the New Building Style*), with the S-word in the title. This book begins with a *Zeitgeist* argument imbued with *Kunstwollen*:

Influenced by the powerful spiritual forces in which the creative work of our time is embodied, the mighty drama of a sweeping transformation is taking place before our eyes. It is the birth of the *form of our time* [original emphasis]. In the course of this dramatic play – amid the conflict and convulsions of old, now meaningless traditions breaking down and new conventions of thinking and feeling arising – new, previously unknown forms are emerging. Given their congruous features, they can be discussed as the elements of a new style of building.[57]

Further on, Behrendt tried to detach Modernism from the short-lived avant-garde style labels (the 'isms') and claimed it for an international *Kunstwollen*:

The efforts to renew architecture examined here concern a spiritual movement, not a fleeting artistic fashion or some new 'ism'. The originality of this movement and its intimate connection with the spiritual life of our time is well attested by its international character – the fact that it has arisen in various countries simultaneously and with similar goals … There can be no better evidence for the living relevance of the ideas that support this movement.[58]

Modernists clung to the idea of style because it could be seen as more permanent and serious than fashion and yet more 'spiritual' than utilitarianism or functionalism. At any rate, Modernism quickly became a style in the conventional sense, whose forms were copied, adapted and developed from magazine illustration to building across the world.

In 1927 Le Corbusier formulated a slogan, 'the five points of a new architecture', intended to draw together the architectural consequences of Modernism in a set

5.18 **Le Corbusier**, *Comparison of a traditional house and a modern house on piloti*, 1929 (cat.109)

of easy rules.[59] He even tried to impose these rules on the second CIAM congress in Frankfurt (1929). The five points were: *piloti* (point supports), the roof garden (on a flat roof), the free plan, the horizontal window and the free façade (pl.5.18). All this flowed from the separation of structure from enclosure. Within a framework of thin steel or concrete stanchions, walls and windows could be placed in such a way that their non-structural character was evident. Inside, the structure could be exposed as thin columns. Sometimes this meant extending floor slabs beyond the line of the supports, allowing un-interrupted bands of fenestration or open balconies. Sometimes it meant the inclusion of projecting balconies, or deep overhangs, to express the hidden structural sinews within. The 'free plan' meant that internal walls need no longer be aligned, one above the other, for support. Internal divisions could be placed freely to suit the needs of the user, and this meant that they were usually artfully placed to reveal the *piloti*. These principles were summed up in drawings, used by Le Corbusier to illustrate one of his lectures in Buenos Aires in 1929. Compared with the traditional house with its masonry walls and small windows (each one a compromise between letting in light and weakening the wall), the Modernist house

floated free above the ground on its concrete *piloti*, with façades consisting of long windows and each plan configured differently. The result was a 'conquest' of surface area, below and on top of the house, for greenery.

Le Corbusier's house for the American journalist William E. Cook and his French wife Jeanne in Paris (1926) is a demonstration of the 'five points' (pls 5.19–20). The façade is cantilevered beyond the concrete post that supports the floor slab, allowing the full width of the house to be opened up (joining the dining room to the double-height salon), illuminated by a continuous window.

Rational as Le Corbusier's logic was, in some ways, he was one of the first to explicitly list formal elements as the badges of Modernism, and he was criticized for doing so. The 'five points' effectively describe a style, which could be imitated and deployed in many different circumstances.

The International Style

When, in 1932, Henry-Russell Hitchcock and Philip Johnson mounted an exhibition at the Museum of Modern Art in New York (with a catalogue and an accompanying book entitled *The International Style*),

5.19 **Le Corbusier**, *Design for Villa Cook*, Boulogne-sur-Seine, 1926 (cat.107)

5.20 **Le Corbusier**, Dining room and salon, Villa Cook, Boulogne-sur-Seine, 1926–7

5.19

5.20

their aim was both to celebrate Modernism and to redefine it for the American public as politically innocuous and aesthetically coherent.[60] Their definition of the style was centred around three principles: 'Architecture as volume', 'Regularity rather than symmetry in planning' and 'the avoidance of applied decoration'. The book includes a chapter on 'Building and Architecture' in which the authors applaud the functionalist aims of good building (better than much of what purports to be architecture), but reserve architecture for a higher level, 'edifices consciously raised above the level of mere building'.[61] Although '… the European functionalists usually reach the level of architecture despite their refusal to aim consciously at achieving aesthetic value', their political motivation tends to undercut their aesthetic quality. Hitchcock and Johnson were confident in the importance of architecture as an art and style as the ultimate goal: 'Good modern architecture may be as richly and coherently imbued with the style of our day as were the great edifices of the past with that of theirs.'[62]

Most European Modernists, even those attacked by the functionalists as lyrical formalists, would have rejected the simple way Hitchcock and Johnson separated the aesthetic sphere from the social, practical and structural. Modernism was to remain an ideology of conviction until the 1960s, based on the canonical texts of the 1920s by Behne, Ginzburg, Le Corbusier, Gropius, Giedion and Taut.

History of Modernism

The ideas I have outlined did not appear all at once, but emerged over a long period of time, extending back at least into the eighteenth century. The main lines of their later evolution can be summarized briefly. A long-running series of theoretical debates in the nineteenth century about how to replace the copying of the past by a style based on modern technical, economic and social conditions prepared a generation of architects and designers for significant change. Almost all the important ideas behind Modernism in architecture had been published and debated before 1914, and a number of key buildings had been constructed, in which the bold use of the new materials could be seen.[63] In successive editions of Wagner's widely read book *Moderne Architektur* (1896–1902), in such books as Muthesius's *Stilarchitektur und Baukunst* (1902), H.P. Berlage's *Gedanken über Stil* (*Thoughts about Style*, 1905) and *Grundlagen und Entwicklung der Architektur* (*Foundations and Development of Architecture*, 1908) and in a series of articles by Loos published in Vienna between 1898 and 1910, all the basic ideas of Modernism can be identified. Furthermore, two influential publications of the work of Frank Lloyd Wright in 1910–11, and the translation of some of his writings, made an impact on a number of architects, especially in Holland and Germany.[64]

In the field of design, the principles of truth to materials and fitness for purpose of the Arts and Crafts movement in Britain had been expanded to include the challenge of design for mechanized manufacture and a consequent measure of standardization.[65] In Germany a trend was set in the foundation of the *Deutscher Werkbund* in 1907 and a propagation of their views in a series of exhibitions and an influential journal *Die Form* (1922–34).[66] The *Deutsche Werkstätten* (German Workshops) began advertising machine-made furniture designed by artists intent on combining simplicity of form and high quality.[67]

The First World War interrupted this debate at a critical point and threw everything into doubt. Taut could even assert, in 1929:

> With the outbreak of the War, the history of modern architecture may be considered closed. For the War not only occasioned an interruption in building activities in all countries, it was also responsible for a far more deplorable state of affairs … an epidemic of mental aberration might be said to have set in – a hopeless obscurantism, which has not been overcome up to the present day. Indeed the groping and gradual victory over this shameful epoch in the history of Europe might be said to synchronize with the groping and gradual development of modern architecture.[68]

That Taut could refer to Expressionism and the other avant-garde movements as a 'mental aberration' and as 'hopeless obscurantism' shows how rapidly ideas had evolved between 1919 and 1929. Working from different sources and a different perspective, including those of the decorative arts in Britain, Nikolaus Pevsner arrived at a similar conclusion in 1936, when he published his *Pioneers of the Modern Movement*.[69] This book ends with the buildings of Gropius from 1911 to 1914, and he stated, '. . . the new style, the genuine and legitimate style of our century, was achieved by 1914'.[70] But Modernism in architecture and design did not consist only or principally of the rationalism of the pre-war 'pioneers'. It was the 'hopeless obscurantism' of which Taut writes, and in which he himself was an active participant in his Expressionist phase, that implanted many of the central ideas of Modernism and welded together its formal characteristics (see Chapter 2).

The ideas and works under discussion are nowadays given the style label of Modernism, to distinguish them from many other expressions of modernity in architecture and design (such as Art Deco, 'modernized classicism' and various variants on regional vernacular) in which some at least of the characteristics described can be seen.[71] For example, the Perret brothers continued to design rational, clearly articulated buildings in reinforced concrete, where the principles of structural rationalism (basing the design on structure) were united with design principles based on Beaux Arts classicism. Those architects who had pioneered building in the new

5.21 **Weissenhof Housing Estate**, part of *Die Wohnung* (The Dwelling) exhibition, Stuttgart, 1927 (cat.95)

5.22 **Willi Baumeister**, Poster, *Die Wohnung* (*The Dwelling*) Werkbund Ausstellung Stuttgart (*The Werkbund Exhibition Stuttgart*), 1927 (cat.96)

materials before the war – such as Peter Behrens, H.P. Berlage, Auguste Perret and Victor Horta – did not make the transition, with a few exceptions, into the forms of the new building, which they criticized as formalist and unfunctional. They were in turn remorselessly attacked by the Modernists.[72] For example, Muthesius, who had been a leader in the movement to found the *Deutscher Werkbund* and develop a new architecture and design practice based on the new materials, was trenchant in his criticisms of the *Werkbund*-sponsored exhibition *Die Wohnung* (The Dwelling) at Weissenhof, Stuttgart (1927, pls 5.21–2):

> If you look at the root of the problem you'll see that what's really motivating this group of architects, is the new Form ... The new Form has such a tyrannical effect on its advocates ... that it overthrows all other considerations. It's the new Form which dictates the flat roof ... with all that that entails in the way of unresolved arrangements. It's the new Form which leads to the excessive over-lighting of living rooms, dictating to its apologists that they must run completely unbroken, continuous windows all round the house ... All these things have absolutely nothing to do with rationalization, nor with economics, nor with constructional necessity. It's purely a question of form.[73]

It was the intense experience of the post-war avant-garde art movements that welded together the younger generation behind the utopian idea of transforming society and developing a quite new architectural form. This went considerably further than reasonable use of the new materials and fitness for purpose. The new building may not have denoted

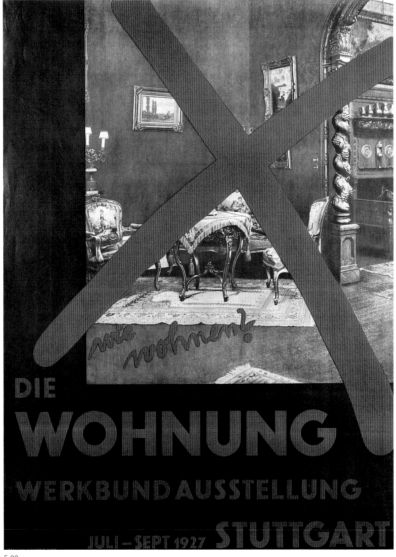

meaning through ornament or stylistic references, but it connoted a rich set of ideas pointing towards a radically different future. The 'look' of the new building was necessary to indicate adherence to this collective aspiration.

By 1923 the pooling of avant-garde ideas in Europe was virtually complete. The art journals *De Stijl* (*The Style*) in Holland (1917–31), *L'Esprit Nouveau* (1920–25) and *Cahiers d'Art* in Paris, *Veshch*/*Gegenstand/Objet* (*Object*, 1922) and *G* (1923–4) in Berlin, followed by *ABC* (1923–8) in Switzerland distributed many of the same ideas and images to their increasingly international constituencies. Exhibitions such as that of Van Doesburg and Van Eesteren in the galeries de l'effort moderne in Paris (October 1923) and Gropius's *Internationale Architektur* in Weimar combined with the publication of Le Corbusier's *Vers une Architecture* (September 1923) gave the impression that a Europe-wide movement was in progress. As in the history of all sects, these avant-garde groups thrived on a vigorous condemnation of each other's efforts. Van Doesburg accused the Bauhaus of romantic individualism, Le Corbusier accused De Stijl of being ornamental. By 1928 the serious split between functionalists and formalists was well established. But to the external observer there was an obvious affinity between the work published by the different groups of Modernists. Most of what was shown in 1923 was still on the drawing board, or in the form of drawings and plaster models, and this may have increased the illusion of convergence. In the next five years the key buildings that were to constitute the iconic canon of International Modernism were built, and several Modernists found themselves in charge of important building work, at an urban scale.

Avant-garde movements

Cubism, Futurism, Purism, De Stijl, Constructivism and Expressionism had in common a rejection of the drabness and materialism of the everyday world in favour of a heightened consciousness and the ambition to make art (see Chapter 2). As the German critic Behne wrote in the Introduction to the Expressionist pamphlet *Ruf zum Bauen* (*Call to Build*, 1920) published by the *Arbeitsrat für Kunst* (Work Council for Art):

> We refuse to be a party to building prison cells and ghettoes for our fellow men. We shall join in when it becomes a matter of building real houses for people to live in, but not as the tools of profiteers and exploiters … Until then we must shelter our pure flame carefully, so that when people at last begin to build again … there will still be something called architecture.[74]

Summing up in 1931, Van Doesburg concluded: 'Art should not deal with the "useful" or "nice", but with the "spiritual" and "sublime". The purest art forms do not cause the decorative change of some detail from life, but the inner metamorphosis of life, the "revaluation of all values" ("*Umwertung aller Werte*" as Nietzsche called it).'[75]

The 'ex-Expressionists' played an important role in the development of Modernism. Taut had been at the

centre of the Expressionist movement in architecture after the war, helping to found the *Arbeitsrat für Kunst* and then *Die Gläserne Kette* (the Glass Chain) of correspondents (Walter Gropius, Hans Scharoun, Hermann Finsterlin, Wassily Luckhardt, Wenzel Hablik, Max Taut and Adolf Behne, among others).[76] By 1921 he had taken the job of city architect at Magdeburg, and four years later had moved to Berlin to build vast new housing schemes for the GEHAG housing association (pl.5.23). And yet his housing settlements in Berlin are incomprehensible without an understanding of his Expressionist roots. For example, Taut continued to use bright colours inside and outside his public and private buildings. Architects such as Mendelsohn and Hans Scharoun never lost the habit of drawing in a free-flowing and spontaneous Expressionist style, long after their buildings lost their overtly Expressionist character. And Mendelsohn and Hugo Häring developed theories of 'organic architecture' that lay alongside Elementarist and Constructivist strands. Mendelsohn became the most successful commercial Modernist architect in Europe, building department stores for the Schocken companies in several cities in Germany and Poland. Häring remained the close friend of Mies van der Rohe and influenced him considerably at the level of ideas, although their buildings were very different (see Chapter 10).

It was in the fourth issue of the Expressionist journal *Frühlicht* (*First Light*, edited by Bruno Taut) that Mies published his extraordinary entry for the Friedrichstrasse competition (pl.2.1) and a subsequent design for an undisclosed site. Published as two photographs of a glass model and a drawing and plan, this project could be interpreted both in Expressionist and Modernist terms. Expressionist was the emphasis on glass as a reflecting and diffracting surface, evoking the dreams of Paul Scheerbart and the coloured fantasies of Taut and his friends (pls 2.4–5, cat.25.).[77] Modernist, however, was the underlying principle of the design, brought out in Mies's accompanying text. Here he pointed out what Mendelsohn also observed: 'Only skyscrapers under construction reveal the bold constructive thoughts, and then the impression of the high-reaching steel skeletons is overpowering.'[78] His project responded to two desiderata: first, to use the structure of the office block alone as the generating concept; and second, to use the reflective qualities of glass to best effect to express the idea of a weightless, soaring tower block. Thus his structural rationalism was a means, but not an end. The 'idea' was the important thing. In another highly significant design, for a concrete office block, the apparently utilitarian structural rationalism was taken even further. This time published in the journal *G* in July 1923, the drawing shockingly revealed a building composed only of horizontal bands formed by floor slabs cantilevered out beyond a grid of concrete piers. Again, this design is incomprehensible without a context of Expressionism and Elementarism (see below).

From Cubism and Futurism, architects derived the idea that matter could be thought of dynamically, understandable as lines of force or interpenetrating volumes. As the leading Dutch Modernist J.J.P. Oud put it, the aim was to achieve, 'through the analysis of natural form, the beginning of the transition from the natural to the spiritual, from the illustrative to the creative, from the closed to the spatial'.[79] Sometimes these cubes or prisms have to be imagined, indicated by a line here and an edge there. For example, when the Swiss historian Giedion writes of a row of Le Corbusier's houses at Pessac (cat.105b), he employs the language of Cubist or Futurist art criticism: 'These houses that so rigorously respect the planar surface are themselves being penetrated with expansive, onrushing cubes of air . . . '[80] He is referring to the fact that Le Corbusier has cut into the rectilinear volumes of his houses to provide long windows and open terraces, but the modern reader may have difficulty perceiving the 'onrushing cubes of air' to which Giedion's aesthetic predisposed him. The De Stijl movement went further in the dematerialization of mass.

After 1921 Van Doesburg and Van Eesteren developed the idea of Elementarism – that buildings could be formed of pure planes interlocking to partially enclose spaces, while also indicating a free flow of

5.24 **Ludwig Mies van der Rohe**, *Perspective view and floor plan for Brick Country House Project, Potsdam-Neubabelsberg*. Gelatin silver print, 1924. Städtische Kunsthalle Mannheim

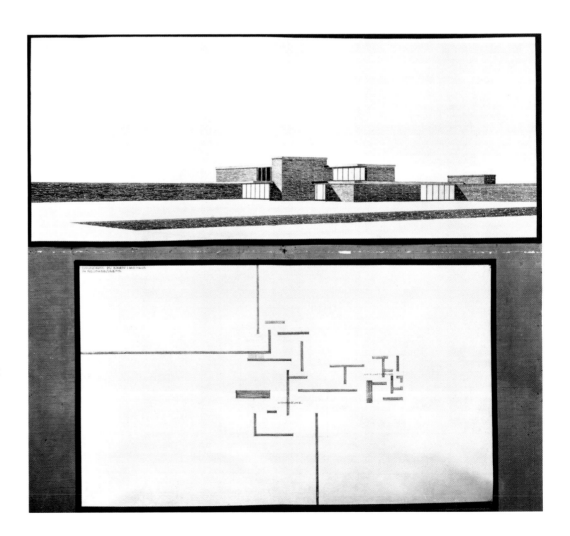

5.25 **Constantin Melnikov**, USSR Pavilion, *Exposition Internationale des Arts Décoratifs*, Paris, 1925. V&A: National Art Library

space in and out of the structure (pl.2.24).[81] Gerrit Rietveld's furniture from 1917 (pl.2.12) had exemplified the idea of form and space delineated by pure 'elements' (machined battens and panels) and it is clear that he had been influenced by the photographs of Frank Lloyd Wright's furniture in the *Ausgeführte Bauten* (*Constructed Buildings*, 1911). The paintings and constructions of El Lissitzky and László Moholy-Nagy explored the ways in which coloured planes might imply a free-flowing sense of space. In 1923 Van Doesburg and Van Eesteren exhibited in Paris coloured models that could be thought of as equally valid if turned in any direction.

By 1921 Van Doesburg was in Berlin, followed by El Lissitzky the next year. The group, which later launched the magazine *G* (1923), met frequently in the house of Hans Richter, and included Hans (Jean) Arp, Tristan Tzara, Frederich Kiesler, Walter Benjamin and Raoul Hausmann. Elementarism soon had an impact on architectural projects. Mies van der Rohe's design for a brick country villa (1922, pl.5.24) is an exercise in Elementarist design, influenced both by Wright's Prairie houses and the De Stijl movement. Mart Stam began to apply Elementarist principles to architectural and urban design in Holland, while the architectural models in the Bauhaus exhibition of 1923 in Weimar largely conform to Elementarist principles.

Meanwhile, from Russian Constructivism and its European derivatives, a quite different kind of imagery was assimilated. Constructivists wished to celebrate the industrial imagery of exposed steel girders, propaganda searchlights and loudspeakers, and the look of factories and pithead winding gear. This was a gritty, proletarian utopia, coloured red and black and inescapably connoting revolution. Certain key figures acted as go-between between the Dutch avant-garde, Russian Constructivism and Berlin. Lissitzky brought the concepts and forms of Suprematism from the USSR in 1921 and combined these with Elementarism in his Proun rooms (pl.2.22) and in a number of exhibition displays and typographic work in Germany (cat.9, pl.10.2).[82] Constantin Melnikov's USSR pavilion at the 1925 *Exposition Internationale des Arts Décoratifs* was one of the most visible, and also one of the last, expressions of Russian Constructivism in Europe (pl.5.25). Many other influential architects, such as Karel Teige from Czechoslovakia and Alvar Aalto from Finland, travelled widely and collected books and ideas from the centres of Modernism.

In April 1922 El Lissitzky and Ilya Ehrenburg launched the avant-garde magazine *Veshch'*, only two issues of which appeared (pl.2.23). Behind this venture was a group of Russian émigrés known as the Scythians

5.26

5.27

(pro-revolution, but nervous about Bolshevism). This context obliged the editors to take an apparently apolitical stance, although they saw all cultural innovation as necessarily linked to social change.[83] The purpose of the journal was to circulate information about avant-garde developments in France and Germany to the community of half a million Russian émigrés in Germany, including articles by Le Corbusier, Van Doesburg, Gino Severini and Ludwig Hilberseimer. To Russian Constructivists like Alexei Gan, *Veshch'* was still too committed to art and soft on revolutionary commitment. At the International Congress of Progressive Artists (Düsseldorf, 29–31 May 1922), Lissitzky, his friend Hans Richter and Van Doesburg claimed to represent an International Faction of Constructivists, and this group went on to found a much more hardline but also more specialized journal, *G*.[84] In the context of considerable controversy along political and aesthetic lines, the editors of *G* declared the separation of functions of the arts, and the need for architects to focus with precision on the technical potential of building. Mies published some of his most pithy and effective statements in *G*, and Richter established conventions in the design of the magazine that would be highly influential on journals with a much wider circulation, such as *Die Form* (especially after its modernization, 1926–33) and *Das Neue Frankfurt* (*The New Frankfurt*, 1925–30, pls 5.26–7). One of the conventions was the use of a bold red X to erase images with which the editors

disagreed, and this was taken over by magazines such as *ABC* and in Willi Baumeister's poster for the Weissenhof Siedlung, Stuttgart (1927) (pl.5.22). *G* and *ABC* (pl.5.29) in turn influenced the foundation of other architectural magazines such as *i10* (1927–9) and its successor *de acht en opbouw* (*Eight and Construction*, 1932–43) in Holland. These were very influential professional journals, which trained several generations of Dutch architects in the principles of Modernism.

A clear example of how an important group absorbed a wide range of avant-garde influences to emerge as a leader of International Modernism around 1925 is the case of the Bauhaus. The success of the Bauhaus masters and their international pupils in publicizing their work has skewed the historical understanding of the development of design in the 1920s. But this success was due to a clear understanding of what was needed to attract public interest, and to the extremely wide range of tendencies passing through the school (see Chapter 2 and pls 2.1, 2.3, 2.6–7, cats 15, 17, 114–21, 134–6, 140–45). From the Expressionist and Constructivist experiments of the first years (1919–23) emerged the Elementarist clarity of Moholy-Nagy's teaching and the products of the first generation of students, who became masters after 1923.

In 1923 the Bauhaus staged an exhibition, with at its centre an exhibition house (the Haus am Horn) full of objects designed by Bauhaus staff and students.

5.26 **Hans** and **Grete Leistikow**, *Das Neue Frankfurt*, vol.3, no.7/8 (July–August 1929) (cat.94a)

5.27 **Willi Baumeister**, *Das Neue Frankfurt*, vol.5, no.12 (December 1930) (cat.94b)

The catalogue, a masterpiece of New Typography, was acknowledged by Teige to be 'the first great publication of the modern movement ...'[85] But many Modernist critics, including Teige, criticized the Bauhaus in 1923 for its formalism, substituting Elementarist squares and chrome steel for Expressionist charcoal sketches and texture studies.

Gropius also mounted an exhibition of international architecture, which he later published as a book, *Internationale Architektur* (1925). In the exhibition most of the buildings were represented in drawings or models, but by the time the book was published, a fair number had been constructed. In this book, and in Adolf Behne's *Der moderne Zweckbau* (*The Modern Functional Building*), prepared in 1923 but published only in 1926, the canon of early Modernism was more or less fixed.

The Bauhaus move to Dessau, when Gropius's office designed the new school buildings and some accommodation for staff and students, also allowed Gropius to tighten up the curriculum and propose a more practical approach. But by 1927 the hard left had made such inroads into the student body that the school became almost ungovernable. Gropius, Breuer, Moholy-Nagy and others resigned to develop their

careers in Berlin, and the Swiss functionalist Hannes Meyer became director (1928–30), to be replaced by Mies van der Rohe. Under Meyer, functionalists such as Hans Wittwer (Meyer's architectural partner), Ludwig Hilberseimer and Stam, as well as Teige himself, taught at the Dessau Bauhaus, contributing to an orientation towards architecture, and in particular housing.

Stam was influenced by both the Elementarist and Constructivist strands, and was a frequent traveller between Russia, Holland and Germany. His project for the Rokin development (designed after the closure of the competition, pl.5.28) contrasts with Van Eesteren's in its mechanistic utopia, the buildings lifted off the ground, vehicle circulation provided by a propeller-driven monorail.

In his influential book *Bauen in Frankreich*, Giedion compared a drawing for this project with an image of the Eiffel Tower (pl.5.15), with the words:

Only now do the seeds that lie in structures such as the Eiffel Tower come to full fruition. The affinity with a building such as the Eiffel Tower lies not merely in the connection and interpenetration by suspended transportation or free-hanging

stations; one reaches the conclusion viewing both buildings: ARCHITECTURE NO LONGER HAS RIGID BOUNDARIES.[86]

Stam worked on many of the most influential building sites in Europe (including the Van Nelle factory outside Rotterdam, pls 3.8–9, the Westhausen housing estate in Frankfurt and the Weissenhof Siedlung exhibition in Stuttgart, pls 5.21–2). His importance was more than his ability as architectural draughtsman and designer. He had the ability to see through external forms to discover the underlying principles of design. It was his prototype tubular-steel chair, said to have been demonstrated in sketches to his fellow-exhibitors in Stuttgart during a meal on 22 November 1926, that is credited with launching the obsession with the cantilevered chair among Modernist architects (see Chapter 6).[87] And in the short-lived avant-garde journal *ABC Beiträge zum Bauen* (*ABC Contributions to Building*, 1923–6), Stam retrospectively rationalized some of the Modernists' early work and helped consolidate Modernist theory.

Founded by two young Swiss Modernists, Emil Roth and Hans Schmidt, alongside El Lissitzky and Stam, this newspaper-format magazine followed in

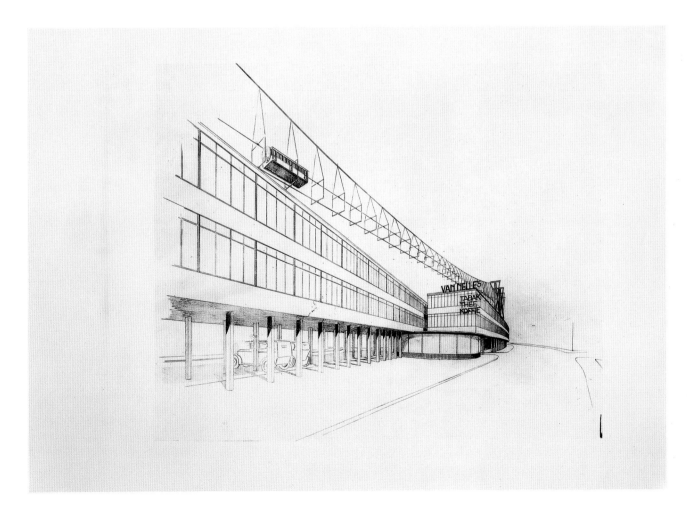

5.28 **Mart Stam**, *Design proposal for rebuilding the area 'Rokin at Dam', in Amsterdam*. Gelatin silver print, 1926. Deutsches Architekturmuseum, Frankfurt-am-Main

the footsteps of *Veshch'* and *G* , both founded in Berlin. Although still highly committed politically, *ABC* was distinctive in its internationalism and in the clarity of its pedagogic instruction. Although its circulation was small, *ABC* maintained an exchange with magazines such as *Ma* (*Today*), *Manomètre*, *Merz* and *Stavba* (*Building*) and was read by French, Czechoslovak, Dutch, Austrian, German and Swiss Modernists. For our purposes, *ABC* provides a useful summary of the evolution of Modernism from its avant-garde roots.

In the first issue of *ABC* (Summer 1924) Stam made the case for 'collective design' (*Kollektive Gestaltung*), arguing that 'the individual must make way for the general' (an idea already well established in the De Stijl group). The stress was on the need for the artist to stand alongside the engineer (understood both as technical and social) to resolve the practical problems in the supply of food and shelter. Artists must learn about technology until 'Design (*Gestaltung*) will emerge that is removed from any formalistic tendency, that is not born of a particular artist's disposition or the fantastic inspiration of the moment but is instead solidly based on the general, the absolute.'[88] In the double-issue 3/4, Stam analysed two early works by Mies van der Rohe (his glass tower of 1921 and office block of 1923) and one by Le Corbusier (the diagram of his Domino project of 1915, pl.2.15). Whereas Mies had been concerned, above all, with his glass tower projects, with the effects of transparency and reflection, Stam extracts the simplest structural principle: a central column supporting floor slabs like simple discs.[89]

Comparing Mies's concrete office-block project with his own design for an office block in Königsberg (pl.5.29), Stam points out the technical superiority of Mies's design: beams supporting the floor slabs are carried by only two stanchions, and the beams are cantilevered out beyond the line of windows to provide space for shelving.[90] In later issues *ABC* continued with its proselytizing instruction and propaganda for the Modernist cause, attacking formalism wherever it found it, including on occasions the work of Van Doesburg and Van Eesteren.

Several of the young men and women who would form the core of Dutch, German and Swiss functionalists passed through the *ABC* circle. For example, the Swiss architect Hannes Meyer, whose partner Wittwer had already contributed to *ABC*, was invited as guest editor of the second issue of the second series, which he dedicated to painting and sculpture by Baumeister, Malevich, Lissitzky, Naum Gabo, Piet Mondrian and Moholy-Nagy. The last-named also wrote a piece on the 'isms' (that is, the avant-garde movements), in which he claimed that journalistic attention to the disparity of the avant-garde movements disguised the real underlying process, which was that a number of individual artists were all trying to resolve fundamental problems of elementary design and expression. Mart Stam and Hans Schmidt explained this focus on modern art because modern

artists had 'objectives congruent with our own: the goal of restoring colour and form to their elementary values and thus supplying the architect with materials that are more useful than those previously available for the execution of his tasks … Art should not embellish, but should design and organize life.'[91] In the last issue, edited by Schmidt and Stam (1927/8), the tone of the magazine becomes harder, attacking the commercial kitsch of some modern architecture and declaring: 'ABC demands the dictatorship of the machine. The Machine is neither the coming paradise of the technical fulfilment of all our bourgeois wishes – nor the imminent hell of the destruction of all human development – the Machine is nothing but the merciless dictator of our shared lives and work.'[92] By this time Meyer had replaced Gropius as head of the Bauhaus and had nailed his colours to the mast before taking up his post.

It is important to realize how these things fit together. Meyer's selection of artworks and articles for *ABC* is compatible with his apparently unaesthetic remarks only if you give due weight to the commitment to 'form' and 'design' as both being above the outdated concept of 'art'. The supreme measures were to be 'life', 'truth' and 'the mind', within which there was room for the 'psyche'. Thus, further down the piece, Meyer accepts that colour, properly used, can be valid as 'a means of intentional psychological influence'. Art, in the form of Lissitzky's or Moholy-Nagy's work (or even Meyer's own sculptures), was therefore a necessary part of the research of the architect (or builder). The stage was set for one of the defining conflicts within Modernism.

The Czechoslovak architect, poet and artist Karel Teige had been an early supporter of Le Corbusier in

5.29 **Mart Stam**, *Analytical drawings of two projects by Ludwig Mies van der Rohe: The concrete office block*, 1923. *ABC*, 3/4 (1925), p.5

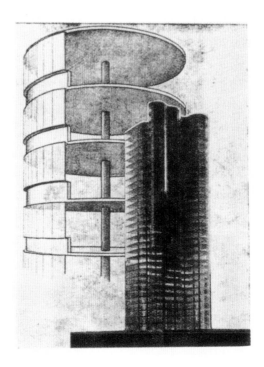

the 1920s, translating and publishing his articles in the various journals he edited.[93] By 1928, however, Teige, Meyer and Stam stood at the head of leftist groups of young architects who were dismayed at the formalistic tendencies they perceived in the work of Mies van der Rohe, Gropius and Le Corbusier. These groups had stood behind Le Corbusier's prize-winning competition entry for the Palace of the League of Nations (1926–7), but resisted Le Corbusier's attempts at leadership in the first meetings of CIAM. They were horrified at Le Corbusier's design for a 'Mundaneum', a city of learning based on a museum and library of books and bibliographical cross-references built up in Brussels by the eccentric Paul Otlet. This grand scheme, based on a pyramidal ziggurat, would have been built in Geneva as an addition to Le Corbusier's second project for the League of Nations Headquarters.[94] By now Teige was a fully fledged functionalist, stating, 'Constructivism acknowledges the antique truth: "the useful (i.e. the perfect) is beautiful". Beauty is nothing but an epiphenomenon of functional and objective perfection which stimulates in us the sensation of harmony and equilibrium … Beauty is like a chemical reaction: the fusion of form and function.'[95] In 1929 Teige published an article on the Mundaneum in which he accused Le Corbusier of 'lofty speculation', 'idealism' and 'unrealizable utopia'.[96] For Teige, monumental buildings in themselves were an irrelevant distraction from the vital objectives of life, and Le Corbusier's use of systems of geometrical proportion in the plan compounded the error. Le Corbusier wrote to Teige in August 1929 and sent him a long piece entitled 'Defence of Architecture', which was eventually published in the Czechoslovak journal *Mousaion* and in the French *L'Architecture d'Aujourd'hui* (*Architecture of Today*).[97] In it, Le Corbusier insisted that ordering of forms required composition and imagination and that the useful could never be automatically beautiful. This very public exchange marked the definitive split between the 'functionalists' and the 'formalists' within Modernism.

Conclusion

The conflict between the formalists and the functionalists continued into the 1930s, along increasingly entrenched political lines, making it almost impossible for anyone on the left to promote an architectural aesthetic, and driving men like Le Corbusier politically to the right. By 1928 many of the leaders of the modern movement, such as Le Corbusier, J.J.P. Oud and Josef Frank (all exhibitors at the Weissenhof Siedlung), had developed strong criticisms of some of the fundamental positions of Modernism. Frank, for example, wrote:

The goal … in designing an interior is not to make it as luxurious as possible or as simple as possible, but rather to make it as comfortable as possible … The most comfortable interiors have always been those that the occupant himself has put together over the course of time which betray no intention or plan.[98]

Frank's story is characteristic of the dissolution of consensus around 1928. Recognized as one of the best Modernist Austrian architects, he was invited to build a pair of houses at the Weissenhof Siedlung, where they met with criticism from other Modernists. Van Doesburg criticized them for their 'feminine appointments' and for being 'middle-class'.[99] Frank derived the opposite conclusions from the *Zeitgeist* to his Modernist contemporaries. Far from carrying the world of mechanized efficiency from the workplace into the home, the architect should strive to produce a haven of comfort, cosiness and intimacy, in compensation. In an article defending himself from criticisms of his Weissenhof houses, he maintained that 'Frippery' (*Gschnas*) had an important role in humanizing architecture.[100]

Frank subsequently resigned from the CIAM in 1929 and delivered an outspoken attack on many of the fundamental Modernist principles in a speech at the opening of the 1930 *Werkbund* Congress in Vienna. Architects should not discard the lessons and traditions of history and should seek out a deeper and more scientific understanding of the world, which would leave room for individualism. The next year he published a book entitled *Architektur als Symbol: Elemente deutschen neuen Bauens* (*Architecture as Symbol: Elements of German Modern Building*).[101] The housing exhibition he organized for the Austrian *Werkbund* in Vienna for the summer of 1932 included none of the Weissenhof Siedlung architects (except himself). The houses were all Modernist in conception, with flat roofs, large windows and open interiors, and included some very important architects, including Adolf Loos, Richard Neutra, Hugo Häring (the only German), Gerrit Rietveld and André Lurçat. The exhibition was interpreted as a challenge to the functionalists. Soon after this, the Austrian *Werkbund* split into two factions, socialist (and Jewish) versus proto-National Socialist (and Catholic). Frank and most of his Austrian colleagues and friends were politically on the left and would soon be driven out of Austria by the *Anschluss*. Had the polarization of European politics not happened, Modernism would have disintegrated. As it was, Modernism was condemned by Stalinist Russia, Nazi Germany and Francist Spain, and became the automatic allegiance of the democratic left.

86

Perspective drawing: *Daal en Berg Estate, Papaverhof*
Designed 1919–22
Jan Wils (1891 Alkmaar,
The Netherlands –1972 The Hague)

Pen and ink
63 × 97.2cm
Nederlands Architectuur Instituut, Rotterdam (WILS 1461)

Although the Dutch government was already subsidizing popular housing during the First World War (based on a Housing Act of 1901), a social and economic crisis in 1920, with many days of industrial action and the threat of revolution, led to a reinvigoration of the programme.[1] With the private construction industry hampered by rent restrictions, national and local government were prepared to invest in new methods of construction and large-scale production in the hope of finding significant economies of scale. These conditions allowed Modernists, both in the De Stijl group in Rotterdam and in the rival Expressionist *Wendingen* group in Amsterdam, to produce innovative housing experiments at a time when German construction was virtually at a standstill. An important influence on both groups was Hendrik Petrus Berlage, who had been trained under Gottfried Semper in Zurich and who was familiar with the work of Louis Sullivan and Frank Lloyd Wright, having visited America in 1911.[2] His urban plans for Amsterdam South, The Hague and Utrecht influenced all his younger colleagues.

Wils and other Dutch architects, such as J.J.P. Oud, J.B. van Loghem and Dick Grenier, responded to the challenge posed by Wright's designs for cheap concrete workers' houses in a series of housing estates in Rotterdam, Haarlem, Watergraafsmeer and The Hague in the immediate post-war period. Already in 1918 Wils had published a design for a villa with hollow concrete walls, horizontal windows, a flat roof and a Wrightian plan.[3] The Daal en Berg estate, Papaverhof, was designed as middle-class housing, laid out as semi-detached houses with small gardens around a central square. The overall impression of horizontality is accentuated by the flat roofs and wide windows, grouped together to give visual continuity from house to house. The plan follows closely Wright's project for workers' cottages for the Larkin company (1904), published in the *Ausgeführte Bauten* (1911).[4] Wils's rendering evokes the delicate graphic style of Wright's book. This is one of the first completed housing estates built in concrete and with flat roofs, with the windows grouped in bands and the individual houses flowing together to give the impression of unified blocks. TB

1 Hans Ibelings, *20th Century Architecture in the Netherlands* (Rotterdam, 1995); Giovanni Fanelli, *Architettura, edilizia, urbanistica in Olanda 1917–1940* (Monteoriolio, 1978); J.B. van Loghem, *Bouwen=Bauen=Bâtir=Building: Holland: een dokumentatie van de hoogtepunten van de moderne architektur in Nederland van 1900 tot 1932* (Nijmwegen, [1932] 1980); Jan Molema, *The New Movement in the Netherlands 1924–1936* (Rotterdam, 1996).
2 Frank Lloyd Wright, *Frank Lloyd Wright Ausgeführte Bauten* (Berlin, 1911) and Frank Lloyd Wright, *Ausgeführte Bauten und Entwürfe von Frank Lloyd Wright* (Berlin, 1910).
3 *De Stijl*, vol.1, no.8 (1918).
4 Wright (1911).

87 Plate 5.1

Drawing: *Competition design for a shopping street with housing above in Den Haag*
1924
Cornelis van Eesteren (1897 Kinderdijk, The Netherlands –1988 Amsterdam), coloured by Theo van Doesburg (1883 Utrecht –1931 Davos, Switzerland)

Ink, gouache and photo-collage mounted on board
54 × 53cm
Nederlands Architectuur Instituut, Rotterdam (III 250)

Van Eesteren was trained as an architect and in 1921 won Holland's most important prize for a young architect.[1] He met Theo van Doesburg in Weimar Germany in May 1922 and came under the influence of the De Stijl group. This was precisely the period in which Van Doesburg was becoming increasingly interested in architecture, and he needed the support of a professional. Together they exhibited a group of models and drawings at the Léonce Rosenberg gallery in Paris in October 1923.[2] From Van Doesburg, Bart van der Leck and Gerrit Rietveld, Van Eesteren absorbed De Stijl theory and the practice of using primary colours to distinguish horizontal and vertical planes.

This competition entry, proudly displaying its De Stijl colouring, is very different from the brick housing of the Dutch tradition in which Van Esteren had trained. It exemplifies the 'Elementarist' approach proclaimed by Van Doesburg on the occasion of the Rosenberg gallery exhibition (pl.2.24): 'The new architecture is elementary, that is, it is developed from the elements of building, in the widest sense. These elements, such as function, mass, plane, time, space, light, colour, material, etc., are at the same time elements of plasticism.'[3] De Stijl primary colours are used to draw attention to pure volumes and planes and to unify the houses and shops along the street frontage.

Van Eesteren won an urban competition in Berlin in 1925 and went on to become a leading proponent of Modernist urbanism (see cat.110). He was a central figure in CIAM, organizing the fourth Congress in 1933, which took place in Athens and on a boat from Marseilles. In 1929 he became the chief architect of the Amsterdam urban planning department and masterminded a major extension to the city. TB

1 Jan Molema, *The New Movement in the Netherlands 1924–1936* (Rotterdam, 1996), pp.56–7.
2 Yves-Alain Bois and Bruno Reichlin (eds), *De Stijl et l'architecture en France* (exh. cat., Mardaga, Bruxelles, 1985).
3 *De Stijl*, no.6, vol.6/7 (1923), pp.78–83, cited in Hans L.C. Jaffé, *De Stijl* (London, 1970).

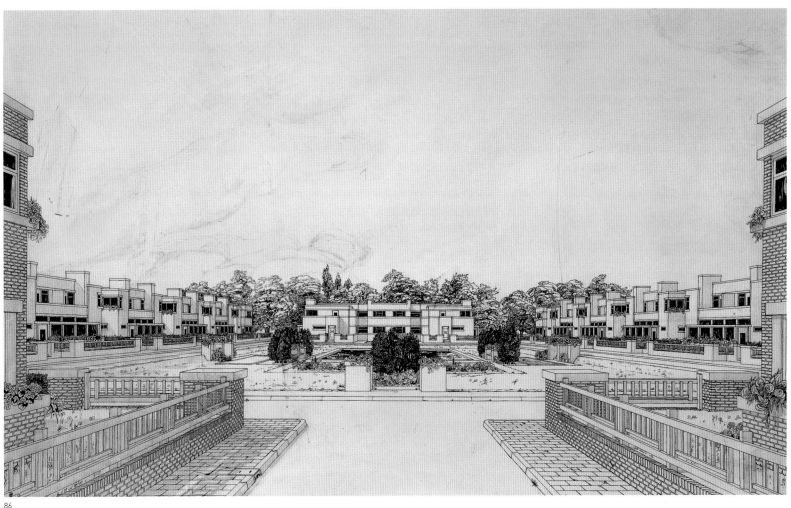

88a

Drawing: Kiefhoek Workers' Housing, Rotterdam Hilledijk

1926–30
J.J.P. Oud (1890 Purmerend,
The Netherlands –1963 Wassenaar,
The Netherlands)

Pencil on paper
19.5 × 30.5cm
Nederlands Architectuur Instituut, Rotterdam (KH5)

88b

Design: Kiefhoek Workers' Housing, Rotterdam Hilledijk

1926–30
J.J.P. Oud (1890 Purmerend –
1963 Wassenaar

Colour on photograph mounted on board
40 × 59.5cm
Nederlands Architectuur Instituut, Rotterdam (PH 1697)

Oud's experience of training with the influential German architect Theodor Fischer (1911–12), and his exposure to German theories of urban planning and housing, predisposed him to become an innovative exponent of mass housing. At the very young age of 28 he was appointed municipal architect of Rotterdam and supervised and designed a number of housing estates.[1]

The two estates that made Oud's name in Modernist circles were at the Hook of Holland (1927) and the Kiefhoek development in Rotterdam (1926–30). These two white, flat-roofed projects with large windows became staple images of European Modernism in advanced architectural journals, and led to Oud's invitation to build a row of houses at the Weissenhof Siedlung in 1927 (cat.18). Kiefhoek was featured during the CIAM Congresses at Frankfurt (1929) and Brussels (1930), and the American historian Henry-Russell Hitchcock helped to establish Oud's reputation by including him as a leading figure of European Modernism alongside Walter Gropius, Ludwig Mies and Le Corbusier in his book *Modern Architecture Romanticism and Reintegration* (1929) and in the influential exhibition at the Museum of Modern Art and its accompanying book, *The International Style: Architecture since 1922* (1932).[2]

The Kiefhoek estate (originally intended for 291 dwellings) was designed for large families (up to six children) and built to a very tight budget. Oud himself referred to the standard house types as 'Wohn-Ford' (using the same analogy as

Le Corbusier's Citrohan Houses) (pl.2.16).[3] The 4.10 × 7.54m house plans were extremely simple, consisting of a single living room and tiny kitchen and washroom on the ground floor and three bedrooms above. Some of the design ideas that Oud later incorporated in his Weissenhof houses, such as a folding ironing board and a dresser accessible from the kitchen and dining room, were here eliminated by the municipality as too expensive. No bathrooms were provided in the final building, only WCs; Oud's intention to provide a combined shower and WC under the stairs was discarded, as was his plan to provide the bedrooms with running water. When exhibited at the CIAM Congress in Frankfurt devoted to the subject of the *Existenzminimum* (minimal existence, cat.100), the Kiefhoek plans were applauded as realistic examples of working-class housing.

Oud deployed colour more subtly here than in his De Stijl designs: the white walls, red front doors and front garden walls were offset against the yellow brick of the ground-floor walls and grey galvanized windows. TB

1 Ed Taverne, Cor Wagenaar and Martien de Vletter, *J.J.P. Oud, 1890-1963 : The Complete Works* (exh. cat., Netherlands Architecture Institute, Rotterdam, 2001), pp.191–6.
2 Henry-Russell Hitchcock, *Modern Architecture Romanticism and Reintegration* (New York, 1929); Henry-Russell Hitchcock and Philip Johnson, *The International Style: Architecture since 1922* (New York, 1932); and Philip Johnson, Henry-Russell Hitchcock and Lewis Mumford, *Modern Architecture International Exhibition* (New York, 1932).
3 Taverne, Wagenaar and de Vletter (2001), pp.274–84.

89 Plate 5.23

Photograph: 'Horseshoe' building of the GEHAG Housing Association, Berlin-Britz

1925–6
Designed by Bruno Taut (1880 Königsberg, Germany–1938 Ankara) and Martin Wagner (1885 Königsberg –1957 Cambridge, USA)

Unlike many of the Modernist architects in Germany, Taut had considerable pre-war experience, first as assistant to Theodor Fischer (1904–08) and then as consultant architect to the German *Gartenstadtgesellschaft* (Garden City Association), for which he built important housing estates in Magdeburg and Berlin. His interest in the architectural use of colour is evident in the Falkenberg garden suburb in Berlin (1913–14), and he became a leading figure in post-war German Expressionism (cats 24–5).[1] As city architect in Magdeburg (1921–3), he developed his expertise as planner of low-cost housing and became notorious for commissioning modern artists to cover prominent buildings with abstract decorative schemes.[2] In 1924 Taut joined the central group of

Modernist architects in Berlin (*Der Ring*) and became consultant architect to one of the leading housing associations, the GEHAG, designing a series of very large estates in the Berlin suburbs.[3] Britz is unusual for its organic plan, with a great horseshoe block encircling a large green with a pond and a red-painted, almost windowless wall facing the street. Although the estate is built of brick, with coloured stucco surfaces to emphasize the vertical articulation of the staircases, the project was completed in record time due to the application of economic and efficient Taylorist methods of building.

Wagner – like Taut, already experienced as an architect and planner before the war – became director of the GEHAG and invited Taut to collaborate in the design of Britz. In 1926 Wagner became the city architect of Berlin and began a series of radical transformations of the city. Like Ernst May in Frankfurt (cat.91), Wagner saw himself primarily as organizer and manager. The book he wrote in 1929 with Adolf Behne is an important record of the aspirations of municipal housing.[4] TB

1 Kurt Junghanns, *Bruno Taut 1880-1938* (Berlin, 1970), pp.31–48; and Iain Boyd Whyte, 'Taut visionario' in Winfried Nerdinger, *Bruno Taut 1880-1938* (Milan, 2001).
2 Olaf Gisbertz, *Bruno Taut und Johannes Göderitz in Magdeburg* (Berlin, 2000).
3 Dieter Rentschler et al, *Berlin und seine Bauten: Band A, Teil 4* (Berlin, 1970)/, pp.82–91, and Kristina Hartmann, 'Bruno Taut, architetto e urbanista della citta-giardino', in Nerdinger (2001), pp.137–55.
4 Martin Wagner and Adolf Behne, *Das Neue Berlin; Grossstadtprobleme* (Berlin, 1929).

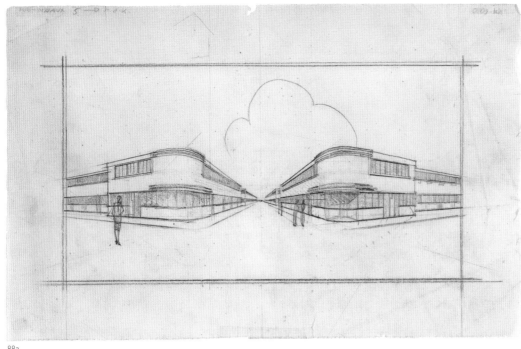

88a

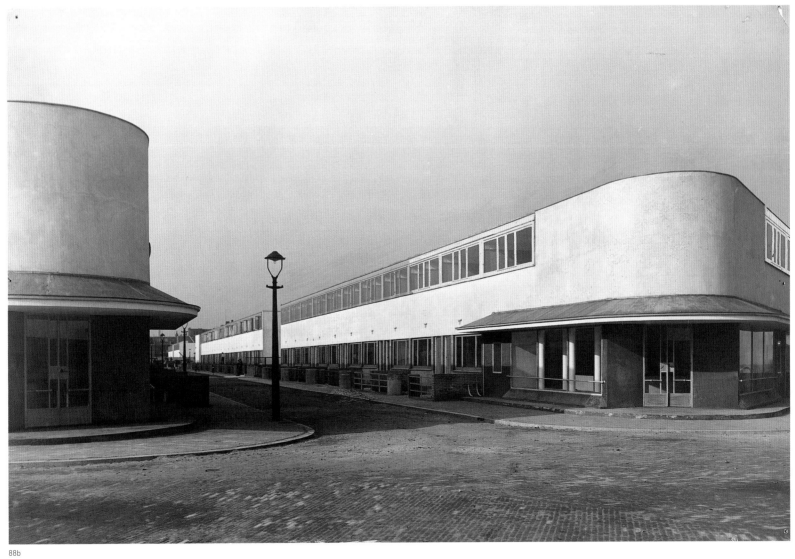

88b

90

Photograph: Karl-Marx-Hof, Vienna
1926
Designed by Karl Ehn (1884 Vienna –
1957 Vienna)

Historisches Museum Wien

Following the punitive conditions of the Versailles Treaty and the dismantling of the Austro-Hungarian Empire in 1918, Vienna was swamped with immigrants. The socialist municipality decided to attack the housing problem with a building tax and subsidized rents, and by constructing 62,000 dwellings in 15 years. The housing policy of 'red Vienna' became famous throughout Europe, building cheap and spartan accommodation with lavish social services. Individual apartments in Karl-Marx-Hof had no bathrooms and often employed 'kitchen-alcoves' in the living room rather than separate kitchens. Coal-fired stoves provided heat for washing and food preparation, but there were no lifts to help bring the coal into the apartments.[1] The Viennese housing blocks were visited by housing reformers from all over the world and were compared favourably to other Modernist estates.[2] The shared washrooms were imitated by many left-wing municipalities (for example, at Drancy, Paris, in 1935–8 and at Quarry Hill, Leeds, in 1936–40).

Washingtonhof (1927–30), by Karl Krist and Robert Oerley, was the largest of the estates, with 1,085 dwellings in a network of long blocks straddling several streets, on a 12-hectare site. This was one of the showcases of Viennese housing, and visitors were invariably impressed by the kindergarten, crèche, community centres, playgrounds and hanging baskets full of flowers. The washrooms, provided with hand and machine washing facilities and large hot-air drying racks, were particularly admired and were copied in socialist housing developments all over Europe.

The Karl-Marx-Hof was the most notorious of all these blocks, its red-painted façade appearing to symbolize giant serried ranks of the proletariat waving banners. Huge arches, whose only practical purpose was to lead to the metro station, symbolized the collective power and gigantic scale of the enterprise. As a centre of socialist solidarity, the blocks came under artillery fire from the right-wing *Heimwehr* during the civil war in February 1934. TB

1 Manfredo Tafuri, *Vienna rossa: la politica residenziale nella Vienna socialista, 1919–1933* (Milan, 1980).
2 Elizabeth Denby, *Europe Re-housed* (London, 1938), pp.148–83, and Catherine Bauer, *Modern Housing* (London, 1935), p.149.

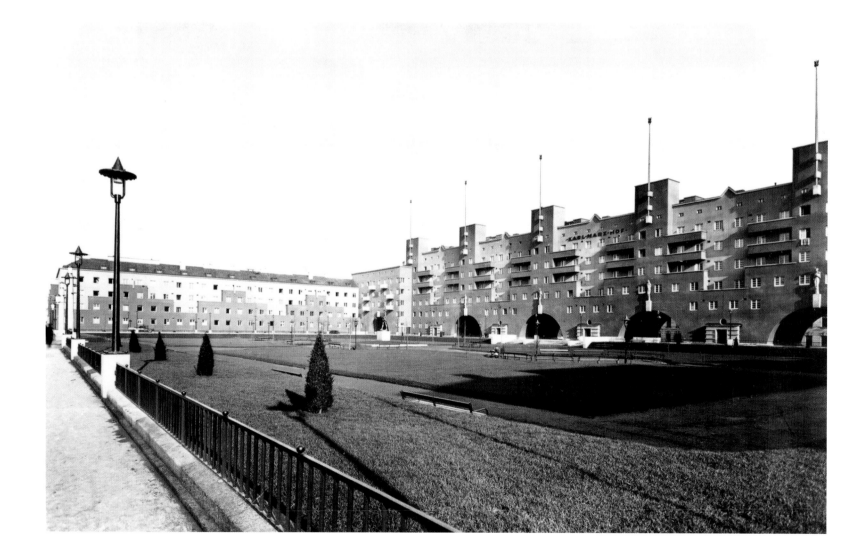

91

Photograph: Bruchfeldstrasse estate, Frankfurt
1926
Ernst May (1886 Frankfurt –1970 Hamburg)
and C.H. Rudloff (dates unknown)

May inherited the traditions of the English Garden City movement in a most direct fashion, studying in London (1907–08) and working with Raymond Unwin (1910–12) before returning to Munich to study under Theodor Fischer, himself a primary advocate of Garden City planning. In 1924 May was appointed city architect of Frankfurt and given far-reaching powers by Mayor Ludwig Landmann. The city of Frankfurt had fortunately purchased, before the war, an extensive suburban green belt of land along the River Nidda, and May exploited

this to lay out a series of spectacular housing estates surrounded by greenery. Some of these, such as the Bruchfeldstrasse estate, betrayed the remains of Expressionist influence. An enclosed space with sandpits and paddling pool is surrounded by a zigzag arrangement of apartments. Others, such as Praunheim and Römerstadt, reflected the undulating terrain in their plans, while yet others, such as Westhausen (1930), designed by the Dutch Modernist Mart Stam, were laid out on a rigid grid to maximize efficiency. In some parts of Praunheim and in the small Mammolshainstrasse estate, May experimented with a truly industrialized system of construction, employing pre-cast concrete panels, and he liked to give the impression that this system was widely used in the Frankfurt estates. In fact, however, the main breakthrough was in a very high level of standardization, incorporated in a set of *Normenblätter* (drawings of standard details), which extended from window

frames and doors to the smallest details of fixtures and fittings. The architect Eugen Kaufmann was in charge of this great effort of *Typisierung* (standardization). The journal *Das Neue Frankfurt* (pls 5.26–7) helped publicize these achievements and became a clearing house for Modernist ideas and imagery. TB

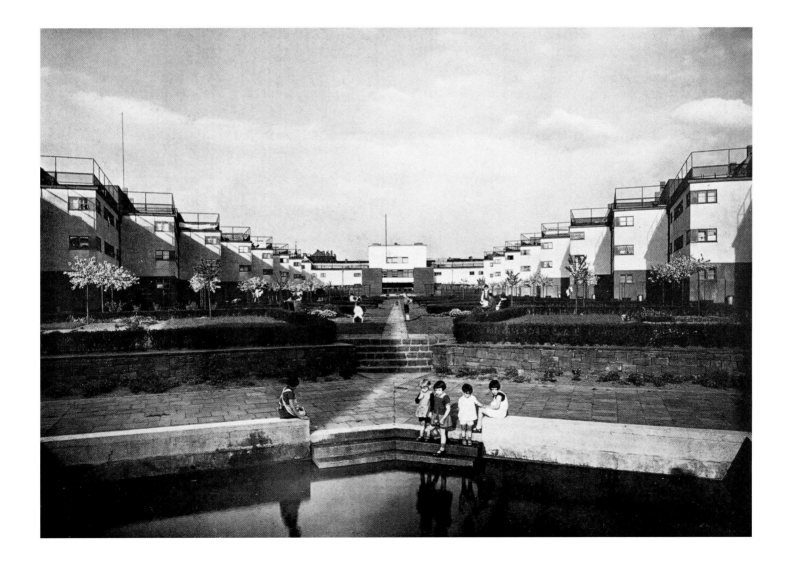

Frankfurt Kitchen

1926–7
Designed by Grete Lihotsky
(Margarete Schütte-Lihotsky)
(1897 Vienna – 2000 Vienna)
From the Am Höhenblick housing estate,
Ginnheim, Frankfurt[1]

Various materials
About 3440 × 1870cm in plan
V&A: W.15–2005

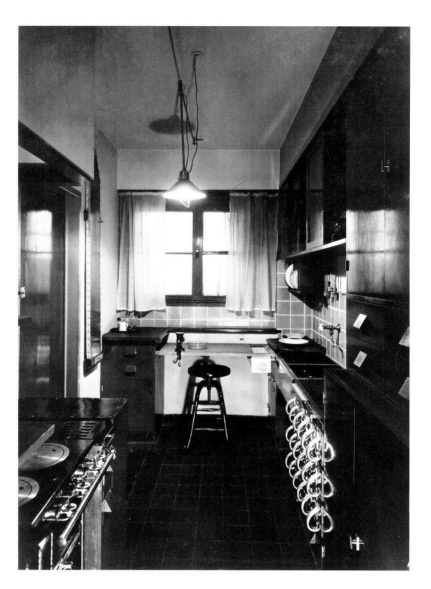

The Frankfurt Kitchen
as illustrated in *Das
Neue Frankfurt* in 1927.

The vast Frankfurt housing projects built by Ernst May's Municipal Building Department (where architect Grete Lihotsky worked) aimed to standardize building elements and mechanize construction along Taylorist and Fordist lines. [2] These attempts at rationalization and efficiency applied also to the design of flats and, notably, to the design of this kitchen, versions of which were installed in around 10,000 of the Frankfurt flats. The Frankfurt Kitchen (as it was known at the time) was not the first fitted kitchen, or even the earliest Modernist fitted kitchen, but it was the first to be made in quantity. It was undoubtedly the most successful and influential kitchen of the period, and stood as a symbol of the principles of 'scientific' professionalization of the domestic workspace.[3]

Like many designers aiming at efficiency in the home, Lihotsky would have been conversant with Erna Meyer's hugely popular manual for the home, *Der neue Haushalt* (*The New Household*, 1926), which was itself based on the classic American text *The New Housekeeping: Efficiency Studies in Home Management* (1913) by Christine Frederick. In these, the bodily movements and circulation patterns of the housewife as she engaged in daily work were analysed to arrive at new principles for household design and labour. These were reflected in the close analysis of the positioning of each element of the Frankfurt Kitchen in relation to others to minimize unnecessary steps, and in the provision of features aimed at saving labour and providing physical comfort. Among these were the work table for preparing food under a light-giving window and adjacent to the sink, both at a height for using while seated; the storage chutes with handles and pouring spouts for dry comestibles, obviating the need for the steps involved in opening cupboards, then jars, and spooning out the contents; and the drop-down ironing board, omitting the need for another object requiring assembly and storage.

Not only was the idea of labour-saving important to the layout of the kitchen, but it was central to its construction and cheap price. The cabinets had no backs and, owing to the continuity of the units, there was just one side wall required.

Financing was offered to flat residents to enable them to buy a kitchen, which they paid off through their monthly rent.[4] The kitchen was made in three sizes, to fit different flats, including those with no servants, one or even two servants (which was possible even for those living in municipal housing, given the low wage costs at the time). The small size of the kitchen reflected a pursuit of efficiency, the belief that eating in the kitchen was unhygienic, and a desire to save space for the living areas of the flat. The principle of the compact kitchen owes much to the design of galleys in ships and trains of the era.[5] CW

1 The kitchen came from a flat at Kurhessenstrasse 132, 2nd floor. The estate was also referred to as the *Siedlung Ginnheimer Hang* (Ginheim Hillside estate), in 'Führer durch die Frankfurther Siedlungen', *Das Neue Frankfurt*, vol.2, no.78 (1928), p.136. The image of the Frankfurt Kitchen illustrated on this page was published in the first article on the kitchen by Grete Lihotsky, 'Rationalisierung im Haushalt', *Das Neue Frankfurt*, vol.1, no.5 (1927), p.120–23.

2 'Internationaler Verband für Wohnungswesen', *Wohnungspolitik der Stadt Frankfurt am Main* (Frankfurt [1929]), pp.31,33.

3 Modernist experiments in rational kitchen design pre-dating the Frankfurt Kitchen included those at the Haus am Horn exhibition house at the Bauhaus exhibition of 1923, Anton Brenner's Vienna Living Machine Project (1924), Gustav Wolf's kitchen for the Westfalian Heimstätte and Bruno Taut's in Berlin Zehlendorf (1926). See Marjan Boot and Marisella Casciato, *La casalinga riflessiva, La cucina razionale come mito domestico* (exh. cat., Palazzo delle Exposizioni, Rome, 1983) and Bettina Rink and Joachim Kleinmanns, *Küchenträume* (exh. cat., Lippischen Landesmuseums, Detmold, 2005).

4 The cost of a kitchen has been calculated at 1.5 times the monthly income of a factory worker; see Rink and Kleinmanns (2005), p.23.

5 Susan R. Henderson, 'A Revolution in the Woman's Sphere: Grete Lihotzky and the Frankfurt Kitchen', in Debra Coleman, Elizabeth Danze and Carol Henderson, *Architecture and Feminism* (Princeton, 1996), n.35, has pointed out the similar influences on the nineteenth-century authors Catherine Beecher and Harriet Beecher Stowe in their *The American Woman's Home* (New York, 1869).

93

Chair, model B403
1927
Designed by Ferdinand Kramer
(1898 Frankfurt –1985 Frankfurt)
Manufactured by Gebrüder Thonet,
Frankenberg

Bent beechwood frame, moulded plywood seat and back
81.5 × 43.5 × 64.5cm
V&A: W.3–2005

Frankfurt city architect Ernst May was able to use the city's capital to set up a municipal company, Hausrat GmbH (literally 'household equipment'), to buy in or commission chairs, tables, stoves and even complete kitchens (cat.92) and bathrooms for use in the city housing estates built by his department. Selected approved products (whether produced by the Hausrat or by others) were listed in the *Frankfurt Register*, which contained all the technical details (price, dimensions, materials) for use by architects in their projects.[1] Numbered sheets were published, grouping objects from the *Register* by type, acting both as advertisements and as design statements. These sheets were eagerly collected by architects all over Germany and helped to promote the movement towards general standards (the DIN standards). Many of these items were designed by Kramer, who won a competition organized by Hausrat in 1925. One of his most successful designs was a cast-iron stove with back boiler, capable of heating an apartment and supplying hot water. Many of the objects on the *Register* were designed by others, such as the ex-Bauhaus designers Christian Dell (cat.139) and Wilhelm Wagenfeld (cat.135), whose lamps were included, as were those by Adolf Meyer (Gropius's partner) and Poul Henningsen (cat.138). Some of

Kramer's designs, such as his door handles, were used in other large-scale housing developments.

Kramer's bentwood chair, designed for manufacture by the Thonet company and costing a modest 28 Reichsmarks, was included in the *Register*, along with several other Thonet chairs.[2] Kramer's chair featured on the cover of the exhibition catalogue *Der Stuhl* (The Chair), mounted by Adolf Schneck in Stuttgart in 1928. Kramer designed this chair for simplicity of manufacture and robust construction, rather than elegance in Modernist terms. There is no attempt to exploit

the flexibility of bent beechwood in cantilevered curves or flexing seat or backrests. Furthermore, it was far from being the cheapest of the Thonet chairs; the B9 chair much loved by Le Corbusier (pl.3.25) was nearly half the price (15RM).

In an interesting article Kramer defended the need to create 'type' equipment for the home, arguing from economic necessity in the marketplace, but also on aesthetic and spiritual grounds: 'The type dwelling requires type furniture on rational and aesthetic grounds.'[3] The personality of the individual does not have to be expressed by one-off objects made by hand or inherited from family. The dwelling and its contents should simply be a backdrop for the expression of individuality through other means. TB

1 See Heinz Hirdina, *Neues Bauen, neues Gestalten: das neue Frankfurt/die neue Stadt eine Zeitschrift zwischen 1926 und 1933* (Berlin, 1984), which reprints 12 of 17 of the numbered sheets as well as several articles from *Das Neue Frankfurt* on the *Register*.
2 On the chair, see Claude Lichtenstein, *Ferdinand Kramer: der Charme des Systematischen* (Giessen, 1991), pp.28–9, 174.
3 Ferdinand Kramer, 'Individuelle oder typisierte Möbel?', *Das Neue Frankfurt*, vol.2, no.1 (1928).

94a Plate 5.26

Magazine: *Das Neue Frankfurt*, vol.3, no.7/8 (July–August 1929)
Cover design by Hans (1892 Elbing, Germany –1962 Frankfurt-am-Main) and Grete (1893 Elbing, Germany–unknown) Leistikow

V&A National Art Library (501.E.14)

94b Plate 5.27

Magazine: *Das Neue Frankfurt*, vol.5, no.12 (December 1930)
Cover design by Willi Baumeister (1889 Stuttgart –1955 Stuttgart)

V&A National Art Library (501.E.16)

Das Neue Frankfurt first appeared in October 1926 and soon became an essential work of reference for Modernist architects, alongside the Bauhaus magazine (first issue 4 December 1926) and the *Deutscher Werkbund* (DWB) journal *Die Form* (relaunched in October 1925). The city architect Ernst May kept a tight rein on the journal, considering it an organ of propaganda for his housing activities in Frankfurt. Josef Gantner was the editor for most of its run, writing many of the articles. The New Typography of the design (with its connotations of Russian and German Constructivism), the integration of product and housing design, the strongly left-wing thrust of the articles (visually symbolized by the frequent use of black and red blocks of colour) and the effective use of photography, made it a benchmark of Modernist magazine production. The

covers were particularly admired for their impact and vigorous political symbolism. Hans Leistikow was only named as the designer – alongside his sister, the photographer Grete Leistikow – in the second year of production. They remained in charge until they joined the 'May brigade', a group of the ablest and most committed architects and designers in Frankfurt who left for the Soviet Union in 1930. From issue 10 (1930), Willi Baumeister took over the artistic direction of the journal, but it ran out of steam in the face of political reaction in Frankfurt, and closed in 1932.[1] TB

1 Heinz Hirdina, *Neues Bauen, neues Gestalten: das neue Frankfurt/die neue Stadt eine Zeitschrift zwischen 1926 und 1933* (Berlin, 1984), p.13.

95 Plate 5.21

Photograph: Weissenhof Siedlung
(Housing Estate), part of *Die Wohnung*
(*The Dwelling*) exhibition, Stuttgart
1927

Towards the end of 1925 the Württemberg section of the *Deutscher Werkbund* (DWB) decided to propose a housing exhibition that would demonstrate new building techniques and draw together architects and designers in the DWB tradition. Until 1926 conservative Stuttgart was largely under the influence of the established architectural leaders Paul Bonatz (architect of the neo-Romanesque railway station) and Paul Schmitthenner (a passionate advocate of neo-vernacular garden suburbs). A group of young Modernists (including Richard Döcker, Richard Herre and the painter Willi Baumeister) looked to the Berlin group *Der Ring*, led by Ludwig Mies van der Rohe and Hugo Häring, taking courage in the appointment of Mies and Walter Gropius to the board of the DWB in 1925. On 12 June 1926 Mies was named deputy director of the DWB, further increasing the influence of the Modernists.[1]

The architects selected to build new housing as part of the exhibition (the Weissenhof Siedlung) were dominated by members of *Der Ring* (Mies, Max and Bruno Taut, Hans Scharoun, Adolf Räding, Gropius, Peter Behrens, Hans Poelzig, Ludwig Hilberseimer). Two Stuttgart architects were included (Richard Döcker and Adolf Schneck), the pioneer of Belgian Modernism Victor Bourgeois, two radical Dutch architects, J.J.P. Oud and the functionalist Mart Stam, and the moderate Austrian Josef Frank. Apart from two architects from the older generation, Behrens and Poelzig, the architects were in their thirties or forties. Although Ernst May was not asked to build a house, his exhibition of industrialized building techniques dominated the experimental building exhibition that accompanied the housing estate.[2] Hendrik Petrus Berlage, Henry van de Velde, Heinrich Tessenow, Adolf Loos, Theo van Doesburg, Hugo Häring, Eric Mendelsohn and even Paul Bonatz were included on preliminary lists of architects to invite, but were eventually dropped. The original intention was to make the houses suitable for families on low incomes, but by the time Mies sent out his instructions to the architects, this brief had changed. Mies listed four housing types, of which all but one had at least one maid's room and between four and six rooms.

The DWB exhibition, including the Weissenhof Siedlung, was opened on 23 July 1927 by Peter Bruckmann, chairman of the *Werkbund*, amidst considerable publicity and controversy. Baumeister's poster (pl.5.26), and several booklets and magazine articles, emphasized the exhibition's radical, anti-bourgeois message.[3] Mies's opening

statement highlighted the ideological character of the exhibition: 'The problem of the new home is ultimately a problem of the mind, and the struggle for the new home is only one element in the great struggle for new forms of living.'[4] Most of the European architectural journals reviewed the exhibition, and influential books were produced by people associated with it.[5] Walter Riezler, editor of the DWB journal *Die Form*, welcomed the replacement of the 'particular and the unique' by a 'striving after the universal' and the 'social convictions for which at the moment only one problem exists: to provide model dwellings that will meet the requirements and the economic capacity of the masses'.[6] Not all the response was positive. Riezler went on to criticize the houses for their impracticality and lack of human warmth. Bonatz, writing in the *Schwäbische Merkur* in 1927, was characteristically forthright: 'A heap of stark cubes, uncomfortably crowded, pushes up the slope in a series of horizontal terraces, looking more like a suburb of Jerusalem than dwellings for Stuttgart.'[7] Criticisms like this from the traditionalist right helped to form a coalition of architects – *Der Block* – that would campaign against Modernism in architecture in Germany until the National Socialist regime began in 1935, at which point they assumed a dominant position. A 'counter-exhibition' led by Paul Schmitthenner of 100 neo-vernacular houses – *Der Kochenhof* – was mounted between 1927 and 1933 by this group in Stuttgart.

Criticisms were also levelled by Modernists who noted the high cost of the houses and their impractical, avant-garde quality. Hermann Muthesius was particularly scathing:

It is the new form that calls for the flat roofs and puts up with the manifold disadvantages, still at present unforeseen, which go with it. It is the new form that gives us the tremendous overlighting of the living-rooms, because it dictates to its disciples the absolute need to run unbroken lines of windows all round the house. It is the new form that leaves the outer walls defenceless against the weather, from which in the past, our climate being what it is, they had generally been protected by a projecting roof. All these are things that have nothing to do with rationalization or economy or structural requirements. It is simply a question of form. The ideal is to create cubic blocks.[8]

The Swiss functionalist Hans Schmidt commented on Le Corbusier's single house (pl.5.5):

To have the living room, dining room stairs, study, bedroom, bath and bidet gathered within four walls, as it were, without any insulation against sound and odours, hardly expresses the current concept of gracious living ... Is it merely an extension of the lifestyle of the artist's studio, where an impromptu dinner is spread on a rickety table close to the artist's easel, where the clatter of crockery and the

tinkling of the piano intrude agreeably on the writer's thoughts as he sits at his desk, where the bed stands ready for models and lady friends alike, with bath and bidet conveniently at hand?'[9]

Schmidt criticized the lack of practical detailing for protecting wall surfaces, the obsession with movable partitions and open planning, and the consequent lack of privacy.

The Weissenhof estate was submitted to intense economic and technical scrutiny. Thanks to a detailed report in 1929 by the Government Research Association (*Reichsforschungs-gesellschaft*), the economic facts and figures are precisely documented.[10] The houses were meant to be constructed to the Württemberg cost yard-stick of 35RM per cubic metre. In fact, all the houses, even the most functionalist in appearance, came out at between one and a half and three times the cost. The most economical were those with the most conventional construction techniques (Behrens's apartment block built of breezeblock walls and concrete floors, and Josef Frank's masonry houses). Among the more unusual and cheapest construction methods were wood-reinforced concrete (Poelzig's house) and a system of wood planks nailed together in a zigzag pattern to make solid walls and floors (one of Richard Döcker's houses).

When the exhibition finally closed on 31 October 1927, half a million visitors, many of them foreigners, had inspected the best that Modernism had to offer. The exhibition helped to forge the sense of international unity that led directly to the campaign in defence of Le Corbusier's prize-winning but unconstructed project for the League of Nations building in Geneva (1927) and to the launching of CIAM in 1928. TB

1 Karin Kirsch, *The Weissenhofsiedlung: Experimental housing built for the Deutscher Werkbund, Stuttgart, 1927* (Stuttgart, 1987) and Richard Pommer and Christian F. Otto, *Weissenhof 1927 and the Modern Movement in Architecture* (Chicago, 1991).
2 *Amtlicher Katalog der Werkbundausstellung DIE WOHNUNG Stuttgart 1927* (Stuttgart, 1927), reprint; Franz J. Much, *Amtlicher Katalog: Schriftenreihe Weissenhof Band 2* (Stuttgart 1998), pp.76–80.
3 *Bau und Wohnung* (Stuttgart, 1927); Werner Gräff, *Innenräume*: (Stuttgart, 1927).
4 *Werkbund Ausstellung* (catalogue of the Weissenhof exhibition, 1927), p.5, cited in Kirsch (1987), p.19.
5 Heinz and Bodo Rasch, *Wie Bauen?*, (Stuttgart, 1927); Gräff (1928).
6 Walter Riezler, 'Die Wohnung', in *Die Form* (1927), cited in Charlotte Benton (ed.), *Documents* (Milton Keynes, 1975), p.19.
7 Trans. in Benton (1975), p.22.
8 Hermann Muthesius, 'The controversy about the shape of the roof', from *Baukunst und Bauhandwerk*, no.2 (1927), trans. in Benton (1975), pp.23–4.
9 Hans Schmidt, 'Die Wohnung', *Das Werk*, vol.15 (1927), in ibid., p.20.
10 Jürgen Joedicke and Christian Plath, *Die Weissenhof Siedlung* (Stuttgart, 1968), pp.44–7.

96 Plate 5.22

Poster: *Die Wohnung (The Dwelling)*
Werkbundausstellung Stuttgart
(*Werkbund Exhibition Stuttgart*)
1927
Willi Baumeister
(1889 Stuttgart –1955 Stuttgart)

Lithograph on paper
114.3 × 81.6cm
V&A: E.226–2005

97

Exhibition leaflet: *Werkbundausstellung
Die Wohnung* (*Werkbund Exhibition
The Dwelling*)
1927

Printed paper
210 × 17.5cm
Private Collection

This leaflet, originally produced in German, French and English, shows the whole array of things to see on the Weissenhof hill during the exhibition: the houses and their interiors, an exhibition of domestic appliances and furniture, an exhibition of bathrooms and kitchens, a display area for new building techniques and an exhibition of photographs and models of new international architecture.[1] In the *Internationale Plan- und Modell-ausstellung neuer Baukunst* (International Exhibition of Plans and Models of New Architecture) held in the Städtischen Ausstellungshallen, which accompanied the housing exhibition, 531 designs were shown from architects from all over Europe and the US (but omitting Britain and the Scandinavian countries).[2] In the Gewerbehalle and its annexe, the Stadtgartenumgang, Lilly Reich designed an exhibition of fixtures and fitments, including a Mitropa railway kitchen, a complete Frankfurt kitchen by Grete Lihotsky (cat.92) and a display of kitchen equipment by Erna Meyer, who had written a best-selling book on modern domestic equipment in 1926.[3] The exhibition included modern lights designed by the Danish designer Poul Henningsen (cat.135), as well as others by Marianne Brandt (cat.134), Adolf Meyer, Max Ernst Haefeli and Heinz and Bodo Rasch. Hall 4 in the Gewerbehalle was laid out as a 'hall of mirrors' – a kind of abstracted domestic environment stripped of almost all furniture, with walls and screens of glass and mirrors of various colours and textures. This was a practice run for the German Pavilion that Ludwig Mies van der Rohe would design for the Barcelona exhibition

in 1929. A demonstration site for new building techniques included a range of new materials and fixings and the construction of a whole section of prefabricated concrete housing, as pioneered by Ernst May in Frankfurt (cat.91), plus examples of a prefabricated steel house and a corrugated-iron weekend cottage.

The new dwellings that constituted the Weissenhof Siedlung (as well as the separate exhibition) were billed as demonstrations of furniture and fittings. The School of Arts and Crafts in Stuttgart had an enviable reputation for innovative furniture design under the leadership of Professor Adolf Schneck, who hosted a major exhibition of modern chairs in Stuttgart in 1928. Many consumers were won over to Modernism not by architecture but by design, and by the production of affordable, well-designed and practical household goods that had been a speciality in Germany since the war. It was also a major claim made by the Modernists at the Weissenhof exhibition that modern architecture was based on sound hygienic principles (see Chapter 7).

Designed in a sans-serif face and with a graphic use of images and slogans, this leaflet communicates well the convictions behind the exhibition. 'No luxury!' and 'mass production', it proclaims, and ends with the exhortation: 'Let's go to Stuttgart'. Interestingly, for an exhibition dedicated to the search for the universal and the discrediting of individuality, the architects are represented in the leaflet by mug-shots and labels identifying their nationality. TB

1 See Karin Kirsch, *The Weissenhofsiedlung: Experimental housing built for the Deutscher Werkbund, Stuttgart, 1927* (Stuttgart, 1987), including pp.21–31 on the various exhibitions that accompanied the housing estate.
2 *Amtlicher Katalog der Werkbundausstellung DIE WOHNUNG Stuttgart 1927* (Stuttgart, 1927), reprint; Franz J. Much, *Amtlicher Katalog: Schriftenreihe Weissenhof Band 2* (Stuttgart 1998), pp.101–112.
3 Erna Meyer, *Der Neue Haushalt, Ein Wegweiser zu Wissenschaftlichen Hausführung* (Stuttgart, 1926).

The technique of defacing images of buildings or interiors to be criticized with red crosses had been developed in avant-garde magazines such as *G* and *ABC*. Fritz Stahl, writing in the *Berliner Tagblatt*, sharply criticized the tactic of the poster, which presented a turn-of-the-century interior as if it were the current norm to be overcome by Modernism. 'That kind of apartment went out twenty years ago. Present day homes look completely different. But then, of course: if they had illustrated a room by Bertsch, Pankok, Riemerschmid [all members of the DWB] ... there would have been a risk that the public would turn against the most modern designs and prefer the one that is destined to be eliminated.'[1]

Few artists were as closely associated with architectural circles as Baumeister. He knew well members of the Bauhaus and *Der Ring*, as well as Le Corbusier. He designed a wide range of graphic materials for the Weissenhof exhibition, including books, brochures and even stamps.[2] TB

1 Fritz Stahl, 'Die neue Wohnung', cited in *Schwäbisches Heimatbuch*, vol.14 (1928), p. 88. Cited in Karin Kirsch, *The Weissenhofsiedlung: Experimental housing built for the Deutscher Werkbund, Stuttgart, 1927* (Stuttgart, 1987), p.20.
2 Wolfgang Kermer, *Willi Baumeister: Typographie und Reklamegestaltung* (Stuttgart, 1989), pp.73–84.

97

98a

Isometric drawing: *Plan of garden and row houses at Weissenhof*
1926–7
J.J.P. Oud (1890 Purmerend,
The Netherlands –1963 Wassenaar,
The Netherlands)

Ink, pencil, pen on tracing paper
73 × 58.1cm, scale 1:100
Nederlands Architectuur Instituut, Rotterdam (ST 17)

98b

Isometric drawing: *Kitchen for five row houses*
1926–7
J.J.P. Oud (1890 Purmerend –
1963 Wassenaar)

Ink on strong tracing paper
55.7 × 45.1cm
Nederlands Architectuur Instituut, Rotterdam (ST 381)

98c

Photograph: Five row houses, rear view
Designed by J.J.P. Oud (1890 Purmerend,
–1963 Wassenaar)
1927

Oud's terrace row was built of a reinforced concrete frame filled in with a lightweight mixture of gravel, sand, pumice and clinker, set in concrete poured from a giant cement mixer and distributor (the Kossel system).[1] This material had good insulation properties and could be very swiftly constructed. Unfortunately, the walls were left very rough in this system and the mass of concrete required months to dry out properly. With such a big overhead cost, and with all the hand labour required to acquire a reasonable finish, the system was hopelessly uneconomic for five houses, costing more than twice the standard rate (see cat.95).[2]

Oud's houses were much admired, however, for their practical details. The street door, which could be opened remotely from the kitchen, gave onto a small patio with access to a coal cellar and a bicycle or pram shed. The kitchen was particularly successful, with a hatch opening onto the living–dining room.[3] This isometric drawing shows the kitchen towards the front patio. A sliding cover exposed either the sink or access to the rubbish pail. Placing the food preparation surface under the window – now taken for granted – was unusual at this time. Adjoining the front patio was a scullery (combining the functions of pantry and laundry) and above this, opening off the landing, was a clothes-drying space, ventilated by horizontal windows under the roof slab. A dumb waiter linked the laundry and drying area. The tiny bathroom on the first floor opened onto bedrooms front and back, with a small bedroom also facing the garden. The bathroom, a WC and a closet off the landing (which were not indicated on the plan) were illuminated and ventilated by skylights in the flat roof, allowing the bedrooms to use every inch of the frontages. Small gardens to the rear allowed a cheerful Dutch exuberance of flowers and fruit trees to soften the geometry of the exteriors. Oud gave the presence of these gardens as the main reason for his restraint in the use of colour. Most commentators recognized that Oud's houses went much further than most in meeting the practical needs of the working mother. Oud was able to put into practice ideas impossible for him to achieve in Rotterdam (cat.88), where cost restraints prohibited luxuries such as bathrooms, reasonably sized kitchens and clothes-drying areas.

One of the interiors was decorated with Oud's distinctive steel furniture, with its narrow, painted, tubular-steel frame fitted with ball feet to protect the linoleum floor; the lamps were made by Wilhelm H. Gispen. Another of the houses was furnished by Ferdinand Kramer with standard pieces from the catalogue of the *Frankfurter Register*, the Frankfurt municipal furniture factory that supplied all the housing estates in the city (see also cat.93). TB

1 Karin Kirsch, *The Weissenhofsiedlung: Experimental housing built for the Deutscher Werkbund, Stuttgart, 1927* (Stuttgart, 1987), pp.90–99; Richard Pommer and Christian F. Otto, *Weissenhof 1927 and the Modern Movement in Architecture* (Chicago, 1991), pp.116–22; Ed Taverne, Cor Wagenaar and Martien de Vletter, *J.J.P. Oud, 1890–1963: The Complete Works* (exh. cat., Netherlands Architecture Institute, Rotterdam, 2001), pp.291–303.
2 The cost worked out at 68RM per cubic metre; Jürgen Joedicke and Christian Plath, *Die Weissenhof Siedlung* (Stuttgart, 1968), pp.46–7.
3 Mies had sent Oud notes about the arrangement of the kitchen based on Erna Meyer's book *Der neue Haushalt* (1925), along with a programme for an efficient home prepared by a group of Stuttgart housewives, which Oud later published in the Dutch magazine *i10*. Ed Taverne, Cor Wagenaar and Martien de Vletter (2001), p.294. See also Pommer and Otto (1991), pp.118–19.

99

Drawing: *Elevation of houses at Weissenhof*
1927
Walter Gropius (1883 Berlin –1969 Boston, USA)

Ink and tempera
22.1 × 60.3cm
Busch-Reisinger-Museum, Harvard University Art Museums, Gift of Walter Gropius (BRM-GA 23.2)

Part of the brief for the Weissenhof exhibition was for architects to experiment with new structural systems, including such unusual systems as 'wood-reinforced concrete' and '*zick-zack bau*' (a system that used planks of wood nailed together in a concertina profile to make rigid floors and walls). One of two houses designed by Gropius, this one was constructed of a steel skeleton with prefabricated asbestos panels lined with cork.[1] A significant advantage of this system of dry assembly was that it avoided the long drying out periods that afflicted concrete houses such as J.J.P. Oud's. Despite the apparent simplicity of construction, this was one of the more expensive houses. Gropius was concurrently building the Törten housing settlement in Dessau (1926–7), in which he attempted to use a system of semi-prefabricated concrete construction, with disastrous results. At Weissenhof, the prefabricated panels lining the walls and ceilings established a planning grid, which also determined the layout of the floor plans, indicating the potential for large-scale industrial production. The ground-floor plan provided for a large living–dining room linked to a kitchen by a big serving hatch. A room on the first floor was designated as laundry and drying area, but in the event was converted into a fourth bedroom in order to accommodate the eight children belonging to the first family to occupy the house. By 1930 the house was lived in by a doctor and his wife and was furnished with Marcel Breuer-designed tubular-steel furniture. TB

1 Karin Kirsch, *The Weissenhofsiedlung: Experimental housing built for the Deutscher Werkbund, Stuttgart, 1927* (New York, 1989) pp.131–8.

98a

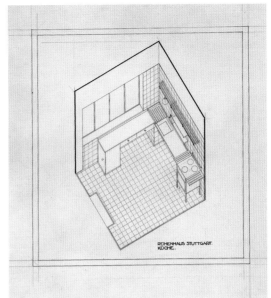

98b

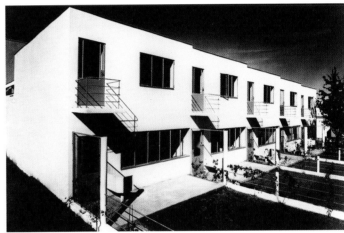

98c

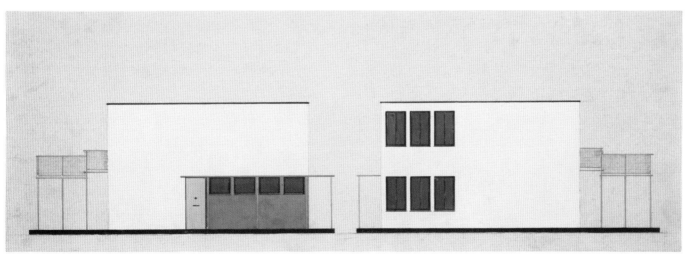

99

100

Poster: *Die Wohnung für das Existenzminimum* (*The Dwelling for Minimal Existence*)
1929
Hans Leistikow (1892 Elbing, Germany –
1962 Frankfurt-am-Main)

Offset lithograph
117 × 84cm
Merrill C. Berman Collection

The first working conference of CIAM was held in Frankfurt in 1929. A feature of the attendant exhibition, and the accompanying publication, was the presentation of large plans on panels projecting at an angle from the walls of the exhibition hall. These plans, prepared by delegates from many different countries, were all drawn to the same scale and to the same convention, marking the 'free' space and the enclosed volume and indicating furniture in grey halftone. The aim was to provide significant comparative data for the standardization of *Existenzminimum* (minimal existence) housing units.[1] In fact, one of the discoveries of the exhibition and conference was the variation in standards of comfort provided in different countries, leading to the later eradication of plans lacking separate bathrooms and kitchens. Almost all the plans were for apartment dwellings or terraced houses, with the exception of those of Le Corbusier, who exhibited his Maison Loucheur, semi-detached, dry-assembly steel houses. The exhibition and conference also prompted the separation of thinking between those (mostly on the political left) who believed that their mission was to build the maximum number of dwellings at the minimum acceptable standard of space and convenience, compared with others (such as Le Corbusier) whose aesthetic sensibilities turned them against this kind of functionalism.

Leistikow pays tribute to the conference hosts, illustrating the plan of the two-storey terrace houses in the Praunheim estate, Frankfurt.[2] The poster is given a Constructivist kick with its diagonal displacement and coloured lettering. The message is quite clear: this is to be a serious and 'objective' event, concerned with the essentials of the housing problem. TB

1 The term *Existenzminimum* was used within the context of the social policy of the Weimar Republic and indicated the bare economic minimum need for a decent everyday existence. Within the architectural community the meaning was altered to indicate the rationalized minimum space required for a flat.
2 *Die Wohnung für das Existenzminimum* (Frankfurt, 1930), Plan 11, unpaginated.

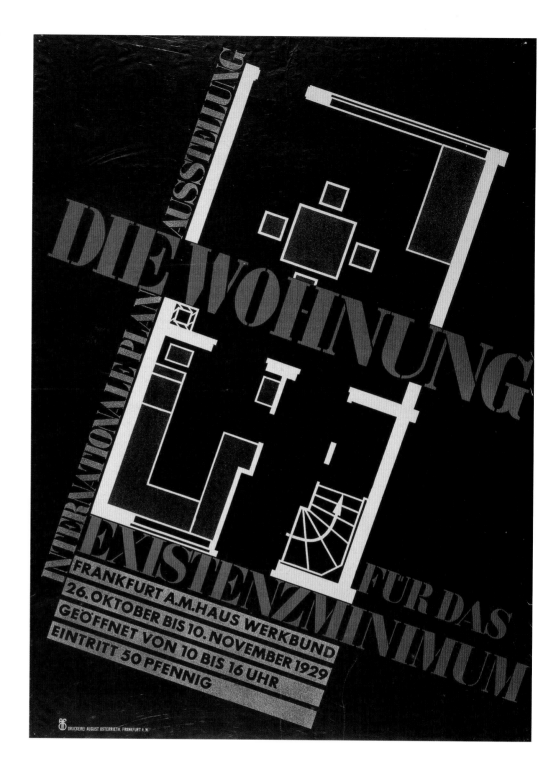

101a Plate 5.10

Book: *Nejmenší byt* (*The Minimum Dwelling*)

1932

Karel Teige (1900 Prague –1951 Prague)

26 × 18.3cm
The Museum of Decorative Arts, Prague (GK 9398C)

101b

**Proof of book cover: *Nejmenší dům*
(*The Minimum House*)**

1931

Designed by Ladislav Sutnar (1897 Pilsen,
Bohemia –1976 New York)

Letterpress
21 × 15cm
Merrill C. Berman Collection

Teige, the Czech poet, artist and architect, developed during the 1920s from an engagement with Dada, Constructivism and Purism into a hard functionalist.[1] Like the Russian functionalists and men like Hannes Meyer, Teige advocated the construction of collective housing in which private spaces would be reduced to the minimum and the functions of eating, recreation, washing and childcare would be grouped together in units of various size. His political engagement as a communist comes through clearly in his writings, notably in his Marxist defence of Modernism, *Architektura a tridní boj* (*Architecture and the Class Struggle*), which was published in one of the magazines he edited, *Red* (1931). As Stalinism began to reject Modernism in favour of Socialist Realism and a populist return to classical styles, Teige struggled to combine his loyalty to the party with his commitment as a Modernist architect. Refusing to give in to the party line, he wrote a series of articles (some of them reproduced in this book) using arguments framed in Marxist dialectical materialism against the Stalinist line. By the time this book was published, Teige was under strong attack from members of his own party, while still proposing his radical Marxist attack on 'liberal' proponents of Modernism in Europe. *The Minimum Dwelling* is the setting for a war on two fronts, therefore, simultaneously attacking Le Corbusier and Ludwig Mies van der Rohe while pouring scorn on the official Soviet architecture practised by the VOPRA group, which was eclectic and sometimes neo-baroque. Sutnar and Oldřich Starý's (1884–1971) book published 18 designs for houses submitted to a 1929 competition. The striking abstraction of the cover contrasted with Teige's more polemical design. TB

101b

1 Karel Teige, *Modern Architecture in Czechoslovakia and Other Writings* (Santa Monica, 2000), see Jean-Louis Cohen, introduction, pp.1–55; Woljciech Lesnikowski, *East European Modernism; Architecture in Czechoslovakia, Hungary and Poland between the Wars* (London, 1996), pp.59–100; and see also Gustav Peichl and Vladimir Slapeta, *Czech Functionalism* (London, 1987).

102

Photograph: Siemensstadt settlement, Berlin, 1930

1930

Designed by Hans Scharoun
(1893 Bremen –1972 Berlin)

The giant electrical company Siemens invested in a large model housing estate near its factory in Berlin in 1930.[1] Scharoun drew up the master plan and his colleagues from *Der Ring* built a series of blocks of flats offering a unified overall aesthetic, while at the same time employing subtly different approaches. Scharoun designed both the most spectacular and the most ingenious of the blocks, using the curve of the road and the cut-out form of the balconies to create a memorable impression, leading to his block being nicknamed the 'battleship'. Inside, he turned the living-room windows into a double-glazed winter garden where tenants could grow plants. Hugo Häring also tried to soften the impact of his blocks by extending the balconies in a generous curve, allowing room for a family of four to eat in comfort on their balcony. Walter Gropius used a plan that he had also applied at his large estate at Dammerstock.

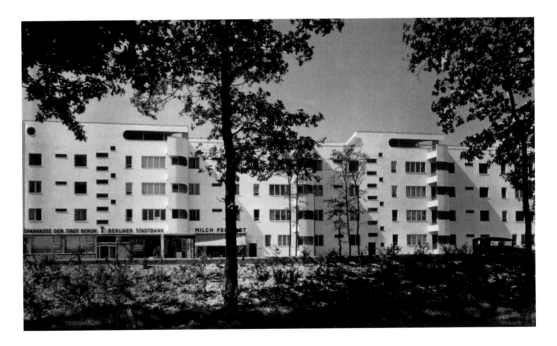

Siemensstadt became a showpiece of modern housing in Berlin and featured in all the major exhibitions and publications on modern architecture of the time. The apartments are well looked after today and much appreciated by their inhabitants. TB

1 Dieter Rentschler et al., *Berlin und seine Bauten: Band A, Teil 4* (Berlin, 1970), pp.174–6.

103a Plate 1.1

Drawing: *Perspective of Courtyard*,
Blijdorp Municipal Housing, Rotterdam
1931–2
J.J.P. Oud (1890 Purmerend,
The Netherlands–1963 Wassenaar,
The Netherlands)

Watercolour, pencil and metallic paint
76 × 61cm
Nederlands Architectuur Instituut, Rotterdam (OUDJ-bd 14)

103b

Drawing: *Bird's-eye view*, Blijdorp
Municipal Housing, Rotterdam
1931–2
J.J.P. Oud (1890 Purmerend –
1963 Wassenaar)

Watercolour, pencil and metallic paint
54 × 72cm
Nederlands Architectuur Instituut, Rotterdam (OUDJ-bd 17)

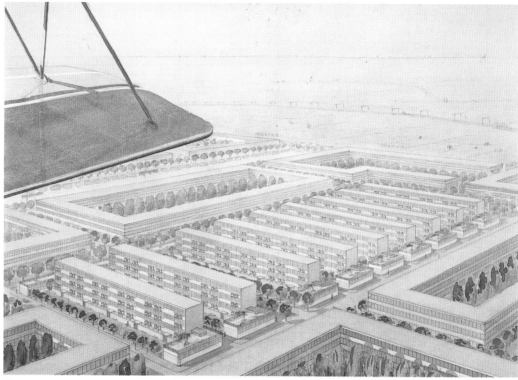

103b

The Blijdorp Municipal Housing project (306 dwellings projected for a site to the north of the centre of Rotterdam) is an example of International Modernism, reflecting debates within CIAM and developments in housing in Germany, Holland and Czechoslovakia (for example, the Westhausen estate at Frankfurt and Siemensstadt in Berlin, cat.102).[1] Nine long buildings were laid out in parallel rows in the arrangement known as *Zeilenbau* (at right angles to the street) and oriented to make the best of the sunlight. Plans were organized so that the living rooms looked out onto an enclosed communal garden and the bedrooms and bathrooms of the facing block. These communal areas were later criticized as lacking 'territorial definition'; not

being the responsibility of individual tenants, they fell into disrepair.[2] Oud's design could have been conceived in any of a dozen countries in Europe at the turn of the decade, reflecting the consensus of views among Modernists. This was the last of the housing estates designed by Oud for Rotterdam. Shortly afterwards he resigned his post as city architect in 1933 on the grounds of ill health. The political and cultural climate was moving against Modernism in Holland, and he was also beginning to have doubts about functionalism in design.

These renderings stress the two aspects of modern housing claimed by the Modernists: their modernity (symbolized by the view from the air)

and their elegance (expressed in the chic hat and coat worn by the young lady on the balcony). By 1930 architects realized that they had to 'sell' their housing, rather than appeal to the spirit of the *Existenzminimum*. Oud used colour and careful compositions to make these *Zeilenbau* dwellings as attractive as possible, emphasizing the gardens between the blocks. TB

1 Ed Taverne, Cor Wagenaar and Martien de Vletter, *J.J.P. Oud, 1890–1963: The Complete Works* (exh. cat., Netherlands Architecture Institute, Rotterdam, 2001), pp.304–311.
2 Oscar Newman, *Defensible Space: People and Design in the Violent City* (London, 1972), pp.51–77.

104 Plate 5.17

Photograph: Narkomfin complex, Moscow
1929–30
Designed by Moise Ginzburg (1892 Minsk–1946 Moscow) and Ignatii Milinis (dates unknown)
Photographed by Sigfried Giedion (1888 Prague–1968 Zurich)

It is not surprising that some of the most extreme experiments in designing apartments for communal living took place in the communist Soviet Union.[1] Some existing tenement blocks were

adapted to provide shared cooking, eating and washing facilities, to allow the remaining space to be used most efficiently for sleeping. In 1927 the architectural magazine *SA* promoted a campaign for research into housing types, and this led to the appointment of Ginzburg as head of a research group in the State Committee for Construction (RSFR Stroikom).[2] Ginzburg's group worked up two standard plan forms, one for single or double bedrooms supported by shared facilities (on the model of a student hostel) and another of more conventional apartments with their own cooking and washing facilities, but also with shared communal dining rooms, laundries, kindergarten and library. The result of this latter planning was the Narkomfin block of flats on the Novinsky Boulevard (later renamed Tchaikovsky Street) in

Moscow, designed to house civil servants from the Ministry of Finance. The Minister of Finance, Miliutin, lived on the top floor. The six-storey block was lifted off the ground on *piloti* and included two corridors, one on the first floor and the other on the fifth, giving access to a range of flats. Some of these were deployed on two storeys in an ingenious interlocking arrangement, which proved influential in Germany, Italy and England. TB

1 Selim O. Khan-Magomedov and Catherine Cooke, *Pioneers of Soviet Architecture: The search for new solutions in the 1920s and 1930s* (London, 1987), pp.341–98; Jean-Louis Cohen, Marco De Michelis and Manfredo Tafuri, *Les avant gardes et l'Etat URSS 1917–1978* (Paris, 1979); Oleg A. Schvidkovsky, *Building in the USSR 1917–1932* (London, 1971).
2 Khan-Magomedov and Cooke (1987), pp.347–8, 389.

105a

Model: Skyscraper, Pessac housing estate, near Bordeaux
1925–6 date of model unknown
Le Corbusier (Charles-Edouard Jeanneret)
(1887 La Chaux-de-Fonds, Switzerland–
1965 Cap-Martin, France) and Pierre
Jeanneret (1896 Geneva–1967 Geneva)

Wood and painted cardboard
101 × 41 × 67cm
Fondation Le Corbusier, Paris

105b

Photograph: Skyscrapers, Pessac housing Estate
1926
Photographed by Sigfried Giedion
(1888 Prague–1968 Zurich)

105a

In Henri Frugès, the manager of a large wine importing and sugar-refining company in Bordeaux, Le Corbusier found a generous and enthusiastic patron, who tirelessly supported his activities at the cost of contributing to his own ruin.[1] Fifty houses (out of a planned total of 132) were built in an estate named Quartiers Modernes to the west of Bordeaux. The plans were standardized around elements of 5 × 5m and 5 × 2.5m, combined in a number of different configurations. Although Le Corbusier persuaded the hapless Frugès to invest a sum equivalent to the estimated cost of three houses, on the purchase of American 'cement cannons' (capable of spraying concrete onto formwork), these turned out to be incapable of giving the smooth, even, machine-made look that Le Corbusier desired. After six trial houses were built, Le Corbusier insisted on calling in his favourite builder Georges Summer, who sent a team from Paris to take over the work. Construction of most of the houses at Pessac was in breezeblock with hand-finished cement render and the 'P.I.M.A.' tile and concrete floor slabs patented by Summer. The estate was a laboratory for experimentation with mass-produced standard building elements. More than 1,000 2.5-m steel windows with matching roller blinds were ordered (less than a third of them were eventually used), and the bathrooms, kitchens and most of the details were standardized. Nevertheless, as Le Corbusier ruefully admitted in his book *Almanach de l'Architecture Moderne* (*Almanac of Modern Architecture*, 1926), this standardization was a failure, because he felt compelled to make countless adjustments to the plans and details to extract maximum advantage from each situation.

This model and photograph represent the 'skyscrapers': three-storey semi-detached structures that lined one of the streets and created a heroic impression. A distinctive feature was the external staircase, which linked the bedrooms to the roof terrace. These staircases could be cast from the same moulds as the internal staircases linking the ground to the first floors. Le Corbusier used colours from his Purist palette to liven up the estate in time for the visit of Minister Anatole de Monzie in June 1926. TB

1 Philippe Boudon, *Lived-in Architecture: Le Corbusier's Pessac revisited* (Cambridge, MA, 1972); Tim Benton, 'Pessac and Lege revisited: standards, dimensions and failures', *Massilia*, vol.3 (2004), pp.64–99.

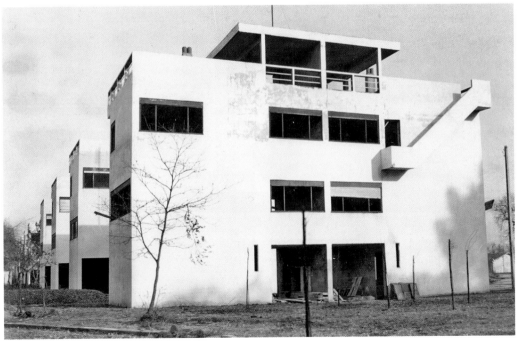

105b

106

Drawing: *Designs for Villa Meyer*,
Neuilly-sur-Seine

1925

Le Corbusier (Charles-Edouard Jeanneret)
(1887 La Chaux-de-Fonds, Switzerland –
1965 Cap-Martin, France)

Indian ink on tracing paper
109 × 61cm
Fondation Le Corbusier, Paris (FLC 31525)

As part of the processes of persuasion and seduction of his clients, Le Corbusier produced illustrated 'letters' like this, in the early years of his practice in Paris.[1] This is the first of two such attempts to charm the young and pregnant woman who might have been a client for a large house in the Parisian suburb of Neuilly, overlooking the Folie Saint-James. The sketches lead the client through the house, from the ground floor to the roof, with written descriptions of the pleasures of living in a Modernist house. He likened the project to an 'Innovation' suitcase, rectilinear on the outside, but capable of opening out in a series of drawers and hanging spaces.[2] He also used the metaphor of a treasure chest, or box of surprises. He compared the roof terrace to a painting by the Renaissance master Vittore Carpaccio, and assured his potential client that she would hear the birds in the adjoining Folie Saint-James singing all year round. Finally, he insisted on the personal and loving care he had put into the project: 'This project, madam, was not born abruptly under the hasty pencil of a draughtsman between telephone calls. It has matured over a long period and caressed during days of perfect calm, in front of a landscape of high classicism.'[3]

The landscape described and sketched in the letter was the view from the lakeside at Le Corbusier's mother's house, where he had recently spent his summer holidays. And when Madame Meyer – and, more importantly, her father, who was to pay for the house – hesitated to commit to the design, Le Corbusier drew the emotional strings even tighter: 'My paternity is suffering! You are cruel, madam, to make us wait so long. I told you how much care I put into this project and how excited we have been to see it emerge into the world. A house which remains on paper is a stillbirth. I tell you honestly, I suffer to the root of my being as a father.'[4]

The Villa Meyer projects (there were five of them) were an important laboratory for the design of Le Corbusier's complex town houses, leading directly to his important Villa Stein De Monzie (pl.1.2). TB

1 Another such sheet exists FLC 31525, 31514 (Fondation Le Corbusier, Paris).
2 Le Corbusier used this luggage as an example of the 'spirit which underlies our work: to make standardized type objects for standard requirements' in his publications. See, for example, *Almanach d'architecture moderne* (Paris, 1925), p.196.
3 FLC 31525, see Benton, *The Villas of Le Corbusier, 1920–1930* (London, 1987), pp.144–5.
4 FLC letter of Le Corbusier to Mme Meyer, 24 February 1926. Ibid. pp.142, 144–5.

107 Plate 5.19

Axonometric drawing: *Villa Cook*, **Boulogne-sur-Seine**
1926
Le Corbusier (Charles-Edouard Jeanneret) (1887 La Chaux-de-Fonds, Switzerland– 1965 Cap-Martin, France) and Pierre Jeanneret (1896 Geneva –1967 Geneva)

Gouache on collotype
92 × 90cm
Fondation Le Corbusier, Paris (FLC 8309)

Few axonometric or isometric renderings were produced in the Le Corbusier studio until the arrival of Swiss and German students in 1926–7, hired to help with the preparation of the competition drawings for the League of Nations building in Geneva (1926–7). This coloured drawing shows this influence, as well as that of De Stijl in the colouring. In the event, the colouring of the Villa Cook did not follow this design.[1]

William Cook was an American journalist and amateur painter. This house is located a few hundred metres from the studios Le Corbusier had designed for Jacques Lipchitz and Oscar Miestchaninof and for the musician Paul Ternisien, in the suburb of Boulogne-sur-Seine. The Cook house was the first realized expression of the Five Points of a New Architecture, which were initially announced in a lecture written for the inauguration of the two houses at the Weissenhof Siedlung (1927).[2] The separation of structure from enclosure is demonstrated in the set-back *piloti*, which allows unbroken windows along the façade (the free façade and the long window). The free plan is demonstrated by designing each storey independently from the ones below. A small roof terrace is provided, opening off the study, which, as in so many of Le Corbusier's houses, is located at the top of the house. The ground floor is reduced to a small rounded nacelle (like the front of a Farman Goliath bomber) housing the staircase, with a garage on one side and a sheltered open space on the other. Le Corbusier arranged a double-height studio-living room at the top of the house, adjoining the dining room in an open-plan arrangement. Stairs lead up to the library and office. This is one of the most successful spaces in Le Corbusier's 1920s output. TB

1 Tim Benton, *The Villas of Le Corbusier, 1920–1930* (London, 1987) pp.155–63.
2 The five points are: the use of *piloti*, the free plan, the free façade, the long window and the roof garden. Le Corbusier and Pierre Jeanneret, 'Fünf Punkte zu einer neuen Architektur', *Die Form*, vol.2, no.1 (1927).

108 Plate 1.2

Drawing: *Design for the Villa Stein De Monzie*, **Vaucresson**
1926
Le Corbusier (Charles-Edouard Jeanneret) (1887 La Chaux-de-Fonds, Switzerland – 1965 Cap-Martin, France)

Coloured chalk on tracing paper
44 × 74cm
Fondation Le Corbusier, Paris (FLC 10588)

Sarah and Michael Stein (brother to Gertrude Stein) were wealthy Americans living in Paris with a taste for modern art (notably Matisse) and a surprisingly bohemian lifestyle. They commissioned Le Corbusier to design a house, to be shared with the estranged wife of the government minister Anatole de Monzie in the rural suburb of Vaucresson, to the west of Paris.[1] Drawings like this in coloured chalk are fairly rare in Le Corbusier's work, since he only used them in the presentation of projects to clients at a moment when decisions had to be made. They were the speciality of Le Corbusier's cousin and associate, Pierre Jeanneret.

The site was a typical suburban plot, 27 metres across and 186 metres deep. After experimenting with different plans, Le Corbusier settled on placing the house as a single block across the plot, at the end of a long drive. This elevation is for an unexecuted variant of the project, designed around 13 November 1926. The basic arrangement of the house, with the service entrance on the left and the main entrance on the right, has already been resolved. A strong geometric rhythm (ABABA), consisting of 5-metre and 2.5-metre bays, articulates the elevation and helps to organize the plan. In this variant, the entrance façade is shown with an extension on the left, at first-floor level, which extended the space of the kitchen. Compared to the finished design, this elevation is relatively fussy, with a range of different window shapes. In the next stage of the design process, the concrete structure (visible here as thin struts) is moved back from the façade, allowing for two rows of unbroken long windows on the first and second floors. The expression of the ABABA grid became considerably more subtle as a consequence. TB

1 Tim Benton, *The Villas of Le Corbusier, 1920–1930* (London, 1987), pp.165–89.

109 Plate 5.18

Lecture drawing: *Comparison of a traditional house and a modern house on piloti*
1929
Le Corbusier (Charles-Edouard Jeanneret)
(1887 La Chaux-de-Fonds, Switzerland–
1965 Cap-Martin, France)

Pencil, charcoal and pastel on cardboard
99 × 70cm
Fondation Le Corbusier (FLC 32089)

Le Corbusier lectured regularly from 1924 onwards, developing and refining his theory that new structural systems, such as reinforced concrete, allowed the architect to free up plan and elevation. This sketch was made during one of his lectures in Buenos Aires, in October 1929.[1] Le Corbusier drew as he talked, hanging out the completed drawings on a clothes line. He used charcoal and coloured pastels, insisting on the importance of colour for 'classification' – in this case, brick red for masonry, concrete and earth, green for vegetation and blue for the flow of space underneath the *piloti* of the modern house.

This drawing uses a common technique of comparing bad old traditional practice with the new potential of reinforced-concrete construction. On the left, the traditional masonry house depends on load-bearing walls, which have to be repeated on successive storeys and can only permit a certain number of windows. The concrete house, on the right, liberates the ground floor by raising the house on *piloti* and leaving only a small staircase housing. The floor plans above are 'free' – the first-floor walls can be deployed without worrying about the walls below – because the reinforced-concrete floor slabs are carried by thin *piloti*. On the roof, more space is 'won' by making a roof garden, which gives back the surface area occupied by the house for recreation. The sketches demonstrate that raising the building on *piloti* avoids the need to dig massive foundations, with the consequent requirement to dispose of the displaced earth. The sketch exaggerates the separation of structure and infill, representing the ground floor as nine thin *piloti* and a staircase, while the first floor scrupulously separates the *piloti* from the walls, including the external walls, which are shown as windows all round. The Villa Savoye, in construction as Le Corbusier made the drawing, came closest to carrying out this formula. TB

1 Le Corbusier, *Precisions on the present state of architecture and city planning: with an American prologue, a Brazilian corollary followed by the temperature of Paris and the atmosphere of Moscow* (Cambridge, MA, [1930] 1991).

110

Axonometric drawing: *Business district of a large modern city*
1926
Cornelis van Eesteren (1897 Kinderdijk, The Netherlands–1988 Amsterdam) and Louis-Georges Pineau (1898–1987)

Pencil and ink
104.2 × 74.5cm
Nederlands Architectuur Instituut, Rotterdam (P46)

Stimulated by Le Corbusier's *Contemporary City for Three Million Inhabitants* (cat.36), a number of architects in the Netherlands and Germany concentrated on rationalizing the organization of work and dwelling in imagined cities of the future.[1] Ludwig Hilberseimer, in his book *Grossstadtbauten* (*City Architecture*, 1925) went further than most in laying out a relentless grid of high- and middle-rise building on the American model, thereby achieving renown among functionalists and notoriety among critics of Modernism in architecture. Le Corbusier managed to infuriate the public more effectively with his *Plan Voisin* (1925) than with his more theoretical exercise, the *Contemporary City* (cat.36). Applying his urban scheme to Paris, he would have wiped out most of the right bank, saving only the Hotel Crillon, the Louvre, the Palais Royal, the Place des Vosges and other historic buildings close to the Seine. Although a large part of this area (including most of the Marais) was designated as a slum and slated for redevelopment anyway, his plan would have replaced the heart of commercial Paris.

Van Eesteren was still working in the studio of the De Stijl architect Jan Wils (cat.86) when he made this design, which was part of a competition entry for resolving traffic problems in the centre of Paris. He had attended classes at the École des Hautes Études Urbaines (School for Advanced Studies in Urbanism, 1923–4), encouraged by his friend Louis-Georges Pineau. In this axonometric drawing, Van Eesteren arranged a tall office building in the centre of each block, with low-rise shops and houses facing onto the street.[2] In between these local streets were sunken motorways, allowing fast through traffic. This project can be understood as a commentary on Le Corbusier's *Plan Voisin* of the previous year. Accepting the abstract and theoretical aspects of Le Corbusier's plan, Van Eesteren tried to integrate tall buildings into a practical system of streets and motorways. In Paris he learned to analyse detailed urban data and present it in a planning dossier (Pineau's speciality).[3] He put his developing expertise to good use in his teaching at the Bauhochschule Weimar (1927–30) and in his later career in the Amsterdam urban development department (1929–59).

This design was not conceived in a vacuum. Dutch architects concurrently experimented with mixed development schemes, combining high- or middle-rise residential buildings with terrace rows and shops, some of which were later built. A great deal of research went into the problem of circulation, which culminated in a Dutch National Highways Plan (1927). The third CIAM meeting (Brussels, 1930) focused on systems of housing development, with Walter Gropius presenting a paper entitled 'Low, middle or tall building' and Le Corbusier presenting the first version of his Radiant City. Van Eesteren, combining professional urban planning skills and a radical approach to design and representation, quickly rose to be one of the most authoritative figures in International Modernism, serving as president of CIAM from 1930 to 1947. TB

1 Francesco Passanti, 'Le Corbusier et le gratte-ciel: aux origines du Plan Voisin', in Jean-Louis Cohen and Hubert Damisch (eds), *Americanisme et modernité...*, (Paris, 1993), pp.171–89.
2 For the cultural importance of the axonometric, see Yves-Alain Bois, 'Metamorphoses of Axonometry', in *Het Nieuwe Bouwen, De Nieuwe Beelding in de architectuur* (Delft, 1983), pp.101–53.
3 Vincent Van Rossern, 'Cornelis Van Eesteren und die Bauhochschule in Weimar: ein vergessenes Kapitel in der Geschichte des modernes Städtebaus', in *Das andere Bauhaus Otto Bartning und die Staatliche Bauhochschule Weimar 1926–1930* (Berlin, 1997), pp.45–60.

111 Plate 5.14

Photograph: Cadillac Hotel, Detroit
1923
Photographed by Knud Lönberg-Holm
(1895 –1972)

From a very early moment in the development of Modernism, architects realized that the aesthetic potential of steel construction was not in expressing the structure, but in cladding it with reflective glass surfaces. Architects had admired the structural efficiency of steel since the 1870s, but had difficulty accepting the network of stanchions and girders as aesthetically satisfying. It was not until Modernist architects found new ways of thinking about steel frames that a new aesthetic could be forged. The German architect Erich Mendelsohn was one of

those who interpreted steel construction as a kind of 'truth' underlying modern building. He used the term 'X-Ray' to describe this photograph, referring to a hidden reality, which it was the duty of the architect to expose and exploit aesthetically.

This was one of a number of photographs by the Danish architect Knud Lönberg-Holm, which Mendelsohn used in his book *Amerika: Bilderbuch eines Architekten* (*America: An Architect's Picture Book*, 1926), in which he recorded his impressions of a trip to America in 1924.[1] The 'deception' of covering steel or concrete structural carcasses with stone or brick walls was also often compared to the hypocrisy of bourgeois attitudes to life. It was Sigfried Giedion who theorized this comparison between structural rationalism and the ideology of the class system, which he associated with the aesthetic attributes of transparency as a kind of spiritual liberation from the material world.[2] In practical terms, the approach of

Modernist architects (Mendelsohn included) was to use glass to demonstrate the independence of structure and cladding and to emphasize the horizontal floor slabs. When Ludwig Mies van der Rohe cased his cross-shaped steel stanchions in reflective chrome in the Barcelona Pavilion and the Tugendhat House in Brno (both 1929), he was taking this dematerialization of the steel structure a step further. A different approach was used by the Russian Constructivists, for example in Vladimir Tatlin's *Monument to the Third International* (cat.3), where the gritty industrial quality of steel girders symbolizes the proletarian revolution. TB

1 Erich Mendelsohn, *Amerika: Bilderbuch eines Architekten* (Berlin, 1926), p.171. Lönberg-Holm emigrated to America just before Mendelsohn's trip in 1924.
2 Sigfried Giedion, *Building in France; Building in Steel; Building in Ferroconcrete* (Santa Monica, [1928] 1995), p.145, and Hilde Heynen, *Architecture and Modernity: A critique* (Cambridge, MA, 1999), pp.29–37.

110

112a Plate 5.15

Photograph: Eiffel Tower, Paris
1905
Photographed by Sigfried Giedion
(1888 Prague –1968 Zurich)

112b Plate 5.16

Photograph: Pont Transbordeur, Marseilles
1905
Photographed by Sigfried Giedion
(1888 Prague –1968 Zurich)

Bruno Taut and his Expressionist friends had already found their own way of celebrating the delirious vision of a future composed of coloured glass architecture (see Chapter 2). The sketches in the *Gläserne Kette* letters focused on the effects of colour and light, but the Expressionist architects knew that coloured glass could only cover vast spaces if supported by concrete or steel. After 1924 the emphasis shifted from coloured light to the new and surprising perspectives of the New Photography. A key step in this appreciation occurred in the photographic representation of steel structures, such as the Eiffel Tower and the

Pont Transbordeur in Marseilles, which were dramatized by plunging views to emphasize the filigree effects of steel girders.[1] This new way of perceiving steel constructions meshed with a strand of art historical writing, which, for different reasons, began to value space as an intangible but aesthetically determinant factor in the appreciation of architecture (see Chapter 5). Giedion's book *Bauen in Frankreich* (1928) developed these ideas in a consistent theoretical framework.[2] Architects like Ludwig Mies van der Rohe began to exploit the transparent effects of glass as much for the numinous suggestion of fluid or ambiguous space as for the exposure of structural members behind. Taking their cue from art critics writing about Cubism, influential authors such as Theo van Doesburg and Giedion began to refer to space and time as 'elements' or significant parts of architectural experience.[3] This was a potent metaphor for the presence of spiritual or higher artistic feeling in buildings. Mies van der Rohe's Glass Hall in the Weissenhof exhibition (1927) and his Barcelona Pavilion (1929) carried this spiritualization of architecture to a new level of abstraction.

Giedion's photograph of the Marseilles bridge, reversed and in negative, was used by László Moholy-Nagy for the cover of Giedion's book *Bauen in Frankreich* (Moholy-Nagy also made a film, *Marseille Vieux Port*, which included the bridge). Printed conventionally, this photograph

also appeared in the book (as fig.60) and in a four-page advertising brochure. The *Transbordeur* bridge, designed by Ferdinand-Joseph Arnodin in 1905, spanned the mouth of the old harbour at Marseilles. It was in effect a giant crane, carrying people and vehicles on a platform suspended from a moving gantry high above. The design allowed continual passage of boats and avoided the necessity of raising the roadways on each side. In the caption to the photograph Giedion refers to the 'graceful combination of stationary and moving parts', as if the literal mobility of the gantry created a kind of time and space continuum. In describing a photograph of the Eiffel Tower, Giedion claimed: 'the air [or space] drawn into the interior of the piers now becomes, in an unprecedented way, a formative material'.[4] By this he meant that he thought of the space enclosed by the openwork girders as an active, rather than passive, element in the perceived form. A similar quality in the Marseilles photograph must have struck Giedion, as well as the sublime contrast between the gigantic scale of the bridge and the masonry buildings in the background. TB

1 Sigfried Giedion, *Building in France; Building in Steel; Building in Ferroconcrete* (Santa Monica, [1928] 1995), p.145.
2 Ibid., see introduction by Sokratis Georgiadis, pp.1–78.
3 Serge Lemoine, *Theo Van Doesburg: peinture, architecture, theorie* (Paris, 1990) and Theo van Doesburg, *Principles of neo-Plastic Art* (London, [1925] 1969).
4 Giedion (1995), p.143.

113 Plate 5.13

Book: *Amerika: Die Stilbildung des Neuen Bauens in den Vereinigten Staaten* (*America: The Development of the New Building Style in the United State*) by Richard Neutra
Vienna, 1930
Cover design by El Lissitzky (Lazar Lisitskii)
(1890 Pochinok, Russia –1941 Moscow)

29 × 23cm
Merrill C. Berman Collection

El Lissitzky's cover for Richard Neutra's book *Amerika: Die Stilbildung des Neuen Bauens in den Vereinigten Staaten* combines a Constructivist delectation in the texture of industrial steel girders for their own sake with an exploration of the transparency that Sigfried Giedion had praised in his book *Bauen in Frankreich* (1928). In fact, Lissitzky's use of photographs printed in negative took up the theme of László Moholy-Nagy's cover for Giedion's book, while the superimposition of negative images copied the technique of illustration 209 in Moholy-Nagy's seminal Bauhaus

book *Von Material zu Architektur* (*From Material to Architecture*).[1] Moholy-Nagy's superimposed photographs were of the Van Nelle factory (pls 3.8–9), which he captioned as follows: 'Superimposing two photographs in negative creates the illusion of spatial interpenetration [*raumlicher Durchdringung*] which the next generation will perhaps finally be able to appreciate as glass architecture.' This succinctly expresses the aesthetic aim of El Lissitzky's cover design. His image places in the background the characteristic forms of the Manhattan skyscrapers, faced in stone, which he dematerializes with a lattice of steel girders. The image can be read as the heightened X-ray vision of modern man, seeing through the pretension of American capitalism to the proletarian potential within. This was the aesthetic sensibility that could introduce social and spatial interpenetration where none, in fact, existed in the 1920s American skyscraper. TB

1 László Moholy-Nagy, *Von Material zu Architektur* (Munich, 1929), reprinted in the series Hans M. Wingler (ed.), *Neue Bauhausbücher* (Mainz, 1968), p.236.

114a

Model: Bauhaus Dessau
Designed by Walter Gropius
(1883 Berlin –1969 Boston, USA)
Made by Alfred Arndt (1896 Elbing,
Germany –1976 Darmstadt)
1967–8

Mixed media
36.5 × 156 × 127cm
Bauhaus Archiv, Berlin

114b

Photograph: Bauhaus from south
1927
Lucia Moholy (1894 Prague –1989 Zurich)

114c

**Photograph: Bauhaus workshop
building from west**
1927
Lucia Moholy (1894 Prague –1989 Zurich)

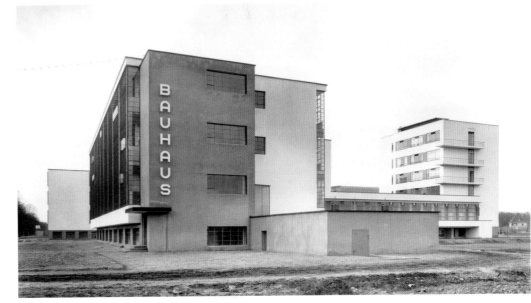

114b

When the Bauhaus moved to Dessau in March
1925, Walter Gropius was given a plot of land on
the outskirts of the city. Here, with the help of
his friend Carl Fieger and his chief assistant
Ernst Neufert, he designed a building for both the
Bauhaus and the Technische Lehranstalt (Technical
College), joined by a bridge in which Gropius's
office and the architecture department were
located. In addition to a workshop block, faced
with a wall of glass like a factory building, there
was a lecture theatre, refectory and residential
block for students and staff.[1] The building was
inaugurated on 4 December 1926 with a party that
many of the leading German intelligentsia attended.

The model emphasizes the asymmetrical
plan of the Bauhaus complex. Two of the basic
principles of Modernist architecture were that
academic symmetry must be avoided at all
costs and that the plan should express different
functions. Thus the open spaces of the Bauhaus
studio block, with its three-storey glass wall, are
clearly differentiated from the technical college,
with its rows of windows indicating smaller
teaching rooms. Similarly, the residential block
is separated from the teaching areas by the
refectory and assembly hall and is detailed to
emphasize the standardization of accommodation.
The 28 rooms in the Prellerhaus (named after a
studio building in Weimar) were eagerly sought
after and allocated on a three-month rota basis
by the Master's Council.

Most of the furniture for the Bauhaus – including
the folding auditorium chairs, the stools in the
canteen (pl.6.6) and the trestle tables and chairs –
was designed by Marcel Breuer in nickelled tubular
steel. They were manufactured by Standard-Möbel,
a company set up for the purpose by Marcel

Breuer and Kalman Lengyel in 1927. Gropius
emphasized in his publications that the Bauhaus
buildings constituted 'an acid test of attempting
to coordinate several different branches of design
in the actual course of building' and that it was
'entirely successful'.[2] TB

1 Margret Kentgens-Craig (ed.), *The Dessau Bauhaus Building
 1926–1999* (Berlin, 1998), and Winfried Nerdinger, *Walter Gropius*
 (Berlin, 1986), pp.70–81.
2 Walter Gropius, *The New Architecture and the Bauhaus*
 (London, [1930] 1965), p.96.

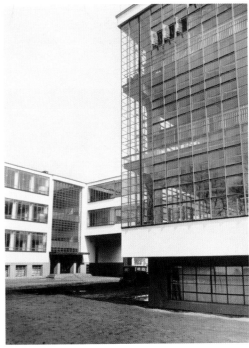

114c

115a

Isometric drawing: *Colour plans for the exterior of the Bauhaus Masters' Houses*, Dessau
1926
Designed by Walter Gropius
(1883 Berlin –1969 Boston)
Colour scheme designed by Alfred Arndt
(1896 Elbing, Germany –1976 Darmstadt)

Ink and tempera
76 × 56cm
Bauhaus Archiv, Berlin (BHA 976)

115b

Photograph: Living room,
Moholy-Nagy House, Dessau
1927/8
Interior designed by Marcel Breuer
(1902 Pécs, Hungary–1981 New York)
Photographed by Lucia Moholy
(1894 Prague –1989 Zurich)

Gropius designed three double houses for a chosen few of the Bauhaus masters, with a single house for the director. Paul Klee and Wassily Kandinsky shared one house, Georg Muche and Oscar Schlemmer another, and László Moholy-Nagy and Lyonel Feininger the third. The luxury of these houses, which were only allocated to the older generation of masters, provoked jealousy and caused controversy among the more politically engaged masters and students.[1] Although Gropius insisted on designing every detail of these houses, the masters' wives tried to intervene in the design of their homes, proposing a range of modifications. Like the Bauhaus buildings, these houses were designed to a standard plan, which was inverted for variety. They were designed to avoid symmetry and to express functions of the plan in elevation. Living areas are given large windows and staircases expressed with vertical windows. Balconies and overhangs demonstrated the potential of the structure. Black and white photographs of the interiors disguise the fact that bright and surprising colours were used to enliven the rooms. Muche's house, for example, had a pink living room with a niche lined in gold foil and a bedroom in almond green. Gropius's house, which was twice the size of the others, was designed as a showpiece of the new architecture; a film was made of it.[2]

Arndt was one of the early Bauhaus students who had studied with Klee, Schlemmer and Kandinsky, graduating in the Mural Painting Workshop. Gropius used Arndt's skills as colourist and draughtsman to prepare presentation drawings of a number of his buildings.[3] Arndt's architectural renderings frequently use colour to enliven and articulate the architectural forms, even though often these were not eventually executed. For the masters' houses, Arndt conceived of a dramatic scheme with grey and pink walls, dark red or blue overhangs, with red trim on windows and other details. The ambition to add bright colour in controlled relationships to produce spatial effects was a staple principle of the Mural Painting Workshop. Hinnerk Scheper, the master of the Workshop in 1926, made polychromatic designs for the Bauhaus buildings themselves, but these too were not executed. Behind these designs was the idea (common in De Stijl circles) that easel painting would give way to coloured three-dimensional forms, at the larger scale of the building and indeed the city. TB

1 Winfried Nerdinger, *Walter Gropius* (Berlin, 1986), p.76.
2 *Wie wohnen wir gesund und wirtschaftlich?* (Humbolt Film, 1926).
3 Hans M. Wingler, *Bauhaus Archiv Museum: Sammlungs-Katalog, Auswahl: Architektur, Design, Malerei, Graphik, Kunstpädogogik* (Berlin, 1981), p.191.

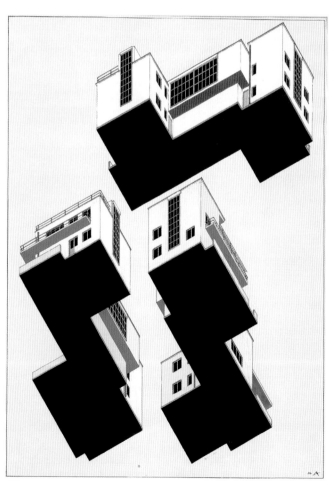

115a

115b

116

Leaflet: *Bauhausverlag Bauhausbuecher*
(*Bauhaus Publishing Bauhaus Books*)
1924
László Moholy-Nagy (1895 Bácsborsod,
Hungary –1946 Chicago)

Red line block and black letterpress
25 × 15cm
V&A: E.1484–1984

László Moholy-Nagy aimed to give Bauhaus publications a highly distinctive image, using graphic devices of the New Typography for maximum effect. 'Typography is modern in concept if it derives its design from its own laws . . .

The utilization of the possibilities offered by the machine is characteristic and, for the purposes of historical development, essential to the techniques of modern productions.'[1] Extreme simplicity was the watchword, offsetting the weight of a few words in a heavy black sans-serif font against the dynamic red bars. There is a continuity between this work and Moholy's own Elementarist paintings, some of which were designed to be defined by number, coordinates and colour descriptors dictated over the telephone and manufactured in enamel (cat.47). In this leaflet Moholy makes a kind of logo from the square, triangle and circle shapes that formed part of the teaching of the Bauhaus courses. TB

1 László Moholy-Nagy, 'Contemporary typography', *Offset*, 7 (1926). Cited in Hans M. Wingler, *The Bauhaus* (Cambridge, MA, 1969), pp.80–1.

117

Insert pages for the *Katalog der Muster*
(**Pattern Catalogue**)
1925
Herbert Bayer (1900 Haag, Austria –
1985 Santa Barbara, USA)

Letterpress print on art paper
21 × 29.7cm (DIN A4)
Bauhaus Archiv, Berlin (BHA 8547/6 [illustrated],
BHA 8676/1, BHA 8676/2)

The Bauhaus's entry into commercial sale of its products arose from both ideological and practical origins. Since 1923 Gropius had turned his back on the craft-based self-expression proclaimed in the school's early days (pl.2.6–8, cat.15a) and aimed to bring art and technology together as the 'new unity'.[1] With the move to Dessau, art was little mentioned and Gropius stressed that 'The Bauhaus workshops are essentially laboratories in which prototypes of products suitable for mass production and typical of our time are carefully developed and constantly improved.'[2] In practical terms, the financial position of the Bauhaus had never been anything other than precarious. It was Gropius's hope that by establishing a trading company, Bauhaus GmbH to market its products, the school could at least secure regular income.[3]

His plan was that these products would be manufactured by outside firms and sold through the school. Bayer's catalogue was part of this plan and its title page announced that these products were 'distributed through Bauhaus GmbH'.

Bayer's design represented a new level of invention in modern typographic design. His tools were photographs, sans-serif type, colour, unprinted areas and a range of geometric shapes arranged and balanced on the page in a highly aestheticized composition, where simplification and reduction were the guiding principles. (Bayer would undoubtedly have disapproved of this description, with its mention of aesthetics.) The repetition of the shapes from page to page – orange rectangle for workshop name, circles for product numbers, thick band of black for product name – helped to unify the different formats and designs of the numerous sheets. The page illustrated shows furniture by Marcel Breuer designed in 1922–4 (pl.2.13) and a rug by Gunta Stölzl. CW

1 'Art and technology: A new unity' was the title of a lecture delivered by Gropius in 1923 (see Hans M. Wingler, *Bauhaus* [Cambridge, MA, 1969], p.76), and a slogan used on posters (see Karl-Heinz Hüter, *Das Bauhaus in Weimar* [Berlin, 1976], p.252, for Gerhard Marcks's complaint about these).
2 Walter Gropius, 'Bauhaus Dessau – Principles of Bauhaus Production' (printed sheet published by the Bauhaus, March 1926), text printed in Wingler (1969), p.109.
3 The company was established in October 1925, though design of the catalogue had begun in 1924. See Ute Brüning, *Das A und O des Bauhauses* (exh. cat., Bauhaus Archiv, Berlin, 1995), p.141.

118

Book: *Holländische Architektur* (*Dutch Architecture*) by J.J.P. Oud
Munich, 1926
Cover design by László Moholy-Nagy
(1895 Bácsborsod, Hungary–1946 Chicago)

23.1 × 18.5cm
V&A, National Art Library (31.B Box II)

Walter Gropius put László Moholy-Nagy in charge of the graphic design and typography of the Bauhaus books, published regularly by Albert Langen in Munich after the school moved to Dessau.[1] The covers of the Bauhaus books, on the other hand, were designed by different people, reflecting the content of the books. Fourteen volumes appeared, between 1925 and 1931 (eight in 1925 alone) and many of them became classic publications of Modernist theory and taste. Moholy-Nagy was influenced, as Bayer was, by the graphic and typographic work of Kurt Schwitters (cat.126), El Lissitzky (pl.2.23, cat.9) and Jan Tschichold (cat.125), the most inventive advocates

of the New Typography. Tschichold's book *Die neue Typographie* (1928) was the bible of the movement. Lissitzky had specialized in adapting Constructivist and Suprematist practice to commercial typography.

Holländische Architektur, the tenth in the Bauhaus books series, followed two others in which Gropius acknowledged the debt of German Modernism to the Dutch De Stijl movement: *Neue Gestaltung* (*New Form-Giving*) by Piet Mondrian (no.5, 1925) and Theo van Doesburg's *Grundbegriffe der neuen gestaltenden Kunst* (*Foundations of the new formal art*, usually translated as *Principles of Neo-Plastic Art*, written in 1917 and published as Bauhaus book no.6, 1925). While conforming to the typographic conventions of the Bauhaus books, Moholy-Nagy's cover is unusual for its stress on photographs of architecture and its sober use of colour. TB

1 Hans M. Wingler, *Bauhaus Archiv Museum: Sammlungs-Katalog, Auswahl: Architektur, Design, Malerei, Graphik, Kunstpädogogik* (Berlin, 1981), p.155; Jan Tschichold, *Die neue Typographie: Ein Handbuch für zeitgemass Schaffende* (Berlin, [1928] 1987), pp.160–1, where Tschichold applauds the impact of one of Moholy-Nagy's brochures for the Bauhaus books. See also Magdalena Droste, Janeannine Fiedler and Peter Hahn, *Experiment Bauhaus* (exh. cat, Bauhaus Dessau, 1988), pp.154–97.

118

119

Brochure: *Bauhaus Dessau*
1927
Herbert Bayer (1900 Haag, Austria – 1985 Santa Barbara, USA)

21 × 14.8cm (DIN A5)
V&A, National Art Library (II.RC.CC Box I Copy [A])

This brochure included the revised prospectus for the Bauhaus, which incorporated, for the first time, an architecture school.[1] The cover relies on a characteristic New Photography image (taken by Irene Bayer) of the student dormitory with a simple overlay of blue sky and white typography. TB

1 Ute Brüning (ed.), *Das A und O des Bauhauses: Bauhauswerbung: Schriftbilder, Drucksachen, Ausstellungsdesign* (exh. cat., Bauhaus Archiv, Berlin, 1995), cat.88, p.100.

120

Magazine: *Bauhaus*, vol.2, no.4, 1928
Joost Schmidt (1893 Hanover – 1948 Nuremberg)

29.9 × 21.1cm (DIN A4)
V&A, National Art Library (S.89.1002)

The Swiss architect Hannes Meyer made his name in partnership with Hans Wittwer, designing a controversial entry for the League of Nations competition (1926–7) and the functionalist Peterschule (Peter school) at Basle (1926). Meyer was close to Mart Stam, Hans Schmidt and others behind the avant-garde journal *ABC*, editing one of its numbers. Walter Gropius invited him to join the Bauhaus to teach architecture (from April 1927) at a time when Gropius's own work was coming increasingly under attack from left-wing groups among the students. Meyer immediately announced his position: 'The fundamental direction of my teaching will be absolutely towards the functional-collectivist-constructive...'[1] Succeeding Gropius as director of the Bauhaus in July 1928, Meyer brought in functionalists such as Wittwer, and later Ludwig Hilberseimer, and pushed the architecture school in a more practical and professional direction. He also developed the Advertising Workshop (introduced by Herbert Bayer in 1927) under the leadership of Schmidt. It was to become a serious means of promotion

and revenue generation. The ethos of the Bauhaus under Meyer changed markedly from the avant-garde individualism of the Gropius years. With Gropius, Bayer, Marcel Breuer and László Moholy-Nagy leaving in 1928 and Oskar Schlemmer in 1929, the Meyer years represented a clean break with the past.

This issue of the Bauhaus magazine was edited by Meyer and designed by Schmidt. It picks up on the slogan 'Young people come to the Bauhaus!', which was also used on the cover of a brochure publicizing the transformed curriculum. Compared to the bold graphics of Moholy-Nagy and Bayer, Schmidt's cover is cool and focuses on life rather than art. The photograph was taken by Meyer's student Lotte Besse.[2] Its circular frame of students' heads wittily evokes the circular microscopic photographs of materials beloved of Moholy-Nagy and used in his form classes at the Bauhaus.[3] TB

1 Cited in Magdalena Droste, *Bauhaus* (Berlin, 1990), p.166.
2 Jeannine Fiedler, Fotographie am Bauhaus (exh. cat., Bauhaus Archiv, Berlin, 1990), pp.220, 328.
3 For example, László Moholy-Nagy, *Von Material zu Architektur* (Berlin, [1929] 1968), p.35.

119

120

121

Brochure: *Bauhausbücher*
(*Bauhaus Books*)
1929
László Moholy-Nagy (1895 Bácsborsod,
Hungary –1946 Chicago)

21 × 14.8cm (DIN A5)
V&A, National Art Library (JP Box 22b)

For Moholy-Nagy, photography and typography, as mechanical arts, formed a paradigmatic Modernist partnership. In 1923 he had already written:

> The most important aspect of contemporary typography is the use of zincographic techniques, meaning the mechanical production of photoprints in all sizes. What the Egyptians started in their exact hieroglyphs . . . has become the most precise expression through the inclusion of photography into the typographic method.[1]

In this brochure Moholy-Nagy captured the mixture of abstract design and physicality of the design style used for the Bauhaus books series. The cover plays at the limits of realism, showing the printer's block as if it were a concrete statement of the means of production, while subverting the realism of the photograph with the use of colour and negative and inverted images. This image illustrates what Moholy meant by working with 'elementary, purely optical images'.[2] A highly evocative, ambiguous image composed only of mechanical elements of hand printing types communicates a simple message with great clarity. TB

1 László Moholy-Nagy, 'The new typography', in *Staatliches Bauhaus in Weimar, 1919–1923* (Munich, 1923), reprinted in translation by Sibyl Moholy-Nagy in Richard Kostelanetz, *Moholy-Nagy*, (New York, 1970), p.75.

2 'The invention of photography destroyed the canons of representational, imitative art . . . The creator of optical images learned to work with elementary, purely optical means.' László Moholy-Nagy, 'From pigment to light', *Telehor* (Brno, 1936), reproduced in Kostelanetz (1970), p.30.

121

122a

Book: *L'art décoratif d'aujourd'hui*
(*The Decorative Art of Today*)
Paris, 1925 (this copy 12th edition, undated)
Le Corbusier (Charles-Edouard Jeanneret)
(1887 La Chaux-de-Fonds, Switzerland–
1965 Cap-Martin, France)

24.6 × 16.5cm
V&A, National Art Library (505.C 118)

122b

Magazine: *L'Esprit Nouveau*, no.10, 1921
Magazine: *L'Esprit Nouveau*, no.18, 1923
Le Corbusier (Charles-Edouard Jeanneret)
(1887 La Chaux-de-Fonds –
1965 Cap-Martin)

V&A, National Art Library (86.K.25 and 86.K.29)

The third of Le Corbusier's books based on articles in *L'Esprit Nouveau* (no.22–8, 1924), *L'art décoratif d'aujourd'hui* targets not only the decorative art professionals preparing for the Paris 1925 exhibition, but also the institutionalization of design. Le Corbusier had huge respect for the decorative art of the past, especially what he referred to as 'folklore' (he was devoted to his collection of Serbian pots), but he was hostile to the taste for the elaborate productions of '*les styles*' (Louis XIV, Louis XV, etc.). Rather than putting expensive works of decorative art into museums or exhibitions, societies should celebrate and transmit their culture by conserving artefacts that were genuinely representative of their time and satisfying in form. Le Corbusier illustrated this precept with a photograph of a bidet over the chapter heading '*Autres Icones Les Musées*' ('Other Icons: Museums'). Design in a Machine Age should dispense with decoration. What was needed in objects of everyday use was not decoration, but art ('the application of knowledge to the realization of an idea').[1] Industry will provide the cheap, useful and well-designed objects of everyday use that will meet human needs, which are all roughly similar. These can also be raised to a higher aesthetic level if the precision of the machine can be associated with pure geometry, but the main conclusion drawn by Le Corbusier in this book is that design is necessarily inferior to Fine Art and Architecture, and no amount of craftsmanship and ornament could change that.

Although Le Corbusier later claimed that the printers of *L'Esprit Nouveau* found his design ideas incomprehensible, the graphic design and typography of the articles and books was conservative, compared to the German New Typography. Le Corbusier expressed his avant-garde intentions not by the choice of new sans-serif fonts or abstract compositions, but by the surprising juxtaposition of word and image. In particular, he contrasted the decorative arts with simple modern goods (leather bags, briar pipes, bottles and glasses) and the productions of industry (machines, automobiles, propeller screws). TB

1 Larousse dictionary definition cited by Le Corbusier in *L'Art décoratif d'aujourd'hui* (Paris, 1925), p.84.

123

Book: *Die neue Wohnung: die Frau als Schöpferin* (*The New Dwelling: The Woman as Creator*) by Bruno Taut
(1880 Königsberg, Germany–1938 Ankara)
Leipzig, 1926 (4th edition)

20.4 × 14.7cm
V&A, National Art Library (47.W.238)

This little book ('dedicated to women', as the flyleaf announces) drew together the conclusions of a campaign for the reform of the interior, which had been carried out in newspapers and journals since the war by Taut, Adolf Behne and others. 'Woman must sweep away domestic nostalgia and make a new beginning.'[1] Taut compared the bourgeois home unfavourably with better examples in the Renaissance, seventeenth-century Holland and vernacular architecture. In particular, he pointed to the Japanese house as a model for the organization of space. Next, he reviewed the impact of the avant-garde designers (De Stijl, Bauhaus, as well as his own designs) before applying the aesthetic lessons to some 'before and after' comparisons. Underneath photographs of two cluttered dining rooms (one the house of an antique dealer and the other a working-class dwelling) he drew make-over versions that retained the necessary furniture while eliminating the inessential. These were real worked examples, in which the taste of the owner resisted too-extreme changes, and the text insists that the new reforms should be a gradual process.

The struggle for the new aesthetic was a struggle for the hearts and minds of housewives.[2] Taut went on to appeal to their practical sense, by referring to the theories of the American writer Christine Frederick, whose study of efficiency in the home was based on the industrial time-and-motion studies of Frederick Winslow Taylor (see also cat.92).[3] Taut was prescient in identifying this source and in illustrating Frederick's Taylorist diagrams of inefficient and efficient kitchens, since her book was not yet translated into German. Frederick's work would stimulate a whole literature in Europe.[4] Taut applied similar principles to the apartment plans, sweeping away loose furniture and the underused parlour to create a larger L-shaped living room that communicated directly with the kitchen. In a financial table he claimed that cuts of 13 per cent in building and furnishing costs could be achieved by such methods, while affording more usable space. TB

1 Bruno Taut, *Die neue Wohnung: die Frau als Schöpferin* (Leipzig, 1924), p.5.
2 Taut ends the book with a slogan 'The architect thinks; the housewife directs.'
3 Christine Frederick, *The new housekeeping: Efficiency studies in home management* (New York, 1913), originally published in *Ladies' Home Journal* (September–December 1912).
4 Erna Meyer, *Der neue Haushalt* (Stuttgart, 1925), the subtitle of which was '*ein Wegweiser zur Wirtschaftlicher Hausführung*' ['a guide to running an economic household']; Paulette Bernège, *De la méthode ménagère* (Paris, 1928) and *Si les femmes faisaient les maisons* (Orléans, 1928).

124a

Book: *Bauen Der neue Wohnbau* (*Building: The New Dwelling*) by Bruno Taut
Leipzig, 1927
Cover design by Johannes Molzahn
(1892 Duisburg, Germany – 1965 Duisburg)

26.8 × 19.1cm
V&A, National Art Library (311.B.22)

124b

Book: *Neues Wohnen, neues Bauen* (*New Dwelling, New Building*) by Adolf Behne
Leipzig, 1927
Cover design by Walter Dexel (1890 Munich – 1973 Braunschweig, Germany)

19.4 × 13.6cm
V&A, National Art Library (31.HH.18)

Modernism, unlike other contemporary tendencies in architecture and the decorative arts, was subject to acutely self-aware introspection and a proselytizing mission that produced a string of publications – books, exhibitions and journals – throughout its history. Buildings only recently built, and sometimes only represented in drawings or models, were published and explained at an increasingly fast tempo during the 1920s and '30s. Publications included both theoretical and historical justification for the new forms, in terms that clearly indicated a struggle for power between the 'old' and the 'new'; a battle that was easily interpreted as generational and/or political. The words 'new' and 'building' (as opposed to architecture), invariably gave this battle inflammatory connotations. Although the New Typography influenced some of these books, many of them were designed for a broad readership by publishers unprepared to risk poor sales with unusual graphic design and fonts.[1]

When Behne wrote the text and assembled most of the illustrations for his first significant book, *Der moderne Zweckbau* (*The Modern Functional Building*) in 1923, the atmosphere of the avant-garde movements was heady. Although Behne was a member of Taut's Expressionist *Gläserne Kette*, he was also committed to social reform and had played a role in the revolutionary politics of the immediate post-war period. Behne's book was important as a historical explanation of the roots of Modernism and for his survey of Modernist work in Europe and America. By the time of its publication in 1926, utopian dreams were giving way to the practical problems of construction. In it Behne makes a case for functionalism, but also reserves a place for what he calls 'play', without which life would be unliveable.

By the time Behne's *Neues Wohnen, neues Bauen* and his booklet *Eine Stunde Architektur* (*An Hour of Architecture*, 1928) were published, he was emphasizing the social utility of architecture while rejecting the more mechanistic implications of functionalism.[2] The title, placing 'new dwelling' ahead of 'new building' underlined Behne's view – shared by many Modernists – that by far the biggest task for architects was to solve the housing problem. In his writings at this time he was not afraid to criticize functionalism, over-reliance on standardization and the *Zeilenbau* system of planning (parallel blocks at right angles to the street). As befits a book with this practical and socially committed emphasis, the cover is simple, more comparable with books by Taut than with those within the Bauhaus circle.

Taut's *Bauen Der neue Wohnbau*, carrying the subtitle 'published by the association "The Ring"', is very similar to Behne's. Taut, as the architect of a dozen large housing estates in Berlin, was in a good position to present this survey of modern housing practice from a German perspective. TB

1 See Rosemarie Haag Bletter, introduction to Adolf Behne, *The Modern Functional Building* (Santa Monica, [1927] 1996).
2 Ibid., pp.55–6.

123

124a

125

Book: *Die neue Typographie*
(*The New Typography*)
1928
Jan Tschichold (1902 Leipzig –
1974 Locarno, Switzerland)

Letterpress
21.1 × 30.2cm
Merrill C. Berman Collection

From its frontispiece – a page printed entirely
in black, facing its title page – Tschichold's
book asserted itself as something very new.
The author and designer trained as a calligrapher
and typographer and his theories merged
Russian Constructivism with Bauhaus principles
of design.[1] Tschichold, who began work as a
typographic designer in 1923, was profoundly
influenced by his visit to the Bauhaus's first major
exhibition in Weimar the same year. There he was
introduced to the term 'New Typography' through
László Moholy-Nagy's exhibition essay *'Die neue
Typographie'*.[2] Its theoretical basis was partly
found in abstract painting, which emphasized
the elimination of surface ornamentation and
disorder (cat.47). One manifestation of this was
the Modernists' promotion of sans-serif typefaces,
which were admired for their legibility and
simplicity. In 1923 Tschichold began setting type
according to precise layouts. He published the
essay *'elementare typographie'* ('elementary
typography') in October 1925: by employing all
lower-case letters in the title, Tschichold made
a hugely radical step in the German language,
where all nouns appear with initial upper-case
letters.[3] This essay laid the groundwork for the
seminal text he would produce three years later.

Die neue Typographie was published in Berlin in
June 1928 by the Bildungsverband der Deutschen
Buchdrucker (the German printing trade union's
educational body), which had also published
his 1925 essay. The book aimed to develop a
philosophy of good design with international
applications that could be adapted and could
sustain relevance in the modern world. It was
divided in two parts: socio-historical contexts
in the first, followed by design philosophy and
applied theory in the second.

The two pages shown seek workable solutions
for magazine layouts, contrasting the 'schematic,
thoughtless centring of blocks' on the left, which
Tschichold describes as 'decorative, impractical,
uneconomic (= ugly)', and the type-area on the
right, which the designer concludes is 'construc-
tive, meaningful, and economical (= beautiful)'.
Tschichold's didactic concepts in *Die neue
Typographie* often employ Marxist rhetoric,
demonstrating that the discourse around
typography was, like most aspects of Modernism,
heavily politicized. He would later distance himself
from such dogmatic theories, though the book
became one of the most influential publications in
the history of typography and graphic design. zw

1 On Tschichold, see Ruari McLean, *Jan Tschichold: A Life in
 Typography* (London, 1997); *Jan Tschichold: Typographer and
 type designer* (Edinburgh, 1982); *Jan Tschichold: Reflections and
 reappraisals* (New York, 1995).
2 See Robin Kinross's introduction to Jan Tschichold, *The New
 Typography* (Berkeley, [1928] 1995), p.xxiv.
3 The movement for *Kleinschreibung* (lower case) began in 1917.
 See Jeremy Aynsley, *Graphic Design in Germany 1890–1945*
 (London, 2000), p.103.

125

126

Book: *Die neue Gestaltung in der Typographie* (*New Typographic Design*)
c.1930
Kurt Schwitters (1887 Hanover –
1948 Kendal, England)

Letterpress
14.9 × 21.6cm
Merrill C. Berman Collection

Schwitters's book explored the laws and permutations of two-dimensional image layout that was made possible through modern photo-mechanical processes. In a typical double-page spread Schwitters opposed a traditional graphic approach with a more contemporary layout. The latter adopts diagonal axes, oblique shapes and dynamic thrusts to create dynamic and varied advertisement. Whereas the conservative format relies strictly on a spread of perpendicular blocks and intersections, the innovative design focuses the reader's eye on a resonant central area. Words, letters, numbers, punctuation and even negative spaces were all considered crucial variable elements in the overall character of the New Typography. Schwitters's particular artistic sensibility led him to emphasize beauty, originality

and experimentation within the otherwise formalized frameworks of ordered, readable and uncluttered commercial design configurations.

Schwitters is perhaps best known as a painter and proponent of Dada, who worked to a significant extent in collage and photomontage. He was heavily influenced by the De Stijl principles of Theo van Doesburg, whom he first met in 1922 at the *Kongress der Konstructivisten* (Congress of Constructivists) in Weimar. He published *Merz* magazine, which appeared irregularly from 1923 to 1932, and established his own graphic design agency in 1924, Merz-Werbezentrale.[1] In the same year a special issue of *Merz*, called *Typoreklame* (Typo Advertising) was devoted entirely to typography. Schwitters's enthusiasm for design led him to coordinate *der ring'neue werbegestalter* (Circle of New Advertising Designers) in 1927. This group included artist-practitioners such as Jan Tschichold (cat.125) and Max Burchartz (cat.132), who were committed to advancing print as a primary means of linking the arts and of communicating in the modern world. zw

1 On Schwitters as a graphic designer, see John Elderfield, *Kurt Schwitters* (New York, 1985), pp.47–8, 186–8; Paul Jobling and David Crowley, *Graphic Design: Reproduction and Representation since 1800* (Manchester, 1996); Jeremy Aynsley, *Graphic Design in Germany 1890–1945* (London, 2000), p.157.

126

127 Plate 1.11

Poster: *Wohnung und Werkraum*
(*Dwelling and Workspace*) exhibition
1929
Johannes Molzahn (1892 Duisburg,
Germany –1965 Duisburg)

Lithograph
60 × 85.6cm
Merrill C. Berman Collection

The 1929 *Deutscher Werkbund* exhibition
Wohnung und Werkraum was dominated by the
ex-Expressionists Hans Scharoun (cat.102) and
Adolf Räding, both of whom had exhibited at the
Weissenhof Siedlung in 1927 (cat.95). The Breslau
exhibition was designed to a more organic plan
than the Weissenhof, with a curving building and a
straight building linked by a communal restaurant
area. Scharoun's apartment plans were highly
innovative, incorporating the 3/2 section. In other
words, the floor levels were split, allowing an
apartment to spread over three floors on one side
and two on the other. Moise Ginzburg had explored
a similar idea in one of the standard plans that he
was researching for the *Stroikom* (Government
Building Research Department) in Moscow at
exactly this time. The Breslau exhibition buildings

display a much richer formal vocabulary than
Weissenhof, and this is reflected in Molzahn's
poster.

Molzahn began his career painting in a Cubist
style, exhibiting at Herwarth Walden's Der Sturm
gallery in 1917. He had connections with Walter
Gropius and the Bauhaus (some of his work was
exhibited in a Bauhaus portfolio in 1921) and
taught at Magdeburg before obtaining his post at
the Breslau Academy in 1928.[1] Although continuing
as a painter, he developed an expertise in graphic
art. In this poster Molzahn collaged a large
number of images, stressing the human hand
and the process of design. He also created a kind
of commercial logo out of the letters 'W' and 'e'
and 'o' (superimposed), representing the words
'*Wohnung*' (dwelling) and '*Werkraum*' (workspace).
TB

1 Petra Hölscher, *Die Akademie für Kunst und Kunstgewerbe zu
 Breslau: Wege einer Kunstschule 1791–1932* (Kiel, 2003), pp.306–14.

128

Poster: *Neues Bauen* (*New Building*)
1928
Theo Ballmer (1902 Lausanne –1965 Basle)

Lithograph
127 × 90.1cm
Merrill C. Berman Collection

Throughout inter-war Europe public exhibitions
dedicated to displaying and promoting modern
design and architecture proliferated. This poster
announced a travelling exhibition of work by archi-
tects associated with the *Deutscher Werkbund*
held at Zurich's Kunstgewerbemuseum (Applied
Art Museum). Ballmer, its designer, studied
under Swiss master poster designer Ernst Keller,
the most influential teacher of his generation and,
briefly, at the Bauhaus.[1] In the Swiss system,
the study of graphic design lay at the core of all
design education. Typography and other forms of
graphic design therefore had (and continue to
have) a higher status within the design hierarchy
than in other countries.

Ballmer pioneered the International Typography
style, which merged De Stijl, Bauhaus and New
Typography theories. Key traits of this style are
evident in the exhibition poster *Neues Bauen*: it is

formal, ordered and balanced. Ballmer constructed
his posters according to a grid, basing his design
layout on geometric correlations and symmetry.
Careful attention is paid to form, density and the
incorporation of negative space in the overall
composition. The absence of photographic imagery
in this poster emphasizes the cultural focus on
typography. Two-thirds of the overall poster is
dominated by the heavy, sans-serif N and B.
Typefaces previously printed by time-consuming
letterpress techniques were increasingly geared
towards advanced printing processes, such as
photo offset lithography, which permitted new
freedom in font weights and sizes. The typography
advertising the event is used as a symbolic device
to suggest the stature, solidity and imposing
nature of the New Architecture. ZW

1 On Ballmer, see Philip B. Meggs, *A History of Graphic Design*
 (New York, 1983), pp.380–81; Alain Weill, *The Poster* (Boston,
 1985), p.252; Ute Brüning (ed.), *Das A und O des Bauhauses:
 Bauhauswerbung: Schriftbilder, Drucksachen, Ausstellungsdesign*
 (exh. cat., Bauhaus Archiv, Berlin, 1995), pp.269, 320.

129

129

Poster: *Exposition du Commerce Moderne*
(*Exhibition of Modern Trade*)
1929
Ladislav Sutnar (1897 Pilsen, Bohemia –
1976 New York)

Lithograph
47 × 63cm
The Museum of Decorative Arts, Prague (P25071)

Czechoslovakia was one of Europe's most
dynamic, technologically oriented and outward-
looking societies during the inter-war period.
With a thriving middle class, it was a nation that
officially and commercially adopted Modernist
architecture and design as a symbol of its
modernity and international orientation.[1] Bohemia
(including the capital Prague) was formerly the
industrial engine of the Austro-Hungarian empire,
and Moravia (with its capital Brno) had been a
leading textile and metal manufacturing centre.
Following the establishment of the Czechoslovak

Republic in 1918, and recovery from the loss of the
Austrian market, Brno eventually reasserted itself
as an industrial centre and hosted many trade fairs,
including the one advertised in this poster. It illus-
trated a trio of notable, recently built buildings in
Brno: the vaulted Commercial-Industrial Palace
(Josef Kalous and Jaroslav Valenta, 1927–8, at top
right) and the Commercial Tradesmen's Pavilion
(Bohumír František, 1927–8, middle), both built
for the Exhibition of Contemporary Culture in
Czechoslovakia, and (at far left) the Avion Hotel
(Bohuslav Fuchs, 1926–7).

The familiar Modernist icons of ocean liner
and train engine appear, along with, unusually,
an adding machine suggesting commerce, in case
the message of the poster was insufficiently clear.
Sutnar's design employs photo-collage, bands of
bold colour and serif and sans-serif type. The use
of a French version of the poster (in addition to the
Czechoslovak edition) reflected the Czechoslovak
cultural and political orientation towards France
following the First World War, as well as the
continued desire for economic links. CW

1 Jean-Louis Cohen, 'Introduction' to Karel Teige, *Modern
 Architecture in Czechoslovakia* (Los Angeles, 2000), pp.2–3.

130

Poster: *Bauten der Technik* (*Buildings for Technology*) exhibition
1929
Hieri Steiner (1906 Zurich–1983 Zurich)

Lithograph
46 × 78.5cm
Merrill C. Berman Collection

Steiner worked as an illustrator, book and poster designer and a typographer in his native Switzerland.[1] In this poster the interplay between image and text is used to great effect. Advertising an exhibition of construction engineering, it illustrates the interest of the Modernists in new technology.

The poster delivers its message with stark elegance. Pushed to the corners of the image, the lettering is simple and functional, letting the bridge at the centre dominate the poster, with attention being drawn to its structure. The skeleton of the partly built construction is simplified to the extreme, to further underline the subject of building technology. The bridge is in the process of being built, suggesting that the work of the New Architecture has only just begun. It not only speaks of the possibilities that the new approach to building could offer, but also suggests a visual metaphor for the optimistic future promised by Modernism: bridging the gap between now and the New World. RK

1 Manuel Gasser, *Exempla Graphica* (Zurich, 1968), p.93.

131

Poster: *Film und Foto, Internationale Ausstellung des Deutschen Werkbunds* (*Film and Photo, International Exhibition of the German Werkbund*)
Designer unknown
1929

Lithograph
83.8 × 58.8cm
Merrill C. Berman Collection

Artists enthusiastic about the potential of early twentieth-century photography quickly applied photographic images to creating eye-catching posters such as this one. In terms of the subjects of the *Film und Foto* (FiFo) Werkbund exhibition, motion pictures radically altered the means of social communication and artistic experimentation. FiFo celebrated the creative potential of modern technology. Both film and photography were seen as novel means of capturing the essence of modernity. The mechanical nature of the camera was hailed as a new, objective, unflinching means of recording life. Film editing shared a natural affinity with the art of photography, particularly in the form of photomontage. The subject of the FiFo exhibition owed a clear debt to László Moholy-Nagy's publication *Painting, Photography, Film* (1925), a seminal text in which Moholy-Nagy featured many of his own photographs.

The graphic content of this poster, the designer of which is unknown, is drawn from experimental cinema and photography. The devices used include strong, sweeping diagonals, extreme perspective and manipulation of scale. The figure of the cameraman, taken from a photograph by Willi Ruge, looms disconcertingly large, dominating the composition. The construction of image and text also sets up dramatic contrasts between the flatness of the two-dimensional surface and the sculptural composition of man and machine. This visual technique echoes the early cinematic experience of being simultaneously enveloped in and dwarfed by screen images. Further visual contrast is provided by the red lettering against the black-and-white image. The camera lens peers out from between the lettering, creating a focal point to draw in the viewer.

Influential graphic designer and New Typography theorist Jan Tschichold (cat.125) was one of three members of the Executive Committee for the FiFo exhibition and even designed the *Film und Foto* letterhead.[1] He argued that, 'As a consequence of the purity of its appearance and of the mechanical production process, photography is becoming the obvious means of visual representation in our time.'[2] ZW

1 Ruari McLean, *Jan Tschichold: A Life in Typography* (London, 1997). See example on p.29.
2 Jan Tschichold, *The New Typography* (Berkeley, [1928] 1995), p.88.

132

Poster: *Kunst der Werbung*
(*Art of Advertising*)
1931
Max Burchartz (1887 Elberfeld,
Germany –1961 Essen)

Lithograph
59 × 83cm
Merrill C. Berman Collection

This poster is a striking example of the new
combination of typography and photography –
or Typophoto – that became widely used in the
1920s thanks to the efforts of designers working
in Germany. Burchartz belonged to *der ring'
neue werbegestalter*, which was headed by Kurt
Schwitters (cat.126). Other members included
Willi Baumeister (cat.96) and Hans Richter. They
organized exhibitions and conferences, but the
group was short-lived, disbanding once the Nazis
came to power in 1933.[1]

Burchartz was one of a number of artists from
the *ring* who created advertising for commercial
clients; the dialogue between artists and commerce
allowed Modernist ideas to seep into the main-
stream. A number of the most important designers
worked in academia: Burchartz taught design,
photography and advertising at the Folkwang-
schule in Essen, until he was expelled from his
post by the Nazis.[2]

The academic backbone of Modernist thinking
is evident in Burchartz's work. He relies on severe
typography, as well as the viewer's ability to
interpret the image as puppeteer's hands pulling
strings, referring to manipulation and power.
The photographic image is a witty comment on
the world of advertising, and the poster uses
photography, visual clarity and simple typography,
all defining features of the new Typophoto design
employed by Burchartz and his contemporaries. RK

1 Volker Rattemeyer, Dietrich Helms with Konrad Matschke,
 '*Typographie kann unter Umständen Kunst sein*'. *Ring 'neue
 werbegestalter', Amsterdam Ausstellung von 1931* (exh. cat.,
 Landesmuseum Wiesbaden, 1990).
2 *Fotografía pública: Photography in Print 1919–1939* (exh. cat.,
 Museo Nacional Centro de Arte Reina Sofía, Madrid, 1999), p.74.

133

Poster: *Arts ménagers* (*Domestic Art*)
1933
Francis Bernard (1900 Marseilles –1979)

Lithograph
156.9 × 116cm
Merrill C. Berman collection

Bernard joined the Union des Artistes Modernes
(UAM) in 1930, along with many great poster
designers of the period who worked for the same
clients. The commission for the *Salon des Arts
Ménagers* (Domestic Art Exhibition) came from
an official source, the *Office national de recherches
scientifiques et industrielles et des inventions*
(National Office for Scientific and Industrial
Research and Inventions). This lengthy bureau-
cratic name clearly signalled the purpose of the
exhibition, which had been held annually since
1923.[1] Its aim was to further the rationalization of
domestic work to promote hygiene, technological
progress and efficiency, as more and more
middle-class women joined their working-class
contemporaries in fulfilling a dual role at home
and in the workplace outside it.

The premise for rationalizing housework came
from the widespread application of Taylorism,
Fordism and other forms of time-saving systems of
labour in onto the private sphere (cat.92). Frederick

Taylor's functionalist approach (of 1911), alongside
widespread electrification, indoor plumbing and
central heating, had been applied early to the
domestic sphere.[2] Bernard's design with the
internal workings of the housewife represented as
cogwheel and V-belt 'powering' the movement of
the broom is therefore humorous only to a certain
extent. The stark reality of mechanization, which
so many contemporary artists signified in the
man-machine graphics (see Chapter 3), began to
loom very large indeed over every aspect of public
and private life.

The couple gazing up to the giant female
automaton are montaged onto the colour litho-
graph, a technique that set Bernard apart from
the purely drawn images of contemporary French
poster designers such as A.M. Cassandre or
Jean Carlu. This technique injects a realist
element that underscores the contrast between
the grand scheme of rational housework as
promoted by the government and the anxious
wonder of the visitors, confronted with such
utopian social ideals. UL

1 With the exception of 1925 and the wartime interruption between
 1940 and 1947, the Salon des Arts Ménagers was held in Paris
 until the end of 1983. On its history, see Jacques Rouaud, *60 ans
 d'arts ménagers* (Paris, 2 vols, 1989 and 1993); the Centre des
 Archives Contemporaines in Fontainebleau (Seine-et-Marne)
 contains all 48 commissioned posters for the Salon.
2 See Christine Frederick, *Household Engineering: Scientific
 Management in the Home* (Chicago, 1919) and Susan R. Henderson,
 'A Revolution in the Women's Sphere: Grete Lihotzky and the
 Frankfurt Kitchen', in Deborah Coleman, Elizabeth Danze and
 Carole Henderson (eds), *Architecture and Feminism* (New York,
 1996), pp.221–53.

132

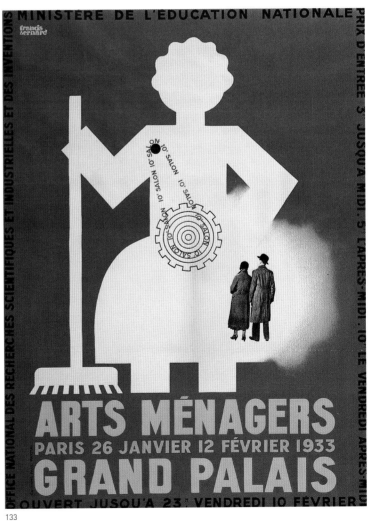

133

134a

Ceiling lamp with aluminium reflector, model ME 85b

1926

Marianne Brandt (1893 Chemnitz, Germany –1983 Kirchberg, Germany)

Manufactured in the Bauhaus Metal Workshop, Dessau

Matt-finish aluminium
diam. 29cm
Bauhaus Archiv, Berlin (BHA 3881/3)

134b

Ceiling light with counterweight pull, model ME 105a

1926

Marianne Brandt (1893 Chemnitz, – 1983 Kirchberg, Germany) and

Hans Przyrembel (1903 Halle, Germany – 1945)

Manufactured in the Bauhaus Metal Workshop, Dessau

Nickel-plated sheet brass
diam. 29cm
Bauhaus Archiv, Berlin (BHA 1530)

134c

Spherical ceiling light with opaque glass ball, Kandem-model no.709

1928–9

Hin Bredendieck (1904 Aurich, Germany –1995 Atlanta)

Manufactured by Körting and Mathiesen, Leipzig

Brass with chrome finish, opaque glass
l. 150 cm, diam. 27cm
Bauhaus Archiv, Berlin (BHA 12074)

Under the leadership of László Moholy-Nagy, a concentrated effort was made in the Metal Workshop at the Bauhaus to design industrial products that could be put into manufacture. In the new workshops at Dessau, more sophisticated equipment was installed, allowing the students to simulate processes of industrial production such as spun aluminium and drop-forged shapes. Brandt, one of the most talented of Moholy-Nagy's students, evolved in her work from the making of exquisitely hand-crafted pieces of silver and copper ware to the design of lamps, such as the ME 85b with its simple aluminium shade.[1]

A version of Brandt and Przyrembel's ME 105a ceiling light design was used in the workshops of the Dessau Bauhaus to illuminate the working surfaces in the Workshop Block. This ceiling lamp, with its efficient rise-and-fall mechanism, was designed to appeal to the more expensive taste in domestic and office fittings, suitable for use in a dining room.[2] This was a problem that intrigued a number of architects: Bruno Taut studied the problem of lighting a dining table without glare in the eyes of the seated diners in the house he designed for himself.[3] Brandt and Przyrembel's design uses hidden pulleys and a counterweight (through which the lamp cord runs) to take up the slack as the lamp is raised or lowered. Although this system was commonly used in Germany at this time (for example, in Adolf Schneck's house at the Weissenhof Siedlung and in the 'Giso-lampen' design illustrated in the W. H. Gispen catalogue (cat.137b), the designers drew attention to the mechanism with a formal play of shiny and semi-matt surfaces. This demonstrated the influence of the *Vorkurs* (Preliminary Course) teaching of Moholy-Nagy and others, who emphasized contrasts of reflectivity, tone and colour of materials, as a means of creating decorative effects without recourse to ornament. In 1927 this light was, as well as Brandt's ME 94 ceiling light, used to furnish Walter Gropius's house no.16 at the Weissenhof exhibition (pl.6.4).[4] As a result these two light fittings were manufactured by Paul Stotz AG, Stuttgart. This small-scale cooperation with industry ceased in 1928, when the Bauhaus announced contracts with both Schwintzer and Gräff in Berlin and Körting and Mathiesen in Leipzig.

Hin Bredendieck's classically simple globe lights, such as the Kandem-model no.709, were used in the Dessau Bauhaus buildings. Hanging globe lamps of this kind had long existed in functional buildings such as hospitals and schools. The Bauhaus added status to these modest fittings with the use of chrome finishes and small details, such as the provision of retention chains inside the globe, which allowed the bulb to be replaced without risk of breakage.[5] TB

1 Klaus Weber, *Die Metallwerkstatt am Bauhaus* (exh. cat., Bauhaus Archiv, Berlin, 1992), pp.27, 165.
2 bid., p.164, and Karsten Kruppa, 'Marianne Brandt. Annäherung an ein Leben', in ibid., p.52.
3 Bruno Taut, *Ein Wohnhaus* (Stuttgart, 1927), pp.4, 51.
4 On the Gropius house, see Werner Gräff, *Innenräume* (Stuttgart, 1928), pp.8, 57; and Weber (1992), p.29.
5 Ibid., p.186.

134a

134b

134c

135

Table lamp MT8/ME2

c.1924

Wilhelm Wagenfeld (1900 Bremen –
1990 Stuttgart)

Manufactured at the Bauhaus Metal
Workshop, Dessau

Nickel-plated brass and opaque glass
h. 35cm, diam. 17.8cm
V&A: M.28 to A–1989

Wagenfeld studied in the Bauhaus Metal Workshop
under László Moholy-Nagy and went on to become
one of the most successful designers of metal
and glassware. During the 1930s his popularity
allowed him to continue practising throughout the
Nazi regime (pl.10.17). Unlike most of the Bauhaus
students, Wagenfeld had served a professional
apprenticeship as a silversmith in Bremen and
he stayed in Weimar after the Bauhaus moved to
Dessau, teaching in the Bauhochshule until its
closure in 1930.

Wagenfeld's table lamp, with its clear expression
of function and emphatic use of materials, clearly
demonstrates the influence of Moholy-Nagy's
teaching at the Bauhaus Metal Workshop.[1]
The design of its translucent glass globe was

cleverly thought out to provide a mix of ambient
light and direct light for reading. This lamp is very
closely related to the MT9 table lamp credited to
Wagenfeld and Carl Jacob Jucker. Both were
illustrated in the 1925 publication *Neue Arbeiten der
Bauhauswerkstätten* (*New Works from the Bauhaus
Workshops*); the jointly designed MT9, with its
glass base and stem, is dated 1923–4, whereas
Wagenfeld's lamp is identified as having been
made in 1924.[2] The two lamps, alongside other
similar designs, were exhibited extensively by
the Bauhaus in 1924 and attracted considerable
international attention. Moholy-Nagy noted that
although the lamps' high price put them out of
the reach of many, their popularity confirmed
the necessity of such new forms of light fitting.[3]

This example was purchased by Carl
Benscheit, the owner of the Fagus Shoe Last
Company, and was probably used in his office
in the new factory building in Alfeld, Germany.[4]
Built between 1911 and 1925, the Fagus factory
was Walter Gropius's first major architectural
commission after having left the office of Peter
Behrens. CJG/TB

1 Magdalena Droste, *Bauhaus 1919–1933* (Berlin, 1990), p.80.
2 Beate Manske, 'Zwei Lampen sind nie gleich. Wilhelm Wagenfeld
 in der Metallwerkstatt des Staatlichen Bauhauses', in Klaus
 Weber, *Die Metallwerkstatt am Bauhaus* (exh. cat., Bauhaus
 Archiv, Berlin, 1992), pp.79–91, esp. p.80.
3 Moholy-Nagy, report 4 September 1924, cited in Manske (1992), p.84.
4 V&A RF 89/1659.

136

**Kandem-Bedside Light,
basic model no.702**

1928

Marianne Brandt (1893 Chemnitz,
Germany –1983 Kirchberg, Germany)
and Hin Bredendieck (1904 Aurich,
Germany –1995 Atlanta)

Manufactured by Körting and Mathiesen,
Leipzig

Lacquered sheet steel
h. 25cm
Bauhaus Archiv, Berlin (BHA 3883)

In 1928 the Bauhaus secured contracts with two
lighting manufacturers, Schwintzer and Gräff,
and Körting and Mathiesen. Despite producing
53 Bauhaus-designed lamps, collaboration
with Schwintzer and Gräff ceased in late 1929 or
1930. Under Hannes Meyer's directorship of the
Bauhaus, a concerted effort was made to limit
the number of light fittings in production and to
concentrate on a smaller number of standard
designs. Manufactured under the name 'Kandem-
home-lamps', these standard designs were

manufactured exclusively by Körting and Mathiesen.
The Leipzig-based company continued to work
with the Bauhaus Metal Workshop until the
closure of the Bauhaus in 1932.[1]

This bedside light designed by Brandt and
Bredendieck was the first of this type of light
fitting in the Kandem range. Its design borrowed
heavily from their design for a desk light (Kandem
no.756) of the same year. The base of the light
was cleverly simplified so that the flat surface onto
which the light shade pointed when angled down-
wards acted as a reflector and produced an indirect
source of light.[2] Its comparatively large size further
ensured that the light was stable, even when
nudged in the dark.[3] The ivory enamel finish on
this lamp was intended to unify materials with
very different properties: thin sheet-metal (or
sometimes aluminium) shade, steel tube stalk
and heavy cast-iron base.[4] The lamp was a simple
and practical design, which was produced in this
basic version and in a luxury model with a different
surface finish, joints and base. The luxury model
was discontinued in 1931, while the basic version,
which outsold it, was manufactured in very large
numbers at least until 1942.[5] TB

1 Magdalena Droste, *Bauhaus 1919–1933* (Cologne, 1990), p.176.
 See also Klaus Weber, *Die Metallwerkstatt am Bauhaus*
 (exh. cat., Bauhaus Archiv, Berlin, 1992), pp.30–31.
2 Ibid., pp.31, 176–7.
3 Justus A. Binroth et al., *Bauhausleuchten? Kandemlicht! Bauhaus
 Lighting? Kandem Light!* (exh. cat., Grassimuseum, Lepzig, 2002),
 pp.29–36, 106–107.
4 Droste (1990), p.176.
5 Binroth (2002), p.106.

137a

Giso 404 piano lamp

c.1928

J.J.P. Oud (1890 Purmerend,
The Netherlands –1963 Wassenaar,
The Netherlands)

Lacquered patinated brass
11.4 × 19.7 × 29.8cm
The Metropolitan Museum of Art
Purchase Charina Foundation Inc. Gift (2002 2002.16)

137b

Poster: Giso Lampen

1928

W. H. Gispen (1890 Amsterdam –1981
The Hague)
Printers Kuhn and Zoon, Rotterdam

Lithograph
99 × 71cm
V&A: E.13–1986

This lamp was originally designed as a wedding gift for Oud's friends Harm Kamerlingh Onnes and Titia Easton, who were married in July 1927. The single example was made by Gispen and, in 1928, he manufactured it in bronzed and nickelled copper. Production continued into the 1950s with slight changes in the form.[1] The juxtaposition of spheres and cylinders of different proportions harks back to the early days of De Stijl formalism, and to the experiments in the Metal Workshop at the Bauhaus. A related lamp by Gerrit Rietveld (1925) may have served as inspiration to Oud.[2]

Gispen first set up in business with a small metalworking studio in Rotterdam in 1916. Coming under the influence of the De Stijl group, he began to abandon the Arts and Crafts manner of his early work to become, by 1927, the leading manufacturer of Modernist furniture and fittings in The Netherlands. A good friend of Oud, he also had close connections with many leading designers in Europe, including Ludwig Mies van der Rohe and Marcel Breuer, many of whose designs he manufactured under licence. He also marketed the work of other Modernist designers. From 1926 he began to design the range of lamps that were sold, beginning in 1927, under the trade-name of Giso-Lampen. A feature of these lamps was the use of a special kind of glass, dubbed 'Giso glas', which provided exceptionally even illumination. The avant-garde quality of Gispen's products was expressed in their publicity material, which was invariably of a high standard.[3] TB

1 Ed Taverne, Cor Wagenaar and Martien de Vletter, *J.J.P. Oud, 1890–1963: The Complete Works* (exh. cat., Netherlands Architecture Institute, Rotterdam, 2001), p.371.
2 André Koch, *W.H. Gispen* (Rotterdam, 1988), p.54.
3 Ibid., p.59.

137a

138

Table lamp
1928
Poul Henningsen (1894 Ordrup,
Denmark–1967 Hillerød)
Manufactured by Louis Poulsen for the
Deutsche PH-Lampengesellschaft MBH,
Karlsruhe

Nickel-plated brass, Bakelite, aluminium,
white opalescent glass
h. 53cm, diam. 40cm
V&A: M.26-1992

Henningsen began to experiment with lighting design in 1919, and gained international attention when he was awarded a gold medal for his prototype of the PH lamp at the *Exposition des Arts Décoratifs* in Paris in 1925.[1] The table lamp had three nested, moulded opalescent glass shades with mathematically determined curvatures which reflected the maximum amount of light that at no point dazzled the user. A set of PH lamps, including wall-mounted, hanging and standing versions, manufactured by Deutsche PH-Lampengesellschaft MBH, were published in the *Frankfurt Register* in 1930. This supplement to *Das Neue Frankfurt* (cat.94) advertised the 'PH three shade system' as an example of 'pure "technical light" design', which, due to its even distribution of light, meant that the lights were suitable for all purposes.[2] A seven-reflector hanging light designed to take a 100-watt bulb was also featured.

PH lamps were installed at the Bauhaus's new premises in Dessau, and by Ludwig Mies van der Rohe, who used them to light several rooms in his Tugendhat house in Brno (1928–30).[3] Henningsen went on to develop more than 40 types of the PH light, all with possible variations, numerous of which have remained in continuous production.

Henningsen trained both as a mechanical engineer and as an architect in Copenhagen, though he did not qualify formally in either profession. A supporter of Cubism and Expressionism in his native Denmark, he worked as an art critic and film maker, and in 1926 founded the journal *Kritisk Revy* (*Critical Review*). Running for two years, this publication drew together avant-garde thinkers and practitioners across Scandinavia, putting them in touch with the latest developments in Modernism in the rest of Europe.[4] CJG/TB

1 See Steen Jørgensen, Tina Jørstian and Poul Erik Munk Nielsen, 'The Taming of the Light: From Prisms to Reflective Shades', in Tina Jørstian and Poul Erik Munk Nielsen, *Light Years Ahead: the Story of the PH Lamp* (Copenhagen, 1994), pp.75–116.
2 *Das Neue Frankfurt*, no.2/3 (1930), reprinted in Heinz Hirdina, *Neues Bauen neues Gestalten: das neue Frankfurt/die neue Stadt eine Zeitschrift zwischen 1926 und 1933* (Berlin 1984), p.201.
3 Poul Erik Munk Nielsen and Allan de Waal, 'The Spread of the PH Lamp', in Jørstian and Munk Nielsen (1994), pp.210–11, 224.
4 Allan de Waal, 'Progress and the Concept of Light: PH as an artist between the Wars', in Jørstian and Munk Nielsen (1994), pp.35–6.

139

Dell-lamp type K

1930

Christian Dell (1893 Offenbach,
Germany –1974 Wiesbaden, Germany)
Manufactured by C. Zimmermann GmbH,
Frankfurt

Lacquered steel, nickelled brass, cast iron and 'ebonite'
h. 52.5cm, diam. of base 21.5cm
V&A: M.27–1992

Dell was a metalworking craftsman who was
the master of the Metal Workshop before László
Moholy-Nagy's arrival in 1923, and evolved into
a significant industrial designer. Until 1925 Dell
was still designing beautiful crafted tableware in
silver or copper. After the closure of the Weimar
Bauhaus, he went on to teach in the Arts and
Crafts School in Frankfurt and specialized in the
design of lamps.

This lamp, the 'Dell-lamp type K', like many
designed by those who passed through the
Bauhaus, combined clarity of form, subtle
contrasts of sheen and colour of metal, and an
ingenious structure. Included in the *Frankfurt
Register* no.8 as no.211 (priced at 31.50RM), this
was one of a series of lamps designed by Dell
with the same reflector and friction-adjustable
swivel.[1] One variant could be attached to the wall,
another mounted on a stand to make a reading
lamp and a third mounted on a table clamp.
Thousands of these lamps were used in the
Frankfurt housing estates and they feature in
many middle-class houses and apartments. They
were advertised as having 'functional form and
the lightest, most extreme adaptability'.[2] In an
article introducing the series of *Frankfurt Register*
sheets, Fritz Wichert explained that standardiza-
tion of furniture and equipment required nothing
less than the replacement of the hand by the
machine. Machine-made goods could only satisfy
if, alongside their physical functionality, there was
also a psychological functionality, when form,
surface treatment and mechanisms matched the

purpose intended.[3] In these designs Dell made
the full transition from the expression of indi-
viduality in hand craftsmanship to the search
for the 'anonymous' work of industrial design.
Nevertheless, the series was patented and given
a name that clearly identified Dell as designer.[4]
In 1931 Richard D. Best, of Best and Lloyd Ltd of
Birmingham, brought out a close copy of this
lamp, the Bestlite, which was widely published
and became a feature of the British Modernist
interior throughout the 1930s.[5] TB

1 *Das neue Frankfurt*, no.7/8 (1929), reprinted in Heinz Hirdina,
 *Neues Bauen neues Gestalten: das neue Frankfurt/die neue Stadt
 eine Zeitschrift zwischen 1926 und 1933* (Berlin, 1984), p.197.
2 Ibid.
3 Fritz Wichert, 'Der neue Hausrat Zum Hauptthema dieses Heftes
 und zur Einführung des "Frankfurter Registers"', *Das neue
 Frankfurt*, no.1 (1928).
4 Klaus Weber, '"Sachliche Bauart. Höchste Qualitätsarbeit."
 Christian Dell als Lehrer, Silberschmied und Gestalter', in Weber,
 Die Metall Werkstatt am Bauhaus (exh. cat., Bauhaus Archiv,
 Berlin, 1992), pp.61–2.
5 Kate Child, 'Best and Lloyd Ltd. 1868–1989', in Barbara Tilson
 (ed.), *Made in Birmingham: Design and Industry 1889–1989*
 (Studley, Warwickshire, 1989), pp.129–32.

140

Wall hanging
1926, this version woven by
Gunta Stölzl in 1967
Anni Albers (1899 Berlin–1994 Orange, USA)

Woven rayon and silk
203 × 119cm
V&A: CIRC.534–1968

The Bauhaus proclaimed in its founding
Programme (pl.2.6) that it welcomed 'Any person
of good repute, without regard to age or sex'.[1]
In 1922 Anni Fleischmann (who married to Josef
Albers in 1925) must have headed there with a
sense that opportunities would be available for
an aspiring female artist. Once she completed the
Vorkurs (Preliminary Course), she entered 'unen-
thusiastically, as merely the least objectionable
choice', the Weaving Workshop, the only Bauhaus
workshop consisting entirely of female students.[2]
Albers later explained that she made this choice
because her physical frailty ruled out woodworking
or wall painting, and the Stained Glass Workshop
already had a full complement of one (male)
student, sufficient for the opportunities that arose
to execute stained-glass windows. She may not
have known that from 1919 to 1920 the Bauhaus
had a Women's Workshop, devoted mainly to
textiles and including dollmaking. Once it was
renamed the Weaving Workshop (in 1920), Walter
Gropius took formal steps to confine women
students (of whom, he believed, there were too
many) to weaving only.[3] Nevertheless in Weimar,
under the informal direction of talented student
Gunta Stölzl, Albers learned to weave. In terms
of her artistic education, though she studied with
Johannes Itten, she later described her formative
influences as the art of Bauhaus teacher Paul
Klee ('my great hero') and Peruvian textiles
('my great teachers').[4]

This hanging was designed after the school's
move to Dessau, where Albers continued her
studies. It is very different from more expressive,
early Bauhaus work (cat.17), and typical of Albers's
rigorously composed, abstract compositions. Like
most of her textiles, it was based on a drawing –
Albers's usual working method and one at odds
with the work of peers who 'composed' on the
loom. This hanging, which reconstructs a lost
original, was woven as a double cloth, from rayon
(black and yellow areas) and silk (cream-coloured
sections). CW

1 Walter Gropius, *Programme of the State Bauhaus in Weimar*,
 trans. in Ulrich Conrads, *Programs and manifestos on 20th-century
 architecture* (Cambridge, MA, 1975), p.53.
2 From an interview by Sigrid Wortmann Weltge, quoted in her
 Women's Work, Textile Art from the Bauhaus (New York, 1993), p.47.
 For a more extended excerpt from an unpublished Archives of
 American Art, Smithsonian Institution interview (5 July 1968),
 see Nicholas Fox Weber, *Josef and Anni Albers: Designs for living*
 (exh. cat., Cooper-Hewitt Museum, New York, 2004), p.38.
3 Weltge (1993), p.42, citing Minutes of the Bauhaus Masters'
 Council (20 September 1920) and a Circular to the same group
 (15 March 1921). The original intention was to limit women
 students to Pottery, Weaving and Bookbinding, but Pottery
 declined to accept them and Bookbinding was closed in 1922.
4 Anni Albers, *On Weaving* (Middletown, CT, 1965), p.69 or 70, and
 interview with Albers (5 July 1968, Archives of American Art) cited
 in Nicholas Fox Weber and Pandora Tabatai Ashagi, *Anni Albers*
 (exh. cat., Peggy Guggenheim Collection, Venice, 1999), p.28.

141

Wall hanging

1926–7

Gunta Stölzl (1897 Munich–1983 Zurich)

Woven silk and cotton
130 × 73.5cm
V&A: CIRC.709–1967

Despite their stated aim to educate designers in the crafts and in architecture, fine artists who took the role of form master in the Bauhaus workshops had an especially profound influence. This resulted in an initial lack of emphasis on technical proficiency and material application, but at the same time allowed the freedom to experiment with production processes and formal solutions, uninhibited by traditional practice. For Stölzl this meant that, after entering the Weaving Workshop at the Bauhaus in 1920, she had to learn for herself about the possibilities offered by the loom and by the material nature of textiles. Yet her early work with artists such as Johannes Itten and Georg Muche, as well as with fellow-student Marcel Breuer, also meant that she could develop an approach to weaving furniture textiles, wall hangings and rugs that was akin to the visual experiments of contemporary non-objective painting.[1] Indeed, as her drawings show, the method of devising patterns to be woven on looms varies little from the serial motifs and grids found in drawings and watercolours by contemporary artists, from Paul Klee to those associated with the De Stijl movement.

In summer 1925 Stölzl was formally appointed technical director of the Weaving Workshop in Dessau. Her wall hanging was made there on the new, small-scale hand-operated Jacquard looms, which enabled weavers to produce geometric patterns with precisely defined borders – qualities unattainable with traditional hand looms.[2] The weave of this textile is complex, using twill and damask weaving. It is a one-off piece, autonomous in its visual reference to abstract art and in the absence of a repeat pattern (usually a hallmark of mechanized weaving). The simple bordering of the geometric motif by two rows of fringes signals it as an artistic product for the modern home. Whereas an underlying graphic design is allowed to penetrate to varying degrees, the arrangement of colourful horizontals displays the influence of artworks by Wassily Kandinsky or Carl Buchheister. UL

1 See Sigrid Wortmann Weltge, *Bauhaus Textiles: Women Artists and the Weaving Workshop* (London, 1993), pp.46–9.
2 *Gunta Stölzl: Meisterin am Bauhaus. Textilien, Textilentwürfe und freie Arbeiten 1915–1983* (exh. cat., Stiftung Bauhaus Dessau, 1997), pp.208–9.

142

Prototype samples for furnishing fabric and wall coverings
1927–31
Gunta Stölzl (1897 Munich–1983 Zurich)

Hand-woven, various combinations of wool, silk, cotton and cellophane yarns
Largest size 23 × 11.5cm, smallest 11 × 11cm
V&A: CIRC.404–1969, CIRC.406–1969, CIRC.413–1969, CIRC.414–1969, CIRC.415–1969, CIRC.420–1969, CIRC.421–1969 and CIRC.422–1969

By 1926 Stölzl was the only woman among 12 men on the Bauhaus Masters' Council.[1] The medieval guild structure with its progression from apprentice and journeyman to assistant master and finally master, which had been adopted by the Bauhaus, implied a traditional hierarchy not only in educational structure, but also in terms of gender. The Weaving Workshop was correspondingly accorded inferior status, despite the considerable revenue that the dyers and weavers brought to the strained Bauhaus coffers.

In 1928 Hannes Meyer succeeded Walter Gropius as director. Immediately he set out to make the workshops commercially productive and their output socially responsible, both in terms of eschewing luxury handicraft and contributing to the formation of a contemporary material language. 'Let us compare the Bauhaus with a factory,' Meyer said in his first address to students and staff.[2] He urged the Weaving Workshop to develop prototypes for manufacture rather than the previously hand-crafted pictorial experimentation. Stölzl's swatches reflect this shift and the increasing demand for sample fabrics from textile mills in Germany and abroad. Such demand led to the establishment of the *Bauhausstoffe* (Bauhaus Fabrics) brand. Stölzl's swatches show the new possibilities that had opened up, both through the use of new machinery and through artistically influenced experimentation with synthetic materials, including cellophane. The combination of fibres with diverse properties reflected the emphasis on the tactile that the teachers of the *Vorkurs* (Preliminary Course) impressed on students, but also ensured that the new fabrics were colour-fast and hard-wearing. Their monochromatic colouring catered to the demand from manufacturers for unified planes of fabric to complement trends in Modernist interior design.[3] UL

1 The official appointment was made in April 1927; see *Gunta Stölzl: Meisterin am Bauhaus. Textilien, Textilentwürfe und freie Arbeiten 1915–1983* (exh. cat., Stiftung Bauhaus Dessau, 1997), pp.41–2.
2 Hans M. Wingler, *The Bauhaus* (Cambridge, MA, 1969), p.141.
3 Magdalena Droste and Manfred Ludwig (eds), *Das Bauhaus webt: Die Textilwerkstatt am Bauhaus* (exh. cat., Bauhaus Archiv, Berlin, 1998), p.203.

143 Plate 1.3

Wall hanging

*c.*1930

Ruth Hollós-Consemüller (1904 Lissa,
Poland –1993 Cologne)

Cotton and wool
120 × 79cm
Bauhaus Archiv, Berlin (N 421)

Ruth Hollós was another Weaving Workshop student who began her studies in Weimar (in 1924) and then moved with the school to Dessau.[1] Although, by 1928, the orientation of the school had turned towards design for industry, this hanging is a hand-woven tapestry with no industrial application. It was made to replace an earlier example of the same design, which she had sold. It was woven like a tapestry on an upright loom (the technique called 'Gobelin' in Germany). Considerable skill was required for its making and this hanging is very finely woven. Though made in a traditional manner, its innovative and abstract design is characteristic of the Bauhaus.

In its technique and design this wall hanging draws on historical weaving, including the *Kelim* tradition, which was greatly admired by Bauhaus weavers and by Bauhaus teacher Paul Klee.[2] Hollós was also interested in local weaving traditions and, when she graduated from the Bauhaus in 1930 (just before it was closed for some months when director Hannes Meyer departed), she became the chair of the *Verein für volkstümliche Heimarbeit in Ostpreussen* (Association of Traditional Domestic Work in East Prussia). CW

1 On Hollós, see Sigrid Wortmann Weltge, *Bauhaus Textiles: Women Artists and the Weaving Workshop* (London, 1993), pp.93, 203. On this piece, see Magdalena Droste and Manfred Ludwig (eds), *Das Bauhaus webt: Die Textilwerkstatt am Bauhaus*, (exh. cat., Bauhaus Archiv, Berlin, 1998), pp.263–4, with bibliography.
2 See Hamid Sadghi Neriz, 'Paul Klee und die Kelims der Nomaden', in Droste and Ludwig (1998), pp.120–21.

144

Design: *Der Bauhaustapete gehört die Zukunft* (The future belongs to Bauhaus wallpaper)

1931

Joost Schmidt (1893 Wunstorf,
Hanover –1984 Nuremberg)

Photographs mounted on paper, ink and
applied typewritten paper
15 × 20.7cm
Bauhaus Archiv, Berlin (BHA 1483)

This is a rare example of original collages for a printed catalogue, in this case for the Bauhaus wallpaper collection to be manufactured by the Rasch company.[1] The image was composed of cleverly arranged photographs of a roll of wallpaper and a mirrored sphere in which a back-to-front promotional message could be read in reflection. This message – 'The future belongs to Bauhaus wallpaper' – would have appeared unthinkable a few years before in the Bauhaus, when the whole idea of using wallpaper would have been anathema. In the more commercially minded atmosphere of Hannes Meyer's directorship (from 1928), the Bauhaus workshops had to focus their attention on winning contracts for products people actually wanted to buy. The Bauhaus wallpapers, featuring unremarkable textures in tasteful tones, were successful in the marketplace. TB

1 Hans M. Wingler, *Bauhaus Archiv Museum: Sammlungs-Katalog, Auswahl: Architektur, Design, Malerei, Graphik, Kunstpädogogik* (Berlin, 1981), pp.160–61.

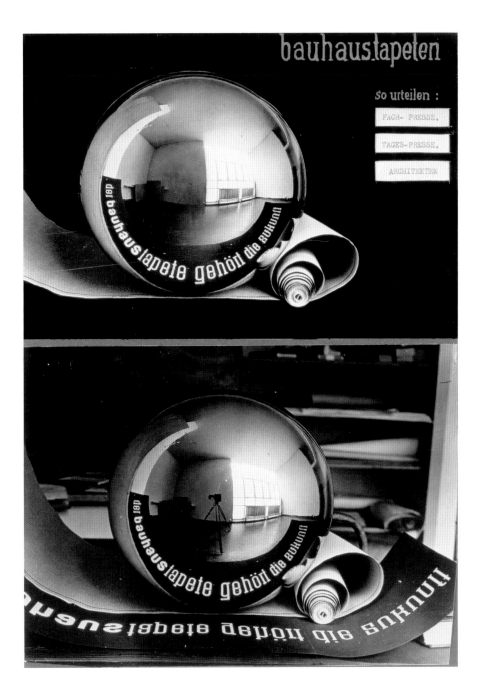

145

Teapot
1928
Naum Slutzky (1894 Kiev – 1965 Stevenage)

Brass with a matt chromium surface and ebony knop
17.5 × 24.5 × 15cm
V&A: CIRC.1232–1967

As a form, the teapot lent itself to the sort of geometrical interpretation favoured by Modernists. Slutzky's design was one of his most successful, though it is less well known than other teapots and infusers, especially those of Marianne Brandt

(pl.3.1).[1] It was clearly influenced by the emphasis on pure geometry at the Bauhaus, where Slutzky had worked as assistant master in the Metal Workshop from 1919, and then as master for goldsmithing from 1921 to 1924. Under the influence of Bauhaus teacher Johannes Itten, Slutzky's early work (cat. 15a), though highly geometrical, had aimed to make evident the mark of the maker's hand.

This teapot was made after Slutzky had left the Bauhaus for Hamburg where, from 1924 to 1933, he practised interior and lighting design (his stationery referred to him as a Lighting Architect), as well as jewellery making (cat.148). Versions were made in different materials, including an electroplated nickel silver example, which he lent to the first exhibition of his work at the Museum für Kunst und Gewerbe (Museum of Applied Arts) in Hamburg in 1929. It was exhibited alongside an accompanying coffee pot of tall, cylindrical form with a handle, knop and spout very similar to those of the teapot.[2] These two vessels in turn bear a remarkable similarity to the teapot and coffee jug in a silver tea and coffee service, designed and made by Slutzky in either 1927 or 1928.[3] The only significant difference between the silver vessels and the later versions in nickel silver is in the design of the handles. ET

1 On this and similar examples, see Rüdiger Joppien, *Naum Slutzky 1894–1965, Ein Bauhaus Künstler in Hamburg* (exh. cat., Museum für Kunst und Gewerbe, Hamburg, 1995), pp.64–5.
2 Monika Rudolf, *Naum Slutsky, Meister am Bauhaus Goldschmied und Designer* (Stuttgart, 1990), p.170 ill.
3 Joppien (1995), pp.62–3.

146a

Coffee service: *Hallesche Form*
1930
Marguerite Friedländer-Wildenhain
(1896 Lyons – 1985 Guerneville, USA)
Manufactured by Staatliche
Porzellanmanufaktur (SPM), Berlin

Glazed porcelain
Plate, diam.16.5cm
Coffee pot, 12.6 × 21.8 × 12.6cm
Creamer, 7.6 × 12.2 × 8.5cm
Coffee cup and saucer, 7.8 × 14.1 × 14.1cm
Die Neue Sammlung, State Museum of
Applied Arts and Design, Munich

146b

Table service: *Form 1382*
1931
Hermann Gretsch (1895 Augsburg –
1950 Stuttgart)
Manufactured by Porzellanfabrik Arzberg,
Bavaria

Glazed porcelain
Soup tureen with lid, 14.7 × 25.4 × 21.7cm
Serving dish with lid, 19 × 28.9 × 24.2cm
Consommé bowl and saucer, 5.7 × 17.1 × 17.1cm
Die Neue Sammlung, State Museum of
Applied Arts and Design, Munich

146c

Tea service: *Neu-Berlin*
1931
Trude Petri (1906 –1968)
Manufactured by Staatliche
Porzellanmanufaktur (SPM), Berlin

Glazed porcelain
Teapot, 15.7 × 25.6 × 15cm
Tea cup and saucer, 5.3 × 15.6 × 15.6cm
Plate, diam.20.7cm
Die Neue Sammlung, State Museum of
Applied Arts and Design, Munich

Putting theory into practice was the great challenge for designers of modernist ceramics, just as for architects, furniture designers and practitioners of the other applied arts. So it was an achievement of no small importance when, in 1930, a group of Modernist potters managed to find factories to manufacture their porcelain tablewares. The breakthrough came when Günther von Pechmann, a member of the *Deutscher Werkbund* and the former founding director of the Neue Sammlung in Munich, won the job of director of the Staatliche Porzellanmanufaktur (SPM) in Berlin.[1] The first tangible product of his leadership there was the production of the line *Hallesche Form* by the Bauhaus potter Friedländer-Wildenhain. The name was a nod to the Kunstgewerbeschule (Arts and Crafts School) in Halle, where Friedländer-Wildenhain had led the ceramics programme since the closing of the Bauhaus pottery in 1926, and where she had designed and made the prototypes for the line. *Hallesche Form* was rapidly followed by the *Urbino* and *Neu-Berlin* lines, both by SPM's in-house designer Petri, who had trained at the Vereinigten Staatschulen (United State Schools) in Berlin. All three SPM lines were manufactured in a monochrome white, which must have seemed shockingly stark to most consumers, but communicated the sense that the porcelain was 'based upon systematic scientific research and experimentation', as one partisan art historian wrote.[2] Perhaps as a concession to the market, *Hallesche Form* was also offered with restrained geometric decoration designed by Petri, while *Neu-Berlin* was produced in an alternate celadon glaze or (in seeming contradiction to the aesthetic principles of the effort) a lily pattern.[3]

The Bavarian manufacturer Arzberg soon followed SPM's example with *Form 1382*, designed in 1931 by Gretsch. Trained in architecture and ceramics at the Kunstgewerbeschule in Stuttgart, Gretsch had a commitment to modern design that was influenced by the 1924 *Werkbund* exhibition 'Die Form ohne Ornament' (Form without Ornament). Arzberg initially hired him as a consultant, but he proved so opinionated on the subject of the company's existing wares that he was hired as a designer. The result was *Form 1382*. The line achieved early critical and commercial success, winning gold medals at the sixth Milan Triennial in 1936 and the Paris World Fair of 1937. Gretsch, active throughout the 1930s as a regional government adviser for architecture and applied art and as the head of the Landesgewerbemuseum, would go on to design another line (*Form 1495*) for Arzberg in 1940. *Form 1382* remains in production today.[4]

Though Petri's and Gretsch's designs would prove the most enduring of Modernist German porcelain, widely published and admired, it was Marguerite Friedländer-Wildenhain whose personal influence was the most significant. After her move to the United States in 1940 she founded her Pond Farm pottery in northern California.[5] She became perhaps the most prominent proponent in America of the Bauhaus fusion of craft skills with industrial manufacture. Her 1959 book *Pottery: Form and Expression* demonstrated that principle through the direct comparison of *Hallesche Form* with hand-thrown versions of the same shapes. The book became a bible for ceramists sympathetic to the post-war American 'designer-craftsman' movement, which advanced the quintessentially Modernist, if ultimately quixotic, goal of inserting skilled artisans into the mass-production system as a means of design reform.[6] GA

145

146a–c

1 Von Pechmann had founded Die Neue Sammlung in 1925, and
acquired several objects from the *Exposition Internationale des
Arts Décoratifs et Industriels Modernes* of that year. Frustrated
by the lack of space and resources at the collection, which was
then installed in a wing of the Bavarian National Museum, he
took up the job at SPM in 1929 and remained there until 1940.
See Klaus Weber, *Keramik und Bauhaus* (Berlin, 1989), p.159.
2 Walter Passarge, *Deutsche Werkkunst der Gegenwart* (Berlin,
1938), p.77.
3 Judy Rudoe, *Decorative Arts 1850–1950: A Catalogue of the
British Museum Collection* (London, 1991), pp.50–51, 89.
4 *Eine Form der Geschichte Macht: Artzberg 1382* (Munich, 1986);
Rudoe (1991), p.54.
5 On Pond Farm, see Charles Talley, 'School for Life', *American
Craft*, no.51/2 (April/May 1991), pp.36–9, 72–3; B. Stephen
Carpenter, II, 'Ripples on the Pond: Marguerite Wildenhain
and Her Students', *Ceramics: Art and Perception*, no.50 (2002),
pp.57–60.
6 Marguerite Wildenhain, *Pottery: Form and Expression*
(New York, 1959).

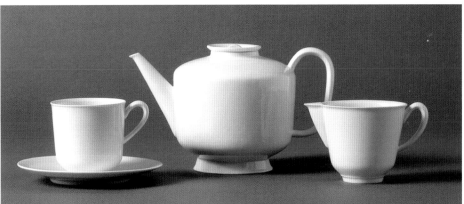

146a

146b

146c

147

Tea service

1931

Wilhelm Wagenfeld (1900 Bremen –
1990 Stuttgart)

Made by Schott & Genossen, Jenaer
Glaswerke, Jena

Mould-blown, heat-resistant, boro-silicate glass
Teapot, 11.9 × 24.4 × 15.3cm
Sugar bowl, 4.7 × 9.8cm
Creamer, 4.8 × 12.6 × 9.8cm
Cup, 3.8 × 12.4cm
Saucer, diam.16.6cm
V&A: C.31 to D–1980

The Bauhaus designer Wagenfeld went into private practice after the closure of the Weimar Bauhaus and developed his ceramic and glassware designs with some of the foremost companies in Germany.[1] The Jenaer Glaswerke manufactured scientific and optical glassware and, at the instigation of Erich, son of the founder Otto Schott, began producing domestic glassware in the 1920s. Wagenfeld had first met Erich Schott when giving a lecture on the Bauhaus in Jena in 1922.[2]

The transparency and geometry of laboratory wares clearly appealed to the Modernist admiration for the functional, rigorously engineered form.[3] Wagenfeld's set is an attempt to bring those qualities into the domestic setting. The drinking of tea in a glass was a tradition in many Central European countries and the glass teapot had the added practicality of its own strainer, which allowed the strength of tea to be judged by eye. Although Ladislav Sutnar designed a similar set at precisely the same time (cat.243b), Wagenfeld's set was more widely published and better known. The first of a series of designs for Schott & Genossen, Wagenfeld's tea set became a classic transparent glass tea set, continuously manufactured (even if slightly modified) during the post-war era. CJG

1 On Wagenfeld, see Beate Manske (ed.), *Wilhelm Wagenfeld (1900–1990)* (Ostfildern-Ruit, 2000).
2 Judy Rudoe, *Decorative Arts 1850–1959: A Catalogue of the British Museum Collection* (London, 1991), p.120.
3 Wilhem Wagenfeld, 'Jena Glas', in *Die Form*, vol.6, no.12 (1931), pp.461–4.

148a

Bracelet

1930

Naum Slutzky (1894 Kiev –1965 Stevenage)

Steel with chromium finish
h. 3.6cm, diam. 7 cm
V&A: CIRC.1236–1967

148b

Brooch

1928

Naum Slutzky (1894 Kiev –1965 Stevenage)

Gilded brass
l.6.4 × 2.6 × 0.4cm
V&A: CIRC.1237–1967

148c

Necklace

1929

Naum Slutzky (1894 Kiev –1965 Stevenage)

Chromium-plated brass
diam. of pendant 7cm, l.32cm
V&A: CIRC.1233–1967

Naum Slutzky had a distinguished career as an inspirational teacher, both in Germany and in England, as well as the distinction of being one of the most original jewellers associated with the Bauhaus (see cat.145). His jewellery designs, such as this necklace, brooch and bracelet, are characterized by a simple, elemental elegance in which the geometric construction is pared down to the irreducible minimum. Even such features as the clasp on a bracelet have an engineered simplicity that was typical of Slutzky's approach to his metalwork designs. The decorative effect of his necklace relies on showing the thin linking elements between the thicker straight or curved brass sections. This same element allows the form of the necklace to change depending on the wearer's movement, thus introducing a kinetic element to the design. Modernist jewellery such as these examples is rare, as is jewellery made without any sort of historical reference.

Slutzky's interest in jewellery came from his father (Gilel Slutzky), a goldsmith who moved his family to Vienna in 1905. The younger Slutzky received his training in Vienna, where from 1908 to 1912 he was a student of goldsmithing under Cheine Litweie.[1] He briefly worked for the *Wiener Werkstätte* before undertaking engineering studies at the Technical High School (1914–19), along with formal artistic training at the Viennese Art School. In 1919 Slutzky accepted Walter Gropius's invitation that he become assistant, then master goldsmith, in the Metal Workshops of the Weimar Bauhaus. In 1924 he moved to Hamburg and, in addition to his other design work, made jewellery such as these examples in his own workshop, and was employed as a goldsmith for the retailer Kaufmann of Hamburg.[2] After fleeing Germany in 1933, he worked briefly as a designer for the Birmingham lighting firm Best and Lloyd, and from 1934 began a long teaching career in England. ET

1 On Slutzky's life and work, see Rüdiger Joppien, *Naum Slutzky 1894–1965, Ein Bauhaus Künstler in Hamburg* (exh. cat., Museum für Kunst und Gewerbe, Hamburg, 1995) and Monika Rudolf, *Naum Slutsky, Meister am Bauhaus Goldschmied und Designer* (Stuttgart, 1990).
2 It was during this period in the late 1920s that he met and became friendly with Gesche Ochs, who was to become an important patron. The Slutzky jewellery and teapot (cat.145) held in the collections of the V&A were all acquired from Gesche Ochs in 1967. V&A RP 67/835.

Christopher Wilk

Sitting on Air

Every chair seems to be a stylization of
an attitude to life.[1]

Gerrit Rietveld
De werkende vrouw (The Working Woman)
(1930)

6.1 **Marcel Breuer**, Chair,
model B32, 1928 (cat.155)

In 1926 Bauhaus teacher Marcel Breuer illustrated the development of the modern chair using images of his own work of the 1920s, presented in the form of a filmstrip on the printed page (pl.6.2).[2] Through this visual conceit he suggested a process of progressive abstraction (the realm of aesthetics), of the move from wood to metal (materials and manufacture), and of the gradual diminishing of the structure of the chair (technical innovation) until, as the caption read, 'at the end one sits on a resilient column of air'. This dream of dispensing with visible structure, of sitting on air, was widely held during the period (pl.6.3), and was directly analogous with the desire

of architects to construct buildings that exploited or even revolutionized innovative building technology such as the steel frame, or which allowed for visible structural daring, such as the cantilever. The filmstrip, presented in the Bauhaus's own magazine, also pointed to the place of the chair in the contemporary imagination and defined it as a potential and powerful vehicle for arguing the case for Modernism. Thus, the chair – an essential element of daily life – was subject to the same interrogation, investigation and rethinking that designers and architects applied to all aspects of their environment.

Beyond architecture no object type exerted a

6.2 **Marcel Breuer**, 'A Bauhaus Film', *Bauhaus*, no.1 (July 1926). Bauhaus Archiv, Berlin

6.3 **Der Stuhl** by Heinz and Bodo Rasch, 1928 (cat.158)

6.3

6.2

stronger hold on the imagination of inter-war designers than the chair. Virtually every architect and designer of note (and many more) felt compelled to turn their attention to the design of at least one chair. Some chairs never went beyond the concept stage, others were realized as hand-made prototypes; some were produced in small numbers and only a very few were manufactured in any quantity. While various periods since the eighteenth century have seen architects engage noticeably with the design of furniture (famously Robert Adam and A.W.N. Pugin in Britain, Karl Friedrich Schinkel in Germany, and scores of others in Europe and America around 1900), no era had yet produced so many designs for chairs by architects. As examples of Modernist architecture were increasingly built in the years between 1925 and the early 1930s, why did the chair become a paradigmatic object type, one which, as much as architecture, could embody Modernism's key values? Although most furniture used during the period was made of wood, why did the metal chair and, in particular, the metal cantilevered chair capture the imagination of so many contemporaries, achieving a symbolic importance beyond its commercial success?

The lack of opportunity to engage in architectural work resulting from the poor economic climate in Europe in the years after the First World War and during the Depression that followed was, of course, an important motivation for architects to apply themselves to seating design. Architects did this in a similar spirit to their investment in clientless, visionary architectural projects, to writing and to participation in exhibitions. That so much furniture came to be conceived in the 1920s and '30s was testimony to the fact that it was, of course, infinitely simpler (and cheaper) to build a chair than a building, and that no commissioning client was required. Indeed, most of the major seating designs of the 1920s were speculative projects. The chair was thus a compact design problem which, because the results had a reasonably good chance of being realized at least to the stage of photography and exhibition, if not manufacture and use, held enormous appeal for designers, who were perpetually looking for work and thus valued something that might bring them attention.

When opportunities to build finally arrived, most architects wished as a matter of course to retain the unity of their vision (cynics would say, to control it) by specifying, if not designing, every element of their project. The nature of the Modernist interior required ambitious levels of unity and consistency of design, and it demanded at least sympathetic – and at most, radically new – furnishings that enhanced and developed its architectural principles (pls 5.6–5.9, 6.4, 6.9, 6.12). Architects generally urged their clients to purge themselves of the inessential. Bruno Taut advised the housewife: 'When everything, absolutely everything which is not directly necessary to life has, through stringent and ruthless selection, been thrown out of a dwelling, then not only is your work

made easier but a new beauty emerges of its own accord.'[3]

This position, not an unusual one among Modernist architects, was demanding of clients and they responded in different ways. When Gerrit Rietveld designed a new house for, and with, Truus Schröder (cat.22), the client's commitment to living in a new way was absolute. The fitted and free-standing furniture, abstract and geometric, was part of a completely integrated design in which architecture and furnishings were inseparable. In another case, Le Corbusier's clients Michael and Sarah Stein, to the architect's apparent dismay, insisted on retaining their Renaissance furniture in the salon of their new villa (pl.1.2), a room that, as a result, Le Corbusier never published.[4] What was patently clear to most designers (if not their clients) was that traditional furniture was inappropriate within an interior composed of surfaces deliberately conceived without ornament and with forms based largely on simple geometry.

The fact that there was barely any Modernist furniture available on the European market in the mid-1920s, as the New Architecture was being built, was a powerful incentive for architects to design their own. Indeed, in her best-selling book for the housewife in German-speaking countries, *Der neue Haushalt* (*The New Household*, in its 36th edition by 1929), Erna Meyer wrote that the state of manufactured furniture was 'woeful'.[5] Among existing furniture, only the everyday café furniture of the Thonet company was deemed suitable by leading architects.[6] It was Le Corbusier who became the most influential proponent of the simplest of these bentwood models as he used them in his interiors from the early 1920s, most significantly in the widely published Pavillon de l'Esprit Nouveau (pl.3.25). On that occasion he wrote that 'the humble Thonet chair … certainly the most common as well as the least costly of chairs … possesses nobility'.[7] Bentwood chairs were also used by no fewer than eight of the 16 architects in the furnished houses and flats they designed for the Weissenhof exhibition in 1927 (pl.5.8), as well as appearing as stand-alone exhibits in the accompanying exhibition spaces.[8] Extensive publication in architectural magazines and books of these interiors, as well as of the houses of Le Corbusier, identified the bentwood chair closely with Modernism in the mid-1920s. More significantly, it associated Modernism with an object that, despite its late nineteenth-century origins, expressed in the 1920s many of Modernism's most important values. Like the machines (pl.3.24), aeroplanes and products of industry (pl.3.3) that Modernists published and exhibited as examples of what contemporary design should aspire to, here was a truly mass-produced product, sold globally, the simple, unornamented form of which derived from its rigorously organized manufacturing process.

Even Le Corbusier's endorsement of bentwood was not unconditional. 'There is no reason,' he wrote,

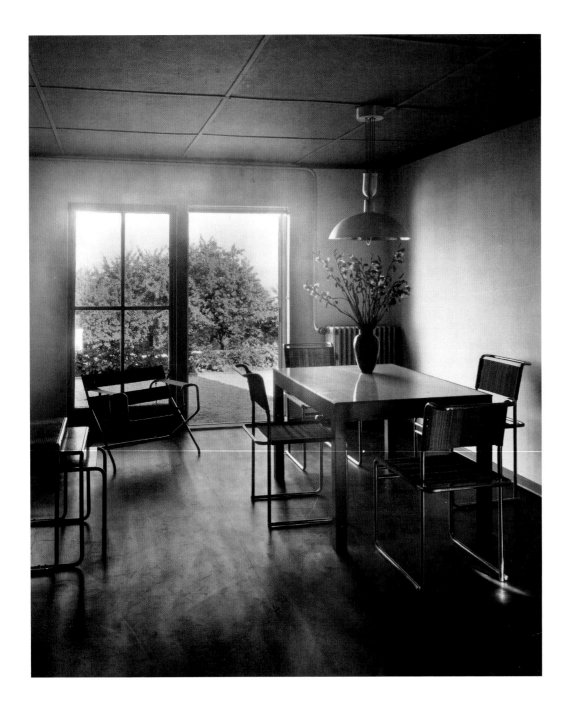

6.4 **Marcel Breuer**, Interior of house no.16 (designed by Walter Gropius) at the Weissenhof Housing Estate, Stuttgart, 1927. Bauhaus Archiv, Berlin

'why wood should remain the essential primary material for furniture.'[9] As economic and market conditions constrained the availability of suitably modern furniture products in the 1920s, the only solution, for those in a position to do so, was to design new furniture; and the material that seemed perfect was steel. The qualities of bentwood, however, retained a presence within debate about the radically new material. In 1932 Czechoslovak architect Ladislav Žák lamented the lack of springiness in bentwood, while acknowledging that 'Only furniture made of bentwood can be compared to metal furniture.'[10]

Modern tubular-steel furniture was developed by Marcel Breuer at the Bauhaus in 1925–6 (pl.3.21).

That this new furniture made of shiny, nickel-plated steel furnished interiors at the school, one of the era's most published and visited (by designers and architects) buildings, proved hugely important for its future.[11] It led directly to the first wave of Dutch and German Modernist metal furniture, which would be exhibited at the Weissenhof exhibition in 1927. This included the first cantilevered chairs by Mart Stam and Mies van der Rohe (pls 6.7–8), as well as furniture by Breuer (pls 6.4–5) and J.J.P. Oud. Combined knowledge of the Bauhaus furniture, as well as that shown at Weissenhof, set off a remarkable wave of metal furniture design in the Netherlands and Germany and by 1929 it was being made by Thonet, as well as by smaller firms.[12] By the

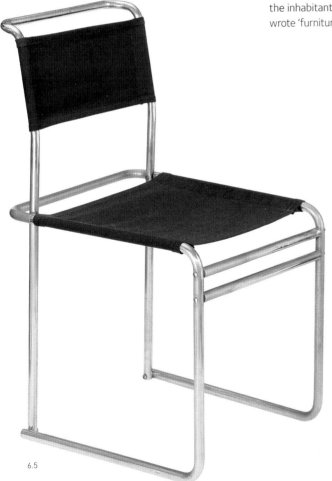

6.5 **Marcel Breuer**, Chair, model B5, 1926–7 (cat.151)

6.6 **Marcel Breuer**, Nest of tables, 1925/6–7 (cat.152)

mid-1930s it was being made or sold in virtually every other European country and in the United States as well, though most of it was used in commercial or institutional interiors.

The spatial, aesthetic and social concerns of Modernist architecture naturally set the agenda for the design of furniture. Chief among these was that interior space should be open and free-flowing. This was one of the central tenets of Modernist architecture and the subject of much experimentation. Within an architectural project, once a spatial solution had been found in the conception of the plan, an important factor in its realization in three dimensions was the role that furniture would play in furnishing and defining space, ideally without interrupting its flow. Within more open, relatively empty interior spaces, furniture assumed a visual prominence that it had not always had, even within architect-designed interiors of the past. The result for those experiencing the spaces, or for those looking at photographs of them, was that the status of furniture within the interior was raised. Furniture became an object to view, an element in the vistas and sight lines of the interior, and an integral element of its spatial composition.

One strategy for furnishing the spatially open interior was to purchase, or design, furniture that was visually transparent, minimal in terms of bulk. Ideally, furniture in the Modernist interior was not meant to encumber the experience of space or stop the inhabitant's eye from looking through it. Breuer wrote 'furniture … is no longer massive, monumental,

apparently rooted to the ground or actually built-in. instead it is broken up airily, sketched into the room, as it were; it neither impedes movement nor the view through the room.'[13] Furniture that was in itself spatially complex and dynamic could also be part of the construction of equally dynamic interior space (pls 2.12, 3.21, cat.22b). In the early 1920s the commercially available furniture that best satisfied this desire for visual transparency had been bentwood, but maximum transparency was achieved in tubular steel, above all in the cantilever chair, which stood on two legs rather than four. Steel (in tubular or more expensive flat, rectangular form) allowed the minimum use of material to achieve maximum strength, and therefore to perform feats of engineering in seating design that made the space within the frame of the chair a significant feature of its aesthetic.

Building furniture into the structure of the interior, especially around the perimeter, was another way of organizing, varying and freeing up interior space, and the 1920s saw a veritable explosion in the design of built-in seating (cat.115b), storage (pl.5.7, cat.22b) and kitchens (cat.92). Built-in furniture also addressed social concerns that focused on the important role of the minimal (or minimum) dwelling (cat.101) as the most efficient and economic type of housing, especially important for rehousing those living in substandard accommodation. The simple equation was: the smaller the living space, the greater the number of such spaces that could be built. Therefore anything that could contribute to the saving of space was

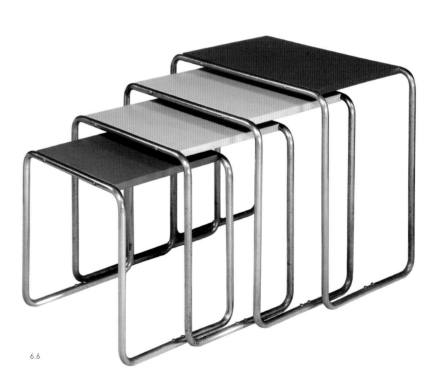

6.5

6.6

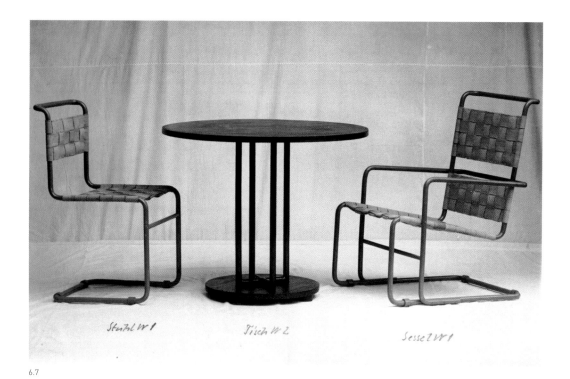

6.7

6.7 **Mart Stam**, *Stahlrohrmöbel* for house no.28 at the Weissenhof Housing Estate, Stuttgart, 1927. Deutsches Architekturmuseum, Frankfurt-am-Main

6.8 **Ludwig Mies van der Rohe**, Chair model MR 10/3, 1927 (cat.153)

desirable, if not imperative.[14] Seating for a single sitter, rather than benches or couches, was singled out as a form that should remain independent and free-standing, even by advocates of built-in furniture.[15]

Further contributing to more efficient and less costly production – or so advocates believed – was the idea that a limited range of standardized product types would lead to the production of a smaller number of better-designed and more economic products for the home. In Germany, where the idea of standardized types was the subject of much debate, a specialized vocabulary emerged that articulated these concepts. Hence, the word *Typisierung* was created to describe the development of standardized types of all manner of products, and the word *Typenmöbel* identified standardized furniture types (pl.6.11).[16] Le Corbusier wrote on 'type-objects, responding to type-needs: chairs to sit on, tables to work at, devices to give light ...'[17] Describing the furnishing of the Weissenhof houses, Willi Lotz wrote that the ideas 'represented an attempt to replace matching sets of furniture, designed to go together in a room, by an assembly of individual pieces chosen from good, existing standard designs. The idea was to present *the* chair, *the* table, *the* bed.'[18] Le Corbusier wrote that 'apart from chairs and tables' the only furniture type required was the *casier* or pigeon-hole box, which in a multiplicity of dimensions and shapes could fulfil every possible storage need, functioning as shelving, cupboard and room divider.[19] Behind all the debates surrounding standardized types lay the presumption that such forms were to be mass-produced. Owing to its industrial associations, metal furniture seemed to offer a particular potential for the development of mass-produced, standardized types.

The ideal of mass production was powerful within Modernist ideology and rhetoric. Techniques of cheaper and more efficient manufacture lay at the foundation of dreams about building a better world. These dreams were key to both the social agenda of Modernism and also to its aesthetics, which sought to give expression to the machine ideal (see Chapter 3). Corbusier's famous remark that 'the house is a machine for living' was perhaps the most repeated credo during the 1920s and '30s. In a lecture, Breuer said that 'The necessity for the utmost economy in space demands a machine for living, which must actually be constructed like a machine, with engineering developments and the latest in mechanization.'[20] Turning to furniture, Le Corbusier himself wrote: 'If requested, industry will at once suggest new companions [to wood]: steel, aluminium, concrete ... the unknown. Then the faubourg Saint-Antoine [the historical furniture-making district of Paris] will send its apprentices to ... the aircraft and automobile factories ...'[21] While the extent to which tubular steel was truly mass-produced needs further research, it is inarguable that, to contemporaries, chairs made of industrial materials offered the real promise of cheap mass production.

When Charlotte Perriand wrote that 'metal plays the same part in furniture as cement has done in architecture', she was suggesting the unique structural utility of both materials as well as their important symbolic roles.[22] Although neither material was new, the period saw a dramatic increase in the use of both, though not as much as advocates had

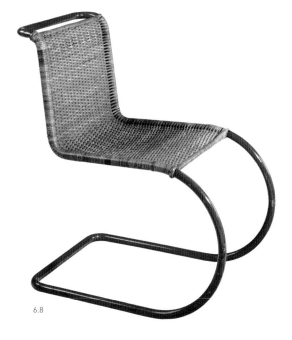

6.8

6.9 **Le Corbusier** and **Charlotte Perriand**, Equipment for a dwelling, view from the living area towards the dining area, *Salon d'Automne*, 1929. Archives Charlotte Perriand

6.10 **Le Corbusier, Pierre Jeanneret** and **Charlotte Perriand**, *Fauteuil à dossier basculant*, 1929 (cat.157)

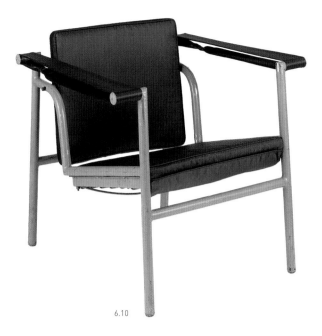

6.10

hoped and not at as highly developed a state of technology as was dreamed of. In terms of the two materials, the rhetoric far outpaced the application of, and commercial demand for, the technology.

It was, of course, the use of steel that made the cantilevered chair possible. While steel was a building material revered by Modernists, emblematic of strength and of 'truth' (see Chapter 5), it was commonly hidden beneath some sort of cladding, except in works of engineering. In tubular-steel furniture, the truth of the structure was revealed and even celebrated. When the first modern cantilevered chairs, newly designed and made of tubular steel, were publicly exhibited at the Weissenhof exhibition in 1927, they were conceptually and visually arresting. The invention of a chair that apparently defied gravity came close to Theo van Doesburg's description of 'the new architecture' as having 'a more or less floating quality that . . . works against nature's gravity'.[23] Sitting on a cantilevered chair was the closest anyone

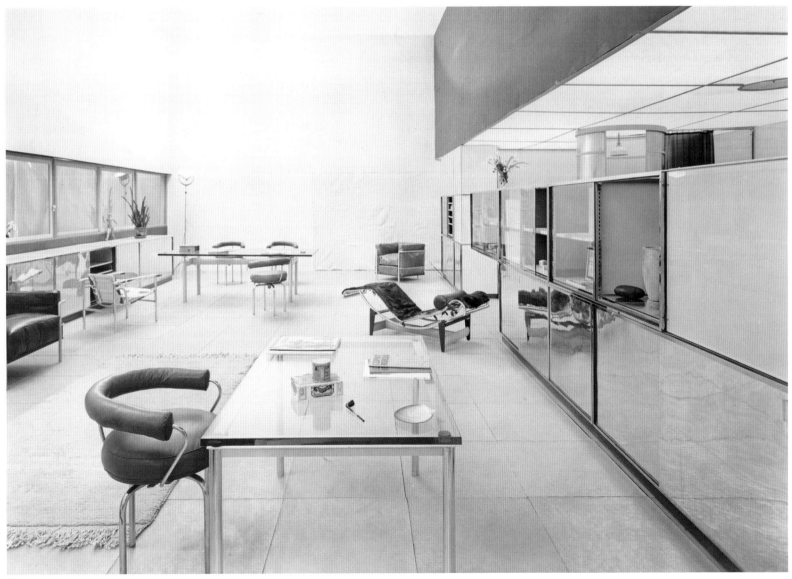

6.9

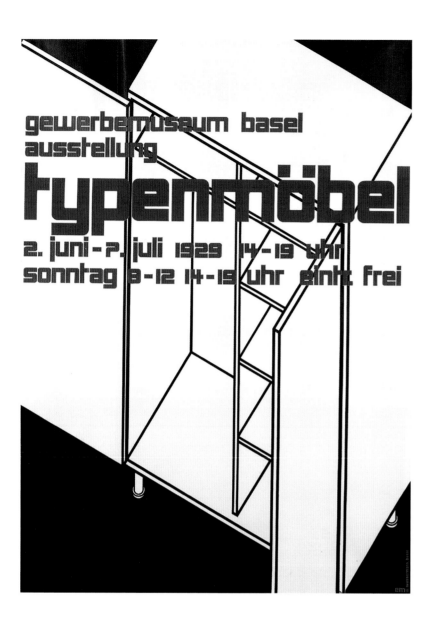

6.11 **Ernst Mumenthaler**,
Poster, *Typenmöbel*, 1929
(cat.159)

could realistically get to sitting on air. The resilient nature of Ludwig Mies van der Rohe's cantilevered chair and most subsequent designs (pl.6.1, cats 161–4) meant that the sitter actually moved gently in space. Visible structure was reduced to an absolute minimum and maximum transparency was achieved. The design of the frame implied an ease and continuity of manufacture which, however misleading, suggested that it was made of a single length of material. And the chairs looked, for all appearances, like industrial products originating in a factory, possibly even made in large numbers. The industrial origins of tubular-steel furniture were made explicit at the time: Breuer attributed his interest in tubular steel to a bicycle (pl.3.21), and Stam's chair was inspired by the folding, cantilevered seat of an automobile (pl.6.7).[24]

The Weissenhof exhibition of 1927 offered, for many, the first opportunity to see tubular-steel furniture as well as the first chance to see cantilevered models.

The scores of books and articles published during and after the exhibition spread knowledge of the new furniture far and wide, and the cantilevered seat shortly afterwards became one of the most imitated ideas in the history of furniture.[25] Images of the sitter floating on air became more common from the late 1920s and, indeed, as with metal furniture in general, the cantilevered chair was the object of satire and even ridicule.[26]

Tubular-steel furniture offered an opportunity to demonstrate the kind of structural rationalism that Modernists cherished. From the earliest four-legged designs to the two-legged cantilever chairs, frame and support for the sitter were separately articulated. The sitter did not necessarily have to come into contact with the steel frame. Indeed the very notion that these chairs clearly had a steel frame which supported the structural elements that carried the sitter (seat and back) emphasized further the analogy

between furniture and architecture. The idea of separating, in constructional and visual terms, frame and support became embedded in Modernist furniture designs, not only in those made of metal and not only in cantilevered chairs. Wooden chairs, or chairs made of a combination of wood and metal, employed a similar design vocabulary to that of metal furniture, although the different structural properties of wood (often plywood) meant that the supporting structure was necessarily bulkier. Designs by Breuer (pl.9.3) Alvar Aalto (pl.9.2), and Bruno Mathsson (pl.1.6) provided frames from which a single-piece seat and back (or what appeared to be so) was hung.

The cantilever was not, of course, only an expression of Modernist structural innovation; it also revealed a keen interest in aesthetics. Most early tubular-steel furniture can be described as Constructivist or Elementarist, derived from De Stijl, especially from the principles exemplified in Gerrit

Rietveld's 1918 chair (pl.2.12).[27] When Van Doesburg wrote in 1919 that, 'Our chairs, tables, cupboards and other objects for use, those are the (abstract – real) sculptures within our future interiors', he admitted a truth that was frequently denied by many of his peers: that architects were very interested in and conscious of the aesthetics of their designs, and that furniture played more than a functional role in the interior.[28] By the mid-1920s, the new emphasis on the technology-based rationalism of Modernism seemed to require that designers, at least, deny an interest in aesthetics and, at most, claim that the form of their work was reliant solely upon function or programme. Mies van der Rohe, who wrote a great deal about the question of form, did not deny an interest in formal matters, but he was at pains to point out that 'Form is not the goal but the result of our work ...'[29] In his buildings and in his chairs he put enormous effort into the choice of materials and their detailing and, like many of his contemporaries, was acutely interested in aesthetics.

An additional item on the Modernist agenda that steel furniture uniquely addressed was that of hygiene.

The inorganic nature of metal and the shiny, smooth surfaces of tubular steel meant that it was not only easy to clean, but that it looked hygienic. The hygienic qualities of tubular steel were frequently commented upon by designers and contemporaries, and this description was used in both polemic and in advertising of the period to advocate use of this type of furniture.[30] The fact that the one context in which people were most likely to have previously come into contact with metal or part-metal furniture was at the doctor's or dentist's surgery or in a hospital meant that, for many, the new tubular-steel furniture carried with it associations of hygiene within a medical context. For some, this was the source of intense displeasure. Reviewing a *Deutscher Werkbund* exhibition of mainly former Bauhaus designers in Paris in 1930, Aldous Huxley referred to 'the aseptic, hospital style of furnishing', complaining that, 'To dine off an operating table, to loll in a dentist's chair – this is not my idea of domestic bliss ...'[31] Indeed, he expressed a widely held view that metal furniture was inappropriate in the domestic interior and reflected that it was not the general use or existence of metal furniture that

seemed so remarkable to contemporaries (and was the source of much vituperative criticism), but the use of metal furniture in the domestic interior specifically.

When Huxley wrote his review in 1930, tubular-steel furniture was only just beginning to find its way into the wider marketplace. However, avant-garde designers were to abandon it quickly except in regions where they had engaged with it relatively late (for example, in Italy [pl.10.14], Sweden and America). In 1935 Mart Stam would decry the proliferation of 'effete and decadent', overcomplicated 'steel macaroni monsters'.[32] Among Modernists who had pioneered the new furniture, the turn to nature and the rejection of any sort of machine aesthetic in the 1930s meant that wood, especially plywood, became the favoured material for experimental furniture design and that, with the exception of a few designs, the short-lived possibility of sitting on air was over.

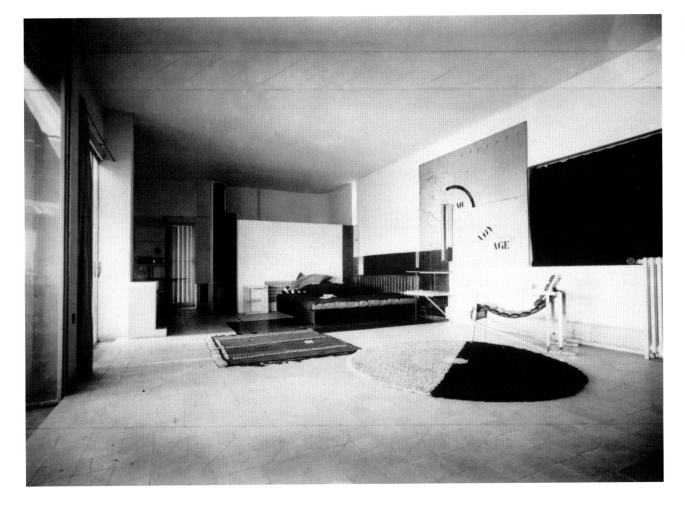

6.12 **Eileen Gray**, Living room at E.1027, 1926. Collection Alberto Sartoris. See cat.149.

149

Fauteuil Transatlantique
1925–29
Eileen Gray
(1879 Enniscorthy, Ireland–1976 Paris)
Made by galerie Jean Désert, Paris

Sycamore frame with chromium-plated mounts and fixtures, leather upholstery
79 × 55 × 98cm
V&A: CIRC.578-1971, given by the designer

The Irish designer Gray had a glittering career behind her in Paris as an Art Deco designer when she began to take an interest in Modernism, around 1925. Her young Romanian friend Jean Badovici introduced her to the work of Le Corbusier and other Modernists and helped her with a number of architectural commissions, including the house they shared in Roquebrune (1925–9). The design of this house (named E.1027) (pl.5.4), by Gray with technical help from Badovici, turned into a laboratory for a new kind of Modernism, not only in architecture, but even more so in design.[1] Gray admired Le Corbusier, who gave her a set of his architectural drawings, but retained an acute and critical eye of her own. Her Modernist furniture designs, many of them designed for E.1027 (pl.6.12), are a case in point. The so-called 'Transat' armchair was beautifully made of sycamore with metal fixtures, evoking the elegant craft of the ship chandler. Several prototypes exist, but it was to be a long time before it was manufactured commercially.[2] The principle was that of a suspended loop of leather-upholstered material, with a headpiece that could pivot to suit the posture of the sitter. Some versions use an upholstered sling of leather for the seat, like a deckchair, indicating that one of the sources of inspiration was the ocean-liner deckchair. Although Gray used chromed joints and connecting rods to allow for the use of straight sections of wood – simplifying manufacture and enabling the chair to be taken to pieces – the two side frames are expertly mortised in a way that could be industrially produced only with difficulty. TB

1 E.1027 is a cipher of their names based on the sequential numbers of their initials as they appear in the Latin alphabet; E for Eileen is followed by 10 (J for Jean), 7 (G for Gray) and finally by 2 (B for Baldovici). See Caroline Constant, *Eileen Gray* (London, 2000), pp.93–121.

2 Indeed, the date of the chair is unclear. Peter Adam, *Eileen Gray* (London, 1987), p.230, states that the chair was first designed in 1924 and patented in 1930. Constant (2000), p.50, dates the chair to 1925–30 and publishes drawings dated *c*.1927.

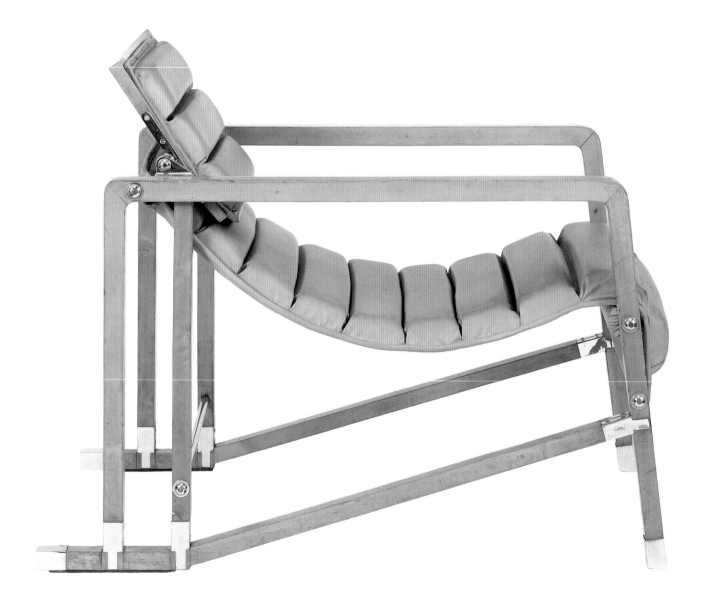

150

Catalogue: *Breuer Metallmöbel*
(*Breuer Metal Furniture*)
1927
Designed by Herbert Bayer (1900 Haag,
Austria–1985 Santa Barbara, USA)
Probably printed at the Bauhaus

Halftone and letterpress
c.16 × 20cm
V&A: E.1483–1981

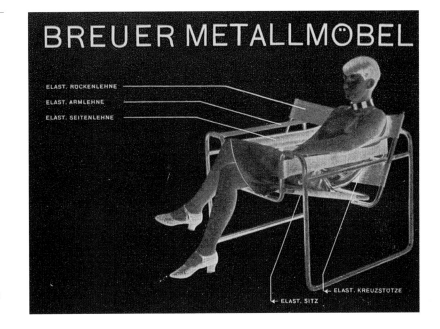

The was the first catalogue published for
Standard-Möbel, the firm founded in 1927 by
Marcel Breuer and his Hungarian compatriot
Kalman Lengyel (cat.162) to manufacture Breuer's
recent tubular-steel furniture designs.[1] The choice
of the company name relates closely to idea that
the furniture offered in the catalogue represented
a series of standard furniture types (see Chapter 6,
cats 93, 159), with application to a variety of uses.
The product line included a modest number of
items: theatre seating, the Club Chair (cat.58),
a folding club chair, two versions of an armless
chair (pl.6.5), a swivel desk chair and a stool
(pl.6.6).

 The catalogue was designed by Breuer's close
friend Bayer and printed at the Bauhaus. The two
arrived to study at the Bauhaus within a year of
one another (1920–21), were appointed teachers in
1925, travelled frequently together and tendered
their resignations at the same time (April 1927).[2]
The photograph of a female figure sitting in the

chair is a type used in numerous Bauhaus
photographs of the period (pl.6.2). Bayer's
transformation of the photograph into a negative
image gives the catalogue the feel of an X-ray
(cat.51), precisely the objective, rational, scientific
association that Modernist designers sought.
The text (in sans-serif type) points out the many
flexible and resilient, and hence soft and supportive,
textile elements of the club chair depicted.

 Standard-Möbel must have been a very small
company, which made furniture by hand in small
batches rather than manufacturing in any quantity.
It was not a commercial success. It may have

consisted only of Breuer, Lengyel (as business
manager and occasional designer) and one
craftsman.[3] Breuer sold his stake in Standard to
Lengyel after barely more than a year, and not
long thereafter Lengyel sold out to Thonet. CW

1 The precise date when Standard-Möbel began making furniture
 is unknown. They were in business by the time the Weissenhof
 exhibition opened (July 1927) as they are listed in the official
 exhibition catalogue, *Amtlicher Katalog der Werkbundausstellung
 Die Wohnung* (Stuttgart, [1927] 1998), pp.70, 88.
2 See Christopher Wilk, *Marcel Breuer: Furniture and Interiors*
 (exh. cat., Museum of Modern Art, New York, 1981), pp.84–5.
3 Sigfried Giedion, *Mechanization Takes Command* (New York, [1948]
 1969), p.491, mentions 'a single craftsman'.

151 Plate 6.5

Chair, model B5
1926–7
Marcel Breuer (1902 Pécs, Hungary–
1981 New York)
Manufactured by Standard-Möbel, Berlin

Chrome-plated tubular steel and canvas
86 × 54 × 44.5cm
V&A: W.61–1977, given by Mr R.F. Bull

This chair was a refinement of the first, somewhat
complex tubular-steel chair without arms that
Breuer designed in 1926, which was used to
furnish interiors at the Dessau Bauhaus school
and in its Masters' Houses.[1] The revised design –
which changed the form of the front legs and
screwed the back legs to the base – might be seen
as having been composed from one of Breuer's
Bauhaus stools (later nesting table, cat.152), laid
on its side to form the seat and base, to which was

added a U-shaped length of tube (turned upside
down) comprising rear legs and back. It was
simple in appearance and widely used in Breuer's
well-published interiors of the period (pl.5.7). The
chair was made in small batches and retailed by
Breuer and Lengyel's Standard-Möbel by mid-1927
and later by Thonet (see cat.150, n.1).

 Breuer's establishment of his own furniture
firm (small though it was) was the source of great
tension between the designer and Walter Gropius,
who expected all Bauhaus designers to put their
work forward for manufacture or licensing by the
school's own limited company, established in 1926
(Bauhaus GmbH, see cat.117). In her diary, Ise
Gropius wrote about 'a very unpleasant event with
Breuer . . . [who has] made a deal about his metal
chairs with a Berlin friend without telling anybody
and that will now lead to great difficulties in the
negotiations . . . for a Bauhaus GmbH.' She noted
the sense of betrayal felt as, 'during the final
negotiations [for the new company] one of the
most important pieces of the enterprise has been
removed'.[2] Although Breuer had been thinking of

leaving the Bauhaus since at least November
1926, the incident over the furniture led him to
resign formally two weeks later in April 1927,
though he was convinced to stay until the end of
the next school term.[3] CW

1 Both chairs are illustrated side-by-side in Magdalena Droste
 and Manfred Ludewig, *Marcel Breuer* (exh. cat., Bauhaus Archiv,
 Berlin, 1992), p.67. The first design was in the much-published
 dining room of the Moholy-Nagys' Master's House.
2 Diary entry for 24 March 1927, cited in Christopher Wilk, *Marcel
 Breuer: Furniture and Interiors* (exh. cat., Museum of Modern Art,
 New York, 1981), pp.53–4. See also Droste and Ludewig (1992), p.17.
3 Ise Gropius diary entries for 27 November 1926, 6 April 1927 and
 21 May 1927 (provided by Ise Gropius to author in 1987, now in
 Bauhaus Archiv, Berlin).

152 Plate 6.6

Nest of tables, model B9
1925/6–7
Marcel Breuer
(1902 Pécs, Hungary–1981 New York)
Made by Standard-Möbel, Berlin or
Gebrüder Thonet, Frankfurt

Nickel-plated tubular steel, painted blockboard
Overall size 60.2 × 66.4 × 40cm
Bauhaus Archiv, Berlin (BHA 3823/1–4)

This nest of tables began life in 1925 or 1926 as a stool that was used in the new Bauhaus buildings.[1] There, in its original nickel-plated version, it was used in large quantities as seating in the canteen and in the students' rooms, where it also served as a table.[2] It was an ingenious design of outstanding strength and versatility, capable of being carried around in one hand. Far simpler than Breuer's previous (and all subsequent) metal chair design, it encapsulated all of the qualities desired of the New Furniture: structural rationalism, lightweight and visual unobtrusiveness. The stool/table was remarkable for its introduction of the continuous steel base, or runner, which became the one near-universal feature of all subsequent tubular-steel furniture.[3] It gave users of such furniture (especially taller or heavier models) the ability to pull or slide them along the floor, contributing to their literal (but also conceptual) mobility. The process of making the elements of the stools and their finishing for the Bauhaus was undertaken by various firms.[4] The translation of the stool into a set of tables seems to have occurred in 1927, coinciding with the beginning of commercial sale by Standard-Möbel (Standard Furniture). The manufacture was taken over by Thonet from 1929. This set belonged to the sculptor Georg Kolbe (1877–1947).

The idea of a nest of tables was a traditional one in the history of furniture, popularized in early nineteenth-century England and in nearly continuous use in many countries through the century that followed. Josef Hoffmann designed early twentieth-century versions in Vienna. Both Le Corbusier and Ludwig Mies van der Rohe designed stools in imitation of Breuer's. CW

1 It is commonly said that the stool, along with auditorium seating and an armless chair, was designed 'for' the Bauhaus. Breuer maintained that he designed them 'independently' and that Gropius 'asked me after I had designed them to make stools for the Bauhaus buildings' (interview with Marcel Breuer, 30 November 1978).
2 For photographs of the stool in use at the Bauhaus, see Christian Wolsdorff, *Bauhaus Möbel/Bauhaus Furniture* (exh. cat., Bauhaus Archiv, Berlin, 2003), pp.230, 247, 251, and for this nest of tables p.248. On the design, see Christopher Wilk, *Marcel Breuer: Furniture and Interiors* (exh. cat., Museum of Modern Art, New York, 1981), pp.42–3.
3 See cat.58, n.3.
4 Robin Krause, 'Marcel Breuer's early tubular steel furniture', in Margret Kentgens-Craig (ed.), *The Dessau Bauhaus Building 1926–1999* (Basle, 1998), p.34, refers to a 1926 inventory of the building. It is unknown if they were assembled at the school or by one of these firms.

153 Plate 6.8

Chair, model MR 10/3
Designed 1927
Ludwig Mies van der Rohe (1886 Aachen–1969 Chicago)
Manufactured by the Berliner Metallgewerbe Joseph Müller, Berlin

Painted tubular steel, woven cane
79 × 40 × 47cm
Bauhaus Archiv, Berlin (BHA 12362/1)

The Weissenhof housing exhibition, *Die Wohnung* (The Dwelling, see pls 5.21–2, cats 97–9), not only marked the start of a period before the Depression during which Mies van der Rohe built several important buildings (including the Villa Tugendhat and Barcelona Pavilion), but also the beginning of a seven-year period during which he would design a number of the century's most influential chairs. Designed to furnish the block of flats Mies was building at Weissenhof, this chair was directly inspired by a sketch of a cantilevered chair drawn by Dutch architect Mart Stam at a dinner attended by Mies, Le Corbusier and Heinz Rasch.[1] Mies immediately took Stam's idea and created a design that, except for its cantilever, bore little resemblance to the source of its inspiration. When the two chairs were first shown at Weissenhof, Stam's (pl.6.7) was rigid and rectilinear, very much in the functionalist mode of his architecture; Mies's reflected his own, very different architectural sensibility: it was elegant, of artful simplicity and meticulously detailed in its fluid, curvilinear appearance and its comfort-giving springiness. Manufactured also in a version with arms, it quickly became the best-known cantilevered chair in Modernist circles.

Mies's chairs were among the most expensive metal designs on the market, though they compared favourably to upholstered, wooden furniture. From its first manufacture by the Müller Metalworkshop in 1927, the chair was offered (in ascending order of cost) in painted, nickelled and chrome finishes, and with (in the same order) canvas, woven cane and leather upholstery.[2] In 1930 an example of the present chair (at 55.50 Reichsmarks, the cheapest version) cost more than Marcel Breuer's B5 chair (38RM, cat.151), nearly double the cost of Ferdinand Kramer's chair (30RM, cat.93) and more than three times the cost of the Thonet B9 armchair used extensively by Le Corbusier (as illustrated in pl.3.21).[3] This particular example of Mies's chair was purchased by the Bauhaus student (and theatre designer) Roman Clemens (1910–1992) in 1929. CW

1 First recounted in Heinz Rasch, 'Aus den zwanziger Jahren', *Werk und Zeit*, vol.9, no.11 (November 1960), pp.1–3, and repeated in Ludwig Glaeser, *Ludwig Mies van der Rohe, Furniture and Furniture Drawings* (exh. cat., Museum of Modern Art, New York, 1977), p.9. The most recent and fullest account of the story of Mies's cantilever chairs and their relationship to Stam's is Otakar Máčel, 'From mass production to design classic: Mies van der Rohe's metal furniture', in Alexander von Vegesack and Matthias Kries, *Mies van der Rohe, Architecture and Design* (exh. cat., Vitra Design Museum, Weil-am-Rhein, 1998), pp.18–61.
2 Catalogues said to be of 1927 and 1931, with prices included, are reprinted in Alexander von Vegesack, *Deutsche Stahlrohrmöbel* (Munich, 1986), pp.64–7.
3 Prices for these and a wide range of contemporary furniture are listed in Dr Wilhelm Lotz, *Wie richte ich meine Wohnung ein?* (Berlin, 1930), pp.102–106. See also Mia Seeger, *Der neue Wohnbedarf* (Stutgart, 1935) for prices a few years later.

154

Bow Chair 1

1927

Gerrit Rietveld (1888 Utrecht–1964 Utrecht)

Manufactured by Metz & Co., Amsterdam,
c.1931

White-painted plywood on painted tubular steel
73 × 57 × 39.7cm
V&A: W.14–2005, purchased with funds provided by
the Horace W. Goldsmith Foundation

Compared to most tubular-steel chair designs
that appeared between 1925 and 1927, this is a
highly practical but unspectacular design, making
no dramatic claims on the tensile strength of
tubular steel and allowing for a comfortable

sitting position to be achieved simply with a sheet
of moulded plywood. This marks a significant
departure from Rietveld's De Stijl designs (pl.2.12),
in which straight rails of wood are joined together
in a way that emphasizes their interdependence
(rather as in a Mondrian painting, in which the
different-coloured rectangles appear to be both
separate and interdependent). In the first proto-
types, Rietveld used fibreboard for the seat and
back, which could be easily moulded to fit the
profile of the tubular-steel frame.[1] Although
simple to use, fibreboard cracked easily and
proved unreliable. Few of the fibreboard prototypes
survive. Later, when the technology of heat-
moulded plywood became available to him, he
used plywood. This version appears to be a serious
attempt to create a mass-produced chair that
could be sold at an affordable price. Only three
pieces are used in its construction: two tubular-

steel frames braced by the curved wooden seat
and back. It was made for and sold by the Metz &
Co. department store in a series of models (dining
chair, two sizes of easy chair, one with arms), but
never attracted a large market.[2] TB

1 Marijke Küper and Ida van Zijl, *Gerrit Th. Rietveld, 1888–1964: The
 complete works* (exh. cat., Centraal Museum, Utrecht, 1992), p.117.
2 Peter Vöge, *The Complete Rietveld Furniture* (Rotterdam, 1993),
 pp.74–5, no.94.

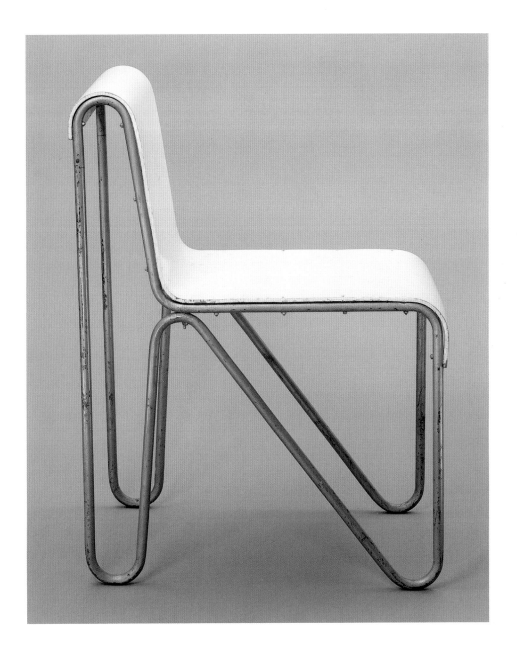

155 Plate 6.1

Chair, model B32
Designed 1928
Marcel Breuer (1902 Pécs, Hungary –
1981 New York)
Made by Gebrüder Thonet, Frankenberg,
Germany, after 1930

Chrome-plated tubular steel, bent solid beechwood, cane
82 × 47 × 57.5cm
V&A: W.10-1989

Marcel Breuer designed this chair the year after Mart Stam (pl.6.7) and Ludwig Mies van der Rohe (pl.6.8) introduced their cantilevered designs to the public in 1927, though it apparently was not manufactured until about 1930.[1] It was an innovative design in several respects. Breuer broke a convention that he himself had introduced: the use of a continuous tubular-steel frame behind the back. In this design he attached to the frame a seat and back made of wood and cane. This resulted in a more complex, more interesting design in which the textures of the natural materials contrasted markedly with the shiny steel frame. The use of cane would have been, for contemporaries, an unmistakable allusion to Thonet bentwood furniture, which had enjoyed renewed popularity among Modernist architects (see Chapter 6 and pl.3.25).

As a result of a complex series of lawsuits brought by Anton Lorenz, the man who had taken over the fledgling Standard-Möbel company in 1928 (cat.150), Breuer was denied the right to claim the B32 as his own design. This was because in 1929, following the sale of Standard-Möbel to the Thonet company, Lorenz obtained from Stam the rights to Stam's cantilevered chair.[2] Armed with this, Lorenz sued Thonet asserting that they were, by manufacturing any cantilever chair, infringing his patent rights. Dispirited both by Lorenz's actions (referring to him as 'a patent brigand') and by being dragged into court, Breuer gave up designing in tubular steel. When the court finally handed down its ruling in 1932, Lorenz – as owner of the licence to produce Stam's patented cantilever – legally obtained the sole right to manufacture all rectilinear chairs with only two legs, including the B32. Stam's name therefore replaced Breuer's in the Thonet catalogues. Nonetheless, the chair was still generally published in contemporary and post-war publications as Breuer's design and, later, between 1962 and 1963, production of the B32 resumed under Breuer's name. Since that time it has become one of the most ubiquitous of all Modernist chairs.[3] CW

1 It does not appear in any Thonet catalogue or advertisement before a small folder with loose pages published by Thonet c.1930. This is not entirely surprising, as Thonet first sold Breuer's furniture in 1929 by simply overstamping existing Standard-Möbel catalogues with their firm name. These catalogues featured only Breuer's earlier designs. On this history, see Christopher Wilk, Marcel Breuer: Furniture and Interiors (exh. cat., Museum of Modern Art, New York, 1981), pp.75, 81–3. The c.1930 Thonet catalogue has been reproduced by the Vitra Design Museum, Thonet Stahlrohr-Möbel: Steckkartenkatalog: erste vollständige Zusammenstellung der deutschen und französischen Ausgabe von 1930–1931 (Weil-am-Rhein, 1989).
2 This story was first told in Wilk (1981), pp.73–8. The discovery of new documents enabled fuller explication in Otakar Máčel, 'Avantgarde Design and the Law: Litigation over the Cantilever Chair', Journal of Design History, vol.3, no.2/3 (1990), pp.125–43, and in Werner Möller and Otakar Máčel, Ein Stuhl macht Geschichte (Munich, 1992).
3 Donatella Cacciola, 'Establishing Modernisn – the Furniture of Marcel Breuer in Production by Gavina and Knoll International', in Alexander von Vegesack and Mathias Remmele (eds), Marcel Breuer Design and Architecture (exh. cat., Vitra Design Museum, Weil-am-Rhein, 2003), pp.150–65.

156 Plate 1.12

Fauteuil pivotant (swivel armchair)
Designed 1928
Charlotte Perriand (1903 Paris –1999 Paris)
Manufactured by Gebrüder Thonet,
Frankenberg, early 1930s

Tubular steel and leather upholstery
c.74 × 57 × 57cm
V&A: W.35-1987

Perriand designed this tubular-steel chair before she met Le Corbusier and joined his studio, in November 1927.[1] Its first use was in the apartment that she designed for herself and her English husband Percy Scholefield, adapting a top-floor photography studio on the place Saint-Sulpice in Paris. Similar chairs had been designed by friends of hers (René Herbst, Djo-Bourgeois and Louis Sognot) in Paris, under the influence of designs by Marcel Breuer and Mart Stam illustrated in design magazines in 1926–7. Perriand's design is, in visual terms, the most successful of these variants of the circular chair with tubular-steel backrest, due to her meticulous attention to detail in the upholstery and joining of the tubular steel. However, the backrest presented an almost impossible challenge to upholsterers, as there was no way to fix the round form to the metal frame; the result was that it tended to rotate and lose its shape.

A version with an angular stand and green leather upholstery was sold to her friend the jeweller Gérard Sandoz. Most of the 26 chairs manufactured by Labadie were upholstered in red leather. Chairs like this appeared in the dining room she exhibited in 1928 at the Salon des Artistes Décorateurs, which, along with her 'Bar in the Attic' (1927, both of these based on rooms in her own apartment), achieved rave notices from the press: 'Overnight, I went from being practically unknown to having camera bulbs flashing in my eyes . . . I was the youngest, "the prettiest", "the best", and was bound to get knocked off my pedestal.'[2] This chair was also illustrated on the cover of Adolf Schneck's exhibition catalogue Der Stuhl (The Chair) in Stuttgart, 1928 (cat.158, n.3).

Four of these chairs, in blue leather, were exhibited at the Salon d'Automne, when the three chairs designed by Le Corbusier, Pierre Jeanneret and Charlotte Perriand were put on display. Manufactured by Thonet from 1930 as the B302, the chair appeared in a 'luxe' leather finish and a cheaper fabric finish labelled 'série', to indicate quantity production. In fact, more than a hundred were sold by Thonet in France and abroad from 1930 to 1932.[3] This example was purchased by W.F. Crittall, the first manufacturer of steel-framed windows in Britain, in around 1936.[4] TB

1 Arthur Rüegg, Charlotte Perriand Livre de bord (Basle, 2004), pp.23–5, 238–40, 276.
2 Charlotte Perriand, A Life of Creation: An Autobiography (New York, 2003), p.22.
3 Ruegg (2004), p.276.
4 V&A RF 87/1309. According to Mr Crittall's daughter-in-law (letter, 7 May 2005, Ariel Crittall to Gareth Williams, V&A), family tradition has it that Mr Crittall visited Le Corbusier's studio to collect the chair.

157 Plate 6.10

Fauteuil à dossier basculant
(swing-back armchair)

1929

Le Corbusier (Charles-Edouard Jeanneret)
(1887 La Chaux-de-Fonds, Switzerland –
1965 Cap-Martin, France), Pierre Jeanneret
(1896 Geneva–1967 Geneva) and Charlotte
Perriand (1903 Paris–1999 Paris)

Painted tubular steel, metal springs, silk cushion covers
64 × 64 × 67cm, seat height 39cm
V&A: W.31-4-1987

In his lecture 'The furniture adventure', delivered in Buenos Aires in October 1929, Le Corbusier retrospectively explained the thinking behind the three tubular-steel chairs that he designed in collaboration with Pierre Jeanneret and Charlotte Perriand (pl.6.9): people are comfortable sitting in a range of different ways to match their actions – talking, reading, eating, writing – and chairs should be flexible accordingly.[1] Of the three chairs, the chaise longue was designed for total, lounging comfort, like the Wild West cowboy with his feet on the table. The *grand confort* club chair was a variant of the luxurious English club

armchair, big enough to move about in and find comfortable positions while reading a book, talking or listening to music. This *fauteuil à dossier basculant* was a working chair, based on the traditional wooden 'colonial chair', with its leather strap arms.

Perriand had the three chairs made up by her workmen some time in the winter of 1928–9 and prototypes were made for two houses designed by Le Corbusier's architectural office: for Raoul for La Roche (cat.37), and for Henry and Barbara Church.[2] Different textiles were used in these chairs. The most common textile used for the *fauteuil à dossier basculant* was blue satin. Five of those delivered to Henry Church for the new villa designed by Le Corbusier were covered in blue satin and three in brown satin, while another was covered in parchment.[3] This chair appears to have been one of those nine chairs, though its grey paint is almost certainly not original.[4] These early prototypes were made by a number of manufacturers, including the firms of Duflon, Hour & Le Gac (Duflon was one of Le Corbusier's trusted metalworkers) and Labadie. When the chairs went into manufacture by Thonet in 1930, they were more usually finished in leather or calf-hide. TB

1 Le Corbusier, 'L'aventure du mobilier', in *Précisions sur un état present de l'architecture et de l'Urbanisme* (Paris, 1930), pp.105–22.
2 Charlotte Perriand, *A Life of Creation: An Autobiography* (New York, 2003), pp.29–31, and Arthur Rüegg, *Charlotte Perriand Livre de*

bord (Basle, 2004), pp.30–33. See also Mary Mcleod (ed.) *Charlotte Perriand: An Art of Living* (New York, 2003), pp.44–8.
3 Rüegg (2004), p.275.
4 It was sold to the V&A by Mr T. Nash, whose father lived in an house adjoining the Villa Church and who purchased the chair 'at the auction of the contents of the Villa Church' (V&A RP 87/599).

158 Plate 6.3

Book: *Der Stuhl* (*The Chair*) by Heinz and Bodo Rasch

1928

Published by Akademischer Verlag
Dr Fritz Wedekind & Co., Stuttgart

24.7 × 17.9cm
V&A, National Art Library (803.AF.0003)

Der Stuhl was one example of the spate of books and exhibitions on the subject of furniture, especially 'the chair', published during the late 1920s and early '30s.[1] It was written by two architect brothers who were also furniture designers. The cover of the book significantly represented the idea of 'sitting on air', Marcel Breuer's earlier female figure (pl.6.2) was here replaced by a man who writes or draws at an invisible table which, along with his seat, also floats in space. While Breuer's earlier image had the floating sitter as the culmination of a process of development, the Raschs' image, with the book title superimposed, seemed to be asking a question of what the chair should be, implicitly presenting the design problems that required solution; and indeed, inside, the Rasch brothers presented more than

22 of their own furniture designs that offered answers.[2]

The tone of *Der Stuhl* was didactic, emphasizing the central importance of industrial manufacture, the qualities of materials (solid wood, plywood and tubular steel), the utility of folding chairs and the constructional efficacy of diagonal supports. None of the Rasch chairs was designed with four traditional legs. The book is filled with visual and textual analogies between the position of the human body (at rest and in motion) and the form of the chair designs.

Der Stuhl appeared the year after the Rasch brothers showed furniture in *Die Wohnung* (The Dwelling) exhibition in Stuttgart (in the exhibition section and in both the Peter Behrens and Ludwig Mies van der Rohe blocks of flats), and in the same year that they exhibited 12 chairs in the major exhibition *Der Stuhl*, also in Stuttgart.[3] CW

1 It was issued by a distinguished local publisher who had published books by the Rasch brothers, as well as by Erna Meyer, Adolf Behne and Werner Gräff, including the series of titles that accompanied the Weissenhof exhibition the previous year.
2 See Egidio Marzona (ed.), *Brüder Rasch, Material Konstruktion Form 1926–1930* (Düsseldorf, 1981), which includes brief selections of their writings, also in English translation; and Otakar Máčel and Marijke Küper, 'The Chairs of Heinz Rasch', *Journal of Design History*, vol.6, no.1 (1993), pp.25–44. *Der Stuhl* was issued in a facsimile edition published by the Vitra Design Museum, Weil-am-Rhein in 1992.

3 *Der Stuhl* exhibition was organized by the designer, teacher and author Adolf Schneck and by Hugo Keuerleber, also a Stuttgart design professor. It included some 394 mainly German (but also American, English and French) chairs. See *Der Stuhl* (exh. cat., Städitischen Ausstellungsgebäude, Stuttgart, 1928). On Schneck's many furniture publications, see *Adolf G. Schneck 1883–1971* (exh. cat., Staatlichen Akademie der bildenden Künste, Stuttgart, 1983).

159 Plate 6.11

Poster: *Typenmöbel* (*Standardized Type Furniture*)
1929
Ernst Mumenthaler (1901 Basle–1978 Basle)
Printed by W. Wassermann

Colour lithograph
127 × 90cm
V&A: E.267–2005

This poster was designed by the architect Mumenthaler who, together with his partner Otto Meier, won a Swiss competition in 1927 for 'Contemporary Simple Furniture' with their *Typenmöbel* system.[1] For the exhibition at the Gewerbe- museum (Museum for Trade and Industry) in Basle they exhibited examples of this furniture and created not only this poster, but, among other designs, a living room for 460 Swiss francs, with modular bookshelves and chairs, as well as a folding day bed.[2] The exhibition displayed a succession of uniform rooms featuring basic furniture that was independent from spatial arrangement and could therefore be positioned in different parts of the home, fulfilling a variety of functions.

The concept of the *Typenmöbel* (see Chapter 6) was particularly illustrative of Modernist tendencies since it aspired to functional neutrality, social purpose and formal simplicity, without overplaying the style of the furniture. It had to suit contemporary programmes of housing reform and required a basic type-form that could be modified and added to in order to arrive at an integral series of designs for the home. In the 1920s *Typenmöbel* were developed widely at the Bauhaus (ostensibly for subsequent industrial production) and were championed by architects such as Ernst May and Le Corbusier, among others.

The Basle exhibition of 1929, and Mumenthaler's poster, adhered to these design principles. The diagonal placement of the wardrobe, extending beyond the edges of the poster, creates a dynamism within what appears to be a simple graphic design. The motif represents the Mumenthaler and Meier wardrobe shown at the exhibition, distilling it into a form that, on first viewing, is not immediately obvious – even abstract. UL

1 Ursula Suter, 'Mumenthaler und Meiers "3-m Möbel"', in Arthur Rüegg and Ruggero Tropeano (eds), *Wege zur 'Guten Form'* (Basle, 1995).
2 *Typenmöbel* (exh. cat., Gewerbemuseum, Basle, 1929), and Ulrike Jehle-Schulte Strathaus and Ueli Kräuchi (eds), *Ernst Mumenthaler und Otto Meier* (Basle, 1995).

160

Reclining chair
1930
Jean Prouvé (1901 Paris–1984 Nancy)
Made in the workshop of Jean Prouvé, Nancy, France

Painted sheet steel, canvas upholstery
96 × 44 × 52cm
Musée National d'Art Moderne, Paris, given by the Prouvé family (AM 1993-1-757)

Prouvé's chair is another variation on the cantilever principle. An L-shaped seat and back unit is cantilevered from two pivoting points in a design that (like many of Prouvé's) eschews tradi- tional, vertical legs in favour of a base, conceived as a structural support – a form seemingly related more to engineering or automotive design than to furniture. The chair reclines, but only slightly, moving on the round pivots fixed to each side of frame and seat. It is made from sheets of steel cut and pressed into different shapes (and supported by tubes spanning the seat), welded or fixed together. It dates from a time when he had just begun developing folded metal elements for use in building construction. This chair is part of a

series of seating experiments that clearly relate to that work, and which Prouvé used in his own home.[1]

Prouvé's furniture was different from architect-designed tubular steel of the period. His was much more complex in its construction, but also partook of an entirely different aesthetic, one arising from an interest in constructional technology, in the material and techniques of making, rather than from a desire to create a lightweight, visually transparent and springy form. Prouvé's interest in constructing architectural elements from steel was based on an intimate knowledge of metal working, learned during his apprenticeship as a craftsman in wrought iron. His training as a maker, rather than a designer, is rare among Modernists, and largely explains his original approach.

Later in life Prouvé assigned the date of 1924 to this chair – an improbable date not only because he was just starting his career, but also when considered in the context of contemporary furniture.[2] During a period when furniture was so often published and exhibited, such a revolutionary chair (if dating from 1924) would have become known. The chair can only be documented for the first time in 1930, when it was exhibited on Prouvé's stand at the first exhibition of the Union des Artistes Modernes (Union of Modern Artists), Paris.[3] CW

1 Peter Sulzer, *Jean Prouvé, Œuvre complète/Complete works*, vol.I (Berlin, 1995), p.19, the most reliable source on Prouvé.
2 This date has nonetheless been routinely followed; see Catherine Coley, *Jean Prouvé* (exh. cat., Centre Georges Pompidou, Paris, 1993), p.17, or, most recently, *La collection de design du Centre Georges Pompidou* (Paris, 2001), p.24.
3 The redating was proposed in Sulzer, vol.I (1995), p.223. He points out that Prouvé did not own the electric arc-welding equipment required to make this chair until 1926, and that a range of other machinery for grinding and shearing metal was not bought until 1929 (see pp.19, 21).

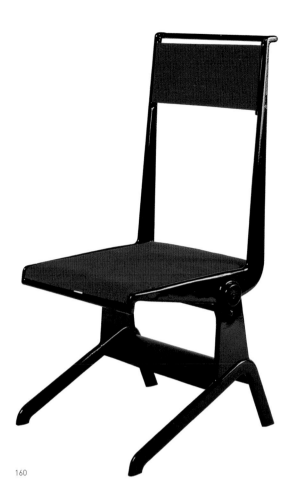

160

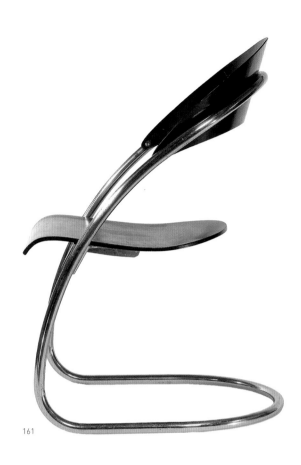

161

161

Chair, model ST 14
Designed 1929–30
Hans Luckhardt (1890 Berlin –1954 Bad
Wiessee, Germany)
Manufactured by DESTA, Berlin, 1930
Part of the original furnishings of the
Music Room of the Palace of the
Maharajah of Indore, 1930

Chrome-plated tubular steel, painted plywood
87.5 × 53.5 × 61cm, seat height 44cm
V&A: W.49–1984

So accomplished were the first Modernist
cantilevered chairs of Stam (pl.6.7), Mies van der
Rohe (pl.6.8) and Breuer (pl.6.1) that it became
difficult for others to design cantilevered chairs
that seemed anything other than either pale
imitations or outlandish attempts at novelty. Yet
Hans Luckhardt's design, which approached the
borders of novelty, went beyond even Mies van der
Rohe's in its eschewing of anything approaching
rectilinearity. Like other cantilevered chairs, it

relied on the tensile strength of extruded steel
tube to achieve its minimal structure. However,
it made use not only of a cantilevered frame (like
previous designs), but also of a cantilevered seat
of extraordinarily thin plywood, which seemed
to float in the middle of the frame despite being
attached at two points by steel flanges. The chair
proclaimed itself as a triumph of industrial
materials and contemporary design over the
laws of nature.

DESTA (Deutsche Stahlrohrmöbel) manufac-
tured one chair from 1930.[1] The firm was founded
by Anton Lorenz, the entrepreneur who in 1929
had turned the world of cantilevered furniture
into a litigious battleground.[2] Although credited
in contemporary magazines, manufacturers'
catalogues and later accounts to the brothers
Hans and Wassili (1889–1972) Luckhardt, and also
sometimes to their architectural partner Alfons
Anker, the furniture designs were apparently
exclusively the work of the younger Luckhardt,
Hans.[3] DESTA was formally liquidated in 1933,
though it may have stopped trading in 1932.

The Luckhardt brothers were at the cutting
edge of German architectural practice after the
First World War. As members of the *November-
gruppe*, the *Arbeitsrat für Kunst*, *Der Ring* and *Die

Gläserne Kette* (see Chapter 2), they worked in
an Expressionist mode until around 1924 when,
after they set up in practice with Anker (1872–1958),
they generally embraced the rectilinear geometry
of Le Corbusier and Walter Gropius. CW

1 The chair did not appear in a DESTA catalogue dated 18 November
1929, but for the first time in a price list dated 8 April 1930. This
specific example was sold in Sotheby Parke Bernet, Monaco,
Mobilier Moderniste Provenant du Palais du Maharaja d'Indore
(25 May 1980), lots 222–222b. It was bought by the Museum of
Modern Art, New York, which kept one chair from the lot of four,
selling other examples to Lord & Taylor's Department Store in
New York shortly after the auction. On the commission, see Reto
Niggi, *Eckhart Muthesius: International Style, 1930. The Maharaja's
Palace in Indore* (Stuttgart, 1996).
2 See Otakar Máčel, 'Avantgarde Design and the Law: Litigation
over the Cantilever Chair', *Journal of Design History*, vol.3, no.2/3
(1990), pp.125–43. Lorenz went on to work with Hans Luckhardt
for more than two decades; see Fridtjof F. Schliephacke,
'Erinnerungen an Hans Luckhardt – Erfinder, Konstrukteur,
Architekt', in *Brüder Luckhardt und Alfons Anker* (exh. cat.,
Akademie der Künste, Berlin, 1990), pp.98–112. Papers related
to DESTA survive in the Lorenz Archive, now in the Vitra Design
Museum.
3 Fridtjof F. Schliephacke, 'Hans Luckhardt – Verzeichnis der
Modelle und Entwürfe: Stahlrohrmöbel und Bewegungsstühle',
in *Brüder Luckhardt* (1996), p.305.

162

Armchair, model ST3
Designed 1930
Kalman Lengyel (Hungary, dates unknown)
Manufactured by Gebrüder Thonet,
Frankenberg, 1935

Tubular-steel frame, plywood seat and back
78 × 60 × 53cm
Private Collection

In the mid-to-late 1930s tubular-steel furniture found a larger marketplace than had previously been the case, owing to its use in commercial interiors such as hotels, restaurants and shops. The catalogues of Thonet and its competitors throughout Europe and, slightly later, the US, offered a wide and ever-increasing array of models. It is, in some ways, hard to believe that by the mid-1930s there were still designs for cantilevered chairs that had not yet been attempted. Yet Lengyel's represented something new. Though the cantilevered seat and emphatically diagonal front leg and arm had been used before (cat.161), Lengyel's combination of these elements with a rectangular back, and a horizontal steel arm that attached directly to it, was original. The thickness of the plywood back called attention to the way it floated in the air, supported only by the arms, much as the thick, rectangular, but undulating seat also hovered in space. More than other chairs, it gave the impression that some structural element had simply been removed, a design sleight-of-hand.

Relatively little is known about Lengyel beyond the fact that he was Breuer's business partner at Standard-Möbel (cat.150), that he designed three pieces of furniture for the company around 1928 (after which it was renamed Standard-Möbel Lengyel & Co.); that he carried on at the firm once it was taken over by Anton Lorenz; and that he set up his own company, KA-LE, in Berlin.[1] In Lorenz's papers he is referred to as a Hungarian architect.[2] The dating of this chair relies on a surviving KA-LE catalogue of 1930.[3] As happened with Standard-Möbel, Thonet clearly took over Lengyel's designs, as they appear in a Thonet catalogue of 1935. CW

1 The three designs appear in the second Standard-Möbel catalogue (1928) reproduced in Alexander von Vegesack, *Deutsche Stahlrohrmöbel* (Munich, 1986), p.33, the models designated by the letter L.
2 For example, in 'Bericht die Entstehung des aus federnden Stahlrohren durch Kaltbiegeverfahren hergestellten Stuhles in kubischer Form' (27 March 1939) and 'Résumé of life of Mr Anton Lorenz' (undated), in Anton Lorenz papers (DESTA file, Lorenz Archive), now in the possession of the Vitra Design Museum.
3 *Verkaufskatalog KA-LE Möbel* (Berlin, 1930), fig.3. Lengyel registered the design on 7 February 1931 (German Design Registration DRGM 1163303). It is indicative of Lengyel's relationship with Lorenz that, after Standard-Möbel closed, both men, around 1930, established new furniture companies, the names of which were abbreviations of their full names, written in capital letters (see cat.161).

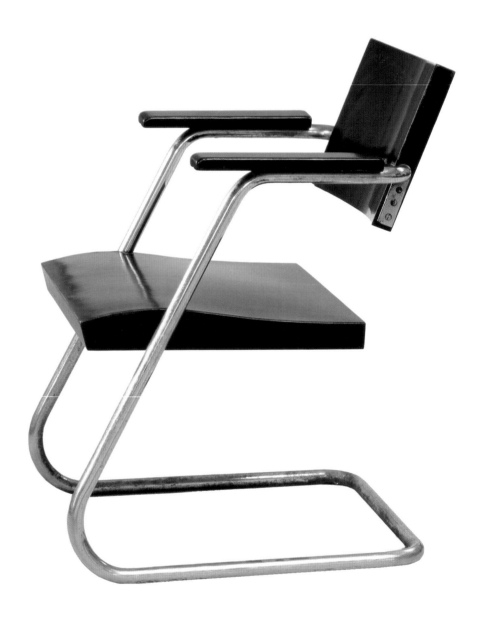

163

Stackable chair, model 7
1931
Flora Steiger-Crawford
(1899 Bombay –1991 Zurich)
Manufactured by Embru-Werke, Rüti,
Switzerland for Wohnbedarf, Zurich

Cast steel and wood
71 × 54 × 47.5cm, seat height 41.5cm
Private Collection

This stacking chair was originally designed for the Zett Restaurant in the ultra-contemporary Zett-Haus (1930–32). A combined apartment, office and retail building in Zurich's centre, it was designed by Carl Hubacher and Rudolf Steiger (Flora Steiger-Crawford's husband).[1] The Zett-Haus was one of the key buildings of Swiss Modernism, the subject of what has retrospectively been described as 'the Swiss Avant-garde's

first advertising campaign' (designed by Max Bill), and the home to leading architects and designers.[2]

Steiger-Crawford's chair is made not from tubular, but from cast steel. It must have been a conscious decision to eschew tubular steel in favour of the smaller-profiled and relatively flat cast steel, in the hope of designing a cantilevered chair with minimal structure. This made the frame stronger (though heavier) and allowed for the stacking of more chairs than was otherwise possible. A stack of 10 was shown in the Wohnbedarf catalogue published by the eponymous Modernist retailer (see cat.166).[3] This example of the chair was purchased by Jack Pritchard, the founder of Britain's Isokon Company, who had business dealings with Wohnbedarf during the 1930s (cats 217, 249). A notable link between the two firms was Marcel Breuer, a friend of Wohnbedarf founder Sigfried Giedion and the designer of Wohnbedarf interiors and several pieces of furniture sold by the firm, as well as Isokon's chief designer.[4]

Steiger-Crawford was one of the most prominent women architects practising in Switzerland in the 1920s and '30s. She worked in partnership with her husband Rudolf Steiger (a founding member of CIAM) from the time they married in 1925. They designed buildings, furniture and lighting both jointly and independently of one another.[5] She abandoned architecture for sculpture in 1938. CW

1 Peter Meyer, 'Neuzeitliche Geschäftshäuser', *Das Werk*, vol.21, no.1 (1934), pp.1–11, the restaurant and chairs illustrated on p.8.
2 On Bill's designs, see Christoph Bignens, 'Forbidden Fruit in Advertising' in *Max Bill – Typografie, Reklame, Buchgestaltung/ Typography, Advertising, Book Design* (Zurich, 1999), p.110–45.
3 For an illustration of the catalogue page, see Friederike Mehlau-Wiebking, Arthur Rüegg, Ruggero Tropeano, *Schweizer Typenmöbel 1925–1935* (Zürich, 1989), p.132.
4 On Breuer and Wohnbedarf, see Christopher Wilk, *Marcel Breuer: Furniture and Interiors* (exh. cat., Museum of Modern Art, New York, 1981), pp.112–35. Unrealized projects are the subject of correspondence in Breuer's papers at the George Arents Research Library, Syracuse University, New York. Correspondence between Pritchard and Wohnbedarf is in the Pritchard Archive, University of East Anglia.
5 Arthur Rüegg (ed.), *Swiss Furniture and Interiors in the 20th Century* (Basle, 2002) pp.122–3, 436–7.

164

Stacking cantilevered side chair

1932–3
Alvar Aalto (1898 Kuortane, Finland–1976
Helsinki)
Manufactured by Huonekalu- ja
Rakennustyötehdas Oy, Turku

Moulded, laminated birch and plywood
82.5 × 42.5 × 57cm
V&A: W.38–1981

Between 1928 and 1932 Aalto was in the thrall
of tubular-steel furniture. In 1928 he ordered
many pieces of Breuer's furniture for his own
house and the following year he designed his first
cantilevered chair, made from tubular-steel legs
and a plywood seat.[1] He designed other armchairs
and armless chairs in the following few years, all
of which were inspired by Breuer's and other
European models.

In 1931, though he was still working in tubular
steel, Aalto began a move away from metal.
Perhaps inspired by his thinking about the needs
of patients at the Paimio sanatorium (cat.182), he
began designing all-wood chairs. In an oft-cited
lecture in 1935 Aalto specified the ways in which
tubular-steel furniture was not 'rational', in so far
as it did not 'form a totality without conflict':

> ... a piece of furniture that forms part of a
> person's daily habitat should not cause exces-
> sive glare from light reflection; ditto, it should
> not be disadvantageous in terms of sound,
> sound absorption, etc. A piece that comes into
> the most intimate contact with man, as a chair
> does, shouldn't be constructed of materials
> that are excessively good conductors of heat ...
> These criticisms ... when put together form
> the mystical concept of 'cozy'.[2]

This chair might be termed a transitional design
that marked the end of Aalto's attempts to create
cantilevered chairs with tubular-steel bases, and
his move to designing two-legged chairs entirely
in wood. In its form, it was still a translation rather
than the radical rethinking that his contemporary
furniture for Paimio was (cat.219).[3] A child's
version of this chair had been designed in 1931–2,
but an adult-sized chair required relatively thick
legs to support the sitter. As Aalto clearly wished
the chair to be springy, the leg design needed
considerable development. The legs were made
from moulded, laminated Finnish birch and the
seat from much thinner birch plywood. The nature
of the material was emphasized by the choice, in
this example, of the figured (or curly) birch for the
seat and back. CW

1 For illustrations of these pieces, see Göran Schildt, 'The Decisive
 Years', in Juhani Pallasmaa, *Alvar Aalto Furniture* (exh. cat.,
 Museum of Finnish Architecture, Helsinki, 1984), p.69; on the
 subsequent tubular-steel chairs see pp.70–5, 125–6; and *Alvar
 Aalto Designer* (Helsinki, 2002), pp.66–73, 163–4.
2 Alvar Aalto, 'Rationalism and Man' lecture, 9 May 1935, trans.
 in Pallasmaa (1984), p.116.
3 On the relationship between tubular steel and Aalto's wood
 furniture, including the Paimio furniture, see Christopher Wilk,
 'Furnishing the Future', in Derek E. Ostergard (ed.), *Bent Wood
 and Metal Furniture: 1850–1946* (exh. cat., American Federation
 of the Arts, New York, 1987), pp.153–4.

165

Zig-Zag Chair
1932
Gerrit Rietveld
(1888 Utrecht –1964 Utrecht)
Made for Metz & Co., Amsterdam

Elm with brass nuts and bolts
74 × 37 × 44cm, seat height 43.5cm
Stedelijk Museum, Amsterdam (KNA 3414 (1))

Rietveld was always interested in the idea of diagonal forms or elements in his furniture design (pl.2.12 and cat.154) and, during the 1930s, he concentrated on building a single-piece cantilevered chair with a diagonal brace. He experimented with a variety of materials and base designs, including tubular steel (produced by Metz & Co., 1932); he sketched a chair with a fluid and continuous Z-shape made of a single piece of material, before achieving the final form of the chair in welded (flat) iron covered with fibreboard.[1] In an exhibition review, Mart Stam noted that Rietveld found 'metal . . . [and] vulcanized fibreboard' inadequate, and that he needed 'to find new materials with another and more simple form of assembly'.[2] Eventually Rietveld settled on hardwood as the best solution for dealing with the considerable structural demands of the design. He made the chairs from one-inch 'cupboard planks', which were glued, bolted together and reinforced with an applied wooden batten.[3] Rietveld's concept of the cantilevered 'zig-zag' shape was a novel one, but almost certainly owed something in its conception to Heinz and Bodo Rasch's unusual plywood cantilevered chair, shown at the 1927 Weissenhof exhibition and widely published at the time.[4]

Although Rietveld started with the idea of a single-piece chair, and later made a prototype version of continuous plywood, the final chair was constructed from no fewer than four planks. To create a cantilevered chair from separate pieces was certainly audacious; in terms of a design that would stand up to use from a structural point of view, it even seemed a bit mad.[5] But as the culmination of a process in which Rietveld had carefully explored the constructional possibilities of his design, the choice of material was ultimately appropriate and successful (the chair was manufactured for two decades). Unusually for chairs during this period, which were rarely named, this chair apparently always carried the name 'zig-zag'.[6] CW

1 Marijke Küper and Ida van Zijl, *Gerrit Th. Rietveld 1888–1964* (exh. cat., Centraal Museum, Utrecht, 1992), p.145, for his early sketches and description of a prototype 'made of fibreboard . . . fastened with screws to an iron band', and pp.145–7 on the series of zig-zag designs; Luca Dosi Delfini, *The Furniture Collection, Stedelijk Museum Amsterdam* (Amsterdam, 2004), no.484–5, for two welded iron versions; and Peter Vöge, *The Complete Rietveld Furniture* (Rotterdam, 1993), pp.18, 20 (in Paul Overy's introduction) and pp.38, 82–7 on the series.
2 Mart Stam, 'De Stoel gedurende de laste 40jaar', *De 8 en Opbouw*, vol.6, no.1 (1935), p.5.
3 Küper and van Zijl (1992) cite a drawing (without date) marked 'one inch deal cupboard planks'. The use of such a softwood seems inadequate for the design and the surviving examples are mainly elm or oak.
4 Werner Gräff, *Innenräume* (Stuttgart, 1928), p.17, and Heinz and Bodo Rasch, *Der Stuhl* (Stuttgart, 1928), p.42. The Rasch brothers also designed a related folding chair of similar form to Rietveld's, but with long diagonal supports on each side; see Rasch (1928), pp.36–7.
5 Paul Overy in Vöge (1993), p.18, called it 'one of his most astonishing designs', one that could only have been designed by 'a man who had worked with wood since childhood'.
6 Rietveld said that he 'always called it the zigzag'; from a filmed interview cited in Küper and van Zijl (1992), p.145.

166

Poster: *Wohnbedarf*
1933
Max Bill (1908 Winterthur, Switzerland–
1994 Berlin)

Letterpress
128 × 90.5cm
Merrill C. Berman Collection

Wohnbedarf was not only a retailer of home furnishings, but a proselytizing force for Modernist design in Switzerland.[1] Founded by art historian and critic Sigfried Giedion, architect Werner Moser and businessman Rudolf Graber, it aimed to make available to the public the best of Swiss and international Modernist design. It commissioned products for the home that were manufactured by Swiss firms, retailed some products from other countries and sold its goods internationally (see cat.163). Bill, an ardent Modernist who studied at the Bauhaus (1927–8) and then returned to Zurich, was a natural choice to design graphics for Wohnbedarf. Although trained as a silversmith, he worked as an artist, architect, exhibition designer and graphic designer at this time. For Wohnbedarf he designed the company's logo, its stationery and advertising material. Like Herbert Bayer, whose work he admired and who designed catalogues for Wohnbedarf, Bill avoided the use of upper-case letters in his work, and the type he designed for Wohnbedarf was a variation on Bayer's 'universal type'.[2] Rather than use sans-serif type, as favoured by Bayer, for the rest of the poster Bill employed 'typewriter type', an idea advocated by Jan Tschichold.[3] The biomorphism of the white areas indicates the influence, widespread at the time in Switzerland and abroad, of the artist Hans (Jean) Arp (cat.215).

Wohnbedarf was committed to the idea of *Typenmöbel* (see pl.6.11 and cat.163), and the poster shows the range of different *Typenmöbel* sold at Wohnbedarf: Bill is seen at top left, folding the work and garden table designed by Moser (1932); at top right is the 'Inkombi' wardrobe designed by Max Ernst Haefeli (1933); at lower right Bill's wife Binia sits in Moser's *Volkssessel* (people's chair); and at lower left is one of Wohnbedarf's numerous adjustable lamps. CW

1 See Friederike Mehlau-Wiebking, Arthur Rüegg, Ruggero Tropeano, *Schweizer Typenmöbel 1925–1935* (Zurich, 1989) and, on Bill's work, pp.100–101.
2 See especially the version published in Ute Brüning, *Das A und O des Bauhauses* (exh. cat., Bauhaus Archiv, Berlin, 1995), fig.232, p.186, as 'variation'.
3 Jan Tschichold, *Eine Stunde Druckgestaltung* (Stuttgart, 1930), p.7. See *Max Bill – Typografie, Reklame, Buchgestaltung/Typography, Advertising, Book Design* (Zurich, 1999), p.30.

167

Poster: *Der Stuhl* (*The Chair*)
1935
Artur Bofinger [dates unknown]

Lithograph, printed on two sheets
128 × 89.5cm
V&A: E.1298–2004, Schreyer Collection

Many exhibitions of the inter-war period, including the one advertised in this poster, reflected Modernist interest in standardized type forms, particularly *Typenmöbel* (standardized type furniture, see pl.6.11). This notion of standardization was represented in the somewhat abstracted and regularized quality of the chair image that fills the poster. Though the Kunstgewerbemuseum (Applied Arts Museum) had organized a chair exhibition in 1921, and many others on the subject of objects for the home, this 1935 show must have been influenced by German exhibitions of the 1920s, especially one of the same title organized in Stuttgart in 1928.[1] The German *Der Stuhl* exhibition was the subject not only of a catalogue, but also of a widely circulated publication by its co-organizer, the designer and teacher Adolf Schneck.[2] Unlike the 1928 display, the Zurich exhibition included not only contemporary furniture, but also historical objects, as indicated by its subtitle, *'Die Geschichte seiner Herstellung und seines Gebrauchs'* ('The history of its manufacture and function').[3] One-third was devoted to contemporary furniture, including a display on *Die Modernen Stuhltypen* (The Modern Chair Types): dining, work or rest (easy) chairs. Tools and machines were exhibited in an effort to explain the process of furniture making, but also served to emphasize – in an argument that Modernists would have appreciated – that the shape (*Formgebung*) of a chair was dependent upon the development of the tools (or machines) that make it, and that these interdependent factors allowed for the true sense of form (*Formsinn*) of the time to be realized. Moreover, technical innovations were catalysts to the development of new forms.[4]

The notion of standardization applied not only to the subject of this poster, but also to its size. Like all Swiss posters after 1913, it follows the regularization of poster sizes (and kiosks and hoardings) established by the Allgemeine Plakatgesellschaft (General Poster Company), distributors of posters in Switzerland. This system remains in use today, though with a number of standard sizes for both national and international use. CW

1 The previous exhibition, 'fourteen years earlier', is mentioned in a review of the 1935 exhibition; see 'Kunstgewerbemuseum Zurich: Der Stuhl', *Das Werk*, no.3 (March 1935), p.27–8.
2 See cat.158, n.3. The subject of the numerous inter-war exhibitions on type forms and on goods for the home is not well covered in the literature.
3 *Ausstellung Der Stuhl* (exh. cat., Kunstgewerbemuseum der Stadt Zürich, 1935). The Zurich exhibition was an expanded version of a show first seen in November 1934 at the Gewerbemuseum, Basle; see *Ausstellung Der Stuhl* (exh. cat., Gewerbemuseum, Basle, 1934).
4 See the review cited in n.1, p.27.

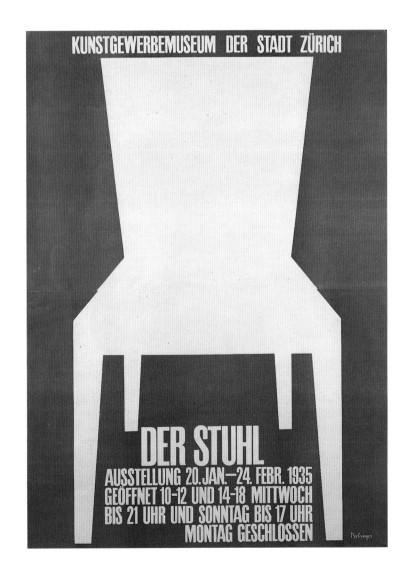

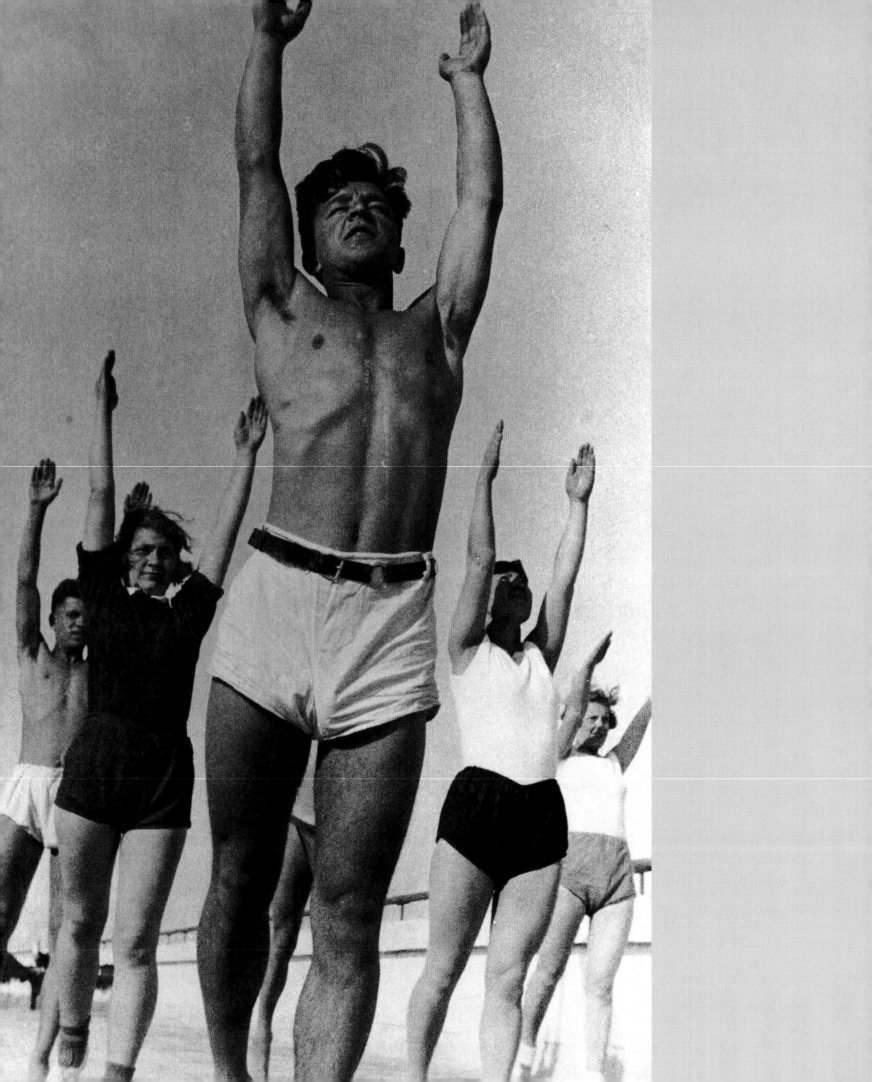

Christopher Wilk

The Healthy Body Culture

The effect of that time of destruction seems to have been a burning desire for sunlight and clean air and clear thought. [1]

Raymond McGrath
Twentieth Century Houses
(1934)

7.1 **Alexander Rodchenko**,
Sun-Lovers, 1932 (cat.174)

7.2 *Der Mensch als Industriepalast* (*Man as Industrial Palace*), didactic poster accompanying Fritz Kahn's *Das Leben des Menschen* (Stuttgart, 1926–31) (cat.168)

The entire Modernist enterprise was permeated by a deep concern for health. Modernism's social agenda – one of its defining elements – was a direct response to the interrelated problems of poor health and poor housing affecting large segments of the population in the early twentieth century (see Chapter 5). On this level alone, but also on others, health lay at the very core of Modernism. Health was discussed and written about in literal terms (for example, designing spaces and furnishings filled with light and fresh air that would not accumulate dirt and dust), but also as a metaphor (of a bright, utopian future), as an ideology (of social engineering) and as an idea that could (sometimes covertly) support aesthetic positions (such as a preference for the unornamented surface). A concern for health profoundly shaped the appearance of mass housing, but also that of expensive private houses (pl.7.4), and it was central to the attention given in the period to certain building types: sanatoria, hospitals and health centres, schools, sports facilities and swimming pools. The new domestic interior directly reflected the concern that people should live in well-lit, easy-to-clean spaces supplied with the most up-to-date furnishings, equipment, technology and amenities that would increase personal and communal health. The connection between health and the body was seen explicitly in the mass media of the period, as well as in the visual arts: images of sports men and women, dancers and gymnasts, swimmers and sunbathers (pl.7.1) were everywhere, shown in mass-circulation magazines and in newsreels, in design publications, in art galleries and in public exhibition spaces. When, in a text on typography and the photo, the Bauhaus teacher László Moholy-Nagy wrote that 'The hygiene of the optical, the health of the visible is slowly filtering through', the extent to which the language of health had become integrated into contemporary culture was made clear.

This is not to say that all who were concerned with health during this period were Modernists. Indeed, there were rabid anti-Modernists passionately devoted to the healthy body culture, including leaders of related movements in numerous countries.[2] However, most Modernists embraced a concern with the healthy body as an integral part of their endeavour and, often, their lifestyles; they created structures and spaces, devices and furnishings, art and design that served, reflected and symbolized the new lifestyles and the wider cultural attitudes they represented. The link between Modernist design and art and the new body culture was described by one contemporary as symptomatic of 'a new way of life characteristic of the post-war population.

Bolshevism, fascism, sports, body culture, and the New Objectivity are all interrelated.'[3] Although the roots of the healthy body culture can be traced to the Enlightenment, with a genuine flowering in the nineteenth century, it developed in new directions and addressed a much wider audience in the 1920s–30s. Modernism is implicated in the development and dissemination of the healthy body culture, in just the same way as the healthy body culture informed the development of Modernism.[4]

Despite its all-pervasiveness, the healthy body culture is one of the least analysed aspects of Modernism. Design and art historians tend to ignore the subject, as if it somehow lacks the dignity of weightier questions of (in the past) form and style or (more recently) production and consumption.[5] It is also possible that Modernism's complex relationship with the body has, until recently, ruled it a problematic topic of study.[6] The body, during the early twentieth century, bore the weight of history, in particular of antiquity. Modernists were deeply concerned with abstraction rather than representation and, indeed, writing of the period attempted to provide a theoretical basis for the move away from the classical body as the basis of art.[7] Until recently, unless the body was presented in the guise of an abstracted or robotic form, it was deemed insufficiently abstract and detached from memory to be a proper subject for analysis within a Modernist context. While social and literary historians have more willingly engaged with different aspects of the topic – they are less constrained than those focusing on art and design by questions of Modernist or anti-Modernist motivations or imagery – a broad overview of the subject in all its complexities is still lacking.

Inter-war healthy body culture did not invent itself, and its immediate origins, unsurprisingly, are to be found in the nineteenth century. One historian of Britain has written: 'No topic more occupied the Victorian mind than Health – not religion, or politics, or Improvement, or Darwinism.'[8] In many European countries, and in the United States, physical exercise regimes and formal physical education, modern sports, health-promoting diets (including vegetarianism) and medicines, alternative health therapies, as well as sun and air bathing, all appeared in the nineteenth century. The acceptance of these was gradual, and some existed on the margins of mainstream society.[9]

While interest in health and exercise grew hugely in the decades before 1914, it was the First World War that, at least in Europe, signalled a decisive transformation. As war began, nations focused on the physical fitness (or lack thereof) of young soldiers, much as they had at the time of previous conflicts

and, in particular, after defeats. By 1918 more than eight million had been killed, by which time the sight of maimed soldiers back from the front had become commonplace. Adding to the horror of the post-war years was the influenza pandemic of 1918–19, the worst epidemic in world history, which killed more than 25 million people. 'The effect of that time of destruction,' wrote architect Raymond McGrath, 'seems to have been a burning desire for sunlight and clean air and clear thought.'[10] The utopian yearnings of the war years, wrote McGrath, especially the 'search for a physical and spiritual unity', the longing 'to hear the heartbeat of the living', gave the culture of the body a special meaning and much more universal appeal than had previously been the case. Health therefore became an important element in the post-war utopian agenda, an integral part of creating the New Mankind for a New World, but also a concern that was central to modern societies. It could no longer be marginalized.

As with most aspects of Modernism, Germany was an important centre for all aspects of the healthy body culture. Germans, as well as foreigners working or living in Germany, played a leading role in terms of theory and practice, and German publishers provided much of the literature surrounding the healthy body culture. Within Modernist circles in other European countries and in America, the concern with health found widespread expression.

The body

The early twentieth century saw a decisive change in the ways in which the body was thought about, described and represented, in both popular and elite culture. Any overview of Modernist depictions of men's and especially women's bodies would inevitably conclude that the body was, during this period, a site of preoccupation, alteration, transformation and even reinvention.[11] Indeed, the subject of the woman's or man's body came to the fore as part of a new self-consciousness about social, cultural and sexual identity. This had begun earlier, but was, inevitably, sharpened and increased by the experience of war,

7.3 **Willy Petzold**, Poster, *Hygiene Ausstellung Dresden 1930*, 1928 (cat.177)

which had radically altered the nature of daily life in Europe. A significant aspect of this was the different ways in which the body could be made healthier, or, at least, could be made to appear healthier. The New Man and New Woman of the 1920s looked different from previous generations: the slimmer, fitter and tanned body, shown off by shorter hair (for women) and, at times, body-revealing clothing became outward signs of modernity.[12] It was, of course, the woman's body that was seen and revealed as never before in daily life and, significantly, in magazines and films. Widespread participation in sport (whether Olympic or in a public park) and exercise saw men, and even more so women, dressing in both practical clothing for sport and in fashionable sportswear, which drew attention to their bodies. The 'undressed' state of women participating in amateur gymnastics and dance, and in professional and amateur sport, was much commented upon at the time, as was the danger of women performing in front of male audiences.[13]

The perfectible body was perhaps made most clearly manifest in its association with the machine,

not least in the fascination with the idea of the body as a machine (see Chapter 3 and pl.7.2). The machine analogy suggested that the human body was capable of all manner of productivity, that it could be improved and repaired. It also suggested an emotional detachment, a scientific objectivity with which the body might be considered and deployed. The body as objectified or productive machine could be analysed, and its output measured.[14]

A striking representation of the human body as revealed and understood by science was the Transparent Man (pl.10.16) created for the new German Hygiene Museum in Dresden in 1930.[15] Seen by millions in Germany (pl.7.3), but also on tour in the United States (numerous versions of transparent men and women were made), the glass figure allowed the internal bone structure and organs of the body to be made visible. It was, like many publications and images of the period, an attempt to make different aspects of science – in this case, the body and its relationship to health and hygiene – comprehensible to a wider public. It suggested that science had unlocked the mysteries of the body, allowing

viewers to glimpse its secrets and its workings, and ultimately suggesting that it could be controlled and regulated.

The idea of perfecting and altering the body perhaps found its visual equivalent in the form of the photomontage and the image manipulated in the darkroom. Man Ray, László Moholy-Nagy and Herbert Bayer, among others, created photographic prints in which bodies were depicted with parts missing or added, where transparency was much emphasized or where there was a reversal of traditional poles of light and dark that heightened awareness of the subject.[16] These depictions of the human form, and the unusual viewpoints from which they were presented in New Photography, represented strategies for avoiding traditional modes of depiction, suggesting a new view of the body. Indeed, it has been suggested that the camera itself, in such contexts, 'acts as a kind of prosthesis, enlarging the capacity of the human body'.

As it had for centuries, the body continued to be used as a metaphor for the nation state (the body politic), but it was also widely used to describe

individual cultures or races, or even western society as a whole. The verdict was that the body was not healthy, that it was at risk and urgently in need of strengthening. The decline of the 'vital energies' of the German people was described by one writer: 'In the face of this threat to our national body, adequate social-hygienic measures must be implemented to reinvigorate our endangered common vitality.'[17]

Sun, light and the naked body

Exposing the clothed and the naked body to the air and sun became a widespread practice in the inter-war years, though for very disparate reasons. Nudism was more common in northern European countries than in southern (and Catholic) countries, and rare in Britain and the United States. Social nudism began in Germany in the late nineteenth century as an upper-middle-class pursuit of Greek beauty and nature, a rejection of both industrialization and the proletarian masses, as well as an expression of a desire to re-invigorate the German race. It was transformed during the 1920s into a widespread movement of all political persuasions and all classes, especially the proletarian Workers' Culture movement, which was closely associated with similar groups throughout Europe.[18] *Freikörperkultur* (free body culture) or *Nacktkultur* (naked culture) also tapped into deep

cultural yearnings that appealed to Modernists and non-Modernists: 'More sun! More light! Is the cry of our desperate age,' wrote a female correspondent in a German nudist magazine.[19]

For some advocates, nudism represented a literal stripping away of societal conventions (a parallel to the metaphor of Modernist architecture stripping away its fashionable clothing (see Chapter 5), a liberation from bourgeois society and the restrictions of class.[20] Many in German movement, exercise and dance culture (see below) undertook their practices in the nude to symbolize this liberation, but also to express individuality, to aid health and to increase expressivity.[21] The movement spread mainly from Germany to other countries through publications, through foreigners who had spent time in Germany and through Germans travelling or emigrating to other countries.[22]

The nudists' belief in the therapeutic power of sunshine gained medical credibility during the 1920s as the Swiss doctors August Rollier and Oskar Bernhard, working independently, proved the efficacy of the so-called sun cure (heliotherapy) on tuberculosis, most importantly as an alternative to surgery, and on malnutrition. Heliotherapy became known beyond the medical community when, between 1920 and 1933, Bernhard was nominated for the Nobel Prize five times and Rollier three times.[23] Rollier's clinic in

Leysin, Switzerland, founded 1903, – which, although not Modernist in form, incorporated sun balconies where patients could lie in the sun (they took the sun when it was low in the sky rather than when it was at its strongest) – would almost certainly have been known to architects designing sanatoria.

The influence of the medical pioneers of helio-therapy was clearly seen in the designs of three architecturally significant and widely published sanatoria of the years around 1930: Johannes Duiker and Bernard Bijvoet's Zonnestraal in Hilversum (pl.7.5), Alvar Aalto's Varsinais-Suomi in Paimio (pls 7.6–7, which drew upon Zonnestraal) and, less known today, Jaromír Krejcar's sanatorium in Trencianské Telpice, Slovakia. Long balconies for patients to lie in the sun (though not necessarily in the nude), as well as roof terraces and indoor sun-filled spaces, were the chief characteristics of all (Zonnestraal was particularly noted for being 'constructed almost entirely of glass').[24] Though Zonnestraal was a series of low-slung buildings, the Aalto and Krejcar sanatoria were unusually tall buildings situated in non-urban areas, with the aim of maximum sun exposure and, presumably, the isolation of the patients and the local community in mind. In 1928 Walter Gropius had argued that the high-rise building had 'the biologically important advantages of more sun and light'.[25]

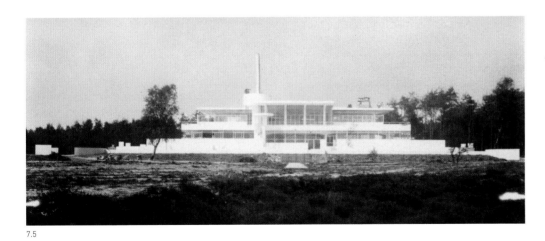

7.5

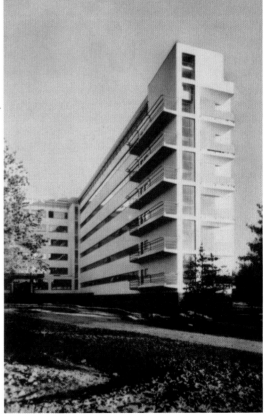

7.6

7.5 **Jan Duiker, Bernard Bijvoet** and **Jan Gerka Wiebenga**, Zonnestraal sanatorium, 1925–31 (cat.180)

7.6 **Alvar Aalto**, Varsinais-Suomi sanatorium, 1928–33 (cat.182a)

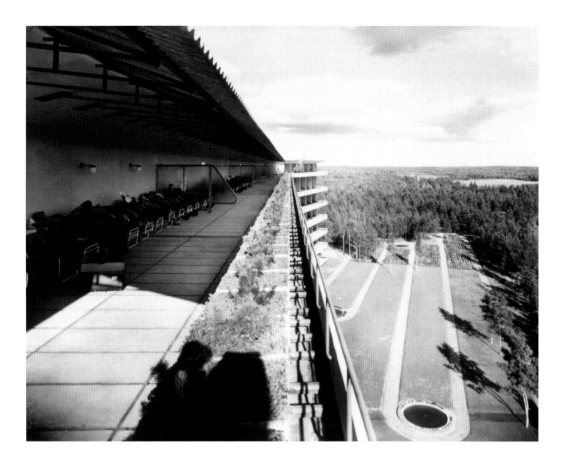

Treatment for tuberculosis was not, of course, only reliant upon sun or light therapies, but on an overall approach that included a good diet and an environment where cleanliness and hygiene were emphasized. Accordingly the sanatorium, at least those founded by government or trade unions, might be said, along with social housing, to be the building type that most fully reflected the concerns of Modernism. It is also very telling that the combination of building forms based on insistent geometry, the perception that such buildings were white (fuelled by black-and-white photography), the emphasis on light and lack of clutter, and the use of metal furniture gave rise to the common criticism of Modernist buildings and their interiors that they resembled hospitals, operating theatres or dentist surgeries.[26]

Despite the medical endorsement of the sun cure, nudist organizations turned to alternative therapies rather than the medical profession for support of their belief in the efficacy of sun exposure. The 'sun bath', along with the 'air bath', was widely advocated by enthusiasts as leading to greater health.[27]

Not all believers in the utility of sun bathing – whether on the basis of its health-giving properties or its aesthetic ones – believed in nudity. The bronzed body, though popular in some circles in Germany and Scandinavian countries after the turn of the century, is said to have become internationally fashionable (at least with the wearing of bathing costumes) following its embrace by the French fashion world, emulating the tan acquired in the 1920s by Coco Chanel.[28] In the 1930s Chanel marketed 'Liquid Tan for the Summer' and tanning powder. In popular literature she is frequently given credit for having made tanning fashionable.[29] Italian children spending the summers at the *colonie* (summer camps that, with the rise of Benito Mussolini, became used for ideological reasons) were offered supervised sunning (pl.7.8).[30] Indoor light therapy had been pioneered by 1903 Nobel Prize winner Dr Niels Finsen, who developed his 'Finsen lamps' to deliver ultraviolet radiation to patients when sunlight was not available at his Light Institute in Copenhagen.[31] Such practice was widely followed during the inter-war period and was offered at clinics such as London's Finsbury Health Centre (cat.186) and the Pioneer Health Centre in Peckham.

The belief in the importance of light in daily life was translated into design terms by architects. Designing buildings that allowed light to enter the interior became one of the fundamental tenets of Modernist architecture. Paul Scheerbart's *Glass Architecture* called for introducing 'glass architecture, which lets in the light of the sun, the moon, and the stars, not merely through a few windows, but through every possible wall'.[32] However, the call for light in Expressionist architecture represented a symbolic dimension of a spiritualized, utopian architecture (see Chapter 2), less pragmatic and less

concerned with the specifics of physical health than designers of the 1920s. In his *Five Points of a New Architecture* Le Corbusier called for roof gardens and long windows 'through which light and air can come flooding in'.[33] The CIAM (*Congrès Internationaux d'Architecture Moderne*, International Congresses of Modern Architecture) declaration of 1928 urged the establishment of 'a body of fundamental truths … forming the basis of domestic science (for example … the effects of sunlight, the ill effects of darkness, essential hygiene …).'[34] By this time the (over) use of light was mocked by some. 'Not even nature affords as much light and air as some of the new dwellings,' wrote the Berlin newspaper feature writer Josef Roth. 'And in the evening concealed fluorescent tubes light the room so evenly that it is no longer illuminated, it is a pool of luminosity.'[35] Health-giving light was not only to be physically absorbed by the occupant to improve bodily health, but was intended to play a hygienic role, inhibiting the growth of germs and bacteria (widely associated with tuberculosis) in the interior, effectively acting as a disinfectant and allowing for more efficient cleaning.

The belief in the efficacy of light and air in curing childhood illness, especially tuberculosis, led also to the establishment of open-air schools, which, though first opened in 1904, were most popular in the inter-war period.[36] Some of these were, in fact, mainly outdoor schools with little consideration for architecture, though they were also popular in urban locations and in northern Europe and America, where architectural solutions were required to compensate for the cold weather. In Modernist circles, Johannes Duiker's Open Air School in Amsterdam (1928–31; pl.7.9) was undoubtedly the most influential. In all schools over-exposure to the sun was avoided.

Hygiene and physical health

In the early twentieth century the term hygiene carried a meaning that it retains today: it was used to describe that which preserves and promotes health; above all, it was associated with cleanliness, both literal and metaphorical. Hygiene, in its varied manifestations and meanings, was an obsession of the inter-war years. It was a term used for social, political, artistic and other cultural purposes. The Futurist Filippo Tommaso Marinetti had famously written of 'war – the world's only hygiene', while virtually all architectural polemic of the 1920s invokes hygiene as a key aspiration of the built environment.[37]

It is hardly surprising that in the aftermath of the First World War and the influenza pandemic – with large numbers of people throughout Europe and America living in sub-standard housing and with tuberculosis (known as 'the proletarian disease') the greatest and most omnipresent threat to public health, particularly in cities – the quest for hygienic

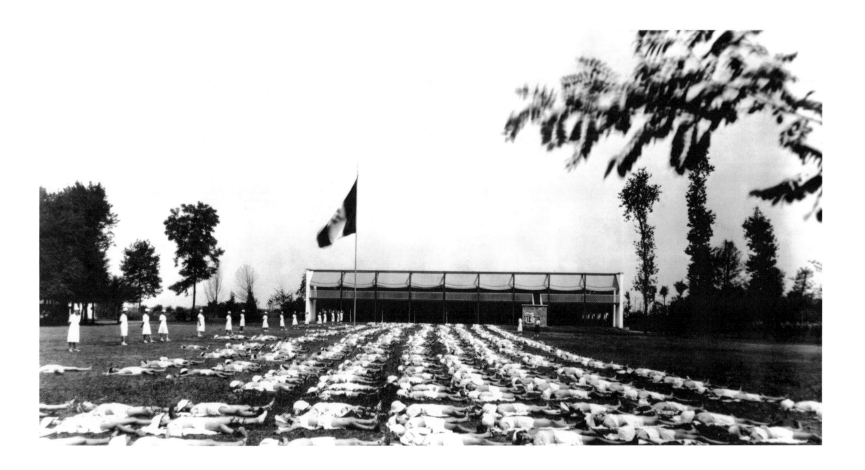

living environments and personal hygiene became a priority.[38] The Czechoslovak critic Karel Teige was one of many in the architectural world who decried 'the jungle of housing misery in the slums and on the periphery of all European cities…' and the 'housing cesspools … [that] sharpen the class contrast in the distribution of housing space' (pl.5.10).[39] Social reformers of all political persuasions embarked on crusades directed at healthy living, and contemporaries (including architects and designers) frequently cited the range of different approaches necessary. Writing on the physical decline of the German population (though similar accounts occur throughout Europe and America), one commentator noted that, 'aside from proper nutrition, the general promotion of a healthy practice of personal hygiene and physical exercise must be undertaken in addition to the provision of maternal counselling, infant care, suitable dwellings and recreational opportunities, and the endeavours of the housing movement'.[40]

Governments acknowledged the need for action and became more actively engaged in promoting hygiene. In 1920 the French government created Le ministère de l'hygiène, de l'assistance et de la prévoyance sociales (the Ministry for Hygiene and Social Affairs, from what had been part of the Ministry of the Interior).[41] Public education was a priority, and the 1920s in Germany have been described as 'a golden age of health education and propaganda'.[42] In America and Germany, health films were made as a strategy to attract the attention of a wider segment of the population, to go beyond printed leaflets.[43]

As was the case for the term 'healthy' and its opposites, the words hygiene and hygienic were used in varied ways. Following months of travel in the Swedish countryside in 1938, the writer Ludvig 'Lubbe' Nordström published the book *Filthy Sweden* as a literal description of what he found, but also as a metaphorical characterization of a conservative and old-fashioned society that, according to its author, needed to radically adapt itself to the new society that Sweden was building. This society was to be based on 'reason, rationality, and science' and was clearly inspired by the model of the Stockholm Exhibition of 1930 (cat.236).[44]

During the inter-war years, however, hygiene also had a broad range of interrelated and overlapping meanings, which represented issues of pressing concern. Social hygiene was used to identify the conditions in which working-class people lived, and the problems of health and hygiene arising from them (alcoholism, crime, disease, poor housing) and their treatments. The meanings of social hygiene (as with all terminology surrounding health and hygiene) varied according to the methodology and approach of the user. Often it was used in a narrower sense and was aimed at promoting sex education, and at eradicating (or controlling) prostitution and venereal disease, sometimes through contraception.[45] Morality campaigns waged in many countries by conservative groups were another aspect of this effort. Of most immediate relevance to the built environment is the suggestion that in directing 'its attention to social conditions', social hygiene (in the broadest sense of the term) 'legitimized the structuring of social behaviour' that was fundamental to the large-scale rehousing of the population that occurred during the 1920s.[46] These social housing schemes (pl.5.23, cats 90–1, 102) often not only included bathrooms and

7.10 **Bohuslav Fuchs**, *Brno Town Baths*, 1929 (cat.178)

7.11 **Marcel Breuer** and **Gustav Hassenpflug**, Gymnastics room in a sports teacher's home, Berlin, 1930. Bauhaus Archiv, Berlin

7.10

7.11

fitted kitchens within flats, but also led to the building of crèches, kindergartens, swimming pools and other sports facilities, public baths (pl.7.10), health clinics and hospitals on or near the new estates. Whereas the bourgeois chose the hygienic lifestyle, and even embraced it as both moral and fashionable (pl.7.11), social hygiene was imposed upon the working class for its own good. The triumph of an allegedly 'scientific, neutral concept' of health and, indeed, the context of a new world planned and 'based on applied social science', provided the intellectual framework in which large numbers of (mainly working-class) people could be rehoused in what were described as

rationally designed, functionalist, hygienic buildings, furnished and equipped in a suitable manner.[47]

'Racial hygiene', closely related to social hygiene, aimed to affirm the purity of the race and its future, though the definition of race was, in each instance, defined by nationality. While we retrospectively associate eugenics with fascism, many democrats and those on the left in the 1920s and '30s believed that eugenics offered a means of promoting national health and of increasing the birthrate (a pressing issue in the post-war era).[48] Public health education was also promoted in Germany through travelling exhibitions on topics such as alcoholism, infant care

and venereal disease and larger-scale endeavours such as the 2nd International Hygiene Exhibition in Dresden (1930). This included El Lissitzky's spectacular Russian pavilion and was immediately followed in 1931 by the opening of the German Hygiene Museum's permanent building. Including – but also going beyond – hygiene concerns was the GE SO LEI (*Gesundheit, soziale Fürsorge und Leibesübungen* or Health, Welfare and Exercise) exhibition held in Düsseldorf in 1926, which was attended by seven and a half million people.[49]

It is indisputably true that eugenics underpinned or provided a framework for much contemporary debate on a variety of health-related subjects, especially among medical practitioners and policy makers, politicians and social activists, just as it had in the period leading up to the First World War. In most countries there was, beginning in the nineteenth century, a discourse about health and hygiene that both on the broadest level – when discussing the health of the nation, either literally or metaphorically – and when discussing particular means of improving health (exercise, sport, sun therapy, and so on) aimed at preserving or improving the race.[50] Nearly all who wrote on eugenics discussed methods for improving health and, similarly, nearly all who engaged formally with on the healthy body at least touched on the subject. Few Modernist designers actively entered, at least in print, into these debates. They occurred across a wide political spectrum, although the rise of fascism in the 1930s shifted the focus to the political right, and consequently alienated anti-fascists. Nevertheless, it was universally the case that among campaigners for all types of hygiene, physical activity was seen to play a key role in promoting and maintaining hygiene. It was in this context that contemporary sociologists, historians and cultural critics, including figures such as Karl Mannheim and Johann Huizinga, acknowledged active physical culture, and above all sport, 'as a potential vehicle for social hygiene'.[51] In the Soviet Union, scientists and medical personnel concerned with preventing disease and mortality argued that 'physical culture' was the best means to ensure awareness of 'personal hygiene and bodily fitness'.[52]

The active body

The huge impact of what might be called active body culture, the range of its expression and activity, and the close relationship of its different manifestations was vividly captured by the polymath Wolfgang Graeser in his 1927 book *Körpersinn. Gymnastik, Tanz, Sport* (*Body Sense. Gymnastics, Dance, Sport*):

> Something new has appeared. It could be called a movement, a wave, a fashion, a passion, a new feeling for life; this is a reality that has inundated, pursued, inspired, reformed and influenced millions of people.

> It had no name but was called by a hundred old names and a hundred new ones … Body culture, gymnastics, dance, cult dances, the new corporeality, the new physicality, the revival of the ideals of antiquity, the new gymnastics, physical exercise and hygiene, sport in all its incarnations such as those played in the nude, nudism, life reform, functional gymnastics, physical education, rhythmical exercise with all its countless expressions, and so on.

> The entire Western world and its sphere of influence has been transformed by this strange new sensibility and way of life – from America to Australia, from Europe to Japan. The individual manifestations may be different, but essentially it is always the same thing.[53]

A similar coming together of contemporary attitudes towards active body culture, underpinned by a belief in ancient Greek ideals of beauty, was seen in the full-length German documentary film *Wege zu Kraft und Schönheit – Ein Film über moderne Körperkultur* (*Ways to Strength and Beauty – A Film About Modern Physical Culture*, 1925), which was widely distributed, including in an English-language edition.[54] A large number of well-known dancers and dance practices, movement techniques, as well as amateur, professional and Olympic sport from around the world, were shown, and even international heads of state offered testimonials to the efficacy of sport and exercise. This educational film, made, effectively, with government backing and written by a doctor, suggested the ways in which different types of active body culture could be presented to, or perceived by, contemporaries as part of the same endeavour.[55] It also reflected the integration of healthy body culture into the cultural and political mainstream.

One of the most noteworthy aspects of the active body culture was the important place of women. Participation by women in exercise and sports was a relatively new phenomenon in the years after 1918, and the rate of increase in active involvement during the 1920s was nothing short of remarkable, despite objections by some in the medical profession that certain types of exercise would inhibit child-bearing.[56] In the world of dance and rhythmic gymnastics, women were more prominent than men, both as teachers and as participants.[57] In sport, women were increasingly active in terms of amateur participation, including the international Olympic Games and, within professional sport, tennis. The profile of women's sporting achievements had been enhanced in 1926 when Gertrude Ederle became the first woman to swim the English Channel (beating the men's record by two hours) and later, in 1932, when Amelia Earhart piloted her Lockheed Vega aeroplane across the Atlantic. French designer Charlotte Perriand wrote, '*Sport, indispensable for healthy life in a mechanical age*'.[58]

Dance-exercise

Dance and various dance-related movement and
exercise techniques developed after the turn of the
century played a particularly significant role in the
spread and influence of the healthy body culture
between the wars.[59] Personal experience of these
techniques by Modernist designers and artists, as
well as by their clients, and the generally close links
between dance and other areas of Modernist culture,
give these practices a special place in any considera-
tion of the healthy body culture of the inter-war
years. The leading figures in what dance critics and
historians have called Modernist dance were linked
to one another through formal study, collaboration
and/or influence.[60]

The foundations of inter-war Modernist dance
can be found in the work of turn-of-the-century
dancers Loïe Fuller, Isadora Duncan and Ruth Saint
Denis (all American, but most successful in Europe
before the First World War).[61] They made the break

from classical ballet, and even from the most
contemporary forms of ballet, and it is within the
establishment of a dance tradition separate from
ballet, concerned with free movement, abstraction
and spirituality, that the new culture of dance and
movement established itself.

A cornerstone of much new practice was the
work of Émile Jacques-Dalcroze (1865–1950), the
Swiss founder of eurythmics, also called rhythmic
gymnastics. He did not teach dance, but the study
of movement based in music.[62] His technique aimed
to instil in students a deep awareness of rhythm
through group exercises following music played with
an emphasis on its tempo. He had little interest in
drama and expressivity *per se*, but instead wanted
his students to use rhythm as the basis for carefully
directed expression. In 1909 he moved from his
position as professor of music at the University of
Geneva to become director of the Educational
Institute for Music and Rhythm at the model workers'
community founded in Hellerau, Germany, by the

Deutscher Werkbund. At Hellerau, Dalcroze taught not only members of the community, but students who came to study with him from many countries. In addition to those who would become important dancers, teachers and choreographers, his students included Ada Bruhn, who was being courted by and would shortly marry Ludwig Mies van der Rohe, and Albert Jeanneret, the brother of Le Corbusier, who became a Dalcroze teacher.[63]

With its rational approach, lacking the soulful mysticism that would characterize many other dance/exercise techniques, this experiment in utopianism was significant in numerous ways: for creating a pedagogical system of movement, for emphasizing the intimate connection between music and movement, and for stressing the importance of improvisation as a tool of teaching and learning. In addition, the direct association between the *Werkbund* (the most significant organization in Germany devoted to collaboration between industry and design) and the integration within it of an institution devoted to the healthy body signalled the key place that attention to the body had in Modernist culture. Dalcroze's influence would be spread by the founding of his institutes in cities throughout Europe and by his disciples.[64] The establishment of dance and exercise schools throughout Europe and beyond would become an important means of creating a larger, mainly amateur, community who would support and sustain the spread of movement culture.

The other key figure in the development of inter-war European dance and movement, of perhaps greater influence and importance, was Rudolf von Laban (1879–1958; he later dropped the von).[65] Having studied art, he worked as a graphic designer and caricaturist (his drawings were published in *Simplicissimus*). Von Laban turned to dance in 1912, influenced by Wassily Kandinsky's *Über das Geistige in der Kunst* (*Concerning the Spiritual in Art*, 1912). He lived and taught at the bohemian Monte Verita community in Switzerland, and his dancers (including the artist Sophie Taeuber-Arp) performed in the first Dada cabarets in Zurich. He stressed freedom and improvisation, aiming to develop self-expression in the moment in his dancers. His students performed outdoors, sometimes in the nude. Unlike Dalcroze, music was not central to Laban dance. His key contributions to contemporary dance were *Bewegungstanz* (rhythmic movement dance), *Ausdruckstanz* (expressive dance), the concept of the *Bewegungschöre*

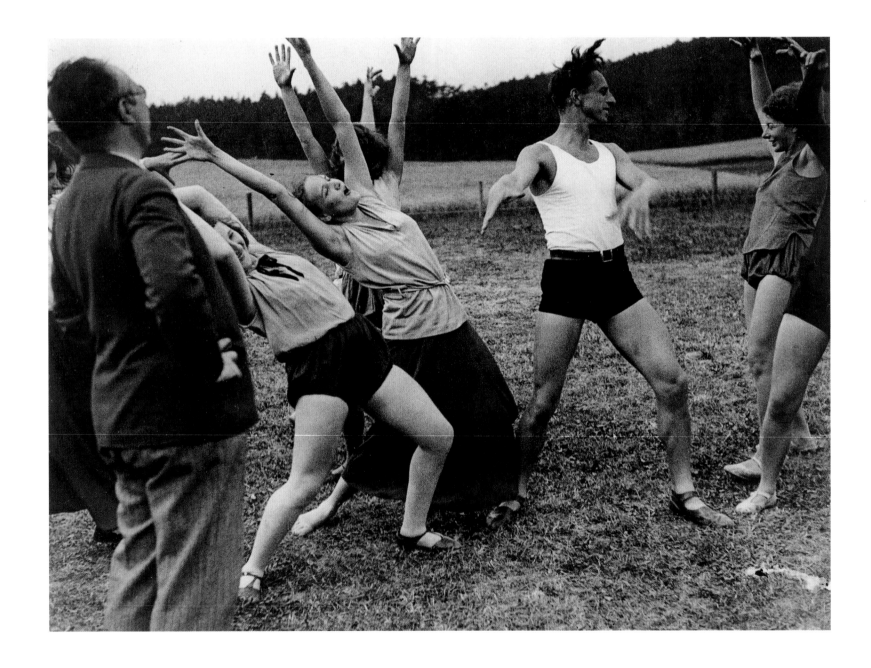

7.15

7.14

Opposite:
7.13 **Felix H. Man**, *Laban Group*, c.1930 (cat.172)

7.14 **Piet Zwart**, Photograph for *Kamergymnastiek voor iedereen* (*Home Gymnastics for Everyone*) by Dr W.P. Hubert van Blijenburgh, 1930 (cat.173a)

7.15 **Piet Zwart**, Cover design for *Kamergymnastiek voor iedereen* (*Home Gymnastics for Everyone*) by Dr W.P. Hubert van Blijenburgh, 1930 (cat.173b)

(movement choir) (pl.7.13) and his system of dance notation, Kinetography.

Von Laban was widely credited by contemporaries with freeing the body. One wrote, 'Only with Laban came complete liberation.'[66] Laban's profound influence was not as a choreographer of staged dance pieces, but as a teacher ('of comprehensive movement education for dance gymnastics') and as a shaper of attitudes towards dance and movement, furthered by the large number of Laban schools and his extensive publications.[67] Among pupils who studied directly with him were the most influential dancers and teachers of the next generation, including Mary Wigman and Kurt Jooss. Of significant importance, however, were the amateur students who flocked to his dance schools, taking the principles of Laban dance to a much wider audience.

Most avant-garde designers and artists would have been very familiar with contemporary body culture and, for those who ignored it, images of dance as well as gymnastics were extensively published in art, architecture and design magazines of the 1920s, as well as in the popular press. As Swiss architect Hannes Meyer (later director of the Bauhaus) wrote in a seminal overview of contemporary culture entitled 'The New World' (1926): 'Palucca's dances, von Laban's motion choirs, and D. Mensendieck's functional gymnastics outstrip the aesthetic eroticism of painted nudes.' It would seem that in the minds of many at the time there

were not rigid distinctions to be made between dance, gymnastics and exercise, as suggested also by the text of a programme of the Hertha Feist dance group (1925): 'WE ARE NOT A DANCE COMPANY. NOT BALLET! Our dance work is spiritualized gymnastics.'[68]

Personal exercise

There were other exercise techniques that did not involve dance or gymnastics or concern themselves with spiritual aims, but which were directed at the improvement of physique and physical health. One new aspect of this in the inter-war years was the proliferation of techniques, publications and apparatus for personal exercise – another aspect of the healthy body culture reflected in Modernist design and art (pls 7.14–15).

Particularly influential during the inter-war period was the Mensendieck System, developed by the Dutch-American physician Bess Mensendieck (1864–1957). She taught a system of posture-based exercise, undertaken in the nude, aimed at 'grace' and 'correct posture', eschewing music and athleticism and distancing herself from what she called 'exaggerated types of dance movement'.[69] She described the body as a machine, and there is an objectivity and lack of spirituality in her system that is very much at odds with much movement culture. The goal for the individual was to be able to analyse and comprehend

the body in normal, everyday activities, including housework. Her many books in German, Dutch and English gave her a large audience in Europe and America.[70] Mensendieck schools – for women only – were opened in five European countries and in America. Richard Neutra designed the so-called Mensendieck House for a wealthy American teacher in Palm Springs, California, in 1936–7, which included a studio for teaching and a large screened porch for outdoor living.[71]

The physically demanding nature of housework was recognized in numerous publications, which suggested exercises to be undertaken by women during housework.[72] Among them, the most widely circulated and the most closely related to Modernist projects was Erna Meyer's best-selling manual for the German housewife, *Der neue Haushalt* (*The New Household*, 1926), which advocated a system of 'housework gymnastics', in addition to explaining the need for good light and air in the home, as well as a good diet.[73] Meyer had been hired by Mies van der Rohe to offer advice to architects building houses at the Weissenhof exhibition and she published widely.[74]

Many artists, designers and architects of the period engaged in physical exercise. Among them Le Corbusier swam regularly (indeed, died swimming); the photographer Jacques-Henri Lartigue undertook regular exercise with his family (he also boxed), which he documented; and the designer Gustavs Klucis and his wife Valentina Kulagina also photographed themselves exercising.[75]

Published exercise manuals for use in the home became common during this period and there were radio programmes offering instruction in gymnastics, including Radio Hamburg's *Funkgymnastik* (Radio Gymnastics), which ran from the 1930s until 1942 and was taught by the head of the Laban School in Altona (Hamburg), Lola Rogge.[76]

Sport

The boundaries between exercise and sport were frequently blurred during this period and, like today, distinctions between the two terms would depend upon the motivation of the individual or organizing group. Sport, like dance or gymnastics, offered exercise to the individual and, frequently, participation in a group activity. As with most aspects of cultural life, dance, gymnastics and especially sport became politically charged during the 1930s, owing to the rise of fascism in Germany and Italy and to the politicized origins (in the nineteenth century) of some of the most influential organizations and practices: the German *Turnverein* (gymnastics club, from the verb to rotate or turn) the Czechoslovak *Sokol* (Falcon)

movement and (less politicized) Per Henrik Ling's Swedish gymnastics were more active and popular than ever, at least up to 1933 and, in some countries, later.[77] In Soviet Russia, politics effected terminology: the term 'physical culture' was used rather than 'sport' to remove the competitive dimension, which was considered antithetical and, indeed, damaging to the universal values of physical culture, and to the main aim of exercise, the recreation of the masses.[78] The association between politics and exercise was closer in Russia than anywhere else, due to its adoption as official state policy in a revolutionary society, and because leading designers were responsible (as they were in other areas of Soviet society until the Stalinist crackdowns) for the design of dress and uniforms, and all of the printed material and publicity associated with public events (pls 7.16–17, cat.196). The Workers' Sport movement, which existed in numerous countries (but not in the Soviet Union), declared its aim (at least in Germany) 'to reshape the human body deformed by work'.[79]

Beyond the specifics of national politics, it has been argued that sport assumed a wider prominence for those concerned with the intellectual state of contemporary society: 'during the inter-war period . . . sport emerged as nothing less than a modern style in which an ideologically diverse collection of temperaments found an issue of sociological significance and,

7.16

7.17

7.16 **Varvara Stepanova**, Design for sports clothing for footballer, 1923 (cat.192a)

7.17 **Varvara Stepanova**, Design for sports clothing for footballer, 1923 (cat.192b)

in not a few cases, a locus of value in a value-starved world'.[80]

Modernist designers, architects and artists participated in sport, imbibed a contemporary culture filled with news and images of athletes, amateur and professional, and produced work directly related to the subject. The cultural and political immediacy of sport was suggested by Hannes Meyer in 1926:

> The stadium vanquishes the art museum, and bodily reality replaces beautiful illusion. Sport unifies the individual with the masses. Sport is becoming the advanced school of collective feeling: hundreds of thousands were disappointed by [tennis star] Suzanne Lenglen's cancellation. Hundreds of thousands were shaken by [boxer] Hans Breitensträter's defeat. Hundreds of thousands followed [Olympian Paavo] Nurmi's ten-thousand-metre run ... [81]

Stadia, along with other sports facilities, were built at an increasing rate in the 1920s and '30s all over Europe (cat.185).[82]

7.19

As suggested by Meyer, many sports figures were internationally known during the inter-war period, the profile of the international Olympic Games rose, and boxing and tennis captured the public imagination (to which he might have added football). The profile of the Olympic Games increased immensely during the inter-war years, contributing to the interest in sport worldwide. With each successive Games – Antwerp 1920, Paris 1924, Amsterdam 1928, Los Angeles 1932 and, finally, Berlin 1936 (pl.8.8) – attendance and media coverage soared and Olympic athletes became household names, seen in newsreels, in picture magazines and reported on in the press, including art and design magazines.[83]

Boxing had a particular hold on the imagination of many Modernists (pl.7.18, cat.197a). One contemporary cited boxing as the sport most likely to excite the public.[84] Bertolt Brecht was perhaps the most famous Modernist fan of boxing, writing 'Hook to

the Chin' in 1926 and frequently citing the sports arena and its audience ('the fairest and shrewdest audience in the world') as the model for contemporary theatre.[85] Images of boxers appear extensively in art and design publications of the period: John Heartfield and George Grosz famously boxed in public (or at least posed for photographs, with Brecht and Erwin Piscator in attendance); Grosz painted German champion Max Schmeling; and the subject of boxing and the names of famous boxers appear in the writings of architects, as well as playwrights and poets, male and female.[86] The brutality and manliness of boxing had great appeal for fascists and, following the crowning of Italian Primo Carnera as world heavyweight boxing champion, Mussolini declared that boxing is an 'essentially Fascist method of self expression'.[87]

No sporting figure was more famous than French tennis champion Suzanne Lenglen, who played a

sport that became increasingly fashionable during the 1920s (cats 194, 197b). Famed, above all, for her sporting prowess, she was also famous (sometimes infamous) for her fashionable outfits designed by Jean Patou: white dresses tied at the waist with a coloured sash, her arms uncovered, her ankles and calves exposed, with a bright, turban-style *bandeau* wrapped round her head. Her image appeared in the press, in artworks and even in stage designs (pl.7.19). A German novel of 1929 referred not only to 'the divine Garbo', but also to 'the divine Lenglen'.[88]

By the 1920s, swimming had developed as a leisure activity involving both sexes bathing together and wearing attire radically different from the previous decade.[89] Women's swimming costumes became smaller, edging towards the appearance of men's, and women bared their arms and abandoned the wearing of stockings (pl.7.20). By the 1930s men began to uncover their bodies above the waist. Diving was a

particularly photogenic subject matter, offering the opportunity to capture visually the body in balletic poses flying through space (cats 200–1).

Mass exercise and sport

While mass sportive activity, especially mass gymnastic demonstrations, have been correctly described as a tool of 'nationalizing the masses', as a means of rehearsing 'the very unity of the polity' and hence 'a valued activity in all totalitarian countries', it is owing to the powerful and infamous images of Nazi rallies that, today, these demonstrations are exclusively but erroneously linked with fascism.[90] Behind all mass demonstrations of exercise and sport one finds the influence of the Czechoslovak *Sokol* movement, founded in 1862. *Sokol* was an expression of Czechoslova nationalism and aspirational democracy during a period when Czechs had no nation state. Their mass displays (called *Slets*, or flocking of the birds, pl.7.21) welcomed women from 1901 and allowed Germans and Jews to join, but not fascists. Much as the Nazis banned the *Turnverein* in Germany, so they banned the *Sokol* almost immediately after

invading Czechoslovakia.[91] The international, left-wing Workers' Sport movement also included mass displays as part of their national activities (though not in Russia, where the party federation, which was known as the Red Sport International, coordinated activities from 1921.[92] The most significant mass events in the Soviet Union were the national Spartakiads, communist Olympics first organized in 1928 (cat.196), which, although consisting mainly of competitive events for individuals, also included marches in formations of tens of thousands of athletes.[93]

Fascism and sport came to be closely associated not only through mass displays in the Stalinist Soviet Union and Nazi Germany, but through the public persona of certain fascist leaders. Mussolini, most famously, ensured that he was depicted as a virile man of sportive action, skiing bare-chested, jumping over hurdles on horseback and driving at breakneck speed.[94] Hitler apparently abhorred Mussolini's 'posing with bare torso among the peasants', but, unsurprisingly, inveighed against physical weakness.[95] The Briton Oswald Mosley has been described as the fascist leader who took 'athletic culture' and the idea of the political or statesman-athlete most seriously.[96]

7.20

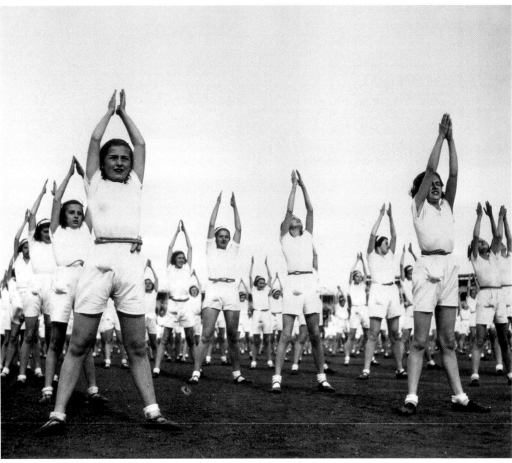

7.21

7.21 *10th All-Sokol Slet at Strahov Stadium in Prague, 29 May 1938* (cat.203b)

7.22 **Sasha Stone**, *Mrs Piscator at her dressing table*, 1928 (cat.190)

7.23 **Dr Flaxlander's pneumatic hip-shaper**, *UHU* (Berlin, vol.4, no.7 [April 1929]). Private Collection

Altering the body – beauty strategies

For some who partook of exercise, spiritual or moral aims, or the desire to be physically fit, were insignificant. For many, the overt or covert aim was to preserve a youthful appearance or become more beautiful. The reasons for this may have been strictly personal, strongly influenced by contemporary advertising and media and may, for many women, especially in the period following the 1914–18 war, have had much to do with the loss of so many men of marriageable age in the war.[97] Different strategies were adopted by consumers to maintain or change bodily appearance, including, as we have seen, sport, exercise and dance. Various practices and groups either founded or sold themselves on the basis of this appeal. The Women's League of Health and Beauty was founded by Mary Bagot Stack in London in 1930 to encourage women working in and outside the home to 'conserve and improve their physique'.[98] Even the socialist Workers' Sport movement stated that 'The aim of the sports movement is the beautiful person.'[99] Bess Mensendieck urged bodily discipline and good posture in the service of 'beauty' and 'grace'.[100]

This desire for beauty (mainly articulated by women and those who sought them as consumers)

could also be met by dieting, by the use of fashionable dress, make-up, beauty therapies and, in the most extreme circumstances, by what came to be called cosmetic surgery. Articles and advertising (especially in women's magazines) showed the extent to which dieting had permeated public consciousness, and although the origins of modern dieting are to be found in efforts to lead a healthier life, efforts to stay slim were the primary motivation.[101] A German magazine advertisement for soap suggested a shift from keeping a husband happy through traditional cooking ('but nowadays we live on salads and count calories') to doing so by preserving 'youthful beauty'.[102]

The use of make-up increased dramatically during the 1920s as products became cheaper, were marketed more widely and in more sophisticated ways, and were increasingly socially acceptable (pl.7.22).[103] Both Helena Rubenstein and Elizabeth Arden commissioned and purchased what contemporaries called 'ultra-modern' art as part of a strategy to be perceived as up-to-date, which included the design of their shops. Arden hung Georgia O'Keeffe's *Jimson Weed* (1936–7) in her 'Gymnasium Moderne' room, where women undertaking exercise were photographed in front of the large canvas.[104]

Health and beauty machines were produced – as they had been in the nineteenth century – offering cures and new energy for the body (cats 187–9), often through the use of electricity.[105] These devices promised the application of science to problems of the nervous system, the skin, the figure (pl.7.23) and the mind, and appear to have been immensely popular.

The extreme intervention of cosmetic surgery began in the inter-war period, largely as a result of techniques of plastic (or reconstructive) surgery developed to treat the casualties of the First World War.[106] However, by the 1920s a German song mentioned having one's nose operated on, having fat removed from one's thighs, as well as bust enhancement.[107] In the United States, where the founding of the first professional medical society devoted to plastic surgery coincided with the first Miss America beauty pageant, the inter-war years saw the flourishing of both cosmetic surgery undertaken by qualified surgeons and a wide range of procedures carried out by unlicensed quacks.[108]

The legacy of the inter-war healthy body culture is very much with us today. Unlike the inter-war period, however, today's health obsessions seem focused on an imagined ideal of immortality. Above all, they focus on a model of youthfulness which, many seem to believe, can be achieved through traditional and alternative medical care, cosmetic surgery, exercise and diet. Whereas health was debated by Modernists in terms of a collective ideal (creating housing and facilities for the population as a whole), today's body culture is created and consumed on an individual basis. The decline of diseases associated with poor hygiene (above all, tuberculosis) and, in at least much of the first world, a dramatic increase in living standards since the 1930s, mean that hygiene-related problems no longer create as pressing a set of social issues, even if they still exist. As a consequence, today's designers and architects seem less engaged with a broader culture of health for children and adults than was the case in the 1920s and '30s. Concern with the threats posed by environmental pollution has become the wider social issue of today, which, one might hope, would have greatest impact on all aspects of the designed world. Nevertheless, this issue, despite its crucial importance for our future, does not seem to permeate the discourse around design and the visual arts in the urgent manner of the healthy body culture in the years between 1914 and 1939.

7.22

Pneumatischer Hüftformer, die wichtigste Erfindung der Flaxlanderschen Therapie
Diese schlanke Gestalt verdankt ihre moderne Hüftlinie dem neuen Hüftform-Apparat, der rings um den Rumpf einen luftleeren Raum erzeugt. Die Ausschaltung jeglichen Luftdrucks, unterstützt von Wechselströmen, die durch den Apparat laufen, erhöht sofort die Blutzirkulation fühlbar, das überflüssige Fett löst sich auf und wird ausgeschieden. (Etwa zehn Behandlungen genügen, um zwanzig Pfund loszuwerden.)

49

7.23

168 Plate 7.2

Poster: *Der Mensch als Industriepalast* (*Man as Industrial Palace*), **from Fritz Kahn,** *Das Leben des Menschen* (*The Life of Man,* **5 vols, Stuttgart, 1926–31)**

*c.*1930

Chromolithograph
95.7 × 48cm
Westfälisches Schulmuseum, Dortmund

This didactic poster accompanied one of the most widely circulated books of popular science published in inter-war Germany, Fritz Kahn's *The Life of Man*, subtitled 'A popular anatomy, biology, physiology and development history of man'.[1] Kahn aimed to explain the functions of the human body in terms of technological processes mainly – though not exclusively – of the factory, as a means to making bodily functions visible and thus more readily understood by the lay reader. This image was one of many detailed ones that illustrated the

book, and which were reproduced widely in publications of the period.[2] The human body was here portrayed as composed of machinery of varying sorts. In the top part of the brain figures in suits confer at meeting tables or command large control panels; the ear (centre) is a large receiver; the eye, a camera; to the far left of the nose is the 'nerve centre'; oxygen goes into the nose and carbonic acid is poured out as a waste product. Below, the heart is a pair of pumps; the lungs are literally pipes; in the liver, manual labourers (in workmen's clothes) filter and stack sugar; waste on its way out through the stomach is sprayed with pepsin and hydrochloric acid, and (at lower right) the muscles are motors.

Kahn's illustrations represented the concept of *Veranschaulichung* (visualization), by which complicated scientific concepts or processes could be explained to the lay public, most famously in the 'Transparent Man' created for Dresden's Hygiene Museum (see Chapter 7 and cat.177). Verbal analogies between the human body and technology were not new in the 1920s and there was, in Germany, a specific tradition of

making pictorial analogies between the human body and technology.[3] In addition, the separation of the body into distinct spheres of management and production related to the contemporary view that the body was 'a model for modern enterprise'.[4] CW

1 Vol.4 of the book was accompanied by a small brochure, 'Der Mensch als Industriepalast', which offered diagrams with keys to the poster (called a *Wandtafel*) and which suggested that it could be purchased separately from the book.
2 For example, images were used by Hans Surén in later editions of *Der Mensch und die Sonne* (Stuttgart, 1929), table 2; and this poster was used in its entirety as panel 9 of Czechoslovak architect Jiří Kroha's *Sociological Fragments* (see cat.179).
3 Michael Hau, *The Cult of Health and Beauty in Germany* (Chicago, 2003). Cornelius Borck, 'Urbane Gehirne. Zum Bildüberschuss medientechnischer Hirnwelten der 1920er Jahre', *Archiv für Mediengeschichte*, no.2 (2002), p.264, refers to visual comparisons between the national grid system of electricity and the human nervous system in 1875. American magazine articles as well as advertisements referred to the body as a human machine in need of maintenance and fuel; see Cecelia Tichi, *Shifting Gears. Technology, Literature, Culture in Modernist America* (Chapel Hill, NC, 1987), pp.35–40.
4 See Karl August Lingner, *Der Mensch als Organisationsvorbild* (Berne, 1914), cited in Hau (2003), p.142. Lingner was the owner of the Odol company and was responsible for the founding of the Dresden Hygiene Museum (see cat.177). Hau (2003), p.143, but reference is to Lingner's book of 1914, p.10ff.

169

Drawing: *Man in a Sphere of Ideas*
1928
Oskar Schlemmer (1888 Stuttgart –1943 Baden-Baden)

India ink, pencil and coloured pencil on paper, mounted on board
51.5 × 38cm
Bühnen Archiv Oskar Schlemmer, collection C. Raman Schlemmer

Oskar Schlemmer's drawing was both a practical tool used in the *Vorkurs* (Preliminary Course) he taught at the Bauhaus, and a complex summation of his intellectual and aesthetic ideas.[1] Virtually all of Schlemmer's work, from choreography and stage design (cat.72) to painting and sculpture, was concerned with the human form, and it formed the basis of his teaching and his book entitled *Man* (Mainz, 1969).

Man in a Sphere of Ideas has an artistic genealogy, drawing on Leonardo da Vinci's 'Vitruvian Man' and later representations of the natural processes of the body. However, Schlemmer is not primarily concerned with depicting the ideal proportions of the human figure as an aid to drawing or with reproducing a biological map of the body. Instead he visualizes a complete image of man in his environment, whereby material surroundings are combined with theoretical, even esoteric ideas.

The terms surrounding the mobile, activated human figure fuse scientific disciplines, including psychology and mechanics, with contemporary areas of investigation, for example, *Entwicklungs-geschichte* (the Darwinian history of development) or theological *Keimlehre* (seed-doctrine), as well as alternative trends such as magnetism or astrology. Added to these are the 'practical' elements observed for the construction of the human figure in art (joints, bones and muscles), as well as environmental influences such as natural space, the sense of touch, or the appreciation of the world through aesthetics or ethics.

Schlemmer's drawing could thus be used in teaching either to emphasize a holistic pedagogy coined by Rudolf Steiner's anthroposophist approach, or for more orthodox artistic training as part of the Bauhaus philosophy to expand the student's awareness from artistic preoccupation to socio-cultural understanding.[2] It thereby reflected Schlemmer's own aim to show man within space, as defined simultaneously by material, intellectual and aesthetic confines, as the self-reflexive centre of his world. UL

1 With its two circular perforations at the top, this drawing was clearly used in Schlemmer's classes. On Oskar Schlemmer as teacher, see Heimo Kuchling's introduction in Oskar Schlemmer, *Man, Teaching Notes from the Bauhaus* (London, 1971) and Karin von Maur, *Oskar Schlemmer* (Munich, 1982), pp.259–72.
2 On the influence of Steiner on Bauhaus teaching philosophies, see the recent exhibition catalogue, Christoph Wagner (ed.), *Johannes Itten – Wassily Kandinsky – Paul Klee: Das Bauhaus und die Esoterik* (Hamm, 2005). Steiner's death (30 March 1925), and the resulting public discussion of his legacy, coincided with the relocation of the Bauhaus from Weimar to Dessau (1 April 1925).

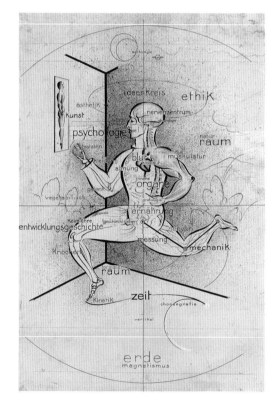

170a

Analytical drawing according to photographs by Charlotte Rudolph of the dancer Gret Palucca: *Three curves meeting at a single point*
1925
Wassily Kandinsky (1866 Moscow–1944 Neuilly-sur-Seine, France)

Ink on tracing paper
19.3 × 15.5cm
Staatliche Kunstsammlungen Dresden, Kupferstich-Kabinett (C 1981-630)

170b

Photograph: *Palucca with Double Shadow*
1925
Charlotte Rudolph (1896 Dresden–1983 Hamburg)

Gelatin silver print
19.2 × 17cm
Staatliche Kunstsammlungen Dresden, Kupferstich-Kabinett (D 1981-399)

170c

Analytical drawing according to photographs by Charlotte Rudolph of the dancer Gret Palucca: *Two large parallel lines supported by simple curve*
1925
Wassily Kandinsky (1866 Moscow–1944 Neuilly-sur-Seine)

Ink on tracing paper
16.5 × 16.2cm
Staatliche Kunstsammlungen Dresden, Kupferstich-Kabinett (C 1981-629)

170d

Photograph: *Palucca: Lunge towards left*
1925
Charlotte Rudolph (1896 Dresden–1983 Hamburg)

Gelatin silver print
16.4 × 16.4cm
Staatliche Kunstsammlungen Dresden, Kupferstich-Kabinett (D 1981-400)

In February 1925 Kandinsky made his first visit to Dresden and stayed, as he did during all his subsequent trips, with the dancer Gret Palucca and her then partner Fritz Bienert.[1] One of these visits, or Kandinsky's attendance at a dance evening given by Palucca at the National Theatre in Weimar that same year, may well have prompted the artist to make analytical drawings recording her dancing. Kandinsky's drawings are directly based on photographs of Palucca taken by the innovative dance photographer Charlotte Rudolph. When placed over the photographic image, the drawn figures follow precisely the shape of the dancer.[2]

Rudolph's images are some of the earliest examples of 'dance photography' and contrast markedly with earlier depictions of rigidly posed dancers. She defined this new type of photography as '...the representation of the motion of the dancer in picture form, that means that the dancer dances during the shooting'. For her, the 'picture should reproduce the characteristic movement of the dancer.[3] In the two photographs shown here, the figure of the dancer is captured while in motion and fills the entire photograph. The limited background and the simple floor give no indication of the environment, yet the space

170a

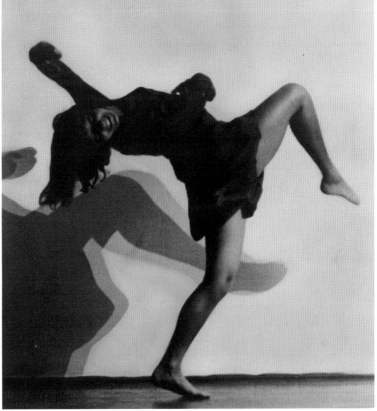

170b

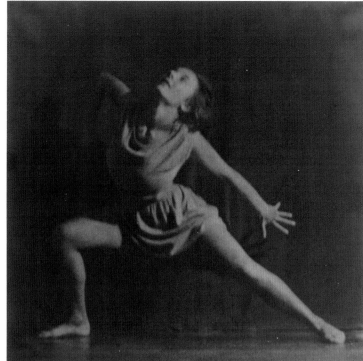

170c

170d

within which the dancer moves is clearly defined, as advocated by Rudolph. The spatial effect is heightened by the heavy double shadow in the first photograph.

The simplicity of the photographs is echoed in the drawings, which depict abstractly nothing more than the dancer's body in movement. Kandinsky translates the main axes of the dancer's body into simple groups of lines to capture the energetic movements and dynamism for which Palucca was famous. Differing weights of line suggest the momentum of the movement.[4] Much as Rudolph sought to portray 'characteristic' movement, so Kandinsky's drawings can be defined as documentations of movement rather than illustrations of a dance and/or a dancer.

Kandinsky himself apparently considered recording Palucca in slow motion in a series of drawings, to accurately examine all stages of a single dance.[5] This method can be compared to an increasing number of dance-notation systems developed during this period by Rudolph von Laban and others (cat.172). Kandinsky's use of the term 'dance curves' to describe Palucca's dances suggests that he intended to document the progression of movement within a single dance by creating a series of drawings for each dance.

In Kandinsky's article on Palucca, which published four drawings alongside Rudolph's photographs, he emphasized the quality of Palucca's dance in terms of its compositional accuracy. In the captions to the drawings he elaborated upon the short descriptive titles. For the drawing *Two large parallel lines supported by simple curve*, he remarked: 'Energetic development of the diagonal. Precise composition of the fingers as an example for the accuracy in each detail', whereas for *Three curves meeting at a single point*, he noted, 'As a contrast: two straight lines in an angle. Example for the extreme flexibility of the body – curves as best means.'[6] JS

1 See *Künstler um Palucca: Ausstellung zu Ehren des 85. Geburtstages*, (exh. cat., Kupferstich-Kabinett, Dresden, 1987).
2 The exhibited drawings and photographs were previously owned by Gret Palucca and each pair was mounted one above the other. Thanks to Hans-Ulrich Lehmann for this information.
3 Charlotte Rudolph, 'Dance Photography', in *Schrifttanz*, vol.2, no.2 (July 1929), reprinted in Valerie Preston-Dunlop and Susanne Lahusen, *Schrifttanz: A View of German Dance in the Weimar Republic* (London, 1990), pp.79–80.
4 For a discussion of Kandinsky's schematic drawings, see Clark von Poling, *Kandinsky: Unterricht am Bauhaus. Farbenseminar und analytische Zeichnungen* (Weingarten, 1982); for remarks on these, see p.127.
5 Wassily Kandinsky, 'Tanzkurven. Zu den Tänzen der Palucca', in *Kunstblatt*, vol.10, no.3 (March 1926), p.118.
6 Ibid., pp.119–20.

171 Plate 7.12

Poster: *Tanzfestspiele zum 2. Deutschen Tänzerkongress, Essen 1928* (*Dance Festival at the 2nd German Dancers' Congress*)
1928
Max Burchartz (1887 Elberfeld, Germany–1961 Essen, Germany)

Letterpress and gravure
*c.*89.8 × 83.6cm
The Museum of Modern Art, New York, Purchase Fund,
Jan Tschichold Collection (326.1937)

Max Burchartz's poster is an aesthetically engaging, abstract composition that expresses the free and dynamic spirit of contemporary German dance. Not only did he blend photography with typographic forms in the manner of classic 'Typophoto', but he created a design of extraordinary wit through his choice of an image of a dancer who both stands on the ledge of the truncated circle and interacts with the type above. It specifically promoted the dance festival that formed the performance part of the Congress, advertising stage performances by well-known names as well as an international session featuring dancers from Java, Sumatra, Russia and England.

The first Congress, held in Magdeburg in 1927 and attended by 300, had been dominated by the work of Rudolf von Laban (cat.172) and was marked by a boycott of the event by his former student, the celebrated dancer Mary Wigman.[1] The second Congress, held in Essen in 1928 and attended by both Laban and Wigman, was organized mainly by Kurt Jooss, also a former Laban disciple, and attracted 1,000 participants.[2] Both Jooss and Burchartz (cat.132) taught at the recently established (1927) Folkwang art school in Essen until its enforced closure in 1933.

Dance congresses in Germany were intensely political events and the second Congress debated how populist or elitist dance should be, whether it should be an essentially amateur or a professional field, and the extent to which it should abandon its grounding in the physical culture movement and embrace the rigorous training and commercial possibilities of ballet to ensure its future.[3] A further Congress was held in Munich in 1930, but, as in other forms of cultural life, the rise to power of the Nazis in 1933 spelled the end of such freely organized gatherings. Instead the regime organized German Dance Festivals (Berlin, 1934, 1935) that extolled the purely German nature of dance. This poster was owned until 1937 by the graphic designer Jan Tschichold (cat.125). CW

1 Valerie Preston-Dunlop and Susanne Lahausen (eds), *Schrifttanz, a View of Dance in the Weimar Republic* (London, 1990), p.83, and Susan A. Manning, *Ecstasy and the Demon, Feminism and Nationalism in the Dances of Mary Wigman* (Berkeley, 1993), p.133.
2 Karl Toepfer, *Empire of Ecstasy: Nudity and Movement in German Body Culture, 1910–1935* (Berkeley, 1997), pp.312–13.
3 Manning (1993), p.134.

172 Plate 7.13

Photograph: *Laban Group*
Felix H. Man (Hans Felix Siegismund Baumann) (1893 Freiburg–1985 London)
*c.*1930

Gelatin silver print
17.7 × 23.9cm
Private Collection

The subject of this photograph is a group of students from one of Rudolf von Laban's dance schools, participating in what he termed a *Bewegungschöre* (movement choir), a new dance mode he developed in his earliest years as a dancer and teacher before the First World War, but formalized and named just after it.[1] Felix Man's photograph probably shows a male teacher (in the centre) leading the other dancers, who follow the teacher's improvised movements until they themselves would improvise within the group. Movement choirs were a semi-mystical, utopian endeavour aimed at recovering 'a much earlier artistic community'.[2] The idea of communal dance, of dance as a social activity, was an important part of Laban's philosophy. His belief in improvisation arose from his view that dance 'originates from the inner world'.[3]

Most movement choirs were composed of lay dancers (as Laban called them) rather than professionals, and many attended Laban's schools, which had sections for movement choirs. They took place mainly out-of-doors and were therefore directly connected with Nature. Composed of dozens or even hundreds of dancers, movement choirs were aimed primarily at the participants, though they also attracted audiences, especially as part of large festival productions organized by Laban.[4] He also believed that participation in a movement choir would lead to a better appreciation of theatre dance.

Man's photo, probably taken on assignment for a German illustrated newspaper or magazine, captures the dynamism of the movement of the group and their joy, even their ecstasy. Man was one of the most celebrated photojournalists of the twentieth century. In 1929 he began working for Berlin's DEPHOT news agency and, in the same year, his work began appearing in the *Münchner Illustrierte Presse* (*Munich Illustrated Press*) and the *Berliner Illustrierte Zeitung* (*Berlin Illustrated Newspaper*) (see cats 255, 256).[5] CW

1 A pencil inscription on the back reads 'Labangruppe'. Laban's key text on this subject is 'Vom Sinn der Bewegungschöre', first published in the physical culture magazine, *Die Schönheit*, vol.22, no.1 (1926), pp.84–91; also in the dance magazine (which championed Laban's work) *Schrifttanz*, vol.3, no.2 (June 1930), pp.25–6. See also Vera Maltic, *Body-Space-Expression, the Development of Rudolf Laban's Movement and Dance Concepts*

(Berlin, 1987), pp.14–15, 17, and John Hodgson and Valerie Preston-Dunlop, *Rudolf Laban* (Plymouth, 1990), pp.43–7, 128–9.
2 Rudolf Laban quoted in Karl Toepfer, *Empire of Ecstasy: Nudity and Movement in German Body Culture, 1910–1935* (Berkeley, 1997), pp.312–13.
3 Rudolf Laban, 'Das Tänzerische Kunstwerk', *Die Tat* (November 1927), pp.588–91, quoted in Maltic (1987), p.10.
4 Rudolf Laban, *A Life for Dance* (London [1935], 1975), pp.142–51, 184.
5 Felix H. Man (exh. cat., National Book League/Goethe Institute, London, 1977).

173a Plate 7.14

Photograph: *Kamergymnastiek* (Home Gymnastics)
1930
Piet Zwart
(1885 Zaandijk, The Netherlands – 1977 Wassenaar, The Netherlands)

Gelatin silver print with applied paint and paper
27.3 × 17cm
Collection of Gemeentemuseum, Den Haag
The Hague, The Netherlands (TEK 1970-0456)

173b Plate 7.15

Cover design: *Kamergymnastiek voor iedereen in 10 Lessen* (*Home Gymnastics for everyone in 10 lessons*) by **Dr W.P. Hubert van Blijenburgh**
1930, published by W.L. & J. Brusse, Rotterdam
Designed by Piet Zwart
(1885 Zaandijk –1977 Wassenaar)

Coloured pencil on paper and cardboard, with applied paper
25 × 17cm
Collection of Gemeentemuseum, Den Haag
The Hague, The Netherlands (TEK 1970-0457)

Books on exercise for the individual became increasingly common during the inter-war period. Zwart's cover was designed for a book by a former Olympic fencing champion who wrote six popular titles on exercise and fitness for Brusse publishers.[1] They commissioned Zwart to design the cover and binding for van Blijenburgh's book, though not its inside pages.

By 1930 Zwart was already a distinguished graphic designer closely associated with international avant-garde circles.[2] He had made use of photograms (his own) and photomontage (using photographs taken by others) in his published graphic designs, but it was not until 1929 that he turned seriously to photography.[3] It was Zwart's visits to the Pressa exhibition (Cologne, 1928, see pl.10.2) and, especially, his involvement with the *Film und Foto* exhibition (Stuttgart, 1929, see cat.131), for which he organized the Dutch display, that inspired him to take a new approach towards photography. Convinced that Dutch photographic practice (including his own) was inadequate in comparison with American and German work that he saw in *Film und Foto*, he focused on greater technical proficiency as the foundation of the successful photograph. In 1929 he purchased a view camera, worked to improve his skills and then began using his photographs more actively in his graphic designs.[4] Zwart became a passionate advocate for the New Photography and for improving the state of Dutch photography through his work, teaching and occasional writing.

His cover for this book began with a series of photographs taken of Dick Elffers (1910–1990), who also, in turn, took views of Zwart.[5] In the image finally chosen, Zwart tilted his camera to obtain a diagonal viewpoint and, within that, the angles of Elffers's body play against those of the window. The photograph exhibited shows Zwart's first steps at turning the photograph into the cover, painting onto it blocks of white that would carry the publication details. In the cover mock-up, the different elements of the composition were traced onto paper. The image of Elffers was overlaid with a detail of one of the large exercise charts inserted into the back of the book (but not designed by Zwart), and the colours were added. The differing angles of the chart, of the title information and of the photograph create a design full of movement and a sense of space, qualities that came into sharper focus in the published cover, where the distinctions between type and photograph were much clearer than in the design drawing. CW

1 See *W.L. & J. Brusse's Uitgeversmaatschappij 1903–1965* (Rotterdam, 1963). Hubert van Blijenburgh fenced for Holland in numerous Olympic Games between 1906 and 1924, winning medals in 1912 (in two events) and 1920. He was the US men's sabre-fencing champion in 1914. See http://www.olympic.org/uk/athletes and www.hickoksports.com/history/usfencing champs.shtml (consulted 27 May 2005)
2 He knew El Lissitzky, Jan Tschichold and Kurt Schwitters, among others, and the last-named eventually convinced him to join *der ring neue werbegestalter* (Circle of New Advertising Designers, see cats 126, 132) in 1928.
3 Zwart had created photograms as early as 1925 and one was published by Jan Tschichold in his *Die Neue Typographie* (1928, see cat.125), but Zwart was not much enamoured of the form. For Zwart's photographic career, see Flip Bool et al. (eds), *Piet Zwart [1885–1977]* (Amsterdam, 1996).
4 In Piet Zwart, 'De Fifo te Stuttgart', *Het Vaderland* (9 July 1929), trans. in Bool et al. (1996), p.157.
5 Elffers assisted Zwart on numerous projects. He would later become a highly successful and renowned designer in his own right.

174 Plate 7.1

Photograph: *Sun-Lovers*
1932
Alexander Rodchenko
(1891 St Petersburg–1956 Moscow)

Gelatin silver print
37.4 × 23.4cm
Private Collection

Surprising though it may seem today, organized physical exercise was a feature of leading art schools during the inter-war period (see cat.198). This photograph is one of a series that Rodchenko made of students taking morning exercises on the roof of a newly built (1929–30) student hostel in eastern Moscow.[1] The roof was designed for such use and the building also housed a swimming pool. The students photographed studied design or art in the successor institutions to the VKhUTEMAS (closed 1927, cat.7), where Rodchenko had taught photography. The figure in the foreground can be identified as Alexander Kokorin, who became a well-known poster designer.

Taken by Rodchenko with a Leica (pl.11.7) fitted with a 50mm lens, the angle of the shot is characteristically from below, a viewpoint by then much associated with the photographer, and which in this case emphasizes the upward stretches of the students. Rodchenko was highly conscious of the compositional role of geometry in his photographs. In a series of lectures for photojournalists given in 1931, he explained very precisely the ways in which photographs could be based on pyramids, diagonals, circles, crosses, etc.[2] The pyramidal or triangular composition of the figures in this image was, accordingly, carefully created by the photographer's viewpoint; it was achieved only by having the central figure block the view of another student behind him. Indeed, as other photographs show nine students exercising, he may have omitted some from this particular shot. This emphasis on formal qualities was part of Rodchenko's effort to ensure that photography was perceived as art, a task he devoted himself to with considerable energy and at some risk to himself during the Stalin era (see cat.202). CW

1 On the series, see Alexander Lavrentiev, *Alexander Rodchenko. Photography 1924–1954* (New York, 1996), pp.248–53, though this image is not reproduced. Additional information generously provided by Mr Lavrentiev. The building was designed by Boris Gladkov, Alexeir Zalzman and Pavel Blokhin.
2 'Programme on Composition. Lectures', *Sojuzfoto* (May 1931), Lavrentiev (1996), pp.27–8.

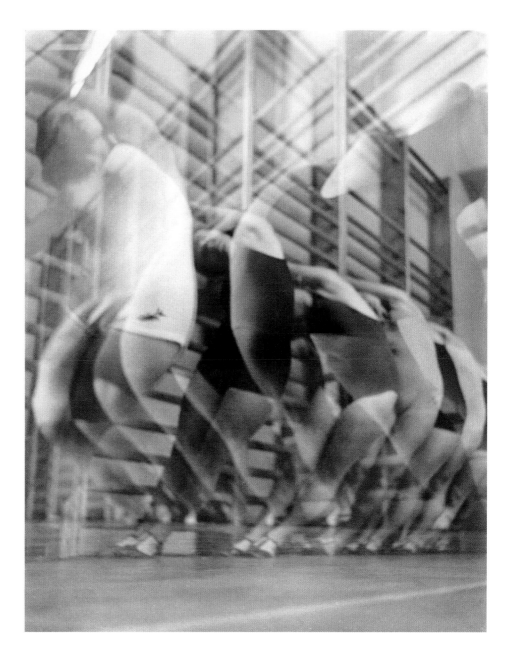

175

Photograph: *Swedish Ladder*
Václav Jírů (1910 Doubravany,
Czechoslovakia–1980 Prague)
1929

Gelatin silver print
37.7 × 29.8cm
Union of Czech Photographers, Prague

Though Jírů took this photograph the year after
he graduated from Prague High School, he had
already embarked on a career as a photojournalist
and, from 1928, was working for the Prague
Chamber of Commerce.[1] This image, which
depicts a dance or exercise class working at
a Swedish ladder in Prague, was taken with a
Rolleiflex.[2] It was created in the darkroom by

using two different negatives. The image is
given a sense of abstraction by the overlay of
the different shots and by the lack of sharp
focus. Jírů uses the repetition of the forms of the
women and of the ladder to construct a dynamic
composition. Healthy body culture was such a
common part of Czechoslovak life (see cat.176)
that Jírů took many images of people engaged
in exercise and sport.[3]

Swedish systems of exercise had enjoyed great
popularity, beginning in the nineteenth century
through the influence of the teachings of Per
Henrik Ling (1776–1838), the 'inventor' of Swedish
gymnastics.[4] The history of the Swedish ladder
is elusive, though vertical ladders were used by
German *Turners* for exercise during Ling's life-
time. The Swedish ladder may well have been
developed and named towards the end of the
century and was in widespread use in the early
twentieth century. CW

1 One of his photographs was published in 1927, while he was
 still at school. For information on Jírů, see Michele and Michel
 Auer, *Encyclopédie internationale des photographes des débuts
 à nos jours* (Neuchâtel, 1997, digital publication), n.p. Further
 information generously supplied by Jiri Jírů.
2 See Vladimír Birgus, *Czech Photographic Avant-Garde*
 (Cambridge, MA, 2002), pp.146 (image), 296 (biography).
3 For example, ibid., p.147; other examples are in the possession
 of Jiri Jírů
4 See Gertrud Pfister, 'Cultural Confrontations: German *Turnen*,
 Swedish Gymnastics and English Sport – European Diversity in
 Physical Activities from a Historical Perspective', *Culture, Sport,
 Society*, vol.6, no.1 (Spring 2003), pp.68–70ff. and n.25; and Jens
 Ljunggren, 'The Masculine Road Through Modernity: Ling
 Gymnastics and Male Socialization in 19th Century Sweden', in
 J.A. Mangan (ed.), *Making European Masculinities. Sport, Europe,
 Gender* (London, 2000), pp.86–111.

176

**Exhibition panel with cover for *Žijeme*
(*We Live*) magazine**
1931
Ladislav Sutnar (1897 Pilsen, Bohemia –
1976 New York)

Mounted magazine cover mounted on board
59.5 × 41cm
The Museum of Decorative Arts, Prague (GS 19213/20)

This is both an example of one of Sutnar's covers
for an important magazine of the inter-war period
and one of a series of panels designed for a
retrospective exhibition of the designer's work
held in 1934. *Žijeme* was what might today be
called a 'lifestyle' magazine. It was published for
only 19 months from April 1931 by the Czechoslovak
Arts & Crafts Association, a crucially important
organization in the spread of Modernism in
Czechoslovakia, whose name belied its interest in
the mass production of household goods. Along
with the group's many exhibitions – including the
Baba Colony Housing Exhibition of 1932 – the
magazine was a key means of promoting that
organization's embrace of 'modern living'.[1] An
advertisement for the magazine stated that 'Its
function is to promote the modern way of living
with all its beauty ... as the new ways of life need
nurturing, the subscribers will become endorsers
and apostles of the modern lifestyle governed by
beauty and function'.[2] Sutnar not only designed
the magazine, but was its co-editor, and the
magazine served also to promote the activities
of the Krásná jizba (Beautiful Household) shop
and gallery (see cats 242–4).

 Žijeme's interest in healthy living as an
integral part of the interior was reflected in this
photomontaged cover. The strength and clean
lines of the gymnasts are compared to those of
the Breuer tubular-steel chair. The 'frames' of
bodies and chair are minimally and similarly
clothed. The combination of colour, typography
and photography results in a dynamic composition
that associates free movement and modern
design, an optimistic image of life in the modern
world.

 This exhibition panel was one of more than 64
panels made for an exhibition of Sutnar's work at
Krásná jizba, which were bought in their entirety
by the Czechoslovak Popular Education Ministry,
apparently with the intent of circulation.[3] CW

1 See Iva Janáková, 'In the Community of the Czechoslovak Arts
 & Crafts Association', in *Ladislav Sutnar: Prague. New York.
 Design in Action* (Prague, 2003), pp.96–101. See also the entry
 under 'Chronology' for April 1931, p.370.
2 Jan Rous, 'Living! – Design as a New Lifestyle Medium', in
 ibid., p.309.
3 See Iva Janáková, 'Exhibition Design', in ibid., p.326, and
 56 examples of the panels illustrated on pp.152–9.

177 Plate 7.3

Poster: *Hygiene Ausstellung Dresden 1930*
(*Hygiene Exhibition, Dresden*)
1928
Willy Petzold (1885 Mainz–1978 Dresden)

Offsett lithograph
118.5 × 89cm
Merrill C. Berman Collection

This poster advertises the 2nd International Hygiene Exhibition in Dresden, though the use of the eye motif harks back to Franz von Stuck's poster, created for the first such exhibition in 1911.[1] The eye originally represented 'the shining eye of God', a symbol of the Trinity and also of Masonry. It was chosen as a motif by the sponsor of the 1911 exhibition, Karl August Lingner (1861–1916), owner of the Odol mouthwash and toothpaste company.[2] Through the clever use of advertising and packaging, Lingner had created one of the most successful and identifiable brand names of the early twentieth century and the longevity of the eye was entirely due to him.

By 1930, however, the eye may have been less connected to the Trinity or to Masonry and more associated with the idea of an all-seeing eye that could discover and uncover hidden secrets of the human body and of biology. This, indeed, was one of the leitmotifs of the 1930 exhibition, which coincided with the opening of the new Hygiene Museum and featured, among other things, the 'Transparent Man', the most famous and influential object in the exhibition (see pl.10.16).[3] More than three million visitors attended the Hygiene Exhibition between May and October 1930.[4] It was described as *eine Volkshochschule für Jedermann* (an adult education centre for everyone). The exhibition included spaces devoted to science, industry, sports clubs, health spas and insurance societies, and a prototype house, hospital and hygienic farmyard. So popular was the exhibition that, in 1931, it was opened again for a number of months. CW

1 Von Stuck poster illustrated in Klaus Vogel, *Das Deutsche Hygiene-Museum Dresden 1911–1990* (Dresden, 2003), p.42.
2 On Lingner and the early history of the Hygiene Museum, see the brief accounts in Paul Weindling, *Health, Race and German Politics Between National Unification and Nazism 1870–1945* (Cambridge, 1989), pp.228–30, and Vogel (2003), p.42.
3 Rosemarie Beier and Martin Roth (eds), *Der gläserne Mensch – eine Sensation, Zur Kulturgeschichte eines Ausstellungsobjektes* (Stuttgart, 1990).
4 On the exhibition, see Vogel (2003), p.85, and *Internationaler Hygieneausstellung Dresden 1930: Amtlicher Führer* (Dresden, 1930). Compared to the GE SO LEI (*Gesundheit, soziale Fürsorge und Leibesübungen* or Health, Welfare and Exercise) exhibition held in Düsseldorf in 1926 (organized largely by the Dresden Hygiene Museum), which has been the subject of numerous articles and books, the Dresden exhibition has received relatively little attention.

178 Plate 7.10

Collage: *Brno Town Baths*
1929
Bohuslav Fuchs (1895 Všechovice,
Moravia–1972 Brno, Czechoslovakia)

Gelatin silver prints, ink and paint on paper
53.2 × 53.2cm
Brno City Museum

The collage was possibly part of a series of presentation panels related to Fuchs's entry for the competition to design the municipal baths for Brno.[1] Its only other possible function might have been as a design for a poster. The selection of images seems less likely and appealing than would have been images of the enormous outdoor swimming pool with its concrete diving-board structure, which formed the centrepiece of the project. The collage emphasized the modern technology and hygiene of the new facility, with its illustration of a boiler room, plumbing fixtures and tubular-steel furniture. The blue and red bars of colour on the left, combined with the white background, refer to the Czechoslovak flag. The use of photo-collage for architectural presentations was common in Modernist Czechoslovak architecture of the period and emphasized the modernity of the Brno Baths project. The impressive 17,000 square metre grouping of buildings was constructed with reinforced concrete frames.[2] The frame was exposed in the outdoor elements of the building – including the diving boards and two storeys of changing rooms, surrounded by elevated walkways – and infilled with brick for the sections that were enclosed.

Brno was Czechoslovakia's second city (after Prague), which for Karel Teige, 'meant the most' to Czechoslovak Modernism.[3] It experienced remarkable growth and architectural activity in a country that adopted Modernist architecture as symbolic of the aspirations of the young republic (see cat.129). Fuchs was the leading Modernist architect in Brno in the inter-war years. He worked in the architecture office of the Muncipal Building Department from 1923, becoming city architect in 1925, before moving back to private practice in 1929.[4] Teige described Fuchs as being 'in the vanguard of Brno activities' when he published drawings for the Brno baths along with other Fuchs buildings, pointing out not only the number of opportunities Fuchs had had to build, but also how his projects had not been subject to 'dangerous compromises'. CW

1 Although this collage has been published, its purpose is rarely discussed; see, for example, *El Arte de la Vanguardia en Checoslovaquia 1918–1939* (exh. cat., IVAM Centre Julio González, Valencia, 1993), p.240. Drawings from the entry are published in Karel Teige, 'moderni architektura v československu', in *Mezinárodni soudobá architektura*, no.2 (1930), reprinted as *Modern Architecture in Czechoslovakia* (Los Angeles, 2000), p.246. The building is published in Zdeněk Kudělka and Jindřich Chartný, *For New Brno, the Architecture of Brno 1919–1939* (Brno, 2000), vol.II, pp.239–41, where it is dated 1929–31. Iloš Crhonek, *Architekt Bohuslav Fuchs* (Brno, 1995), writes that it was built in 1931–2.
2 See Kudělka and Chartný (2000), vol.II, pp.239–41.
3 Teige ([1930] 2000), p.236 for the quotations in this paragraph.
4 On Fuchs, see Crhonek (1995). A biography of Fuchs is published in Kudělka and Chartný (2000), vol.I, pp.78–81.

179a and **179b**

From the series *Sociologický fragment bydlení* (*The Sociological Fragments of Living*):
Plate 43 *Body Hygiene*
Plate 50 *People without Clothing: Natural Nakedness*
1930–32
Jiří Kroha (1893 Prague –1974 Brno, Czechoslovakia)

Collage on cardboard
Each panel 69 × 99cm
Brno City Museum (261.895 and 261.897)

The architect Kroha and many of his Czechoslovak colleagues advocated not only a new type of architecture and design, but a new approach to life. To them, architecture had to be rooted in a fundamental transformation of society, one that would create – especially through social housing – a more equitable society. In an ambitious series of 89 panels created as part of his teaching of architecture and town planning at the Technical College in Brno, but intended also for public exhibition, Kroha put forth his broad view of the constituent elements of society that most directly affected daily life.

By 'Sociological Fragment' Kroha meant 'a visual representation of the most important circumstances which determine today's living conditions', with particular reference to the family and the household.[1] He aimed to make the public aware of 'the different factors which influence the individual, and the various processes that are carried out by him'. Though political views among Modernist architects were anything but uniform, there was a broad, left-leaning consensus reflected in the anti-capitalist, collectivist rhetoric that was employed. In *Sociological Fragments* he argued that the ultimate aim of 'a new and healthy way of life' must be grounded in 'the economic realities of living today' and overcoming 'the contradictions of a planned economy'.

Both panels are composed of illustrations from contemporary books and magazines.[2] The 'Body Hygiene' panel, like many in the series, illustrates examples of practice by separate columns of working-, middle- and upper-class people. The text on that panel defines hygiene as 'taking care of health, the combination of treatments . . . [to] protect . . . the external organs [from] the possible damage from the dirt with which they come into contact', and defines washing as 'the chemical

and mechanical removal of dirt from the skin . . . the medium through which the body communicates with the outside world'. The development of washing apparatuses, from basic to sophisticated, is shown at the top of the panel. Hygiene is depicted as part of the life of everyone in the family, leading to happiness.

'People without Clothing' illustrates different approaches to nudity. The captions to the top row read (from left to right, in translation): 'nudity as necessary evil'; 'femininity'; 'nudity as sporting attire'; and 'ruins of wealth/prosperity'. The bottom row reads: 'nudity as festive attire'; 'nudity as the pride of beauty'; 'the woman as model'; and 'nudity as the magic of the sexes'. As was typical of Central and Northern European culture, nudity was portrayed as positive and health-giving, part of everyday life. Indeed, the only clothed figures on the panel are the nun looking at the draped medieval sculpture and the Nike of Samothrace.

Kroha was a successful architect known, in his early years, for his work in the Czech Cubist style and, in the 1930s, for his Modernist work, mainly in Brno. He designed for the celebrated New House housing-estate exhibition and the Exhibition of Contemporary Culture (both in Brno, 1927–8), as well as his own house in Brno (1928–9, much published at the time) and the Czechoslovak *Werkbund*'s Baba model housing estate outside Prague (1930–31).[3] Some of these buildings and, indeed, his conversion to Modernism were the subject of a typically stinging attack from Karel Teige in 1930, who accused Kroha of misunderstanding and romanticizing the new architecture, as well as 'personal arbitrariness of form entirely alien to rational architectural conception'.[4] Mart Stam, however, during a visit to Brno met Kroha and is said to have expressed interest in his *Sociological Fragments of Living*.[5] CW

1 *Sociologický fragment bydlení* [*The Sociological Fragments of Living*], flyer for the exhibition at the Palais Clam-Gallas, Prague, 11 March–1 April 1934 (Prague, 1934), n.p., as quoted in *Jiří Kroha 1893–1974* (exh. cat., Architektur Zentrum, Vienna, 1998), p.72, the source for all quotations in this paragraph.
2 For example, the group of men emerging from the water at the top edge of the 'People without Clothing' panel is cut from Hans Surén, *Der Mensch und die Sonne* (Stuttgart, 1924).
3 See *Jiří Kroha* (1998), pp.53–5; and Zdeněk Kudělka and Jindřich Chartný, *For New Brno, the Architecture of Brno 1919–1939* (Brno, 2000), vol.II, pp.156, 161, 181–2, 224–6.
4 Karel Teige, 'moderní architektura v československu', in *Mezinárodní soudobá architektura*, no.2 (1930), reprinted as *Modern Architecture in Czechoslovakia* (Los Angeles, 2000), p.262.
5 See Eric Dluhosch and Rostislav Švácha (eds), *Karel Teige 1900–1951* (Cambridge, MA, 1999), p.241.

HYGIENA TĚLA

HYGIENA JE PÉČE O ZDRAVÍ,
SOUHRN ÚKONŮ, JIMIŽ REGULU-
JEME FUNKCE HLAVNĚ POVR-
CHOVÝCH ORGÁNŮ A ŠKODLIVÝ
VLIV NEČISTOTY JEŽ JIMI PRO-
CHÁZÍ

MYTÍ JEST CHEMICKÉ A ME-
CHANICKÉ ODSTRAŇOVÁNÍ NEČI-
STOTY S POKOŽKY JIMŽ SE U-
VOLŇUJÍ PRŮCHODY KTERÝMI TĚ-
LO KOMUNIKUJE S VNĚJŠKEM

179a

LIDÉ BEZ ŠATŮ

nahota rouchem sportovním

ruiny blahobytu

nahota nutným zlem

ŽENSTVÍ

nahota kouzlem pohlaví

nahota pýchou krásy

...hem slavnostním ŽENA MODELEM

179b

180 Plate 7.5

Photograph: Zonnestraal sanatorium

Designed by Jan Duiker (Johannes) (1890
The Hague–1935 Amsterdam), Bernard
Bijvoet (1889 Amsterdam–1979 Houten,
The Netherlands) and Jan Gerka Wiebenga
(1886 Surakarta, Indonesia–1974 The Hague)
1925–31

The Zonnestraal (Sunbeam) sanatorium in
Hilversum was built by the Diamond Workers'
Union, through a special fund aimed at providing
for the social welfare of workers in Amsterdam's
diamond industry. It was an 'after-care colony' for
members recovering from tuberculosis and respi-
ratory ailments contracted as a result of inhaling
dust while polishing diamonds.[1] Zonnestraal was
based on British models where recuperating
patients had manual work gradually reintroduced
into their lives.[2] It was a project with a carefully
thought-out brief, commissioned from the young
architects who were architectural consultants to
the Diamond Workers' Union and who had only
just, in 1924, designed a special laundry facility for
the union. The entire Zonnestraal project, from
its plan and internal organization of spaces to its
materials and methods of construction, was an

exercise in hygiene and in bringing light into the
building.

The sanatorium consisted of a central medical
and administrative building and two separate
wings with wards for recovering patients, which
radiated from it. At the top of the main building,
overlooking the entire complex, was a large,
dramatically glazed dining and recreation room,
bathed in light, above which was a roof terrace.
Each tripartite patients' wing was composed of
two long ward buildings connected by a communal
'conversation room'. All patients' rooms gave onto
a terrace running the full length of the wings and
all had unrestricted views to the outside. The
construction, done to an exceedingly tight budget,
made use of an unusually thin, reinforced-
concrete frame, cantilevered in parts, and large
plates of metal-framed glass. The structure
was whitewashed, further enhancing the literal
and metaphorical lightness of the building.
Emphasizing openness, lightness and trans-
parency, its design became a hymn to sunlight
and lived up to its name. The Zonnestraal
sanatorium became one of the most photo-
graphed and published of Modernist buildings. CW

1 On Zonnestraal, see Jan Molema and Wessel de Jonge, '
 Johannes Duiker', *Architectural Review*, vol.177, no.1055 (January
 1985), pp.50–53; Peter Bak et al., *J. Duiker bouwkundig ingenieur*
 (Rotterdam, 1982), pp.88–143; Ronald Zoetbrood, *Jan Duiker en
 het sanatorium Zonnestraal* (Amsterdam, 1985); Ton Idsinga,
 Zonnestraal (Amsterdam, 1986); and Paul Overy, 'Zonnestraal:

Modernism in Ruins', in the same writer's *Modernism* (London,
forthcoming), generously shared by the author.
2 D. van Werkom, M. Bock and A de Groot, *Het Nieuwe Bouwen:
 Voorgeschiedenis/Previous History* (Delft, 1982), p.147. On British
 examples, see Linda Bryder, *Below the Magic Mountain, A Social
 History of Tuberculosis in Twentieth-Century Britain* (Oxford, 1988),
 pp.54–67. She also cites (p.50) Frimley sanatorium as an example
 of a 'radial pavilion' design.

181 Plate 7.4

Photograph: Lovell 'Health' House
1927–9

Designed by Richard Neutra
(1892 Vienna–1970 Wuppertal, Germany)

Rarely can there have been clients more
concerned with creating architecture for
health than Philip and Leah Lovell who, in 1928,
commissioned Viennese émigré Neutra to design
a luxurious house in the Hollywood Hills.[1] Philip
Lovell was a naturopath, founder of the Lovell
Physical Culture Center in Los Angeles and author
of a *Los Angeles Times* column entitled 'Care of the
Body'. The Lovells were part of a progressive and
free-thinking Los Angeles community interested
in art, architecture and radical thinking in all fields.
Neutra, his wife Leah, as well as the architect
Rudolf Schindler (who had built three houses
for Lovell) and his wife Pauline, were part of
that circle.[2]

Philip Lovell described himself as giving
Neutra a free hand in the design of the house, as
long as the building included what he described
as his 'idiosyncrasies'. These included spaces
for exercise and healthy living ('rooms for body
culture', as described in *Das Neue Frankfurt*),

among them a swimming pool, a gym area in the
garden and protected areas for nude sunbathing.[3]
Within the house were special outdoor sleeping
porches for the Lovells and their children, and a
kitchen fitted with especially large surfaces and
plumbing equipment to enable the cook to cater
to the strict vegetarian diet of the household.
Easy-to-clean, largely industrial materials that
were thought to be hygienic were used through-
out, including tubular-steel seating, painted
walls and furniture, and headlight lamps from
automobiles fixed above the main staircase.
The steel-framed construction (see Chapter 9)
allowed for large areas of glass, 'permeable to
the vital ultra-violet rays'.[4]

Designing for healthy living was made easier
by the Southern California climate and the large
budget of the clients. Los Angeles was also the
ideal location for Neutra to realize his view that
'the open air has a dominant place in the contem-
porary conception of building'.[5] The house was
dubbed by Neutra the 'Demonstration Health
House', a name that assumed a public dimension
when Lovell opened the house to readers of his
newspaper column: 15,000 visited. CW

1 For this commission, see Thomas S. Hines, *Richard Neutra and
 the Search for Modern Architecture* (Oxford, 1982), pp.75–91, based
 also on interviews with Philip Lovell.
2 See ibid., and Robert Sweeney, 'Life at Kings Road: As It was,
 1920–1940', in Elizabeth A.T. Smith and Michael Darling, *The*

Architecture of R.M. Schindler (exh. cat., Museum of Contemporary
Art, Los Angeles, 2001), esp. pp.100–109. Leah Neutra established
a progressive kindergarten together with Pauline Schindler. The
interest in body culture was demonstrated by performances at
the Schindler house by expressive dancer John Bovingdon, who
in 1928–30 performed a series entitled 'the New Dance being
experiments toward a life dance rooted in hygiene'.
3 The caption 'Halle für Körperkultur' appeared in the article
 'Amerika, Körperübung und gegenwärtige Bauarbeit', in
 Das Neue Frankfurt, vol.2 (May 1928), p.91.
4 Richard Neutra, 'Aesthetics and the Open Air', *The Studio*,
 vol.99 (1930), p.79.
5 Ibid., p.82.

182a Plate 7.6

Photograph: Patients' wing, Varsinais-Suomi sanatorium, Paimio, Finland
1928–33
Designed by Alvar Aalto (1898 Kuortane, Finland–1976 Helsinki)

182b Plate 7.7

Photograph: Roof terrace, patients' wing
1933
Designed by Alvar Aalto (1898 Kuortane–1976 Helsinki)

Though Aalto's sanatorium in Paimio is today the best-known and most-published Modernist sanatorium, it derives from Duiker, Bijvoet and Wiebenga's Zonnestraal project (pl.7.5).[1] Like the latter, which Aalto visited, the design of the Finnish sanatorium separates the building according to functional use. Its overall plan is modelled on the Zonnestraal's patients' wings, where two long wards were set at 45-degree angles to one another and connected by a communal area. Aalto devoted only one, much taller wing to patients' rooms and connected this to a central building for treatment, dining and other common spaces. Behind this were smaller service wings. Unlike the Dutch example, where sun terraces opened directly off the patients' rooms, here Aalto appended to the patients' building a series of south-facing, long, 'lying hall' solariums or terraces angled from the end of each floor and supported by an asymmetric concrete frame.[2] At the other end of the patients' wing he inserted a dramatic glazed lift of startling originality.

Aalto's design embraced established medical conventions that emphasized the curative power of light, fresh air, good diet and a hygienic environment (see Chapter 7). He was, however, also deeply interested in the therapeutic value of colour, as well as in marshalling every element of his design to encourage patient recovery.[3] Aalto's office designed all aspects of the sanatorium's interiors, from balustrades and door handles to furniture and lighting fixtures. 'The main purpose of the building', he wrote:

is to function as a medical instrument . . . one of the basic prerequisites for healing is to provide complete peace . . . The room design is determined by the depleted strength of the patient, reclining in his bed. The colour of the ceiling [sky blue] is chosen for quietness, the light sources are outside the patient's field of vision, the heating is oriented towards the patient's feet, and the water runs soundlessly from the taps to make sure that no patient disturbs his neighbour'.[4] cw

1 The influence of Zonnestraal is set out in Paul David Pearson, *Alvar Aalto and the International Style* (New York, 1978), pp.84–8. Aalto began work on a competition entry for the sanatorium in November 1928 and submitted designs in January 1929. Construction began that year and was completed in 1933.
2 The building was built in concrete, but, owing to the severe weather, brick infill and much less glazing was used than was possible at Zonnestraal; see ibid. The quotation is from P. Moton Shand, 'A Tuberculosis Sanatorium. Finland', *Architectural Review*, vol.74 (September 1933), p.87.
3 The interiors were painted in soft blue, grey, yellow and white. Details of the interior and the therapeutic programme are little discussed in the literature, though it has figured in the well-illustrated website created by the Alvar Aalto Foundation, 'Alvar Aalto Paimio Sanatorium 1928–1933', www.alvaraalto.fi/alvar/buildings/paimio/paimio.html (consulted 27 May 2005)
4 Quoted from the manuscript of a 1956 lecture in Göran Schildt, *Alvar Aalto, The Complete Catalogue of Architecture, Design and Art* (London, 1994), p.69.

183 Plate 7.9

Drawing: *Open Air School for Healthy Children, Amsterdam*
1929–30
Jan Duiker (Johannes) (1890 The Hague–1935 Amsterdam) and Bernard Bijvoet (1889 Amsterdam–1979 Houten, The Netherlands)

Pencil on paper
43.5 × 53cm
Nederlands Architectuur Instituut, Rotterdam
(no.57, Folder 128)

At the beginning of the twentieth century the development of open-air schools spread across many European countries as well as North America. They combined the notion of healthy open-air culture and the educational tenets of liberal school reforms with new architectural ideas that favoured open plans with large window areas and terraces. In the Netherlands the open-air school was promoted in the 1920s as a new social and architectural category, largely as the result of advances in the treatment of tuberculosis in children.[1]

The Zonnestraal sanatorium in Hilversum (cat.180), provided the conceptual template for the Amsterdam school. The spatial arrangement of facilities and the therapeutic principles employed here were conceived together and demonstrated how innovations in hygiene, education and building techniques could be brought together to create what has been described as a 'modern cultural form'.[2] The city-centre school, which rose vertically to allow maximum exposure to light and air, contrasted with the horizontality of the sanatorium. The drawing of the school clearly emphasizes the spatial constraints of the setting, but also signals its engineered solution. Duiker and his partner Bijvoet positioned the school block diagonally to the surrounding buildings in order to maximize exposure of the window areas, placed the staircase at the back and turned the three balconies, which make up one quarter of the square ground plan, towards the open schoolyard and front gate.[3] The movable chairs and desks in the classrooms were positioned diagonally within the plan so that the dynamic configuration would echo the early open-air schools, where lessons at times took place wholly out of doors. Pupils at the city school would thus not sit directly alongside the window panes, which were also raised above desk height so that, when opened, no direct draught would hit the children. UL

1 See Dolf Broekhuizen, *Openluchtscholen in Nederland: Architectuur, onderwijs en gezondheidszorg 1905–2005* (Rotterdam, 2005).
2 Ed Taverne and Dolf Broekhuizen, 'Clio Revisited. Doctors, Teachers and Open-Air Schools in the Netherlands (1905–1931)', in Anne-Marie Châtelet et al. (eds), *L'École de plein air* (Paris, 2003), p.109.
3 See Peter Bak et al. (eds), *J. Duiker: Bouwkundig Ingenieur* (Rotterdam, 1982), pp.148–67.

184

Perspective drawing: Communal room of a High-Rise Apartment building, view of bar from pool, German Section, Salon of the Société des Artistes décorateurs, Paris
1930
Designed by Walter Gropius (1883 Berlin–1969 Boston), drawing by Herbert Bayer (1900 Haag, Austria–1985 Santa Barbara, USA)

Pencil and tempera
55.3 × 48.2cm
Busch-Reisinger-Museum, Harvard University Art Museums, Gift of Walter Gropius (BRGA 45.2)

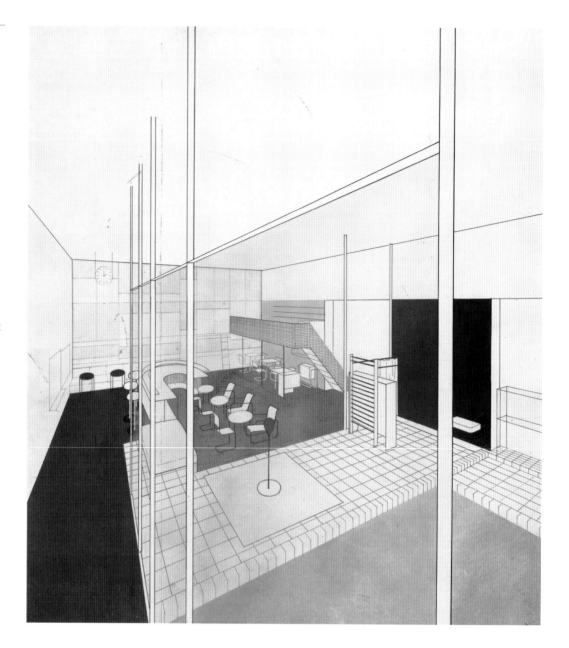

Spaces and facilities devoted to health, including sport and exercise, became common in Modernist architectural projects of the inter-war years. Private houses and flats were often fitted with gym rooms, or at least with equipment such as punch bags or exercise bars; social housing included outdoor spaces for sport and swimming pools for adults and children; and factories and offices offered football pitches or even squash courts for their workers (pl.3.8).[1] Sports facilities were a central feature in interiors created for exhibitions, including the communal spaces for a proposed tall apartment building designed by Gropius, depicted in this drawing and mocked-up at the Paris salon.[2] Taking up much of the space in this section of the exhibition, the facilities consisted of a swimming pool and a gymnasium area with punch bag, a 'Swedish ladder', rings and an exercise area.

The 1930 *Salon* was a momentous event in terms of the presentation of German design in France. It marked the first time that Germans had been allowed to exhibit in Paris since the First World War. Organized by the *Deutscher Werkbund*, the display featured the spaces from Gropius's apartment block, with some rooms designed by Marcel Breuer. It also included a lesser-known area designed by Bayer and László Moholy-Nagy featuring displays of furniture, furnishings, fashion, architectural photographs and theatre designs, the last-named by Moholy-Nagy and Oskar Schlemmer.[3] Although Gropius, Breuer, Bayer and Moholy-Nagy had all left the Bauhaus by 1928 and the ethos of the school had since changed, this exhibition was presented and reviewed by some as if it were a Bauhaus show.[4]

The exhibition of the communal space provoked a great deal of French press attention, much of it hostile. The uncompromising style of the displays was seen as analogous with German authoritarianism, as lacking 'sensibility' and very much in contrast to the French exhibitions in the other sections of the Salon.[5] cw

1 For a brief consideration of this subject, see Andreas K. Vetter, *Die Befreiung des Wohnens* (Berlin, 1996), pp.263–76.
2 On the project, see Paul Overy, 'Visions of the Future and the Immediate Past: The Werkbund Exhibition, Paris, 1930', in *Journal of Design History*, vol.17, no.4 (2004), pp.337–57, which rightly restores Gropius's project to the centre of discussion; also the special issue of *Die Form*, vol.6, no.11–12 (7 June 1930).
3 This part of the display was not, in relative terms, much published. The Busch-Reisinger Museum holds a large collection of photographs of the exhibition, including unaccessioned images.
4 Overy (2004), pp.337–8.
5 From reviews in *Art et décoration* (André Salmon), *L'Opinion* (Henri Clouzot) and *Journal des Débats* (Paul Fierens), all excerpted in Matthias Noel, 'Zwischen Krankenhaus und Mönchszelle: "Le nouveau visage de l'Allemagne" – Die Werkbund-Ausstellung 1930 im Spiegel der Französischen Tagespresse', in Isabelle Ewig, Thomas W. Gaehtgens and Matthias Noel, *Das Bauhaus und Frankreich 1919–1940* (Berlin, 2002), pp.313–46.

185a

Drawing: *Stadium Feijenoord*
1934–6

Johannes Brinkman (1902 Rotterdam –
1945 Rotterdam) and Leendart Cornelis van
der Vlugt (1894 Rotterdam–1936 Rotterdam)

Ink, white pencil on photographic paper
26.9 × 39.3cm
Nederlands Architectuur Instituut, Rotterdam
(Folder Box 290T)

185b

Drawing: *Stadium Feijenoord*
1934–6

Johannes Brinkman (1902 Rotterdam–
1945 Rotterdam) and Leendart Cornelis van
der Vlugt (1894 Rotterdam–1936 Rotterdam)

Pencil and coloured pencil on paper
29.5 × 35.2cm
Nederlands Architectuur Instituut, Rotterdam
(Folder Box 290T)

During the inter-war period stadia were built
at an ever increasing rate, owing to greater
participation in amateur sport and the growth in
attendance at the Olympic Games and at commer-
cial sporting events, especially football. Two
architecturally significant stadia were built in the
Netherlands at this time: the Olympic Stadium in
Amsterdam (designed by Jan Wils, and built for
the 1928 Summer Olympics) and the Feijenoord
football ground. The positive economic impact
of the Amsterdam stadium inspired a group of
Rotterdam businessmen to work with city authori-
ties to build a new stadium for the city's main
football team, RV & AV (Football and Athletic Club)

Feijenoord Rotterdam. The Feijenoord stadium
was a relief project in the south Rotterdam docks
area during a period of high unemployment.[1]
Celebrated local designers of the Van Nelle
factory (pls 3.8, 3.9), Brinkman and Van der Vlugt,
were commissioned to design a stadium with the
unusually large capacity of 61,500. Traditional
rivalry between Holland's first and second cities
may have played a part in the ambition of the
project: rival Ajax's relatively modest De Meer
stadium in Amsterdam (architect Daan
Roodenburgh) had recently opened in 1934 with
a capacity of 22,000.[2]

Brinkman and Van der Vlugt's dramatic interior
rendering emphasizes the sweeping concrete
surfaces of the part-covered stands, and shows
the unobstructed views throughout the ground

resulting from the ingenious steel-framed design.
It illustrates why supporters referred to the
stadium as *De Kuip* (The Tub). The exterior
drawing shows the functionalist use of steel, the
unusual and extensive use of glass, and three of
the 22 stair towers that ringed the stadium, said
to allow the ground to be vacated in six minutes.
The first match was held in March 1937, and
Feijenoord became Dutch champions in the
year after the stadium opened. CW

1 Marlite Halbertma and Particia van Ulzen, *Interbellum Rotterdam,
 Kunst en culture 1918–1940* (exh. cat., Nederlands Architectuur
 Instituut, Rotterdam, 2001), pp.346–7, illustrating 185a. See
 also www.ajax-usa/com/teams/Feijenoord.html (consulted
 27 May 2005).
2 http://english.ajaz.nl/show/id=121201/nodb=true (consulted
 27 May 2005) and www.Feijenoord.com (history pages). The spelling
 of Feijenoord was internationalized to Feyenoord in 1971.

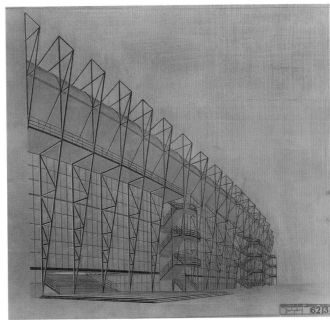

185b

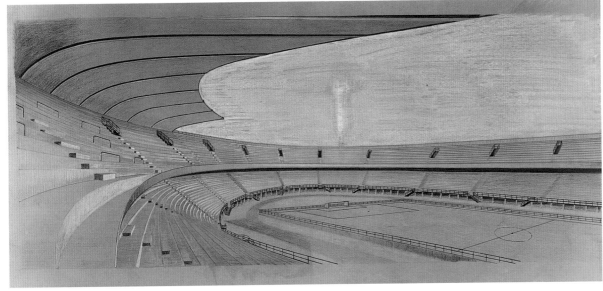

185a

186

Photograph: Finsbury Health Centre, London
1938
Designed by Tecton

Sanatoria located outside city centres were not the only means of tackling tuberculosis and other diseases resulting from poverty, lack of sunlight and poor diet during the 1930s. The local council of Finsbury, in central London, commissioned Berthold Lubetkin's Tecton group to design a novel building type a decade before the founding of Britain's National Health Service.[1] The building's function, to amalgamate the borough's health services, was somewhere between a general practitioner's surgery and a small hospital.[2] The main facilities serving the local population were a tuberculosis clinic, small wards for men and women, specialist clinics for women, dentistry and foot problems, X-ray, disinfection and cleansing departments, and a large public health section.

The architectural scheme was reminiscent of Russian Constructivist projects or Le Corbusier's Centrosoyus Administration Building (Moscow, 1929–30), though it also reflected the Beaux Arts tradition of axial planning. Its H-shaped plan enabled all the elevations to be cross-ventilated and flooded with light from both casement windows and exterior walls made of glass bricks. The lightness and airiness of the building served a practical, hygienic function, but also aimed to convince patients of the value of light and air in their own homes. This notion of the building as a vehicle for public education extended to the inclusion of a lecture theatre, and to murals and slogans in the public areas that encouraged healthy living. Bright and welcoming public spaces were furnished informally with Aalto furniture and lighting designed by Lubetkin. Along with south London's earlier and more experimental centre for preventative medicine, the Pioneer Health Centre (Owen Williams, 1933–5), Finsbury represented sophisticated architectural approaches to community health-care needs.[3] CW

1 The building was extensively published at the time; see especially, 'Health Centre for the Borough of Finsbury', *Architectural Review*, vol.85, no.506 (January 1939), pp.7–22; and 'Finsbury Health Centre', *Architect and Building News*, vol.157 (13 January 1939), pp.65–74, which includes a series of exhibition panels ('Getting It Across . . . To the Layman').

2 John Allan, *Berthold Lubetkin* (London, 1992), p.334, writes that the project 'raised the question of building typology, for which as yet no clear pattern had been established'; see pp.330–48 on the project.

3 See 'Pioneer Health Centre', *Architectural Review*, vol.77 (May 1936), pp.203–16 (including J.M. Richards, 'The Idea Behind the Idea', pp.207–16).

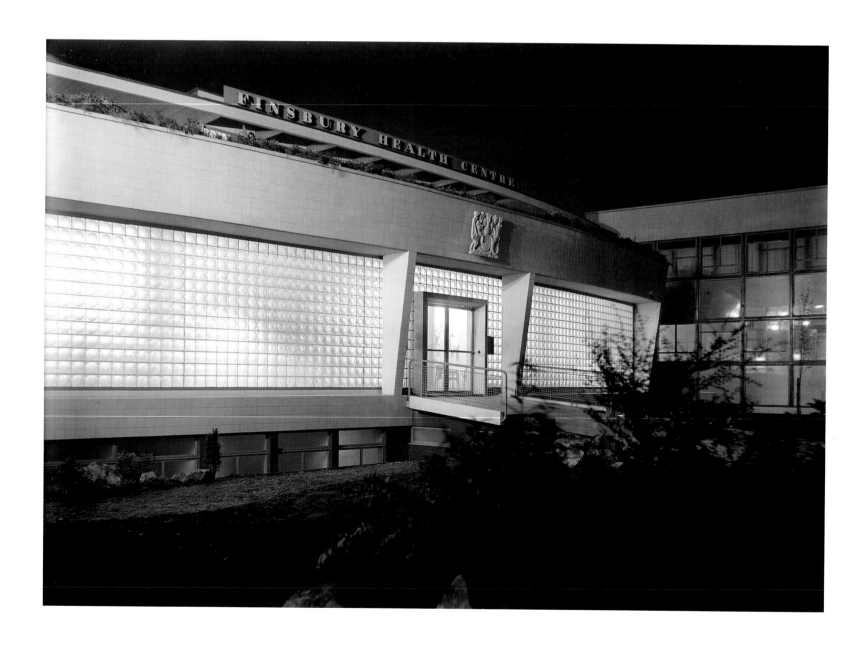

187

Omniskop X-ray apparatus
1926–36
Made by Ernst Pohl
(1872 Kiel–1962 Kiel)

Metal, wood, glass, rubber, plastic
240 × 80 × 220cm
Science Museum, London (A600315)

Medical science, modern technology and the machine, and a design sensibility informed by 1920s Modernism, here combine to create an apparatus that rendered visible the physical condition of the body in photographic form. As a diagnostic tool that would ultimately lead to a cure, this Omniskop embodies the Modernist faith in the process of objective analysis that would result in improving life in the real world.

Though the X-ray was first discovered in 1895 and in use shortly thereafter, this machine, with its tubular-steel structure, is in its appearance very much a product of the inter-war years and related to the increased use of tubular steel in various applications in the 1920s.[1] The elaborate structure allows the entire apparatus – the couch on which the patient lay, the X-ray screen placed over the patient and the X-ray tube located behind – to be rotated 180 degrees (originally by hand, but from 1936 with an electric motor) while maintaining the relationship between all parts, a decisive innovation in X-ray design. This elaborate unit is one part of a larger machine that included a control station and transformer.

The product of the machine, the X-ray image, had a special fascination for Modernists (see cat.150): it represented a new way of seeing through what could be called a photo apparatus; and it was a new type of photograph, visually comparable to the photogram experiments of

Christian Schad, Man Ray (cat.51) and László Moholy-Nagy. It embodied what Rosalind Krauss (in writing on the camera) characterized as 'an extraordinary extension of normal vision, one that supplements the deficiencies of the naked eye'.[2] The X-ray photograph might also be seen as material evidence of one aspect of what Moholy-Nagy meant when he wrote that 'the hygiene of the optical, the health of the visible is slowly filtering through'.[3] CW

1 On the X-ray machine, see Emanuel R.N. Grigg, *The Trail of the Invisible Light* (Springfield, IL [1964], 1991). On the use of tubular steel, see the very brief John Heskett, 'Germany: The Industrial Applications of Tubular Steel', in Barbie Campbell-Cole and Tim Benton (eds), *Tubular Steel Furniture* (London, 1979), pp.22–7.
2 Rosalind E. Krauss, 'Photographic Conditions of Surrealism', *The Originality of the Avant-Garde and Other Modernist Myths* (Cambridge, MA, 1986), p.116.
3 László Moholy-Nagy, *Painting, Photography, Film* (London [1929], 1969), p.38.

188

Ultraviolet sun lamp
1928
Manufactured by Hanovia, Slough

Base and stand, steel; lamp housing, aluminium
Max. height 186cm; tripod diam. 30.5cm; lamp diam. 36cm
Science Museum, London (A639403)

Heliotherapy became a widely accepted medical therapy and popular cure in the early twentieth century. It was as a treatment for tuberculosis, but also for rickets, lupus and skin diseases or for those with symptoms affecting the skin (see Chapter 7). When sunlight was not available or impractical, sun lamps such as this example, which bathed the body in ultra-violet rays, were employed in indoor settings. Sanatoria, clinics and doctors' surgeries across Europe incorporated special rooms where patients, including children, sat under lamps, often with some form of protection on their eyes.[1] For those few who could afford them, smaller sun lamps were also made for home use by Hanovia (founded 1924) and similar firms.

Not all in the medical profession believed in heliotherapy, although its efficacy in treating rickets, for example, seemed incontrovertible.[2]

The overuse of sun lamps was touched on by Thomas Mann in the quintessential novel about sanatorium life, *The Magic Mountain*, when his narrator Hans Castorp mocked the use of sun lamps: 'They already had two, but these did not suffice for the demands of those who wished to get sunburnt by electricity – it was so becoming to the ladies, young and old, and made all the men, though confirmed horizontallers, look irresistibly athletic'.[3] CW

1 See, for example, the solarium of the Finsbury Health Centre reproduced in John Allan, *Berthold Lubetkin* (London, 1992), p.334, or children at London's Institute of Ray Therapy, in William Beaumont, *Infra-red irradiation* (London, 1936), p.77.
2 Andrew Mcclary, 'Sunning for Health: Heliotherapy as seen by Professionals and Popularizers 1920–1940', *Journal of American Culture*, vol.15, no.1 (1982), p.66.
3 Thomas Mann, *The Magic Mountain* (London, [1924] 2005), p.469.

189

Vitalator (Violet Ray High-Frequency Electro-Medical Appliance)
1920–40
Manufactured by Ideal Home Electrical Appliances Ltd, London

Mixed media
Box 10 × 28 × 16cm
Science Museum, London (N1152-1982-778/2)

The Vitalator represented a belief in what was then perceived as scientific technology, and electricity in particular, as a means to cure or enhance the body. It was one of a number of electrical devices sold during the early twentieth century with the promise of increasing health and beauty. Such devices existed in primitive form from the early days of electricity in the 1870s, but became more common in the twentieth century once electricity was more widely distributed and accepted.[1] Through the use of 'high-frequency currents', the Vitalator claimed to improve the flow of blood, cause deeper and easier breathing, and cure all manner of diseases and ailments, including rickets, rheumatism and arthritis.[2] As a beauty treatment, the Vitalator could tighten and

smooth the skin, firm the bust, remove freckles and moles, etc. An 'ozone inhaler' attachment could be used to breathe in pine-scented electric currents to treat tuberculosis, bronchitis and hay fever. The Vitalator was used by attaching a glass-covered electrode (45 different, body-specific shapes were available) to the handle and applying it to the appropriate external or internal parts of the body. The user would experience a sensation

of heat, but no discomfort. It was claimed, though some skin disorders were treated with sparks emanating from the machine.

The manual accompanying this machine trumpeted its 'British manufacture', though the inventor of the device would appear to be George D. Rogers of Cleveland, Ohio, whose Rogers Electric Laboratories Company manufactured identical devices from at least 1914.[3] CW

1 Carolyn Thomas de la Peña, *The Body Electric* (New York, 2003), esp. ch.3; and Linda Simon, *Dark Light: Electricity and Anxiety from the Telegraph to the X-Ray* (New York, 2004), pp.97–114, 144–67.
2 'Health is Wealth/High Frequency/Your Safeguard', instruction booklet for Rogers Vitalator, (Science Museum, London, Documentation Centre, Technical File A602429).
3 See US Patent 1,092,398 for 'High-Tension Discharge Apparatus (applied for 31 May 1913, granted 7 April 1914), reproduced at http://www.electrotherapymuseum.com, Turn of the Century Electrotherapy Museum, Patent Library Collection (consulted 27 May 2005). Violet ray sets with the firm's American label also survive.

190 Plate 7.22

Photograph: *Mrs Piscator at her dressing table*
1928
Sasha Stone (Alexander Serge Steinsapir)
(1895 St Petersburg – 1940 Perpignan)

Gelatin silver print
21.7 × 16.3cm
Ullstein Bild, Berlin

This photograph depicts the actress Hildegard (née Jurezyss) Piscator, wife of Germany's most famous left-wing theatre director, Erwin Piscator (1893–1966, cat.81). Published as an illustration to an article written for a leading women's magazine by Mrs Piscator on the subject of the Piscators' new Modernist flat in Berlin, designed by Marcel Breuer (pl.5.7), it depicts Mrs Piscator as a stylish, cosmopolitan 'New Woman', fashionably dressed and sporting the up-to-date short hairstyle of the time.[1] Like most of her Berlin peers, she would have regarded make-up and perfume as essential to the presentation of herself in public, and was at ease being portrayed sitting at her dressing table buffing her nails.

During the 1920s make-up was increasingly consumed by women, who also took the lead in its sale and manufacture, and indeed in creating the beauty culture and industry in the period.[2]

In Germany, but equally in other western countries, more women were employed outside the home than ever before. With newly acquired disposable income, they were able to afford consumer items intended for their own use. Make-up that could darken or lighten the skin allowed the user to present herself as fashionable, but also as healthy, depending upon whether she preferred a pale or tan look (see Chapter 7). Though surveys showed that the middle class found make-up (which had not been used before the First World War by 'respectable' women during the day) the most distasteful aspect of the New Woman of the 1920s, it was widely used and advertised. Photographs of women clearly wearing make-up were a staple of magazines of the period.[3]

In 1927–8 photojournalist Sasha Stone – who was well connected with the Berlin avant-garde and a close friend of writer Walter Benjamin (1892–1940) – worked for Erwin Piscator's Nollendorfplatz theatre taking publicity photographs.[4] It seems likely that the commission to take this photograph arose from that work. CW

1 Hildegard Piscator, 'Das Heim Piscators', *Die Dame*, no.14 (1928), pp.10–11. The article is reproduced in Eckhardt Köhn, *Sasha Stone Fotografien 1925–39* (exh. cat., Museum Folkwang Essen, 1990), p.103, the commission discussed on p.14 and the image reproduced on p.105.
2 Kathy Peiss, *Hope in a Jar: The making of America's beauty culture* (New York, 1998), introduction and ch.4–5. On 'beauty … and industry', see Janet Ward, *Weimar Surfaces* (Berkeley, 2001), p.82.
3 Sabine Hake, 'In the Mirror of Fashion', in Katharina von Ankum, *Women in the Metropolis* (Berkeley, 1997), p.189.
4 Köhn (1990), pp.6–9.

191 Plate 7.18

Collage: *Bloody Boxing Debut*
1926
GAN (Gösta Adrian-Nilsson) (1884 Lund, Sweden – 1965 Stockholm)

Collage of printed matter and watercolour on paper
31.5 × 23cm
Museum of Cultural History, Kulturen, Lund, Sweden
(KM 50.794:50)

Nilsson, who signed his work as 'GAN', began making collages on the subject of boxing in 1922, while living in Paris. The subject clearly had homoerotic overtones for GAN and the boxing collages, unlike his paintings (some of which depicted sportsmen and toreadors), enabled him to celebrate the part-clothed male form. He was particularly enamoured of American boxer Jack Dempsey, whom he saw in newsreels as well as newspapers and magazines and referred to as a 'big, strong boy'.[1] Dempsey was the subject of a 1922 boxing collage to which the present work is related. Although *Bloody Boxing Debut* was also

long dated to 1922, it has recently been suggested that the illustration of boxers Jack Dempsey and Gene Tunney in the upper left-hand corner, and the use of the number 26 in the centre, refer to the fight between the two boxers in 1926, which resulted in Dempsey's loss of the heavyweight boxing title.[2] The words collaged onto the work read, 'Bloody/boxing debut/body/a happy woman'.

GAN was a well-travelled artist who visited and exhibited in Berlin (in the 'Swedish Expressionists' exhibition at the Galerie der Sturm in 1915) and whose work of the period owed much to German Expressionism, Italian Futurism, as well as Cubism.[3] He lived in Paris from 1920 to 1925, a period that included the 1924 Olympic Games. His turn to collage was evidently inspired by an exhibition of Dada work by Max Ernst, which he saw in May 1921, as well as by the collages of Kurt Schwitters.[4] He returned to Sweden in 1925 as a leading figure in Swedish Modernist art. CW

1 Daybook entry for 8 July 1921, cited in Jan Torsten Ahlstrand, 'Moderniteten och idrotten. GAN som unikt svenskt exempel', in *Aspekter på Modernismen* (Lund, 1997), p.118.
2 Ibid., p.120.
3 See *GAN. Gösta Adrian-Nilsson Perioden 1914–1932* (exh. cat., Mjellby Konstgård, 2002).
4 Ahlstrand (1997), p.118.

192a Plate 7.16

Design: Sports clothing
1923
Varvara Stepanova (1894 Kovno,
Russia –1958 Moscow)

Gouache and ink
28.5 × 22cm
Private Collection

192b Plate 7.17

Design: Sports clothing
1923
Varvara Stepanova (1894 Kovno –
1958 Moscow)

Gouache and ink
30.5 × 22cm
Private Collection

As one of the founder members of the Moscow-based Working Group of Constructivists, Varvara Stepanova was committed to using her artistic expertise to assist in constructing the new socialist environment. This included developing a form of clothing that would reflect the principles governing the new way of life. The concept of

prozodezhda or *proizvodstvennaya odezhda* (which literally means production or work clothing) emerged in 1922 and entailed designing garments rationally, in accordance with the function they had to perform (cats 41–43). Such mass-produced clothing, it was argued, would acquire individuality through the detailing of the cut, the treatment of the seams, the variety of fastenings and the different nature of the material used, rather than through the arbitrary imposition of extraneous elements.[1] As Stepanova explained in an important article of 1923, sports clothing (*sportodezhda* from *sportivnaya odezhda*) represented a specific type within the general category of *prozodezhda*.[2] She argued that although *sportodezhda* naturally varied according to the designated sport, it also had to answer certain specific requirements: it had to allow for freedom of movement and therefore had to be minimal in nature, light to wear, as well as easy to put on. In addition, spectators had to be able to identify individual sportsmen, women and teams from a distance. To facilitate this, Stepanova suggested using bold colour in combination with badges and emblems.

Her designs of 1923, including the four that illustrated this article, exemplify these principles. All of them geometricize and rationalize the structure of the body and the garment. They consist of loosely cut, short-sleeved tops, with shorts or short skirts, in which three colours (red, yellow or blue, along with black and white) were organized in terms of strictly rectilinear and geometrical motifs. Large simple shapes, such as a star, lozenge, circles or letters on the chest, serve as distinguishing elements, giving the clothing a decorative quality that added to its general boldness and exuberance. CL

1 See Christina Lodder, *Russian Constructivism* (New Haven, 1983), pp.147–51, and Alexander Lavrentiev, *Varvara Stepanova: A Constructivist Life* (London, 1988), pp.78–81.
2 Varst [Varvara Stepanova], 'Kostyum segodnyashenego dnya – prodzodezhda' ['The Dress of the Present Day – Production Clothing'], *Lef*, no.2 (1923), pp.65–8.

193

Photograph: *Runner in the City*
*c.*1926
El Lissitzky (Lazar Lisitskii) (1890 Pochinok, Russia –1941 Moscow)

Gelatin silver print
13.1 × 12.8cm
The Metropolitan Museum of Art, Ford Motor Company Collection, Gift of Ford Motor Company and John C. Waddell (1987.1100.47)

The *Runner in the City* was designed as a photographic fresco for the Moscow sport club, Record. Starting around 1923, El Lissitzky experimented with what he called *Schaupoesie* (visual poetry).[1] He wanted to combine technical progression with propagandist techniques that he had learned while creating packaging design and advertising for companies in Germany and Switzerland. The visual language resulting from this can be termed 'anti-materialist' in that it privileges transparency, overlapping imagery and implicit movement rather than the creation of an autonomous artwork based on a single image.[2] This is different from contemporary photomontage or collage, as Lissitzky was not interested in a heterogeneous combination of elements to create fantastic or

critical contrasts, but in developing a coherent formal language that is explicitly modern both in its adherence to technological progress and to popular, even commercial, pictorial expressions.

In the 1920s the Soviet Union decided not to follow the western model of international sport, as its capitalist and exploitative concept of extreme competitiveness could not be reconciled with the public model of mass physical education and the promotion of the collective spirit that was to be part of a distinct proletarian culture.[3] The Soviet sport clubs fulfilled a political function in allowing leisure activity to be consumed by the working class, and hitherto 'exclusive' sports such as tennis and yachting were democratized by providing new facilities and institutions. The promotion of the healthy body culture to further the development of a progressive society was echoed in the visual representation of sport. Lissitzky's photograph situates the sportsman not in his habitual environment (although the cinder track and hurdle are suggested), but in front of a modern metropolis, denoted by neon signs in English (meant to signify international and modern). The two distinct levels of the photograph, the frozen action of the runner and the long double exposure of the city are unified by a pattern of vertical lines that suggest an increase in speed when the eye follows them from left to right. The lines are in effect cut through the picture plane, expanding

it and elongating the figure of the hurdler to provide an impression of the utmost mobility, as well as creating a panel structure appropriate for its enlargement and installation as wall decoration. UL

1 Nicolai Khardzhiev (1962), in Sophie Lissitzky-Küppers, *El Lissitzky: Life, Letters, Text* (London, 1968), pp.382–3.
2 See Peter Nisbet, *El Lissitzky 1890–1941: Retrospektive* (Hanover, 1988), p.23, and Margarita Tupitsyn et al., *El Lissitzky: Beyond the Abstract Cabinet* (New Haven, 1999), pp.25–9.
3 Barbara Keys, 'Soviet Sport and Transnational Mass Culture in the 1930s', *Journal of Contemporary History*, vol.38, no.3 (2003), p.414. In 1925 Lissitzky proposed architectural studies for a yachting club in Gorki Park (for which the fresco might have been intended), as well as a large stadium complex.

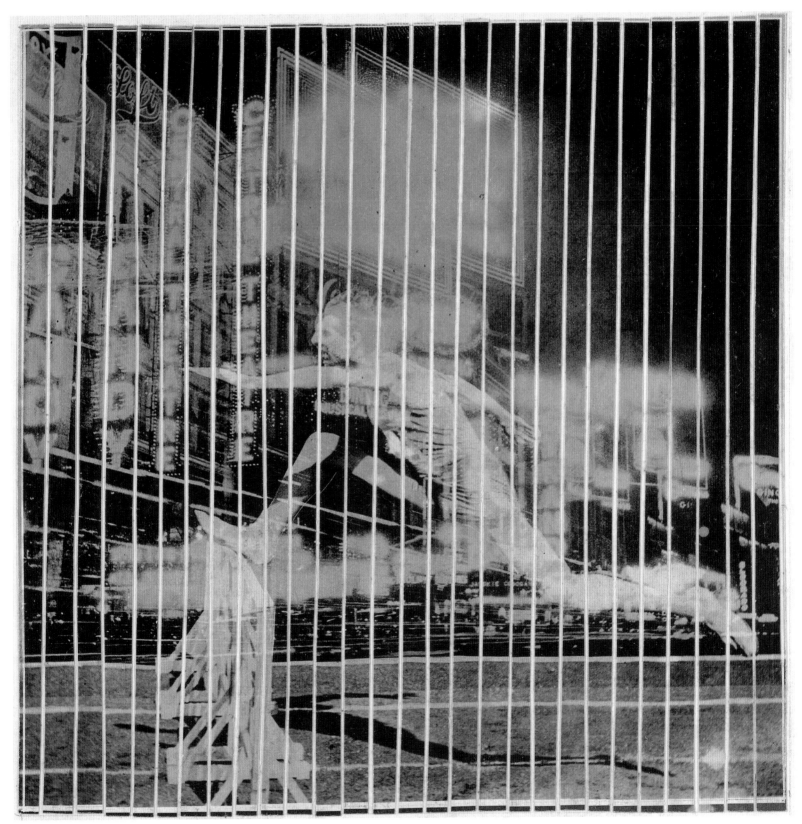

193

194

Drawing: *Tennis*
1927
Willi Baumeister (1889 Stuttgart –
1955 Stuttgart)

Pencil, charcoal and photo-collage
41.8 × 30.4cm
Willi Baumeister Archiv, Staatsgalerie Stuttgart

Few Modernist artists created as many works devoted to the subject of sport and exercise as Baumeister. Between 1925 and 1938 especially, his canvases and drawings were filled with images of gymnasts, footballers, boxers, divers, runners, swimmers and tennis players. For Baumeister, athleticism was a powerful representation, even a metaphor, of the New Person of the inter-war period. He saw in the portrayal of athletes not a depiction of the individual, but of a new, collective 'type'.[1] Physical 'activity', which Baumeister allied to 'affirmation', revealed nothing less than 'the truth of existence'.[2]

Baumeister's paintings and drawings concentrated on the representation of the human form in a variety of styles. During the 1920s, under the influence of Fernand Léger in particular (pl.3.2), but also Purism (pl.3.7), he abstracted figures based on machine shapes and grappled with how to represent three-dimensional forms on the flat surface.[3] The tennis player in this drawing (of which no related painting was apparently made) strongly echoes his Machine paintings, though instead of a composition of solid shapes and areas of dense, overlapping colour, he employs thin pencil lines and occasional shading to depict the figure. The ingenious introduction of photographic collage, with its realistic depiction of the subject

and inclusion of players, officials and crowd, seems startling in its contrast to the drawn areas. It creates a positive tension with the monumentality and abstraction of the drawn figure. Baumeister deeply admired the ability of film and photography to depict movement, and his application of photographs surely aimed to give a dynamic quality to the subject. The incorporation of photographs in the drawing earned it a place in the important *Film und Foto* exhibition (Stuttgart, 1929, cat.131). *Tennis* was one of 20 Baumeister works printed as heliographs by the Galerie Flechtheim in a portfolio entitled *Sport und Maschine* (Sport and Machine).[4] CW

1 See Willi Baumeister, 'Moderne Baukunst', *Bauzeitung*, no.45 (13 November 1926), p.373, quoted in Ursula Zeller, '"Bewegung gegen Ruhe", Willi Baumeisters zeichnerisches Werk der 20er Jahre', in *Willi Baumeister, Zeichnungen, Gouachen, Collagen* (exh. cat., Staatsgalerie, Stuttgart, 1989), pp.39–40. This drawing is cat.34. It is cat.207 in Dietmar J. Ponert, *Willi Baumeister 1889–1955: Werkverzeichnis der Zeichnungen, Gouachen und Collagen* (Collogbe, 1998).
2 Willy [*sic*] Baumeister, untitled article in *ABC*, series 2, no.2 (1926), p.1.
3 Zeller (1989), p.33.
4 Düsseldorf/Berlin, 1929, sheet 15. On Alfred Flechtheim and his keen interest in sports, see David Bathrick, 'Max Schmeling on the Canvas: Boxing as an Icon of Weimar Culture', *New German Critique*, no.51 (1990), p.126.

195 Plate 7.20

Swimming costume
*c.*1928
Sonia Delaunay (1885 Gradizhsk,
Ukraine – 1979 Paris)

Knitted wool
65 × 40cm
Musée de la Mode de la Ville de Paris,
Musée Galliera, Paris (1971.24 7)

In the mid-nineteenth century women usually wore modified chemise dresses, stockings and special shoes for swimming. Men often swam in the nude or in cumbersome long-sleeved and long-legged knit suits.[1] By the 1920s women's swimwear was more like men's: both generally wore a one-piece knitted wool swimsuit with a

silhouette similar to Delaunay's design. This kind of semi-unisex, abbreviated garment made water exercise more practical for both men and women. Thus comfortably clad, they could more readily pursue the utopian healthy ideal.

This swimsuit's shape is typical of its time. Though a piece of functional sportswear, it shows that by the 1920s swimming costumes had become a carefully considered sartorial choice and had entered into the realm of high fashion. Delaunay was an artist and fashion designer who understood the printed fabric as a work of art in its own right.[2] She and her husband Robert were proponents of 'simultaneity', an aesthetic theory that sought to convey the complexity of modern life through the juxtaposition of colour. Characteristic of the Delaunays' theory was the careful arrangement of the blocks of printed colour in this suit.

Designed mainly for women, Delaunay's clothes featured textiles with dynamic patterns of

discs, spirals, stripes and other abstract shapes.[3] Her vibrant designs were particularly appropriate to, and successful on, the uninterrupted flat planes of 1920s fashions. At her Paris workshop, Atelier Simultané, Delaunay produced a wide range of textiles for furnishing and clothing. She also executed a variety of clothing designs, which included coats, dresses, scarves, bags and hats – extending the Delaunays' artistic vision from the canvas to the human form. SS

1 Susan Ward, 'Swimwear', in Valerie Steele (ed.), *Encyclopedia of Clothing and Fashion* (Detroit, 2005).
2 Jacques Damase, *Sonia Delaunay, Fashions and Fabrics* (London, 1991), p.111.
3 Tag Gronberg, 'Sonia Delaunay's Simultaneous Fashions and the Modern Woman', in *The Modern Woman Revisited* (New Brunswick, 2003), p.115.

196a

Postcard design: *Moscow Spartakiada*
1928
Gustavs Klucis (1895 Rujiena, Latvia –
1938 Moscow?)

Colour paper and photo-collage and gouache on paper,
on cardboard
57.8 × 36.1cm
The State Museum of Arts, Riga (VMM Z-7884)

196b

Proofsheet: *Moscow Spartakiada*
1928
Gustavs Klucis (1895 Rujiena –
1938 Moscow?)

Lithograph on cardboard
48.1 × 36.7cm
The State Museum of Arts, Riga (LGR-36)

196b

Klucis designed these postcards devoted to
the theme of physical culture and sport to
commemorate the All Union Spartakiada, which
opened on 12 August 1928. The Spartakiada was
a form of national Olympic Games, organized
by the Supreme Council of Physical Culture,
which also commissioned the postcards.[1] Each
postcard illustrates one specific sport or a group
of related sporting activities. Diving is linked with
other water sports such as swimming and rowing,
while motorcycle racing is celebrated alongside
the pole vault, cycling, the long jump and
equestrian events.

For the Bolsheviks, sporting success and
physical perfection demonstrated the triumph
of the revolution, the efficacy of socialism and
the achievements of the Soviet state.[2] The
Spartakiada therefore possessed considerable
propaganda potential, and, as a committed
communist and Constructivist, Klucis orches-
trated his photomontages to maximize this. While
seeking to capture the dynamism of sporting
activities and reveal the beauty of the physical
gestures involved, he was also concerned to bring
out the fundamental connection between sport
and communist ideology. Diagonal arrangements
and combinations of various stances at different
scales create a sense of vibrant physical move-
ment, the ideological significance of which is
underlined by slogans such as 'Soviet physical
culture is one of the links in the cultural revolution
in the USSR' (tennis postcard) or 'Long live the
unity of the worker sportsmen of all countries'

(runners postcard). Klucis reinforced the
political message by using images of Lenin or
the mausoleum (denoting Lenin's enduring
presence and inspiration), so that the former
leader accompanies an image of a man putting
the shot, and stands next to the mausoleum
while watching the female discus thrower.

This proofsheet shows all the postcards
together and is therefore particularly effective
in revealing the variety of ways in which Klucis
combined photographic and graphic elements
to produce emotionally powerful and politically
resonant images of physical activity. CL

1 Margarita Tupitsyn, *Gustav Klutsis and Valentina Kulagina:
 Photography and Montage after Constructivism* (New York, 2004),
 p.184.
2 Larisa Oginskaya, *Gustav Klutsis* (Moscow, 1981), p.84.

196a

197a

Photograph: Boxer

*c.*1930

Max Penson (1893 Velizh, Belarus –
1959 Tashkent, Uzbekistan)

Gelatin silver print
11.2 × 16.4cm
House of Photography, Moscow

197b

Photograph: Tennis player

*c.*1930

Max Penson (1893 Velizh –1959 Tashkent)

Gelatin silver print
12.8 × 21.7cm
Moscow House of Photography

Though a newspaper photographer working in Central Asia, Penson was clearly aware of recent, formal developments in Russian, if not European, photography. The work of Alexander Rodchenko (cats 200, 202) seems to have been particularly significant for Penson. In both of these photographs of athletes, the images are closely cropped, giving an immediacy to the compositions. Both make use of geometricized backgrounds (in the tennis image, a fence or enclosure is imposed on top of the woman), which, combined with the close view, create a sense of abstraction. This is increased in the photograph of the boxer by the diagonal viewpoint and foreshortening of the boy. These images of boxing with boxing gloves and of tennis playing probably represented part of the Soviet attempt to 'westernize' the Asian republics, for they have little to do with the traditional culture of leisure and sport that Penson documented in other photographs.[1]

Penson was a prolific photojournalist who documented daily life in the largely Muslim Uzbekistan, a part of the Soviet Union subject to enormous change in the decades after the Revolution.[2] For 23 years he was the photo-correspondent of *Pravda Vostoka (Eastern Truth)* newspaper and his photographs were also published in numerous Soviet photo magazines, including *SSSR na stroyke* (*USSR in Construction*, pl.10.6). Anti-semitic pogroms had forced Penson to abandon his native Belarus in 1915 and move to Turkestan and, shortly thereafter, to Uzbekistan. He eventually taught art in local schools, winning the prize of a camera for his teaching. Within two years he was working as a professional photographer. Anti-semitism marked the end of his career, as his religion led to his dismissal from *Eastern Truth* in 1948. He never worked again. CW

1 Alexander D. Borovsky, 'Max Penson in Uzbekistan', *History of Photography*, vol.22, no.1 (5 February 1998), pp.81–2, discusses the close connection between Soviet photography and the 'social surgery' that the Asian part of the Soviet Union endured.
2 On Penson's work, see *Soviet Photography of the 1920s and 1930s* (exh. cat., Fotomuseum Winterthur, 2004), pp.150–65. Exhibitions on Penson resulted in the publication of information on his life and work that had his family as its source. See, for example, www.photorussia.com/Max Penson (exhibition August–September 2001) or publicity material connected with 'Max Penson 1925–1945', Palazzo Musei Capitolini – Palazzo Caffarelli (May–June 2003).

198 Plate 1.9

Photograph: *High jumper in front of Prellerhouse*

1930

Hajo Rose (Hans Joachim)
(1910 Mannheim –1989 Leipzig)

Gelatin silver print
36.8 × 31.2cm
Bauhaus Archiv, Berlin (BHA 10245)

There are perhaps few images that bring together more succinctly Modernism and the interest in the healthy body culture. In his first year at the Bauhaus, possibly even before he began his studies, Rose took this photograph of Bauhaus sports teacher Otto Büttner high-jumping in front of the Prellerhouse, the student building at the school.[1] Though the subject inevitably recalls El Lissitzky's earlier *Runner in the City* (cat.193), photographs of exercise were common at the Bauhaus, as was the use of school buildings as a backdrop for them. Rose abstracts the building, treating it as an architectural pattern, by having it fill the frame and by omitting both sky and ground.

Sport and exercise were nearly always a part of Bauhaus life. During the early years, students in Johannes Itten's *Vorkurs* (Preliminary Course) engaged in exercise at the start of class as a means of achieving relaxation as well as control over the body.[2] Though director Walter Gropius cited gymnastics as part of the school's reforming programme, Itten's departure in 1923 was followed by several years during which physical education disappeared from the curriculum. The new buildings in Dessau designed by Gropius (1925–6, cat.114) did, however, include a large playing field and flat roofs where physical exercise took place.[3] By 1927 exercise was back on the curriculum, though on a voluntary basis. When Hannes Meyer took over as director in 1928, he hired separate physical education teachers for men and women, Büttner and Carla Grosch. Meyer viewed sport and exercise as an integral part of contemporary culture and of particular necessity to counter 'the proverbial collective neuroses of the Bauhaus, the result of a one-sided emphasis on brainwork'.[4] Teaching of sport and exercise continued when Ludwig Mies van der Rohe became director in 1930. CW

1 Jeannine Fiedler, *Fotografie am Bauhaus* (exh. cat., Bauhaus Archiv, Berlin, 1990), p.353, notes that Rose arrived in April 1930, but became a student in October.
2 Willy Rotzler (ed.), *Johannes Itten. Werke und Schriften* (Zurich, 1978), pp.12, 225–6, quoted in Swantje Scharenberg, 'Physical Education at the Bauhaus, 1919–1933', *International Journal of the History of Sport*, vol.20, no.3 (September 2003), pp.116–17; the latter is a good digest of its subject.
3 For images of students exercising on the Prellerhouse roof, see Ute Ackermann, 'Body Concepts of the Modernists at the Bauhaus', in Jeannine Fiedler and Peter Feierabend (eds), *Bauhaus* (Cologne, 1999), pp.88–95. Additional unpublished photographs are in the collection of the Bauhaus Archiv, Berlin.
4 See Hannes Meyer, 'Die Neue Welt', *Das Werk*, vol.13, no.7 (1926), pp.205–24, trans. in Charlotte and Tim Benton and Dennis Sharp, *Form and Function* (London, 1975), p.106; and for the quotation Hannes Meyer, *Das Tagebuch* (Berlin, 1930), vol.2, p.1307, cited in Scharenberg (2003), p.119.

197a

197b

199 Plate 7.19

Set design: *Jeux: Poème Dansé –*
Tennisplatz (Game: Dance Poem
– Tennis Court)
1931
Teo Otto (1904 Remscheid, Germany –
1968 Frankfurt)

Collage, tempera and photo
48. 2 × 65.8cm
Theaterwissenschaftliche Sammlung,
University of Cologne

The popularity, even fashionability, of tennis was
reflected by the choice of a tennis court as the
setting for a production of Claude Debussy's *Jeux*,
performed at Berlin's centre for progressive
opera, the Kroll Opera.[1] Stage designer Otto
worked for the Kroll's director, conductor Otto
Klemperer, from the time the company was
founded in 1927 until it was closed owing to
right-wing pressure in 1931. *Jeux* premiered on
7 January 1931 as the main piece in a private
gala performance for the Red-White Tennis
Club, which included Paul Hindemith's short
opera sketch *Hin und zurück (There and Back)*,
with a set designed by László Moholy-Nagy,

and Kurt Weill's *Threepenny Opera* (a musical
performance).[2]

Debussy's music was originally written for
Serge Diaghilev's Ballets Russes (premiered in
1913), but was here choreographed by Rudolf von
Laban (see cat.172). Two female and one male
dancer performed a story described by a reviewer
as one of 'erotic attraction and rejection' played
out through a game of tennis.[3] Though the design
drawing was almost certainly made for presenta-
tion purposes (photographs of the performance
are yet to be found), it was apparently not so
different from the actual set. Large red, white
and black 'circles and rhombuses' occupying the
stylized set are referred to in the review cited
(though the connection with the Red-White Tennis
Club remains unclear). The appearance and colour
of the design evoked Russian Constructivist theatre
designs, as did the appearance of the crowd within
the monumental tennis racket at the back of the
set. The tennis-playing figure montaged onto the
court is undoubtedly Suzanne Lenglen, the most
famous tennis player in the world at the time (see
Chapter 7). Her image was probably used only as
a pictorial device by Otto. CW

1 The company's proper title was Staatliche Oper am Platz der
 Republik, at the Theatre Kroll. See Hans Curjel, *Experiment*
 Krolloper 1927–1931 (Munich, 1975).
2 Ibid. lists the production details. It was at the Kroll that Otto came
 into contact with leading members of the avant-garde, including

Moholy-Nagy and Oskar Schlemmer; see *Teo Otto: Der*
Bühnenbildner, der Maler, der Lehrer (exh. cat., Galerie der
Stadt, 2000), p.14, and pp.16–17 on *Jeux*.
3 Review by Alfred Einstein, *Berliner Tageblatt* (1 December 1930),
 reprinted in Curjel (1975), p.302.

200

Photograph: *The Dive*
1934
Alexander Rodchenko
(1891 St Petersburg–1956 Moscow)

Gelatin silver print
58.3 × 39cm
Private Collection

The Dive belongs to an extensive series of photo-
graphs that Rodchenko took of sports activities in
which he captured people in the very midst of a
specific movement, whether anonymous indivi-
duals doing their morning exercises (pl.7.17) or
outstanding sports personalities in action.[1] His
numerous shots of divers show human beings
with athletic physiques performing their difficult
manoeuvres to perfection. This photograph
emphasizes the grace of the dive and the way the
body is for a moment airborne, liberated from
gravity and caught against the water as it moves
through the air. *The Dive* reflects the notion of new
socialist man – physically and mentally perfect –
and the social liberation of the revolution that
has made this perfection possible. In this respect

The Dive meets the propaganda requirements of
the Soviet Union to project the image of a healthy
country, ready and able to defend itself, but the
image also embodies a poetic aspiration towards
this new and ideal human being.

A leading Constructivist, Rodchenko had
abandoned painting for design in 1921 (cat.42),
but started taking photographs in 1924, attracted
by the mechanical qualities of the medium, which
provided realistic images but escaped the elitist
quality of the unique work of art. Photography
allowed Rodchenko and other avant-garde artists
to produce the comprehensible images demanded
by Soviet officialdom, while permitting them to
manipulate the image, adopting oblique angles and
using different viewpoints, such as bird's-eye and
worm's-eye views. Such means defamiliarized the
objects, removing them from everyday experience
and making the resulting compositions almost
abstract.[2] Despite being attacked for his distortions,
Rodchenko continued to produce them, hoping
that they would educate the masses into a new
way of seeing and envisaging perhaps that
photography would replace painting as the new art
of socialist man.[3] In this way, while documenting
life in the present, Rodchenko aspired to embody
the ideals of the revolution and of the progressive
values associated with it. CL

1 Alexander Lavrentiev, *Alexander Rodchenko: Photography*
 1924–1954 (Edison, NJ, 1995), pp.246–83.
2 Peter Galassi, 'Rodchenko and Photography's Revolution', in
 Magdalena Dabrowski, Leah Dickerman and Peter Galassi,
 Aleksandr Rodchenko (New York, 1998), pp.100–137.
3 For the text of the anonymous attack on Rodchenko in 1928,
 see Christopher Phillips (ed.), *Photography in the Modern Era:*
 European Documents and Critical Writings, 1913–1940 (New York,
 1989), pp.243–4. For Rodchenko's reply, see ibid., pp.245–8, and
 Alexander Lavrentiev, *Aleksandr Rodchenko: Experiments for*
 the Future: Diaries, Essays, Letters, and Other Writings (New York,
 2005), pp.204–207. On criticism of Rodchenko's photography, see
 'The Paths of Contemporary Photography', in Lavrentiev (2005),
 pp.207–212, and Phillips (1989), pp.256–63; also Christina Lodder,
 Constructive Strands in Russian Art 1914–1937 (London, 2005),
 pp.368–91.

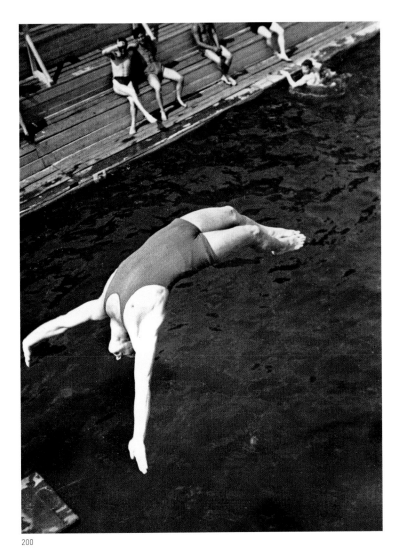

200

201

201

Photograph: *Class* (*Olympic High Diving Champion, Marjorie Gersting*)
1936
John Gutmann (1905 Breslau, Silesia –
1998 San Francisco)

Gelatin silver print
34.1 × 26.9cm
The Metropolitan Museum of Art, Ford Motor Company
Collection, Gift of Ford Motor Company and John C. Waddell,
1987 (1987.1100.401)

The diver was an irresistible subject for inter-war photographers, and the advent of the hand-held camera made it increasingly possible to take stop-action photographs of divers flying through the air (see also cat.200). Such images were routinely published in illustrated newspapers and magazines of the period.[1] Gutmann's subject was Marjorie Gersting (b.1922) who had only recently received a gold medal at the Berlin Olympics of 1936 at the age of 13. His print focuses closely on

her, the diving board providing the only context for Gersting's acrobatic display. Swimming pool, crowd and landscape are all omitted, and the tonality of the photograph results in her appearing to be set against a dark background. The top half of Gersting's body is slightly out-of-focus, suggesting the speed at which she is moving. *Class* was published in the Chicago-based *Cornet* magazine, edited by Hungarian émigré Arnold Gingrich, who frequently published Gutmann's work.[2] Gutmann would have chosen the title of his photograph, with its implication in American parlance that Gersting was a 'class act'.

The rise of the Nazis led directly to Gutmann becoming a photographer. He had studied painting with the artist Otto Müller (1874–1930, an original member of *Die Brücke*), exhibited at the Berliner Secession, and had a one-man show in 1931, while working as an art teacher and, briefly, as a magazine editor.[3] When Hitler took power in 1933, Gutmann decided to emigrate, advised by a friend that 'The only country you want to go to is the U.S. The only state is California. The only city, San Francisco.'[4] Having had no previous interest in photography, he purchased a Rolleiflex, convinced

that it might help him earn a living in America, and began experimenting with it before leaving Berlin for San Francisco via the Panama Canal.[5] He spent the rest of his life as a photographer and teacher in San Francisco. CW

1 See, among many examples, a *New York Times* photograph published in the influential book with text by Franz Roh and designed by Jan Tschichold, *Foto-Auge/Oeil et Photo/Photo-Eye* (Stuttgart, 1929), plate 2.
2 *Coronet* (July 1939), p.83, the page spread reproduced in Maia-Mari Sutnik, *Gutmann* (exh. cat., Art Gallery of Ontario, 1985), p.29.
3 On Gutmann's German career, see ibid., p.11, which draws on the author's interviews with Gutmann; and Sandra S. Phillips, *The Photography of John Gutmann: Culture Shock* (exh. cat., Cantor Center, Stanford University, Berkeley, 2000), pp.15–24, 142, and p.80 for this image.
4 Lew Thomas (ed.), *The Restless Decade: John Gutmann's Photographs of the Thirties* (New York, 1982), p.9.
5 Phillips (2000), pp.23–4.

202

Photograph: *The Dynamo sports club*
1935
Alexander Rodchenko
(1891 St Petersburg–1956 Moscow)

Gelatin silver print
40 × 48.5cm
Private Collection

Rodchenko's photograph (shot with a Leica with 50mm lens) shows members of the Dynamo sports club turning to enter Red Square during a celebration, possibly from a viewpoint on the newly built Hotel Moscow.[1] It dates from a period when Rodchenko concentrated on subjects related to sport, an activity associated in the Soviet Union with liberation through revolution (see also cat.200) and, in the 1930s, military preparedness. Shot from above, the repeating patterns of the straight lines of the marchers' white shorts and dark heads are punctuated by the thin lines of the guns they carry. The structured geometry of the parade, in the process of turning, must have spoken directly to Rodchenko's love of geometric composition (cat.174).

The year 1935 was a turning point for Rodchenko. He had been denounced as a plagiarist and formalist in 1928 and, although he defended himself in print immediately, his work continued to be attacked in the coming years.[2] Coinciding with the closure of the VKhUTEMAS school where he taught, Rodchenko suffered both personally and professionally. He recovered gradually in the early 1930s, obtaining work for photo magazines, as the status of photography as an official part of the Stalinist propaganda machine

rose. The positive critical reaction to his display at the exhibition 'Masters of Soviet Photo Art' in 1935, in which this photograph was first exhibited, marked a new beginning for Rodchenko.[3]

The Dynamo sports club was founded in 1923 for members of the internal security agency (the All-Russia Extraordinary Commission for Combating Counter-Revolution and Sabotage). It was (along with only the Red Army Club) allowed to remain largely independent of the Supreme Council of Physical Culture, an organization set up to purge Soviet sport of professionalism and elitism, and ensure that all sport should involve 'the vast mass of working people'.[4] In its first year it had more than 3,000 members who participated

in a range of sports, including gymnastics, boxing, basketball and soccer, and in 1929 it built its own stadium, which remains in use today. CW

1 Information from Alexander Lavrentiev.
2 See cat.200, n.3. The original page from *Sovetskoe foto* is reprinted in Alexander Lavrentiev, *Aleksandr Rodchenko, Experiment for the Future: Diaries, Essays, Letters and Other Writings* (New York, 2005), p.205.
3 For Rodchenko's explanation of this period, see Lavrentiev (2005), pp.297–312, and Alexander Lavrentiev, *Alexander Rodchenko, Photography 1924–1954* (New York, 1996), pp.23–7, 32–4, 36. Both illustrate Rodchenko's display at the 1935 exhibition, in which this image can be seen at lower left.
4 James Riordan, *Sport in Soviet Society* (Cambridge, 1977), pp.92–4.

203a

Photograph: *10th All-Sokol Slet at Strahov Stadium in Prague, 5 July 1938*

203b Plate 7.21

Photograph: *10th All-Sokol Slet at Strahov Stadium in Prague, 29 May 1938*

Photographed for CTK (Czech Press Agency), Prague
(F001215931 and F001215943)

The mass displays of the Czechoslovak *Sokol* movement (see Chapter 7), called *Slets* or flocking of the birds, were the most influential demonstrations of movement and gymnastics in the early twentieth century. They had by this time already gained followers and imitators throughout Central Europe, but also in the United States and,

later, England.[1] Although derived from the German *Turnvereine* (gymnastic clubs), the *Sokol* developed their own sequences of exercises and forms of mass display which – along with their slogan, 'Every Czech a *Sokol*' – were an exuberant expression of Czechoslovak nationalism. In May–July 1938, after neighbouring Austria acceded to Nazi rule and just as Hitler was threatening to invade Czechoslovakia, the *Sokol* presented a series of mass gymnastic performances involving tens of thousands of male and female participants of all ages.

The *Slets* took place in Prague's Strahov Stadium, a vast structure built in 1926 and renovated in 1932, holding more than 200,000 spectators. The photograph of the May *Slet* shows some of the 3,362 secondary-school girls who performed basic physical-education movements to music.[2] The other image, showing a section of the 70 circles of 100 pupils, depicts the type of geometrical formation that was typical of the *Slet*.

Still photographs suggest the drama of the spectacle, but do not convey the choreographed gymnastics performed within the circular shapes, or the sequence of movements preceding and following the formation of the circles, which made the performance so visually compelling and ultimately beautiful. The 1938 *Slet* was described by Czechoslovak author and playwright Karel Čapek as 'a dream created out of a crowd of souls'.[3] A moving and suitably patriotic finale to the event was provided by 30,000 male participants taking the 'Oath to the Republic', pledging to defend it against the Nazis. CW

1 On the *Sokol*, see Chapter 7, n.91, on followers, see n.98.
2 Information on these images generously provided by Petr Roubal.
3 Cited in Petr Roubal, '"Today the Masses Will Speak": Mass Gymnastic Displays as Visual Representation of the Communist State', in Arnold Bartetzky, Marina Dmitrieva and Stefan Troebst (eds), *Neue Staaten – neue Bilder? Visuelle Kultur im Dinst staatlicher Selbstdarstellung in Zentral- und Osteuropa seit 1918* (Cologne, 2005), p.328.

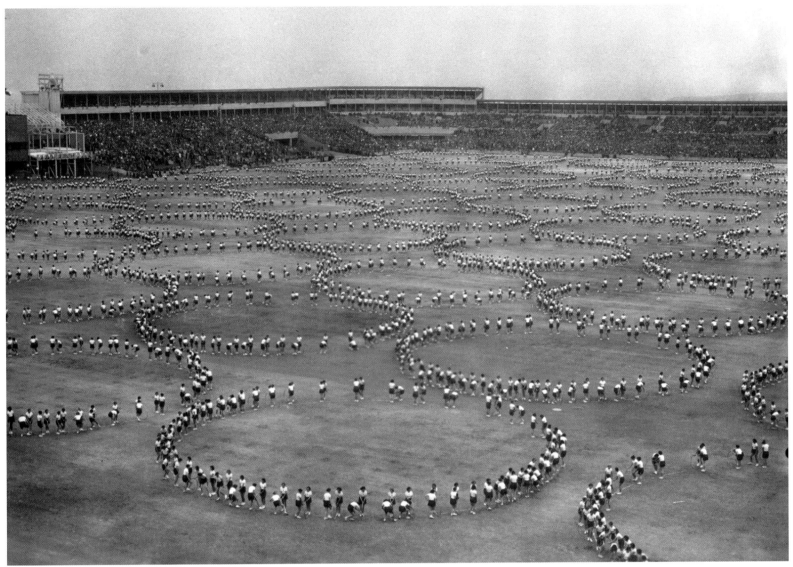

203a

Film: *Olympia*
Directed and edited by Leni Riefenstahl (1902–2003)

Part 1: *Festival of the People* (*Fest der Völker*), 126 mins
Part 2: *Festival of Beauty* (*Fest der Schönheit*), 100 mins
Music by Herbert Windt, black and white
Produced by Olympia Film, Tobis Filmkunst,
International Olympic Committee, Germany, 1938

Riefenstahl's account of the 1936 Berlin Olympic Games appeared two years after the event as a monumental two-part film running for nearly four hours. It has long provoked violent partisanship. For some, its lyrical portrayal of the athletic body – enhanced by slow-motion photography and the opportunity to cut between multiple viewpoints – was a landmark, 'doing superbly what only the camera can do, refashioning the rhythms of the visible'.[1] For others, repelled by Riefenstahl's complicity with Nazism and her use of similar techniques in the Nuremberg Rally film *Triumph of the Will* (1935), even its portrayal of athleticism is tainted, celebrating as it does 'the rebirth of the body ... mediated through the worship of an irresistible leader'.[2]

Undoubtedly the scale and rhetoric of the film, and its framing with an evocation of the ancient Olympic Games, follow directly from the strategy of the *Triumph of the Will* (in which Hitler arrives by air at Nuremberg to be greeted by the adoring masses).[3] Riefenstahl's claims that she worked independently of the Nazi government and included footage of black athletes against Goebbels's wishes have been disproved.[4] And yet the film's portrayal of the full range of Olympic sports, with a detail that had never previously been attempted (and rarely since), continues to fascinate. Historically, the film marks the climax of a 1930s healthy body culture that had been celebrated in such diverse films as Jean Vigo's *Taris* (France, 1931) and Abram Room's *A Strict Young Man* (*Strogii yunost*, USSR, 1932). But its refulgent aestheticism and appearance of objectivity have also been identified as important contributions to its propaganda success; and for all the claims of artistic achievement, it seems to have had little impact on the subsequent course of documentary film.[5] IC

1 Dilys Powell, contemporary review in *The Sunday Times*, quoted in Leslie Halliwell, *Halliwell's Film and Video Guide* (London, 2001), p.600.
2 Susan Sontag, 'Fascinating Fascism' (1974), reprinted in Sontag, *Under the Sign of Saturn* (London, 1983), p.96.
3 Manohla Dargis, 'Leni Riefenstahl, Art and Propaganda', *Village Voice* Literary Supplement (March 1994); reprinted in Kevin Macdonald (ed.), *Imagining Reality: The Faber Book of Documentary* (London, 1996), p.131. See also Alan Marcus, 'Reappraising Riefenstahl's *Triumph of the Will*', *Film Studies* no.4 (Summer 2004), pp.75–86.
4 Leni Riefenstahl, *A Memoir* (New York, 1993); Renata Berg-Pan, *Leni Riefenstahl* (Boston, 1980), p.142.
5 Robert C. Schneider and William F. Stier, 'Leni Riefenstahl's "Olympia": Brilliant Cinematography or Nazi Propaganda?', *The Sport Journal*, vol.4, no.4 (Fall 2001).

Film as a Modernist Art

The latest discoveries of science, the world war, the theory of relativity, political upheavals, everything indicates that we are heading towards a new synthesis of the human spirit, towards a new humanity, and that a new race of men will appear. Their language will be cinema.[1]

Blaise Cendrars
L'ABC du cinéma
(*The ABC of Cinema*)
(1917–21)

8.1 **Len Lye**, *Rainbow Dance*,
1936 (cat.254)

It is 1928 and two sophisticated young Americans have come to Soviet Russia to discover how a new world is being created, and what effect this is having on the arts. One wrote in his diary: 'In the kino at least the revolution has produced great art even when more or less infected with propaganda. Here at last is a popular art; why, one wonders, does the Soviet bother with painters?'[2] The writer was Alfred Barr, soon to become founding director of New York's Museum of Modern Art (MoMA), whose enthusiasm for what he had seen of Sergei Eisenstein's and Vsevelod Pudovkin's films would lead to MoMA becoming the first museum to collect and show film alongside other modern art. Here in its purest form is the potent myth of film, and especially Soviet film, as a revolutionary new form that challenged the traditional arts with its simultaneous modernity and popularity. If Soviet workers and peasants were indeed happy to watch Constructivist-style cinema based on montage rather than sentimental narrative, then film might solve the dilemma facing many in the inter-war years when radical politics often seemed to be at odds with their enthusiasm for contemporary art.

Another scene from the 1920s, this time recorded in a photograph of 1923 (pl.8.2), shows a moustachioed man dressed in tweeds and wearing a worker's cap, standing amid what looks like a large Cubist sculpture. It is the painter Fernand Léger, surrounded by the setting he has created for Marcel L'Herbier's film *L'Inhumaine* (*The New Enchantment*, 1924), which, like other futuristic films of the 1920s – notably *Aelita* and *Metropolis* (pl.8.9) – featured the work of Modernist designers. L'Herbier was a leader of the French cinema avant-garde, which, even before Soviet cinema emerged as a new phenomenon, proclaimed its belief that film possessed a new artistic quality – *photogénie*.[3] But even as Léger was contributing to the modernity of a story with its roots in late romanticism – the updated tale of an ice-queen who lives in chilly luxury – he was also planning his own radical film, *Le Ballet mécanique* (*Mechanical Ballet*, pl.8.6) as a protest against the banality of most cinema.

Next, a revealing encounter between film and Modernism from the late 1930s. The leading English painter Paul Nash was invited to write on 'The Colour Film' in 1938, when colour cinematography was still in its infancy.[4] Confessing that 'to an artist the appearance of the average colour photography picture is more or less of an abomination', Nash championed Walt Disney's *Silly Symphonies* and the work of the New Zealand artist Len Lye as the only instances to date of colour film being used creatively. Lye painted shapes directly onto film in time to dance music, allowing the photochemical process to determine how these appeared in colour; and in *Rainbow Dance* (1936, pl.8.1) he combined this technique with the live-action figure of a dancer in silhouette. Nash singles this out as 'full of possibilities for development in its particular genre', not mentioning that all

of Lye's work in this period is effectively advertising, with sponsors' messages included among the exhilarating visual and musical rhythms. Like many Modernists working in new and expensive media, Lye could only use their full resources when offering his art as commercial design.

In this imaginary space between Soviet montage cinema, two versions of the French avant-garde in *L'Inhumaine* and *Ballet mécanique,* and Lye' s abstract animated advertisements lie some of the great successes of film as Modernist art in the inter-war period. Film seemed to promise nothing less than a revolution in, and of, art: a medium that combined the key features of the modern era – mechanization, speed, internationalism, reproducibility – and at the same time rendered the very idea of the unique hand-made object redundant, a relic of the past when art fulfilled a sacred or cultic role.[5] Film was, by nature, objective, democratic and universal; and for some this amounted to a prima facie case against not only traditional but also contemporary fine art. Shortly before Barr's Moscow epiphany, Iris Barry – a founder member of the London Film Society who would later head the Museum of Modern Art's film department – threw down the gauntlet: if the everyday experience of cinema offers so much of what the pre-war avant-gardes sought to achieve, 'why do the Montmartre cubists go on cubing?'[6]

This was of course deliberately provocative. In an equally striking phrase, Robert Graves and Alan Hodge observed in their memoir of the inter-war years that, whatever its ubiquity, 'film was neither art nor smart'.[7] Cinema was certainly pervasive across the period and provided a constant point of reference for artists and public alike, but few of the films being widely made and seen were considered 'art', either Modernist or even modern. If anything, they related to popular stage and print forms, such as music hall, vaudeville and feuilleton newspaper serials. Charlie Chaplin's frenetic comedy, Douglas Fairbanks's athletic adventures and the new femininity signalled by Clara Bow's and Louise Brooks's bobbed hair – these were all immensely popular and were widely embraced as emblematic of modernity, with Chaplin in particular becoming virtually a mascot among 'advanced' artists (see Chapter 4 and cats 68, 73).[8] But what of the Westerns of Tom Mix, the smouldering sensuality of Rudolph Valentino, or the pomp and religiosity of such films as *The Ten Commandments* (1923) and *Ben-Hur* (1925), all equally popular, yet scarcely modern in either their visual styles or sources of appeal. Indeed, popular cinema was often seen as entrenching what Modernism opposed – a form of contamination, according to Eisenstein's contemporary Dziga Vertov;[9] an alternative to modern art in the form of a new 'folk art', in the approving account by Erwin Panofsky;[10] or a 'jazzy' perversion of Modernism, according to Nikolaus Pevsner.[11]

To trace the roots of film's appeal and challenge to Modernists of the inter-war years, it is necessary to recall briefly the earliest debates about its nature –

8.2 **Marcel L'Herbier**, *L'Inhumaine*, 1924

which were of course no older than the childhood of most of the 1920s artists and audiences. Moving pictures had first seemed to many, in an age of wide belief in spiritualism, like a new kind of mediumship, eerily bringing the absent or even the dead to life. But they were also inescapably dependent on whirring, noisy machines, and this mechanical quality repelled many early observers. An English critic writing in 1896 saw the cinematograph as 'an onslaught on art', akin to naturalism and other forms of excessive realism, for which he nonetheless predicted a 'statistically' successful career: 'its results will be beautiful only by accident', though its colourless 'slabs of life' may provide evidence for the future.[12] Twenty years later, reinforcing a sceptical attitude that had become characteristically English, D.H. Lawrence traced the downfall of a middle-class woman in *The Lost Girl*, as the concert party she has joined reluctantly gives in to the workers' fascination with pictures: 'they are cheap, they are easy and they cost the audience nothing, no feeling of the heart, no appreciation of the spirit'.[13] Elsewhere, in Russia, the future Constructivist poet Vsevelod Mayakovsky declared in 1913 that 'cinema and art are phenomena of a different order', while believing that film's ability to reproduce 'mechanically' would push the other arts to redefine themselves more creatively.[14]

Part of the impact of cinema was indeed to deprive theatre and painting of their most traditional role as purveyors of alternative worlds. But the second decade of the twentieth century also saw the flowering of what could be considered a 'proleptic' cinema of artists' projects and improvisations – few of which have left any tangible trace – that bears witness to the early impact of moving pictures and has too often been ignored in the historiography of both art and film. Moreover, the fact that this proleptic period overlaps with the emergence of the historic avant-gardes – literary Modernism, Expressionism, Cubism, Futurism, Constructivism and their offshoots – only adds to the complexity of mapping the place of film in Modernism. In fact, conflict between different film aesthetics, and different uses or definitions of cinema, would play an important part in challenging purist versions of Modernism during the late 1920s and early '30s. The internationalism of film, travelling across borders and seas more rapidly and easily than traditional artworks, would also introduce a new dynamic into the contested geography of Modernism.

First journey: visible harmonies

An exploration of this terrain can begin with the speculations of Wassily Kandinsky and Arnold Schoenberg around 1912–13. Both painter and composer, poised to take their art forms into the distinctively Modernist realms of abstraction and atonality, saw film as a potential ally that could 'dematerialize' theatre and make possible a new spectacle of pure sound and image.[15] Kandinsky apparently thought that his musical fantasy *Der Gelbe Klang* (*The Yellow Sound*, c.1909), with its lumbering giants and flying spirits in a variety of hues, might be realized on film.[16] Schoenberg was more definite, suggesting that for his 'drama with music', *Die glückliche Hand* (*The Lucky Hand*, 1913), the use of film – 'nasty idea that it is', as he remarked in a revealing aside to his publisher – could achieve the opposite of cinema's usual aspiration to realism and create a feeling of unreality, stripped of symbolism: 'simply the play of colours and forms'.[17] To achieve this, he suggested Kandinsky as one of the artists who might be invited to make such a film.

Neither of these sophisticated conceptions came close to realization, which in any case would have been difficult technically within the limited scope of colour processes in cinema at that time, even if Kandinsky and Schoenberg had found appropriate collaborators. But, more crucially, both seem to have their roots in older traditions, as much as in any special recognition of cinema's Modernist potential; the magic-lantern phantasmagoria of the late eighteenth century were an ancestor of Kandinsky's Symbolist vision and the colour-music experiments of the late nineteenth century an influence on both.[18]

This tradition of seeking a synthesis between visual art and music, often through the idea of correspondence between the visible and the auditory spectrum, certainly stretches back to the Enlightenment and had been given new impetus by the nineteenth-century Romantics' and Symbolists' interest in finding correspondences between the senses.[19] It would continue within the new Cubist and Futurist avant-gardes of the early twentieth century. The Italian Futurist Bruno Corra wrote in 1912 of his experiments with his brother Arnoldo Ginna in creating 'a music of colours', first by means of a 'chromatic piano' linked to an array of light bulbs, then by painting directly onto film.[20] Corra went on to describe two 'recent' abstract films, each approximately 10 minutes long, in some detail: *The Rainbow* permutated the rainbow's colours with increasing intensity until a final 'dazzling explosion', while *The Dance* had colours 'pirouetting like spinning tops'.[21] Unfortunately, no independent corroboration or copies of these pioneering experiments appear to exist, and the earliest authenticated Italian Futurist films, dating from 1914 to 1916, are acted rather than abstract. These range from Marcel Fabre's witty *Amore Pedestre* (*Love Afoot*, 1914), in which a romantic intrigue is narrated entirely in close-ups of the protagonists' feet, to the elaborate melodrama *Thaïs*, with geometric settings by Enrico Prampolini, and the collective *Vita futurista* (*Futurist Life*, 1916), made up of provocative sketches such as *Futurist Lunch* and *How a Futurist Sleeps* (upright, apparently). However, this was anticipated by the Russian Futurists' film *Drama in the Futurist Cabaret no.13* (1914), which followed their manifesto *A Slap in the Face of Public Taste* (1912). The film is known only from one surviving still, which shows the Cubo-Futurist painters Mikhail

Larionov and Natalia Goncharova with hieroglyphic symbols painted on their faces, and the latter bare-breasted.[22] The idea of an avant-garde movement with a flamboyant style of group behaviour lent itself to a kind of film-making that often parodied popular genres, very different from the formal experimentation of Corra, although both of these would continue into the 1920s and beyond.

Among Cubists, it was the Russian-born Leopold Survage, based in Paris since 1908, who produced a series of abstract designs intended as the basis of a short film to be called *Le rhythme coloré* (*Coloured Rhythm*, 1913).[23] The Gaumont company's launch of its Chronochrome colour process in 1912 seems to have encouraged his project, although it remained unrealized. However, Survage's abstract imagery, worked out in more than a hundred surviving paintings, anticipated many of the motifs that would recur in experimental films of the following two decades. It suggested a kind of choreography of forms evolving and conflicting, while seeming to move freely in a new multi-dimensional space.

Survage's paintings were intended as key images for sequences that would be elaborated by others working to his direction, effectively anticipating the division of labour that became standard in industrial animation. But there were other artists during the 'teens who conceived works that can be seen as pointing towards a new fascination with the relationship between space and time. Sonia Delaunay produced a visual interpretation of Blaise Cendrars's poem *La Prose du Transsibérien* (*The Prose of the Trans-Siberian*) in 1913 in the form of a two-metre banner or scroll folded into a book, its length evoking the vast distances covered by Cendrars's text.[24] Another version of such a scroll was produced in 1914 by Duncan Grant, a member of the Bloomsbury circle, whose *Abstract Kinetic Collage Painting with Sound* is a four-metre strip with irregular geometric forms attached, apparently intended to be wound past a viewing window in a box and accompanied by a gramophone recording.[25] Grant's account of the effect he wanted to produce – 'black green white yellow to grey to dark grey to black' – brings it into the line that leads from *fin-de-siècle* colour music experiments, especially by the Russians Alexander Skriabin and Mikalojus Ciurlionis, through Corra's hand-painted films, to the scrolls produced by Viking Eggeling and Hans Richter at the end of the decade.[26]

It was another avant-garde movement, Dada, that brought Eggeling and Richter together in Zurich in 1918. Eggeling was already working on rolls of paper, developing forms of stylized notation in what he called 'Symphonies', as he searched for 'the rules of a plastic counterpoint'.[27] Richter, meanwhile, had moved from Cubist-style paintings in 1914 through an Expressionist phase, until he began producing simplified black-and-white Dada heads in Zurich. During the three years that Eggeling and Richter worked together, they produced a series of musically inspired scroll drawings, which seemed to point to

film as the ideal means of presenting this 'art of becoming, of unfolding, of constant reference forward and backward in space and time'.[28] In 1920 the support of a Berlin banker enabled them to publish a pamphlet entitled *Universelle Sprache* (*Universal Language*) and to have their ideas tested in practice at the leading Ufa Film Studio, which brought them to the attention of the De Stijl theorist Theo van Doesburg.

Van Doesburg effectively reversed the long-standing mechanical charge against film, insisting that the artwork required for 'abstract dynamic plasticism' *must* be mechanically produced, and offered further evidence of 'the helplessness of primitive hand-work'.[29] However, it was handwork that produced

8.3 **Walther Ruttmann**, *Lightplay, Opus I–IV*, sections of animated film strips 1920–24 (cat.21)

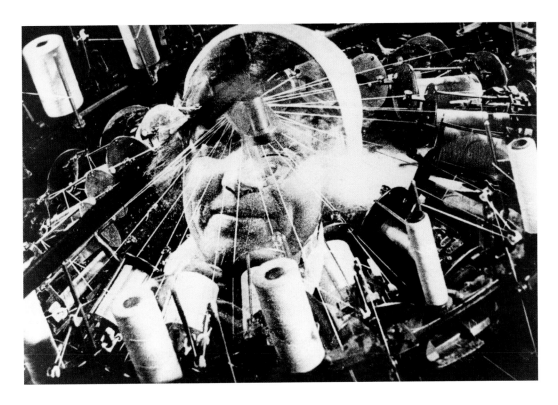

8.4 **Dziga Vertov**, *The Man with a Movie Camera*, 1929 (cat.67)

Richter's *Rhythmus 21* (1921) and the one film that Eggeling managed to complete before his early death, *Diagonal Symphony* (1924). The former treats the screen as a picture frame, with constantly moving rectangular shapes in black, grey and white that echo the geometry of Malevich's and Mondrian's paintings (pls 2.8, 2.11), creating an eerie illusion of depth. Eggeling meanwhile created a form of motion drawing, with a series of linear comb-like motifs in white, all balanced on the diagonal, which emerge out of a black screen to which they return in a steady rhythm.

Independently of Richter and Eggeling, another German artist with a musical background had created an abstract film that was coloured and accompanied by an orchestral score. Walter Ruttmann's *Lichtspiel Opus I* (*Lightplay Opus I*, pl.8.3) had its premiere in Frankfurt in 1920 and another performance in Berlin the following year, where a review hailed its pulsating organic forms as 'a sound painting where the tone colour seemed literally to fulfil the meaning, content and character of the music'.[30] Ruttmann would go on to create three further abstract *Lightplay* films, before contributing an animated dream sequence to Fritz Lang's monumental *Die Niebelungen* (*The Nibelungs*) in 1924 and turning to live-action film, although still underpinned by a musical conception, in *Berlin: Symphonie der Grosstadt* (*Berlin: Symphony of a Great City*) in 1927. Recognizing the growing interest in abstract film, Ufa organized in 1925 at their largest Berlin cinema an Absolute Film Matinée, which included – as well as work by Richter, Eggeling and Ruttmann – two films from France: Léger's *Ballet mécanique* and René Clair's *Entr'acte*. What had been experimental work now faced what has been termed

a 'contextual dilemma with fine art on one side and [commercial] animation on the other'.[31] Shortly after the matinée, the head of a Berlin advertising company commissioned the Ufa cameraman Guido Seeber to collaborate on an advertising film 'in the style of Léger' and the result was *KIPHO* (1925), a lively advertisement for the cinema and photography trade exhibition *KIno und PHOtoausstellung* (Cinema and Photography Exhibition). It was also a pioneering film about the film-making process that anticipated Vertov's *The Man with a Movie Camera* (1929, pl.8.4).[32]

The example set by a small number of film-makers in Germany, France and Russia in the early 1920s had created a new belief in the potential of film, not only meeting traditional artistic criteria, but as a new kind of art that could overcome the 'limitations' of painting, sculpture, theatre and literature. The founder of Russian Suprematism, Kazimir Malevich, wrote in 1926 that 'cinema should have overturned the entire visual culture', while castigating his contemporaries – even those regarded as revolutionaries by film-makers elsewhere – for creating images that could have been painted in the nineteenth century.[33] While on a visit to Germany in 1927, Malevich went on to prepare his own script for an 'artistic-scientific film', which would show the transformation of the basic Suprematist motifs of the square, the circle and the cross in primary colour combinations, and would demonstrate, in the words of its title, 'the emergence of a new plastic system of architecture'.[34] Malevich's project can also be seen as a further example of the Russian avant-garde's concern to 'modernize' narrative, as in El Lissitzky's *Tale of Two Squares* (1922) and Mayakovsky's unrealized non-fiction script 'How Are You?'[35]

The project's fate, like many earlier artists' dreams of a radical cinema, was to remain unrealized (and indeed unknown until the 1970s).[36] Malevich had proposed collaboration to Richter, who had meanwhile abandoned purely abstract imagery for mixed materials in his topical 'essay film' *Inflation* (1927), made during Germany's financial crisis. He then turned to live-action cinematography for the playful Dadaism of *Vormittagsspuk* (*Ghosts Before Breakfast*, 1928), featuring a number of contemporary musicians, and with an accompanying score by the leading German Modernist composer Paul Hindemith, which was later added to the film. But Malevich could still represent an ideal for one of his most important contacts in Germany, the pioneer Constructivist and Bauhaus teacher László Moholy-Nagy. Having coined the term 'polycinema' as early as 1925, Moholy-Nagy suggested three years later that the cinema screen itself represented an 'interpretation of Malevich's last picture [a white square on a white canvas]', which he later interpreted as 'symbolic of the transition from painting in terms of light'.[37] Malevich, however, rejected Moholy-Nagy's promotion of what he termed 'photo-mechanization', insisting in a letter that painting, albeit abstract, remained a 'primary art', even

though photography may serve, like the brush or pencil, as a technical tool.[38] By 1930 Moholy-Nagy had moved beyond the cinema paradigm and had begun to exhibit his own demonstration of a new art of light, freed from the limitations of film, in the form of a projector eventually known as the *Lichtrequisit einer Elektronischen Bühne* (*Light Prop for an Electric Stage*, pls 4.9–11). Meanwhile, Malevich would find the filmic version of the 'additional element' that he traced through the history of progressive painting in Vertov's use of 'displacement and surprise' in *The Man with a Movie Camera* (1929), thus finally bringing true dynamism to the otherwise disappointingly 'static' achievements of cinema.[39]

Second journey: an avant-garde and an end to avant-gardes

Although France could reasonably claim to have fostered a culture of cinema from the earliest period of the Lumières, with a succession of leading artists and critics welcoming the new medium more enthusiastically than elsewhere, there was no equivalent production that reflected this until after the First World War. The spark that ignited a new approach, ironically, proved to be an American film: Cecil B. DeMille's *The Cheat* (1915), released as *Forfaiture* in France, where it transfixed the Parisian intelligentsia. According to the novelist Colette, 'every evening, writers, painters, composers and dramatists come and come again … like pupils'.[40] What fascinated the 'pupils', many of whom would become the avant-garde film-makers of the next decade, was the sheer focus of DeMille's highly charged erotic melodrama, in which a Long Island society hostess is brutally forced to honour her debt to an eastern merchant. Starkly lit and stripped of distracting detail, American film-making seemed far superior to the theatricality and empty spectacle of French production. At last, the cinema seemed modern.

However, modern, as we have seen, was not necessarily Modernist; and the various strands of avant-garde film-making in France that stemmed from this moment of revelation had complex relations with Modernism in the contemporary visual and other arts. The common denominator among film-makers as diverse as Louis Delluc, Jean Epstein, Marcel L'Herbier, Germaine Dulac and Abel Gance was a preoccupation with 'cinematic specificity', meaning that which could be considered unique or specific to cinema, as distinct from the other arts.[41] For Delluc, the founder of this first avant-garde as both a critic and film-maker, cinema's greatest power was to represent nature and, in so doing, transform it. He revived Daguerre's original term for the transformative quality of photography, *photogénie*, but after his premature death this was interpreted in strikingly different ways by his followers. Epstein, also a prolific essayist as well as a film-maker, defined it as the quality of 'varying simultaneously in space and time', while his own practice ranged from the costume drama of *L'Auberge rouge* (*The Red Inn*, 1923) to 'modern' psychological studies such as *La glace à trois faces* (*The Three-sided Mirror*, 1927), making use of rapid editing, complex narrative structures, superimpositions and extreme close-ups. Specificity lay in multiplying distinctively filmic devices.

For L'Herbier, modern subjects were also important, and in three ambitious features of the 1920s he would marshal impressive resources to create a genre of Modernist spectacle. As already noted, Léger contributed his prestige to *L'Inhumaine*, but L'Herbier also drew on the fashionable architecture of Robert Mallet-Stevens, the furniture designer Pierre Chareau, the couturier Paul Poiret and the music of Darius Milhaud, to make this a veritable anthology of Modernist design. It was all in the service of a script by the novelist Pierre MacOrlan, which incorporated elements of the traditional fairy tale and early science fiction in a futuristic love story between a diva and an engineer. In *Feu Mathias Pascal* (*The Late Mathias Pascal*, 1926), L'Herbier adapted a novel about the instability of modern identity by one of the central figures in literary Modernism, Luigi Pirandello, already renowned for his 1921 play, *Six Characters in Search of an Author*. For *L'Argent* (*Money*), in 1928, L'Herbier updated Zola's classic analysis of the corruption inherent in capitalism to produce a film that anticipated the Wall Street Crash of the following year, with its frenetic portrayal of stock-exchange trading.

Compared with Epstein and L'Herbier, Germaine Dulac's feminist concerns appeared closer to those of literary Modernism and the 'visual music' tradition. In a series of films centring on women's consciousness and sexual repression, including *La souriante Madame Beudet* (*The Smiling Madame Beudet*, 1922), *L'Invitation au voyage* (*Invitation to a Voyage*, 1927) and *La coquille et le clergyman* (*The Seashell and the Clergyman*, 1928), she dealt with themes raised by the first generation of Modernist writers and artists, and the last of these duly brought her into conflict with the often militantly macho Surrealist group, who accused her of 'feminizing' a provocative scenario by Antonin Artaud.[42] At the same time Dulac was deeply involved in pursuing the analogy between film and music, writing in 1925 of 'the integral film which we all hope to compose [as] a visual symphony made of rhythmic images' and producing at the end of the decade two short films apparently intended to be synchronized with gramophone recordings, *Disque 957* (*Record 957*, 1928) and *Etude cinégraphique sur une arabesque* (*Cinegraphic Study on an Arabesque*, 1929).[43] These concerns were also explored in non-musical terms by Henri Chomette in two 'pure cinema' films, *Jeux de reflets et de la vitesse* (*Play of Reflections*, 1924) and *Cinq minutes de cinéma pur* (*Five Minutes of Pure Cinema*, 1925), which used a kaleidoscopic variety of imagery and filmic devices to 'leave behind the logic of events and the reality of objects' and 'create visions which are unknown'.[44] This attempted bracketing of the representational and narrative dimensions of film brought Chomette

8.5

close to Man Ray, who had assembled the pioneering collage of diverse filmic material *Retour à la raison* (*Return to Reason*) for a Paris Dada event in 1923, and they collaborated on a commissioned film *A quoi rêvent les jeunes films?* (*What do young films dream of?* [an ironic skit on the title of Alfred de Musset's play, *What do young girls dream of?*], 1924), from which Chomette later extracted *Jeux de reflets* and Man Ray *Emak Bakia* (1926).

The most paradoxical and influential figure associated with the French avant-garde was undoubtedly Abel Gance, who had begun his cinema career before the First World War as a prolific director of comedies and, increasingly, melodramas. At the end of the war his passionate *J'accuse* (*I Accuse*, 1919) had revealed a growing ambition to work on the grand scale, with such massive set-pieces as the ghostly 'march of the dead' and a mass of figures seen from above, spelling out the film's title. Later, Gance's fondness for sweeping historical images and grandiose imagery would result in his epic *Napoleon* (1927), today perhaps the best known of all 1920s films, since its restoration and extensive concert-style screening. But if there seems little that could be considered Modernist in Gance's extravagantly Romantic rhetoric, it was his *La Roue* (*The Wheel*, 1923, pl.8.5) that proved seminal for the development of a Modernist film aesthetic. Gance's vast film, made amid much personal tragedy, was essentially an elaborated melodrama about the quasi-incestuous love of an engine driver for the girl he had raised as his daughter. Framing and punctuating the extended scenes of emotion are two kinds of filmic material, which registered powerfully with those who first saw the film. One is a semi-documentary record of the railway world, showing, as one critic wrote at the time: 'a new material whose photogenic qualities are clearly apparent: the mechanical world of iron and steam, of rails and smoke, of wheels and manometers, of connecting rods and regulators … [of] order and accuracy, desire and love'.[45]

The other material was Gance's intensification of visual impact by means of fast-paced cutting, or *montage court*, during key scenes when disaster threatens or occurs on the railway. Part of the responsibility for this radical shaping of the filmed material can be attributed to the poet Cendrars, who worked with Gance on the editing of the film. But its most celebrated, and influential, admirer was Léger, who described in his 'Critical Essay on the Plastic Quality of Gance's *La Roue*' how this new 'mechanical element … projected at a heightened speed that approaches the state of simultaneity and crushes the human object … has elevated the art of film to the plane of the plastic arts'.[46] For Léger, as for others in the nascent cinema avant-garde, these passages of dynamic plasticity were vastly superior to the film as a whole, and were indeed soon shown separately as extracts at both the *Salon d'Automne* in 1923 and special ciné-club screenings. Several years later they would be taken to Russia, along with Clair's *Entr'acte* (commissioned and written by Francis Picabia, who

also appears in it) and Léger's own *Ballet mécanique*, to be seen by the emerging Russian avant-garde.

Meanwhile, 1923–4 saw a rising level of interest and activity in France around the new concept of cinema as 'art', with an exhibition of stills, scripts, designs and models at the Musée Galliera, and an accompanying series of lectures by critics and film-makers.[47] Two films emerged that reflected the new willingness of established artists to engage with film-making, albeit with some practical assistance, and both quickly became benchmarks. *Entr'acte* was originally commissioned as a series of film inserts for Francis Picabia's ballet *Relâche* (*Cancelled*), performed by the Ballets Suédois at the Théâtre des Champs-Elysées in December 1924. Partly a group portrait of the Paris Dada circle, with appearances by Duchamp, Man Ray, Satie and Picabia, the film also pokes fun at high culture (with repeated shots looking up the skirt of a transvestite ballerina), before turning into an accelerating chase comedy, punctuated by bad-taste gags, and ending with a gesture of defiance towards the audience as Jean Borlin of the Ballets Suédois invites them to disappear.

Ballet mécanique (pl.8.6) seems to have resulted from a combination of Léger's growing interest in cinema and the appearance in Paris of a young American film-maker, Dudley Murphy, able and willing to realize his ideas. Behind this happy introduction, and the score by George Antheil that later accompanied what would be Léger's only completed film, stood the poet and impresario of Modernism, Ezra Pound, who had moved from London to Paris in 1920 and was already friendly with many artists.[48]

8.5 **Abel Gance**, *La Roue*, ultra-rapid montage sequence, 1922 (cat.48)

8.6 **Fernand Léger**, *Le Ballet mécanique*, 1924 (cat.75)

8.6

Controversy has long continued over how much responsibility Léger had for the film, with claims being made that much of its imagery was in fact already developed by Man Ray and Murphy, before the latter was advised that Léger could afford to finance such a film.[49] Whatever the merits of these competing claims, there is little doubt that Léger's seniority and prestige – together with the fact that his painting at the time of working on the film reflected the same concerns with machine detail and with the kaleidoscopic fracturing of surfaces and forms (as in the painting *Mechanical Elements,* 1924) – contributed strongly to the success of the film, after its premiere at the *Internationale Ausstellung neuer Theatertechnik* (International Exhibition of New Theatre Technique), organized by Frederick Kiesler in Vienna (see Chapter 4). Above all, in the shaping of the film's various episodes, such as the washerwoman's perpetual climbing of a staircase and the 'postcard in motion' of a woman swinging, or the 'ballets' of kitchen utensils and newspaper headlines, there was a careful calculation of how duration and speed would affect the audience. Léger wrote about his own film and *Entr'acte*, aligning both with the search for specificity:

> Whether it is *Ballet mécanique*, somewhat theoretical, or a burlesque fantasy like *Entr'acte* … the goal is the same: to avoid the average, to be free of the dead weight that constitutes the other films' reason for being. To break away from the elements that are not purely cinematographic, to let the imagination roam freely despite the risks, to create adventure on the screen as it is created every day in painting and poetry.[50]

Two other significant aspects of the film's production were that it took place across the period when Léger was contributing to L'Herbier's *L'Inhumaine*, which no doubt served to reinforce his determination to react 'against the films that have scenarios and stars', and that it belongs to the period when 'Purism' offered to lead Cubism to an orderly and constructive conclusion.[51] In many ways, *Ballet mécanique* provides an inventory of Purist motifs, such as *objets types* that fulfil constant human needs rather than the aridity of abstraction, and a model of the movement's cooperative ideology. And by its invocation of the spirit of Chaplin, with Léger's animated Cubistic puppet, it aligns its theoretical aspect with the popular. Adventure, certainly, but with a purpose.

A sense of purpose soon became obligatory in Russia after the revolutions of 1917, as artists were expected to serve the needs of the Bolshevik regime and to produce art that was, according to the later watchwords, 'intelligible to the millions'.[52] The central paradox of the later 1920s was that, while the achievements of Soviet avant-garde film-makers rapidly became the touchstone by which all other cinema was judged, these same film-makers were viewed with increasing suspicion at home. However, in the immediate aftermath of 1917, when the material

life of Russia was at its lowest ebb, the pioneering efforts of two film-makers in particular, Dziga Vertov and Lev Kuleshov, served to set Soviet cinema on very different paths from the cinema that had flourished previously. The former Futurist Vertov became a newsreel editor and developed his theory of the 'cine-eye', which shunned fiction in favour of the revelatory and analytical value of 'life caught unawares'.[53] Kuleshov had worked as a designer in pre-revolutionary cinema, but when this industry collapsed during 1918, he was forced to embark on a rediscovery of the bare elements of film that would shape his work as a teacher and theorist of 'montage', or the 'efficient assembly of shots', as 'the essence of film art'.[54] Kuleshov advocated close study of American popular cinema, especially the suspense thrillers favoured by Russian audiences, since its method alone could be considered 'truly cinematic' by virtue of making every shot count towards a 'maximal impression'.[55] Teaching a workshop at one of the world's first film schools in Moscow in the early 1920s, he developed a series of 'experiments' or demonstrations of image association and inference, intended to justify his emphasis on montage and give it quasi-scientific grounding by appeal to recent studies in reflexology by Bechterev and Pavlov. The group then put their theory into practice with one of the first popular domestic cinema successes of the Soviet era, a satirical comedy entitled *The Extraordinary Adventures of Mr West in the Land of the Bolsheviks* (1924).

Vertov continued to argue for the even more radical position of rejecting all fiction film as 'a poor imitation of life', insisting that the builders of socialism had no need for such distractions when the emancipated 'cine-eye' could make use of montage to edit reality and furnish 'a new perception of the world'.[56] He began to assemble the documentary material that had already been used for cine-magazine series such as *Kino-Pravda* (*Cinema-Truth*) into feature-length films, beginning with *Kino-Eye* (*Cinema-Eye*, 1924), which shared a prize with Sergei Eisenstein's first film, *The Strike* (1925), at the 1925 *Exposition Internationale des Arts Décoratifs et Industriels Modernes* (International Exhibition of Modern Decorative and Industrial Arts) in Paris. Eisenstein had emerged from a brief but hectic apprenticeship in the revolutionary Proletkult theatre, determined to apply similar shock-techniques to cinema. After *The Strike* (which remained unknown outside Russia until the late 1960s), he embarked on a film intended to commemorate the failed 1905 Russian Revolution, eventually focusing on just one episode: the mutiny on a warship in Odessa. *The Battleship Potemkin* (pl.8.7) was launched with some fanfare (though little box-office success) in Russia early in 1926, but its release in Germany in April sparked a wholly unprecedented response that sent shockwaves around the world. No previous film, with the possible exception of D.W. Griffiths's *Birth of a Nation* (1914), had provoked such strong emotions and been considered a major political event.

Restrictions governing the film's screening were hastily introduced in countries around the world, with many banning it outright.[57]

The ideological impact of *Potemkin* was closely bound up with its aesthetic novelty, as Eisenstein drew a parallel between the concept of dialectic and the practice of montage. All film had to be 'tendentious', he insisted, even if it was not as overtly political as *Potemkin*; and building on Kuleshov's theory of montage as triggering the spectator's reflexive response, Eisenstein added an increasingly elaborate account of intellectual and aesthetic responses in a series of articles.[58] He also attacked positions that might be confused with his own, dismissing the programme of artists' films brought by Ilya Ehrenburg from Paris to Moscow in 1926 as mere 'children's playthings – based on the photographic possibilities of the photographic apparatus', and repudiating Bela Balazs's praise for *Potemkin* as revealing a failure to understand that 'the expressive effect of cinema is the result of juxtapositions', instead of 'effective shots'.[59] With another montage-based agitational film in wide circulation, Vsevelod Pudovkin's *The Mother* (1925), Soviet revolutionary cinema quickly established a leading international position, challenging 'pure' or 'abstract' film and establishing its own terms of reference in the specialist film journals that began to appear. At the first meeting of a proposed International Association of Independent Cinema, held in Switzerland in 1929 and attended by representatives from a dozen countries, Eisenstein and his colleagues were the main focus of attention.

But however vigorously Eisenstein promoted his position, claiming that his next film, a celebration of the October Revolution itself, would be 'an experiment, intelligible to the millions', there were clear challenges and threats. Although the Soviet avant-garde had defined specificity in terms of montage, other Russian theorists were ready to challenge this. The Formalist critic Boris Eikhenbaum, writing in 1927, linked the French theory of *photogénie* with the Russian Futurist concept of *zaum* or trans-sense, also advancing the idea of 'inner speech' as an under-pinning of montage.[60] And when Eisenstein pushed his experiments with intellectual montage to their furthest limit in *October* (1928), while rebutting criticism of the film's obscurity, he would eventually admit to being depressed by 'the imperfect methods of a cinema operating only in visual images'.[61] As noted earlier, Eisenstein also had a trenchant domestic critic in Malevich, who insisted that none of the Soviet 'revolutionary' films, except Vertov's, had advanced beyond the artistic level of the nineteenth-century 'Wanderers', since they still relied on naturalistic images. Clearly stung by this, Eisenstein responded in a 1929 essay that 'not even a film novice would now analyse a film shot as if it were an easel painting'.[62]

October had been criticized for its obscurity and for its intensive formal elaboration, in such passages as the 'Gods and Country' montage and the intercutting

8.7 **Sergei Eisenstein**, *The Battleship Potemkin*, 1925 (cat.8)

of the Provisional Government's leader Kerensky with a mechanical peacock. Several critics suggested that behind its Constructivist exterior lay a work conceived in hermetic Symbolist terms.[63] But even more pressing was the fact that the film had been subject to draconian political censorship by Stalin; and Eisenstein's next project, *The General Line*, was also abruptly reshaped into *The Old and the New* (1929) before quickly being shelved. After an extended period abroad, in Western Europe, Hollywood and eventually Mexico, the film that Eisenstein made in Mexico was taken away from him on Stalin's orders, and his remaining projects of the 1930s were all aborted, up to *Alexander Nevsky* (1938). By the time *Nevsky* appeared, many Russian Modernists were either dead or silenced, and the period when the Soviet avant-garde had proclaimed a progressive and seemingly popular Modernism – to the delight of Barr and many western sympathizers – seemed not only finished, but firmly repressed.

Another, admittedly lesser, challenge faced supporters of Modernism in Western Europe from the 1930s onwards. The Surrealist movement that had emerged in the mid-1920s defined itself in part by a hostility to avant-gardism, and this was especially shrill in relation to film. After the scandalous success of Luis Buñuel and Salvador Dalí's *Un Chien andalou* (*Andalusian Dog*) in 1929, it became routine for Surrealists to denigrate the work (and character) of non-Surrealists. Members of the French film avant-garde – L'Herbier, Epstein, Dulac and Gance – suffered particularly from the history of avant-garde film being written largely from a Surrealist perspective. But Surrealism was also deeply anti-Modernist,

rejecting the rationalism and utopianism that had inspired many Modernists during the inter-war years, and celebrating instead the 'unconscious' and excess of popular culture, as found in genre films. Under the combined pressure of Soviet anti-formalism, which affected many 'fellow-travellers' in the West, and Surrealist anti-avant-gardism, the concept of Modernism was forced onto the defensive – even before it met the further challenges of fascism.

Third journey: soundscape and documentary

Despite a climate of hostility towards avant-gardism, experimental film-makers at the end of the 1920s were faced with a range of opportunities that would bring them into new relationships with industry and technology, of the kind that were already familiar to artist-designers in other fields. The synchronization of recorded sound was the most immediate opportunity, and in 1927 Warner's success with *The Jazz Singer* and their Vitaphone musical shorts launched the Talkie revolution. In Germany, Ruttmann expanded the cross-sectional technique of his *Berlin* to assemble material from many countries in *Melodie der Welt* (*World Melody*, 1929), under such themes as transport, architecture, religion, warfare, sport and love. Sponsored by the Hamburg-Amerika shipping company, *World Melody* also used the German Tri-Ergon sound system to produce a *Kulturfilm* (documentary) with educational pretensions, rather than the sentimental melodrama of *The Jazz Singer* or a thriller such as Britain's first Talkie, *Blackmail* (1929). The following year Ruttmann's pioneering acoustic collage for radio, *Weekend*, used sound-film equipment to record natural noises and fragments of speech. These experiments were paralleled by those of Dziga Vertov in Soviet Russia, whose documentary about Russian industry and natural resources, *One Sixth of the World* (1926), had been commissioned by the state trading organization Gostorg, and who rapidly adopted sound recording for his celebration of the Soviet Five-Year Plan in *Enthusiasm* (1931).

The concept of documentary became widely current in the late 1920s, gaining a new status for film among those still suspicious of cinema's roots in escapist fiction, and influencing Modernist literature through the development of 'filmic' structures and of the non-fiction novel by such writers as John Dos Passos and Ilya Ehrenburg.[64] In Britain the documentary film movement launched by John Grierson drew on Robert Flaherty's poetic portrayal of exotic societies – Grierson first used the term 'documentary' when writing about Flaherty's South Sea film *Moana* in 1926 – and on Soviet cinema as a model for the vivid presentation of social and industrial themes. Crucially, documentary emerged at a time of economic and political crisis, during the Depression of the early 1930s, and early impulses towards the playful and the lyrical, such as Jean Vigo's *A propos de Nice* (*About Nice*, 1927) and Joris Ivens's *Rain* (1929), gave way to

reportage and polemic, as in Henri Storck and Ivens's portrayal of a bitter miners' strike in *Borinage* (1930), and Norman McLaren and Helen Biggar's passionate anti-armaments protest, *Hell Unltd* (1935). Despite Grierson's attempt to define the form as 'the creative treatment of actuality', the variety of purposes and styles remained as wide as the horizons of documentarists, subject to the trust or flexibility of their funders.[65] Enlightened commercial and state sponsorship could make possible Joris Ivens's study of modern industry in *Philips Radio* (1931), Basil Wright's evocation of the exotic in *Song of Ceylon* (1932), Edgar Anstey's and Harry Watt's exposé of squalor in *Housing Problems* (1932) and Pare Lorenz's lyrical, yet passionate account of the challenges facing rural America in both *The Plow That Broke the Plains* (1935) and *The River* (1937).

As the political tensions of the 1930s deepened, documentary film came to play an increasingly important propaganda role, with a corresponding growth in state investment and control. Mussolini's commitment to aviation as the supreme demonstration of fascism led to a bombastic account of Italo Balbo's 1933 transatlantic expedition, *Gli Atlantici* (*The Atlantics*, 1933), and in Germany propaganda minister Joseph Goebbels backed Leni Riefenstahl to make two major Nazi propaganda films in documentary form, *Triumph des Willens* (*Triumph of the Will*, 1935) about the Nuremberg Party Rally, and *Olympia* (pl.8.8) about the 1936 Olympic Games held in Berlin. Both of these contributed to enlarging – or at least inflating – the formal vocabulary of documentary.[66] Films from the left were inevitably on a smaller scale, although the Spanish Civil War produced a number of powerful documentaries in support of the Republic, including Ivens's *Spanish Earth* (1937) and *Defence of Madrid* (1936) by Ivor Montagu and Norman McLaren. Even more modestly, in both Britain and the United States workers' film groups emerged to document strikes and rallies, and their films circulated through union networks and political film societies, often shown alongside the Soviet classics that these groups kept alive.[67]

For film-makers wanting to follow the path opened up by Eggeling, Richter and Ruttmann, the development of abstract graphic film benefited from the arrival of synchronized sound systems and photographic colour processes at the end of the decade, although the cost of these would often require – or invite – the support of advertisers. Len Lye's work in abstract animation, which attracted Paul Nash's admiration, was funded by his films carrying their sponsors' messages, usually woven into the rhythmic texture of the film as separate stencilled letters, to produce an effect that recalls the use of typographic elements in earlier Modernist painting. The resulting films proved so delightful that exhibitors were happy to show them, and *A Colour Box* (1935) was screened throughout Britain's Granada cinema chain.[68] In Germany, Oskar Fischinger ran an advertising company during the 1920s while producing his own largely abstract *Studies*, and collaborated with Bela

Gaspar, the inventor of Gasparcolor.[69] A 1934 advertising film, for Muratti cigarettes, allowed him to animate these like soldiers in marching formation, thus producing a work that escapes the anthropomorphism of most animation, while using colour and music to produce a spectacular 'object dance' that lies somewhere between the Bauhaus and Busby Berkeley's choreography. When Fischinger moved to America after being denounced as a degenerate artist by the Nazis, his efforts to work in Hollywood met with frustration. A virtuoso abstract short, using the motif of pulsating concentric circles that Fischinger had developed in his *Circles* (*Kreise*, 1933) was commissioned as an insert for Paramount's *Big Broadcast of 1937*, but rejected when he insisted that it appear in colour. Further frustration ensued when Fischinger worked for Disney on *Fantasia* (1940), developing an early version of what survived as the Bach

Toccata and Fugue sequence in the finished film.[70]

The United States had given refuge to many European artists and designers during the 1930s, making it, effectively, the home of a displaced Modernism. Like other industries, Hollywood made extensive (if erratic) use of the talent available to it.[71] Slavko Vorkapich, for example, had belonged to the Serbian Futurist group known as Zenithists in the early 1920s before emigrating to America, where he made an experimental short, *The Life and Death of a Hollywood Extra* (1928), with a fellow-immigrant, the French director Robert Florey. But Vorkapich's future would lie in designing concentrated montage sequences for mainstream studio films, such as the revolution sequence in *Viva Villa* (1934) and the famine montage in *The Good Earth* (1937). Indeed, it was the contribution of so many specialists from different backgrounds working in hierarchical studio

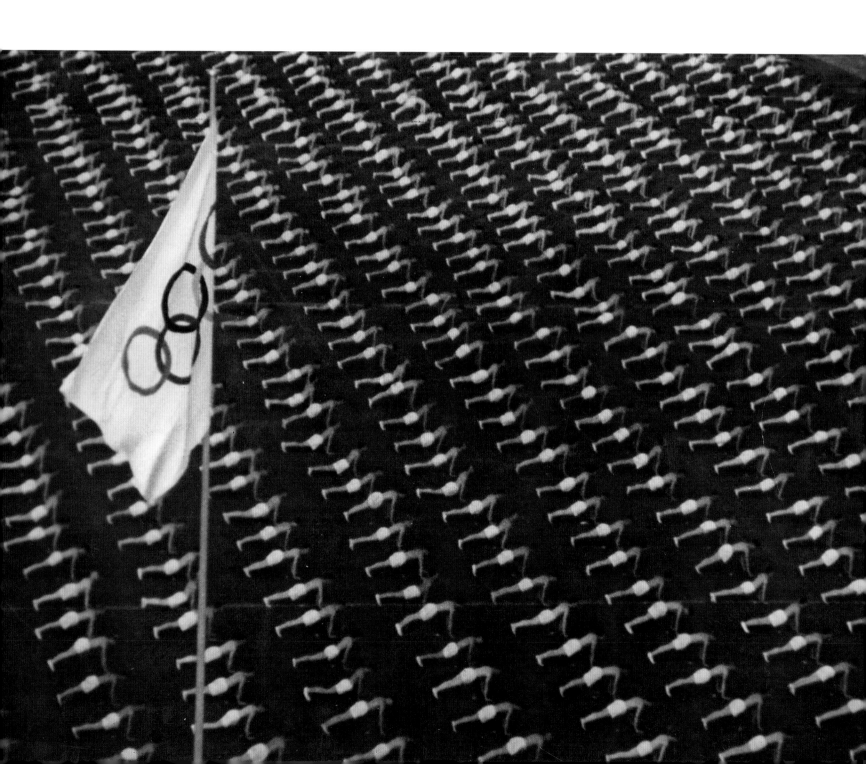

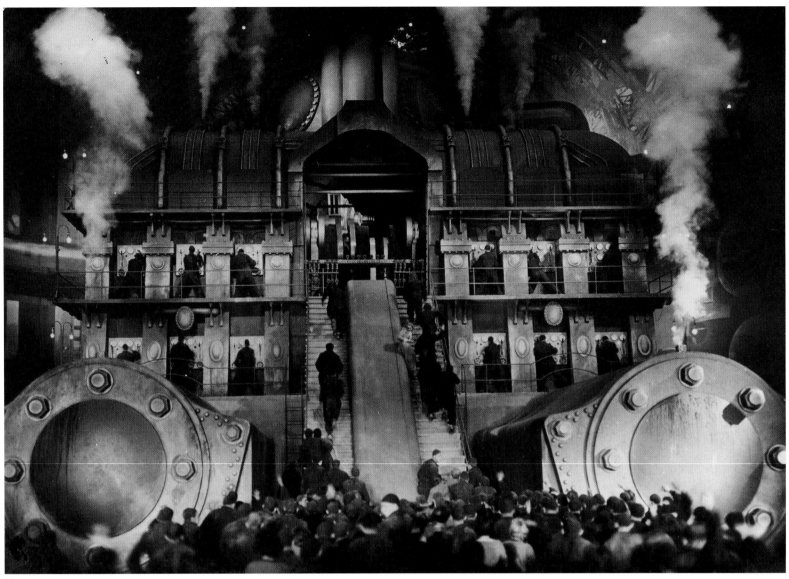

8.9

structures that helped maintain Hollywood's dominance. Some, like Vorkapich, devoted most of their careers to such craft work; others, like Fischinger, withdrew and tried to remain independent artists. The chequered history of Modernism's relationship to mainstream cinema includes many episodes of censorship, compromise and simple expediency. Andrei Burov's design for a model collective farm appeared as the climax of Eisenstein's *The Old and the New*, but a shift in Stalin's agricultural policy, combined with Eisenstein falling into disfavour, led to the film being quickly withdrawn from circulation.[72] Alexander Korda's apocalyptic warning adapted from H.G. Wells's novel, *Things to Come* (1936), showed a world shattered by war being rebuilt along rational lines and should have offered an exceptional opportunity to display Modernist design. Moholy-Nagy, Léger and Le Corbusier were all invited to contribute. In the end, however, most of what appears on screen was produced by the production designer Vincent

Korda and his staff, no doubt drawing on many sources, but also attuned to the peculiar demands (and freedoms) of film design.[73]

A handful of mainstream films made in the 1920s and '30s that featured Modernist design did so precisely because of the values that Modernism had popularly come to represent. Their decor makes them anxious allegories of Modernism's radical mission – with international-style architecture standing for sterility or dehumanization. In *L'Inhumaine*, Modernist decor by Cavalcanti, Mallet-Stevens and Léger not only signifies the future, but also a state of emotional frigidity, until the engineer Norsen miraculously, yet mechanically, brings the ice-queen Claire 'back to life'.[74] Modernist design plays a similar role in both *Aelita* (1924) and *Metropolis* (1927, pl.8.9), two super-productions that traded heavily on visual display. In the Soviet film an imagined Martian civilization is portrayed in Cubo-Futurist style, drawing on the design tradition of the Kamerny Theatre with

costumes by Alexandra Exter, which is contrasted with the down-to-earth reality of Soviet Russia still recovering from the civil war.[75] The ultra-modern Babylon of *Metropolis*, designed by Otto Hunte and Erich Kettelhut, drawing on motifs from Ludwig Mies van der Rohe, Erich Mendelsohn, Bruno Taut and others, hides a segregated society of rulers and slaves.[76] The former are free to enjoy pleasure gardens and stadiums above ground, while the latter are confined to underground factories and tenements. Between these two spaces stands a Gothic church, which connects the futuristic city with recognizable German cities. *Metropolis* proposes less a choice between dream and reality, as in *Aelita*, than a 'humanization' of the inevitable future; while *Things to Come* shows a 'rational', somewhat neo-classical future, which only reactionary individualists will seek to disrupt.

If the establishment of documentary was perhaps the major manifestation of Modernism in the cinema

8.9 **Fritz Lang**, *Metropolis*, 1926–7 (cat.65)

8.10 **Orson Welles**, *Citizen Cane*, 1941

of the 1930s, and one that would play a major part in the war to come, is there any other substantial legacy? Three instances will indicate how this question might be answered. Consider first Frank Capra's *Lost Horizon* (1937), based on James Hilton's enormously popular novel about a chimerical Himalayan retreat that offers peace and harmony for weary refugees from the modern world. The film's designer, Stephen Goosson, had already created a spectacular vision of a future New York in the film musical *Just Imagine* (1930); and for the design of the Lamasery in Shangri-La he drew upon elements of Mallet-Stevens and Le Corbusier, although the structure is most obviously inspired by Frank Lloyd Wright's 1915 Imperial Hotel in Tokyo.[77] Unlike Modernism's more common dystopian role, here is an intriguing example of the 'positive' use, albeit of a hybrid Modernist architecture; and the very mysticism of *Lost Horizon* might also recall how important theosophy and other forms of quasi-scientific mysticism had been in shaping canonic Modernism.[78]

A second instance is the already-mentioned *Fantasia*, Disney's great cabinet of animation curiosities.

Despite the obvious unevenness of this work, its experimental aspects deserve to be celebrated – including the Bach episode, which brought abstract 'colour music' to a vastly wider audience than had previously seen the work of Ruttmann, Fischinger and Lye. But even if the rest of *Fantasia* is anthropomorphic and anecdotal, its rhythmic and chromatic vitality owe much to Modernist inspiration, and neither Paul Nash nor Eisenstein had any doubts about Disney's importance.

Finally, the film that has come to be regarded as cinema's official masterpiece, *Citizen Kane* (1941, pl.8.10), should also be regarded as a synthesis of many of Modernism's themes.[79] With its faked *March of Time* newsreel and elaborate collage of styles and perspectives, Orson Welles's film drew equally on Modernist trends in photography, literature, radio and cinema, to present a media tycoon as an ambivalent hero of our time.[80] *Kane*'s lasting reputation has placed it in the same company as other canonic modern masterpieces, and so, arguably, redeemed the promise of film as a Modernist medium.

8.10

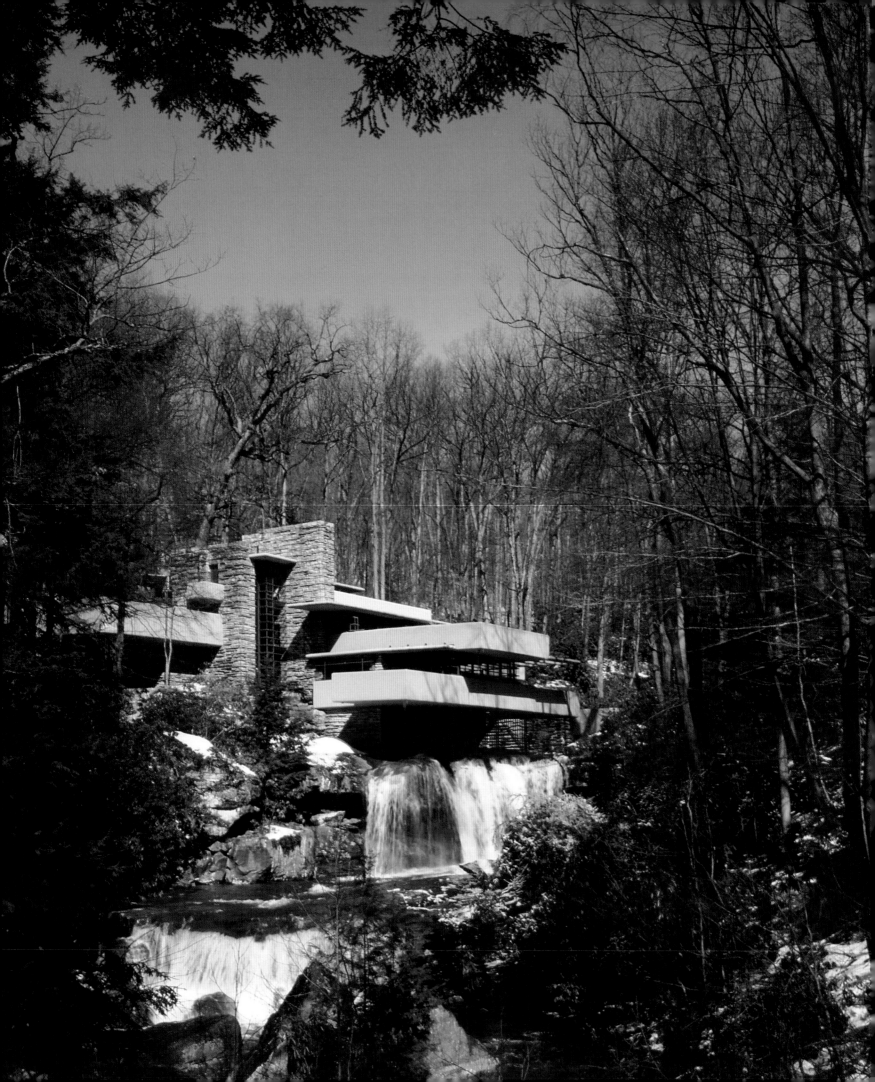

9

Tim Benton

Modernism and Nature

There is a path to form, followed by all [natural] things, even crystals and geometrically shaped ones, which allows each to develop according to its own inner plan, while on that other path [the geometric], things have their forms bestowed on them from without, which contradicts this innate tendency ... There is no other way forward but consciously to act as nature acts, consciously ordering things in a way that allows their individuality to unfold, while this unfolding also serves the life of the whole. This whole is the form [*Gestalt*] of our life.[1]

Hugo Häring
Die Form [*Form*]
(October 1925)

9.1 **Frank Lloyd Wright**,
Fallingwater, Bear Run,
Pennsylvannia, 1935–7.

In so far as Modernism in architecture and design has often been represented as the triumph of the machine over the hand, of the artificial over the natural, of reason over feeling and of geometry over free form, any reference to nature might appear to constitute a challenge to its fundamental principles.[2] And yet it is clear that, even at the heart of high Modernism, reference to nature was never absent, and that the spirit of the machinist era was not welcomed by all. In the words of the Finnish architect Alvar Aalto, 'The process of mechanization, having been the prime cause of change in society, now threatens to smother its initial objective.'[3] Aalto is often seen as the antipode to Ludwig Mies van der Rohe or Le Corbusier, dedicated to trying to 'humanize' technology and place emotion at the centre of design and architecture (pl.9.2). But Aalto was also the architect of the Paimio sanatorium (1929–33), one of the high works of International Modernism in which nature is understood in hygienist terms as purveyor of the healing properties of sun and fresh air in the treatment of pulmonary disease. In this building he had been influenced by the Zonnestraal sanatorium built by the Dutch functionalist architects Jan Duiker and Bernard Bijvoet near Hilversum (pl.7.5), which he visited in the summer of 1928. But Aalto was also a friend of Le Corbusier, and their relationship was one of mutual respect and cross-influences. Aalto's close friends also included 'hard' Modernists, such as J.J.P. Oud and László Moholy-Nagy, and artists including Fernand Léger. In fact, Aalto had the rare talent of being loved by a very wide range of people, including those, such as Sigfried Giedion, who did not agree with many of his views. The warmth and humour of Aalto's character were reflected in his work and help to explain its lasting influence.

Aalto emerged on the international scene at just the point (1928–9) at which many of the founding Modernists were beginning to have second thoughts. We will see that Le Corbusier himself increasingly turned towards nature as a source of imagery and comfort. Similarly, Mies van der Rohe was very much influenced by the theorist and architect who shared his offices in the early 1920s: Hugo Häring. And yet Häring was a vocal critic of reductive functionalism and an ardent proponent of organic architecture. The debate about the place of nature within architecture and design practice occurred throughout the history of Modernism, taking a number of different forms.[4]

We must distinguish between nature constructed as earthy, physical, chaotic, instinctual and 'female', and nature understood in terms of the 'laws of nature', form deriving naturally and inexorably from function and 'natural geometry'. These two ways of understanding nature have often been confused in architectural and design discourse. Natural forms evolve, diversify and take on extraordinary features by processes of Darwinian selection. Paradoxically, creative invention – the imposition of the individual will on natural materials – was often set against natural form as a profoundly human gesture, even

when the form this invention took was abstract, artificial and geometric. The opposite of nature was therefore not necessarily understood to be the machine, but instead was human will and creativity. Solving a design problem 'rationally' may well resolve certain problems and be pleasing as an act of profoundly human ingenuity, while also appearing 'un-natural' and artificial. Aalto coined the phrase 'functional formalism' to describe Modernist work of this kind. Hostile critics had been referring to 'cubistic' forms since the origins of Modernism, but functionalism could be organic, and human invention does not have to be arbitrary. If architects and designers worked like nature does, so the argument runs, their products would be supremely functional without being artificial. When Louis Sullivan coined the phrase 'form forever follows function', he was referring to the evolution of natural forms, and he was as interested in the decorative lessons to be derived from natural evolution and growth as he was in the principles of structural rationalism.[5]

One of the characteristics of the movement of ideas discussed in this essay was that some of those who had experimented with tubular-steel furniture later rediscovered the warmth and comfort associated with wood. There is a whole history of Modernism in wooden furniture design to be written, which runs parallel with high Modernism.[6] The key figures in this history would include the Stuttgart firm of Walter Knoll; Professor Adolf Schneck, who taught at the School of Applied Arts in Stuttgart in the 1920s; the Austrian Franz Schuster, who designed interiors for the mass housing at Frankfurt (1925–30); and the Rasch brothers, who specialized in plywood furniture. Schneck designed two of the houses at the Weissenhof Siedlung and he, Schuster and the Rasch brothers designed furniture for several of the interiors. Many of the developments that have changed the modern interior more profoundly than the more spectacular designs of high Modernism came from this tradition. For example, it was the Knoll firm that established the systems of springing and upholstery for modern armchairs. Schneck published a series of books showing how the modern plywood and blockboard materials could be used in cupboards, sideboards, tables and chairs. The Rasch brothers pioneered lightweight plywood furniture, whose curves and unusual shapes still astonish.[7] Schuster developed modular and Unit furniture, which was imitated in many countries, including Britain, where Serge Chermayeff based his Plan furniture avowedly on Schuster's designs.[8] This history cannot be told in this essay. I will introduce the revision of Modernist values between 1928 and 1939 by an introduction to some of Alvar Aalto's work, turning then to the theme of the vernacular as a means of coming closer to nature, followed by a consideration of the theme of organic architecture, and finishing with three examples of modern houses in the organic tradition.

Alvar Aalto and the humanizing of Modernism

For Aalto, brought up by his father in the hostile environment of the Finnish forests, nature was unforgiving and brutal, as well as nurturing and rewarding.[9] He once defined architecture as 'an instrument that collects all the positive influences in nature for man's benefit, while sheltering him from the unfavourable influences that appear in nature'.[10] He frequently called not for the replacement of rationalism in architecture, but for its enlargement, to take into account more subtle psychological responses. Close proximity to nature, according to Aalto, could satisfy these needs better than any building alone could and, by inference, architects should incorporate natural materials and forms into their buildings, while also trying to design like nature. Significantly, however, Aalto remained committed to finding ways of using industrial methods to produce furniture and housing at prices that people could afford.

The development of Modernism in Scandinavia after 1929 was markedly different from that in most other countries (see Chapter 11). Committed to social reform and nourished by a long tradition of Cooperative Societies, Swedish, Danish, Norwegian and Finnish architects and designers saw nothing odd about advocating the mass production of well-designed artefacts and standardized housing units, while praising and incorporating aspects of hand-crafted vernacular design. Before the arrival of Modernism, a well-developed movement existed in Sweden for subsidized self-build houses made of prefabricated wooden sections, but in a traditional style. For centuries it had been the practice in Scandinavia and Russia to prefabricate wooden buildings (including churches) and assemble them on site. The 1931 catalogue of the timber firm Burohus offered prefabricated wooden houses in National Romantic, Classical and Modernist styles.[11] The furniture factory of Bodafors was among the first to manufacture wooden chairs with linen webbing in industrial quantities. This context certainly predisposed Aalto to turn to wood for his furniture designs, while remaining within the principles of Modernism.

Socialism and nationalism went hand in hand in Scandinavia. Erik Gunnar Asplund, Uno Åhrén, Sven Markelius and Gregor Paulsson collaborated on the Stockholm Exhibition of 1930 (pl.10.8) and wrote a manifesto *acceptera!* (*Accept!*), which argued both for industrialization of design and architecture and for a distinctively Scandinavian approach to materials and form. The authors stressed the need for the 'local colour [and] tone of our "original culture"'.[12] These men had visited the key works of European Modernism and had popularized the work of the Bauhaus and Le Corbusier in Scandinavian magazines. The image projected by the Stockholm Exhibition was one of gaiety, bright and cheerful interiors and colourful exteriors, a shot in the arm after the hard and cold expressions of Dutch and German functionalism.

In a lecture given to the Swedish Society of Craft and Industrial Design on 9 May 1935, Aalto gave two vivid examples, drawn from his own design practice, of the limitations of 'rational design'.[13] A close observer of European Modernism, Aalto had designed tubular-steel chairs as early as 1927–8 and had ordered a set of Breuer tubular-steel furniture for his own home. In 1929 he exhibited tubular-steel furniture in the exhibition of the Finnish Association for Craft and Design, and again in 1930 in a 'Minimum apartment' exhibited in Helsinki. He sold one of these designs to the Swiss firm of Wohnbedarf, which manufactured them under licence. But Aalto quickly saw the limitations of these designs. According to him, steel transmitted heat and cold too readily, the chrome surfaces reflected too much light and distracted from the unity of an interior, and the hard surfaces had a bad effect on the acoustics.[14] The very functionalism of the designs – inventing a seating position with a loop of steel tube and some fabric – was satisfying as an intellectual exercise and, potentially, as a means of mass-producing furniture, but it failed the test of close human contact and could not sustain a restful environment.

Aalto responded by adapting the principles of tubular-steel furniture to production in wood. The wood-felling and wood-treatment industries were crucial to Finland's precarious economy, and Aalto designed factories and housing for timber manu-facturers. In 1932 he exhibited two armchairs made of bentwood strips combined with plywood sheets formed in a steel press, by the Huonekalu- ja Rakennustyötehdas company. These hybrid chairs were used in the interior design of the Paimio sanatorium, alongside a range of other wooden and tubular-steel designs. Similarly, work on the Paimio sanatorium had convinced Aalto that his lighting designs – globe lights hermetically sealed in white glass bowls – may have been efficient in terms of light distribution and dust control, but failed to meet the hyper-sensitive needs of patients in distress and suffering from nervous tension. A more restful and balanced lighting system needed to be invented for them. So, when he came to design the lighting for the Viipuri Public Library (1930–35), he introduced a mixed system of diffused natural daylight and ceiling reflectors, which bathed the walls with light without creating glare. The ultimate test, then, was not what a designer or architect thought of his or her design, but how it was perceived by the user. Aalto was not afraid to pick up lessons from traditional design and architecture:

> It can be said that the yellow light of a candle or, again, the taste of a woman who flatters her interior by spreading the light of her lamps with yellow silk veils, works better, from the point of view of the human instinct, than any expert electrician . . .[15]

Between 1929 and 1931 Aalto set about adapting all he had learned to the problem of the modern wooden

chair. His friend Otto Korhonen invested a great deal of time in his family firm in the research of new industrial methods of forming plywood sheets, and the plywood seats offered genuine economy of scale, combined with comfort and warmth to the touch.[16] Among these experiments were some bentwood reliefs by Aalto (pl.1.10), which were later worked up into artworks.

The birchwood readily found in Finland was not as flexible as the beechwood used by the Austrian company Thonet-Mundus in its bentwood chairs. The first experiments with cantilevered birchwood frames supporting plywood seats were unreliable, due to the sharp angle of curvature required to make the transition from leg to seat. To achieve their full potential, birchwood strips had to follow a smoother curve. A breakthrough came with the Paimio arm-chair (pl.9.2), which used a plywood seat and back, composed of a single sheet of plywood, attached to a frame of birchwood strips. Instead of attempting to follow the acute angle of the seat, the frame followed the line of an armrest, creating a particu-larly satisfying play of form and structure. In true Modernist fashion, the structural frame is clearly differentiated from the supported sitting surface, but Aalto's chair also has a subtle naturalness about it.

Aalto went on to develop this idea with his cantilevered chair, which became one of the classic designs of the 1930s. His attention to the detail of industrial production and the nature of the materials led to a careful detailing of the bends, cutting open the laminated-ply sandwich and inserting reinforcing strips, which ensured that the bends kept their shape.

Aalto's wooden furniture found a quick and ready market in England. Aalto had met P. Morton Shand, the architectural critic of the British journal *Architectural Review*, at the 1930 Stockholm Exhibition and again at the conference of CIAM (*Congrès Internationaux d'Architecture Moderne*, International Congresses of Modern Architecture) in Athens, in 1933. Shand was the first journalist to promote European Modernism in Britain, and he was quick to see the potential of Aalto's more humane and warm approach to design. Arranging an exhibition at Fortnum & Mason's in November 1933 with the enticing title 'Wood only', Shand quickly found a market for Aalto's wooden furniture. British resistance to 'cold' and 'industrial' tubular-steel furniture melted before Aalto's charm offensive. Soon a company – Finmar – was set up (by Shand and Geoffrey Boumphrey) to market Aalto's furniture in Britain.[17] Aalto's furniture

was used in Erich Mendelsohn and Serge Chermayeff's De La Warr Pavilion at Bexhill-on-Sea (1933–4) and in many other Modernist buildings in England. Just before the establishment of Finmar in England, an English director of a plywood company, Jack Pritchard, set up a small company – Isokon – to manufacture modern wooden furniture (1931).[18] The first designs produced were by the Modernist architects Wells Coates, Egon Riss and Marcel Breuer, who adapted a design for aluminium-strip chaises longues for bentwood production (pl.9.3). Although Aalto's firm later tried to sue Breuer for taking patented ideas from Aalto's designs, Isokon helped to promote Aalto's furniture.[19]

Before either Isokon or Finmar were set up in Britain, however, engineer Gerald Summers had begun to manufacture somewhat eccentric furniture in plywood for his company, Makers of Simple Furniture.[20] The early designs were indeed simple and also cheap, but, after talking to Jack Pritchard, Summers began to produce much more inventive chairs. Some of these may have been stimulated by the Rasch brothers' plywood chairs, but others drew their inspiration from Aalto's designs.[21] Summers's bent-plywood chair went even further than Aalto in forming a whole armchair out of a single piece of plywood. The Dutch designer and architect Gerrit Rietveld had also tackled this problem in 1927, with a prototype chair cut out of a single sheet of fibreboard.[22] Summers took from Aalto the idea of slotting the plywood sheet and bending up the arms as a stiffener to the seat. But his design did not rely on a separate frame. This chair marks the most abstract extent of the Modernist experiments with the industrial production of wooden furniture.

Wooden furniture by Breuer, Aalto, Summers and many other designers was sold through the main department and furniture stores as well as specialized companies, and quickly helped to establish the look of the Modernist interior in Britain. Elsewhere, Aalto's wooden furniture had been given prestigious showings at the International Exhibition in Paris of 1937 and at the Museum of Modern Art in 1938. In 1939 Aalto's Finnish Pavilion, with its curving and sloping wooden walls, was received as one of the high points of the exhibition at the New York World's Fair.

9.3 **Marcel Breuer**, 'Short Chair', 1936 (cat.217)

Vernacular: building as natural evolution

Modernism is usually presented in opposition to regionalism in architecture and the vernacular revival. But Aalto shared the attitude of many Finnish writers, artists and musicians towards Finnish vernacular architecture, especially that of the Karelia region on the Finnish and Russian border.[23] According to his biographer Göran Schildt, Aalto considered the Niemelä farmhouse, transported from the village of Konginkangas close to Aalto's birthplace to the Seurasaari Open Air Museum in Helsinki in 1909, to be 'the highest goal architecture could aim for' (pl.9.4).[24] Part of this was due to assumptions about the nobility of hard-working peasants uncorrupted by 'civilization', but in large part it was due to beliefs about the value of close contact with nature.

Founded in 1909 following the lead of the Skansen Open Air Museum in Stockholm in 1891, the Open Air Museum on the island of Seurasaari included buildings from all over Finland. For those involved in the Scandinavian National Romanticism movement, these buildings retained some of the authority, lost innocence and authenticity of antiquity and were at the same time part of the cultural roots of the region, along with its myths and sagas. Aalto's teacher, Armas Lindgren, had been a proponent both of National Romanticism and of the vernacular revival, constructing with Hermann Gesellius and Eliel Saarinen one of the most brilliant examples of European neo-vernacular in their colony of houses, Hvitträsk (c.1900). There was nothing illogical for Aalto in comparing the vernacular to the antique buildings of Greece and Rome, because both seemed

to him to be authentic and original expressions of their own time and conditions. At the same time these buildings evoked direct contact with remote and primitive nature. The Niemelä tenant farm was a cluster of barns, a smokehouse, sauna and smoke-filled living quarters, perfectly evolved for combating the harsh conditions.

Le Corbusier, too, had always considered the vernacular and the classical to be on a par. When he made his long voyage to the East in 1911, he wrote as much on the vernacular buildings of the Balkans, Greece and Italy as he did on the famous temples of Greece and Rome. As a young man in the Swiss watch-making town of La Chaux-de-Fonds, he had turned away from the industrialized city, with its apartment blocks and grid of streets, to seek out the high slopes of the Jura, spending several months each

winter snowed into a vernacular farmhouse with its *tué* (a snug built around the fireplace).[25] His teacher at art school, Charles L'Eplattenier, fired his students with his enthusiasm for capturing the essence of the local flora and fauna, and creating a local variant of the pan-European National Romanticism movement. These ideas were rooted in the English Arts and Crafts movement and German Romanticism. Charles-Edouard Jeanneret (Le Corbusier's real name) built his early villas in this style, incorporating decorative forms based on the snow-covered pine trees of the region.[26] Throughout his Modernist period, Le Corbusier retained his fascination with vernacular architecture, sketching details and taking measurements on his travels.[27] For Le Corbusier, no architect could match the judgement and skill of the humble peasant who builds his own house around his daily

9.5

9.4

9.4 Niemelä farmhouse, Seurasaari Open Air Museum, Helsinki in 1909.

9.5 **Le Corbusier**, Sketch of holiday shack. Pencil on paper, 1932. Fondation Le Corbusier

actions. [28] His idea of a perfect vacation was an unbuttoned existence in the open air, living in and around a modest wooden house or cabin. For several years, from 1928, he had taken his summer vacation on the Bay of Arcachon near Bordeaux, staying in a wooden guest-house. On 10 July 1932 he sketched a wooden shack, raised on stilts, rented by friends of his for a vacation (pl.9.5). He noted, 'life enfolds entirely under the pilotis…' and he clearly considered this casual existence idyllic. [29]

In *La Ville Radieuse* (1935) Le Corbusier illustrated the interior of one of the traditional stone houses that his friend Jean Badovici had converted, and wrote:

> In Vézelay, sixteenth century and modern times and modern people … Why this astonishing freedom? … Why this sweeping generosity? … and this intimacy? … Because a proper human scale (that which has the true dimension of our gestures) has conditioned each thing. There is no longer old or modern. There is what is permanent: the proper measure. [30]

It is clear from the text that this 'measure' did not refer to quantities of dimensions, but to values.

> It was in Vézelay, where St Bernard preached the second crusade. A majestic site: at the tip of a spur jutting from deep in the hollow of the valley, the basilica, notable achievement of Romanesque art. A street climbs up to it. On either side of the street, houses as old as time, whose windows open onto distant horizons. The architect Jean Badovici, director of *L'Architecture Vivante*, has bought up some of these crumbling houses. He brings in the modern spirit. Here is his own home: an old, old house with an oak-beamed ceiling. The height between storeys is 2.20 meters. He breaks through one floor; in this way he connects two storeys; he turns them into a modern living unit … Everything is minute, but everything is big. It is a jewel-box on the human scale. It is a place of well-being, of calm and diversity, of measure and proportion, of thoroughly human dimensions.

And in the text he attacked the *Existenzminimum* mentality that he had helped to promote:

> The minimum home, as it has spread so tremendously these past few years in Germany, in Czechoslovakia, in Poland, in Russia, is no longer a place to live in: it is a cage. It is harmful, it is inhuman, it imprisons life within minimum limits, life that needs room. [31]

From 1929 Le Corbusier had begun to try to incorporate some of these values in his own architecture, just as he had already abandoned the geometric discipline of Purism for a more voluptuous and earthy style of painting. [32] He designed a house in stone and wood for a Chilean friend, Matías Errázuriz Ortúzar, in 1929 and built another for his Swiss friend and patron, Hélène de Mandrot (1929–31).

Aalto and many other Modernist architects never lost their enthusiasm for vernacular architecture and, in a sense, measured everything they did against this standard. [33] They understood the vernacular as being the secure link between man and nature, uncontaminated by abstract reasoning.

The fascination with the vernacular and the conviction that contact with fresh air and greenery was essential for family life, led to the development of the vernacular revival and the Garden City movement. This formed an unbroken strand in the theory and practice of housing and urban design from the founding of the Garden City Association in England following the publication of Ebenezer Howard's *Tomorrow: A Peaceful Path to Real Reform* in 1898, through its widespread imitation in Europe and its faint echo in the speculative development of suburbs surrounding many European cities. Most Modernists rejected the suburb out of hand, although many Modernist architects were fascinated by the challenge of combining Modernist architecture with open space and greenery. Le Corbusier, for example, would not have allowed a suburban ring around his *Ville Radieuse* and he referred to the Garden City ideal, which he had enthusiastically supported in his youth, as a 'pre-machinist utopia'. In *La Ville Radieuse* he located his zigzag housing slabs in vast parks of greenery where the 'essential joys' of sun, space and greenery could provide the city dweller with natural surroundings. [34] In the 1930s the remains of the Garden City ideal belonged mostly to the reactionary supporters of regionalism and *Blut und Boden* (Blood and Soil) nationalism, for whom the settling of workers in outlying low-density housing estates was seen as a stimulus to vigorous population growth. A variant of the interest in the vernacular that escaped such associations was the fascination with Japanese houses, which made a huge impression on Frank Lloyd Wright, Bruno Taut and many others. Japanese houses seemed to combine intensely human and intimate values with the clean, uncluttered surfaces and brightly lit spaces that matched Modernists' expectations.

The example of the vernacular remained fascinating for modern architects, however, throughout the 1930s. In fascist Italy a number of articles, books and exhibitions sought to find the roots of modern architecture in the simple cubic forms of Mediterranean vernacular architecture. [35] At the VI Triennale in Milan in 1936, Giuseppe Pagano mounted an important exhibition of vernacular Italian architecture, entitled *Funzionalità della casa rurale* (Functionalism of the Rural House), drawing on his own collection of photographs and designed to draw out the parallels with Modernist architecture (pl.9.6). [36]

The context in fascist Italy was the need to defend Modernism from the charge of being 'international' or 'Bolshevik' and to assert the 'Italian' roots of modern architecture. But it is also true that architects such as Giovanni Michelucci, Gio Ponti and Pagano derived much of their inspiration from Mediterranean

vernacular architecture. The villa designed by Adaberto Libera for the brilliant but erratic poet and intellectual Curzio Malaparte was an animistic hymn to nature (pl.9.7). Clamped to its rocky outcrop on the Punta Massullo in Capri, the villa is both open and closed. The building guides the visitor to a solarium open to the four horizons along a building-wide staircase. But the interior also encloses an intimate living space, with a rough stone-flagged floor, heated by an enormous fireplace and offering selective views to the coastline.

In the 1930s many architects tried to capture the essential intimacy and naturalness of vernacular building, while introducing a modern approach to materials and the controlled appreciation of nature. For example, in 1934–5, Charlotte Perriand carried out a study of vernacular buildings in the Jura and Savoie, and wrote an article to accompany the publication of one of her design entries for a weekend house competition (pl.9.8).[37] This article combined her deep knowledge of vernacular architecture with her trenchant Marxist views and was clearly intended to provide support for her design. Her project for a *maison au bord de l'eau* (house by the shore) was based on a simple steel and wooden structure providing dwelling units on either side of an open deck. Large panels could be swung up and over to provide shade, or inclined upwards to allow free

9.7

9.6

ventilation at night while maintaining privacy. At the end of the holiday season, these same panels could be closed up to render the houses secure. Pierre Jeanneret and Perriand also worked on another competition for *L'Architecture d'Aujourd'hui* (*The Architecture of Today*) in 1936, for a holiday centre in the Bandol region on the Côte d'Azur.[38] These examples demonstrate the association, in the minds of architects trained in the functionalist tradition, between vernacular architecture, close proximity to nature and a simple life in sympathy with the agrarian working class.

Le Corbusier too built a weekend house for Henry Félix (see Chapter 10), the administrator for Carlos de Beistegui, for whom Le Corbusier had just designed a Surrealist penthouse apartment overlooking the Champs-Elysées, entirely lit by candles and with a roof garden laid out like a living room open to the sky and with grass for a carpet. Among the preparatory drawings for Félix's villa (pl.9.9) are some sketches for an unpretentious stone and wood shack, and another showing two schemes with Catalan tile vaults copied from Antonio Gaudí's school for the Sagrada Familia church in Barcelona, which Le Corbusier had seen in 1928.[39]

The house as completed would become much more formal, but these sketches show how Modernist architects such as Le Corbusier yearned for the simple and natural (pl.9.9). At the same time,

9.6 **Giuseppe Pagano**, Photograph of vernacular buildings in Sardinia, 1936

9.7 **Adaberto Libera**, Casa Malaparte, Capri, 1938–40

he and Pierre Jeanneret designed a very unpretentious but comfortable vacation house near Bordeaux for Albin Peyron, the Salvation Army general and client of the large building that Le Corbusier had designed for the Salvation Army in Paris. Perriand designed the wooden cupboards for the kitchen (pl.9.10). Like the holiday shacks that Le Corbusier admired, the lifestyle was designed around open-air living, with a sheltered area and the simplest of living quarters, built of rough stone and wood.

Alongside the rediscovery of vernacular architecture and the simple life, architects such as Le Corbusier and Perriand became very interested in the aesthetic stimulus of natural 'found' objects.

Surrealism clearly stimulated this interest in the late 1920s, but many architects had collected shells, stones and driftwood as domestic exhibits for some time. For example, on 8 January 1923 Le Corbusier wrote to Hendrik Wijdeveld, the editor of the Dutch magazine *Wendingen*, admiring a special issue he had put together on sea shells. Le Corbusier claimed to have studied a collection of sea shells in a museum 20 years previously. By 1928 Le Corbusier began to collect *objets trouvés* more systematically, for exhibition in his and his clients' houses and for inclusion in his paintings (pl.9.11). His canvas *Léa*, for example (1930) (see the study, pl.9.12) plays on the erotic implications of a blue oyster and a bone, contrasted

9.8

9.9

9.8 **Charlotte Perriand**,
Sketch for competition for
a weekend house.
Pen on tracing paper, 1935.
Archives Charlotte Perriand

9.9 **Le Corbusier** and
Pierre Jeanneret, Maison de
week-end, La Celle-Saint-
Cloud, 1935 (cat.208)

9.10 **Le Corbusier** and
Pierre Jeanneret (fittings
by Charlotte Perriand),
Kitchen of Villa Peyron
'Le Sextant', Le Mathes,
near Bordeaux, 1935

9.10

9.12

with the traditional female icon of a violin. We know from sketches he made that these objects were imagined in an open-air setting on a metal table and close to a tree trunk at the vacation house in which he stayed on the Bay of Arcachon. Thus, close proximity to nature, natural objects and artistic invention are brought together. Simultaneously Perriand replaced her famous ball-bearing necklace (pl.3.4) with ones made from sea shells and mussels (pl.9.13).

When designing the Swiss Pavilion at the Cité Universitaire in Paris at this time, Le Corbusier described the curved profile of the massive piers made to support the structure as being a 'dog-bone'. When he came to decorate the dining room of the Swiss Pavilion, he composed a mural of photographic blow-ups of natural details (pl.9.14). This mural, which was fiercely criticized by Swiss traditionalists as an example of Bolshevik 'materialism', stands in a line of abstract or Surrealist photographs from nature used as art or decoration during the 1930s.[40] Pierre Jeanneret and Perriand also took photographs of this kind (pl.9.16). In an exhibit at the *Exposition*

9.13

9.11

9.11 **Le Corbusier**, *Objets à reaction poétique* (objects that stimulate poetic reaction) (cat.207)

9.12 **Le Corbusier**, *Etude sur le thème 'Léa'*, 1930 (cat.206)

9.13 **Charlotte Perriand**, Necklace made of sea shells, c.1935 (cat.210a)

9.14

Internationale (International Exhibition) in Brussels, in 1935, Perriand worked up a display that relied on natural references on a number of levels (pl.9.15). A selection of her *objets trouvés* (stones and sea shells, cat.210) were displayed on a shelf, near a painting by Léger. Léger had the same enthusiasm for *objets trouvés* and made a number of drawings and etchings of the objects he and Perriand found, often on shared walks in the country. Perriand's table design had a heavy slate top to it, on which messages could be written. In the spirit of her new fascination with natural materials and the vernacular, she also added a new design, a wooden chair with a straw seat made by convicts. With this there is a strange return to the *bergères à paille* (straw shepherdess chairs), which the young Le Corbusier had bought for his parents' house in La Chaux-de-Fonds in 1915–16.[41] As recently as 1930 Perriand had written a vigorous defence of metal for furniture design, associating it with modern life, healthy living and a dynamic existence.[42] During the 1930s she would increasingly turn to wood and natural forms for her furniture. Many Modernist architects and designers followed a similar path.

9.15

The organic tradition
(and Expressionism)

Another tradition, with its roots in the nineteenth century, was the concept of 'organic architecture'.[43] This included a respect for nature, not merely as a source of formal motifs, but as a model for the designer, the idea of *Einfühlung* (empathy) and a suspicion of the straight line and cube.[44] All European architects educated between 1890 and 1910 were exposed to these ideas, which flowered in the international Art Nouveau movement (c.1890–1914) and were kept alive in German and Dutch Expressionism in the 1920s. Within this discourse, one strand was of particular importance, linking theories of perception and feeling to the physiological effects of forms and spaces. A key text was Wilhelm Wundt's *Grundzüge der physiologischen Psychologie* (*Principles of Physiological Psychology,* 1874), which was a highly technical but accessible study of the detailed way in which the body responds to external sensations, including architecture. Wundt sought to find a mechanistic link between the response of muscles and nerves to visual stimuli and feelings of well-being or discomfort.

Thirty-nine years before Sigmund Freud's *Die Traumdeutung* (*The Interpretation of Dreams,* 1900), the writings of Karl Albert Scherner, especially *Das Leben des Traums* (*The Life of Dreams,* 1861) developed a theory of the symbolism of dreams that associated theories of feeling with architecture. According to Scherner, the dreaming mind transposes erotic longings and wish fulfilment into the metaphor of the house. It was a short step for writers such as Robert Vischer, Theodor Lipps, Heinrich Wölfflin and August Schmarsow to attempt to turn the process round and analyse artistic creativity in terms of empathy.[45]

The significance of these debates about empathy, feeling and form, which fell out of fashion early in the twentieth century, is that certain assumptions were passed on to other debates during the development of Modernism. For example, Häring, the difficult but highly respected theoretician of early Modernism, assumed that there was a seamless continuity between how the architect should try to design and how the body responds to nature. In an important article '*Wege zur Form*' ('Approaches to Form', 1925), Häring turned round the usual way of distinguishing function and expression. According to him, functional objects should emerge naturally from life, like forms in nature. These would then be 'fundamentally eternal and universal'.[46]

> Under and during the reign of the geometrical culture, formal expression was derived from laws which were contrary to life, to the creation of life, to movement and to nature, laws recognized in purely geometric forms. We have since discovered that purely functional things have forms which can satisfy us in terms of expression, and indeed some forms created solely out of functional necessity become more satisfying in terms of expression as they become functionally purer, and that this kind of expression resulted in a new aesthetic.[47]

Häring could play games with the notion of expression (as artistic intention, but also as the expressive quality of objects) because creative production and aesthetic response were, for him, inextricably linked by the physiological laws of empathy. His idea of 'organic formalism' was based on an 'intrinsic dwelling within the object'. The architect's imagination should submit itself to the physical properties and requirements of the materials, site and brief just as, in the theory of empathy, the viewer's feelings are stirred by the physical aspects of space and form. The architect should try to design like nature does:

> In nature, form is the result of the organization of many distinct parts in space in such a way that life can unfold, fulfilling all its effects both in terms of the single part and in terms of the integrated whole; whereas in the geometrical cultures form is derived from the laws of geometry.[48]

Häring attacked architects such as Le Corbusier precisely for this reliance on geometry at the expense of life-nurturing form. Häring's credo of organic architecture was to let the form find itself from an understanding of the living conditions of the brief:

> If we prefer to search for shapes rather than to propose them, to discover forms rather than to construct them, we are in harmony with nature and act with her rather than against her ... We no longer take a motif on which we plan to base the form we create out of the geometrical world but take it instead from the world of organic forms, as we have seen that, in order to create for life, we must create as nature does, organically and not geometrically.[49]

In an incomplete project for farm buildings at Gut Garkau near Lübeck, Häring put his theories to the test, allowing each building to find a form appropriate to the activities within it (pl.9.17). The functionalist Ludwig Hilberseimer described this plan: 'It is as if something dead had been transformed into something alive, as if life itself had been breathed into this plan.'[50] A close observer of German vernacular farm buildings, Häring wanted to give the impression that the buildings had accumulated over time, in response to need. The different functions of caring for cows, pigs, chickens and horses were differentiated from each other and from the living quarters. Free-form curves expressed the plan of the building, designed to house 41 cows, some calves and bulls. Ironically the function of this building was changed, without affecting its form, to accommodate 400 pigs – this has always been the argument against over-determining architectural form to meet precise functions .

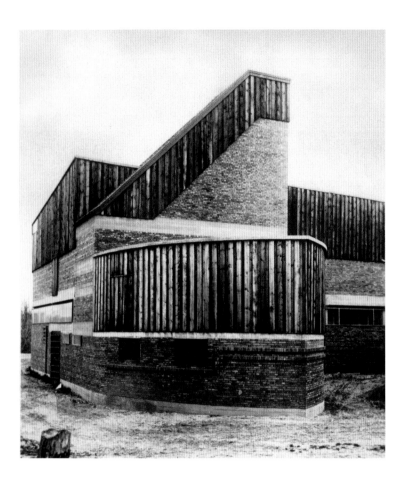

9.17 **Hugo Häring**, Gut Garkau farm building on the Pönitzer See, 1925. Collection Alberto Sartoris

Häring's understanding of 'building' had a mystic, archaic quality to it, which many of his contemporaries found distasteful: 'The tradition of the new building, the tradition of building organically, older even than architecture ... the structural basics of organic building are elementary, are pre-existing in nature, practically deeded to man.'[51]

Although all this sounds fantastic and remote from Modernism, many German and Scandinavian architects managed to combine such thoughts with a strictly functionalist approach to design. We have already seen how the functionalist Hannes Meyer understood architectural design as a 'biological process' (see Chapter 5). For Mies van der Rohe, for example, Häring was a very important source of inspiration. Although he later criticized Häring for architectural formalism, many of Mies's ideas and expressions were derived from Häring or shared his sources. As late as 1938, Mies could introduce himself to the Armour Institute of Technology as seeking 'an organic principle of order, that makes the parts meaningful and measurable while determining their relationship to the whole'.[52] Häring, despite being the secretary of the very influential group of German Modernists *Der Ring* (The Ring), was forced out of CIAM in 1929 partly because of the controversial nature of his remarks, but largely due to his intransigent and difficult character.[53] Long after Mies had abandoned the last vestiges of Expressionism in his own work, he remained fascinated by the poetics of nature and the yearning for certain truths in harmony with natural causes and effects. As well as retaining an admiration for Häring's writings, Mies was a great admirer of the writer Raoul H. Francé, whose series *Cosmos* had been published by the Society of the Friends of Nature in the early 1920s.[54] Mies collected 40 books and pamphlets by this author, with titles such as *Das Liebesleben der Pflanzen* (*The Love-Life of Plants*, 1926) and *Harmonie in der Natur* (*Harmony in Nature*, 1926). When Mies was director of the Bauhaus in Berlin, in its last, difficult years, his students were all reading Francé while they learned to design in Mies's minimalist and scrupulously disciplined manner. As the student Karl Kessler wrote:

> ... that the direction of our solutions is good became clear to me on reading the book *bios* by Raoul Francé. What this biologist says in respect to engineering and that it must stand in harmony with the laws of nature, just as with the smallest measure of energy or with the law of harmony, that is Bauhaus thought, that is Bauhaus *Geist* [spirit].[55]

Mies underlined with approval Francé's citation from Goethe: 'One must treat nature decently if one wants to benefit from it.'[56] Francé not only preached an environmentalist approach to nature, but also a high moral duty to live with 'respect for the whole', which he explained in terms of 'lawfulness-equilibrium-adjustment'.[57] Man must discipline himself against

the wilfulness of the ego and search for the intrinsic, for 'what really is' and for a balance between science and art, man and nature, geometry and free form.

Erich Mendelsohn was the single most successful Modernist architect in practice in Germany in the period before Hitler's seizure of power. His Schocken department stores made the principles of Modernism popular and commercially successful in many towns in Germany and Czechoslovakia.[58] When he emigrated to England in 1933, he immediately set the standard for Modernist architecture by winning the competition for the De La Warr Pavilion at Bexhill-on-Sea, in partnership with Serge Chermayeff. His buildings in England and Palestine were important examples of Modernist architecture. Mendelsohn formulated a theory of 'dynamic functionalism', which had many features in common with Häring's 'organic functional-ism'.[59] An interested observer of the development of Expressionism in the *Wendingen* circles in Amsterdam and of De Stijl in Rotterdam, Mendelsohn saw the need to combine the best qualities of both. In an important lecture in November 1923, given in Amsterdam, The Hague and Rotterdam, entitled 'The international agreement in new architectural thought, or dynamic and function', Mendelsohn attacked Gropius, Mies, Le Corbusier and other Modernists as formalists and argued that the new materials of steel and concrete allowed a freedom of expression that should be exploited to best meet the needs of each project:

> The revolutionary play of the forces of tension and compression in steel releases movements that are amazing to the initiated and still utterly incomprehensible to laymen. It is our task to find architectonic expression for these forces, and to find an equilibrium for these tensions in the architectonic form.[60]

This statement depends on the notions of empathy and the obligation to respond to materials as if they had natural energies and movement. Mendelsohn's language has the heightened rhetoric of the prophet:

> Seize, hold, construct and calculate anew the earth! But shape the world that is waiting for you. Shape with the dynamics of your own vision the actual conditions on which reality can be based, elevate these to dynamic transcendence. Simple and sure like the machine, clear and bold like construction.[61]

Mendelsohn, like Häring, accepted the implications of functionalism in so far as it excluded unnecessary ornament and arbitrary planning. Like Häring, he believed that the architect should put himself into a kind of sympathetic vibration with the building he was designing, so that it would appear to emerge as a 'natural' production. 'The new architecture strives towards the immediate, free and original shaping of every job; towards the optimum; towards the planned organism, towards the architectural organism. As a consequence of this, function and aesthetic enjoyment coincide in it.'[62]

The organic house

Mendelsohn was a direct link between Europe and America. In November 1924 he spent two days with Frank Lloyd Wright at Taliesin. He believed that he and Wright were on the same wavelength, sharing ideas about organic architecture. Wright knew Mendelsohn's work because the Austrian architect Richard Neutra had just moved from Mendelsohn's office in Berlin to Wright's studio at Taliesin. In looking up Wright in Wisconsin, Mendelsohn was searching out the best-known international proponent of organic architecture. As Sigfried Giedion rather despairingly wrote: 'Wright's whole career has been an endeavour to express himself in what he calls "organic architecture", whatever that may be.'[63] Wright absorbed from his *lieber Meister* (dear master) Louis Sullivan the German Romantic tradition of organic architecture. In his work between the wars, Wright moved closer and closer to an earth-bound sense of natural form, using rough-hewn stone and timber and aiming always in his houses to achieve an effect of intimate and protective shelter. The house he built for Edgar J. Kaufmann, Fallingwater, straddling the stream known as Bear Run (pl.9.1), brings together a number of features of the organic tradition and the relationship of Modernism and nature. It forms a fascinating contrast with two other houses which, in their different ways, also encapsulate Modernism's obsession with nature. I will finish by comparing these houses, by Wright, Neutra and Aalto.

On the one hand, the design for Fallingwater brings out Wright's obsession with making the dwelling partake of the landscape in as intimate a way as possible. The house not only straddles a small waterfall, but is open to the stream (via a suspended staircase) and bathed in the sounds of the moving water. But, just as Le Corbusier had his Villa Savoye float above the open pasture, so Wright both accepts the landscape and separates the forms of his archi-tecture from it, in long, cantilevered bands. There is no attempt at a vernacular 'modesty', blending in with the landscape, despite the fact that parts of the house are faced in stone. The horizontal concrete balconies symbolize the movement of water in a metaphorical way, and it is this dialogue between Modernism and nature that makes the house 'organic'. A similar dialogue, at a more abstracted level, can be found in the best-known inter-war building of Mendelsohn's and Wright's pupil Richard Neutra, the Lovell Health House (1928, pl.7.4).

Neutra built on the ideas of Freud and Wundt to develop a whole theory of the psychotherapeutic potential of houses in the 1940s.[64] As a young man, Neutra had known Freud and Otto Rank in Vienna, and he was also familiar with the literature on empathy. Mendelsohn was a close friend of Ernst Jung, who followed his lectures and encouraged him to develop his ideas. Both Mendelsohn and Neutra therefore liked to think that a building could work positively on

the mental and physical health of its inhabitants. The house that Neutra designed for Dr Lovell was specifically intended to incorporate a health programme. Lovell was a naturopath who believed in the beneficial properties of sunbathing and sleeping in the open air. Neutra's plan was to build the house on as wild and undomesticated a site as possible, and to make minimal changes to the landscape. The house was therefore prefabricated in steel sections and assembled on a steep site high up a ravine in Los Angeles. The balconies were supported by cables from the floor beams. The walls were composed of liquid concrete sprayed onto steel mesh.[65] All this technological wizardry, reported in the international architectural press, gave Neutra a reputation as a hardline structural functionalist. But his motivation was as much to place his client in direct relation with nature as to experiment with structural innovation.

The third house that covers the range of approaches to nature within the leading figures of architectural Modernism is Aalto's Villa Mairea.[66] The brief was for a country retreat in the woods for Harry and Maire Gullichsen, wealthy industrialists for whom

Aalto had produced numerous buildings. Aalto's first response was a rustic cabin based on his studies of vernacular architecture, but he was prompted by the publication of Wright's Fallingwater to try a different tack. In the finished design, Aalto aimed for a similar contrast between machine-perfect blocks and some more rustic elements. He went further than Wright, however, in incorporating incredible attention to detail in hand-crafted finishing. From the exterior to the smallest detail, a deliberate juxtaposition is made between machine-made and natural materials. The house incorporates almost all the kinds of reference to nature discussed above: the use of curves and textures to evoke nature in a symbolic way, opening out of the interior to views of the exterior, and an extension of the living quarters into a sheltered open space underneath the house. Even the articulation of the interior was conceived by Aalto as a 'forest space': less enclosed than vernacular architecture, but more complex and less open than most Modernist interiors (such as Neutra's Lovell house). To emphasize the continuity between interior and forest exterior, Aalto made use of thin poles to screen

the staircase, and wrapped many of the industrial steel supports in rattan or faced them with thin wooden strips. Around the library, he evoked the effect of sun glancing through tree-trunks with a glazed attic framed with curving panels, which allowed shafts of sunlight through. The Villa Mairea comes closest of the three houses discussed to imitating nature directly, but even here the poetic juxtaposition of natural and industrial keeps the Modernist dialogue in play.

Buildings such as the Villa Mairea, Fallingwater and the Lovell house are not exceptions to the development of Modernism, but central statements, bearing witness to the continual dialogue between the call of nature and the stimulus of the Machine Age within Modernism itself.

9.18 **Alvar Aalto**, Villa Mairea, Noormarkku, 1938–9. Villa Mairea Foundation, Helsinki

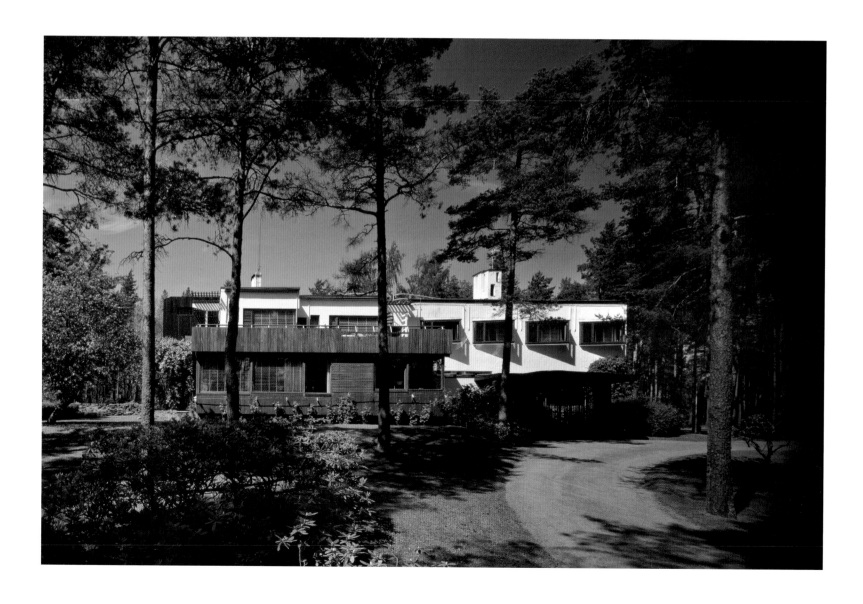

205

Lecture drawing: *A little preliminary biology*
1929

Le Corbusier (Charles-Edouard Jeanneret)
(1887 La Chaux-de-Fonds, Switzerland–
1965 Cap-Martin, France)

Charcoal and pencil on paper
c.100 × 70cm
Fondation Le Corbusier, Paris (FLC 33497)

The ancient Roman architect Vitruvius famously
described the elements of good architecture as
firmitas, utilitas, venustas (solidity, function and
beauty). Le Corbusier began his lecture 'The plan
of the modern house', delivered at the Association
Amigos del Arte in Buenos Aires on 11 October
1929, with two interpretations of the Vitruvian
triad. He explained his argument in the book of
the lecture series: 'A little preliminary biology: this
skeleton *to support* [*pour porter*]; these muscular
bulges *to be active* [*pour agir*]; these viscera *to
nourish and make functional* [*pour alimenter et
faire fonctionner*].'[1] The three sketches show
a male skeleton (recognizably a self-portrait)
representing *firmitas*, a distinctly female *utilitas*,
sectioned to reveal the bodily systems of circula-
tion and, for *venustas*, the torso of an athlete
whose voluptuous curves are those of a modern
athlete rather than antique Venus. (Le Corbusier
pursued his dedication to physical fitness with
weekly workouts in the gymnasium of his friend
Dr Winter and punishing games of basketball.)

The body, for Le Corbusier, was not an
Enlightenment abstraction, but a very personal
measure of engagement in architectural design.
The visual attributes of the bodily functions find
their way into his architectural plans (sketched

out in the top right corner): the free (*libre*) plan
combines the rectilinear grid of the structure with
the curving partition walls, which express both
ease of circulation and sensuous form. In his
buildings, curves are invariably introduced in
plan to signal bathrooms, WCs and corridors,
while curving walls on the exterior constitute an
important part of the 'knowledgeable, correct and
magnificent play of volumes assembled in light',
which was one of Le Corbusier's definitions of
architecture.[2] The argument is repeated in a single
sketch of a motor car (at the lower left): 'a chassis;
the coachwork; an engine with its organs of
distribution and exhaust'.[3] In fact, this sketch
betrays a curious confusion of the argument that
sometimes occurred in these hastily drawn lecture
series. If the chassis obviously corresponds to the
(masculine) human skeleton and *firmitas*, the
elements of (male) action/beauty (*venustas*) and
(female) circulation/function (*utilitas*) appear to
be muddled up in the engine and coachwork. In
the drawing, the rectilinear attributes of *firmitas*
seem to be associated with the cross-like lines
of the coachwork (*venustas*?), while the power of
the motor is rendered feminine by the sensuous
curve given to the exhaust. Le Corbusier had
already conflated coachwork with structure in the
photograph of the wooden coachwork of a luxury
Bellanger limousine used to introduce his article
'Maisons en série' ('Mass-produced houses').[4] The
photograph there works only because the lattice-
work of wooden battens supporting the coachwork
roof looks like a reinforced concrete structure. TB

1. Le Corbusier, *Précisions sur un état présent de l'architecture et
de l'urbanisme avec un Prologue Americain, un Corollaire Bresilien
suivi d'une Temperature Parisienne et d'une Atmosphere Muscovite*
(Paris, [1930] 1960), pp.123–4. Le Corbusier had already turned to
the human body as a Vitruvian metaphor in his article 'Besoins-
types meubles-types', *L'Esprit Nouveau*, no.23 (May 1924,
unpaginated), where a page from the Larousse illustrated

dictionary showed three diagrams of the body as a skeleton,
the circulation of blood and the lymphatic system. Reprinted
in Le Corbusier, *L'Art Décoratif d'Aujourd'hui* (Paris, 1925, p.69).
2. Le Corbusier, 'Trois rappels à MM les architectes', *L'Esprit
Nouveau*, no.1 (October 1920), p.92.
3. Ibid.
4. Le Corbusier, 'Maisons en série', *L'Esprit Nouveau*, no.13
(December 1921), p.1525. He had already used the same
photograph in issue 10 (July 1921, unpaginated), illustrating
his article 'Des yeux qui ne voient pas . . . III: Les Autos',
apparently to make the point that architectural proportion is
the 'necessary superfluity' required by cultivated men over
and above functionalism. See Tim Benton, 'From Jeanneret to
Le Corbusier: rusting iron, bricks and coal and the modern
Utopia', *Massilia*, vol.2 (2003), pp.28–39.

206 Plate 9.12

Drawing: *Etude sur le thème 'Léa'*
1930

Le Corbusier (Charles-Edouard Jeanneret)
(1887 La Chaux-de-Fonds, Switzerland–
1965 Cap-Martin, France)

Pencil, crayon and pastels on paper, mounted on card
48 × 36cm
Fondation Le Corbusier, Paris (FLC 3349)

After 1925 and his break-up with Amédée Ozenfant,
Le Corbusier's paintings moved gradually away
from the strongly controlled geometric still-lifes
of his Purist period towards a new subject matter
(pl.3.7).[1] Many of his paintings by 1928 were based
either on assemblages of natural objects placed

in surprising and Surrealist juxtaposition or on
studies of women. A rich source for these paintings
were the sketches he made on holiday at Le Piquey,
on the bassin d'Arcachon, west of Bordeaux
(1930–31). This drawing is one of a number of
pencil studies that exist for the painting known
as 'Léa' (1931, Private Collection). These sketches
include a rickety metal table and chair, a tree
with a distinctive knobbly form, a Purist violin
and two closely observed natural forms, a bone
and an oyster.[2] This sketch shows the painted
composition in its penultimate stage, with the
almost spaceless stage filled with a number of
discordant but highly evocative forms. The open
door (in this sketch represented by a vertical
red line) juxtaposed with the sexually allusive
blue oyster confirms the erotic implications of
the violin superimposed on the fleshy form of
the tree. Le Corbusier's association of natural

forms and human biology could not be more
explicit.

His interest in the *objets à reaction poétique*
(objects that stimulate poetic reaction) (pl.9.11),
natural objects picked up on the beach or by the
roadside and kept for display and contemplation,
began at an early stage, but it was only at the end
of the 1920s that he made them the centre of his
artistic activity. The confident sensuality of these
paintings may well have to do with his marriage to
Yvonne Gallis in 1930, whose face and body feature
in many of his sketches from this point onwards.
TB

1. Christopher Green, 'The Architect as Artist', *Le Corbusier
Architect of the Century* (exh. cat., Hayward Gallery, London, 1987),
pp.124–6.
2. Le Corbusier, Françoise de Franclieu and Fondation Le Corbusier,
Le Corbusier Sketchbooks (Cambridge, MA, 1981), vol.1, pp.488,
536, 514.

207 Plate 9.11

Objets à reaction poétique
(objects that stimulate poetic reaction)
Collected by Le Corbusier (Charles-Edouard
Jeanneret) (1887 La Chaux-de-Fonds,
Switzerland–1965 Cap-Martin, France)

Stone 1, 17 × 12.5cm
Stone 3, 11 × 10cm
Stone 7, 16 × 9.5cm
Stone 8, 15 × 10cm
Bone 2, 16.5 × 10cm
Tree branches 1, l. 44cm
Pebble 27, 18.4 × 13cm
Shell 23, 7 × 4.5cm
Shell 25, 9.5 × 7.8cm
Shell 32, 6.4 × 4.5cm
Shell 57, 4 × 4cm
Pebble: no number (*Pierre rouge*), 19 × 10 × 11cm
Fondation Le Corbusier, Paris

Le Corbusier not only collected '*objets à reaction
poétique*' such as these bones, sea shells, stones
and tree branches, but photographed and drew
them and provided ledges and niches in his apart-
ment to display them. In an interview later in life,
he referred to his favourite found objects as his
'Personal Collection', ranking them on a par with
his artworks.[1] Their primary importance was in
their use as objects of study in drawings, stimu-
lating complex pictorial ideas difficult to put into
words, but the *objets à reaction poétique* also had a
place in Le Corbusier's ideas about the world. For
example, he likened the processes of erosion and
smoothing of stone formations and pebbles to the
process of purification of form to meet universal
needs, which he saw in objects of mass produc-
tion and popular appeal. In an astonishing article
entitled 'Holiday memories', Le Corbusier rumi-
nates about the natural processes of sun, wind
and tide, stimulated by the sight of wind-eroded
rocks in Brittany and a large smooth stone he had
collected on the Brandenbourg plain, presumably
in 1911. He concluded that nature tends towards
the 'mathematical' perfection of form, suggesting,
as if it were a logical deduction, that architects
and painters should peel away the extraneous to
arrive at the pure form within.[2] Bones, bleached
and polished by the elements, appeared to Le
Corbusier to reveal unexpected truths about the
body, not only its structure, but also hidden and
poetic aspects of the unconscious.

Le Corbusier used some of his own photo-
graphs of these objects, some by Pierre Jeanneret
as well as some taken by other photographers,
for his photo-mural for the dining room of the
Student Hostel he had designed for the Swiss
students at the Cité Universitaire in Paris
(1929–33) (pl.9.14). TB

1 From an interview with Rector Mallet (1951) in Giles Ragot and
 Mathilde Dion, *Le Corbusier en France* (Paris, 1997), p.176.
2 Le Corbusier, 'Divers: Souvenirs de vacances', *L'Esprit Nouveau*,
 no.28 (January 1925), pp.2328–30.

208 Plate 9.9

Drawing: *Maison de week-end*,
La Celle-Saint-Cloud
1935
Le Corbusier (Charles-Edouard Jeanneret)
(1887 La Chaux-de-Fonds, Switzerland–1965
Cap-Martin, France) and Pierre Jeanneret
(1896 Geneva–1967 Geneva)

Indian ink on transparent paper
75 × 111cm
Fondation Le Corbusier, Paris (FLC 9242)

By 1935 Le Corbusier had completely abandoned
the machine aesthetic as a dominant idea in his
domestic architecture. His youthful fascination
with vernacular architecture, never extinguished
during his Purist years, revived with the added
force of his political engagement with the Regional
Syndicalist movement. His hero now was not the
engineer, but *l'homme réel* (also the name of a
Syndicalist periodical, which Le Corbusier briefly
edited). *L'homme réel* was the down-to-earth
man of the people in tune with his emotions,
'biological man'.[1]

The small weekend villa he proposed for Henri
Félix (Count Charles de Beistegui's accountant) in
the chestnut forest of La Celle-Saint-Cloud, to the
west of Paris, was designed from the start as a
rustic shack. It was roofed with vaults on which
grass would grow and used rough stone blocks
and glass bricks for the walls and plywood linings
in the interior. The design of this house marked
the beginnings of a serious rift in political and
architectural thinking between Le Corbusier and
his cousin Pierre Jeanneret. Pierre first designed
a triangular hut, constructed of rough stone
walls, glass bricks and concrete vault, and
his drawings feature a gathering of socialist
comrades. Le Corbusier retained the materials,
but transformed the design to make it architec-
turally more formal.[2] In his design, the triangular
plan form is transposed into three parallel rows
of vaulted bays and an additional bay for the stairs
to the cellar. Despite the organic use of materials
and embedding in the landscape, the plan retains
the idea of composing out of standard 'cells',
which could be extended in different ways. This
house proved shocking to Le Corbusier's admirers
across the world, who looked to Le Corbusier for
a lead in the struggle to make the International
Style acceptable to the authorities. TB

1 Mary McLeod, 'Le Corbusier and Algiers', *Oppositions*, no.19/20
 (Winter/Spring 1980), pp.54–85.
2 Tim Benton, 'The Little "Maison De Week-End" and the Parisian
 Suburbs', *Massilia*, vol.1 (2002), pp.112–19.

209

Lecture drawing: *Birdseye perspective of the Bay of Rio*

1929

Le Corbusier (Charles-Edouard Jeanneret) (1887 La Chaux-de-Fonds, Switzerland– 1965 Cap-Martin, France)

Pencil, pastel and charcoal on strong paper, mounted on card
76 × 85cm
Fondation Le Corbusier, Paris (FLC 32091)

When Le Corbusier lectured abroad, he invariably concluded by advocating a radical urban plan for the city. His visit to Rio de Janeiro in December 1929 was no exception. There he immersed himself in the spectacular geology of the site, as well as the no less memorable squalor of the *favelas* (slums), which he visited in the company of the performer Josephine Baker. In this sketch made during his lecture on 8 December 1929 before the Architects' Association in Rio de Janeiro, Le Corbusier proposed a solution for the problem of the press of people squeezed by the mountains into a series of bays facing the sea. The business district would be moved out of the existing city into a new development built out into the harbour, and a long, snaking motorway would link the city to the Sugar Loaf and to the Vermelha and Botafogo bays beyond, while absorbing a proportion of the inhabitants, without (as he saw it) contaminating the beautiful landscape. In his book *Précisions*, Le Corbusier described his plan in a '*corollaire brésilien*' (Brazilian corollary): 'From an aeroplane, I sketched for Rio an immense motorway connecting the fingers of the promontories opening onto the sea so as to quickly link the city to the raised hinterlands of the healthy plateaux.'[1] The motorway would be 100 metres above the ground and would incorporate a continuous line of 10-storey duplex apartment blocks, themselves raised 30 metres above the ground, so that only thin concrete piers would disrupt the existing city. These 'immeuble-villa' apartments, based on the model of the *Esprit Nouveau* pavilion (1925), would offer spectacular views over the sea, like 'eagles' nests'. And he described the design process, sketching the landscape: 'The whole site began to speak, about water, earth and air: it talked of architecture. The eye perceived two things: nature and the products of human labour.'[2]

This 'organic' model, as opposed to the more rigid planning of the Radiant City designs (1930–35), was later adapted to the similar shorefront site of Algiers in his so-called Plan Obus (artillery shell plan) in December 1932. TB

1 Le Corbusier, *Précisions sur un état présent de l'architecture et de l'urbanisme avec un Prologue Americain, un Corollaire Brésilien suivi d'une Temperature Parisienne et d'une Atmosphere Muscovite* (Paris, [1930] 1960), p.242.
2 Ibid., p.245.

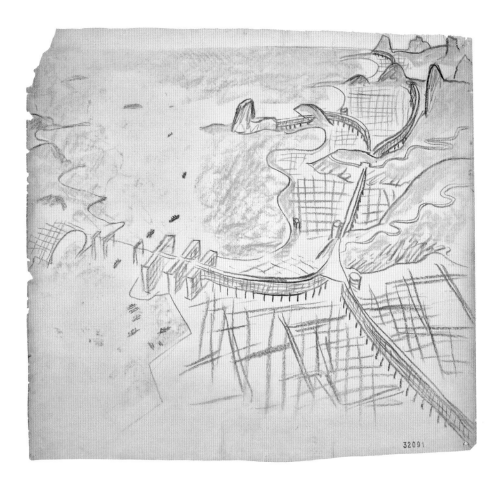

210a Plate 9.13

Necklace
c.1935
Charlotte Perriand (1903 Paris–1999 Paris)

White sea shells
Private Collection

210b

Rock (silex)
Found by Charlotte Perriand
(1903 Paris–1999 Paris)

43 × 70cm
Private Collection

210c–d Plate 9.16

Photographs: *Fishbone and wishbone*
c.1936
Found by Charlotte Perriand (1903 Paris–
1999 Paris), Fernand Léger (1881 Argentan,
France–1955 Gif-sur-Yvette, France) and
Pierre Janneret (1896 Geneva– 1967 Geneva)

210e–f Plate 9.16

Photographs: *Compressed metal*
Charlotte Perriand
Found by Charlotte Perriand and
Pierre Jeanneret

Charlotte Perriand had a necklace made of metal balls chromed to look like ball bearings, which she wore frequently at the time of her break-through as a modern designer, between 1927 and 1930 (pl.3.4). Many critics and friends remarked on this necklace of hard, geometric elements, which seemed to establish a particularly poignant contrast to the beautiful young woman in her fashionable clothes. In the 1930s, however, Charlotte Perriand turned her back on the machine aesthetic and embraced the organic and the primitive, of which this shell necklace is emblematic. In addition to the white sea shell necklace, one made from sensuous mussel shells has survived.[1]

Charlotte Perriand worked closely with Le Corbusier's partner, Pierre Jeanneret, photo-graphing natural objects. They made increasingly abstract and aesthetically satisfying compositions out of them. The photographs that Pierre Jeanneret and Charlotte Perriand took together cannot easily be distinguished. Their interest was further sharpened by Fernand Léger, who accompanied them on some of their trips collecting and sketching objects, which he later converted into graphic work and paintings. One of these paintings, along with some of the objects collected by Charlotte Perriand, including this piece of grey silex, were exhibited together on the stand of the bachelor's apartment at the International Exhibition at Brussels, in 1935 (pl.9.15).[2] TB

210b

1 Jacques Barsac, *Charlotte Perriand Un Art D'habiter* (Paris, 2005).
2 Le Corbusier, *Oeuvre Complete 1934–1938* (Zurich, 1964), p.122.

211

Sculpture: *Tree Root*
After 1924
Mikhail Matyushin (1861 Nizhny Novgorod,
Russia –1934 Leningrad)

Wood
CKC-3076, 23 × 50 × 41cm
CKC-3077, 11 × 14 × 21cm
CKC-3078, 8 × 16 × 23cm
State Tretyakov Gallery, Moscow

The artist and musician Mikhail Matyushin was one of the first Russian avant-garde artists to look to nature as a primary source of inspiration, and he did this at a time when his colleagues were embracing the Italian Futurists' enthusiasm for the machine and technology. He painted studies of branches, considering these natural forms to be perfect examples of the way things grow, and of the inherent dynamism within matter.[1] He called his artistic approach 'spatial realism', and was concerned to enhance humanity's perceptions of space and the natural world. He was interested in the fourth dimension as a higher state of

consciousness, and by 1923 had created a series of eye exercises intended to develop 360-degree vision in a system that he called *Zor-ved* ('see-know').

He incorporated these notions into his teaching when he became head of the department of Organic Culture within the GINKhUK (State Institute for Artistic Culture) in Petrograd in 1923. In 1919 he had exhibited a series of branches and tree roots as sculptures, minimally adjusting the forms so that they resembled human figures in motion.[2] By 1924 he had discarded figurative allusions, and exhibited branches and tree roots as abstract forms, either attached to the wall or free-standing on plinths. One work consisted of a complex construction of roots and branches attached to a rectangular painting on a board, in which the painted forms literally extend out from the picture plane into space.[3] The sculpture on show relates to these works, encouraging the observer to focus on the way that the form has grown organically and to appreciate the various shapes that have resulted from the operation of the dynamic forces of nature. No longer chosen because of its resemblance to any figurative subject, this abstract sculpture embodies nature's vitality and the passage of time. CL

1 Christina Lodder, *Russian Constructivism* (New Haven, 1983), pp.205–207.
2 These are illustrated in *Matjuschin und die Leningrader Avantgarde* (Karlsruhe, 1991), p.116, pl.17.
3 Alla Povelikhina (ed.), *Organica: The Non-Objective World of Nature in the Russian Avant-Garde of the 20th Century* (Cologne, 1999), p.15.

212

Photograph: *Dunes, Oceano*
1936
Edward Weston (1886 Highland Park, USA –
1958 Carmel, USA)

Gelatin silver print
19 × 24cm
Wilson Centre for Photography (05:8533)

'Nature has all the abstract forms that Brancusi or any artist could imagine,' Edward Weston noted in his daybook in 1932. 'With my camera I go directly to Brancusi's *source*. I find *ready to use* what he has to "create".'[1] Weston first put this theory into practice in 1928 in his extreme close-up views of peppers, shells, artichokes and the like; eventually he turned to the genre of landscape photography. Beginning in 1934, at the sand dunes of the evocatively named town of Oceano, California, he pursued two intertwining but in some ways antithetical series of photographs

on the theme of natural beauty: a series of nude portraits of his lover Charis Wilson against the backdrop of the sand, and another series depicting the dunes themselves.

Much has been made of the implicit comparison in the Oceano pictures between Wilson's lolling body and the forms of the surrounding desert landscape. Certainly the nudes possess a frank, almost confessional, sexuality and an essentialist attitude towards women that is entirely typical of Weston.[2] But it is the landscapes that are more significantly Modernist, for they exhibit a compression and dissection of space that borders on pictorial violence. Despite Weston's declared disdain for Constructivist-inspired experiments with extreme angles, he too could play the game of dynamic disorientation.[3] This example from the series is cut by diagonal rifts, which demarcate three bands of irreconcilable space. The changing grain of the sand's texture, progressing from rough at the bottom to fine at the top, schematically approximates an effect of perspectival recession. In its detail, the photograph exemplifies the Modernist principle of finding in landscape an

ageless world of abstract form – the instinct that Sigfried Giedion captured in 1948: 'We want around us objects that bear the trace of life. Bark, grotesque roots, shells, fossils. Things that have passed through time and tide.'[4] But as a composition Weston's image dramatizes the inherent conflict between nature and the artificial ordering structure of the camera lens. It is a tacit admission of the internal contradictions of photography that Weston's nudes, for all their psychological freight, rarely acknowledge. GA

1 Nancy Newhall, *The Daybooks of Edward Weston, Vol. II: California* (New York, 1966), p.242.
2 See, for example, Gilles Mora, 'Introduction: Weston the Magnificent', in Mora (ed.), *Edward Weston: Forms of Passion/Passion of Forms* (London, 1995), pp.22–3.
3 In his daybook for 2 February 1934 Weston dismissed 'young intellectuals, radicals, who imagine that to be "modern" one must "shoot" a skyscraper at a dizzy angle. It is not certain subject matter that makes one contemporary, it is how you see *any* subject matter. Once exciting, the repeated photography of distorted perspective is becoming boresome.' Newhall (1966), p.241.
4 Sigfried Giedion, *Mechanization Takes Command: A Contribution to Anonymous History* (New York, [1948] 1969), p.508.

a

c

d

213a–d

Photographs:
Monster Field, Study 1
Monster Field, Study 2
Untitled
Untitled
1938
Paul Nash (1889 London–1946 Boscombe)

Gelatin-silver prints
20.3 × 25.5cm
Tate, London (1108/L27, 1107/L2, 1111/L, 1109/L)

During the 1930s the relationship between nature and abstraction became increasingly central to the practice of Nash, the leading British artist of the inter-war period. His writings on art and design and his membership of *Unit One* did much to promote Modernism in Britain. He started experimenting with abstracting the forms of landscape in his paintings of 1914–18. His progressively formalized style of the 1920s culminated in a series of purely abstract paintings around 1929–30. In 1935 he declared that, despite his sympathy with abstract art, he needed to retain 'partially organic features' in his own work; 'the hard cold stone, the rasping grass, the intricate architecture of trees and waves, or the brittle sculpture of the dead leaf'.[1] He explained,

'– I cannot translate altogether beyond their image without suffering in spirit.' Nash showed at the International Surrealist exhibitions in London in 1936 and in Paris in 1938. Although the influence of the Surrealists (notably Max Ernst) runs through his work of this period, and while he rejected the total abstraction associated with Modernism, Nash also established a distance between his work and Surrealism. He wrote in 1937 that his concern was not with the unconscious, but with imaginative interpretation of natural objects.[2]

The camera offered the perfect means for Nash to interrogate nature while retaining a grounding in figuration and narrative.[3] He was given a camera in 1931 and took photographs throughout the rest of his career with an increasing visual, if not technical, sophistication that betrays an awareness of international developments in the field. His photographs of found objects and landscape details functioned both as studies for paintings and as stand-alone images, often published alongside Nash's writings.

The *Monster Field* photographs were taken in Gloucestershire in 1938. In the accompanying text, Nash recalls the two felled elms that, ripped from their roots and forced on to the horizontal, 'had assumed, or acquired, the personality of monsters'. 'Both as a painter and a collector of objects,' Nash explains, 'it was impossible for me to ignore the occupants of Monster Field.' As the evening light faded, he made a series of water-colours and photographs, before discovering

that the field was infected with foot-and-mouth disease.[4]

The photographs convey the same sense of fascination and foreboding as in the accompanying text – which pictures the trees as rearing horses, monstrous dogs, or even 'the cow of Guernica's bull'. Equally they relish both the textural explosion of their ripped trunks and their associative possibilities. Composed as close-ups, but with views of the tranquil fields beyond, they also convey Nash's delight in finding figuration in natural abstractions while extracting imaginative (abstract) narratives from them, suggestive of his visionary, neo-Romantic work of the 1940s. But with their formal and associative link to Picasso's *Guernica* (1937) and actual contamination, the *Monster Field* works also resonate with wide-spread unease about the insidious prospect of war in 1938. KB

1 Paul Nash, 'For, but not with', *Axis* (January 1935), also published in Andrew Causey, *Paul Nash: Writings on Art* (Oxford, 2000), pp.110–12.
2 Paul Nash, 'The Life of the Inanimate Object', *Country Life* (1 May 1937), also published in Causey (2000), pp.137–9.
3 See Andrew Causey (ed.), *Paul Nash's Photographs: Document and Image* (exh. cat., Tate Gallery, London, 1973), and David Alan Mellor, *Germany: The New Photography, 1927–1933. Documents and essays selected by David Mellor* (London, 1978).
4 Paul Nash, *Monster Field* (Oxford, 1946), also published in Causey (2000), pp.150–52. The manuscript of the *Monster Field* text was dated 1939, but not published in Nash's lifetime. Photographs, text and watercolours were all published posthumously in 1946.

214

Drawing: *Aquatic and Terrestrial Volnovik*
(*Caterpillar Volnovik*)
1933
Petr Miturich
(1887 St Petersburg – 1956 Moscow)

Ink on paper
31 × 33cm
Private Collection

During the 1920s in Russia, Vladimir Tatlin and Miturich moved away from mainstream technology and sought inspiration for their designs in the world of living matter and organic form. They studied animals, insects and birds in order to understand the mechanics of movement. On the basis of his observations, Miturich developed the concept of 'wave-like motion' (which he called *volnovoe dvizhenie* or *kolebatelnoe dvizhenie*). This was based on the principle that the curved line conserves more energy than the straight line. He demonstrated this idea with an apparatus that consisted of two three-metre paths; one of these possessed three level stretches, with inclined planes between them (like three large, descending steps); the other comprised three downward, curved swoops. When two metal balls were set off simultaneously, the ball on the curved path completed the course, while the other was only two-thirds of the way along its trajectory.[1] Although the experiment seems to have been convincing, the greater speed of the curved path is actually caused by the fact that the ball gains momentum as the path descends.[2] Nevertheless, convinced that wave-like motion was faster, Miturich used this principle as the basis for a whole series of vehicles, the *Volnoviks* and the *Letun* or flying machine, the forms of which were derived from various living creatures. He even extended this idea to the design of an entire city, in which every building and road was conceived in terms of curvilinear form.

While the flying machine was only capable of transporting one individual, the *Caterpillar Volnovik* was conceived as a mode of mass transportation. It consisted of 11 segments: one housing the driver, one acting as the tail and presumably as a means of propulsion, while the other nine provided seating for 18 passengers. Each segment was distinct, being joined to the others, but capable of independent movement, so that the machine could move in curves, like a snake. CL

1 Christina Lodder, *Russian Constructivism* (New Haven, 1983), p.217.
2 George Gerstein, 'The Miturich idea of *volnovoe dvizhenie* (wave-like motion)' [1987], unpublished note quoted in Christina Lodder, 'Constructivism and Productivism in the 1920s', in *Art into Life: Russian Constructivism 1914–1932* (Seattle, 1990), p.116, n.70.

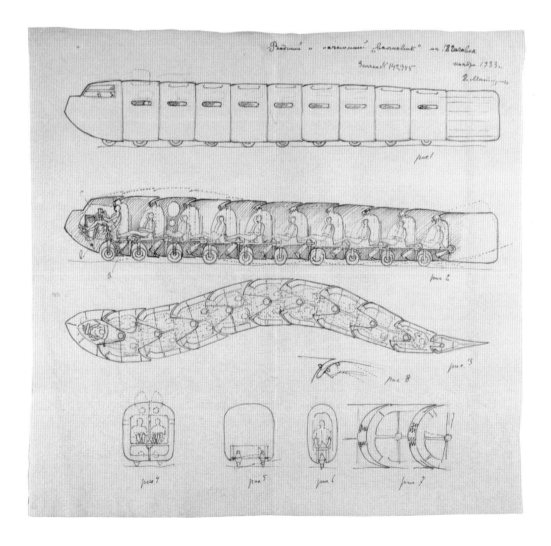

215

Relief: *Constellation According to the Laws of Chance*

*c.*1930

Hans Arp (Jean)
(1886 Strasburg, Germany –1966 Basle)

Painted wood
54.9 × 69.8cm
Tate, London, bequeathed by E.C. Gregory 1959 (T00242)

The title for this relief is misleading, if not disingenuous. Arp did not leave the arrangement of wooden elements to chance. On the contrary, this work is a deliberate composition that resulted from perfecting a technique that he had pioneered around 1916/17 in Zurich. At that time, in the playful and anarchic spirit of Dada, Arp had moved from carefully constructed and smoothed collages to assemblages that were roughly screwed together. He had abandoned the narrative content of his earliest colour reliefs, which echoed non-western ritual woodwork, to arrive at non-objective (and deliberately 'non-sensical') compositions. Under the subsequent influence of Surrealism, Arp adapted from 1919–20 onwards his preferred medium of the relief once again and allowed biomorphic and infantile forms to invade the wooden plane. Narrative structures also returned, and by the end of the 1920s his *Constellation* series combined the free association of forms with symbolic contents of a cosmic nature.[1]

The Constellations are, however, not necessarily configurations of celestial bodies. They represent primary forces moving particles about the picture plane. These particles can be seen as magnified amoeba on a Petri dish or as electrons bouncing off an atomic nucleus, or even as immense gas clouds surrounding a supernova. Like Goethe's *Urblume* (*Original Flower*) the Constellations therefore present elementary structures of universal value, from which an infinite number of compositions and arrangements could spring.

Arp was a particularly influential figure in the 1930s. His preoccupation with the organic to develop a universal language of forms was echoed in contemporary sculptures by Alberto Giacometti, Joan Miró and Alexander Calder. His reliefs were owned by a wide range of Modernists, including Hannah Höch, Nelly van Doesburg, Max Ernst, Jan Tschichold and, in the case of the present example, E. McKnight Kauffer.[2] UL

1 See Bernd Rau (ed.), *Hans Arp: Die Reliefs. Œuvre catalogue* (Stuttgart, 1981) and the essays by Harriet Watts and Jane Hancock, in Hancock and Stephanie Poley (eds), *Arp 1886–1966* (Cambridge, 1987), pp.112–23.
2 See Rau (1981), cats 12, 17, 223, 70, 92, 240, 346 and 221.

216

'First Model' Lounge Chair (prototype)
1927
Gerrit Rietveld (1888 Utrecht–1964 Utrecht)

Birch plywood
83 × 69 × 94cm
Stedelijk Museum, Amsterdam (KN A 1265)

Like Alvar Aalto, Rietveld was fascinated by the problem of exploiting the inherent properties of natural materials to manufacture genuinely cheap mass-produced products. Industry had shown how sheet metal could be stamped, folded and joined to make an astonishingly wide range of objects. One of the most successful industrially produced chairs in the 1930s was the sheet-metal café chair produced by the Société Industrielle des Meubles Multiples, Lyons (c.1928). This chair could be literally stamped out and assembled in true assembly-line manner. Rietveld had already designed furniture assembled from rails and planks (pl.2.12), during his De Stijl phase, which was one way (theoretically) of approaching the industrialized production of furniture, but making a wooden chair in a manner similar to the French café chair was not easy. In 1927 Rietveld experimented with an armchair that could be cut and folded out of a single piece of plywood.[1] He made a paper cut-out for this chair and constructed a full-size prototype in fibreboard (because it could be bent and moulded by hand), with the intention of persuading a manufacturer to stamp out and assemble the chair in industrial quantities. In the same year he designed a chair consisting of two thin tubular-steel supports and a seat and back made of a single sheet of fibreboard.[2]

In the so-called 'First Model', he replaced the tubular-steel sides with two sheets of ply.[3] Sides and seat interlocked in an ingenious fashion and two folded pieces glued to the sides provided armrests. The design never went beyond the prototype stage. In an interesting article published in 1930, Rietveld recognized that designing chairs meant more than searching for cheap and efficient means of manufacture. 'Every chair seems to be a stylization of an attitude to life. The cheapest mass-produced chair, no less than the most imposing armchair, is being made of wood, cane, leather, plush or metal.'[4] TB

1 Peter Vöge, *The Complete Rietveld Furniture* (Rotterdam, 1993), 'Birza (one-piece) chair'. Luca Dosi Delfini, *The Furniture Collection, Stedelijk Museum Amsterdam* (Amsterdam, 2004), p.306.
2 Marijke Küper and Ida van Zijl, *Gerrit Th. Rietveld: The complete works* (Utrecht, 1992), p.117.
3 Ibid., p.118, and Dosi Delfini (2004), p.304.
4 Gerrit Rietveld, 'Chairs', *De werkende vrouw* (1930), in Küper and van Zijl (1922), p.27.

217 Plate 9.3

'Short Chair'
1936
Marcel Breuer
(1902 Pécs, Hungary–1981 New York)
Manufactured by Isokon Furniture Co.

Moulded birch plywood with zebrano veneer
79.2 × 62.2 × 98.5cm
V&A: CIRC.80–1975, given by Mr and Mrs Dennis Young

The Isokon 'Short Chair' – along with its companion piece, the full-length 'Long Chair' – was a translation into plywood of an aluminium chair designed by Marcel Breuer in 1932.[1] When Breuer emigrated to England, Walter Gropius had just been appointed controller of design to Jack Pritchard's fledgling Isokon Furniture Company, and it was Gropius's suggestion that Breuer design a version of the aluminium chair in plywood.

In December 1935 Pritchard offered Breuer a small retainer and 5 per cent of sales to work for Isokon. Lacking Aalto's technical expertise in the forming of plywood strips and sheets, Breuer's wooden Long Chair (made before the Short Chair) suffered teething problems in manufacture, due to the Scotch glue used. Prototype chairs made and displayed next to the indoor swimming pool in Dolphin Court came spectacularly unstuck, resulting in what John Gloag described as 'an embarrassing collection of veneer'.[2] Breuer resolved the structural problem of stiffening the supports for the armrests with a piece of reinforcing plywood.

The Short Chair took up less space than the Long Chair and required less agility to get into and out of. The sensuous curves of the plywood seat, with its built-in headrest, are played off against the four strips of bentwood that support it and also supply the armrests. This is one of the most comfortable chairs of the 1930s, and one that has provoked many a Hampstead intellectual to fall asleep over his or her Penguin book (pl.11.20). English traditional notions of comfort and Modernist principles of clear expression of materials and structure were perfectly combined in this design. TB

1 Christopher Wilk, *Marcel Breuer Furniture and Interiors* (exh. cat., Museum of Modern Art, New York, 1981), pp.115–24 (on the aluminium furniture) and 126–35 (on Isokon); see also Alistair Grieve, *Isokon* (London, 2004).
2 An anecdote recounted with humour by Jack Pritchard in an Open University Radio programme (Open University course A305, radio programme 30, 1975) and repeated in his autobiography: Jack Pritchard, *View from a long chair* (London, 1984), p.112.

218

Stacking stools
1929–30
Alvar Aalto (1898 Kuortane, Finland –
1976 Helsinki)
Probably manufactured by Artek, about 1936

43.2 × 38.1 × 38.1cm
Solid birch and birch plywood
V&A: W.50 to C-1977

Devising rigid bent elements that could simulta-
neously serve as leg and support for a seat was
the object of considerable research by Alvar Aalto
and can be seen in several of his plywood reliefs
(pl.1.10). For Aalto, the creation of a structural
element that could serve simultaneously as
a horizontal and vertical support was a 'type'
solution in wood, analogous in its importance to
the concrete *piloti* or the antique Doric column.
He called the standard leg of his three-legged
stools the 'Doric' leg or the 'bent knee'.[1] Aalto
and Otto Korhonen patented (in Scandinavia and
Britain) the method by which the Doric legs were
formed: thin sawcuts were made along the grain
of a birchwood lath (most of the length of which
formed the leg), thereby allowing the necessary
flexibility to bend the piece at the top. Into these
slots were glued thin sheets of veneer, which,
when set, maintained the right-angle bend. At first,
the L-shaped legs had to be manufactured by

hand, forming the tight curve out of the separate
veneers of wood as it was glued, but a machine
was soon developed that could perform this action
in a hot press. The stool is reduced to its basic
industrial components: an L-shaped leg and a
circular top. Dozens of stools could be stacked
in a corner, and the resultant spiralling form
became a motif of displays of Aalto furniture in
the 1930s and ever since.

Many thousands of these stacking stools were
produced.[2] They were used in quantity in the Vipuri
Library, which was built and furnished between
1930 and 1935. The original stools had the tradi-
tional three legs, which avoid any rocking on an
uneven surface. Four-legged stools were manu-
factured by special request from 1935 and, in the
1940s and '50s, Aalto developed this leg in a more
elegant and refined form in two very different stool
designs.[3] The basic bent leg is, however, a classic
development of Modernist thinking without the
hard and cold qualities of metal construction.
In modified form the three-legged stools are still
produced today in huge quantities, meeting the
basic need of robust additional seating. TB

1 Göran Schildt, *Alvar Aalto, The Decisive Years* (New York, 1986),
 p.82, and Juhani Pallasmaa (ed.), *Alvar Aalto Furniture*
 (Helsinki, 1984), p.77.
2 Asdís Ólafsdóttir, *Le mobilier d'Alvar Aalto dans l'espace et dans
 le temps; la diffusion internationale du design entre 1920 et 1940*
 (Paris, 1998), pp.113–39 and 211–17; Kevin Davies, 'Finmar and
 the Furniture of the Future: The Sale of Alvar Aalto's Plywood
 Furniture in the UK 1934–1939', *Journal of Design History*, vol.11,
 no.2 (1998).
3 Timo Keinänen et al., *Alvar Aalto Designer* (Helsinki, 2002),
 p.169, and later stools, pp.177–9, 182–3.

219 Plate 9.2

Armchair
1930
Alvar Aalto (1898 Kuortane, Finland –
1976 Helsinki)
Manufactured by Huonekalu- ja
Rakennustyötehdas Oy, Turku

Birch plywood and solid birch, painted seat
63.5 × 61 × 89cm
V&A: W.41-1987

Like many of Alvar Aalto's furniture designs, this
chair was conceived of for the Paimio sanatorium
(1927–32, pls 7.6–7), this model for its lecture hall.[1]
Anxious to provide seating that was as welcoming
and comfortable as possible, Aalto decided
against tubular-steel designs and opted for
an all-wood construction. These armchairs,
manufactured for sale by Otto Korhonen's firm
and from 1935 by Artek, became among the
most successful of Aalto's productions in the

1930s and one of the defining objects of humanized
Modernism. The structural rationalism of separating
support and supported was a fundamental principle
of Modernist design. The delightful juxtaposition
of coloured plywood seat and back and light birch
frame has a biomorphic quality to it, which invites
one to sit down in the chair. By this time Aalto had
mastered the possibilities of forming plywood in
hot metal presses; the freeform curve of the seat
and back is both an expression of the free will
of the artist and a masterly deployment of the
elasticity of the material. The chair is still in
production by Artek. TB

1 Timo Keinänen et al., *Alvar Aalto Designer* (Helsinki, 2002),
 pp.74–6, 165.

220 Plate 1.10

Experimental Relief

1933

Alvar Aalto

(1898 Kuortane, Finland –1976 Helsinki)

Laminated birch
c.35 × 40cm
Alvar Aalto Foundation

Aalto seems to have begun making these reliefs from strips of bent birch in conjunction with his friend and business associate Otto Korhonen, whose factory (Huonekalu-ja Rakennustyötehdas Oy, Turku) produced the furniture that both men designed.[1] Sometimes the reliefs are purely decorative, but sometimes they can be seen to test a structural principle that was important for Aalto's furniture designs. This relief demonstrates various possibilities of forming and gluing birch ply. The ply sandwich is both opened up to reveal the different strands and its thickness varied by adding or removing layers. Splitting a strip and bending up the two halves in opposite directions provided rigidity, which also suited the need to provide armrests in a chair. One of the first embodiments of this principle was a hybrid chair (1931–2), consisting of tubular-steel base and bentwood top. In this prototype chair, the seat and back are formed of a single sheet of ply and the arms are formed of strips slotted in the sheet and bent up to provide armrests and help support the back.[2] By contrast, sandwiching additional strips of wood into the ply to reinforce bends was a necessary part of the design of cantilevered chairs.

Aalto's reliefs are also a celebration of the native birchwood of the Finnish forests. He increasingly used wood as a decorative surface in his buildings in the 1930s, giving his interiors a warmth and human interest lacking in the work of most Modernists. TB

1 Juhani Pallasmaa (ed.), *Alvar Aalto Furniture* (Helsinki, 1984), pp.70–87; Timo Keinänen et al., *Alvar Aalto Designer* (Helsinki, 2002).
2 Ibid., pp. 71–3.

221

Savoy Vase

1936

Alvar Aalto (1898 Kuortane, Finland – 1976 Helsinki)

Manufactured by Karhulan Lasitehdas, Karhula, Finland, 1937

Mould-blown bottle glass
h. 14.5cm, w. 21cm
V&A: C. 226–1987

Aino and Alvar Aalto submitted a number of designs for glass to competitions.[1] In 1932 they had submitted designs for moulded glass beakers, plates and saucers for a competition promoted by the Karhula and Ittala glassworks. In the autumn of 1936 the same firm invited a select group of designers to compete for the glass designs to be shown in the Finnish Pavilion at the International Exhibition in Paris, 1937. Alvar Aalto had just won the competition to design the pavilion. His competition drawings for glass, given the bizarre pseudonym of 'the Eskimo woman's leather breeches', were astonishingly inventive, using an almost completely abstract line and making use of collage. Although various sources have been offered for these vases (including the sculptures of his friend Hans (Jean) Arp (cat.215), Timo Keinänen believes that a more obvious source lay close to hand in the freeform plates and shallow vases produced by Orrefors in 1935.[2] From these designs emerged the so-called Savoy glass vases; 10 of these vases were exhibited at the 1937 Paris Exhibition. TB

1 Göran Schildt, *Alvar Aalto, The Decisive Years* (New York, 1986), pp.136–9, and Timo Keinänen, 'Alvar and Aino Aalto as glass designers', in Timo Keinänen et al., *Alvar Aalto Designer* (Helsinki, 2002), pp.136–48, are the main sources for information.
2 Ibid., p.145.

222a and 222b

Furnishing fabric

1936–7
Designed by Antonín Kybal (1901 Nové Město nad Metuj, Czechoslovakia–1971 Prague)
Made in the designer's studio

Hand-printed linen
a. 49 × 31cm (74.174/9)
b. 49 × 31cm (74.174/6)
The Museum of Decorative Arts, Prague

The son of a textile factory owner, Kybal trained as a painter and sculptor at the School of Arts and Crafts in Prague in the 1920s and subsequently as a drawing master at the city's Technical High School.[1] Like many fellow Czech designers, he became familiar with the work of Le Corbusier and other leading Modernists in the early 1920s, and was keenly interested in the work of the Bauhaus.[2] In 1928, having worked in Slovakia, and prompted by his study of folk textiles, embroidery and national costume, Kybal decided to focus on textile design as a career and established his own workshop. He became closely connected to Ladislav Sutnar (cat.242–3) and other members of the Czechoslovak Arts and Crafts Association, on whose board he sat from 1929.[3] Despite its title, the association advocated serial production rather than traditional handicrafts.

While Kybal accepted the Association's emphasis on creating objects suited to new ways of living (by which they meant for Modernist interiors), he rejected their embracing of the Modernist idea on standardization and, in much of his work, adopted a more decorative approach. Kybal sought in all his work to make textiles that relied on a deep knowledge of the specific materials and techniques of textile-making and which were varied in their appearance and methods of manufacture. In particular he used colour as the chief means of expression in his work and assigned special value to it. He experimented extensively with dyes; in the case of these boldly coloured fabrics, he almost certainly used chemical dyes. He undertook the very exacting weaving to achieve the right fabric weight required for the hand-block printing, as well as the printing itself. He also designed, as in these examples, biomorphic or ectoplasmic patterns for furnishing fabrics, which he then reduced in scale for dress fabrics. CW

1 On Kybal, see Jan Spurný, *Modern Textile Designer: Antonín Kybal* (Prague, 1960) especially pp.8–12.
2 Iva Janáková, 'In the community of the Czechoslovak Arts and Crafts Association', in *Ladislav Sutnar. Prague. New York. Design In Action* (Prague, 2003), p.99.
3 Ibid., pp.99–100.

222a

222b

223

Sculpture: *Construction in Space:
Stone with a Collar*
1935–6, this version about 1937
Naum Gabo (Neemiya Pevzner) (1890
Klimovich, Belarus–1977 Waterbury, USA)

Stone, cellulose acetate, slate and brass
37 × 72 × 55cm
Tate, London (T06975)

Naum Gabo conceived *Stone with a Collar* while
living in France, where he made a small model,
but he executed it first as a full-scale sculpture
soon after settling in Britain in 1936.[1] It was
his first stone carving; prior to this he had
constructed his works from clearly articulated
elements of material, principally metal, plastic and
glass. His constructions of the 1920s had been
very rectilinear (e.g. *Column*, c.1921–2, Solomon
R. Guggenheim Museum), but by the early 1930s
he had begun to introduce curvilinear shapes

with a more organic quality into his work
(e.g. *Construction in Space: Soaring*, 1930, Leeds
City Art Gallery). In conceiving and executing
Stone with a Collar, he seems to have been
stimulated by the direct carving techniques of
his British colleagues, such as Henry Moore
and Barbara Hepworth.

In London, Gabo became an important
catalyst and inspirational presence in the
emergence of British Constructivism and
a moving force in the publication of *Circle:
International Survey of Constructive Art* (1937),
which he co-edited with the painter Ben
Nicholson and the architect Leslie Martin.
There he illustrated this work and modified the
credo of *The Realistic Manifesto* (Moscow, 1920),
in which he had rejected mass as a sculptural
element and proclaimed construction as the only
way to indicate space and time, which were for
him the essence of reality. In 1937, he justified his
current combination of carving and construction
techniques on the basis that mass was another
way of indicating volume, and that through carving
it was possible to show that space penetrated all
solid materials.[2]

This particular sculpture is the third version
in the series to be executed, and Gabo retained
it until the end of his life.[3] During that time, it
underwent several changes. At one time, a strip of
plastic arched over the top of the work, and it also
possessed an additional pair of plastic collars.
Gabo removed the arching strip before 1957 and
one of the collars sometime afterwards, presum-
ably in the interests of greater simplicity and
dramatic impact.[4] It is difficult to judge precisely
when, because he tended to use old photographs
for his catalogue illustrations. CL

1 Martin Hammer and Christina Lodder, *Constructing Modernity:
 The Art and Career of Naum Gabo* (New Haven, 2000), pp.247–9.
2 Naum Gabo, 'Sculpture: Carving and Construction in Space',
 Circle: International Survey of Constructive Art (London, 1937),
 pp.103–12, reprinted in Hammer and Lodder (2000), pp.107–115.
3 Colin Sanderson and Christina Lodder, 'Catalogue Raisonné of
 the Constructions and Sculptures of Naum Gabo', in Jörn Merkert
 and Steven Nash (eds), *Naum Gabo: Sixty Years of Constructivism*
 (Munich, 1985), p.218, which published an incorrect date of
 1930/32.
4 See illustration in Herbert Read and Leslie Martin, *Gabo:
 Constructions, Sculpture, Paintings, Drawings, Engravings*
 (London, 1957), pl. 51.

1934·XII

SI

ROMA 301.403 ● AGRIGENTO 103.162 ● ALESSANDRIA 218.289 ●
ANCONA 78.107 ● AOSTA 70.550 ● AQUILA 88.695 ● AREZZO 77.231
● ASCOLI PICENO 66.566 ● AVELLINO 112.656 ● BARI 170.078
● BELLUNO 58.719 ● BENEVENTO 58.668 ● BERGAMO 143.164
● BOLOGNA 190.976 ● BOLZANO 47.985 ● BRESCIA 175.996 ●
BRINDISI 59.692 ● CAGLIARI 80.903 ● CALTANISETTA 56.496 ●
CAMPOBASSO 89.205 ● CATANIA 138.057 ● CATANZARO
132.959 ● CHIETI 81.603 ● COMO 138.685 ● COSENZA 136.098
● CREMONA 99.461 ● CUNEO 170.292 ● ENNA 58.464 ● FROSINONE
78.509 ● FERRARA 87.465 ● FIRENZE 243.226 ●
FIUME 24.858 ● FOGGIA 97.924 ● FORLI'
105.578 ● GENOVA 221.321 ● GORIZIA
54.464 ● GROSSETO 50.025 ● IMPERIA
43.423 ● LECCE 113.923 ● LIVORNO 57.805
● LITTORIA 13.319 ● LUCCA 84.281 ●
MACERATA 61.396 ● MANTOVA 111.289 ●
MASSA CARRARA 46.140 ● MATERA 32.410
● MESSINA 126.394 ● MILANO 543.598 ●
MODENA 120.629 ● NAPOLI 471.201 ●
NOVARA 114.201 ● NUORO 48.530 ● PADOVA
126.766 ● PALERMO 166.091 ● PAVIA 137.803
● PERUGIA 115.881 ● PESCARA 47.949 ●
PESARO 78.102 ● PIACENZA 79.263 ● PISA
93.333 ● PISTOIA 58.683 ● POLA 75.919 ●
POTENZA 66.310 ● RAGUSA 50.684 ●
RAVENNA 80.611 ● REGGIO CALABRIA
109.327 ● REGGIO EMILIA 86.900 ● RIETI
34.543 ● ROVIGO 72.730 ● SALERNO 127.304 ●
SASSARI 73.583 ● SAVONA 54.398 ● SIENA
71.858 ● SIRACUSA 65.487 ● SONDRIO
35.553 ● SPEZIA 52.616 ● TARANTO 62.749 ●
TERAMO 60.978 ● TERNI 52.490 ●
TORINO 320.676 ● TRAPANI 14.560 ●
TRENTO 108.212 ● TREVISO 140.277 ●
TRIESTE 75.553 ● UDINE 210.426 ● VARESE
108.005 ● VENEZIA 131.475 ● VERCELLI
108.295 ● VERONA 134.772 ● VICENZA
136.232 ● VITERBO 57.801 ● ZARA 3526

Elettori iscritti 10.526.504
Votanti (96.25%) 10.061.978
Favorevoli (99.84%) 10.045.477
Contrari (0.15%) 15.201

David Crowley

National Modernisms

Politics and architecture overlap . . . But even this connection is by no means a definite one. For instance, how does it help us to know that Stalin and the promoters of the Palace of Soviets are communists. . .? Their arguments are very much the same as those of any primitive-minded capitalistic, or democratic, or Fascist, or merely conservative motor-car manufacturer with a hankering for the cruder forms of symbolism.[1]

Marcel Breuer
'Where do we stand?'
(1934)

10.1 **Xanti Schawinsky**,
Poster: *1934 Year XII of the Fascist Era*, 1934 (cat.232)

In the summer of 1933 leading Modernist architects boarded a liner, the SS *Patris II*, to hold the fourth congress of CIAM (*Congrès Internationaux d'Architecture Moderne*, International Congresses of Modern Architecture). Sailing from Marseilles to the Greek capital, the delegates debated what later became the 'The Athens Charter' (1943), the credo of 'The Functional City'. The largest gathering of Modernist 'pioneers', the *Congrès* has become a celebrated event in the history of the 'Modern movement'.[2] CIAM representatives from different nations presented the problems and future plans of 34 cities spanning the globe from Los Angeles to Dalat in French Vietnam. Discussions, presentations and propositions made during the *Congrès* later came to constitute the Athens Charter, a statement dedicated to solving the common problems of the city throughout the world. Although this document was drawn up in retrospect, the delegates broadly concurred in their belief that rigid urban zoning – the division of areas of the city according to function and separated by green belts – would guarantee coherence and efficiency, while high-density housing in the form of 'high, widely-spaced apartment blocks' would solve the housing crisis. Here were solutions to universal urban problems.

CIAM's discussions on the *Patris* were not solely limited to architects: Otto Neurath, the Vienna-based founder of ISOTYPE (International System of Typographic Pictorial Education), a *lingua franca* of graphic symbols that aspired to transcend national and linguistic boundaries, made a presentation on new techniques for representing the city as graphic data. So strong was the mood of international cooperation that some participants regretted they could not communicate with one another in Esperanto.[3] Internationalism was not only a reflection of the huge ambitions of this generation of architects: it expressed for most the post-war dream of a world ordered by peaceful diplomacy and, for some, it carried an attractively conspiratorial echo of the Soviet-backed Communist International and the revolutionary mood of the early 1920s triggered by revolution in Russia.

CIAM IV was not only a high-water mark of the 'Modern movement' in terms of the lofty social and inherently political ambition of the ideas presented there: it also exposed the limits of its idealism. In fact, the *Congrès* had originally been planned for the spring in Moscow, but the hardening of the official line towards modern architecture had become so pronounced in Stalin's Russia that the meeting had to be relocated. Events elsewhere in Europe were equally menacing. Hitler's appointment as temporary Chancellor in Germany in January 1933, and the Enabling Act that followed in March granting him the powers of a dictator, gave licence to reaction. The formal closure of the Bauhaus School in Berlin at the beginning of the summer semester in April 1933 (after being forced out of Dessau in October of the previous year by the National Socialist city authorities) was

only one of the most visible signs of this changing climate. Equally important was the steady intellectual haemorrhage of modern artists and designers from the region:[4] within months of the National Socialists' seizure of power, for instance, Jan Tschichold, the Swiss-born pioneer of *Die neue Typographie* (*The New Typography*, cat.125) was forced out of his teaching position at the Munich Meisterschule. He spent six weeks in prison under 'protective custody'.[5] It was not just Tschichold's enthusiasm for the Soviets (see below) or his work for German trade unions that had drawn the Nazi strike; it was his status as a prominent advocate of Modernist, 'un-German' graphic design. In the years that followed he embarked on a journey into exile shared by a large number of prominent Modernist artists, architects and designers.

In the early 1930s Modernist design was becoming political in ways that its key theorists and ideologues could hardly have expected a few years earlier. For much of the 1920s they had argued that city planning, architecture and even graphic design should be understood as politics conducted by other means. Le Corbusier, in asking his oft-quoted 1923 rhetorical question 'architecture or revolution?', presented a dramatic choice to any state facing social unrest: modern industry was not only remaking everyday spaces and things; it was also producing new kinds of consciousness and desires and, in turn, new inhabitants and citizens. Failure to satisfy these aspirations would open the door to conflict: 'Our minds have consciously or unconsciously apprehended these events and new needs have arisen, consciously or unconsciously.' Modern architecture was, therefore, both a stimulant of new desires and the means by which these aspirations could be met, if only authority grasped the opportunities before it. The alternative was periodic crisis. In Le Corbusier's words, 'The machinery of Society, profoundly *out of gear*, oscillates between an amelioration, of historical importance, and a catastrophe.'[6]

When, in the following decade, catastrophe struck Europe, it threatened the reforming vision of modern architecture and design that Le Corbusier and his CIAM allies strove to promote. Architectural historian Kenneth Frampton characterized the age as one in which the progressive impulse of modernity was threatened by a series of crises:

… the prevailing backwardness and chronic insecurity of the newly urbanized masses, the upheavals caused by war, revolution and economic depression, followed by a sudden and crucial need for psycho-social stability in the face of global interests of both monopoly and state capitalism are, for the first time in modern history, divorced from the liberative drives of cultural moderniza-tion. Universal civilization and world culture cannot be drawn upon to sustain 'the myth of the State', and one reaction-formation succeeds another as the historical avant-garde founders on the rocks of the Spanish Civil War.[7]

10.2 Page spread from **El Lissitzky**, leporello book *Pressa Köln* (1928), illustrating the USSR display at the International Press exhibition, Cologne, 1928. David King Collection, London

The economic and political instability of the age had profound social, cultural and even psychological effects. The utopian visions of a new rational order governed by the machine increasingly gave way to new anxieties about disorder in society and in the mind. Constructivism was 'replaced' in its role as the pacemaker of modern culture by Surrealism: its fascination with psychic and social repression in pitch with the age.

Modernism did not fade away in the crisis years: in fact, it was increasingly drawn centre-stage, albeit in unpredictable ways. It was claimed as the means to underwrite democracy at a time when it was under the gravest threat. In France, artists and architects from across the artistic spectrum – from former Surrealist Louis Aragon to CIAM member Charlotte Perriand – rallied to support the *Front Populaire* (Popular Front), the alliance of left-wing parties that formed in 1934 in the wake of fascist riots in Paris. The extensive commissioning of Modernist artists and designers for the *Exposition Internationale des Arts et Techniques dans la Vie Moderne* (International Exhibition of Arts and Techniques in Modern Life), held in the capital in the summer of 1937, has been seen as repayment of this debt.[8] By contrast, modern art and design were elsewhere excoriated by regimes of all stripes in order to establish their own bona fides as defenders of tradition, of ethnicity, of class or of any other 'popular' interest that could be used to stir up feeling. Witnessing the activities of the National Socialist state in Germany, critic and philosopher Walter Benjamin famously observed that fascism had

aestheticized politics, substituting public debate and dispute for a series of stage-managed spectacles, and replacing social critique with pageants, flags and slogans.[9] At the same time it had politicized aesthetics – albeit in paranoid fashion – by sacrificing modern art and architecture as a scapegoat in order to conceal its own illegitimacy.

Yet, as a number of historians have demonstrated in recent years, the relationship between authority and Modernism is not so clear-cut. Authoritarian governments were often riven by internal conflict and far less united than they liked to claim. Even when the internecine battles appeared to be won, those right- and left-wing regimes that aggressively broadcast their disdain of modernity were perfectly capable of exploiting its benefits. In the most dramatic revision of this relationship, writers exploring Nazi Germany and the Soviet Union under Stalin have claimed that, far from extinguishing avant-gardism, these dictatorships embraced the totalizing impulse of Modernism, which, in its most ambitious expression, took the wholesale transformation of life as its aim. Boris Groys has argued that the Soviet authorities sought to make a 'total artwork out of society':

> The world promised by the leaders of the October Revolution was not merely supposed to be a more just one . . . it was also and in perhaps even greater measure meant to beautiful . . . When the entire economic, social and everyday life of the nation was totally subordinated to a single authority . . . the Communist Party leadership was transformed into a kind of artist whose material was the entire world and whose goal was to 'overcome the resistance' of this material and make it pliant, malleable, capable of assuming any desired form.[10]

The Soviet Union

For many socialist and liberal intellectuals in Western Europe in the inter-war years the Soviet Union was a beacon, illuminating the possibility of a world-changing alliance between the artistic and political avant-gardes. This expectant view was encouraged by the compelling image of modernity promoted by the Soviet avant-garde abroad. The Soviet display at the *Internationale Presse Ausstellung* (*Pressa* / International Press Exhibition) in Cologne in 1928 (pl.10.2), for instance, could hardly have been more dramatic. El Lissitzky's huge exhibition pavilion was a complete graphic environment in which Marxist-Leninist ideology, channelled by designers who had emerged from the avant-garde, such as Gustavs Klucis and Sergei Senkin, was powerfully expressed through astonishing typographic, photographic and symbolic devices. Organized in 20 sections, massive photomontage murals captioned with bold slogans and free-standing displays – in the symbolic forms of the rollers of rotary printing presses and the red five-pointed star bedecked with print – celebrated the social and political achievements of the Soviet press.

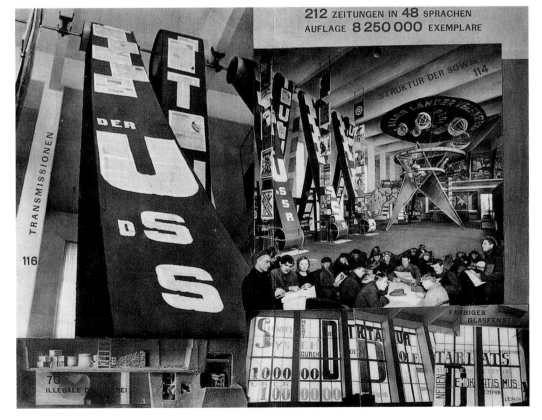

Jan Tschichold described the palpable excitement that Lissitzky's pavilion produced:

> … by bringing a dynamic element into the exhibition by means of continuous films, illuminated and intermittent letters and [a] number of rotating models. The room thus became a sort of stage on which the visitor himself seemed to be one of the players. The novelty and the vitality of the exhibition … was proved by the fact that this section … had at times to be closed owing to overcrowding.[11]

This impression of the irresistible force of Soviet modernity was formed at the same time as Joseph Stalin was claiming total authority over the Communist Party and Soviet society. Declaring a programme to 'build socialism in one country', he set about revolutionizing the economy and consolidating the rule of the party. Announcing the First Five-Year Plan in April 1929, Stalin boasted:

> We are advancing full steam ahead along a path of industrialization to socialism, leaving behind the age-long 'Russian' backwardness … when we have put the USSR on an automobile, and the muzhik on a tractor, let the worthy capitalists, who boast so much of their 'civilization', try to overtake us! We shall yet see which countries may then be 'classified' as backward and which as advanced.[12]

Stalin's revolution (pl.10.3) had a number of megalomaniac urban and industrial projects at its heart. The construction of the world's largest metallurgical works was begun on virgin soil at Magnitogorsk in the Urals; a hydroelectric plant, drawing the energy of the Dnepr River, was completed in 1932; and massive tractor factories based on Ford's River Rouge complex (pl.3.14) were built at Chelyabinsk and Stalingrad to advance the cruel programme to collectivize agriculture.[13] While some Soviet citizens threw themselves behind Stalin's vision, others had little choice. The human cost of this hasty race to industrialize was appalling: hundreds of thousands of *zeks* (prisoners) died labouring on the building sites. Those who survived endured wretched conditions. The backward state of Russian engineering and industry also meant that these schemes needed to draw upon the expertise of *spetsi* (specialists) imported from the West. German and American engineers and architects provided know-how lacking in Soviet society.

The *Brigada Maya* (May Brigade) was formed in October 1930 after a Soviet commission visited the famous social housing estates in Frankfurt (cat.91). Ernst May, CIAM member and chief city architect until the economic crisis and a new right-wing authority put a halt to the ambitious social housing schemes there, was invited to bring a team of 30 specialists to Moscow to design new Soviet *sotsgoroda* (socialist cities). Among this group was Grete Schütte-Lihotsky, best known for her rational

Frankfurt Kitchen (cat.92). Prominent architects Hans Schmidt and Mart Stam were also members. The brigade's first task was the urban plan of Magnitogorsk. For May, writing in *Das neue Russland* (*The New Russia*) in 1931, Soviet conditions presented unique opportunities for the Modernist architect or urban planner. Here was the *tabula rasa* that visionaries of the 1920s had so desired. 'No other place on earth,' he stressed:

> provides a better opportunity for the realization of the linear city than the USSR, where industrial combines are sprouting on the desolate steppe like spring mushrooms, evolving their own particular form apparently well suited to embrace a wide range of functional requirements, such as the organization of industry according to assembly line methods and the settlement of large masses of people at a short distance from work.[14]

In 1930 Hannes Meyer, who had been the second director of the Bauhaus, was also invited to form a team to work in the Soviet Union. Living as a collective, his group of seven Czech, German and Dutch former students known as the Bauhaus Brigade worked in various planning institutes in Moscow. A long-standing communist activist, Meyer went further than May in his enthusiasm for Stalin's 'second revolution'. In a lecture in Berlin in October 1931 he claimed that the dictator's programme was already dissolving the bourgeois consciousness that inhibited progress towards the communist nirvana:

> In the Soviet Union the factory replaces the family in almost all respects. The factory takes care of everything: it is the centre of our collective existence. The office worker is in no way different from his comrade on the construction site. The chasm between worker and scientist has ceased to exist.[15]

At a time when communists and Nazis in Germany were engaged in a bitter struggle over the frail body of Weimar democracy, the former director of the Bauhaus was, it seems, unprepared to acknowledge the brutal realities of life on Stalin's colossal building sites.

Despite his renowned asceticism, Meyer described the Palace of Soviets project to his Berlin audience in unmistakably favourable terms. His enthusiasm was probably genuine. The competition to design a Moscow monument to the new era unfolding in the Soviet Union had first been announced in February 1931. When he spoke later in the year, the mega-structure existed only as a series of open stipulations. They stressed that the scheme's 'architectural design must correspond with':

> a) the character of the times, in order to reflect the will of the workers to build socialism;
> b) the special purpose of the building;
> c) the building's special significance as an artistic and architectural monument of the capital of the USSR.[16]

10.3 **Gustavs Klucis**, Poster: *Under the Banner of Lenin for Socialist Construction*, 1930 (cat.229)

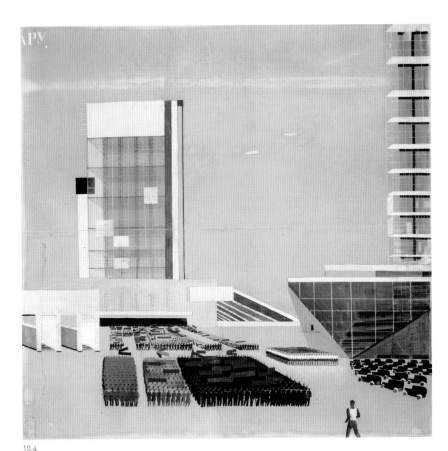

10.4

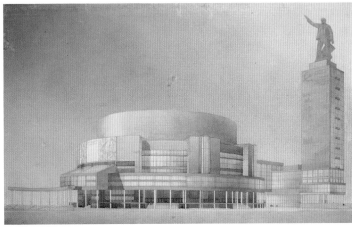

10.4 **ARU Brigade**, *Palace of Soviets competition, first stage*, 1931 (cat.230a)

10.5 **Leonid**, **Viktor** and **Alexander Vesnin**, *Palace of Soviets competition, third stage (closed)*, 1932 (cat.230b)

10.5

By the time the contest reached the end of the fourth and final round in early 1933, after a series of sharp, vicious press and jury assaults on the Modernist entries from the Soviet Union and abroad, the ideologues had drawn a clearer line on the as-yet-unresolved question of what socialist art and architecture were to be like.

The prestige and prominence of this new landmark drew 160 entries to the competition from around the world, including schemes by Le Corbusier (pls 10.4–5), Walter Gropius, Erich Mendelsohn and Auguste Perret, as well as 'local' Constructivist designs proposed by Moise Ginzburg and Nikolai Ladovsky. Le Corbusier proposed the most Constructivist design of his career – two wedge-shaped halls in the shadow of a huge parabolic arch – and was rebuffed for its alienating effects: his design was likened to a machine for processing huge numbers of people. When no clear winner emerged, further rounds of the competition were held. The eventual winning design by Boris Iofan, announced in early 1933, was a stepped skyscraper crowned with a figure of a worker holding a red star, which towered 250 metres above the ground. Success was accompanied by a series of new demands, not least that the figure of the worker be replaced by one of Lenin and that the building be extended to 415 metres in height.

Cultural and political conditions were changing in ways that determined the outcome of the competition and, ultimately, the fate of Modernist architecture in the Soviet Union until the second half of the 1950s. Public debate had already begun to feature a new, menacing tone of political denunciation. Stalin's concept of 'Socialism in One Country' licensed a new chauvinism that threatened the internationalism and intellectual ambition of the Constructivist architects associated with the Union of Contemporary Architects, such as Ginzburg. The loudest voices of reaction came from young architects – often from peasant backgrounds – who had formed VOPRA (the All-Russian Union of Proletarian Architects) in 1929. Their aggressive politicking brought personal and professional dividends: VOPRA members came to occupy major positions in the architectural hierarchy in the 1930s. In fact, the relative pluralism of the 1920s – albeit within the church of Marxist-Leninism – was ended in one clear gesture in July 1932, the formation of a single Union of Soviet Architects replacing all rival organizations. Iofan's victory in the Palace of Soviets competition was a clear sign of the eclipse of Constructivism (even though its defenders made efforts to preserve their principles by participating in the other major schemes of the mid-1930s).

The unveiling of Iofan's final design in February 1934 – with its heavy dose of the Leninist cult – also anticipated the formal declaration by Andrei Zhdanov of the official Soviet aesthetic dogma, Socialist Realism, at the First All-Russian Congress of Soviet Writers. From that point, all Soviet art was compelled to depict aspects of the struggle towards socialist progress. Only realistic, optimistic and heroic art and architecture could serve the proletariat. Conversely, all forms of aesthetic experiment were now cast as degenerate and pessimistic. In architectural terms, optimism usually translated as decorativism and monumentalism. In its grandeur and lack of imagination, Iofan's design reflected a new arrogant ideological tenor in the Kremlin. The first Five-Year Plan had been completed in 1932, one year ahead of schedule. The 17th Party Congress in January 1934, known as the 'Congress of Victors', celebrated the defeat of Stalin's enemies (and was itself a prelude to the Terror).

In retrospect, the Palace of Soviets competition, and the announcement of Socialist Realism, lend 1934 the appearance of a watershed year. But Socialist Realism was not a new aesthetic: it had been prefigured by the work of classicizing architects and realist painters active in the 1920s and claimed a much longer heritage. In the twisting fashion of dialectical materialism, Modernist aesthetics had already been unfavourably compared with transparently 'classical art', such as that of the Renaissance. This, argued Anatoli Lunacharsky, the first Commissar of Enlightenment in the Lenin era, was to be the logical expression of a society that had not experienced the dislocating effects of modernity. The Russian

proletariat and peasantry were moving from conditions of imperial-era *ostalost'* (backwardness) to socialism in one revolutionary leap and had no 'need' for artistic expressions of the capitalist era, such as Futurism and Cubism.[17] Nevertheless, the state in the Stalin years exploited those 'errant' aesthetic innovations of the 1920s that best served its propaganda purposes. Modernist film-makers, graphic designers and photographers were charged with representing the Soviet Union as an industrial utopia in the making, populated by a new order of happy men and women guided by a leader with unwavering vision and boundless generosity. Related to the cult of personality by myth and nomination, the grand industrial projects became the subject of a steady stream of propaganda for domestic and international consumption. Soviet contributions to international exhibitions, films and publications functioned like the cultural wing of Kremlin foreign policy: here, in particular, the techniques of Modernist visual culture continued to have political uses.

The monthly magazine *USSR na Stroike* (*USSR in Construction*, pl.10.6), founded in 1930 on the initiative of Maxim Gorky, for instance, was published in four separate language editions and printed using the richly toned photogravure printing process. Modelled on the spectacular 'cinematic' format of the German weekly photojournals, which privileged image over word, and addressing a sophisticated audience abroad, *USSR na Stroike*'s editors needed to make use of Modernist photographers and designers. El Lissitzky, then prominent as an exhibition designer, took on the art direction of the magazine, often working closely with his photographers; later, artists and photographers such as Alexander Rodchenko and Varvara Stepanova contributed powerful spreads. While the magazine offered opportunities for figures once at the forefront of Constructivism (and thereby to demonstrate their commitment to the regime at a time when zealous cultural *apparatchiki* and proletarian associations were alert to any sign of disloyalty), it was not an oasis of avant-gardism. Nevertheless it did make skilful use of the language of Modernist design.

The formal innovations of the 1920s – including montage and *ostranenie* (making strange) – had once been claimed as techniques for revolutionizing the viewer's perspective of the world. Rodchenko, for instance, had announced in *Novy Lef* (*New Left*) in April 1928 that 'We who are accustomed to seeing the usual, the accepted, must reveal the world of sight. We must revolutionize our visual reasoning.'[18] Such techniques of defamiliarization had by the 1930s, however, become a set of visual conventions exploited by graphic designers and artists in the Soviet Union *and* in the capitalist West. Photographs from unexpectedly low perspectives were used on the pages of *USSR na Stroike* to turn proletarians and party activists into monuments; and montage established the 'correct' ideological relations between things, not least between the inevitably *giant* figure

of Stalin and the marginal scale of the individual, who gained significance only when ranked in the serried lines of the working classes. The messages contained in the pages of *USSR na Stroike* – as well as the work of prominent poster designers such as Gustavs Klucis – appear to have achieved the ultimately tragic feat of reconciling Modernist aesthetics with the dogma of Socialist Realism. In fact, as Margarita Tupitsyn has observed, the modern media of photography and montage far outstripped easel painting – then so fetishized by the Stalinist ideologues – in its capacities to simulate a benign vision of the Stalinist utopia.[19] This was not enough to ensure that Lissitzky, Rodchenko or Klucis were exempt from ideological critique. Periodically, zealots would call for these artists to account for the 'formalist' tendencies apparent in their work. In the paranoid and sadistic atmosphere of Stalin's Soviet Union – as the show trials evolved into the purges devouring yet more people – denunciation could have tragic consequences.

The outcome of the Palace of Soviets competition triggered consternation in western Modernist architectural circles. CIAM officers Cornelis van Eesteren, Victor Bourgeois and Sigfried Giedion wrote a stinging letter of protest to the Kremlin:

> Turning its back on the inspiration of modern society which found its first expression in Soviet Russia, this verdict sanctifies the establishment architecture of the monarchic *anciens regimes*.
>
> The world which has its eyes fixed on the development of the great Soviet construction effort will be stupefied by it.[20]

While many Modernists in Western Europe – sympathetic to the Soviet cause – struggled to come to terms with what they regarded as a profound blow to progress, these events caused others to reconsider on the technocratic basis of their thinking. Commentators in Czechoslovakia – generally better informed about developments in the Soviet Union than their colleagues elsewhere in Europe – recognized the malign influence of ideologues such as Zhdanov, but also admitted that the rationalist priorities of modern architecture had ignored what they called the 'psycho-ideological' aspects of architectural form (or what VOPRA architects had called the 'emotional-ideological component' of architecture). In 1936 the uncompromising Modernist and long-standing apologist for Stalin, Karel Teige, in a gesture of *samokritika* (self-criticism), wrote in his book, *Sovětska architectura* (*Soviet Architecture*), 'Narrow, materialistic utilitarianism cannot continue to provide the only basis for architectural work.' Rostislav Švácha has even claimed that the crisis engendered by the triumph of Socialist Realism in the Soviet Union encouraged left-wing architects to think about the subconscious impact of architecture on man and to develop a greater interest in reconciling psychoanalytical theory with modern technology.[21]

10.6 **El Lissitzky**, *USSR in Construction*, no.6, 1934. David King Collection, London

Regionalism

Revision of 'narrow, materialistic utilitarianism' was inevitable. The core principles of Modernist design were tested and modified as it spread around the world. The proliferation of the style was remarkably rapid. By the mid-1930s unmistakably Modernist buildings were being built in South America, the Middle East and Japan. Modernism had a profound appeal to those states that wished to demonstrate their place in the modern world and shake off the associations of a colonial or foreign-dominated past. New states like Poland employed modern architecture as an instrument of national affirmation. The new city of Gdynia, for instance, on the Baltic coast, was built by the young state to compensate for the problems it encountered with the German authorities in the Free City of Danzig. While the early image of the city drew on the nineteenth-century idiom of national romanticism, the plans for the city made by Stanislaw Filipkowski in the mid-1930s – only partly realized – projected a Polish utopia of 250,000 people living in suburban villas and long terraces of apartment buildings, and working in monumental glass-walled offices along the city's wide avenues. The urban fabric was to be modern as the marine engineering of Gdynia's docks.[22] Similarly, Mustafa Kemal Atatürk visualized a modern, secular Turkey emerging out of the ruins of the Ottoman Empire.[23] Just as citizens in Turkey were to demonstrate their modernity by abandoning the fez and the veil, so too would the republic dress itself in a new architectural fabric. In 1928 German architect Hermann Jansen was commissioned to design a masterplan for the new capital in Ankara, thereby usurping Istanbul (as Constantinople was known from 1930), an act with almost as much ambition as Stalin's Five-Year Plan.

While many authors characterize the spread of modern architecture throughout the world in the 1930s as the realization of ideas processed at the heart of Europe a few years earlier, new buildings in these 'peripheral' settings were not necessarily European transplants onto foreign soil.[24] Nor, in fact, were such designs usually derivative of their European predecessors. In Mexico, for instance, Juan O'Gorman, stimulated by the agenda set by the post-revolutionary government under President Alvaro Obregón for *mexicanidad* ('Mexicanness') in the early 1920s, and by his encounters with Machine Age thinking, sought to reconcile modernity with local culture in a series of important villas. For the best known of these structures, the Mexico City studios of the artists Frida Kahlo and Diego Rivera (pl.10.7), O'Gorman's design of two cubic buildings standing on slender columns and connected by a bridge has been described as being indebted to Le Corbusier's house-studio for Amédée Ozenfant of 1922–4 (pl.3.20, an interpretation reinforced by O'Gorman's acknowledgment of the impact of *Vers une Architecture* [*Towards a New Architecture*], where this Paris scheme had been reproduced). Susana Torre has claimed that these twinned buildings remained overlooked, indistinguishable from the main corpus of European architecture, until several decades later when the issue of how to accommodate popular sources in modern design became a pressing question.[25]

What gives these buildings historical significance today are the differences they assert from their European precursors. O'Gorman – no doubt working closely with his artist clients – made vigorous reference to local traditions. The exteriors were coloured 'Indian' red and rich blue, echoing vernacular building materials and symbolism.[26] A 'pipe organ' cacti fence – cultivated in the Mexican peasant manner – created a striking contrast with the exposed pipes and ducts and steel-framed industrial glazing of O'Gorman's designs. Divided by a bridge, the buildings articulated a clear view of Kahlo's independence from the better-known Rivera and, in fact, from bourgeois conventions of marriage. Yet even this progressive aspiration was realized in 'local' terms: the exterior staircase was also a feature of rural Mexican homes. In such ways, a distinctly Mexican post-revolutionary sentiment can be traced in the design, reflecting both the cultural nationalism of *mexicanidad* and the reforming spirit of its socialist advocates. Musing on O'Gorman's interest in exposing the pipework and ducts like 'veins and arteries', and on Kahlo and Rivera's taste for indigenous religious and pre-Columbian art inside, Edward R. Burian has also detected a Surrealist character in the studios: a Mexican unconscious within the rational shell.[27]

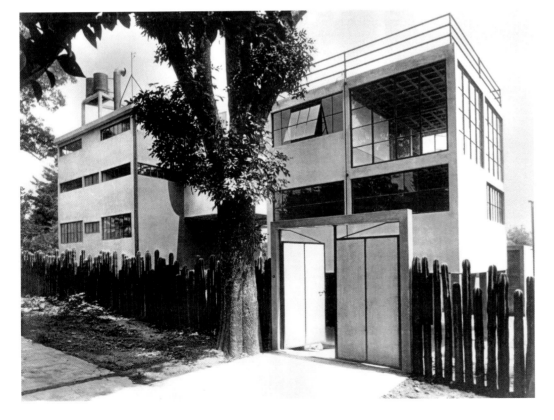

The Kahlo/Rivera studio houses also demonstrate how the Surrealist sensibility could puncture architectural Modernism in the 1930s, particularly as interest in organic forms grew (see Chapter 9).

Reflecting on the relationship between 'international rhetoric' and 'local responses', Jean-Louis Cohen has suggested that it 'is not one of mutual exclusion, but rather of constantly moving exchange between the level of professional and the level of practical action'.[28] Practical considerations might very well play a determining role: architects and builders often had to adapt to local conditions and materials. But the meeting of ideas and action was, as Cohen emphasizes, an 'exchange': Modernist architects who travelled outside Europe increasingly began to modify their thinking in the light of their experiences. Le Corbusier, for instance, famously travelled to Argentina, Brazil (cat.209) and Uruguay in 1929, an experience that brought new perspectives – quite literally from the air – of the natural environment and the people who lived there: 'from the plane I saw sights that one might call cosmic … those daring outlines of rocks that give us an idea of the sublime … if I think of architecture as the "houses of man" I become Rousseauist …'[29]

His South American tour appears to have been the stimulus of profound changes in his conception of symbolic form which were to reverberate long into the post-war period. His discovery of different ways of living and of vernacular architectural forms there encouraged a growing interest in the primitive. In the Petite Maison de Weekend (Villa Félix, pl.9.9), a country retreat for a company director in La Celle-St-Cloud, for which Le Corbusier was contracted in 1933, the Swiss architect explored these themes and, in so doing, demonstrated a new flexibility. The single-storey, small building – organized as a series of cells under a barrel-vaulted, reinforced concrete roof – combines rustic stone walls and inexpensive plywood facings with glass bricks and cement render painted in rich colours. Rather than standing above the landscape in the aloof manner of his white cube villas of the 1920s, the building appears to be set *into* the sloping site. Sods of earth generated during the construction were used to raise the ground level along the side walls, and the roof was seeded with grass. The building not only offered shelter (cave-like, at least from some perspectives), La Petite Maison de Weekend symbolized it, too. Although modest in architectural terms, this small home was – in its subtle regionalism – an important revision of Le Corbusier's universal conception of domestic architecture and, in its assertion of local character, had much in common with other designs of the period.[30]

As a conscious response to the homogenizing and universalizing effects of modernity, regionalism – design that recognizes differences in local cultures, materials, climates and topographies – has long been the subject of architectural debate (and has roots going back to the Romantic movement during the French and Industrial Revolutions). And, as I will describe below, it was a leitmotif of anti-Modernism in the Third Reich, too. Regionalism was, however, lent critical impetus when it was theorized in the 1980s. Seeking to avoid the 'simple minded attempts to revive the hypothetical forms of lost vernacular' and the empty mythologization of 'genius loci', Kenneth Frampton has stressed the power of synthesis. Writing about Alvar Aalto, he argued that the form of 'critical' regionalism demonstrated by the Finnish architect's 1950s buildings was developed *within* Modernism. Although the term was coined and lent ideological purpose largely much later (and mainly in response to the placelessness of the megalopolis), there are many examples of modern regionalist design in the 1930s, from Aalto's spare stacking stools produced by Korhonen (cat.218) to the elegant Southern California homes of Richard Neutra. And, for some young architects and designers in these years, regionalism was akin to an ideology.[31] It contained a critique of the uneven experience of modernity and, in recognizing the limits of technology, challenged the extravagant Machine Age rhetoric of the 1920s.[32]

Sweden

Sweden's high reputation abroad as a centre of inter-war Modernist design is, in part, due to identification of a regionalist aesthetic there. The 1930 Stockholm Exhibition (*Utställningen av konstindustri, konsthantverk och hemslöjd*, Exhibition of industrial art, applied

10.8 **Erik Gunnar Asplund**, Stockholm Exhibition, 1930, Paradise Restaurant, 1930. Alberto Sartoris Collection

Opposite:
10.9 **Erik Gunnar Asplund**, Design for an advertising mast, Stockholm Exhibition, 1930 (cat.236)

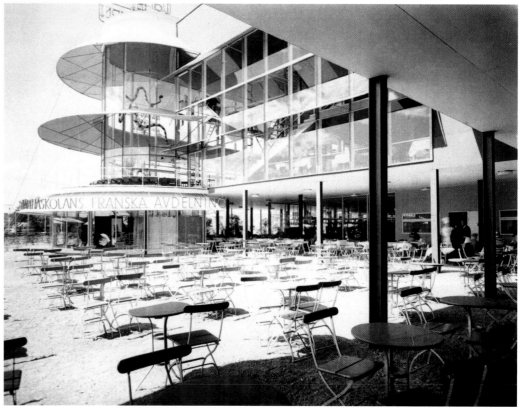

10.8

10.9

art and handicraft, pl.10.8), organized by Gregor Paulsson for the *Svenska Slöjdföreningen* (Swedish Society of Craft and Industrial Design) is usually claimed as the 'breakthrough' of the 'Modern movement' in Sweden.[33] On an island site and shaded by trees, the exhibition presented a convincingly complete modern environment: its buildings suggested a townscape of homes, hospitals, schools and hotels, fitted out with new textiles and furnishings, including Erik Gunnar Asplund's stark tubular-steel designs. Like a number of Central European exhibitions of the day, the Stockholm Exhibition addressed the cramped housing conditions of ordinary people by seizing the promise of new technologies and materials. Mass production, standardization and utility were offered as solutions to pressing social problems. However, unlike many of its precursors, it was not the rational or scientific character of the exhibition that drew praise, but its human qualities and atmosphere of everyday practicality. This was in part due to Asplund's urban planning. Unlike the dramatic 1920s schemes for cities composed of massively long structures like those proposed by Ludwig Hilberseimer or Le Corbusier's vertical cities (cat.36), he produced 'an essentially traditional urban scheme, with esplanades, cul-de-sacs and buildings arranged to form streets'.[34] Moreover, with its iconic advertising mast (an echo of Soviet models) (pl.10.9) and brightly coloured flags, the exhibition signalled pleasure as well as utility.

The Stockholm Exhibition poured fuel on a debate about the extent to which Modernism (or Functionalism, as it was known there) was suited to the national setting. Tradition-minded critics – on the right and the left – claimed that the style lacked 'Swedishness', a loose concept typically associated with vernacular characteristics and with craft traditions of construction and manufacture. Defenders of the style responded by asserting that Modernism's modest and practical qualities were in fact traditional 'national' virtues, the long-standing product of Lutheranism and the nation's struggle with its harsh climate. In *Swedish Functionalism* (1930), ally Gustaf Näsström claimed that a premonition of the Modernist sensibility could be found in housing provided by the military for its officer class on the Stockholm island of Skeppsholmen.[35] While Modernism's supporters and enemies were in sharp disagreement over its virtues, what is clear is that, like many commentators in Europe, they shared the view that it should be judged on regional or national terms. For Modernism to thrive here and elsewhere, it had to demonstrate its local bona fides.

Great impetus was given by official imprimatur. Social democrat Prime Minister Per Albin Hansson's vision of the *folkhemmet* (the home of the people) in the 1930s increasingly put modern architecture and design at its heart. The government's Social Housing Commission, established in 1933, for instance, included several Modernist architects among its

members. Well-connected architect Sven Markelius and housing reformer Alva Myrdal became something like state officials, and Functionalism became an instrument of social planning.[36] Long and low *barn-rikehus* (houses for families with large numbers of children), with high-quality sanitation and a well-provided kitchen, were planned in the green suburbs of Swedish cities, serviced by kindergartens and playgrounds. While the real achievements of Swedish housing policy were made after the Second World War, new housing forms and the appearance of products with which to furnish them lent weight to the social democratic vision. Wilhelm Kåge's *Praktika* stacking service for Gustavsberg (pl.10.10) is the best known of these reforming commodities. Such designs have often been described in terms of their 'democratic values'. For its supporters, the close connections with social democratic politics were not the determining fact: the aesthetic itself signalled liberty in what increasingly was becoming an authoritarian age. But as historian Eva Rudberg has noted, it had been shaped by a highly didactic and paternal ethos, which afforded little agency to the individual occupant or user – another important condition of democracy. In fact, outlining their programme in *acceptera* (*Accept!*) in 1931, leading functionalist architects (including Asplund and Markelius) berated Swedish society for its conservative taste: 'even though modern society gets most of its features from the new democracy, certain values are allowed to remain completely untouched, as pure relics of a bygone cultural era. This particularly concerns aesthetics.'[37] In this light, the democratic qualities of Swedish design should be understood not in terms of agency, but as the advance of Modernist design into everyday life in the form of low-cost housing and simple goods.

Others – more recently – have identified anti-democratic tendencies within Swedish Modernism. In the late 1930s the state employed consultants to advise the general public on the design and function of the homes, a strategy underscored by the availability of furnishing grants for new home-makers. This scheme was augmented in 1944 by the *Hemkommitté* (Home Committee) initiated by women's organizations, which sought to discipline the tastes and practices of new home-makers. Young couples attending training schemes were encouraged to scorn the tradition of the *finrum* (parlour) and the popular taste for sentimental decoration, in favour of the *vadagsrum* (living room) furnished with hygienic modern design. Such reform activities, viewed alongside other relatively modest aims, such as the reorganization of housework and the reform of diet promoted by Markelius and Myrdal, were hardly tyrannical, but they emerged from the same paternal impulse that advocated sterilization and compulsory birth control for 'unfit' members of the nation, as well as the promotion of large, healthy families to boost the population. 'Positive' and 'negative' eugenics was promoted and practised without controversy in Sweden from the 1920s. In noting the professional and intellectual relations between Swedish eugenicists and Modernist housing reformers, Kirsi Saarikangas has claimed, 'it was only a step from hygiene in general to racial hygiene'.[38]

The illiberal strains of Swedish social democracy and the overweening self-assurance of Swedish design have been a matter of controversy in recent

10.10 **Wilhelm Kåge**, *Praktika* stacking bowls, 1933 (cat.239)

10.11 **Giuseppe Terragni**, Casa del Fascio, 1932–6 (cat.233a)

years. It should be stressed, however, that at the time Swedish Modernism was highly regarded, both for what was perceived as its humanism and for its distinctly local character. Editor of *The Architectural Review*, J.M. Richards, wrote in 1940:

> …the somewhat doctrinaire puritanism typical of Central Europe at this time, and especially associated with the Bauhaus, was modified in Sweden particularly, by a strong craft tradition. A preference for more natural materials gave the Swedish brand of modern architecture a more human character which appealed strongly to those who preferred the break with the past to be softened by the charm of manner generally only associated with period reminiscence.[39]

Elsewhere, other commentators made equally favourable judgements of Swedish design in the touring exhibitions that crossed the Baltic. When Warsaw received an exhibition of furniture and interior schemes from the energetic *Svenska Slöjdföreningen*, the critics purred at Bruno Mathsson's bentwood furniture (pl.1.6) and Kåge's

ceramics, as well as Josef Frank's vivid decorative fabrics.[40]

Italy

It is illuminating to note here that modern Italian design and architecture – or, more precisely, one of their many faces – were viewed in *equally* favourable terms as Swedish Modernism throughout Europe in the mid-1930s. Describing CIAM member Giuseppe Terragni's Casa del Fascio at Como of 1934 (see below), Jerzy Munzer wrote in the leading Polish architectural journal, 'Modern Italy is motivated by its great claim and ambition to matchless national works of spirit, thought, skill and art, just as ancient generations enriched humanity.'[41] While it seems inflammatory to rank liberal Swedish democracy as expressed in modest furnishings and the monumental architecture of Italian fascism side by side, the fact that both societies could demonstrate their modernity and 'national' character through design was, for many contemporaries, more important than their differences in political outlook. While Swedish

Modernism accommodated local materials and craftsmanship, modern Italian architecture and design were applauded for their deep historical reserves.

The fortunes of Modernist art and design in fascist Italy are as complex as they are anywhere else in Europe. The years after Mussolini's consolidation of power in October 1926 were marked by a strong degree of cultural pluralism. In fact, as Richard Etlin has argued, Il Duce appears to have been somewhat an undecided dictator on matters cultural, viewing the diversity of artistic tendencies in Italy as evidence of the richness and 'natural' vibrancy of national culture.[42] At the same time, artists and designers of all stripes were keen to court power. While some promoted conservative, neo-classical styles as a way of reviving the splendour of ancient Rome (*Romanità*); others promoted Modernism as the means to represent Italy as a modern industrial state.[43] Pluralism sometimes led to bizarre dichotomies: the Foro Mussolini, a classical sports stadium in Rome initiated in 1928, was ornamented with bold antique mosaics in the Roman manner depicting a motorized truck carrying flag-waving

10.12 **Giuseppe Terragni**, Casa del Fascio, Federal Hall, 1936 (cat.233b)

squadistri, paramilitary gangs associated with the struggle for power at the beginning of the 1920s. By contrast, the Ministry of Aeronautics made effective propaganda of modern industrial design and engineering. The image of flight and, conversely, the view of the Earth from the air became a nationalized field of vision under Mussolini (rendered in art by the practice of *aeropittura* and claimed by the Futurists as the basis of a new architecture).[44] In 1933, for instance, Air Minister Italo Balbo led a squadron of 24 twin-hulled Savoia-Marchetti SM.55X flying boats across the Atlantic (see Chapter 11). Landing to great international acclaim in Chicago at the Century of Progress exhibition, Balbo was fêted by Mussolini as the embodiment of the fascist hero.

The Savoia-Marchetti SM.55X seaplane was a technical object, albeit one that was fetishized by political rhetoric and media spectacle. Its fascist character was a matter of discourse rather than design. By contrast, the question of whether a distinctly modern fascist architecture was fashioned remains subject to debate. This was, after all, the loudly expressed aim of architects such as the *Gruppo Sette* (Group Seven), formed by self-appointed 'rationalist' disciples of Le Corbusier in Milan in December 1926. According to Diane Ghirardo, they remade the ideas of the Swiss architect in their own image, drawing succour from the authoritarian tone and classical themes in his writings of the early

1920s (and it should be noted that their hero sought the favours of Il Duce).[45] Terragni's Casa del Fascio in Como (1932–4) (pls 10.11–12), the best-known building conceived by a member of the group, is a case in point. His design for the local party head-quarters was based on the play of volumes and voids, reflections and screens within a carefully proportioned, regular framework of blank white walls, slender columns and floors. The starkly Modernist and abstract character of this white cube was undeniable. To offset criticism, Terragni went to great lengths seeking official endorsement for the design. The use of glass and concrete was defended with reference to incontrovertible authority: 'Here the Mussolinian concept that fascism is a glass house into which all can look,' wrote Terragni, 'gives rise to this interpretation ... no encumbrance, no barrier, no obstacle between the political leaders and the people.'[46] The building also struck ideologically resonant notes of tradition: the ground plan – organized around a courtyard under glass – made reference to the spatial traditions of the palazzo, as did the use of marble facings. Nevertheless, some historians have detected expressions of resistance to fascist authority in Terragni's Como building.[47] His refusal – under pressure – to incorporate obvious fascist symbols, such as a *torre del Littorio* (tower of the Lictorate) and an *arengario* (podium or balcony from which speeches could be delivered), has been interpreted

as a refusal to compromise the geometric prevision and harmony of his modern design. While there is evidence of conflict, the disagreement was, it seems, one of personalities and contracts rather than ideologies.[48]

In provincial Como, Terragni's disputes with local party officials were relatively minor. Of greater significance were the grand projects initiated by the regime in Rome in the 1930s. Tim Benton has described the refashioning of the Italian capital in the 1930s as an attempt at 'dramatization of Fascist values', which marked the eclipse of rationalism by overbearing monumentalism as the expression of authority in built form.[49] Major interventions in the city centre along the Via dell'Impero, a symbolic axis containing classical monuments including the Basilica of Maxentius, were planned. They included the Palazzo del Littorio, a shrine to fascism incorporating apartments for Il Duce, a museum and the party headquarters. Like the Palace of Soviets competition, which it clearly echoed, this scheme (announced in 1933) appeared to promise great opportunity to Modernists. It seemed as if the moment to delineate the architectural form of fascist modernity had arrived. When a shortlist was selected from more than 70 schemes exhibited in September 1934, the jury struck an even balance between Modernists and academic architects. All entries recognized the state's interests in a muscular display of power: Terragni's team put the figure of Mussolini at the heart of their scheme, which took the form of a monumental curved wall sliced in two by an *arengario*. Mussolini's furious oratory would project from this stage into the street below, as if transmitted by the architecture. This 'dam', as the architects described it, or an urban rock face, appeared to be split apart by his voice. While this design – with the massive wall elevated off the ground by four reinforced columns and held in tension with steel trusses – demonstrated a clear interest in modern building technology, it was its abstract monumental effect that commanded attention.

The second round of the competition – for a building now redefined as simply the party head-quarters, and relocated to the southern part of the city – resulted in a winning design in 1937, which signalled the state's preference for bombastic monumentality. The commission was awarded to a group of academic architects (and eventually built in the north of the city). Arguably, however, the differences between camps were less pronounced than their designs might suggest. All competing architects recognized fascism's interests in spectacle. In fact, the major public projects of this period, such as the Palazzo del Littorio, were never intended to be public in the modern, democratic sense: they maintained what Walter Benjamin in his famous essay on technology and art described as a pre-modern auratic distance, thus inhibiting critical interaction between the public and the party. Many Modernist architects and designers working in Mussolini's Italy appeared to

recognize this political 'fact' when they represented the masses in their schemes for new buildings or posters for the party (pl.10.1) as the thronging audience magnetically drawn, like iron filings, to these symbols of power.

The steady move towards imperial and neo-classical imagery in fascist architecture was given a boost by the campaign to establish an empire in East Africa, launched in 1935. Mussolini asserted that the fall of the Ethiopian capital to Italian forces in May 1936 marked 'the reappearance of the empire on the fateful hills of Rome after fifteen centuries'.[50] While Rome sought to 'restore' its imperial heritage, it is noteworthy that the Italian colonial architecture on the African continent took ambiguously modern forms. The city of Asmara in Eritrea on the edge of the Red Sea was used by Mussolini as the base from which to seize his African possessions. Italian Modernists grasped this opportunity to design a city (built largely between 1935 and 1941) that might fulfil their rationalist preoccupations and fascist enthusi-asms. Giuseppe Pettazzi's 1938 FIAT Tagliero office resembles an aeroplane taking off, its extended wings supported by a steel frame, thereby dispensing with the need for columns. In Asmara, reported *Il Corriere dell'Impero* (*Imperial Courier*) in 1936, 'the rational architecture of our great and undervalued architect Sant'Elia will have undisputed dominion'.[51] In reality, the city became a remarkable and animated mix of highly theatrical Modernist and Art Deco buildings. Distinct from the nation-building experiments in Tel Aviv, Gdynia or Ankara, which it resembles in architectural form, Asmara is a rare example of Modernist imperialism.

Children in Mussolini's Italy, as in other authori-tarian regimes in inter-war Europe, were given special political and social significance.[52] Not only were the young incorporated into the life of the Fascist Party through membership of the paramilitary *Operazione Nazionale Ballila* (the National Youth Organization) and, when older, the *Avanguardisti* (the Avant-guardists, a fascist youth organization for boys from 15 to 18), but they became a powerful symbol of the fascist hold on the future. The control over and symbolism of youth were united in the form of the *colonie*, health and education camps for the children of the urban poor and peasant families (pl.7.8). This was the incorporation of a long-standing, charitable programme into the fascist social and political agenda. In strictly regimented environments located throughout the country, Italian children became subject to fascist demagogy: 'after morning ablutions, tidy and proud in perfectly disciplined rows, the young inmates attend the ritual of raising the flag, shouting their love and gratitude to Il Duce'.[53] When the new economic policy of *autarchia* (self-sufficiency in the production of food and consumer goods) was introduced in response to the sanctions set by the League of Nations as punishment for Italy's activities in East Africa, new *colonie* were equipped with special farms. This was collective society in the

10.13

10.13 **Renato di Bosso**,
*Flight over the 'M. Bianchi'
Colonial Village*, 1938 (cat.235)

10.14 **Gabriele Mucchi**,
Chair, model S. 5, 1934–6
(cat.234)

10.14

making, with the paternalistic state performing the role of guardian, doctor, teacher and provider.

New *colonie* built in the 1930s were often set in spectacular sites to accentuate their visibility on the horizon and to foster a special relationship to the landscape in the minds of their young residents. While some projects were conceived as dramatic monuments in sublime settings – spectacular round-walled towers in the mountains and linear 'cities' (such as Angiolo Mazzoni's 1934 three-kilometre-long structure along the coastline at Calambrone, Tuscany), others were located in newly reclaimed sites such as Sabaudia, the new town built on the Pontine Marshes south of Rome.[54] The fascist state drew political capital from its struggle with nature. In 1928 Mussolini had written a newspaper article for *Il popolo d'Italia* (*The Italian People*) entitled 'Sfollare le città' ('Evacuate the city'), which opened a new phase in anti-urban and anti-capitalist propaganda. Seeking to halt the drift to the city, the fascist authorities promised to deliver new roads, railways, schools and social amenities to the countryside. In the fascist vision, the countryside was not the sacred site of autochthonous tradition from which *italianità* (Italianness) could be drawn (in the manner claimed by some National Socialist ideologists in Germany), but a world to be improved. The *colonie* were an instrument in what was described as the consolida-tion of the 'domestic' empire before 'the march to the sea'. The young were trained to take up arms and

refashion the landscape: the *colonie* were to be their training ground for the imperial adventure to come.

The significance of the *colonie* did not lie in their 'abstract lines and volumes' (though this has added greatly to their appeal among architectural historians). In fact, they demonstrate the reverse. That these buildings and their furnishings were drawn in a Modernist idiom is an indicator that style was often less important for the fascist authorities than the uses to which they were put or the ideological meanings that could be attached to their construction. The defining character of fascist culture cannot, it seems, be found in the 'correct' identification of a 'regional' aesthetic, or in classical formal characteristics threaded into the modern fabric of a building or chair. Each design should be judged by the intentions behind its making and effects in use. While political ideologies might not necessarily be expressed in the particular style or form of artefacts, as Langdon Winner famously observed, objects such as buildings, bridges and even domestic goods often have political effects.[55]

Germany

In considering the political role of art and design, Hitler appears, at least at first, to have been much more decisive than Mussolini. When the National Socialists took power in Germany in 1933, they initiated a politically driven purge of Modernist culture. Writing

to Herbert Read, former Bauhaus tutor László Moholy-Nagy described the intellectual atmosphere in the capital one year into the Third Reich: 'The situation of the arts around us is devastating and sterile. One vegetates in total isolation, persuaded by newspaper propaganda that there is no longer any place for any other form of expression than the emptiest phraseology.'[56] Once a magnet attracting the visionary artists and designers from across Europe, Germany now cast them as subversives and aliens. And Berlin, the centre of artistic expression and efforts in the Weimar era, was scorned as the home of 'decadence' and 'degeneracy'. Tapping deep currents of nationalism and xenophobia, Modernism was excoriated by Nazi cultural ideologues such as Alfred Rosenberg, founder of *Kampfbund für Deutsche Kultur* (Combat League for German Culture), as *'Kulturbolschewismus'* (cultural Bolshevism). And exploiting the social disquiet and alienation wrought by the failures of modernity that were evident in Depression-hit Germany, the National Socialists promoted a romantic, conservative vision of a nation rooted in the rural landscape or the historical urban settings of Nuremberg and Munich. The successful promotion of these strains of Nazi ideology required a scapegoat that was found in the internationalist, anticipatory and often socialist culture of Modernism.

At the outset, however, official cultural policy was unclear in Germany, not least to those within the ranks of the National Socialist Party. In the summer

of 1933, for instance, the National Socialist League of Students declared their enthusiasm for an Expressionist vision of the national *Geist* (spirit) and *Kultur* (culture), mounting an exhibition of art by figures such as Emil Nolde (an early member of the Nazi Party and a favourite of Minister of Propaganda Joseph Goebbels). Later, in 1937, his work was ridiculed in the notorious 'Degenerate Art' exhibition in Munich. Major new public architectural works announced by the regime promised opportunity for Modernist architects at a time when the economy was stagnant: the 1933 competition for the new Reichsbank in Berlin was the first of these. Ludwig Mies van der Rohe's design offered long, unrelieved expanses of glass set into an austere geometric frame. In the early years of the new regime, Mies's taste for monumentalism and 'noble' materials like marble, as well as an apparent disinterest in the social calling of architecture, appeared to suit the interests of modernizing factions within the new regime.[57] And the former director of the Bauhaus, for his part, was keen to be patronized, notoriously signing the '*Aufruf der Kulturschaffenden*' ('Proclamation of the Creative Artists') published in the pro-Nazi newspaper *Völkischer Beobachter* (*The People's Observer*) in August 1934, supporting Hitler's candidacy for Chancellor and submitting a design for the German Pavilion in the Brussels World's Fair (pl.10.15). The new Reichsbank competition, however, was to be the first and last open major architectural competition in the Third Reich. Angry with the result, Hitler personally intervened, awarding the commission to an academic architect. While Mies's Modernism was antithetical to the *völkisch* ideology being promoted by some Nazi factions, and to the classical vision of granite and marble preferred by Hitler, the issue — at least in the first year of the new regime — was one of control as much as aesthetics. Like the nationalization of the press and suppression of political opposition, the formation of the *Reichskulturkammer* (Reich Culture Chamber) in September 1933 — an organization that ensured official monopoly over architectural commissions and art exhibitions — was an attempt to control the creative arts.[58]

Professional life in Nazi Germany for Modernist designers who eschewed politics and the high profile achieved by public commission (and who were not disqualified by vicious ethnic decrees) could, however, be sustained at least until the clouds of war gathered over Central Europe. Until 1938 Herbert Bayer enjoyed a busy career as art director for German *Vogue* and as chief designer for the Dorland Advertising Studio in Berlin, working on major accounts such as Elizabeth Arden, the Kellogg Company and Blaupunkt.[59] Invited to cross the Atlantic by the Museum of Modern Art in New York to design its 'Bauhaus, 1919–1938' exhibition, Bayer departed from Germany in 1938 well equipped for the world of American business. As if to lament his leaving, *Gebrauchsgraphik* (Applied Graphics), a leading

10.15 **Ludwig Mies van der Rohe**, Design (1934) for German Pavilion for the Brussels *Exposition Universelle et Internationale*, 1936 (cat.225)

design periodical, published a survey of his work in advertising over the previous decade.[60] Works illustrating this article suggest a kind of thawing (or, perhaps, exhaustion) of the doctrinal and radical rigour of Weimar Modernism. The use of 'unmodern' typography in advertising was, for example, acceptable to Bayer in Berlin because of valuable associations that such forms might trigger in the minds of consumers with the product being advertised. His designs, elegant montages of drawings, photographs and 'found' images, were strongly inflected with an introspective, Surrealist mood. Even though advertising seemed a neutral sphere and outside Nazi interest, Bayer came under political pressure. Working on the design of a catalogue for the exhibition *Das Wunder des Lebens* (The Miracle of Life, pl.10.16), organized by the *Messeamt* (Fair Office) in Berlin, he was obliged by the Ministry of Propaganda to insert an image of Hitler to illustrate the *Führerprinzip* (leadership principle), a central tenet of Nazi ideology.[61]

As Bayer's career in the 1930s demonstrates, commerce and capitalist industry continued to provide opportunities for modern designers, as well as refuge from the official dictates that shaped art and architecture. Despite the anti-commercial rhetoric of the early Nazi ideology, large corporations could operate with a degree of autonomy that was not extended to other social and cultural organizations. And, controversially, many corporations such as IG Farben (the chemical manufacturing conglomerate) and Siemens (Germany's largest manufacturer of electrical products) had profited from contracts from the state and its agencies.[62] Moreover, while a set of prototypes were put in place for the politically charged sphere of public architecture – from the pitched roofs and half-timbering of the *Heimat-schutzstil* (homeland heritage style) to Albert Speer's banal monumentalism – other technologies could not be so easily 'corrected'.

In ordinary settings like the home, objects could demonstrate their modernity unhindered. Wilhelm Wagenfeld, a former Bauhaus tutor, was appointed art director of a large glassware manufacturer, Lausitzer Glasverein, in 1935. His simple and economic designs for domestic glassware – including the famous 'Kubusgerchirr' range of storage containers (pl.10.17) – represented precisely the kind of commercial objects that the Dessau Bauhaus had aspired to produce in its campaigns to unify art and industry. Moreover,

10.16

10.17

10.16 **Herbert Bayer**, Poster for *Das Wunder des Lebens* (The Miracle of Life) exhibition, 1934 (cat.226)

10.17 **Wilhelm Wagenfeld**, Kubus stacking storage containers, 1938 (cat.227)

Weimar-era consumerism was clearly revived by the Nazi authorities, albeit in emphatically nationalist terms. Opening the Berlin Photography Fair, *Die Kamera* (The Camera), in November 1933, for instance, Goebbels trumpeted Germany's advanced technology in terms that combined consumerism, militarism and idealism:

> Photography today is accomplishing a lofty mission in which every German should collaborate by buying a camera. The German people are ahead of every other in the technical domain and, thanks to its exceptional qualities, the small camera has conquered the whole world. It is used by scientists, scholars, researchers and tourists from every country. The conditions thus exist for art, technical progress and the photographic industry to unite in a great national endeavour: to create a labour front evolved from the vast domain of photography.[63]

Despite the evident promise of German industrial design, such was the strength of anti-modern sentiment in Nazi Germany, expressed in *völkisch* pastoralism and *Blut and Boden* (Blood and Soil) mysticism, that some Nazi modernizers felt it necessary to defend against *Maschinenfeindlichkeit* (hostility to the machine).[64] Modern industrial technology was necessary to meet the state's promises to improve standards of living and to achieve its drive to rearm in time for war (anticipated by Hitler to break out in 1941). The policy of autarky (economic self-sufficiency) at the heart of the Four-Year Plan of 1937 put great emphasis on the production of light metals, plastics and other synthetics. Contradictions abounded: in this land being rebuilt with the ethos and efforts of the peasant, the rural population was actually dwindling; and while Germany was ridding

itself of 'cosmopolitan influences', there was, for instance, a massive increase in the consumption of Coca-Cola (and the American company was one of three official beverage sponsors at the 1936 Olympics in Berlin).[65] When it came to its own symbolic armoury, Nazi policies were equally contradictory. Within the general vilification of Modernist culture, for example, the 'new typography' had been identified as alien, proto-communist and un-German. By contrast, the Nazis celebrated and encouraged the use of black-letter Gothic forms, which were declared to be an historical expression of Germanness. This view, reinforced by official practice and policy, corresponded to the Nazis' *völkisch* and conservative ideology. But, as Robin Kinross has shown, there was not an absolute hegemony of Gothic type in Germany after 1933. Futura, the Modernist typeface *par excellence,* continued to be widely used because of its simple clarity. And in 1941 official attitudes vis-à-vis typography reversed; the Gothic was suddenly disparaged as a 'Jewish' letterform and Roman faces found favour, as a graphic analogue of Hitler's favoured neo-classical architecture.[66]

Alongside the continued interests of capitalism in modern technology, the state initiated high-profile projects that made unmistakable claims on the intellectual superiority of the German 'race'. These included the Zeppelin programme, until the tragic destruction of the *Hindenburg* in New Jersey in 1937; the network of Autobahns that cut their way through the German landscape (pl.10.18), symbolically uniting the nation; and, of course, the people's car, the KdF-Wagen (also known as the Volkswagen), which appeared in prototype form in 1936 (pl.10.19) and was promised to Germany's workers in return for weekly contributions to the *Deutsche Arbeiter Front* (German Workers' Front). Less well known are the

10.18

10.19

liners and hotels provided for the benefit of loyal workers through the *Kraft durch Freude* (Strength through Joy) organization and the *Volksempfänger*, the 'people's radio'(cat.224), which was inexpensive to purchase and was provided to factories and offices. Moreover, these ornaments of modernity were spectacularized by their representation in the German media, now a branch of Joseph Goebbels's *Reichsministerium für Volksaufklärung und Propaganda* (Ministry for People's Enlightenment and Propaganda). In fact, they performed their propaganda function first and their practical functions second. Despite Hitler's promises, no German workers ever drove their own Volkswagen car along the majestic autobahns; but many could imagine themselves behind the wheel, when watching newsreels in the cinema or visiting promotional exhibitions that toured Germany.[67] As Siegfried Kracauer observed of Leni Riefenstahl's film of the 1934 Nazi Party rally:

> … from the real life of the people was built up a faked reality that was passed off as the genuine one; but this bastard reality, instead of being an end in itself, merely served as the set dressing for a film that was then to assume the character of an authentic documentary. *Triumph of the Will* is undoubtedly the film of the Reich's Party Convention; however, the convention itself had also been staged to produce *Triumph of the Will*, for the purpose of resurrecting the ecstasy of the people through it.[68]

The dark core of Nazi ideology – the assertion of a 'right' to refashion Germany and Europe according to its own social and racial blueprint (or, as Riefenstahl had it, 'the will') – was a defining feature of its dystopian modernity.

While it is clear that the order of avant-gardism associated with prominent Weimar-generation intellectuals (already a spent force by the Depression) was snuffed out by Hitler, Nazi Germany can hardly be characterized as an anti-modern state. Various strains of Modernism continued throughout the 1930s, some enjoying official sanction. The question of just how they should be characterized has taxed historians.[69] Some have adopted Jeffrey Herf's expression, 'reactionary modernism', to describe the incorporation of Modernist technology into the reactionary ideologies of conservative sections of Weimar society and National Socialism. For Herf, the central symbolic figure of the era was that of the engineer, lionized by radicals and conservatives alike. Others have gone further. Peter Fritzsche has suggested that Nazi Germany's 'totalitarian version of the Modern' can be traced back to radical Modernism of the Weimar era.[70]

Modernism and progress

The 'dream' of reshaping cities and homes to make healthier, happier or cultured citizens was a feature of authoritarian and social democratic ideologies and can, ultimately, be traced back to Enlightenment visions of progress. As Frankfurt School philosophers Max Horkheimer and Theodor Adorno famously observed, core aspects of Enlightenment modernity and rationalism assisted wide-scale repression:

> On one hand, the growth of economic productivity furnishes the conditions for a world of greater justice; on the other hand it allows the technical apparatus and the social groups which administer it a disproportionate superiority to the rest of the population. The individual is wholly devalued in relation to the economic powers, which at the same time press the control of society over nature to hitherto unsuspected heights.[71]

The fact that degrees of 'reactionary modernism' can be identified in fascist, communist and even democratic societies in the 1930s should not, however, be confused with equivalence: Swedish paternalism was not the same as Nazi authoritarianism. Nor should it obscure the fact that modern artists and designers paid high prices for their utopianism. While the economic and political crisis in Europe detonated at the beginning of the 1930s, circumstances for many of the prominent architects, designers and artists discussed in this essay did not become acute until the second half of the decade. For many, the years between 1935 and 1938 were devastating in professional and even personal terms. In these years, for instance, the Soviet Union was convulsed by the bloody purges of Stalin in which millions were murdered. In an atmosphere of paranoia, one denunciation could end a career or a life: former Constructivist Constantin Melnikov was denounced and barred from practising as an architect in 1937; Gustavs Klucis, who had supplied some of the most stirring propaganda for the cult of Stalin (pl.10.3), was arrested and murdered in 1938 by the NKVD – like many long-standing Bolsheviks and revolutionaries. Propaganda for Stalin did nothing to spare him his fate.

Foreign specialists fared only marginally better. Distrusted from the moment of their arrival, their expertise and worth were systematically undermined as the decade progressed. In the field of architecture and city planning, the international brigades were disbanded in 1934 and their members incorporated into the Soviet State Institute of Urban Design, where they were often given trivial tasks. The crisis point for most came in 1937 when Westerners were required to become Soviet citizens. Many – though not all – chose to return to the West. Former member of Meyer's Bauhaus Brigade, Philipp Tolziner had already committed his life to the Soviet cause by taking citizenship in 1935: as a communist and a Jew, his return to Germany was unimaginable. In 1938 the plans for Orsk, on which he was working, were confiscated and he was imprisoned in a Gulag after being falsely convicted of espionage.

10.20 **Tecton**, *Site plan showing gardens, pathways, tennis court and swimming pool*, Highpoint I and Highpoint II, 1936–8 (cat.241b)

10.21 **Tecton**, Portico entrance, Highpoint II, 1936–8. Royal Institute of British Architects, London

10.20

10.21

10.22 **Tecton**, Highpoint I, Penthouse interior with chair designed by Berthold Lubetkin, 1937–8 (cat.241e)

Britain and beyond

In the second half of the 1930s the diaspora from Nazi Germany was joined by other exoduses, including a stream of exiles from Czechoslovakia following the German occupation; from Austria after the declaration of the *Anschluss* in 1938; and from Spain after the fall of the Republic to Franco in 1939. Britain became home to many artists and designers from Central Europe. The centre of a global empire and a liberal democracy, Britain was a relatively welcoming environment. 'England,' wrote architect Berthold Lubetkin in 1937, 'has become almost the only country in which modern architecture can flourish with comparative freedom. The circumstance has … attracted many foreign architects fleeing from political restrictions or economic stagnation in other countries.'[72] Georgian-born Lubetkin, who arrived in London in 1931 after six years in Paris, fared better than many of the new arrivals who followed him. Many found it difficult to obtain work: architects, for instance, needed professional endorsement from native architects to secure permission to practise from the Home Office.[73] This was not easy to acquire as the British profession had, in its conservatism and haughtiness, remained largely indifferent to and isolated from developments on the continent.[74] Nevertheless, those who did secure commissions and won their battles with British planning authorities produced remarkable and original schemes.

Lubetkin and Tecton's sophisticated apartment block Highpoint II (1936–8) (pls 10.20–2, cat.241) was an important development in the language of modern architecture, not only by conservative British standards, but by international ones. Like Le Corbusier, Lubetkin sought to rebuff the narrow emphasis on function that was characteristic of the preceding decade, through the introduction of poetic and metaphoric forms into his designs: this was most clearly and controversially asserted in the famous flowing entrance porch of Highpoint II, supported by two facsimile caryatids from the Erechtheion in Athens. John Allen, Lubektin's biographer, has interpreted the inclusion of these figures as a 'warning' against 'Modernism's reductivist tendency'.[75] Other émigrés accommodated local or what might be described as regionalist characteristics: Hungarian architect Ernö Goldfinger described his neat terrace of three houses under a flat roof, built in reinforced concrete with brick facings in London's Hampstead, as 'an attempt to reintroduce … the conception of the terrace houses of the eighteenth and the nineteenth centuries modified by modern ways of living and new means of construction, equipment and materials'.[76] At the same time, British magazine publishing was changed for ever by the efforts of Stefan Lorant, the pioneering art director of German photo-weeklies, who established *Picture Post* (pl.11.9) with publisher Edward Hulton in 1937.[77]

For many who found opportunities lacking in Britain (or, like Lorant, feared a German invasion), America beckoned. Moholy-Nagy, for instance, moved to London in 1935, working extensively in advertising, photography and film. Two years later he emigrated to America, where he became the first director of the New Bauhaus in Chicago. Other journeys across the Atlantic were laced with drama. While Ladislav Sutnar, the Czech designer, was working in America on the Czechoslovak national pavilion at the New York World's Fair in 1938, Hitler annexed the Sudetenland. Rather than return to an occupied country, Sutnar chose to remain. By 1939 the list of Central European émigré architects and designers living in America was a remarkable and tragic indictment of the failure of European politics: they included Walter Gropius, José Luis Sert, Ludwig Mies van der Rohe, Ludwig Hilberseimer, György Kepes, László Moholy-Nagy, Will Burtin and Herbert Bayer. The regimes that held much of Europe in their authoritarian grip had used Modernism as a scapegoat. In so doing, however, they heartened its transmission around the world. Artists and designers from the cauldron of Europe became an effective and highly motivated international force of propagandists for Modernism.

224

Volksempfänger radio VE 301 W
1933
Designed by Walter Maria Kersting
(1889 Münster–1970 Waging, Germany)

Bakelite case and linen speaker cover
38.5 × 27.7 × 17cm
V&A: W.7–2005

The Nazi state made a high investment in propaganda. Reichsminister for National Enlightenment and Propaganda, Joseph Goebbels, placed particular value on the modern mass media, trumpeting 'the revolutionary impact of the invention of radio, which gave the spoken word true mass effectiveness'.[1] The Volksempfänger VE 301 was at the heart of his campaign to influence German public opinion. Launched at the Tenth German Radio Fair in August 1933, the model number represented the day on which Hitler had taken power in January that year and was a startling indication of the Nazi resolve to reshape Germany rapidly. Selling for 76 Reichsmarks, this radio was one-third of the price of the cheapest equivalent on the market. Nevertheless, in Depression-hit Germany this sum represented half the average monthly wage for a manual or semi-skilled worker. The promise of a radio for the masses was only really achieved some years later when the Deutscher Kleinempfänger was introduced in 1938 at 35 Reichsmarks.[2]

With its plain Bakelite case and clearly expressed speaker and dials, the Volksempfänger was a simple modern design. Made by 28 different manufacturers under licence, the radio could receive long, medium and shortwave signals. Once

Germany was at war, restrictions were placed on listening to stations of hostile countries. Labels were attached to the radios, stating: 'Think about this: Listening to foreign broadcasts is a crime against the national security of our people. This is a Führer Order punishable by hard labor in prison.'[3]

In this 1936 poster, the Volksempfänger is transformed into a public monument. The entire nation appears to be transfixed and united as the Führer speaks. While the image – in its montaged form – accentuates the modernity of the radio, it is notable that the designer used traditional 'fractur' lettering. This was a requirement of official publications of the early years of Nazi rule, a product of their promise to restore German national pride and their rebuttal of the Modernist typographic innovations of the Weimar era. DC

1 Joseph Goebbels, Nuremberg Rally speech, in *Der Kongress zur Nürnberg 1934* (Munich, 1934), p.133. See also Horst Bergmeier and Reiner Lotz, *Hitler's Airwaves: The Inside Story of Nazi Radio Broadcasting and Propaganda* (New Haven, 1997).
2 Wolfgang König, *Volkswagen, Volksempfänger, Volksgemeinschaft. 'Volksprodukte' im Dritten Reich: Vom Scheitern einer national-sozialistischen Konsumgesellschaft* (Berlin, 2004).
3 Label cited by Robert Rowen, 'Gray and Black Radio propaganda against Nazi Germany', a paper presented to the New York Military Affairs Symposium, April 2003. Listening to radio stations of neutral countries (e.g. Switzerland or Sweden) was allowed.

10.23 **Leonid**, Poster: *Ganz Deutschland hört den Führer mit dem Volksempfänger* (*All Germany Listens to the Führer with the People's Receiver*), lithograph, 1936. The Wolfsonian–Florida International University, Miami Beach, Florida

225 Plate 10.15

Sketch of design for German Pavilion for the Brussels *Exposition Universelle et Internationale*
1934
Ludwig Mies van der Rohe
(1886 Aachen–1969 Chicago)

Crayon on paper
21.6 × 29.1 cm
Private Collection, Connecticut,
Courtesy of Leslie Rankow Fine Arts, NY

Ludwig Mies van der Rohe was invited by the Nazi authorities to enter the competition for the German Pavilion at the 1935 Brussels *Exposition Universelle et Internationale*.[1] This was to be his last such invitation. His designs for the prestigious

Reichsbank competition had been rejected only a few months earlier as the regime's line against Modernist architecture had hardened.[2] For an architect at the forefront of architectural Modernism, entering yet another competition organized by the Nazi state was bound to be an exercise in compromise. As Claire Zimmerman observed, Mies's dilemma was how to satisfy the classicizing, conservative interests of the German state and maintain his reputation abroad as an innovative architect.[3]

While the designs submitted to the competition by Mies have never been discovered and are presumed to have been destroyed during the Second World War, some sketches and correspondence remain. This sketch describes the principal façade, organized symmetrically and capped with an emblematic device, possibly an eagle mounted on a laurel wreath, a Nazi motif. More than the other drawings that survive, this design, with its formality and symmetry, and

suggestion of columns on the façade, seems to indicate Mies's attempt to conform to the classical order then being imposed on German architecture. Other drawings – particularly those indicating his thinking about internal organization – reveal his attempts to employ asymmetrical, free-standing walls and are based on a much more dynamic conception of space.

From today's perspective, the architectural elements in Mies's sketch are overshadowed by the startling effect of the swastikas on the flags. It should be, noted, however, that the competition brief demanded that such symbolic elements feature in the design. DC

1 Claire Zimmerman, 'German Pavilion, International Exposition, Brussels, 1934', in Terence Riley and Barry Bergdoll, *Mies in Berlin* (New York, 2002), pp.284–7.
2 Vittorio Magnago Lampugnani, 'Berlin Modernism and the Architecture of the Metropolis', in ibid, pp.63–4.
3 Zimmerman, in Riley and Bergdoll (2002), p.284.

226 Plate 10.16

Poster: *Das Wunder des Lebens*
(*The Miracle of Life*)
1934
Designed by Herbert Bayer (1900 Haag,
Austria–1985 Santa Barbara)

Lithograph
147.4 × 82cm
Bauhaus Archiv, Berlin (BHA 4224)

Bayer's poster, commissioned to promote a
major popular science exhibition held in Berlin
in 1935, depicts a translucent figure emerging
from an ovum. This strange image seeks to
capture the enigma of existence and, as such,
shares the Surrealist and introverted mood of
much of Bayer's advertising work in the Third
Reich. The human figure also literally represents
one of the central exhibits in the 1935 exhibition,
a glass body threaded with illuminated veins,
a nervous system and internal organs. This
spectacular object was first exhibited at the
second International Hygiene Exhibition in
Dresden in 1930 (pl.7.3) and testified to German
advances in medical science.[1] In the 1935 poster he
juxtaposes the figure with sans-serif typeface
to produce a design that is resolutely Modernist.

Das Wunder des Lebens was one of a series of
exhibitions held in the German capital, including
Deutsches Volk, Deutsche Arbeit (German People,
German Work, 1934) and *Deutschland Ausstellung*
(Germany Exhibition, 1936), designed to promote
trade and industry. These exhibitions cannot,
however, be seen as purely commercial events.
The grip that the Nazi authorities held over
national life meant that they also served as
instruments of national and, at times, racist
propaganda. Some of Bayer's work of this period
has been a matter of controversy.[2] The catalogue
for *Das Wunder des Lebens* – also designed by
Bayer – contained a photomontage setting
images of Hitler and the labour schemes that
were a cornerstone of Nazi economic policy
over a sweeping landscape of autobahns. The
accompanying text emphasized the paramount
importance of the *Führerprinzip* (Leadership
principle), which gave Hitler incontrovertible
authority. In his own personal copy, Bayer defaced
the image of Hitler in a violent wash of black ink,
perhaps a sign of his later disquiet at serving
fascism.[3] He was to depart from Germany for a
successful career in America in 1938, prompted
in part by the fact that one of his earlier paintings,
Landscape in Ticino (1924), was displayed at the
notorious *Entartete Kunst* (Degenerate Art)
exhibition of 1937, a spectacle mounted to
ridicule modern art.[4] DC

1 *Das Deutsches Hygiene-Museum 1911–1990* (Dresden, 2003).
2 Jeremy Aynsley, *Graphic Design in Germany, 1890–1945*
(Berkeley, 2000), pp.201–11.
3 Steven Kasher, 'The Art of Hitler', in *October*, vol.59
(Winter 1991), pp.78–9.
4 Stephanie Barron (ed.), *Degenerate Art: The Fate of the
Avant-Garde in Nazi Germany* (exh. cat., Los Angeles County
Art Museum, 1991), p.202.

227 Plate 10.17

Kubus stacking storage containers
1938
Designed by Wilhelm Wagenfeld
(1900 Bremen–1990 Stuttgart)

Manufactured by Vereinigte Lausitzer Glaswerke AG,
Germany
Moulded glass
21 × 18 × 27cm (stacked)
V&A: C.154-p–1980

The Kubus storage containers are a concise
expression of a number of classic Modern
Movement preoccupations, including modularity,
rectilinear geometry and transparency of materials
and function. An efficient system for use in the
kitchen, the set was modular and stackable with
interchangeable lids. Mass-produced in pressed,
heat-resistant glass, the containers represented
the application of technology to everyday life. They
were designed by Wilhelm Wagenfeld, a highly
successful product designer in Germany between
the wars. Trained at the Bauhaus as a student of
László Moholy-Nagy, he joined the faculty in 1926,
becoming director of the Metal Workshop there.
At the Bauhaus, Wagenfeld designed his famous
MT8 table lamp (cat.135). Between 1931 and 1935

he taught at the Berlin Staatliche Kunsthoch-
schule. He combined a career as a teacher with
that of product designer, becoming the design
director of the Lausitzer glass works in 1935.
Although he outlined his functionalist approach
to design in articles for journals such as *Die Form*,
Wagenfeld was a pragmatist, rejecting the theories
of Weimar Modernism as too doctrinaire.

Wagenfeld's relationship to the Nazi regime
has been a matter of some controversy and
illustrates the dilemmas facing those Modernist
designers who worked in Germany during the
Third Reich.[1] He was both an opponent of Nazi
policy, protesting for instance when the *Deutscher
Werkbund* was incorporated into the official cultural
structure, and was on the official committee
selecting the exhibits for the German Pavilion
at the Paris Exhibition of 1937, a propaganda
triumph for the regime. DC

1 Beate Manske and Gudrun Scholz, *Täglich in der Hand:
Industrieformen von Wilhelm Wagenfeld aus sechs Jahrzehnten*
(exh. cat., Landesmuseum, Bremen, 1987).

228a Plate 10.19

Model: Kdf-Wagen
1938
Designed by Ferdinand Porsche
[1875 Maffersdorf, Austria–1951 Stuttgart]

Metal
25.5 × 17 × 32cm, scale 1: 12.5
Deutsches Museum, Munich (Inv. no.68748)

228b Plate 10.18

Brochure: *Der Kdf Wagen*
1938
Designed by DEMAR
(Ernst Demar, Austria?)

Printed by Cyliax, Vienna
*c.*21 × 29cm
Technisches Museum Berlin (III.2. 10170)

While the Volkswagen is widely known as a project of the Third Reich, its origins predate Nazi rule.[1] The car's designer, Dr Ferdinand Porsche, had been actively developing the idea of an inexpensive family car in the 1920s and established his own design office, later known as the Porsche Büro, to promote his popular vision of future transport. In a series of prototypes produced by motorcycle manufacturers in 1932 and 1933, Porsche established the main characteristics of the Volkswagen design: the flowing, streamlined body; an air-cooled engine mounted at the rear; and a weight-reducing independent front suspension system.

Porsche's prescience was seized upon by the Nazi regime. Alongside the Autobahn-building scheme, the German people's car became an incontestable symbol of Nazi modernity. It also became the focus of various Nazi political, social and commercial contracts: in 1936 Mercedes Benz was persuaded to develop and produce prototypes of what was called the *Kraft-durch-Freude-Wagen* (Strength-through-Joy-Car). This scale-model was one of four produced to present the refined design and broader concept of the Volkswagen (literally, People's Car) to Nazi politicians in 1938. In the same year Hitler laid the cornerstone of the Wolfsburg factory, an American-style mass-production plant, where the car was to be built and which remains the firm's headquarters; and aspiring Volkswagen owners were encouraged to invest in the project by paying weekly contributions to the *Deutsche Arbeiter Front* (German Worker's Front). To keep prices down, the car had to be sold directly by company employees. This advertising brochure promoted the car to the prospective consumer. It was conceived as a family car, and the brochure shows a family of five travelling along the *Autobahn*. The pleasures of ownership were, however, never experienced by these loyal investors. The 210 cars built before the outbreak of war were largely used for propaganda purposes or were 'toys' for the Nazi elite.[2] When war broke out, the Volkswagen was then redesigned by Porsche for combat purposes. Made by slave labour in the Wolfsburg factory, these wartime cars included an amphibian motorcar and a desert vehicle. DC

1 Colin Chant, 'Cars, contexts and identities: The Volkswagen and the Trabant', in Mark Pittaway (ed.), *Globalization and Europe* (Milton Keynes, 2003), pp.199–248.
2 Karl E. Ludvigsen (ed.), *People's Car: A Facsimile of BIOS Final Report no. 998 Investigation into the Design and Performance of the Volkswagen or German People's Car* (London, [1947] 1996), p.2.

229 Plate 10.3

Poster: *Under the Banner of Lenin for Socialist Construction*
1930
Designed by Gustavs Klucis (1895 Rujiena, Latvia–1938 Moscow?)

Published by the State Publishing House, USSR
Colour lithograph
97.2 × 70.2cm
V&A: E.404–1988

This poster celebrates the industrialization of Russian society under the first Five-Year Plan of 1928. It also represents the leader-cult centred on Stalin, which was to become a defining feature of Soviet culture in the 1930s. Despite Lenin's widely recorded distrust of his future successor, Klucis's poster (created six years after Lenin's death) suggests that Lenin and Stalin shared the same vision in the most literal sense, by sharing the same eye. In fact, Lenin had warned against mythologizing his leadership after his own death. Nevertheless, this image reinforces the cult of personality (Lenin's and Stalin's) that was operating in Stalin's Russia.

Klucis's design achieves powerful visual effect through the montage of photographic images. Klucis and other Modernist graphic designers associated with the Soviet avant-garde favoured the photograph over the hand-produced image because its mechanical character suggested modernity, and its reproducibility suggested democracy. In particular, the combining of photographs – the practice of photomontage – was claimed as a way of fixing the inherently open and fluid meaning of the single photograph.[1] The combination of images could deliver clear political messages. Despite this step towards popular comprehension, the hardening of political and aesthetic culture that occurred under Stalin unleashed serious criticism of the avant-garde and led to the optimistic and romantic style of Socialist Realism.[2] Montage and dramatic compositional effects were increasingly damned as 'formalism'. A veteran of the October Revolution, Klucis was to die at the hands of the secret police, despite producing – often in partnership with his wife Valentina Kulagina – such loyal and flattering images of Stalin.[3] DC

1 Alexander Rodchenko, 'Foto-montazh' in *LEF*, no.4 (1924), p.41, quoted in Christina Lodder, *Russian Constructivism* (New Haven, 1981), p.187.
2 Matthew Cullerne-Bown, *Socialist Realist Painting* (New Haven, 1998).
3 Margarita Tupitsyn, *Gustav Klutsis and Valentina Kulagina: Photography and Montage After Constructivism* (Gottingen, 2004).

230a Plate 10.4

Drawing: *Palace of Soviets competition,*
first stage
February–May 1931
Designed by ARU Brigade (Nikolai Beseda,
Georgii Krutikov, Vitalii Lavrov and Valentin
Popov), perspective drawing by Alexander
Deineka (1899 Kursk–1969 Moscow)

Pencil, ink, gouache, white ink and photographs on paper
117.8 × 117.5cm
Shchusev State Museum of Architecture, Moscow

230b Plate 10.5

Drawing: *Palace of Soviets competition,*
third stage (closed)
1932
Leonid Vesnin (1880 Yur'evets, Russia–
1933 Moscow), Viktor Vesnin (1882 Yur'evets
–1950 Moscow) and Alexander Vesnin
(1883 Yur'evets–1959 Moscow)

India ink and watercolour on paper
80.7 × 128cm
Shchusev State Museum of Architecture, Moscow

The Palace of Soviets was to be the centrepiece
of the new vision of Moscow launched under the
auspices of Stalin's Five-Year Plan of 1928. To be
located on the site of the demolished Cathedral
of Christ the Saviour, its primary function as a
national parliament (with two main auditoria for
15,000 and 6,000 people) was overshadowed by
its ideological importance as a demonstration of
the power of the Soviet Union.[1]

When the scheme was initiated in February
1931, a wide range of Soviet architectural groups
was invited to participate, including leading
Constructivists. After the initial designs were
exhibited in Moscow, drawing public criticism, the
project was reorganized as an open competition
attracting 160 designs from around the world.
Comprising young Soviet architects, the ARU
Brigade (Union of Architects and Urbanists)
presented an unambiguously Modernist vision of
the Palace in the form of two steel-framed glass
towers in a perpendicular arrangement around a
public square. The triangular plan of an accom-
panying auditorium at the base of the taller block
was indebted to the dynamic compositional
principles of Constructivist design of the 1920s
(including those developed by theorist Nikolai
Ladovsky [pl.2.18], who had taught members of
the Brigade).[2] To illustrate the Palace's political
function, artist Deineka's perspective drawing
produced for the competition depicts lines of
Soviet citizens parading before it. The unmistakably
progressive form of the Palace was reinforced by
the serried ranks of automobiles imagined by

Deineka. The ARU Brigade scheme – like all the
others in this phase of the competition – was
rejected for failing to deliver the grandeur and
monumentalism necessary to reflect 'the great
process of the construction of socialism'.[3] In a
clear attack on their Modernist preoccupations,
the ARU Brigade were criticized for destroying the
atmosphere of the auditorium 'by turning it into a
stadium' and for the 'superfluous mechanization'
of their design.[4]

When the second and third (closed) rounds
of the competition were announced in 1932, a
new set of strongly ideological imperatives were
imposed, requiring architects to engage with
traditional forms and materials. Nevertheless
prominent Modernists were still invited to partici-
pate. The Vesnin brothers – central figures in the
Soviet architectural avant-garde as founders of
OSA (Union of Contemporary Architects) in 1925 –
submitted a sparse design to the third round of
the competition. Based on a cylindrical auditorium
set into a long, heavily fenestrated structure on
a rectilinear plan, the design made use of many
principal innovations of modern architecture.
The upper floors of the structure were, for
instance, supported by *piloti*. While in its massing
of geometric forms the design achieved a
powerful monumental effect, the Vesnins'
scheme made little attempt to meet the
demands of Socialist Realism.

The competition concluded in 1933 when Boris
Iofan and his team (Vladimir Gelfreikh, Vladimir
Shchuko and Sergei Merkurov) were pronounced
winners. Iofan's design (modified at the instruction
of the state) – a stepped skyscraper crowned with
the figure of Lenin, which towered 400 metres
above the ground – not only marked the end of
the competition: it signalled the hegemony of
monumentalism and academicism in Soviet
architecture. Soviet Modernists had to adapt to
the new style or withdraw from practice. Of Iofan's
design, Le Corbusier wrote to Alexander Vesnin,
'It is hard to accept the fact that they will actually
erect that odd thing which has recently flooded all
the journals.'[5] The Paris-based architect's rueful
view of the building's impending construction
was premature (and perhaps a symptom of the
effective mythology that this design was produced
to promote): the building was never completed.
During the Second World War the unfinished
steel framework of the Palace was dismantled
to provide materials for war. DC

1 Catherine Cooke, 'Socialist Realist Architecture', in Matthew
 Cullerne Bown and Brandon Taylor (eds), *Art of the Soviets:
 Painting, sculpture and architecture in a one-party state, 1917–1992*
 (Manchester, 1992) pp.93–6.
2 Catherine Cooke, 'Students and teachers: Avant-garde
 Architecture in the schools', in *Russian Avant-garde Theories
 of Art, Architecture and the City* (London, 1995), pp.160–78.
3 See Alexei Tarkhanov and Sergei Kavtaradze, *Stalinist
 Architecture* (London, 1992), p.27.
4 Catherine Cooke, 'Mediating Creativity and Politics: Sixty Years
 of Architectural Competitions in Russia', in *The Great Utopia.
 The Russian and Soviet Avant-Garde* (New York, 1992), p.708.
5 Le Corbusier cited by Vladimir Paperny, *Architecture in the
 Age of Stalin* (Cambridge, 2002), p.4.

231

Sculpture: *Continuous profile of Il Duce*
1933
Renato Giuseppe Bertelli (1900–1974)

Terracotta with black glaze
34 × 28 × 28cm
Imperial War Museum, London (IWM ART LD 5975)

Many Futurist artists were enthusiastic servants of fascism, keen to flatter Mussolini's insatiable ego. Bertelli's sculpture takes a literal approach to the representation of the revolutionary spirit that Il Duce claimed for Italian fascism.[1] Bertelli matched fascist rhetoric by making a bust that creates the illusion of Mussolini's famous profile spinning through 360 degrees. Both abstract and instantly recognizable, this bust expressed the Futurist concept of 'simultaneity' in its attempt to capture multiple phases of motion simultaneously.[2] Moreover, it carried a strong accent of industrial machinery. The design of the bust may also derive from images of the two-faced Roman god, Janus.[3] The first versions were apparently made in terracotta, while later ones were manufactured in a variety of sizes in polished metal and were sold – often as desk ornaments – with Mussolini's approval. This example was owned by Mussolini's son-in-law, Count Galeazzo Ciano, and was acquired by the Imperial War Museum in 1945. DC

1 Marla Stone, *The Patron State: Culture and Politics in Fascist Italy* (Princeton, 1998).
2 Dennis P. Dooran, 'Political things: Design in Fascist Italy', in Wendy Kaplan (ed.), *Designing Modernity: The Arts of Reform and Persuasion 1885–1945* (exh. cat., Wolfsonian, Miami Beach, 1995), p.228.
3 Imperial War Museum catalogue record for IWM ART LD 5975.

232 Plate 10.1

Poster: *1934 Year XII of the Fascist Era*

1934

Designed by Xanti Schawinsky
(Alexander) (1904 Basle–1979 Locarno)

Letterpress
c. 89.9 × 71.2cm
Merrill C. Berman Collection

The image of the leader as towering monument was a key trope of propaganda in the 1920s and 30s (pl.10.3). In this 1934 poster commemorating the 12th anniversary of the 1922 March on Rome (which secured Mussolini as Italian Prime Minister), Schawinsky symbolized the fascist claim to represent the popular will. This poster demonstrates the ways in which he experimented with the materials and techniques of print. Schawinsky enlarged the halftone dots that are typically used by printers to reproduce photographic images. The halftone dots and the crowd that forms Il Duce's body echo one another, suggesting both the magnetic appeal of the charismatic leader and his command of the modern media.

A Swiss-born Bauhaus graduate, Schawinsky was a highly skilled designer and brilliant photographer who had been employed by the progressive German city of Magdeburg in the late 1920s to design all its publicity and official documents.[1] Following the establishment of the Third Reich, Schawinsky moved to Italy, where he was employed as a designer by the manufacturer Olivetti, producing work that now marks him as a pioneer of corporate design. DC

1 *Xanti Schawinsky* (exh. cat., Galleria comunale d'Arte Moderna, Bologna, 1975).

233a Plate 10.11

Drawing: Casa del Fascio, perspective of the piazza façade

1932–6

Giuseppe Terragni (1904 Meda, Italy – 1943 Pavia, Italy)

Pen and ink
84.5 × 84.5cm
Centro Studi G. Terragni, Como (23/16/D1/D/E)

233b Plate 10.12

Photograph: Casa del Fascio, Federal Hall

1936

Designed by Giuseppe Terragni
(1904 Meda –1943 Pavia)

The Casa del Fascio is the best-known building designed by the Italian architect Terragni. This drawing of its façade, which includes a projecting loggia never built, was coloured after the architect's death, possibly for an exhibition. The final form of the actual building is even more spartan than the preliminary perspective drawing reproduced here: Luigi Cavadini has suggested that the loggia was rejected by the architect as a disruption of his scheme.[1]

Despite its clear connection to fascist politics as the Como party headquarters, the building has been much celebrated by architects and critics since the 1970s.[2] Architectural historian Reyner Banham called it 'one of the most brilliant formal exercises of the thirties … a monumental diagram of the rules of *divina proporzione* immortalized in marble'.[3] Interest has been drawn by the rigorous geometric precision of Terragni's design. Arranged on a square plan, the building has a height, for instance, that is half the length of each of its sides. A rigid proportional system governed the shape and arrangement of windows, floors, doors and walls. Terragni also achieved a remarkable sense of both transparency and cubic volume by employing a regular framework of openings (some fenestrated), blank white walls and slender columns. Each of the four elevations is a subtle articulation of this system.

The platonic purity of Terragni's design was a matter of controversy, with local party officials finding fault with its failure to express the drama of the fascist revolution. The furnishing and fitting out of the building, as well as Terragni's own writings about the project, have been interpreted as an attempt to reassert its fascist character in the face of criticism.[4] The Federal Hall (furnished with Terragni's own Benita chair of 1936, pl.10.12) features Mario Radice's abstract murals. The twice life-size figure of Mussolini was etched onto a slab of marble and inserted into the design. Standing at the head of the table, Il Duce was always present at party meetings. DC

1 Luigi Cavadini, *Il Razionalismo Lariano Como, 1926–1944* (Milan, 1989), p.46.
2 See Bruno Zevi, *Giuseppe Terragni* (London, 1989); Peter Eisenman, *Giuseppe Terragni. Transformations, Decompositions, Critiques* (New York, 2003); Attilio Terragni, Daniel Libeskind, Paolo Roselli, *The Terragni Atlas: Built Architecture* (Milan, 2004).
3 Reyner Banham, *The Age of the Masters. A Personal View of Modern Architecture* (New York, 1975), p.93.
4 Thomas L. Schumacher, *Surface and Symbol. Giuseppe Terragni and the Architecture of Italian Rationalism* (London, 1991) p.162–5.

234 Plate 10.14

Chair, model S. 5
1934–6
Designed by Gabriele Mucchi
(1899 Turin–2002 Milan)

Manufactured by Emilio Pino di Parabiago
Tubular steel and plywood
78 × 40 × 47cm
The Michell Wolfson Jr Collection – Fondazione Regionale
C. Colombo, Genoa

The S. 5 illustrates the growing commercial
interest in tubular-steel chair design in Europe
in the 1930s. It was designed by Mucchi, an artist
and engineer with strong connections to the

Italian Rationalists, during a two-year period of
collaboration with the Pino factory in Parabiago
in the mid-1930s.[1] Designed for use in public
buildings, this tubular-steel chair is stackable and
hard-wearing. Despite its appearance of spare
utility, Mucchi's design offered flexibility: a variety
of materials could be used for the seat and back,
including raffia, cord or, as in this case, plywood.

This chair was one of many used to furnish
the Colonia Montana Rinaldo Piaggio, a building
designed by the Genoa-based architect Luigi Carlo
Daneri. With the purpose of housing and educating
Italian children on subsidized vacations, dozens
of colonie were opened by the government and by
patrician businesses to improve children's health
and their loyalty to the fascist state. Like most of
the colonie, the Colonia Montana Rinaldo Piaggio
was a highly ordered space: the 260 children

staying there had, for instance, to pass through
the wash and shower rooms before entering the
dormitories to sleep. Writers in Domus, the leading
Modernist architecture magazine in Italy at the
time, saw the colonie and their furnishings as
tools to shape minds and bodies: 'Having come
from poor or very modest homes, the majority of
boys and girls ... will feel disposed here, for the
first time, to accept the influence of a taste, to
appreciate architectural form not just from the
outside, but adapted for living within.'[2] DC

1 Ornella Selvafolta, 'Gabriele Mucchi', in Rassegna, vol.2, no.4
 (October 1988), p.46.
2 Domus editorial (1942), cited by Sefano de Martino, 'Architecture
 and Territory', in Cities of Childhood. Italian Colonies of the 1930s
 (exh. cat., Architectural Association, London, 1988), p.12.

235 Plate 10.13

Painting: *Flight over the 'M. Bianchi' Colonial Village*
1938
Renato di Bosso (born Renato Righetti)
(1905 Verona–1982 Verona)

Oil on Masonite (fibreboard)
89.5 × 100cm
The Michell Wolfson Jr Collection – Fondazione Regionale
C. Colombo, Genoa (87.1070.5.1)

In this painting di Bosso represents the fascist
conquest of North Africa through an aerial view of
a new Italian village built in Libya in the 1930s.[1]
The dizzying perspective and post-Cubist treatment

of space were characteristic features of the
aeropittura (aeropainting) aesthetic developed by
the second generation of Italian Futurist artists in
the late 1920s.[2] This new vision was announced in
the publication of the Manifesto dell'Aeropittura on
22 September 1929. It proclaimed, 'the changing
perspectives of flight constitute an absolutely
new reality, one that has nothing in common with
the reality traditionally constituted by earthbound
perspectives'.[3] Although the manifesto was
signed by established figures within the move-
ment, such as Filippo Tommaso Marinetti, the
aesthetic was created by younger painters such
as Gerardo Dottori and di Bosso.[4] Whilst Futurist
artists in the 1910s had been fascinated with the
speed of the motor car, aeropittura paintings of
the 1930s represented the drama of flight by
attempting to capture the experience of high

altitudes and the racing effects of speed. These
images also corresponded with official attempts
to use aeronautics to demonstrate fascist tech-
nology and heroism. In 1933, for instance, Minister
of Aviation Italo Balbo led a team of pilots across
the Atlantic, landing with great acclaim at the
Chicago Century of Progress exhibition. DC

1 Silvia Barisione, Matteo Fochessati and Gianni Franzone,
 Parole e Immagini Futuriste dalla Collezione Wolfson (Milan, 2001),
 pp.86, 139.
2 Alberto Fiz, In Volo: Futurist Aeropainting: Aeropittura futurista
 (Milan, 2003).
3 www.futurism.org.uk/manifestoes/manifesto47.htm (consulted
 12 May 2005).
4 Willard Bohn, The Other Futurism: Futurist Activity in Venice,
 Padua, and Verona (Toronto, 2004), pp.161–78; Maurizio Scudiero
 (ed.), Di Bosso futurista (Modena, 1988).

236 Plate 10.9

Design for an advertising mast, the Stockholm Exhibition
1930
Erik Gunnar Asplund
(1885 Stockholm–1940 Stockholm)

Gouache, graphite, chalk
61.5 × 35.6cm
The Metropolitan Museum of Art, New York.
Edward Pearce Casey Fund, 1984 (1984.1168.3)

The Stockholm Exhibition (pl.10.8) was a landmark
event in the history of Modernist architecture and
design in Scandinavia. More than four million
visitors (in a country with a population of six
million) were presented with an attractive and

humanist vision of modernity on a waterside
site planned by Asplund in central Stockholm.[1]
Asplund was at that time the leading architect
of his generation in Sweden as the designer of
prominent schemes such as Stockholm Public
Library (1920–27). The advertising mast, designed
by Asplund with Nils Einar Eriksson, Viking
Göransson and Hans Quidling and engineer
B. Ahlström, was located at the end of the chief
axis of the exhibition in the main exhibition square
and was visible from all directions. It became an
iconic symbol of the event.

Asplund's colourful image was probably a
presentation drawing. With sweeping lights
and billowing flags, it suggests a rather more
dramatically vertical and animated design than
the structure as built. Seventy-four metres high,
the tensioned-steel mast was capped with the
exhibition logo, a symbol of freedom, designed by
Sigurd Lewerentz. Inspired by a winged Egyptian

figure of a man as a pair of stylized wings, this
utopian symbol was dubbed 'the cut-throat razor'
by the public.[2] A press stand was suspended above
the ground. Although in Asplund's colourful design
this cabin was to be reached by a tight circular
staircase, in its built form it was accessed by a
gently inclined set of stairs, which diminished
the dramatic verticality of the overall design. A
number of commentators have seen a connection
between Asplund's mast and the kiosks and
propaganda towers designed by Vladimir Tatlin
and Alexei Gan in the Soviet Union in the early 1920s.
Echoes of Soviet advertising of the same years were
seen in the floating neon signs with brand names
for chocolate, scarves and radios .[3] DC

1 Eva Rudberg, The Stockholm Exhibition 1930: Modernism's
 Breakthrough in Swedish Architecture (Stockholm, 1999).
2 Eva Rudberg, 'Early Functionalism 1930–40', in Claes Caldenby
 et al., Twentieth Century Architecture, Sweden (Munich, 1998), p.90.
3 Ibid, pp.81–111.

237

Poster: *Spår Efter 10 Års Arbetarestyre*
(*The Effects of 10 Years of Workers' Rule*)
1931
Designed by Ivar Starkenberg (1886–1947)

Lithograph
98 × 67.5cm
The Royal Library, Stockholm

This local election poster celebrates a decade
in office of the *Socialdemokratiska arbetareparti*
(Swedish Social Democratic Workers' Party).
It was designed by Starkenberg, who was best
known as a left-wing cartoonist. The poster
emphasizes the transformation of the public
realm.[1] Images of transport, housing schemes
and schools are accompanied by captions that
stress their modernity, which is reinforced by
the poster's dynamic composition. The use of
irregularly arranged photographs and an animated
red flash carrying the poster's primary message
suggest the force of progress. In its use of photog-
raphy, eye-catching graphic devices and a limited
colour range, Starkenberg's design shared much
with contemporary ideas of effective propaganda.
In the 1930s, regimes on the right and the left
made strong use of such techniques to assert
their 'right' to rule.[2] However, in the case of
this poster, the forceful language of Modernist
graphic design was put to democratic ends. The
Social Democratic Workers' Party subscribed to
a strongly welfarist vision for society, described
by the term *folkhemmet* (home of the people), in
which all citizens enjoyed equal rights and equal
opportunities. DC

1 *Ivar Starkenberg 1886–1947* (exh. cat., Stockholms
 stadsmuseum, 1977).
2 Paul Jobling and David Crowley, *Graphic Design. Reproduction
 and Representation since 1800* (Manchester, 1996), pp.107–36.

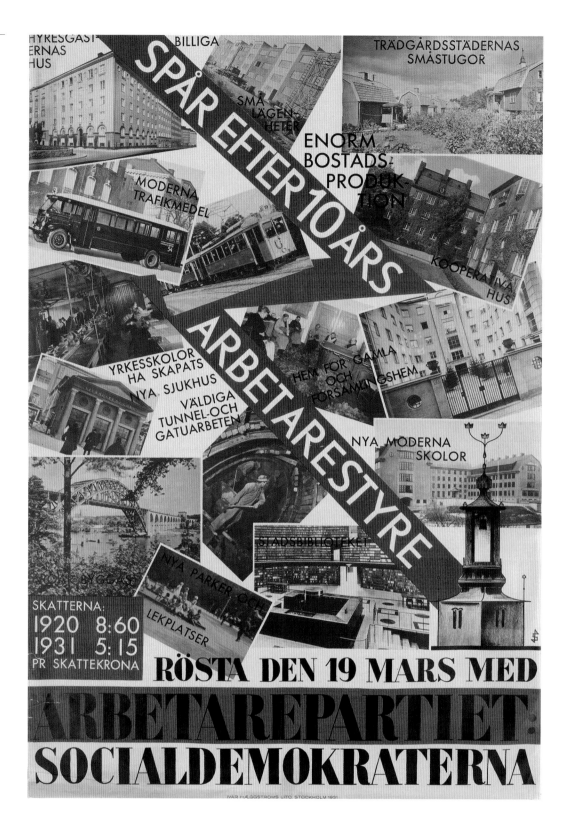

238

Poster: *Gör pengarna dryga – köp i konsum*
(*Make the most of your money – buy at
the Co-op*)
1931 (this version 1951)
Designed by Harry Bernmark and
Knut Krantz

Lithograph
98 × 67.5cm
Co-operative Union, Stockholm

This typographic poster was designed by
Bernmark and Krantz of the Svea advertising
agency, Stockholm. Remarkably simple in its use
of lower-case letters on a plain field of colour,
its primary graphic effect – the use of shadow
and perspective – creates the illusion of three-
dimensionality. This device was used to suggest
the collective power of ordinary incomes when
spent in Kooperativa Förbundet (Co-operative
Union) stores.

The Co-operative Union had been established
in 1899 to improve the access of the poor to
services and goods in Sweden.[1] While it stood
against the divisive effects of capitalism, the
co-operative recognized that advertising was
necessary to remind consumers of the benefits
of the Co-op. Employing the condensed language
of Modernist design, such posters provided a
suitably economical and ascetic identity for the
Co-operative Union, which represented another
aspect of Swedish social democracy in which
the resources of the nation were to be equally
distributed.[2] The poster still seemed so fresh
in 1954 that it was only slightly modified and
reprinted.[3] DC

1 Hugo Kylebäck, *Kooperativa ledare och livscykler, historia och
 framtid ett hundrafemtiårsperspektiv* (Gothenburg, 1999).
2 Knut Krantz (ed.), *Co-op reklam i Sverige under ett kvarts sekel*
 (Stockholm, 1955).
3 Cecilia Widenheim (ed.), *Utopia and Reality: Modernity in Sweden
 1900–1960* (New Haven 2002), p.223.

239 Plate 10.10

Stacking bowls: *Praktika* pattern, 'Weekend' decoration
1933
Designed by Wilhelm Kåge
(1889 Stockholm –1960)

Manufactured by the Gustavsberg factory, Sweden
Hand-painted earthenware
9 × 32.2 × 25.5cm (largest bowl)
Given by the maker and Helena Dählback Lutteman
V&A: C.182 to D–1988

The *Praktika* service was both a critical success and a commercial failure. It represented a significant attempt by a long-established manufacturer, the Gustavsberg factory, to address Modernist design thinking. These functional bowls, produced in high volume in a variety of sizes with interchangeable lids, were – owing to their ease of storage – the logical element of the galley kitchen in the new flat or in the communal kitchen of the *barnrikehus* (houses for families with large numbers of children). Produced in the wake of the 1930 Stockholm Exhibition, which sought to demonstrate the potential of modern design in the face of cramped housing conditions of ordinary people and matching the demotic rhetoric of Social Democratic politics, *Praktika* sought to capture the *Zeitgeist*. The stark utilitarian forms of these designs, however, failed to satisfy popular taste.[1]

Kåge, the designer of the *Praktika* service, trained as a painter in Gothenburg, Stockholm and Copenhagen between 1908 and 1912, and attended the Plakatschule (Poster School) in Munich in 1914. Under the impetus of a scheme organized by *Svenska Slöjdföreningen* (Swedish Society of Craft and Industrial Design) to place artists in industry, he began work at the Gustavsberg factory in 1917 and stayed there until 1949. Despite the bold modernity of his *Praktika* designs, Kåge was not an ideologue. In the same year he designed the popular *Pyro* service with figurative decorations and bright colours.[2] DC

1 Arthur Hald et al., *Wilhelm Kåge* (Stockholm, 1989).
2 Penny Sparke, 'Swedish Modern. Myth and reality', in Nicola Hamilton (ed.), *Svensk Form* (London, 1981), p.16.

240 Plate 1.6

Vilstol (easy chair)
Designed 1933/6
Designed by Bruno Mathsson (1907
Värnamo, Sweden –1988 Värnamo)

Manufactured by Firma Karl Mathsson, Värnamo
Laminated and solid beech, jute (webbing),
linen and wool (cushion)
80 × 52 × 112cm
V&A: W.50–2005

Swedish designer Bruno Mathsson was fascinated by the act of sitting. In designing the *Vilstol*, he sought to create a modern chair that was based on the position of the sitting body. He brought his considerable practical experience to this design problem, having been an apprentice in his father's cabinet-making firm for most of the 1920s.[1] Without stuffed upholstery, he addressed the challenge of comfort by forming the seat from bands of woven jute, an idea that he adapted from the underbelly belts used to secure saddles. The chair is also remarkably light, having been made from a laminated and bent birch frame.

Although Mathsson's anthropomorphic design and use of natural materials are widely credited with tempering the severity of Modernist design, the *Vilstol* has a clear relationship to Aalto's contemporary designs (pl.9.2, cats 164, 218). With a stable frame, economical use of materials and small number of parts, Mathsson's chair shares many of the principles underlying the design of contemporary tubular-steel furniture.

Mathsson's designs of this period enjoyed a great deal of attention. He was given a one-man show in 1936 at the Röhsska Konstslöjdmuseet (Design and Applied Art Museum) in Gothenburg and his work was well received at the Paris *Exposition Internationale des Arts et Techniques dans la Vie Moderne* in 1937. Nevertheless, he struggled to find a manufacturer willing to take on his design and so the family firm continued to make the chair in its own workshops in the postwar period, when it was adopted as a powerful icon of Swedish modern design.[2] DC

1 Ingrid Böhn-Jullander, *Bruno Mathsson, Möbelkonstnären, Glashusarkitekten, Människan* (Lund, 1992); Carl Christiansson, *Bruno Mathsson. Dikten om människan som sitter* (exh. cat., Nationalmuseum Stockholm, 1993).
2 Barbara Mundt, 'The Scandinavian Model for a new Germany', in Widar Halén and Kerstin Wickman (eds), *Scandinavian Design Beyond the Myth. Fifty years of design from the Nordic countries* (Oslo, 2003), pp.76–85.

Highpoint I (1933–5) and Highpoint II (1936–8), London

Designed by Tecton

241a

Drawing: *Perspectives and details*, Highpoint II

1936

Print with grey wash added on board
63.5 × 95cm
Royal Institute of British Architects, London (PA 120/2 (1))

241b Plate 10.20

Drawing: *Site plan showing gardens, pathways, tennis court and swimming pool*, Highpoint I and Highpoint II

Drawing by Robert C.W. Browning

*c.*1936–8

Watercolour and ink on board
39.3 × 53.2cm
Royal Institute of British Architects, London (PA122/1 (4))

241c

Drawing: *Street elevation*, Highpoint I and Highpoint II

*c.*1938

Ink on tracing paper
50 × 101cm
Royal Institute of British Architects, London (PA 122/1 (5))

241d

Drawing: *Garden elevation*, Highpoint I and Highpoint II

c. 1938

Ink on tracing paper
50 × 100.5cm
Royal Institute of British Architects, London (PA 122/1 (6))

241e Plate 10.22

Chair for Penthouse, Highpoint II

1937–8

Designed by Berthold Lubetkin
(1901 Tbilisi–1990 Bristol)

Wood, steel, cowskin seat and back, leather cushion (originally tartan)
72 × 116 × 79cm
Private Collection

Highpoint I and Highpoint II are widely regarded as the major architectural achievements of Modernism in Britain before the Second World War. Highpoint I was originally planned on another London site by Sigmund Gestetner, an office-machine manufacturer, as housing for the company's workers.[1] The commission was taken on by Tecton, a new practice founded in 1932 by six recent graduates of London's Architectural Association and Berthold Lubetkin, a Georgian-born architect with considerable experience of practice on the continent before his arrival in Britain in the previous year. Tecton and Lubetkin viewed the commission as an opportunity to demonstrate the potential of Modern movement housing theory. With its well-serviced flats and green site, the eight-storey building owed much to the concept of the vertical Garden City advocated by visionary architects such as Le Corbusier since the mid-1920s (cat.36). Double-cruciform in plan, the upper storeys contain two kinds of accommodation: larger flats along the projecting wings and smaller apartments along the central spine of the building. In contrast to the regular arrangement of space above, the ground-floor plan is composed from a flowing sequence of public areas opened up by the use of *piloti* and a ramp leading into the garden. Despite the social democratic interests of the architects, the high market value of Highpoint I flats, located in Highgate, ensured that it was occupied by aesthetically minded, middle-class residents.[2] The chic associations of this building (and its neighbour Highpoint II) were reinforced by the high quality of the land-scaping of the site, designed by Clarence Eliot, with gardens, tennis courts and a swimming pool.

When the site next to Highpoint I became available, Gestetner was prompted to commission Lubetkin and Tecton again. He was concerned not to see an alien development that would diminish the effect of Highpoint I. To assist their application for planning permission, Lubetkin and Tecton mounted a campaign against the local authorities, who had expressly forbidden another Highpoint I. The architects argued that the defining features of the new building followed well-established precedents. Permission to build was secured, albeit with restrictions. The council, for instance, required a 1.8-metre gap between the two buildings (a separation that, incidentally, emphasized the development of Lubetkin and Tecton's design thinking in the mid-1930s). Far from inhibiting the architects, John Allan has suggested that such limitations produced greater invention.[3]

Employing an architectural vocabulary of brick infill, tiled panels, floating balconies and glass brick walls, Highpoint II offers the viewer rich, textural effects, which contrast with the white walls and severe fenestration of Highpoint I. Although the actual building is less exacting in its arrangement of forms than the original designs, Highpoint II is still remarkable for its 'classical sobriety'.[4] From Lubetkin's perspective, the building marked a significant revision of a narrow functionalist view of architecture, which sought to derive architectural forms from technology and function. Some elements – not least the Erechtheion caryatids, which support the sweeping entrance canopy (pl.10.21) – were a puzzling detail even for the most loyal supporters of the 'Modern movement' in Britain.

Highpoint II also provided more luxurious accommodation than Highpoint I. Some flats are arranged over two floors, with the living room enjoying a double-height ceiling and a picture window offering dramatic views of Hampstead Heath. In this regard, the Penthouse – Lubetkin's own London home until 1955 – outstripped the flats below. In a technical sleight-of-hand, its long window can be slid into the wall, a celebration of the fact that the Penthouse offered the highest view over the capital at the time. Just as the caryatids produced unsettling effects, so Lubetkin's interior scheme (pl.10.22) contained strange visual and material devices: wall coverings included popular Pollock's theatre prints, board-marked concrete shuttering, and blown-up photographic images of microscopic marine life. The furnishings included low chairs, which looked more like soft sculpture than the kind of quasi-industrial 'tools' favoured by Modernist architects in the 1920s. Produced by Lubetkin himself, these rough-textured chairs made from yew and cowhide struck an odd and even uncanny note in the urbane setting of Highpoint II. They seemed to declare themselves as part of a tradition of sophisticated, highly designed rustic furniture. In its furnishings, Lubetkin's Penthouse displayed a distinct Surrealist sensibility within the rational shell of Modernist architectural design. Taken together, Highpoint I and Highpoint II show the rapid development of Modernism in Britain from imitation to innovation. They represent a complex, even subversive Modernism informed by non-rectilinear geometry, the natural world and Surrealism. DC

1 John Allan, *Berthold Lubetkin. Architecture and the Tradition of Progress* (London, 1992), pp.253–311.
2 Howard Robertson, '"Highpoint" Highgate', in *Architect and Building News* (10 January 1936), p.50, cited by Allan (1992), p.278.
3 John Allan, *Berthold Lubetkin* (London, 2002), p.96.
4 Peter Coe and Malcolm Reading, *Lubetkin and Tecton. Architecture and Social Commitment* (London, 1981), p.33.

241a

241c

241d

11

Ian Christie

Mass-Market Modernism

...everything necessary to the Modern Man
A phonograph, a radio, a car and a frigidaire.

W.H. Auden
'The Unknown Citizen'
(1939)

11.1 **Serge Chermayeff**,
Ekco Model EC 74 radio, 1933
(cat.250a)

Modernism in daily life and popular entertainment

As shadows lengthened at the end of the 1930s, the fate of Modernism may have seemed relatively un-important compared with the threat of the barbarism to be unleashed. Yet the world that went to war in 1939 had been significantly shaped by Modernist ideals and practices, on the political right as well as the left.[1] 'Modernism' had always meant different and often seemingly incompatible things in different contexts – from the 'something decisive' that changed around Édouard Manet's time in Paris, as evoked by T.J. Clark,[2] to the subjectivism, relativism and jagged forms of avant-garde movements before the First World War;[3] and on to the 'architecture of reason and functionalism', which Nikolaus Pevsner observed to be gaining ground in the mid-1930s.[4] Italian Modernists had welcomed war in 1915, only for some of their number to perish in it, and for most of the remainder to embrace Mussolini's fascism. Many Russian Modernists had similarly welcomed the Bolshevik revolution, which would eventually consume or silence most of those who had forged its Modernist image abroad. America would eventually shelter many of Europe's refugee Modernists in the 1930s, building the world's first museum dedicated to Modernism, but perhaps more influentially applying Modernist styling and methodology to the manufac-ture and marketing of countless products. For it was in the 1930s that Modernism became identified as a style that could be applied to all types of design. Still emphatically associated with the new and character-ized by abstraction and the use of geometric forms, Modernism was gradually stripped of its hitherto left-wing political associations and embraced by capitalism as an aid to selling.

Did this dilute or pervert the course of Modernism – or fulfil it? Much ink and rhetoric have been expended on this debate, and this is not the place to summarize. But some historical clarification is vital. By 1930 few Modernist artists and designers who had ambitions to change the course of public taste could have felt much satisfaction. The pioneering work of Modernists in France, Germany, Italy and Russia had scarcely revolutionized fine art; academicism, neo-classicism and currents of anti-Modernism were widespread, and their impact on industrial and environmental design was less than we might imagine.[5] The 'Modern movement', as it was generally known in the English-speaking world, may have been numerically small, but dynamic modernization was under way everywhere, among nations recovering from the First World War and its aftermath, and among those newly emerging. So too was the spirit of modernity, or simply the sense of living in 'modern times' – portrayed critically by Chaplin in his 1936 film that canonized the phrase, but clearly having more positive everyday connotations for the majority of the generation who had come of age since the Great War.

The major event that cast its shadow over the 1930s was the Wall Street Crash of October 1929, which precipitated financial crisis around the world, leading to mass unemployment and stoking political upheaval. While the immediate consequences of the Depression would appear to have been negative for art and design, leading to a reaction against the utopian and socialist aspirations of early Modernism, it can also be argued that the indirect effects were more positive. As industry struggled to recover, competitiveness became vital; and John Heskett has argued that 'it was in this economic context that a new generation of industrial designers emerged'.[6] In America, these included the major stylists Walter Dorwin Teague, Raymond Loewy, Henry Dreyfuss and Norman Bel Geddes, as well as the designer Russel Wright, who brought Modernism to a mass market through the department store in 1935 (pl.11.2). The rhythm of recovery was slower and more varied in Europe. In Germany, Wilhelm Wagenfeld (pl.10.17) and Walter Maria Kersting (cat.224) could be seen as adapting the Bauhaus's theoretical approach to design into a practical-production mode in their household goods. Similarly, in Finland Alvar Aalto was able to have his functionalist furniture designs commercially produced by 1935 (cat.164, pls 9.3, 9,18); in Czechoslovakia, the publishers Družstevní práce expanded into domestic tablewares (pl.1.7, cat.243); while substantial companies such as the coffee and tobacco merchants Van Nelle in Holland and Bata footwear in Czechoslovakia were implementing coherent Modernist design policies. The situation in Britain was less promising. Despite a flurry of reports and books advocating improvements in design education, and the acceptance of 'machine art' by Herbert Read in his *Art and Industry* (1934), Pevsner's report on industrial design in 1937 concluded that 90 per cent of commercial goods produced in England (excepting a few items such as Ekco and Murphy wirelesses, pls 11.1, 11.10) were 'artistically objection-able' – at least from a viewpoint shaped by the evangelical Modernism of the Bauhaus.[7]

What fuelled the attack on complacent tradition-alism on both sides of the Atlantic was a consequence of the second major historical crisis of the inter-war period: the Nazi Party coming to power in Germany in 1933. Pevsner was part of a mass emigration of German artists and intellectuals, including many key Bauhaus figures and their supporters, who would bring to Britain and to the United States a first-hand advocacy of Modernism. But was this purist Modernism compatible with the demands of an industrialized mass society? For one of the Nazi regime's victims, Walter Benjamin, mechanized media such as photography and film had fundamentally altered the very concept of art, undermining its former elitist 'cult' status and making it instead more democratically accessible and related to everyday life. Moreover, the new popular arts could change the masses' 'reactionary attitude towards a Picasso painting …into the progressive reaction to a Chaplin

movie'.[8] Another refugee from Hitler's Germany, Theodor Adorno, passing through Britain on his way to America, disagreed with Benjamin and wrote to him insisting that Modernist art and mass culture were two symptoms of the cultural crisis produced by capitalism: 'both are torn halves of freedom, to which however they do not add up'.[9] As a convinced supporter of avant-garde Modernism, exemplified by Schoenberg's serial approach to musical composition, Adorno denounced the 'culture industry' of popular media – seen as a 'nonspontaneous, reified, phony culture rather than the real thing'– which the Frankfurt School regarded as an extension of nineteenth-century capitalism's relentless drive towards commodification.[10]

Adorno's position would continue to be influential, insisting on the autonomy of the Modernist artwork, but recent critiques by Andreas Huyssen and Miriam Bratu Hansen have challenged its hierarchical absolutism.[11] Hansen in particular insists on a broader conception of Modernism, encompassing:

> a whole range of cultural and artistic practices that register, respond to, and reflect on processes of modernization and the experience of modernity … such as the mass-produced and mass-consumed phenomena of fashion, design, advertising, architecture, and urban environment, of photography, radio and cinema.[12]

What Hansen calls 'vernacular Modernism' (avoiding the loaded term 'popular'), not only reconnects with Benjamin's and Siegfried Kracauer's pioneering analyses of mass culture in Weimar Germany, but addresses the pressing issue of how Hollywood – the very epitome of Adorno's culture industry – could nonetheless spark Modernist responses in many local contexts.

Cinema was indeed the dominant mass-entertainment medium of the inter-war years, with Hollywood largely controlling the international film industry by the end of the First World War, and American business well aware of its importance, as summed up in the slogan 'Trade follows film'.[13] According to an article in *Collier's Weekly* in 1918:

> The American film … is familiarizing South America and Africa, Asia and Europe with American habits and customs. It is educating them up to the American standard of living … showing them American clothes and furniture, automobiles and homes. And it is subtly but surely creating a desire for these American-made articles.[14]

Throughout the 1920s many European countries fought back against American dominance, by means of domestic quota schemes to boost local production, and through the Film-Europe movement, which helped forge production alliances between Germany, France and Britain. But in spite of these measures, the majority of audiences worldwide watched Hollywood stars in films from the Californian dream factory – and they did so in increasingly elaborate cinema buildings, designed to transport them from mundane reality into a realm of fantasy. Few of these vast palaces of popular entertainment were any more strictly Modernist in conception than the films they showed; and yet the combination of architectural novelty with a glamorous screen image was certainly the most 'modern' experience of many people's daily

lives. Erich Mendelsohn, the architect responsible for the Universum in Berlin (1928), with its horseshoe-shaped auditorium reflected in a bold circular-drum exterior, one of the few explicitly Modernist cinema buildings, evoked this quintessential modern experience in a poem:

We spectators – one thousand, two thousand
 retinas, which soak up and reflect, each one
 happy or living an experience. Thus, no Rococo
 castle for Buster Keaton, no stucco pastries
 for Potemkin and Scapa Flow [...]
Fantasy!
Under the swinging circle of the foyer, the street
 disappears, under the conical beams of the
 ceiling lights, the haze of evening disappears.
Then – left or right pass by the beacon of the
 pay-box into the twilight of the passage –
 Here you surely meet 'them'.
Bend down in tension!
Compressor!
But then at full speed
All planes, curves and light-waves flash from
 the ceiling to the screen through the medium
 of music into the flickering image – into the
 Universe.[15]

Most new cinemas of the 1920s and many of the 1930s, however, traded in eclectic, highly decorated styles, often evoking exotic locations by means of theatrical skylines and starlit sky effects. The chief architect of the Gaumont circuit in Britain, W.E. Trent, described the New Victoria cinema that opened in London in 1930 as 'a fairy palace under the sea – a place of one's dreams, fantastic, mystical, unlike any place of one's waking experience, built in unusual form ... to produce in the spectator the proper frame of mind for relaxation'.[16]

Cinema owners were nervous about outlandish new designs discouraging audiences, but they were also commercially aware of the need for distinctiveness. Theo van Doesburg's experimental L'Aubette in Strasburg (1926–8) tried to combine the geometric vitality of De Stijl with a modern café-cinema environment (cat.80), though this could scarcely serve as a model for general cinema building. However, one developer boldly embraced Modernist decoration and architecture as the best image for a network of specialist cinemas showing only newsreels and documentaries. Not having star names and well-publicized titles to display, Reginald Ford's Cinéac theatres had to catch the attention of passers-by, including railway passengers at their station venues, and took the

11.3 **Erich Mendelsohn**, Auditorium of the Universum Cinema, Berlin, 1928. Bildarchiv Preussischer Kulturbesitz

11.4 **Johannes Duiker**, Cinéac
'Handelsblad', Amsterdam,
1933–4. City Archives
Amsterdam

11.5 **Gerrit Rietveld**, Vreeburg
Cinema, Utrecht, 1936.
Centraal Museum, Utrecht

11.6 **Andrew Mather** with
Harry Weedon, Odeon
Cinema, Leicester Square,
London, 1937. Allen Eyles
Collection

newspaper headline as their model.[17] With 12 theatres in France and a similar number elsewhere in Europe, opened between 1931 and 1939, the Cinéac concept showed exceptional unity of form and function, and with one theatre at least – Johannes Duiker's strikingly vertical Cinéac 'Handelsblad' in Amsterdam, the corner site of which faces the rococo extravagance of the Tuchinsky theatre – demonstrated the possibility of cinema offering an integral Modernist experience of factual film seen in a rationally efficient building.[18]

The mutation of Expressionist into Modernist architecture that produced Mendelsohn's Universum also led Hans Poelzig to design the neo-classical octagonal drum of the Capitol in Berlin (1926) and Rudolf Frankel the curving stripes of the Scala Cinema in Bucharest (1937). This streamlined curving motif would reappear often in cinema design during the 1930s in the United States and Britain – to the disgust of Modernists such as Pevsner – forming part of a vernacular style that came to be known as the 'moderne'.[19] The leading cinema architect of this period in Britain was Harry Weedon, who was responsible for many Odeon cinemas in suburbs and provincial towns during the frenzy of cinema-building that marked the decade. *Pace* Pevsner, a more enthusiastic recent account of these 'fantastic, landmark buildings' draws attention to their avoidance of excessive decoration and their use of both streamlined decks and narrow towers, to 'position the cinema in an often featureless suburban landscape in which the bright neon lights and expressionistic fins and towers enjoyed a virtual monopoly on the skyline'.[20] Massive architectural lettering would play a bigger part in the equivalent American movie theatres, many designed by S. Charles Lee, while their illuminated towers would redefine the small-town main street. Light – the very medium of cinema – also played a vital part in some of the most ambitious cinema designs, from the illuminated signage that dominated Gerrit Rietveld's Vreeburg cinema in Utrecht (1936, pl.11.5) to Weedon's and Andrew Mather's Odeon Leicester Square (1937, pl.11.6), which attracted attention by day through its austere black stone facing, only to 'reverse' at night, when its physical bulk disappeared, giving way to an architecture of neon and illuminated signage.[21]

Cinema's adoption of synchronized sound during the late 1920s not only encouraged the boom in new building, but also provided a stimulus for local production in many countries. Audiences throughout Europe wanted to hear their own language spoken and sung on screen and, with quotas introduced to limit American imports in many countries, the film

11.4

11.5

11.6

industries of Britain, Germany, France and – under the very different conditions of Stalin's first Five-Year Plan – Russia enjoyed unaccustomed popular success.[22] The new technology of 'the Talkies' was a big selling point, yet it was the musical that emerged as a major genre, creating new stars with strong national and occasionally international appeal.[23] The London-born Lillian Harvey became Germany's greatest musical comedy star, while Maurice Chevalier appeared in both French and American films. The Polish opera singer Jan Kiepura became an international star of the early 1930s musical when he appeared in 'multinational' versions of such films as *My Heart is Calling You* (1934). But the musical also promoted two significant new trends that made 1930s cinema an agent of modernization. A new kind of working-class heroine became popular, often featured in a working situation. Gracie Fields played a Lancashire mill-girl in such British musicals as *Sally in Our Alley* (1931) and *Sing As We Go* (1934); Lyubov Orlova also portrayed a worker in the immensely popular Russian musicals *Volga-Volga* (1938) and *The Shining Path* (1940); and Ruby Keeler most often played a New York chorus-girl in backstage musicals such as *42nd Street* (1933), *Footlight Parade* (1933) and *Dames* (1934).

The work of the supreme choreographer of the backstage screen musical, Busby Berkeley, has often been described as machine-like, with the bathing beauties of *Footlight Parade* creating a giant zip-fastener tableau, and the precision-drilled rotating chorus lines of *42nd Street* forming the image of gear-wheels.[24] The tyranny of the assembly line and the enslaving machine would be satirized in René Clair's *A nous la liberté* (*Liberty for Us*, 1931) and Chaplin's *Modern Times* (1936). Perhaps paradoxically it was apparently escapist musicals from Hollywood, Mosfilm and Ealing that would screen for the first time the working life of women – a key feature of society since the First World War – that cinema's audiences knew only too well, albeit in an optimistic fantasy version that fitted well with the mood of recovery following the Depression.

The other contrasting role that Hollywood cinema played during the 1930s was to create and circulate highly attractive images of Modernist decor and dress, effectively promoting these as part of an integral style associated with glamour and success.[25] In the smart hotels and apartments that are the main settings for the Astaire-Rogers RKO musicals, from *Flying Down to Rio* (1933) to *Swing Time* (1936) and *Carefree* (1938), the style of dancing required large, unfussy sets to be seen in long-shot; and with Astaire in dark formal dress, these settings were predominantly white.[26] Certainly the detailed styling is often Art Deco or playfully exotic, but these films are above all about movement; and what is distinctively modern is Astaire's and Rogers's dynamic mastery of spaces that would otherwise merely signify the playgrounds of the rich or the citadels of the Establishment. In these unlikely settings, through 'a kind of divine frenzy … with the spirit to find freedom from social restraint',[27] Astaire and Rogers extended the range of Modernist dance that had originally been opened up by Sergei Diaghilev, especially in his collaborations with Darius Milhaud and Sergei Prokofiev.[28]

With growing scenic ambition and the technical demands of sound and, by the mid-1930s, colour, new film studios were needed; and these sprawling complexes, part factory and part city, became emblematic of the 1930s.[29] In Russia, Stalin planned a Soviet 'Cine-City' to be built in the Crimea, and Mussolini created the Cinecittà studios on the outskirts of Rome. Germany's studios were the first in Europe to be fully equipped for sound; while in Britain, where studios remained small and technically backward, Alexander Korda persuaded the Prudential insurance company to finance a completely modern development at Denham, which would house his futuristic epic *Things to Come* (1936). Meanwhile Hollywood continued to expand, not only physically and economically, but also in the global imagination, as writers, artists and celebrities succumbed to the fascination of 'the dream factory' as the very epicentre of modernity.

The visible and the invisible: photography, radio and television

Cinema may have captured the world's attention, but other communications media had undergone dramatic development by the beginning of the 1930s. The oldest of these, photography, had already passed beyond both its initial acceptance as 'art', through the efforts of the Pictorialists, and its recognition as modern art in the hands of Alfred Stieglitz, Alvin Langdon Coburn and Man Ray (cat.51); as well as its democratization at the end of the nineteenth century by George Eastman, with his popular Kodak box cameras. Taking photographs was now within the reach of almost all. The new trend, however, was towards miniaturization and concealment of the process. After the German Leitz company launched its Leica in 1925, a compact all-metal design by Oscar Barnack that used perforated 35mm cinema-type film (pl.11.7), other manufacturers responded with variations on the concept, including the Ermanox (pl.11.8) and Zeiss-Ikon's Contax, all with a range of interchangeable lenses. Further miniaturization was demonstrated by Walter Zapp's Minox from Latvia (cat.259) and by the Compass camera (both 1937–8), made from aluminium by a Swiss watchmaker to the design of the English inventor Noel Pemberton Billing (cat.258).

These ultra-miniatures were soon linked to the idea of clandestine picture-taking and espionage. But the Leica and its competitors ushered in a new aesthetic of photography born of the technical parameters of the 35mm camera – a prime example of form following function. Small and inconspicuous, they could be used in situations unsuited to bulky cameras; and with panchromatic emulsion and faster

film speeds, they produced pictures well suited to magazine reproduction. Photographers such as Felix H. Man (using the Ermanox), André Kertesz and Henri Cartier-Bresson (both Leica users) employed them to capture fugitive situations in a dynamic manner, which lent itself to a new kind of illustrated magazine. The prototype for this was the Munich *Illustrierte Presse* (*Illustrated Press*), started in 1928 by a Hungarian former film-maker, Stefan Lorant. Forced into exile in Britain in 1934, he launched and edited a series of illustrated magazines, including *Lilliput* and *Picture Post* (1938) (pl.11.9), before moving to the United States and working on illustrated books. In America, Henry Luce's *Life* magazine (from 1936) also promoted the rise of what became known as 'photojournalism', treating the personal response of the photographer not as mere illustration, but as the main journalistic thrust of its coverage.

The Modernist vision of a new syntax of photography combined with a reformed typography was proclaimed in Russia by artists associated with the Lef group through the journal *Kino-Fot* (*Cinema-Photo*) which featured work by Varvara Stepanova (cat.73b) and Alexander Rodchenko, and in Germany at the Bauhaus by László Moholy-Nagy, whose book *Painting Photography Film* appeared in 1926 as a manifesto for his concept of Typofoto.[30] Although its emphatic use of typographic elements, such as rules and circles, to make the page a kind of filmic script would not reach the western mass market, Moholy's and colleague Herbert Bayer's concept of a dynamic page layout, treating both photographs and text as design elements (cat.117), would have an influence on popular magazines such as *Life* and *Picture Post*. The most spectacular use of this new design syntax would be in Russian posters and public art of the late 1920s and early '30s by Rodchenko, Stepanova, the Stenberg brothers and many others, before a naturalistic realism became the Soviet norm in the mid-1930s. But the idea of photographic reportage, and of newsreel or documentary as a new way of seeing, had become deeply influential by the end of the decade (see Chapter 8). The American novelist John Dos Passos interspersed a series of 'newsreels' throughout his widely admired *U.S.A.* trilogy (1938) and told its most personal story through the 'camera eye',[31] while Christopher Isherwood would reflect the photographically aware culture that he had known in Germany in the still-famous framing device of his 1939 novel *Goodbye to Berlin*:

> I am a camera with its shutter open, quite passive, recording, not thinking. Recording the man shaving at the window opposite and the woman in the kimono washing her hair. Some day, all this will have to be developed, carefully printed, fixed.[32]

Another, still newer medium – radio – played an important part in defining modernity in the inter-war period. Ezra Pound composed two experimental radio 'operas' for BBC radio in the early 1930s; and in Isherwood's and Auden's experimental play, *The*

11.7

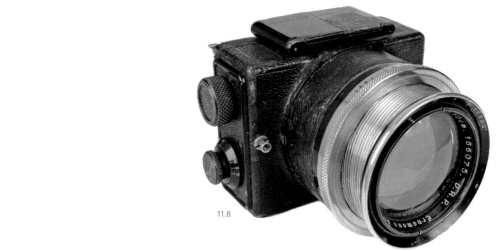

11.8

11.9

11.7 **Oscar Barnack**, Leica camera, 1925 (cat.257)

11.8 Ermanox camera, 1924–5 (cat.256)

11.9 *Vu*, 1931, *Life*, 1936, and *Picture Post*, 1939 (cat.255)

Ascent of F6 (1936), radio broadcasting stands for the alienation of the modern masses, reporting the exploits of climbers in distant colonial 'Sudoland' to a domestic audience starved of excitement in their drab lives.[33] Auden went on to write a radio documentary for the BBC regional service in 1937, and both he and Isherwood spoke on radio and on the BBC's experimental television service in 1938 about their visit to China, contributing to the sense that radio was the most 'modern' of all communications media – instantaneous, immaterial and global in its reach.[34]

Radio had emerged after the First World War from its incubation phase as a technological wonder sharing some of the eeriness originally associated with photography and film – an early experience of hearing the disembodied voice was described as 'Angels singing in the air', and Rudyard Kipling associated it with mediumship in his story 'Wireless' – to become a powerful new force requiring national and international regulation.[35] The regular broadcasting of programmes began first in the United States after the end of wartime restrictions and was well established by 1922, with two major corporations, RCA and AT&T, seeking to dominate the new industry and the 500-plus stations that were operating.[36] Lenin's enthusiasm for modernization ensured that radio was a high priority after the Russian Revolution, and by 1921 a powerful transmitter was operating in Moscow, with programmes mainly received through communal loudspeakers.[37] Regular broadcasting programmes were launched in Britain, Czechoslovakia, Germany and France between 1922 and 1923, with Britain alone adopting an arms-length monopoly model for the new industry through the BBC.

The initial impetus to provide regular services came from equipment manufacturers (except in Soviet Russia) seeking to promote sales of the radio receiver or 'wireless'. Rapidly expanding demand led to many decorative variations on what is essentially a box containing and protecting sensitive electrical equipment. The earliest receivers resembled scientific instruments, with controls occupying most of their horizontal fascias; and an early 1927 Philips model (attributed to Louis Kalff) consisted of a control unit with separate free-standing loudspeaker. An intermediate stage was represented by the English furniture designer R.D. Russell's elegant 1930 plywood casing for Murphy radios, which placed the speaker to one side, with a tuning dial and three knobs arranged in a regular pattern on the other. But gradually the radio set became more vertical, as headphones gave way to loudspeakers and the need for a porous panel covering these invited decoration – which, given that the rise of radio coincided with the international vogue for the style of decorative Modernism then known as the 'moderne' (and only later as Art Deco), was most often in some version of this ubiquitous style.[38] With the radical circular shape echoing the round loudspeaker and making full use of the new plastic Bakelite for its moulding, the set

designed by Wells Coates for Ekco in 1932 demonstrated the new direction in which Modernism was moving. Another Ekco set designed by Serge Chermayeff followed the basic box shape, using Bakelite for rounded corners and making the speaker panel and dial functional design features.

A more radically Modernist plastic cabinet design by Walter Kersting from Germany in 1928 served as the (unauthorized) basis of the National Socialist 'People's receiver' (*Volksempfänger*) of 1933 (cat.224), which would form part of a series of 'people's' designs introduced by the Nazi regime. In Russia, similar propaganda priorities produced both the functionalist SI-235 model (1935) and a series of Art Deco-styled models clearly intended to appeal to the emerging Soviet bourgeoisie. Elsewhere, as the first widely adopted domestic electrical gadget intended for the sitting room (gramophones were still clockwork), radios were often disguised to look like furniture – in contrast to the generally functional cabinet shape of the kitchen refrigerator. Pioneering demonstrations of television began in Britain with John Logie Baird's disc system, leading to the prototype Emitron television camera.[39] But with only limited experimental television services operating in Britain, Germany and America before the outbreak of war, there was little scope for television receiver design to develop – even though the idea of remote imaging had been a staple of popular entertainment from the French crime serial *Fantômas* (1912) to the American newspaper comic-strip *Buck Rogers* (1929).

11.10 **Wells Coates**, Ekco radio AD-65, 1932 (cat.250b)

11.11 Model of the Douglas DC-3 aeroplane, 1938 (cat.267)

Meanwhile, the 'invisible' medium of radio had already made its mark in architecture, with such landmark buildings as Broadcasting House in London and Radio City Music Hall in New York, both combining Art Deco elements with the functional demands of broadcasting.

Transport and travel: speed and treamlining

The pioneers of Modernism had instinctively incorporated new forms of transport into their polemical manifestos. Speed, represented by the automobile, is hymned in the original Futurist Manifesto (1909); and in *Vers une architecture* (*Towards a New Architecture*, 1923) Le Corbusier declared that steamships, aeroplanes and motor cars could not but transform the architecture of the future.[40] In spite of economic and political crises, the inter-war period saw a preoccupation that amounted to obsession with speed and distance. New records for speed on land, water and in the air were set with dizzying frequency. Between 1919 and 1939 the land-speed record rose from 150 mph to 370 mph (240 to 590 kph), while the air record went from 170 to 470 mph (275 to 750 kph). Prizes and trophies stimulated competition, and while the technical innovation that was involved transformed

both engine construction and aerodynamic design, the exploits of pioneer drivers and especially flyers captured the world's imagination as they were enthusiastically reported by newspapers and newsreels. Pilots became the new hero-figures of Modernism, celebrated by poets and film-makers alike.[41] Charles Lindbergh established the real-life template for these new celebrity heroes when he achieved the first non-stop transatlantic flight in 1927 with a single-engined monoplane funded by a consortium of Midwestern businessmen. Lindbergh not only collected a prize offered by a New York hotelier, but earned enduring fame – as would other aviators, such as Amy Johnson, the first woman to fly from England to Australia in 1930, and the Russian Valery Chkalov, fêted for his trans-polar flight from Moscow to Vancouver. In the mid-1930s the wealthy Howard Hughes designed a radically streamlined speed plane, the H-1, to take the world air-speed record in 1935, and led a four-man crew to set a new round-the-world record in a modified twin-engined Lockheed Electra.

The link between such celebrity and progress in commercial aircraft design is clearest in the case of Hughes, who shrewdly combined the publicity resulting from his records with profitable ventures into airline operation and aircraft design. However, the first true commercial passenger plane, the German

Junkers F-13, already marked an important design achievement in 1919. Instead of the hitherto common style of wooden framed biplane covered in canvas, the Junker was a monoplane built entirely of lightweight aluminium alloy with a distinctive corrugated covering. More than 300 of these aircraft were built during the 1920s and their reliability encouraged the growth of commercial air services throughout Europe. In America, the Boeing company launched its streamlined all-metal passenger plane, the Boeing 247, in 1933, but its competitor, the Douglas DC-1, would prove even more successful when it entered service with TWA later the same year, and inaugurated a series of DC models that became the most widely used commercial aircraft in the world over the next three decades.[42] The DC concept moved on from the Junker's box fuselage and cantilevered wings to use a streamlined monocoque structure, with the wings moulded into the fuselage and an overall stressed-skin aluminium covering (pl.11.11). According to a pilot taking part in the London–Melbourne race of 1934, both the Douglas and Boeing entries demonstrated an 'aerodynamically clean ... advance over all contemporary design'.[43]

While aviation increasingly developed as a business in America, it still carried strongly political overtones in Europe. The Schneider Cup races,

inaugurated before the First World War in order to promote seaplane development, became a battle for national supremacy during the 1920s between Italy, Britain and America, attracting vast crowds of up to a quarter of a million spectators and wide media coverage. Speeds rose rapidly as each country developed ever more powerful streamlined racing seaplanes for the competition, before Britain managed to win for the third consecutive time in 1930, though only due to the intervention of a private sponsor who financed a new design. The winning design would eventually lead to the Supermarine Spitfire, a key Second World War fighter, while Italian interest in aviation would stir veterans of the Futurist movement to publish an *Aeropittura* (Manifesto of Aeropainting) in 1929 and promote a school of painting, at once bombastic and mystical, though also distinctly Modernist, which reflected the popular appeal of flying (pl.10.13).[44] Some *aeropittura* works also anticipated the sinister role that flight would play in present and future wars: Tullio Cral's 'Nosediving' pictures of 1939 can hardly be divorced from the contemporary accounts of Junker's 'Stuka' dive-bombers supporting the German Condor Legion in Spain in 1937.[45] Nor can the fact be overlooked that both of Leni Riefenstahl's major documentaries promoting National Socialism, *Triumph of the Will* (1935) and *Olympia* (1938, pl.8.8), begin in the air, before their heroes are delivered to Earth.

Although the monoplane was the key aircraft type that developed between the wars, there were plenty of rivals exploiting older principles that offered different modes of flight and visions of modernity. The autogiro used a rotating wing or vertical propeller similar to that originally envisaged by Leonardo da Vinci in the fifteenth century; while the gas-filled airship or dirigible represented the modernized form of the traditional hot-air balloon. Both of these allowed hovering and variations of speed and direction, unlike the aeroplane; and the Zeppelin seemed throughout much of the 1930s to point the way towards an alternative form of aviation, combining the luxury of the great passenger liner with a stream-lined near-silent serenity, unlike its immediate competitor in luxury travel, the flying boat.[46] Despite the loss of the British *R101* on her maiden flight in 1930, airships flew successfully until the explosion of the *Hindenburg* in 1937 ended the airship dream (pl.11.12).[47] During the same period rocketry was still in its infancy, yet the pioneering work of Konstantin Tsiolkovsky in Russia, Hermann Oberth and Wernher von Braun in Germany and Robert Goddard in the United States pointed towards the realization of another ancient dream through modern technology. Although von Braun's programme would lead to the V-1 and V-2 military rockets used by Germany against Britain, most rocket research was inspired by the idea of space exploration, already envisaged by Jules Verne and H.G. Wells at the turn of century and further celebrated in popular films such as *Aelita* (1924), *The Woman in the Moon* (1929) and *Things*

to Come (1936). In the era of speed and streamlining, what had hitherto been science fiction was fast becoming reality.[48]

Passengers v. drivers: public and private transport

Travel in the air, and even by sea, remained the privilege of the few – apart from the huddled masses of immigrants who continued to reach America – during the inter-war years. But everyday transport was changing, in response to the widespread demand for urban modernization, and it provided yet another means by which Modernism entered the daily lives of large numbers of people. The electric tramways that had appeared in many cities around the world in the decade before the First World War began to be replaced or supplemented by rubber-tyred trolley buses during the 1930s; and the even older under-ground railway systems urgently needed modernization. The oldest of these, London's Underground railway network, had grown haphazardly between 1863 and 1915, but in 1933 it came under a single body charged with coordinating all forms of transport, the London Passenger Transport Board (LPTB). Under the leadership of Frank Pick, who had a long-standing interest in design, the LPTB became a major force in promoting integrated design across all its activities, with a marked bias towards Modernism.

11.12

11.13

The most visible results of this policy included Edward Johnston's boldly geometric Underground logo and sans-serif typeface, a diagrammatic Tube map by Harry Beck developed between 1931 and 1934 (cat.261) and bus-stop signs designed by Hans Schleger in 1935. Pick also encouraged the systematic display of posters in the Underground and promoted Modernist design through his choice of designers such as Edward McKnight Kauffer, Abram Games and, after he was forced to leave Germany, Moholy-Nagy. After travelling with Pick to Germany, Sweden and the Netherlands, the architect Charles Holden produced a prototype for a new Underground station design, which would be used on the extension of the Piccadilly Line to the north and west during the 1930s. Stations such as Sudbury Town, Turnpike Lane, Bounds Green, Southgate and Arnos Grove (pl.11.13) used striking cylindrical and rectangular structures, with exposed brickwork – and, in the case of Hammersmith, an early use of bare concrete – and

meticulously designed fittings, making them the first series of Modernist public buildings in Britain. Pick's belief in integrated design extended to the commissioning of new rolling stock, with technological novelties such as pneumatic doors, and to its interior decoration, using designers such as Marion Dorn, Enid Marx and Paul Nash to create modern patterns for the moquette seat-covering. Pick was putting into practice Modernism's underlying principles on a scale that none of its pioneers could have imagined. As Charlotte Benton has written: 'Pick was committed to a particular view of the relationship between architecture and civic responsibility, to the need to provide organization, definition and focus to an otherwise uncontrolled urban scene, through a consistent, dignified and instantly recognizable image.'[49]

In this, Pick can be compared with other managerial figures of the era, notably John Reith at the BBC, the documentary film producer John Grierson and the

head of Shell-Mex advertising, Jack Beddington – all committed to projecting holistic identities for their new and forward-looking institutions. Ironically, having brought the elements of Modernist design to Britain, Pick was invited to advise on the development of the Moscow underground system in the early 1930s – a system that would eventually become best known for its flouting of Modernist economy in a proliferation of extravagantly decorated thematic stations. But the lasting influence of Pick's unifying approach is to be found in many post-war metro systems, where signage and navigation, often based on Beck's 'circuit diagram' concept, and architecture pay tribute to Britain's unlikely pioneering of the modern metro.

Underground trains were not the only rail development during the inter-war years. Faced with a decline in business due to the Depression and rising automobile use, American train operators launched the 'streamliner' in 1933. Union Pacific's M-10000 and

11.12 **Jupp Wiertz**, Poster, *2 Days to Europe*. Offset, 1937. The Wolfsonian-Florida International University, Miami Beach, Florida

11.13 Exterior of Arnos Grove Underground station, London, 1933. London's Transport Museum

11.14 **Edward McKnight Kauffer**, Design for a petrol-pump top, Shell-Mex, 1934 (cat.264a)

11.15 **Edward McKnight Kauffer**, Design for a printed advertisement, Shell-Mex BP, c.1937 (cat.264b)

11.14

11.15

the Burlington Railroad's Zephyr were both oil-fired and made of stainless steel, but it was their dramatic streamlined profile that made the greatest impact. Although streamlining offered aerodynamic advantages, helping to boost speeds and cut fuel bills, the consensus view is that it played a vital part in attracting passengers back to the railways and in modernizing the image of rail travel.[50] Different forms of streamlining appeared in different countries: the German 'flying Hamburger' was introduced in 1933, followed by a wedge-fronted locomotive designed by Ettore Bugatti for French State Railways in 1934 and Nigel Gresley's teardrop-shaped Mallard for the British LNER company, which later set a new world speed record for steam locomotives of 126 mph (203 kph) in 1938. Further afield, Japanese and Russian manufacturers contributed to the 1930s fashion for streamlined trains in a syndrome that reversed Modernism's insistence on function influencing form, since many of the newly encased locomotives were made harder to service by their streamlined fairings. Yet their emblematic modern look attracted passengers and even spectators, helping to reinvent the first harbinger of the industrial age.

The inter-war years also saw remarkable diversification and democratization of the railway's original competitor, the motor car. Even before the First World War, the open sports car had become an icon of modernity, written into such diverse texts as Kenneth Grahame's *Wind in the Willows* (1908), in which Mr Toad discovers the joys of speeding along country roads, and the Futurist Manifesto of 1909, which proclaimed that a racing car 'that seems to ride on grapeshot is more beautiful than the *Victory of Samothrace*'.[51] After the war, sports and luxury motoring expanded dramatically, with racing and rallying becoming mass spectator attractions. Special racing circuits were built across Europe, with the first Italian Grand Prix taking place at Monza in 1922, followed by race tracks near Marseilles and at Spa-Francorchamps in Belgium in 1925. Road racing was popularized by the Le Mans 24-hour endurance race, established in 1923 to promote better lighting for standard-production cars, and by the *Mille Miglia*, covering 1,600 kilometres, which drew attention to the poor state of Italian roads. The Italian-born Bugatti dominated the racing and luxury-car business, with the first Monaco Grand Prix in 1929 being won by one of his cars. But other manufacturers saw the potential of motor sport to publicize their standard models: in 1930 Alfa Romeo appointed a specialist company headed by Enzo Ferrari to manage their racing, while the German Mercedes and Auto Union companies began to dominate racing in the 1930s, with growing state support after 1933. Speed – the original Futurist dynamic – had been effectively commodified and branded; and images of motoring would become among the most potent Modernist motifs of the inter-war years, reaching a wide audience through the popular press and newsreels.

11.16 Burlington Zephyr streamlined passenger train, 1934. Museum of Science and Industry, Chicago

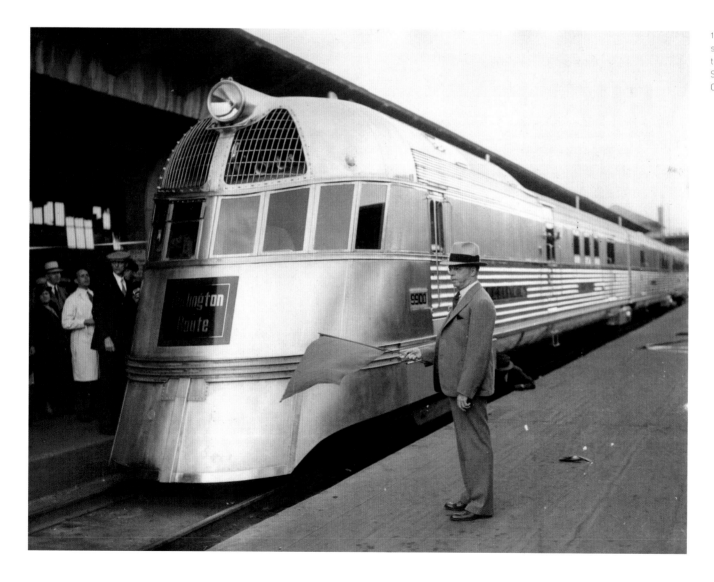

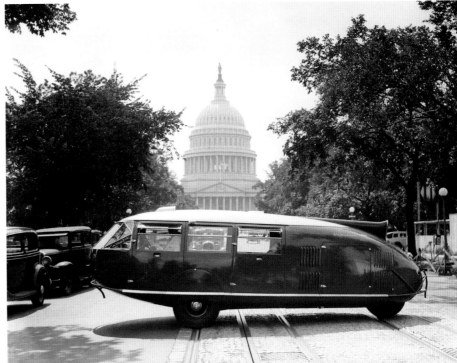

11.18

11.17

Rapid post-war developments in engine power and aerodynamic design made possible a sustained attack on the land-speed record, which stood at 125 mph (200 kph) in 1914. After formal rules for the record were established in the 1920s, a quartet of English drivers dominated the competition for 15 years, using courses at Daytona Beach in Florida and later the Bonneville Flats in Utah. Malcolm Campbell held the record nine times, in a succession of vehicles all named *Bluebird* (after Maurice Maeterlinck's play, pl.11.17), eventually retiring when he reached 300 mph (483 kph) in 1935. Henry Seagrave briefly gained the record in his *Golden Arrow* in 1929 (pl.11.17) and like Campbell also sought the water-speed record, which led to his death in 1930. Then George Eyston took Campbell's land-speed record to over 350 mph (563 kph) in the *Thunderbolt* during 1937–8, before John Cobb fell just short of 400 mph (644 kph) in 1939 and again in 1947, in what would be the last records achieved with internal combustion engines.[52] Although the land-speed record competition originally grew out of racing-car design, it later drew on aircraft engine and fuselage development, as well as contributing to boat design as the three speed records became intertwined. The competitors were household names, a new kind of hero combining technological expertise with reckless bravado; and the image of the speed car – reaching its culmination in Cobb's teardrop-shaped Railton – combined the era's fascination with ever-increasing engine capacity and aerodynamic streamlining.

Streamlining would also find its way into the developing market for automobiles aimed at ordinary consumers, although this market was very different in America compared with the rest of the world. Henry Ford's basic Model T had created a nation of private car owners since its launch in 1908 – as well as inspiring the mechanized assembly line that became modernity's defining image – and by 1920 it accounted for 2.3 million of the 2.4 million cars being sold throughout the world. The second-largest producer, France, sold 40,000 per year and Britain's output stood at 25,000. By the end of the decade the US domestic market was saturated, with 4.5 million cars sold in 1929, and after the Model T had been discontinued manufacturers began to compete with models offering greater comfort and style. Ford's rival, General Motors, invested heavily in a Styling Section, led by Harley T. Earl, while the other member of the 'big three' auto companies, Chrysler, launched its striking 'Airflow' saloon design in 1934. Less radical than Buckminster Fuller's oval Dymaxion car – a true specimen of 'native' American Modernism (pl.11.18), shown at the Chicago World's Fair in 1934 – the Airflow was not the commercial success Chrysler intended, but it helped to establish streamlining in the mainstream of American automobile design.

Although car ownership in Europe remained far below American levels, it rose rapidly during the inter-war period, boosted by cheap mass-produced models from Fiat, Citroën, Morris and other companies. Advertising played a major part in selling private motoring to the middle classes, and provided an outlet for Modernist designers; while newsreels and fiction films embedded motoring within a conception of modern, mobile life. The most 'modern' bodywork

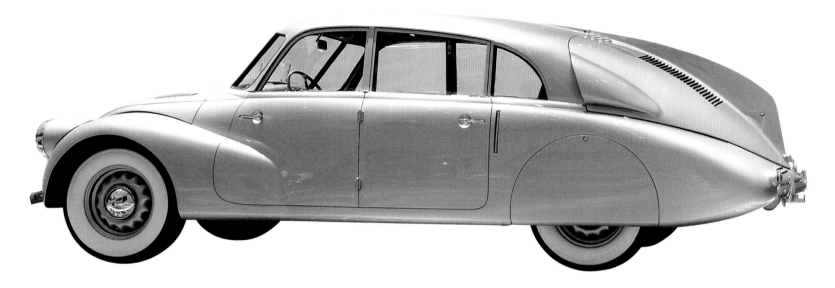

designs were generally those of open sports cars, such as the BMW 328 and various MG models, but two saloon designs stood out for their radical styling and engineering. The Czech Tatra company, which had been making railway carriages and cars since the turn of the century, began in around 1930 to explore the combination of a rear-mounted engine and aerodynamic bodywork to improve performance. In 1934 an unusual six-seater saloon emerged, the T77, with the driver seated centrally and a stabilizing fin above its V-8 engine, which produced a top speed of 140 kph. This was a luxury car, as was the more compact T87 of 1937 (pl.11.19), but only the German annexation of Czechoslovakia in 1938 prevented the more compact T97 from becoming a truly modern 'people's car'. Tatra's production was halted to give greater scope for Ferdinand Porsche's *Volkswagen*, another rear-engined streamlined sedan, which had been in development in Germany at Hitler's request since 1933 (pls 10.18–19).[53] The outbreak of war in 1939 curtailed mass production of Porsche's KdF-wagen, but this resumed under Allied supervision after the war and launched the Volkswagen Beetle as one of the most successful products of 1930s Modernist industrial design for the mass market, combining engineering efficiency with innovative functional styling.

The vision of motoring as a popular new form of recreation was common to many in Europe during the 1930s, and even further afield in Japan, where the government acted in 1936 to boost domestic car production.[54] Mussolini and Hitler built impressive

new road systems that were widely admired, even by their political opponents, and insisted on cheaper cars for a public that had hitherto regarded these as luxury items. In Britain, where annual car production had increased from 25,000 in 1919 to 340,000 by 1938, tyre and especially oil companies ran imaginative advertising and promotional campaigns to stimulate recreational motoring. Shell-BP advertising (pls 11.14–15), led by Jack Beddington, engaged leading Modernist designers and artists as well as traditionalist fine artists to design posters, in addition to producing the surprisingly experimental film by Humphrey Jennings and Len Lye, *Birth of a Robot* (1936), which animated the Shell 'robot' figure in colour; their County Guides also made innovative use of photography and design to offer a new appreciation of English landscape in the age of motoring.

At home with Modernism?

The shattered world that Modernism proposed to rebuild after the First World War had been transformed in some ways by the late 1930s, but in others had scarcely changed since the nineteenth century. It is salutary to see in one of the key films of the British documentary movement, *Housing Problems* (1936), interviews with ordinary Londoners living in Dickensian squalor, before being shown gleaming new blocks of flats in which some at least were to be rehoused. While a very few could aspire to live in almost wholly Modernist surroundings – such as

the 'minimum flats' of the Isokon building in London, designed by Wells Coates and with furniture and decoration by leading Modernist designers and artists (pl.9.3) – the vast majority inevitably continued to live in surroundings and with artefacts that remained largely untouched by the new spirit.

Or did they? The new media of radio and sound cinema, by the very nature of their diffusion and reception, brought messages of modernity – vastly increasing the horizons of their audiences, keeping them abreast of new technologies, new styles, new ideologies. The role of cinema to deprovincialize those living far from metropolitan centres, and to stimulate an appetite for new experiences and new products, should not be underestimated – and was indeed highly valued in both America and Soviet Russia, as well as in Mussolini's Italy and Hitler's Germany. Advertising also became a more dynamic and pervasive experience, with traditional wall posters supplemented by new sites, including hoardings and, controversially, underground stations, and the enthusiastic use of Modernist designers by many commercial as well as public clients. German, Czech, Dutch and Scandinavian industries were among the first to grasp the importance of coherent design policies, including product design, packaging and advertising, to build a brand's contemporary image.

Even before Hitler's anti-semitic policies drove many German Modernists abroad after 1933, bringing an inadvertent art and design bonus to Britain and

11.20 *Britain by Mass-Observation*, Penguin Books, 1939 (cat.248)

11.21 **Philip L. Goodwin**; **Edward Durrell Stone**, The Museum of Modern Art, New York, 1939. The Museum of Modern Art, New York

11.21

11.20

America, there were moves to modernize industrial design in these countries. In addition to such enlightened patrons as Pick and Beddington, the designer Ashley Havinden, as art director at Crawford's advertising agency in London, was able to promote graphic styles and whole campaigns that used a Modernist vocabulary.[55] Committees, association and trade exhibitions began to popularize new techniques and styles, especially the use of photography and the adoption of geometric motifs and sans-serif typefaces. Publishers played an important part in naturalizing such styles when they adopted them as branding. Allen Lane's Penguin imprint linked uncompromising modern typography (in Gill Sans) and flat colour in its influential series of cheap paperbacks (pl.11.20); and Victor Gollancz's Left Book Club similarly used the austerity of typography and colour alone to suggest the serious nature of the club, which had a surprisingly large membership.

Though Pevsner found Britain shockingly backward, 'industry gradually came round to accepting Modernism as a code for progress'.[56] But when

Herbert Bayer, László Moholy-Nagy, Alexey Brodovitch and other leading Modernists arrived in America, they accelerated a revolution already under way in product design, graphics and advertising, as well as influencing the training of future generations of designers through teaching. Publications as diverse as *Harper's Bazaar* (designed by Brodovitch for more than 20 years), *Life* and *Popular Mechanics* all promoted versions of modernity and helped to develop an American Modernist idiom. Meanwhile, the major design consultancies run by such star figures as Walter Dorwin Teague, Raymond Loewy, Henry Dreyfuss, Norman Bel Geddes and Jean Reinecke worked for a wide variety of clients, and in doing so imprinted their styles on many everyday products. Reinecke's Scotch Tape dispenser of 1939 (pl.11.22) is a case in point, elegantly combining an industrial material with the most functional form of packaging in a modern classic that has become so ubiquitous as to appear anonymous, even invisible. Dreyfuss's 1937 Bell telephone receiver has a similar quality of seeming inevitability – as have many of the

more specialized designs for new technology of the period, such as spark plugs, radio valves, cathode-ray tubes and the fluorescent light. Similarly, new electrical 'labour-saving' gadgets, such as food mixers, hair dryers, electric shavers, electric kettles and coffee pots, were all products of the inter-war period and benefited to some extent from the professionalization of design.

Many of these products were also, of course, associated with 'progress' and hence with the wealth and higher material living standards that continued to prevail in America, despite the Depression. Hansen's concept of 'vernacular Modernism' is a way of understanding the wide appeal of Americanism during the 1920s and '30s, which she defines as 'the promises of mass consumption, and the dreams of a mass culture often in excess of and in conflict with the regime of production that spawned that mass culture'.[57] To deny or dismiss this appeal – or merely to set it against a beleaguered 'true' Modernism – is, as Hansen suggests, to miss the larger point, namely that American mass culture 'functioned as a powerful matrix for modernity's liberatory impulses'.

Promoting Modernism or modernity?

Ironically, much of the authority underpinning purist definitions of Modernism would emanate from post-war America, and specifically from New York, where Modernism found its first shrine as a movement in the Museum of Modern Art (MoMA). Launched in 1929, with Alfred Barr, Jr as its first director and most passionate evangelist, the museum set out to collect and display the 'Modern movement'. Two features distinguished its approach. First, it was educational. This was unsurprising in a national context, where museums were long held to be educational institutions, but MoMA also recognized that even a cultured New York public would require help in understanding how art had reached its present bewildering complexity. And second, the definition of modern art was cast widely to include architecture, design, photography and film. In the course of his teaching and proselytizing, Barr made use of several diagrams that offered a genealogy of modern art (pl.11.24), showing how it had evolved from the time of Goya, Ingres and Constable through Impressionism and Cubism to the then contemporary 'School of Paris', 'East of Europe' and 'Americans'. Barr's account does not differ greatly from that proposed by Kazimir Malevich in his wall-charts of 1927–8, prepared for lecturing in Western Europe, and has since become a familiar genealogy.[58] For Malevich, its conclusion was Suprematism, the goal towards which art had been moving; for Barr and his contemporaries, it would be a purified, aestheticized Modernism, owing something to Adorno's rejection of mass culture as kitsch and canonically defined by Clement Greenberg.[59]

The New York World's Fair of 1939, devoted to the 'world of tomorrow', could be regarded as a counter-balance to MoMA's earnest mission to educate. With

11.22 **Jean Reinecke** Scotch Tape Dispenser, 1939

11.23 **Norman Bel Geddes**, General Motors *Futurama*, New York World's Fair, 1939. Corbis

11.22

11.23

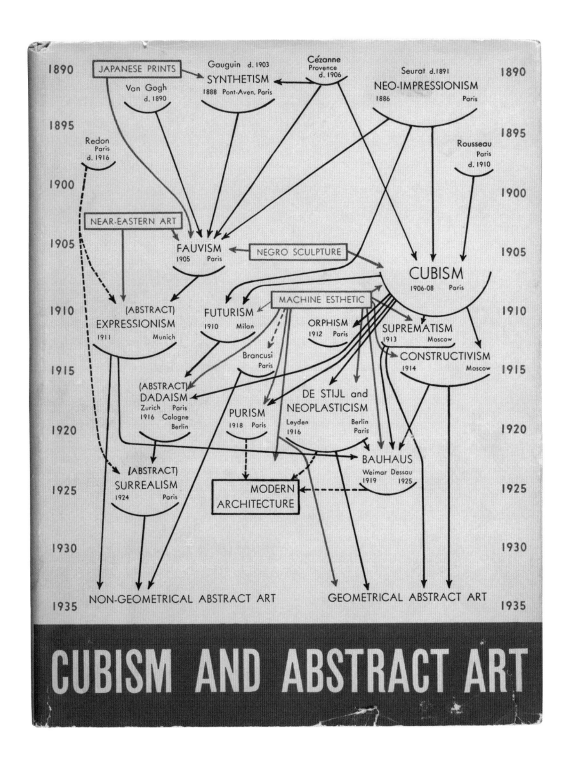

11.24 **Alfred Barr**, Diagram of *The Development of Abstract Art*, 1936. The Museum of Modern Art, New York

its carnival atmosphere, offering an array of modern achievements and predictions – culminating in General Motors' 'Futurama' electric theatre designed by Norman Bel Geddes (pl.11.23) – the fair was a celebration of a modernity at once futuristic and yet, for many Americans, achievable.[60] America had, by then, already assimilated many of Modernism's innovations and principles. In doing so, it had vernacularized them, just as Modernism would become vernacular elsewhere. American Modernism would henceforth play a dominant role in the dissemination and definition of Modernism. The post-war world would adopt much of this mass-market Modernism as a *fait accompli*, or at any rate a starting point, adapting it to the material conditions of the era, for example in Henry Kaiser's mass housing schemes, British 'prefab' housing, 'austerity' furniture and household goods, and later to the Paris couturiers' geometric 'New Look'.[61] No longer avant-garde, Modernism had become, to borrow Auden's phrase, 'a whole climate of opinion'[62] – and in doing so, in a final extended irony, it had achieved something that many of its avant-garde progenitors had desired: the reintegration of art and life.[63] It was time to start again…

242a

Poster: *Výstava harmonického domova*
(**Exhibition of the Harmonious Home**)
1930
Designed by Ladislav Sutnar
(1897 Pilsen, Bohemia–1976 New York)
Published by Družstevní práce, Prague

Offset lithograph
94 × 61.5cm
The Museum of Decorative Arts, Prague (GP 5166)

242b

Covers for books by G.B. Shaw
a) *Obrácení kapitána Brassbounda*
 (*Captain Brassbound's Conversion*)
b) *Trakař jablek, Americký císař*
 (*Apple Cart, American Caesar*)
c) *Člověk nikdy neví* (*You Never Can Tell*)
d) *Druhý ostrov Johna Bulla*
 (*John Bull's Other Island*)
e) *Vzorný sluha Bashwille, Jak lhas jejímu*
 manželu (*The Admirable Bashville,*
 How he lied to her husband)

f) *Výstřižky z novin, Prohlédnuti Blanco*
 Posneta (*Press cuttings, The Shewing-up*
 of Blanco Posnet)

1932
Designed by Ladislav Sutnar
(1897 Pilsen–1976 New York)
Published by Družstevní práce, Prague

c.19 × 14cm
The Museum of Decorative Arts, Prague
(GK12579, GK12574, GK9763, GK12578)

Družstevní práce (Co-operative Work), a subscription-based publishing house with a large middle-class readership, was established in Czechoslovakia in 1922. By 1927 it had a thriving membership, which led it to open a shop and gallery in Prague under the name Krásná jizba (Beautiful Household), selling domestic products designed by associates of the co-operative, as well as other Modernist designers (in the early 1930s, for instance, it sold Bauhaus furniture).[1] In 1929 Sutnar became the principal art director of many of the co-operative's publications, and designer of many of its ceramic and glass products. Družstevní práce thereby embraced leading-edge Modernism and gained greater international attention. A key advocate of functionalist design, Sutnar used Družstevní práce's products to demonstrate that the ways of living mapped out in 'Modern movement' ideas were no longer distant avant-garde dreams: they were becoming part of mainstream experience. Rejecting doctrinaire views of design, Sutnar and his colleagues sought to provide high-quality and inexpensive household objects for middle-class Czechoslovak citizens.

Sutnar's book-cover designs for works by the Irish left-wing playwright George Bernard Shaw, published by Družstevní práce, are witty combinations of type and imagery in the spirit of what Jan Tschichold described as *Die neue Typographie* (the New Typography), also the title of his 1928 book (cat.125).[2] Futura, asymmetric composition and Typophoto (the combination of photography and lettering to maximum visual effect) had become standard signifiers of the Modernist sensibility by 1930. In his use of publicity photos of the jaunty septuagenarian writer, Sutnar achieved a notable degree of playfulness.

In his 1930 poster promoting the 'Harmonious Home', a touring exhibition, Sutnar represented the Modernist preoccupation with the reform of the home. This poster presents an image of everyday Modernism: Družstevní práce's titles casually line the shelves of one of Krásná jizba's bookcases.

242a

a

b

c

d

e

f

Sutnar's design included a blank block that could be over-printed with the name of the exhibition venue. When the exhibition was displayed in the Town Museum in Hradec Králové, the poster was given the caption 'every exhibited object is for sale'. Družstevní práce's didacticism should not be confused with dogmatism: its subscribing members (20,000 people by the end of the 1930s) were regularly invited to comment on the merits of its products.[3] *Panorama*, a magazine for its membership, gave space for critical comment and discussions that sometimes resulted in design revisions of Krásná jizba's products.[4] DC

1 Ladislav Sutnar in *Ladislav Sutnar: Prague. New York. Design in Action* (Prague, 2003), p.118.
2 Jan Tschichold, *Die neue Typographie, Ein Handbuch für zeitgemäss Schaffende* (Berlin, 1928).
3 Iva Janáková, 'Managing Krásná jizba', in *Ladislav Sutnar* (2003), p.114.
4 Ibid, pp.114–16.

243a Plate 1.7

Tea and mocha set

1929–32

Designed by Ladislav Sutnar
(1897 Pilsen, Bohemia–1976 New York)
Manufactured by Epiag Porcelain Works, Loket, for Družstevní práce, Prague

Porcelain
Mocha pot, h.13.3cm, diam.13cm (87.658 a, b)
Tea and mocha pot, h.15.8cm, diam.15.6cm (102.106 a,b)
Tea cup and saucer, h.5.3cm, diam.15cm (17/85612 a,b)
Mocha cup and saucer, h.3.6cm, diam.10.1cm (18/87665 a,b)
Sugar bowl, h.10.4cm, diam.10.1cm (85.608 a,b)
Milk pitcher, h.10.4cm, diam.12cm (85.609 a,b)

The Museum of Decorative Arts, Prague

243b

Tea set

1931

Designed by Ladislav Sutnar
(1897 Pilsen–1976 New York)
Manufactured by Kavalier, Sázava, for Družstevní práce, Prague

Heat-resistant glass, steel, wood
Teapot, h.19.6cm, diam.17.5cm (14/7643 a,b)
Sugar bowl, h.10.7cm, diam.11.4cm (11/66185 a,b)
Milk pitcher, h.10.8cm, diam.11.4cm (66184 a,b)
Cup and saucer, h.5.9cm, diam.14.7cm (13/76441 a,b)
Rum decanter 16.7cm, diam.8.6cm (15/82.683 a,b)

The Museum of Decorative Arts, Prague

In the late 1920s Krásná jizba, Družstevní práce's retail outlet in Prague, became a manufacturer in its own right. Under art director Ladislav Sutnar, a number of classic Modernist tableware designs were produced, including these two sets. The origins of these products lay in the shop's difficulty in sourcing products that met its ambitious vision of modern life. Sutnar's tea service – made by the Epiag Porcelain Works in Loket in the Czechoslovakian industrial region of Bohemia – was first conceived in 1929, but did not find its way into Czechoslovak homes until 1932.[1] Sutnar's designs utilize 'pure' geometric spheres and semi-spheres, achieving an elegant and simple effect. Although the white model was produced as the standard version, consumers could choose others that were decorated with thin red lines on the rim, or with bright colourful bodies (blue, yellow, terracotta and red). Sutnar's tableware – and the entire Družstevní práce project – was given official imprimatur when in the mid-1930s an ivory set with green trim and the state emblem was purchased for President T.G. Masaryk's stateroom.

Krásná jizba's glass tea service represents Družstevní práce's interests in technological innovation. The use of heat-resistant glass in tableware had been pioneered in America in 1915 and was still in its infancy when in 1930 representatives from the company commissioned the Czechoslovak patent-holder, Kavalier, to make a tea service designed by Sutnar.[2] The shape of the service is based on an ellipsoid form, which is quite different from the more circular geometry of the porcelain set. The handle was originally made in Bakelite and in later versions in wood. Although Sutnar and his colleagues were drawn to the transparency and purity of glass, the manufacture of the service was problematic. The glass contained chemical impurities and bubbles, which detracted from the simplicity of Sutnar's design. Moreover, the Kavalier factory found it difficult to achieve a regular pot spout form.[3] Nevertheless, this product was produced in large numbers and was widely used in Czechoslovak homes.

Sutnar's glass tea set is exactly contemporary to a very similar service designed by Bauhaus teacher Wilhelm Wagenfeld (cat.147). Its manufacture by a leading make of scientific glass, its widespread publication and manufacture after the Second World War have ensured that Wagenfeld's design is better known than Sutnar's. DC

1 Milan Hlaveš, 'Designing Objects of Everyday Use', in *Ladislav Sutnar. Prague. New York. Design in Action* (Prague, 2003), p.314.
2 Regina Lee Blaszczyk, *Imagining Consumers. Design and Innovation from Wedgwood to Corning* (Baltimore, 1999), pp.212–23.
3 Ibid, pp.313–14.

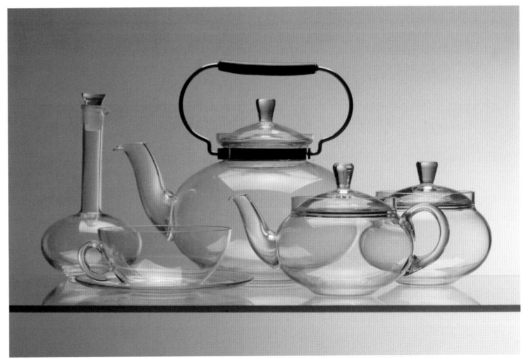

243b

244a

Photograph: Porcelain service

1932

Josef Sudek (1896 Kolín, Bohemia–
1976 Prague)

Gelatin silver print
24 × 18cm
The Museum of Decorative Arts, Prague (GF55345)

244b

Photograph: Glassware

1932

Josef Sudek (1896 Kolín–1976 Prague)

23.5 × 17.4cm
Gelatin silver print
The Museum of Decorative Arts, Prague (GF55301)

Sudek is best known for his highly atmospheric
pictorial photographs of the Czechoslovak country-
side and Prague streets and homes, taken from
the early 1920s until the mid-1970s.[1] For a short
period in the early 1930s, however, he was an
exponent of the photographic aesthetic known
as 'New Objectivity'.[2] Across Central Europe,
photographers who embraced this emphasized
the inherent precision and realism of photography
by recording man-made and natural objects in
sharp focus, often concentrating on their formal
qualities through the use of close-ups or repetition.
For the advocates of the new aesthetic, such
techniques were able to capture the qualities of
'the thing in itself'. It is perhaps not surprising
then that this visual language was adopted in
the field of commerce.

Sudek's photographs were commissioned by
Ladislav Sutnar, art director for Družstevní práce,
to promote his company's new domestic wares in
catalogues and advertising material (cat.243a–b).[3]
Anna Farova notes that, while Sutnar wished to
have his glass arranged and photographed in
straight lines in the manner of an architect,
Sudek's response was to produce 'organized
chaos, ingeniously playing with the reflective,
illusory quality of the glass, shadow and light'.[4]
This is apparent in the photograph of the drinking
glass sets, which suggests the chance effects
of rain on the surface of water, rather than the
precision of their elementary geometric forms. In
this way Sudek's preoccupations with atmosphere
and imagination were sustained through the most
'functional' phase (Sutnar's preferred phrase to
describe Modernist aesthetics) of his career as
a photographer. DC

1 Sonja Bullaty, *Sudek* (New York, 1978); Zdenek Kirschner,
 Josef Sudek (Prague, 1982).
2 David Mellor, *Germany. The New Photography 1927–33* (London,
 1978).
3 Vojtech Lahoda, *Josef Sudek. The Commercial Photography
 for Družstevní práce* (Jyväskylä, 2003).
4 Anna Farova, *Josef Sudek. Poet of Prague* (London, 1990), p.75.

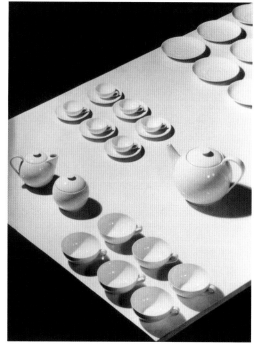

244a

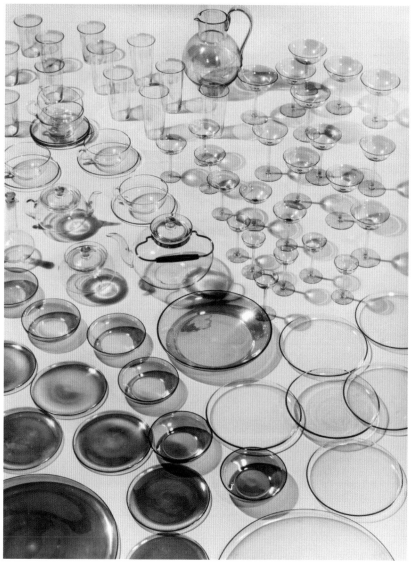

244b

245

Upholstery fabric swatch book
1930–40
Designed by Antonín Kybal (1901 Nové Město
nad Metuj, Czechoslovakia–1971 Prague)
Made in the designer's studio

Hand-woven wool and linen swatches
35 × 37 × 26cm
The Museum of Decorative Arts, Prague (74.159/1–19)

When Ladislav Sutnar took over as art director of
the Krásná jizba (Beautiful Household) shop and
gallery in 1929, he established much closer ties
with the Czechoslovak Arts & Crafts Association,
on whose board he and Antonín Kybal served. The
association had been instrumental in its advocacy
of Modernist (they used the term 'Functionalist')
design and architecture in Czechoslovakia, but
had had little luck convincing manufacturers to
adopt a contemporary outlook. By manufacturing
(or subcontracting the manufacture of) new designs
(cat.243–4) and selling Modernist objects made by
others, Krásná jizba decisively influenced the
Czechoslovak interior of the 1930s.[1] Kybal's textiles
were prominently sold in the shop, though they
apparently were never produced by Krásná jizba.

By 1930 Kybal made textiles by hand (including
carpets) in his studio and worked with manufac-
turers to produce his work.[2] This swatch book
consists of fabrics woven in his studio for use
in upholstery, though it is possible they were
intended for manufacture. Through the choice
of dyes and threads, the sturdy patterned fabrics
generally had a handsome architectural quality
and sober colouring, which contrasted with
Kybal's biomorphic work (cat.222) and his
characteristically decorative designs.

In 1939, with Sutnar in New York and unable
to return to Czechoslovakia under the Nazis,

Kybal took over the directorship of Krásná jizba.
Consistent with his love of pattern, he even
applied a geometric pattern to Sutnar's famous
tea and mocha service (pl.1.7).[3] CW

1 Iva Janáková, 'Managing Krásná jizba', in *Ladislav Sutnar.*
 Prague. New York. Design in Action (Prague, 2003), pp.114–15.
2 Jan Spurný, *Modern Textile Designer: Antonín Kybal*
 (Prague, 1960), p.11.
3 Milan Hlaveš, 'Designing Objects of Everday Use', in
 Ladislav Sutnar (2003), p.315.

246

Women's fashion: *Sports Elements*
1934
Designed by Claire McCardell
(1905 Frederick, USA–1958 New York)
Manufactured by Townley Frocks, New York

Wool jersey
Jacket length 48cm
Skirt length 86.5cm
Cullottes length 85cm
Trousers length 117cm
Halter length 35cm
The Metropolitan Museum of Art, New York,
gift of Claire McCardell, 1949 (C.I.49.37–49 a–f)

This six-piece wardrobe of interchangeable
separates embodies the Modernist preoccupation
with systems. American fashion designer
McCardell created this collection for Townley
Frocks, a New York-based, mid-priced dress and
sportswear manufacturer. One of her earliest
products for the company, it appeared two years
after Townley promoted her to chief designer.
The mix-and-match system of jacket, skirt, halter
top, culottes, trousers and coat offered the wearer
a number of desirable features: the same black
wool jersey material that enabled all pieces to

coordinate and be worn with one another; garments
suited for varying levels of formality; a fabric
resistant to creasing and thus convenient for
travel; and pockets in several of the pieces. The
carefully edited grouping featured both culottes
and trousers well before such practical garments
became standard. The coordinated wardrobe
became a McCardell speciality. She went on to
create similar groupings from other fabrics such as
cotton, denim and taffeta.[1] Like all of McCardell's
designs for the Townley label, these clothes were
affordable, mass-produced and readily available
in moderately-priced American stores.[2]

Throughout the nineteenth century and into
the twentieth, American women looked to Europe
for fashion leadership. Yet they often simplified
these foreign fashions and adapted them to suit
their need for well-designed, unrestrictive clothing
that could be worn all day.[3] McCardell's designs
epitomized this American fashion tradition. Her
clothes featured uncomplicated silhouettes, simple
fastenings and easy-care fabrics. In her early
years with Townley, she designed anonymously,
but the popularity of her designs and a new focus
on the individual fashion designer in the post-war
years put McCardell's name onto the Townley label
and into the pages of American *Vogue*.[4] In 1955
Time magazine acknowledged her influence as
an American fashion catalyst and put her on
its cover. SS

1 Kohlee Yohannan, 'Claire McCardell', in Valerie Steele (ed.),
 Encyclopaedia of Clothing and Fashion (New York, 2004), p.397.
2 Kohlee Yohannan and Nancy Nolf, *Claire McCardell: Redefining*
 Modernism (New York, 1998), p.38.
3 Caroline Rennolds Milbank, *New York Style* (New York, 1989), p.48.
4 Sandra Stansbery Buckland, 'Promoting American Designers,
 1940–4', in Linda Welters and Patricia A. Cunningham (ed.),
 Twentieth Century American Fashion (Oxford, 2005).

246

247a Plate 11.2

American Modern dinnerware
Designed 1937
Russel Wright (1904 Lebanon, USA–
1976 New York)
Manufactured by Steubenville Pottery,
East Liverpool, Ohio, from 1939

Glazed earthenware
Large pitcher, 27 × 17.5 × 21cm (83.108.44)
Salt shaker, 4.9 × 4.5 × 2.1cm (83.108.43)
Pepper shaker, 5.1 × 5.5 × 5.5cm (83.108.42)
Gravy bowl, 6.4 × 6.4 × 26.2cm (83.108.32)
Pitcher, 16.2 × 15.9 × 19.1cm (84.124.3)
Plate, diam.25.4cm (80.169.2)
Bowl, 5.1 × 17.8 × 14.6cm (80.169.5)
Beaker, h.74cm, diam.6.1cm (76.99.21)
The Brooklyn Museum

247b

Coffee urn
*c.*1935
Designed by Russel Wright
(1904 Lebanon–1976 New York)

Spun aluminium, walnut
40.6 × 33.0 × 21.0cm
The Brooklyn Museum, gift of Paul F. Walter (1994.165.1a–d)

For those who see the popularization of Modernist design as a lamentable distortion of rigorous design principles, Russel Wright could not be better typecast as the villain. More than any other designer, he embodied the seeming transformation of Modernism from a set of challenging social and formal principles to an easily digested style, compatible not only with capitalist enterprise, but even with patriotic nationalism. He saw his work as an expression of the 'American character', and consciously sought to temper the potentially threatening avant-garde aspects of his work by offering a compensating rhetoric of Colonial Revival conservatism and pastoral suburban utopianism.[1] Even the ceramicist Frederick Hurten Rhead, whose colourful *Fiestaware* anticipated Wright's *American Modern* service more than any other previous tableware design, saw Wright's curvilinear pitchers, plates and bowls as disingenuous: 'slithery and wise-cracking'.[2] The historian Miles Orvell sums up this view of Wright well: he saw design 'not [as] a means of elevating popular taste, particularly, but a way of confirming it'.[3]

From another perspective, however, Wright's work in the pre-war period must be seen as uncommonly courageous. He achieved modest early success with spun aluminium wares, many based on a simple sphere, such as a coffee urn, a lemonade pitcher, a bun warmer and an ice bucket. Yet these products, sold under the name of *Informal Serving Accessories*, were hardly the

inevitable result of American mass marketing. They were in fact made entirely by hand, as variation across examples attests. Russel and his wife Mary – the marketing genius of the husband-wife business partnership – may have stressed the soft commercial appeal of biomorphic form, but they embraced it quite early (as is seen in their 1935 *Oceana* line of wooden tableware). The novelty of the biomorphic style meant that the Wrights struggled to bring their now famous *American Modern* dinnerware to market, succeeding only because their chosen manufacturer, Steubenville, was on the verge of bankruptcy. They and a business partner were forced to pay for the moulds speculatively.[4] The *American Modern* line was mass-produced and sold widely in department stores. Like the slightly later biomorphic ceramics designed by Wright's contemporary Eva Zeisel, he took advantage of industrial slip-casting to produce seamless contours. Unlike Zeisel's early designs, which were produced entirely in white or off-white in the manner of European Modernist tableware, Wright's line was presented in a palette of unusual colours, which could be mixed and matched into sets at the consumer's discretion.

In the immediate post-war period, even as Wright became increasingly involved in shaping and promoting his own image and as his designs became increasingly mild-mannered, he retained a quietly radical streak. The home-making guide that Russel and Mary published in 1950, *The Guide to Easier Living*, included such surprisingly anti-materialistic advice as 'dramatically reduce the number of your possessions to make maintenance easier'.[5] GA

1 Donald Albrecht, Robert Schonfeld and Lindsay Stamm Shapiro, *Russel Wright: Creating American Lifestyle* (New York, 2001), p.31, 168 n.11; *The Machine Age in America 1918–1941* (Brooklyn, 1986), p.336.
2 F.H. Rhead correspondence quoted in Regina Blaszczyk, *Imagining Consumers: Design and Innovation from Wedgwood to Corning* (Baltimore, MD, 2000), pp.165–6.
3 Miles Orvell, *The Real Thing: Imitation and Authenticity in American Culture, 1880–1940* (Chapel Hill, NC, 1989), p.189.
4 Robert Schonfeld, 'Marketing Easier Living: The Commodification of Russel Wright', in Albrecht, Schonfeld and Shapiro (2001), p.151.
5 Russel and Mary Wright, *The Guide to Easier Living* (New York, 1950); see also William J. Hennesey, *Russel Wright: American Designer* (Cambridge, MA, 1983), p.53.

247b

248 Plate 11.20

Book: *Britain by Mass-Observation*
edited by Charles Madge and Tom Harrisson
1939
Designed by Edward Young
Published by Penguin Books,
Harmondsworth

18.2 × 11.7 × 1.5cm
V&A, National Art Library (589.0332)

Britain by Mass-Observation was the first book from this pioneering social research movement to reach a wide public, owing to its publication by Penguin Books, which had revolutionized the book trade in Britain since its launch in 1935. Both Penguin and Mass Observation were born of democratic and modernizing impulses typical of the mid-1930s, and both had natural links with Modernism.

Penguin founder Allen Lane was influenced by German pocket-book series when he launched his cheap paperback imprint in 1935. He had to persuade British publishers and authors that reprints selling for sixpence in Woolworths would be commercially viable.[1] His design policy was guided by a shrewd sense of marketing: 'a bright splash of flat colour with a white band running horizontally across the centre for displaying author and title in Gill Sans'.[2] Eric Gill's sans-serif typeface was itself based on the sign lettering first designed by Edward Johnston for London Underground in 1916, and provided Britain with its first indigenous Modernist type design.[3] Meanwhile the inside text was set in Stanley Morrison's 1931 revision of a classic face, New Times Roman.

The immediate success of Penguin Books encouraged Lane to launch additional series, including Penguin Specials in 1938 to address issues of topical concern – as Victor Gollancz had already done for a narrower audience with his Left Book Club.

Lane published *Mass-Observation*, a survey of public opinion, as part of this topical series at the time of the Munich crisis, when Neville Chamberlain returned from a meeting with Hitler promising peace. The text was compiled by two of Mass Observation's founders. This organization was started in 1937 by the poet Charles Madge, the anthropologist Tom Harrisson and the film-maker and painter Humphrey Jennings, to conduct 'an anthropology of ourselves'.[4] Closely aligned with both the documentary film movement and the English Surrealist group, Mass Observation recruited 500 volunteers to record their immediate observation and personal experiences in a typically Modernist combination of the scientific and the poetic. The 1939 Penguin Special spoke for 'the people', less than convinced by Chamberlain's claims, as the quotation on the cover of the book from *The Times* noted. It struck a blow for a new conception of book design based on typography that was itself as radical as anything proposed by the Bauhaus. IC

1 The Albatros series, published in Hamburg from 1932, used colour coding for genres, as Penguin would do. Phil Baines, *Penguin by Design: A Cover Story 1935–2005* (London, 2005), p.13.
2 Allen Lane quoted in *Thirties: British Art and Design before the War* (exh. cat., Hayward Gallery, London, 1979), p.266. On Lane and Penguin, see also Jeremy Lewis, *Penguin Special: The Life and Times of Allen Lane* (London, 2005).
3 Gill and Johnston were originally asked to work together on the Underground lettering, which was completed by Johnston alone. However, Gill produced his Gill Sans face for Monotype in 1928, causing 'a storm of excitement', according to the typographer Beatrice Warde (*Advertising Display*, 1928).
4 Madge's letter containing this phrase appeared in the *New Statesman* in January 1937 and led to the formation of the organization with Harrisson, Jennings, Madge and others, including the photographer Humphrey Spender. For a selection of Mass Observation texts, see Angus Calder and Dorothy Sheridan (eds), *Speak For Yourself: A Mass-Observation Anthology 1937–49* (London, 1984). The journal *New Formations*, no.44 (autumn 2001) included a number of useful articles on aspects of Mass Observation.

249

Penguin Donkey bookcase
1939
Egon Riss (1901 Vienna–1964 Scotland)
and Jack Pritchard (1899 London–
1992 Blythburgh)
Manufactured by Isokon Furniture Co.,
London

Plywood
43.3 × 59.8 × 41.5cm
V&A: W.19–1993, gift of Mr J.E. Tinkler

Pritchard's Isokon company was one of the few British examples of a firm truly devoted to Modernism. In addition to building London's Lawn Road Flats, Pritchard employed a succession of continental Modernists to work for his furniture company (pl.9.3). These included the Germans Walter Gropius and Arthur Korn, and the Hungarian Marcel Breuer, as well as the Viennese émigré Egon Riss.[1] Riss (who lived briefly in Lawn Road Flats, as had Gropius and Breuer) designed one of Isokon's most intriguing products.

The Penguin Donkey was created specifically to carry the new type of paperback book, which for the first time made available reasonably priced, best-quality international literature to a wide public for the price of a pack of cigarettes (which were themselves relatively cheaper than today).[2] The books were stacked in the side elements (appropriately referred to as panniers) and newspapers and magazines were slotted into the centre. The organic, curvilinear shape of the Donkey, raised on legs rounded in elevation, was made possible by the use of very thin plywood.

Isokon's production was always very small, but it appears that only a few of the Donkeys were made before war began.[3] Pritchard had agreement from Penguin publisher Allen Lane to insert leaflets advertising the Donkey into every Penguin book. Had war not broken out, it is possible that the Donkey would have been Isokon's first commercially successful product. Despite its very limited production, the Donkey had an afterlife. While many Modernist designs have been manufactured after the 1960s (some for the first time in quantity), the Penguin Donkey has been reinvented several times. In 1963 Pritchard sold a new version ('Mark 2'), redesigned by well-known designer Ernest Race; and in 2003 Isokon's successor firm, Isokon Plus, began making the Donkey 3, designed by Shin and Tomoko Azumi. CW

1 On Riss, see Charlotte Benton, *A Different World: Émigré Architects in Britain 1928–1958* (exh. cat., RIBA Heinz Gallery, London, 1995), pp.199–201.
2 Phil Baines, *Penguin by Design: A Cover Story 1935–2005* (London, 2005), p.13.
3 Alastair Grieve, *Isokon* (London, 2004), p.40, writes that the Donkey never went beyond the prototype stage. However, Jack Pritchard, *View from a Long Chair*, (London, 1984), p.117, recalled that 100 were made. The donor of this example wrote that he purchased it after seeing an advertisement in the *New Statesman* or *The Listener*. He had no connection with Isokon, did not live in London and his assertion that he ordered it by post has some credibility (letter from Mr J.E. Tinkler to CW, 7 September 1993, V&A RP 93/1613).

250a Plate 11.1

Wireless set: Ekco model EC 74
1933
Designed by Serge Chermayeff (1900
Groznyy, Russia–1996 Wellfleet, USA)
Manufactured by E.K. Cole & Co. Ltd,
Southend-on-Sea

Bakelite case
45.5 × 38 × 26.5cm
V&A: CIRC.12–1977

250b Plate 11.10

Wireless set: Ekco model AD-65
Designed 1932
Designed by Wells Coates (1895 Tokyo–
1958 Vancouver)
Manufactured by E. K. Cole & Co. Ltd,
Southend-on-Sea, 1934

Bakelite case
45.5 × 38.1 × 26.5cm
V&A: W.23–1981, bequeathed by David Rush

Radio emerged as a global mass medium during the 1930s, which created unprecedented opportunities to design the new medium's visible presence – in landmark studio and headquarters buildings, such as Broadcasting House in London and Radio City in New York, and in domestic wireless receivers. Most consumer radios were essentially rectangular wooden boxes, often with some Rexine or fabric detailing. However, one of Britain's largest radio manufacturers, the Ekco company of Southend, adopted the plastic Bakelite, created by Dr Leo Baekland in the US before the First World War, as a synthetic material that lent itself to cheap mass-production moulding. To promote the status of what many consumers regarded as an inferior substitute for wood, the firm's founder E.K. Cole invited radical Modernist designs: the two most famous were by the architects Chermayeff and Coates.

The Russian-born Chermayeff was firmly in the Modernist camp in Britain.[1] He was a successful designer of Modernist tubular-steel furniture and a member of MARS (Modern Architecture Research Society), which was devoted to the promotion of Modernism. Shortly after designing the EC 74 radio, he would partner Erich Mendelsohn (cat.27) on the design of the De La Warr Pavilion in Bexhill, one of the most important Modernist buildings in Britain. His approach to the radio could also be considered architectural, emphasizing the two basic forms already associated with this apparatus, the squared box and the circular tuning dial and knobs, and combining them in a simplified geometric whole, which also suggests something of a Machine Age 'face'.

Like Chermayeff, Coates (a Canadian) would make his lasting mark as an architect, responsible for the Isokon Lawn Road Flats in London in 1933–4. He was already associated with radio through designing ultra-modern studio interiors for Broadcasting House in 1931, before he produced the revolutionary circular AD-65 for Ekco.[2] With an international background in engineering and journalism before he embarked on architectural practice in London in the late 1920s, Coates was strongly influenced by Le Corbusier and the ideals of Modernism, writing in 1933 that 'the most fundamental technique is the replacement of natural materials by scientific ones'.[3] The use of Bakelite fitted this programme well, and Coates went even further than Chermayeff in challenging the rectilinear box convention of previous radios. He approached the design as 'a piece of modern machinery', wrote Nikolaus Pevsner, rather than as 'good modern furniture'.[4] Here, the novel form of the case alludes directly to the circular shape of the loudspeaker, while the tuning dial is expanded to become an emblematic semi-circular strip, counterbalanced by the understated control knobs. In 1937 Pevsner singled out these two radios as examples of innovative design, remarking on their immediate popularity with the buying public.[5] IC

1 See Alan Powers, *Serge Chermayeff: Designer Architect Teacher* (London, 2001).
2 Wells Coates's Broadcasting House studios were faithfully reproduced for the film *Death at Broadcasting House* (directed by Reginald Denham, 1934), written by and co-starring the actual head of BBC production at the time, Val Gielgud.
3 Wells Coates, 'Response to Tradition', in *Architectural Review*, 72 (November 1932), pp165–8.
4 Nikolaus Pevsner, *An Enquiry into Industrial Art in England* (New York, 1937), p.106.
5 Ibid., p.106.

249

251

Silvertone 'Rocket' Turbine Radio, Model 6111
1938
Designed by Clarence Karstadt
(1902 Long Island–1968 Santa Monica)
Manufactured by Sears, Roebuck, & Co.,
Philadelphia

Phenolic plastic case
16.8 × 30.2 × 16.5cm
The Brooklyn Museum (1998.143.2)

In the popular imagination, Modernism proliferated in America thanks to the efforts of a handful of celebrity industrial designers such as Raymond Loewy, Walter Dorwin Teague and Henry Dreyfuss. Yet many of the progressive designs of the 1930s were created by figures who are considerably less well known today. Often these designers worked 'in-house' for just one company, and were therefore unable to undertake (or uninterested in) the sort of self-promotion that is so much associated with the first generation of American industrial designers. One such figure is Karstadt, who had worked as an 'in-house' stylist at the Briggs

Manufacturing Company in Detroit, and under Harley Earl at General Motors, before coming to Chicago as a Sears, Roebuck & Co. staff designer.[1] Because of its widely distributed catalogue and vast system of providers, Sears was well positioned to participate in the popularization of Modernism and did not shy away from the rhetoric of the movement. Its 1938 catalogue described Karstadt's Silvertone 'Rocket' as a 'style sensation ... designed for modern people living in a modern world'.

Like many of the anonymously designed radios of the 1930s, the Silvertone exemplifies the stylistic potential of phenolic plastic (conventionally called Bakelite, though manufactured in America mostly by the Catalin Corporation after 1927). For a diversity of reasons – because it could not cleanly be cast in moulds with sharp corners and thus forced rounded shapes on the designer; because it was inexpensive and durable; and because it was a manifestly new material with no previous stylistic associations – phenolic plastic became the premier medium for popular 'streamlined' designs in the 1930s.[2] Karstadt's Silvertone radio is an unusually pure example of a mass-marketed Machine Age design, in that it mimics the form of an electrical dynamo. A round tuning dial forms one end of the case, which is flanked on the other three sides by a wrap-around ribbed façade. GA

1 Author's communication with Mr Hampton Wayt, 24 August 2005, and conversation with Ms Claire Karstadt, the designer's daughter, 26 August 2005. After losing his job as a result of the Depression, Karstadt was hired by Harley Earl as a staff designer for General Motors. Once at Sears, according to patents located by Mr Terry Schwartz, Karstadt worked on household products; Ms Karstadt also recalls that her father designed refrigerators, power tools, toasters and clothes irons for Sears. The author would like to thank Ms Karstadt, Mr Schwartz and Mr Wayt for their assistance.
2 For pictorial overviews of Modernist radio production, see Ken Jupp and Leslie Piña, *Genuine Plastic Radios of the Mid-Century* (Atglen, PA, 1998), and Philip Collins, *Radios Redux : Listening in Style* (San Francisco, 1991). On the connections between early industrial design and plastic generally, see Jeffrey L. Meikle, *American Plastic: A Cultural History* (New Brunswick, NJ, 1995) and Jeffrey L. Meikle, 'Streamlining: 1930–1955', in Jocelyn de Noblet (ed.), *Industrial Design: Reflection of a Century* (Paris, 1993), pp.182–92.

252a

Poster: *Light*
1937
Designed by Lester T. Beall
(1903 Kansas City –1969 New York)

Silkscreen on paper
101.6 × 76.2cm
V&A: E.265–2005

252b

Poster: *Radio*
1937
Designed by Lester T. Beall
(1903 Kansas City –1969 New York)

Silkscreen on paper
101.6 × 76.2cm
Merrill C. Berman Collection

Beall's boldly simplified posters for the Rural Electrification Administration captured the crusading spirit of President Franklin Delano Roosevelt's 'New Deal', the bold attempt by a liberal Democratic administration to enable the social and economic recovery of the United States from the effects of the Depression through government intervention. The Rural Electrification Administration (founded 1935) was a New Deal agency, which promoted cooperatives to bring electricity to rural Americans, 90 per cent of whom were without. In doing so, and in competing with the entrenched private power monopolies who refused to provide power unless the proposed clients paid their construction costs, it seemed dangerously socialist to some. The REA deliberately used modern publicity methods to spread awareness of electricity's benefits, including poster campaigns and films.[1] Beall's three series of posters for the REA between 1937 and 1941 stripped the message to its near-abstract basics, using his favourite motif of the arrow for the radio and a giant bulb for lighting, with frontier-style lettering, both set against an archetypal 'little house on the prairie' to emphasize how electricity would transform rural life. The lack of literacy among many rural inhabitants explains the sparing use of type.[2] Beall's posters were very different from the sophisticated use of photomontage in equivalent Soviet publicity advocating modernization (pls 10.2–3). They demonstrate how American Modernists working in different media were inspired during the 1930s by the values of the New Deal and by the rediscovery of rural America.[3]

Beall was largely self-taught as a designer, although he had studied art history at Chicago University and was aware of European Modernist trends.[4] He moved to New York in 1935 and began to develop a successful commercial practice while forging a dynamic style well suited to the REA posters and to such *Collier's* magazine covers as 'Will There Be War?' and 'Hitler's Nightmare'. Although the suggestion that Beall 'almost single-handedly launched the Modern movement in American design' may be slightly overstated, Beall's work was the subject of the first monographic exhibition of American design at the Museum of Modern Art in 1937. He later became a leading figure in corporate design.[5] IC

1 Kenneth Davis, *FDR: The New Deal Years 1933–1937: A History* (New York, 1986). The leading documentary film-maker Joris Ivens made *Power and the Land* in 1940 for the REA.
2 Roger Remington, *Lester Beall: Trainblazer of American Graphic Design* (New York, 1996), p.74.
3 Other examples include Walker Evans's photographs of the rural poor for the Farm Security Administration (from 1935); Aaron Copland's ballet *Appalachian Spring* (1944) for the Martha Graham Dance Company; and Georgia O'Keeffe's sojourn in New Mexico (1929 onwards).
4 Remington (1996), p.42.
5 Philip Meggs, *A History of Graphic Design* (New York, 1998), pp.300–303.

252a

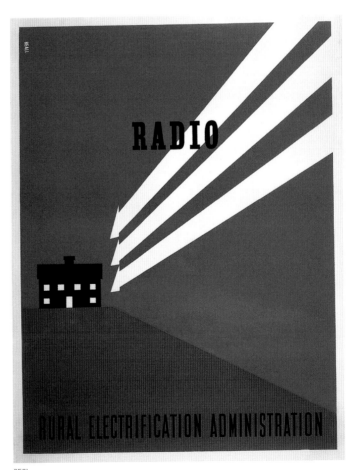

252b

Film: *Gold Diggers of 1933*
Directed by Mervyn LeRoy
(1900 San Francisco–1987 Beverly Hills)
Musical numbers directed by
Busby Berkeley (1895–1976)
Designed by Anton Grot
Dick Powell, Ginger Rogers

96 mins, sound, black and white
Produced by Warner Bros, USA, 1933

Gold Diggers of 1933 erupted onto the screen at a crucial moment in the history of Hollywood and indeed of America. It was the second of three successful Warner Brothers backstage musicals released in 1933, which all featured spectacular dance sequences devised and directed by Busby Berkeley.[1] Both the opening number, 'We're in the Money', where a chorus line parading in dollar-studded costumes is interrupted by bailiffs who have come to close down their bankrupt show, and the finale, 'My Forgotten Man', which tele-

scopes a whole history of Great War veterans facing poverty and humiliation, dealt directly with the Depression and its human impact. *Gold Diggers* reached cinemas in June 1933, just weeks after the incoming President Roosevelt, had launched his New Deal to end America's economic crisis, and exhibitors reported an enthusiastic response.[2]

If the film turns out to be unexpectedly rooted in social reality, its lasting reputation rests on the kaleidoscopic invention of Berkeley's four set-pieces. Apart from the two already mentioned, 'Pettin' in the Park' takes advantage of the relatively liberal censorship regime that would shortly be ended to show near-naked chorus girls at play, culminating in Dick Powell using a can-opener to 'open' Ruby Keeler's metal bathing suit; while 'The Shadow Waltz' welds its rows of crinoline-clad girls playing neon-lit violins into the composite image of a single violin playing itself. The motif in Berkeley's choreography may be conventional, but the effect of so many regimented dancers constructing it through their movements and costumes is one that has often been linked with industrial process, and also with the self-referentiality typical of Modernism.[3] Like the zip-fastener image created as floating chorus girls

mesh together in Berkeley's next film, *Footlight Parade* (1933), the electrified violin of 'The Shadow Waltz' represents a distinctly new *kind* of image – at once hyperbolic and ironic – which is strikingly similar to the goal aimed at by abstract and 'graphic' film-makers of the avant-garde.[4] IC

1 Many film critics and historians have tried to evoke Berkeley's distinctively brash, vulgar and even childish approach to the sequences he devised and directed for films whose dramatic narratives were directed by others. Most insist that, however spectacular, Berkeley's entertainments should not be confused with art. For a representative verdict, see David Thomson, *The New Biographical Dictionary of Cinema* (New York, 2002), pp.77–9. For a more engaged analysis of *Gold Diggers of 1933*, see Peter Kemp, 'Grit 'n' Glitz', *Senses of Cinema*, no.29 (November–December 2003), http://www.sensesofcinema.com/contents/cteq/03/29/gold_diggers_of_1933.html (consulted 9 May 2005)
2 Colin Schindler, *Hollywood in Crisis: Cinema and American Society 1929–1939* (London, 1996), p.161.
3 Nicole Armour, 'The Machine Art of Dziga Vertov and Busby Berkeley', *images* no.5, http://www.imagesjournal.com/issue05/features/berkeley-vertov/htm (consulted 9 May 2005).
4 Compare Berkeley's trademark overhead images – looking down at a pattern made by dancers – with those of abstract film-makers such as Hans Richter, Len Lye (whose abstract films all relate to dance, and who also designed dance sequences for narrative films) and especially Oskar Fischinger. The Soviet film-maker Vladimir Nilsen would entitle his book based on Sergei Eisenstein's teachings *The Cinema as a Graphic Art* (London, 1937).

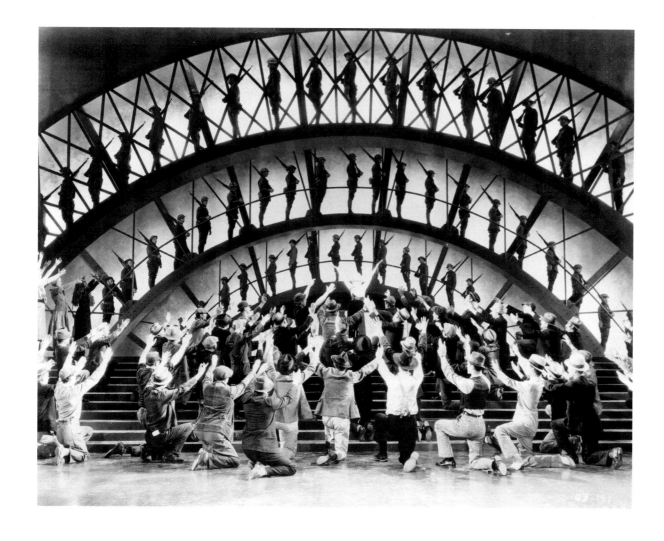

254 Plate 8.1

Film: *Rainbow Dance*
Conceived and directed by Len Lye (1901
Christchurch, New Zealand–1980 New York)
Photography by Frank Jones
Synchronization by Jack Ellitt, with the
song 'Tony's Wife' by Rico's Creole Band
Produced by Basil Wright and Alberto
Cavalcanti

4 mins, sound, colour (Gasparcolor process)
Produced by GPO Film Unit, for the Post Office
Savings Bank, Great Britain, 1936

Although ostensibly a Post Office promotional
film, *Rainbow Dance* evokes the modern pastoral
myth of escaping the city for a life of recreational
pleasure by the sea. Abandoning his raincoat and
umbrella for a knapsack, guitar and tennis racket
– all emblems of 1930s healthy outdoor recreation
– the silhouetted protagonist finds his 'pot of gold
at the end of the rainbow', in the words of the
tongue-in-cheek final announcement. Played by
Rupert Doone, who had danced for Diaghilev and
launched London's avant-garde Group Theatre in

1932, this was the first human figure to appear
in a film by the New Zealand-born painter and
sculptor Lye.[1]

Lye arrived in London in 1927 and began
exhibiting Modernist sculpture with the 7 and 5
Society, while also making his first experimental
abstract animated film in 1928, *Tusalava*, which
was monochrome, silent and based on his
biomorphic drawings. Taking advantage of new
colour film processes and synchronized sound,
he made his name in 1935 with the abstract
A Colour Box, created by painting and scratching
onto a blank filmstrip. It was widely hailed as a
breakthrough in film's fulfilment of its promise
as a new art medium.[2]

For *Rainbow Dance*, Lye filmed Doone in
monochrome, created a matte of his silhouette,
and then used the three dyes of the Gasparcolor
process to add colour. This produced an effect
similar to contemporary poster art, although
in motion, and distantly evoking Jules Marey's
chronophotography from the turn of the century.
Combining elements of Modernist dance with
motifs from sport and recreation that had
become part of the vocabulary of Modernism,
Rainbow Dance points away from a filmic purism
towards the engagement with commerce and
contemporary life that many Modernist artists
were seeking by the mid-1930s. IC

1 On the full range of Lye's work as a painter, sculptor and film-
maker, see *Len Lye: A Personal Mythology* (exh. cat., Auckland City
Art Gallery, 1980); and Jean-Michel Bouhours, Roger Horrocks
(eds), *Len Lye* (exh. cat., Centre Pompidou, Paris, 2000), especially
Ian Christie, 'Colour, Music, Dance, Movement: Len Lye in
England, 1927–1944'.
2 Paul Nash was one of many artists who applauded Lye, in an
essay on 'The Colour Film', published in Charles Davy (ed.),
Footnotes to the Film (London, 1938), pp.133–4. *A Colour Box* was
awarded a special prize at the 1935 Brussels Exhibition; and its
adaptation to serve as a Post Office advertisement had enabled
John Grierson to fund Lye's work through the Post Office Film
Unit that he headed.

255 Plate 11.9

Illustrated magazines
Vu (Seen), 21 January 1931

36.8 × 27.2cm
Private Collection

Life, 23 November 1936

35.6 × 27.2cm
Private Collection

Picture Post, 16 December 1939

34.7 × 26cm
Private Collection

Photographic illustrated magazines such as *Vu*,
Picture Post and *Life* became an important inter-
national cultural form in the 1930s, forging a new
style of reporting and layout that is now often called
'photojournalism'.[1] While some articles in these
magazines would be topical, reporting on a war
or a major political event (as in *Picture Post*'s cover
on the Nazi hierarchy), others would celebrate
new achievements (such as the Hoover Dam
photographed by Margaret Bourke-White for
the first issue of *Life*); and yet others would find

imaginative visual ways of reporting current
affairs and marking past events (the battlefield of
Verdun in *Vu*).

While the reproduction of photographs along-
side text had been made technically possible by
the invention of the rotary press before the First
World War, it was the new immediacy of the
images produced by the Leica and other discreetly
portable cameras in the mid-1920s (pl.11.7, cat.258)
that prompted a shift of balance from word to
image in the new magazines. The spontaneous,
unposed photographs by Felix H. Man, Henri
Cartier-Bresson, André Kertesz, Ilse Bing and
others created a new feeling of realism in the
magazines, making them seem the modernized
print equivalent of the newsreel or documentary
film and a popular realization of the Constructivist
goal of a new visual language.[2]

Such magazines also needed a new breed of
publisher, willing to take risks to establish the
large circulations needed to cover their costs. The
pioneers in this field were Lucien Vogel (1886–1954),
who had launched his first Paris fashion magazine
in 1912, before going on to found *Vu* in 1928, with
Kertesz as a collaborator and a host of Surrealist
contributors; and Hungarian-born Stefan Lorant
(1901–1997), who started the Munich *Illustrierte
Presse* in the same year and later emigrated to
Britain, where he launched *Picture Post* for the
publisher Edward Hulton in 1938. The central

figure in American photojournalism was Henry
Luce (1898–1967), founder of *Time* in 1923, who had
employed Margaret Bourke-White on his business
magazine *Fortune* from 1930 before launching *Life*
in November 1936, with Bourke-White as one of
its four staff photographers.[3] IC

1 Peter Pollack, *The Picture History of Photography, from the
Earliest Beginnings to the Present Day* (New York, 1969);
Robert Lebeck and Bodo von Dewitz (eds), *Kiosk: A History of
Photojournalism* (Göttingen, 2002).
2 On émigré photographers and *Picture Post*, see Colin Westerbrook
and Joel Meyerowitz, *Bystander: A History of Street Photography*
(London, 1994), pp.183–5. The Constructivist Alexander Rodchenko
would work on a Russian publication, *USSR In Construction*, in
the 1930s; while Moholy-Nagy worked for Lorent's *Lilliput* during
his stay in Britain.
3 Stephen Bennett Phillips, *Margaret Bourke-White: The Photography
of Design, 1927–1936* (Washington, 2003).

256 Plate 11.8

Ermanox camera with F.2 Ernostar lens
1924–5

Manufactured by Heinrich Ernemann AG, Dresden

Metal body covered with black leather
11 × 12.5 × 11cm
National Museum of Photography, Film and Television, Bradford

Originally advertised with the slogan, 'What you can see, you can photograph', and soon nick-named 'the cyclops' because its large-aperture F.2 lens dominated the functional body, the Ermanox was the first camera that allowed photographs to be taken in low light without flash. Apart from this revolutionary lens, the camera used small 4.5 × 6cm glass plates. However, the arrival of the Leica 35mm camera only a year later made it seem cumbersome for unobtrusive use in the field. Nonetheless, the quality of image and depth of field remained attractive for pioneer photojournalists.

The reputation of the Ermanox owed much to famous photographs taken with it by Erich Salomon (1886–1944) and Felix H. Man for the German illustrated papers of the late 1920s. Salomon adopted the Ermanox in 1925 and used his familiarity with high society to take clandestine photographs of Berlin night-life, and later of leading statesmen and celebrities, including Ramsay MacDonald, Albert Einstein and Aristide Briand – the French Foreign Minister, who as a consequence of being photographed labelled Salomon 'the king of the indiscreets'. From 1928 Salomon contributed to the British magazine, *The Graphic*, which coined the phrase 'candid camera' to describe his work.[1] Salomon was later arrested by the Nazis and died in a concentration camp. His compatriot Felix H. Man (pl.7.13) also used the Ermanox (though always on a tripod, he later said) to shoot such celebrated photo-essays as 'A Day in the Life of Mussolini' in 1931, before he emigrated to Britain and become chief photographer for *Picture Post* from 1938 to 1945 (pl.11.9).[2]

When the Leica put an end to the Ermanox's chances of major commercial success, its manufacture was taken over by Zeiss, who equipped it with an even faster F1.8 lens, but soon discontinued the model. It has since become a collectors' item, largely thanks to its close association with the birth of photojournalism and its pioneering functional design. IC

1 David Mellor, 'London–Berlin–London: A Cultural history of the reception and influence of the new German photography in Britain, 1927–33', in David Mellor (ed.), *Germany: The New Photography 1927–33* (London, 1978), p.122.
2 'Photojournalism in the 1920s: A Conversation between Felix H. Man, Photographer, and Stefan Lorant, Picture Editor' (1970), in Beaumont Newhall (ed.) *Photography: Essays and Images* (New York, 1980), p.272.

257 Plate 11.7

Leica L1 camera
1925

Designed by Oscar Barnack (1879 Lynow, Germany –1936 Bad Nauheim)
Manufactured by Leitz, Wetzlar, Germany

Steel and brass case
7 × 13.2 × 6cm
National Museum of Photography, Film and Television, Bradford

Miniature cameras had been a popular novelty since the late nineteenth century, but it was not until the launch of the Leica in 1925 that they became a practical – indeed, desirable – option for serious photographers seeking a new approach to photography.[1] Modernist artist-designers such as Alexander Rodchenko and László Moholy-Nagy became early and enthusiastic users.[2] Pioneers of social documentation, such as Giselle Freund in Germany, André Kertész, Brassaï and Henri Cartier-Bresson in France and Alfred Eisenstaedt in America, also adopted this inconspicuous and versatile camera to capture images of social life, as well as the fleeting moments that became associated with Leica use.[3]

Leitz was a specialist optical company in the small town of Wetzlar when its head of research, Barnack, began experimenting in 1913 with 35mm ciné-film negative, from which prints would then be enlarged. The resulting miniature camera was not ready for production until 1924, when it mounted a challenge to the plate cameras still widely used and to the drop-front bellows system that offered greater portability, but required the camera to be opened before use. The black, all-metal Leica was robust, with a near-silent focal plane shutter, and constantly ready for use, even if its small (though precise) viewfinder took experience to use. The fact that the film could be quickly advanced proved particularly suited to taking rapid series of photographs.

Equipped with high-quality lenses and supported by a precision enlarger, the Leica produced images of a standard suitable for the new illustrated magazines such as *Vu* (*Seen*), *Picture Post* and, after some resistance, *Life* (pl.11.9). Certain photographers became closely associated with the camera: Paul Wolff lectured and exhibited as 'the Leica wizard' in the late 1920s; Ilse Bing became known as 'Queen of the Leica' in 1930s Paris; and Cartier-Bresson's aesthetic of the 'decisive moment' was canonized after the Second World War.[4] Although other manufacturers entered the 35mm miniature camera market, Leica quickly became a benchmark for quality and functionality. IC

1 Trevor Williams, *A Short History of Technology, c.1900–1950* (Oxford, 1982), p.328.
2 Rodchenko acquired his Leica in 1928 and entitled one of his best-known photographs *Girl with a Leica* (1934). Evelyn Weiss, *Rodtschenko: Fotografien 1920–1938* (Cologne, 1978), p.98.
3 The significance of small-format or 'miniature' photography was championed by the Museum of Modern Art in New York, first in Beaumont Newhall, *Photography: A Short Critical History* (New York, 1938), p.73; and later by Lincoln Kirstein and Beaumont Newhall in *The Photographs of Henri Cartier-Bresson* (New York, 1947).
4 Jean-Claude Gautrand, 'The Leica', in Michael Frizot (ed.), *A New History of Photography* (Cologne, 1998), p.590. When Cartier-Bresson's *Images à la Sauvette* was published in New York in 1952 as *The Decisive Moment*, this phrase became inescapably associated with his work.

258

Compass camera

1937

Designed by Noel Pemberton Billing
(1881–1948)

Manufactured by Jaeger LeCoultre et Cie,
Le Sentier, Switzerland for Compass
Camera Company Ltd, 1938

Aluminium case
27.5 × 9 × 9cm (incl. tripod)
National Museum of Photography, Film and Television,
Bradford

The Compass, like the near-contemporary Minox
(cat.259), exemplified a trend in compact camera
design during the inter-war years to combine
miniaturization with a radical approach to the
overall shape of the casing. In its original form,
the Compass used glass plates rather than the
35mm or smaller film of most compact cameras,
although a roll-film option was added later.[1] But
its sleek, squared aluminium casing, with an
extending lens turret, housed more advanced
technical features than any other miniature
camera of the era. The Compass can be seen as
having influenced the future of compact camera

design, from the Canon Dial of the 1960s to con-
temporary digital models. The visual and functional
modernity of the Compass was emphasized by a
range of specially designed accessories, including
a miniature folding tripod.[2]

Manufactured in Switzerland by the celebrated
LeCoultre watch-making company, which had
recently created the smallest watch movement
ever, as well as the Atmos perpetual clock,
the Compass was designed by the eccentric
English inventor Pemberton Billing. He had been
a pioneer yacht and aircraft designer before the
First World War, establishing the Supermarine
company that would later produce both the record-
breaking Schneider Trophy seaplanes of 1929–31
and the Spitfire fighter. He was also a high-profile
right-wing independent MP and self-appointed
scourge of sexual deviation.[3] No longer an MP
or involved with the company, he later sought to
awaken public awareness of the dangers of modern
war with a pacifist play, *High Treason* (1928), which
he also helped to produce as one of Britain's first
sound films the following year.[4]

Together with its post-war successor,
Pemberton Billing's 1946 Phantom 'spy' camera, the
Compass represented an almost visionary approach
to the emerging field of miniature photography.
Both cameras featured cleverly built-in accessories,
integral system design and streamlined casing
conveying a futuristic impression. IC

1 James and Joan McKeown, *Price Guide to Antique and Classic Cameras* (Grantsburg, WI, 1996), p.123.
2 A 2005 vintage camera dealer's advertisement listed the Compass kit as including 'sheaths, cable release, pocket tripod, carrying chain, negative print filing system, case, plates and films, roll film back, zip purse, processing service and plate holders'.
3 Pemberton Billing was sued for libel by the dancer Maud Allan in 1918 over his allegation that she was a lesbian. See Philip Hoare, *Oscar Wilde's Last Stand: Decadence, Conspiracy and the Most Outrageous Trial of the Century* (New York, 1999).
4 The film of *High Treason*, directed by Maurice Elvey, was British Gaumont's first all-sound release in 1929 and has often been disparaged for alleged amateurism (in *Close Up*, September 1929, quoted in Rachael Low, *A History of the British Film 1918–29*, London [1971], p.174). Like many British films of the period, this has recently been re-evaluated more sympathetically.

259

Minox camera
Designed 1936
Walter Zapp
(1905 Riga–2003 Binningen, Switzerland)
Manufactured by VEF, Riga, Latvia

Steel case
1.8 × 10 × 2.8cm
National Museum of Photography, Film and Television,
Bradford

The concept of the Minox emerged from the burst of miniature camera development during the 1920s, which first produced the Leica. However, the young engineer Walter Zapp wanted to create an even smaller camera that could be held in the palm of the hand. The starting point of his

pioneering, ergonomic design was a carved block of wood with rounded corners.[1]

Compactness and convenience were key features of the final Minox design, and the camera is readied for use simply by pulling on and expanding its case by 1.5cm to reveal the lens. But Zapp also wanted to produce a precision instrument, and the 15mm focal length of the high-quality lens corresponds closely with that of the human eye, resulting in the Minox having unusual depth of field and giving distinctively natural photographic results as compared with other camera formats.[2] The miniature film with an 8 × 11mm frame size was supplied in a cassette that provided 50 exposures and, like all components of the Minox 'system', had to be specially produced.

The Minox was manufactured by the Riga engineering company VEF (National Electro-Technical Factory), makers of torches, irons and other consumer products. Production of the

camera began in 1937 at the rate of two per day and, in its original brass version, the Minox was an unusual luxury item.[3] Owing to its miniature size, it was soon perceived to have military and intelligence uses. When production restarted in Germany after the war, with a new ultra-light aluminium casing, it became an icon of the Cold War and in particular of espionage fiction, a reputation that has tended to obscure Zapp's original contribution to the passion of the inter-war years for spontaneous photography. IC

1 D. Scott Young, *Minox – Marvel in Miniature* (Bloomington 2000).
2 As recently analysed by the physicist Peter Zimmerman, 'The Eye is a Minox', www.slonet.org/~mhd/minox/m1.htm
3 Two per day is the figure given by the Minox Historical Society, http://www.minox.org/minoxencyclopedia/z/zapp.html. According to a leaflet from the Latvian Museum of Photography – *VEF MINOX* – approximately 17,000 were manufactured between 1937 and 1942.

260a Plate 11.17

Clockwork toy car: *Golden Arrow* Racer
1929
Manufactured by Kingsbury
Manufacturing Co., Keene, NH

Lacquered steel
49.5 × 11.7 × 7.3cm
V&A Museum of Childhood, London (MISC.195–1978)

260b Plate 11.17

Clockwork toy car: Napier–Campbell *Bluebird* Racer
1928
Manufactured by Kingsbury
Manufacturing Co., Keene, NH

Lacquered steel
47 × 12.7 × 10.8cm
V&A Museum of Childhood, London (MISC.194–1978)

Two detailed toy cars produced in America, complete with miniature Dunlop tyres, testify to the wide appeal of the intense contest for the world land-speed record during the 1920s and

'30s.[1] The history of cars specially designed for this purpose began in 1927, with Malcolm Campbell's *Bluebird* – a name he had used for all his racing and speed cars since before the First World War. This vehicle with a 12-cylinder 450-hp aero engine enabled Campbell to reach 175 mph (281 kph); but when his rival Henry Seagrave promptly raised the record to over 200 mph (322 kph), driving a 1,000-hp Sunbeam, Campbell retaliated with the 1928 *Bluebird* reproduced in the contemporary toy, using an 875-hp aero engine and aerodynamic bodywork designed with the aid of wind-tunnel testing. He regained the record in early 1928, only to lose it within weeks to an American contestant, Ray Keech, who combined three aero engines on a minimally streamlined truck chassis.[2]

The streamlined wheel fairings and aircraft-style tailfin of the 1928 *Bluebird* proved vital for later entrants in this competition, and were soon developed further in the radical design of Seagrave's *Irving–Napier Special*, which was immediately christened the *Golden Arrow*. J.S. Irving's design, using a Napier aero engine similar to that of *Bluebird*, conceived the aluminium body effectively as a fuselage, with two extended fairings on the bonnet, which, when looked at from the front, formed a distinctive 'cross'-section with the

driver's headrest tapering into a rear fin. But the most striking feature of the *Golden Arrow* was its continuous fairings linking the front and rear wheels, a design innovation that would lead to the complete encasing of wheels in the next generation of speed cars, beginning with the 'teardrop' of George Eyston's *Thunderbolt* in 1937 and John Cobb's *Railton* of the following year. In the *Golden Arrow*, however, the wheel fairings also provided additional cooling, enclosing tanks filled with ice.

Irving's radical, yet elegant *Golden Arrow* design proved highly effective when Seagrave comfortably beat Campbell's record, achieving 231 mph (372 kph) on its first outing at Daytona in March 1929. This record would stand for two years, before Campbell returned with a series of increasingly powerful *Bluebird* variants, holding the record a total of nine times. Seagrave was killed in an attempt on the water-speed record soon after his 1929 triumph, and the *Golden Arrow* was retired after travelling less than 20 miles in its whole career. IC

1 Halina Pasierbska, 'Landspeed Cars', http://www.everyobject.net/story.php?id=156 (posted 4 March 2005).
2 R.M. Clarke, *The Land Speed Record 1920–1929* (Surrey, 1999); Peter J.R. Holthusen, *The Fastest Men on Earth: 100 Years of the Land Speed Record* (Stroud, 1999).

261a

Pocket map of the Underground Railways of London
1930–32
Fred H. Stingemore
Printed by Waterlow & Sons Ltd, London, Dunstable and Watford
Published by the London Passenger Transport Board

Colour lithograph
14 × 16.6cm
V&A: E.211–1994

261b

Sketch for London Underground Map
1931
Henry C. (Harry) Beck (1903–1974)

Pencil and coloured ink
19 × 24.1cm
V&A: E.814–1979

261c

First edition of the London Underground Diagram
1933
Henry C. (Harry) Beck (1903–1974)

Printed by Waterlow & Sons Ltd, London, Dunstable and Watford
Published by the London Passenger Transport Board

Colour lithograph
22.8 × 16cm
V&A: E.815–1979

The iconic London Underground map, which has been in use continuously since 1933, is in fact a diagram of the network, showing relationships rather than distances to scale and using only vertical, horizontal and diagonal lines, with different colours for each of the Tube lines.[1] It has become a design classic, implicitly demonstrating the importance of simplicity, economy and utility – all key values promoted by Modernist design. Yet the Underground map was devised and produced in its own time by an engineering draughtsman, Harry Beck, after he had been made temporarily redundant by London Underground. Beck reasoned that 'if you're going underground, why do you need bother about geography? . . . Connections are the thing.'[2] Although often assumed to be based on electrical circuit diagrams, Beck's design was apparently modelled on sewer mapping.

Previous maps of the Underground railway system had followed conventional mapping principles, however selectively (for instance, Leslie Macdonald Gill's 1922 map and Stingemore's series produced between 1925 and 1932). Beck's radical simplification was at first viewed sceptically, but after a successful trial production of 500 copies in 1932, it was published in a first edition of 700,000 in 1933 and quickly became a vital element in Frank Pick's campaign to project London Transport as a modern, rational and efficient system.[3] Pick would become founding chairman of the Council for Arts and Industry the following year, joining the movement to promote better design in British industry. Beck's 'geoschematic' map, for which he received just five guineas, has since become the (often unacknowledged) basis for most urban transit (and many other transport) maps.[4] IC

1. An informative tribute by a major designer to the creator of the Underground design is Ken Garland, *Mr Beck's Underground Map* (London, 1994). See also 'A History of the London Tube Maps', http://homepage.ntlworld.com/clivebillson/tube/tube.html (consulted 23 August 2005).
2. Harry Beck quoted by Ken Garland in a television series, *Design Classics* (BBC, 1984) referenced in Janin Hadlow, 'The London Underground Map: Imagining Modern Time and Space', *Design Issues*, vol.19 no.1 (Winter 2003), p.32.
3. Charlotte Benton, 'Design and London Transport', in Jennifer Hawkins et al., *Thirties, British art and design before the war* (exh. cat., Hayward Gallery, London, 1979), p.219.
4. Bob Bayman and Piers Conner, *Underground Official Handbook* (London, 1994); see also R. Last, *The London Underground Map* (BBC video recording, 1987); Doug Green, 'London underground Map: The who, what, where, when, how and why...', *Internet Information Design*, http://members.iinet.net.au/%7egreen2/journal /html/essays/underground1.html (consulted 23 August 2005).

261b

261a

261c

262

Poster: *Aero*
1932
Designed by František Zelenka
(1904 Kutné Hoře, Bohemia–
1943 Auschwitz)
Printed by Melantrich, Prague

Colour offset lithograph
92 × 122cm
The Museum of Decorative Arts, Prague (GP 2224)

One of a series of advertising designs for the Czechoslovak aircraft manufacturer's venture into automobiles, Zelenka's poster wittily makes the case for owning an Aero car, thus avoiding the need to buy tram and train tickets. The stark asymmetrical geometry of crossed red lines and facsimile tickets on a plain background recalls the idiom of Russian Suprematist design, especially of Kazimir Malevich and El Lissitsky,

and also, more immediately, the work of Kurt Schwitters (cat.126).[1] Czechoslovak design of this period was, however, also shaped by local factors.

Following the establishment of the Czechoslovak Republic after the First World War, the avant-garde Devětsil group was formed in 1920 to promote a functionalist Modernism across all spheres of cultural work, while maintaining international contacts with Dada, Constructivism and De Stijl.[2] Although this group broke up in 1931, its influence continued to be felt and is apparent in the work of the architect and designer Zelenka. Primarily a stage designer – best known for his work at the avant-garde Prague Free Theatre and, after the German Occupation, for his productions in the Terezin concentration camp (where he died) – Zelenka also contributed to the renaissance of Czechoslovak cinema and other industries during the 1930s.[3]

In his advertising for the Aero car, Zelenka evokes the Devětsil 'picture-poem', a distinctive form 'composed of collaged lexical and visual elements, including photographs culled from popular magazines, ephemera such as stamps,

postmarks, postcards, train and subway tickets, and fragments of maps' (cat.63a).[4] The poster reflects the spirit of enterprise that gripped Czechoslovak engineering as well as the arts in the 1930s, at once intensely nationalistic and ultra-modern. As an early Devětsil manifesto stated: 'A picture must be active / It must do something in the world.'[5] IC

1 On Schwitters's work for Hanover, see Jeremy Aynsley, *Graphic Design in Germany 1890–1945* (London, 2000), pp.157–8.
2 On Devětsil, see Derek Sayer, *The Coasts of Bohemia: A Czech History* (Princeton, 1998), pp.208–20; and František Smejikal and Rostislav Svacha, *Devětsil: Czech avant-garde art, architecture, and design of the 1920s and 1930s* (Oxford, 1990).
3 Zelenka produced film posters and is credited with sets and costumes for Jindrich Honzl's film *Pudr a benzin* (*Powder and Petrol*, 1932). In Terezin he designed Krása's children's operetta *Brundibár*. See also Sayer (1998), p.228.
4 Julie Newton, Abstract for 'Poetry in the Age of Mechanical Reproduction: The Devetsil Picture-Poem', http://www.columbia.edu/cu/slavic/art_tech/newton.htm (consulted 7 April 2005).
5 'Picture', in *Disk*, no.1 (1923), trans. in Stephen Bann (ed.), *The Tradition of Constructivism* (London, 1974), p.99.

263

Photograph: *Pan-American Airways S-42 Seaplane*
1934
Margaret Bourke-White
(1904 New York–1971 Darien, USA)

Gelatin silver print
33.5 × 24cm
Wilson Centre for Photography (98:5789)

The wing of the Sikorsky S-42 seaplane makes a sail-like abstract shape, hiding the fuselage and creating a strikingly evocative image of mechanized power by America's leading photographer of industry during the 1930s. The subject was significant, even if it was sub-ordinated to the composition. Seaplanes had developed rapidly in the inter-war years, initially owing to their high flying speed and later becoming versatile passenger and cargo carriers able to operate independently of airport runways, especially on Latin American and Pacific routes. Newly introduced in 1934, the S-42 could fly a record 32 passengers in comfort from Miami to Buenos Aires.[1]

Bourke-White's concern was less in celebrating the aircraft's design and performance than in creating an image that balanced abstraction with the evocation of industrial progress. The use of dramatic receding perspective is a recurring feature of her photographs of factories and industrial sites from 1928 to the mid-1930s (pl.3.13). Originally inspired both by her father's amateur photography and his work as engineer, she learned from Clarence H. White about Modernist trends in art and design, and became part of the generation of American photographers trained by him who set out to document American 'progress' with formal sophistication.[2] Through her association with *Fortune* and *Life* magazines, her industrial images were widely disseminated, providing an American equivalent to the work of Russian and German Modernist photographers (pl.11.9).[3] IC

1 Roy Allen, *The Pan Am Clipper – A History of Pan Am's Flying Boats 1931–1946* (London, 2000). In her book, *Shooting the Russian War* (New York, 1942), Bourke-White would describe her own journey on a flying 'clipper', en route to China and Russia (pp.6–10).
2 Vicki Goldberg, *Margaret Bourke-White: A Biography* (New York, 1986); John Pultz, 'New Photography in the United States', in Michel Frizot (ed.), *A New History of Photography* (Paris, 1994–8), p.482. Another graduate of White's School of Photography was Dorothea Lange, who focused on the human cost of American capitalism in her documentation of unemployment and strikes.
3 John R. Stomberg, *Power and Paper: Margaret Bourke-White, Modernity and the Documentary Mode* (exh. cat., Boston University Art Gallery, 1998), pp.13–38.

264a Plate 11.14

Design: *Petrol-pump top, Shell-Mex*
1934
E. McKnight Kauffer
(1890 Great Falls–1954 New York)

Photomontage, body colour and pen
V&A: E.3767-2004

264b Plate 11.15

Design: *Printed advertisement Shell-Mex BP*
c.1937
E. McKnight Kauffer
(1890 Great Falls–1954 New York)

Photomontage, body colour and pen
c.30 × 21cm
V&A: E.3765-2004

Shell-Mex's distinctive advertising owed much to its advertising manager Jack Beddington (1893–1959), who commissioned from leading Modernists as well as from traditional and popular artists, and who first employed Edward McKnight Kauffer in 1929. After the company's success with its 'lorry bill' posters, Shell's recent development of the electrically operated garage petrol pump, at a time of intense competition, provided opportunities to display an illuminated pump-top sign. Kauffer's design of 1934 was never implemented, but shows his characteristic awareness of the 'square' motif in Modernism, from its polemical use by Kazimir Malevich (cats 1, 6) in 1915 to its later use in Bauhaus design theory. In the form of a witty *'moderne'* trophy, Kauffer's design proposes a sculptural treatment of 'pure' sans-serif lettering and geometric form.

The monochrome design *Lubrication by Shell*, intended for a printed advertisement, uses the robot figure, based on the traditional artists' lay-figure, which became Shell's trademark motif and appeared in a range of media during the 1930s, cleverly combined with a dynamically angled photographic image.[1] The elements are essentially those of Constructivist and Bauhaus Typophoto (cat.131) and the Modernist fascination with the image of the machine, here brought into the sphere of commercial advertising.[2]

The American-born designer Edward McKnight Kauffer lived in Britain for most of his career and, having studied in Paris and helped found the Vorticist group, had more links with Modernist fine art and design than many other designers of the inter-war period. As well as major work for London Underground, the BBC and Shell, he designed books for Faber & Faber and published *The Art of the Poster* in 1924.[3] IC

1 The figure appeared on oil cans and posters, and 'starred' in Len Lye and Humphrey Jennings's 1936 Shell advertising film *Birth of a Robot*.
2 The integration of typography and photography was promoted especially by Varvara Stepanova and Alexander Rodchenko in the Soviet Union, and by the Bauhaus printing workshop, in the 1920s. László Moholy-Nagy's book, *Malerei, Fotografie, Film* (Dessau, 1925) provided an early manifesto for this concept.
3 On McKnight Kauffer and British advertising art of the 1930s, see Mark Haworth-Booth, *E. McKnight Kauffer: A designer and his public* (London, [1979] 2005); Oliver Green, *Art for the London Underground* (New York, 1990); Steven Heller and Louise Fili, *British Modern: Graphic Design Between the Wars* (San Francisco, 1998).

265

Poster: *XXV Mezinárodní Jubilejní Výstava Automobilů v Praze* (*25th International Automobile Exhibition, Prague*)
1935
Designed by P. Flenyko/aur-studio
Printed by Melantrich, Prague

Offset
94 × 63cm
The Museum of Decorative Arts, Prague (GP 16803)

By the mid-1930s streamlining had become an international styling fashion. This poster for the Prague Automobile Exhibition in 1935 used an aerodynamic 'teardrop' shape as its main motif, suggesting the airflow around the body as it might appear in a wind-tunnel test – which had in fact provided the engineering basis of streamlining.[1] Such quasi-technological imagery as the basis for an essentially abstract design recalls one of Bohemia's founding contributions to Modernism:

the pre-First World War 'Orphist' abstract painting of František Kupka, such as *Discs of Newton* (1911–12).[2]

Although the car form in the poster is stylized, it evokes at least two contemporary references. One was the increasingly aerodynamic type of vehicle being developed in the early 1930s for attempts on the world-speed record by Henry Seagrave and Malcolm Campbell, whose intense competition had made the *Golden Arrow* and *Bluebird* familiar images around the world (see Chapter 11 and cat.260). The other more immediate source was the 'pure' streamlined saloon design that the Czech Tatra company had pioneered in 1933, and which caused a sensation at the Berlin Autosalon the following year. Three other manufacturers showed aerodynamically styled models at the 1934 Berlin exhibition, while Tatra launched its production model T77a in Prague in 1935, a 'local' achievement that Flenyko may have been celebrating in the poster.[3]

Although the Czechoslovak economy suffered from the worldwide recession in the early 1930s, the young republic's automobile industry was among its most competitive sectors, with Skoda,

Wikow, Karosa and Aero, as well as Tatra, all producing innovative models. Much of this innovation was suppressed, or stolen, when Germany invaded Czechoslovakia, only to re-emerge in Tatra's cult post-war T600 Tatraplan, a teardrop car that is eerily prefigured in the 1935 poster.[4] IC

1 The Hungarian Paul Jaray (1889–1974) was working for Zeppelin as an airship designer when he used wind-tunnel experiments to arrive at his 1922 patent for an aerodynamically efficient form, which was then used by such companies as Budd in the USA and Tatra in Czechslovakia. John Heskett, *Industrial Design* (London, 1980), p.121.
2 František Kupka (1971–1957) was born in Bohemia and studied in Prague, before settling in Paris in the mid-1890s, where he remained for the rest of his career. However, he retained links with Czechoslovakia, and his book *Creation in the Plastic Arts* was published in Prague in 1923 during the post-war period of intense avant-garde activity in the arts. The term 'Orphism' was coined by Apollinaire in 1912: see Virginia Spate, *Orphism* (Oxford, 1979).
3 The others were Chrysler, with their *Airflow*, designed with the help of a wind tunnel; the Austrian Steyr 32 PS; and the German DKW 1-litre. See 'Automobiles, 1885–1940', *Petite Encyclopédie* (Paris, 1995) and http://pboursin.club/fr/tatra.htm (consulted 7 April 2005).
4 On the Tatraplan and other Tatra history, see Ivan Margolius, 'Tatra 600 – Tatraplan: A Mass-Produced Teardrop Car', *Architectural Design*, vol.71, no.5 (September 2001).

266 Plate 11.19

Tatra T87 Saloon Car

1937

Designed by Hans Ledwinka (1878
Klosterneuburg, Austria–1967 Munich)
Manufactured by Tatra Werke, Koprivnica,
Czechoslovakia

Silver-grey lacquered metal
l. 474cm, w. 167cm, h. 150cm
Die Neue Sammlung, Munich

The Tatra T87 emerged in 1937 as the first true
streamlined production motor car. The Austrian-
born Ledwinka led the team of engineers at
the Czech Tatra company who developed the
pioneering design.[1] The company had built
carriages and rail coaches since the mid-nineteenth
century before entering into motor-car production
in 1897 (which was also the year Ledwinka joined
the firm). In around 1930 Tatra engineers conceived
a radical redesign of what had become the standard
box-shaped automobile, mounting an air-cooled
engine at the rear of a backbone chassis.

Several prototypes appeared in 1931 and 1933,
before the launch in 1934 of the T77, a six-seater
luxury car powered by a V-8 engine, with the
distinctive features of a driver seated centrally and
a dorsal rear fin similar to those being used by
contemporary racing cars. Despite its advanced
design, the car's road-holding was criticized
and relatively few were produced before the T87
appeared two years later. The new model handled
better, was lighter and more compact, and
delivered an even higher top speed of 160 kph
and better fuel consumption. Many of these
improvements followed from its monocque shell
structure, which had first been used in aircraft
and racing cars; and although the driver was
now conventionally placed, the T87 retained its
predecessor's central third headlight and what
had now become Tatra's trademark fin. Introduced
for aerodynamic reasons, the fin emphasized the
T87's striking streamlined form, which had drawn
on studies in minimizing air resistance and drag
by the Swiss-based designer Paul Jaray and on
bodywork patents licensed from the American
Budd company (responsible for the Zephyr train,
pl.11.16).[2] Other suggested influences on the overall
design include the sculptor Constantin Brancusi
and the architect Erich Mendelsohn (cat.27).

When Nazi Germany invaded Czechoslovakia
in 1938, Tatra's output was closely monitored,
with the T87 permitted in limited numbers as an
'Autobahn car', while its successor, the intended
mass-market T97, was suppressed in order to
eliminate competition for Porsche's *Volkswagen*
(pls 10.18–19), the design of which may have been
influenced by the Czech car. IC

1 Ivan Margolius, *Automobiles by Architects* (Chichester, 2000);
 Ivan Margolius and John G. Henry, *Tatra: The Legacy of Hans
 Ledwinka* (Harrow, 1990); and www.tatra.cz/cz/;
 www.tatraworld.nl (consulted 15 August 2005).
2 Ivan Margolius has suggested the influence on the design of
 the T87's post-war successor. See 'Tatra 600-Tatraplan, a
 mass-produced teardrop car', in *Architectural Design*, vol.71,
 no.5 (September 2001), p.65.

267 Plate 11.11

Aeroplane model: Douglas DC-3

1938

Designed by Arthur Raymond
(1899 Boston–1999 Santa Monica)

Metal, plastic and paint
17 × 79.5 × 53cm, scale 1:36
Science Museum, London (1938-170)

Widely regarded as the most successful
commercial aeroplane of all time, the DC-3
resulted from intense competition in the American
airline industry of the 1930s. United Airlines had
exclusive access to the Boeing 247, a revolutionary
twin-engined design based on a bomber, which
used an all-metal monocoque construction and
retractable wheels to achieve an overall stream-
lined design. Transworld Airlines asked the
aircraft manufacturer Donald Douglas to produce
a viable competitor, resulting in the DC-1 (1933)
and DC-2 (1934). The larger DC-3 was designed
in response to a commission from American
Airlines and launched in mid-1936.[1]

Both the Boeing 247 and Douglas DC models
were capable of racing against specially designed
competition planes, with speeds of 160–80 mph
(260–90 kph) and increased range, but their
most important specification was the number of
passengers they could carry in unprecedented
comfort: 24 seated or 12 sleeping in the case of
the DC-3. Soundproofing, elegant cabin styling
and on-board catering became vital features in
the battle to attract customers from rival airlines
as American government subsidies for carrying
mail was withdrawn. The era of true air-passenger
travel had arrived.

Twelve thousand DC-3s were built and, like
other highly successful commercial designs of
the 1930s, what had once seemed the epitome of
modern technological design eventually became
familiar and unnoticed, especially in its wartime
'Dakota' guise and many post-war roles.[2] In an
era of often exaggerated streamlining for visual
effect, the plane's aerodynamic 'teardrop' shape,
with a less bulbous nose than its Boeing fore-
runner and even more smoothly integrated wings
and tailplane, succeeded in realizing the Modernist
ideal of wholly functional form – becoming a
'symbol of the age [and] a key-object in technical
aesthetics'.[3] IC

1 Rene J. Francillon, *McDonnell Douglas Aircraft Since 1920*
 (London, 1979); Ed Davies, Scott Thompson and Veronica
 Nicholas, *Douglas DC-3: Sixty Years and Counting* (Elk Grove, CA,
 1995); 'DC-3 Commercial Transport', Boeing-McDonnell Douglas
 History, http://www.boeing.com/history/mdc/dc-3.htm
 (consulted 7 April 2005); 'The DC-3', www.centennialofflight.gov/
 essay/Aerospace/DC-3/Aero29.htm (consulted 7 April 2005).
2 Some 2,000 DC-3s are believed to be still flying.
3 John Heskett, *Industrial Design* (London, 1980), p.122.

Notes
Bibliography
Picture Credits
Index

Notes

1 Introduction: What was Modernism?

1 See, for example, Tim Armstrong, *Modernism, technology and the body* (Cambridge, 1998), a rich study that concentrates on literature and aspects of popular culture in the English-speaking world; or Adrian Forty, *Words and Buildings: A Vocabulary of Modern Architecture* (London, 2000), a book devoted to the use of language in architecture, in which the term Modernism figures in nearly every chapter. Neither defines the term. Of direct relevance to this catalogue are the vast numbers of books on architecture that employ the term in their title without explanation. One notable exception is Sarah Williams Goldhagen and Réjean Legault, *Anxious Modernisms* (Cambridge, MA, 2001), especially 'Coda: Reconceptualizing the Modern'. Books aimed at the student or reference market generally define the term. An excellent example, concentrating on fine art, is Charles Harrison, *Modernism* (London, 1997). See also Chris Baldick, *The Concise Oxford Dictionary of Literary Terms* (New York, 1991). At the other end of the spectrum, collectors' books and websites use the word to indicate, in the narrowest sense, objects without ornament or made of new materials and, in the widest, a visual style (see http://www.bbc.co.uk/homes/design/ period_modernism.shtml, consulted 27 May 2005).

2 On these origins in Central America and, later, Spain, see Matei Calinescu, *Five Faces of Modernity* (Durham, NC, 1987), pp.69–78, a book that notably delves into the etymology and history of the term Modernism, mainly in literature.

3 Ibid., pp.81, 83, cites *The Modernist: A Monthly Magazine of Modern Arts and Letters* (New York, from 1919) and Laura Riding and Robert Graves's *Survey of Modernist Poetry* (London, 1927). Examples of the term in other fields include 'Agnès Who First Sponsored Modernism in Dress', *Vogue* (London, early October 1925), p.60; and, in an architectural magazine, Stanley Casson, 'Modernism', *Architectural Review*, vol.LXVIII (September 1930), p.123, an article quoting from William Aumonier's *Modern Architectural Sculpture* (London, 1930).

4 The use of 'modern' to indicate the new or the contemporary had a long history: chroniclers of art and aesthetics as diverse as Giorgio Vasari, Charles Baudelaire and Walter Pater used the term in this way, albeit with different nuances.

5 Henry Russell-Hitchcock, *Modern Architecture, and Regeneration* (New York, 1929), p.205.

6 Nikolaus Pevsner, *Pioneers of the Modern Movement from William Morris to Walter Gropius* (London, 1936) was retitled *Pioneers of Modern Design from William Morris to Walter Gropius* when it was published by the Museum of Modern Art, New York, in 1949.

7 See, for example, Alfred H. Barr, Jr's reference to 'the most impractical and fantastic "styler" of "modernistic" plumbing fixtures', in the foreword to *Machine Art* (exh. cat., MoMA, New York, 1934), n.p.

8 See the section headed 'Modernism in All the Heresies' in http://www.vatican.va/holy_father/pius_x/encyclicals/documents/hf_p-x_enc_19070908_pascendi-dominici-gregis_en.html, np (consulted 27 May 2005); Darrell Jodock (ed.), *Catholicism Contending With Modernity: Roman Catholic Modernism and Anti-Modernism in Historical Context* (Cambridge, 2000); and Calinescu (1987), pp.78–9.

9 Clement Greenberg, 'Avant-Garde and Kitsch', *Partisan Review* (Fall 1939), reprinted in Greenberg, *The Collected Essays and Criticism*, vol.1 (Chicago, 1986), p.9.

10 Clement Greenberg, 'Modernist Painting', *Forum Lectures* (Washington, 1960), reprinted in Greenberg, *The Collected Essays and Criticism*, vol.4 (Chicago, 1993), p.87.

11 In particular was the widespread move to explain the role of popular culture in Modernist art and the distinction made by Peter Bürger between Modernism (which he described as autonomous and divorced from life, concerned with the individual only) and the avant-garde (which 'attempts to organize a new life praxis from a basis in art' and is therefore radically opposed to Modernism). See Bürger, *The Theory of the Avant-Garde* (Minneapolis, 1984), quotation from p.49. See also T.J. Clark, *Farewell to an Idea: Episodes from a History of Modernism* (New Haven, 1999), for a view of Modernism directly connected to life and practice.

12 Giedion referred to the Modern Movement in a letter of 1929 to Le Corbusier, cited in Beatriz Colomina, *Privacy and Publicity: Modern Architecture as Mass Media* (Cambridge, MA, 1994) p.199.

13 From the *Architectural Review* see, for example, 'Foreword', vol.121, no.720 (January 1957), p.7; J.M. Richards, 'Europe Rebuilt 1946–56 – What Has Happened To The Modern Movement?', vol.121, no.722 (March 1957), p.172; Reyner Banham, 'The One and the Few – the Rise of Modern Architecture in Finland', vol.121, no.723 (April 1957), p.247; and 'Foreword', vol.123, no.732 (January 1958), p.7. The terms Modern Movement and International Style were also used widely at the time. There may well be earlier instances, but what seems important is when the term is used generally. American adoption seems to be later, with usage common by the early 1960s.

14 The exhibition was entitled 'Modern Architecture, International Exhibition' and the Museum of Modern Art published a book of the same title, while W.W. Norton published Henry-Russell Hitchcock and Philip Johnson's *The International Style: Architecture since 1922*. See Terence Riley, *The International Style: Exhibition 15 and the Museum of Modern Art* (New York, 1992). Pevsner (1936), p.41, referred to the Modern Movement as the 'new style . . . of our century', though this had much to do with his training as an art historian in early twentieth-century Germany. References to the modern 'style' are common in periodicals and decorating books of the mid- to late 1930s. For a collection of American examples, see Kristina Wilson, *Livable Modernism* (exh. cat., Yale University Art Gallery, 2005).

15 George Steiner, *Extra-Territorial, Papers On Literature And The Language Revolution* (London, 1972).

16 Mies van der Rohe indirectly quoted in Willi Lotz, 'Werkbund-Ausstellung Die Wohnung, Eröffnung', *Die Form*, vol.2 (1927), p.251.

17 Pevsner (1936), p.41, wrote that '. . . this new style, a genuine and adequate style of our century, was achieved by 1914'. He later revised this to read, 'the genuine and legitimate style of our century . . .' (New York, 1949 and all subsequent editions). See also Chapter 5, Building Utopia.

18 Jürgen Habermas, 'Modernity versus Postmodernity', *New German Critique*, no.22 (Winter 1981), p.9, and Marshall Berman, *All That is Solid Melts Into Air* (London, 1983), p.15, and, for the quotations in the following two sentences, p.16.

19 The publication of Reyner Banham's ground-breaking *Theory and Design in the First Machine Age* (London, 1960) offered what was then an innovative grounding in art and architectural theory of the early twentieth century.

20 Jacobs's text was not only a critique of Corbusian city planning, but also took to task the Garden City movement and the civic bombast of Daniel Burnham and the American 'White City' movement. In his book, Venturi (working with Denise Scott-Brown) decried Modernist simplicity ('Less is a bore,' he wrote) and embraced the popular architectural culture of the American main street.

21 Notably David Watkin, *Morality and Architecture* (London, 1977), and Roger Scruton, *The Aesthetics of Architecture* (London, 1979), though Scruton's subsequent writings addressed architectural Modernism at greater length.

22 Public acceptance of such views was encouraged by the widespread reporting of Prince Charles's attacks on Modernist architecture and city planning in speeches at a celebration of the 150th anniversary of the RIBA (30 May 1984) and in a further speech to the Corporation of London Planning and Communication Committee's annual dinner (1 December 1987). The complete texts are at http://www.princeofwales.gov.uk/speeches/speeches_index_arc.html (consulted 27 May 2005).

23 T.J. Clark (1999), pp.2–3, has written in metaphorical terms that 'already the modernist past is a ruin, the logic of whose architecture we do not remotely grasp . . . Modernism is our antiquity, in other words; the only one we have . . .'

2 Searching for Utopia

1 Le Corbusier, 'L'Esprit Nouveau Programme', *L'Esprit Nouveau*, no.1 (October 1920), p.3.

2 Victor Margolin, *The Struggle for Utopia 1917–1946* (Chicago, 1997), p.3.

3 Utopia comes from the Greek, and suggests two neologisms simultaneously: *outopia*, meaning no place, and *eutopia*, meaning a good place.

4 Thomas More, *De Optimo Reipublicae Statu deque Nova Insula Utopia* (London, 1516). It is commonly referred to as *Utopia*.

5 Plato, *The Republic*, 360 BC.

6 William Morris, 'News from Nowhere', *The Commonweal* (London, January–October 1890), subsequently *News from Nowhere* (London, 1891).

7 Reinhold Heller, 'Bridge to Utopia: The Brücke as Utopian Experiment', in Timothy O. Benson, *Expressionist Utopias: Paradise, Metropolis, Architectural Fantasy* (exh. cat., Los Angeles County Museum of Art, 1994, 2nd edn 2001), p.62ff. Of course, alongside such pastoral idylls, *Die Brücke* also produced images of urban angst and alienation.

8 Wassily Kandinsky, *Concerning the Spiritual in Art* (New York, [1912] 1977).

9 Ibid., p.15.

10 Paul Scheerbart, *Glasarchitektur* (Berlin, 1914), trans. in Ulrich Conrads, *Programs and Manifestoes on 20th Century Architecture* (Cambridge, MA, 1975), p.32. See also Iain Boyd Whyte, 'The Expressionist Sublime', in Benson (2001), p.127.

11 Bruno Taut, 'Program for Architecture' (1918), cited in Conrads (1975), p.41.

12 Boyd Whyte, in Benson (2001), p.120ff.

13 Walter Gropius, 'Programm des Staatlichen Bauhauses in Weimar' (April 1919), trans. in Hans M. Wingler, *The Bauhaus: Weimar, Dessau, Berlin, Chicago* (Cambridge, MA, 1976), p.31.

14 Ibid., p.32.

15 Ibid., p.32.

16 Gropius may have been seeking a revolutionary new art form, but the initial programme was closely related to that of a conventional craft school. Gillian Naylor, *The Bauhaus Reassessed: Sources and Design Theory* (New York, 1986), p.56.

17 *Poslednaya futuristicheskaya vystavka kartin 0,10 (nol'-desyat'). Katalog* [*The Last Futurist Exhibition of Pictures 0.10 (Zero-Ten): Catalogue*], (Petrograd, 1915), p.3, no.40.

18 See Tamara Kudryavtseva, *Circling the Square: Avant-Garde Porcelain from Revolutionary Russia* (London, 2004).

19 See *UNOVIS*, no.1 (Vitebsk, 20 November 1920).

20 cf. Kazimir Malevich, *Future Planits for Leningrad: The Pilot's Planit* (1924), pencil on paper, Stedelijk Museum, Amsterdam; and Malevich, *Future Planits for Leningrad: The Pilot's Planit* (1924), pencil on paper, Museum of Modern Art, New York.

21 Kazimir Malevich, caption on *Unovis – the future Planits (houses) of the Earthlings* (1924), pencil and ink on paper, Stedelijk Museum, Amsterdam.

22 Kazimir Malevich, *Suprematizm: 34 Risunok* [*Suprematism: 34 Drawings*] (Vitebsk, 1919). The quote continues, 'Study of the Suprematist formula of movement leads us to conclude that rectilinear motion towards any planet can only be achieved by the circling of intermediary satellites, which would provide a straight line of circles from one satellite to the other.'

23 See Nikolai Fedorov, *Filosofiya obshchego dela* [*The Philosophy of the Common Task*], vol.1 (Moscow, 1906); vol.2 (1913).

24 See George M. Young, *Nikolai F. Fedorov: An Introduction* (Belmont, MA, 1979) and Michael Hagemeister, 'Russian Cosmism in the 1920s and Today', in Bernice Glatzer Rosenthal (ed.), *The Occult in Russian and Soviet Society* (New York, 1997), pp.185–202.

25 Piet Mondrian, sketchbook, cited in Harry Holtzman and Martin S. James (eds and trans), *The New Art – The New Life: The Collected Writings of Piet Mondrian* (Boston, 1986), p.18.

26 Nancy J. Troy, *The De Stijl Environment* (Cambridge, MA, 1983), p.3.

27 William S. Rubin, *Dada and Surrealist Art* (New York, 1968), p.9.

28 Michel Foucault, 'Of Other Spaces', *Diacritics*, no.16 (Spring 1986), p.24.

29 Timothy O. Benson, 'Fantasy and Functionality', in Benson (2001), pp.43–4.

30 Tristan Tzara, 'Lecture on Dada', delivered at the Weimar Congress of 1922 and published as 'Conference sur Dada', *Merz* (January 1924); reprinted in Robert Motherwell (ed.), *The Dada Painters and Poets: An Anthology* (New York, 1951), p.250.

31 Filippo Tommaso Marinetti, 'The Founding and Manifesto of Futurism', in Umbro Apollonio (ed. and trans.), *Futurist Manifestos* (London, 1973), pp.19–20.

32 Umberto Boccioni, Carlo Carrà, Luigi Russolo, Giacomo Balla, Gino Severini, 'Manifesto of the Futurist Painters 1910', in Apollonio (1973), p.25.

33 Marinetti, in Apollonio (1973), p.23.

34 Giacomo Balla and Fortunato Depero, 'Futurist Reconstruction of the Universe 1915', in Apollonio (1973), pp.199–200.

35 Antonio Sant'Elia, 'Manifesto of Futurist Architecture 1914', in Apollonio (1973), p.25.

36 Francis Bacon, *New Atlantis with Sylva Sylarum; or, A Naturall Historie* (London, 1627).

37 See Krishnan Kumar, *Utopia and Anti-Utopia in Modern Times* (Oxford, 1987), p.30.

38 Le Corbusier, *Towards a New Architecture* (London, [1927] 1992), p.276.

39 Ibid., p.199ff.

40 For a revisionist view of Le Corbusier, see, for instance, Lewis Mumford, 'Yesterday's City of Tomorrow', *Architectural Record*, no.132 (New York, November 1962), pp.139–44.

41 Le Corbusier (1992), p.289.

42 Ibid., p.289.

43 See Mary McLeod, '"Architecture or Revolution": Taylorism, Technocracy, and Social Change', *Art Journal*, vol.43, no.2 (Summer 1983), pp.132–47.

44 Jyrki Siukonen argues that 'the aeroplane elevates the architect's spirit to a whole new perspective', and provides an interesting analysis of the *Plan Voisin* from this point of view. See Siukonen, *Uplifted Spirit, Earthbound Machines: Studies on Artists and the Dream of Flight 1900–1935* (Helsinki, 2001), p.111.

45 Le Corbusier, *The City of Tomorrow* (London, [1927] 1970), p.56.

46 Ibid., p.51.

47 Andrew McNamara, 'Between Flux and Certitude: The Grid in Avant-Garde Utopian Thought', *Art History*, vol.15, no.1, (March 1992), p.66; Le Corbusier (1992), p.68.

48 Peter Serenyi, 'Le Corbusier, Fourier and the Monastery at Ema', in Peter Serenyi (ed.), *Le Corbusier in Perspective* (Englewood Cliffes, NJ, 1975), p.105.

49 Jonathan Beecher and Richard Bienvenu, *The Utopian Vision of Charles Fourier* (Boston, 1971), p.243.

50 Robert Fishman, *Urban Utopias in the Twentieth Century: Ebenezer Howard, Frank Lloyd Wright and Le Corbusier* (Cambridge, MA, 1977), pp.180–87.

51 Boris Arvatov, 'Oveshchestvlennaya utopiya' ['Objectified Utopia'], *Lef* [*Left Front of the Arts*], no.1 (Moscow, 1923), pp.61–4.

52 Vladimir Tatlin, Tevel Shapiro, Iosif Meerzon and Pavel Vinogradov, 'Nasha predstoyashaya rabota' ['The Work Ahead of Us'], *VIII s'ezd sovetov. Ezhednevnyi byulletin s'ezda* [*VIII Congress of the Soviets: Daily Bulletin of the Congress*], no.13 (1 January 1921), p.11.

53 Richard Stites, *Revolutionary Dreams: Utopian Vision and Experimental Life in the Russian Revolution* (Oxford, 1989), pp.48–50.

54 Tommaso Campanella, 'La Citta del Sole', 1602, first published in Latin as *Civitas Solis* (Frankfurt, 1623). For a discussion of Campanella's influence on Lenin, see Christina Lodder, *Russian Constructivism* (New Haven, 1983), p.53.

55 Nikolai Chernyshevsky, *Chto delat?* [*What is to be done?*] (Moscow, 1863) in *Polnoe sobranie sochinenii* [*Complete Works*] (Moscow, 1947), vol.III, p.236.

56 William J. Leatherbarrow, *Dostoevskii and Britain* (Oxford, 1995), p.8.

57 'Programme of the Working Group of Constructivists of Inkhuk' (March 1921), in Selim Omarovich Khan-Magomedov, *Rodchenko: The Complete Work* (London, 1986), p.290.

58 Vladimir Tatlin, 'Iskusstvo v tekhniku' ['Art into Technology'], *Brigada khudozhnikov* [*Artists' Brigade*], no.6 (1932), p.16, trans. in Larissa Zhadova (ed.), *Tatlin* (London, 1988), p.311.

59 Kornelii Zelinskii, 'Letatlin', *Vechernaya Moskva* [*Evening Moscow*], no.80 (6 April 1932), trans. in Zadova (1988), p.309.

60 Ibid., p.311.

61 Rubin (1968), p.9.

62 There are other notable instances, including the fact that Theo van Doesburg worked simultaneously as a Dadaist, editor of *De Stijl* and a co-founder of the International Faction of Constructivists.

63 Hans Richter, *Dada Profile* (Zurich, 1961), p.27. The texts mentioned refer to material published in the magazine *G: Material zur elementaren Gestaltung*.

64 El Lissitzky and Ilya Ehrenburg, 'Die Blockade Russlands geht ihrem Ende entgegen' ['The Blockade of Russia moves towards its end'], *Veshch'/Gegenstand/Objet*, no.1–2 (March–April 1922), pp.1–2, trans. in Stephen Bann, *The Tradition of Constructivism* (London, 1974), pp.55–6.

65 The faction's declaration was published in *De Stijl*, vol.4, no.4 (1922), trans. in Bann (1974), pp.68–9. The September 1922 'Manifesto of International Constructivism' was also signed by Max Burchartz and Karel Maes, *De Stijl*, vol.5, no.8 (1922).

66 'Statement of the International Faction of Constructivists' (1922), in Bann (1974), p.69.

67 Michael White, *De Stijl and Dutch Modernism* (Manchester and New York, 2003), p.1.

68 Theo van Doesburg, 'Towards a Plastic Architecture', *De Stijl*, vol.VI, no.6/7 (1924), pp.78–83, trans. in Hans L.C. Jaffe, *De Stijl* (London, 1970), pp.185–8.

69 See, for instance, Naylor (1986).

70 Ernö Kállai, Alfréd Kemény, László Moholy-Nagy, László Péri, 'Nyilatkozat' ['Manifesto'], *Egység* [*Unity*], no.4 (1923), p.51, trans. in Timothy O. Benson and Éva Forgács (eds), *Between Worlds: A Sourcebook of Central European Avant-Gardes, 1910–1930* (Cambridge, MA, 2002), pp.443–4.

71 See, for instance, Fredric Jameson, 'The Politics of Utopia', *New Left Review* (January–February 2005), p.36.

72 Benson (2001), p.47.

73 Oscar Wilde, 'The Soul of Man under Socialism' (1890), in *The Complete Works of Oscar Wilde* (London, 1966), p.35.

3 The Machine

1 Enrico Prampolini, 'The Aesthetic of the Machine and Mechanical Introspection in Art', *Broom 3* (October 1922), p.236.

2 My particular thanks to John Milner, Christopher Wilk, Jana Scholze and Corinna Gardner for their invaluable help in the preparation of this essay.

3 Between 1920 and 1922 Léger often inscribed his canvases as numbered 'états' or 'états définitifs', in order to place them in the process of perfecting that led from the initial idea, usually in a work or works on paper, to the final statement. This practice is not followed in this work, which is simply inscribed 'Nature Morte/F.LÉGER, 26' on the verso. There is no smaller oil 'état', but a carefully executed gouache very close to the final picture. Below the ball bearings is Léger's reductive sign for a typewriter. See Georges Bauquier, assisted by Nelly Maillard, *Fernand Léger, Catalogue raisonné, 1925–1928* (Paris, 1993), pp.124–5, and Jean Cassou and Jean Leymarie, *Fernand Léger: Drawings and Gouaches* (London, 1973), p.97.

4 Ordering a picture by telephone was an idea first mooted by Richard Huelsenbeck in *Dada Almanach* (Berlin, 1920). As Passuth points out, Lucia Moholy asserted that the pictures were actually ordered in person by Moholy-Nagy, and that only when they were completed did he say he might have done it on the telephone. The decision to produce the same picture on three different scales went with Moholy-Nagy's interest in how colour sensations were altered by scale. The pictures were not shown until 1924 at the Der Sturm gallery in Berlin, when they were singled out, without mention of the telephone story, because of their mechanical reproducibility and use of industrial materials by Moholy-Nagy's Hungarian associate, Ernö Kállai in the *Jahrbuch der jungen Kunst* 5 (Leipzig, 1924). See Kristina Passuth, *Moholy-Nagy* (London, 1985), pp.31–3, and Eleanor M. Hight, *Picturing Modernism: Moholy-Nagy and Photography in Weimar Germany* (Cambridge, MA, 1995), p.27.

5 For the important work referred to, see Paula Feldman, *Made to Order: American Minimal Art in the Netherlands, late 1960s to early 1970s* (Ph.D. dissertation, Courtauld Institute of Art, University of London, 2004).

6 Le Corbusier-Sanguier, 'Des yeux qui ne voient pas', *L'Esprit Nouveau*, no.8 (Paris, April 1921), n.p.

7 He does this under the pen-name De Fayet in 'Revue de l'année, peinture ancienne et peinture moderne', *L'Esprit Nouveau*, no.11–12 (Paris, November 1921).

8 Vladimir Tatlin, 'My Answer to "Letter to the Futurists"' (March 1918), trans. in Alelseevna Zhadova, *Tatlin* (London, 1988), p.185.

9 Responses to the Haus am Horn are discussed in Barbara Miller-Lane, *Architecture and Politics in Germany 1918–1945* (Cambridge, MA, [1968] 1985), p.77.

10 Karel Teige, *The Minimum Dwelling* (Cambridge, MA, [1932] 2002), p.218.

11 See Miller-Lane (1985), p.136.

12 Ibid., p.77.

13 Christina Lodder makes this point, citing Marx's 'German Ideology', in Lodder, *Russian Constructivism* (New Haven and London, 1983), p.95.

14 Moise Ginzburg, 'Konstruktivizm kak metod laboratornoi i pedagogisheskoi raboty' ['Constructivism as method of laboratory and teaching work'], *SA*, no.6 (Moscow, 1927) pp.160–66, trans. in Catherine Cooke, *Russian Avant-Garde Theories of Art, Architecture and the City* (London, 1995), p.102.

15 Guy Debord, *Société du spectacle* (Paris, 1967).

16 Amédée Ozenfant and Charles-Edouard Jeanneret, 'Où en est la vie moderne', in *Après le cubisme* (Paris, 1918), n.p.

17 For the inscribing of the first replica of *Bottle Dryer* (dated by Schwarz c.1921) 'Antique certifié', see Arturo Schwarz, *The Complete Works of Marcel Duchamp* (London, 1997), p.615.

18 Figures from Eric Hobsbawm, *The Age of Extremes: The Short Twentieth Century, 1914–1991* (London, 1994), p.97.

19 Figures from ibid., p.91; and Mary Nolan, *Visions of Modernity: American Business and the Modernization of Germany* (New York, 1994), p.38.

20 The visits by the German trade-union (ADGB) delegation and by German industrialists are dealt with in detail in ibid.

21 Sigfried Giedion, *Mechanization takes Command* (New York, [1948] 1969), pp.79, 96–107. Frederick Winslow Taylor's experiments began in the 1880s at the Midvale and then the Bethlehem Steel Works in Pittsburgh. His key publications were *Shop Management* (1903) and *The Principles of Scientific Management* (1911).

22 Giedion cites Frank B. Gilbreth's *Bricklaying System* (New York, 1909); see Giedion (1969), pp.100–101.

23 His innovations and the results achieved are described in detail in Ford's enormously influential autobiography: Henry Ford with Samuel Crowther, *My Life and Work* (London, [1922] 1923).

24 For the 'average man's' wish for repetitive work, see ibid., p.103; for Ford's wish to provide 'a very definite incentive to better living', ibid., pp.128–9.

25 Ford's autobiography was translated into German in 1923. German reactions are discussed at length in Nolan (1994).

26 As Ford saw it, paying more meant expanding markets and could only be good if production allowed it. 'Good work, well managed, ought to result in high wages and low living costs.' Ford (1923), p.122. Taylor too had seen higher productivity and thus shared profits as peace-maker in labour relations.

27 'It is the function of business to produce for consumption and not for money or speculation.' Ibid., p.12.

28 See Richard Guy Wilson, 'Selling the Machine Age', in R.G. Wilson, Dianne H. Pilgrim and Dickran Tashjian, *The Machine Age in America, 1918–1941* (exh. cat., Brooklyn Museum, 1986), p.78.

29 For the history of advertising in America, see Stephen Fox, *The Mirror Makers: A History of American Advertising* (London, [1984] 1990); T.J. Jackson Lears, *Fables of Abundance: a cultural history of advertising in America* (London, 1994); and Michele H. Bogart, *Artists, Advertising and the Borders of Art* (Chicago, 1995).

30 Walter Dill Scott, *The Psychology of Advertising. A Simple Exposition of the Principles of Psychology in their relation to Successful Advertising* (Bristol, [1908] 1998), p.193.

31 Teige (2002), p.95.

32 Nolan cites Moritz Bonn, *Die Kultur der Vereinigten Staaten von Amerika* (Berlin, 1930): 'A civilization has emerged whose essential feature lies exclusively in the satisfaction of more or less material needs with the technically most perfect, most comfortable, labor saving machines.' Nolan (1994), p.109.

33 Wilson, 'Machine Aesthetics', in Wilson, Pilgrim and Tashjian (1986), pp.43–55.

34 See Wilson, 'Selling the Machine Age', ibid., p.65ff.

35 An account of this is given in Fox (1990).

36 The short text signed by Tatlin and his three helpers, 'Nasha predstoyashehaya rabota' ['The Work Ahead of Us'], disseminated in the *Ezhednevnyi byilletin VIII – go sezda sovetov* [*Daily Bulletin of the Eighth Congress of Soviets*], no.13 (Moscow, 1 January 1921), p.11, is published in translation in John E. Bowlt (ed. and trans.), *Russian Art of the Avant-Garde: Theory and Criticism, 1902–1934* (New York, 1976), p.206; and in Zhadova (1988), p.239.

37 See Geoffrey Hosking, *A History of the Soviet Union, 1917–1991* (final edn, London, 1992), pp.62–70, 76–7, 91–107.

38 Figures from ibid., pp.74, 120.

39 Information from Cooke (1995), pp.29, 132.

40 Hosking (1992), pp.127–9.

41 The letter from Kiev to Pavel Ivanovitch Novitskii, rector of the VKhUTEMAS-VKhUTEN in Moscow, is published in Zhadova (1988), pp.260–61. Tatlin's wish was granted and he moved to teach in the metal and woodworking faculty of the Moscow school in 1927.

42 The quotation comes from Brik's contribution to the INKhUK debates, as cited in Lodder (1983), p.90. She tells the story of the emergence of Constructivism in 1920–21 in what remains the best study of Constructivism in Russia, though Cooke has given an important supplementary account and analysis of the development of Constructivism in architecture; see Cooke (1995). My analysis here is especially dependent on these sources, and on Zhadova (1988) and John Milner, *Vladimir Tatlin and the Russian Avant-Garde* (New Haven and London, 1983).

43 An account of their work designing textiles for production is found in Lodder (1983), pp.146–7.

44 The manufacturing trusts it was involved with in Petrograd were the New Lessner Factory, the Low-Voltage Electrical Factories Trust and the Leningrad Clothing Manufacturers. Petrograd became Leningrad with Lenin's death early in 1924. Zhadova publishes a series of reports written for official sponsoring bodies by Tatlin on the Section and its work, beginning in 1922 and going on to 1924, which give a full picture of how he wanted to represent his work to the Soviet authorities. Zhadova (1988), pp.243–57.

45 Among the reports, the most telling in this respect is one dated 1 November 1924, written for the director of the Petrograd Directorate of Scientific and Artistic Institutions (PUNU), in ibid., pp.254–5.

46 The piece by Nikolai Punin, 'Routine and Tatlin', dated 5 July 1924, survives in manuscript, and is published in full in translation in ibid., pp.403–6.

47 For Gastev and Taylorism in Russia, see Cooke (1995), p.112. Nolan points out that the Russian translation of Ford's autobiography went through four editions, and that before 1930 there were 13 printings and 200,000 copies were sold. Nolan (1994), p.34.

48 El Lissitzky notes that 'the structure is built honestly of wood', but also that it 'represents a characteristic solution in a period yearning for glass, steel, and concrete'. Lissitzky, *Russia: An Architecture for World Revolution* (London, [1930] 1970), pp.32–4.

49 See Cooke (1995), pp.112, 122.

50 For the 'social consumer' as brought into Ginzburg's writing in the important Constructivist architectural periodical *SA* in 1926, see Cooke (1995), p.126.

51 Given the prioritizing of the metaphysical in De Stijl work and the lack of any explicit referencing of engineering method, it is difficult to call it machine Modernist in the sense that Baumeister and Léger were, though Van Doesburg did take on leadership of the so-called International Faction of Constructivists at the 'Congress of International Progressive Artists' in Düsseldorf in May 1922. In Belgium, Josef Peeters and Fernant Berkelaers (Michel Seuphor) led a 'Constructivist' group in Antwerp, and some of the work produced in Belgium is strongly machine Modernist, in particular that of Viktor Servrankcx. The 'quarantine belt' phrase used here was coined by the American President Wilson and applied to the new states created by the Treaty of Versailles after the First World War.

52 Jaroslav Rössler experimented with photographing radio parts in 1922 and making photograms in 1925, before producing his photomontages in 1926–7. He moved to Paris in 1926. See Vladimír Birgus et al., *Czech Photographic Avant-Garde, 1918–1948* (Cambridge, MA, and London, 2002), pp.73–4. Of the new Central European states created in 1918–19, Czechoslovakia was the only one whose economy was not dominated by agriculture, and the only one to avoid the great inflation of 1922–3.

53 The relationship between Germany and France, and especially that between Léger, the Purists and Baumeister, has been exhaustively explored in *Willi Baumeister et la France* (exh. cat., Musée d'art moderne, Saint-Etienne, 1999).

54 Teige (2002), p.66.

55 Ibid., pp.66–7.

56 Ibid., pp.145–8.

57 Léger's admiration for the energy released in Soviet Russia is expressed in letters of August and September 1919 to Léonce Rosenberg. His admiration for American businessmen is expressed in a letter to Rosenberg of 4 June 1924. See Christian Derouet (ed.), *Une correspondance d'affaires. Correspondances Fernand Léger – Léonce Rosenberg 1917–1937* (Paris, 1996), pp.52–60, 137–40.

58 For the Ozenfant studio, 1923–4, see Christopher Green, 'Ozenfant, Purist painting and the Ozenfant studio', in *Le Corbusier, Architect of the Century* (exh. cat., Hayward Gallery, London, 1987), pp.119–20; and Tim Benton, *The Villas of Le Corbusier, 1920–1930* (New Haven, 1987), pp.30–41.

59 The idea of an 'esprit nouveau' formed by a new, mechanized world is perhaps most comprehensively put by Ozenfant and Le Corbusier in 'Formation de l'optique moderne', *L'Esprit Nouveau*, no.21 (Paris, March 1924). For Taylorism in France in the 1920s, see Mary Mcleod, '"Architecture or Revolution": Taylorism, Technocracy and Social Change', *Art Journal*, vol.43, no.2 (New York, Summer 1983), pp.132–47.

60 Ozenfant and Jeanneret (1918), n.p.

61 The idea of the type object was set out in Amédée Ozenfant and Charles-Edouard Jeanneret, 'Le purisme', *L'Esprit Nouveau*, no.4 (Paris, January 1921).

62 For the multiplication of the 'Citrohan' dwelling unit in its Pavillon de l'Esprit Nouveau form, see Le Corbusier, *Almanach d'architecture moderne* (Paris, 1926).

63 Lissitzky (1970), pp.38–42.

64 Benton (1987).

65 Teige (2002), pp.64–5.

66 Bruno Taut was director of municipal construction in Magdeburg 1921–3, and then chief designer for the major Berlin housing cooperative, Gehag, from 1923. His *Die neue Wohnung: Die Frau als Schöpferin* (Leipzig, 1924) was widely influential. For Frankfurt am Main, see Chapter 5.

67 Miller-Lane (1985).

68 Ibid., pp.78–85.

69 Ibid., p.11.

70 Siemensstadt was begun in 1929 by the building society set up by Siemens to house its Berlin workers. Besides Gropius, Bartning, Häring and Scharoun all participated. Ibid., p.111.

71 Among the organizations set up were the National Association of German Industry (RDI), in which the views of Siemens' general director, Karl Kötgen, were dominant; the National Productivity Board (RKW), a government initiative to develop norms and standards, which generated a Home Economics Group; the National Committee for Time Study (Refa), an initiative of the metal industries and factory engineers working together, which advocated wage-systems to go with scientific management. For the work of these organizations and the visits of employers and trade unionists to America, see Nolan (1994). My account is indebted to Nolan's work.

72 Karl Kötgen, *Das Wirtschaftliche Amerika* (Berlin, 1925). For Kötgen, see n. 71, above.

73 For Nolan on this, see Nolan (1994), pp.76, 172–3.

74 See Miller-Lane (1985), pp.90–103.

75 Ibid., p.103. They were disappointed by their experience in the USSR, and when they returned to Germany found the Nazis in power.

76 By the end of 1920 the circle of *Ma* in Vienna was hearing lectures on the work of Malevich, Tatlin and Rodchenko. In 1921 the *Ma* associate Alfred Kemény brought back to Berlin news of the Moscow INKhUK debates, having lectured there himself. Late that year Lissitzky arrived, and in 1922 he and Ilya Ehrenburg started publication in March–April of *Veshch'/Gegenstand/Objet* with an article to mark 'The Blockade of Russia . . . coming to an end'. For Moholy-Nagy's contact with Russian ideas, see Hight (1995), pp.32–4. For Moholy-Nagy's writings of 1922–3 in response to Constructivism, see Passuth (1985), pp.286–9.

77 László Moholy-Nagy, 'Das Bauhaus in Dessau', *Qualität*, vol.4, no.5/6 (May/June 1925), trans. in Passuth (1985), pp.295–9.

78 Important statements supporting this argument are to be found in Alexei Gan, *Konstruktivizm* [*Constructivism*] (Tver, 1922), excerpted in Bowlt (1976), pp.218–23, and Boris Arvatov, 'Proletariet I levoe iskusstvo' ['The Proletariat and Leftist Art'], *Vestnik iskusstv* [*Art Herald*], no.1 (Moscow, January 1922), trans. in Bowlt (1976), pp.226–30.

79 The Red Terror was proclaimed on 5 September 1918. The quotation here is from a directive from Letzis, chairman of the eastern front Cheka, to his officers, November 1918, trans. in Hosking (1992), p.70.

80 Lodder cites Stepanova dismissing fashion in *Lef*, no.2 (Moscow, 1923). See Lodder (1983), p.148.

81 Rodchenko makes this argument in 'Rabota Mayakovskim', 1940, a manuscript cited in translation in ibid., p.193.

82 Zelinskii's Interview 'Letatlin', published 6 April 1932, trans. in Zhadova (1988), p.309.

83 El Lissitzky and Ilya Ehrenburg, 'The Blockade of Russia is Coming to an End', Editorial, *Veshch/ Gegenstand/Objet*, no.1–2 (Berlin, March–April 1922), trans. in Stephen Bann (ed.), *The Tradition of Constructivism* (London, 1974), pp.18–19.

84 The phrase is coined by Norbert M. Schmitz, 'László Moholy-Nagy', in Jeannine Fiedler and Peter Feierabend (eds), *Bauhaus* (Cologne, 1999), p.292.

85 These ideas are developed in both Moholy-Nagy's *Malerei, Fotografie, Film* (Dessau, 1925), and in *Von Material zu Architektur* (Dessau, 1929).

86 László Moholy-Nagy, 'Az ember és Láza' ['Man and House'], *Korunk*, no.4 (1929), pp.298–9, trans. in Passuth (1985), pp.309–10.

87 László Moholy-Nagy, 'Produktion-Reproduktion' ['Production-Reproduction'], *De Stijl*, no.7 (1922), pp.97–101, trans. in ibid., pp.288–9.

88 The role given to 'passion' is clear in Le Corbusier's manifesto book, *Vers une architecture* (Paris, 1923). I discuss this question more fully in Christopher Green, *Art in France* (New Haven, 2000), pp.163–4.

89 When Ozenfant and Jeanneret exhibited together as Purists at the galerie Druet in 1921, their painting was very closely related, but over the next half decade, up to the dissolution of Purism and the end of *L'Esprit Nouveau* in 1925, their practices moved decisively apart, something I discuss more fully in Green (1987), pp.89–91. This was strikingly brought out in the exhibition *L'Esprit Nouveau. Le purisme à Paris* at Grenoble and the version of it shown at the Los Angeles County Museum in 2001–2.

90 'Since it is primarily production (productive-creation) that serves human construction, we must strive to turn the apparatuses (instruments) used so far only for reproductive purposes into ones that can be used for productive purposes as well.' Moholy-Nagy (1922), in Passuth (1985), p.289.

91 In relation to Moholy's first camera as against camera-less photographs, the appearance on the market of the Leica (pl.11.7) in 1925 is important (its short exposure times and easy portability made hitherto inaccessible subjects and view-points available). See Katherine C. Ware, 'Photography at the Bauhaus', in Fiedler and Feierabend (1999), p.506. There is no evidence that Moholy-Nagy started to use a camera before 1925; only one camera photograph appears in the 1st edition of *Malerei, Fotographie, Film* that year, as Hight points out. See Hight (1995), p.101.

92 László Moholy-Nagy, *Painting, Photography, Film* (London, [1925] 1969), p.25.

93 For Cooke's discussion, see Cooke (1995), pp.108–10, esp. pp.122–6.

94 Ginzburg (1927), in ibid, p.101.

95 For Tatlin and *Letatlin*, see Milner (1983), ch.10; Lodder (1983), pp.213–17, and Zhadova (1988), pp.147–9. For Moholy on the Haus am Horn, see Moholy-Nagy (1925) in Passuth (1985), pp.295–9. For Léger's *Mechanic* and Egyptian and Assyrian references, see Christopher Green, *Léger and the Avant-garde* (New Haven, 1976), pp.199–201; and Fernand Léger, 'L'esthétique de la machine', lecture given in June 1923, first published in *Der Querschnitt*, vol.III (Berlin, 1923), and *Bulletin de l'effort moderne*, no.1 and 2 (January and February 1924); trans. in Edward F. Fry (ed.), *Functions of Painting* (New York, 1973).

96 He does this very clearly in 'L'esthétique de la machine', ibid. It is also worth noting the resistance in Germany to the assembly line as a threat to 'quality' and the skilled worker, and the degree to which the Bauhaus approach to high-quality production as well as design is aligned with this. For Nolan on German resistance to de-skilling, see Nolan (1994), pp.84–9.

97 Moholy-Nagy (1969), as cited in Passuth (1985), p.37.

98 Nikolai Tarabukin, cited from a manuscript in Lodder (1983), p.82.

99 'The manufactured object is there, absolute, polychromatic, clean and precise, beautiful in itself; and it is the most extreme competition that the artist has ever experienced.' Florent Fels, 'Propos d'artistes, Fernand Léger', *Les nouvelles littéraires* (Paris, Saturday, 13 June 1923), p.4.

100 Alexander Vesnin, 'Credo' (April 1922), trans. from manuscript notes of a statement to INKhUK in Cooke (1995), p.98.

101 See especially Zervos's response to the Baumeister exhibition at the Galerie d'Art Contemporaine in Paris in 1927, where he puts Léger and Baumeister together as representatives of important 'architectural tendencies' in painting. Christian Zervos, 'Les Expositions', *Feuilles volantes* supplement to *Cahiers d'art*, no.1 (Paris, 1927), pp.6–8.

102 The first version of the scenario was published in *Ma*, no.8–9 (Vienna, 1924). It did not incorporate photographic material, as did the version published a year later in *Painting, Photography, Film*. According to Passuth, the first version was probably written in 1921–2. See Passuth (1985), p.38.

103 When the theatrical producer Vladimir Meyerhold committed himself to Constructivist methods in around 1922, tempo and movement were central to the method he called biotechnics, which concerned the management of mechanical and bodily movement on the stage. It was a method in large part translated for the theatre from the Taylorist management of human movement in factory work. For Meyerhold and biotechnics, see Edward Braun, *The Theatre of Meyerhold, Revolution on the Modern Stage* (London, 1979), ch.7.

104 The other artist whose view of advertising as a Trojan horse for Modernism comes close to Léger's was the Hungarian Vilmos Huszár, who designed both the cover for the earlier numbers of *De Stijl* (cat.13) and an advertisement for the Rotterdam flooring company C. Bruijnzeel & Zonen, which regularly appeared in it. His engagement with advertising is explored in Michael White, *De Stijl and Dutch Modernism* (Manchester, 2003). Léger's views on advertising were expressed in a statement published in *L'Art vivant*, which in the mid-1920s carried regular articles on advertising art. See the statement by Léger in Louis Cheronnet, 'La Publicité moderne, Fernand Léger et Robert Delaunay', *L'Art vivant* (Paris, 1 December 1926), p.890. I discuss this more fully in Christopher Green, *Cubism and its Enemies: Modern Movements and Reaction in French Art, 1916–1928* (New Haven, 1987), pp.212–14.

105 The Bauhaus, of course, taught advertising at Dessau in the printing workshop, its timetable including from 1926 'advertising psychology'. For a short while under Hannes Meyer, Joost Schmidt led an 'advertising institute' there. See Ute Brüning, 'The Painting and Advertising Workshop', in Fiedler and Feierenband (1999), p.488ff.

106 The use of 'Machine Age' motifs by Louis Lozowick as a backdrop for a Lord and Taylor department-store fashion show in 1927 is a relevant instance. It is discussed in Wilson (1986), p.65.

4 Performing Modernism

1 Yurii Annenkov, *Teatr chistogo metoda* (1921), manuscript from Central State Archive of Literature and Art, Moscow, cited in Nancy Van Norman Baer, *Theatre in revolution: Russian avant-garde stage design, 1913–1935* (exh. cat., Fine Arts Museums of San Francisco, 1991), p.72.

2 Manfredo Tafuri explores the importance of performance for the avant-garde in 'The Stage as "Virtual City": From Fuchs to the Totaltheater', *The Sphere and the Labyrinth: Avant-Gardes and Architecture from Piranesi to the 1970s* (Cambridge, MA, 1992), ch.3.

3 Futurist performance is discussed below. On Dada performance, see Mel Gordon, *Dada Performance* (New York, 1987) and Annabelle Melzer, *Dada and Surrealist Performance* (Baltimore, 1994).

4 This was the decade in which Bertolt Brecht evolved his ideas on the 'Epic Theatre' and Erwin Piscator developed his concept of 'Total Theatre', an important period for experiments with the theatre as an agent of political, social and aesthetic change. See Michael Schwaiger (ed.), *Bertolt Brecht und Erwin Piscator. Experimentelles Theater im Berlin der Zwanzigerjahre* (exh. cat., Österreichisches Theatermuseum, Vienna, 2004).

5 Dieter Bogner (ed.), *Friedrich Kiesler. Architekt, Maler, Bildhauer 1890–1965* (Vienna, 1988), p.12. On Kiesler, see also Barbara Lesák, *Die Kulisse explodiert: Friedrich Kieslers Theaterexperimente und Architekturprojekte 1923–25* (Vienna, 1988) and *Frederick Kiesler. Artiste-architecte* (exh. cat., Centre Georges Pompidou, Paris, 1996).

6 Kiesler's poster for the 1924 Exhibition is reproduced in *Traum und Wirklichkeit: Wien 1870–1930* (exh. cat., Kunstlerhaus Wien, 1985), p.667. The 'Katalog/Programm/Almanach' was edited by Kiesler under the title *Internationale Ausstellung neuer Theatertechnik unter Mitwirkung der Gesellschaft zur Förderung Moderner Kunst in Wien im Rahmen des Musik- u. Theaterfestes der Stadt Wien 1924*. (A facsimile edition was published in 1975.) On Van Doesburg's typeface, see no.616, Els Hoek (ed.), *Theo Van Doesburg oeuvre catalogue* (Utrecht, 2000), p.244.

7 *De Stijl*, no.10 and 11, serie xii (1924–5), pp.432–8. Kiesler had been a member of the De Stijl group since 1923.

8 The 1924 caricature of Kiesler's *Raumbühne* by Ladislaus Tuszynsky is reproduced in *Traum und Wirklichkeit* (1985), p.670.

9 Peter de Francia, *Fernand Léger* (New Haven and London, 1983), pp.182, 184.

10 The *Bulletin de l'effort moderne* (no.17, July 1925) illustration is reproduced in de Francia (1983), p.183. Léger, along with Rosenberg, apparently visited the Vienna Exhibition on the way back to Paris following their trip to Venice and Ravenna.

11 Fernand Léger, 'The Spectacle: Light, Color, Moving Image, Object-Spectacle', in Edward F. Fry (ed.), *Functions of Painting by Fernand Léger* (London, 1973), p.35. Kiesler also saw shop display as an important aspect of modernity; in 1930 he published his *Contemporary Art applied to the Store and its Display*.

12 *Fernand Léger et le Spectacle* (exh. cat., Musée National Fernand Léger, Biot, 1995), pp.89–106; Norman Abramovic, *La Création du monde. Fernand Léger et l'art africain dans les collections Barbier-Mueller* (Paris, 2000).

13 Léger, 'The Spectacle', in Fry (1973), pp.35–47.

14 Christopher Innes, *Edward Gordon Craig: A Vision of the Theatre* (Ontario, Canada, 1998).

15 On Prampolini's 'Magnetic Stage', see Michael Kirby, *Futurist Performance* (New York, 1971), pp.86–9; Günter Berghaus, *Italian Futurist Theatre, 1909–1944* (Oxford, 1998), pp.444–6.

16 Nancy Van Norman Baer, *Theatre in Revolution: Russian Avant-Garde Stage Design 1913–1935* (exh. cat., Fine Arts Museum of San Francisco, 1991).

17 Ibid., pp.105, 104.

18 On the connections between Modernism, modernity and primitivism in the context of performance, see Nancy J. Troy, 'Figures of the Dance in De Stijl', *The Art Bulletin*, vol.66, no.4 (December 1984), pp.645–56.

19 For an English translation of the play, see Josef and Karel Capek, *R.U.R. and The Insect Play* (Oxford, 1961). Peter Wollen assesses the significance of robot imagery during this period in 'Modern Times: Cinema/Americanism/The Robot', *Raiding the Icebox: Reflections on Twentieth-Century Culture* (London and New York, 1993), ch.2.

20 The photograph of Léger appears on p.8 of the 1924 Exhibition catalogue and has been widely reproduced since.

21 On the complex genesis of *Ballet mécanique* and the different surviving versions of the film, see for example *Fernand Léger et le Spectacle* (1995), pp.117–24; Jean-Michel Bouhours, 'D'images mobiles en ballets mécaniques', *Fernand Léger* (exh. cat., Centre Georges Pompidou, Paris, 1997), pp.158–63; also Christian Derouet, 'Léger et le cinéma', *Peinture, Cinema, Peinture* (exh. cat., Centre de la Vieille Charité, Marseilles, 1989).

22 Léger, 'A Critical Essay on the Plastic Quality of Abel Gance's Film *The Wheel*' (originally published in *Comoedia*, Paris, 1922), in Fry (1973), p.21.

23 Léger, 'Ballet Mécanique' (unpublished, c.1924), in Fry (1973), p.50.

24 For a photograph of the Blue Blouse Theatre performance of *Us and Henry Ford*, see Baer (1991), p.120; on the Blue Blouse, see Frantisek Deak, 'Blue Blouse', in *The Drama Review*, Russian issue, vol.17, no.1 (March 1973), pp.35–46.

25 Baer (1991), p.137. On Foregger's machine dances, see Natalya Sheremetyevskaya, 'The Search for new Dance Forms on the Variety Stage in the U.S.S.R. 1920–1930', in Gunhild Oberzaucher-Schüller (ed.), *Ausdruckstanz. Eine mitteleuropäische Bewegung der ersten Hälfte des 20. Jahrhunderts* (Wilhelmshaven, 2004), pp.421–9.

26 On concepts of 'eccentricity' as 'a protective reaction to the anonymity of life in the large capitalist city', see Sheremetyevskaya, in Oberzaucher-Schüller (2004), p.422.

27 On Moholy Nagy's development of the 'Typophoto' (originally as a scenario for his film project *Dynamic of the Metropolis*), see Kristina Passuth, 'Film Nostalgia: "Dynamic of the Metropolis"', *Moholy-Nagy* (London, 1985), pp.37–9.

28 On the 1923 'Mechanical Ballet' at the Bauhaus, see Magdalena Droste and Bauhaus Archiv, *Bauhaus 1919–1933* (Cologne, 1993), p.102–3; Hans M. Wingler, *The Bauhaus: Weimar, Dessau, Berlin, Chicago* (Cambridge, MA, 1993), p.367.

29 For a discussion on this aspect of Bauhaus theatre, see Juliet Koss, 'Bauhaus Theater of Human Dolls', *Art Bulletin* (December 2003), p.724ff.

30 On the *Lichtrequisit*, see Passuth, 'The Light-Space Modulator', Passuth (1985), pp.53–6. On the German section of the 1930 Paris Exhibition (also known as the 'Werkbund Exhibition'), see Isabelle Ewig, Thomas W. Gaehtgens and Matthias Noell (eds), *Das Bauhaus und Frankreich. Le Bauhaus et La France, 1919–1940* (Berlin, 2002). There is a reconstruction of Moholy-Nagy's project, with coloured lighting, at the Van Abbe Museum, Eindhoven.

31 On Huszár's project, see Troy (1984), n.17 above.

32 Peter Nisbet (ed.), *Andor Weininger in the Busch-Reisinger Museum* (exh. cat., Cambridge, MA, 2004). See also *Weininger in Wahn – Arbeiten fürs Bauhaus/Works for the Bauhaus* (exh. cat., Schloß Wahn, Cologne, 1999). Weininger showed his designs for the 'Mechanische Bühnen-Revue' and his utopian plans for a 'Kugeltheater' (spherical theatre) at the Magdeburg Theatre Exhibition in 1927.

33 Wassily Kandinsky, 'Modeste Mussorgsky, "Pictures at an Exhibition"', *Das Kunstblatt*, vol.14 (August 1930), as cited in Wingler (1993), p.478. On Kandinsky's 'kinetic stage pictures', see also Kenneth C. Lindsay and Peter Vergo (eds), *Kandinsky: Complete Writings on Art* (London, 1982), pp.749–51, and Jelena Hahl-Koch, 'A Theater Project', *Kandinsky* (London, 1993), pp.303–6.

34 For a recent study of *Abeceda*, see Matthew W. Witkovsky, 'Staging language: Mila Mayerova and the Czech book Alphabet', *The Art Bulletin* (March 2004), p.1ff.

35 Eric Dluhosch and Rotislav Svácha (eds), *Karel Teige/1900–1951: L'Enfant Terrible of the Czech Modernist Avant-Garde* (Cambridge, MA, 1999), p.79.

36 On Teige's connections to the literary activities of the Czech avant-garde group Devětsil, see Zdenek Pesat, 'Devětsil and Literature', *Devětsil: Czech Avant-Garde Art, Architecture and Design of the 1920s and 30s* (exh. cat., Museum of Modern Art, Oxford, 1990), pp.52–7.

37 On Schlemmer's dance productions, see for example Nancy J. Troy, 'The Art of Reconciliation: Oskar Schlemmer's Work for the Theater,' pp.127–47, and Debra McCall, 'Reconstructing Schlemmer's Bauhaus Dances: A Personal Narrative', pp.149–59, both in Arnold L. Lehman and Brenda Richardson (eds), *Oskar Schlemmer* (exh. cat., Baltimore Museum of Art, 1986); and *Oskar Schlemmer-Tanz-Theater-Bühne* (exh. cat., Vienna Kunsthalle, 1997). On the Triadic Ballet, see Dirk Scheper, *Oskar Schlemmer, 'Das Triadische Ballett' und die Bauhausbühne* (Berlin, 1988).

38 Tut Schlemmer, *The Letters and Diaries of Oskar Schlemmer* (Middletown, CN, 1972), 'Letter to Otto Meyer', 11 February 1918, pp.50, 49.

39 Ibid., 'Diary Entry', 12 July 1915, p.28.

40 Ibid., 'Diary Entry', October 1915, p.32.

41 Ibid., 'Diary Entry', April 1926, p.193.

42 Ibid., 'Diary Entry', September 1922, pp.126, 127.

43 Ibid., pp.127, 128.

44 Ibid., p.128.

45 Ibid., 'Diary Entry', 5 July 1926, p.196.

46 Ibid., 'Diary Entry', September 1922, p.126.

47 Ibid., 'Diary Entry', May 1929, p.243.

48 Wingler (1993), pp.158–9.

49 It should be pointed out, however, that it is widely recognized today that Schlemmer's work was not necessarily well known in (or influential on) the dance communities of his day. See Witkovsky (2004), p.25, n.39.

50 Andor Weininger, 'The "Fun Department" of the Bauhaus', pp.34–9 in Nisbet (2000). Weininger's essay was written in 1957, at the request of architecture students at the University of Toronto, and published in the department's journal *Mosaic* (November 1957), pp.15–17.

51 'Letter to Tut Schlemmer', 5 February 1926, Schlemmer (1972), p.190. Other avant-garde groups, such as the Italian Futurists, also staged elaborate festive events; see, for example, Berghaus, 'Futurist Cabarets, Artists' Festivals, and Banquets', in Berghaus (1998), pp.384–95.

52 Schlemmer (1972), 'Diary Entry' 1929, p.239.

53 Wingler (1993), p.59.

54 Droste and Bauhaus Archiv (1993), p.101.

55 On cabaret, see Lisa Appignanesi, *The Cabaret* (New Haven, 2004).

56 Baer (1991), p.48.

57 Thomas Y. Levin (ed.), *Siegfried Kracauer: The Mass Ornament. Weimar Essays* (Cambridge, MA, 1995), pp.75–86. Günter Berghaus, '*Girlkultur*: Feminism, Americanism, and Popular Entertainment in Weimar Germany', *Journal of Design History*, vol.1, no.3–4 (1988).

58 Levin (1995), p.85.

59 Léger, 'Ballet Mécanique', in Fry (1973), p.51. Le Corbusier seems to have found 'girl' performances similarly exhilarating. His notes to a series of 50 watercolours for the costumes of a music-hall production (1926) read: 'Music hall is something rapid and transitory. Its dazzle is born from this, as it is from the cacophony of sound and the thighs of the ladies!' de Francia (1983), p.172.

60 Léger, in Fry (1973), pp.21, 72, 102. On Léger's interest in Chaplin, see *Fernand Léger et le Spectacle* (1995), n.1, p.117. Prior to *Ballet mécanique* in 1921, Léger had planned an animated cartoon *Charlot-Cubiste*. This was never made, but three written scenarios survive. See de Francia (1983), n.13, pp.267–8.

61 Schlemmer (1972), 'Diary Entry', September 1922, p.126; 'Letter to Tut Schlemmer', 13 February 1928, p.226.

62 Baer (1991), p.115. Natalya Sheremetyevskaya discusses the significance of Chaplin's popularity in the Soviet Union; see n.24 above.

63 Alexander Lavrentiev, *Varvara Stepanova: A Constructivist Life* (London, 1988), pp.104–9.

64 Mayerova, for example, lamented with respect to dance performances: 'You cannot imagine how depressing this craft is in its evanescence.' Witkovsky (2004), p.14.

65 In her essay on the Bauhaus theatre, Koss highlights the importance of the camera as an implied audience,

at events such as parties as well as in the case of stage productions. Koss (2003). At the same time, Gisela Barche cautions against reading photographs of Schlemmer performers in their costumes and masks as straightforward indications of the dance performances. Gisela Barche, 'The Photographic Staging of the Image – On Stage Photography at the Bauhaus', in Jeannine Fiedler (ed.), *Photography at the Bauhaus* (London, 1990), pp.238–53.

66 As Troy points out, Schlemmer accepted a concept of the stage as a self-contained volume to which the audience had only visual access: 'he did both acknowledge and accept that primordial condition of the theater, which resides in the "confrontation of passive spectator and animate actor." This concept is important because it distinguishes Schlemmer from many other visual artists of the period whose work either involved the theater or in some other way directly engaged the issue of the spectator's relationship to the work of art.' Troy (1986), p.139. At the level of stage performances, this distinguishes Schlemmer's ideas from those, for example, of the Soviet Constructivists. The Bauhaus parties, on the other hand, offered a different and more 'interactive' kind of performative experience.

67 Herbert Bayer incorporated the photograph (1927) of masked figures on the Bauhaus studio block in his design for the cover of the catalogue to the 1938 Museum of Modern Art's *Bauhaus 1919–1928* exhibition catalogue (reprinted 1975). See Jeannine Fiedler and Peter Feierabend (eds), *Bauhaus* (Cologne, 1999), pp.580, 615.

5 Building Utopia

1 Theo van Doesburg, 'Obnova umjetmost i architekture u Evropi' ['The Rebirth of Art and Architecture in Europe'], *Hrvatska Revija*, vol.4, no.8 (1931), pp.419–32, trans. in Evert van Straaten, *Theo van Doesburg Painter and Architect* (The Hague, 1988), p.18.

2 For a contemporary description of modern building that makes similar points, see Walter Curt Behrendt, *The Victory of the New Building Style* (Los Angeles, [1927] 2000), p.89.

3 Ibid., p.97.

4 For example, the Swiss architect Alexander von Senger wrote two books, *Krisis der Architektur* (Zurich, 1928) and *Die Brandfackel Moskaus* (Zurich, 1931), in which he accused Le Corbusier of serving the interests of the Communist International. In France, the art critic Camille Mauclair wrote a series of articles in *Le Figaro*, similarly accusing Le Corbusier and others of trying to turn the French into soulless and nationless 'termites', while in Britain the architect Reginald Blomfield could say, in the course of a radio discussion: 'Whether it is communism or not, *modernismus* is a vicious movement which threatens that literature and art which is our last refuge from a world that is becoming more and more mechanized every day.' Blomfield, during a BBC debate with Amyas Connell, 'For and against modern architecture?', published in *The Listener* (28 November 1934).

5 The anti-semitism of these views is systemic and is perhaps most tellingly revealed in a chance remark by Sir Duncombe Mann, a resident of Bexhill-on-Sea, who commented on Erich Mendelsohn and Serge Chermayeff's design for the De La Warr Pavilion in December 1935, 'I don't like this Epstein stuff', thus making a racial association between the architects and the notorious modern sculptor. Tim Benton, 'The De La Warr Pavilion' in *Leisure in the Twentieth Century* (London, 1977), p.72.

6 'Modernism' refers to the movement of ideas and practices outlined in this essay (see Chapter 1). The term is borrowed from post-war American criticism of modern art, although there are many differences between the beliefs of Modernism in art and architecture. Like most style labels, it is an anachronistic convenience. The English term more commonly used from the 1930s to the 1960s was 'Modern movement', but to use this would be to focus on an English and American subset of Modernism.

7 Otto Wagner, *Modern Architecture* (Santa Monica, [1895] 1988).

8 Albert Sigrist (pseud. for Alexander Schwab) *Das Buch vom Bauen 1930 – Wohnungsnot, neue Technik, neue Baukunst, Städtebau aus sozialistischer Sicht* (Düsseldorf, 1930).

9 Karel Teige, *The Minimum Dwelling* (Cambridge, MA, [1932], 2002), pp.1–6.

10 Sigfried Giedion, 'Le problème du luxe dans l'architecture moderne. A propos d'une nouvelle construction à Garches', *Cahiers d'Art*, vol.5–6 (1928), pp.254–6.

11 See Adrian Forty, *Words and Buildings: A Vocabulary of Modern Architecture* (London, 2000), pp.174–95, for a discussion of the history of functionalism.

12 Hannes Meyer, 'Bauen', in *Bauhaus*, vol.2, no.4 (1928). The associations between the biological analogy and functionalism are explored in Chapter 9.

13 Bruno Taut, *Modern Architecture* (London, 1929), p.9. Cf. Taut, *Die neue Baukunst in Europa und Amerika* (Stuttgart, [1929] 1979), p.7: 'Aufgabe der Architektur ist die Schaffung des schönen Gebrauchs'.

14 Discussed in Hilde Heynen, *Architecture and Modernity* (Cambridge, MA, 1999), pp.118–28.

15 Ernst Bloch, *Das Prinzip Hoffnung* (Frankfurt, 1959), p.860.

16 *L'Esprit Nouveau*, vol.1, no.1 (1920), title page.

17 Ibid., p.3.

18 Mies van der Rohe, 'Office building', *G*, no.1 (July 1923), cited in Fritz Neumeyer, *The Artless Word; Mies van der Rohe on the Building Art* (Cambridge, MA, 1991), p.241.

19 *Déclaration De La Sarraz* (1928), in Martin Steinmann, *CIAM: Dokumente 1928–1939* (Basle, 1979), p.30.

20 Ibid., pp.28, 30.

21 Modernity is here understood as perceived change, especially of a technical kind, characterized by industrial production, the use of new materials and new forms of transportation. There was a widespread perception that changes of this kind in the late nineteenth and early twentieth centuries marked a major historical shift, often referred to as the 'Machine Era'.

22 Now known as Meadow Green, the village was originally dubbed 'Daily Mail' and consisted of 41 cottages, many of them built with revolutionary structural systems, but almost all in a traditional neo-Georgian style. Deborah Ryan, *Daily Mail Ideal Home Exhibition through the 20th century* (London, 1997), pp.40–41.

23 Sigfried Giedion, *Mechanization takes Command* (New York, [1948] 1969), p.3.

24 Ibid., p.4.

25 Walter Riezler, 'Preface', in Wolfgang Pfleiderer, *Form ohne Ornament* (exh. cat., *Deutscher Werkbund*, Stuttgart, 1924).

26 For a discussion of fashion and modern architecture, see Mary McLeod, 'Undressing architecture: fashion gender and modernity', in Deborah Fausch et al., *Architecture in Fashion* (Princeton, 1994), pp.38–123. The Wagner quotation is on p.53. See Wagner (1988), p.77.

27 For Adolf Loos, men's fashion and the best forms of craftsmanship evolved imperceptibly in response to the times, without recourse to ornament. The aim of the well-dressed gentleman or the well-made leather saddle was to be 'correct'.

28 Marcel Breuer, 'Where do we stand?', lecture (1934), in Tim and Charlotte Benton and Dennis Sharp., *Form and Function* (London, 1975), p.180.

29 Le Corbusier-Saugnier, 'Le standart, imposé par la loi de sélection, est une nécessité économique et sociale', *Vers une Architecture* (Paris, 1923), p.115.

30 Ibid., pp.106–107.

31 Adolf Loos, 'Ornement et Crime', *L'Esprit Nouveau*, vol.1, no.2 (1920), pp.159–68 (originally published in 1908 as 'Ornement und Verbrechen', but given wider coverage in 1912 in *Der Sturm* and in French in 1913 in *Les Cahiers d'Aujourd'hui*). For Loos, writing in Vienna before the First World War, the epitome of fashion was the well-dressed Englishman, whose aim was not to be noticed. Similarly, modern architecture should not be subject to modish vagaries of taste, but should evolve gradually in response to new conditions.

32 For example, Sigfried Giedion on Robert Mallet-Stevens, *Building in France; Building in Steel; Building in Ferroconcrete* (Santa Monica, [1928] 1995), p.190.

33 Mark Wigley, 'White-out: Fashioning the Modern', in Fausch (1994), pp.148–269, and Wigley, *White Walls and Designer Dresses, The Fashioning of Modern Architecture* (Cambridge, MA, 1995), p.153.

34 André Lurçat, 'Architecture Internationale', *Deuxième exposition annuelle du comité Nancy-Paris* (exh. cat., Nancy, March 1926), in Jean Louis Cohen, *André Lurçat, 1894–1970; Autocritique d'un moderne* (Liège, 1995), p.75. Cohen notes the influence of the text 'Towards a collective construction', by Theo van Doesburg and Cornelis van Eesteren, published in *De Stijl*, ser.XII, 6–7 (1924), pp.89–92.

35 Behne began his book *Der moderne Zweckbau* with the assertion that, from primitive times, 'the instinctive joys of play cannot be separated from practical matters . . . from the very beginning the house has been as much a toy as a tool'. Adolf Behne, *The Modern Functional Building* (Santa Monica, [1926] 1996), p.87. Le Corbusier constantly referred to the desirable qualities of sun, space and greenery and placed the slogan on the cover of his book *La Ville Radieuse* (Paris, 1935).

36 Joseph August Lux, *Ingenieur-Aesthetik* (Munich, 1910). Many of the illustrations were reused in Werner Lindner and Georg Steinmetz, *Die Ingenieurbauten in ihrer guten Gestaltung* (Berlin, 1923), a book in which the aesthetic of engineering structures was more formally considered. Lindner's photographs and arguments were illustrated in the second issue of *G*, thus forging the direct link with avant-garde Modernism.

37 Ibid., p.4, cited in Georgiadis Sokratis, 'Introduction' to Giedion (1995), p.31.

38 Among the relevant sources are Adolf von Hildebrand's *Das Problem der Form in der bildenden Kunst* (1893), August Schmarsow's lecture 'Das Wesen der architektonischen Schöpfung' (1893) and Theodor Lipps's 'Raumästhetik und Geometrisch-optische Täuschungen' (1893), cited in Forty (2000), pp.260–61.

39 See Neumeyer (1991), pp.171–7.

40 Giedion (1995), p.87.

41 Mies van der Rohe, inaugural address as Director of Architecture at the Armour Institute of Technology, 1938, cited in Neumeyer (1991), p.24.

42 For an analysis of this term, see Heynen (1999), pp.30–35.

43 Giedion was later explicit about the connection between Cubist space and the transparency of Modernist buildings. In his book *Space, Time and Architecture* (Cambridge, MA, 1941), pp.298–9, he juxtaposed Picasso's *L'Arlesienne* with a photograph of Walter Gropius and Adolf Meyer's Bauhaus building, Dessau, 1925–6, in the context of a discussion of theories of relativity and what they called 'the artistic equivalent of space-time', p.14.

44 Giedion (1995), p.91.

45 The DWB was founded in 1907. 13 photographs of American, Canadian and Argentinean industrial buildings, in an unpaginated section, illustrating Walter Gropius, '*Die Entwicklung moderner Industrie-Baukunst*', in *Die Kunst in Industrie und Handel, Jahrbuch des Deutschen Werkbundes* (Leipzig, 1913), pp.17–22. A number of books had previously published similar (and often identical) images; see especially Alfred Meyer, *Eisenbauten, ihre Geschichte und Aesthetik* (Esslingen, 1907).

46 Le Corbusier-Saugnier, 'Trois Rappels à MM les architectes', *L'Esprit Nouveau*, vol.1, no.1 (1920), pp.91–6.

47 Ibid., p.92, reprinted in Le Corbusier-Saugnier (1923), p.16.

48 Tim Benton, 'From Jeanneret to Le Corbusier: rusting iron, bricks and coal and the modern Utopia', *Massilia*, vol.2 (2003), pp.28–39.

49 Le Corbusier, *L'Art Décoratif d'Aujourd'hui* (Paris, [1925] 1959).

50 For a discussion of the place of *Kunstwollen* in Austrian and German thought, see Werner Oechslin, *Otto Wagner, Adolf Loos, and the Road to Modern Architecture* (Cambridge, 2002), esp. pp.76–9.

51 Walter Gropius, *Internationale Architektur*, trans. in Charlotte and Tim Benton, *Images* (Milton Keynes, 1975).

52 Ibid.

53 Herman Muthesius, 'Style-Architecture and Building-Art: Transformations of Architecture in the Nineteenth Century and its present condition' (1902), cited in Detlef Mertens, 'Introduction', in Behrendt (2000), pp.1–84.

54 Moise Ginzburg, *Style and Epoch*, (Cambridge, MA, [1924] 1982).

55 The INKhUK *Productivist Manifesto* and Alexei Gan's *Konstruktivizm* (1922) included attacks on art as necessarily bourgeois and imbued with mystical premises.

56 Ginzburg (1982), p.42.

57 Behrendt (2000), p.89.

58 Ibid., p.102.

59 Le Corbusier, 'Five Points of a New Architecture', *Die Form*, vol.2 (1927), pp.272–4, trans. in Benton, Benton and Sharp (1957), pp.153–5 (originally published in *Almanach de l'Architecture Moderne* (Paris, 1926).

60 Terence Riley, *The International Style: Exhibition 15 and the Museum of Modern Art* (exh. cat., Museum of Modern Art, New York, 1992). *Modern Architecture International Exhibition* (exh. cat., Museum of Modern Art, New York, 1932) consisted mainly of illustrations with a short introduction by Alfred H. Barr and text by Hitchcock, Johnson and Louis Mumford. The simultaneously published book by Hitchcock and Johnson, *The International Style: Architecture Since 1922* (New York, 1932), includes a more considered and detailed text.

61 The use of 'functionalism' – or its French, German or Dutch equivalents – as here, to denote an anti-aesthetic utilitarianism motivated by political radicalism, was relatively new. I will use the term as a convenient, if largely anachronistic descriptor in the same way. In German, the words 'sachlich', 'zweckmässig' and 'funktionell' all have subtly different meanings, of which the most common, 'sachlich', was often used in aesthetic discourse to mean 'rational' or 'down-to-earth'. See Rosemarie Haag Blätter's useful introduction to Behne (1996) for a discussion of these terms.

62 Hitchcock and Johnson (1932), p.80.

63 Among these the most notable are the Stock Exchange, Amsterdam, 1900, by H.P. Berlage (exposed steel truss); the apartment block by Auguste and Gustave Perret, Paris, 1903 (reinforced concrete frame); the first block of the Fagus Shoe-Last factory, Alfeld-an-der Leine, by Gropius and Meyer, 1912 and their exhibition buildings at the Deutscher Werkbund Exhibition, 1914 (use of glass walls); Otto Wagner's Post Office Savings Bank building, Vienna, 1903 (effects of transparency in the main hall); various buildings by Adolf Loos in Vienna (the aesthetic of white geometric forms); and several buildings by Frank Lloyd Wright in the

United States (open space and strong horizontals in roof lines).

64 The German publisher Wasmuth produced a lavish portfolio of Wright's designs in two volumes, including a number of house and housing projects in reinforced concrete; Frank Lloyd Wright, *Ausgeführte Bauten und Entwürfe von Frank Lloyd Wright* (Berlin, 1910). Also a smaller edition of photographs of his completed buildings, with an introduction by the English Arts and Crafts designer C.R. Ashbee, who had visited him in 1901 in Chicago; Wright, *Frank Lloyd Wright Ausgeführte Bauten* (Berlin, 1911). Berlage was one of the first European architects to promote the work of Wright, prompting the visit by Erich Mendelsohn to meet Wright in America after the war. The journal *De Stijl* published pieces on Wright from the first volume. The influential Dutch journal *Wendingen* dedicated a special issue to Wright in 1925. Wright eloped to Europe with the wife of a client in October 1909 and was in Berlin to work on these editions from 1909 to 1910. See Anthony Alofsin, *Frank Lloyd Wright, The Last Years, 1910–22* (Chicago, 1993).

65 For the debates in Germany in these years, see Marcel Franciscono, *Walter Gropius and the creation of the Bauhaus in Weimar: The ideals and artistic theories of its founding years* (Urbana, 1971).

66 See G.H. Magnus and E.M. Keller (eds), *Zwischen Kunst und Industrie; Sonderausgabe für den Deutschen Werkbund* (Stuttgart, 2nd edn 1987), for a history of the *Deutscher Werkbund* and an anthology of writings by its members. The *Werkbund* journal *Die Form* was edited by Walter Curt Behrendt (1925–6) and then Walter Riezler (1926–33). For a history of the *Werkbund*, see Lucius Burckhardt, *The Werkbund: studies in the history and ideology of the Deutscher Werkbund 1907–1933* (London, 1980).

67 For a recent survey, see Owen W. Harrod, 'The Deutsche Werkstätte and the dissemination of mainstream modernity', *Studies in the decorative arts*, vol.10, no.2 (Spring–Summer 2003), pp.21–41.

68 Taut (1929), p.71.

69 Nikolaus Pevsner, *Pioneers of the Modern Movement* (London, 1936).

70 Reyner Banham was one of the first to challenge this account and insist on the impact of the avant-garde movements. Banham, *Theory and Design in the First Machine Age* (exh. cat., V&A Museum, London, 1960).

71 For a comparison with Art Deco, see Charlotte and Tim Benton, 'The Style and the Age', and Tim Benton, 'Art Deco architecture', in Charlotte Benton et al., *Art Deco 1910–1939* (exh. cat., V&A Museum, London, 2003), pp.12–27, 244–59. See also Janet Ward, *Weimar Surfaces: Urban visual culture in 1920s Germany* (Los Angeles, 2001), for an attempt to place Modernism in Germany into the context of promotion and display.

72 Le Corbusier turned against his master Perret, Mies against his mentor Behrens, and Oud against Berlage.

73 Hermann Muthesius (1927), 'Der Kampf um das Dach', *Baukunst und Bauhandwerk*, vol.2 (1927), reprinted in Charlotte Benton, *Documents* (Milton Keynes, 1975), p.23.

74 Adolf Behne, 'Ruf zum Bauen', in Behne and Hans Hansen, *Ruf zum Bauen: Zweite Buchpublikation des Arbeitsrat für Kunst* (Berlin, 1920), pp.3–6.

75 Theo van Doesburg (1931), in Straaten (1988), p.19.

76 Taut opened the series of exchanges of illustrated letters among a group of Expressionist friends on 24 November 1919 and the sequence finished with Hermann Finsterlin's of 24 December 1920. Oswald M. Ungers, *Die gläserne Kette; Visionäre Architekturen aus dem Kreis um Bruno Taut 1919–1920* (exh. cat., Akademie der Künste, Berlin, 1963).

77 Paul Scheerbart had published a number of futuristic books before the war, in which coloured glass was used as a metaphor for a mystical transformation of society. Bruno Taut's Glass Pavilion at the *Deutscher Werkbund* Exhibition of 1914 in Cologne (pl.2.4) had been dedicated to Scheerbart. Most of the fantastic coloured sketches exchanged by the members of Taut's correspondence circle, the Glass Chain, used concrete and coloured glass, often to cover vast spaces of social meeting places.

78 Mies van der Rohe, text accompanying the publication of the Friedrichstrassse competition designs in *Frühlicht*, vol.4 (1922), cited in Neumeyer (1991), p.240.

79 J.J.P. Oud, 'Über die zukünftige Baukunst und ihre architektonischen Möglichkeiten', *De Stijl*, vol.4 (1921), cited in Reyner Banham, *Theory and Design in the Machine Age* (London, 1960), p.159.

80 Giedion (1995), p.176.

81 Kazimir Malevich had used the phrase 'fundamental suprematist elements' as early as 1915, and Lissitzky probably brought an under-standing of Suprematism to Europe in 1921. An *Aufruf zur elementaren Kunst* was signed by László Moholy-Nagy, Ivan (Jean Pougny) Puni and a number of Dadaist artists, and this text was reprinted in *De Stijl*,vol.4 (1921), p.156.

82 Victor Margolin, *The Struggle for Utopia* (Chicago, 1997).

83 'We cannot imagine a creation of new forms in art unrelated to change in social form', cited in ibid., p.57.

84 *G* (for *Gestaltung*, meaning both formation and education) was founded by Hans Richter, with Lissitzky and Van Doesburg, supported by Mies van der Rohe, who subsidized the journal in its later stages. In the meantime, Van Doesburg published a Constructivist Manifesto in *De Stijl*, vol.5, no.8 (August 1922).

85 Karel Teige, 'Deset let Bauhausu' ['Ten Years at the Bauhaus'], *Stavba*, vol.8 (1929–30), pp.146–52.

86 Giedion (1995), p.145. The aerocar illustrated by Stam was based on Francis Laur's 150 kph suspended monorail project; *ABC* published a proposed application of this invention linking Paris and its suburb of Saint-Denis, *ABC*, ser.2, no.1 (1926), p.4.

87 Stam's was by no means the first cantilevered chair to be designed, but he grasped the significance of the principle as a Modernist article of faith. Jan van Geest and Otakar Mácel, *Stühle aus Stahl* (Cologne, 1980), pp.26–7.

88 Mart Stam, 'Kollektive Gestaltung', *ABC*, no.1 (1924), p.2. Translation taken from reprint, Catherine Schelbert and Michael Robinson, *ABC Beiträge zum Bauen 1924–8* (Baden, 1993), p.31.

89 For the text of Mies's article on his glass towers in *Frühlicht*, vol.1, no.4 (1922), see Neumeyer (1991), p.240. Even though Mies had stressed the rationality of basing his design on the impression made by the steel skeletons of skyscrapers in construction, he explains that the apparently arbitrary curves of the plan were determined in part 'by the play of the desired light reflection'.

90 Mies published his office block in *G*, no.1 (July 1922), with a brief text insisting on the rejection of all aesthetic speculation.

91 *ABC*, ser.2, no.1 (1926), p.1, cited in Werner Möller, 'Das nutzlose Schöne', in Schelbert and Robinson (1993).

92 *ABC*, ser.2, no.4 (1927/8), p.1. This was printed underneath an image of pipes from a hydroelectric plant slicing through the landscape.

93 Teige was associated at one time or another with *Stavba* (1923–31), *ReD* [*Butterbur Review*] (1927–8) and *Devětsil* [*Butterbur*] (1919–27).

94 Giuliano Gresleri and Dario Matteoni, *La citta' mondiale: Anderson, Hébrard, Otlet, Le Corbusier* (Venice, 1982).

95 Karel Teige, 'K teorii konstruktivismu', *Stavba*, vol.7 (1928–9).

96 Karel Teige, 'Mundaneum', *Oppositions*, no.4 (1975), pp.83–91.

97 Le Corbusier, 'Défense de l'architecture', *L'Architecture d'Aujourd'hui* (1933), pp.38–64.

98 Josef Frank, 'Fassade und Interieur', *Deutsche Kunst und Dekoration* (31 June 1928), p.187, cited in Christopher Long, 'The wayward heir: Josef Frank's Vienna years, 1885–1933', in Nina Stritzler-Levine (ed.), *Josef Frank Architect and Designer* (exh. cat., Bard Center for Graduate Studies, New York, 1996), p.51.

99 Theo van Doesburg, 'Stuttgart-Weissenhof 1927: Die Wohnung' (1927), as cited in Stritzler-Levine (1996), p.22.

100 Josef Frank, '*Der Gschnas fürs G'mut und der Gschnas als Problem*', Deutscher Werkbund, *Bau und Wohnung* (Stuttgart, 1927), p.49, cited in ibid., p.54.

101 Josef Frank, *Architektur als Symbol: Elemente deutschen neuen Bauens* (Vienna, [1931], 1981).

6 Sitting on Air

1 Gerrit Rietveld, 'Stoelen', *De werkende vrouw* (1930), trans. in Marijke Küper and Ida van Zijl, *Gerrit Th. Rietveld, the Complete Works* (exh. cat., Central Museum, Utrecht, 1992), p.27.

2 This was a common graphic device of the period, suggestive of the important place of film in the contemporary imagination. Actual filmstrips were also printed on the pages of Bauhaus books; see, for example, Walter Gropius, *Bauhaus Bauten Dessau* (Munich, 1930), *passim*.

3 Bruno Taut, *Die neue Wohnung* (Leipzig, 1924), p.31.

4 On Schröder, see 'Interview with Truss Schröder' in Paul Overy et al., *The Rietveld Schröder House* (Houten, 1988), pp.42–103, and Alice T. Friedman, *Women and the Making of the Modern House* (New York, 1998), pp.65–91. The Stein salon is illustrated in ibid., p.120, and briefly commented upon on p.119.

5 Erna Meyer, *Der neue Haushalt* (Stuttgart, 1929, 36th edn), p.86 on the 'woeful' (*traurig*) state of commercially available furniture, where she also cites Bauhaus and *Deutscher Werkbund* publications as useful sources of good advice.

6 Bentwood was closely associated with the name of Thonet, but was also manufactured by other European firms, most notably Kohn, with which Thonet had merged in 1922; see Christopher Wilk, *Thonet: 150 Years of Furniture* (Woodbury, NY, 1989), p.78, and, on the bentwood chairs favoured by Modernists, pp.83–91.

7 Le Corbusier, *Almanach d'Architecture Moderne* (Paris, 1925), p.145, trans. in Sigfried Giedion, *Mechanization Takes Command* (New York, [1948] 1969), p.492.

8 The interiors are illustrated in Werner Gräff, *Innenräume* (Stuttgart, 1928), an official exhibition publication, illustrating both furnished interiors of the houses and the chairs shown in the separate exhibition areas.

9 Le Corbusier, *The Decorative Art of Today* (London, [1925] 1987), p.47.

10 Ladislav Žák, 'Über Metallmöbel', in *Měsíc*, vol.1, no.11–12 (1932), pp.33–5, trans. into German in Jan van Geest and Otakar Mácel, *Stühle aus Stahl* (Cologne, 1980), pp.163–4.

11 For a list of early visitors, from Ise Gropius's unpublished diary, see Walter Scheiffele, '"You must go there" – contemporary reactions', in Margret Kentgens-Craig (ed.), *The Dessau Bauhaus Building 1926–1999* (Basle, 1998), pp.113–15.

12 The widest survey of inter-war steel furniture remains van Geest and Mácel (1980), though much of its information has been superseded.

13 Marcel Breuer, 'metallmöbel und moderne räumlichkeit', *Das neue Frankfurt*, vol.2, no.1 (1928), trans. in *50 Years Bauhaus* (exh. cat., Royal Academy of Arts, 1968), p.109.

14 A forceful polemic in favour of the minimal dwelling and the reduction of all but the essential is Mart Stam, 'For mit den Möbelkunstlern', in Gräff (1928), pp.128–30, trans. in Tim and Charlotte Benton and Dennis Sharp, *Form and Function* (London, 1975), pp.227–8.

15 For example, by Le Corbusier in *Précisions* (Paris, 1930), p.111.

16 On the development of types (*Typisierung*) and its myriad definitions, as well as the early use of the word *Typenmöbel* between 1911 and 1921, see Frederic J. Schwartz, *The Werkbund* (New Haven, 1996), pp.121–46.

17 Le Corbusier, *The Decorative Art of Today* (London, [1925] 1987), p.75.

18 Willi Lotz, 'Möbeleinrichtung und Typenmöbel', *Die Form*, vol.3, no.1 (1928), p.161, trans. in Benton, Benton and Sharp (1975), p.229.

19 Le Corbusier, 'The Furniture Adventure', in *Précisions* (Paris, 1930), p.111, excerpts from this chapter trans. in Benton, Benton and Sharp (1975), pp.233–8.

20 Marcel Breuer, 'The House Interior', from the manu-script of a lecture given at the Technical University, Delft, 1931, trans. in Christopher Wilk, *Marcel Breuer: Furniture and Interiors* (New York, 1981), p.186.

21 Le Corbusier (1987), p.47.

22 Charlotte Perriand, 'Wood or Metal? A Reply', *The Studio*, vol.97, no.433 (1929), p.278.

23 Theo van Doesburg, 'Tot een Beeldende Architectuur', *De Stijl*, vol.6, no.6–7, series 12 (1924), p.81.

24 On Stam's inspiration, see the publication in 1928 by architects Heinz and Bodo Rasch, *Der Stuhl* (Stuttgart, 1928), p.50, of an illustration of Stam's chair compared to a cantilevered 'folding [Mercedes] automobile seat', and Ferdinand Kramer's mention of the folding tubular-steel seat in a Hanomag car in John Heskett, 'Germany: the Industrial Applications of Tubular Steel', in Barbie Campbell-Cole and Tim Benton (eds), *Tubular Steel Furniture* (London, 1979), p.23. On Mies, see Ludwig Glaeser, *Mies van der Rohe. Furniture and Furniture Drawings from the Design Collection and the Mies van der Rohe Archive* (exh. cat., Museum of Modern Art, New York, 1977), p.9.

25 See Gräff (1928), *passim*.

26 See, for example, the satirical drawings of Heath Robinson, in Robinson and K.R.G. Browne, *How to Live in a Flat* (London, 1936). For a summary of the controversy surrounding tubular steel, see Wilk (1981), pp.68–9.

27 It was Reyner Banham who first wrote that Breuer and Le Corbusier 'produced chairs which were, in terms of their overall conception, Rietveld's chair reworked in fabric and steel'. Banham, *Theory and Design in the First Machine Age* (London, 1960), p.198.

28 Theo van Doesburg, 'Aanteekeningen bij een Leunstoel van Rietveld', *De Stijl*, vol.2, no.11 (1919), n.p. (between 132 and 133).

29 'Building', *G*, no.2 (September 1923), p.1, trans. in Fritz Neumeyer, *The Artless Word, Mies van der Rohe on the Building Art* (Cambridge, MA, 1991), p.242.

30 'Hygienic' was one of a series of words denoting the qualities of tubular-steel furniture in one of the earliest sales catalogues, that published by the Standard-Möbel firm of Berlin in 1928. The full list was: 'Economic · hygienic · light · comfortable · resilient [*elastisch*] · springy [*federnd*] · practical · objective [*sachlich*] · aesthetic · indestructible'. The catalogue is reproduced in Alexander von Vegesack, *Deutsche Stahlrohrmöbel* (Munich, 1986), pp.32–3.

31 Aldous Huxley, 'Notes on Decoration', *Creative Art*, no.4 (October 1930), p.242.

32 Mart Stam, 'De Stoel gedurende de lartste 40 jaar', in *De 8 en Opbouw* (1935), p.7, cited in van Geest and Mácel, (1980), p.47.

7 The Healthy Body Culture

1 Raymond McGrath, *Twentieth Century Houses* (London, n.d. [1934]), p.19. I am grateful to Jeremy Aynsley and Sarah Medlam for their comments on this essay.

2 Among them were: Benito Mussolini (1883–1945), who embraced the healthy body culture as part of a fascist cult of virility and action (see Dennis Mack Smith, *Mussolini* [London, 1981], pp.113–14); Hans Surén (1885–1972), German army officer and, from 1933, enthusiastic Nazi, author of the best-selling *Der Mensch und die Sonne* (Stuttgart, 1924), later translated as *Man and Sunlight* (London, 1927); and in Denmark, the fascist Niels Bukh (1880–1950), who taught 'primitive gymnastics' at his Ollerup Gymnastic Academy, establishing what came to be called the 'Danish system' (see Niels Kayser Nielsen, 'The Cult of the Nordic Superman – Between the Pre-Modern and the Modern', *The Sports Historian*, vol.19, no.1 [May 1999], pp.61–80). The term 'healthy body culture' was used by Marcel Breuer in an interview conducted by the author on 19 January 1979.

3 Wolfgang Graeser, *Körpersinn. Gymnastik, Tanz, Sport* (Munich, 1927), p.10, trans. in Anton Kaes, Martin Jay and Edward Dimendberg, *The Weimar Republic Sourcebook* (Berkeley, 1994), p.685.

4 A similar view is expressed in Harold Segal, *The Body Ascendant: Modernism and the Physical Imperative* (Baltimore, 1998), p.8, a book that concentrates mainly on literature and drama.

5 One notable exception was the extensive treatment of the Life Reform movement in Germany around 1900 in Kai Buchholz et al. (eds), *Die Lebensreform*, 2 vols (exh. cat., Institut Mathildenhöhe, Darmstadt, 2001).

6 Karl Toepfer, *Empire of Ecstasy: Nudity and Movement in German Body Culture, 1910–1935* (Berkeley, 1997), p.32, discusses aspects of this. He cites the Futurist demand to suppress painting of the nude.

7 Wilhelm Worringer's influential *Abstraktion und Einfühlung* (Munich, 1908; trans. as *Abstraction and Empathy*, 1953) had as its subject the analysis and substantiation of 'the urge for abstraction' (p.14) and, at its core, a plea to abandon 'the one pole . . . [of] Classical art' and 'banal theories of imitation' (p.127). Frederic J. Schwartz's *Blind Spots: Critical Theory and the History of Art in Twentieth-Century Germany* (London, 2005), published after this essay was written, includes a chapter on 'Mimesis' and many subtle observations on 1920s visual culture.

8 Bruce Haley, *The Healthy Body and Victorian Culture* (Cambridge, MA, 1978), p.3.

9 The degree of acceptance is often difficult to gauge. Among the literature on the nineteenth century, see, for example, Harvey Green, *Fit for America: Health, Sport and American Society* (Baltimore, 1998) and Michael Hau, *The Cult of Health and Beauty in Germany* (Chicago, 2003), ch.1–6.

10 McGrath ([1934]), p.19.

11 There is a vast literature on this subject. A particularly provocative view, centred on the relationship between literary Modernism and technology, is Tim Armstrong, *Modernism, Technology and the Body* (Cambridge, 1998), where he writes of modernity bringing both 'a fragmentation and augmentation of the body in relation to technology' (p.5).

12 Among the large bibliography on the New Woman, see Ellen Wiley Todd, *The 'New Woman' Revised* (Berkeley, 1993); Estelle B. Friedman, 'The New Woman: Changing Views of Women in the 1920s', *Journal of American History*, vol.61 (September 1974), pp.372–93; Lynne Attwood, *Creating the New Soviet Woman* (New York, 1999); Katharina von Ankum (ed.), *Women in the Metropolis: Gender and Modernity in Weimar Culture* (Berkeley, 1997). In France, mainstream fashion magazines of the period are a rich source of contemporary attitudes.

13 For example, contemporary objections to women appearing before male audiences or participating in the Olympic Games are cited in Allen Guttmann, *A History of Women's Sports* (New York, 1991), pp.139–40. Fellow-tennis star Bill Tilden described Suzanne Lenglen's 'costume' as 'a cross between a prima donna's and a streetwalker's'; see Larry Engelmann, *The Goddess and the American Girl: The Story of Suzanne Lenglen and Helen Wills* (Oxford, 1988), p.25. The German film *Wege zu Kraft und Schönheit* (see below) was apparently censored in Britain and America for depicting nudity (see Toepfer [1997], p.373, although no source is given).

14 See Anson Rabinbach, *The Human Motor: Energy, Fatigue and the Origins of Modernity* (New York, 1990), p.183.

15 Rosemarie Beier and Martin Roth (eds), *Der gläserne Mensch – eine Sensation, Zur Kulturgeschichte eines Ausstellungsobjektes* (Stuttgart, 1990).

16 See Emmanuelle de l'Ecotais and Alain Sayag (eds), *Man Ray, Photography and its Double* (exh. cat., Centre Georges Pompidou, 1998), *passim*; László Moholy-Nagy, *Painting Photography Film* (London, [1925] 1969), p.109; and Magdalena Droste (ed.), *Herbert Bayer, Das künstlerische Werk 1918–1938* (exh. cat., Bauhaus Archiv, Berlin, 1974), p.17, cat.54. The quote is from Rosalind Krauss, 'Photographic Conditions of Surrealism', in *The Originality of the Avant-Garde and Other Modernist Myths* (Cambridge, 1987), p.116. With thanks to Jeremy Aynsley for raising this issue.

17 Ernst Preiss, 'Die Körperausbildung – eine Volksnotwendigkeit', in *Neue Wege der Körperkultur* (Stuttgart, 1926), trans. in Kaes (1994), p.683.

18 Wilfried van de Will, 'The Body and the Body Politic as Symptom and Metaphor in the Transition of German Culture to National Socialism', in Brandon Taylor and Wilfried van de Will, *The Nazification of Art* (Wincester, 1990), pp.29–30, though it is the central argument of Chad Ross, *Naked Germany* (Oxford, 2005), that the regeneration of the German race through the regeneration of the body was the most fundamental feature of naked body culture.

19 Marguerite Bink-Ischeuschler, 'Die Frau und die Nacktkultur', in *Das Freibad*, vol.1 (1929), p.2, cited in Ross (2005), p.129.

20 Hau (2003), p.196, and Ross (2005), p.32, though only occasionally covered as a topic in the rest of the text.

21 Among them, the followers of Bess Mensendieck and Rudolf van Laban. Many more are listed in Toepfer (1997), pp.41–96, a veritable encyclopaedia of information on mainly dance practices and figures. Although some dancers and polemicists embraced the eroticism of nudity, publications of the *Nacktkultur* movement devoted endless articles to refuting the notion that nudity was in any way erotic.

22 For contemporary testimony of the influence of German nudist culture from an American perspective, see Jan Gay, *On Going Naked* (Garden City, 1932), one nudist's tour of Europe, which includes as an appendix a list of nudist organizations in Europe (brought to my attention by Claire Wilcox). The American League for a Physical Culture was said to have been founded in 1929 by German immigrant Kurt Barthel (www.clothesfree.com/history.html, consulted 5 February 2005). For a Czechoslovak example, see Jiří Kroha's *Sociological Fragments* (cat.179), which is illustrated with images clipped mainly from German publications. For a British perspective, see the introduction by C.W. Saleeby to the English edition of Hans Surén (1927), pp.i–vii.

23 See their entries in 1920, 1924, 1927, 1929, 1932 and 1933 in www.nobelprize.org (consulted 27 April 2005). For popular recognition, mentioning Rollier, see 'Heliotherapy', *Time Magazine*, vol.1, no.23

(6 August 1923), p.19, as well as many articles in the American journal *Hygeia*. On the relationship between nudist culture and alternative therapies, see Ross (2005), ch.3. The work of Rollier and Bernard entered wider public consciousness in a way that contemporary research into the benefits of vitamin D did not; see 'History of Vitamin D' at http://vitamind.ucr.edu/history.html (consulted 27 May 2005) for a summary of the main discoveries, all made in the 1920s and '30s.

24 The Australian architect Arthur Stephenson cited by Julie Willis, 'Machines for Healing', *Architecture Australia* (July–August 2002).

25 Gropius's address to the 1928 Frankfurt meeting of CIAM, reprinted in English in 'The Sociological Premises for the Minimum Dwelling of Urban Industrial Populations', in Gropius, *The Scope of Total Architecture* (New York, 1950), p.116.

26 See, for example, John Gloag, 'Wood or Metal?', *The Studio*, vol.97 (1929), pp.49–50; Maurice Dufrêne, 'A Survey of Modern Tendencies in Decorative Art', *The Studio Yearbook of Decorative Art* (London, 1931), pp.2–4, reprinted in Tim and Charlotte Benton and Dennis Sharp, *Form and Function* (London, 1975); and Aldous Huxley, 'Notes on Decoration', *Creative Art*, no.4 (October 1930), p.242.

27 One of the leading *Nacktkultur* journals in Germany was entitled *Licht Luft Leben* (*Light, Air, Life, 1904–32*).

28 This is an oft-repeated story, but there is little reliable literature on the Chanel story and no well-documented information on tanning in France during this period.

29 Packaging exhibited at the Metropolitan Museum of Art 'Chanel' exhibition, 2005 (but not published in the catalogue).

30 See Stefano de Martino and Alex Wall, *Cities of Childhood, Italian Colonie of the 1930s* (exh. cat., Architectural Association, London, 1988), p.38 and *passim*.

31 Finsen pioneered research into the effects of ultra-violet light on the human body, in particular as a cure for smallpox and skin disease. His development of 'Finsen lamps' won him the Nobel Prize in 1903. Non-medical literature on the subject of heliotherapy is sparse. A very brief history of the major figures for the general reader, with good references, is offered in Richard Hobday, *The Healing Sun* (Forres, 1999), pp.87–110, a polemical book concerned with the role of sunlight on health.

32 Paul Scheerbart, *Glass Architecture* (New York, [1914] 1972), p.41.

33 Le Corbusier, 'Five Points of a New Architecture', *Die Form*, vol.2 (1927), pp.272–4, trans. in Benton, Benton and Sharp (1975), pp.153–5 (originally published in *Almanach de l'Architecture Moderne* [Paris, 1926]).

34 Ulrich Conrads, *Programmes and Manifestoes of 20th-century Architecture* (Cambridge, MA, 1975), p.111.

35 From 'Skyscrapers', *Berliner Börsen-Courier* (27 October 1929), trans. in Joseph Roth, *What I Saw. Reports from Berlin 1920–33* (London, 2004), p.117.

36 See the useful compilation of papers on practice in 10 European countries, Anne-Marie Châtelet, Dominique Lerch and Jean-Noël Luc, *L'école de plein air/Open-Air Schools* (Paris, 2003). The first such school was the Waldschule in Charlottenburg, Berlin.

37 'The Foundation and Manifesto of Futurism' (1909) reprinted in Charles Harrison and Paul Wood, *Art in Theory 1900–2000* (Oxford, 1992), p.148. There is no full consideration of the significance of the idea and terminology of hygiene in Modernist architecture, though it is touched on in a published Ph.D. dissertation: Andreas K. Vetter, *Die Befreiung des Wohnens* (Berlin, 2000), especially pp.238–44. He also considers the architectural expressions of healthy body culture, for example on pp.194–211 and 245–91.

38 The quotation is from Alfons Labisch, 'Doctors, Workers and the Scientific Cosmology of the Industrial World: Of the Social Construction of "Health" and the "Homo Hygienicus"', *Journal of Contemporary History*, vol.20 (1985), p.599. Such health-based reform movements had existed regularly in the century before 1918 as each generation dealt with the health threat of the day, such as the building of municipal sewers in response to typhoid epidemics in the 1840s and after (see Haley, 1978, pp.9–10).

39 Karel Teige, *Nejmenší Byt* (Prague, 1932), p.53, trans. in Eric Dluhosch and Rostislav Švácha, *Karel Teige 1900–1951* (Cambridge, MA, 1999), p.162.

40 Ernst Preiss, 'Die Körperausbildung – eine Volksnotwendigkeit', trans. in Kaes (1994), p.683.

41 Information from www.sante.gouv.fr/presidence/fr/ministere_fr.htm (consulted 27 May 2005)

42 Paul Weindling, *Health, Race and German Politics Between National Unification and Nazism 1870–1945* (Cambridge, 1989), p.409.

43 Ibid., pp.380–81, 412–13. See also the list of American films at the University of Michigan School of Medicine, http://www.med.umich.edu/medschool/chm/resources/healthfilmslist.htm (consulted 27 April 2005).

44 Ludvig Nordström, *Lort-Sverige* (Stockholm, 1938), cited in Jonas Frykman, 'Pure and rational. The Hygienic Vision: A Study of Cultural Transformation in the 1930s, the New Man', *Ethnologia Scandinavica* (1981), pp.38, 40.

45 See Cornielle Usborne, *Politics of the Body in Weimar Germany* (London, 1992), esp. ch.3. The British Social Hygiene Council (1925–57) had formerly (1914) been called the National Council for Combating Venereal Diseases (Wellcome Trust, London, Wellcome Library, SA/BSH).

46 Quotation from Alfons Labisch, 'Doctors, Workers and the Scientific Cosmology of the Industrial World: Of the Social Construction of 'Health' and the 'Homo Hygienicus', *Journal of Contemporary History*, vol.20 (1985), p.605.

47 Ibid., p.600, and Weindling (1989), p.404.

48 The left avoided the term 'racial hygiene' in favour of 'eugenics' or 'reproductive hygiene'; see Usborne (1992), p.133ff., and Angelique Richardson, 'The birth of national hygiene and efficiency, Women and eugenics in Britain and America 1865–1915', in Ann Heilmann and Margaret Beetham, *New Woman Hybridities: Femininity, feminism and international consumer culture 1880–1930* (London, 2004), pp.240–62.

49 On these topics see ibid., pp.378–9, 412–15; the very general Klaus Vogel, *Das Deutsche Hygiene-Museum Dresden 1911–1990* (Dresden, 2003); and Hans Körner and Angela Stercken (ed.), *1926–2002 GE-SO-LEI, Kunst Sport und Körper* (Ostfildern-Ruti, 2002).

50 Robert A. Nye, 'Degeneration, Neurasthenia and the Culture of Sport in Belle Epoque France', *Journal of Contemporary History*, vol.17 (1982), p.52, writes of the hope that in France 'sport and fitness would stimulate a total moral and physical regeneration of the French race'. He cites G.R. Searle, *Eugenics and Politics in Britain, 1900–1914* (Leyden, 1976) on the widespread fear among the medical profession and the public of the 'biological degeneration' of the population. C.W. Saleeby not only wrote the highly regarded *Sunlight and Health* (London, 1923, with four subsequent editions to 1928), but was also the author of three books on eugenics and chairman of the National Birthrate Commission (1928–30). See also Mark B. Adams (ed.), *Wellborn Science: Eugenics in Germany, France, Brazil, and Russia* (Oxford, 1990); Weindling (1989), *passim*; Hau (2003); Anne Carol, *Histoire de l'Eugénisme en France* (Paris, 1995).

51 Hoberman (1984), p.123, cites Mannheim's *Man and Society in an Age of Reconstruction* (New York, [1935]) and Huizinga's *In the Shadow of Tomorrow* (New York, 1936).

52 James Riordan, *Sport in Soviet Society: Development of Sport and Physical Education in Russia and the USSR* (Cambridge, 1977), pp.94–101, on the physical culture and what he calls the 'hygienists'.

53 Graeser (1927), pp.7–8, trans. from Kaes et al. (1994), pp.683–4.

54 Ufa (1925), directed by Wilhelm Prager, written by Nicholas Kaufmann, Wilhelm Prager and Ernst Krieger, 104 mins. It appears that a British sound version shorter in length (42 mins) was made in 1932, entitled *Back to Nature*, which included additional gymnasium scenes not shot by the original production team (see www.riefenstahl.org/actress/1925, consulted 27 May 2005). Leni Riefenstahl may have appeared as part of the Mary Wigman dance group in the film.

55 For a similar view, see Toepfer (1997), p.373.

56 See Gertrud Pfister, 'The Medical Discourse on Female Physical Culture in Germany in the 19th and Early 20th Centuries', *Journal of Sport History*, vol.17, no.2 (Summer 1990), pp.189, 191–2. See also Ellen W. Gerber, *American Women in Sport* (Reading, 1974); and Sheila Fletcher, *Women First: The Female Tradition in English Physical Education 1880–1980* (London, 1984).

57 Indeed, the desire to attract more men was the subject of discussion at the time. See, for example, Rudolf von Laban, *A Life for Dance* (London, 1975), trans. of *Ein Leben für den Tanz* [Dresden, 1935]), p.182.

58 Charlotte Perriand, 'Wood or Metal? A Reply', *The Studio*, vol.97, no.433 (1929), p.278.

59 Harold B. Segel, *The Body Ascendant, Modernism and the Physical Imperative* (Baltimore, 1998), esp. ch.3, 'The Dance Phenomenon', discusses the influence and appearance of dance in Modernist drama and literature. Segel argues that Modernism's preoccupation with physicality arose from a disenchantment with traditional intellectual culture, including language. See also Terri A. Mester, *Movement and Modernism: Yeats, Elliott, Lawrence, Williams, and Early Twentieth-Century Dance* (Fayetteville, 1997), which is most concerned with ballet rather than new movement culture.

60 John Martin, *Introduction to the Dance* (New York, 1939), offers one contemporary view of the development of modern dance, specifically relating it to 'the principles of modernism' (p.200).

61 See Nancy Reynolds and Malcolm McCormick, *No Fixed Points: Dance in the Twentieth Century* (New Haven, 2003), pp.1–29.

62 On Dalcroze, see Toepfer (1997), pp.15–21, 119–25, and Frank Martin (ed.), *Émile Jacques-Dalcroze* (Neuchâtel, 1965).

63 Information on Ada Bruhn from Franz Schulze, *Mies van der Rohe, a Critical Biography* (Chicago, 1985), pp.70–71. Interestingly, until her marriage Ada Bruhn lived in Dresden with Mary Wigman (see below), who knew Mies well and who would become a major figure in German Modernist dance (ibid., pp.75–6). Albert Jeanneret studied in Hellerau from 1909 to 1914. From 1919 to 1939 he led the Ecole française de rhythmique et d'education corporelle in Paris. Le Corbusier, an enthusiastic advocate of sport and exercise, sent Dalcroze a copy of *Vers une architecture* in 1924. See Stanislaus von Moos, *L'Esprit Nouveau, Le Corbusier und die Industrie 1920–25* (Berlin, 1987), pp.230–31, 240–43, and, with references to Le Corbusier's correspondence, Flora Samuel, *Le Corbusier, Architect and Feminist* (Chichester, 2004), pp.46–7.

64 According to Toepfer (1997), p.16, there were Dalcroze schools throughout Germany, but also in Stockholm, London, Paris, Geneva and St Petersburg.

65 The retrospective literature on Laban, written chiefly by disciples, is uncritical and mainly hagiographic. See Vera Maletic, *Body-Space-Expression, the Development of Rudolf Laban's Movement and Dance Concepts* (Berlin, 1987), with a bibliography of Laban's writings.

66 Hans W. Fischer, *Körperschönheit und Körperkultur. Sport Gymnastic Tanz* (Berlin, 1928), p.178. Fischer's is a particularly complete review of contemporary body culture, especially the differences and relationships between dance and sport, and between male and female activity.

67 Quotation from ibid., p.220.

68 Cited in Toepfer (1997), p.252.

69 Bess Mensendieck, *It's Up to You* (New York, 1931), pp.1, 9, 196, the last quotation being part of her consistent attacks directed at Dalcroze, Laban and most forms of expressive physical body culture. There is no monograph on Mensendieck. Cogent summaries of her work are provided in the entry by Arnd Krüger and Claudia Meimbresse in Karen Christensen, Allen Guttman and Gertrud Pfister (eds), *International Encyclopedia of Women and Sports* (New York, 2001), pp.727–8, which includes a bibliography; in Stephen Leet, *Richard Neutra's Miller House* (Princeton, 2004), pp.55–61; and in Toepfer (1997), pp.39–41.

70 Her major book was *Körperkultur des Wiebes* (1906, with subsequent editions in the 1920s).

71 Illustrated in Leet (2004), pp.108, 132.

72 One magazine article suggested that undertaking housework in the nude would lead to less exhaustion: 'hausarbeit ermüdend? . . . für uns nicht!'; *Lachendes Lebel*, vol.VIII, no.3, p.21, reproduced in Ross (2005), p.102.

73 By 1929 the book had gone through 36 editions. References are from Erna Meyer, *Der neue Haushalt* (Stuttgart, 1929), pp.21–2, 25, 113, 120. A Swedish example was *Gymnastikförbundets årsbok* (Stockholm, 1936), cited by Jonas Frykman, 'Pure and rational. The Hygienic Vision: A Study of Cultural Transformation in the 1930s, the New Man', *Ethnologia Scandinavica* (1981), p.51.

74 According to Richard Pommer and Christian Otto, *Weissenhof 1927 and the Modern Movement in Architecture* (Chicago, 1991), pp.117, 119, 123, J.J.P. Oud was the only architect among the group who actively collaborated with Meyer.

75 See Martine d'Astier et al. (eds), *Lartique: album of a century* (exh. cat., Hayward Gallery, London, 2004), pp.106–7, 148, 195. Shown in the exhibition 'Gustav Klutsis and Valentina Kulagina: Photography and Montage after Constructivism' (International Center of Photography, New York, 2004), though not published in the accompanying catalogue written by Maragrita Tupitsyn.

76 Described in Nils Jockel and Patricis Stöckemann, *Flugkraft in goldene Ferne: Bühnenentanz in Hamburg seit 1900* (exh. cat., Museum für Kunst und Gewerbe, Hamburg, 1989), p.83. The Deutsches Rundfunkarchiv has in its collection other shows, including 'Morgengymnastik' (1934) and 'Gymnastiksendung mit Musik' (1938).

77 Each of these has its own literature, but a recent synopsis of origins and interactions is Gertrud Pfister, 'Cultural Confrontations: German *Turnen*, Swedish Gymnastics and English Sport – European Diversity in Physical Activities from a Historical Perspective', *Culture, Sport, Society*, vol.6, no.1 (Spring 2003), pp.61–91. On the *Sokol*, see n.91 below.

78 Riordan (1977), pp.82–3.

79 'So hat der Arbeitersport den Zweck, den durch die Berufsarbeit verunstalteten menschlichen Körper zu bilden, Ziel der Sportbewegung ist der schöne Mensch.' ('Workers' sport aims to reshape the human body deformed by work. The aim of the sports movement is the beautiful person.') From Arthur Artzt (ed.), 'Sport und Politik', in *Agitationsbroschüre Nr. 7* (Leipzig, n.d.), quoted in Horst Ueberhorst, *Frisch, Frei, Stark und Treu. Die Arbeitersportbewegung in Deutschland 1893–1933* (Düsseldorf, 1973), p.347. See also n.91.

80 Hoberman (1984), p.123, offers a rich summary of contemporary political and sociological commentaries that discuss or touch upon sport, as well as the topic of sport and the intellectual.

81 Hannes Meyer, 'Die Neue Welt', *Das Werk*, vol.13, no.7 (1926), pp.205–24, trans. in Benton, Benton and Sharp (1975), p.106, and Kaes et al. (1994), p.447.

82 The history of such building types is not well served by the literature. On some of the structures built under fascism, see Simon Martin, *Football and Fascism, the National Game Under Mussolini* (Oxford, 2004), esp. ch.4.

83 Allen Guttman, *The Olympics: A History of the Modern Games* (Urbana, 1992).

84 Herbert Jhering, 'Boxen' *Das Tagebuch* , vol.8 (1927), p.589, trans. in Kaes et al. (1994), p.688.

85 Bertholt Brecht, 'Mehr guten Sport', *Berliner Börsen-Courier* (6 February 1926), trans. in Kaes et al. (1994), p.536. Brecht, 'Hook to the Chin', in John Willett and Ralph Manheim (eds), *Short Stories 1921–1946* (London, 1983), pp.68–71, and David Bathrick, 'Max Schmeling on the Canvas: Boxing as an Icon of Weimar Culture', *New German Critique*, no.51 (1990), p.126, which draws extensively on the autobiography of Max Schmeling.

86 See, for example, Le Corbusier's illustration of boxers in *L'Art Décoratif d'Aujoud'hui* (Paris, n.d. [1925]), p.172; Hannes Meyer's mention of Hans Breitenstäter, cited at n.81 above. For images of the Schmeling portrait, the boxing match and Karl Günther's painting (1919–20) of a boxing match between a British and American boxer, which includes the painter Otto Dix as a spectator, see John Willett, *The Weimar Years* (London, 1984) pp.106–107. American poet Mina Loy and writer Djuna Barnes both wrote about boxing; see Armstrong (1998), pp.123–8.

87 Cited without source in *Art and Power, Europe under the dictators 1930–45* (exh. cat., Hayward Gallery, London, 1996), p.20f.

88 René Schickle, *Symphonie für Jazz* (Berlin, 1929), p.40, cited in Wolfgang Rothe, 'When Sports Conquered the Republic', *Studies in Twentieth Century Literature*, vol.4, no.1 (1980), p.16. The same novel stated that 'no one is indispensable, not even the Kaiser, not even the dear Lord himself. Both are replaced completely by sportsmen. Yesterday it was the film stars.' On Lenglen's Patou attire, see Meredith Etherington-Smith, *Patou* (London, 1983), pp.51–2.

89 Any comparison of photographs of bathers in most European countries (and America) demonstrates the change. The cultural history of swimming (including its attire) has not been the subject of particularly meaningful analysis. A useful view of British behaviour is Catherine Horwood, '"Girls Who Arouse Dangerous Passions": Women and bathing, 1900–39', in *Women's History Review*, vol.9, no.4 (2000), pp.653–73.

90 See George L. Mosse, *The Nationalisation of the Masses: Political Symbolism and Mass Movements in Germany from the Napoleonic Wars through the Third Reich* (Ithaca, 1975) and, for the last two quotations, Susan Sontag, 'Fascinating Fascism', *New York Review of Books* (6 February 1975), p.26.

91 The basic early history is in Claire E. Nolte, *The Sokol in the Czech Lands to 1914* (New York, 2002); more provocative and interpretive is Petr Roubal, 'Politics of Gymnastics: Mass Gymnastics Displays under Communism in Central and Eastern Europe', *Body & Society*, vol.9, no.2 (2003), pp.1–25, which is complemented by the well-illustrated exhibition website 'Bodies in Formation' at http://www.osa.ceu.hu/galeria/spartakiad/online/index.html (consulted 27 May 2005). See also Petr Roubal, '"Today the Masses Will Speak": Mass Gymnastic Displays as Visual Representation of the Communist State', in Arnold Bartetzky, Marina Dmitrieva and Stefan Troebst (eds), *Neue Staaten – neue Bilder? Visuelle Kultur im Dienst staatlicher Selbstdarstellung in Zentral- und Osteuropa seit 1918* (Cologne, 2005), pp.323–36. The Nazis murdered 3,000 members of the *Sokol*, including its leader Augustin Pechlat and its most senior members, due to their involvement in the resistance movement. While the *Turnverein* undertook mass gymnastic demonstrations, the influence of the *Sokol*, in this respect, seems to have been much wider.

92 This Workers' Sport movement was composed of both the Socialist Workers' Sport International and the Red Sport International. According to David A. Steinberg, 'The Workers' Sport Internationals 1920–28', *Journal of Contemporary History*, vol.13 (1978), p.233 (largely concerned with the structures of the movement), each of these groups had more than two million members, 'making the sport movement by far the largest working class cultural movement'. Riordan (1977) does not mention the RSI. See also Arnd Krüger and James Riordan (eds), *The Story of Worker Sport* (Champaign, IL, 1996), containing essays on the movement in Germany, the Soviet Union, Finland, Austria, Sweden, Norway, Britain, Canada and Palestine.

93 Riordan (1977), p.110. In fact the term came from Czechoslovakia, where the first Spartakiad was organized in 1921 and described a mass gymnastic display (see Roubal [2005], p.327).

94 The image of Mussolini standing on a ski slope (but noticeably not on skis or in ski boots, bare-chested), is in *Mussolini il Mito* (Rome, 1983), fig.67. See also Mack Smith (1981), pp.113–14 and illus. between pp.146–7.

95 Mack Smith (1981), pp.107, 151, cited by Hoberman (1984), p.99; and, on Hitler's response to Mussolini and physicality, Hoberman (1984), p.83.

96 Hoberman (1984) writes extensively on the subject, citing Eugen Weber. The reference to Mosley is on p.61, but see also p.99.

97 It is even possible that the increased use of cameras by individuals in the inter-war years may have influenced the entire realm of self-image (suggested to me by Sarah Medlam).

98 The attaining of personal health was, to Bagot Stack, the means to achieve personal peace and balance, which, as she wrote in 1933, could 'root out . . . misunderstanding, and hatred, which leads to war' (cited by Jill Julius Matthews, 'They had Such a Lot of Fun: The Women's League of Healthy and Beauty Between the Wars', *History Workshop Journal*, vol.30, no.1 [1990], p.25). The Women's League drew inspiration initially from the Czechoslovak *Sokol* movement; see Prunella Stack, *Movement is Life, the Autobiography of Prunella Stack* (London, 1973), pp.43, 65–6. Matthews cites the numerous editions of the books and autobiographies written by Mary Bagot Stock and her daughter Prunella. Pathé's Eve Film Review (an inter-war newsreel for women) included footage of the Women's League.

99 Arthur Artzt (ed.), 'Sport und Politik', in Ueberhorst (1973), p.347. See also n.92.

100 Mensendieck (1931), 'Introduction', and p.36 (quoting Nietzsche on 'superior grace and beauty').

101 Hillel Schwartz, *Never Satisfied, a Cultural History of Diets, Fantasies and Fat* (New York, 1986) discusses dieting in America at some length and, in particular (on pp.200–202), the popular Hay diet, which was also followed in Europe in the 1920s.

102 'Die Liebe des Mannes', in *Berliner Illustrierte Zeitung*, vol.17 (1927), p.696, cited in Ingrid Short, 'Riding the Tiger in the Weimar Republic: Ambivalent images of the New Woman in the popular press of the Weimar Republic', in Ann Heilmann and Margaret Beetham, *New Woman Hybridities: Femininity, feminism and international consumer culture 1880–1930* (London, 2004), p.131.

103 Kathy Peiss, *Hope in a Jar: The making of America's beauty culture* (New York, 1998), ch.4–6.

104 On this topic, see Marie J. Clifford, 'Helena Rubenstein's Beauty Salons, Fashion, and Modernist Display', *Winterthur Portfolio*, vol.38, no.213 (Summer/Autumn 2003), pp.83–108. The photograph (fig.10 in the article) was published in the business magazine *Fortune* , vol.18, no.4 (October 1938), p.60.

105 See Carolyn Thomas de la Peña, *The Body Electric* (New York, 2003). Several fascinating examples of such therapies were published in the German women's magazine *UHU*, in the article 'Ein neuer Schlankheits-Apostel, Die Erfolge des amerikan- ischen Kosmetikers Dr Flaxander', *UHU*, vol.4, no.7 (April 1928), pp.48–53 (brought to my attention by Carol Tulloch).

106 Elizabeth Haiken, *Venus Envy, a History of Cosmetic Surgery* (Baltimore, 1997), pp.29–36, which covers only the United States.

107 Patricia Ober, *Der Frauen Neue Kleider: Das Reformkleid und die Konstruktion des modernen Frauenkörpers* (Kempten im Allgäu, 2005), p.209, a publication brought to my attention by Christopher Breward.

108 Haiken (1997), p.16, and ch.1–3 on the inter-war period.

8 Film as a Modernist Art

During the final revision of this essay I was fortunate to read two outstanding doctoral dissertations, which contributed useful perspectives. These were: *Avant-garde Culture and Media Strategies: The networks and discourse of the European film avant-garde, 1919–39* by Malte Hagener (University of Amsterdam, 1995); and *'A Picture Feverishly Turned': Cinema and Literary Modernism in the UK, 1911–1928* by Andrew Shail (University of Exeter, 2005).

1 Blaise Cendrars, *L'ABC du cinéma*, in Cendrars, *Hollywood, La Mecque du cinéma suivi de l'ABC du cinéma* (Paris, 1987), p.215.

2 Alfred H. Barr, Jr, 'Russian Diary 1927–28' (22 January 1928), *October 7* (Winter 1978), p.37.

3 *Photogénie* was originally one of the terms considered for the new process of photography by its official French inventor, Jacques Daguerre, in 1893. It was revived by the critic and film-maker Louis Delluc in 1919 to characterize the uniquely transformative or fascinating quality of the filmic image. Becoming a watchword for the French avant-garde of the 1920s, it has never been widely used outside France.

4 Charles Davy (ed.), *Footnotes to the Film* (London, 1938), pp.116–34.

5 The challenge of film to traditional conceptions of art was most fully expressed by Walter Benjamin in his 1936 essay, 'The Work of Art in the Age of Mechanical Reproduction', trans. in Harry Zohn (ed.), *Illuminations* (London, 1970), pp.219–53.

6 Iris Barry, *Let's Go to the Cinema* (London, 1926), p.43.

7 Robert Graves and Alan Hodge, *The Long Weekend* (London, 1940), p.129.

8 The virtues of 'Charlie's arse' over classic art were proclaimed in the Futurist-inspired *Eccentrism* manifesto, published by Grigori Kozintsev and Leonid Trauberg in Petrograd in 1922; trans. in Richard Taylor and Ian Christie (eds), *The Film Factory: Russian and Soviet Cinema in Documents, 1896–1939* (London, 1988), pp.58–64. Léger wrote various versions of a film scenario entitled *Charlot cubiste*, and created a wooden Cubist Chaplin figure for *Le Ballet mécanique*; see Peter de Francia, *Fernand Léger* (New Haven, 1983), pp.56–60, 267–8, n.12.

9 'We declare the old films, the romantic, the theatricalized, etc. to be leprous'; Dziga Vertov,

'We. A Version of a Manifesto' (1922), trans. in Taylor and Christie (1988), p.69.

10 Erwin Panofsky, 'Style and Medium in the Moving Pictures', first given as a talk at Princeton in 1934 to promote the Museum of Modern Art; revised version in Daniel Talbot (ed.), *Film: An Anthology* (Berkeley, 1966), pp.15–32.

11 Nikolaus Pevsner, *A History of Building Types* (London, 1976), p.88. (See also Chapter 11 , Mass-market Modernism).

12 O. Winter, 'The Cinematograph', *The New Review* (May 1896); reprinted in *Sight and Sound* (Autumn 1982). The identity of Winter has not so far been established.

13 D.H. Lawrence, *The Lost Girl*, ed. John Worthen (London, [1920] 1995), pp.148–9.

14 Vseveold Mayakovsky, 'The Relationship between Contemporary Theatre and Cinema and Art', *Kine-Zhurnal* (1913), trans. in Taylor and Christie (1988), p.36.

15 See Ian Christie, 'Before the avant-gardes: Artists and Cinema, 1910–1914', *La decime musa/The Tenth Muse* (Udine, 2001), pp.369–70.

16 The only source of this claim appears to be Kandinsky's partner Gabriele Münter, as reported in correspondence collected by Standish Lawder, *The Cubist Cinema* (New York, 1975), pp.30–32.

17 In a letter to his publisher, quoted in Erwin Stein (ed.), *Arnold Schoenberg – Letters* (London, 1964), pp.43–4.

18 There had been theories and experiments relating colour to pitch since the seventeenth century, involving Athanasius Kircher, Isaac Newton, Erasmus Darwin and others, before Wallace Rimington constructed a Colour Organ in 1895. See Christie (2001), pp.368–9.

19 Baudelaire's poem 'Correspondances' (in *Les Fleurs du Mal*, 1857) evoked a mystical unity of the universe in which everything is interrelated, with perfumes, sounds and colours all interchangeable; and this 'synaesthesia' between the senses would become central to *fin-de-siécle* aesthetics, not only in France.

20 Bruna Corra, 'Abstract Cinema – Chromatic Music' (1912), in Umbrio Apollonio, *Futurist Manifestos* (Boston, 2001), pp.66–70.

21 Ibid., pp.69–70.

22 Reproduced in Taylor and Christie (1988), p.32.

23 Lawder (1975), pp.21–6.

24 See Stanley Baron, Jacques Damase, *Sonia Delaunay: The life of an artist* (London, 1995), pp.45–50. For a fuller account of this, see Christie (2001), p.372.

25 See Christie (2001) for further information about Grant's work and its filmic re-presentation by the Tate Gallery.

26 Skriabin included a colour stave in his tone poem *Prometheus* (1911). On this and other art-music relationships, see Simon Shaw-Miller, *Visible Deeds of Music: Music and Art from Wagner to Cage* (New Haven, 2002).

27 Jean Arp (1938) quoted in Lawder (1975), p.39.

28 Ibid., p.46.

29 Theo van Doesburg, 'Abstracte Beeldinge', *De Stijl*, no.5 (June 1921), pp.71ff.; quoted in Lawder (1975), pp.47–9.

30 Leonhard Adelt, 'The Filmed Symphony', *Berliner Tagblatt* (1921).

31 Maximalliane Zoller, 'Polycinema – Paracinema – Expanded Cinema', paper given at the College Art Association (Atlanta, 2005). I am grateful to Zoller for sharing her interpretation of the German situation in the 1920s, which forms part of her doctoral research.

32 Commissioned to advertise the Berlin exhibition, Seeber's short film 'demonstrates the inextricable proximity of avant-garde and industry' at this time in Germany, according to Hagener (1995), p.159. Vertov's film, by contrast, was intended as an 'experiment in cinematic communication', to prove

that a work 'about' the process of cinema could be as engrossing as any 'theatrical' film. See Yuri Tsivian, '*Man with a Movie Camera*, Reel One', *Film Studies* no.2 (Spring 2000), pp.51–76.

33 Kazimir Malevich, 'The Artist and the Cinema', *Kinozhurnal ARK* (1926), trans. in Oksana Bulgakowa (ed.), *Kazimir Malevich: The White Rectangle: writings on Film* (Berlin, 1997), p.47.

34 *Art and the Problem of Architecture. The Emergence of a New Plastic System of Architecture. Script for an Artistic-Scientific Film* was written in 1927 during Malevich's visit to Germany, where he had seen abstract films for the first time. It is reproduced in Bulgakowa (1997), pp.51–8.

35 Lissitsky illustrated a number of Mayakovsky's poems in 1922–3, including 'A Tale of Two Squares' and 'For Reading out Loud', using typographic forms such as squares, circles and lines. Mayakovsky's scenario 'How are You?', subtitled 'A Day in Five Movie Details', was written in 1927 and intended for production by Kuleshov, but was never made. A translation appears in *Screen*, vol.12, no.4 (Winter 1971–2), pp.124–35.

36 Richter wrote in 1966 that he had 'completely forgotten about [his] film work with Malevich', and was only reminded when the script was published in 1964. See Bulgakowa (1997), p.13.

37 Moholy-Nagy, *The New Vision* (1928); and *The Problems of Modern Film* (1932). I am grateful to Maxa Zoller for these references.

38 Malevich, 'Painting and Photography: a letter to Laszlo Moholy-Nagy' (1927), in Bulgakowa (1997), p.59.

39 Malevich, 'Pictorial Laws in Cinematic Problems' (1929), ibid., p.84.

40 Colette, 'Cinéma: *Forfaiture*', in *Excelsior* (7 August 1916), trans. in Richard Abel (ed.), *French Film Theory and Criticism*, vol.1 (Princeton, 1988), p.128.

41 See my essay, 'French Avant-Garde Film in the Twenties: from "Specificity" to Surrealism', in *Film as Film: Formal Experiment in Film, 1910–1975* (exh. cat., Arts Council, 1979), pp.37–45.

42 See the account of Artaud's 'betrayal' by Dulac 'making a *feminine* film', by the leading Surrealist critic Ado Kyrou, *Le Surréalisme au cinema* (Paris, 1953), p.186.

43 Dulac, 'The Essence of Cinema: the Visual Idea', in *Les Cahiers du mois* (1925).

44 Quotations from an article by Chomette in the same issue of *Les Cahiers du mois*.

45 Leon Moussinac, quoted in Abel (1988), p.329.

46 Fernand Léger, 'Essai critique sur la valeur plastique du film d'Abel Gance, La Roue', *Comoedia* (1922), in Léger, *Fonctions de la peinture* (Paris, 1965), p.160.

47 Details of the lectures are given in Richard Abel's indispensable *French Cinema: The First Wave, 1915–29* (Princeton, 1984), p.255.

48 There seems to be no doubt that Pound, who had contemplated making a 'Vorticist' film with Murphy, was responsible for introducing the latter to Man Ray and to Léger, and for bringing Antheil into the collaboration. See Christopher Green, *Léger and the Avant-Garde* (New Haven and London, 1976); John Alexander, 'Parenthetical Paris, 1920–1925: Pound, Picabia, Brancusi and Léger', in Richard Humphreys (ed.), *Pound's Artists* (London, 1985).

49 For an account that emphasizes Léger's competence and creative control, see Judi Freeman, 'Léger's *Ballet mécanique*', in Rudolf E. Kuenzli (ed.), *Dada and Surrealist Film* (New York, 1987), pp.28–45. And for an opposing view, attributing most of the responsibility to Man Ray and Murphy, see William Moritz, 'Americans in Paris: Man Ray and Dudley Murphy', in Jan-Christopher Horak (ed.), *Lovers of Cinema: The First American Film Avant-Garde, 1919–1945* (Madison, WI, 1995), pp.118–36. It might be noted that none of Murphy's other films achieved any comparable reputation.

50 Fernand Léger, '*Ballet mécanique*' (c.1924, or later?), in Léger, *Functions of Painting*, (New York, 1965), p.53.

51 This formulation is by Christopher Green, 'Purism', in Nikos Stangos (ed.), *Concepts of Modern Art* (London, [1974] 1981), p.79.

52 The phrase appeared in a resolution by the Conference of Sovkino Workers in December 1928: see Taylor and Christie (1988), p.249ff.

53 Through his many polemical writings in the years 1922–4, Vertov moved from championing the 'mechanical' aspect of the 'kino-eye' to its ability to portray 'life caught unawares': 'Kino-eye as the negative of time/ as the possibility of seeing with-out limits and distances/ as the remote control of movie cameras/ as tele-eye/ as X-ray eye . . .', from 'The Birth of Kino-Eye' (1924), in Annette Michelson, *Kino Eye: The Writings of Dziga Vertov* (Berkeley and London, 1984), p.41.

54 Lev Kuleshov, 'The Banner of Cinematography' (1920), in Ekaterina Khokhlova (ed.), *Lev Kuleshov: Selected Works* (Moscow, 1987), pp.37–55.

55 Lev Kuleshov, 'Americanitis', *Kino-Fot*, no.1 (1922), trans. in Ronald Levaco, *Kuleshov on Film* (Berkeley, 1974), p.130.

56 Dziga Vertov, 'The Cine-Eyes: A Revolution', *Lef*, no.3 (1923); trans. in Taylor and Christie (1988), pp.89–93.

57 Servicemen were forbidden to attend performances in Germany, and there were restrictions in France. Many American states demanded cuts or banned it. Assurances were demanded in the British Parliament that it would not be imported, and it remained banned from public exhibition in the UK until after the Second World War. See Taylor and Christie (1988), pp.3–8; also Ian Christie, 'Censorship, Culture and Codpieces: Eisenstein's influence in Britain during the 1930s and 1940s', in Al Lavalley and Barry P. Scherr (eds), *Eisenstein at 100: A Reconsideration* (New Brunswick, 2001), pp.109–20.

58 For a full selection of Eisenstein's theoretical and polemical articles following the success of *Potemkin*, see Richard Taylor (ed. and trans.), *Eisenstein: Selected Writings 1922–1934* (London, 1988).

59 Eisenstein, 'Bela Forgets the Scissors', *Kino* (July 1926), trans. in Taylor (1988), pp.77–81.

60 Boris Eikhenbaum, 'Problems of Cine Stylistics', in *Poetika kino* (1927); Richard Taylor (ed.), *Russian Poetics in Translation*, vol.9 (1982), pp.5–31.

61 Eisenstein, Grigori Alexandrov and Vsevelod Pudovkin, 'Statement on Sound' (1928), in Taylor (1988), vol.1, p.114.

62 Eisenstein, 'Beyond the Fourth Dimension', ibid., p.191.

63 For example, Adrian Piotrovsky, '*October* must be re-edited!'; T. Rokotov, 'Why is *October* difficult?'; the Lef ring, 'Comrades! A clash of views!': all in Taylor and Christie (1988), pp.216–32.

64 Filmic influences can be found in non-fiction works by Soviet writers such as Viktor Shklovsky, *The Third Factory* (1926), Ilya Ehrenburg, *The Life of the Automobile* (1929) and Valentin Kataev, *Time Forward!!* (1932). John Dos Passos would make such filmic and documentary structures central to his novels from *Manhattan Transfer* (1925) onwards.

65 Grierson's achievement in Britain was to create a protective structure around the film-makers he recruited to his documentary groups at the Empire Marketing Board and General Post Office units, enabling them to work with little or no interference from sponsors. Documentarists elsewhere, such as Vertov, Ruttmann and Ivens, were often less fortunate. See Hagener (1995), pp.281–99.

66 Susan Sontag has suggested that Riefenstahl's films 'may be the two greatest documentaries ever made', while also arguing that 'they are not really important in the history of cinema as an art form', in order to raise important questions about the relationship between art and politics. See 'Fascinating Fascism' in Susan Sontag, *Under the Sign of Saturn* (London, 1983), p.95.

67 On the relationship between sponsored and spontaneous film-making, and what both owed to

the Soviet example, see Annette Kuhn, 'British Documentary in the 1930s and "Independence": Recontextualizing a Film Movement' and other essays, in Don Macpherson and Paul Willemen (eds), *Traditions of Independence. British Cinema in the Thirties* (London, 1978), pp.24–33.

68 Sidney Bernstein promoted it through his Granada cinema chain, ensuring that 'it was seen by a larger public than any experimental film before it, and most since'. David Curtis, *Experimental Cinema: A fifty year evolution* (London, 1971), p.36.

69 On Fischinger, see David Curtis (1971), pp.53–5; and William Moritz, 'The Films of Oskar Fischinger', *Film Culture*, no.58, 59, 60 (1974).

70 William Moritz, 'Fischinger at Disney, or, Oskar in the Mousetrap', *Millimeter*, vol.5, no.2 (February 1977).

71 On Hollywood's use of Modernist decor, see Donald Albrecht, *Designing Dreams: Modern Architecture in the Movies* (New York, 1986).

72 The film was started as *The General Line* in 1926, but was interrupted so that Eisenstein could make *October* (1928). When work resumed on it, agricultural policy had changed and the First Five-Year Plan was getting under way. Eisenstein was also emboldened by his experiments in intellectual montage in *October*, which led to a highly charged film that celebrated fecundity and offered Burov's model collective farm as its climax. It was removed from the repertoire while Eisenstein was abroad in 1929–31.

73 On the complex design history of *Things to Come*, see Christopher Frayling, *Things to Come* (London, 1995).

74 In so doing, it reverses the theme of Villiers de l'Isle Adam's 1888 novel *L'Eve future*, in which a fictionalized Thomas Edison creates a life-like 'android' to replace the dead lover of his friend.

75 On the significance of different design styles in *Aelita*, see Christie, 'Down to Earth: *Aelita* Relocated', in Richard Taylor and Ian Christie (eds), *Inside the Film Factory: New Approaches to Russian and Soviet Cinema* (London, 1991), pp.92–6.

76 For a range of illustrations of *Metropolis* and a bibliography on its design, see Dietrich Neumann, *Film Architecture: Set Designs from Metropolis to Blade Runner* (exh. cat., Munich, 1999), pp.94–103.

77 Ibid., pp.122–5.

78 Theosophy was an important inspiration for such pioneering Modernist artists as Kandinsky, Malevich and Mondrian. A good account of its influence appears in Robert C. Williams, *Artists in Revolution: Portraits of the Russian Avant-Garde 1905–1925* (London, 1977), pp.102–107.

79 *Citizen Kane* has been voted the greatest film of all time in a series of international critics' polls organized every decade since 1962 by *Sight and Sound*.

80 The modernity and longevity of *Citizen Kane* owe much to its complex and varied use of sound, which in turn owed much to Orson Welles's experience of working in that other Modernist medium of radio in the late 1930s. In 1938 he produced one of the most famous of all radio broadcasts: a pseudo-documentary dramatization of H.G. Wells's *War of the Worlds*, which caused widespread panic.

9 Modernism and Nature

1 Hugo Häring, 'Wege zur Form', *Die Form*, vol.1 (October 1925), p.4.

2 '. . . for most of the last five hundred years "nature" has been the main, if not *the* principal category for organizing thought about what architecture is or might be. The only significant break was in the early to mid-twentieth century when, in the era of high Modernist, "nature" was largely put into abeyance.'

Adrian Forty, *Words and Buildings: A Vocabulary of Modern Architecture* (London, 2000), p.220.

3 Alvar Aalto, reported by Göran Schildt, in Markku Lahti et al., *Alvar Aalto, de l'oeuvre aux écrits* (exh. cat., Centre Georges Pompidou, Paris, 1972), p.20.

4 Colin St John Wilson, *The Other Tradition of Modern Architecture* (London, 1995).

5 'Generally speaking, outer appearances resemble inner purposes. For instance, the form oak tree resembles and expresses the function or purpose, oak . . . ' Louis Sullivan, *Kindergarten Chats* (1901), in Forty (2000), p.178. For the origins of theories of organic functionalism, including Sullivan's, in German Romantic thought, see Forty (2000), pp.155–7, 177–80.

6 Tim Benton, 'Background to the Bauhaus', in Thomas Faulkner (ed.), *Design 1900–1960: Studies in Design and Popular Culture of the 20th Century* (Newcastle upon Tyne, 1976), pp.26–41.

7 Egidio Marzona, *Brüder Rasch, Material Konstruktion Form 1926–1930* (Düsseldorf, 1981).

8 Barbara Tilson, 'Plan furniture 1932–1938: The German connection', *Journal of Design History*, vol.3, no.2–3 (1990), pp.145–55.

9 Aalto's father, J.H. Aalto, was a surveyor who spent weeks at a time trekking through the forests of central Finland, surveying new railway lines. The young Alvar often accompanied him on these trips.

10 Alvar Aalto, *The Reconstruction of Europe* (1941), in Sarah Menin and Flora Samuel, *Nature and Space: Aalto and Le Corbusier* (London, 2003), p.3.

11 See Eva Rudberg, 'Utopia of the Everyday', in Cecilia Widenheim (ed.), *Utopia and Reality; Modernism in Sweden 1900–1960* (exh. cat., Bard Graduate Center, New York, 2002), pp.150–73, esp p.154.

12 Erik Gunnar Asplund, *acceptera!* (Stockholm, 1931), in Barbara Miller Lane, *National Romanticism and Modern Architecture in Germany and the Scandinavian Countries* (Cambridge, 2000), p.286.

13 Alvar Aalto, *Rationalism and Man*, in Lahti (1972), pp.128–35. The Swedish Society of Industrial and Crafts Design, directed from 1920 to 1934 by the hugely influential Gregor Paulsson, was highly unusual in bringing together both the crafts and industrial design for mass production.

14 In this he was closely following the criticisms of his Danish friend Poul Henningsen, whose PH lamps (cat.138) were much admired by Modernists and whose journal *Kritisk Revy* was a rallying point for Scandinavian Modernists.

15 Lahti (1972), p.132.

16 Göran Schildt, *Alvar Aalto: The Decisive Years* (New York, 1986), pp.78–80.

17 Kevin Davies, 'Finmar and the furniture of the future: The sale of Alvar Aalto's plywood furniture in the UK 1934–1939', *Journal of Design History*, vol.11, no.2 (1998); and Ásdís Ólafsdóttir, *Le mobilier d'Alvar Aalto dans l'espace et dans le temps; la diffusion internationale du design entre 1920 et 1940* (Paris, 1998). Aalto established a Finnish firm, Artek, to manage the manufacture and distribution of his furniture in 1936.

18 Jack Pritchard worked for the plywood manufacturing firm Venesta in the 1920s. See Jack Pritchard, *View from a Long Chair* (London, 1984).

19 Davies (1998), p.152.

20 The firm began part-time manufacture early in 1932. See Martha Deese, 'Gerald Summers and Makers of Simple Furniture', p.199 on the bent plywood chair discussed below, *Journal of Design History*, vol.5, no.3 (1992), pp.183–205.

21 See the Rasch chairs exhibited in the Peter Behrens block and Apartment 18 in the Mies building at the Weissenhof Siedlung, 1927. Karin Kirsch, *Die Weissenhofsiedlung* (Stuttgart 1987), pp.85, 190.

22 Luca Dosi Delfini, *The Furniture Collection, Stedelijk Museum Amsterdam* (Amsterdam, 2004), p.306.

23 For the context of Finnish enthusiasm for Karelia, see Miller Lane (2000), pp.90–103.

24 From Göran Schildt, *Alvar Aalto: The Early Years* (New York, 1984), in Menin and Samuel (2003), p.36.

25 H. Allen Brooks, *Le Corbusier's Formative Years: Charles-Edouard Jeanneret at La Chaux-de-Fonds* (Chicago, 1997), pp.5, 185–90.

26 Ibid.

27 Francesco Passanti, 'The vernacular, Modernism and le Corbusier', *Journal of the Society of Architectural Historians*, vol.56, no.4 (December 1997), pp.438–45.

28 Le Corbusier, *Une maison, un palais: à la recherche d'une unité architectural* (Paris, [1928] 1989), pp.48–52.

29 The original sketches are in Le Corbusier *Sketchbook*, I, B6, pp.389, 390, redrawn later and included in *La Ville Radieuse* (1935), trans. as *The Radiant City* (New York, 1967), p.29.

30 Ibid., pp.53–5.

31 Ibid., p.53.

32 Christopher Green, 'The architect as artist', in *Le Corbusier Architect of the Century* (exh. cat., Hayward Gallery, London, 1987), pp.110–57.

33 In addition to Le Corbusier and his friends, André Lurçat and the Italian Modernists looked to the white-painted vernacular of the Mediterranean, while German architects valued the half-timbered barns and collective houses of their regions.

34 'Suburban life is a despicable delusion entertained by a society stricken with blindness!', Le Corbusier (1967), p.91, and on p.12: 'The garden city leads to individualism. In reality to an enslaved individualism, a sterile isolation of the individual. It brings in its wake the destruction of social spirit, the downfall of collective forces.'

35 Giovanni Michelucci, 'Contatti fra architetture antiche e moderne', *Domus* (February 1932), pp.70–71; (March 1932), pp.134–6; (August 1932), pp.460–61.

36 Published as a book, *Architettura rurale italiana* (Milan, 1936); see Richard A. Etlin, *Modernism in Italian Architecture, 1890–1940* (Cambridge, MA, 1991), p.471.

37 *L'Architecture d'Aujourd'hui*, yr 6, no.1 (January 1935).

38 For a more complete list of these weekend and mountain homes designed by Pierre and Charlotte, see Jacques Barsac, *Charlotte Perriand: Un art d'habiter* (Paris, 2005), pp.152–61.

39 I have argued that the preliminary designs for this villa reveal a tension between Pierre Jeanneret and Le Corbusier, in which the former was prepared to go much further towards an informal, 'life-centred' approach to domestic architecture, while the latter in the end insisted on more formal, architectural values. Tim Benton, 'The little "maison de week-end" and the Parisian suburbs', *Massilia*, vol. 2 (2002), pp.112–19.

40 In an article by C.H.-F. Landry in the *Gazette de Lausanne* on 28 December 1933 the mural was described as 'corrupting young people' and as 'propaganda' for a materialist culture derived from the USSR. Le Corbusier published this article in the second volume of his *Œuvre complète 1929–34* (Zurich, [1934] 1964), p.76.

41 Stanislaus von Moos and Arthur Rüegg (eds), *Le Corbusier before Le Corbusier: Applied Arts, Architecture, Painting, Photography, 1907–1922* (New Haven, 2002), p.2.

42 Charlotte Perriand, 'Wood or Metal? A Reply', *The Studio*, vol.97, no.433 (April 1929), pp.278–89.

43 Peter Collins, *Changing Ideals in Modern Architecture* (London, 1965), pp.149–58.

44 For the nineteenth-century literature on empathy, see Harry Francis Mallgrave and Eleftherios Ikonomou, 'Introduction', in Robert Visher et al., *Empathy, Form and Space: Problems in German Aesthetics 1873–1893* (Santa Monica, 1994), pp.17–29.

45 Robert Vischer, *Über das optische Formgefühl: ein Beitrag zur Aesthetik* (Leipzig, 1873); Theodor Lipps, *Raumästhetik und geometrisch-optische Täuschungen* (Leipzig, 1897); Heinrich Wölfflin, *Prolegomena zu einer Psychologie der Architektur* (Munich, 1886); August Schmarsow, *Grundbegriffe der Kunstgeschichte vom Übergang vom Altertum zum Mittelalter, kritisch erörtet und in systematischem Zusammenhänge dargestellt* (Leipzig, 1905).

46 Häring (1925), trans. as 'Approaches to Form', in Charlotte and Tim Benton, *Form and Function* (London, 1975), pp.103–5.

47 Ibid.

48 Ibid.

49 Ibid.

50 Ludwig Hilberseimer, 'Hugo Häring und das neues Bauen', in Hilberseimer, *Die neue Stadt* (Berlin, 1952), pp.188–91.

51 Hugo Häring, 'Kunst und strukturprobleme des bauens', *Zentralblatt der Bauverwaltung*, no.29 (15 July 1931), in Fritz Neumeyer, *The Artless Word; Mies Van der Rohe on the Building Art* (Cambridge, MA, 1991), p.107.

52 Mies van der Rohe, inaugural address as director of architecture at the Armour Institute of Technology, 1938, cited in Neumeyer (1991), p.108.

53 Sabine Kremer, *Hugo Häring (1882–1958): Wohnungsbau Theorie und Praxis* (Stuttgart, 1985), pp.27–32.

54 Neumeyer (1991), pp.102–104.

55 Ibid., p.104.

56 Raoul Francé, *Der Wert der Wissenschaft: Aphorismen zu einer Natur- und Lebensphilosophie* (Zurich, 3rd edn 1908), p.119.

57 Raoul Francé, *Richtiges Leben: Ein Buch für Jedermann* (1924), in Neumeyer (1991), p.105.

58 Mendelsohn built department stores in Nuremberg, Stuttgart, Petersdorff, Berlin, Chemnitz and Moravska-Ostrava. His Columbushaus on the Potsdamerplatz, Berlin (1929–30), provided the model for the curtain wall (a wall of glass and thin metal frames suspended from the cantilevered ends of the floor slabs). Offices and shops in the 1930s, such as Peter Jones in London, increasingly adopted this solution, which became almost universal for office buildings after the war.

59 Mendelsohn did not himself use the term 'dynamic functionalism', but did include the phrase 'dynamic and function' in the title of one of his lectures and frequently talked of 'dynamic function'. 'The International Consensus of the New Architectural Concept or Dynamics and Function', lecture given in Mannheim, Amsterdam and The Hague, 1930.

60 Letter from Mendelsohn to J.J.P.Oud, 16 November 1923, in Oskar Beyer (ed.), *Eric Mendelsohn: Letters of an Architect* (London, 1967), pp.62–3.

61 Extract from the lecture 'The international agreement in new architectural thought', ibid., p.61.

62 From a lecture entitled 'The creative spirit of the world crisis', delivered in May 1932 at the Congress of the International Institution for Cultural Collaboration in Zurich, ibid., p.122.

63 Sigfried Giedion, *Space, Time and Architecture* (Oxford, [1941] 1954), p.412.

64 Sylvia Lavin, *Form Follows Libido: Architecture and Richard Neutra in a Psychoanalytic Culture* (Cambridge, MA, 2004).

65 Esther McCoy, *Richard Neutra* (New York, 1960), pp.13–14.

66 Richard Weston, *Villa Mairea* (London, 1992).

10 National Modernisms

1 Marcel Breuer, 'Where do we stand?', lecture presented in Zurich, 1933, published in *Architectural Review*, vol.77, no.461 (April 1935), p.135.

2 Eric Mumford, *The CIAM Discourse on Urbanism, 1928–1960* (Cambridge, MA, 2000), p.73; John Gold, 'Creating the Charter of Athens: CIAM and the

functional city, 1933–43', *Town Planning Review*, vol.69, no.3 (July 1998), pp.225–48.

3 See Sigfried Giedion, 'The Work of the CIAM', in J.L. Martin, Ben Nicholson and Naum Gabo (eds), *Circle. International Survey of Constructive Art* (London, 1937), p.274.

4 See Charlotte Benton, *A Different World. Émigré Architects in Britain 1928–1958* (London, 1995), ch.2, 'The Background to Emigration'.

5 Edith Tschichold described this traumatic event in an interview published in *Die zwanziger Jahre des Deutschen Werkbunds*, Werkbund-Archiv 10 (Giessen, 1982), pp.188–91.

6 Le Corbusier, *Towards a New Architecture* (London, [1923] 1946), p.251.

7 Kenneth Frampton, 'Towards a Critical Regionalism: Six Points for an Architecture of Resistance', in Hal Foster (ed.), *Postmodern Culture* (London, 1985), p.18.

8 Dudley Andrew and Steven Ungar, *Popular Front Paris and the Poetics of Culture* (Cambridge, MA, 2005); Danilo Udovicki-Selb, 'C'était sur l'air du temps: Charlotte Perriand and the Popular Front', in Mary MacLeod (ed.), *Charlotte Perriand: An Art of Living* (New York, 2003), pp.68–89.

9 Walter Benjamin, 'The Work of Art in the Age of Mechanical Reproduction' (1936), in *Illuminations* (London, 1970), p.243.

10 Boris Groys, *The Total Art of Stalinism* (Princeton, 1993), p.4.

11 Jan Tschichold, 'Display that has Dynamic Force. Exhibition Rooms designed by El Lissitzky', *Commercial Art* (January 1931), p.22.

12 Joseph Stalin, 'A Year of Great Change', *Pravda* (7 November 1929), in J. V. Stalin, *Works* (Moscow, 1955), vol.12, pp.124–41.

13 See Jean-Louis Cohen, *Scenes of the World to Come. European Architecture and the American Challenge 1893–1960* (Paris, 1995), p.83.

14 Ernst May, 'Moscow. City Building in the USSR', *Das Neue Russland*, VIII–IX (1931), in El Lissitzky, *Russia: An Architecture for a World Revolution* (Cambridge, MA, 1984), p.191.

15 Hannes Meyer, 'City Building in the USSR', *Der Neue Russland* (1931), in Lissitzky (1984), p.191.

16 *Izvestia* announcement (20 October 1931), cited in Alexei Tarkhanov and Sergei Kavtaradze, *Stalinist Architecture* (London, 1992), pp.25–7.

17 Anatoli Luncharsky (1920), cited by Catherine Cooke, 'Socialist-Realist Architecture', in Matthew Cullerne Bown and Brandon Taylor (eds), *Art of the Soviets* (Manchester, 1993), p.89.

18 Alexander Rodchenko, 'The Paths of Modern Photography', *Novy Lef*, no.9 (April 1928), in *Photography in the Modern Era. European Documents and Critical Writings* (New York, 1989), p.262.

19 Margarita Tupitsyn, 'From the Politics of Montage to the Montage of Politics. Soviet Practice 1919 through 1937', in Matthew Teitelbaum (ed.), *Montage and Modern Life, 1919–1942* (Cambridge, MA, 1992), p.125.

20 Correspondence March/April 1932 in the CIAM archives, ETH-Zurich, cited by Catherine Cooke, 'Socialist Realist Architecture', in Cullerne Bown and Taylor (1993), p.96.

21 Rostislav Švácha, *The Architecture of New Prague 1895–1945* (Boston, MA, 1995), p.330.

22 See Maria Sołtysik, *Na styku dwóch epok. Architektura gdyńskich kamienic okresu miedzywojennego* [*The Meeting of Two Eras. Architecture in Gdynia in the Inter-War Period*] (Gdynia, 2003).

23 See Sibel Bozdogan, *Modernism and Nation-Building. Turkish Architectural Culture in the Early Republic* (Washington, 2001).

24 See Alfred H. Barr in his preface to Henry-Russell Hitchcock and Philip Johnson, *The International Style* (New York, [1932] 1966), p.16.

25 Susana Torre, 'The Esthetics of Reconciliation: Cultural Identity and Modern Architecture in Latin America', in Hubert-Jan Henket and Hilde Heynen (eds), *Back from Utopia. The Challenge of the Modern Movement* (Rotterdam, 2002), p.144.

26 Ibid., p.143. In her diary Kahlo described these colours as 'Reddish purple: Aztec, old Blood, prickly pear. The most alive and oldest' and 'Cobalt blue: electricity and purity. Love.' See *The Diary of Frida Kahlo: An Intimate Self-portrait* (London, 1995), p.211.

27 Edward R. Burian, 'The Architecture of Juan O'Gorman', in E.R. Burian (ed.), *Modernity and the Architecture of Mexico* (Austin, 1997), pp.137–40.

28 Jean-Louis Cohen, 'International Rhetoric, Local Response', in Henket and Heynen (2002), p.85.

29 Le Corbusier, *Précisions sur un État Présent de l'Architecture et de l'Urbanisme* (1930), cited by Fernando Pérez Oyarzun, 'Le Corbusier in South America: Reinventing the South American City', in Tim Benton et al., *Le Corbusier and the Architecture of Reinvention* (London, 2003), p.146.

30 It should be noted that recent scholarship has emphasized the regional characteristics of iconic Modernist buildings of the 1920s, including Rietveld's Schröder house and Le Corbusier's Villa Savoye. See Friedrich Achleitner, 'Region, ein Konstrukt? Regionalismus, eine Pleite?', in F. Achleitner (ed.), *Region, ein Konstrukt? Regionalismus, eine Pleite?* (Basle, 1997), pp.101–11.

31 See, for instance, my discussion of regionalism in Poland in the 1930s in *National Style and Nation-state. Design in Poland from the Vernacular Revival* (Manchester, 1992), pp.109–18.

32 Reyner Banham observed in his classic account of the Modern Movement, *Theory and Design in the First Machine Age* (London, 1960), pp.320–21: 'The architecture of the Twenties, though capable of its own austerity and nobility, was heavily, and designedly, loaded with symbolic meanings that were discarded or ignored by its apologists in the Thirties . . . Emotion had played a much larger part than logic in the creation of the style . . . it was no more an inherently economical style than any other.'

33 See Eva Rudberg, *Stockholmsutställningen 1930: Modernismens Genombrott i Svensk Arkitektur* (Stockholm, 1999).

34 Stuart Wrede, *The Architecture of Erik Gunnar Asplund* (Cambridge, MA, 1980), p.129.

35 G. Näsström, *Svensk Funktionalism* (Malmö, 1930).

36 Sverker Sörlin, 'Prophets and Deniers. The Idea of Modernity in Swedish Tradition', in Cecilia Widenheim (ed.), *Utopia and Reality – Modernity in Sweden 1900–1960* (New Haven, 2002), p.18.

37 *accepterá* (1931), cited by E. Rudberg, 'Utopia of the Everyday', in Widenheim (2002), p.159.

38 Kirsi Saarikangas, 'Alva Myrdal's Questions for our Time', conference paper (Uppsala, 2002).

39 James M. Richards, *An Introduction to Modern Architecture* (Harmondsworth, 1940), pp.91–2.

40 See Piotr Lubiński, 'Dobry Mebli' ['Good Furniture'], in *Arkady* [*Arcadia*] (June 1938), pp.201–5.

41 Jerzy Munzer, 'Tradycja i racjonalizm' ['Tradition and Rationalism'], in *Architektura I Budownictwo* [*Architecture and Building*], vol.11/12 (November/December 1938), p.383.

42 Richard Etlin, *Modernism in Italian Architecture 1890–1949* (Cambridge, MA, 1991), pp.387–9.

43 Simonetta Falasca-Zamponi, *Fascist Spectacle: The Aesthetics of Power in Mussolini's Italy* (Berkley, 2000), pp.90–99.

44 See Marinetti, Mazzoni and Somenzi, 'Futurist Manifesto of Aerial Architecture', published in *Sant'Elia* (Rome, 1 February 1934). <http://www.futurism.org.uk/manifestos/manifesto48.htm>

45 Diane Y. Ghirardo, 'Italian Architects and Fascist Politics: An Evaluation of the Rationalist Role in Regime Building', *Journal of the Society of Architectural Historians*, vol.39, no.2 (May 1980), p.188.

46 Giuseppe Terragni, cited by Dennis Doordan, *Building Modern Italy: Italian Architecture 1914–1936* (Princeton, 1988), p.137.

47 See Peter Bondanella, *The Eternal City* (Chapel Hill, 1987), p.192.

48 Ghirardo (1980) has charted the clashes between architect and local party secretary who was vexed by delays and rising building costs. He demanded that the building articulate its function in a literal fashion (despite the bloody 'Shine to Fascist Martyrs' and portrait of Il Duce that the architect had specified in its entrance). Terragni's proposed (and unrealized) solution was the addition of a light-weight frame to the main exterior overlooking the piazza, on which graphic panels could be mounted (including a photomontage of Il Duce by Marcello Nizolli).

49 Tim Benton, 'Rome Reclaims its Empire', in Dawn Ades et al. (eds), *Art and Power. Europe Under the Dictators 1930–45* (London, 1995), p.125.

50 Bondanella (1987), p.187.

51 Alcor, 'La città coloniale di domani', *Il Corriere dell'Impero* (21 July 1936), cited by Sandro Raffone, 'Il razionalismo dimenticato in Africa Orientale', *Casabella*, vol.53, no.558 (June 1989), pp.34–7; see also Giuliano Gresleri, Pier Giorgio Massaretti and Stefano Zagnoni, *Architettura italiana d'oltremare 1870–1940* (Venice, 1993).

52 See 'Class Dismissed: Fascism's Politics of Youth' (ch.4), in Ruth Ben-Ghiat, *Fascist Modernities: Italy, 1922–1945* (Berkley, 2001).

53 Teresa Maria Mazzatosta cited in Giorgio Frisoni, Elizabetta Gavazza, Mariagrazia Orsolini and Massimo Samini, 'Origins and History of the Colonie', in Architectural Association, *Cities of Childhood. Italian Colonies of the 1930s* (London, 1988), p.8.

54 Steen Bo Frandsen, 'The war that we prefer: The Reclamation of the Pontine Marshes and Fascist Expansion', *Totalitarian Movements and Political Religions*, vol.2, no.3 (Winter 2001), pp.69–82; Falasca-Zamponi (2000), pp.149–61.

55 Langdon Winner, 'Do Artifacts Have Politics?', in *The Whale and the Reactor* (Chicago, 1988), pp.19–39.

56 Lázló Moholy-Nagy, letter to Herbert Read (Berlin, 24 January 1934), in Krisztina Passuth, *Moholy-Nagy* (London, 1985), p.405.

57 Winfried Nerdinger, 'Versuchung und Dilemma der Avantgarden im Spiegel der Architekturwettbewerbe 1933–35', in Hartmut Frank (ed.), *Faschistische Architekturen: Planen und Bauen in Europa 1930 bis 1945* (Hamburg, 1985), pp.66–8. See also Winfried Nerdinger (ed.), *Bauen im Nationalsozialismus: Bayern 1933–1945* (exh. cat., Munich, 1993).

58 See David Welch, *The Third Reich: Politics and Propaganda* (London, 1993).

59 See Gwen Finkel Chanzit, *Herbert Bayer and Modernist Design in America* (Ann Arbor, 1987).

60 See *Gebrauchsgraphik*, vol.15, no.6 (June 1938), pp.2–16.

61 This catalogue is reproduced in *Industrial Arts*, vol.1, no.4 (Winter 1936), pp.313–18. It is notable that Bayer defaced the image of Hitler in his own copy. See S. Kasher, 'The Art of Hitler', *October*, vol.59 (Winter 1991), pp.49–86.

62 On the question of the relations between industry and National Socialism, see Paul Erker, *Industrie-eliten in der NS Zeit: Anpassungsbereitschaft und Eigeninteresse von Unternehmern in der Rüstung- und Kriegswirtschaft, 1936–1945* (Passau, 1994); Peter Hayes, *Industry and Ideology: IG Farben in the Nazi Era* (Cambridge, 1987); Esther Leslie, *Synthetic Worlds. Nature, Art and the Chemical Industry* (London, 2005); and John Gillingham, *Industry and Politics in the Third Reich* (London, 1985).

63 Joseph Goebbels, *Hefte der Betriebsausstellung Druck und Reproduktion*, no.1 (1933), pp.3–6, cited by Ute Eskildsen, 'Germany: The Third Reich', in Jean-Claude Lemagny and André Rouillé (eds),

A History of Photography. Social and Cultural Perspectives (Cambridge, 1987), p.150.

64 Iain Boyd White, 'National Socialism and Modernism', in Ades et al. (1995), p.261.

65 Ralph Willet, *The Americanization of Germany, 1945–1949* (London, 1989).

66 See Robin Kinross, *Modern Typography* (London, 1992), pp.101–102.

67 Edward Dimendberg, 'The Will to Motorization: Cinema, Highways and Modernity', in *October*, vol.73 (Summer 1995), pp.91–137.

68 Siegfried Kracauer, *From Caligari to Hitler: A Psychological History of the German Film* (Princeton, 1947), p.301.

69 Like Boris Groys's analysis of the Soviet Union under Stalin, Peter Fritzsche draws threads from the utopianism of the artistic avant-garde to the radical modernization of the 1930s. This is a provocative argument, which not only casts a controversial light on the phenomenon of Nazism, but also points to the ambition and arrogance at the heart of the Modernist project. For an overview of this historiography, see Paul Betts, 'The New Fascination with Fascism. The case of Nazi Modernism', *Journal of Contemporary History*, vol.37, no.4 (2002), pp.541–58.

70 Peter Fritzsche, 'Nazi Modern', in *Modernism/Modernity* (January 1996), pp.1–21.

71 Max Horkheimer and Theodor Adorno, *Dialectic of Enlightenment* (London, 1979), p.xiv.

72 Berthold Lubektin, cited by C. Benton (1995), p.7.

73 Ibid., ch.3.

74 In a debate over the merits of modern architecture sponsored by *The Listener* in 1933, for instance, architect Sir Reginald Blomfield struck an exaggerated, if not untypical, note: 'As an Englishman and proud of my country, I despise and detest cosmopolitanism.' Cited in A. Jackson, *The Politics of Architecture* (London, 1970), p.15.

75 John Allen, *Lubetkin. Architecture and the Tradition of Progress* (London, 1992), p.298.

76 *Builder*, vol.7, no.1 (1938), p.5.

77 Stefan Lorant, *I Was Hitler's Prisoner* (Harmondsworth, 1939).

11 Mass-Market Modernism

1 A majority of literary Modernists were on the anti-democratic right or the authoritarian left, as John Carey provocatively demonstrated in *The Intellectuals and the Masses* (London, 1992). The proportions among visual artists and designers were certainly different, due to the large part played by left-wing Russians and Germans. But although Hitler's vendetta against *Kulturbolschewismus* (cultural Bolshevism) helped to foster the assumption that Modernism was inherently communist, many Modernists remained apolitical, as Herbert Read argued in *Art Now* (London, 1933), pp.10–12, or were pro-capitalist or indeed fascist.

2 Clark writes of the 'customary, somewhat muddled' use of the term 'Modernism' in works about nineteenth-century art, while locating their point of departure as Manet's revolutionary painting of the 1860s, in T.J. Clark, *The Painting of Modern Life* (Princeton, 1984), p.10.

3 The label 'Modernist' was successively attached to Naturalist writing such as that of Émile Zola and Henrik Ibsen, to Cubist and Futurist painting, to the Imagist writing promoted by Ezra Pound and to 'stream-of-consciousness' tendencies in the novel, from Marcel Proust to James Joyce and Virginia Woolf.

4 Pevsner's *Pioneers of the Modern Movement* was first published by Faber in 1936, then in a revised version as *Pioneers of Modern Design* by the Museum of Modern Art in 1949; and finally was

further revised, by Penguin in 1960. The phrase quoted is from the foreword to the Penguin edition, which refers to 'the architecture of reason and functionalism [being] in full swing in many countries' when the book was first written (p.10).

5 Summing up the Bauhaus's achievement up to its closure by the Nazis in 1933, John Heskett writes: 'in the context of the overall development of design in one of the world's leading industrial nations [Germany], Bauhaus products appear no more than a minuscule contribution from an avant-garde fringe group'. *Industrial Design* (London, 1980), p.103.

6 Ibid., p.105.

7 Nikolaus Pevsner, *An Inquiry into Industrial Art in England* (London, 1937), p.179ff. Earlier, Herbert Read had emerged as the leading interpreter of 'modern art' for a wider public than was previously addressed by the Bloomsbury aesthetes, Roger Fry and Clive Bell, bringing up to date John Ruskin's nineteenth-century debate on art and industry in his 1934 book.

8 Walter Benjamin, 'The Work of Art in the Age of Mechanical Reproduction' (1936), in Hannah Arendt (ed.), *Illuminations* (London, 1973), p.236.

9 Theodor Adorno in a letter to Benjamin, quoted in Andreas Huyssen, *After the Great Divide: Modernism, Mass Culture and PostModernism* (Basingstoke, 1986), p.24.

10 The explanation is Martin Jay's, in his indispensable *The Dialectical Imagination: A History of the Frankfurt School and the Institute of Social Research 1923–1950* (Boston, 1973), p.216.

11 Huyssen's key essays are 'The Hidden Dialectic: Avantgarde – Technology – Mass Culture' and 'Adorno in reverse: From Hollywood to Richard Wagner', both in Huyssen (1986).

12 Miriam Bratu Hansen, 'The Mass Production of the Senses: Classical cinema as vernacular Modernism', in Linda Williams and Christine Gledhill (eds), *Reinventing Film Studies* (London, 2000), p.333.

13 The phrase seems to have been first used by Frank J. Marion, an executive of the US government's First World War Creel Committee, responsible for exporting promotional film, in an article entitled 'Internationalising the American Idea', *Collier's Weekly*, vol.19, no.10 (1918), cited in Kristin Thompson, *Exporting Entertainment: America in the World Film Market 1907–1934* (London, 1985), p.22.

14 C.J. North, 'Our Silent Ambassadors', *Independent* (12 June 1926), quoted in ibid., p.122.

15 Quoted in Edwin Heathcote, *Cinema Builders* (Chichester, 2001), p.34.

16 *The Bioscope* (15 October 1930), quoted in Allen Eyles, *Gaumont British Cinemas* (Burgess Hill, 1996), p.36.

17 Pierre de Montaut, 'Les cinemas d'actualité', in *L'Architecture d'Aujourd'hui*, no.7 (1933); reproduced in Jean-Jacques Meusy, 'Cinéac: une concepte, une architecture', *Les Cahiers de la Cinémathèque*, no.66 (July 1997), p.99. Reginald Ford was an Englishman, born in Cardiff, who developed his business in France and Holland, before his death in an accident in 1937.

18 Cinéac theatres were often 'sponsored' by news-papers, incorporating their titles into the cinema's name and offering reciprocal publicity. The Amsterdam Cinéac has been refurbished and still stands opposite the Tuchinsky, although it no longer operates as a cinema. Many newsreel theatres appeared during the 1930s, with Modernist examples in Britain including Victoria Station and the Bristol News Theatre.

19 Pevsner referred to the 'jazzy' Modernism of Odeon cinemas in his entry on the cinema in *A History of Building Types* (London, 1976). See my discussion in 'What counts as art in England: How Pevsner's minor canons became major', in Peter Draper (ed.), *Reassessing Nikolaus Pevsner* (Aldershot, 2004), pp.49–59.

20 Heathcote (2001), p.38.

21 This analysis of the effect of transition to the cinema's nocturnal appearance appears in Heathcote (2001), p.39.

22 For an overview of the impact of sound and local quotas on US film exports to Europe, see Thompson (1985), p.125ff.

23 Evelyn Waugh's fashionable 'bright young things' talk knowingly about how 'boring' it is to be late for a Talkie in his novel *Vile Bodies* (London, [1930] 1938), p.90.

24 Nicole Armour compares Berkeley with Vertov in her article 'The Machine Art and Dziga Vertov and Busby Berkeley', *Images*, no. 5 (Nov. 1977), www.imagesjournal.com/issue05 (consulted 14 June 2005).

25 This thesis is persuasively argued and illustrated in Donald Albrecht, *Designing Dreams: Modern Architecture in the Movies* (New York, 2000).

26 Christened the 'Big White Set' or BWS by Arlene Croce, in *The Fred Astaire-Ginger Rogers Book* (New York, 1972), p.75.

27 Bruce Babbington and Peter William Evans, *Blue Skies and Silver Linings: Aspects of the Hollywood Musical* (Manchester, 1985), pp.98–9.

28 Notably in such Modernist works as Darius Milhaud's *Le Train bleu* (Paris, 1924), to a story by Jean Cocteau, and Sergei Prokofiev's *Le Pas d'acier* (1927).

29 Various colour processes were introduced during the 1930s, including Dufaycolor, Gevaert colour and Agfa colour in Europe and Kodachrome in America. But in cinema the three-strip Technicolor dye-transfer process was taken up by Hollywood and developed as a worldwide system (see Chapter 8).

30 A second revised edition of *Malerei Fotografie Film* appeared in 1927.

31 The three novels *The 42nd Parallel*, *1919* and *The Big Money* were finally collected as *U.S.A.* in 1938.

32 Christopher Isherwood, *Goodbye to Berlin* (London, 1939). The phrase 'I am a camera' was later used as the title of John van Druten's stage adaptation of Isherwood's Berlin stories, which provided the basis of the musical *Cabaret*.

33 For details, see Margaret Fisher, *Ezra Pound's Radio Operas: The BBC Experiments, 1931–1933* (Cambridge, MA, 2002).

34 Both left-wing Modernists such as Dziga Vertov and Bertholt Brecht, and the right-wing Filippo Marinetti, were among radio's passionate enthusiasts.

35 The naval operator's response to a transmission by the radio pioneer Lee De Forest in 1907 is reported in Francis Chase, *Sound and Fury* (New York, 1942), p.1. In Kipling's story, first published in 1902 and collected in *Traffics and Discoveries* (London, 1904), a naval experiment in radio signalling seems to inspire a young man to 'receive' John Keats's poem 'Eve of St Agnes' as if in a trance.

36 Thomas H. White, http://earlyradiohistory.us/ (consulted 14 June 2005).

37 Lenin had made an early broadcast during the 1917 revolution, and in 1921 declared: 'Every village should have radio! Every government office, as well as every club in our factories, should be aware that at a certain hour they will hear political news and major events of the day. This way our country will lead a life of highest political awareness, constantly knowing the actions of the government and views of the people.' B.H. Ruznikov, *Tak Nachinalos* (Moscow, 1987), p.169, quoted by L. Zeltser, 'Early Radio Broadcasting in the Soviet Union', www.zeltser.-com.radio-history (consulted 14 June 2005).

38 On the ubiquity of 'moderne'/Art Deco styling, see Charlotte Benton and Tim Benton, 'The Style and the Age', in Charlotte Benton et al. (ed.), *Art Deco 1910–1939* (exh. cat., V&A Museum, London, 2003).

39 Asa Briggs, *The History of Broadcasting in the United Kingdom*, vol. 2, *The Golden Age of Wireless* (Oxford, 1965), pp.595–600.

40 F.T. Marinetti, 'The Founding and Manifesto of Futurism', first published in *Le Figaro* (Paris, 20 February 1909), and 'The New Religion – Morality of Speed', both in R.W. Flint (ed. and trans.), *Marinetti: Selected Writings* (London, 1972), pp.39–41, 94–6. Le Corbusier, *Towards a New Architecture* (London, [1923] 1972), pp.123, 135.

41 Writers who celebrated flyers and the aerial perspective include W.B. Yeats in his poem 'An Irish Airman Foresees his Death' (1919); Bertolt Brecht in his radio play, originally inspired by Lindbergh, *The Flight over the Ocean* (1929); William Faulkner in his novel *Pylon* (1935); F.T. Marinetti, in his first draft of the *Manifesto of Futurist Aeropainting* (1928); and Antoine de Saint-Exupéry, *Night Flight* (1931). The aviator became a familiar figure in films of the inter-war years, combining modernity and heroism: see Peter Wollen, '*La Règle du jeu* and Modernity', *Film Studies*, no. 1 (1999), pp.5–13.

42 The DC-3, introduced in 1935, served as both a passenger plane on many new services and as a bomber during the Second World War; more than 13,000 were built.

43 Cyril Kay, quoted in Heskett (1980), p.122.

44 See Renato Miracco (ed.), *Futurist Skies: Italian Aeropainting* (exh. cat., Estorick Collection, London, 2005).

45 The JU87 *Sturzkampfbomber* was popularly known as the 'Stuka' after its devastating introduction by the German Condor Legion during the Spanish Civil War, and particularly after the bombing of Guernica in 1937, which inspired Picasso's painting. Thomas Gordon and Max Morgan, *Guernica: The Crucible of WWII* (New York, 1975).

46 'Flying boat' aircraft for passengers and cargo were built by a number of manufacturers in the 1930s, including Sikorsky and Boeing in the US and Shorts in the UK; and regular services were being linked between North and South America, the USA and China, and the UK and Australia. *Flying Down to Rio* (1933) and *China Clipper* (1936) were two Hollywood films that celebrated this short-lived vogue. See Robert L. Gandt, *China Clipper: The Age of the Great Flying Boats* (Annapolis, MD, 1991) and Stéphane Nicolaou, *Flying Boats and Seaplanes: A History from 1905* (Osceola, WI, 1998), pp.63–110.

47 The *R101* was the largest airship in the world, built at Cardington, near Bedford, when it crashed early in its maiden flight to India in 1930. Other airships operated successfully during the 1930s until, in 1937, the even larger German zeppelin *Hindenburg* exploded while landing in Lakehurst, New Jersey, after a flight from Germany – a disaster that effectively marked the end of the hydrogen-filled passenger dirigible. See Harold G. Dick and Douglas H. Robinson, *The Golden Age of the Great Passenger Airships: Graf Zeppelin and Hindenburg* (Washington, 1992).

48 Oberth claimed to have been inspired by reading Jules Verne's *From the Earth to the Moon* as a youth, and advised Fritz Lang on the rocket design for his 1929 film. See Roger D. Launius, *Frontiers of Space Exploration* (Westport, CT, 1998).

49 Charlotte Benton, 'Design and London Transport', in Jennifer Hawkins et al., *Thirties, British Art and Design before the War* (exh. cat., Hayward Gallery, London, 1979), p.219.

50 A 1938 article on recent railway development began by emphasizing the importance of the streamline image: 'Railroads, in spite of the Depression, have made notable improvements in their equipment, which to the public appear in the streamlining of trains, greater speed, and more comfortable traveling. Perhaps the most spectacular trains are the high-speed diesel-engine driven, with cars of aluminum and stainless steel, which are particularly suited for long runs through thinly populated districts . . .' (*Colliers Year Book*, 1938; archived in MSN Encarta at encarta.msn.com/sidebar_461-500725/ 1938_Railroad_Equipment (consulted

14 June 2005). The 'streamliners' introduced by various American railway companies during the 1930s combined a number of design and construction features to achieve higher speeds with up to 50 per cent savings in operating costs. See Karl Zimmerman, *Burlington's Zephyrs* (Osceola, WI, 2004); and Gregory L. Thompson, *The Passenger Train in the Motor Age: California's Rail and Bus Industries, 1910–1941* (Columbus, 1993).

51 Kenneth Grahame, *The Wind in the Willows* (London, 1908), ch.2, 'The Open Road'; Marinetti (1909).

52 Craig Breedlove inaugurated the jet-powered era in 1963 at Bonneville, reaching 407 mph (655 kph), but his record was not recognized outside America, and Malcolm Campbell's son Donald took the first recognized jet-powered record in 1964.

53 According to the *Daily Telegraph* motoring correspondent, 'For the motorist there is no country more interesting today than Germany, where, whatever the triumphs or failures of the Hitler government in general, both the motor-maker and the motor-user are decidedly better off.' *Daily Telegraph* (20 February 1936).

54 On the expansion of private motoring in the 1930s, see L.J.K. Setright, *Drive On! A Social History of the Motor Car* (London, 2003), ch.5. The Japanese government passed the Automobile Manufacturing Industries Act in 1936 to put pressure on the US 'big three' companies (Ford, General Motors and Chrysler), which had dominated car production in Japan, and to encourage domestic companies such as Mitsubishi and Toyota to enter this field.

55 Ashley Havinden (1903–1973) spent most of his working life at Crawford's advertising agency, working on campaigns for the Milk Marketing Board, the GPO, Simpson's department store and Eno's Fruit Salts in the 1930s. An early assessment of his work appeared in M. Gowing, 'The Creative Mind in Advertising: Ashley', *Art and Industry*, vol.62, no.367 (January 1957), pp.11–15. In a later appreciation Paul Rennie wrote: 'The mythology of Modernism suggests a narrative that connects Moscow, Berlin, Paris and New York while ignoring Britain. The movement of the stellar Bauhaus names to America might be taken to confirm this narrative. In fact, many other designers arrived in Britain and stayed. Havinden was well placed through his role as creative director at Crawford's and as a member of the RoSPA publicity committee to help these designers by providing a steady flow of jobs.' Paul Rennie, 'RoSPA's WWII safety posters challenge orthodox views of British Modernism', *Eye Magazine*, no.52, vol.13 (Summer 2004).

56 Steven Heller and Louise Fili, *British Modern: Graphic design between the wars* (San Francisco, 1998), p.72.

57 Hansen (2000), p.341.

58 Malevich prepared 22 charts to illustrate the lectures he would give in Poland and Germany, grouped in three series: 'Analysis of a Work of Art', 'Analysis of Perception' and 'Teaching Method'. The central series of these densely illustrated diagrams proposes an historical investigation of 'painterly behaviour', tracing two systems at work since Cézanne: the 'object exploiting' and the 'non-objective'; 17 of these charts are held by the Stedelijk Museum, Amsterdam. See Linda S. Boersma, 'On Art, Art Analysis and Art Education: The Theoretical Charts of Kazimir Malevich', in Yu. Korolev and E.N. Petrova (eds), *Kazimir Malevich 1878–1935* (exh. cat., Amsterdam, 1988), pp.206–24.

59 Clement Greenberg, 'Avant-garde and Kitsch', in *Art and Culture: Critical Essays* (Boston, 1961). Barr's essentially European view of Modernism, however, would come under attack in the late 1940s from Greenberg's belief that American Abstract Expressionism represented the only vital branch of

Modernism. See Alice Goldfarb Marquis, *Alfred H. Barr: Missionary for the Modern* (Chicago, 1989), pp.248–9. Then the concept of post-Modernism would emerge, initially in literary studies and in architecture, to challenge what was now routinely termed 'high Modernism'. See Huyssen (1986), p.183ff.

60 Sponsored by General Motors, the 'Futurama' exhibit was an automated ride that offered a journey across America as it might be in 30 years' time. This proved to be the Fair's most popular attraction, bequeathing its name as a generic term for imagining the future.

61 Building ships on a massive scale for America's Second World War effort led the industrialist Henry Kaiser to devise high-quality prefabricated housing for his workers, which set a new standard, demonstrating how modern construction methods and materials could be used for social ends, following Kaiser's motto 'find a need and fill it'. Mark Foster, *Henry J. Kaiser: Builder in the Modern American West* (Austin, 1989). By contrast, Britain's temporary housing programme of 1944–9 produced a variety of 'prefabs' that certainly used new materials – notably aluminium and asbestos – but were generally considered inferior forms of housing, which in many cases long outlived their intended life. See Greg Stevenson, *Palaces for the People: Prefabs in Post-War Britain* (Lampeter, 2003). Britain's wartime Utility scheme, standardizing the production of furniture around a limited range of designs that reflected Modernist principles, might be considered a more successful instance of necessity leading to wider acceptance of 'good design'. See H. Dover, *Home Front Furniture: British Utility Design, 1941–1951* (Aldershot, 1991). Meanwhile the success of the post-war Parisian 'New Look' has often been interpreted as a response *against* wartime austerity – albeit one that was also contested by women adjusting to new gender roles in the post-war world. See Elizabeth Wilson, *Adorned in Dreams: Fashion and Modernity* (London, 1985).

62 W.H. Auden, 'In Memory of Sigmund Freud' (1939), *Selected Poems* (London, 1950), p.174.

63 Huyssen (1986), p.31.

Bibliography

This bibliography is a list of sources used in the essays. Where space permits, additional key texts have been added. English translations of texts have been cited when possible. Within these references, dates in square brackets refer to original editions. Catalogue entry footnotes should be consulted for further sources.

Primary sources

This section includes anthologies and critical editions of contemporary texts.

Aalto, A., 'Rationalism and Man' (1935), translated in M. Lahti et al., *Alvar Aalto, de l'oeuvre aux écrits* (exh. cat., Centre Georges Pompidou, Paris, 1972)

Apollonio, U., *Futurist Manifestos* (London, 1973)

'The Artist and the Cinema', *Kinozhurnal ARK* (1926), translated in O. Bulgakowa (ed.), *Kazimir Malevich: The White Rectangle: Writings on Film* (Berlin, 1997)

Arvatov, B., 'Oveshchestvlennaya utopiya', *Lef*, no.1 (1923)

Asplund, E.G., *Acceptera!* (Stockholm, 1931)

Balla, G. and F. Depero, 'Futurist Reconstruction of the Universe 1915', in U. Apollonio (ed.), *Futurist Manifestos* (London, 1973)

Bann, S. (ed.), *The Tradition of Constructivism* (London, 1974)

Barr, A.H., 'Russian Diary 1927–1928', *October* 7 (Winter 1978)

Barry, I., *Let's Go to the Cinema* (London, 1926)

Bau und Wohnung (Stuttgart, 1927)

Bayer, H., 'Das Wunder des Lebens', *Industrial Arts*, vol.1, no.4 (Winter 1936), pp.313–18.

Bayer, H. and W. and I. Gropius, *Bauhaus 1919–1928* (exh. cat., Museum of Modern Art, New York, 1938)

Behne, A., *Der moderne Zweckbau* (Munich, 1926), translated as *The modern functional building* (Santa Monica, CA, 1996)

Behne, A. and H. Hansen, *Ruf zum Bauen: Zweite Buchpublikation des Arbeitsrats für Kunst* (Berlin, 1920)

Behrendt, W.C., *Der Sieg des Neuen Baustils* (Stuttgart, 1927), translated as *The Victory of the New Building Style* (Los Angeles, 2000)

Benjamin, W., 'The Work of Art in the Age of Mechanical Reproduction' (1936), in W. Benjamin, *Illuminations* (London, 1970)

Benton, C. (ed.), *Documents; a collection of source material on the Modern Movement* (Milton Keynes, 1975)

Benton, T., C. Benton and D. Sharp, *Form and Function; a source book of the history of architecture and design, 1890–1939* (London, 1975)

Benson, T. and E. Forgács, *Between worlds: A sourcebook of Central European avant-gardes, 1910–1930* (Cambridge, MA, 2002)

Bernège, P., *De la méthode ménagère* (Paris, 1928)

Bernège, P., *Si les femmes faisaient les maisons* (Orléans, 1928)

Beyer, O. (ed.), *Eric Mendelsohn: Letters of an architect* (London, 1967)

Bourke-White, M., *Shooting the Russian War* (New York, 1942)

Bowlt, J.E. (ed.), *Russian Art of the Avant-Garde: Theory and Criticism, 1902–1934* (New York, 1976)

Breuer, M., 'Metallmöbel und moderne räumlichkeit', *Das Neue Frankfurt*, vol.2, no.1 (January 1928), p.11, translated in *50 Years Bauhaus* (exh. cat., Royal Academy of Arts, London, 1968)

Breuer, M., 'The House Interior' (lecture, 1931), translated in C. Wilk, *Marcel Breuer: Furniture and Interiors* (New York, 1981)

Capek, J. and K., *R.U.R. and The Insect Play* (London, 1961)

Cheronnet, L., 'La publicité moderne, Fernand Léger et Robert Delaunay', *L'Art vivant* (Paris, 1 December 1926), p.890

Clurman, H., 'Photographs by Paul Strand', *Creative Art*, no.5 (October 1929), pp.735–8

Colette, 'Cinéma: *Forfaiture*' *Excelsior* (7 August 1916), translated in R. Abel (ed.), *French Film Theory and Criticism*, vol.1 (Princeton, 1988)

Conrads, U., *Programmes and Manifestoes on 20th-Century Architecture* (Cambridge, MA, 1975)

Corra, B., 'Abstract Cinema – Chromatic Music' (1912), in U. Apollonio, *Futurist Manifestos* (Boston, 2001)

Davy, C. (ed.), *Footnotes to the Film* (London, 1938)

De Franclieu, F., *Le Corbusier Sketchbooks*, vol.1 (Cambridge, MA, 1981)

Dickinson, T. and C. De la Roche, *Soviet Cinema* (London, 1948)

Dufrêne, M., 'A Survey of Modern Tendencies in Decorative Art', *The Studio Yearbook of Decorative Art* (London, 1931)

Dulac, G., 'The Essence of Cinema: The Visual Idea', *Les Cahiers du mois*, no.16/17 (1925)

Eckstein, H., *Die Schöne Wohnung* (Munich, 1934)

Ehrenburg, I., *The Life of the Automobile* (London, [1929] 1999)

Eikhenbaum, B., 'Problems of Cine Stylistics', *Poetika kino* (1927)

Eisenstein, S., 'Bela Forgets the Scissors', *Kino* (July 1926), translated in R. Taylor, *Eisenstein: Selected Writings 1922–1934* (London, 1988)

Eisenstein, S., 'Beyond the Fourth Dimension', translated in R. Taylor, *Eisenstein: Selected Writings 1922–1934* (London, 1988)

Eisenstein, S., G. Alexandrov and V. Pudovkin, 'Statement on Sound' (1928), translated in R. Taylor, *Eisenstein: Selected Writings 1922–1934* (London, 1988)

El Lissitzky, *Russia: An Architecture for World Revolution* (London, [1930] 1970)

El Lissitzky and I. Ehrenburg, 'The Blockade of Russia is Coming to an End', *Veshsch'/Gegenstand/Objet*, no.1–2 (Berlin, March–April 1922), translated in S. Bann (ed.), *The Tradition of Constructivism* (London, 1974)

Fedorov, N., *Filosfiya obshchego dela*, 2 vols (Moscow, 1906 and 1913)

Fels, F., 'Propos d'artistes, Fernand Léger', *Les nouvelles littéraires* (13 June 1923)

Fischer, H.W., *Körperschönheit und Körperkultur. Sport Gymnastik Tanz* (Berlin, 1928)

Flint, R.W., *Marinetti: Selected Writings* (London, 1972)

'For or against modern architecture?', *The Listener* (28 November 1934), p.1145

Ford, H. and S. Crowther, *My Life and Work* (New York, 1922, and London, 1923)

Frank, J., *Architektur als Symbol: Elemente Deutschen Neuen Bauens* (Vienna, [1931] 1981)

Frederick, C., *The new housekeeping: Efficiency studies in home management* (Garden City, New York, 1913)

Gan, A., 'Konstrucktivizm' ['Constructivism'] (Tver, 1922), in J.E. Bowlt (ed.), *Russian Art of the Avant-Garde: Theory and Criticism, 1902–1934* (New York, 1976)

Gay, J., *On Going Naked* (Garden City, New York, 1932)

Giedion, S., 'Le probleme du luxe dans l'architecture moderne. A propos d'une nouvelle construction à Garches', *Cahiers d'Art*, no.5–6 (1928), pp.254–6

Giedion, S., *Building in France; Building in Steel; Building in Ferroconcrete* (Santa Monica, CA, [1928] 1995)

Giedion, S., *Befreites Wohnen* (Zurich, 1929)

Giedion, S., 'The Work of the CIAM', in J.L. Martin, B. Nicholson and N. Gabo (eds), *Circle. International Survey of Constructive Art* (London, 1937)

Giedion, S., *Space, Time and Architecture* (Oxford, 1941)

Giedion, S., *Mechanization takes Command* (New York, [1948] 1969)

Ginzberg, M., *Style and epoch* (*Stil' I epokha*), (Cambridge, MA, [1924] 1982)

Ginzberg, M., 'Konstrucktivizm kak metod laboratornoi I pedagogisheskoi raboty', *SA*, no.6 (Moscow, 1927), translated in C. Cooke, *Russian Avant-Garde Theories of Art, Architecture and the City* (London, 1995)

Gloag, J., 'Wood or Metal?', *The Studio*, vol.97 (1929), pp.49–50

Graeser, W., *Körpersinn. Gymnastik, Tanz, Sport* (Munich, 1927)

Gräff, W., *Innenräume* (Stuttgart, 1928)

Gräff, W., *Es kommt der neue Fotograf!* (Cologne, [1929] 1978)

Gropius, W., 'Die Entwicklung moderner Industrie-Baukunst', in *Die Kunst in Industrie und Handel, Jahrbuch des Deutschen Werkbundes* (Leipzig, 1913), translated in T. Benton, C. Benton and D. Sharp, *Form and Function* (London, 1975)

Gropius, W. (ed.), *Die Bühne am Bauhaus* (Munich, 1924), translated as *The Theater of the Bauhaus* (Baltimore, 1996)

Gropius, W., *Internationale Architektur* (Munich, 1925)

Gropius, W., *Bauhaus Bauten Dessau* (Munich, 1930)

Gropius, W., *The Scope of Total Architecture* (New York, 1950)

Gropius, W., 'Programm des Staatlichen Bauhauses in Weimar', translated in H.M. Wingler, *The Bauhaus: Weimar, Dessau, Berlin, Chicago* (Cambridge, MA, 1976)

Häring, H., 'Wege zur Form', *Die Form*, no.1 (October 1925), translated in T. Benton, C. Benton and D. Sharp, *Form and Function* (London, 1975)

Häring, H., 'Kunst und Strukturprobleme des Bauens', *Zentralblatt der Bauverwaltung*, no.29 (15 July 1931)

Harrison, C. and P. Wood (eds), *Art in Theory 1900–2000* (Oxford, 1992)

Hilberseimer, L., 'Hugo Häring und das neue Bauen', in Hilberseimer, *Die neue Stadt*, vol.15 (Berlin, 1925), pp.188–9

Hitchcock, H.R., *Modern Architecture, and Regeneration* (New York, 1929)

Holzman, H. and M.S. James, *The New Art – The New Life: The Collected Writings of Piet Mondrian* (Boston, 1986)

Huelsenbeck, R., *Dada Almanach* (Berlin, 1920)

Huxley, A., 'Notes on Decoration', *Creative Art*, no.4 (October 1930)

International Faction of Constructivists, 'Declaration', *De Stijl*, vol.4, no.4 (1922), translated in S. Bann, *The Tradition of Constructivism* (London, 1974)

Johnson, P. and H.R. Hitchcock, *The International Style: Architecture Since 1922* (New York, [1932] 1966)

Kaes, A., M. Jay and E. Dimendberg, *The Weimar Republic Sourcebook* (Berkeley, 1994)

Kállai, E., *Jahrbuch der jungen Kunst* no.5 (Leipzig, 1924)

Kállai, E. et al., 'Nyilatkozat' [Manifesto], *Egység*, no.4 (1923), translated in T. Benson and E. Forgács, *Between worlds: A sourcebook of Central European avant-gardes, 1910–1930* (Cambridge, MA, 2002)

Kandinsky, W., *Über das Geistige in der Kunst* (Munich, 1912), translated as *Concerning the Spiritual in Art* (New York, [1914] 1977)

Kandinsky, W., 'Modest Mussorgskij: Bilder einer Ausstellung', *Das Kunstblatt*, year 14 (August 1930)

Khokhlova, E. (ed.), *Lev Kuleshov: Selected Works* (Moscow, 1987)

Kiesler, F., *Internationale Ausstellung neuer Theatertechnik* (Vienna, [1924] 1975)

Kouola, J.E., *Obytný dům Dneška* (Prague, 1931)

Kracauer, S., *From Caligari to Hitler* (Princeton, [1947] 1966)

Kuleshov, L., 'The Banner of Cinematography' (1920), translated in E. Khokhlova (ed.), *Lev Kuleshov: Selected Works* (Moscow, 1987)

Kuleshov, L., 'Americanitis', *Kino-Fot*, no.1 (1922), translated in R. Levaco, *Kuleshov on Film* (Berkeley, 1974)

Le Corbusier, 'Maisons en série', *L'Esprit Nouveau*, no.13 (December 1921), pp.1525–42

[Le Corbusier], '1925. Expo. Arts. Déco. Besoins-types meubles-types', *L'Esprit Nouveau*, no.23 (May 1924), n.p.

Le Corbusier, 'Divers souvenirs des vacances…', *L'Esprit Nouveau*, no.28 (January 1925), n.p.

Le Corbusier, *L'art décoratif d'aujourd'hui* (Paris, [1925] 1959), translated as *The Decorative Art of Today* (London, 1987)

Le Corbusier, *Urbanisme* (Paris, 1925), translated as *The City of Tomorrow* (London, 1927)

Le Corbusier, *Almanach d'architecture moderne* (Paris, 1926)

Le Corbusier, 'Fünf Punkte zu einer neuen Architektur', *Die Form*, vol.2 (1927), pp.272–4

Le Corbusier, *Une maison, un palais: à la recherché d'une unité architectural* (Paris, [1928] 1989)

Le Corbusier, *Précisions sur un état présent de l'architecture et de l'urbanisme avec un Prologue Americain, un Corollaire Brésilien suivi d'une Température Parisienne et d'une Atmosphère Muscovite* (Paris, [1930] 1960)

Le Corbusier, 'Défense de l'architecture', *Architecture d'aujourd'hui* (10 October 1933), pp.38–64

Le Corbusier, *La Ville Radieuse* (Paris, 1935), translated as *The Radiant City* (New York, 1967)

Le Corbusier and P. Jeanneret, *Œuvre complète 1910–29* (Zurich, [1937], 1948)

Le Corbusier and P. Jeanneret, *Œuvre complète 1929–34* (Zurich, [1934] 1964)

Le Corbusier and P. Jeanneret, *Œuvre complète 1934–1938* (Zurich, 1938)

Le Corbusier-Saugnier, 'Trois rappels à MM les architectes', *L'Esprit Nouveau*, vol.1, no.1 (1920), pp.90–95

Le Corbusier-Saugnier, 'Des yeux qui ne voient pas … les paquebots', *L'Esprit Nouveau*, no.8 (April 1921), pp.845–55

Le Corbusier-Saugnier, 'Des yeux qui ne voient pas … III: Les Autos', *L'Esprit Nouveau*, no.10 (July 1921), pp.1139–51

Le Corbusier-Saugnier, *Vers une architecture* (Paris, 1923), translated as *Towards a New Architecture* (London, [1928] 1972)

The Lef Ring, 'Comrades! A clash of views!', translated in R. Taylor and I. Christie (eds), *The Film Factory: Russian and Soviet Cinema in Documents, 1896–1939* (London, 1988)

Léger, F., 'Essai critique sur la valeur plastique du film d'Abel Gance, La Roue', *Comoedia* (1922) translated in F. Léger, *Functions of Painting* (London, 1973)

Léger, F., 'L'esthétique de la machine', *Der Querschnitt*, vol.III (Berlin, 1923), translated in F. Léger, *Functions of Painting* (New York and London, 1973)

Léger, F., 'The Spectacle: Light, Color, Moving Image, Object-Spectacle', *Bulletin de l'effort moderne* (1924), translated in F. Léger, *Functions of Painting* (London, 1973)

Léger, F., 'Autour du "Ballet mécanique"' (1924–5), in F. Léger, *Fonctions de la peinture* (Paris, 1965)

Léger, F., *Fonctions de la peinture* (Paris, 1965), translated as *Functions of Painting* (London, 1973)

Levaco, R., *Kuleshov on Film* (Berkeley, 1974)

Levin, T.Y. (ed.), *Siegfried Kracauer: The Mass Ornament. Weimar Essays* (Cambridge, MA, 1995)

Lindner, W. and G. Steinmetz, *Die Ingenieurbauten in ihrer guten Gestaltung* (Berlin, 1923)

Lindsay, K.C. and P. Vergo (eds), *Kandinsky: Complete Writings on Art* (London, 1982)

Lloyd Wright, F., *Ausgeführte Bauten und Entwürfe von Frank Lloyd Wright* (Berlin, 1910)

Loos, A., 'Ornament et Crime', *L'Esprit Nouveau*, vol.1, no.2 (1920)

Lorant, S., *I Was Hitler's Prisoner* (Harmondsworth, 1939)

Lotz, W., 'Möbeleinrichtung und Typenmöbel', *Die Form*, vol.3, no.1 (1928), translated in T. Benton, C. Benton and D. Sharp, *Form and Function* (London, 1975)

Lubiński, P., 'Dobry Mebli', *Arkady* (June 1938)

Lurçat, A., 'Architecture Internationale', *Deuxième exposition annuelle du comité Nancy-Paris* (exh. cat., Nancy, 1926)

Lux, J.A., *Ingenieur-Aesthetik* (Munich, 1910)

McGrath, R., *Twentieth Century Houses* (London, [1934])

Malevich, K., *Suprematizm: 34 Risunok* (Vitebsk, 1919)

Malevich, K., 'Art and the Problem of Architecture. The Emergence of a New Plastic System of Architecture. Script for an Artistic-Scientific Film' (1927), translated in O. Bulgakowa (ed.), *Kazimir Malevich: The White Rectangle: Writings on Film* (Berlin, 1997)

Malevich, K., 'Painting and Photography: A letter to Laszlo Moholy-Nagy' (1927), translated in O. Bulgakowa (ed.), *Kazimir Malevich: The White Rectangle: Writings on Film* (Berlin, 1997)

Malevich, K., 'Pictorial Laws in Cinematic Problems' (1929), translated in O. Bulgakowa (ed.), *Kazimir Malevich: The White Rectangle: Writings on Film* (Berlin, 1997)

'Manifesto of International Constructivism', *De Stijl*, vol.5, no.8 (1922)

Man Ray, 'Sur le Réalisme Photographique', *Cahiers d'Art*, no.5–6 (1935), translated in C. Phillips (ed.), *Photography in the Modern Era: European Documents and Critical Writings, 1913–1940* (New York, 1989)

Marinetti, F.T., 'The Founding and Manifesto of Futurism', *Le Figaro* (Paris, 20 February 1909), translated in R.W. Flint, *Marinetti: Selected Writings* (London, 1972)

Marinetti, F.T., 'The New Religion – Morality of Speed' (1916), translated in R.W. Flint, *Marinetti: Selected Writings* (London, 1972)

Marinetti, F.T., A. Mazzoni and M. Somenzi, 'Futurist Manifesto of Aerial Architecture', published in *Sant'Elia* (1 February 1934), translated in http://www.futurism. org.uk/manifestos/manifesto48.htm

Marion, F.J., 'Internationalising the American Idea', *Collier's Weekly*, vol.19, no.10 (1918)

Martin, J., *Introduction to the Dance* (New York, 1939)

Martin, J.L., B. Nicholson and N. Gabo (eds), *Circle. International Survey of Constructive Art* (London, 1937)

May, E., 'Moscow. City Building in the USSR', *Das Neue Russland*, VII–IX (1931), translated in El Lissitzky, *Russia: An Architecture for a World Revolution* (Cambridge, MA, 1984)

Mayakovsky, V., 'The Relationship between Contemporary Theatre and Cinema and Art', *Kine-Zhurnal* (1913), translated in R. Taylor and I. Christie (eds), *The Film Factory: Russian and Soviet Cinema in Documents, 1896–1939* (London, 1988)

Mayakovsky, V., 'How Are You: A Day in Five Movie Details' (1927), in *Screen*, vol.12, no.4 (Winter 1971–2), pp.124–35

Mesendieck, B., *It's Up to You* (New York, 1931)

Meyer, A., *Eisenbauten, ihre Geschichte und Aesthetik* (Esslingen, 1907)

Meyer, E., *Der neue Haushalt* (Stuttgart, 1925)

Meyer, H., 'Die Neue Welt', *Das Werk*, vol.13, no.7 (1926), pp.205–24, translated in A. Kaes, M. Jay and E. Dimendberg, *The Weimar Republic Sourcebook* (Berkeley, 1994)

Meyer, H., 'Bauen', *Bauhaus*, vol.2, no.4 (1928)

Meyer, H., 'City Building in the USSR', *Das Neue Russland* (1931), translated in El Lissitzky, *Russia: An Architecture for a World Revolution* (Cambridge, MA, 1984)

Michelson, A. *Kino Eye: The Writings of Dziga Vertov* (Berkeley, 1984)

Michelucci, G., 'Contatti fra architetture antiche e moderne', *Domus* (February 1932), pp.70–71; (March 1923), pp.134–6; (August 1932), pp.460–61

Mies van der Rohe, L., 'Building', *G*, no.2 (September 1923), translated in F. Neumeyer, *The Artless Word, Mies van der Rohe on the Building Art* (Cambridge, MA, 1991)

Milhaud, D., *Le Train bleu* (Paris, 1924)

Modern Architecture International Exhibition (exh. cat., Museum of Modern Art, New York, 1932)

Moholy-Nagy, L., 'Produktion-Reproduktion', *De Stijl*, no.7 (1922), translated in K. Passuth, *Moholy-Nagy* (London, 1985)

Moholy-Nagy, L., *Malerei, Fotografie, Film* (Munich, 1925), translated as *Painting, Photography, Film* (London, 1969)

Moholy-Nagy, L., 'Das Bauhaus in Dessau', *Qualität*, vol.4, no.5/6 (May/June 1925), translated in K. Passuth, *Moholy-Nagy* (London, 1985)

Moholy-Nagy, L., 'Az ember és Láza', *Korunk*, no.4 (1929), pp.298–9, translated in K. Passuth, *Moholy-Nagy* (London, 1985)

Moholy-Nagy, L., *Von Material zu Architektur* (Dessau, 1929)

Moholy-Nagy, L., 'The Problems of Modern Film', *Telehor*, no.1–2 (Brno, [1932] 1936)

Moholy-Nagy, L., Letter to H. Read (Berlin, 24 January 1934), translated in K. Passuth, *Moholy-Nagy* (London, 1985)

Moholy-Nagy, L., *The New Vision* (New York, 1947)

Müller-Wulckow, W., *Deutsche Wohnung der Gegenwart* (Königstein, 1931)

Munzer, J., 'Tradycja I racjonalizm', *Architekura I Budownictwo*, no.11/12 (November/December 1938)

Muthesius, H., 'Der Kampf um das Dach', *Baukunst und Bauhandwerk*, no.2 (1927), extract translated in C. Benton (ed.), *Documents* (Milton Keynes, 1975)

Nash, P., 'The Colour Film', in C. Davy (ed.), *Footnotes to the Film* (London, 1938)

Näsström, G., *Svensk Funktionalism* (Malmö, 1930)

Newhall, B., *Photography: A Short Critical History* (New York, 1938)

Nilsen, V., *The Cinema as a Graphic Art* (London, 1937)

Nordström, L., *Lort-Sverige* (Stockholm, 1939)

Oud, J.J.P., 'Über die zukünftige Baukunst und ihre architektonischen Möglichkeiten', *De Stijl*, no.4 (1921)

Ozenfant, A. (under pen-name De Fayet), 'Revue de l'année, peinture ancienne et peinture moderne', *L'Esprit Nouveau*, no.11–12 (Paris, November 1921), n.p.

Ozenfant, A. and Ch.-E. Jeanneret, *Après le cubisme* (Paris, 1918)

[Ozenfant, A. and Ch.-E. Jeanneret], 'L'Esprit Nouveau', *L'Esprit Nouveau*, vol.1, no.1 (October 1920), n.p.

Ozenfant, A. and Ch.-E. Jeanneret, 'Le purisme', *L'Esprit Nouveau*, no.4 (Paris, 1921), pp.369–86

Ozenfant, A. and Ch.-E. Jeanneret, 'Formation de l'optique moderne', *L'Esprit Nouveau*, no.21 (March 1924), n.p.

Panofsky, E., 'Style and Medium in the Moving Pictures' (1934), in D. Talbot (ed.), *Film: An Anthology* (Berkeley, 1966)

Perriand, C., 'Wood or Metal? A Reply to John Gloag's article in our January issue', *The Studio*, vol.97, no.443 (1929), pp.278–89

Pevsner, N., *Pioneers of the Modern Movement* (London, 1936)

Pevsner, N., *An Inquiry into Industrial Art in England* (London, 1937)

Pevsner, N., *Pioneers of Modern Design from William Morris to Walter Gropius* (New York, 1949)

Phillips, C., *Photography in the Modern Era. European Documents and Critical Writings 1913–1940* (New York, 1989)

'Picture', *Disk*, no.1 (1 May 1923), translated in S. Bann (ed.), *The Tradition of Constructivism* (London, 1974)

Piscator, E., *Das Politische Theater* (Berlin, 1929), translated as *The political theatre* (London, [1963] 1980)

Platz, G., *Die Baukunst der neuesten Zeit* (Berlin, 1933)

Platz, G., *Wohnräume der Gegenwart* (Berlin, 1933)

Poslednaya futuristicheskaya vystavka kartin 0,10 (nol'-desyat') (Petrograd, 1915)

Preiss, E., *Neue Wege der Körperkultur* (Stuttgart, 1926)

Programme of the Working Group of Constructivists of Inkhuk, translated in S.O. Khan-Magomedov, *Rodchenko: The Complete Work* (London, 1986)

Rasch, H. and B., *Der Stuhl* (Stuttgart, 1928)

Read, H., *Art Now* (London, 1933)

Richards, J.M., *An Introduction to Modern Architecture* (Harmondsworth, 1940)

Rietvelt, G., 'De Stoel', in *De Werkende Vrouw* (1930), translated in M. Küper and Van I. Zijl, *Gerrit Th. Rietveld, the Complete Works* (exh. cat., Central Museum, Utrecht, 1992)

Riezler, W., 'Preface', in W. Pfleiderer, *Form ohne Ornament* (exh. cat., Deutscher Werkbund, Stuttgart, 1924)

Robinson, H. and K.R.G. Browne, *How to Live in a Flat* (London, 1936)

Rodchenko, A. 'Foto-montazh', *LEF*, no.4 (1924)

Rodchenko, A., 'The Paths of Modern Photography', *Novy Lef*, no.9 (April 1928), in C. Phillips (ed.), *Photography in the Modern Era. European Documents and Critical Writings* (New York, 1989)

Rokotov, T., 'Why is *October* difficult?', translated in R. Taylor and I. Christie (eds), *The Film Factory: Russian and Soviet Cinema in Documents, 1896–1939* (London, 1988)

Roth, J., 'Skyscrapers', *Berliner Börsen-Courier* (27 October 1929), translated in J. Roth, *What I Saw. Reports from Berlin 1920–33* (London, 2004)

Saleeby, C.W., *Sunlight and Health* (London, 1923)

Sant'Elia, A., 'Manifesto of Futurist Architecture 1914', in U. Apollonio (ed.), *Futurist Manifestos* (London, 1973)

Sartoris, A., *Gli elementi dell' architettura funzionale* (Milan, 1932)

Scheerbart, P., *Glass Architecture* (1914), translated in D. Sharp (ed.), *Glass Architecture by Paul Scheerbart and Alpine Architecture by Bruno Taut* (London, 1972)

Scheffauer, H.G., *New Vision in the German Arts* (New York, 1924)

Schlemmer, T., *The Letters and Diaries of Oskar Schlemmer* (Evanston, IL, 1972)

Schmarsow, A., *Grundbegriffe der Kunstwissenschaft am Übergang vom Altertum zum Mittelalter, kritisch erörtert und in systematischem Zusammenhange dargestellt* (Leipzig, 1905)

Schneck, A., *Der Stuhl* (Stuttgart, 1937)

Schwitters, Kurt, *Die neue Gestaltung in der Typographie* (Hanover, 1930)

Scott, W.D., *The Psychology of Advertising. A Simple Exposition of the Principles of Psychology in their Relation to Successful Advertising* (Bristol, [1908] 1998)

Seeger, M., *Der neue Wohnbedarf* (Stuttgart, 1931)

Shklovsky, V., *The Third Factory* (Ann Arbor, MI, [1926] 1977)

Sigrist, A. [Alexander Schwab], *Das Buch vom Bauen 1930 – Wohnungsnot, neue Technik, neue Baukunst, Städtebau aus sozialistischer Sicht* (Düsseldorf, 1930)

Stalin, J., 'A Year of Great Change', *Pravda* (7 November 1929), in J. Stalin, *Works*, vol.12 (Moscow, 1955)

Stam, M., 'Kollektive Gestalung', *ABC*, no.1 (1924), translated in C. Schelbert and M. Robinson, *ABC Beiträge zum Bauen 1924–8* (Baden, 1993)

Stam, M., 'Fort mit den Möbelkünstlern', in W. Gräff, *Innenräume* (Stuttgart, 1928), translated in T. Benton, C. Benton and D. Sharp, *Form and Function* (London, 1975)

'Statement of the International Faction of Constructivists' (1922), in S. Bann, *The Tradition of Constructivism* (London, 1974)

Steinmann, M., *CIAM: Dokumente 1928–1939* (Basle, 1979)

Surén, H., *Der Mensch und die Sonne* (Stuttgart, 1924), translated in *Man and Sunlight* (London, [1924] 1927)

Tatlin, V., 'My Answer to "Letter to the Futurists"' (March 1918), translated in A. Zhadova, *Tatlin* (London, 1988)

Tatlin, V., 'Iskusstvo v tekhniku' ['Art into Technology'], *Brigada khudozhnikov*, no.6 (1932), translated in L. Zhadova, *Tatlin* (London, 1988)

Tatlin, V. et al., 'Nasha predstoyashaya rabota' ['The Work Ahead of Us'], *VIII s'ezd sovetov. Ezhednevnyi byulletin s'ezda*, no.13 (1 January 1921)

Taut, B., *Die neue Wohnung? Die Frau als Schöpferin* (Leipzig, 1924)

Taut, B., *Die neue Baukunst in Europa und Amerika* (Stuttgart, [1929] 1979), translated as *Modern Architecture* (London, 1929)

Taylor, F.W., 'Shop Management', in *Transactions of the American Society of Mechanical Engineers*, 26 (1903), pp.1408–09

Taylor, F.W., *The Principles of Scientific Management* (New York, 1911)

Taylor, R. and I. Christie (eds), *The Film Factory: Russian and Soviet Cinema in Documents, 1896–1939* (London, 1988)

Teige, K., 'K teorii konstruktivismu', *Stavba*, no.7 (1928–2)

Teige, K., 'Deset let Bauhausu (Ten Years at the Bauhaus)', *Stavba*, no.8 (1929–30)

Teige, K., *The Minimum Dwelling* (*Nejmenší byt*) (Cambridge, MA, [1932] 2002)

Teige, K., 'Mundaneum', *Oppositions*, no.4 (1975)

Teige, K., *Modern architecture in Czechoslovakia and other writings* (Los Angeles, 2000)

Tschichold, J., *Die neue Typographie* (Berlin, 1928)

Tschichold, J., 'Display that has Dynamic Force. Exhibition Rooms designed by El Lissitzky', *Commercial Art* (January 1931)

Typenmöbel (Basle, 1929)

Tzara, T., 'Conference sur Dada', *Merz* (January 1924), reprinted in R. Motherwell (ed.), *The Dada Painters and Poets: An Anthology* (New York, 1951)

Van Doesburg, T., 'Aanteekeningen bij een Leunstoel van Rietveld', *De Stijl*, vol.2, no.11 (1919), p.135

Van Doesburg, T., 'Tot een Beeldende Architectuur', *De Stijl*, vol.6, no.6–7, series 12 (1924), pp.78–83

Vertov, D., 'We. A Version of a Manifesto' (1922), translated in R.Taylor and I. Christie (eds), *The Film Factory: Russian and Soviet Cinema in Documents, 1896–1939* (London, 1988)

Vertov, D., 'The Cine-Eyes: A Revolution', *Lef*, no.3 (1923), translated in R.Taylor and I. Christie (eds), *The Film Factory: Russian and Soviet Cinema in Documents, 1896–1939* (London, 1988), pp.89–93

Vertov, D., 'The Birth of Kino-Eye' (1924), in A. Michelson, *Kino Eye: The Writings of Dziga Vertov* (Berkeley, 1984)

Vischer, R., *Über das optische Formgefühl: Ein Beitrag zur Aesthetik* (Leipzig, 1873)

Von Laban, R., *A Life for Dance* (London, [1935] 1975)

Von Senger, A., *Krisis der Architektur* (Zurich, 1928)

Von Senger, A., *Die Brandfackel Moskaus* (Zurich, 1931)

Wagner, O., *Moderne Architektur* (Vienna, 1895), translated as *Modern Architecture* (Santa Monica, CA, 1988)

Winter, O., 'The Cinematograph', *The New Review* (May 1896), in *Sight and Sound* (Autumn 1982)

Wölfflin, H., *Prolegomena zu einer Psychologie der Architektur* (Munich, 1886)

'The Work Ahead of Us', *Daily Bulletin of the Eighth Congress of Soviets*, no.13 (1 January 1921), translated in J.E. Bowlt (ed.), *Russian Art of the Avant-Garde: Theory and Criticism, 1902–1934* (New York, 1976)

Worringer, W., *Abstraktion und Einfühlung* (Munich, 1908), translated in *Abstraction and Empathy* (London, 1953)

Žák, L., 'Über Metallmöbel', *Měsíc*, vol.1, no.11–12 (1932), pp.33–5, translated into German in J. Van Geest and O. Máčel, *Stühle aus Stahl* (Cologne, 1980)

Zelinskii, K., 'Letatlin', *Vechernaya Moskva*, no.89 (6 April 1932), translated in L. Zhadova, *Tatlin* (London, 1988)

Zervos, C., 'Les Expositions', *Feuilles volantes*, supplement to *Cahiers d'art*, no.1 (Paris, 1927), pp.6–8

Secondary sources

Abel, R., *French Cinema: The First Wave, 1915–29* (Princeton, 1984)

Abel, R. (ed.), *French Film Theory and Criticism*, vol.1 (Princeton, 1988)

Abramovic, N., *La Création du monde. Fernand Léger et l'art africain dans les collections Barbier-Mueller* (Paris, 2000)

Achleitner, F., 'Region, ein Konstrukt? Regionalismus, eine Pleite?', in F. Achleitner (ed.), *Region, ein Konstrukt? Regionalismus, eine Pleite?* (Basle, 1997)

Adams, M.B. (ed.), *Wellborn Science: Eugenics in Germany, France, Brazil, and Russia* (Oxford, 1990)

Albrecht, D., *Designing Dreams: Modern Architecture in the Movies* (New York, 2000)

Albrecht, D., R. Schonfeld and L. Stamm Shapiro, *Russel Wright: Creating American Lifestyle* (exh. cat., Cooper Hewitt Museum, New York, 2001)

Alexander, J., 'Parenthetical Paris, 1920–1925: Pound, Picabia, Brancusi and Léger', in R. Humphreys (ed.), *Pound's Artists* (London, 1985)

Allen, J., *Lubetkin. Architecture and the Tradition of Progress* (London, 1992)

Allen, R., *The Pan Am Clipper – A History of Pan Am's Flying Boats 1931–1946* (London, 2000)

Andrew, D. and S. Ungar, *Popular Front Paris and the Poetics of Culture* (Cambridge, MA, 2005)

Appignanesi, L., *The Cabaret* (London, 2004)

Armstrong, T., *Modernism, Technology and the Body* (Cambridge, 1998)

Art and Power, Europe under the Dictators 1930–45 (exh. cat., Hayward Gallery, London, 1996)

Art into Life: Russian Constructivism 1914–1932 (exh. cat., Henry Art Gallery, Seattle, 1990)

The Art of the Avant-Garde in Czechoslovakia 1918–1938 (exh. cat., IVAM Centre Julio Gonzalez, Valencia, 1993)

Attwood, L., *Creating the New Soviet Woman* (New York, 1999)

Aynsley, J., *Graphic Design in Germany 1890–1945* (London, 2000)

Babbington, B. and P.W. Evans, *Blue Skies and Silver Linings: Aspects of the Hollywood Musical* (Manchester, 1985)

Baer, N., *Theatre in Revolution: Russian Avant-Garde Stage Design 1913–1935* (exh. cat., The Fine Arts Museum of San Francisco, 1991)

Baines, P., *Penguin by Design: A Cover Story 1935–2005* (London, 2005)

Bak, P. et al., *G. Duiker Bouwkundig Ingenieur* (Rotterdam, 1982)

Banham, R., *Theory and Design in the First Machine Age* (London, 1960)

Bann, S. (ed.), *The Tradition of Constructivism* (London, 1974)

Barche, G., 'The Photographic Staging of the Image – On Stage Photography at the Bauhaus', in J. Fiedler (ed.), *Photography at the Bauhaus* (London, 1990)

Baron, S. and J. Damase, *Sonia Delaunay: The life of an artist* (London, 1995)

Barsac, J., *Charlotte Perriand: Un art d'habiter* (Paris, 2005)

Barthes, R., 'The Poor and the Proletariat', in R. Barthes, *Mythologies* (London, 1972)

Bathrick, D., 'Max Schmeling on the Canvas: Boxing as an Icon of Weimar Culture', *New German Critique*, no.51 (1990)

Bauquier, G., with N. Maillard, *Fernand Léger, Catalogue raisonné, 1925–1928* (Paris, 1993)

Bayman, B. and P. Conner, *Underground Official Handbook* (London, 1994)

Beecher, J. and R. Bienvenu, *The Utopian Vision of Charles Fourier* (Boston, 1971)

Ben-Ghiat, R., *Fascist Modernities: Italy, 1922–1945* (Berkeley, 2001)

Bennett Phillips, S., *Margaret Bourke-White: The Photography of Design, 1927–1936* (New York, 2003)

Benson, T. (ed.), *Expressionist Utopias: Paradise, Metropolis, Architectural Fantasy* (exh. cat., Los Angeles County Museum of Art, 2001)

Benson, T. (ed.), *Central European avant-gardes: Exchange and transformation 1910–1930* (exh. cat., Los Angeles County Museum of Art, 2002)

Benton, C., *A Different World. Émigré Architects in Britain 1928–1958* (London, 1996)

Benton, T., 'Background to the Bauhaus', in T. Faulkner (ed.), *Design 1900–1960 Studies in Design and Popular Culture of the 20th Century* (Newcastle upon Tyne, 1976)

Benton, T., 'The De La Warr Pavilion', in *Leisure in the Twentieth Century* (London, 1977)

Benton, T., *The Villas of Le Corbusier, 1920–1930* (New Haven, 1987)

Benton, T., 'Rome Reclaims its Empire', in D. Ades et al., *Art and Power. Europe Under the Dictators 1930–45* (London, 1996)

Benton, T., 'The little "maison de week-end" and the Parisian suburbs', *Massilia*, vol.1 (2002), pp.112–19

Benton, T., 'From Jeanneret to Le Corbusier: rusting iron, bricks and coal and the modern Utopia', *Massilia*, vol.2 (2003), pp.28–39

Benton, T. and C. Benton (ed.), *Images* (Milton Keynes, 1975)

Benton, T., C. Benton and G. Wood, *Art Deco 1910–1939* (London, 2003)

Benton, T., B. Campbell Cole and D. Sharp, *Pel and Tubular Steel Furniture of the Thirties* (London, 1977)

Berg-Pan, R., *Leni Riefenstahl* (Boston, 1980)

Berghaus, G., 'Girlkultur: Feminism, Americanism, and Popular Entertainment in Weimar Germany', *Journal of Design History*, vol.1, no.3–4 (1988), pp.193–219

Berghaus, G., *Italian Futurist Theatre, 1909–1944* (Oxford, 1998)

Bergmeier, H., and R. Lotz, *Hitler's Airwaves: The Inside Story of Nazi Radio Broadcasting and Propaganda* (New Haven, 1997)

Berman, M., *All That is Solid Melts Into Air* (London, 1983)

Betts, P., 'The New Fascination with Fascism. The case of Nazi Modernism', *Journal of Contemporary History* vol.37, no.4 (2002), pp.541–58

Betts, P., *The Authority of Everyday Objects* (Berkeley, 2004)

Birgus, V. et al., *Czech Photographic Avant-Garde, 1918–1948* (Cambridge, MA, 2002)

Blaszczyk, R., *Imagining Consumers: Design and Innovation from Wedgwood to Corning* (Baltimore, MD, 2000)

Blau, E., *The Architecture of Red Vienna, 1919–1934* (Cambridge, MA, 1999)

Bloch, E., *Prinzip Hoffnung* (Frankfurt, 1959)

Boersma, L.S., 'On Art, Art Analysis and Art Education: The Theoretical Charts of Kazimir Malevich', in Y. Korolev and E.N. Petrova (eds), *Kazimir Malevich 1878–1935* (exh. cat., Amsterdam, 1988)

Bogart, M.H., *Artists, Advertising and the Borders of Art* (Chicago and London, 1995)

Bogner, D. (ed.), *Friedrich Kiesler. Architekt, Maler, Bildhauer 1890–1965* (Vienna, 1988)

Bondanella, P., *The Eternal City* (Chapel Hill, 1987)

Bouhours, J.-M., 'D'images mobiles en ballets mécaniques', *Fernand Léger* (exh. cat., Centre Georges Pompidou, Paris, 1997)

Bouhours, J.-M. and R. Horrocks (eds), *Len Lye* (exh. cat., Centre Georges Pompidou, Paris, 2000)

Bourke-White, M., *Portrait of Myself* (London, 1964)

Bozdogan, S., *Modernism and Nation-Building. Turkish Architectural Culture in the Early Republic* (Washington, 2001)

Braun, E., *The Theatre of Meyerhold, Revolution on the Modern Stage* (London, 1979)

Briggs, A., *The History of Broadcasting in the United Kingdom*, vol.2, *The Golden Age of Wireless* (Oxford, 1965)

Brooks, H.A., *Le Corbusier's formative years: Charles-Edouard Jeanneret at La Chaux-de-Fonds* (Chicago, 1997)

Brownlow, K., *The Parade's Gone By* (London, 1968)

Bruckmüller, E. and H. Strohmeyer (ed.), *Turnen und Sport in der Geschichte Österreichs* (Vienna, 1998)

Brüning, U., *Das A und O des Bauhauses: Bauhauswerbung, Schriftbilder, Drucksachen, Ausstellungsdesign* (exh. cat., Bauhaus Archiv, Berlin, 1995)

Brüning, U., 'The Painting and Advertising Workshop', in J. Fiedler and P. Feierabend (eds), *Bauhaus* (Cologne, 1999)

Buchholz, K. et al. (eds), *Die Lebensreform*, 2 vols (exh. cat., Institut Mathildenhöhe, Darmstadt, 2001)

Bulgakowa, O., *Sergei Eisenstein: A Biography* (Berlin, 2001)

Bürger, P., *The Theory of the Avant-Garde* (Minneapolis, 1984)

Burian, E.R., 'The Architecture of Juan O'Gorman', in E.R. Burian (ed.), *Modernity and the Architecture of Mexico* (Austin, 1997)

Burkhardt, L., *The Werkbund: Studies in the History and Ideology of the Deutscher Werkbund 1907–1933* (London, 1980)

Calder, A. and D. Sheridan (eds), *Speak For Yourself: A Mass-Observation Anthology 1937–49* (London, 1984)

Calinescu, M., *Five Faces of Modernity* (Durham, NC, 1987)

Carey, J., *The Intellectuals and the Masses* (London, 1992)

Carol, A., *Histoire de l'Eugénisme en France* (Paris, 1995)

Cassou, J. and J. Leymarie, *Fernand Léger: Drawings and Gouaches* (London, 1973)

Cendrars, B., 'L'ABC du cinéma', in B. Cendrars, *Hollywood, La Mecque du cinema suivi de l'ABC du cinéma* (Paris, 1987)

Chanzit, G.F., *Herbert Bayer and Modernist Design in America* (London, 1987)

Chaplin, C., *My Autobiography* (London, 1964)

Châtelet, A., D. Lerch and J. Luc (eds), *L'école de plein air/Open-Air Schools* (Paris, 2003)

Christie, I., 'French Avant-Garde Film in the Twenties: from "Specificity" to Surrealism', in *film as Film: Formal Experiment in Film, 1910–1975* (exh. cat., Arts Council, 1979)

Christie, I., 'Down to Earth: *Aelita* Relocated', in R. Taylor and I. Christie (eds), *Inside the Film Factory: New Approaches to Russian and Soviet Cinema* (London, 1991)

Christie, I., 'Colour, Music, Dance, Movement: Len Lye in England, 1927–1944', in J.-M. Bouhours and R. Horrocks (eds), *Len Lye* (exh. cat., Centre Georges Pompidou, Paris, 2000)

Christie, I., 'Before the Avant-gardes: Artists and Cinema, 1910–1914', in I. Christie, *La decime musa/The Tenth Muse* (Udine, 2001)

Christie, I., 'Censorship, Culture and Codpieces: Eisenstein's influence in Britain during the 1930s and 1940s', in R. Lavalley and B.P. Scherr (eds), *Eisenstein at 100: A Reconsideration* (New Bunswick, 2001)

Christie, I., 'What Counts as Art in England: How Pevsner's Minor Canons Became Major', in P. Draper (ed.), *Reassessing Nikolaus Pevsner* (Aldershot, 2004)

Clark, T.J., *The Painting of Modern Life* (Princeton, 1984)

Clark, T.J., *Farewell to an Idea: Episodes from a History of Modernism* (New Haven, 1999)

Clarke, R.M., *The Land Speed Record 1920–1929* (Surrey, 1999)

Clifford, M.J., 'Helena Rubenstein's Beauty Salons, Fashion and Modernist Display', *Winterthur Portfolio*, vol.38, no.213 (Summer/Autumn 2003), pp.83–108

Cohen, J.-L., *André Lurçat, 1894–1970; Autocritique d'un Moderne* (Liège, 1995)

Cohen, J.-L., *Scenes of the World to Come. European Architecture and the American Challenge 1893–1960* (exh. cat., Canadian Centre for Architecture, Montreal, 1995)

Cohen, J.-L., 'International Rhetoric, Local Response', in H. Henket and H. Heynen (eds), *Back from Utopia. The Challenge of the Modern Movement* (Rotterdam, 2002)

Collins, P., *Changing Ideals in Modern Architecture* (London, 1965)

Collins, P., *Radios Redux: Listening in Style* (San Francisco, 1991)

Colomina, B., *Privacy and Publicity: Modern Architecture as Mass Media* (Cambridge, MA, 1994)

Conrad, P., *Modern Times, Modern Places* (London, 1998)

Constant, C., *Eileen Gray* (Berlin, 1996)

Cooke, C., 'Socialist-Realist Architecture', in M. Cullerne-Bown and B. Taylor (eds), *Art of the Soviets* (Manchester, 1993)

Cooke, C., *Russian Avant-Garde Theories of Art, Architecture and the City* (London, 1995)

Croce, A., *The Fred Astaire-Ginger Rogers Book* (New York, 1972)

Crowley, D., *National Style and Nation-State. Design in Poland from the Vernacular Revival* (Manchester, 1992)

Cullerne-Bown, M., *Socialist Realist Painting* (New Haven, 1998)

Curtis, D., *Experimental Cinema: A Fifty Year Evolution* (London, 1971)

Czech Modernism 1900–1945 (exh. cat., Museum of Fine Arts, Huston, 1989)

Dargis, M., 'Leni Riefenstahl, Art and Propaganda', in K. Macdonald (ed.), *Imagining Reality: The Faber Book of Documentary* (London, 1996)

Davies, E., S. Thompson and V. Nicholas, *Douglas DC-3: Sixty Years and Counting* (Elk Grove, CA, 1995)

Davies, K., 'Finmar and the furniture of the future: The sale of Alvar Aalto's plywood furniture in the UK 1934–1939', *Journal of Design History*, vol.11, no.2 (1998), pp.145–56

Davis, K., *FDR: The New Deal Years 1933–1937 A History* (New York, 1986)

Deak, F., 'Blue House', *The Drama Review*, vol.17, no.1 (March 1973), pp.35–46

Debord, G., *Société du spectacle* (Paris, 1967)

Deese, M., 'Gerald Summers and Makers of Simple Furniture', *Journal of Design History*, vol.5, no.3 (1992), pp.183–205

De Felice, R. and L. Goglia, *Mussolini Il mito* (Rome, 1983)

De Francia, P., *Fernand Léger* (New Haven, 1983)

De la Peña, C.T., *The Body Electric* (New York, 2003)

Delfini, L.D., *The Furniture Collection, Stedelijk Museum Amsterdam* (Amsterdam, 2004)

De Martino, S. and A. Wall, *Cities of Childhood, Italian Colonie of the 1930s* (exh. cat., Architectural Association, London, 1988)

De Montaut, P., 'Les cinémas d'actualité', *L'Architecture d'Aujourd'hui*, no.7 (1993), reprinted in J.-J. Meusy, 'Cinéac: une concepte, une architecture', *Les Cahiers de la Cinématheque*, no.66 (July 1997)

Derouet, C., 'Léger et le cinéma', in *Peinture, Cinema, Peinture* (exh. cat., Centre de la Vieille Charité, Marseilles, 1989)

Derouet, C. (ed.), *Une correspondance d'affairs. Correspondances Fernand Léger– Léonce Rosenberg 1917–1937* (Paris, 1996)

Dettingmeijer, R., 'De strijd om een goed gebouwde stad', in *Het Nieuwe Bouwen in Rotterdam* (exh. cat., Museum Boymans-Van Beuningen, Rotterdam, 1982)

Devětsil: Czech Avant-Garde Art, Architecture and Design of the 1920s and 30s (exh. cat., Museum of Modern Art, Oxford, 1990)

Dick, H.G. and D.H. Robinson, *The Golden Age of the Great Passenger Airships: Graf Zeppelin and Hindenburg* (Washington, 1992)

Dimendberg, E., 'The Will to Motorization: Cinema, Highways and Modernity', in *October*, no.73 (Summer 1995), pp.91–137

Dines, E. (ed.), *Paul Outerbridge: A Singular Aesthetic* (exh. cat., Laguna Beach Museum of Art, Laguna Beach, 1981)

'Il Disegno del Mobili Razionale in Italia 1928–1948', *Rassegna*, special issue, vol.2, no.4 (October 1980)

Dluhosch, E. and S. Rotislav (eds), *Karel Teige 1900–1951: L'Enfant Terrible of the Czech Modernist Avant-Garde* (Cambridge, MA, 1999)

Doordan, D., *Building Modern Italy: Italian Architecture 1914–1936* (Princeton, 1988)

Dover, H., *Home Front Furniture: British Utility Design, 1941–1951* (Aldershot, 1991)

Droste, M., *Bauhaus 1919–1933* (Cologne, 1993)

Elsaesser, T., *Metropolis* (London, 2000)

Erker, P., *Industrie-Eliten in der NS Zeit: Anpassungsbereitschaft und Eigeninterese von Unternehmern in der Rüstungs-und Kriegswirtschaft, 1936–1945* (Passau, 1994)

Eskildsen, U., 'Germany: The Third Reich', in J.C. Lemagny and A. Rouillé (eds), *A History of Photography. Social and Cultural Perspectives* (Cambridge, 1987)

Etlin, R., *Modernism in Italian Architecture, 1890–1940* (Cambridge, MA, 1991)

Ewig, I., I. Gaehtgens and M. Noell (eds), *Das Bauhaus und Frankreich. Le Bauhaus et La France, 1919–1940* (Berlin, 2002)

Eyles, A., *Gaumont British Cinemas* (Burgess Hill, 1996)

Falasca-Zamponi, S., *Fascist Spectacle: The Aesthetics of Power in Mussolini's Italy* (Berkeley, 2000)

Fernand Léger et le Spectacle (exh. cat., Musée national Fernand Léger, Biot, 1995)

Fiedler, J. (ed.), *Photography at the Bauhaus* (London, 1990)

Fiedler, J., *Paul Outerbridge, Jr* (Munich, 1996)

Fiedler, J. and P. Feierabend (eds), *Bauhaus* (Cologne, 1999)

Fisher, M., *Ezra Pound's Radio Operas: The BBC Experiments, 1931–1933* (Cambridge, MA, 2002)

Fishman, R., *Urban Utopia in the Twentieth Century* (London, 1980)

Flavin, S., *Form Follows Libido: Architecture and Richard Neutra in a Psychoanalytic Culture* (Cambridge, MA, 2004)

Fletcher, S., *Women First: The Female Tradition in English Physical Education 1880–1980* (London, 1984)

Forty, A., *Words and Buildings; A Vocabulary of Modern Architecture* (London, 2000)

Foster, M., *Henry J. Kaiser: Builder in the Modern American West* (Austin, 1989)

Foucault, M., 'Of Other Spaces', *Diacritics*, no.15 (1986)

Fox, S., *The Mirror Makers: A History of American Advertising* (London, 1990)

Frampton, K., *Modern Architecture* (London, 1980)

Frampton, K., 'Towards a Critical Regionalism: Six Points for an Architecture of Resistance', in H. Foster (ed.), *Postmodern Culture* (London, 1985)

Francillon, R.J., *McDonnell Douglas Aircraft Since 1920* (London, 1979)

Franciscono, M., *Walter Gropius and the Creation of the Bauhaus in Weimar: The Ideals and Artistic Theories of its Founding Years* (Urbana, 1971)

Frandsen, S.B., 'The war that we prefer': The Reclamation of the Pontine Marshes and Fascist Expansion', *Totalitarian Movements and Political Religions*, vol.2, no.3 (Winter 2001)

Frayling, C., *Things to Come* (London, 1995)

Frederich Kiesler. Artiste-architecte (exh. cat., Centre Georges Pompidou, Paris, 1996)

Freeman, J., 'Léger's *Ballet méchanique*', in R.E. Kuenzli (ed.), *Dada and Surrealist Film* (New York, 1987)

Friedman, A.T., *Women and the Making of the Modern House* (New York, 1998)

Friedman, E.B., 'The New Woman: Changing Views of Women in the 1920's', *Journal of American History*, vol.61 (September 1974), pp.372–93

Fritzsche, P., 'Nazi Modern', *Modernism/Modernity* (January 1996), pp.1–21

Fry, E.F. (ed.), *Functions of Painting* (New York and London, 1973)

Frykman, J., 'Pure and rational. The Hygienic Vision: A Study of Cultural Transformation in the 1930s, the New Man', *Ethnologia Scandinavica* (1981)

Gandt, R.L., *China Clipper: The Age of the Great Flying Boats* (Annapolis, MD, 1991)

Garland, K., *Mr Beck's Underground Map* (London, 1994)

Gautrand, J.-C., 'The Leica', in M. Frizot (ed.), *A New History of Photography* (Cologne, 1998)

Gerber, E.W., *American Women in Sport* (Reading, 1974)

Ghirardo, D.Y., 'Italian Architects and Fascist Politics: An Evaluation of the Rationalist Role in Regime Building', *Journal of the Society of Architectural Historians*, vol.39, no.2 (May 1980), pp.109–27

Gillingham, J., *Industry and Politics in the Third Reich* (London, 1985)

Glaeser, L., *Mies van der Rohe. Furniture and Furniture Drawings from the Design Collection and the Mies van der Rohe Archive* (exh. cat., Museum of Modern Art, New York, 1977)

Gold, J., 'Creating the Charter of Athens: CIAM and the functional city, 1933–43', *Town Planning Review*, vol.69, no.3 (July 1998), pp.225–48

Goldberg, V., *Margaret Bourke-White: A Biography* (New York, 1988)

Goldhagen S.W. and R. Legault (eds), *Anxious Modernisms* (Cambridge, MA, 2000)

Gordon, M., *Dada Performance* (New York, 1987)

Gordon, T. and M. Morgan, *Guernica: The Crucible of WWII* (New York, 1975)

Gowing, M., 'The Creative Mind in Advertising: Ashley', *Art and Industry*, vol.62, no.367 (January 1957), pp.11–15

The Great Utopia: The Russian Avant-Garde 1915–1932 (exh. cat., Stedelijk Museum, Amsterdam, 1992)

Green, C., *Léger and the Avant-garde* (New Haven and London, 1976)

Green, C., 'The architect as artist', in *Le Corbusier Architect of the Century* (exh. cat., Hayward Gallery, London, 1987)

Green, C., *Cubism and its Enemies: Modern Movements and Reaction in French Art, 1916–1928* (New Haven and London, 1987)

Green, C., 'Ozenfant, Purist Painting and the Ozenfant Studio', in *Le Corbusier, Architect of the Century* (exh. cat., Hayward Gallery, London, 1987)

Green, C., *Art in France* (New Haven and London, 2000)

Green, H., *Fit for America: Health, Sport and American Society* (Baltimore, 1998)

Greenberg, C., 'Avant-garde and Kitsch', *Partisan Review* (Fall 1939), reprinted in C. Greenberg, *The Collected Essays and Criticism*, vol.1 (Chicago, 1986)

Greenberg, C., 'Modernist Painting', *Forum Lectures* (Washington, 1960), reprinted in C. Greenberg, *The Collected Essays and Criticism*, vol.4 (Chicago, 1993)

Gresleri, G., P. Massaretti and S. Zagnoni, *Architettura italiana d'oltremare 1870–1940* (Venice, 1993)

Gresleri, G. and D. Matteoni, *La citta' mondiale: Anderson, Hébrard, Otlet, Le Corbusier* (Venice, 1982)

Grieve, A., *Isokon* (London, 2004)

Groys, B., *The Total Art of Stalinism* (Princeton, 1993)

Gunning, T., *The Films of Fritz Lang: Allegories of Vision and Modernity* (London, 2000)

Guttmann, A., *The Olympics: A History of the Modern Games* (Urbana, 1992)

Guttmann, A. and G. Pfister (eds), *A History of Women's Sports* (New York, 1991)

Hagemeister, M., 'Russian Cosmism in the 1920s and Today', in B.G. Rosenthal (ed.), *The Occult in Russian and Soviet Society* (New York, 1997)

Hagener, M., 'Avant-garde Culture and Media Strategies: The networks and discourse of the European film avant-garde, 1919–39' (PhD thesis, University of Amsterdam, 1995)

Hahl-Koch, J., *Kandinsky* (London, 1993)

Haiken, E., *Venus Envy, a History of Cosmetic Surgery* (Baltimore, 1997)

Haley, B., *The Healthy Body and Victorian Culture* (Cambridge, MA, 1978)

Hammer, M. and C. Lodder, *Constructing Modernity: The Art and Career of Naum Gabo* (Yale, 2000)

Hansen, M.B., 'The Mass Production of the Senses: Classical cinema as vernacular Modernism', in L. Williams and C. Gledhill (eds), *Reinventing Film Studies* (London, 2000)

Harrod, O.W., 'The Deutsche Werkstätte and the dissemination of mainstream modernity', *Studies in the Decorative Arts*, vol.10, no.2 (Spring–Summer 2003)

Hau, M., *The Cult of Health and Beauty in Germany: A Social History, 1890–1930* (Chicago, 2003)

Hawkins, J. and M. Hollis, *Thirties: British Art and Design before the War* (exh. cat., Hayward Gallery, London, 1979)

Hays, P., *Industry and Ideology: IG Farben in the Nazi Era* (Cambridge, 1987)

Heathcote, E., *Cinema Builders* (Chichester, 2001)

Hein, B. and W. Herzogenrath, *Film als Film: 1910 bis Heute* (Cologne, 1977)

Heller, R., 'Bridge to Utopia: The Brücke as Utopian Experiment', in T. Benson (ed.), *Expressionist Utopias: Paradise, Metropolis, Architectural Fantasy* (exh. cat., Los Angeles County Museum of Art, 1994)

Heller, S. and L. Fili, *British Modern: Graphic design between the wars* (San Francisco, 1998)

Henket, H. and H. Heynen (eds), *Back From Utopia. The Challenge of the Modern Movement* (Rotterdam, 2002)

Hennesey, W.J., *Russel Wright: American Designer* (Cambridge, MA, 1983)

Heskett, J., *Industrial Design* (London, 1980)

Heynen, H., *Architecture and Modernity* (Cambridge, MA, 1999)

Hight, E.M., *Picturing Modernism: Moholy-Nagy and Photography in Weimar Germany* (Cambridge, MA, and London, 1995)

Hirdina, H. (ed.), *Neues Bauen, Neues Gestalten: Das Neue Frankfurt/Die Neue Stadt* (Berlin, 1984)

Hobday, R., *The Healing Sun* (Forres, 1999)

Hoberman, J.M., *Sport and Political Ideology* (Austin, 1984)

Hobsbawm, E., *The Age of Extremes: The Short Twentieth Century, 1914–1991* (London, 1994)

Hoek, E. (ed.), *Theo Van Doesburg Oeuvre Catalogue* (Utrecht, 2000)

Holthusen, P.J.R., *The Fastest Men on Earth: 100 Years of the Land Speed Record* (Stroud, 1999)

Horkheimer, M. and T. Adorno, *Dialectic of Enlightenment* (London, 1979)

Hornborstel, W. et al. (ed.), *Mit voller Kraft: Russische Avantgarde 1910–1934* (exh. cat., Museum für Kunst und Gewerbe, Hamburg, 2001)

Horwood, C., '"Girls Who Arouse Dangerous Passions": women and bathing, 1900–39', *Women's History Review*, vol.9, no.4 (2000), pp.653–73

Hosking, G., *A History of the Soviet Union, 1917–1991* (London, 1992)

Huyssen, A., *After the Great Divide: Modernism, Mass Culture and PostModernism* (Basingstoke, 1986)

Innes, C., *Edward Gordon Craig: A Vision of the Theatre* (Ontario, Canada, 1998)

Jameson, F., 'The Politics of Utopia', *New Left Review*, (January–February 2005)

Jaromír Krejcar 1895–1949 (exh. cat., Galerie Jaroslava Fragnera, Prague, 1995)

Jay, M., *The Dialectical Imagination: A History of the Frankfurt School and the Institute of Social Research 1923–1950* (Boston, 1973)

Jensen, P.M., *The Cinema of Fritz Lang* (New York, 1969)

Jiří Kroha, Kubist Expressionist Funktionalist Realist (exh. cat, Architektur Zentrum Wien, 1998)

Jockel, N. and P. Stöckemann, *Flugkraft in goldene Ferne: Bühnentanz in Hamburg seit 1900* (exh. cat., Museum für Kunst und Gewerbe, Hamburg, 1989)

Jupp, K. and L. Piña, *Genuine Plastic Radios of the Mid-Century* (Atglen, PA, 1998)

Kahlo, F., *The Diary of Frida Kahlo: An Intimate Self-Portrait* (London, 1995)

Kasher, S., 'The Art of Hitler', *October*, no.59 (Winter 1991), pp.49–86

Katarzyna Kobro, 1898–1951 (exh. cat., Henry Moore Institute, Leeds, 1999)

Keinänen, T. et al., *Alvar Aalto Designer* (Helsinki, 2002)

Kentgens-Craig, M. (ed.), *The Dessau Bauhaus Building 1926–1999* (Basle, 1998)

Kinross, R., *Modern Typography* (London, 1992)

Kirby, M., *Futurist Performance* (New York, 1971)

Kirsch, K., *The Weissenhofsiedlung* (New York, 1989)

Kirstein, L. and B. Newhall, *The Photographs of Henri Cartier-Bresson* (New York, 1947)

König, W., *Volkswagen, Volksempfänger, Volksgemeinschaft. 'Volksprodukte' im Dritten Reich: Vom Scheitern einer nationalsozialistischen Konsumgesellschaft* (Berlin, 2004)

Koss, J., 'Bauhaus Theater of Human Dolls', *Art Bulletin* (December 2003), pp.724–45

Kremer, S., *Hugo Häring (1882–1958) Wohnungsbau Theorie und Praxis* (Stuttgart, 1985)

Krüger, A. and J. Riordan (eds), *The Story of Worker Sport* (Champaign, IL, 1996)

Kuchling, H. (ed.), *Oskar Schlemmer, Man* (London, 1971)

Kudělka, Z. and J. Chartný, *For New Brno; The Architecture of Brno 1919–1939*, 2 vols (Brno, 2000)

Kudryavtseva, T., *Circling the Square: Avant-Garde Porcelain from Revolutionary Russia* (London, 2004)

Kuhn, A., 'British Documentary in the 1930s and "Independence": Recontextualising a Film Movement', in D. Macpherson and P. Willemen (eds), *Traditions of Independence. British Cinema in the Thirties* (London, 1978)

Kumar, K., *Utopia and Anti-Utopia in Modern Times* (Oxford, 1987)

Küper, M. and I. Van Zijl, *Gerrit Th. Rietveld The complete works* (exh. cat., Centraal Museum, Utrecht, 1992)

Kyrou, A., *Le Surréalisme au cinema* (Paris, 1953)

Labisch, A., 'Doctors, Workers and the Scientific Cosmology of the Industrial World: Of the Social Construction of "Health" and the "Homo Hygenicus"', *Journal of Contemporary History*, vol.20 (1985)

Ladislav Sutnar – Praha – New York – Design in Action (exh. cat., Museum of Decorative Arts, Prague, 2003)

Lahti, M. et al., *Alvar Aalto, de l'oeuvre aux écrits* (exh. cat., Centre Georges Pompidou, Paris, 1972)

Lampugnani, V.M., 'Berlin Modernism and the Architecture of the Metropolis', in T. Riley and B. Bergdoll, *Mies in Berlin* (New York, 2002)

Lane, B.M., *Architecture and Politics in Germany 1918–1945* (Cambridge, MA, 1985)

Lane, B.M., *National Romanticism and Modern Architecture in Germany and the Scandinavian Countries* (Cambridge, 2000)

Launius, D., *Frontiers of Space Exploration* (Westpoint, CT, 1998)

Lavrentiev, A., *Varvara Stepanova: The Complete Work* (Cambridge, MA, 1988)

Lavrentiev, A., *Varvara Stepanova: A Constructivist Life* (London, 1988)

Lawder, S., *The Cubist Cinema* (New York, 1975)

Lears, T.J.J., *Fables of Abundance: A cultural history of advertising in America* (London, 1994)

Leatherbarrow, W.J., *Dostoevskii and Britain* (Oxford, 1995)

Lebeck, R. and B. Von Dewitz (eds), *Kiosk: A History of Photojournalism* (Göttingen, 2002)

Le Corbusier et Le Livre (exh. cat., Collegi d'Arquitectes de Catalunya, Barcelona, 2005)

Leet, S., *Richard Neutra's Miller House* (Princeton, 2004)

Lehman, A. and B. Richardson, *Oskar Schlemmer* (exh. cat., Baltimore Museum of Art, 1986)

Len Lye: A Personal Mythology (exh. cat., Auckland City Art Gallery, 1980)

Lesák, B., *Die Kulisse explodiert: Friedrich Kieslers Theaterexperimente und Architekturprojekte 1923–25* (Vienna, 1988)

Leslie, E., *Synthetic Worlds. Nature, Art and the Chemical Industry* (London, 2005)

Leśnikowski, W. (ed.), *East European Modernism, Architecture in Czechoslovakia, Hungary and Poland Between the Wars 1919–1939* (New York, 1996)

Lewis, J., *Penguin Special: The Life and Times of Allen Lane* (London, 2005)

Leyda, J., *Kino: A History of the Russian and Soviet Film* (London, 1960)

Lodder, C., *Russian Constructivism* (New Haven, 1983)

Lohmann, D. (ed.), *Film Architecture: Set designs from Metropolis to Blade Runner* (Munich, 1999)

Low, R., *A History of the British Film 1918–29* (London, 1971)

McCall, D., 'Reconstructing Schlemmer's Bauhaus Dances: A Personal Narrative', in A. Lehman and B. Richardson, *Oskar Schlemmer* (exh. cat., Baltimore Museum of Art, 1986)

McCoy, E., *Richard Neutra* (New York, 1960)

Machedon, L. and E. Scoffham, *Romanian Modernism: The Architecture of Bucharest, 1920–1940* (Cambridge, MA, 1999)

McKeown, J. and J., *Price Guide to Antique and Classic Cameras* (Grantsburg, WI, 1996)

Mack Smith, D., *Mussolini* (London, 1981)

Mcleod, M., 'Le Corbusier and Algiers', *Oppositions*, no.19/20 (Winter/Spring 1980), pp.54–85

Mcleod, M., '"Architecture or Revolution": Taylorism, Technocracy and Social Change', *Art Journal*, vol.43, no.2 (Summer 1983), pp.132–47

Mcleod, M., 'Undressing architecture: fashion, gender and modernity', in D. Fausch et al., *Architecture in Fashion* (Princeton, 1994)

McLeod, M. (ed.), *Charlotte Perriand: An Art of Living* (New York, 2003)

Magnus, G.H. and E.M. Keller (eds), *Zwischen Kunst und Industrie; Sonderausgabe für den Deutschen Werkbund* (Stuttgart, 1987)

Maletic, V., *Body-Space-Expression, the Development of Rudolf Laban's Movement and Dance Concepts* (Berlin, 1987)

Malgrave, H.F. and E. Ikonomou, 'Introduction', in R. Vischer et al., *Empathy, Form and Space: Problems in German Aesthetics 1873–1893* (Santa Monica, 1994)

Manning, S.A., *Ecstasy and Demon: Feminism and Nationalism in the Dances of Mary Wigman* (Berkeley, 1993)

Mansbach, S.A., *Standing in the Tempest: Hungarian Avant-Garde 1908–1930* (Cambridge, MA, 1991)

Mansbach, S.A., *Modern Art in Eastern Europe; From the Baltic to the Balkans, ca.1890–1939* (Cambridge, 1999)

Manske, B. and G. Scholz, *Täglich in der Hand: Industrieformen von Wilhelm Wagenfeld aus sechs Jahrzehnten* (exh. cat., Landesmuseum, Bremen, 1987)

Marcus, A., 'Reappraising Riefenstahl's *Triumph of the Will*', *Film Studies*, no.4 (Summer 2004), pp.75–86

Margolin, V., *The Struggle for Utopia* (Chicago, 1997)

Margolius, I. and J.G. Henry, *Tatra: The Legacy of Hans Ledwinka* (Harrow, 1990)

Margolius, I., *Automobiles by Architects* (Chichester, 2000)

Margolius, I., 'Tatra 600-Tatraplan, a mass-produced teardrop car', *Architectural Design*, vol.71, no.5 (September 2001), pp.84–91

Marquis, A.G., *Alfred H. Barr: Missionary for the Modern* (Chicago, 1989)

Martin, F. (ed.), *Emile Jacques-Dalcroze* (Neuchâtel, 1965)

Matthews, J.J., 'They had Such a Lot of Fun: The Women's League of Health and Beauty Between the Wars', *History Workshop Journal*, vol.30, no.1 (1990)

Meggs, P., *A History of Graphic Design* (New York, 1998)

Meikle, J.L., 'Streamlining: 1930–1955', in J. De Noblet (ed.), *Industrial Design: Reflection of a Century* (Paris, 1993)

Meikle, J.L., *American Plastic: A Cultural History* (New Brunswick, NJ, 1995)

Mellor, D. (ed.), *Germany: The New Photography 1927–33* (London, 1978)

Melzer, A., *Dada and Surrealist Performance* (Baltimore, 1994)

Menin, S. and F. Samuel, *Nature and Space: Aalto and Le Corbusier* (London, 2003)

Mester, T.A., *Movement and Modernism: Yeats, Elliott, Lawrence, Williams, and Early Twentieth-Century Dance* (Fayetteville, 1997)

Milner, J., *Vladimir Tatlin and the Russian Avant-Garde* (New Haven, 1983)

Miracco, R. (ed.), *Futurist Skies: Italian Aeropainting* (exh. cat., Estorick Collection, 2005)

Moholy-Nagy, S., *Moholy-Nagy, Experiments in Totality* (Cambridge, MA, 1969)

Moritz, W., 'The Films of Oskar Fischinger at Disney, or, Oskar in the Mousetrap', *Millimeter*, vol.5, no.2 (February 1977)

Moritz, W., 'American in Paris: Man Ray and Dudley Murphy', in J.-C. Horak, *Lovers of Cinema: The First American Film Avant-Garde, 1919–1945* (Madison, 1995)

Mosse, G.L., *The Nationalisation of the Masses: Political Symbolism and Mass Movements in Germany from the Napoleonic Wars through the Third Reich* (Ithaca, 1975)

Mumford, E., *The CIAM Discourse on Urbanism, 1928–1960* (Cambridge, MA, 2000)

Mumford, L., 'Yesterday's City of Tomorrow', *Architectural Record*, no.132 (November 1962), pp.139–44

Naegele, D., 'Object, Image, Aura: Le Corbusier and the Architecture of Photography', *Harvard Design Journal*, no.6 (Fall 1998), pp.1–6

Naylor, G., *The Bauhaus Reassessed: Sources and Design Theory* (New York, 1986)

Nerdinger, W., *Walter Gropius* (Cambridge, MA, 1985)

Nerdinger, W., *Bauen im Nationalsozialismus* (Munich, 1993)

Neumann, D., *Film Architecture: Set Designs from Metropolis to Blade Runner* (exh. cat., David Winton Bell Gallery, Munich, 1999)

Neumeyer, F., *The Artless Word, Mies van der Rohe on the Building Art* (Cambridge, MA, 1991)

Nicolaou, S., *Flying Boats and Seaplanes: A History from 1905* (Osceola, WI, 1998)

Nielsen, N.K., 'The Cult of the Nordic Superman – Between the Pre-Modern and the Modern', *The Sports Historian*, vol.19, no.8 (May 1999), pp.61–80

Nisbet, P. (ed.), *Andor Weininger: Works in the Busch-Reisinger Museum* (exh. cat., Cambridge, MA, 2000)

Noever, P. (ed.), *Die Frankfurter Küche von Margarete Schütte-Lihotzky* (Vienna, n.d.)

Noever, P. (ed.), *Margarete Schütte-Lihotzky: Soziale Architektur. Zeitzeugin eines Jahrhunderts* (Vienna, 1996)

Nolan, M., *Visions of Modernity: American Business and the Modernization of Germany* (Oxford, 1994)

Nolte, C.E., *The Sokol in the Czech Lands to 1914* (New York, 2002)

Nye, R., 'Degeneration, Neurasthenia and the Culture of Sport in Belle Epoch France', *Journal of Contemporary History*, vol.17 (1982), pp.51–68

Oberzaucher-Schüller, G. (ed.), *Ausdruckstanz. Eine mitteleuropäische Bewegung der ersten Hälfte des 20. Jahrhunderts* (Wilhelmshaven, 2004)

Oechslin, W., *Otto Wagner, Adolf Loos, and the Road to Modern Architecture* (Cambridge, 2002)

Ólafsdóttir, Á., *Le mobilier d'Alvar Aalto dans l'espace et dans le temps; la diffusion internationale du design entre 1920 et 1940* (Paris, 1998)

Orvell, M., *The Real Thing: Imitation and Authenticity in American Culture, 1880–1940* (Chapel Hill, NC, 1989)

Oskar Schlemmer (exh. cat., Musée Cantini, Marseilles, 1999)

Oskar Schlemmer Tanz-Theater-Bühne (exh. cat., Vienna Kunsthalle, 1997)

Overy, P. et al., *The Rietveld Schröder House* (Houten, 1988)

Oyarzun, F.P., 'Le Corbusier in South America: Reinventing the South American City', in T. Benton et al., *Le Corbusier and the Architecture of Reinvention* (London, 2003)

Pallasmaa, J. (ed.), *Alvar Aalto Furniture* (Helsinki, 1984)

Passanti, F., 'The vernacular, Modernism and Le Corbusier', *Journal of the Society of Architectural Historians*, vol.56, no.4 (December 1997), pp.438–45

Passuth, K., *Moholy-Nagy* (London, 1985)

Peiss, K., *Hope in a Jar: The making of America's beauty culture* (New York, 1998)

Pevsner, N., *A History of Building Types* (London, 1976)

Pfister, G., 'The Medical Discourse on Female Physical Culture in Germany in the 19th and Early 20th Centuries', *Journal of Sport History*, vol.17, no.2 (Summer 1990), pp.183–97

Pfister, G., 'Cultural Confrontations: German Turnen, Swedish Gymnastics and English Sport – European Diversity in Physical Activities from a Historical Perspective', *Culture, Sport, Society*, vol.6, no.1 (Spring 2003), pp.61–91

Phillips, S.B., *Margaret Bourke-White: The Photography of Design, 1927–1936* (Washington, 2003)

'Photojournalism in the 1920s: A Conversation between Felix H. Man, Photographer, and Stefan Lorant, Picture Editor' (1970), in B. Newhall (ed.), *Photography: Essays and Images* (New York, 1980)

Pollack, P., *The Picture History of Photography, from the Earliest Beginnings to the Present Day* (New York, 1969)

Pommer, R., 'The Flat Roof: A Modernist Controversy in Germany', *Art Journal*, vol.43, no.2 (Summer 1983), pp.158–69

Pommer, R., 'Mies van der Rohe and the Political Ideology of the Modern Movement in Architecture', in F. Schulze (ed.), *Ludwig Mies van der Rohe: Critical Essays* (Boston, 1986)

Pommer, R. and C. Otto, *Weissenhof 1927 and the Modern Movement in Architecture* (Chicago, 1991)

Powers, A., *Serge Chermayeff: Designer Architect Teacher* (London, 2001)

Prak, N.L., 'De Van Nelle fabriek te Rotterdam', *Bulletin K.N.O.B.* (1970), pp.130–33

Pritchard, J., *View from a long chair* (London, 1984)

Pultz, J., 'New Photography in the United States', in M. Frizot (ed.), *A New History of Photography* (Cologne, 1998)

Rabinbach, A., *The Human Motor: Energy, Fatigue and the Origins of Modernity* (New York, 1990)

Raffone, S., 'Il razionalismo dimenticato in Africa Orientale', *Casabella* vol.53, no.558 (June 1989), pp.34–7

Ragot, G. and M. Dion, *Le Corbusier en France* (Paris, 1997)

Rasch, B., *Material Konstruktion Form 1926–1930* (Düsseldorf, 1981)

Remington, R., *Lester Beall: Trainblazer of American Graphic Design* (New York, 1996)

Richardson, A., 'The birth of national hygiene and efficiency, Women and eugenics in Britain and America 1865–1915', in A. Heilmann and M. Beetham, *New Woman Hybridities: Femininity, feminism and international consumer culture 1880–1930* (London, 2004)

Richter, H., *Dada Profile* (Zurich, 1961)

Riefenstahl, L., *A Memoir* (New York, 1993)

Riley, T., *The International Style: Exhibition 15 and the Museum of Modern Art* (New York, 1992)

Riley, T. and B. Bergdoll, *Mies in Berlin* (exh. cat., Museum of Modern Art, New York, 2002)

Riordan, J., *Sport in Soviet Society: Development of Sport and Physical Education in Russia and the USSR* (Cambridge, 1977)

Robinson, D., *Chaplin: His Life and Art* (London, 1985)

Robinson, D., *Charlie Chaplin: The Art of Comedy* (London, 1996)

Ross, C., *Naked Germany* (Oxford, 1995)

Rothe, W., 'When Sports Conquered the Republic', *Studies in Twentieth Century Literature*, vol.4, no.1 (1980), pp.5–35

Roubal, P., 'Politics of Gymnastics: Mass Gymnastic Displays under Communism in Central and Eastern Europe', *Body & Society*, vol.9, no.2 (2003), pp.1–25

Roubal, P., '"Today the Masses Will Speak": Mass Gymnastic Displays as Visual Representation of the Communist State', in A. Bartetzky, M. Dmitrieva and S. Troebst (eds), *Neue Staaten – neue Bilder? Visuelle Kultur im Dienst staatlicher Selbstdarstellung in Zentral- und Osteuropa seit 1918* (Cologne, 2005)

Rubin, W.S., *Dada and Surrealist Art* (exh. cat., Museum of Modern Art, New York, 1968)

Rudberg, E., *Stockholmsutställningen 1930: Modernismens Genombrott i Svensk Arkitektur* (Stockholm, 1999)

Rutsky, R.L., 'The Mediation of Technology and Gender: Metropolis, Nazism, Modernism', *New German Critique*, no.59 (Spring/Summer 1993)

Ryan, D., *Daily Mail Ideal Home Exhibition through the 20th Century* (London, 1997)

Sayer, D., *The Coasts of Bohemia: A Czech History* (Princeton, 1998)

Schelbert, C. and M. Robinson, *ABC Beiträge zum Bauen 1924–8* (Baden, 1993)

Scheper, D., *Oskar Schlemmer, "Das Triadische Ballett" und die Bauhausbühne* (Berlin, 1988)

Schildt, G., *Alvar Aalto: The decisive years* (New York, 1986)

Schindler, C., *Hollywood in Crisis: Cinema and American Society 1929–1939* (London, 1996)

Schneider, R.C. and W.F. Stier, 'Leni Riefenstahl's "Olympia": Brilliant Cinematography or Nazi Propaganda?', *The Sport Journal*, vol.4, no.4 (Fall 2001)

Schulze, F., *Mies Van der Rohe, A Critical Biography* (Chicago, 1985)

Schwaiger, M. (ed.), *Bertolt Brecht und Erwin Piscator. Experimentelles Theater im Berlin der Zwanzigerjahre* (exh. cat., Österreichisches Theatermuseum, Vienna, 2004)

Schwartz, F.J., *The Werkbund: Design Theory and Mass Culture before the First World War* (New Haven, 1996)

Schwarz, A., *The Complete Works of Marcel Duchamp* (London, 1997)

Segal, H., *The Body Ascendant: Modernism and the Physical Imperative* (Baltimore, 1998)

Serenyi, P. (ed.), *Le Corbusier in Perspective* (Englewood Cliffes, NJ, 1975)

Setright, L.J.K., *Drive On! A Social History of the Motor Car* (London, 2003)

Shail, A., 'A Picture Feverishly Turned': Cinema and Literary Modernism in the UK, 1911–1928' (PhD thesis, University of Exeter, 2005)

Shaw-Miller, S., *Visible Deeds of Music: Music and Art from Wagner to Cage* (New Haven, 2002)

Sheremetyevskaya, N., 'The Search for New Dance Forms on the Variety Stage in the U.S.S.R. 1920–1930', in G. Oberzaucher-Schüller (ed.), *Ausdruckstanz. Eine mitteleuropäische Bewegung der ersten Hälfte des 20. Jahrhunderts* (Wilhelmshaven, 2004)

Short, I., 'Riding the Tiger in the Weimar Republic: Ambivalent images of the New Woman in the popular press of the Weimar Republic', in A. Heilmann and M. Beetham, *New Woman Hybridities: Femininity, feminism and international consumer culture, 1880–1930* (London, 2004)

Siukonen, J., *Uplifted Spirit, Earthbound Machines: Studies on Artists and the Dream of Flight 1900–1935* (Helsinki, 2001)

Smejikal, F. and R. Svacha, *Devětsil: Czech avant-garde art, architecture, and design of the 1920s and 1930s* (exh. cat., Museum of Modern Art, Oxford, 1990)

Sołtysik, M., *Na styku dwóch epok. Architektura gdyńskich kamienic okresu międzywojennego* (Gdynia, 2003)

Sontag, S., 'Fascinating Fascism', reprinted in S. Sontag, *Under the Sign of Saturn* (London, 1983)

Sörlin, S., 'Prophets and Deniers. The Idea of Modernity in Swedish Tradition', in C. Widenheim (ed.), *Utopia and Reality – Modernity in Sweden 1900–1960* (New Haven, 2002)

Spate, V., *Orphism* (Oxford, 1979)

Stack, P., *Movement is Life, the Autobiography of Prunella Stack* (London, 1973)

Stangos, N. (ed.), *Concepts of Modern Art* (London, 1981)

Stein, A. (ed.), *Arnold Schönberg – Letters* (London, 1964)

Steinberg, D.A., 'The Workers' International and the Red Sport Internationals 1920–28', *Journal of Contemporary History*, vol.13 (1978)

Stites, R., *Revolutionary Dreams: Utopian Vision and Experimental Life in the Russian Revolution* (Oxford, 1989)

Stomberg, J.R., *Power and Paper: Margaret Bourke-White, Modernity, and the Documentary Mode* (exh. cat., Boston University Art Gallery, 1998)

Stone, M., *The Patron State: Culture and Politics in Fascist Italy* (Princeton, 1998)

Strizler-Levine, N. (ed.), *Joseph Frank Architect and Designer* (exh. cat., Bard Center, New York, 1996)

Švácha, R., *Od moderny k funkcionalismu* (Prague, 1985)

Švácha, R., *The Architecture of New Prague, 1895–1945* (Cambridge, MA, 1995)

Tafuri, M., 'The Stage as "Virtual City": From Fuchs to the Totaltheater', in M. Tafuri, *The Sphere and the Labyrinth: Avant-Gardes and Architecture from Piranesi to the 1970s* (Cambridge, MA, 1992)

Tarkhanov, A. and S. Kavtaradze, *Stalinist Architecture* (London, 1992)

Taverne, Ed et al., *J.J.P. Oud 1890–1963, The Complete Works* (Rotterdam, 2001)

Taylor, R. (ed.), *Russian Poetics in Translation* (Oxford, 1982)

Taylor, R., *Eisenstein: Selected Writings 1922–1934* (London, 1988)

Taylor, R. (ed.), *Beyond the Stars; The Memoirs of Sergei Eisenstein* (Calcutta, 1995)

Taylor, R., *The Battleship Potemkin* (London, 2000)

Taylor, R. and I. Christie (eds), *The Film Factory: Russian and Soviet Cinema in Documents, 1896–1939* (London, 1988)

Thompson, G.L., *The Passenger Train in the Motor Age: California's Rail and Bus Industries, 1910–1941* (Columbus, 1993)

Thompson, K., *Exporting Entertainment: America in the World Film Market 1907–1934* (London, 1985)

Thomson, D., *The New Biographical Dictionary of Cinema* (New York, 2002)

Tilson, B., 'Plan furniture 1932–1938: The German connection', *Journal of Design History*, vol.3, no.2–3 (1990), pp.145–55

Todd, E.W., *The 'New Woman' Revised* (Berkeley, 1993)

Toepfer, K., *Empire, of Ecstacy: Nudity and Movement in German Body Culture, 1910–1935* (Berkeley, 1997)

Torre, S., 'The Esthetics of Reconciliation: Cultural Identity and Modern Architecture in Latin America', in H. Henket and H. Heynen (eds), *Back From Utopia. The Challenge of the Modern Movement* (Rotterdam, 2002)

Traum und Wirklichkeit: Wien 1870–1930 (exh. cat., Künstlerhaus Wien, 1985)

Troy, N.J., *The De Stijl Environment* (Cambridge, MA, 1983)

Troy, N.J., 'Figures of the Dance in De Stijl', *The Art Bulletin* (December 1984), pp.645–56

Troy, N.J., 'The Art of Reconciliation: Oskar Schlemmer's Work for the Theatre', in A. Lehman and B. Richardson, *Oskar Schlemmer* (exh. cat., Baltimore Museum of Art, 1986)

Troy, N.J., *Modernism and the Decorative Arts in France: Art Nouveau to Le Corbusier* (Yale, 1991)

Tsivian, Y., 'Man with a Movie Camera, Reel One', *Film Studies*, no.2 (Spring 2000), pp.51–76

Tupitsyn, M., 'From the Politics of Montage to the Montage of Politics. Soviet Practice 1919 through 1937', in M. Teitelbaum (ed.), *Montage and Modern Life, 1919–1942* (Cambridge, MA, 1992)

Tupitsyn, M., *Gustav Klutsis and Valentina Kulagina: Photography and Montage After Constructivism* (Göttingen, 2004)

Uchalová, E. *Czech Fashion 1918–1939* (Prague, 1996)

Udovicki-Sleb, D., 'C'était sur l'air du temps: Charlotte Perriand and the Popular Front', in M. McLeod (ed.), *Charlotte Perriand: An Art of Living* (New York, 2003)

Ueberhorst, H., *Frisch, Frei, Stark und Treu. Die Arbeitersportbewegung in Deutschland 1893–1933* (Düsseldorf, 1973)

Ungers, O.M., *Die gläserne Kette; Visionäre Architekturen aus dem Kreis um Bruno Taut 1919–1920* (exh. cat., Akademie der Künste, Berlin, 1963)

Usborne, C., *Politics of the Body in Weimar Germany* (London, 1992)

Van de Will, W., 'The Body and the Body Politic as Symptom and Metaphor in the Transition of German Culture to National Socialism', in B. Taylor and W. van de Will, *The Nazification of Art* (Winchester, 1990)

Van Geest, J. and O. Máčel, *Stühle aus Stahl* (Cologne, 1980)

Van Straaten, E., *Theo van Doesburg Painter and Architect* (The Hague, 1988)

Vetter, A.K., *Die Befreiung des Wohnens* (Berlin, 2000)

Vöge, P., *The Complete Rietveld Furniture* (Rotterdam, 1993)

Vogel, K., 'The Transparent Man – some comments on the history of a symbol', in R. Bud et al. (eds), *Manifesting Medicine, Bodies and Machines* (Amsterdam, 1999)

Von Ankum, K. (ed.), *Women in the Metropolis: Gender and Modernity in Weimar Culture* (Berkeley, 1997)

Von Moos, S. and A. Ruegg (eds), *Le Corbusier before Le Corbusier: Applied arts, architecture, painting, photography, 1907–1922* (New Haven, 2002)

Von Vegesack, A., *Deutsche Stahlrohrmöbel* (Munich, 1986)

Ward, J., *Weimar Surfaces: Urban visual culture in 1920's Germany* (Los Angeles, 2001)

Ware, K.C., 'Photography at the Bauhaus', in J. Fiedler and P. Feierabend (eds), *Bauhaus* (Cologne, 1999)

Weindling, P., *Health, Race and German Politics Between National Unification and Nazism 1870–1945* (Cambridge, 1989)

Weininger, A., 'The "Fun Department" of the Bauhaus', in P. Nisbet (ed.), *Andor Weininger: Works in the Busch-Reisinger Museum* (exh. cat., Cambridge, MA, 2000)

Weininger in Wahn – Arbeiten fürs Bauhaus/Works for the Bauhaus (exh. cat., Schloß Wahn, Cologne, 1999)

Weiss, E., *Rodtschenko: Fotografien 1920–1938* (Cologne, 1978)

Welch, D., *The Third Reich: Politics and Propaganda* (London, 1993)

Westerbrook, C. and J. Meyerowitz, *Bystander: A History of Street Photography* (London, 1994)

Weston, R., *Villa Mairea* (London, 1992)

White, M., *De Stijl and Dutch Modernism* (Manchester and New York, 2003)

Whyte, I.B., *The Crystal Chain Letters; Architectural Fantasies by Bruno Taut and His Circle* (Cambridge, MA, 1985)

Whyte, I.B., 'The Expressionist Sublime', in T. Benson (ed.), *Expressionist Utopias: Paradise, Metropolis, Architectural Fantasy* (exh. cat., Los Angeles County Museum of Art, 1994)

Whyte, I.B., 'National Socialism and Modernism', in D. Ades et al., *Art and Power: Europe Under the Dictators 1930–45* (London, 1995)

Widenheim, C. (ed.), *Utopia and Reality – Modernity in Sweden 1900–1960* (New Haven, 2002)

Wigley, M., 'White-out: Fashioning the Modern', in D. Fausch et al., *Architecture in Fashion* (Princeton, 1994)

Wigley, M., *White Walls and Designer Dresses: The Fashioning of Modern Architecture* (Cambridge, MA, 1995)

Wilk, C., *Marcel Breuer: Furniture and Interiors* (exh. cat., Museum of Modern Art, New York, 1981)

Wilk, C., *Thonet: 150 Years of Furniture* (Woodbury, NY, 1989)

Willett, J., *The New Sobriety: Art and Politics in the Weimar Period 1917–1933* (London, 1978)

Willett, J., *The Weimar Years* (London, 1984)

Willett, R., *The Americanization of Germany, 1945–1949* (London, 1989)

Willi Baumeister et la France (exh. cat., Musée d'art moderne, Saint-Etienne, 1999)

Williams, R.C., *Artists in Revolution: Portraits of the Russian Avant-Garde 1905–1925* (London, 1977)

Williams, T., *A Short History of Technology, c. 1900–1950* (Oxford, 1982)

Willis, J., 'Machines for Healing', *Architecture Australia* (July–August 2002)

Wilson, C., *The Other Tradition of Modern Architecture* (London, 1995)

Wilson, E., *Adorned in Dreams: Fashion and Modernity* (London, 1985)

Wilson, R.G., D.H. Pilgrim and D. Tashjian, *The Machine Age in America, 1918–1941* (exh. cat., Brooklyn Museum, 1986)

Wingler, H.M., *The Bauhaus: Weimar, Dessau, Berlin, Chicago* (Cambridge, MA, 1976)

Winner, L., 'Do Artefacts Have Politics?', in L. Winner, *The Whale and the Reactor* (Chicago, 1988)

Witkovsky, M., 'Staging language: Mila Mayerova and the Czech book Alphabet', *The Art Bulletin* (March 2004), pp.114–35

Wollen, P., *Raiding The Icebox: Reflections on Twentieth-Century Culture* (London, 1993)

Wollen, P., '*La Règle du jeu* and Modernity', *Film Studies*, no.1 (1999), pp.5–13

Wrede, S., *The Architecture of Erik Gunnar Asplund* (London, 1980)

Wright, R. and M. Wright, *Guide to Easier Living* (New York, 1950)

Young, D.S., *Minox – Marvel in Miniature* (Bloomington, 2000)

Young, G.M., *Nikolai F. Fedorov: An Introduction* (Belmont, MA, 1979)

Zhadova, A., *Tatlin* (London, 1988)

Zimmerman, K., *Burlington's Zephyrs* (Osceola, WI, 2004)

Die Zwanziger Jahre des Deutschen Werkbunds (Giessen, 1982)

Picture Credits

Frontispiece, cat.32b Museo Civico, Palazzo Volpi
1.1, cat.88a, cat.88b, cat.98a, cat.98b, cat.103a Nederlands Architectuur Instituut, Rotterdam © DACS 2005
1.2, 2.15, 2.16, cat.36, 3.20, 3.25, 5.18, 5.19, 5.20, cat.105a, cat.106, 9.5, 9.9, 9.10, 9.11, 9.12, 9.14, cat.205, cat.209 © FLC/ADAGP, Paris and DACS, London 2005
1.3, 1.9, cat.15a, cat.15b, cat.29b, 4.8, 4.20, 5.6, cat.134c, cat.144, 6.2, 6.6, 7.11 Bauhaus Archiv, Berlin
1.4 The State Museum of Art, Riga. Photo: Normunds Braslins © ARS, NY and DACS, London 2005
1.5 Muzeum Sztuki Lodz
1.7, cat.176, cat.242a, cat.242b, cat.243b The Museum of Decorative Arts, Prague. Photo: Gabriel Urbánek © Ladislav Sutnar, reproduced with the permission of the Ladislav Sutnar Family
1.8 Courtesy: Corkin Shopland Gallery, Toronto
1.10 Alvar Aalto Museum. Photo © R.C. Snellman 2005
1.11, 4.5, cat.100, cat.125, cat.128, cat.130, cat.131, cat.133, cat.166, 7.3, 10.1 Collection Merrill C. Berman. Photo: Jim Frank
1.12 Victoria and Albert Museum, London © ADAGP, Paris and DACS, London 2005
2.1, cat.9, 3.5, 3.6, 4.13, cat.80a Digital image © 2005 The Museum of Modern Art, New York/Scala, Florence
2.2 State Hermitage Museum, St Petersburg © ADAGP, Paris and DACS, London 2005
2.3 Bildarchiv Foto Marburg
2.4 Werkbundarchiv – Museum der Dinge, Berlin
2.5 Collectie Centraal Museum, Utrecht
2.6, 2.17, 2.25, cat.28, cat.45, 5.2, cat.114b, cat.114c, cat.115b, cat.117, cat.134a, cat.134b, cat.136, 6.8, 10.16 Bauhaus Archiv, Berlin © DACS 2005
2.8, cat.213a, cat.213b, cat.213c, cat.213d © Tate, London 2005
2.9 State Russian Museum, St Petersburg
2.10 Stedelijk Museum Amsterdam
2.11 Collection of the Gemeentemuseum Den Haag © 2006 Mondrian/Holtzman Trust c/o hcr@hcr-international.com
2.12, 3.22, cat.55, 5.22, cat.118, cat.135, cat.147, cat.150, cat.154, 10.10, 10.17 Victoria and Albert Museum, London © DACS 2005
2.14 Ottavio and Rosita Missoni Collection © DACS 2005
2.18, 2.19, 2.20, 10.4 Schusev State Museum of Architecture, Moscow
2.21, 4.6 Rodchenko and Stepanova Archive, Moscow
2.22 Collection Van Abbemuseum, Eindhoven © DACS 2005
2.23, cat.42c Private Collection © Rodchenko & Stepanova Archive © DACS 2005
2.24, 5.1, cat.110 Nederlands Architectuur Instituut, Rotterdam/Collection Van Eesteren-Fluck & Van Lohuizen-Foudation, The Hague

cat.43, cat.57, cat.84a The Bakhrushin State Theatrical Museum, Moscow
cat.4 Museum of Private Collections, Moscow
cat.6 The Porcelain Museum, State Hermitage Museum, St Petersburg © DACS 2005
cat.7, cat.196a, cat.196b The State Museum of Art, Riga © ARS, NY and DACS, London 2005
cat.17 Kunstsammlungen Chemnitz Photo: May Voigt, Chemnitz
cat.19 National Technical Museum
cat.22a, cat.165, cat.216 Stedelijk Museum Amsterdam © DACS 2005
cat.22b, cat.22c Collectie Centraal Museum, Utrecht © DACS 2005
cat.25b Deutsches Spielzeugmuseum, Sonneberg
cat.27a bpk/Kunstbibliothek, Staatliche Museen zu Berlin. Photo: Dietmar Katz
cat.27b, 5.28, 6.7 Deutsches Architekturmuseum Frankfurt-am-Main
cat.29a Photo: Tobias Adam, Bauhaus-Universität Weimar © DACS 2005
cat.30 © Wenzel-Hablik-Foundation, Itzehoe
cat.37 Photo Boissonnas © FLC/ADAGP, Paris and DACS, London 2005
3.1 © The Trustees of The British Museum © DACS 2005
3.2 Kunstmuseum Basel, Martin Bühler © ADAGP, Paris and DACS, London 2005
3.3 © Aktiebolaget SKF
3.4, 9.8, 9.13, 9.16, cat.210b Archives Charlotte Perriand, Paris © ADAGP, Paris
3.7 Digital image © 2005 The Museum of Modern Art, New York/Scala, Florence © FLC/ADAGP, Paris and DACS, London 2005
3.8 Nederlands Architectuur Instituut, Rotterdam
3.9, 10.21 RIBA Library Photographs Collection
3.10, 3.26 Moderna Museet Stockholm © Succession Marcel Duchamp/ADAGP, Paris and DACS, London 2005
3.11 Photograph © 1989 The Metropolitan Museum of Art
3.12, 3.13, cat.212, cat.263 Wilson Centre for Photography
3.14 Photograph © 1994 The Metropolitan Museum of Art
3.15 Alex Lachmann Gallery, Cologne © DACS 2005
3.16 Russian State Archive of Literature and Art
3.17 University of East Anglia Collection of Abstract and Constructivist Art. Photo: James Austin © DACS 2005
3.18, 10.5 Schusev State Museum of Architecture, Moscow © DACS 2005
3.19 Photo: Galerie Schlichtenmaier, Grafenau/Stuttgart © DACS 2005
3.23 National Gallery of Art, Ottawa © ADAGP, Paris and DACS, London 2005

3.24, cat.187, cat.188, cat.189, 11.11 Science Museum/Science & Society Picture Library
cat.40 Victoria and Albert Museum, London, National Art Library © ADAGP, Paris and DACS, London 2005
cat.41a, cat.41b Archivio Sillabe – Livorno
cat.42a Rodchenko and Stepanova Archives, Moscow
cat.42b Victoria and Albert Museum, London/Rodchenko and Stepanova Archives, Moscow
cat.51 Digital image © 2005, The Museum of Modern Art, New York/Scala, Florence © Man Ray Trust/ADAGP, Paris and DACS, London 2005
cat.56 Hungarian National Gallery Budapest © DACS 2005
cat.63a, 5.10, cat.244a, cat.244b, cat.262, cat.265 The Museum of Decorative Arts, Prague. Photo: Gabriel Urbánek
cat.63b Collection Merrill C. Berman. Photo: Jim Frank © The Heartfield Community of Heirs/VG Bild-Kunst, Bonn and DACS, London 2005
cat.63c Collection of the Gemeentemuseum Den Haag © DACS 2005
cat.63d Photograph © 1989 The Metropolitan Museum of Art © DACS 2005
cat.66 Private Collection
cat.68, cat.253 British Film Institute
4.1, 4.18, 4.19, cat.72e, cat.169 © Photo Archive C. Raman Schlemmer, Oggebbio, Italy. The Oskar Schlemmer Theatre Estate, Collection UJS
4.2 Photo Rijksbureau voor Kunsthistorische Documentatie, Den Haag; Van Doesburg Archief, Schenking Van Moorsel (AB 11289/2053)
4.3 © Österreichische Friedrich und Lillian Kiesler-Privatstiftung
4.4 Photo: Nils-Albert Eriksson © ADAGP, Paris and DACS, London 2005
4.7 Kunstsammlungen zu Weimar, Bauhaus-Museum
4.9 Theaterwissenschaftliche Sammlung, Cologne University
4.10, 4.11 © Hattula Moholy-Nagy, Ann Arbor, Michigan. Digital image © 2005 The Museum of Modern Art, New York/Scala, Florence
4.12 Collection of the Gemeentemuseum Den Haag © DACS 2005
4.14 Theaterwissenschaftliche Sammlung, Cologne University © DACS, London and VAGA, New York 2005
4.15, 4.16 Musée National d'Art Moderne, Paris, Legs Nina Kandinsky 1981 © ADAGP, Paris and DACS, London 2005
cat.71a, cat.211 State Tretyakov Gallery, Moscow
cat.71b Theaterwissenschaftliche Sammlung, Cologne University. Photostudio Fuis
cat.72a Courtesy of the Busch-Reisinger-Museum, Harvard University Art Museums. Photo: Katya Kallsen
cat.73a, cat.73b, 7.1, 7.16, 7.17, cat.200, cat.202 Private Collection © Rodchenko & Stepanova Archive

cat.78, cat.83 The Bakhrushin State Theatrical Museum, Moscow © DACS 2005
cat.80b, 10.8 Collection Alberto Sartoris
cat.81 Courtesy of the Busch-Reisinger-Museum, Harvard University Art Museums. Photo: Katya Kallsen © DACS 2005
5.3 Collection Alberto Sartoris, photograph by Marc Vaux
5.4, 7.5, 9.17 Collection Alberto Sartoris, unsigned photograph
5.5 Collection Alberto Sartoris, photograph by Otto Lossen
5.7, 7.22 © Ullstein Bild
5.8, 5.21 Stadtarchiv Stuttgart
5.9 Collection Alberto Sartoris. Photograph by Crimella
5.11, 5.15, 5.16, cat.105b gta-Archiv/ETH-Zürich: Nachlass Sigfried Giedion
5.13 Collection Merrill C. Berman. Photo: Jim Frank © DACS 2005
5.14 Estate of K. Lonberg-Holm, New York
5.17 Collection Alberto Sartoris, photograph by Sigfried Giedion
5.23 Akademie der Kuenste Berlin
5.24 Staedtische Kunsthalle Mannheim © DACS 2005
cat.86, 7.9, cat.185a, cat.185b Nederlands Architectuur Instituut, Rotterdam
cat.90 Historisches Museum Wien
cat.92 Sammlungen der Universität für angewandte Kunst Wien (Collections of the University of Applied Art, Vienna)
cat.98c Nederlands Architectuur Instituut, Rotterdam © Beeldrecht Foundation, Amsterdam/the Oud heirs © DACS 2005
cat.99, cat.184 Courtesy of the Busch-Reisinger-Museum, Harvard University Art Museums. Photo: Photographic Services © DACS 2005
cat.101b Collection Merrill C. Berman. Photo: Jim Frank © Ladislav Sutnar, reproduced with the permission of the Ladislav Sutnar Family
cat.102 Collection Alberto Sartoris, photograph by Arthur Köster
cat.115a Bauhaus Archiv, Berlin/photo: Markus Hawlik © Archive Gertrud and Alfred Arndt, Darmstadt
cat.121 © Hattula Moholy-Nagy, Ann Arbor, Michigan
cat.126, cat.132 Collection Merrill C. Berman. Photo: Jim Frank © DACS 2005
cat.129 © Ladislav Sutnar, reproduced with the permission of the Ladislav Sutnar Family
cat.137a Photograph © 2002 The Metropolitan Museum of Art © DACS 2005
cat.140, 10.3 Victoria and Albert Museum, London © ARS, NY and DACS, London 2005
cat.141, cat.142 Victoria and Albert Museum, London © Bildkunst

Index

Figures in *italics* refer to illustration captions
Figures in **bold** refer to catalogue entries